Modern Art

Painting · Sculpture · Architecture

Third Revised Edition

Sam Hunter · John Jacobus · Daniel Wheeler

Harry N. Abrams, Inc., Publisher

Conceived and produced by The Vendome Press, New York Designer: Marlene Vine Cover / jacket design: Dirk Luykx

Library of Congress Cataloging-in-Publication Data Hunter, Sam, 1923— Modern art : painting, sculpture, architecture / Sam Hunter, John Jaobus, Daniel Wheeler. — 3rd rev. ed. p. cm. Includes bibliographical references and index. ISBN 0–8109–4383–2 ISBN 0–13–924705–X 1. Art, Modern—19th century. 2. Art, Modern—20th century. I. Jacobus, John M. II. Wheeler, Daniel. III. Title. N6447. H86 2000 709'.04—dc21 99–35573

Copyright © 2000 The Vendome Press, New York

Published in 2000 by Harry N. Abrams, Incorporated, New York All rights reserved. No part of the contents of this book may be reproduced, in any form or by any means, without the written permission of the publisher.

ABRAMS Harry N. Abrams, Inc. 100 Fifth Avenue New York, N.Y. 10011 www.abramsbooks.com

Printed and bound by RCS Libri & Grande Opere, Milan, Italy

PHOTOGRAPHIC CREDITS: In addition to the caption credits, the following photographers, agents, and archives are gratefully acknowledged as the sources of the images cited by figuire number. Fuirther, it should be noted that many of the art works reproduced in this volume are subject to claims of copyright in the United States and throughout the world, particularly for those artists represented by ADAGP and SPADEM, both located in Paris and exclusively represented in the United States by Artists Rights Society, New York. For other aritsts, mainly American, the copyright agent is VAGA, New York.

ABBREVIATIONS: ARS (Artists Rights Society, New York); SDPRMN (Service de Documentation Photographique de la Réunion des Musées Nationaux, Paris); MoMA (Muiseum of Modern Art, New York); SRGF (Solomon R. Guggenheim Foundation, New York); MMoA (Metropolitan Museum of Art, New York).

12. Giraudon/ARS; 15. ARS, Erich Lessing; 22. ARS, Erich Lessing; 30. SDPRMN; 32. Grayden Wood; 33. SDPRMN; 34. Grayden Wood; 49. Photo APN, Paris; 50. © All Rights Reserved; 52. David Mathews © President and Fellows of Harvard College, Harvard University; 63. Carmelo Guadagno © SRGF; 66. Giraudon/ARS; 113. © 1999 MoMA; 165. Giraudon/ARS; 168. Hans Petersen; 169, 170. Giraudon/ARS; 175. © 1995 Barnes Foundation; 213. © 1999 MoMA; 229. Photo APN, Paris; 232. Lee B. Ewing © SRGF; 242. SDPRMN; 265. A.E. Dolinski; 297. Michael Tropea, Chicago; 303. © ARS; 331. SDPRMN; 380. © 1999 MoMA; 414. © Estate of Mrs. G.A. Wyndham-Lewis; 415. ARS; 423. Ezra Stoller © ESTO; 437. © 1999, Art Institute of Chicago, All Rights Reserved; 439. © MMoA; 445. © 1999 MoMA; 451. © MMoA; 465. G.E. Kidder-Smith; 468. Bartlett Hendricks; 470. Balthazar Korab Ltd., Mich.; 481. eeva-inkeri; 487. © 1999, Art Institute of Chicago, All Rights Reserved; 492. © MMoA; 494. Hans Namuth; 502. G Gianfranco Gorgoni, Contact Press Images; 557. ARS, © Contemporary Art Services, NY; 573. © Harry Shunk, NY; 587. Henry Nelson; 589. Geoffry Clements; 592. Steven Sloman; 598. R. Burckhardt; 608. Hickey-Robertson, Houston; 609. © Harry Shunk, NY; 615. eeva-inkeri; 620. Michael Tropea, Chicago; 639. Ezra Stoller © ESTO; 645. G. E. Kidder-Smith; 670. © Dorothy Zeidman; 673. © Harry Shunk, NY; 678. Bevan Davies; 684. Eric Pollitzer; 688. © Peter Moore; 690. David Allison; 699. Mujashiro; 700. Geoffry Clements; 703. Claudio Abate; 706. Tom Vinetz; 707. John Cliett; 714. Wolfgang Volz; 723. Ann Münchow, Aachen; 727. Steven Sloman; 728. Eugene Mopsik; 729. Paul Macapia; 730. Sarah Wells; 732. Geoffry Clements; 733. D. James Dee; 746. Steven Tucker; 756. Camerats, Inc., Ali Eali; 767. Zindman/Fremont; 771. Ivan Dalla Tana; 773. eeva-inkeri; 775. Ed Owen, Wash., D.C.; 788. Steven Sloman; 793. D. James Dee; 796. Michael Goodman; 798. D. James Dee; 805. © Kiki Smith, photo by Ellen Page Wilson; 808. Geoffrey Clements © Whitney Museum of American Art, NY; 817, 818. Stephen White, London; 820. John Lawrence, Southampton City Art Gallery; 824. Orcutt and Van der Putten; 828. Kira Perov; 829. © Orin Slor; 831, 832. Peter Stietman; 833. © Norman McGrath; 836. Arcaid; 838. Peter Aaron; 839-841. Richard Payne; 842. Pascall/Taylor; 844. Burg/Oliver Schub, Cologne; 845. Arcaid, Richard Bryant; 849. J-M Monthiers; 850. ESTO; 851. Arcaid, Richard Bryant; 854. Alex Vertikoff; 855. Erika Barahona Ede © FMGB Guggenheim Bilbao 1998.

SUPPLEMENTARY CAPTION CREDIT for Fig. 589: Gift of Mr. and Mrs. Eugene M. Schwartz and purchase, with funds from the John I.H. Baur Purchase Fund; the Charles and Anita Blatt Fund; Peter M. Brant; B.HJ. Friedman; the Gilman Foundation, Inc.; Susan Morse Hilles; the Lauder Foundation; Frances and Sydney Lewis; the Albert A. List Fund; Philip Morris, Inc; Sandra Payson; Mr. and Mrs. Albrecht Sallfield; Mrs. Percy Uris; Time-Warner Communiations, Inc; and the National Endowment for the Arts.

Preface and Acknowledgments

n writing this history of the ideas, forms, and events that have brought us the modern and post-modern worlds of art and architecture, we wanted to serve less the interests of specialists than those of intrigued general readers, foremost among them college students. Consequently, we have avoided the encyclopedic approach so often adopted for broad, chronological surveys of this sort, the better to examine selected but highly representative works in greater depth and from an enlarged spectrum of critical discourse. The rise of penetrating critique with claims to artistic status in its own right—a phenomenon especially notable during the last quarter-century-virtually demands such a mode of presentation. Thus, we have also been as much concerned with recent developments and their complex, motivating theories as with the far more familiar ones of classic modernism and now classic late modernism. The former, of course, began with Manet and the Impressionists and continued on through Post-Impressionism, Fauvism, Expressionism, Cubism, Dada, and Surrealism, all of which climaxed in the international postwar surge of creativity generally known as late modernism. Ignited by high-energy Abstract Expressionism, the late-modern experience finally attained its own apogee in those twinned polarities of the "impure" and the "pure": Pop Art and Minimalism. Once Minimalism, in the late 1960s, appeared to bring the entire modernist movement to a close-minimalizing the material until it became immaterial Conceptualism-the post-modern reaction set in, its love/hate challenges to everything that went before so copious and commanding that we have made them the principal focus of our work on the present edition of Modern Art. The results are four substantial new chapters illustrated by some 200 new plates, the great majority of them in full color. Altogether, the book now brings the art history of our time right through the 1990s, a new fin de siècle almost exactly one hundred years after the revolutionary works of Cézanne, Seurat, Gauguin, and van Gogh left no doubt that the art of the 20th century would be unlike anything known before its time.

Art becomes meaningful because it has the power to express important things that would in all likelihood remain unstated, or stated in less coherent or moving ways, in any other language. And this power is borne out by the fact that so much of the greatest in modern art—paintings, sculptures, and buildings that have come to seem the supreme monuments of our time—survive to triumph over the critical and popular hostility that greeted their first appearance. At no time has this been more evident than now, when a century-old modernist aesthetic is being contested by a healthy appetite for antiformalist experiment, bringing to art a new vibrancy comparable to the energy that charged the pioneer modernists of the late 19th and early 20th centuries. Clearly, great art can stand alone and speak directly to the perceptive viewer, regardless of how we or other writers may explicate it. Yet, like so many of the finest things in life, art for those who have been enriched by it constitutes an acquired taste, as worth cultivating, through an exchange of ideas, as fluency and freshness in verbal discourse. As the painter Willem de Kooning said almost a halfcentury ago: "There's no way of looking at a work of art by itself: it's not self-evident—it needs a history, it needs a lot of talking about; it's part of a whole man's life." And so we have written about the modernist experience—not only its forms, sources, and influences but also its cultural context and expressive content fully confident that we cannot exhaust an inexhaustible subject, but nonetheless hopeful that we may bring alert readers together with some remarkable manifestations of recent civilization and thus expand their capacity to confront their own world with heightened awareness and pleasure.

In deference to the greater importance of our subject relative to what we have to say about it, we and our publishers have made a particular point of taking advantage of the opportunity that selectivity allows for reproducing a higher percentage of the plates in color, in large scale, and, more important, on the same pages with the textual discussions. Selectivity has also permitted us to be more thorough than we might otherwise in our assimilation of recent critical literature, which in the modern field has grown to proportions beyond anything imaginable twenty years ago. The revisionism that now reigns among younger artists has been no less invigorating in its effect on art historians. An obvious symptom of this fact is the length of our bibliography, which runs to at least four times the number of entries in the 1976 edition. There is scarcely one aspect of the artistic production of the last two centuries that has not been reconsidered in the light of unexpected evidence and novel ideas. To be taught anew, by an ever mounting wave of scholarly endeavor, that no interpretation can be taken as sacrosanct is tonic for both mind and spirit, albeit a daunting challenge for authors intent upon having their text reflect the best of the latest in the thinking of their colleagues.

The division of labor in this enterprise was such that our associate John Jacobus prepared the text for Chapters 6, 13, and 21, while the first of the undersigned continued to be the principal author of Chapters 1 through 5, 7 through 12, and 14 through 20, considerably aided, in content as well as in form, by the second author signing below in the execution of Chapters 1, 2, 5, 7 through 10, 16, 17, and 19. However, for Chapters 22 through 25—all devoted to post-modernism—it was Daniel Wheeler alone who prepared the text. But many others, in addition to those listed on page 4, have made contributions without which the book would not have been possible or worthwhile. Charles Stuckey, now of the Kimble Art Museum in Fort Worth, and Professor John Hunisak of Middlebury College did critical readings of various portions of the text and offered countless valuable suggestions for their improvement. A similar service was provided by

Phillis Freeman and Julia Moore, editors at Harry N. Abrams, Inc. Ruth Kaufmann generously shared with us her vast, working knowledge of the current art scene. We are especially grateful to Dr. Kaufmann, Professor Noel Frackman, of the State University of New York at Purchase, and Professor Patricia Sands, of Pratt University in Brooklyn, for their close and helpful reading of the manuscript for Chapter 24 on the 1990s. Dr. Sabine Rewald of the Metropolitan Museum dipped into her personal archive of Balthus illustrations for the wonderful picture we have in Figure 525. Without the aid of Dr. Madeleine Fidell-Beaufort, professor of art history at the American University in Paris, we would never have been able to acquire quite so many images from the state museums in Moscow and St. Petersburg. As for illustrations, we looked with total dependence to such major cultural institutions as the Museum of Modern Art, the Solomon R. Guggenheim Museum, and the Whitney Museum of American Art, all in New York and all generously responsive to our many calls for help. No less supportive were the Tate Gallery in London, the Stedelijk in Amsterdam, the Hirshhorn Museum and Sculpture Garden in Washington, D.C., and the Art Institute of Chicago, the Los Angeles County Museum of Art, the Museum of Contemporary Art, also in Los Angeles, and the Carnegie Museum in Pittsburgh.

Then, too, there were the many commercial galleries—all cited in the captions—whose archivists tolerated our endless requests, for images and information, with unfailing grace.

Meanwhile, none of these things would have been feasible without the faith and support of our publishers, in the persons of Alexis Gregory of The Vendome Press and Margaret Kaplan, Michael Loeb, and Julia Moore of Harry N. Abrams, and Bud Therien at Prentice-Hall. Susan Sherman undertook the crucial tasks of assembling photographs, clearing permissions, and compiling the book's detailed index. Linda Bradford was the dedicated proofreader who saved us from many a blunder in the realm of post-modern art. In Milan, where we had access to the immense archive of color plates and the printing facilities of Fabbri Editori, we incurred a major debt of gratitude to Diana Benusigilio, Rosi Chirico, Anna Maria Mascheroni, and Virginia Prina. Moreover, their associates Vittoria Scaramuzza and Pietro Bellocchio proved heroic and utterly selfless in their efforts to make our project the beneficiary of the best that modern graphic expertise can provide. To all these we extend our warmest gratitude.

> SAM HUNTER DANIELWHEELER January 2000

Contents

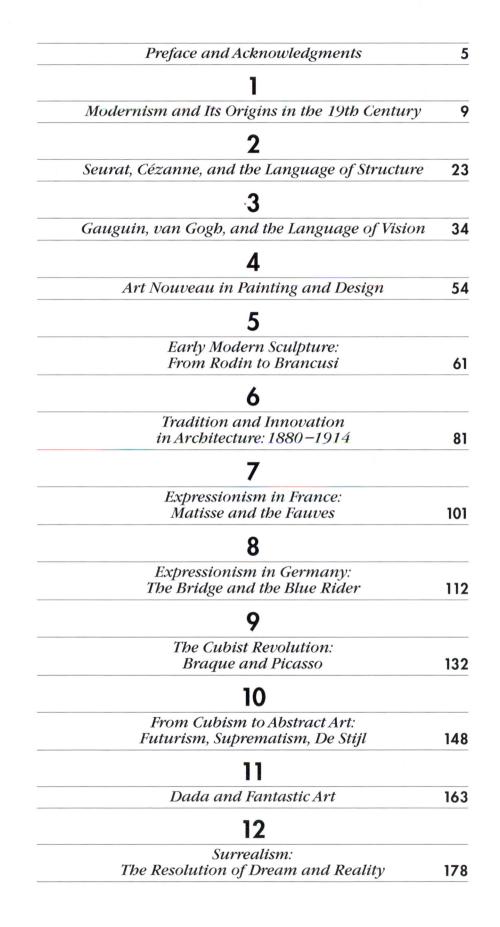

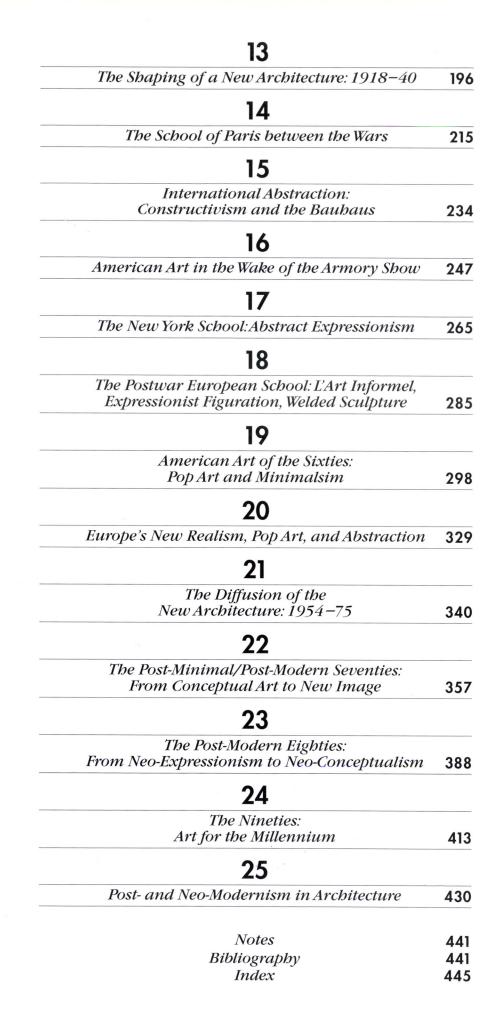

Modernism and Its Origins in the 19th Century

S ince it is in the nature of an artistic experience to deal with such imprecise but important matters as taste, quality, or expressiveness, there has rarely been much unanimity of opinion concerning the exact dates at which any given period in the evolution of painting, sculpture, and architecture may be said to have begun or ended. The modern age, being still very much with us and therefore all the more difficult to objectify, has given rise to an exceptionally wide range of moments when characteristics deemed to be distinctively modern, from a 20th-century point of view, appear in sufficient evidence to warrant talking about the visual arts endowed with those characteristics as somehow belonging to the art history of our time. It has even been persuasively argued that the origins of 20th-century art go back as far as the 1750s, when 18th-century scientism and sentiment combined to initiate an aesthetic rehabilitation that would gradually replace elaborate Rococo artifice with soberer form and a greater sincerity of feeling. A more obvious and frequently cited point of departure is that brought by the French Revolution, which shattered the ancien régime and rapidly accelerated the process whereby artists would be emancipated from the strictures imposed by traditional authority and left to paint as they wished, while often starving until a new system of patronage could emerge, consisting of the commercial galleries, private collectors, and public museums that we know today.

Even more frequently advanced as the chronological beginning of modernism in the visual arts is 1855, the year of the Paris Exposition during which Gustave Courbet laid a solid foundation for the new patronage by building his own pavilion and there displaying such grandly iconoclastic works as The Painter's Studio. Equally important is the year 1863, when the Emperor Napoleon III allowed a Salon des Refusés to take place, in response to the appeals of artists working in ways unacceptable to the official Salon and yet desperate for Salon exhibition, since such exposure offered the period's sole means by which artists could hope for significant recognition and revenue from sales. Among the more than 2,500 submissions that had failed to measure up to the academic standards set by the jury was Manet's Luncheon on the Grass (Fig. 15), the most innovative canvas to be seen and the focus of the most unbridled ridicule that transformed the Refusés into a three-ring circus, attended on a Sunday by as many as 4,000 curiosity-seekers.

Eleven years later, in 1874, the modernist movement made its next decisive inroad into Western consciousness when, once again, the conflict between the values of the French art establishment and those of younger artists ignited a rebellion. Although the Napoleonic monarchy had collapsed, as a consequence of the French defeat in the Franco-Prussian War of 1870, it had been replaced by a republican government scarcely less conservative than that of the preceding Second Empire. Scorning such officialdom, rather than pleading with them, certain progressive painters of Paris pooled their resources and mounted their own exhibition in the studio of the commercial photographer Félix Nadar. This was the famed show that brought before a largely derisive public a small group of artists whose fresh, freely brushed pictures so shocked a reactionary critic that he called the painters mere "Impressionists," to suggest their deliberate and thus all the more contemptible lack of finish. Here, indisputably, were many of the earmarks of the modernism that we have come to know in our own time: boldly independent art independently presented by a beleaguered band of self-confident innovators, scandalized press and public, and the coining of an "ism" to designate a certain radical kind of form.

However, for present purposes, which are to concentrate on the 20th century itself, we have chosen to begin our narrative in 1886, after the last of the eight Impressionist exhibitions in Paris and with the birth of the Independents Salon. By then Impressionism, in its original form as an extension of 19th-century Realism or Naturalism, had run its course and entered a period of crisis, generating a new, essentially antinaturalistic wave of modernism-not only painting but also a body of theoretical writing to support it-upon which Matisse and Picasso, those twin fathers of 20th-century art, would base their own revolutionary and liberating procedures. So rich and varied was this seminal fin-de-siècle period, which ran generally from the mid-1880s to the advent of Fauvism in 1905, that since 1910 the term most often used to identify it has been the allembracing "Post-Impressionism." Albeit vague, such a rubric possesses the virtue of suggesting the one, transcendentally important feature shared by the varied pictorial solutions to the problems posed by the crisis in Impressionism-their search for an autonomous art true to itself more than to the phenomenal world outside. The subjective Gauguin emphasized emotional content, decorative or "synthetic" methods, arabesque lines, and flat color masses to create an art that became the basis of the free forms of 20th-century biomorphic abstraction: the art of Vasily Kandinsky and that of automatic Surrealism. Meanwhile, the relatively objective Cézanne stressed geometric structure and thereby anticipated the more rational and intellectual styles that would follow, beginning with Cubism in 1908. Whether by subjective or objective analysis, the gradual transition to an unprecedented nonrepresentational art may, in fact, be justly described as perhaps the most radical patrimony left to us by Post-Impressionism. But the phenomenon of abstract or nonobjective art, released from the familiar world of appearances, depends, in turn, on a number of unprecedented cultural, historical, and artistic conditions that give definition to the moot and still evolving concept of modernist art. Succinctly stated, these have to do with altered conceptions of the nature of physical reality, a new understanding of artistic tradition, the development of an avant-garde culture, and significant changes in the expressive physiognomy and content of the art object itself.

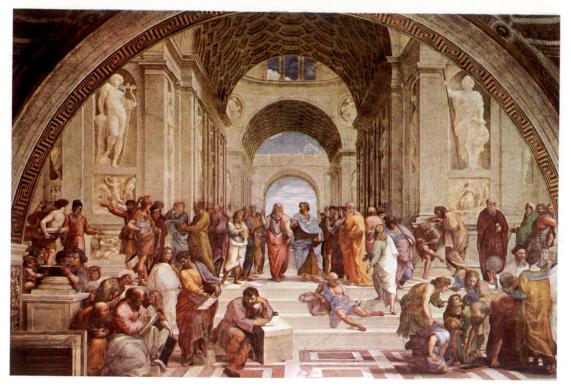

left: 1. Raphael Sanzio. *The School of Athens*. 1509–11. Stanza della Segnatura, Vatican Palace, Rome.

opposite: 2. Jean-Honoré Fragonard. Blindman's Buff. c. 1765. Oil on canvas, 7'1/8" × 6'57/8". National Gallery (Samuel H. Kress Collection), Washington, D.C.

The New Conception of Physical Reality

With the Impressionists a vast change in the artist's response to material reality took place. During the waning years of the 19th century, and in the opening years of the 20th, a series of discoveries in science revolutionized the conception of the structure of the universe that had prevailed since about the time of the Renaissance. Atomic physics and chemistry revealed the new and insubstantial nature of previously accepted assumptions about objects and the universe. When Kandinsky first read, with great astonishment, of the atom and particle physics, he felt his sense of reality slipping and declared: "All things become flimsy, with no strength or certainty." Even making allowances for romantic exaggeration. we must grant modern science and its revolutionary technology a decisive influence on artistic sensibilities. These changes would be reflected equally in the technology-oriented art of the Constructivists-whose principles of beauty were analogous to those of modern engineering-and in Kandinsky's reaffirmation of emotional responses in art based on intuition and expressive gesture.

Great as these have indeed been, they did not arrive in art without considerable preparation extending back at least as far as The Oath of the Horatii by Jacques-Louis David (1748-1825; Fig. 3), a monumental work so purged of Rococo softness and sensuality (Fig. 2) that it has been called a "pictorial call to arms," its exhibition in 1785 an artistic event that electrified Paris in a way comparable to the political and social upheaval that would come with the storming of the Bastille four years later. In the clarity of his solid-seeming figures set within a lucid, convincing volume of space, in the purity of his colors and light, his classical subject, and the directness and stern morality of his message, David would seem to have been reviving the long-honored academic criteria that, despite their perceived corruption by the Rococo, had dominated European art since the Renaissance. But while David's artistic indictment may have been primarily of hedonistic delicacy and refinement, it also undermined the very principles it had ostensibly revived. This can be seen in a comparison of The Oath of the Horatii with Raphael's School of Athens (Fig. 1), a paradigm of the

grand, harmonious balance that Italy's High Renaissance struck between the actual and the ideal.

The wondrous unity of Renaissance art derived primarily from the measured, even geometric control of pictorial space made possible once the rules of perspective had been worked out during the early 15th century by painters in Florence and Flanders. The rationalistic Italians had discovered that by causing all parallel lines, or orthogonals, perpendicular to the painting surface to converge, or recede, toward a single vanishing point at the viewer's eye level, they could so paint a picture that its flat, opaque surface would appear transparent like the glass pane of a window opening onto the real, infinite space of nature. Meanwhile, contemporary Flemish painters had achieved an illusion comparable to that available from the Italians' linear perspective by a system known as aerial perspective, wherein progressively cooler colors, diminished value contrasts, and blurred detail were used to depict objects assumed to be ever-more distant from the spectator. Exploiting both linear and aerial perspective, Raphael realized a vast fresco that seemed to harmonize not only the demands of surface design and depth recession, along with the divergent philosophies of Plato and Aristotle, upon whose images all lines converge, but also the human and the divine, the ancient and the modern, and, perhaps most of all, the terrible conflicts that beset Christendom on the eve of the Protestant Reformation. Such was the power of Renaissance illusionism that it became the chief instrument of expression for many of the Baroque masters of the 17th and 18th centuries (Fig. 2), who exploited the techniques of perspective and foreshortening to create trompe-l'oeil extravaganzas that "fooled," and delighted, the eye by seeming to dissolve thick, impenetrable vaults and expand into vast spaces soaring aloft and rushing into some limitless depth, the whole activated by billowing clouds and miraculously flying figures.

In *The Oath of the Horatii* David clearly wanted to deceive, and thus persuade, with his mastery of Renaissance illusionism, but in his eagerness to instruct and moralize, rather than entertain, he not only "corrected" the excesses of his virtuoso antecedents but also went well beyond the broad, simplified realism of Raphael to display a northern love of minutely defined surface detail. More

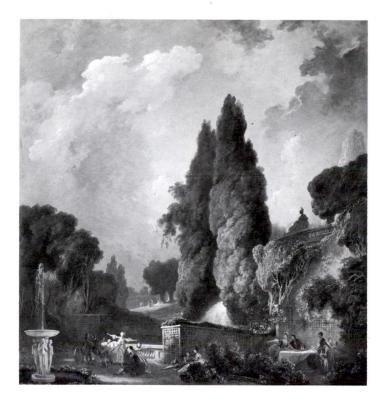

important, he set his figures not in a simulacrum of infinity but in a shallow stage space, there aligning them across the front, just behind the picture plane, in the friezelike organization of a classical bas-relief. Here he initiated, more emphatically than any of his contemporaries, a trend that would yield one of the key, overriding preoccupations of modernist painters: their determination to abandon the "trick" illusionism invented by the Renaissance, which Europe's absolutist rulers transformed into an authoritarian tradition through the official teaching academies, and to acknowledge the three-dimensional world in some manner that would not deny the planar flatness and opacity of the actual painting surface.

Having blunted Renaissance recession and thus compromised the grand unity of the vision so brilliantly articulated by Raphael, David further reflected the character of his own age by dramatizing, rather than resolving, the conflict fundamental to his time. As an object lesson commissioned by the French crown to help improve public morality, the painting represents an episode from early Roman history in which three Horatii brothers swear to die, if necessary, for their nation by fighting three brothers from the rival city of Alba, the oath witnessed by the Horatii women, who collapse in their secret knowledge that one of them is betrothed to a member of the enemy camp. Just as the vanishing point coincides, not with the serene blue of infinity, but with a fist clenched upon a glistening sheaf of sharp-edged weapons, the composition is not so much unified as counterbalanced between the taut, muscular energy and stoic courage on the left and the melting, feminine emotion and compassion on the right. Here again, David anticipated modernism, specifically its urge to renew art by acknowledging the inherent instability within the conditions of both life and art-the disparity, for instance, between the two dimensions of the picture plane and the three dimensions of real space-which would eventually produce the dissolution of form brought about, first, by the English master J.M.W. Turner and, then, by the French Impressionists. Later, it would also lead to the Cubists' analysis of space, the collage method of composition, and Dadaist subject matter, as well as to the variant abstractions of Kandinsky and the Constructivists mentioned above.

From the long-accumulating breakthroughs of modern science, the 20th century could expect further revelations of great importance in experimental psychology regarding the operations of the subconscious mind. But, once more, the implications for art had been prefigured at an earlier date, most particularly by David's contemporary, the great Spanish painter Francisco Goya (1746– 1828), who, unlike the French master, lost faith in the classical tradition and used his breathtaking command of means—equal to

 Jacques-Louis David. The Oath of the Horatii. 1784. Oil on canvas, 10'10"×14'. Louvre, Paris.

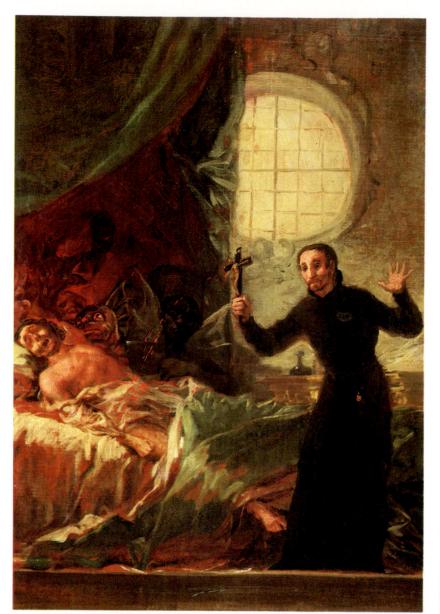

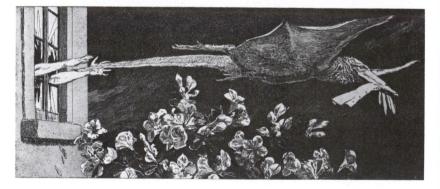

the bravura colorism of Velázquez in painting or the chiaroscuro richness of Rembrandt in etching—to express his bitter conviction that human behavior would be governed not by the rational values of the Enlightenment but by a proto-Freudian realm of nightmares, monsters, and obsessions (Fig. 4). Although not continuous, the tradition commenced by Goya would be carried forward by later 19th-century artists, such as Max Klinger (1857–1920), James Ensor, and Odilon Redon, before climaxing in the dreams and subterranean imaginings that ultimately surfaced in the 20th-century art of de Chirico and the Surrealists. In the work seen here (Fig.

Modernism and Its Origins in the 19th Century

left: 4. Francisco Goya y Lucientes.
Saint Francis of Borgia Attending a Dying Man.
1788. Oil on canvas, 15 × 11".
Collection Marquesa de Santa Cruz, Madrid.

below left: 5. Max Klinger. The Abduction (from A Glove). 1881. Etching, printed in black, $45\% \times 10^{1/2''}$. New York Public Library.

below right: 6 Antonio Canova. Venus Italica. 1812. Marble, 4'10" high. Galleria Pitti, Florence.

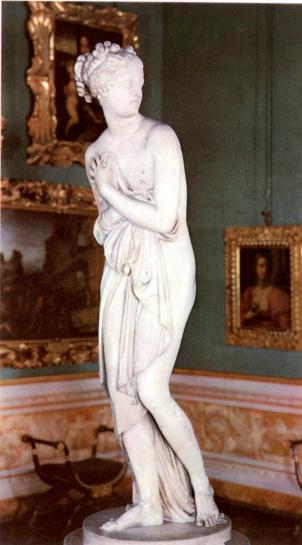

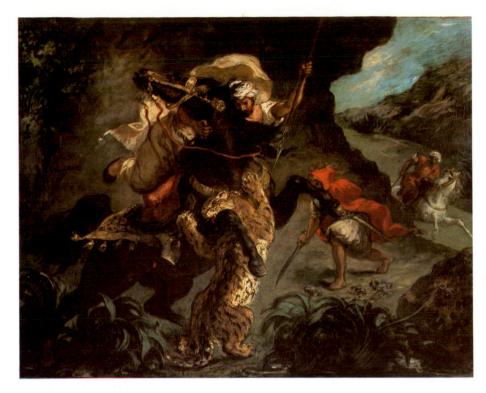

5), a print from a suite of ten etchings, Klinger transformed a lady's glove into an occasion for a fetishistic fantasy about a love object that forever eludes its desperate and traumatized suitor. While less overt and inventively expressed, the psychosexual dimension can also be unmistakably sensed in the fire-and-ice complexity of that arch Neoclassicist, the sculptor Antonio Canova (1757–1822; Fig. 6), the glacially smooth surfaces of whose marbles are charged with an undercurrent of anticlassical erotic involvement.

The New Understanding of Artistic Tradition

All of these new expressions and movements represent a fundamental break with past traditions, and the result has been an immense destruction of received art forms. While this meant a downgrading of classicism, on the positive side it has also invited an almost greedy acquisition of new forms from all over the globe, from non-Western, Oriental, and primitive cultures, and from folk art, the art of children and the insane, and other aspects of *l'art brut*. The outcome of these vast changes has not merely been a spirit of assimilative eclecticism but, instead, the birth of a new tradition more subjective in spirit.

Here too, the search for fresh inspiration among sources alien to the classical world of high Western art began early, not only in the 18th century's growing love of such "low" subject matter as genre, still life, and landscape, in contrast to the elevated mythological and religious themes decreed by the Academy as essential to true history painting, but also in the period's increasing appetite for exotica, from which, ironically, the revived interest in the Greco-Roman world should not be excluded. This is more than evident in the art of Jean-Auguste-Dominique Ingres (1780-1867), a pupil of David and a self-proclaimed guardian of France's classical heritage, but an artist who also gloried in the hothouse, voluptuary enclaves of the Turkish harem (Fig. 7). Such a subject appeared to give a special release to Ingres's supreme gifts for both color and line, the one composed in the most daring, almost atonal contrasts and the other liberated to coil and uncoil in complications that seem simply to luxuriate in themselves as much as they describe, their relative autonomy a symptom of the gathering momentum toward abstractness.

below: 7. Jean-Auguste-Dominique Ingres. Odalisque with Slave. 1842. Oil on canvas, 25¾ × 35‰". Walters Art Gallery, Baltimore.

left: 8. Eugène Delacroix. *Tiger Hunt*. 1854. Oil on canvas, 2'4¾ × 3'¼". Louvre, Paris.

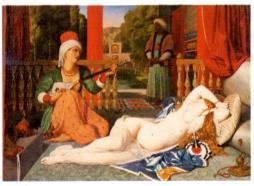

No less sovereign in his command of liberated line was Ingres's great rival Eugène Delacroix (1798-1863), who, however, came to seem the generation's foremost exponent of color (Fig. 8), mainly because, instead of applying pigment as a smooth, continuous glaze, he laid it on with fury and abandon, the sweeping painterliness of his brushwork assuming an autonomy comparable to that of Ingres's drawing. And while Delacroix frequently took antique themes and considered himself "a pure classicist," his brilliance in gaudy Oriental subjects combined with his frenzied handling and dramatic situations to mark him as the peerless Romantic in contrast to the Neoclassical Ingres. Often Ingres and Delacroix were pitted against one another as the leading advocates of Poussinisme and Rubénisme, meaning the linear, cerebral art practiced by the 17th-centurty French master Nicolas Poussin, the principal Baroque heir to the tradition of Raphael, and the luminary, sensuous, dynamic art of Peter Paul Rubens, the 17th-century Flemish master of the Venetian colorism that had begun with Raphael's contemporaries, Giorgione and Titian. Together, the schools of Poussin and Rubens constituted the two main lines of development sanctioned by France's Académie des Beaux-Arts, the most important such institution in Europe for some 250 years, its dominance ending only with the turn of the 20th century.

Along with Turner (Fig. 10), Delacroix offered the Impressionists one of their most important models, not only in the freedom and breadth of his touch but also in the palette he assembled of juxtaposed and mutually intensifying complementaries, such as vermillion and blue-green, set down in resonant chords or, occasionally, in small divided strokes that anticipated first Impressionist practice and then Neo-Impressionist theory. This was his legacy to that branch of modernist art, led by the Impressionists, Cézanne, Seurat, Matisse, and Picasso, taking an objective, analytical, structural approach to issues of form and style. But in the great fecundity of his genius, Delacroix had much to offer those more Romantic heirs, such as the Symbolist Gauguin and the Expressionist Kandinsky, who would seek form and style subjectively, through an analysis less of what they saw without than what they felt within. In 1824, after reading Germaine de Staël's *De L'Allemagne* (1813), the book that did so much to make German culture known in France and England, Delacroix wrote in his diary: "I find precisely in Mme de Staël the development of my ideas about painting. This art, like music, is higher than thought, and both are superior to literature—in their vagueness." For true Romantic vagueness, symbolizing the triumph of emotion over intellect, the visual arts of Delacroix's time could hardly have found a better example than that of the German painter Caspar David Friedrich (1774–1840), whose devotion to landscape and Gothic ruins, saturated with a sublime, pantheistic sense of the mystery and alienation of life on earth, proclaimed by itself the extreme degree to which this master belonged to a world re-

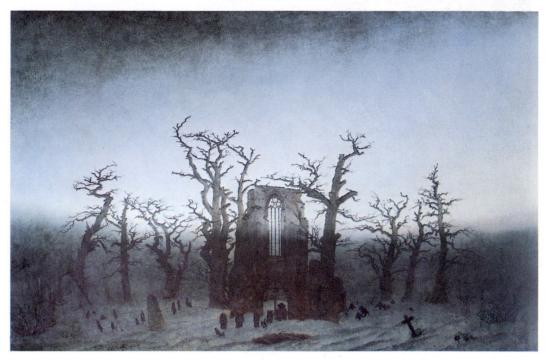

right: 9.

Caspar David Friedrich. Abbey Under Oak Trees. 1809–10. Oil on canvas, 3'71⁄4"×5'71⁄4". Staatliche Schlösser and Gärten, Berlin.

below: 10.

Joseph Mallord William Turner. Rockets and Blue Lights (Close at Hand) to Warn Steamboats of Shoal Water. 1840. Oil on canvas, 3'½" × 4'. Sterling and Francine Clark Art Institute, Williamstown, Mass.

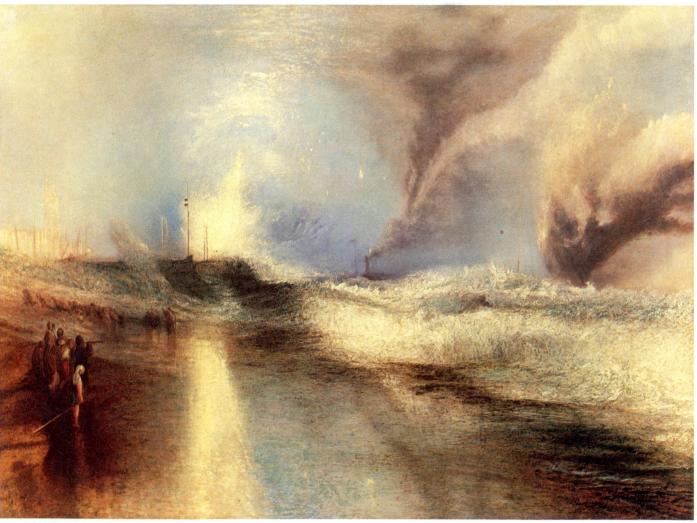

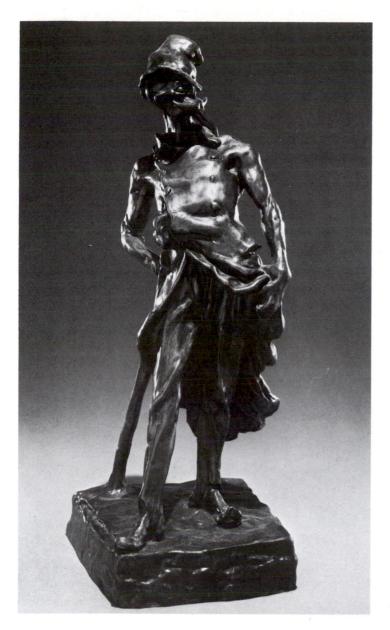

mote from the rationalism of the classical Franco-Italian tradition (Fig. 9). Here was the great 19th-century ancestor of the northern European Expressionists, beginning with the Dutchman Vincent van Gogh, the Norwegian Edvard Munch, the Belgian James Ensor, and continuing with the Bridge and Blue Rider groups in Germany. Another northern spirit closely akin to Friedrich was his English contemporary J.M.W. Turner (1775-1851), who too found a metaphor for the Romantic sublime (Fig. 10), not in the German's febrile, attenuated linearism or his explicit Christianity, but in a storm of painterly effects, a vortex of light and atmosphere shot through with fire and permeated by smoke, all reflecting an artistic sensibility less interested in imitating nature than in manipulating opaque and translucent pigments on a flat surface. Here was a modernist before the fact, if ever there was one, for virtually the same statement could be made about the Abstract Expressionists who emerged in New York during the 1940s, after having assimilated the abstract tradition anticipated by Turner and the late Monet and then realized through the device of Surrealist automatism.

Scarcely less foreign to Europe's high art were the proletarian subjects that began to appear in painting and sculpture once the Romantics' honesty of feeling produced Realism, a reaction against vagueness and escapism that insisted upon acknowledging the facts of life in an art of suitable thematic and formal frankness. Along with Balzac's *Human Comedy* and Marx's *Communist Manifesto*, the social-conscious 1830s and 40s also saw the arrival of Honoré Daumier (1808–79), who employed a mordantly witty genius for caricature to express his contempt for bourgeois exploiters of the poor (Fig. 11) and a profound sympathy to evoke the dignity and suffering of the exploited. His means, in painting, sculpture, and lithography, were a powerful, sometimes whiplash line and the drama of light-dark contrasts, the latter placing him in a line of succession that included those earlier masters of great moral conviction, Rembrandt and Goya.

Manifestly, the "low-life" images projected by Daumier bore little relation to the genre subjects of old, with their picturesque character designed to charm and comfort more than to reform. No less deeply felt were the peasant scenes painted by Jean-François Millet (1814–78), an artist from Normandy who settled in the village of Barbizon on the edge of the Fontainebleau Forest. There he used his sophistication in Old Master art to endow impoverished

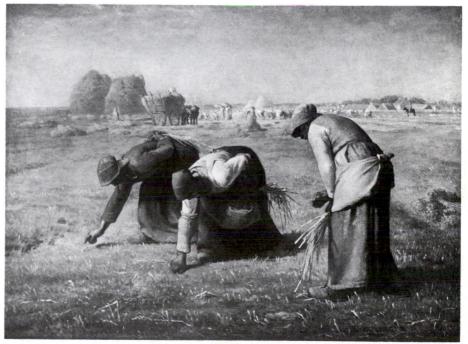

above: 11. Honoré Daumier. Ratapoil. c. 1850 (cast 1925). Bronze, 17¾ x 16½ x 17¼". Hirshhorn Museum and Sculpture Garden, Smithsonian Institution, Washington, D.C.

> right: 12. Jean-François Millet. The Gleaners. 1857. Oil on canvas, 33 x 44". Louvre, Paris.

> > Modernism and Its Origins in the 19th Century

farm workers with Michelangelesque monumentality and the fields they toiled upon with a compositional grandeur worthy of Poussin (Fig. 12). Working in muted, triadic harmonies of the primary colors and with a combination of breadth and delicacy certain to glorify the painting surface, Millet brought forth pictures that looked back to the noble simplicity of Chardin as well as forward to heroic abstractions yet to come.

A still more revolutionary and unsentimental Realist—in both art and activism—was Gustave Courbet (1819–77), the painter who declared his independence of the Salon establishment by setting up his own pavilion at the 1855 Universal Exposition. The paintings he exhibited on that occasion, however, proved even more monumentally scaled, and certainly no less ambitious, than the great "machines" hung by the academic masters in the official Salon. In his preface to the catalogue Courbet stated, with characteristic self-confidence: a heavier, blunter manner, he did so not to suggest vagueness or spirituality, but rather to stress the palpable realities of both his subject and his two-dimensional painting surface. In A Burial at Ornans, one of the machines displayed in the special pavilion, he gathered what appears to be the whole of his village birthplaceclergy, mayor, farmers, laborers-in a dense, friezelike palisade that, even more than David's Horatii, blocks recession into depth. Furthermore, he allowed his democratically monochrome and artlessly assembled crowd none of the compositional or gestural climaxes still very much present in the Davidian work. While such an arrangement brought to the fore and emphasized the rugged factuality and dignity of semi-impoverished country life, it also stressed with ever-greater force the tangible presence and shape of the surface upon which the artist stroked his viscous medium. This overriding tendency to make the means of painting the ultimate reality with which the artist must be concerned may have had more impact

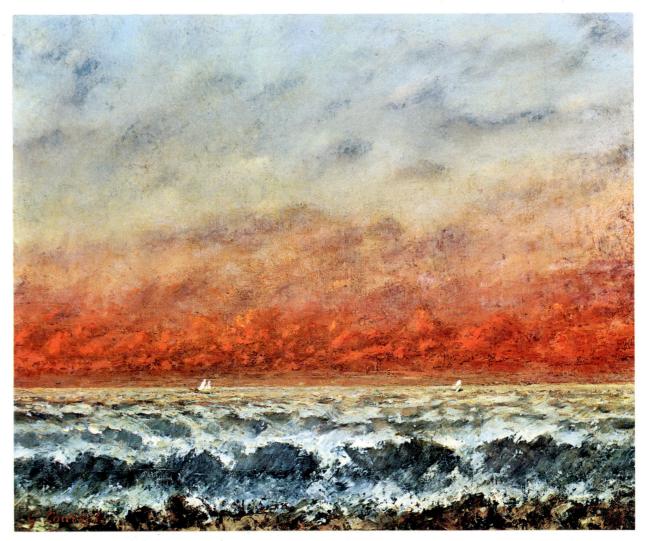

I have studied outside system and without prejudice, the art of the ancients and the art of the moderns. I no more wanted to imitate the one than to copy the other; nor, furthermore, was it my intention to attain the trivial goal of *art for art's sake*. No! I simply wanted to draw forth from a complete acquaintance with tradition the reasoned and independent consciousness of my own individuality. To know in order to be able to create, that was my idea. To be in a position to translate the customs, the ideas, the appearance of my epoch, according to my own estimation; to be not only a painter, but a man as well; in short, to create a living art—this was my goal.

Thus, while Courbet could wield a loaded brush or palette knife with all the rapier skill of a Romantic such as Delacroix, albeit in

Modernism and Its Origins in the 19th Century

16

on evolving modernism through the landscapes and marines that Courbet painted in the mountainous region of his native Franche-Comté and along the coast of Normandy (Fig. 13). Here, perhaps aided by photographs, he cropped his scenes, blurred them, as if viewed at too close a range, and exploited the effects of monochromy, palette-knife facture, and frontal, parallel alignments until he had achieved an overall abstract, pictorial flatness unprecedented in post-Renaissance painting. But quite apart from their formal independence, Daumier, Millet, and Courbet constituted the fountainhead of a liberal-minded, humanitarian social consciousness that would provide the content of not only the 20th century's Social Realism but also some of its most avant-garde expressions.

opposite: 13. Gustave Courbet. Seascape. 1874. Oil on canvas, 177/8x213/8". Private collection.

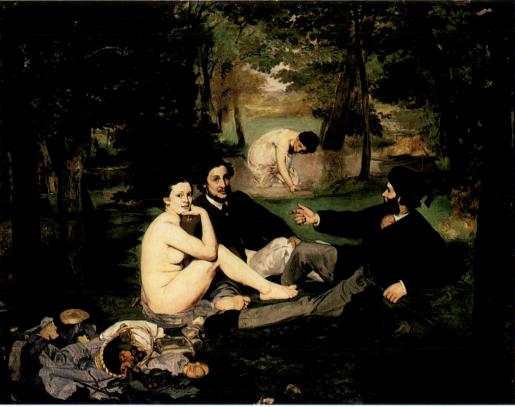

none captured the imagination of progressive painters more than the colored woodcuts of such Japanese masters as Utamaro, Hokusai, and Hiroshige (Fig. 14). With their planes of brilliant, solid color set off and contained by the most radically simplified contour drawing, their steep and sharply angled views, their flat-pattern design, and their bold croppings, such supremely confident works of pictorial art could only reinforce the Europeans' growing awareness that for modern painting made authoritative by its own profound sincerity there could be no compromise with the fact that the surface on which the artist painted constituted a taut skin providing a world of pure art and no illusion.

The ultimate consequence of this insight would not be reached for another century, but in the 1860s it so affected the art of Édouard Manet (1823-83) that when he exhibited Luncheon on the Grass (Fig. 15), at the famous Salon des Refusés of 1863, it generated what probably was the most notorious of all the scandals that, with some regularity and no little drama, would punctuate the history of modern art. A well-to-do bourgeois dandy and man-about-Paris, Manet longed for acceptance by the official Salon, but as a true Realist, persuaded by the writer Charles Baudelaire that he should be "a painter of modern life," Manet could not perpetuate the thematic and spatial make-believe of academic art or the sense of mystery and timelessness that lingered even in the peasant scenes and landscapes of Millet and Courbet. Like those older contemporaries, however, he saw his art as continuous, if not consistent, with the high aspiration and quality of Europe's grandest traditions. Thus, for the composition of Luncheon on the Grass he went to Raphael and for his subject to the long line of fêtes champêtres that had begun in the 16th century with the Venetian Giorgione and been continued by the 18th century's Rococo painters (Fig. 2). Moreover, he handled them with the luscious, painterly fluency and the rich tonal contrasts of his favorite Old Master, 17th-century Spain's Diego Velázquez. An accomplished academician like William-Adolphe Bouguereau (1825-1905; Fig. 16) would use a similar artistic culture to idealize his female nudes until they seem nothing so much

Modernism and Its Origins in the 19th Century

above right: 15. Édouard Manet. Luncheon on the Grass. 1863. Oil on canvas, 6'9"x8'10". Musée d'Orsay, Paris.

> right: 16. William-Adolphe Bouguereau. Nymphs and Satyr. 1873. Oil on canvas, 8'63/8"x.5'107/8". Sterling and Francine Clark Art Institute, Williamstown, Massachusetts.

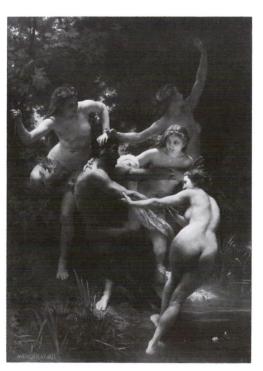

Of all the exotic influences on advanced European art, none would prove more seductive, pervasive, and durable than those from

Japan, which in the form of paintings, sculptures, prints, and house-

hold objects began flowing out of Japanese ports shortly after they

had been reopened by Commodore Matthew Perry in 1853. And of

all the strange and beautiful artifacts to arrive from the Far East,

17

as delicately tinted marbles by Canova, set free to frolic in the caressing mist of a remote grotto somewhere in the never-never land of Greco-Roman antiquity. Manet, on the other hand, represented his unmistakably modern and naked woman accompanied by a pair of fully clothed, mid-Victorian gentlemen and a second, scantily clad female as picnickers on the banks of the Seine, like so many other Sunday refugees from the growing urban crush of modern Paris. And whereas Bouguereau gratified his audience by presenting its male members with the opportunity to savor ripe feminine flesh under the pretext of appreciating the pure and uplifting world of antiquity, Manet left little room for such subterfuge, since his principal "nymph" stares down and fixes the viewer with a brazen directness that, presumably, could have been mastered only by a 'professional," one of those 19th-century courtesans or femmes fatales fully prepared to hold their own in any game of sexual exploitation. In actual fact, the three foreground figures were merely Manet's favorite model, Victorine Meurent, his brother, and his future brother-in-law, but if they seemed so much more threatening, it was thanks to formal audacities equal to the candor of Victorine's unblinking gaze. Instead of softening, rounding, and distancing his principal trio of figures by immersing them in a romantically suffused atmosphere, he pressed them forward near the frontal plane and illuminated the nude with such a blaze of light, as if the party had been caught in the flash of a tabloid camera, that the image struck contemporaries as shockingly flat, like the Queen of Spades on a playing card. Furthermore, the composition, although stabilized by a classical triangle whose apex is the bather in the distance, seems less unified in the traditional sense than assembled, in a manner anticipated by David's Oath of the Horatii (Fig. 3), from an array of independent pictures—a still life, a landscape, and four separately observed figures. This accounts for the giant size of the rearground bather, relative to the depth implied by the scale of her immediate surroundings, a discrepancy that advances the figure and thus collapses the pictorial space, just as the shallow modeling flattens the forms.

Having frustrated coherent recession toward a single vanishing point, and having further scattered focus by painting the central nude with the same dispassionate virtuosity he used for the brilliantly realized still life, Manet fatally undermined the unifying values and hierarchies of classical, Renaissance order. However, he replaced them with a new kind of coherence, based upon what the artist called the simple merit of having "merely tried to be himself and not someone else." As he wrote in the catalogue of the one-man show he organized when excluded from the 1862 International Exhibition in Paris: "The artist does not say today, 'Come and see faultless work,' but 'Come and see sincere work.' This sincerity gives the work its character of protest, albeit the painter merely thought of rendering his impressions." If Luncheon on the Grass seems disjointed, then it could be said truly to mirror the world in which it was made. And if it simply reports the facts of that world, as a newspaperman would, dispassionately and without moral commentary, then he did it with an all-embracing, passionate love of the means for carrying out this task. The evidence is everywhere, in the elegance of a pale silhouette set against the richest of velvety blacks, the variations of green on green that evoke a shaded grove, the bravura subtlety with which the modeling of the nude has been executed, even though so shallow that, with all middle tones omitted, it seems, Japanese fashion, to be little more than a pliant contour line. But along with the wit and sparkle of its myriad aesthetic delights, Luncheon on the Grass may hark back to its compositional source, in an engraving by Marcantonio Raimondi after a detail of river gods from Raphael's Judgment of Paris, and offer an irreverent symbol, implying that in a new contest, modern Paris has awarded the prize not to a goddess but to a selfconfidently modern young woman who dares "to be of her time."

The Development of an Avant-garde Culture

The use of the military term avant-garde in reference to the cutting edge of art originated early in the 19th century with the French critic and social philosopher Saint-Simon as a means of linking progressive social action, art, and science in a unified effort to reform society and ameliorate the fortunes of the oppressed. Later in the century, literary avant-gardism became associated with a more rarefied aestheticism and the doctrine of art for art's sake. However, for the historical conflict between traditional values and those of the vanguard, we must again look to the mid-19th-century era of Manet and Bouguereau, both serious masters but one rejected by his own time for the very reason that he wanted to be of it, in the form as well as in the content of his art, and the other honored because he seemed to materialize, for an aggressively materialistic, literal-minded age, the possibility of escape into a comfortably familiar, albeit exhausted, ideal, a pasteurized, pastoral world far removed from the facts of modern urban existence. Fine art had always been, and would continue to be, even for the 19th century's officially accepted painters and sculptors, the product of a creative elite, directed to a comparatively small, specialized audience of likeminded spirits. However, beginning in the 1850s, 60s, and 70s, with the novels of Flaubert, the Realism of Manet, and the poetry of Baudelaire and Rimbaud, the modernists found, until very recent years, an ever-more restricted audience for their work. The intransigence of the avant-garde-as in the refusal of Manet to compromise his aesthetic integrity despite a yearning for Salon approval-the flow of polemics, manifestoes, and attacks on middleclass ideology that so many of Manet's artistic heirs would generate have been linked to a rapid succession of revolutionary technical and artistic innovations. As these events unfolded over the next century, they would never gain wide popular acceptance, which created a divisive confusion in standards of taste. The sincerity of art forms in the more distant past, a past unified unlike anything known in the republican, democratic, pluralistic modern age, had never been challenged. Art was supported and encouraged by a cultural elite, and its quality, honesty, and meaning were not subject to serious doubt. Only in the modern period of mass culture did questions arise as to whether the artist may, in fact, be a fraud, deceiving the public with unintelligible riddles.

Until 1800 or thereabouts, important artists, writers, and thinkers were usually recognized as such during their lifetimes, since their audiences were limited to a privileged group of amateurs who had some expertise in the field. In the aftermath of the Industrial Revolution and the Romantics, however, public taste and judgment of quality became less certain and contemporary responses erratic. And so they remained from the Impressionists right up through the famous pioneering exhibitions of modern art in the 20th century in Europe, such as the Grafton Gallery shows of Post-Impressionism organized by Roger Fry in London in 1910 and 1912 and the 1913 Armory show in America, which scandalized the critics and public by presenting such revolutionary and seemingly misguided artists as Cézanne, Matisse, and Picasso as if they were serious.

In the 20th century, the neglected artist learned to view his art as a potential aesthetic and social weapon of subversion directed at bourgeois philistinism. The alienation of the progressive artist and the scandal with which traditional authority identified the innovations of modern art were linked to the absence of a cosmetized photographic realism in the art object and a justified bohemian mistrust of any credible system of patronage or support. The resulting muddle in standards of taste coincided with the rise of popular culture in the mass media and the phenomenon of kitsch, a class of vulgarity to which some would assign even the art of Bouguereau. One dramatic result has been to compel the avant-garde to develop its own community with a set of social ideals based on protest and internal criteria of taste and judgment. Because of their precarious social situation as dissenters, avant-garde artists, at least in the early years of the century, often embraced a revolutionary political outlook as well as revolutionary aesthetic attitudes. One of the contradictions of the modern movement, however, has been the frequent conflict between progressive aesthetic beliefs and the direct expression and implementation of reformist social ideals in art forms readily comprehensible to that intended beneficiary of social reform: the common man.

Changes in Expressive Form and Content

This, then, brings us to our final point: the actual change in artistic methods and forms. Something of why the modern artist has been so preoccupied with medium and pure pictorial or sculptural values emerged as we discussed the art and dilemma of Manet. But it becomes even more salient with the arrival of the Impressionists, those younger French painters, led by Monet, Renoir, Pissarro, and Degas, who regarded Manet as their chief mentor but went beyond him both as painters of modern life and in the stylistic shifts this purpose compelled them to make. For generations Claude Monet (1835–1926), the quintessential Impressionist, was thought truly to embody the assessment made by Cézanne when he said: "Monet is merely an eye, but what an eye!" As elaborated and perpetuated over the years, this interpretation held that Monet developed a formal vocabulary of high-key color, broken brushwork, and dy-

namic compositions in order to disclose the instantaneous quality of vision, the beauties of nature, and the expressive possibilities of paint. Always working *plein air*, meaning "out of doors," he would abandon a canvas once the weather or light changed and return to it only when similar conditions reappeared, for, according to arthistorical dogma, he cared only for the fleeting effects of natural phenomena and the vagaries of visual sensation. Ideas, content, or meaning held no value for him, only pleasure, nature, and the moment.

Certain contemporaries, if not Cézanne and the majority of others, knew better. Among them was Frédérick Chevalier, who wrote in 1877 at the time of the third Impressionist exhibition:

The disturbing ensemble of contradictory qualities ... which distinguish... the Impressionists, ... the crude application of paint, the down to earth subjects, ... the appearance of spontaneity, ... the conscious incoherence, the bold colors, the contempt for form, the childish naivete that they mix heedlessly with exquisite refinements, ... all of this is not without analogy to the chaos of contradictory forces that trouble our era.¹

Although less than warmly sympathetic to Monet's art, Chevalier did grasp its essential character as an extension of the period's Realism. Acting on an intuition about the mechanics of vision, the artist had dispensed with the craftsmanly finish so prized in academic art—its blended colors, smooth chiaroscuro modeling, and elegant draftsmanship—and replaced it with painting whose unifying principle is sketchiness and instantaneity, a surface more or less uniformly energized by an all-over crust of colored spots (Fig. 17).

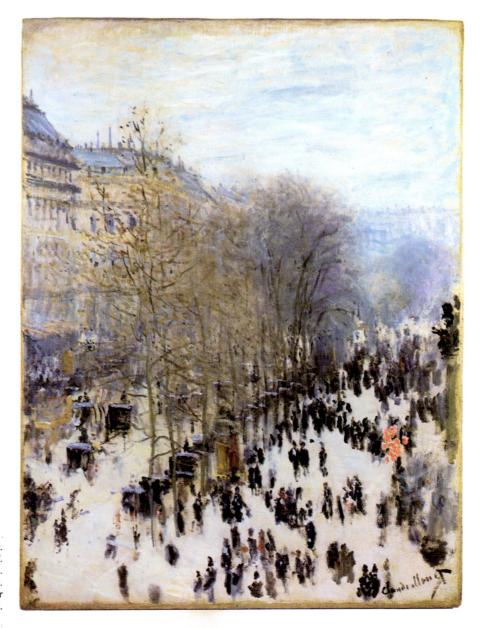

17. Claude Monet. Boulevard des Capucines, Paris. 1873. Oil on canvas, 31³/₄×23¹/₂". Nelson-Atkins Museum of Art, Kansas City. Kenneth A. and Helen F. Spencer Foundation Acquisitions Fund.

To a shocking degree, this surface seemed to reflect the increasing anonymity and atomization of modern life, at the same time that it also carried art toward abstraction well beyond anything seen before even in the *fa'presto* works of Delacroix, Courbet, and Manet. But random and improvised as the handling may appear, Monet had carefully, if quickly, deliberated every stroke so that simultaneously each small separate deposit of relatively pure hue would represent a ray of light, a moment of perception, a molecule of atmosphere or a form in space, and a brick within the mosaic structure of a surface design. Images emerge from this blizzard of hectic brushwork not as a result of contoured shapes filled with local color blended on the palette, but rather as a product of the way small juxtaposed strokes of unmixed hue complement one another and thus blend in the eye, producing the sensation of reality perceived in a fleeting instant of time.

If such a characterization makes the picture seem like a photograph obtained with an old-fashioned, slow-shutter camera, the corollary is not inappropriate, for in fact Monet painted Boulevard des Capucines (Fig. 17) from the second-story window of the studio the Impressionists would rent from the pioneer photographer Félix Nadar for their first self-sponsored exhibition. And the ultimate effect of the picture could be described as that of an urbanscape photographed through a rather grainy filter, which obliterates linear detail but captures the flickering atmosphere and vitality of the new Paris, bustling with activity along the grand, tree-lined avenues that Napoleon III had just constructed and that remain the glory of the French capital. But unlike the photographers of his era, who could work only in black and white, Monet realized his picture entirely in color, for even more than Delacroix and Turner, two of his principal sources of inspiration, the artist understood that color, like vision itself, is the product of light, broken by reflection and refraction into its component rays, ranging from the warm hues of red and yellow to the cool ones of blue and green. Wherever there is vision, there must also be light and color, even in shadows, which Monet represented not as the graying of local color but as a higher incidence of blue and purple among the strokes of various hue employed to evoke form and space. By avoiding black, except where required for such objects as the stovepipe hats worn by mid-19th-century Frenchmen, and by juxtaposing countless flecks of pure color whose complementarity gives an intensified sensation of a third color, Monet and the Impressionists created an image of the world-a Naturalism more than the Realism of such light-dark painters as Courbet and Manet-that for its shimmering freshness, whether snowbound, mist-shrouded, or sun-drenched, has scarcely ever been equaled in the history of art.

Much of this seemingly innocent, ingenuous quality sprang from the painters' direct, instinctual, even extempore manner of working, which can be seen in the variations that occur in the shape, weight, and density of their stroke, from sky to trees, snow, water, Although obviously not without ideas and attitudes, or figures. Monet and his associates were genuine Naturalists-relatively extroverted, hedonistic, and bourgeois in their values-and thus less soul-searching, systematic, or theory-minded about their discoveries than their immediate successors would be. Eventually Impressionism as an aesthetic began to seem too ephemeral and formless to offer further potential either to the Impressionists themselves or to a younger generation of avant-garde artists. But as the Boulevard des Capucines would suggest, with its decorative clustering of color touches, its powerful orthogonals, and its oblique Japanese view, Monet also knew a thing or two about pictorial architecture, which would stand him in good stead as he progressively transformed the generalized weave of his surface-affirming brushwork and opticality into a new kind of "holistic" image bordering on total abstraction. Then the hostile critic who in 1874 coined the term "Impressionism" would be proven right, for Monet, Renoir, and Pissarro indeed wished "not to render a landscape but the sensation produced by a landscape."

Symptomatic of the so-called crisis that developed in Impressionism in the 1880s was a comment made by Pierre-Auguste Renoir (1841-1919), the painter closest to Monet and one of the most devoted of the Impressionists, to the dealer Ambroise Vollard: "A short break . . . came in my work about 1883. I had wrung Impressionism dry and I finally came to the conclusion that I knew neither how to paint nor to draw. In a word, Impressionism was a blind alley." Already in 1881, Renoir had tried to integrate his Naturalism-his expressive delight in the substance and texture of thingswith a more pronounced concern for the fundamentals of traditional pictorial design and structure, mainly by enlarging his style, idealizing his figures, and organizing them with greater deliberation (Fig. 18). For a brief period he even rejected contemporary subject matter, a trend that climaxed in the large Bathers, where the artist explicitly rejected spontaneity and directness in favor of a hard, dry technique and a carefully composed articulation of nearsculptural forms, emphasizing contours rather than color. The idea of painting nymphs bathing around a pool, rather than scenes from contemporary life, seemed a provocative reversion to timeless

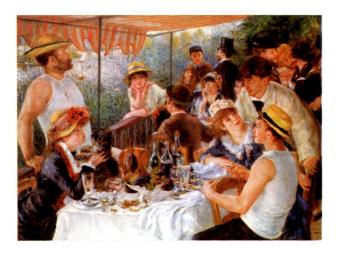

classical subject matter just at the moment when such painting appeared to the Impressionists academic and outmoded.

Meanwhile, Camille Pissarro (1830–1903), the most overtly intellectual and political of the original Impressionists and a born teacher whom virtually all of the great Post-Impressionists would seek out, became so fascinated with the younger artists' attempts to transform haphazard Impressionism into something more scientific and systematic that for a time in 1880s he even took up the Neo-Impressionist "pointillism" devised, as we shall see, by Georges Seurat (Fig. 19). Like Renoir with his linear classicism, however, Pissarro soon found pointillism too rigid for his purposes, and he went on to regain, in modified form, some of the freedom of earlier Impressionism.

Although Edgar Degas (1834–1917) counted among the original Impressionists, showing in seven of their eight exhibitions, he shared with Manet a lifelong interest in the Old Masters, made a supple, Ingresque line a fundamental feature of his art, and cared little for *plein-air* painting. Instead of landscape, he concentrated on portraiture, race horses, scenes from the concert hall and theater, especially the ballet (Fig. 94), and, later, laundresses at their work. Beginning in the 1880s, when he tended toward the same simplification, concentration, and universality already seen in Renoir and Pissarro, Degas progressively limited his subject matter until it consisted exclusively of the female model, whom the artist painted or sculpted performing certain basic and usually

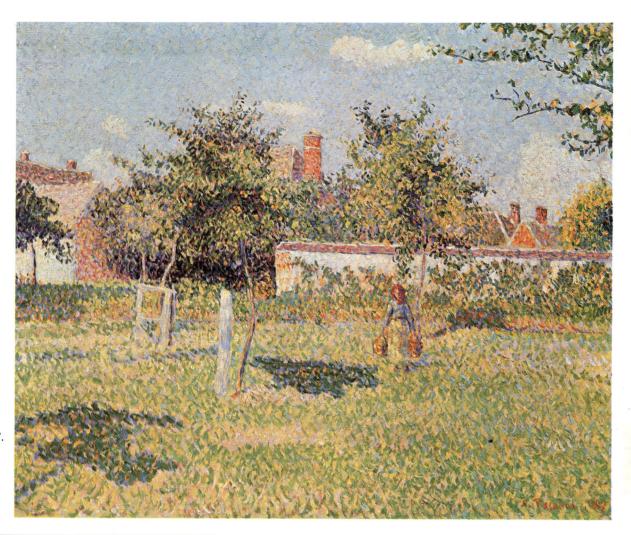

opposite: 18. Pierre-Auguste Renoir. The Luncheon of the Boating Party, 1881. Oil on canvas, 4'3%"×5'9¼". Phillips Collection, Washington, D.C.

right: 19. Camille Pissaro. Spring Sunshine in the Meadow at Eragny. 1887. Louvre, Paris.

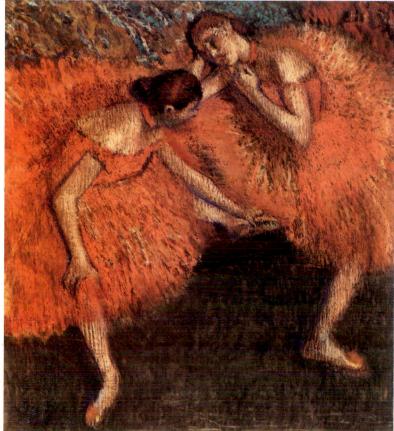

left: 20. Edgar Degas. Two Ballet Dancers. c. 1898. Pastel, 37×33%". Gemäldegalerie, Dresden.

intimate actions—washing and drying herself, stepping in or out of tubs (Fig. 95). Even the actual movement seemed to matter less and less, and while the presence of his figure was essential, as it would be for any artist bred on optical Realism, Degas had become so emotionally detached that the woman's only function seemed to be that of making the creation of a picture possible. After 1886, he worked more broadly, even abstractly, with a direct and more powerful apprehension of bodily movement and the essential structure of the human figure. The expressive studies that Degas made of the female form in these monumental recapitulations of favorite nudes and dancers show a new freedom and dynamism (Fig. 20). Daringly fragmented and viewed from eccentric angles, traceable to photography and Japanese prints, the late pastels are violent chromatically, worthy of the Fauves, and his massive nude forms achieve a prophetic lyrical release.

In the end, however, it was Monet who remained most faithful to optical experience, yet pushed this principle to a point of near abstraction. His late mystique of light, as evinced in serial paintings based on rows of poplars, haystacks, the façade of Rouen Cathedral, or the artist's private water garden at Giverny, curiously constitutes an almost myopic obsession with magnified visual detail and a radical new form of dematerialization. In their marginal recognizability, the emergent new forms seemed to counter Impressionist practice, to the point of linking up with the Abstract Expressionism of the post-World War II New York School, with

its fluent, coloristic "calligraphy," environmental scale, and heightened expressiveness. Prior to the final water-lily paintings, perhaps the most startling innovation, from our vantage point, was the Grainstack series Monet began in 1891. In this group of pictures, conceived as durations or representations of time, the artist fragmented his object into a succession of moments of perception. Such intensity of observation, however, tended to reverse the Impressionist program of empirical objectivity and greatly increased the element of subjectivity. The more the minute deposit of pigment represented nothing but a particle of light sensuously perceived at a precise instant of time, the more the painting as a whole assumed a generalized or uniform texture and tonality, often the very blue or mauve favored by the soulful, introverted fin-de-siècle Symbolists. Like the Symbolists, Monet, who began his career painting such scenes of modern life as the Saint-Lazare train station, the boulevards of Paris, and a new steel bridge spanning the Seine at suburban Argenteuil, had gradually lost faith in the 19th century's positivist, materialistic concept of progress. based on industry and science, and had moved farther and farther away from the encroachments upon the beauties of his beloved nature. Finally, at Giverny, the old Monet withdrew into his own created water garden, where he could look down upon a shimmering surface afloat with lily pads, lotus blossoms, and reflections of the sky above, a piece of the real world, but a remote, timeless one that excluded all but unsullied nature and an ever-fluctuating pattern of light and color (Fig. 21). The pictorial image this yielded seems to reach across the decades-from Monet's death in 1926, three years before the arrival of Jackson Pollock in New York-to the late 1940s, when the American would achieve a similarly all-over indivisible, "holistic," but now entirely abstract image (Fig. 493). In order to attain such an advanced degree of pure opticality, however, Monet had merely changed his subject, not his method or his aesthetic principle, which lay in direct observation of natural forms as revealed through color and light, the purpose being to create a modern landscape art in a rapidly changing, industrial world.

The process of abstraction, already seen here as it evolved from the reformatory art of Jacques-Louis David, clearly accelerated in our own century. Many writers have detected in this attrition of recognizable content the decline of humanism. In fact, it seems, as we have indicated, to be a development entirely understandable in terms of the nature of modern art itself. Manet and the Impressionists rejected traditional illusionism because it no longer seemed capable of expressing their most profound feelings, or sensations, in relation to modern existence. In the wake of these empiricists, "art for art's sake" and even life for art's sake made their appearance, a refined aestheticism that seemed to contradict the more utopian social aspects of other forms of abstraction.

Whatever the social or historical motivation—whose origins and meaning are quite complex—it became clear with Cubism and abstract art that a profound change in the nature of the art object had taken place. The disciplines once supplied by an illusionistic art based on imitations of the familiar world of sight were supplanted by the internal processes, structures, and stylistic disciplines of the language of art itself, as in so much of modern literature. These in themselves became a new subject matter for art. The excitement of the art of Cézanne and Picasso, Braque, and Mondrian in the new century lay in the artist's preoccupation with the intervention and arrangement of shapes, surfaces, and colors for their own sakes, often at the expense of the representational features of art of the past.

The work of art produced by the great modernist tradition can, therefore, be best understood on two levels, as a model of a world that is utterly real since it is the product of artistic intelligence responding to medium and, at the same time, as a wholly imaginary creation, since it is also invented and, in that sense, entirely surrounded by the mind of its creator. The complex tension between objective and subjective realities and the rich spectrum of motives that gives depth, quality, and meaning to modern art forms in their full expressive range and variety are the focus of this study of the masters and movements of modern art.

And that focus remains valid even for the most recent art, which by calling itself "post-modern" emerges as an extension of the very tradition it pretends to repudiate. This becomes especially evident in terms of the avant-garde, which, thanks to the power of the media, ceases to have any meaning once the entire population not only gains awareness of but even embraces the very latest and most daring artistic developments. It leaves the would-be vanguardist little choice but to retreat into the most jealously protected and private reaches of creative endeavor, sometimes into the very kind of isolation that Monet, Cézanne, van Gogh, Gauguin, Picasso, and Matisse drew strength from by the very process of struggling against it. Others, moving in a different direction, achieve comparable withdrawal into an Olympian realm of vast public monuments, the scale and popularity of which have scarcely been seen since the reign of the Beaux-Arts masters. Thus, if only by paradox, the struggle continues, nurturing renewed experiments and discoveries in formerly discredited imagery rendered in once disreputable decorative, narrative, and Expressionist styles, all made powerful by the rigor and integrity of the modernist experience whose heirs they are.

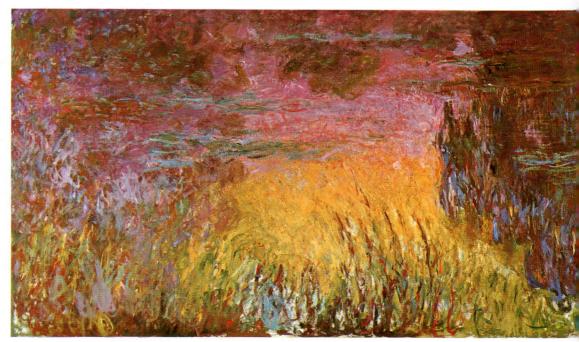

21. Claude Monet. Water Lilies, Sunset. 1914–18. Oil on canvas, 6'%" × 19'6". Musée d'Orsay, Paris.

Seurat, Cézanne, and the Language of Structure

n his book Modern French Painters, R.H. Wilenski rather simplistically describes the reaction against Impressionism in French painting during the 1880s as a general classical revival. According to this recipe, Renoir, Seurat, and Cézanne in particular expressed their dissatisfaction with naturalistic accuracy, which was basic to the Impressionist program, by reverting to classical French tradition and stressing the more enduring architectonic elements of pictorial structure. Although this interpretation of the socalled "crisis of Impressionism" is meaningful to an extent, it is not sufficiently illuminating, for some of the Post-Impressionist styles also represented an effort to preserve Naturalism while reestablishing the fundamentals of traditional pictorial design and structure. Renoir, as we have seen (Fig. 18), did so by monumentalizing his figures and enlarging his manner, only to produce works that recalled the Rococo delights of France's 18th-century fêtes champêtres as much as the classical heritage derived from Raphael. Georges Seurat would pay homage to the spirit of Naturalism under the aegis of "science," while Paul Cézanne would build his most arbitrary formal inventions around the prismatic colors of Impressionism and invest them with the vivacity of his own fresh, sensory perceptions of nature.

Although these artists rejected the spontaneity and "formlessness" of the conventional Impressionist painting, they nonetheless absorbed and extended the movement's basic values and especially its pragmatic, scientific spirit. The artist's sensations before observed nature were considered indispensable. Now, however, they made themselves felt within a more carefully articulated pictorial structure—one that took account of conceptual program and analytical thought. The vital, new traditions of observation and

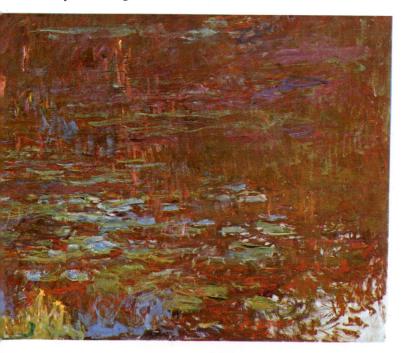

direct painting methods were respected, but a more universal application of the old principles was sought. Even Monet, the model Impressionist who never equivocated in his devotion to optical experience, stretched his art to the very edge of abstraction by the simple, but carefully calculated, act of ever-more intense looking at aspects of the real world far removed, either by location or by the artist's direct intervention, from the polluting side effects of once-admired urbanism and industrialization (Fig. 21). As a result, many of Monet's autumnal pictures seem entirely at home, in form and content alike, among the introspective, "synthetic" works of the *fin-de-siècle* Symbolists, as well as among the heroic and radically abstract painting styles that emerged almost a half-century later in the New York School.

Opposed to the magnificent later work of the reconstituted Impressionists, who had admittedly altered and enhanced their styles but nonetheless retained elements of their earlier attachment to Naturalism, was a profoundly anti-Naturalistic reaction. But the common denominator among French painters in the Post-Impressionist period was the search for new types of subject and new forms of representation, and they all shared a decisive, negative reaction to purely optical sensation of the kind exemplified by Monet's life-long obsession with perceptual experience. Whether in the form of allegory, modified Realism, Symbolism, or Expressionism, there was evident, on all sides, an effort to deepen the meaning of art by a conceptual, rather than a perceptual, approach.

As the 19th century decayed into its final fifteen years, the period became a fertile ground for the active generation of revolutionary and creative individuals. They surged up not only in the visual arts but also in virtually every field of human concern, from politics and economics to philosophy and fiction, most of them notable for having given expressive voice to the peculiar schizoid nature of modern life, polarized by its attraction to the extremes of the romantic and the real. A typical spokesman was the popular French philosopher Henri Bergson (1859-1941), who characterized the world as dualistic, a realm composed of two opposing tendencies: the life force (élan vital) and the resistance of the material world to that force. On the one hand, man knows and measures matter through his intellect, which he uses to formulate the doctrines of science and to apprehend things as entities set out as separate units within a stream of becoming. On the other hand, man is endowed with intuition, which gives him an intimation of the life force that pervades all becoming. Through intuition he perceives the reality of time, that it is a duration, ongoing, indivisible, and immeasurable. While all the great Post-Impressionists would bring new tension and excitement to art by acknowledging and counterbalancing the dualities of mind and spirit, the commensurate and the incommensurate, the real and the romantic, Seurat and Cézanne found their resolutions mainly through intellect and Gauguin and van Gogh primarily through intuition.

Georges Seurat

Both Georges Seurat (1859–91) and Paul Cézanne transcended their "sensations" of nature by creating more abstract and impersonal styles in a radical new structural language of color form. In their paintings they treated the sensuous, palpable things of nature but reorganized them according to the dictates of a lofty intellectual ideal. Seurat's resolute "scientific" objectivity and Cézanne's structuralism were opposed, on the other hand, by the essentially Symbolist approach of Gauguin, van Gogh, Redon, Moreau, Puvis, Munch, and others who tried to synthesize expressive design and subjective emotion. But it is a measure of the universality of the search for new expressive content that even so circumspect a formalist as Seurat, for all his devotion to science, tried to imbue his painting with a new emotional resonance. Speaking of his artistic method, he explained that "gaiety of tone is given by the luminous dominant; of *tint*, by the warm dominant; of *line*, by lines above the horizontal."2 Whether drawn to scientific explanations of artistic method, as Seurat was, or, like van Gogh, to symbols of human suffering and spirituality, the Post-Impressionists shared a common impulse in establishing an art that went beyond realism.

The first public evidence of defection from Impressionism came with Seurat's exhibition of his Bathers at the newly formed Independents Salon in 1884 (Fig. 22). (Like the Impressionist exhibitions, the new salon was founded by progressive artists to combat the reactionary policy of the official salon; Seurat, Redon, Henri-Edmond Cross, and Paul Signac took the lead in organizing the first exhibition.) Seurat divided his tones in this painting as the Impressionists had done, setting contrasting dabs of pure color side by side, and his canvas, similarly, presented a speckled, multicolored surface. His color dots, however, are tinier, more systematically distributed, with an almost parsimonious rigor, and build up concentrated, dense clusters in assertive texture and relief that give a more solid definition to form. Impressionist forms tend to vanish in a chromatic exhalation, lost in an amorphous, flowing mass of light and colored air. By using more sharply defined dark-and-light contrasts, Seurat dislodged his forms from their surrounding atmosphere, established them in space, and created a tension between them and the space they inhabit.

In the Bathers a group of clothed and half-clothed male figures, clearly identified as working class, relax on the banks of the Seine before a broad river view, which includes not only sails and a bridge glinting with sunlight in the distance, but also an array of smokestacks darkening the sky with their anthracite emissions. Unlike the Impressionists, whose preference ran to scenes of preindustrial freshness and innocence, Seurat, a passionate Socialist, tended to take his subjects from the urban and suburban world of working-class or petit-bourgeois Paris. In the Bathers, he dignified each figure with a sculptural roundness, while softening contours so that they merge hazily with a living, sun-drenched atmosphere. One boy, waist-deep in water, cups his hands to his mouth; another young man sits in profile, his feet dangling over the bank; still another is outstretched on his stomach. All these poses are carefully weighed and balanced against each other in a cunningly choreographed tableau that summons up the stately, measured movements of Poussin. The varied play of vertical accents (sails, bridge, piers, and trees) and horizontals (the wide, grassy river bank, the reclining figure) gives the composition a carefully thought-out architectural organization, and also conveys a sense of virtually inexhaustible variety within the otherwise strictly planned formal scheme.

Just as Seurat has carefully controlled the space and volume of his painting, so has he also calculated the character of the scene it depicts. Each figure is sharply typed as a personality by some expressive detail of dress or gesture. With his first major work, Seurat summed up and, in a sense, abstracted a common human activity. His elegantly selective vision, formal invention, and wittily stylized figuration fix the scene with the power of myth. Descriptive detail is particular and exact within a visual formula as severe as an Egyptian wall relief. Seurat's remarkable powers of generalization extended the Impressionists' swift glimpse of a "moment in time" and made an episode stand for something customary and permanent in human activity. And he found a form that could withstand patient and studied contemplation.

As a method of working, the Impressionists attempted to seize the immediate fragment of vision before nature and set it down with a minimum of ratiocination. In their boulevard scenes, Monet, Pissarro, and Renoir spontaneously recorded random, visual data, and by doing so expressed a kind of first principle of artistic freedom.

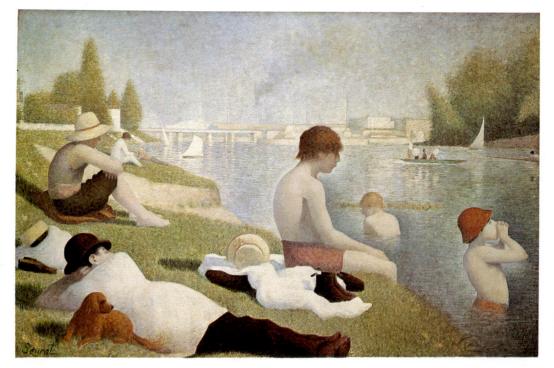

22. Georges Seurat. Bathers, Asnières. Oil on canvas, 6'7" x 9'10". National Gallery, London.

Seurat, Cézanne, and the Language of Structure

Their Paris street scenes show building façades, trees, moving figures, and other incidents that are related to each other pictorially only insofar as they have the blurred, psychological rightness of a vision assimilated by the eye at high speed, unified by the moment of perception. In fact, the Impressionists wished precisely to give the *impression* of something entirely natural and unarranged, and to capture the momentary quality of an arrested action on which they imposed no particular order other than that supplied by the individual artist's sensibility or his personal "handwriting." Seurat, on the contrary, *composed* with unashamed deliberateness and scrupulous care for characteristic detail, working up the picture from countless drawings and color studies of both site (Asnières, now a subdivision of Paris) and subjects. His forms take their place in a preordained, conceptual scheme of things that obeys certain immutable pictorial conventions. Within the context of modernist art, however, Seurat's methods initiated a whole new expression of artistic will.

Seurat's natural love of orderliness had been encouraged and classically disciplined for four years in Paris, first at the Municipal Art School and later at the École des Beaux-Arts studio of Henri Lehmann, a pupil of Ingres's. The young artist rebelled against the narrow and parochial academic training, but he continued to express his sympathy for classicism in masterful drawings after Raphael, Holbein, and Ingres. In 1879 Seurat left the studio to do military service at Brest, where, living next to the sea, he soon came to feel a special affection for the broad skies, crystalline air, and wide distances. He later frequently painted along the Normandy coast (Fig. 23), and his art always seems suffused with the trance-like stillness of coastal regions and that feeling of suspension in an eternity of space which the seaside induces.

In 1880 Seurat returned to Paris and began to draw intensively. He blocked out his figures freely and massed darks and lights to give the broadest expression to his forms. He also painted with "broomswept" strokes and in broad hatchings, building up flat color masses, which gave more distinct definition to his forms. His subjects were of peasant or laboring-class origin and showed a strong moralizing bent. The artist was soon using conté crayon in **left: 23.** Georges Seurat. The Bec du Hoc at Grandcamp. 1885. Oil on canvas, 26 × 32½". Tate Gallery, London.

below: 24. Georges Seurat. Woman Fishing. 1884–85. Conté crayon, 12½ × 9¾". Metropolitan Museum of Art, New York.

a new way, in his associated drawings, building a velvety depth and richness in his blacks, and exquisite nuances of gray and white (Fig. 24). He discovered that by lightly graying the roughened surface of his paper he could create an interesting texture grain, an effect comparable to the pointillism which he later adopted in his

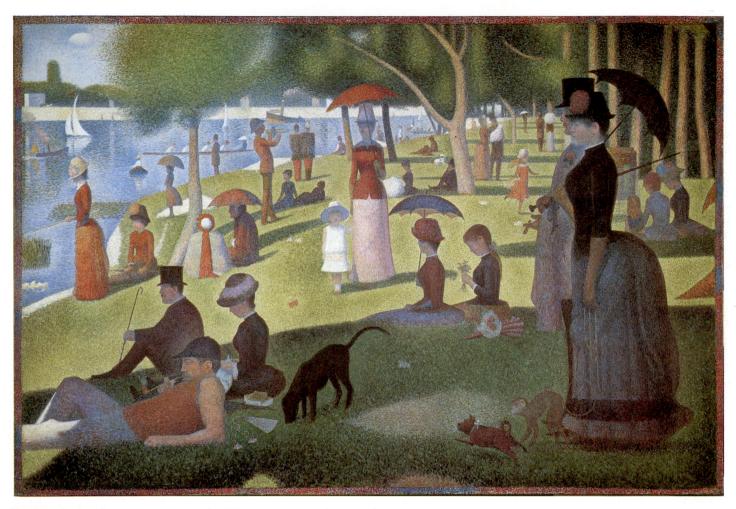

oils. Seurat's drawings are a rare genre in 19th-century art, as rich in tone as they are remarkably sensitive to character, informal and yet full of aristocratic grace.

Through the Independents Salon of 1884, Seurat met Paul Signac (1863–1935). In the following years these artists together formulated the theoretical basis of a new style which had begun to emerge in the Bathers and which the young critic Félix Fénéon later called Neo-Impressionism (Fig. 71), thus seeming to imply that this fresh approach had eclipsed the old Impressionist manner. Camille Pissarro was the only artist of the older generation who did not view Seurat's innovations with suspicion, and he soon, in fact, adopted the younger master's apparently scientific systematization of Impressionist technique (Fig. 19). Although there was more poetry than science in the new procedures, Seurat had investigated, since his student days, numerous relevant studies on color theory and the phenomena of perception, written by Eugène Chevreul, Ogden N. Rood, Charles Henry, Hermann von Helmholtz, and James Clerk Maxwell, among others. Actually, Seurat and his friends simply rationalized discoveries that the Impressionists, for the most part, already knew intuitively and applied in their painting without conscious research or pedagogy. Moreover, Seurat apparently first drew inferences about the possibilities of optical mixtures not from Rood's Studies but from the example of Eugène Delacroix's frescoes, which he examined in a side chapel at the Church of Saint-Sulpice. He and his youthful follower Signac, in fact, developed an absolute cult for Delacroix (Fig. 8). That master's expressive palette also suggested to Seurat the possibility of color used to create certain emotions and states of mind.

Seurat's intense devotion to color theory may be understood as part of the scientific awareness of his historical period, which was sustained by the belief that everything could be formulated and 25. Georges Seurat. A Sunday Afternoon on the Island of La Grande Jatte. 1884–86.
 Oil on canvas, 6'9½"×10'¼".
 Art Institute of Chicago (Helen Birch Bartlett Memorial Collection).

explained in terms of natural law, even the life of the emotions. In the French theoretician David Sutter's *Phenomena of Vision* (1880), for instance, Seurat probably read that "the laws of color harmony can be learned as one learns the laws of harmony in music."

From Chevreul's research—which produced the color wheel of primary and intermediate hues, representing the component colors of white light broken down, or refracted, by a prism, and the concomitant "law of simultaneous contrast of colors"—Seurat deduced that local color was simply one convention among others. In terms of the laws of optics, it can be demonstrated that any hue modifies its neighboring color since it must generate an aureole of a tone that is its own complementary. Rood's experiments, in turn, proved that the juxtaposition of neighboring primary hues—green and red, blue and orange, etc.—creates a more intense intermediate in the optical mixture, blended by the eye, than the actual corresponding tube color.

In the mid-1880s the mathematician Charles Henry was holding audiences in rapt fascination at the Sorbonne in lectures on the emotional values and symbolism of lines and colors, and his ideas soon found their way into Seurat's major compositions. Influenced by Henry, Seurat became convinced that elementary rules of harmony could be established in painting, as they had been in music; for painting, the rules would be based on the new knowledge of perception and on optical laws. He set forth his theory that optical harmonies and contraries produce certain moods and influence feeling. In a well-known letter to Maurice Beaubourg, published posthumously, Seurat declared that the manifold elements of painting could be simplified and codified, in "tone, tint, and line."³ Moreover, he found them capable of inspiring "gay, calm, or sad" emotions according to their character, with descending lines, dark tone, and cold tints producing sadness and rising lines, luminous tone, and warm color engendering gaiety. Curiously enough, Gauguin, whose approach was so different and who derided Seurat as "the little green chemist," later suggested that his own painting could similarly be understood as a kind of visual music, and he was profoundly concerned with the affective potential of colors.

In 1884, at the age of twenty-five, Seurat began the methodical application of his theories in a painting project of a magnitude almost unknown since the days of David and Ingres. His chosen locale was the island of La Grande Jatte, an upscale, middleclass promenade and picnic ground located in the Seine near Asnières, the site of the *Bathers*. There he commenced making preparatory oil sketches and drawings (Fig. 24), just as he had done for the latter picture. Completed two years later, the final painting measured approximately 7 by 10 feet and had been preceded by some twenty drawings and two hundred oil sketches, ranging from individual figures to whole compositions. A Sunday on the Island of La Grande Jatte was shown at the eighth and last Impressionist exhibition, and again in the Independents Salon of 1886 (Fig. 25). Degas openly detested the painting, while the older "Romantic Impressionists," as Monet, Renoir, and Sisley were now called, proved scarcely less severe in their reaction to Seurat's "Scientific Impressionism." So challenging was this great new work that the last three artists withdrew from the Impressionist exhibition, at least in part, because they objected to the inclusion of the Neo-Impressionists.

Seurat's out-of-doors masterpiece, La Grande Jatte shows a crowd of Parisians on a holiday weekend, relaxing on the grass, promenading, fishing, and frolicking in a park framed by a background of trees and water. The atmosphere positively scintillates, the effect of golden light-in fact, sun glare-created by dots of contrasting pigments. Now the color has become much brighter, at the same time that characterizations of the various personages have also been intensified, made sharper and more witty. As in the Bathers, the artist succeeded in distilling a common human activity, doing so in a charmingly stylized manner. Determined to leave nothing to chance in the construction of his painting, he carefully planned every step of the composition. But despite his passion for scientific method, Seurat remained an artist of exquisite sensibility. He even transformed his mannered style into a positive emotional element, designed to enhance a seriocomic mood. The general patterning and the immobile, geometric character of his figures add a note of pomp to the Sunday promenade and give it the formality of a stately ritual. There is something wonderfully mechanical and droll about certain of these characters, particularly the foreground couple at the right. Although emblems of propriety and dignity, they seem to glide along automatically, pulled by invisible wires. If their solemnity were a trifle more exaggerated, the effect would be ludicrous.

Exaggerating, or contrasting with, the more ceremonial figures are such fanciful touches as the monkey, whose curled tail echoes his mistress's bustle; the lyrical relief of the child skipping in the middle distance and of the sails on the river; the informal pose of the gentleman leaning on his elbow. Quite properly this man, so natural and in harmony with nature, has behind him a mongrel dog of a relaxed and friendly character. The rather stiff couple, on the other hand, are accompanied by a monkey and a dainty little beribboned dog of obvious pedigree. Throughout the painting, the artificial and the natural compete, as they had begun to do in so many of the significant works of the Symbolist period, whether in art or in literature. A spellbinding work, *La Grande Jatte* derives much of its fascination from the subtlety with which Seurat energized the monumental calm of his picture. And the means he used included not only the witty juxtapositions, the optical dazzle stimulated by countless points of color, and three isolated instances of depicted action (the charging terrier, the skipping girl, the wind-filled sails), but also a slightly off-center perspective that places the classically frontalized and profiled figures somewhat at variance with the space they inhabit.

Seurat's unfolding panorama of the middleclass at play is an eloquent commentary on contemporary life and manners, just as Renoir's great lyrical paintings *Dancing at the Moulin de la Galette* and *The Luncheon of the Boating Party* had been (Fig. 18).

26. Georges Seurat. The Circus. 1890–91. Oil on canvas, 6'1" × 4'11½". Musée d'Orsay, Paris.

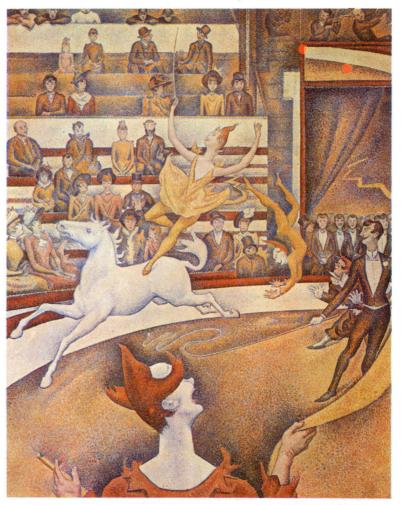

But whereas Renoir's figures are larger than life, with vitality and energy that spill over and animate nature, Seurat's lyricism is more tightly contained. His people have been reduced to delightful statuettes arranged deftly and with good humor in obedience to the artist's will. They take their places almost ritualistically in the compositional scheme, swelling an arabesque, relieving a splash of sunlight or a mass of shade. Much of the curious charm of the work comes from the artist's insistent, exhibited control of forms. Yet, out of a tension between the natural and the artificial, between sensations based on living atmosphere in nature and a contrary, nearly religious dedication to formal problems, Seurat constructed a vital contemporary creation. In its time, however, the painting was generally thought rather frivolous and fanciful. The novelist George Moore reported that the canvas aroused great curiosity, but mainly for its size, its peculiar color scheme, and "a ring-tailed monkey" whose "tail [is said to be] three yards long."⁴ The famous critic Joris-Karl Huysmans wrote: "Strip his figures of the colored fleas that cover them; underneath you will find nothing, no thought, no soul."⁵

Although quintessentially a product of the late 19th century, Seurat, with his analytical methods, theoretical turn of mind, systematic preparations, and precise structures, can be legitimately compared to the great artist-scientists of the Italian Renaissance, such as Piero della Francesca. Like the 15th-century master, Seurat created a world of statuesque, volumetric figures of almost ovoid simplicity, arranged and scaled them in relation to a deep and lucid space, and yet so composed his lines and shapes and manipulated his hues and values that they yield a beautiful, surface-affirming pattern. In the instance of La Grande Jatte, the very regularity of the colored spots not only gives the sense of glittering atmospheric depth; it also endows the canvas with an all-over screenlike consistency that unifies the image and binds every aspect of it to the flatness of the picture plane. By the nature of their genius, both Piero and Seurat could transform science and near-mathematical precision into icons of mysterious, poetic quietude. Rigorously intellectual to the end, however, Seruat said: "They see poetry in what I have done. No, I apply my method, and that is all there is to it.'

After La Grande Jatte, Seurat painted a number of works that again brilliantly caught the essential character and movement of some aspect of contemporary life. The Circus, for example, presents us with a bareback equestrian and a ringmaster in mid-performance (Fig. 26). Here, as elsewhere in his last works, Seurat favored more emphatic and flatter rhythms, while playing up decorative accents in a curvilinear style that anticipated the flourishes and ornamental embellishments of Art Nouveau. The subject matter too provided a foretaste of the 1890s, when popular entertainment, such as fairs, cabarets, and circuses would emerge as the virtual sine qua non of artistic production. And as Seurat flattened his compositions and made them more posterlike, he also allowed his quiet humor to become rather more pointed. Characteristically, The Circus burlesques the action portrayed, and the figures verge on cartoon grotesques of a fantastic nature, their ascending lines, like the picture's overall blond palette, meant to connote lightness and gaiety.

Seurat died at the age of thirty-one, leaving behind only six major paintings, a number of charming marines, innumerable informal oil studies, and a sizable body of exquisite drawings. But if he had painted only La Grande Jatte, Seurat would take his place as one of the finest artists of the modern period. After his death, Pissarro wrote to his son Lucien: "I believe you are right, pointillism is finished, but I think it will have consequences which later on will be of the utmost importance for art. Seurat really added something."⁶ What he brought was, above all, a renewed interest in pictorial structure and design, those major formal considerations that Impressionism was thought to have ignored. He began, tentatively, to use color for plastic definition as well as for description, and his art thereby forms a bridge between Impressionism and the great innovations of Cézanne. Seurat's feeling for flat decorative pattern, his comic exaggeration, and some of his music-hall and circus subject matter also link him to Toulouse-Lautrec, of whom we shall hear more in the next chapter.

Paul Cézanne

The new interest in the solid presence of objects and a deeper concern with the more permanent and formal aspects of nature are even more dramatically illustrated by the revolutionary and profoundly influential paintings of Paul Cézanne (1839–1906). Because of the impact of his experiments on the 20th century, Cézanne has been called, with justice, "the father of modern art." For continuous creative impulse, he is one of the major figures of 19th-century painting, a prodigy of creative innovation, ranking-in the period after 1850-with Manet, Monet, Gauguin, and very few others. Indeed, he has been likened to Giotto, the late-medieval master who initiated the idealized realism that culminated in the Renaissance and Baroque painting styles, an illusionistic, or trompe-l'oeil, mode of expression that continued to dominate Western art until overthrown by the "modernism" considered in this book. Compared to Cézanne, if comparison is valid, or illuminating at all, even Seurat must take his place as a somewhat lesser figure-an incomparable sensibility and formalist, and yet perhaps a narrower, and certainly a less momentous, talent than Cézanne. However, Seurat's paintings, despite their decorative flatness, contrast less sharply with traditional illusionist systems, and therefore make a useful in-

troduction and transition to Cézanne's more radical pictorial solutions.

Like Giotto, who managed to revive the values of classical art, after a thousand years of rejection, mainly by reconciling the real and the ideal, Cézanne, in the course of a life-long struggle, succeeded in producing an art of clarity and calm by bringing into equilibrium a whole array of warring objectives: the orderliness of classical form and the accidentality of nature, the synthetic on the one hand and the imitative on the other, the immutable and the momentary. In his own words (often misunderstood), Cézanne wanted "to do Poussin over again, after nature," the better "to make of Impressionism something solid and durable like the art of the museums." But rather than merely rework Poussin's art to make it seem more atmospheric, Cézanne-a true heir to his time-did just the reverse and, while observing an actual bit of nature, sought within his "sensations" of the motif the alterations that would enable him to "realize" a reconstruction of his subject, a reconstruction offering both the timeless, "unnatural" perfection of a Poussin and the naturalness and instantaneity so esteemed by the Impressionists. And while deriving order out of nature and his sensations of it, Cézanne also hoped to preserve in his art something of nature's organic quality, the sense of its processes of life and growth. Along the way, he found an unprecedented and potent solution to the age-old problem of resolving the conflict between the three-dimensional space of external reality and the two-dimensional limits of the painting surface. The solution, moreover, brought with it an

opposite: 27. Paul Cézanne. Luncheon on the Grass. 1870. Oil on canvas. Collection J.-V. Pellerin, Paris.

right: 28. Paul Cézanne. The House of the Hanged Man. 1872–73. Oil on canvas, 21⁷/₈ × 26¹/₄". Museé d'Orsay, Paris.

astonishing new synthesis of line and color, elements long viewed as rival, not only by the 18th-century followers of Poussin and Rubens, but also by Ingres and Delacroix in the 19th century. Intimately bound up with his historic breakthrough into new artistic meanings and formal expression was the personal struggle that Cézanne waged to gain dominion over his own deeply conflicted nature, torn between a conservative, Provençal background and unruly, bohemian tendencies, a classical education and romantic, even violently emotional drives, contempt for authority and an almost servile respect for such figures as Manet, Monet, and Rodin. Most of all, he suffered, and persevered, endlessly to make the stubborn awkwardness of his talent respond to the urgings of his extraordinary genius.

Cézanne grew up in the southern city of Aix-en-Provence, the only son of a timid, illiterate woman and a tough, self-made banker whom Émile Zola, Cézanne's closest boyhood friend, characterized as "mocking, republican, bourgeois, cold, meticulous, and stingy." Hopelessly unsuited to his father's business, the twentytwo-year-old Cézanne proved intractable enough to win an allowance enabling him to join Zola in Paris and paint. Although drawings from this early period attest to an essential mastery of the classical techniques of working from the nude model, Cézanne's ardent and confused spirit expressed itself more fully in a painting like Luncheon on the Grass (Fig. 27). The title alone invites comparison with Manet and the carefree world of weekend picnicsonly to evoke the most striking contrasts! Whereas Manet's Luncheon on the Grass (Fig. 15) is coolly erotic and technically virtuoso, Cézanne's picture positively seethes with explicit sexuality and vehement brushwork, the artist himself portrayed at the center of it all, an image frustrated with desire and fixated on the lewd temptress at the extreme left. Everywhere the dark, brutally stroked landscape has been activated to express lust and longing. To post-Freudian eyes, there is no denying the sexual connotations of the upward-thrusting wine bottle, met by an analogous shape in the watery reflection of a tall tree silhouetted against a stormy sky. Such distortions gained Cézanne the reputation, which the public long continued to nurse, of a talentless primitive or psychopath. But while no doubt to some extent the product of ineptitude, parallel and contrasting relationships like those seen in Luncheon on the

Grass would become the hallmarks of Cézanne's art, in which formal distortions emerged as the inevitable consequence of a unique aesthetic vision and its expressive needs.

A near contemporary of Monet and Renoir, Cézanne nevertheless lagged behind the Impressionists and found himself in art so late that both formally and psychologically he belongs to the generation of the much younger Seurat. Still, Cézanne sought guidance from the Impressionists, especially Pissarro, who saw Cézanne's latent power and in the 1870s took the troubled artist under his wing, causing him to work "with all his might to regulate his temperament and to impose upon it the control of cold conscience." In his so-called Impressionist period, Cézanne came to depend less on his overheated imagination and more on the optical world outside. At Pissarro's side in southern Normandy and in direct contact with nature, Cézanne began to liberate himself into the discipline of seeing. As The House of the Hanged Man reveals (Fig. 28), he learned to employ divided tones, less gloomy color, and a thinner medium. But the impasto remains more substantial than Pissarro's and already gives more solid definition to form. Moreover, the native gravity of the artist's deliberating approach can be felt everywhere, not only in the way the Impressionist stroke has been rethought in terms of structuring planes of color, rather than colored, flickering atmosphere, but also in the subtle network of corresponding lines. And the macabre title of the work, like the angular view and the stark composition it presents, suggests conflict and even horror, certainly a world at odds with the sun-drenched openness and innocent joy of Impressionist art.

After the disastrous reception given his art at the third Impressionist exhibition (1877), Cézanne retreated to Provence and pursued his own independent goals in isolation and quietude. There he progressed into his "classic" or "constructive"—certainly his most Poussinist—period (1878–87), which produced the Chicago version of *The Bay from L'Estaque* (Fig. 29), a picture so familiar that it becomes difficult to appreciate the degree to which the painting stands as a veritable icon of modernist innovation. First of all, it presents what the artist considered to be a *motif*, a portion of the real world, but one so empty of human activity, and all the disturbing associations such activity held for the artist, that it permitted him, and his viewers, to engage in a visual experience purified of

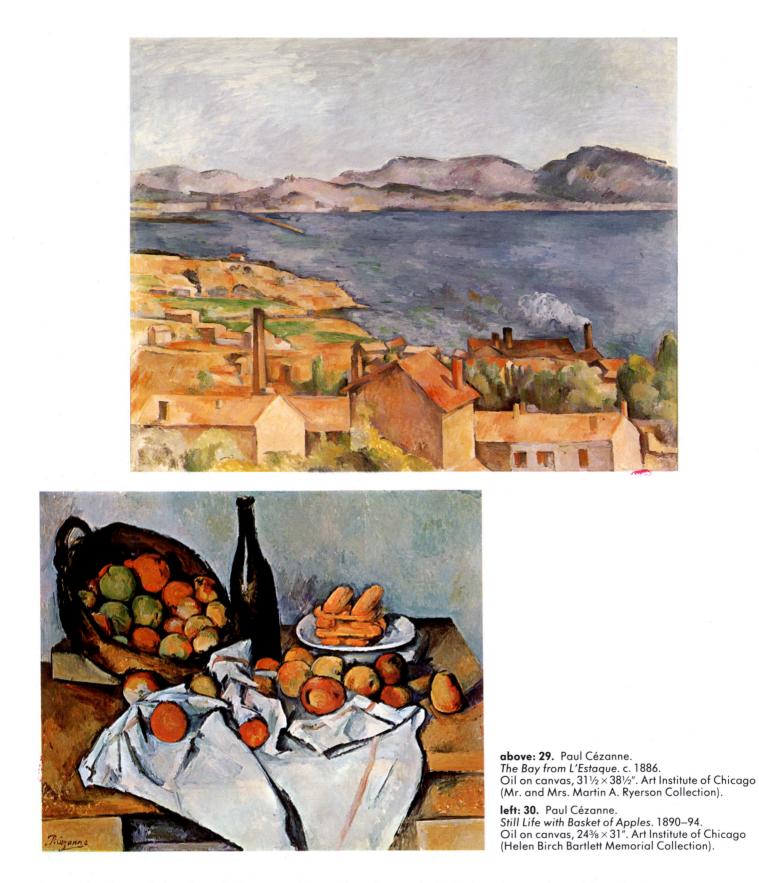

everything but artistic values. Before a motif on this order, Cézanne could "regulate his temperament" and through his own inner logic—his sensations—discover the logic of nature and express it, not in imagery borrowed from religion, history, literature, or the contemporary social scene, but in the language of painting itself, what Cézanne called "plastic equivalents and color." The artist then proceeded to "read," probe, and search the subject for the "cylinder, sphere, and cone," by which he meant the structuring abstractions that he sensed within the variegated shapes, forms, and concretions of visible reality. Having thus dismantled and fragmented the scene, Cézanne could next "realize" his sensations in a "construction after nature," i.e., the painting. And he did so by means of his recently mastered Impressionist color, using it however with all the force and drama that he once poured into erotic fancy. Taking Pissarro's broken-color stroke, Cézanne monumentalized it into large fields of boldly contrasted, complementary colors. But whereas the Impressionists made solid form seem dissolved in fluent, translucent atmosphere, Cézanne locked the orange of the earth and the blue of the sea together with the bluegreen-violet of the mountains and sky in a relationship as structurally stable as pieces in a puzzle. He also clamped them firmly to the picture's lateral edges, where instead of curving gracefully to and fro in the picture space, each color zone-earth, sea, mountains-sky-seems stretched bandlike across the canvas. But while eager to affirm the physical reality of the two-dimensional space offered by the painting surface, Cézanne felt compelled to do it in a way that could harmonize with the three dimensions of nature's own space and its content of solid forms. This meant loosening or blunting the illusionistic techniques of traditional perspective (mainly converging lines and progressively blurred details), with their tendency to "violate" the painting surface and render it as a transparent plane of window glass, in favor of exploiting both the tangible materiality and the expressive possibilities of "color and plastic equivalents." Note, for instance, how the artist used flat planes, differentiated by the value and intensity of their color, to define the foreground houses as cubically solid and overlapped the structures to indicate their positions in depth, yet retarded recession by making the buildings' edges continuous, from roof to roof or from gable to ridge. Moreover, he drew the side of each structure as if it were seen in the same plane as the front or back, which flattens the form into a shape analogous to the rectangle of the canvas itself.

But even more than such manipulations of shape or drawing, Cézanne used color and his "constructive" stroke to reflect his sighting of the motif from multiple vantage points and his ordering of this experience within the limitations of two-dimensional design, while endowing the whole with a rich sense of the density, substance, and depth present in the real world. Thus, not only are the foreground buildings constructed by planes of differentiated color, rather than descriptive contour lines, but such plastic use of color has been applied in both large and small throughout the painting. Being warmer in tonality, the orange of the foreground landmass makes this passage seem distinctly forward of the cold blue of the midground body of water, at the same time that the thinness of the orange and the density of the blue tend to reverse the spacefixing effects of the colors' respective temperatures. In the mountains and sky a sense of great distance emerges out of the low value and low intensity, as well as the very diluteness, of the blue medium used in these passages. But owing to an admixture of yellow, the blue here is less chilly, therefore hardly more recessive, than that of the midground water.

Meanwhile, Cézanne's stroke—each one corresponding to a distinct perception—functions both to establish form in space and bond it to surface, with the variations in the color deposits counterbalanced by the uniformity of the stroke's flat, discrete, slablike quality. Ignoring nature's own textures, the brushwork gives the entire picture surface the uniform materiality of paint. This makes for a certain openness of form, with plane flowing easily into plane, as in the top edge of the roof in the lower left, where one powerful horizontal stroke serves simultaneously to define the roof's sloping surface, its ridge line, and the area beyond. In this way foreground "bleeds" into background, where strokes of color facet the terrain in an abstract, miniature repetition of the more monumental objects represented closer in.

The flat planes of pigment also unify the canvas by transforming an all-illuminating Mediterranean light into a sourceless, "internal" light that casts only those shadows required by the artist's formal purposes. Like the steep, bird's-eye view, which tilts the ground plane forward and aligns it relatively close to the picture plane, Cézanne's steady, sourceless brilliance tends to reveal all, near or far, in equal detail. Each of these, realized in a separate dab of color, functions at once as a bit of nature, a touch of sensation, and an element of construction, while together the strokes combine to reproduce the world as colorful and infinitely varied, ordered, however, into a new unity by the artist's powerfully scrutinizing, creative intelligence.

Deprived of the certitudes enjoyed by the Renaissance, its confidence so beautifully expressed in the pictorial science of onepoint perspective, Cézanne found himself forced to proceed in a sequential, piecemeal, composite manner, which, however, corresponds to the perceptual-cognitive experience of visual reality that we have in actual life. The coherence of his work, with its grand, architectural design, derives not from some readymade and mechanical system of order, but from the consistency with which the artist analyzed every part according to his perceptions of the motif and his sense of the need for pictorial harmony. By basing his art on personal perception, Cézanne arrived at a method, not a formula. Thus, the elaborated network of colored forms makes each painting a record of an heroic attempt to wrest order from the chaos of accidental effects in nature. The method brought splendor to even the most casual or apparently inert motifs, every stroke ennobling them with the artist's powerful spirit and inventive mind. A painting by Cézanne cannot be experienced as an all-at-once revelation such as that offered by a Renaissance work. Rather, it reveals itself as music does-an experience in time, but wedded to space.

Even more than landscape, still life offered Cézanne the ideal motif, for instead of searching the world for its geometric shapes, the artist had only to select and compose them, as in Still Life with Basket of Apples (Fig. 30). Inevitably, however, the picture evinces the fervid dynamics of Cézanne, caught up in the unremitting mental effort that makes his greatest works an almost musical delectation of shifting relationships. To create a sense of thwarted perspective, he tilted the horizontal plane of the table or sideboard up, thereby thrusting the background closer to the foreground, and widened, or "squared," the mouth of an elliptical bowl, as if the spectator suddenly enjoyed a bird's-eye view of it. But while looking down on the tabletop and the objects in the rear. he painted the apples in the foreground at eye level. The process of evoking "flat depth," by utilizing multiple viewpoints in tension, continued in his handling of color, where plane after plane of juxtaposed and overlapped pigment constructs the apples, for instance, as dense, compact forms, at the same time that broken contour lines flatten the modulated volumes by allowing them to "pass" or "bleed" into one another. In a further effort to stress the plastic structure of the painting as a whole, the artist distorted his drawing to make the silhouette of the wine bottle swell, in "sympathy," toward the basket of apples, thereby creating a formal, synthetic continuity that counterbalances the discontinuity of the tabletop's back edge, which runs at different levels from left to right. Having upset nature's balance by factoring it through his own heightened sensibility, Cézanne devised such irrationalities for the sake of reordering the motif into pictorial logic of a superior sort, "something other than reality," he said, actually a "construction after nature." Thus, the final composition, while permeated with tension, possesses a serene poise in which we feel the measured rhythms and solidity characteristic of all great classical paintings.

The human image posed a special challenge for Cézanne, since not only was he painfully lacking in social ease, but the process of making a "reconstruction after nature," with all its attendant distortions, would necessarily have been easier when done from the mute and/or inanimate subjects of landscape and still life. Nevertheless, Cézanne did portraits, as well as self-portraits, throughout his career, and resolved his tensions sufficiently to produce genuine masterpieces in the genre, usually by making his subject seem

31

right: 31. Paul Cézanne. Portrait of Ambroise Vollard. 1899. Oil on canvas, 39½ × 32". Ville de Paris, Musée du Petit Palais, Paris.

below: 32. Paul Cézanne. Mont Sainte-Victoire. 1904–06. Oil on canvas, 27% × 361%". Philadelphia Museum of Art (George W. Elkins Collection).

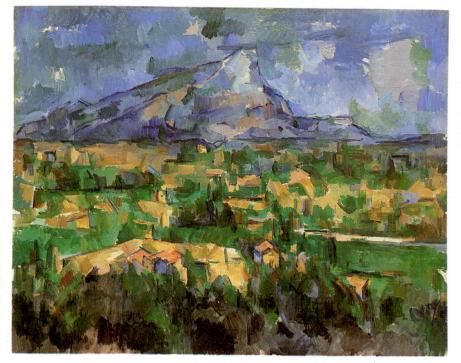

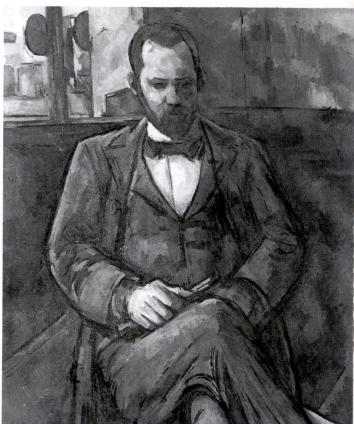

like a statue arranged in a still-life painting. This is particularly evident in the portrait of Ambroise Vollard (Fig. 31), the young dealer whose fearless promotion of avant-garde artists may have encouraged the painter to realize his sensations with rare boldness. To such a degree has the figure been simplified into something close to its essential geometries and then integrated into an all-embracing pictorial unity that the painting, when compared to Picasso's 1910 portrait of Vollard (Fig. 233), assumes the quality of a virtual proto-Cubist work. We have only to observe, for instance, how three different depths have been visually conflated into a single plane-the painting surface—by a vertical line traceable from the window sash above the sitter's head through his shirt front and vest to the left leg. At the same time that the cross this line forms with the horizontal window ledge invests the picture with firm, bracelike underpinnings, the discontinuity of the lines and the oblique angle at which they have been set activate the composition with the pictorial equivalent of life's own energy.

As he entered the final phase of his career-a period lasting from the late 1880s until the artist's death in 1906-Cézanne continued to live and work remote from the Parisian world of art, prompting one critic to write: "Cézanne seems to be a fantastic figure; although still living, he is spoken of as though dead." Far from dead, the aging painter had so mastered his method that in his late, liberated art he produced picture after picture whose sheer chromatic sumptuousness and baroque energies recall the passionate, romantic spirit, if not the violent imagery and handling, of his youthful productions. For the version of Mont Sainte-Victoire seen in Figure 32, Cézanne returned to a favorite motif, one he had already painted almost countless times, but now the artist seems to have broken free into an ecstatic, sensuous mood, without any consequent loss of control, for, as Cézanne declared. "form is at its fullest when color is at it richest." Here the entire canvas surges and pulsates with large, sonorous chords of deep, strong colors that, for all their floating, translucent quality, structure the picture securely along its rectilinear and diagonal axes. In such works as this-really symphonic in character-Cézanne has justifiably been compared to the great Venetians of the 16th century. Like the watercolors in which the aged Cézanne achieved such radiant splendor and clarity (Fig. 33), Mont Sainte-Victoire discloses the artist's method at its most mature. Sighting locally from a multiplicity of angles and nurturing his smallest sensations of the motif, often in an exercise pursued over a long duration, Cézanne might have lost command of his picture except for the fact that he made sure to "advance all of the canvas at one time." This meant that from the very first stroke he composed and structured in terms of both surface and depth. For Cézanne, however, with his acute sense of the rivalry between two- and three-dimensional reality, each stroke had to be balanced by a second one, until, through a process of continuous readjustment, of upsetting and restoring balances, he brought the painting to its ultimate state of equilibrium, of tensions counterbalanced into "an exciting serenity." Thus, no canvas by Cézanne, however little advanced, ever seems unfinished. Even the white, the bare support, of the watercolor in Figure 33 has been so sensitively deliberated that it contributes to the total effect no less than the colors.

Cézanne also persevered in his life-long desire to redo Poussin after nature. Finally he succeeded in representing nude female figures in a landscape setting composed with the grandiloquent rigor of Old Master art, but rendered with all the freshness acquired from years of perceiving nature in the direct manner of the Impressionists. For *The Great Bathers* of 1898–1906 (Fig. 34) Cézanne stretched the largest canvas he ever painted, the very size of which attests to the importance the theme held for him. Having abandoned the notion of arranging actual nudes in a landscape of his choice, the artist settled for formalizing figures in a structure so taut that it drained the human images of their erotic content and then channeled the force of his feeling into the power of the overall conception. Thus, the nudes are assimilated into nature's enframing, high-vaulted architecture, all the while that the artist's touch, as delicate as watercolor, unified sky, foliage, and figures alike in a soft, blue-green haze, shot through with the pale rose and ochre of fleshtones and earth. In its symmetry and restraint, *The Great Bathers* constitutes not only the most monumental but also one of the most perfectly resolved pictures ever to emerge from Cézanne's studio, a work in which romantic and classical, painterly and linear impulses have been wondrously balanced, yet fully expressed.

During the eighties and early nineties Cézanne's art could be seen only at the artists' supply shop of *père* Tanguy, where it helped shape the vision of a whole generation of Post-Impressionist painters. Among the first of these were Paul Gauguin, Émile Bernard, Maurice Denis, Pierre Bonnard, and Édouard Vuillard, who viewed Cézanne as an artist striving after some kind of symbolic union between nature and thought, between observed reality and ideal life. The older Impressionists, dissatisfied with the little they could see of Cézanne's amazing work, persuaded Vollard to mount a one-man exhibition devoted to their reclusive colleague. It took place in 1895, and while conservative viewers considered the artist more bizarre than ever, others asserted that Cézanne, "... a great teller of the truth ... will go to the Louvre." By 1906 one new modernist movement after another would be claiming derivation from Cézanne. To an extent, the master himself encouraged this by insisting that he was no more than "the primitive of a new art," of a "vision" he had failed to realize in all its implications. While Cézanne's emancipated color meant everything to Matisse, Picasso and Braque ignored that element to develop a new pictorial unity out of the underlying geometries Cézanne had counseled them to seek in nature. In his uniform faceting of objects and space, his shallow depths and structural armatures, his simultaneity of vision, and the passage his broken contours made possible from plane to plane of distinct and separate objects, Cézanne blazed a trail that led Braque and Picasso to Cubism in 1908. Thus, while always faithful to recognizable subject matter, Cézanne's painting nevertheless served as a transition between an older, 19th-century, perceptual art and the pure, geometrically abstract, or nonrepresentational, art of the 20th century.

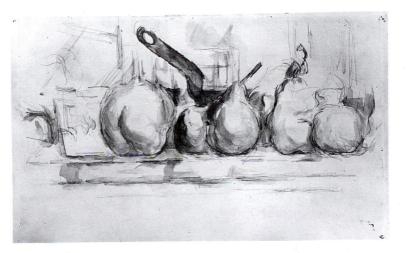

33. Paul Cézanne. Still Life. Apples, Pears, and Pot (The Kitchen Table). 1900–04. Pencil and watercolor, 11 x 18³/8". Cabinet des Dessins, Louvre, Paris.

34. Paul Cézanne.
The Great Bathers. 1898–1906.
Oil on canvas, 6'9³78" x 8'2".
Philadelphia Museum of Art.
Purchased with the W.P. Wilstach Fund.

Gauguin, van Gogh, and the Language of Vision

he climate of art began to change noticeably in the 1880s with the crisis in Impressionism and with the emergence of the new literary and artistic doctrine of Symbolism. Many of the Impressionists openly acknowledged their dissatisfaction with the informal character of their own painting and its relatively passive registration of optical sensation. The need for a more spiritual or emotional approach in art was as evident in the expressive theories underlying Cézanne's premeditated structures and Seurat's science-oriented Neo-Impressionism as in the more subjective attitudes announced in the work of van Gogh and Gauguin after 1888. The term Post-Impressionism, coined in the 20th century by the British art critic Roger Fry, is too imprecise to describe a group of artists so distinct in style and thought as Cézanne, Seurat, Gauguin, and van Gogh. Cézanne and Seurat concerned themselves with an essential pictorial order, although each owed much to Impressionism for its release of color. Vincent van Gogh and Odilon Redon, in their separate ways, and Paul Gauguin and the painters around him drew their support from the current of literary Symbolism. They endeavored to convert art into a vehicle for more personal emotions, for fantasy, reverie, and dream. Within the two major camps that succeeded the Impressionists-the Neo-Impressionists and the Symbolists-there appeared a number of significant divisions, or subgroups, defined by individual manner. New meanings were being sought by artists of different styles, but all veered away from classic Impressionism. The new styles might, in turn, be described as academic, primitive, aesthetically refined, philosophically weighted, or, indeed, mixtures of all of these.

In this period of shifting artistic values, three little-regarded figures who had pioneered literary subject matter and fantasy in their exhibited art of the 1870s emerged from comparative isolation to a new prominence-Gustave Moreau, Pierre Puvis de Chavannes, and the young Odilon Redon. In their hands, and in those of the growing ranks of emulators of the 1885 generation, a bizarre, new romantic beauty came to birth and with it a revised conception of the artistic process. The first conclusive public expression of the altered viewpoint appeared in a sensational novel of 1884 written by Joris-Karl Huysmans, Against Nature (À Rebours). That influential book set forth the essential credo of the new spiritualism two years in advance of the Symbolist movement's official birth in the form of Jean Moréas's Symbolist Manifesto, issued in 1886. Arthur Symons hailed Against Nature as the "breviary of the decadence"---the so-called "Decadence" being the literary movement in France and England characterized by delight in the perverse and the artificial, a craving for new and complex sensations, and a desire to extend the boundaries of emotional and spiritual experience. The year 1884 also saw the formation of the Belgian association of artists, the XX, and although it had no consistent aesthetic program, this group soon became the respected sounding board for new

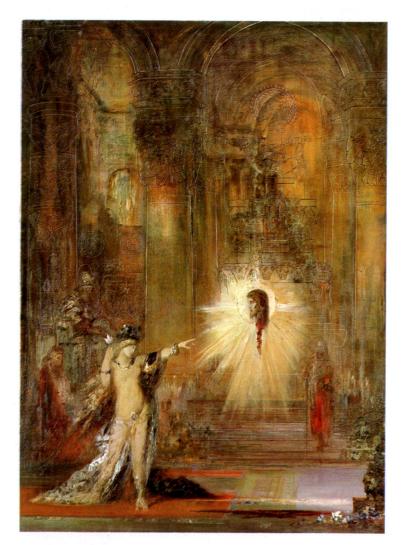

forms of advanced art, including Symbolist painting. In Paris during the spring of that year, another blow was struck at the old order and at the more romantic Impressionists especially, as Pissarro later described Renoir, Monet, and others, with the advent of a rival group, the Society of Independent Artists, one of whose leaders was Redon. The society's first exhibition included Seurat's *Bathers* (Fig. 22), a painting ridiculed in the press, rather interestingly, as *un faux Puvis de Chavannes*.

In his Symbolist Manifesto, Moréas singled out three poets as father figures of the movement: Baudelaire, Mallarmé, and Verlaine. Of the literary giants of Symbolism Moréas wrote: "Charles Baudelaire should be considered the true precursor of the present movement... Stéphane Mallarmé endowed it with a sense of the mysterious and the inexpressible; Paul Verlaine shattered in its honor the cruel chains of verse which the subtle fingers of Théodore de Banville had already made more flexible."¹ The major features of the Symbolist position in painting as well as in poetry can be traced to these three poets. The element of subjectivity acknowledges, above all, Baudelaire's concept of the poetic imagination as a repertory of symbols of a transcendental reality to which the artist has special access. From Mallarmé, the Symbolists gained sanction for one of their primary aims, to intimate things rather than state them directly. Verlaine's pious verse and musical diction, which dissolved sense in sound, confirmed, in terms of religious belief, Mallarmé's aesthetic objectives by calling upon poets to explore the ultimate truths that lay behind the visible world.

Finally, Schopenhauer's oft-repeated view that the world was merely a representation and thus the product of subjective imagination became the basic intellectual rationale for the new mood of spiritual adventure. His philosophical writings also encouraged a pessimism of outlook in its darkest form, suitable to the despairing moods and the cultivation of personal eccentricity in behavior that became familiar features of the *fin de siècle*—the 1890s.

Moréas's more restrained and abstract statement of the Symbolist aesthetic also drew directly upon Schopenhauer's idealism. "Symbolist poetry," wrote Moréas in his manifesto, "endeavors to clothe the Idea in sensitive form."² Sometime later, answering attacks upon the controversial new artistic doctrine, the poet Gustave Kahn asserted: "As to subject matter, we are tired of the quotidian, the near-at-hand, and the compulsorily contemporaneous; we wish to be able to place the development of the symbol in any period whatsoever, and even in outright dreams.... The essential aim of our art is to objectify the subjective (the externalization of the Idea) instead of subjectifying the objective (nature seen through the eyes of a temperament)."³ He thus succinctly expressed the fundamental differences between the liberties that the Impressionists took with nature for the sake of spontaneity and the far more arbitrary and subjective moods of Symbolist invention.

While defining the distinctive character of Symbolism in both the visual arts and literature, it is useful to compare the movement's helplessly egocentric focus with the more outgoing stamp of earlier manifestations of 19th-century Romanticism. The militancy of Romantic poets and painters contrasts sharply with the morbid inaction and aesthetic specialization of the Symbolists, whose subjectivity took a deliberately escapist route. Essentially, the Symbolists set themselves against the facile extroversion of the age. Turning away from social action and from the triumphs of science and technology, they scorned the vulgar present and sought refuge in a dreamworld of languid beauty or one of elaborate and stylish artifice. Oscar Wilde was later to predict the success of a decadent Romanticism in his essay "The Decay of Lying": "Facts will be regarded as discreditable, Truth will be found mourning over her fetters, and Romance, with her temple of wonder, will return to the land."⁴ An even more dramatic and revealing rejection of the engagé heroism of early Romanticism was conveyed in a disillusioned and fanciful letter to Redon from the Belgian Symbolist poet Émile Verhaeren, who wrote: "I fly into a fury with myself because every other form of heroism is forbidden to me. I love things that are absurd, useless, impossible, frantic, excessive, and intense, because they provoke me, because I feel them like thorns in my flesh."5

With such abundant literary and philosophical support for the Symbolist position, the overlooked "idealist" paintings produced in the 1860s by Pierre Puvis de Chavannes (1824-98) and Gustave Moreau (1826–98) began to recapture the public imagination (Figs. 35, 36). Puvis and Moreau had been among the few artists of their generation to espouse a new kind of subject matter, poetic in inspiration yet opposed to the traditional iconography and mythologies that still held validity for Delacroix and Ingres. They had encountered harsh criticism and appeared isolated from contemporary painting. By the time the younger Symbolist painters revived his languishing reputation, Moreau had become something of a recluse. Puvis kept bringing his ambitious allegorical frescoes and smaller easel paintings before the public, only to receive little encouragement from its response. In the 1880s, when the need for a spiritual approach to painting manifested itself, however, a new genertion rallied round these idealist artists. The appeal of Puvis, Moreau, and Redon, moreover, coincided with the emergence of Victorian Symbolist painting and its public triumph in England un-

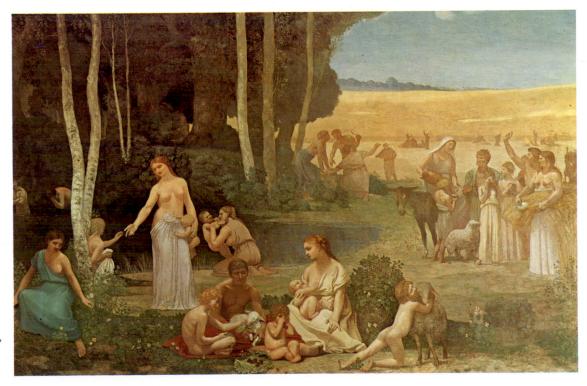

opposite: 35. Gustave Moreau. The Apparition. c. 1876. Oil on cardboard, 12½ × 19¾". Musée Moreau, Paris.

right: 36.

Pierre Puvis de Chavannes. Summer. 1873. Oil on canvas, 11′5¾″×16′7½″. Musée des Beaux-Arts, Chartres.

der the Pre-Raphaelites, whose reputation had already reached the Continent. The arcane world of legendary romance contrived by Edward Burne-Jones (1833–98) and Dante Gabriel Rossetti (1828– 82) especially conferred new prestige on the rediscovered French idealists, for it similarly offered a vision of "beautiful romantic dreams" to counter the noisy and banal age of progress (Figs. 37, 38). Both tendencies had obviously long been out of tune with dominant realist or Impressionist modes, until the climate of art began to shift once more toward a painting of ideas.

The French discovered the Pre-Raphaelites William Holman Hunt and John Everett Millais at the Universal Exhibition of 1855 in Paris.⁶ Many of the minor Symbolist artists in Paris were directly influenced, and turned to the Pre-Raphaelites for a new image of beauty, as they did to William Morris for a new decorative style (Fig. 72), and, later, to Aubrey Beardsley for his provocative draftsmanship and decadent themes (Fig. 73). A key figure, Burne-Jones first showed in Paris at the International Exhibition of 1878, and thenceforth began to enjoy a considerable reputation abroad. His combination of spiritual content and consciously primitive style appealed to a jaded artistic public, discouraged by the dominant materialism of the age and openly seeking refuge in a world of fantasy. Puvis said he never forgot Burne-Jones's *King Cophetua and the Beggar Maid*, shown in the 1889 Paris International exhibition (Fig. 38).

As early as 1850, the obsessive, mediumistic pictures that Rossetti painted of his model, mistress, and, finally, wife, Elizabeth Sidal, had prophesied the fatal Medusan beauty later characteristic of the French Symbolist female temptress. This was, for the most part, the same ambiguous creature whom Walter Pater discerned in the Mona Lisa in his *Studies in the History of the Renaissance* (1873): "A beauty wrought out from within upon the flesh, the deposit, little cell by cell, of strange thoughts and fantastic reveries and exquisite passions." And with words apropos of both the nostalgic and the emancipated aspects of the later Symbolist heroines, Pater concluded his fevered passage on the new beauty of the age: "Certainly Lady Lisa might stand as the embodiment of the old fancy, the symbol of the modern idea."⁷ Pater's Lady Lisa was in fact a curious mixture of *femme fatale* and sacrificial victim, empress and erotic slave, fragile androgyne and raving maenad. She anticipated new types of expressive womanhood found again and again in paintings of the period—with varying degrees of psychological or decorative emphasis—by Jan Toorop, Ferdinand Hodler, Gustave Klimt (Figs.82,84), Aubrey Beardsley, Johan Thorn Prikker, and many other Symbolists. It was in the context of such imagery that Moreau, Puvis, and Redon, heretofore considered archaic and retrograde or stigmatized as primarily literary painters, came to enjoy their new prestige.

As early as 1876, in the ornate, somewhat epicene sensuality of *The Apparition* (Fig. 35), Moreau summarized many of the concepts that linked the melancholy beauty of the Pre-Raphaelites with his own native poetic tradition epitomized by Baudelaire's *femme damnée*, described in *The Flowers of Evil*:

Thou'dst take the world to bed with thee, vile woman! Thy boredom makes thy soul the more inhuman. To keep thy fangs fit in the curious sport, Each day thou need'st a man's heart freshly caught.⁸

Moreau's painting combines an hallucinatory mythic subject matter with the conscious attempt to achieve his own stated objectives of a "beauty of inertia" and a "necessary richness" of pictorial effect. His spangled, jeweled color and voluptuous imagery sent Huysmans into a paroxysm of rhapsodic description in *Against Nature*. The elaborate technique of loaded paint application, tumescent forms, and erotic fantasies conspires to lend his mythic

far left: 37. Dante Gabriel Rossetti. Astarte Syriaca. 1877. Oil on canvas, 6' × 3'6". City Art Galleries, Manchester.

left: 38. Edward Burne-Jones. King Cophetua and the Beggar Maid. 1884. Oil on canvas, 9'7½" × 4'5½". Tate Gallery, London.

scenes the quality of mystery and scandal admired by succeeding Symbolist poets and painters. Moreau introduced into the Paris art world the visual image of pitiless womanhood, the first in a long line of sadistic females in art, from Edvard Munch (Figs. 55, 59), just before the turn of the century, to Gustave Klimt and Egon Schiele just after (Fig. 206). The prototype can be regarded as the reigning goddess of the Decadents, a bizarre and voluptuous image, dominated by the twin forces of eroticism and mysticism.

A mere three years earlier, in his painting Summer (Fig. 36), given the place of honor at the 1873 salon, Puvis seemingly had set himself in clear opposition to Moreau's extravagant fancies with his simple pastoral scene, characterized by naïve handling and archaic style. The agitated and fantastic portrayal of Salomé as a wicked goddess of lust appeared totally alien to Puvis's mood of innocence. Yet, the two works are linked at least by their neotraditional pictorial styles and iconography. Furthermore, they share a revivalist myth-making effort in contrast to the literary Naturalists and the Impressionists, with their exclusive interest in modern life. As a critic of the times noted, Puvis's summer season is nonspecific and nostalgia-laden, a dream of some haunting Golden Age: "Summer in that eternal country where the artist's soul lives; feelings are no less acute in that country, merely more generalized."9 Here then, perhaps for the first time, an art critic had defined Symbolism in painting, underscoring its vague and universal character, and the yearning for an ideal world as escape from the unsatisfactory actual moment so innocently celebrated by the Realists and Impressionists.

Elevated to heroic status by the painters and poets of the 1880s, despite his rather sterile academicism, Puvis conceived an idyllic art that would contain a generalized content without the use of classical personification, allegorical attributes, and other outmoded devices of traditional art, which no longer commanded public credence. The fruit of this would, to his mind, be an ennobling art immediately comprehensible to all viewers. Puvis wrote: "For all clear thoughts there exists a plastic equivalent. ... A work of art emanates from a kind of confused emotion. ... I meditate upon the thought buried in this emotion until it appears lucidly and as distinctly as possible before my eyes, then I search for an image which translates it with exactitude. ... This is symbolism, if you like."¹⁰

Despite his willingness to identify with Symbolism, Puvis remained bound to tradition, to historical and allegorical painting. Although Symbolism was certainly mixed in plastic, spiritual, and psychological motivation, its distinguishing mark in painting was not, in fact, spiritual content but the new relationship *between* form and content. Émile Bernard made this clear: "Thus form and color become the most important elements in a work of art. The artist's role was to reduce every form to its geometrical base in order to allow its mysterious hieroglyph to emerge more clearly. . . . In contrast to the classical artist, the symbolists sought to find and emphasize the significant distortion."¹¹

Odilon Redon (1840–1916) felt himself sympathetically drawn to Puvis's vision and aims, but he translated his own emotion and dream into visual symbols more in keeping with Bernard's formulation (Figs. 39, 40). Although he loaded his art with literary allusions, sensitively illustrating Flaubert, Poe, and Huysmans, among others, Redon worked closer to the plastic invention of Gauguin than to the naïve mythologies of Puvis or the intricate literary archaeology of Moreau. Many of the younger Symbolist writers, such as Gide, Valéry, and Jammes, regarded Redon as the Symbolist artist par excellence, the man who found convincing plastic formulations for his vision and philosophy of life.

The originality of Redon, in his own words, lay "in placing ... the logic of the visible at the service of the invisible."¹² Passing through some kind of mystical experience in the 1870s, Redon

39. Odilon Redon. Cyclops. c. 1895–1900. Oil on wood, 24¼ × 20″. Kröller-Müller Museum, Otterlo.

40. Odilon Redon. *Head of Orpheus Floating on the Waters*. 1881. Charcoal on paper, 16⅓×13⅔″. Kröller-Müller Museum, Otterlo.

seemed compelled to explore the depths of soul. He invented a mysterious world of infinite spaces, limitless vistas of land and sea. strange growths, and monstrous apparitions, most of them inspired by the artist's close, virtually scientific study of microscopic biological life. Unlike some of his compatriots, however, he felt that plastic invention, as he put it, began where literature left off. His smiling, hideous Cyclops (Fig. 39) has the disarming gentleness and sorrowful mien that had become one of the hallmarks of Symbolist imagery, an involuntary melancholy that somehow joined the strange and fantastic with a sympathetic human yearning for the unattainable. As in the severed and transfigured head of Orpheus in one of his delicate drawings (Fig. 40), many of these monstrous creatures seem to embody visual analogues for the dilemma of the alienated artist enduring a lonely exile from the protective community of mankind. Happily, Redon matched the fantasy of his images with an equally liberated plastic expression. The sheer brilliance of the colorism in Cyclops-deep, glowing hues that spread like translucent veils or crystallize in jewel-toned clusters-belies the fact that for the first twenty-five years of his artistic life Redon worked exclusively in black, using charcoal, as in Orpheus, etching, or lithography to realize values and velvety textures of unprecedented richness.

The Belgian painter Fernand Khnopff (1858–1921) provides one of the more extravagant examples of the tormented visions and erudite Romantic iconography explored by the literary Symbolist painters. His most famous painting was I Lock My Door upon Myself (Fig. 41), a work inspired by a line of Christina Rossetti's poetry. The face of his female subject represents both the artist's beloved, dead sister, whom he painted repeatedly, and the Medusa, while the classical cast suggests a preoccupation with death and a lost antiquity, anticipating the Surrealist imagination. The window in the painting opens onto a dead city, evoking a vacant de Chirico piazza (Fig. 280). Khnopff, significantly, had been a pupil in the studio of Gustave Moreau in 1879. He was also infatuated by the Pre-Raphaelites and showed in the first Rose + Croix Salon of 1892 in Paris.

Among the most bizarre phenomena of the Symbolist episode were the six Rosicrucian salons organized between 1892 and 1897 by the outrageously eccentric literary figure Joséphin Péladan, whose bogus spiritualism, provocative manner, and picturesque sartorial style attracted, understandably, the more visionary and irrational of the decadent Symbolists. With them was Khnopff, whom Péladan hailed as "the equal of Gustave Moreau, of Burne-Jones, of Chavannes and of Rops."¹³ For weaker or more self-indulgent personalities, who embarked on the Symbolist adventure, a private dreamworld became an open invitation for literary reveries in a gilded style. The religious mysticism of the Rose + Croix group, led by their self-appointed messiah, the Sâr Péladan, some of Moreau's tortuous imagery and ornamental surface, and Puvis de Chavannes's pallid Pre-Raphaelite Arcadia were at worst symptomatic of the bloodless, introverted styles that characterized the Romantic decadence. Set against the work of Gauguin and van Gogh, that of Khnopff and others who matched his wistful literary interests provides minor, but representative, accents in a still-unresolved creative moment in which bold new affirmations and a decadent Romanticism competed for critical attention.

Paul Gauguin

The more esoteric literary aspects of the Symbolist movement held out an ambivalent promise for the major French Post-Impressionist painters who reached maturity in the last two decades of the century. But while Paul Gauguin (1848–1903), perhaps the most tempted by this promise, paid homage to the Symbolist poets in

41. Fernand Khnopff. I Lock My Door upon Myself. 1891. Oil on canvas, $2'4'' \times 4'7_{8''}$. Staatsgemäldesammlungen, Munich.

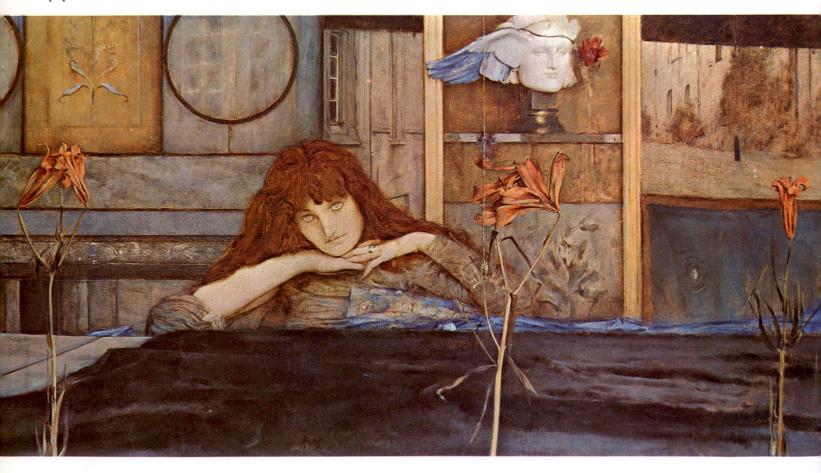

word and image, counted himself a friend of Mallarmé, and frequently attended the latter's literary soirées, he did not follow the Symbolist literary program uncritically. The Symbolist literati enthusiastically took up Gauguin after his Café Volpini exhibition of 1889, but the artist repeatedly made clear his distaste for those painters they particularly admired, such as Gustave Moreau and Puvis de Chavannes, whose methods and use of imagery he compared unfavorably with his own. Gauguin always drew critical distinctions in his paintings between literary content and plastic invention. The Impressionists' rainbow palette and sensuous, painterly brushstroke continued to influence his art, as did their basic respect for material medium. Art, Gauguin declared, was an abstraction to be dreamed in the presence of nature, but impeding that fantasy were the oppressions and the corrupting influence of modern European life, a life Gauguin now abhorred as passionately as the Impressionists had celebrated its innocuous middleclass pleasures.

The founders of the Impressionist movement had been, without exception, men of rude health, vigorous in body, sound of mind, sober in habit. And there was a corresponding simplicity, serenity, and sanity in their paintings despite the bitterest of economic struggles. They perceived the world about them as a healthy social organism, and delighted in translating the spectacle of middleclass life and nature into a rapturous pictorial imagery. They were able to establish a common ground with their fellow men in a shared body of ideals and generous feelings. The Post-Impressionists, especially Gauguin, van Gogh, and Lautrec, different though they were in their lives and art, inhabited a new and ambiguous moral atmosphere, and they did not form among themselves a sustaining Bohemian community-a 20th-century development that made artistic isolation bearable. The pursuit of artistic objectives for their own sakes was not considered a sufficiently compelling raison d'être for the artist, unless he engaged in the dandyish posturing of the more extravagant Symbolists. If he could not make peace with European society, he had either to rage at it in lonely martyrdom or invent an ideal community in the South Seas or in Christian brotherhood, to which he might consecrate his life.

Gauguin had begun to paint as a gifted amateur in 1873 while pursuing a very successful business career with a Paris brokerage firm. His interest in painting was first stimulated by the Impressionists, whom he met soon afterward through his friend and teacher, Pissarro, and he became a modest but discriminating collector of their paintings. One of the canvases Gauguin remained attached to was a still life by Cézanne, which he apparently kept with him always and even introduced into the background of one of his portraits. In 1876 Gauguin had a little landscape accepted by the Salon, and he felt encouraged to give more and more attention to painting until finally, in 1883, at the age of thirty-five, he resigned his position on the stock market to devote himself exclusively to art. He took his Danish wife and their children to Rouen, where life promised to be cheaper, but the experiment proved a failure. When he went to Copenhagen to stay with his wife's family and try his hand at business once again, the results were even more disastrous. Gauguin antagonized his wife's relatives by his arrogance, and his efforts to sell French tarpaulins to the Danes met with no more success than his efforts to find a new market for his paintings. Leaving his wife behind, he returned to Paris with the understanding that the family would be reunited when better days came along, but the separation became permanent as his commitment to painting grew.

In Brittany in 1888 Gauguin arrived at his original style after an apprenticeship in a soft, formless Impressionist manner. The *Self Portrait: "Les Misérables"* (Fig. 42), painted in Brittany and given to van Gogh, already shows Gauguin in the ambivalent role of martyred Christ, with the floral decoration

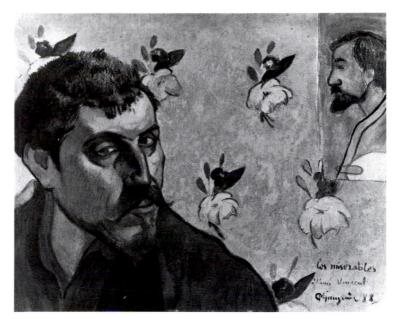

42. Paul Gauguin. *Self-Portrait: "Les Misérables"*. 1888. Oil on canvas, 28½×355%". Stedelijk Museum, Amsterdam.

forming a halo, and yet the facial expression suggests ferocity of character against a background symbolizing purity. The artist was attracted to this remote corner of France by the primitiveness of the life and the savage desolation of the landscape. He felt at home in Brittany because it also, to a degree, had the appeal of the exotic and was inhabited by a simple, pious people whose nature the Symbolists were to equate with soul, or spirituality. "When my wooden shoes ring on this granite, I hear the muffled, dull, powerful tone I seek in my painting,"¹⁴ he wrote early in 1888 to his friend the painter Émile Schuffenecker.

At Pont-Aven, in a little inn frequented by other impecunious artists whose company and talents the morose and egocentric Parisian scorned, Gauguin began to paint with strong expressive outlines and in the bright, patterned colors that were to become characteristic of his later works. The word Synthetism soon figured in his conversations and descriptions of his work. It defined a less imitative approach to nature, a technique of reducing forms to their essential outlines and arranging them with a new simplicity in vividly colored, flat patterns.

By 1889 Gauguin had completely abandoned the amorphous shapes and graduated color of Impressionism for a crisp and more arbitrary definition based on his new theories. He and a young painter friend, Émile Bernard (1868–1941), who had joined him in Brittany, declared that their intention was to "paint like children" (Figs. 44, 46). Gauguin's art of the period has all the quality of naïve, children's art: gay colors, dramatic patterns, an apparent disregard for proportion or natural coloration, deliberate awkwardness, and the substitution of distorted shapes or elliptical references in place of realistic appearances. Despite their evident crudity, and obvious effort to reconstitute a simpler, infantile vision, there was nonetheless a good deal of intellectual sophistication behind these paintings.

Gauguin wished to recover in, and through, painting the fundamental aspects of existence. He felt acutely the desiccation of instinct, as had so many sensitive, overcivilized moderns in the industrial age, and he welcomed the unsophisticated culture of the Breton peasants. But he also sought a new expression for the intangible and mysterious aspects of aesthetic experience, in full awareness of the theory and practice of contemporary Symbolist literature. His art is suffused with the subtle, imaginative shadings and enig-

39

matic subject matter typical of Symbolism (Fig. 43), and there is evidence of some personal demonology (Fig. 47). These traits characterized the most refined literary creations and the more elaborate examples of pictorial Romanticism of the period. With the poet Mallarmé, his contemporary literary champion and friend, Gauguin would no doubt have entirely agreed that the artist must proceed obliquely. Of the Impressionists' direct address to life the painter spoke scornfully: "They look for what is near the eye, and not at the mysterious centers of thought. . . . They are the official painters of tomorrow."¹⁵ And in his most famous letter, he told his confidant Schuffenecker on August 14, 1888: "Don't copy nature too much. Art is an abstraction; derive this abstraction from nature while dreaming before it, and think more of the creation which will result."¹⁶

Gauguin's conflict between a deliberately uneducated style and precocity, between the urge to get back to fundamentals and a romantic escapism, reflects a typical *fin-de-siècle* ambivalence. In Brittany (1888–90) and subsequently in the primitive environment of Oceania (1891–93, 1895–1903), he found and re-created an authentic reality that funneled his fantasies into a new myth. While Gauguin registered his protest against industrial society to some degree in the spirit of an escapist and romantic nostalgia by forsaking Europe for the South Seas, in an even more profound and positive sense he utilized plastic means to make his point. He dreamed of reviving a precivilized, mystical unity between man and nature, but at the same time he set out to create works that went beyond the conventions of easel painting, works whose frankly mural character endowed art with the potential of monumental decoration and a new public significance. If the artist could not control his actual environment, Gauguin seemed to assert, he could at least paint works of art which, by their nature, gave effect to an ideal environment. His approach to an art of a more decorative and public character became the basis for a new aesthetic program elaborated by his numerous followers.

Two of the most influential examples of Gauguin's revolutionary outlook were paintings the artist made upon his second and third trips to Brittany, in the years 1888 and 1889: The Vision After the Sermon and The Yellow Christ (Figs. 44, 45). Undoubtedly, The Vision was directly influenced by Gauguin's encounter with Bernard's new works, such as Market in Brittany, a picture characterized by unmodeled, heavily outlined, and simplified figures placed on a flat abstract ground (Fig. 46). Bernard, claiming to have invented the style, called it Cloisonism, a direct reference to medieval enamels and stained glass, both art forms with "cloisons," or dark, emphatic outlines, defining their areas of flat, brilliant color. The Vision After the Sermon represents the first widely noted and dramatic departure from Naturalism, far outdoing Seurat's fanciful visual inventions in its figure distortions, emotionalism, and arbitrary, if vividly expressive, palette. One of the most startling and novel aspects of the work, apart from its abstract and flat

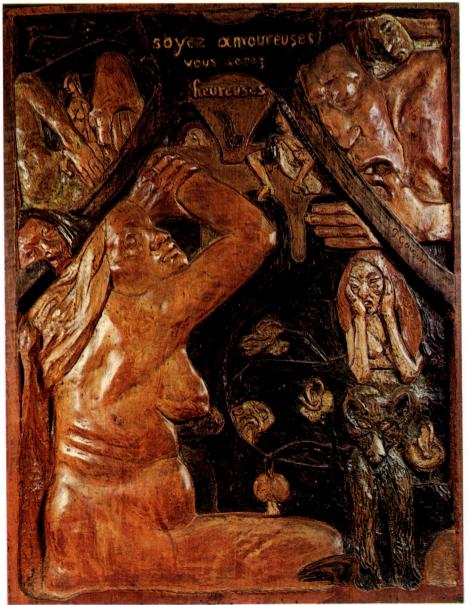

left: 43.

Paul Gauguin. Be in Love and You'll Be Happy (Soyez amoureuse et vous serez heureuse). 1890. Painted wood relief, 37¹/₂×28⁵/₈". Museum of Fine Arts, Boston. Arthur Tracy Cabot Fund.

opposite above right: 44. Paul Gauguin. The Vision After the Sermon (Jacob Wrestling with the Angel). 1888. Oil on canvas, 28³/₄×36¹/₄". National Gallery of Scotland, Edinburgh.

opposite top: 45. Paul Gauguin. The Yellow Christ. 1889. Oil on canvas, 36³/₈×28³/₄". Albright-Knox Art Gallery, Buffalo.

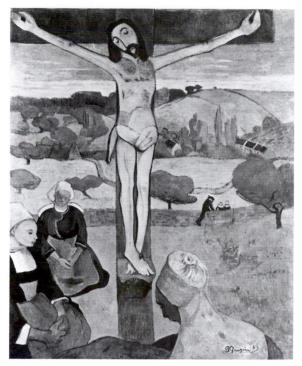

color shapes, is the abrupt psychological division of surfaces between the vision of Jacob wrestling with an angel, which is the spectator's fantasy, and the actual group of credulous peasants huddled in the foreground. The following year, in *The Yellow Christ* and other compositions inspired by Breton stone crucifixes and by a wood Christ in the chapel of Trémalo near Pont-Aven, Gauguin tried to capture a "great and rustic superstitious simplicity," in or-

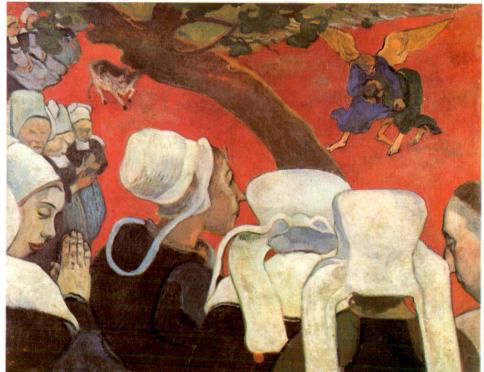

below: 46. Émile Bernard. Market in Brittany (Breton Women in the Meadow). 1888. Oil on canvas, 28¾ × 36¼". Private collection, France.

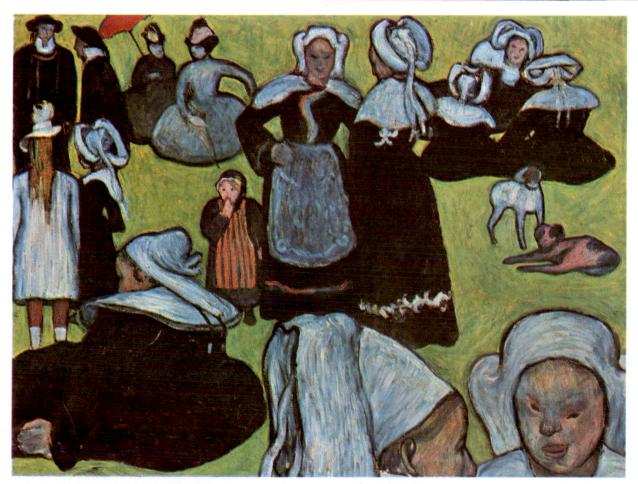

der to liberate himself from an oversophisticated aesthetic and from the Impressionists' faithful record of nature.

An important facet of the ideas formulated by Gauguin, one that helped enforce his revision of painting's syntax, was the element of diabolism. In his choice of subject matter Gauguin attempted to challenge existing systems of good and evil and establish himself as a messiah figure—prophet of a new morality as well as a new art. Thus, in Nirvana he created an almost naïvely didactic, Symbolist portrait of his friend and fellow painter Jacob Meyer de Haan (Fig. 47). The rather sinister-looking artist has virtually been tranformed into a primitive idol, a visual prototype of the enigmatic "dark gods" that Gauguin admired openly as a life-giving force. In this imaginary, equivocal Eden, two wan, disconsolate Western Eves wail and avert their eyes in shame at their nudity. They are the guilt-ridden, "civilized" Eves whom the artist later, in a letter to the writer August Strindberg, compared so scornfully with his sensual and unashamed pagan female figures from Tahiti: "that ancient Eve, who frightens you in my studio."

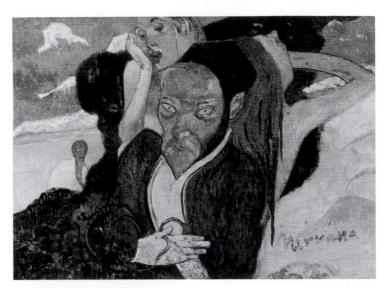

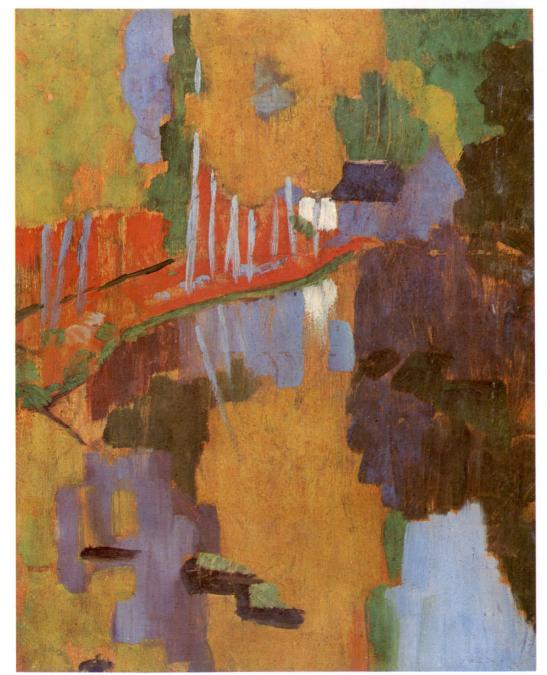

above: 47. Paul Gauguin. Nirvana (Portrait of Jacob Meyer de Haan). c. 1890. Gouache, 8 × 111½". Wadsworth Atheneum (Ella Gallup Sumner and Mary Catlin Sumner Collection), Hartford.

left: 48. Paul Sérusier. The Talisman (Landscape of the Bois d'Amour at Pont-Aven). 1888. Oil on cigar-box cover, 10% × 8%". Private collection, France.

Gauguin, van Gogb, and the Language of Vision

Having mesmerized the admiring young artists who surrounded him, Gauguin in 1888 undertook to demonstrate his method for the benefit of twenty-year-old Paul Sérusier (1863-1927), who left a famous record of the session, held in a picturesque Breton wood called the Bois d'Amour: "How do you see these trees?" Gauguin asked. "They are yellow. Well then, put down yellow. And that shadow is rather blue. Render it with pure ultramarine. Those red leaves? Use vermilion." The resulting picture (Fig. 48), a tiny work painted on a cigar-box lid and so radical in form that its flat color shapes verge on pure abstraction, struck Sérusier and his friends as something endowed with magical power. Thus, they called it The Talisman and themselves the Nabis, a Hebrew word meaning the Prophets. In 1889 the group, composed of Édouard Vuillard (Fig. 62), Pierre Bonnard (Figs. 60, 63), Maurice Denis, Aristide Maillol, and others, had a chance to see Gauguin's theories even more dramatically illustrated when the acknowledged leader and the close friends who had worked with him in Brittany-Bernard, Schuffenecker, Charles Laval, Louis Anquetin, and Daniel de Monfreid, among them-showed their paintings and lithographs at the Café Volpini. They identified themselves as the Impressionist and Synthetist Group. Gauguin soon tired of his small "movement," however, and disassociated himself from the work of his followers, for he felt their mediocrity was compromising. The loose association of Nabis continued, however, and under the leadership of Sérusier grew and attracted more artistic and literary disciples.

Gauguin and Bernard had been influenced not only by the decorative conventions of medieval stained glass but also by the expressive outlines of the Japanese print (Fig. 14). That aesthetic interest, moreover, jibed with their familiar, romantic hopes of restoring to the artist the role of craftsman, which he had enjoyed in the medieval community, the tendency first made manifest by the influential English Arts and Crafts movement. Gauguin never actually carried these ideas very far, but he did at one time articulate a belief in the possibility of a new, more primitive artistic community. He had planned to take a whole group of artists with him to the tropics to begin a new life "free from the bondage of money,

beyond the reach of the corrupting influence of civilization." And it was from a similar urge to revive the role of craftsman in art that he began in Brittany to make rather primitivist woodcarvings (Fig. 43).

Gauguin consciously modeled his style on non-Western cultures, drawing on a variety of traditions—Indian, Indonesian, Egyptian. In Paris he was a regular visitor to the newly created Museum of Ethnography and the Guimet Museum, and he made a thorough study of decorative objects, sculptures, and paintings from many unfamilar cultures, including black Africa—which was to inspire, directly, the later generation of Matisse and Picasso. He advised his friend Monfreid to avoid "the Greek" above all and to have always before him "the Persian, the Cambodian, and a little of the Egyptian." Gauguin's primitivism was in part the result of a socially conditioned aspiration toward a style of monumental decoration and of the wish to rejuvenate art and human feeling, by going to "savage" sources. It was also a product of the encyclopedic museum, which represented a new cultural phenomenon of the late 19th century.

Gauguin's desire to find a new primitive basis for art and for his own life, and his powerful atavism—he had Peruvian and Incan blood on his mother's side—finally took the artist to Tahiti in 1891. Led by the poet Verlaine and the theater impresario Lugné-Poë, Gauguin's friends organized a "Symbolist" evening to help raise money for the trip. Vicariously, the Symbolists seemed to welcome the flight by a fellow artist from decadent European civilization.

In Tahiti, Gauguin lived on "ecstasy, quiet, and art" in "amorous harmony with the mysterious beings around me." The splendor of tropical color and the touching simplicity and mysticism of the natives impressed and inspired him. His paintings subsequently acquired far more luminosity, power, and complexity, and even though the fundamentals of his style changed little from the days in Brittany, the artist's command of chromatic technique grew more expressive. It was now based on an immensely rich palette composed largely of secondary hues—chartreuse, orange, violet, and rose, for instance (Fig. 49). Not only did such clashing,

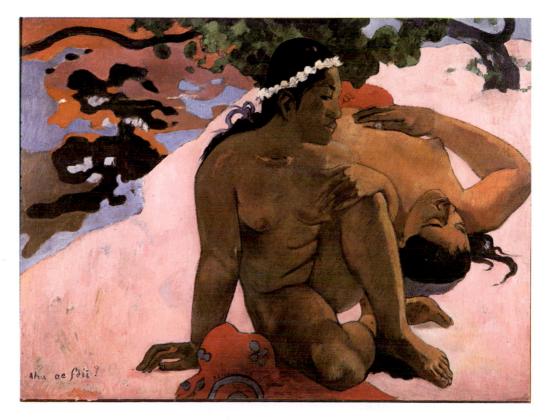

49. Paul Gauguin. "Eh quoi, es-tu jalouse?" 1892. Oil on canvas, 26½ × 35%". Pushkin Museum, Moscow.

Gauguin, van Gogb, and the Language of Vision

close harmonies anticipate the daring colorism of Matisse, but occasional passages of pure design—slow arabesque lines lovingly traced about large floral patches of the most resonant color—forecast the totally abstract art of Vasily Kandinsky. The Tahitian pictures also evince a less crude stylization than those done in Brittany, their forms more sinuous and graceful, as well as more fully modeled. The outlines have become less heavy and the laws of perspective less obviously defied. No longer did Gauguin let the edges of the canvas cut his figures, in the manner of Degas, nor did he depend so heavily on Japanese prints, favoring, instead, a somewhat friezelike arrangement, inspired by photographs of Javanese and Egytpian prototypes (Fig. 50).

Gauguin returned to Paris in 1893 and held an exhibition that impressed at least Mallarmé, who declared his wonder that Gauguin could achieve "so much brilliance" with "so much mystery." The show excited almost as much curiosity as did the artist's exotic appearance and his style of life. He now affected an odd combination of Oceanic and Bohemian costume, outfitted his studio with masks, spears, and native furniture, and kept both a Javanese mistress and a monkey.

In 1895 Gauguin had had his fill of civilization and returned once again to his Pacific paradise. There he worked steadily, first in Tahiti and then, feeling the encroachment of French colonialism, on the more primitive island of Hiva-Hoa in the nearby Marquesan archipelago. Unnerved by friction with the island administration, haunted by mounting debts and deteriorating health, he contemplated suicide. Before making an unsuccessful attempt on his life, he worked for one intense month in 1897 on a huge canvas entitled Where Do We Come From? What Are We? Where Are We Going?, a work that measures approximately 5 by 12 feet (Fig. 50). This painting is another extraordinary and original masterpiece in a period notable for novel and major efforts. Where Do We Come From? offers a flowing composition divided into three main figure groupings set in a jungle clearing with the sea in the background. In the center a Polynesian Eve, reminiscent of Botticelli's Giuliano de' Medici in the Allegory of Spring, reaches up to pick a fruit from a tree branch; at either side are groups of native women and children, apparently representing the various ages of man. In the background an idol glows with an

eerie bluish light, and two rosy phantom-like figures glide by. Before them, in the words of the artist, "an enormous crouching figure, out of all proportion, and intentionally so, raises its arms and stares in astonishment upon these two, who dare to think of their destiny."¹⁷ Setting off the darkish golden yellow of the main figures is the blue-green of the picture's pervasive tonality, its unifying effect further enhanced by the all-embracing pattern of Gauguin's distinctively free, curvilinear drawing.

Gauguin denied that the allegory had any explicit meaning and, in a letter to André Fontainas, stressed the vague and uncertain nature of his creation and its abstract, musical quality. "My dream is intangible," he wrote, "it implies no allegory; as Mallarmé said, 'It is a musical poem and needs no libretto."¹⁸ Be that as it may, the imagery suggests certain general meanings: life and a supernatural Beyond confront each other and merge imperceptibly in a primeval setting. Lascivious, curving forms of jungle growth and the languorous, rhythmic undulation of the sea gently envelop living forms. The painting is both a cyclical allegory of life, from birth to death, and a philosophical meditation played out on a darkening stage. Related allegories, showing a similar preoccupation with the life cycle and with the mystery of what might lie beyond death, preoccupied many artists of the Symbolist movement.

Gauguin died in his little hut in Hiva-Hoa, embittered by his economic struggles and his isolation. With characteristic candor, he had advised his friend Monfreid what he imagined his main contribution to painting would be. "I have wished to establish the right to dare anything ...," wrote Gauguin just before he died: "The public owes me nothing, since my achievement in painting is only *relative-ly* good, but the painters—who today profit by this liberty—they owe something to me."¹⁹

Vincent van Gogh

The painter of the Post-Impressionist generation most profoundly in Gauguin's debt was Vincent van Gogh (1853–90), who had come to Paris from the Netherlands in 1886 to study painting after unsuccessful efforts to make himself into a picture salesman, a pastor, and an evangelist preacher in the Belgian mining country. His many early disappointments included a number of unhappy emo-

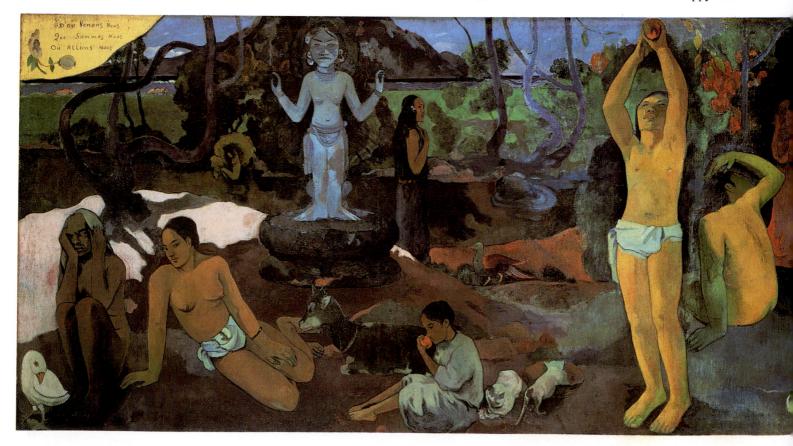

tional experiences with women, whom he frightened away by his intense need for love and by his religious fervor. He had already begun to make drawings, oils, and etchings in the Netherlands, this pre-French work characterized by the powerful, volatile linearity typical of Northern European art (Fig. 51). In Paris, where he was supported by his brother Theo, an art dealer and friend of the avantgarde at the Goupil Gallery, van Gogh met the Impressionists, Seurat, and Lautrec and shared their excitement over color and the Japanese print. Van Gogh also worked with Signac, lightening his palette with bright, sunny colors and employing a pointillist technique. But he also learned to inject a deeply felt emotion into his somewhat moralizing art.

In 1888, weary of café aesthetics, van Gogh left Paris for Arles. He dreamed of a new artistic community "created by groups of men combining together to execute an idea held in common," a dream that was never to be satisfied. His surging emotions found release, however, under the brilliant southern sun, in a "kingdom of light," as he ecstatically described the new locale. Like Seurat, Cézanne, and Gauguin, van Gogh declared his new allegiance to Delacroix rather than to the Impressionists. "Instead of trying to reproduce

below: 51. Vincent van Gogh. The Garden of the Presbytery at Neunen, Winter. 1884. Pen and pencil, 151/2 x 203/4". National Museum Vincent van Gogh, Amsterdam.

left: 52. Vincent van Gogh. Self-Portrait Dedicated to Paul Gaugin. 1888. Oil on canvas, $24^{1/2} \times 20^{1/2}$ ". Fogg Art Museum, Harvard University Art Museums. Bequest from the Collection of Maurice Wertheim, Class of 1906. Cambridge, Massachusetts.

exactly what I have before my eyes, I use color more arbitrarily," he wrote, "in order to express myself forcibly."20 Influenced by Gauguin, whom he had come to know in Paris and whose Symbolist aims he found sympathetic, van Gogh told his brother Theo that he was "trying now to exaggerate the essential and to leave the obvious vague."21

At the Dutchman's behest, Gauguin joined van Gogh at Arles in the fall of 1888, and for a brief time the two artists worked together. Urged on by Gauguin, van Gogh made a decisive shift from an Impressionist manner to a more personal expression that utilized flat areas of uniform color and aggressive outlines. His Self-Portrait (Fig. 52), dedicated to Gauguin, with its almost Byzan-

below: 50. Paul Gauguin. Where Do We Come From? What Are We? Where Are We Going? (D'où venons-nous? Que sommes-nous? Où allons-nous? 1897. Oil on canvas, 4'6¹³/16" x 12'3¹/2 " Museum of Fine Arts, Boston (Tompkins Collection).

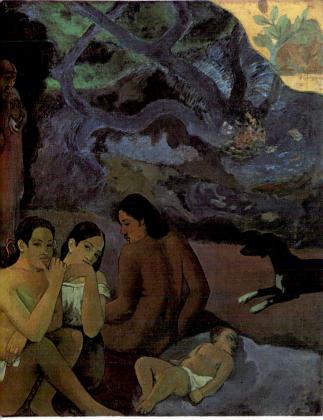

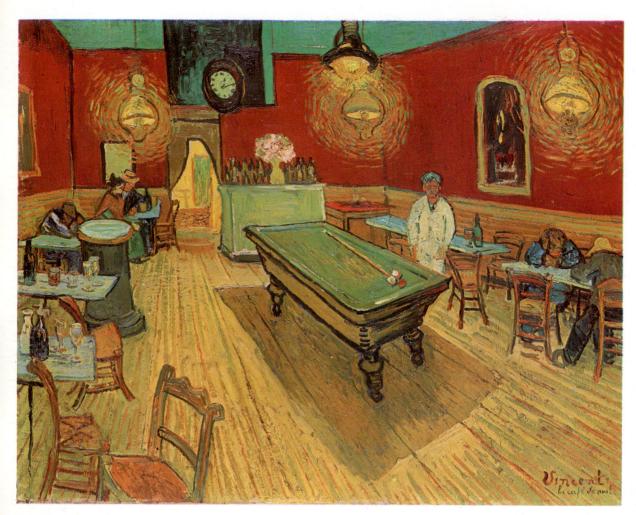

below: 53. Vincent van Gogh. The Starry Night. 1889. Oil on canvas, 28³/₄ × 36¹/₄". Museum of Modern Art, New York. Acquired through the Lillie P. Bliss Bequest.

left: 54. Vincent van Gogh. Night Café. 1888. Oil on canvas, 27½ × 36¼". Yale University Art Gallery, New Haven. Bequest of Stephen C. Clark.

tine, iconic power, is a tribute to that artist's impact as well as to van Gogh's own completely original expressive force. The respective but equally intense temperaments of the artists soon led to violent quarrels. "Our arguments," van Gogh wrote to Theo, "are terribly electric, we come out of them sometimes with our heads as exhausted as an electric battery after it is discharged."²² In this first of his pathological episodes, van Gogh attempted to kill Gauguin, and then cut off his own ear and delivered it as a Christmas present to a prostitute who had once playfully asked for it. On petition of the alarmed townspeople, van Gogh was soon afterward hospitalized in Arles. Although his illness was once attributed to epilepsy, brought on by venereal disease attacking the brain, a more modern opinion holds that he probably suffered from schizophrenia.

During his four years of artistic maturity, from 1886 until his death by suicide in 1890, van Gogh spent brief periods in mental hospitals, at Saint-Rémy and at the asylum of Dr. Gachet in Auvers. But with the exception of a few very late canvases, in which a chilling darkness falls over his ecstatic palette and rhythms become compulsive, his art shows no direct evidence of morbid self-preoccupation. There is struggle, conflict, and even extreme nervous excitement, but neither an oppressive introspection nor a sense of paralyzing despair. His purity and realism as an artist, even in landscape paintings and drawings whose explosive linear energies border on incoherence, won through and subdued his powerful fantasies (Fig. 53). It is interesting that van Gogh, despite his intense need for salvation and his Christian feeling about human solidarity, should have rejected as unhealthy the nostalgic religious pictures of his friend Bernard, revivalist, neotraditional paintings inspired by medieval Christianity (Fig. 46). His sincerity required that he address himself to subjects of contempo-

Gauguin, van Gogh, and the Language of Vision

rary life, which, in his terms, meant the peasant folk of the South of France and their lyrical natural setting. Van Gogh elaborated on some of his themes in his poetic letters to the faithful Theo, but the actual paintings often appear less bizarre than he made them out to be in his own mind.

This is true of one of his masterpieces, the café-poolroom scene in Arles (Fig. 54). Figures hunched over absinthe-green tables are

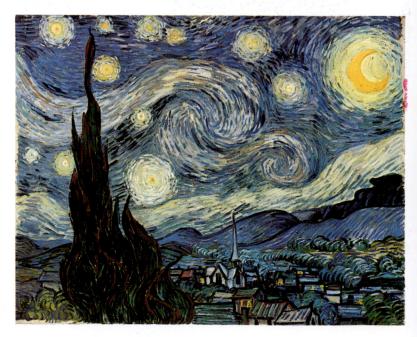

illuminated by the jittery blaze of light globes shining against a shrill décor of vermilion and green walls and a dazzling yellow floor. The floor drives away in rapidly converging perspective lines, only to crash into the massive power of a blood-red background. The dramatic mood of violence and frustration is further heightened by a certain strangeness in the color scheme and by the whole burning brilliance of the impression. But was the scene as sinister as the artist later imagined? He wrote to Theo that he had portrayed the café as a place of wickedness, "a place where one can ruin oneself, go mad, or commit a crime. . . . I have tried to express the terrible passions of humanity by means of red and green."²³ Yet, in the actual work there is no such simple didactic content. If there were, the painting would be only an extended monologue on anxiety, and it surely transcends the author's inner torment and most sinister fantasies.

Whatever the real or imagined symbolism of his art, van Gogh found a nonnaturalistic and more emotional use for color, as did Gauguin at the same time. Like Gauguin, he "simplified" in an effort to get back to fundamentals, to deepen common truths that made him feel more authentic as a man and creative artist. "In a picture," he wrote to Theo, "I want to say something comforting as music. I want to paint men and women with that something of the eternal which the halo used to symbolize, and which we seek to give by the actual radiance and vibration of our colorings."²⁴ In style, van Gogh combined the innocence of children's art with the flat, decorative monumentality and brilliance of color of early Christian mosaics. He, too, was moving away from easel painting toward a broader style of large-scale decoration, characteristic of the great archaic periods in art.

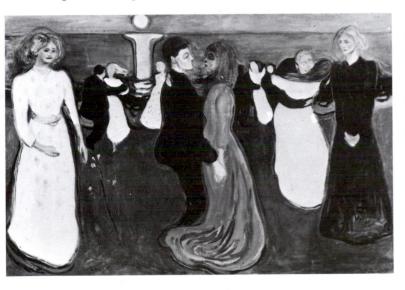

The Symbolist Decade (1890–1900): Graphic Arts and Proto-Expressionism

Without van Gogh's pioneering, self-conscious exploration of pain, and without his powerful, expressive color, line, and stroke, the art of the Norwegian Edvard Munch (1863–1944) is inconceivable. Munch shared the Dutch artist's concern to express human suffering in art, and also invented new pictorial means to visualize his feelings. Although he began as a Naturalist, a visit to Paris in 1889 and the impact of contemporary French painting changed the direction of his art drastically soon thereafter. "No [more] interiors with men reading and women knitting," he wrote, in a possible allusion to the emerging Nabis. "There must be living beings who breathe and feel and love and suffer. I would paint such pictures in a cycle. People would understand the sacredness of them and take off their hats as if they were in church."²⁵

Munch did, in fact, paint what can be considered at least the beginning of a picture cycle, in The Dance of Life (Fig. 55), which combines allegory and psychological penetration within a theme that became obsessive for both the Symbolists and 20th-century Expressionists: the varying roles of women, as unsullied idealized virgin, and as temptress, a ravaged and degraded creature who preys on man. Munch's morbid and pessimistic views of the sexual relationship were derived in part from his friend, the Swedish dramatist August Strindberg, and from his own unfortunate life experiences with family illness, death, and his own mental instability and alcoholism. His extraordinary range of subjects included an understanding of the nameless sexual fears of adolescence and the hysterical anxiety of perhaps his most famous painting, The Cry (Fig. 56), its terrible shriek concretized as lines radiating outward in the fuguelike movement of sound waves, set down in a harsh combination of lurid red and cold, midnight blue. The sense of losing oneself in the cosmos, a fusion of individual personality with the absolute, curiously took its inspiration from the same mania for totality evident in the compulsively agitated, parallel lines of van Gogh's great and disturbing visionary painting, The Starry Night

left: 55. Edvard Munch. The Dance of Life. 1899–1900. Oil on canvas, 4'11/4" × 6'3". National Gallery, Oslo. below: 56. Edvard Munch. The Cry. 1893.

Casein on paper, $35\% \times 29''$. National Gallery, Oslo.

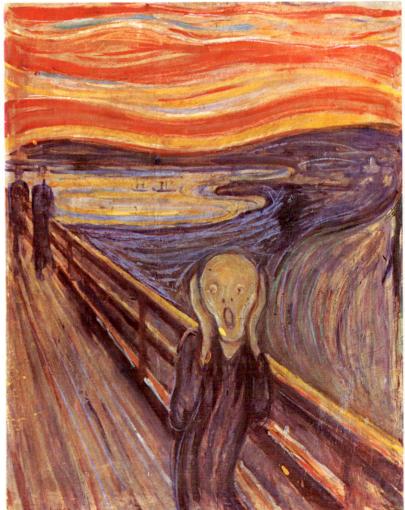

Gauguin, van Gogb, and the Language of Vision

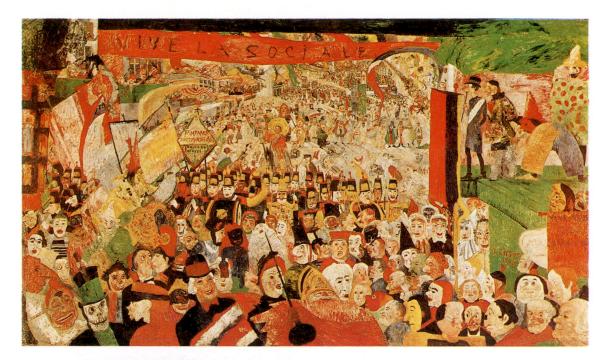

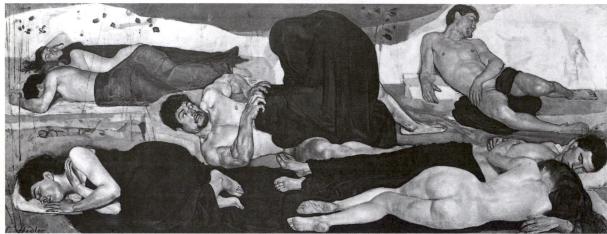

57. James Ensor. Entry of Christ into Brussels in 1889. 1888.
Oil on canvas, 8'5½"×12'5". Musée Royal des Beaux-Arts, Antwerp.

58. Ferdinand Hodler. Night. 1890.
Oil on canvas, 3'11¾"×9'9¾".
Kunstmuseum, Bern.

(Fig. 53). For Expressionist fury, only the works of the Belgian James Ensor (1860–1949), with their grotesque and cynical charade of the persecution of a risen Christ by the populace, can equal the cathartic emotion and violent pictorialism of these influential works (Fig. 57).

Another kindred spirit of both van Gogh and Munch was the Swiss Ferdinand Hodler (1853–1918), who, too, redirected early religious experience and personal tragedy into art, dedicating his pictures to basic questions of life, love, and death. In *Night* (Fig. 58), however, Hodler showed the other side of the Expressionist coin and, instead of fury, evoked the terrors of impending death in an image of utter stillness and purity. The better to elevate stark reality to the realm of cosmic significance, he used human figures as embodiments of ideas and described them with a linear explicitness almost as obsessive as van Gogh's, but, more in the manner of Munch, organized the forms within an overall pattern of emblematic abstraction, often a blatantly simple kind of symmetry the artist called "parallelism." Together, Munch, Ensor, and Hodler, working far from both one another and Paris, helped transform European sensibility at the turn of the century.

Munch's work became known, and especially influential, in the evolution of later German Expressionism as much through his graphic work as his oil paintings. The Norwegian artist translated his mordant images of the distressed modern psyche into litho-

Gauguin, van Gogh, and the Language of Vision

graphs and woodcuts (Fig. 59), finding, like Gauguin, who showed an interest in the graphic art of the Middle Ages, that the crudeness of the medium enhanced his meanings and gave his message added force. Dissatisfaction with traditional media was common to artists of the 1890s, and there occurred, in fact, a remarkable revival of interest in every kind of graphic art—book illustration and poster design as well as the production of prints.

The power and popularity of the graphic arts during the fin de siècle owed much to the Nabis, those artists who, through the contact made by Sérusier (Fig. 48), banded together under the inspiration of Gauguin to theorize about and produce a new Synthetist art, an art, however, with social implications and thoroughgoing alliances with all the arts. These included decoration, book illustration, posters, and stage design for the most progressive playwrights of the time: Ibsen, Maeterlinck, Strindberg, Wilde, and Alfred Jarry. But while Sérusier and Maurice Denis, especially, turned out manifestoes of a sort that would flow from many an artistic group in the 20th century, Aristide Maillol, Pierre Bonnard (1867–1947), and Edouard Vuillard (1868–1940) created the most enduringly significant work. Bonnard and Vuillard proved particularly happy in graphics, and their distinctive touch is nowhere more evident than in the Art-Nouveau-flavored designs they prepared for La Revue Blanche, the leading avant-garde organ of the Symbolist era (Fig. 60).

right: 59.

Edvard Munch. The Kiss. 1902. Color woodcut, 18¾ × 18⅛". Museum of Modern Art, New York. Gift of Abby Aldrich Rockefeller.

far right: 60.

Pierre Bonnard. Poster for La Revue Blanche. 1894. Color lithograph, 29¾ × 22⅛". Private collection, Milan.

below right: 61. Félix Vallotton. *Whirlwind*. 1894. Woodcut, 7½ × 8⅔". Galerie Paul Vallotton, Lausappe

below left: 62.
Édouard Vuillard.
Misia and Vallotton.
1899. Oil on
cardboard, 28 × 205%".
Private collection, Paris.

Another notable graphic artist among the Nabis was Félix Vallotton (1865–1925), whose sheets (Fig. 61), with their forceful exploitation of black and white contrasts, if not their Art Nouveau

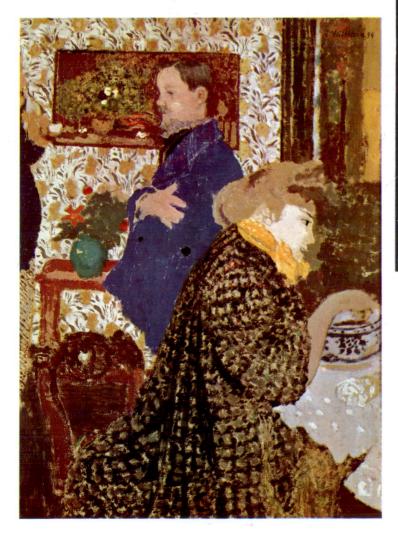

CHAQUE

MOIS

A PAGES

line, did much to generate a revival of the ancient woodcut medium, especially within Germany's Bridge group.

By the mid-1890s, however, Vuillard and Bonnard had abandoned the rather plain, simple colors and increasingly flat, abstract composition associated with Gauguin for more conservative, but also more subtle and nuanced, personal styles (Fig. 62). They returned to their bourgeois backgrounds, and even seemed stylistically retrograde in restoring to their paintings the broken, flecked brushwork of Impressionism. Their unassuming interiors, with family members or intimate friends caught reading or working at unimportant domestic tasks, are treated with humor and tender affection, and also with an almost awesome sense of tranquility

echoed in classical, stable compositions. The paintings of Bonnard, particularly in his later period, are even more luxuriously sensual and abandoned in color than Vuillard's (Fig. 63). His last works are truly a grand meditation on man, whether in his home or an outdoor setting.

One of the most powerful artists of the period, for whom the graphic medium of color lithography proved remarkably congenial, was Henri de Toulouse-Lautrec (1864–1901). Lautrec expressed himself in drastic silhouettes, bold outlines, and original color, a form of dramatic presentation that put over its message in a single statement (Fig. 64). The simplicity and economy of his manner are deceptive, however. Lautrec was an uncannily sharp observer of life as well as a brilliantly succinct and expressive draftsman (Fig. 65). His resourcefulness in the graphic media allowed him to set down his subjects with a stylized flatness and still to characterize them in the psychological round. He had a genius for reducing the whole style of a personality to a few gestures and capturing it with a bold silhouette or a single line. He managed to hold the spectacle of life and pure pictorial values in a wonderful tension. Like Gauguin and van Gogh, Lautrec wished the spectator

to experience his painting directly through the dynamic operation of his surfaces and with a minimum of interference from pictorial illusion. The spectator is invited to participate in the experience of form and color to a much greater degree than, for example, in the paintings of Manet, Degas, and the Impressionists. The elementary potencies of medium and the artist's operations take on an almost independent, abstract significance. This is particularly true in the case of Lautrec's nervous, mobile line, which continually stresses the active presence of the creator in the work of art.

To arrive at his style, a style vitally of its period, Lautrec passed first under the influence of Impressionism and then of Degas and the Japanese print. His painting was also directly connected with the life that he chose for himself in the pleasure traps of Montmartre and with the personal factor which influenced that decision: his physical appearance. Born into a family of provincial aristocrats, the painter was in fact Count Henri-Marie-Raymond de Toulouse-Lautrec-Monfa. He grew up a delicate, rachitic child, and after two falls in early adolescence, which broke both his legs, he never regained normal growth. In maturity Lautrec was physically grotesque, with a fully developed torso and head and tiny, shrun-

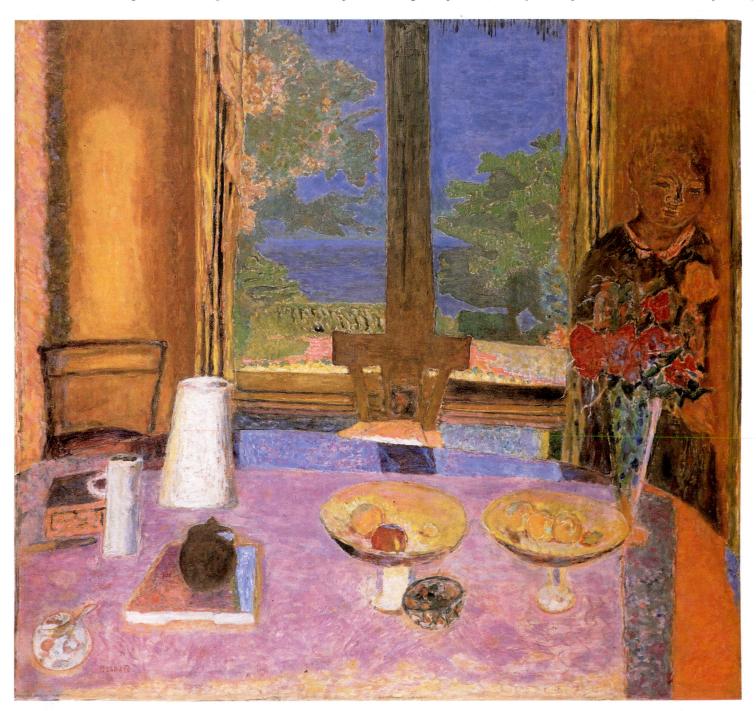

ken legs. His curious appearance cut him off from a normal life and probably caused him to choose the demimonde, an underworld of pleasure and vice, as his social and artistic habitat.

After coming to Paris in 1882, Lautrec attended a number of studios during the next five years. He had begun to paint and sketch scenes of sporting life at home at the early age of sixteen: horses in motion, tandems being driven along at a great clip. Some of these scenes are reminiscent of the reportage of Constantin Guys, but they have a greater-really remarkable-expressive force. Then the young artist learned to work in a soft Impressionist manner, but, unlike Monet and Pissarro, he always fixed on the human figure as a center of interest. He later told his biographer and closest friend, Maurice Joyant, that nothing exists but the figure and that landscape should only be used to make the character of the figure more intelligible. François Gauzi, who attended the Paris studio of Fernand Cormon at the same time Lautrec did, has left a vivid record of his fellow student's artistic tastes and methods. "At Cormon's studio," wrote Gauzi, "he wrestled with the problem of making an accurate drawing from a model; but in spite of himself he would exaggerate certain typical details, or even the general character of the figure, so that he was apt to distort without even trying or wanting to. ... The painter he loved best was Degas, and he worshipped him. ... He was fascinated by the Japanese masters; he admired Velázquez and Goya; and, astonishing as it may seem, he had a high opinion of Ingres; in that respect he was following the taste of Degas."26 At Cormon's, Lautrec also met such independent spirits as van Gogh and Bernard, and, under the influence of the masters cited by Gauzi, especially the Japanese and Degas, he soon began to seek a more original and vital style.

opposite: 63. Pierre Bonnard.

Dining Room on the Garden. 1934–35. Oil on canvas, 4'2" x 4'5¹/4". Solomon R. Guggenheim Museum, New York. Gift, Solomon R. Guggenheim, 1938.

below: 64. Henri de Toulouse-Lautrec. Jane Avril at the Jardin de Paris. 1893. Color lithograph, 4'1" x 2'11¹/4". Musée Toulouse-Lautrec, Albi.

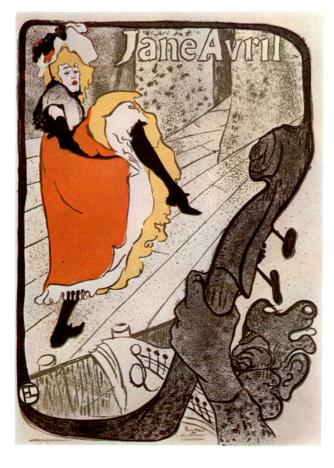

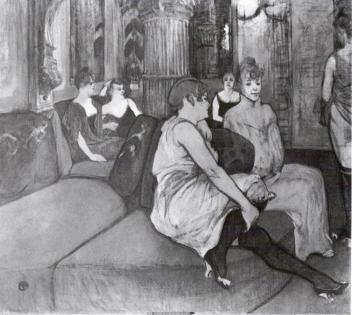

top: 65. Henri de Toulouse-Lautrec. The Trace-Horse. 1888. Gouache on cardboard, $31\frac{1}{2} \times 28\frac{1}{8}$ ". Maison Édita, Lausanne.

above: 66. Henri de Toulouse-Lautrec. In the Salon of the Rue des Moulins. 1894. Oil on canvas, 3'10" × 4'4¼". Musée Toulouse-Lautrec, Albi.

Degas supplied Lautrec with forms of composition, which the latter freely adapted in a simpler and more audacious fashion, and with a whole new repertory of unromantic contemporary subjects. Under the spell of the animated nocturnal life of the Montmartre music halls, cabarets, and brothels, Lautrec pushed on even beyond Degas's most controversial subject matter. Degas, in his collotypes, had depicted inmates of brothels but never with the knowledge and firsthand experience that Lautrec brought to the same themes (Fig. 66). Lautrec went to live in the bordellos and became a confidant of prostitutes and pimps, partly no doubt because he wished to defy convention and thereby assuage his own feeling of being socially undesirable. But Lautrec also approached Sometimes Lautrec, who had a natural instinct for the preposterous, could not help twitting his subjects. In the dress or undress of his models, in their boredom, or in their contrasting characters, he found much that lent itself to ironic treatment or outright comedy. Yet his approach was as serious and detached, rather than professionally disenchanted, and as intensely honest as was Degas's attitude toward his little ballet "rats."

Although Lautree may have achieved his greatest technical innovations in the color lithograph and poster, he did produce, near the end of his career, a series of oil paintings (albeit few in number, as with Seurat) that are extraordinary in their magnitude and power. For each the artist made a major effort, mastering technique until

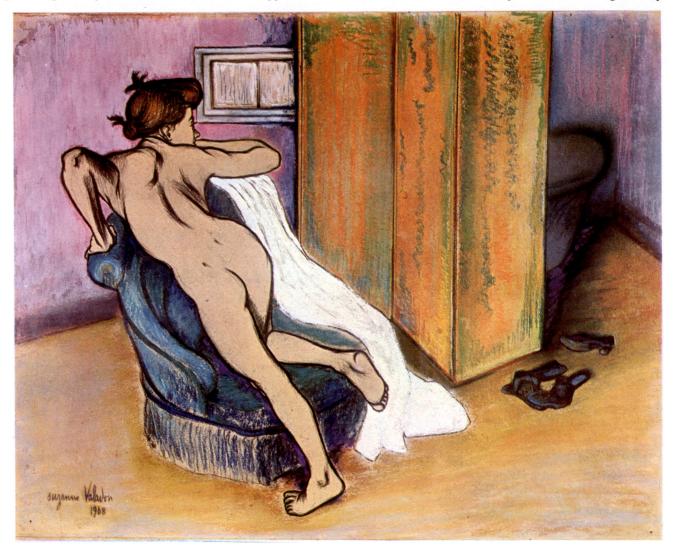

human squalor for the most serious artistic reasons. He refused to be intimidated by taboos on subject matter. For the painter still working in the spirit of 19th-century Naturalism, human degradation and the more sordid truths of sexual life in the great city were simply one set of facts among others. Since art had not dealt squarely with them, they were still fair game. Lautrec's unprejudiced observation of sexual matters, neither morally aghast nor sensational in any way, reaffirmed the artist's prerogative to set down the truth of life as he found it. Something of his dauntless view infected the art of Suzanne Valadon (1865–1938; Fig. 67), a famous model in the studios of Renoir and Lautrec, among others, who developed a tough, unsentimental approach to subject matter and self-taught, trenchant, powerfully linear style quite independent of both her former employers' work and that of her son, the Parisian scene painter Maurice Utrillo (Fig. 373). he had learned to marry line and color. The results stand with the greatest masterpieces of modern art. Among them is *At the Moulin Rouge* (Fig. 68). Here a group of ladies and gentlemen gather around a table; in the right foreground a woman, theatrically illuminated by a greenish light full on her face, is cut off by the picture edge. In the background, a figure we recognize as the dancer La Goulue adjusts her hair while nearby pass an incongruous pair, the tall, funereal Dr. Gabriel Tapié de Celeyran and his cousin, Lautrec himself. The composition burns with electric colors of orange and green; structurally it is organized along the diagonal axis of a handrail, Degas fashion. The Gay Nineties costumes—dresses with leg-of-mutton sleeves, elaborate plumage in the ladies' hats, stovepipes for the gentlemen—have been pushed to the glittering edge of fantasy. The atmosphere is unreal and bizarre; the characterization of personality, brilliantly incisive. Lautrec has endowed

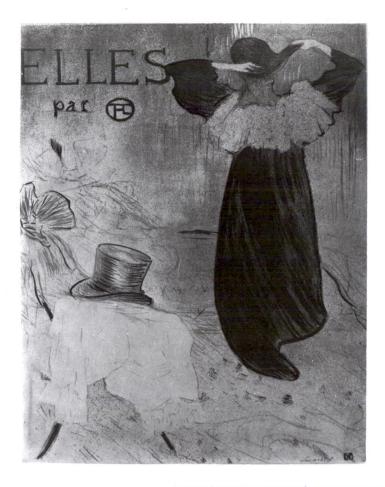

a rather shabby music-hall setting with barbaric splendor. His figures are described by sinuous, curving contours somewhat in the manner of Art Nouveau (despite the artist's open criticism of the new style of decoration). But while fitted into a decorative ensemble of arabesques and curves, the figures give an impression of mass and bulk. They break out of their molds and live an intense life of their own, both as personages and as vigorous plastic forms.

Such candid presentation of the shadier regions of the Paris underworld could only shock and alienate the public. Finally, therefore, Lautrec failed, just as much as van Gogh and Gauguin did, to satisfy the conventional taste and morality of his own time. Between 1891 and his death in 1901, however, Lautrec produced some three hundred lithographs and thirty posters, all distinguished by their boldness of attack, freedom of invention, and expressive color (Fig. 64).

Lautrec's late lithograph series, called "Elles," was devoted to women, women who serve sullenly in a world dedicated to carnal pleasure but whose forms have a monumental import and dignity (Fig. 69). Like Degas, Lautrec made something legendary and immense out of the stereotypes of naturalistic subject matter. He was perhaps the last modern artist who was able to express a vital interest in life and a curiosity about the human animal without compromising his pictorial values. In the process of doing so, he introduced dynamic new elements into his art: irony, fantasy, and an interest in forms and colors as expressive ends in themselves. When he died, the effort to capture modern life in terms of some realistic convention had been exhausted. The 20th century took its inspiration instead from van Gogh's proto-Expressionism, Gauguin's advice that "art is an abstraction," and from the formal logic of Cézanne's last compositions.

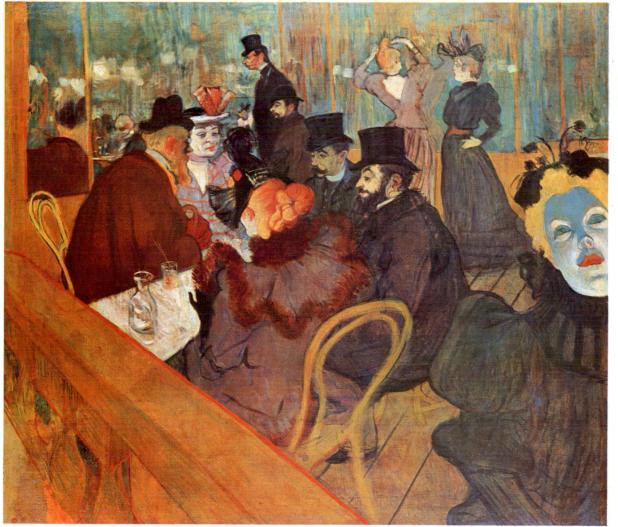

opposite: 67.

Suzanne Valadon. After the Bath. 1908. Pastel, 20% × 25%16″. Fondation d'Art Moderne Oscar Ghez, Geneva.

right: 68.

Henri de Toulouse-Lautrec. At the Moulin Rouge. 1892. Oil on canvas, 4'¾" × 4'7¼". Art Institute of Chicago (Helen Birch Bartlett Memorial Collection).

above: 69.

Henri de Toulouse-Lautrec. Frontispiece for Elles. 1896. Color lithograph, 20% × 15¾". Museum of Modern Art, New York. Gift of Abby Aldrich Rockefeller.

Art Nouveau in Painting and Design

auguin, van Gogh, Seurat, Lautrec, and Munch certainly, and **G** auguin, van Gogii, Scurat, Lautec, and Astronomic Characteris-to some degree even Cézanne, shared stylistic characteristics and elements of ideology, which became the basis of Art Nouveau, the counterpart in the applied arts of Symbolism in painting. While it may seem inappropriate to include Cézanne among these Post-Impressionists in view of his insistence on the basic architecture of form, in another sense, ornamental arabesque and structure were soon found to be interconnected in both painting and design. All the Post-Impressionists showed an increasing interest in decorative values, and they were very much at one, in their different ways, with the most essential trend of the time: the cult of line. For Art Nouveau's leading designer, the Belgian Henry van de Velde, line was a welcome antidote to imitations of nature. He perceived it as a force that might alternately or simultaneously be abstract, symbolic, ornamental, or structural. Van Gogh's flamelike cypress trees, the pine branches and winding roads of Cézanne's Provençal landscapes, Seurat's whiplash line in the ringmaster of The Circus (Fig. 26), innumerable Lautrec music-hall scenes, and Gauguin's curving, decorative forms, not to mention Munch's linear treatment of landscape and figures, where decoration was raised to levels of excruciating emotional intensity-all these pictorial effects directly anticipated Art Nouveau's attenuated curvilinear ornament.

Among architects and designers of the *Jugendstil*, as Art Nouveau was known in Germany, there was a tendency to push decoration over the borderline into an independent abstract art. The

left: 70. August Endell. Façade, Atelier Elvira, Munich. 1897–98 (now demolished).

above: 71. Paul Signac. Against the Enamel of a Background Rhythmic with Beats and Angles, Tones and Colors: Portrait of M. Félix Fénéon in 1890. Oil on canvas, 291/8 × 365%". Private collection, New York.

opposite above: 72. William Morris. Pimpernel (detail). 1876. Wallpaper. Victoria and Albert Museum, London.

opposite below: 73. Aubrey Beardsley. Salomé with the Head of John the Baptist. 1893. India and watercolor, $10\% \times 55\%$ ". Princeton University Library.

famous plaster relief created by August Endell (1871–1925) on the facade of a Munich photographer's studio is an example of the more extreme abstraction of the Jugendstil (Fig. 70). And in France, too, under the aegis of Neo-Impressionism, Paul Signac's Portrait of M. Félix Fénéon (Fig. 71) bore a title that testified to an increasing awareness of abstract expressive elements: Against the Enamel of a Background Rhythmic with Beats and Angles, Tones and Colors. Employing the musical analogy that so frequently entered aesthetic discussions, Endell had envisioned another kind of Symbolism, in the form of an absolute art freed from representational function, with an expressive emphasis given form, line, and color for their own sake: "We stand at the threshold of an altogether new art, an art with forms which mean or represent nothing, recall nothing, yet which can stimulate our souls as deeply as only the tones of music have been able to do."1 Art Nouveau, like so many aspects of Post-Impressionist and Symbolist painting, formed a watershed between new affirmations of expressive novelty, supported by daring artistic theory, and the artifice and escapism of the Romantic decadence.

Art Nouveau dominated architecture and the applied arts in Europe for more than a decade, from the early 1890s until about 1906. In architecture, the style originated in Brussels with the house designed by Victor Horta for the engineer Tassel in 1892–93 (Fig. 143). As for the applied arts, the historian Nikolaus Pevsner has found precedents in English Art Nouveau dating back more than a decade earlier, in the textiles of William Morris and the engravings and household objects of Arthur H. Mackmurdo (Figs. 72, 79). But some formalist critics still tend to dismiss Art Nouveau as little more than a fanciful and capricious style of decoration, a shallow expression of *fin-de-siècle* aestheticism only slightly related to the evolution of serious modern art forms. The phenomenon has been associated, for instance, with the esoteric

convolutions of Aubrey Beardsley's drawings (Fig. 73), the posters of Alphonse Mucha and others (Figs. 74, 80), the attenuations of Tiffany glass, and the curlicued iron grilles of Hector Guimard's Paris Metro entrances (Fig. 145).

Henry van de Velde (1863-1957) became the spokesman and chief theorist of Art Nouveau in Europe (Fig. 75), and he bears a major responsibility for crystallizing its viable structural and modernist ideas, especially in relation to the Arts and Crafts movement in England. Van de Velde's first writings in the early 1890s, such as Déblaiement d'art (The Uncluttering of Art) and articles in L'Art moderne, already showed familiarity with the social ideals of the English craft-oriented artists in the tradition of William Morris, who sought an all-embracing vision of the arts in society. Unlike his English predecessors, van de Velde wished to tap the potential for human betterment as well as the aesthetic felicity of standardized machine products. In place of William Morris's regressive views, which called for a return to handmade crafts and the communal life of the Middle Ages, van de Velde welcomed the machine as an acceptable tool for the designer and the engineer in whom he envisioned "the creator of the new architecture." Otherwise, faithful

left: 75. Henry van de Velde. Abstract Composition. 1890. Pastel, 185/8 × 20". Kröller-Müller Museum, Otterlo.

below: 76. Henry van de Velde. Cover illustration for Elskamp's Dominical. 1892. Houghton Library, Harvard University, Cambridge, Mass.

opposite above: 77. Walter Crane. The House that Jack Built (detail). 1875. Wallpaper. Victoria and Albert Museum, London.

opposite below: 78. James McNeill Whistler. Peacock Room. 1876–77. Freer Gallery of Art, Washington, D.C.

below: 74. Alphonse Mucha. *"Job" Cigarettes*. 1898. Lithograph poster, 5′1″×3′3¾″. Museum of Modern Art, New York. Gift of Joseph H. Heil.

Art Nouveau in Painting and Design

to English theory, the Belgian master showed a more flexible imagination and grasp of the social implications of art. Perhaps his major theoretical contribution lay in the awareness that abstract ornament and structure need not conflict. His respect for functional needs in the context of the fashionable, often frivolous Art Nouveau style was forward-looking and socially enlightened. He tried to bridge the gap between the essentially romantic play with line and form and an artistic style that met the pressing needs of the modern technological age.

Van de Velde wrote that the role of ornament should not be merely decorative, but directed "to structure: the relationship between this 'structural and dynamographic' ornamentation and the form of the surfaces, should appear so intimate that the ornament seems to have 'determined' the form."² Van de Velde's cover vignette for Elskamp's Dominical supports that argument for the formal potential of ornament (Fig. 76). Like a number of other Art Nouveau and Symbolist inventions, it anticipated Kandinsky by two decades in its transformation of a natural scene into expressive linear rhythms and bold abstract design. Unlike his fellow Symbolist painters, with whose work his own rather interesting early graphic design and paintings were associated, van de Velde demanded that utilitarian objects express something beyond themselves. It was not a symbol for transcendental ideas, or for nature in its organic growth, which he sought; instead, he wished to symbolize the decadence of the naturalistic object itself. Van de Velde urged the creation of a "healthy human understanding" of the world through the visual arts, and the formulation of a new art (un art nouveau). He was thus responsible for the first use of that phrase in relation to a rebirth of the visual arts. His views were prophetic of 20thcentury artists' preoccupation with function, structure, and fitness.

Van de Velde parts company with the organicist theory of most other Art Nouveau spokesmen and with those English designers

and book illustrators who, like Walter Crane (Fig. 77), concerned themselves primarily with the emotive and expressive power of their forms. Crane best summarized the Art Nouveau designer's obsession with the abstract and rhythmic quality of the dominant line: "Line is all-important. Let the designer, therefore, in the adaptation of his art, lean upon the staff of the *line*—line determinative, line emphatic, line delicate, line expressive, line controlling and uniting."³ The symbolical powers of line as an evocative force can be seen to correspond generally to the melodious role of sound in Symbolist poetry, going back for its antecedents to the hypnotic use of repeated sounds to dissolve the boundaries between real and imaginary worlds in the poetry of Edgar Allan Poe.

Nothing is more striking than the dual origins of Art Nouveau. On the one hand, there was an evident debt to William Morris's Arts and Crafts movement in the deep and fiercely held ethical sense of the utility of the arts that so many spokesmen of the new articulated. Simultaneously, Art Nouveau also acknowledged the exquisite tastes and esoteric interests of the English Aesthetic movement. Yet both forerunner and follower seemed to agree that a synthesis of the arts was desirable. Even the most spectacular and precocious artist among the English Aesthetes, the American James McNeill Whistler, 'brilliantly, if perhaps inadvertently, established as early as 1877 the integral concept of the unity of art and its environment with his famous Peacock Room, a synthesis of decorative design, fine arts, and architectural setting inspired by Japanese interiors (Fig. 78). Despite its populist character, *The*

FOLIES-BERGÈRE

below: 79. Arthur H. Mackmurdo. Title page for Wren's City Churches. 1883. Victoria and Albert Museum, London.

left: 80. Jules Chéret. Loïe Fuller. 1893. Lithograph poster, 4'¾" × 2'10%". Musée des Arts Décoratifs, Paris.

Hobby Horse, an Arts and Crafts review published by Arthur H. Mackmurdo (1851–1942), demonstrated a fresh artistic approach to problems of design and typography. Pevsner cites the title page for Mackmurdo's *Wren's City Churches* (Fig. 79) as the very first, and conclusively English, example of Art Nouveau in spirit and form, anticipating curvilinear design on the Continent by more than a decade.

Another significant source of Art Nouveau design and of the flat, serpentine linear style evident in Post-Impressionism was the poster art of Jules Chéret (1836–1932). It is worthwhile comparing Chéret's relatively primitive style of drawing (Fig. 80) with the more fully evolved efforts in the same general style by Lautrec and Bonnard, both clearly under the influence of Chéret (Figs. 60, 64). By 1890 poster art and color lithography had become so popular that the critic Robert Koch could speak of a "Poster Movement"

associated with Art Nouveau. Lautrec continued where Chéret left off, with greater verve and expressive power in his nervous contour and color shape.

It is ironic that the excessive refinement and egocentric sensibility basic to Symbolism, in literature and the visual arts, should find its way into the decorative and public concept of the poster. With the example of Post-Impressionist painting and the advent of men of progressive social vision like van de Velde, the idea of a new decorative totality across all the arts began increasingly to suggest concrete ways of implementing a new and healthier environment. The significative qualities of line and form, first discovered by Charles Henry and Georges Seurat (see pp. 26–27) but then associated exclusively with the highly private excursions of Symbolist art, now assumed wider public meanings, pointing to a more productive relationship between art and mass society.

The beginnings of such a relationship can be seen even in the brilliantly ornate and rather diabolical style of Gustave Klimt (1862–1918), the great exponent of Viennese Jugendstil and president of the Vienna Secession. Klimt gained considerable notoriety from the controversial murals he made for the University of Vienna, representing Philosophy, Medicine, and Jurisprudence (Fig. 81). Instead of a familiar allegory of historical figures, Klimt created vermiform masses of huddled naked forms symbolizing varieties of the human condition, both philosophically and medically, and calling attention especially to the degenerative diseases flesh is heir to. The imagery was far too brutal and macabre, as well as erotic, for the academic faculty, and they rejected the murals. By evoking an extreme, if characteristic, Symbolist mood of despair, Klimt had actually painted a true picture of the spiritual condition of the day.

In a series of remarkable portraits and mural-size paintings, Klimt exploited his unparalleled command of materials and techniques to embed illusionistically volumetric figures within fields of gorgeously colored or gilded flat, abstract pattern, yet imposed upon his elements a pictorial coherence that is all the more exciting for being fraught with inherent conflict. But despite its splendidly decorative qualities, such work anticipated the offending mixtures of dream, eroticism, and aberrant personality in subject matter that later marked the anguished art of Klimt's Expressionist descendants in Vienna, mainly Egon Schiele and Oskar Kokoschka.

above: 81. Gustave Klimt. Study for *Medicine*. 1897–98. Oil on canvas, 28×21¾". Private collection, Vienna.

right: 82. Gustave Klimt. The Kiss. 1907–08. Oil on canvas, 5'10" square. Oesterreische Galerie, Vienna. Klimt's glittering, febrile art, exquisite in its draftsmanship (Fig. 83), reached a heady climax in murals made for the dining room of the Palais Stoclet in Brussels (Fig. 84), designed by Joseph Hoffmann, a Viennese Secession architect (Fig. 154). There, sumptuous ornamental detail and geometric pattern in semiprecious stone and mosaic—a Byzantine medium reminiscent of the "primitive" inspiration sought by Gauguin and the Nabis in medieval stained glass—elaborate such vignettes as the tree of life, dancers, and intertwined lovers. But these acceptable subjects only manage to heighten the mood of anxiety and a kind of cerebral eroticism typical of late Symbolist painting. Even so, the visual continuum of the sinuously elegant Art Nouveau design all but absorbs the flattened, stylized figures until the whole abstract expanse becomes a grand metaphor of the work's theme: pantheistic Love.

Although Art Nouveau decoration often retained the appearance of mere whimsical invention, its major designers and theorists managed to penetrate artistic problems and contemporary realities deeply. In their practices and precepts can be discerned the indispensable link to the rational constructions of 20th-century building. For example, when the persistent Art Nouveau plant motifs were rather improbably translated into iron and steel building supports, they assumed potent new functional and aesthetic prerogatives in the revelation of architectural structure. A legitimate analogy can be drawn with the new candor of expressive means that Post-Impressionist painting made explicit. Together, the radical painters and designers broke the stultifying grip of an ex-

hausted Symbolism. At the close of the century, the fine and applied arts realized a rare unity, and together they bridged the gap between 19th-century eclecticism and the distinctive expressions of that collective visual revolution we know as the modern movement.

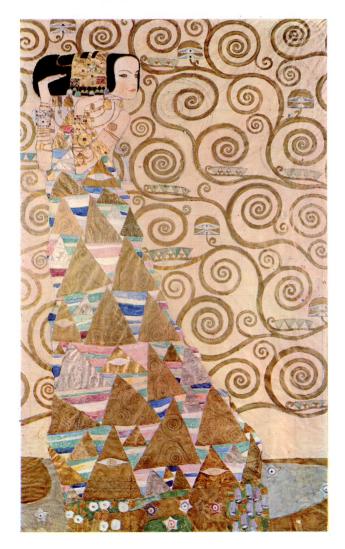

above: 84. Gustav Klimt. Expectation, study for the wall mosaic in the dining room of the Palais Stoclet in Brussels. 1905–09. Mixed media with silver and gold leaf on paper, 6'3¼" × 3'8%". Oesterreichisches Museum für angewandte Kunst, Vienna.

Art Nouveau in Painting and Design

Early Modern Sculpture: From Rodin to Brancusi

During the Impressionist and Post-Impressionist periods, sculpture lagged behind painting in achieving a specifically modern idiom. The dominant academic obsessions with outdated mythologies, historical events, and themes of personal heroism (Fig. 85) inhibited discovery and development of new artistic methods that were evident elsewhere in the visual arts. Neither the realistic observation of life, which in painting dated as far back as Courbet, nor contemporary moods of experiment seemed to have affected sculpture very deeply. The most influential traditions were still linked to the prestige of ancient statuary transmitted through various Neoclassical models established earlier in the century (Fig.

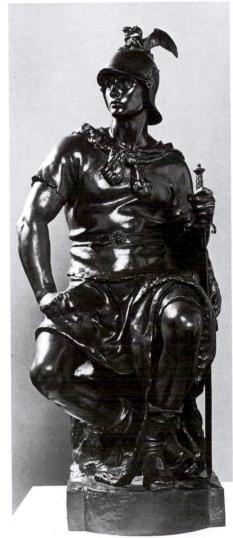

85. Paul Dubois. *Military* Courage. 1876. Bronze, lifesize. Middlebury College. 6). Only with the advent of Auguste Rodin did sculpture emerge as an independent art form with fresh vitality and promise. In part, this came about through the work of several great painters who did important sculpture; in part, a sense of independence asserted itself when the sculptors after Rodin responded to the revolutionary times with new styles.

During the Impressionist period, the best-known and most admired sculptors were products of the Beaux-Arts tradition. They expected to be judged more as dramatists and poets than inventors of new form or searchers for a more valid contemporary subject matter. Virtuosity and painstaking craftsmanship were the accepted criteria of artistic achievement, even though the most serious painters, critics, and patrons were aware of the lack of real feeling, sensitivity, or significant content in academic sculpture. With the all-important exception of Canova (1757–1822; Fig. 6), sculpture had not been the dominant visual art form since the days of Michelangelo or at best Bernini, and 19th-century sculpture was unable to sustain a continuous development or serious aesthetic purpose comparable to advanced painting.

The Impressionists' emergence coincided roughly with Rodin's public notoriety and the scandal of his Age of Bronze (Fig. 89). The lifelike sculpture caused a sensation when it was shown at the Salon of 1877, in the midst of the Impressionists' own controversial series of exhibitions and their regular rejections by the annual Salon juries. But while the best of the conservative sculptors and some critics came to the defense of The Age of Bronze, Rodin enjoyed no sense of solidarity with a contemporary group of fellow sculptors of serious purpose and radical aim. Nor could he look for support to a body of sculpture expressing new attitudes toward nature and past artistic tradition, as was the case in progressive painting. The late 19th-century sculptor understood that in order to enjoy public esteem, or even to attract notice at the vast annual Salons, he must embody such themes as patriotism and the universality of humanist values. This explains why, in the aftermath of the Franco-Prussian War, Rodin first called his statue The Vanguished, although he eschewed the elaborate allegorical form then usual for such subjects in favor of a more direct and naturalistic mode of expression. Even so, he adhered to a relatively conservative line in The Age of Bronze, again for the explicit purpose of appealing to contemporary taste as this prevailed at the Salon. Consequently, the piece was acquired by the French state, cast, and then installed in the Luxembourg Gardens. Along with Rodin's more challenging efforts, much honorable work could be seen at the Salons during the 1870s and later, especially that of Carpeaux, Dubois (Fig. 85), Mercié, and Falguière. Still, one often-quoted visitor to the official exhibitions found himself so benumbed by the overall spectacle of mediocrity and visual bombast that he characterized the panorama as "a white plaster and marble world populated by operatic figures."

left: 86. Jean-Baptiste Carpeaux. The Dance. 1867–69. Plaster model, c. 15' × 8'6". Musée de l'Opéra, Paris.

above: 87. Constantin Meunier. The Soil. 1892. Bronze relief, 17¾" high. Musées Royaux des Beaux-Arts, Brussels.

To evoke the potpourri of subject types that stood in contrast to Rodin's pragmatic honesty and depth of expression, Albert Elsen has with fitting relish compiled the following inventory of improbable juxtapositions:

Olympian divinities and Louis XIII musketeers, ballerinas and Venetian gondoliers, Caesar and Cléo de Mérode, farmers and miners, and such ironic personifications as 'The Force of Hypocrisy Oppressing Truth.' . . . Inveterate Salon visitors could count upon an 'eternal population of women,' sleeping, waking, performing their toilette, bathing, reclining, being taken by surprise, experiencing their first romantic shiver, and grieving at the tomb, all in the service of the renewal of beauty and the sexual education of the young.¹

Against this background of literary themes, frozen neoclassical anguish or other conventional tableaux, and egregious virtuosity in handling-the sculptural equivalent of the painting of Bonnat, Bouguereau (Fig. 16), and Cabanel-The Dance by Jean-Baptiste Carpeaux (1827–75), installed at the Paris Opéra in 1869, seemed novel and compelling (Fig. 86). Here was an allegorical sculpture with a difference; disarmingly baroque in its animated movement and elaborately curvilinear contours, it managed to convey an almost irresistible energy and charm. Yet the bloodless pretensions of academic tradition were so in command of public taste that a scandal was created around Carpeaux's freshly observed nude figures. Their sensibility, which conformed to the new spirit of painting evident in Manet (Fig. 15), among others, only invited violent censure. "The reek of wine and vice ... their lascivious postures and cynical expressions provoke the beholders," wrote a fanatical, but typical, critic in the press, who concluded with the rebuke, "an insult to public morality."²

Even more spontaneous effects of touch in modeling and greater freedom of movement were visible in some of Carpeaux's small statues of a more private character and in his portrait studies. The antagonism Carpeaux aroused at the Academy with his fresh and direct observation of life might be likened to Courbet's liberating and challenging role in painting (Fig. 13). With Honoré 88. Auguste Rodin. The Man with the Broken Nose. 1864. Bronze, 12½" high. Hirshhorn Museum and Sculpture Garden, Smithsonian Institution, Washington, D.C.

Daumier (Fig. 11), he takes his place as one of the few memorable precursors of the Impressionist painters as well as, in his spontaneous modeling techniques, of Rodin. Actually, Carpeaux briefly taught Rodin at the "Petite École" but had no further connection with him before his early death in 1875.

A growing distaste for the conventional and vapid Salon nude and for allegorical "histories" in the later decades of the century resulted in another countertradition, derived essentially from François Millet (Fig. 12), which idealized the worker in the field and the proletariat of the city. This preoccupation with all forms of labor—*la plèbe et la glèbe*, "toil and soil"—replaced the tiresome Salon dream world with a more viable, modern subject matter. The sympathetic treatment of working people and peasants in the art of Constantin Meunier (1831–1905) and Jules Dalou imbued their figures with a new dignity and a certain awkward, if stereotyped, power (Fig. 87). In any case, the introduction of themes of social misery provided relief from the vapid trivia of the Salon in a new, although not strikingly original, genre of sculpture. However, one could scarcely expect such mild forms of social idealism to re-establish sculpture as a major art form. It took the genius of Auguste Rodin (1840–1917) to overcome the profound and numerous obstacles that confronted the modern sculptor. In the fourth quarter of the 19th century, almost single-handedly, Rodin reinstated sculpture as a serious enterprise and re-established its eminence after generations of relative neglect, despite the singular accomplishments of such earlier 19th-century masters as Canova, Rude, and Barye.

For all his veneration of the most ambitious, historical monumental sculpture, from the cathedrals of France to Donatello and Michelangelo, Rodin takes his place as the first significant modernist sculptor, in the sense of breaking with accepted traditions of the past and creating forms more in tune with the temper of the age. Whether in portrait busts or epic figure groups, intimate pieces or public monuments, or forms in calm repose or energetic and contorted action, Rodin breathed new life into the art of sculpture. A phrase he applied to his art, 'the latent heroism of all natural movement,'' defines both his continuing attachment to the rhetoric

89. Auguste Rodin. The Age of Bronze. 1876. Bronze, 5'11" high. Minneapolis Institute of Art. John R. van Derlip Fund. of the heroic past and his interest in the dynamism of contemporary life. It also prefigures the unique synthesis of poetic Symbolism, powerful movement, and vigorous realism that characterizes his sculpture in its many and varied phases of development; and it seems to echo Baudelaire's comment that the heroic nature of modern life could be expressed in everyday dress and gesture. Rodin's most fundamental contribution in redefining the role of modern sculpture, and thus allying it with advanced painting of his time, was to make it the vehicle for his personal interpretation of both nature and art. Despite his reverence for the heroic past, Rodin did more than had any predecessor to free sculpture from extravagant allegory, literary illustration, religious subject matter, and mythologies as presented through the stale conventions of Salon art.

The Man with the Broken Nose (Fig. 88), modeled when the artist was only twenty-three, offered the first stunning evidence of Rodin's expressive complexity and rather brutal realism. The work demonstrates the originality of his inspiration, even before he was exposed to the traditional heroic sculpture of Michelangelo and Donatello, which later had a profound effect on his work. The poet Rainer Maria Rilke, who wrote a sensitive study of Rodin, described the surface of this small sculpture in terms that would have perfectly suited the emerging Impressionist painting of the next decade: "There were no symmetrical planes in this face at all, nothing repeated itself, no spot remained empty, dumb or indifferent."³ It is expressiveness of surface, betraying both the urgent emotion of the creator and his preoccupation with artistic process, that ultimately defines Rodin's modernity. His uninhibited modeling of "lumps and hollows" to define form made Rodin's art distinctive even when the artist seemed preoccupied with psychological realism or was consciously depicting an "ugly," unidealized head. Rilke described how Rodin discovered "the fundamental element of his art; as it were, the germ of his world. It was the surfacethis differently great surface, variedly accentuated, accurately measured, out of which everything must rise-which was from this moment the subject matter of his art."⁴ Symptomatic of his determination to find new expressive power through a candid revelation of process was the decision that Rodin made to submit The Man with the Broken Nose to the Salon jury as a fragment, which the piece became once clay fell from the back during a freezing winter when the sculptor could not afford heat. The gesture proved too radical for the time, and it resulted in a rejection of the head for the Salon of 1864.

The Age of Bronze (Fig. 89), shown at the 1877 Salon, was Rodin's first major figure. It was also his most conservative and traditional work, but with this piece began the pattern of public disapprobation that was to haunt the artist throughout his life, despite public honors, an increasing sculptural eminence, and worldly commercial success. The philistine attacks on this vital form, caught in a pose of awakening consciousness, were based not on the free modeling that would later cause such consternation, but rather on the sheer lifelikeness of the image. There was still a hint of the ominous symbolism of the Salon in the pose, which evoked Michelangelo's tormented Slaves. But public and critics, dulled by frigid Salon statuary, charged Rodin with making a life cast. In fact, the accusation bore an element of truth, for Rodin did meticulously observe his model, in ways previously ignored by the academic sculptor, and he also wanted to emphasize the ever-changing surfaces of his sculptural form, in order "to capture life by the complete expression of the profiles." He thus introduced that technique of working in broken planes to reveal incompletely defined forms as if seen in flickering illumination. Rodin's preoccupation with figure and object under the transitory impact of light was matched by an integral expressive power that owed an acknowledged debt to his Romantic predecessors François Rude and Antoine-Louis Barye.

To dispel the suspicion that he worked from casts of live models, Rodin made his next major sculpture, Saint John the Baptist, and the study for it, which he called The Walking Man (Fig. 90), larger than life and exaggerated, even to the point of melodrama, the vigor of their pose. Created in 1877-78, the torso now incorporated into the study was not conceived as a finished sculpture but rather as a concentrated analysis of skeletal and muscular structure necessary to work out the completed figure. Relevant today, with our advantage of hindsight, was Rodin's use of the partial figure, minus head and arms, as if in emulation of fragments of classical torsos-thus simultaneously evoking and challenging traditional sculpture forms. Also, the sophisticated sense of kinetic action that Rodin himself described as "the progressive development of movement" predicts modern attitudes. He wanted his fractured figure to be read as if vigorously in motion, and yet to synthesize successive stages of movement so that we feel the figure pushing off from the back leg and shifting its weight down on the front leg at the same time, all in a single aggressive, striding pose.

Interestingly, despite his energetic and brilliant descriptive modeling, there was a current of Symbolism in Rodin's complex figure groups. It is an error to limit the achievement of this master to the vivacious manipulation of surfaces of clay or cast bronze. In accord with the Symbolist painters and poets, he believed that "painting, sculpture, literature, and music are more closely related than is generally believed. They express all the sentiments of the human soul in the light of nature."⁵ Many of the most ambitious commissions executed by Rodin, and even his less formal work, accurately reflect the spiritual malaise of the times that gave the Symbolist program its emotional power and relevance. The first evidence, on a large scale, of the sculptor's philosophical ambition and of a certain modern ambivalence of mood emerged in the unfinished Gates of Hell (Fig. 91), commissioned but never installed by the state as a monumental bronze door for a new museum of decorative arts.

Given the choice of theme, Rodin selected a Dantesque program of damnation but modified it by introducing Baudelaire's modern concept of *ennui*, derived from *The Flowers of Evil*, which the sculptor greatly admired and had, in fact, illustrated. For Rodin, Hell was the spiritual nightmare of estranged and impotent modern man, unconsoled by church or state, nor supported by any attachment to nature. Hell could be better defined as a condition of psychic distress than as a place of eternal physical pain. Quite in keeping, then, with Baudelairean imagery and despair, Rodin's *Thinker* sits in the center of the lintel of *The Gates of Hell*, surmounting a turbulent flow of sinners who writhe and gesticulate in the agony of their shame and desire. Later enlarged to heroic scale, as an independent figure, *The Thinker*, in the words of Elsen,

reflects the artist's position in society. The artist-poet has replaced Christ in the seat of Judgment, but he has the power neither to condemn nor to save souls from their personal hells. The tense solitary stillness of *The Thinker* dramatizes the effort of concentrated thought required to comprehend human tragedy and create a poetic art that expresses it truthfully. Commitment to this impossible task, like the passionate strivings of those around him, is the artist's private inferno. Above *The Thinker* and those around and below, Rodin placed a thorn vine, a crown of thorns for the artist and suffering humanity.⁶

The convulsive scenes over which *The Thinker* broods, the rising and falling movement of the carnal lovers and other sinners, are more reminiscent of Michelangelo's *Last Judgment* in the Sistine Chapel than of Ghiberti's doors on the Florentine Baptistery that first inspired Rodin's magnificent invention.

Even more than in Ghiberti's panels, the final effect of Rodin's powerful and monumental relief is essentially pictorial, with its myriad figures (186 in all) covering a surface 18 feet high. Indeed, the forms of *The Gates* are virtually cinematic in their ag-

64

itated movement and in the effect of dissolving into and emerging from the surface. Actually, then, in addition to its spiritual message, which for the first time made Hell a modern existential nightmare rather than the anachronistic metaphor of traditional theology, the concept of flux and metamorphosis dominates this vast, deeply moving structure. Figures are identified with the matrix of the bronze itself to such a degree that even the dynamic character of the surface finally gives way to a dominant Expressionist aesthetic. The sculptural process and the sculptor's creativity and involvement in the artistic act themselves become a decisive part of the subject matter.

At the artist's death in 1917, *The Gates of Hell* was left unfinished in the original plaster and was not cast in bronze until the 1920s. Yet it remained Rodin's incomparable masterpiece, despite its lack of conventional unity, its incompleteness, distracting pictorialism, and episodic character. The monument represented a final synthesis of all the major themes that dominated Rodin's creative expression; he had spent a lifetime reworking many of the principal subjects separately, on a larger scale, including *The Three Shades, The Thinker, Eve*, and *The Old Courtesan*, among others.

The complex nature of Rodin's genius and, indeed, his continuing impact on modern sensibilities are best summed up in two of his large-scale, freestanding ventures: *The Burghers of Calais* (Fig. 92) and the *Monument to Balzac*. The figural composition for the former, undertaken in 1884, was the second major public commission awarded to Rodin. His assigned theme was derived from an account of noble self-sacrifice in Froissart's 14th-century *Chronicles*, the story of six leading citizens of Calais who, during the Hundred Years War, voluntarily surrendered themselves, clad in sackcloth, with ropes tied around their necks, to the English King Edward III laying siege to the medieval French city.

The contorted poses, which impart pathos to his figures, suggest similar poses and the strident emotional content in van Gogh and Munch. They even anticipate the more exaggerated gestures

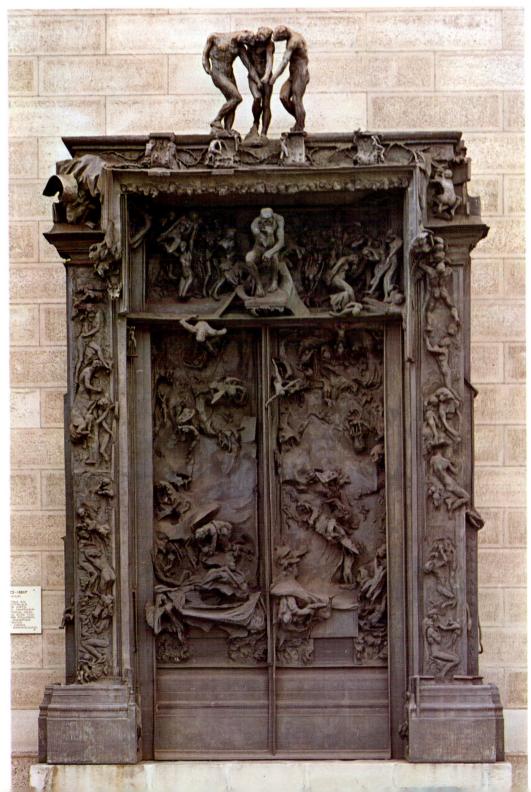

opposite: 90. Auguste Rodin. The Walking Man. 1905 (first cast 1907). Bronze, 6'11¾" high (enlarged scale). Musée Rodin, Paris.

right: 91. Auguste Rodin. The Gates of Hell. 1880–1917 (cast 1925–28). Bronze, 18' × 12' × 2'7". Kunsthaus, Zurich.

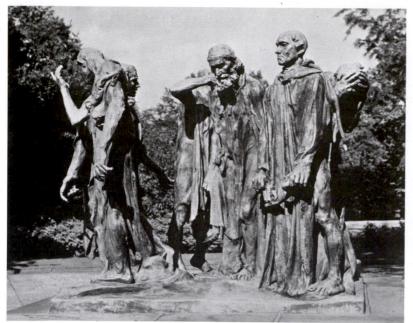

and morbidity of much 20th-century German and Viennese Expressionism, from Lehmbruck's gentle figures of immolation to Schiele's tormented seers (Figs. 216, 205, 206). Perhaps even more modern, however, is the formal concept of the anti-monument, for the figure grouping, in its final form, is conceived virtually without intervention of the pedestal to demarcate the artistic space from that of the observer. The idea of arranging the figures in a kind of *ronde*—to follow Elsen's revealing analysis—as if a single figure were seen in successive moods and positions, became a device favored by many of the later Symbolists, and it predicted the psychological and kinetic effects of early Futurism. Finally, the informal and open arrangement of the figures in successive rhythmic poses was a direct attack on the classical tradition of the stable, closed monument, invariably removed from the spectator's arena.

Rodin apparently would have even preferred the more radical device of setting his figures directly on the ground rather than on a unifying plinth. He later claimed that his original plan had been "to fix my statues one behind the other on the stones of the Place, before the Town Hall of Calais, like a living chapelet of suffering and sacrifice . . . and the people of Calais of today would have felt more deeply the tradition of solidarity which unites them to their heroes."⁷

It is curious that even as Rodin wished to engage the spectator directly in the drama, a contrary impulse took him in the direction of creating sculptural effects bordering on what the conventional eye would have perceived as formal incoherence. The flow of shadows and concavities encountered by the viewer moving around the figure group makes it difficult to read as an intelligible narrative sequence. The drama of light and dark, of recessive shadow playing against protruding mass, erodes the individual figures, their features and physiognomy, and even plays tricks with their anguished expressions. To a surprising degree, dramatic content or narrative substance is denied rather than reinforced by form. An overriding attention to certain shapes and the intervals between them, and the resulting abstract play of forms, disrupt our reading of traditional meanings. In his later works, Rodin often distorted his forms so extravagantly that they lost anatomical coherence and recognizability.

With his imposing *Monument to Balzac* (Fig. 93), completed after seven years of protracted labor, distractions, and numerous preliminary sketches, Rodin realized perhaps his most radical and self-expressive sculpture. The colossal and vital figure, almost su**left: 92.** Auguste Rodin. *The Burghers of Calais*. 1884–88. Bronze, 7'11" x 8'2" x 6'6". Hirshhorn Museum and Sculpture Garden, Smithsonian Institution, Washington, D.C.

below: 93. Auguste Rodin. Monument to Balzac. 1897–98 (cast 1954). Bronze, 9'10" high. Museum of Modern Art, New York. Presented in memory of Curt Valentin by his friends.

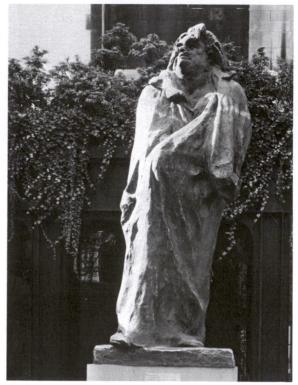

perhuman, seemed to represent the sculptor's effort to identify himself with the writer's creative force. The Balzac project was awarded to Rodin in 1891 by the Writers Association (Société des Gens de Lettres) and was presented publicly at the Salon of 1898. But the pusillanimous literary society, then no longer led by Émile Zola, who had favored Rodin for the commission to memorialize Balzac, rejected the final version of the sculptor's monument on the ground that it was a crude, monstrous, incomprehensible image, ''an ignoble and insane nightmare'' that violated the writer's memory. With its broad summary planes and look of caricature, the work incited a critical tempest in the press, which finally supported the rejection.

Most of Rodin's contemporaries, expecting an academically exact likeness, could see only an ugly, shapeless, and unfinished mass. But the head was recognizably Balzac's, and soon after the sculpture was rejected, the artistic, if not the whole critical, community, came to understand the work for what it was, a symbol of the vigor and heroism of a prolific literary genius. Actually, the monument seemed an almost literal realization of Lamartine's inspired description of the 19th-century novelist: "It was the face of an element; big head, hair dishevelled over his collar and cheeks, like a wave which the scissors never clipped; very obtuse; eye of flame; colossal body."⁸

The contemporary public, however, remained blind to the virtues and power of the Balzac, failing to react, other than negatively, to the work's abstract form and symbolism of a kind "yet unknown," to adopt Rodin's words. The sculpture represented one of the first occasions in which the artist's private values conflicted quite openly with outdated public expectations of monumental art. Even Rodin's psychological realism and activated surface could neither mitigate nor elucidate the sculpture as a new kind of icon. Possibly this was because viewers sensed what could only be feared and left unnamed, for, as Rosalyn Frankel Jamison has recently written,

[Rodin] showed a Balzac whose creative fervor left a tragic imprint on the face, a Balzac leaning back dramatically, gathering his robe [actually a "monk's robe" the great novelist used as a dressing gown to work in], a metaphor for the increasing energy within. One study, in fact, explored the idea of a headless male figure holding an erect penis, suggesting the sexual energy inherent in creative tension. This theme, which he had previously explored in the allegorical context of a muse, he finally included in the Balzac monument as an implied and covert gesture. Rodin's images of creators gradually assumed the form of his personalized muses, openly reflecting the inner dynamics of the creative mind.⁹

As realized in the final work, the sexual reference has ceased to be explicit and become subsumed into the entire form, a thrusting phallic shape making a near-abstract emblem of generative power. Attacked in the press and harassed by his sponsors, the sculptor refused to change his design and withdrew his plaster statue, a bronze cast of which now stands in Paris at the juncture of the boulevards Raspail and Montparnasse. At the time of this public rebuff Rodin made the following statement:

One can find errors in my Balzac; the artist does not always attain his dream; but I believe in the truth of my principle; and Balzac, rejected or not, is nonetheless in the line of demarcation between commercial sculpture and the art of sculpture that we no longer have in Europe. My principle is to imitate not only form but also life. I search in nature for this life and amplify it by exaggerating the hollows and lumps, to gain thereby more light, after which I search for a synthesis of the whole...I am now too old to defend my art, which has sincerity as its defense."¹⁰

In his later work, beginning with *Balzac* and *Flying Figure*, Rodin achieved such violent, contorted poses that the drama of the modeling itself, and the abstract form achieved by his dismembered fragments, became the work's expressive raison d'être. Van Gogh, Gauguin, and the Symbolists similarly had intended to render feelings and ideas through the direct impact of artistic form, and they used external appearance as the equivalent of underlying emotion and a nonperceptual, ideal reality. Rodin took this essentially Symbolist device a step further toward sculptural autonomy.

right: 94. Edgar Degas. Little Dancer Fourteen Years Old. 1881 (cast c. 1920). Bronze, with tulle skirt; 38½" high. Metropolitan Museum of Art (H.O. Havemeyer Collection), New York.

below: 95. Edgar Degas. The Tub. 1886 (cast c. 1920). Bronze, 18½×10½". Metropolitan Museum of Art (H.O. Havemeyer Collection), New York.

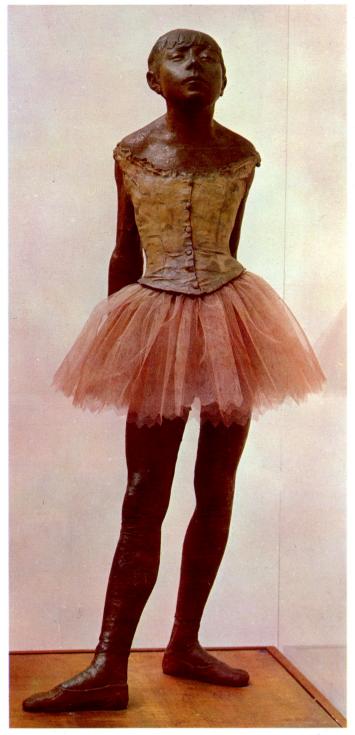

He found a new expressive synthesis in his radical distortions of the human form, which dispensed with the old visual rhetoric of body sculpture and yet retained an anatomical authenticity. His role in sculpture was rather like Cézanne's in painting, and, similarly, gained for him a reputation as the "primitive of a new art."

Almost the same combination of psychological realism, painful figure distortion, and pictorialism could be found in the occasional sculptures of Edgar Degas, whose vivacious wax figures were cast in bronze only after his death. The *Little Dancer Fourteen Years Old* (Fig. 94), doll-like and appealing, was shown at the Impressionist exhibition of 1881, but it only hinted at the unknown aspect of his work comprised by his sculptures. Degas dispensed with the base and pedestal in even more drastic fashion than did Rodin, placing his figure on the floor of a practice hall. *The Tub* (Fig. 95)

left: 96. Medardo Rosso. *Flesh of Others*. 1883. Wax-covered plaster, 17" high. Galleria Nazionale d'Arte Moderna, Rome.

below: 97. Antoine Bourdelle. Beethoven, Tragic Mask. 1901. Bronze, 27" high (including base). Museum of Modern Art, New York. Gift of Mrs. Maurice L. Stone in memory of her husband.

bottom: 98. Antoine Bourdelle. *Hercules the Archer.* 1909. Bronze, 8'1%" high. Musée National d'Art Moderne, Paris.

presents the illusion of bather and water in a metal tub, which functioned, along with a sculpted floor, as an expedient base. Degas's figures in motion were the very essence of momentary action, permanently fixed in the bronze medium. They were modeled so that the fall of light or shade on mass and plane built an exciting, expressive form. Unlike Rodin, however, Degas did not strive for generality, but, rather, for sharply individualized characterization. His *Dancer* even has flesh coloring and a tulle skirt, and conveys an uncanny waxworks verism that rebukes the artificiality of the "white plaster and marble world" of academic sculpture.

Paul Gauguin's occasional relief and freestanding sculptures, of which the wood carving *Be in Love and You'll Be Happy* is a prime example (Fig. 43), carry significance as sculptural expressions for their symbolic themes and for their rejection of the "error of the Greeks" in favor of folk- and tribal-art prototypes. Although 20th-century artists made their discoveries of primitivism independently, it was Gauguin who first pointed the way, when he found his inspiration in sources outside the mainstream of traditional European culture.

In sculpture the synthesis of illusionist naturalism and an enchanting, sensuous formlessness derived from an exaggerated Impressionist technique was most dramatically realized by the Italian Medardo Rosso (1858–1928). Rosso had met Rodin in Paris, but his figure groups are small, casual, and intimate and avoid both the epic scale and the elaborate mythologies of Rodin's heroic compositions (Fig. 96). Rosso chose to portray the banal, everyday world and treated it with the tender humor of Vuillard and Bonnard (Figs. 60–63). Sharply contemporary genre themes, alien to all but a pictorial sculptural mode, served him as inspiration. His preoccupation with light was even more acute than Rodin's, and Rosso keenly responded to its power to dissolve solid bodies in space. He preferred working in wax, which minimized the hard, tactile qualities of sculpture and emphasized momentary appearances. Wax also gave his sculpture a more luminous and chromatic

effect, allowing his molten surfaces to reflect vibrations of suggested movement as well as changes in lighting. Rosso's radical dissolution of form anticipated the Italian Futurists, who greatly admired his work and cited him as a precursor in their manifestoes.

Rodin's influence on Rosso, and others as well, was incalculable. It has been pointed out that the scope and intensity of the imagination of this artistic giant can best be compared to those of the composer Richard Wagner, who died in 1883. The proof of the greatness of Rodin lay not only in his immediate followers, but even

in the work of artists who used his art as a point of departure, like Maillol, Brancusi, and Matisse, and then proceeded to reject his techniques and program in order to assert their own independence.

Rodin may have exerted his strongest and most immediate influence upon his chief studio assistant, Émile-Antoine Bourdelle (1861–1929). Bourdelle's imaginary portrait, *Beethoven, Tragic Mask* (Fig. 97), translated the close-up, highly accented mask of the composer into an expressionistic landscape of powerful emotion bordering on chaos, in anticipation of the turbulent paintings of Soutine and others (Fig. 375). After his first success at the 1901 Salon, however, Bourdelle turned to a more stereotyped, archaic idiom, as in his *Hercules the Archer* (Fig. 98), whose neoclassical mannerism removed him from the vital sources of Rodin's expressionist and realist tradition. Nevertheless, he remained an impressive and influential teacher for many years, and assisted others in seeking out the rich possibilities of architectonic form and poetic

above: 99.

Charles Despiau. Young Girl from the Landes. 1909. Bronze, 19%" high. Musée National d'Art Moderne, Paris.

right: 100.

Aristide Maillol. The Mediterranean. 1902–05. Bronze, 41″ high. Museum of Modern Art, New York. Gift of Stephen C. Clark.

far right: 101.

Aristide Maillol. Action in Chains. 1905. Bronze, 47" high. Private collection.

statement in so-called primitive forms. Another assistant of Rodin's, Charles Despiau (1874–1946), was a master in a minor key, achieving memorable images of poise and restraint in his sensitive nudes and portrait busts (Fig. 99).

During the first decade of the new century, when Rodin was at the height of his fame, a number of other sculptors developed new and opposing ideas, in particular, Aristide Maillol (1861–1944). Maillol turned to sculpture only when he was forty, following a long apprenticeship with the Nabis as a painter and decorator, but he recovered for the art of sculpture a purity of form almost classical in its stability and simplicity, after the long domination of Rodin's agitated figures and complex themes. Reflecting on the serenity and immobility of ancient art, and looking to the unity of the sculptural mass as a regulating idea, Maillol declared: "For my taste, sculpture should have as little movement as possible. It should not fall, and gesture and grimace. The more immobile Egyptian statues are, the more it seems as if they move."¹¹

With his personification of natural forces in the form of stocky, full-bodied country girls, Maillol restored the Greek classical tradition, which the academicians had eviscerated. To Grecian poise, harmony, and containment he added his own robust, earthy vigor and breadth of treatment. Commenting on his replacement of Rodin's dramatic figures with the greatest possible simplicity of gesture and pose, Maillol said: "There is something to be learned from Rodin . . . yet I felt I must return to more stable and self-contained forms. Stripped of all psychological details, forms yield themselves up more readily to the sculptor's intentions."¹²

With Maillol, the human figure became the focus of a detached objectivity, and the artist achieved a new balance of abstract volumes and proportions in his heavy, articulated torsos. His figure titled *The Mediterranean* (Fig. 100) presents a smoothly flowing, carefully constructed balance of contour and volume at odds with the agitation and straining for epic content of Rodin's figures. *Action in Chains* (Fig. 101), originally conceived as a

monument to the Socialist Blanqui, is more dynamic in its rhythmic disposition of masses, but its energy and forceful movement are restrained, even though the fragmentary form had originated with Rodin. The action is held in a controlled tension.

In an earlier work, *The Young Cyclist* (Fig. 102), Maillol had sensitively modeled an adolescent youth with the touch of pathos and introversion reminiscent of the melancholy preoccupation of the Symbolists. The *fin-de-siècle*'s pervasive spiritual malaise even more explicitly shaped the work of the Belgian George Minne (1867–1941), whose *Relic Bearer* suggests, in its fragile figure, inward-turning gesture, and almost excruciating sensitivity of modeling, a withdrawn, unworldly mood. The pose of silent resignation was repeated in five marble figures set on the rim of a large simple basin for a fountain commissioned in 1906 for the museum at Hagen (Fig. 103).

Wilhelm Lehmbruck (1881-1919) took from Minne's Symbolist sculpture its unstable proportions, attenuated limbs, and depiction of inner feelings as outward signs of the spiritual life. While the stylization of Rodin and Bourdelle, who also influenced him, expressed intense and positive emotion, Lehmbruck's tentative, nervous contours and almost painfully articulated elongations of the human anatomy suggest contemplation rather than energy (Fig. 216). The asceticism and denial of his figures, qualities which became more exaggerated as German Expressionism developed, are gentle rather than brutal or self-punitive. The pattern of transforming exasperated feelings into an imagery of violence, which often evoked the darker regions of the human psyche and abnormal psychology, had been sanctioned by the confessional art of Munch and Ensor's savage and grotesque caricature (Figs. 55-57). These precedents, however, had greater impact on painting than upon German Expressionist sculpture. Lehmbruck became probably Germany's greatest 20th-century sculptor. Like the more vehe-

right: 102. Aristide Maillol. The Young Cyclist. 1907–08. Bronze, 38%" high. Musée National d'Art Moderne, Paris.

above: 103. George Minne. Fountain of Five Kneeling Youths (detail). 1898–1906. Marble, 5'7" high. Folkwang Museum, Essen (transferred from Hagen).

right: 104. Wilhelm Lehmbruck. Fallen Man. 1915–16. Bronze, 2'5½" × 7'10½". Collection Frau A. Lehmbruck, Stuttgart.

Early Modern Sculpture **70**

bottom: 106. Gaston Lachaise. Standing Woman. 1932. Bronze, 7'4" x 3'5½" x 1'7½". Museum of Modern Art, New York. Mrs. Simon Guggenheim Fund.

and dramatic action. A most refreshing and apropos characterization of his vernacular subject matter is given by Elsen:

In form and subject, this self-styled 'Low German' sculptor cherished his own type of primitivism that involved places and people he knew, and which encouraged his lifelong epic of the spirit's travail. In the costumes of Baltic peasants and townspeople, Barlach discovered the evidence through ''masked movement'' of true feeling. Folk types provided him with ''problematic characters,'' the grotesque in form and conduct, demoniacal reactions, uninhibited ecstasy, all in genuine rude gestures that mimed human insecurity, perversity, and endurance. These were people who satisfied Barlach's need to feel pity and to give the world an art of consolation.¹³

In the sculpture of Gaston Lachaise (1882–1935), the classical theme of the nude, having been given a variety of inflections from Rodin to Maillol, acquired an overpowering sensual expression. French-born, Lachaise left Europe for America in 1906, where, for some fifteen years before recognition came, he did decorative details as a sculptor's assistant while working out his own concepts. Lachaise sought to express, in his words, "the glorification of the human being, of the human body, of the human spirit." With consummate craftsmanship, he fashioned figures of gargantuan voluptuousness, earthy and swelling with opulent curves. In *Standing Woman* (Fig. 106) flowing lines deftly control the design motif formed by the ample breasts, heart-shaped stomach, wasp waist, swelling thighs, and powerful legs. In other works Lachaise carried the exaggeration of the female's sensual endowments to a point of abstraction.

Early Modern Sculpture
71

105. Georg Kolbe. Dancer. 1922. Bronze, 19¹/₂" high. Wallraf-Richartz Museum, Museen der Stadt Köln.

ment and strident Expressionist painters who followed him, there was in his work more than a touch of the Gothic, and of the anguished contortions of the elongated figures painted by the 16th-century master Matthias Grünewald. Yet they also retained a certain poise and grace even in their extreme departure from naturalistic proportions. Lehmbruck worked in Paris between 1910 and 1914, and there he was first influenced by Maillol. The harmonious serenity of his fully developed style ties him as closely to classical tradition as his distortions and preoccupation with suffering link him to the romantic Expressionist tendency. Lehmbruck's work possesses a moving, inward feeling, a sense of inherent dignity, and is touched with compassion for erring humanity, as well as melancholy. The *Fallen Man* (Fig. 104), a war memorial, is the antithesis of military pomp and posturing, and, surely as a result, it was bitterly attacked during the Nazi regime.

Other German sculptors, particularly Georg Kolbe (1877– 1947) and Gerhard Marcks, refined forms and contours in sensitive figures imbued with an appealing, lyric simplicity (Fig. 105). Contrasting sharply with these are the blunt, terse figures of Ernst Barlach (1870–1938), who took his inspiration from late medieval wood carving (Fig. 215). The strength of folk and primitive art, and respect for the profundity of the peasant soul, which shaped his powerful art, derived from his personal experience and from such artistic sources as Brueghel and van Gogh. Barlach bypasses classical charm in favor of an almost visionary seizure of emotion There were also a number of other artists of European origin who enriched America's first wave of modernist art; foremost among those who found new validity and inspiration in figurative forms was Elie Nadelman (1882–1946). Born in Poland, Nadelman worked in Warsaw, Munich, and Paris before coming to New York in 1914. There, with his American wife, he was among the very first to assemble and exhibit a superb collection of American folk art, whose cleanly incised forms and effigy character obviously contributed to the stylized formulas of his own rather raffish figurines. Nadelman's virtuoso style combines a classic elegance with witty sophistication. In *Man in the Open Air* (Fig. 107), the fashionable bowler hat and detail of string bow tie conspire to create an effect of both gravity and humor, savoir-faire and classical *contrapposto*—a dandified image that is a model of patrician poise and yet hauntingly suggests an archaic torso of Apollo.

We have seen that Rodin's influence on sculpture was pervasive and even overwhelming for many younger artists at the turn of the century. Rodin had almost single-handedly regained for sculpture its long-lost status as an independent art, and his contemporaries were well aware of the magnitude of his achievement. But Rodin also managed to close as many avenues to new expression as he opened. The visual rhetoric, the excessively dramatic character of his themes, and his irregular surfaces had little appeal to the new generation of sculptors that emerged after 1900. Like the dominant painters of the new century, they were looking for a more concrete, compact, and economic style, capable of crystallizing their urgent feelings about modern life. Their aspirations were soon to be realized by the radical art of Brancusi and the Cubists, who shifted interest to the sculpture as an object in itself, rather than as a vehicle of some literary program or philosophical proposition. Even Maillol's classicism, itself a reaction to Rodin's extravagant modeling and pathos, began to appear too static and unimaginative.

A revolutionary Gestalt emerged in these years, whereby the artist became more interested in his total expressive effect than in a convincing articulation of musculature or anatomical balance. Curiously, perhaps the most radical sculpture of the turn of the century came neither from the best known of Rodin's disciples or antagonists, but, rather, from the hand of a painter-sculptor of genius, Henri Matisse (1869–1954). Despite the obvious connection of his occasional sculpture to his major painting oeuvre (see Chaps. 7 and 14), Matisse's unique achievement in that medium was purely sculptural. His great accomplishment was to create sculpture valid on its own terms, divorced from any dominant stereotype or ideology, which embodies personal feeling as intense as the emotion of his Fauve period in painting. His sculpture displayed an acute sense of volume and aesthetic ordering in radically simplified forms and, for a time, put him well ahead of his Paris contemporaries.

Superficially, it seemed that Matisse's first significant sculpture, The Serf (Fig. 108), was actually Rodinesque, with its rudimentary expressionistic modeling, broken surfaces, and physical stance suggestive of The Walking Man (Fig. 90). But with Rodin, the anatomical truth of his figure remained a dominant feature, whereas the Matisse work was far less inhibited by allusions to the model. The aesthetic order was dictated by the artist's internalized sensations rather than by anatomical accuracy. This shifted the center of art from audience to creator, and to the inner structure of the object rather than the spectator's empathy with muscular movement. Matisse later remarked to Raymond Escholier: "My work-discipline was already the reverse of Rodin's. But I did not realize it then, for I was quite modest, and each day brought its revelation. . . . Already I could only envisage the general character of a work of mine, replacing explanatory details by a living and suggestive emphasis." 14

Matisse knew instinctively that to achieve the desired effect of sculptural totality the submergence of individual parts was

required. The wholeness he sought meant the subordination of detail to a dominant rhythm. In his distribution of sculptural masses and the play of light and shade on activated surfaces, Matisse managed to liberate himself from the subject, quite unlike Rodin. The primitivist power, generality of form, and expressive confidence apparent in his early sculpture became characteristic features of his greatest public and monumental painting after 1905, beginning with Joy of Life and terminating with the two grand works of 1910 in Moscow, Dance and Music (Figs. 175-177). The sure sense of plastic volume and its disposition in these paintings actually owe considerable debt to Matisse's private struggles at that time in sculpture. As an example, the modulation of rhythmic arabesque, achieved without undermining the sense of solid form in La Serpentine (Fig. 109), provided Matisse with an experience in linear composition that he clearly put to good use in the Music and Dance compositions.

The impact of Cubism, with its radical restructuring of the art object (see Chap. 9), can be felt in the celebrated Jeannette series (Figs. 110, 111). Here Matisse distorted the human physiognomy most drastically, under pressure from both the Cubists and his own discovery of primitive art. He used form constructively and inventively with a minimal intrusion of representational conventions. The results are virtually unprecedented in Matisse's oeuvre, although

opposite: 107. Elie Nadelman. Man in the Open Air. c. 1915. Bronze, 14'6½" high. Museum of Modern Art, New York. Gift of William S. Paley.

above left: 108. Henri Matisse. The Serf. 1900–03. Bronze, 36¼" high. Hirshhorn Museum and Sculpture Garden, Smithsonian Institution, Washington, D.C.

above right: 109.

Henri Matisse. La Serpentine. 1909. Bronze, 22¼" high. Museum of Modern Art, New York. Gift of Abby Aldrich Rockefeller.

far left: 110.

Henri Matisse. Jeannette, I. 1910–13. Bronze, 13" high. Hirshhorn Museum and Sculpture Garden, Smithsonian Institution, Washington, D.C.

left: 111. Henri Matisse. Jeannette, V. 1913. Bronze, 227/8 x 83/8 x 101/2". Hirshhorn Museum and Sculpture Garden, Smithsonian Institution, Washington, D.C.

Early Modern Sculpture

still more extreme transformations of the model had already been introduced by Picasso's first Cubist sculpture of 1909, *Woman's Head* (Fig. 231). Even in this context, however, Matisse's Jeannette series embodies a radical attack on representationalism, subordinating likeness to artistic form treated as rhythmic design, ruthlessly simplified to stress the organic harmony and relation between mass, plane, and contour. In his five versions of this subject, Matisse began with a relatively detailed naturalism but concluded with a broad, powerful interpretation and transformation of the motif into virtual abstraction.

In addition to the progressively more drastic formal invention, the serial character of the five portrait busts, developed over a three-year period, de-emphasized motif as such. A shift in aesthetic priorities can be perceived, from represented subject matter to the process of artistic creation. In this, Matisse differed fundamentally from Rodin, who remained attached to the model despite the highflown dramatic ends to which he might have manipulated his human figures. No matter how sensual his touch, Matisse created figures in which we always encounter an indifference, typical of all great formal art, to the emotional potential of the subject.

Another hint at the revolutionary aesthetic behind the work of Matisse lies in his willingness to let the five versions of the portrait bust of Jeannette remain in an apparently crude and unfinished state. His own standards of what constituted finished work had little to do with 19th-century preconceptions as to unity of style or surface. Despite their rudimentary lumpiness, expressive distortions, and general ungainly look at first glance, upon study and sustained exposure the Jeannette series is, finally, most impressive in its sculptural clarity and intelligence. On the one hand, Matisse showed an incomparable sensuousness in his use of clay; yet his responses to the model in terms of formal solutions were controlled by the same qualities of intellect and expressive restraint that governed even the most uninhibited of his Fauve paintings. As he himself put it in his "Notes of a Painter" in 1908 (see p. 101), Matisse opposed an emotional and excessively dramatic expressionism, connected primarily with gesture and rhetoric of pose. He preferred to be judged by the total expressiveness of his work, in sculpture as well as in painting. For Matisse, in other words, it is what the sculptor does, his achieved vision and the handling of his materials, that is expressive, rather than the power or drama of the subject.

Matisse's most ambitious exploration of the monumental possibilities of sculpture, corresponding to the impressive paintings made under Cubist influence, such as Piano Lesson (Fig. 380) and the even larger Bathers by a River, occurred with his great Back series (Figs. 112, 113). The artist experimented with these life-size forms in shallow relief between 1909 and 1930. The subject itself had an honorable history going back to Courbet as well as to Cézanne (Fig. 34), a version of whose Bathers Matisse kept in his studio for many years. Back, I was influenced by Rodin, as can be seen in its more naturalistic character, freely expressive modeling, and anatomical detail. The fourth, and final, version, completed after an interval of twenty years, was so radically simplified and stylized that the figure takes on an organic and abstract power. The limbs have become rigid trunks, virtually unrecognizable tubular forms, and the bisecting tail of hair has taken on more of an architectonic than descriptive function. The sense of the living model's ample proportions and sensuous ripple of flesh and muscle somehow survived the reductive process as Matisse reached the rather brutal formal synthesis of his maturity.

The use of modeled relief with such sculptural power was unique in modern art. It is a tribute to Matisse's sense of sculptural volume, and to his unerring pictorial taste as well, that he could produce, in shallow relief, such strong formal tensions. While the work may not have solved the problem of defining monumentality within its medium, as his large paintings did, it was a noble effort. The experiment was constrained by the structure of the vertical rectangle and the condition of physical flatness, which the artist's pictorial preoccupations and habits of a lifetime necessarily imposed upon him. But Matisse probably showed wisdom in choosing shallow relief, even on this large scale, since it was uniquely suited to his pictorial inclinations and enabled him to achieve a work of great originality and sculptural feeling.

In the first two decades of the new century, under the impact of Cubist formalism, sculpture moved toward geometric stylization and a new Purist aesthetic. Matisse's sensuousness and somewhat tortuous treatment of form seemed flabby and *retardataire* by comparison, and sharply limited his influence. The impression of a minor sculptural achievement was enforced by the relatively small number of sculptures Matisse actually produced. However, since World War II his influence has expanded considerably, and his unique synthesis of intellect and sensuality has aroused firm allegiance among the more painterly avant-gardes, in both pictorial and sculptural modes, especially during the 1950s. His capacious achievements in painting, sculpture, and collage are now seen to reflect, separately and together, an integral greatness in different media and forms, and each medium carries the full range and power of his experience in art.

The sculptor with the most revolutionary artistic vision and a profound influence on the early 20th century, whose name became identified with modernism for a universal public, was Con-

opposite: 112. Henri Matisse. The Back, I. 1909. Bronze, 6'2'/4" x 3'8'/2" x 6'/2". Museum of Modern Art, New York. Mrs. Simon Guggenheim Fund.

right: 113. Henri Maisse. The Back, IV. 1911. Bronze, 6'2" x 3'8¹/4" x 6". Museum of Modern Art, New York. Mrs. Simon Guggenheim Fund.

Early Modern Sculpture

left: 114.

Constantin Brancusi. Mlle Pogany. 1913. Polished bronze, with black patina on hair, 17¼" high. Museum of Modern Art, New York. Acquired through the Lillie P. Bliss Bequest.

opposite left: 115.

Constantin Brancusi. The Kiss. 1913. Limestone, 23 × 13 × 10". Philadelphia Museum of Art (Louise and Walter Arensberg Collection).

opposite above right: 116. Jacob Epstein. The Rock Drill. 1913–14. Bronze (cast 1962), 28×26". Tate Gallery, London.

opposite below right: 117.

André Derain. Crouching Man. 1907. Stone, 13×11". Museum des 20. Jahrhunderts, Vienna.

stantin Brancusi (1876-1957). Unlike Matisse, Brancusi was a fulltime sculptor, and his impact was felt immediately by his peers after 1910, when he began to create highly polished and streamlined geometric forms, which displayed a new, vitalistic spirit despite their elementary character. Brancusi retained tenuous attachments to descriptive forms and themes and, in fact, framed these allusions to nature with considerable wit. Nonetheless, he really deserves consideration as the pioneer abstract sculptor of the century, in advance of the Constructivists and contemporaneous with Kandinsky's path-breaking innovations in painting. Like the work of Kandinsky and Mondrian (Figs. 191-193, 195, 272-277), Brancusi's gleaming abstract forms seem less the product of Purist aesthetic theory (see pp. 241-246) than of private intuition and Eastern mysticism. Brancusi and a number of early modernist abstract painters were drawn to the cosmic imagery and universal themes popular with the Symbolists. Kandinsky and Mondrian apparently practiced theosophy, and Brancusi was also an enthusiast.

Early Modern Sculpture

For all of these artists who pioneered abstraction, the visible world veiled mystic truths and obscured the essence of reality. In the purification of one of his best-known images, *Mlle Pogany* (Fig. 114), we sense his neoplatonizing inspiration. Albert Elsen has pointed out that possibly Charles Blanc's text, which students used in Paris at the École des Beaux-Arts, came to his attention, for it suggested that artists elevate individual portrait to type and then pursue their subject's "primitive essence."¹⁵

That sense of primitive essence was, in fact, the basis of Brancusi's first identifiably modern sculpture, *The Kiss* (Fig. 115), completed in 1908 in its original version. Its heavy, blocky forms, massiveness of design, and elementary stylization reflect the primitivist interests of his contemporaries among the French Fauves, German Expressionists, and Picasso. Like so many of his painter friends, Brancusi was influenced directly by the extreme simplifications in form and the erotic candor of African sculpture. Other evidence of the pervasive influence of African forms and archaic

Greek, Cycladic, Iberian, Polynesian and other remote and exotic sculptural examples can be found in the early sculptures of Jacob Epstein (1880–1959) and the painter André Derain (1880–1954), such as those seen here in Figures 116 and 117. Actually, *The Kiss* appeared rather abruptly in Brancusi's development, and after he showed great promise in a Rodinesque manner, complete with soft modeling and the rough-cut stone from which the expressive head emerges in *Sleep* (Fig. 118). A later version of the same subject, *Sleeping Muse* (Fig. 119), forcibly demonstrates the radical result of the meticulous process of formal and technical refinement that his sculpture underwent as Brancusi purified the facial mask and the virtually featureless head into his characteristic primal ovoid mass.

Rejecting Rodin's modeling and naturalism and leaving his post, after a mere few weeks in the spring of 1907, as the older master's studio assistant, Brancusi declared: "What is real is not the external form, but the essence of things. Starting from this truth

Early Modern Sculpture

it is impossible for anyone to express anything essentially real by imitating its exterior surface.¹⁶ It was this revolutionary vision that gave a new visual and tactile reality to modern sculpture and, at the same time, managed to identify the sculptural object with universal elements of spirituality.

In addition to his incomparable purity of form, achieved by simplicity of shape and the use of a single continuous sculptured surface, Brancusi brought to modern sculpture a new respect for the nature of materials, whether carved wood, marble and other stones, or impeccable, polished bronze. His biographer, Ionel Jianou, suggests that Brancusi's "choice of a medium was determined by the content. Marble lends itself to the contemplation of the origins of life, while wood lends itself more easily to the tu-

above: 118. Constantin Brancusi. Sleep. 1906. Marble, 10¼″ long. National Gallery, Bucharest.

right: 119. Constantin Brancusi. Sleeping Muse. 1909–11. Bronze, 105%" long. Musée National d'Art Moderne, Paris.

right: 120.

Constantin Brancusi. Adam and Eve. 1916–21. Oak, chestnut, and limestone; 7'10¼" high. Solomon R. Guggenheim Museum, New York.

> far right: 121. Constantin Brancusi. Bird in Space. 1925. Marble, 4'1¼" high. Kunsthaus, Zurich.

opposite: 122. Constantin Brancusi. The New Born. 1915. Marble, 5%" high. Philadelphia Museum of Art (Louise and Walter Arensberg Collection).

multuous expression of life's contradictions. Brancusi's intimate knowledge of the laws and structures of his materials enabled him to achieve a perfect harmony between form and content."¹⁷ Possibly the mystique of materials may have been exaggerated, in view of the varied versions of such themes as *Mlle Pogany*, which seems an image beyond material considerations, and works as well in stone as in metal. Nonetheless, one senses throughout Brancusi's oeuvre a search for the essence of things, and that search is bound up with inanimate matter. The optical and tactile perfection of his stone and metal contributed to their specific content, whether in the soaring impression of flight in *Bird in Space* (Fig. 121), which became the symbolic abstract work of the early 20th century, or in the myste-

rious presence of the more brutal, direct carving in wood of his extraordinary male-female totem, *Adam and Eve* (Fig. 120).

Brancusi's repertory of shapes conveys poetic and symbolic meanings with the dazzling power of a vision seen in a completely fresh, imaginative manner. Although the sculptor remained attached to such formal prototypes of earliest antiquity as Cycladic sculpture, he also, of course, created forms that influenced the familiar streamlined objects in our culture. Nevertheless, his sculpture comes down to us uncompromised by its degraded imitations, as the very essence of modernity. It is also timeless. A Brancusi sculpture would be equally at home in the presence of archaic Greek sculpture and in a Hindu temple. *The New Born* (Fig. 122) is the

123. Constantin Brancusi. View of the artist's studio with several versions of *The Endless* Column. c. 1918.

essence of his genius, in its summary oval mass and schematic suggestion of the mouth of a howling baby. It symbolizes rather than describes the idea of beginnings.

Contrasting with the perfection and control of his polished metal surfaces, the wood carving of Brancusi recalls the brute force and the libidinal content of African sculptures. Such work also makes allusions to Rumanian folk art, to the repetitive geometrical ornament on peasant houses in the artist's native land, and to the familiar carved screws of wooden farm machines and wine presses, which reappear literally in his notched and grooved sculpture bases. It is interesting to reflect on the dual aspect of his sculpture. Highly rationalized, polished metal forms contrast with the folkloristic and irrational content of the wood carvings; the obsessive theme of the life-force takes form, alternately, as the organic essence of materials refined to the point of pristine absolutism and as a clearly sexual expression allied to tribal faith in potency.

Among Brancusi's major achievements was the remarkable triad of sculptures in the park of Tirgu Jui in the southwest of Rumania: The Endless Column (Fig. 123), The Gate of the Kiss, and The Table of Silence. Rising triumphantly 96 feet in the sky, the immense column is a masterpiece of monumental sculpture that was incomprehensible in its own time. Its repeating, modular units of form forecast a more conceptual role for sculpture that only came to fulfillment, with a comparable formal ambition, in contemporary creations beginning in the late 1960s (Figs. 596-60). One of the most lucid evocations of Brancusi's artistic quality and almost mythic stature in 20th-century sculpture came from Barbara Hepworth, the late English sculptor (Fig. 424), who described a visit to his Paris studio in 1932. Her quietly eloquent appreciation of Brancusi's achievement reminds us that the search for elemental sculptural form and meaning early in the century, notwithstanding a mechanical precision of surface or presumed mystic profundities in content, remained a personal adventure, guided by familiar humanist values:

In Brancusi's studio I encountered the miraculous feeling of eternity mixed with beloved stone and stone dust. It is not easy to describe a vivid experience of this order in a few words—the simplicity and dignity of the artist; the inspiration of the dedicated workshop with great millstones used as bases for classical forms; inches of accumulated dust and chips on the floor; the whole great studio filled with soaring forms and still, quiet forms, all in a state of perfection in purpose and loving execution, whether they were in marble, brass or wood—all this filled me with a sense of humility hitherto unknown to me.

I felt the power of Brancusi's integrated personality and clear approach to his material very strongly. Everything I saw in the studio-workshop itself demonstrated this equilibrium between the works in progress and the finished sculptures round the walls, and also the humanism, which seemed intrinsic in all the forms.... To me, bred in a more northern climate, where the approach to sculpture has appeared fettered by the gravity of monuments to the dead—it was a special revelation to see this work which belonged to the living joy of spontaneous, active, and elemental forms of sculpture.¹⁸

Tradition and Innovation in Architecture: 1880–1914

The last quarter of the 19th century unfolded as an unsettled, contradictory period in architectural history, quite without precedent. Its upheavals were too violent to be merely the normal symptoms of one more transition between established styles. The disappearance of stable values in architectural design had become painfully obvious by the second half of the century despite the efforts of many self-appointed reformers. Even the forceful works of several exceptionally gifted architects failed to re-establish any kind of viable center. As the century progressed, more of the major designers came to occupy maverick positions, gradually detached from a colorless professional mainstream and frequently denied easy access to such sources of work and prestige as government patronage or academic recognition. For all its disorder, however, the period was rich in invention and creative controversy.

No single creative figure or patron presided over the inception of modern architecture as Abbot Suger did over the Gothic or Brunelleschi over the Renaissance. Nor can a single datable event or unique landmark be cited as marking the commencement of the movement that is still struggling through a kind of prolonged adolescence in our own day, even as it seems, in some respects, to have passed its prime. The beginnings of our architecture reach back into the troubled, subversive undercurrents of late 18th-century design and theory (with sources reaching tenuously all the way back to the origins of the Western tradition in the buildings of antiquity), and the gestation process, sporadic rather than continuous, lasted well into the first decade or two of the 20th century. Indeed, the ultimate acculturation of modern design into everyday architecture, extending beyond a small, confined avant-garde to the remotest and most stubbornly recalcitrant corners of the profession, was not achieved until about 1950, a century and a half after the first premonitions of a new movement had appeared. This reluctant, sluggish, tortuous process had no precedent in history, where new styles, while infrequent, usually burst suddenly into the light of day.

The Sources of Modern Architecture in Academic Style and Advanced Technology

During the 19th century, despite internal crises that heralded gradual diminution if not outright collapse, the academic-classic mode produced numerous pertinent public monuments, and even occasional outstanding ones, such as Joseph Poelaert's Palace of Justice in Brussels and the Paris Opéra by Charles Garnier (1825–98; Fig. 124).Matching the exuberance of 19th-century academic monumentality, whose excesses have been regularly censured, if sometimes secretly envied, by modernist theory, was the freshness and probity of the best Neo-Gothic work, whether civic, ecclesiastical, or residential. The work of William Butterfield (1814–

124. Charles Garnier. Grand Staircase, L'Opéra, Paris. 1861–74.

1900), an almost exact contemporary of the loquacious, influential critic John Ruskin, deserves mention for both its scholarship and its originality (Fig. 125). Even more surprising, when viewed from a purist, historically autonomous 20th-century aesthetic, is the candor and relevance of many eclectic, or even bastard, designs of the era, such as Milan's Galleria Vittorio Emmanuele II by Giuseppe Mengoni (1829–77), whose theoretically incompatible components of traditionally massive masonry walls surmounted by a

above: 126. Giuseppe Mengoni. Galleria Vittorio Emmanuele II, Milan. Interior. 1864–67.below: 127. Gustave Eiffel. Eiffel Tower, Paris. 1889

below: 125. William Butterfield. All Saints, Margaret Street, London. Exterior detail. 1859.

light iron and glass barrel vault turn out to be a startling yet convincing design system (Fig. 126).

New scientific discoveries and their applications in technology, together with unprecedented growths of population and venture capital, changed the mode and scale of architectural operations a century ago. However, many of the structural forms provoked by application of new techniques were devoid of economic potential. The steel frame, while making possible the development of fireproof skeleton construction and hence the skyscraper, a typically speculative and profitable office building, was specifically celebrated in the singular tower designed by Gustave Eiffel (1832–1923) for the Paris International Exposition of 1889 (Fig. 127). It was a symbolic monument to technology, expressive of the limits, or frontiers, of the art at that time, but also one that served no contemporary practical function. Ironically, modern technology found superior expression here more than in works of more obviously utilitarian purpose.

Of course, the *form* of Eiffel's 984-foot tower is not conventionally monumental. Rather, its exposed skeletal frame is virtually transparent, its "interior" open to the exterior. The importance of the structure lay in its uniqueness, one key aspect of its modernity. Unlike the first Doric temple or the first Gothic church, the Eiffel Tower had no direct formal progeny. Special to our contemporary tradition is the fact that many of our masterpieces have been hybrids frequently incapable of reproduction. Modern design would, from its very nature, seek to become an antitradition, since whatever is repeatable seems destined to become banal. And yet, if the Eiffel Tower is neither typical nor seminal of our architecture, it nonetheless remains one of the most revealing landmarks of the period, representing in a bold, even outrageous, way powers of extension in height and transformation in substance that had no antecedent.

Eiffel's metamorphosis of pure engineering into the most symbolic of architectural monuments, a performance that would continue to excite the admiration of artists and modernist criticsparticularly the Orphist Robert Delaunay (Fig. 250)—should not lead us to overemphasize the role of technology as a shaper of the new architectural language. Eiffel, one of the great engineers of the golden age of bridge construction, was not truly a pioneer in the use of metal structures in bridges—a tradition that goes back to the 18th century. Moreover, all late-19th-century exhibition structures were in one way or another the progeny of Joseph Paxton's epochal London Crystal Palace (1850–51), where glass and iron were employed on a colossal scale for the first time. Nor did Eiffel's work apply directly to the articulate, expressive use of iron or steel in ordinary architectural design.

Two architects among many in mid-19th-century France, Henri Labrouste (1801-75) and Eugène Viollet-le-Duc (1814-79), had previously addressed the problem thoughtfully, and with notably personal results, both seeking to use iron in the context of historically proven yet contemporary styles. Labrouste had received a conventional academic education, culminating in its ultimate reward, the Prix de Rome, which entitled him to a five-year sojourn at the Villa Medici, the French school in Rome. Violletle-Duc developed as a maverick who eschewed that same academic education. He was partly self-taught and partly tutored by his uncle. Moreover, at a time when it had become grossly unfashionable, he took up the cause of medieval architecture, championing the preservation, often through drastic renovation and restoration, of the Romanesque abbeys and Gothic cathedrals of France. Both architects were thorough historians, partisan to particular styles, although it was only Viollet-le-Duc whose fame rested upon his profuse architectural writings. Labrouste's renown is based upon a handful of buildings, two of which made use of cast iron in the vaulting of large spaces. In the later of the two, the reading room of the Bibliothèque Nationale in Paris (Fig. 128), Labrouste adapted the Roman, or Byzantine, dome with oculi to a repetitive cellular system, drastically slenderizing the columnar supports to accord with the structural advantages of metal. The details are a mixture of old and new, of modified and attenuated classical shafts

128. Henri Labrouste. Reading Room, Bibliothèque Nationale, Paris. 1862–68.

left: 129. Eugène Viollet-le-Duc. Project for a Concert Hall. 1864.

left below: 130. Anatole de Baudot. Church of St. Jean-de-Montmartre, Paris. Interior. 1894–1902.

in conjunction with open-trussed arches. Classical elements here frame a modern, open space.

Viollet-le-Duc's unbuilt project for a Concert Hall (Fig. 129), published in his principal theoretical work on the problems of contemporary architecture, is disconcerting in its application of iron technology to an historical prototype, one that on the surface is infinitely less coherent than Labrouste's essay in the telescoping of past and present. The architect was a firm rationalist who believed that the forms of art were brought about only by a severe, logical study of the nature of a specific problem, and his work was more radical in its departure from precedent. What especially interested Viollet-le-Duc were the principles of structure that he deduced from a study of Gothic piers, vaults, and buttresses, and his published drawings and diagrams of these historic monuments possess a dissecting-room severity that is surely related to the diagrammatic and argumentative nature of his work. The form of his Concert Hall is that of a rotunda covered by a multicelled polygonal dome of variously profiled metal ribs, the linear contours carried down in a consistently tortured way to the masonry walls and foundations by a system of thin vertical and diagonal iron columns. From these tentative beginnings, Anatole de Baudot (1834-1915), a pupil of both Labrouste and Viollet-le-Duc, pioneered in the development of ribbed, reinforced concrete construction in 1894-1902 at St. Jean-de-Montmartre (Fig. 130), a Paris church whose cross-ribbed vaults manifest a passing similarity to those of Viollet-le-Duc's Concert Hall but abandon any suggestion of Gothic articulation, except for the retention of variously pointed arches and ribs. Here, as was so often the case in the 1880s and 1890s, modern design appeared, subversively by negation, by a process of erasure.

Proto-Modern Architecture

The stripping down of traditional forms, with a concomitant blurring of historical references until the result seems starkly original, is revealed in the works of several architects of the late 19th and early 20th centuries, all of whom worked independently in different centers, largely unaware-at least at first-of the accomplishments of the others. Among these are the Viennese academician Otto Wagner; the American Henry Hobson Richardson, trained at the École des Beaux-Arts in Paris, but whose work was deeply influenced by Romanesque prototypes; the English house builder Charles F.A. Voysey; and Hendrikus Petrus Berlage, a Dutch architect of medieval proclitivities. To this group of transitional figures, roughly contemporary with Rodin and the Post-Impressionist painters, may be added Louis Sullivan, the Chicago-based prophet of organic architecture and a key figure in the development of the tall building, and the Catalan, Antoni Gaudí, whose fantastic forms look back to the ideas of the English critic John Ruskin and the structuralism of Viollet-le-Duc, but whose expressive extravagance appealed much later to a Spanish compatriot, the Surrealist Dali (Figs. 312, 313), a proponent of the "paranoiac-critical" method of pictorial invention.

A school or historical group cannot be formulated from so diverse a body of designers, but, nonetheless, a common reductive approach becomes apparent in the way they developed solutions to programs of great functional and cultural diversity. All produced exceptionally individual styles reflective of the values and traditions of their native climes, and yet the works of all can, in one way or another, be cited as premontions, if not as outright models, of 20th-century architecture. To a man they were, at least in their ma-

ture designs, developing away from the articulated, richly sculpted and colored designs of the mid-19th century, whether classic, medieval, or more exotic in allegiance. In certain instances, their works proved comparable to the Romantic and revolutionary designs of the late 18th century, such as those by Claude-Nicolas Ledoux (1736-1806) and Étienne-Louis Boullée (1726-99), whose clear geometric forms broke so emphatically with the extravagant practices and platitudes of the Late Baroque. Moreover, many of the ideals of such mid-Victorian radicals, reformers, writers, and designers as William Morris, Philip Webb, and even Viollet-le-Duc came to the surface in their works. The sources of this architectural transition, on the eve of the 20th century, thus reached into successive, and often subterranean, phases of protomodernism for ideas and support. Late-19th-century architects were increasingly concerned with the employment of contemporary building technology as a means of gaining a degree of freedom from a dogmatic reliance upon past styles, but none made his art subservient to applied science. Richardson and Voysey are exceptions to this pattern, being more conservative in construction methodology, but, by way of compensation, each made a distinctive virtue of traditional craft and material in his work.

Henry Hobson Richardson (1838-86), the most conservative "innovator" of this generation, was educated in Paris in an atelier directed by Théodore Labrouste, brother of the architect of the Bibliothèque Nationale reading room. Richardson's work suggests that he was not overly interested in Labrouste's essays in iron, even less in Viollet-le-Duc's projects and contentious rationalist theories. On the other hand, he was no more inclined to perpetuate the formal classical style of the École des Beaux-Arts or its newly fashionable embellishment as seen in the Opéra. In an eclectic age, he emerged as an individualist who kept his own counsel and who gave his name to a style that he popularized: Richardsonian Romanesque. His work was not outwardly that of a radical, except at the very end, and in his own lifetime he was without doubt the most admired architect at work in the United States. Although neither a progressive thinker nor a radical innovator, Richardson produced buildings, especially in the late part of his career, that were candidly original, works that moved beyond the orbit of their historical sources. He remained a paradoxical, independent artist of great influence, superficially upon the architecture of his own day, profoundly upon that of the next generation.

above: 131. Henry Hobson Richardson. Marshall Field Wholesale Warehouse, Chicago 1885–87 (demolished 1930). below: 132. Otto Wagner. Post Office Savings Bank, Vienna. Interior court. 1905.

In his earliest works Richardson normally revealed Romanesque sources and tended to emphasize decorative clusters of great strength. Stylistically, however, he evolved toward a simple expression of the overall mass, often dispensing with ornament, employing throughout powerful, rusticated masonry, with window and door openings terminating in vast round arches, a magnification of a basic Romanesque, but also a Roman, theme. In domestic work, he replaced this assertive stone rustication, actually more characteristic of ancient Roman engineering than of medieval Romanesque churches, with wood shingles, half-timbering, and related materials (borrowed from late medieval England)-a use of natural surfaces that would be passed on into the 20th century through the organic architecture of Frank Lloyd Wright and, more traditionally, in the Romantic, regional architecture of Bernard Maybeck, another American trained in Paris, and others on the West Coast. In the Marshall Field Wholesale Warehouse (Fig. 131) Richardson realized his greatest achievement, although he died at the age of forty-eight before the building could be completed. An early and important instance of stylistic abnegation on the part of a modern architect, the Marshall Field Wholesale Warehouse came forth as a patient distillation of diverse elements into a clear, ordered solution.

If Richardson's major work, which was also his last, was accomplished in early middle age, the precise opposite was true of his European contemporary, Otto Wagner (1841–1918), who did not design his most influential structures, all portents of the future, until after 1900, when the he was in his sixties. In the world of official Austrian architecture, Wagner played an exploratory, innovative role as artist and pedagogue similar to that performed by Labrouste in Paris a half-century earlier. But this occurred with an important difference, for whereas Labrouste's followers tended to fritter away their opportunities in petty, if occasionally clever, ways, Wagner's pupils and admirers had incalculable impact upon subsequent architecture. The most famous work designed by Wagner was the glass-vaulted Post Office Savings Bank in Vienna (Fig. 132), a stylistically neutral hall, exquisitely detailed with inverse-

tapering steel piers, their rivets visible, intersecting the unusual curve of the vault. This interior would seem to have been a refined miniature study of the vast train sheds or exhibition structures, such as the Machinery Hall (Fig. 133), built as the companion of the Eiffel Tower at the Paris International Exposition of 1889. Here the proportions, details, and structural expression had been treated with all the care that might have been accorded a Doric colonnade or a Gothic vault.

Wagner's eclecticism in its modernist cloak is best seen in the domed Church of St. Leopold (Fig. 134), constructed on the grounds of the Steinhof Asylum outside Vienna in 1905–07. The chic decoration of this structure is consistent with Art Nouveau, or Secession, as it was known in Vienna, after the name of a new society of artists opposed to the academy (see pp. 59, 60). While neoclassical in its fundamentals, the church contains innovations in proportion and decoration that are convincing even if mannered and ironic.

Among the many disciples of Wagner, the most loyal seems to have been Joseph Maria Olbrich (1867–1908), whose Secession Gallery of 1898–99 actually predated most of his mentor's more modern buildings and projects (Fig. 135). A domed and pyloned rectangular block, the Secession Gallery was more forthright in its presentation of a new stripped-bare aesthetic in a traditional format than anything by Wagner at that time. Here we have a remarkable instance in which the student's adventurousness did much to liberate the master from the literalism of his earlier manner. Significantly, Wright manifested an interest in Olbrich's work at an early date, on the basis of photographs reproduced in international magazines of the period.

At the same time, the Amsterdam architect Hendrikus Petrus Berlage (1856–1924), fifteen years Wagner's junior, was working his way out of a neomedieval, rather than an academic-classic, tradition. Berlage was as characteristically Dutch in his plain brick surfaces as Wagner was Viennese in his more gracefully severe façades, yet his work matched Wagner's in its evolutionary modernism. Moreover, the Stock Exchange (Fig. 136), designed by Berlage in 1898–1903, predated Wagner's more advanced works. In the Stock Exchange, the architect transformed an ornate, turreted, local neo-Renaissance style into a calmer, less agitatedly picturesque mass through a direct expression of brick surfaces punctuated by stone-framed windows and entries. The achievement here, and in **left: 133.** Victor Contamin and Ferdinand Dutert. Machinery Hall, International Exposition, Paris. Interior. 1889.

below: 134. Otto Wagner. Church of St. Leopold, Steinhof Asylum, outside Vienna. 1905–07.

other contemporary buildings, lay in simplifying to the point of abstraction and autonomy the fashionable, relevant local style of the day. Berlage had a long career marked by his absorption in many of the new trends of later design. He was one of the first European architects to become interested in the work of Frank Lloyd Wright, and, in addition to inspiring a number of younger Dutch architects, he played an important role in the development of Ludwig Mies van der Rohe, according to the latter's own testimony.

The English architect Charles F.A. Voysey (1851–1941) was also inspired by local historical traditions, in this case the vernacular late- and post-medieval cottages and small manor houses of rural England, whereas Berlage had been moved by the more urban and urbane vernacular of the Netherlands. However, this particularization of early modernism on regional bases does not obscure the similarity of the reductive design methods used in the architecture; rather, it reveals a growing consensus of taste, if not style,

Tradition and Innovation in Architecture: 1880–1914

above: 135. Joseph Maria Olbrich. Secession Gallery, Vienna. 1898–99.

right: 136. Hendrikus Petrus Berlage. Stock Exchange, Amsterdam. Interior. 1898–1903.

above: 137. Charles F.A. Voysey. The Orchard, Chorley Wood, Hertfordsire. 1900. **below: 138.** Charles Rennie Mackintosh. Library, School of Art, Glasgow. 1907–09.

as the century moved to a close. The Orchard, Chorley Wood, Hertfordshire (Fig. 137), a house Voysey designed for his own use, offers a concise example of the architect's neotraditional approach. Because of its distinctively pale, monochromatic surfaces and blunt, rectangular windows, one is tempted to cite the style as a specific predecessor of the autonomous International Style of the 1920s and 1930s, but Voysey later disclaimed any intent at radical innovation. In principle, his art exemplified those ideals of William Morris that sought to restore the importance of the craftsman's role in art.

If Voysey was a special instance of a solitary regional architect whose work, by its very precision and simplicity, seems a relevant, if somewhat accidental, predecessor to modernist design, Charles Rennie Mackintosh (1868-1928), a younger contemporary, designed in a more forthrightly innovative mode, but a mode also based upon a late medieval, regional vernacular. Moreover, he exercised a considerable influence in such centers as Darmstadt and Vienna, where he participated in the annual exhibition of the Secession in 1900. Mackintosh's magnum opus was the Glasgow School of Art (Fig. 138), begun in 1898 in a starkly simplified neomedieval style, only to be completed a decade later with a library wing that became the architect's most autonomous conception, full of mannered manipulations of solid and void, surface and mass, all of which paralleled and equaled the contemporary innovations of Frank Lloyd Wright. The exterior wall treatment and interior lighting transcended specific historical association, and while remaining faithful to the Morris Arts and Crafts tradition, it also represented a rare instance of autonomous design prior to 1914.

The protomodernism of Mackintosh, whose subsequent career languished for the want of suitable commissions, was matched and surpassed in invention and fantasy, in a combination of sophistication and innocence, by the much more autochthonous architecture of Antoni Gaudí, a Barcelona figure of legendary renown. With the exception of Frank Lloyd Wright, no other architect active in these years proved so fertile an inventor, and none managed to liberate himself from the past so gracefully as did Gaudí. More-

over, the streak of fantasy—of expression and imagination freed of rational and traditional constraints—that forms so important a part of our contemporary tradition appeared for the first time in his varied and numerous works.

Gaudí's masterpiece is the cathedral-scaled votive Church of the Sagrada Familia in Barcelona (Fig. 139), on which the architect labored throughout his life and which remained, at his death, a minor fragment of the projected design. Gaudí, having worked on the restoration of medieval churches, inherited a literal Neo-Gothic design for the Sagrada Familia in 1884, and only gradually did he emancipate his imagination, creating, in the process, rich naturalistic decorative motifs, colorful ceramic ornaments applied to sinuous, twisting sculptural forms, and figurative sculpture, the latter occasionally based upon plastic casts of the actual living model. The Sagrada Familia, with its seemingly bizarre transformations of pointed arches and multiple spires, is certainly the most unaccountable work of lyrical imagination in all of 19th-century architecture, but in no way does it provide a characteristic symbol of the new age immortalized by the Eiffel Tower. Nevertheless, taken together, these two diverse monuments-sites of pilgrimage and objects of veneration for totally divergent purposes-suggest the extraordinary conflicts of technique and goal that have remained characteristic of our architecture.

The domestic work produced by Gaudí, notably the Casa Milá (Fig. 140), indicates other issues flowing from this master's always startling inventions. The rippling horizons of curved forms that dominate the masonry bulk, the cast-iron balcony rails, and the fantastic roofscape of wavelike crests and coniferous turrets-all seem to reflect the Art Nouveau style. However, Art Nouveau is much too restricted a term to circumscribe the coruscating variety of Gaudí's art and the ironic consistency of its evolution. Art Nouveau was a fashion of momentary impact, if long-term influence, that flourished in the 1890s, constituting for the most part a transitory phase in the careers of several architects from widely different backgrounds, some of whose lasting importance would have been negligible without their participation in that agitated movement. Not so Gaudí, whose futuristic anachronisms were more profound, isolated from the whims of fashion. Alas, unlike Wright, an equal in autonomous formal innovation, Gaudí, with his impressive constructive vocabulary, exercised almost no immediate, and little subsequent, influence on mainstream developments, although the work was admired by Le Corbusier as early as 1930.

The squandering of Gaudí's potential influence, owing partly to his isolation within the local, separatist avant-garde of Barce**139.** Antoni Gaudí. Church of the Sagrada Familia, Barcelona. 1883–1926.

140. Antoni Gaudí. Street elevation, Casa Milá Apartment House, Barcelona. 1905–07.

Tradition and Innovation in Architecture: 1880–1914

lona, was matched in the United States by the more frequently lamented waste of the special gifts of Louis Sullivan (1856-1924), a complicated, original mind, a courageously independent designer whose many-faceted importance, as well as shortcomings, is still difficult to assess today, some sixty years after his death. Sullivan's work can best be considered in the overall context of the World's Columbian Exposition held in Chicago in 1893 to commemorate, a year late, the four-hundredth anniversary of the discovery of America. The sedate, generously scaled academic classicism adopted for the fair, more reserved and "correct" than that concurrently fashionable in Paris, was an anxiety-ridden rejection of indigenous progressive trends by a culture that had already developed its own distinctive, modern architecture. It represented a craven turning to the past that eliminated adventurous risk in favor of certainty of taste. Sullivan's work at the Columbian Exposition, the Transportation Building (Fig. 141), can in no way be seen as a design expressing the speed, noise, and excitement of modern travel. Rather, it was traditional, but not conventionally academic, in a way that paralleled Gaudí's drastic adaptation of Gothic forms. Sullivan took as his source the massively exaggerated round arch of Richardson (Fig. 131) and transformed it through decorative elaboration (aided by the young Frank Lloyd Wright) into something virtually unrecognizable, a reconstituted Byzantine fantasy that, while elegant to our eyes today, must have seemed coarse and overstated in contrast to the sober, tasteful classicism all about.

Sullivan is customarily remembered for two somewhat distinct contributions: his writings, in which an organic theory of architecture, based largely upon a biological analogy, is developed, including the universally abused epithet "form follows function"; and an original, personal system of ornament that, when applied to the steel-framed skyscraper, then just barely out of its infancy as a building type, seemed to give special promise for the development of a distinctly integrated constructive and decorative system. Unfortunately, after a decade of notable achievement, Sullivan's career, and ultimately his personal life, suffered a series of irreparable reverses, and for the last quarter-century of his existence, the architect declined into a curious provinciality that, while it is of great biographical significance, produced no work that had any major influence.

Early in his career Sullivan had worked in Philadelphia for an intransigent Neo-Goth, Frank Furness. Subsequently, he spent a brief period in Paris sampling the teaching of the École des Beaux-Arts. Then, on returning, he went to Chicago, and there worked for William Le Baron Jenney, who is credited with the first use of modern skyscraper construction—that is, a load-bearing, skeletal steel frame sheathed with a fireproof masonry cladding, this cage finally enclosed by a nonsupporting curtain wall that permitted exceptionally large windows.

Tall buildings had already appeared in New York and elsewhere in the 1870s-made possible by the elevator-but it remained for Chicago architects to develop a consistent steel frame. At first, architects decorated such buildings indifferently, mostly with reference to historical motifs that were as likely as not to be both ineffectual and inappropriate. In his early commercial work of the 1880s, designed in partnership with Dankmar Adler, an astute businessman well versed in the art of building, Sullivan had manifested no special stylistic affiliation until he fell under the spell of Richardson's stark Marshall Field design. The exterior shell of Sullivan's Auditorium Building (1886-89) is the most conspicuous result. Like the successive designs for Berlage's Amsterdam Stock Exchange (Fig. 136), Sullivan's preliminary studies for the Auditorium Building reveal a process of simplification and stripping away of agitated excrescences. The interior of the Auditorium featured a decorative tour de force in its proscenium arch, which

141. Louis Sullivan. Transportation Building (Golden Portal), World's Columbian Exposition, Chicago. 1893 (demolished).

paved the way for the similarly orchestrated ensemble on the 1893 Transportation Building (Fig. 141). But it was not until 1890, and the design of the Wainwright Building in St. Louis that Sullivan addressed, head-on, the problem of establishing a suitably original outline and decorative system for a massive, steel-skeleton commercial building. The problem was altogether different in scale, material, and technological sophistication from the earlier cast-ironfronted commercial buildings that had proliferated in American cities since the middle of the 19th century. This earlier type had been limited in height to about five floors, and ultimately proved to be a fire hazard, since the metal parts were not protected by heatresistant materials.

Skyscraper construction did not evolve directly from this metal-frame type, but resulted from a rethinking of the problem. Moreover, the matter of finding a logically appropriate style for these taller buildings proved especially elusive, since a certain kind of superficial logic suggested that if a steel frame was to support a masonry skin framing windows, the architect would be at liberty to exercise his imagination, calling upon history or upon his own taste. Sullivan chose to restate the entire question in the Wainwright Building, by dividing the building block into three vertical components: a street-level podium, different from the rest because of its function of providing entrances and display windows; a shaft of many floors, basically and appropriately vertical in emphasis while relatively uniform in component parts; and a cornice level that was markedly horizontal, terminating the rising form of the shaft. Sullivan went on to use the logic of this tripartite composition in subsequent buildings, and Midwestern architects employed the formula time and again, ultimately in buildings of tiresome mediocrity.

Later in the decade Sullivan invented still another design type—the large-scale, urban commercial building—when he prepared the Carson, Pirie, Scott Store in Chicago, begun in 1899 and subsequently added to by other architects who followed his simple modular scheme. Here he based the formula upon the proportion of the steel frame, which established the shape of the window. Thus arose the concept that the building could be extended in breadth and in height at the pleasure of the client at whatever future time expansion might be required. The design became Sullivan's most advanced concept. With some exaggeration, it has been cited as a prototype of the glass curtain wall introduced by Dutch, German, and French masters of the International Style of the 1920s. However, it was also the last large commercial structure in Chicago designed by Sullivan, since he gradually became isolated from the profession and from prospective clients. Albeit modest in size, the few commissions he executed in the second half of his career, a series of small banks in Midwestern farm communities, are nonetheless the gemlike designs of a pariah, one of the rare outcasts in the history of architecture, which thus renders him the social and artistic equal of such alienated Post-Impressionist or Symbolist painters as Gauguin, Moreau, or even Cézanne. Yet these late designs by Sullivan had only a minimal influence upon subsequent buildings, although they have found passionate admirers in the past quarter-century. Of greater consequence to succeeding generations were his writings, Kindergarten Chats and The Autobiography of an Idea.

The organic theory evolved by Sullivan seems to resist application to architecture in the fundamentally urban form of art produced throughout much of the 20th century. His sensuous, original, freshly studied decorative motifs represent a reform of various 19thcentury efforts in this direction; but, in a period like ours, where decoration in architecture has been not a matter of applied ornament but of the studied rhythmic modulation of surface-masses and voids-Sullivan's accomplishment seems irrelevant if admirable. His later buildings are simple cubes, normally of brick, vehicles for dense patches of inspired ornament applied to the plane surfaces with which they contrast. If the urban commercial buildings of his first maturity were the most radical and progressive to appear before 1900, the modest-sized works built after that date were stylistically equivalent to the more up-to-date designs of Otto Wagner (Fig. 134), despite their distinctly original, autographic quality. In his isolation Sullivan followed a pattern of conservatism, if not of actual reaction, in accord with the major direction of American architecture in the wake of the Columbian Exposition, a trend counter to Continental architecture at the time.

The Resurgent Beaux-Arts Tradition

Charles F. McKim (1847-1909), an assistant of Richardson's in the 1870s and a partner in the influential, prolific firm of McKim, Mead and White, could not offer a greater contrast to his contemporary, the mercurial, impulsive Sullivan. Nonetheless, McKim towers above all but one or two French academic architects of the day, and his work is readily comparable in quality to that of Berlage or Wagner, although it remains laconic, tightly disciplined, and untouched by the slightest trace of permissive departure from historical prototype in style or ornament, or even the faintest licentiousness in the selection of any but the most orthodox prototypes. If McKim's architecture seems a paradigm of reaction, it should nonetheless be pointed out that his works, notably his masterpiece, Pennsylvania Station in New York City (Fig. 142), have (or had, since the great Pennsylvania Station of 1906-10 fell under the wrecking ball in 1963) a quality of simplified abstraction that is not unrelated to the more modernist works of the time, even those of so inventive a designer as Wright, and this pared-down quality was at odds with the more ornament-charged symmetries of his Beaux-Arts contemporaries at home and abroad. Moreover, the Roman interiors of Pennsylvania Station found a machine-age counterpart in the exposed iron and glass concourse leading to the platforms. McKim may remain an anachronistic figure whose work evokes the ghosts of Ledoux and Labrouste (Fig. 128), but the presence of so skilled a designer in a traditional mode, which refuses to relinquish its position in the face of innovation, indicates the inertial strength of these counterforces in modern architecture. It helps explain the isolation of Sullivan and, subsequently, of othersWright, Le Corbusier, and Louis Kahn—even though all of the architects were, in one way or another, influenced by academic design methods.

Art Nouveau in Architecture

In contrast to Sullivan's fate, the success of Art Nouveau, as an avant-garde expression that found favor with a considerable segment of the public, is instructive. It is tempting to relegate this sprightly movement—headed in architecture by Victor Horta, Henry van de Velde, and Hector Guimard, and drawing into its orbit architects as individual and removed as Gaudí, Sullivan, Mackintosh, those of the Viennese Secession, and Peter Behrens-to the realm of operetta and music hall. While subsequent vanguard movements in modern architecture would usually begin with archaizing, primitivistic, or reductive attitudes toward form, Art Nouveau, taking its cue from contemporary eclecticism, started from a ripe, cosmopolitan base. Compounding the situation was the sheer fashionableness of the decadent in art and literature (see Chap. 4). Thus, the attenuated mannerism of Art Nouveau architecture could be seen as effete transformations of academic eclecticism, tinged with wit and irony, rather than as bold innovation. Interestingly, certain young painters and architects destined for future fame seem to have deliberately resisted or rejected the wiles of Art Nouveau during its heyday in the 1890s. Matisse and most of the Fauves provide a case in point (see Chap. 7). Among the younger architects, Auguste Perret, Tony Garnier, and Adolph Loos remained aloof or were outrightly hostile, and when Le Corbusier arrived in Paris as a wandering student in 1907, he found Art Nouveau to be ludicrous.

However, such rapid, ruthless rejection after a scant decade of *succès fou* did not prevent the completion of a number of important structures in this style, chiefly in Brussels, Paris, and Nancy. In architecture, Art Nouveau was an explicit fusion of rational principles of structural expression to a fresh appreciation of natural forms as themes for ornamental motifs (Fig. 70), an attitude similar in its components to Sullivan's organic theory, although for-

142. McKim, Mead and White. Pennsylvania Station, New York. Original track level and exit concourses. 1906–10 (demolished 1963).

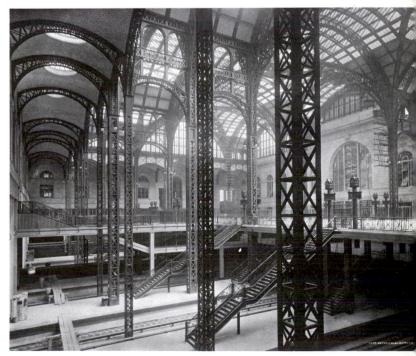

Tradition and Innovation in Architecture: 1880–1914

mulated independently and in a less sonorous language. These ideals were enunciated by Guimard, but they would seem to apply also to the work of Victor Horta (1861–1947), which enjoyed a priority in time. His Tassel House in Brussels, a work of 1892-93, was one of the rare exclamation marks in modern architecture (Fig. 143). The sources of its indolently sinuous iron members, expressively articulated to the masonry, have taxed many commentators. Certainly Viollet-le-Duc's style of combining metal and stone provided a conceptual base (Fig. 129). Beyond this, one must look to possible influences from painting, then as now the more exploratory of the visual arts (Figs. 71, 75, 82, 84), and finally to Horta's own personal growth in the immediately preceding years, a period in which he seems to have deliberately withdrawn from creative work, and in which Brussels was an important center for exhibitions of art by Rodin, Renoir, Seurat, Cézanne, and van Gogh, as well as by William Morris.

Horta's masterpiece was the now-destroyed Maison du Peuple in Brussels (Fig. 144), an 1897–99 building whose façade curved in a serpentine fashion to accommodate the exigencies of an irregular site. On the exterior the architect articulated a mixture of exposed metal, masonry, and glass in a clear and forceful manner. However, his particular mix of metal frame and masonry was a far cry from that of the architects in Chicago, where, because of past experience and new regulations, structural iron or steel could not be exposed. On the interior of the Maison du Peuple, Horta created a ground-floor space roofed with metal trusses in the then outdated manner of Viollet-le-Duc, but, in the auditorium above, he designed an original space dominated by supports inclined inward from the vertical, which were smoothly joined to the crosspieces to produce an organic, expressive structural effect, one of Art Nouveau's most lyrical interiors.

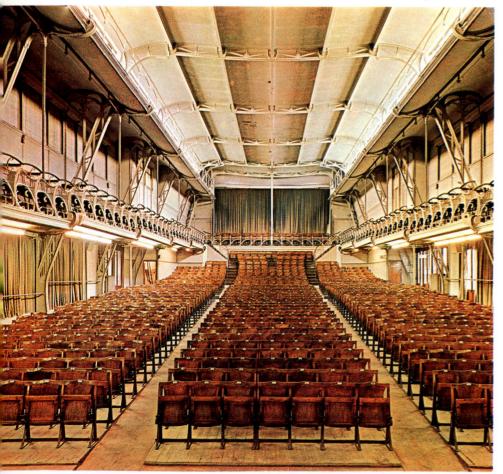

The phenomenon of a close, but not yet completely realized, conjunction of art and technology also appeared in the works of Hector Guimard (1867-1942), a Parisian architect whose earliest projects also revealed an interest in the stridently awkward proposals made by Viollet-le-Duc for the use of iron. But shortly thereafter Guimard, in part probably under the influence of Horta, graduated to the sinuously fluent Art Nouveau line in his ornament and ultimately in his building masses. Known primarily as the designer of chic, luxurious villas and apartments, Guimard designed one large public building, the short-lived Humbert de Romans Concert Hall, a work of 1897-1901, but demolished in 1905, and the famous entrance to the Paris Métro, the first line of which opened in 1900 (Fig. 145). The largest of the entrances were ornamental cast-iron and glass miniatures that have now vanished, with only the balustrades and lamp posts of the lesser stations now remaining. The Metro structures proved to be the most extraordinary bits

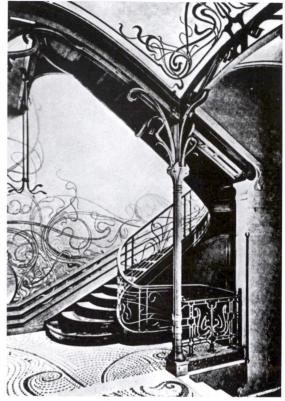

above: 143. Victor Horta. Staircase, Tassel House, Brussels. 1892–93.

left: 144. Victor Horta. Auditorium, Maison du Peuple, Brussels. 1897–99. of architecture ever to grace the squares and boulevards of modern Paris, which had been extended and planted by Haussmann in the 1860s and subsequently celebrated in the Impressionist paintings of Renoir, Monet, and Pissarro (Fig. 17). At odds with the rather uniform, nondescript academicism of the standard street façade of the city, Guimard's expressive, artfully composed cast-metal abstractions of natural forms were intended to mediate between the restful calm of nature and the bustle of modern urban life.

Architecture's First Modernists

The delicate balance of opposites contained in Art Nouveau could not be sustained for long; it was too much of a juggling act. In Paris, the waning of the style became evident with the emergence just after 1900 of two architects, Auguste Perret (1874-1954) and Tony Garnier, both closely associated with, although not inhibited by, the academic tradition from which most Art Nouveau designers had largely disassociated themselves. Perret, who came from a family of builders, is best known as a pioneer in the development of the reinforced-concrete frame method of construction. However, except for a passing and inconclusive reference to Art Nouveau in his earliest work, a block of flats in Paris's Rue Franklin (Fig. 146), he is equally significant for his efforts to relate the advantages of a new technology to the inherited wealth of the academic-classic repertory, especially the latter's concern for regulated proportions, its preference for symmetrical layouts, and its use of details and combinations adapted from the Greco-Roman tradition.

Perret's Rue Franklin apartments show him in the process of working out his synthesis of concrete construction, contemporary taste, and classical heritage. The subsequent Champs-Élysées Theater (a 1911–14 work the design of which had originally been given to Henry van de Velde) is indicative of his early mature style: formal, stately, and a bit stiff. It was destined to be a major formative influence upon the widespread Art Deco fashion of the 1920s, and its scraped-down classicism gave yet one more boost to a stubborn, if momentarily doomed, academicism. His best works, inventive and clearly expressive of function and technique, are the Church of Notre-Dame at Le Raincy (Fig. 147) and the Esders Factory in Paris (1919). In each the architect achieved a precarious balance between tradition and innovation. By this date, however, the vanguard edge of new architecture was moving away from the personal mode developed by Perret, and, while preserving for a

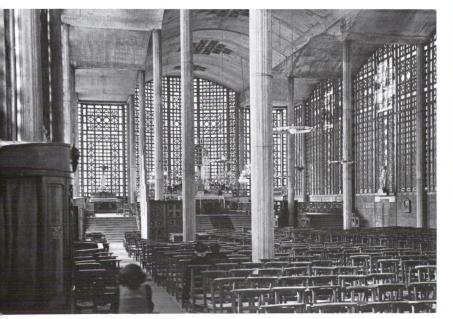

top: 145. Hector Guimard. Métro entrance, Paris. 1898–1901.

above: 146. Auguste Perret. Apartment House, Rue Franklin, Paris. 1902–03.

left: 147. Auguste Perret. Church of Notre-Dame, Le Raincy, France. Interior. 1922–23.

Tradition and Innovation in Architecture: 1880–1914

above left: 148. Tony Garnier. Project for an Industrial City: Residential District. 1901–04. above right: 149. Eugène Freyssinet. Airship hangars, Orly. 1916 (demolished 1944).

right: 150. Peter Behrens. AEG Turbine Factory, Berlin. 1908–09. below: 151. Peter Behrens. Entrance hall, Administration Building, I.G. Farben, Hoechst, Frankfurt. 1923–24.

time the role of patriarch among the avant-garde, particularly in France, Perret was grudgingly and half-heartedly co-opted by a beleaguered academic establishment. In 1945, after the Liberation of France, Perret was assigned the task of rebuilding the war-obliterated heart of Le Havre, where, in addition to a core of commercial and residential buildings around a central, sunken square, he furnished the design for the Church of St. Joseph, a square central plan surmounted by a lantern inspired by the form of a lighthouse, a surprising variant on a dome or cupola, albeit one quite appropriate for a major seaport.

Perret's contemporary, Tony Garnier (1869-1948), was a more typical product of the École des Beaux-Arts. Attaining the Prix de Rome in 1899 after several tries, he had already conceived the idea of designing a modern industrial city the previous year. Garnier spent his years at the Villa Medici working on this project, much to the distress of his teachers, and, concurrently, challenged the relevance of studying antiquity. Upon his return to France in 1905 he was appointed architect to the city of Lyons, where, by the time his projects for an Industrial City had been published in 1917 (Fig. 148), he was already building a hospital, a slaughter house, and a stadium for the municipality-designs in which a Beaux Arts fondness for order and grandiloquence were wedded to a contemporary concern for constructive clarity and efficiently simple forms. In the houses he built at this time Garnier anticipated the Purism of Le Corbusier, and some of the domestic schemes he prepared for his Industrial City appeared in Vers Une Architecture in 1923.

At the time, however, the most spectacular achievement in the use of the new concrete technology for vaulting came from an engineer, Eugène Freyssinet (1879–1962). His 1916 parabolic arched hangars at Orly (Fig. 149) may coincidentally evoke the similar profile of the 3rd-century A.D. brick-vaulted audience hall at Ctesiphon, built by the Sassanian Persians, but they are in fact infinitely freer of historicizing inhibitions than any vaulted space by Perret or Garnier, not to mention de Baudot, the pioneer utilizer of concrete in St. Jean-de-Montmartre (Fig. 130).

Tradition and Innovation in Architecture: 1880-1914

94

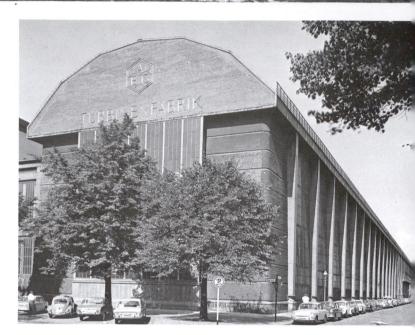

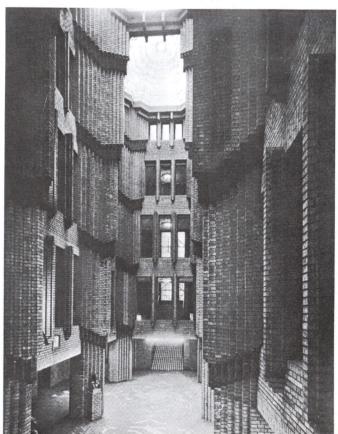

right: 152. Eliel Saarinen. Railway Station, Helsinki. 1904–14.

below: 153. Eliel Saarinen. Project for the Chicago Tribune Tower. 1922.

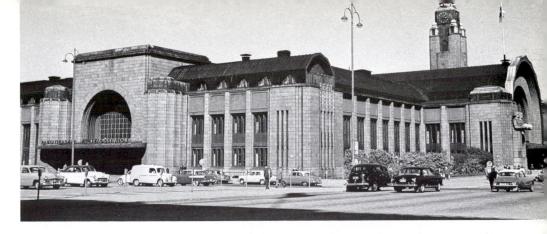

In Germany, Peter Behrens (1868–1940) typified the best of the rising new generation represented elsewhere by Perret and Wright, a generation in succession to Wagner and Richardson, Sullivan and Gaudí. However, Behrens's enormous achievement in industrial design as well as in architecture does not, as we shall see, overshadow the innovative buildings and interiors of Josef Hoffmann, Joseph Maria Olbrich, Adolf Loos, and Eliel Saarinen. Still, Behrens must be considered the linchpin of his generation, an architect who tied together earlier pioneering efforts with later, more radical departures. In this particular respect he almost exceeded even the titanic Wright, whose work is undisputedly the most formally inventive of his generation. And it was in Behrens's office that three of the heroes of modernism, Walter Gropius, Ludwig Mies van der Rohe, and Le Corbusier, served apprenticeships.

Behrens's importance extends to his role in giving direction to the industrial arts as applied to machinery and machine-produced household objects, a movement that paradoxically grew out of a reassessment of issues and values initially raised by the Arts and Crafts movement. As architect and design consultant to the AEG (General Electric Company) in Berlin, Behrens designed a series of factories, beginning with the Turbine Factory of 1909 (Fig. 150), with its recessed, inclined concrete corner pylons (to be contrasted with the corner towers of Wright's Unity Church), that constitute the first landmarks of the new factory style. This was all the more remarkable since Behrens began as a designer in the Art Nouveau manner, and only after 1900 did he turn to a rather personal neoclassic, neo-Renaissance mode of expression, as part of the period's general reaction against both the sinuous linearism of Art Nouveau and the overwrought abundance of fin-de-siècle academicism. The most notable example of Behrens's neoclassicism can be found in the façade of his 1911-12 German Embassy in St. Petersburg, whose attenuated, engaged columns paralleled the modified classicism of Perret's Champs-Élysées Theater and foreshadowed the authoritarian government styles of the 1930s. Behrens's work thus heralded the reactionary as well as the progressive phases of 20thcentury architecture. The Expressionist aspect of his contribution found its outlet in the factory designed for I.G. Farben at Hoechst (Fig. 151), a 1923-24 project whose brick-arched exteriors romanticized the factory style in a way suggestive of Richardson's enlarged simplifications of the Romanesque. Behrens's complex at Hoechst aspired to a somewhat Gaudí-like fantasy, and the enigmatic lobby seen here, an expressionistic evocation of a Gothic cathedral interior, can profitably be compared with the more rational, yet equally ecclesiastical, interior of Wright's Larkin Building (Fig. 162).

Had Olbrich (Fig. 135) not died prematurely in 1908, we could well imagine that he would have designed in the mode of Behrens's Hoechst plant, since his style, formed during the long association with Wagner in the 1890s, was less industrially oriented. The various structures forming an artist's colony of houses and exhibition halls at Darmstadt, beginning in 1899, were Olbrich's

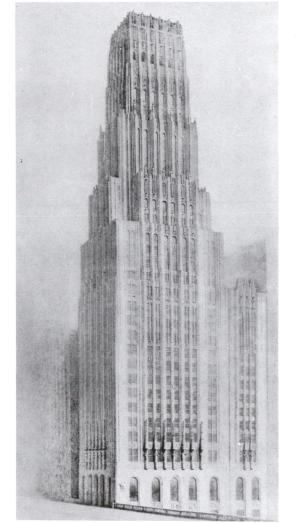

masterpieces, and collectively they suggest that his turning away from Art Nouveau did not imply a rejection of the fanciful.

Among other notable European architects, the one most comparable to Olbrich would seem to have been Eliel Saarinen (1873–1950), whose son Eero was destined to leave his distinctive imprint upon post-1945 American building. The elder Saarinen's 1904–14 Helsinki Railway Station (Fig. 152) is one of the most typical of the day, additive rather than integrated in composition, a rambling collection of related motifs that are a hard-to-define mixture of innovation and historicizing. Saarinen's later career included the much-admired, unbuilt second-place design for the 1922 Chicago Tribune competition (Fig. 153), a Secessionist Neo-Gothic design that had a marked influence upon American commercial skyscraper architecture in the 1920s and 1930s. Finally, the life's work of this master merged with that of his illustrious son, as we shall see.

The architecture of Josef Hoffmann (1870–1956), and especially his masterpiece, the 1905–11 Palais Stoclet in Brussels (Fig. 154), provides a most intriguing foil for the factory-style works of Behrens. The design Hofmann prepared for the Palais Stoclet is of elaborate, almost pretentious simplicity, the general massing of which suggests houses of about 1900 by Voysey or Mackintosh. Its details, and particularly a Secessionist neoclassic cupola, are evocative of Wagner, Olbrich, and Behrens. Moreover the richly furnished interiors feature splendid mosaics by Gustav Klimt (Fig. 84), thus constituting one of the rare collaborations between a major architect and a gifted painter in the 20th century. However, in an age that saw the emergence of the factory aesthetic, this was one of the last vital manifestations of Arts and Crafts. In this way, Hoffmann's work can be understood as analogous to the more elaborate domestic projects designed by Wright in the same decade, houses that were also late examples of the 19th-century effort to elevate craftsmanship to the level of a mystique.

The work of Adolf Loos (1870–1933), another Viennese architect of a stature comparable to Hoffmann's, also demands comparison with that of Wright. This is especially true with respect to his domestic interiors, which he detailed with a sparseness and innate sense of proportion and unusual spatial relationships that bring them into the orbit of the American master. Loos developed a concise, laconic, absolute style, at once severely rational and conceptually Romantic. Two works by Loos, the 1910 Steiner House in Vienna (Fig. 155), and the project in the form of a Doric-column colossus for the 1922 Chicago Tribune competition (Fig. 156), illustrate the extremist, outrageous design frontier always present in

top: 154. Josef Hoffmann. Palais Stoclet, Brussels. Street façade. 1905–11.

right: 155. Adolf Loos. Steiner House, Vienna. Garden façade. 1910.

far right: 156. Adolf Loos. Project for the Chicago Tribune Tower, 1922.

157. Frank Lloyd Wright. Ward Willetts House, Highland Park, Ill. 1900–02.

his work. While his earlier houses indicated a closer relation to Boullée and the generation of revolutionary classicism, the Steiner House, notably its garden façade alone, proved to be his most personal design: symmetrical to a fault and utterly devoid of ornamental softening anywhere. The Doric column enlarged to the scale of a skyscraper, which was to have been taken seriously and not in an ironic manner, as it sometimes has been, recalls similarly outrageous adaptations and tormented changes of scale and context found in the Romantic designs of the late 18th century. Not only does it seem surreal in a way parallel to the architectural fantasies of de Chirico, Magritte, and Delvaux (Fig. 281), but it also formed part of the parentage of the "absolute architecture" of Walter Pichler and Hans Hollein in the 1960s, not to mention the monument projects of such recent sculptors as Claes Oldenburg and Robert Smithson and the historicizing post-modernism of the 1980s (see Chap. 24).

The Early Career of Frank Lloyd Wright

It would be hard to imagine a more searing contrast than that between the elementary, pure work of Loos and the many-sided career of Frank Lloyd Wright (1867-1959). Although in such late works as the Guggenheim Museum (Fig. 370) Wright seems to have drawn inspiration from the strange scale and smooth surfaces favored by late-18th-century revolutionary classicism, this distant, if relevant, antecedent of the modernist tradition was not a major component in shaping his initial style. While he drew upon many aspects of conventional practice as he found it in his day (and in this respect he was much like Behrens) and even took several years to digest these influences, Wright arrived about 1900 at an individual style unique beyond that of his peers elsewhere, a complex fusion of parts quite unlike the more heterogeneous works of his European contemporaries. Of them, only Loos seems more relentless in developing a new architecture, but the Austrian master arrived at his synthesis through negation, while Wright did it through affirmative action. Although Loos's distinctive aesthetic was aristocratic, Wright's work had the more populist character of the egalitarian Midwest where he had equal success in building both modest and elaborate houses-nearly all in a style that, significantly, did not vary much with the client's pocketbook.

It is appropriate that Wright should occupy the penultimate place in this chapter since it was his work, and only his, that, through a process of selection (and, to a lesser degree, of rejection), succeeded in creating a total synthesis of architectural design, the whole leavened with Sullivan's organic theory.

Sullivan's contribution to the realization, as opposed to the idea, of organic architecture had been his imaginatively proportioned and ornamented urban skyscrapers and, later, his small-town banks. Wright's contribution to that American tradition was the Prairie House, with the unusually ordered mass of the exterior and the distinctively integrated spaces of the interior functioning in the place of the older architect's additive ornament. Wright carried the new theory a crucial step further, making a building not just a part of nature, but giving to its overall design a quality that suggested its own inward, plantlike growth from root and stem to leaf and blossom. This was accomplished not through the botanical mimicry of Art Nouveau decoration but through the integrated massing of intersecting rectangular volumes, broadly projecting low-hipped roofs, and a formal landscaping freed of the rigors of the French academic tradition, which drew Wright's characteristic architectural motifs into the out-of-doors where they blended and ultimately died away amid the abundance of the native site. In addition to his perception and use of environmental circumstance as a stimulus for creative design, Wright demands recognition for his extraordinary historical erudition. In the instance of an architect who towered over his contemporaries on account of his "originality," this realization is nothing short of devastating to the critic, and bewildering, to say the least, to the casual spectator. However, Wright acquired much of his initial experience working in the suburban domestic modes popular in his day: the shingled cottage style, popularized a generation earlier by Richardson; the revival of 18th-century Georgian colonial forms, initiated by McKim, Mead and White; and English half-timbered Elizabethan. Moreover, he contended with the academic tradition of symmetrical layouts and hierarchic massing, and came away the winner twice over. Sometimes, in a public structure, Wright employed the suggestion of an academic plan but then did something different for the elevation; or, in a house, large or small, he took the intersecting, balanced axes of the Beaux-Arts and displaced them, altered their proportional relationships, and otherwise manipulated the static geometry into something fluid and dynamic, an architecture of freely flowing spaces.

The layout of the 1902 Ward Willetts House in Highland Park (Fig. 157) constitutes the archetypically organized Prairie House, as centrally anchored as Palladio's 16th-century Villa Rotonda, but with differences so important as to make it an utterly revolutionary design, one the architect would employ in infinite variation. Symbolically, functionally, and structurally, a massive low brick hearth is the central core from which radiate living and dining spaces as

158. Frank Lloyd Wright. Robie House, Chicago. 1909.

well as anteroom and entrance. The entrance is to the side, played down and largely concealed by the porte cochere to the right of the building's mass. The eye is first caught by the unusually low silhouette, compounded out of a very low-hipped roof with an unusually pronounced wide spanning overhang, only barely supported by hard-to-discern, recessed piers. The horizontal, ground-hugging emphasis is furthered by the omission of the conventional cellar or half-basement, so that the main floor seems to float only a step or two above the ground.

In addition to the dozens of houses he designed during his first creative period, which brought forth the well-known Robie House in Chicago (Fig. 158), Wright also designed a few large public buildings, all of them, with one exception, now vanished. Of these the Imperial Hotel in Tokyo (begun about 1915 and completed just before the earthquake of 1923) may have been the greatest work (Fig. 159), in elevation a vast, enlarged Prairie House, giving the aspect of a Midwestern country inn (a prototype of some ideal motel that has, alas, never existed!) in the midst of a thoroughly Westernized business district of Tokyo. Although his Chicago-suburb houses of 1900 and afterward contained many veiled indications of a passionate interest in Japanese art and architecture, Wright banished these references when given the opportunity to actually build in Japan. Here the wealth of perforated cubic ornament suggested many analogies, from contemporary radical trends in European painting to the richly sculpted mosaic-like friezes of Mayan or Toltec buildings. The Imperial Hotel, important as a monumentalization of an essentially domestic style, was also one of the architect's most orthodox, hierarchic academic plans, a double H, in which a central core was flanked by two side wings, the exterior mass piling up in a stepped climax toward the rear center. The composition could be appropriately compared to the more stiffly, literally Roman-revival Pennsylvania Station in New York, by Charles McKim, and, to even greater advantage, to the somewhat more permissively conceived Edwardian academicism of Sir Edwin Lutyens's 1913 Viceroy's House in New Delhi, where the domes and smaller cupolas have been rendered not in the usual Baroque but in the indigenous Mogul style of the 16th and 17th centuries.

Wright's earlier public structures had been built closer to home. Unity Church in Oak Park, Ill., which survives (Fig. 160), was in fact only a few blocks from the house and studio that Wright occupied until 1909. A pioneer edifice in poured concrete, the

98

chunky, cubic, massive Oak Park Church could not be more different from the contemporary concrete structures of Perret. With this building Wright completely transformed, through elimination, the Sullivanian system of ornament that he had inherited more than a decade before. From a stylized naturalism he moved to abstract geometries that, when further refined and denatured, would become the stark primaries and grid rectangles of the painting, sculpture, and architecture propagated by the Dutch De Stijl, one of the major components of the International Style of the 1920s.

Wright's other lost masterpiece of this period, the 1904 Larkin Building in Buffalo (Figs. 161, 162), was an office structure for a mail-order concern. A far-reaching, integrated design tailored to the specific needs of a particular firm, as opposed to the more uniform, flexible space of office buildings which, then and now, have been so frequently constructed on speculation, the very uniqueness of the concept may have helped determine the building's fate. Nonetheless, it represented a landmark of design integration, indeed, one of the first instances of environmental design, from the monumental hulk of its exterior to the smallest detail of metal office furniture on the interior. The enclosed space was unprecedented in its mechanical circulation of fresh air, anticipating later refrigerated air-conditioning, and the central light well, a feature normally treated with disdain in commercial blocks and early skyscrapers, was here given featured treatment. Just as Behrens demonstrated that a factory could have an aesthetic, Wright demonstrated, in his many works, that houses and offices could be works of art. It was not for the first time, but Wright achieved it with greater consistency, and with a memorable appropriateness and originality.

If Wright's early work takes us to the eve of the Great War, there remain a number of other major contemporary efforts worthy of note. However, these were the works of men whose fame would be shaped by their creative efforts following 1918, and analysis of these structures had best wait. There is one exception, the projects for an ideal city conceived by the single Futurist architect of renown, Antonio Sant'Elia (1888–1916). Sant'Elia was the lone major architectural casualty of the war, and, although the exact contemporary of Gropius, Miës, and Le Corbusier, he now seems better treated as a culmination of earlier trends rather than as part of later developments, even if his legacy helped shape aspects of postwar idealism.

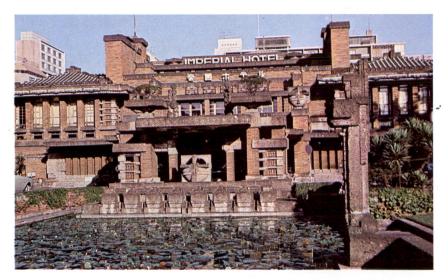

1**59.** Frank Lloyd Wright. Imperial Hotel, Tokyo. 1915–22 (demolished 1968).

right: 160. Frank Lloyd Wright. Unity Church, Oak Park, Illinois.

below left: 161. Frank Lloyd Wright. Larkin Building, Buffalo, New York. 1904 (demolished 1950).

below right: 162. Frank Lloyd Wright. Interior, Larkin Building, Butfalo, New York. 1904 (demolished 1950).

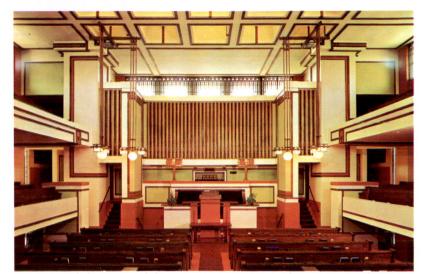

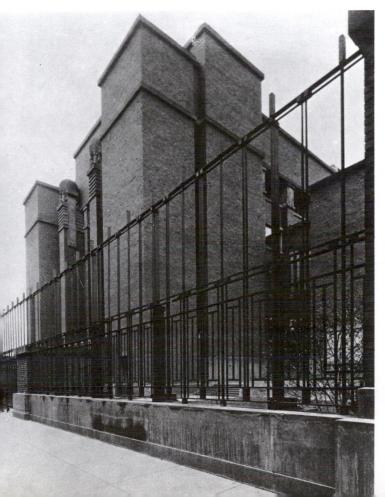

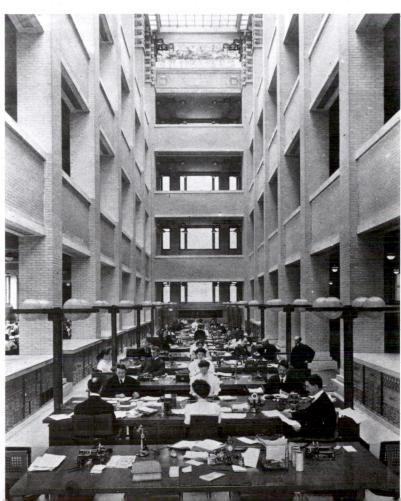

Futurism in Architecture

Of all the prewar tendencies, Futurism seems to have exerted the most incisive influence upon subsequent architecture-either that or it was the first clearly to articulate a series of issues that were on everyone's mind. Sant'Elia's Futurist City (Città Nuova), together with the manifesto prepared with the help of the writer Marinetti, idealized the vertical skyscraper form set on a terraced site where the various means of transportation move swiftly, unhindered, separated on distinct levels. Movement, flux, dynamism-these were the major themes expressed in the impulsive, simply massed forms of the projects designed by Sant'Elia (Fig. 163). His architecture made explicitly modern what Wright's forms only rendered implicitly. In retrospect, we can see how Wright's style of 1900-10 was the vital wave of the future; however, the younger Italian architect's unexecuted projects were more recognizably so at the time and were, significantly, cast in an urban rather than a suburban context. For perhaps the first time the American-bred skyscraper appeared as a commonplace in European design, and in a context that made the American ones look old-fashioned. However, the setback shapes of Sant'Elia's tall buildings, with their detached, outrigged elevator shafts connected to the main form by arched bridges, suggest an analogy with Gothic flying buttresses, implying thus a kind of Futurist cathedral. This effect was most remarkable for two unrelated reasons: Sant'Elia's historical iconoclasm, and the cathedral-of-the-future image, which would become a key element in the writings and projects of later architectural Expressionism. But the Italian architect shaped concepts more than he shaped a new style: "Modern architecture ... has nothing to do with settling on formalistic differences between new buildings and old ones.... It must be as new as our state of mind is new.... In modern life, the process of consequential stylistic development comes to a halt. Architecture, tired of tradition, begins again, forcibly, from the beginning."

Ignored during his lifetime, Sant'Elia later found a receptive audience ready to assimilate his formal inventions, thanks to the groundwork laid by the two generations of consciously modernist designers reaching from Wagner to Loos. This progressive strain was largely absent in the United States in McKim's purged classicism, which sought to reform a wayward traditionalism by a narrow reconsideration of specific historic models rather than an exploration of new frontiers.

The Dilemma of the Modernist Architect in America

A comparison of Loos, the most individualist architect of his generation in Europe, with Irving Gill, an American contemporary of Wright's (and with whom Wright's son Lloyd worked), is instructive. Gill's Dodge House in Los Angeles, a work of 1915-16, seems to offer the same austerity of mass and contour as Loos's houses of the period or a little earlier. However, each architect's style arose out of vastly different local, cultural, and stylistic conditions, and the results, although important as an historical parallel, were hit upon quite independently. It is therefore a curious irony of recent design history that Loos's disciple, Rudolph Schindler, and a Viennese compatriot, Richard Neutra, who migrated to the Los Angeles area, were the ultimate, effective founders of the new architecture in southern California in the 1920s (Figs. 367, 368). Indeed, it could be argued that they usurped the work that might otherwise have gone to the local pioneer, Gill, whose career subsequently petered out in provincial obscurity. But obscurity was the fate of most radical American designers throughout this period, as Gill's experience illustrates. The American had no following to speak of, while Loos, whose works offered a similar austerity of

163. Antonio Sant'Elia. Project for a Futurist City. c. 1914.

mass, made a tremendous mark, after 1918, on the next generation, often through direct contact. Isolated, American architects could not benefit from the social and professional access enjoyed by the Europeans, who were able, before 1914, to participate in international exhibits and to reach beyond their national boundaries. At home, Wright was barely an architect of national reputation during more than the first half of his career, but, rather, a provincial, even old-fashioned one in the eyes of American academic critics. No wonder he considered settling in Europe around 1910. There, his work was not just a part of the mainstream; it precipitously assumed seminal quality just before 1914, and after the war the consequences of this force would continue. It could never have done this in his native land.

Expressionism in France: Matisse and the Fauves

he descriptive epithets we have encountered thus far in our study of modern art, such as Neo-Impressionism or Symbolism, originated usually with the artists themselves who formed a movement, or they emerged from the attempts by critics to describe a clearly defined artistic group with common aims or characteristics. The term Expressionism, however, poses a more complex problem. It denotes, in one sense, a general tendency in any art with strongly asserted emotional content. In keeping with the romantic spirit where its genesis lies, Expressionist art prefers personal vision to knowledge, values inward revelation over the observation of nature. In more precise usage, the term became popular in Munich around 1911 in the pages of Der Sturm, a leading avant-garde periodical edited by Herwarth Walden, who used it to elucidate and support-often in rhapsodic terms-the many divergent revolutionary tendencies in European art of the period. "We call the art of this century Expressionism," he wrote, "in order to distinguish it from what is not art. We are thoroughly aware that artists of previous centuries also sought expression. Only they did not know how to formulate it." But the epithet was soon appropriated by other German critics to characterize the primitivizing Bridge group (Die Brücke), which had begun to show in Dresden in 1905, and to define the more abstract and intellectually oriented Blue Rider group (Der Blaue Reiter) in Munich, led by the Russian Vasily Kandinsky.

A foretaste of the Teutonizing of the term came with the appearance of an essay, "Expressionism," by the critic Paul Ferdinand Schmidt, published in *Der Sturm* in 1912, which outlined the development of an interesting new movement: "Cézanne taught the simplification of tone values, Gauguin the effect of the plane, and van Gogh added the flaming luminosity of color. Maurice Denis, Vuillard, and Bonnard attempted to prepare a planar simplification in the grand style, but they lacked persuasive expression. This was found by the Teutons of the north and south, Munch and Hodler."²

Edvard Munch, in particular, had been an influential figure in Germany, and his works enjoyed considerable fame in Berlin as early as 1892. Later, he was invited to exhibit as "guest of honor" at the Berlin Secession (*Sezession* being the German term adopted by groups of progressive artists in Germany and Austria rebelling against the power of traditionalist, reactionary organizations) and showed such dramatic works as *The Kiss* and *Death Chamber*, which caused wild protests, demonstrations, and public scandal. Munch stayed in Berlin intermittently until 1908, and there painted his great *Dance of Life* (Fig. 55). In the 1920s, when the exasperated feelings of the postwar period were at their height, another German critic wrote that Munch had indeed been the first artist to recognize and adopt the essential characteristic in Expressionist art—communication of emotion through the pictorial elements

themselves. "Munch dared to paint the incidents of the inner life. . . . We saw that brush and stroke were able to divulge deeper things."³

Yet no one seems further from the psychological turmoil, the mood of despair, and the autobiographical obsession of Munch than the artist who apparently first adopted the word "expression" in the 20th century and who painstakingly explained the means for achieving expressiveness in art. This was the Frenchman Henri Matisse (1869–1954), a former law student from a provincial bourgeois milieu who developed so late in art that chronologically he belongs to the generation of Bonnard and Vuillard. The Germans, following the example of Munch, Hodler, and their Gothic forebears (Grünewald particularly), had sought an art that went beyond visual impressions to express emotional states and spiritual values. But Matisse and his group of so-called Fauves deserve priority for investigating the concept of expression as such. Indeed, during a limited period, they painted with an abandon, passion, and even violence of *pictorial* means that justifies their claim to being the century's first Expressionist artists.

The association of Expressionism with Matisse finds support in a passage from the artist's long essay entitled "Notes of a Painter," published in *La Grande Revue* in 1908. One of the fundamental documents in the history of modern art, this work was immediately translated into German and Russian. In it Matisse made a statement that clarifies his independence of the emerging German Expressionists, whose views were taking shape at the same time:

What I am after, above all, is expression. . . . I am unable to distinguish between the feeling I have for life and my way of expressing it.

Expression to my way of thinking does not consist of the passion mirrored upon a human face or betrayed by violent gesture. The whole arrangement of my picture is expressive. The place occupied by figures or objects, the empty spaces around them, the proportions, everything plays a part. Composition is the art of arranging in a decorative manner the various elements at the painter's disposal for the expression of his feelings.⁴

Matisse then goes on to say that there are generally two ways of expressing things: "One is to show them crudely, the other is to evoke them artistically."⁵ Here, then, is an essential difference between Matisse, as the representative of French Expressionism, and the German Expressionists. The French were primarily committed, after Matisse's example and as a matter of both long-standing tradition and deeply rooted habits of mind, to exploring formal problems of pictorial method and design. When Matisse used the term "expression" in reference to something more than a facial expression, as he frequently did around 1908, he quickly coupled it to "sensibility" or to some "higher ideal of beauty" and a "decorative manner." His viewpoint remained essentially aesthetic and

rigorously detached. The Teutonic obsession with the "spiritualization of expression" and with human suffering could hardly have been more alien to Matisse's Mediterranean spirit and classical moderation. The Frenchman was never preoccupied, as were the Germans, with urban themes as such, with the freedom and nudity of the human body understood as a liberating element, or, most importantly, with portraying psychic states, especially of anxiety. The German artists reacted to a corrupt society by assuming the role of savage moralists, and concerned themselves with the psychological situation of modern men and women. Significantly, both the French Fauves and the German Bridge group shared the general interest in the newly discovered "primitive" art of Oceania and Africa, but with antithetical responses. The Germans found an affinity with the life-style and the mysticism of primitive peoples, whereas the early-20th-century French, unlike Gauguin, limited their discovery to the new formal and expressive possibilities of primitive art. Matisse and his associates preferred form to magical content, and diffused the more savage and disruptive elements of primitivism in their paintings by subordinating them to decorative artistic values.

But to understand the relationship of Matisse and French painting to the broader phenomenon of Expressionism after the turn of the century, we must consider some of the salient differences in relation to the development of Matisse's own work and its abiding humanism.

Matisse and the Fauves

In the early years of this century, Henri Matisse was exposed, in Paris, to a number of great retrospective exhibitions of the Post-Impressionist masters, which deeply stirred the new generation of painters. In 1901 the Bernheim-Jeune Gallery put on a sizable show devoted to van Gogh, whose art then became the subject of another large exhibition, this time at the Independents Salon in 1905. In 1903 and 1906 Gauguin was honored with important exhibitions at the Autumn Salon and the Independents. Cézanne's late rise in esteem had begun with Vollard's first retrospective of his work in 1895, which so impressed the Nabis, and in 1904 and 1905 the Aix master received larger salon shows that won him an even more important following among the younger painters. That year Cézanne's name was, more than any other, on the tongues of members of the avant-garde. The effect of the Post-Impressionists' exhibitions was all the more electrifying for the reason that the new painters had had no prior opportunity to examine their works. Cézanne was something of a myth in his lifetime, a recluse in the south whom few had ever seen, and whose work was largely legend.

Van Gogh and Gauguin were known by the somewhat diluted derivatives of their paintings produced by the Nabis. None of the great Post-Impressionists had been experienced at first hand by the neophyte painters. In fact, up to 1900 the most important and influential artistic event had been the 1897 exhibition of the Caillebotte bequest at the Luxembourg. The bold colors and refined crudeness of Gauguin and van Gogh, and Cézanne's modeling with color, had come as revelations to Matisse and his colleagues. Their discovery of these artists was the immediate inspiration for the daring new experiments they undertook and the violent colors they suddenly released in their painting around 1905.

In 1899, after relatively conventional beginnings, Matisse had adopted the Neo-Impressionists' vibrant, intense color and had begun to apply pigment in pointillist dots. But immediately afterward he reverted to a darkish palette, taking his cue from Courbet and the early Manet. *Carmelina* (Fig. 164), a work of 1903, demonstrates the artist's ability to draw together diverse influences. The subject makes us think perhaps of Courbet or the early Lautrec, until we realize that the girl is not given any strongly personal associations except for the blue bow in her hair. She is simply a model, posing in the artist's studio, and in the mirror we catch a glimpse not only of her back but also of the painter himself at work on the picture, a clever mesh of flat, rectilinear shapes setting off the organic, full-bodied form of the sitter. Thus, while demonstrating his mastery of two-dimensional pictorial structure, Matisse reminds us of his attachment to an illusionistic tradition, as did both Courbet and Manet before him, or indeed Velázquez in the *Maids of Honor*. Simultaneously, he also offers a theme—the artist together with his model—through which he would confirm, again and again, the transition he had long since made from the Impressionists' engrossment in the external world into his own absorption in art history and the world of art.

In 1904 Matisse met Paul Signac (Fig. 71), Seurat's colleague, and spent the summer working near him at Saint-Tropez on the French Riviera. Under Signac's influence Matisse began using the bright colors of Neo-Impressionism, but loosened his forms and allowed color to function more freely, much to his mentor's dismay. In the Independents Salon held the following spring, Matisse exhibited a large outdoor figure composition, *Luxe, calme et volupté* (Fig. 165), which was a rather free and personal adaptation of Signac's methods. Actually, despite the greater liberty taken by Matisse, the painting remained unmistakably derivative in character and relatively conservative in both form and spirit.

In the fall, however, Matisse exhibited a new group of paintings whose assertive originality and independence could not be denied. Joining him in the exhibition at the celebrated Autumn Salon were André Derain, Henri Manguin, Albert Marquet, Jean Puy, Louis Valtat, Maurice de Vlaminck, Othon Friesz, and Georges Rouault. Many of these artists, including Matisse, had been students of Moreau, who, although fantastical, hermetic, and literary in his own Symbolist art (Fig. 35), had been an enlightened teacher, urging his pupils to study the Old Masters, sketch in the streets, and, above all, cultivate their own originality. Maurice de Vlaminck, an outsider, was a fellow townsman of Derain's from Chatou, one of Renoir's former painting locales. Matisse had met him with Derain at the van Gogh exhibition at Bernheim-Jeune in 1901, where, legend has it, he heard Vlaminck loudly and extravagantly singing the praises of van Gogh: "You see, you've got to paint with pure cobalts, pure vermilions, pure veronese."⁶ From Le Havre had come Friesz, another charter member of the Fauves. In 1906, at their second exhibition, two more Havrais, Raoul Dufy and Georges Braque, joined the group.

The label *Fauves* ("Wild Beasts") was a witticism, not altogether hostile, coined by the journalist Louis Vauxcelles. After seeing a small bronze in Renaissance style set at the center of the gallery reserved for the young radical painters, he remarked: *Donatello au milieu des fauves* ("Donatello among the wild beasts"). The phrase stuck, and afterward the central gallery where the works of Matisse and his friends hung was jocularly referred to as the *cage centrale* or the *cage des fauves*.

The Fauve exhibition became as much a *succès de scandale* as the first Impressionist group show had been (Figs. 166, 167). Tired old epithets were dusted off and refurbished by glib philistine journalists: "pictorial aberration," "color madness," "unspeakable fantasies," "the barbaric and naïve sport of a child who plays with the box of colors he just got as a Christmas present." The fresh color and free handling blinded critics to the Fauves' originality and, indeed, to their charm. The painters had rendered landscapes, marines, city views, holiday crowds, and the individual human image with savage splashes of pure pigment, but their mood was sanguine and lyrical. The public made no mistake in sensing a genuine violence and even a predatory character in Fauvist color, brushwork, and distortions of form, but it confused means and ends. That violence—which today, however, seems relatively

right: 164.

Henri Matisse. Carmelina. 1903. Oil on canvas, 32×23½". Museum of Fine Arts, Boston.

below: 165.

Henri Matisse. Luxe, calme et volupté. 1904–05. Oil on canvas, 37 × 46". Private collection, Paris.

tame—represented an effort to breathe new life and vigor into pictorial art by restoring the free play of spontaneous feeling.

The Fauves' outlook corresponded to a new, intoxicated rediscovery of natural life and feeling, a development that had already been expressed in the closing years of the old century in such books as André Gide's Fruits of the Earth and by the literary movement of Naturism. As early as 1895, in his Essay on Naturism, Maurice Le Blond had voiced the mounting reaction of writers to Symbolism and the Romantic decadence: "Our elders preached the cult of unreality, the art of the dream, the search for the new shudder. They loved venomous flowers, darkness, and ghosts, and they were incoherent spiritualists. As for ourselves, the Beyond does not move us; we profess a gigantic and radiant pantheism."⁷ And the novelist Charles-Louis Philippe had declared in a letter written in 1897: "What we need now are barbarians. . . . One must have a vision of natural life. . . . Today begins the era of passion."⁸ Fauvism, similarly, grew out of this new spirit of joyous, pagan affirmation and represented a return to natural reality after the Romantic interregnum.

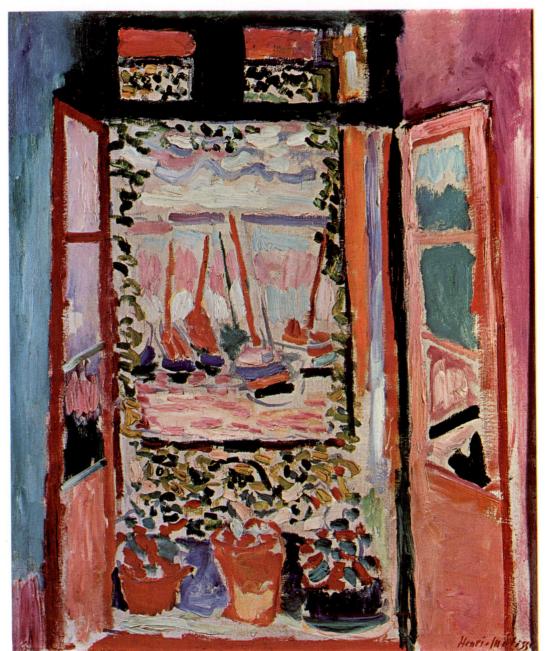

left: 166. Henri Matisse. Open Window, Collioure. 1905. Oil on canvas, $21^{3}_{4} \times 18^{1}_{8}$ ". Collection Mrs. John Hay Whitney, New York.

opposite: 167. Henri Matisse. Woman with the Hat. 1905. Oil on canvas, 32¹/₄ × 23³/₄". Collection Mrs. Walter A. Haas, San Francisco.

The Fauves did not willfully distort reality to attract public notice by their sensationalism. Rather, they were intent on recapturing, through new strategies, the nature that had begun to elude the oversubtle Neo-Impressionists and belated Impressionists. Matisse and his associates intended to revisualize nature freshly, with more spontaneity—just as, in their own time, first Manet and then the Impressionists had rejuvenated the visible world by new methods. The Fauves broadened their techniques and used juxtapositions of complementaries, but in wider slashes, and followed instinct rather than the reasoned or "scientific" analysis attempted by their immediate antecedents, the Neo-Impressionists. Above all, they sought vividness and whatever new combinations of pure pigment would transmit the greatest possible luminosity.

Despite his vehemence of expression and a high pitch of emotion, Matisse was closer to the spirit of Cézanne than to any other Post-Impressionist. While his first Fauvist ventures seemed not at all to emphasize structure, Matisse was conscious of using color to establish solid form. His arbitrary splotches of pigment conveyed vivid impressions of something actually seen or felt in nature. He later spoke of "re-creating" color, of finding a chromatic harmony that at once corresponded to his sensations before nature and created a more intense, independent pictorial reality. By way of explanation of the liberties he took, Matisse wrote: "He [the artist] must feel that he is copying nature—and even when he consciously departs from nature, he must do it with the conviction that it is only the better to interpret her."9 Many other Fauves, however, were content to lapse into an academic style derived from Gauguin's color oppositions or from van Gogh's vehement brushstrokes in pure color. Matisse took Cézanne as his primary source of influence, even though his own exuberant, flat color planes seem remote from the relatively restrained and systematic palette of the 19th-century master. Georges Duthuit, the brilliant historian of the Fauve movement, asked Matisse how it would be possible to associate Cézanne with "the idea of using pure colors." To this Matisse replied: "As to pure color, absolutely pure colors, no. But Cézanne constructed by means of relations of forces, even with black and white."¹⁰ For Matisse, too, pure colors became plastic forces.

Among the canvases Matisse showed at the 1905 Autumn Salon was a small but fully realized picture he had painted that summer at Collioure under strong Mediterranean light. Called *Open* Window, Collioure (Fig. 166), it offers a view from the interior world of human habitation into the exterior world of nature, a motif, like Cézanne's, carefully selected to serve the artist's aesthetic intentions. Here, in the mixed manner typical of early Fauvism, Matisse used an extraordinarily free version of Impressionist brushwork for the natural parts of the scene-the potted plants, the vines climbing up the balcony, the marina and sky beyond-and rendered the architectural abstractions of the room in broad zones of relatively flat, even color. Thus, he also followed Cézanne in his use of both handling and color to acknowledge the rival elements of his picture-depth and surface, geometric structure and spontaneous, organic process-as well as to unify them into a firm but dynamic balance. Even more than Cézanne, however, Matisse magnified the Impressionists' small deposits of pure hue until he had constructed the entire picture of large areas of complementary, almost shockingly contrasted colors. The better to exploit their potential for mutual intensification, he adopted a way of composing-a constant in his art-that allowed complementaries to be set down not only side by side but also in definite separation. Thus, in Open Window, Collioure blue-green and a highly charged pink balance across the flat plane of the canvas, stimulating one another from the walls and casement panes on either side of the open window. But while this motif functions to separate the lateral fields of interacting color from top to bottom, it also unifies the entire work by carrying smaller traces of all the colors across the main, central portion of the canvas.

In Impressionism, the all-over, crustlike texture and generalized distribution of color may have asserted the tangibility of the painting surface, but it also produced an atmospheric effect that solicited visual entrance into the plausible illusion of a world beyond. Matisse, with his broad, flat planes of strongly contrasted color, made light seem not a gentle emanation from within an atmosphere, but a reflection from the taut, skinlike spread of a twodimensional surface. And so the picture surface created by Matisse resists optical penetration and, instead of entrance, invites the eye

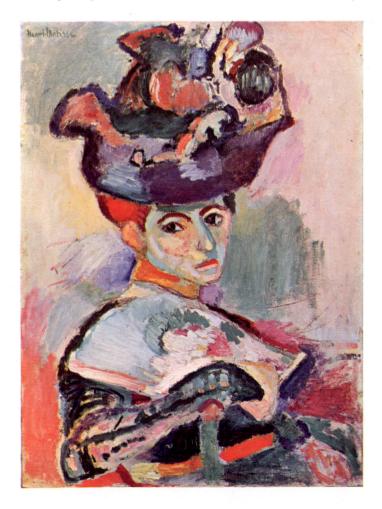

to travel over and traverse, taking in but never violating the integrity of that frontal plane. So explicit is the emphasis on the painting surface in *Open Window, Collioure* that even the "Impressionist" portion—the view onto sun-drenched nature—appears to advance rather than recede, which totally reverses the Renaissance notion of the picture as a window open into the infinite depth of the real world. By thus canceling the illusion of deep space, Matisse made the window motif seem a picture within a picture. In this way, he transformed the image into a metaphor of creative process itself, restating the modernist conviction that the purpose of art is to transcend, or at least conceptualize, the world of appearances, not merely to duplicate it perceptually.

Also in the 1905 exhibition was a portrait, Woman with the Hat (Fig. 167), which the Stein family acquired, on the advice of Leo Stein, the first important Matisse collector, or perhaps at the urging of his sister-in-law, Sarah Stein. It hung for many years in the famous apartment shared by Leo and Gertrude Stein on the Rue de Fleurus, among the many superb early Matisses and Picassos these dedicated patrons of 20th-century art acquired. The painting had aroused considerable dismay in the press owing to its distortions of the human countenance and the liberties taken with composition. Unlike either Cézanne or Gauguin, Matisse made no effort to set up a suave harmony of cool and warm tones. Instead, he let purples, greens, and blues sing out at maximum intensity, creating a wonderfully vivid, if discordant, effect against highkeyed oranges and yellows. The result was a new chromatic magnificence, but it irritated contemporary sensibilities, finally even those of Leo Stein, who took some time getting used to the new color combinations and, after 1907, ceased to accept Matisse's bold innovations.

Along with the offending color, critics singled out an extreme sketchiness of form in Woman with the Hat, its contours defined by changing, ragged patches of color and areas left thinly painted, almost untouched, as Cézanne had done, to take advantage of the luminous show-through of white canvas. Oddly enough, even here, as in Open Window, Collioure, behind the free, spontaneous expression, one feels the invisible organic reality of nature, balanced against the demands of pictorial science. The expressive attitude of the head in Woman with the Hat is the result of careful observation, yet the color zones of the background, for all their patchiness, structure the space as an armature of mutually stimulating complementary colors. Thus, Matisse's most abandoned chromatic expression cannot disguise the operation of intelligence and moderating good taste; something exquisitely cerebral, as well as a real impression of the external world, always controls expressive license in his art.

The most interesting criticism of the Fauves' exhibition was that of the former Nabi Maurice Denis, who in 1890 had written, probably in response to the radically synthetic Talisman (Fig. 48), a sentence often taken to be the first theoretical justification of nonrepresentational art: "Remember that a picture, before being a warhorse, a female nude, or some anecdote, is essentially a flat surface covered with colors assembled in a certain order." Now, writing in L'Ermitage, Denis took a negative stand against what he saw as a new cult of novelty for its own sake and the fashion of the sketch, but he credited Matisse and his friends with vitality and force. As before, his remarks unwittingly anticipated abstract art, which Fauvism would soon engender. "One feels completely in the realm of abstraction," he declared. "Of course, as in the most extreme departures of van Gogh, something still remains of the original feeling of nature. But here one finds, above all in the work of Matisse, the sense of the artificial; ... it is painting outside every contingency, painting in itself, the act of pure painting. ... Here is in fact a search for the absolute. Yet, strange contradiction, this absolute is limited by the one thing in the world that is most rela-

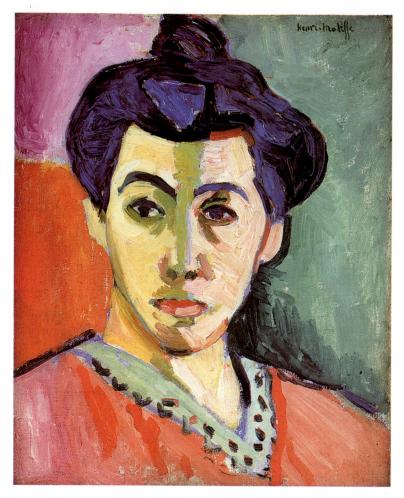

tive: individual emotion.¹¹ The Fauves' lyrical release of emotions and emphasis on "the act of pure painting" were to be major factors in the development of both German Expressionism and abstract painting.

The Fauve group held together for only three years. Individual personalities within it were too independent to sustain common aims, and all the members soon exhausted the high pitch of their feelings and felt compelled to find a more formal structure for painting. Even in the second joint exhibition in 1906 there had been a visible reaction against the informal character of their earliest painting. With its clean divisions of broad color areas, Matisse's portrait of Madame Matisse known as *The Green Stripe* (Fig. 168), for example, is a more compact and simple structure than the *Woman with the Hat*. There is a certain gravity in the mien, and the blue-purple mass of hair and the emphatic eyebrows throw the head into sharp relief, as if Matisse were reverting by means of pure color to the sharp value contrasts and sculpturesque form of *Carmelina*.

The closest artistic collaboration Matisse ever had was with the much younger André Derain (1880–1950), who joined Matisse during the "Fauve" summer at Collioure in 1905. With his quick, cultivated mind and appetite for transforming influences into something fresh and independent, Derain called "for a renewal of expression" and all but matched Matisse in the audacity of his liberated color and drawing. By 1906, however, he too was seeking to tame the "wildness" of his new art. This took him to the cooler climes of London, where, like Monet in 1899–1902, he submitted to the influence of Turner, a consequence of which is *Westminster Bridge* (Fig. 169). While more consistent handling, the dominance of blue, and a grand, sweeping design evince the artist's effort to rein in enthusiasm, the brilliantly synthetic color—lemon-yellow sky and river, brick-red trees, cobalt skyline, sea-green roadway mark the picture as unmistakably Fauve.

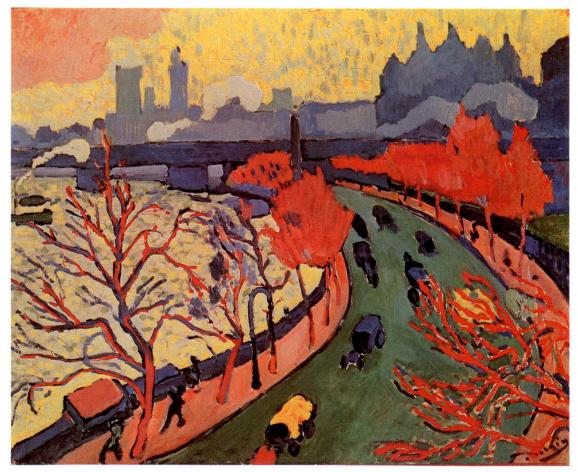

above: 168. Henri Matisse.

The Green Stripe (Portrait of Mme Matisse). 1905. Oil on canvas, 16 × 12¾". Statens Museum for Kunst (Rump Collection), Copenhagen.

right: 169.

André Derain. Westminster Bridge. 1906. Oil on canvas, 317% × 391%". Galerie du Jeu de Paume, Louvre. Kaganovitch Donation.

With Matisse and Derain, Maurice de Vlaminck (1876–1958) completed the triumvirate of major Fauves (Fig. 170). Although artistically the least progressive, Vlaminck was also the only one of the group whose behavior might justify the *fauve* epithet. Committed to anarchist causes, physically and emotionally turbulent, stubbornly anti-intellectual, he worked less from objective analysis than from impulse and instinct. As a result, he produced pictures more notable for their vehement handling, and piquant charm, than for their aesthetic coherence or chromatic daring.

A truly important painter among the Fauves, although not a representative figure in that group, was Georges Rouault (1871-1957), who also happened to be the only French artist comparable in sensibility to the Germans in his anguished Expressionist character. But despite the vigor of his expression, the work he showed at the 1905 Autumn Salon must have looked out of place next to that of Matisse, Derain, and Vlaminck. Rouault set his low-keyed colors in murky washes of blue, animated by a network of energetic black lines (Fig. 171). There was an unusually somber mood to his entries. While in style and imagery his paintings suggested Lautrec, they were also cruder in feeling and full of strong, disapproving moral overtones. Rouault painted professional entertainers and the Paris underworld from the point of view of a stern evangelist loose in the fleshpots. Yet he did it with a profound sense of human pathos. Using forceful line and radically simplified form, Rouault created moral caricatures of remarkable power. Influenced by the Catholic mysticism of Léon Bloy, he intensified the religious character of his art in later years (Fig. 172). These densely luminous paintings took their inspiration from medieval stained glass. (He had begun his career as a stained-glass worker). On the whole, Rouault stood apart from the great movements of his time, a solitary poet of exalted religious feeling.

left: 170. Maurice de Vlaminck. Dancer at the "Rat Mort." 1906. Oil on canvas, 28³/₄ × 21¹/₄".Private collection, Paris.

left: 171. Georges Rouault. Le Chahut. 1905. Watercolor with gouache highlights on paper, 275% × 211/4". Musée d'Art Moderne de la Ville, Paris.

below: 172. Georges Rouault. The Old King. 1916–36. Oil on canvas, 30¼ × 21¼". Museum of Art, Carnegie Institute, Pittsburgh.

Fauvism brought forward two other illustrious names. One of them was Raoul Dufy (1877-1953), the witty, hedonistic décorateur who, in the course of a long career, transformed Fauvism's flat, flaming color and spirited drawing into a personal style of monumental and joyous decoration (Fig. 173). In its mature phase (Fig. 404), the painting of Raoul Dufy would provide a rainbow paradigm for the new, richly embellished art of the 1970s and 1980s. With Dufy came his fellow Havrais Georges Braque (1882–1963), the youngest of the Fauves and an artist whose tentative beginnings in 1905-07 scarcely foretold the epic role he was to play in modernism's next, and most momentous, development. Still, a work like Landscape at la Ciotat (Fig. 174), even with its iridescent colorism, provides hints of what would evolve, especially in the all-over pattern of stylized drawing and the uniform distribution of light and dark, which from hindsight seem the baby talk of the revolutionary pictorial language known as Cubism. The emergence of this movement within the next two years, spurred by a renewal of interest in Cézanne and his formalist doctrines, checked and soon completely stifled the more inspirational impulses of Fauvism. The liberated color and drawing had done their work, however. They had freed instinct and wiped out the lingering, ornamental trivialism of turn-of-the-century styles. Through Matisse, in particular, French painting began ambitiously once again to address itself to the major intellectual and psychological concerns of its long tradition.

In the years after 1908, the various participants in the Fauve exhibitions turned towards other goals and developed individual styles. Some of the most unmanageable Wild Beasts became visibly tame and thus satisfied to work in minor modes. Derain, Vlaminck, and Dufy all developed less controversial and far less "difficult" formal solutions. Only Braque, under the stern discipline of Cubism, and Matisse, in response to his own uniquely exacting standards, had the strength of artistic personality and sustained inventive capacity to continue making pictorial **left: 173.** Raoul Dufy. *Flag-decked Boat.* 1904. Oil on canvas, 26⁷/8 x 31⁵/8". Musée du Havre. Gift of Mme Dufy.

below: 174. Georges Braque. Landscape at la Ciotat. 1907. Museum of Modern Art, New York. Purchase

opposite: 175. Henri Matisse. Joy of Life (Bonheur de vivre). 1905–06. Oil on canvas, 5'6¹/2" x 7'9³/4". Barnes Foundation, Merion, Pennsylvania.

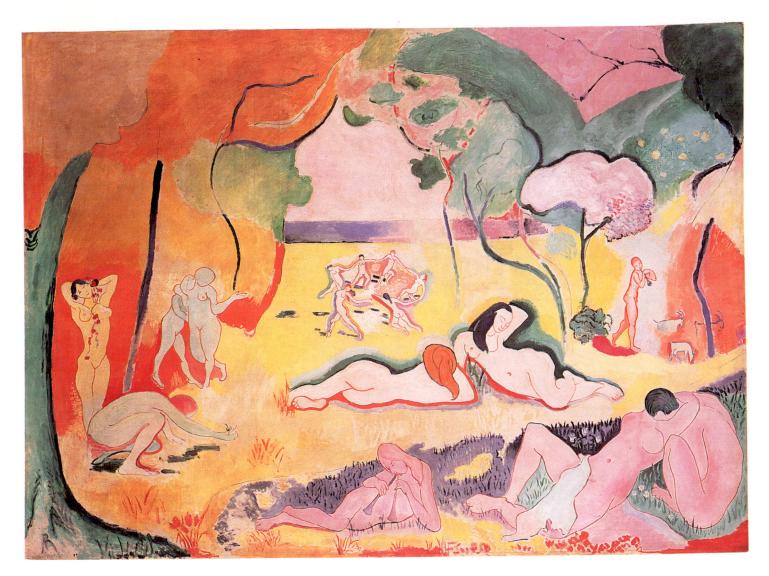

progress, propelled by the tremendous thrust Fauvism had provided. Of the original group, it was Matisse who showed the most consistent development and was able to build constructively on the pure color expression of his Fauve period.

Even while his Woman with the Hat was goading Parisian tempers, Matisse had begun a major composition that was to go well beyond his first Fauve work. The painting Joy of Life (Bonheur de vivre) was completed for the spring 1906 Independents Salon (Fig. 175). Here, on an immense canvas, measuring almost 6 by 8 feet, Matisse abandoned the immediate, everyday world favored by early Fauvism and returned to the serene, sensuous, timeless realm of Luxe, calme et volupté (Fig. 165), now, however, purified even of the reality of modern picnickers on a beach at Saint-Tropez. Indeed, he reached back to some ancient Arcadia-through the great line of pastorals and bacchanals descended from Giorgione and Titian by way of Poussin, Ingres, and Gauguin's Tahitian Golden Age-to embrace a universal, classical theme that allowed him, just as it had Cézanne (Fig. 34), to monumentalize feeling without eliminating it. And Matisse did so stimulated in part by the primitive art he had begun to collect. The effect of this shift away from close dependence on nature was catalytic, for, as Gauguin had proved, it prepared the artist to achieve an art more idealabstract-than ever before. From the outset, Matisse and Derain had wanted to realize a drawing style comparable in its linear freedom to Fauvism's flat, "wildly" independent colors, which in Joy of Life assume the radiant beauty of lavender-pink sky and azure sea set within an overall tonality of golden yellow. And so, just as color is distributed in broad, flat planes in order to express vast, open space and large, deep-breathing movement, the artist's sinuous Art Nouveau line describes the figures as volumetric while their rhythmic contours link up to a surface pattern of flowing arabesques. And just as these define a stabilizing central pyramid—arching trees in a wood clearing—they also run free at the perimeters in a dynamic play of curves and countercurves, knitting together what actually are a series of separately conceived figure groups, vignettes isolated by their colors as well as by their contradictory scales.

The sheer sumptuousness of it all is perfectly matched to the picture's theme—nude celebrants of life's joy who seem still even as they embrace and dance in a ring to the piping of a goatherd— a theme through which Matisse seemed to declare his life-long desire to make his art both a symbol and a creator of human contentment. It also expressed the analogy that, in "Notes of a Painter," he would draw between nature, music, and his art:

I cannot copy nature in a servile way. I must interpret nature and submit it to the spirit of the picture. From the relationship I have found in all the tones there must result a living harmony of colors, a harmony analogous to that of a musical composition.

If this seems a revival of the correspondences sought by Symbolism, it moved clear of the theory-ridden, hothouse atmosphere of *fin-de-siècle* art into the robust calm and lucidity of Cézanne-inspired classicism. The music that *Joy of Life* must be likened to is Debussy's *Afternoon of a Faun* (1892) or Ravel's Daphnis and Chloe (1909–11). Thus, despite the stylistic conflicts typical of Fauve painting—those of modeling and perspective, for instance—Joy of Life created a sensation at the 1906 exhibition and entered history as one of the great breakthrough pictures of modern art. After joining the collection of Gertrude and Leo Stein, where the leading artists of avant-garde Paris could see it, the painting almost certainly stirred Picasso to attempt his own, even more radical test, *Les Demoiselles d'Avignon* (Fig. 226), which too became a major landmark along the route to high modernism, a work long thought of, but recently disputed, as the very seedbed of Cubism.

The next year, in 1907, Matisse sent to the Autumn Salon a figure composition that was yet more stark in design and primitivist in its brutal power, the influential *Music (Study)* (Fig. 176). ties."¹³ As for the eye-smacking color scheme of sapphire-blue sky, fiery terracotta figures, and grass of dazzling green, Matisse made these summary remarks to the Paris editor Christian Zervos: "For the sky, the bluest of blues (the surface was colored to saturation, that is to say, up to a point where the blue, the idea of absolute blue, appeared conclusively), and a like green for the earth and a vibrant vermilion for the bodies."¹⁴ Color saturation over an immense surface and "the idea of absolute blue," or some alternative "absolute" hue, became the keys to the artist's chromatic intention, rather than the ever-changing, broken, multicolored surfaces of his early Fauve period.

A simpler polyphony of color, a cruder, yet still elegant figuration (which more than anything else suggests the lively figures and moving line of Attic or Etruscan vase painting), and a deco-

opposite left: 176.

Henri Matisse. *Music (Study)*. 1907. Oil on canvas, 28³/4 x 23⁵/8". Museum of Modern Art, New York. Gift of A. Conger Goodyear in honor of Alfred H. Barr, Jr.

left: 177.

Henri Matisse. Dance. 1910. Oil on canvas, 8'5³/4" x 12'2¹/4". Hermitage Museum, St. Petersburg.

Of this painting, which Leo and Gertrude Stein first acquired, Alfred Barr wrote in his classic monograph: "Few paintings by Matisse have greater germinal significance than this canvas. . . . For this small composition not only anticipates the subject of two of Matisse's greatest works, the *Dance* and *Music* of 1910... but also their style."¹²

With Music (Study) Henri Matisse began a period of monumental painting that would culminate in the two great wall decorations-or, rather, oils designed for a wall surface-cited by Alfred Barr. These murals were commissioned by the artist's great Russian patron, Sergei Shchukin, a wealthy textile merchant who in time acquired thirty-seven paintings by Matisse. In Dance (Fig. 177), as in Music, Matisse sought a more radical and consistent simplification of form and design, again emphasizing a sinuous arabesque of line and immense, uniform areas of pure color, but now charged with an expressive vigor absorbed from African sculpture, a recent "discovery" that had become the rage of artistic Paris. Matisse himself understood that these reductions were meant to intensify his sensations before nature and the human model. He had written how his methods differed from those of the Impressionists: "A rapid rendering of a landscape represents only one moment of its appearance. I prefer, by insisting on its essentials, to discover its more enduring character and content, even at the risk of sacrificing some of its pleasing qualirative unity by means of rhythmic line, all on a grand scale, were the astonishing new elements of Matisse's expression. They fused into a monumental style that combined powerful expressiveness and refinement, blunt directness, and aesthetic subtlety. The grandeur of Matisse's aspiration was echoed in Paris only by Picasso and the Cubists. Not since the last great canvases of Gauguin and Cézanne had a French artist tried to achieve such an ambitious expression or go so far beyond easel painting.

A strong and independent artist, Matisse had grown all the more so by virtue of the challenge then being put to this whole concept of art. By 1907-08, following a brief period as "King of the Fauves," the artist had found himself aesthetically isolated as, one by one, most of his associates banished color and took up the rigorously analytical approach then being formulated by Picasso and Braque, largely in response to the recently discovered art of Cézanne. But Matisse had owned a small Cézanne Bathers since 1899, and, more than anyone else, understood the essential truth of Cézanne: that color by itself could create the full range of effects which other pictorial elements separately evoke-depth as well as flatness, contours as well as planes, the substantive as well as the illusory. Altogether, color made possible a purely optical or pictorial kind of reality, and once Matisse had taken possession of this fact, he rarely relinquished it in the art of his mature career. It permitted him, as we shall see (Figs. 380-388), to produce pic-

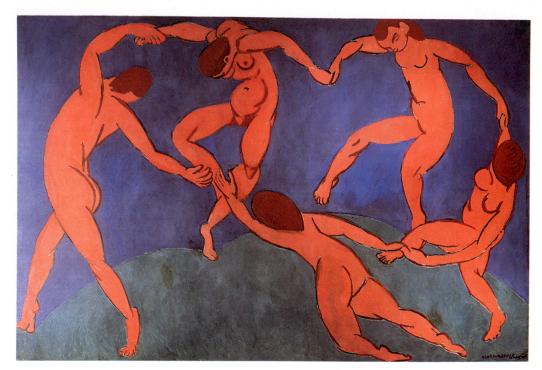

opposite right: 178. Henri Matisse. The Red Studio. 1911. Oil on canvas, 5'111¹/4" x 7'2¹/4". Museum of Modern Art, New York. Mrs. Simon Guggenheim Fund.

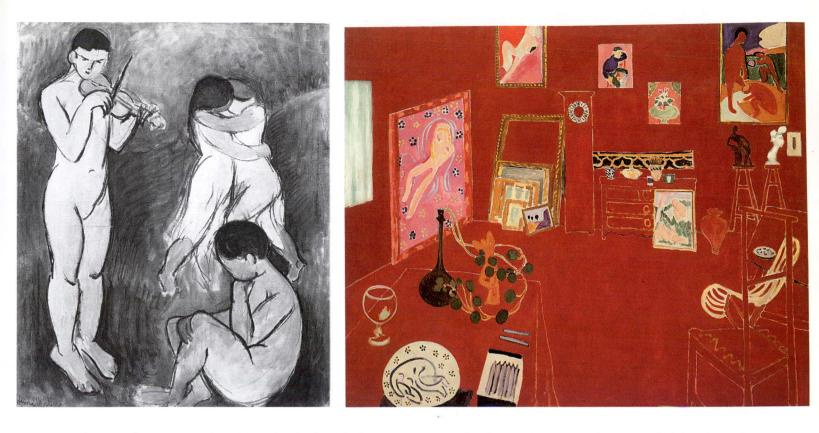

tures of extraordinary ease and opulence, but far from facile, the new works would be enriched and deepened by the artist's own heroic, Cézanne-like struggle to realize a vision of the world—an increasingly dark and troubled world—purified of all but its sensuous beauty.

Matisse went to Munich in 1910 to see an exhibition of Islamic art and made a careful study of the rugs, aquamarines, textiles, and other Eastern objects d'art. The next winter he visited Morocco and then repeated the trip in the winter of 1912–13. His response, like that of Delacroix and Renoir, to the violent color, brilliant light, and lush nature of North Africa was intense (Fig. 187). In conjunction with his growing interest in the ornamental and sophisticated art of the East, it led to stylistic developments based on emphatic decoration and on a more voluptuous feeling for color. In 1911 Matisse played alternately with loaded Rococo decoration and simplified forms. He painted four interiors that show his new interests: flower-figured wall patterns in repeated curvilinear accents and flat-perspective compositions suggesting Persian miniatures and Islamic art. The last version of these related motifs, The Red Studio (Fig. 178), demonstrates again Matisse's admirable ability to simplify ruthlessly, "even at the risk of sacrificing . . . pleasing qualities." As in Music and Dance, he again insisted on a single color statement, this time by steeping his canvas in a vibrant brick red. Against this ground he set many small elements of form and color: a twining green and yellow plant, the outlines of various studio objects and canvases hung on the wall or resting on the floor, which contribute a variety of touches of pink, green, and lemon yellow to the general harmony. Each object is a suggestive cameo and an apparently isolated element, yet each plays its part in the general decorative ensemble and subtly relieves, with a new accent, the overall sonorous red ground.

In *The Red Studio* Matisse converted a decorative, miniaturist style into something grave and monumental. Here, deliberate intellectual control is imposed on color sensibility, limited to a narrow tonal scale, and space is simply diagrammed by bare outlines of form, yet without monotony, the oblique angle the draw-

ing implies flattened by the continuous, underlying sheet of surface hue. A number of small compositional elements are scattered over the large surface, each intact and apparently unrelated. In conjunction they make new patterns and suggest a general movement. Matisse has intellectualized and refined his Fauve chromaticism and yet avoided any rigid schematization. In fact, he seems to have been trying to balance an apparently anarchic effect in his disposition of forms and colors within a very calculated formal pattern. This was Matisse's way of keeping alive his Fauve spontaneity and, to go further back in time, the "freedom" of Impressionist selection. With its shocking and deceptively simple composition, soaked in flat but brilliant monochromy, The Red Studio provides a bridge leading from the tradition of the studio interior that began with Gustave Courbet to the mid-20th-century tradition of Color Field Painting, where by the sheer evidence of personal sensibility artists would inhabit their works more than ever before (Figs. 496, 497).

Matisse wished to be less synthetic than the more controlled Post-Impressionists and to restore to painting instead the freer sensibility of the Impressionists by following the random dictates of his senses. But he also wished to avoid the excessive informality and objectivity of their rather diffuse, amorphous painting. With extraordinary originality he was able to achieve a modern synthesis of these contrary pulls: to organize the senses by the intelligence and to stimulate the mind by fresh perceptions based on nature. In The Red Studio all the little visual data of the room refresh the eye and keep it moving from one pictorial element to another. There are two characteristically French phrases which together might well define the tonic qualities of Matisse's art: arrière-pensée and l'imprévu, the utmost calculation and the unexpected. Active intelligence and an equally active sensibility, ever susceptible to new impressions, exist together harmoniously in the best of his paintings. The Cubists had comparable aims but achieved them by totally different means. By 1911, however, just as Matisse, in his own way, was attaining pictorial structures as firm and grave as theirs, the Cubists were beginning to rediscover the power and gaiety of color.

Expressionism in Germany: The Bridge and the Blue Rider

n many respects so similar to the Fauve works of Matisse, the Expressionist art first produced in 20th-century Germany is readily distinguishable from that of the French master by the clear absence of the latter's balance of intellectual control and response to an harmonious natural world. French and German Expressionism shared certain formal elements, and had a common source not only in Jugendstil-Art Nouveau decorative manner-but also in the more emotional or expressive aspects of the art of Gauguin, van Gogh, and even Cézanne. German artists, however, enjoyed a far less effective and moderating tradition of realism, and thus had little taste for pragmatism and logical analysis, processes inherited from the humanist Enlightenment and firmly fixed as the solid underpinning of French artistic values. The ideals that dominated German art were both more abstract and more individualistic; thus, when the experimental spirit in Germany embraced modernism, it did so in forms that were more obsessive and quirky than anything created in France.

Standing apart from the humanist, classically based Mediterranean civilizations of France and Italy, northern European art had its own strong visual traditions, going back to the spiritually charged art of such late Gothic masters as Grünewald, Schongauer, and Dürer, and continuing in the intensely felt works of not only van Gogh but also the Norwegian Munch, the Belgian Ensor, the Swiss Hodler, and the Austrian Klimt (Figs. 51–59, 81–84). What this tradition gave to young German artists at the outset of the new century was an overriding interest in psychology as subject matter, in an emotional content that, for its tragic power and almost clinical ability to lay bare the depths of tormented, even pathological, personality, went far beyond Matisse's sensible restraint. Given this orientation, German artists contemporary with the Fauve experiment could respond only superficially to the formalist aesthetic then dominant in France.

The anguished sensibility that since the Middle Ages had made German art the antithesis of Gallic rationality, alternating between profundity and bathos, found definition, interestingly, in two important books just at the time the Expressionists achieved public recognition. These books, written by the German art historian Wilhelm Worringer, gave primacy to what the author was to call "the transcendentalism of the Gothic world of Expression."¹ Worringer's two treatises, *Abstraction and Empathy* (1908) and *Form in Gothic* (1912), became decisive documents in the development of German Expressionism, especially as this erupted in the paintings and prints of the Bridge, a utopian group assembled in Dresden.

Unlike France, where all artistic activity gravitated toward Paris, Germany, thanks to its long political and historical discontinuity, had always generated art and culture in a variety of centers, not only Dresden but also Düsseldorf, Berlin, and Munich. With Berlin held back by the reactionary and authoritarian presence of the Emperor, Munich in the 19th century assumed a premier position, its relatively liberal academies and museums fostering an enlightened patronage and attracting a cosmopolitan array of students, many of them from Russia and the United States. Here, Worringer's ideas had been preceded by those of Konrad Fiedler, who, in an influential essay entitled "On Judging Works of Visual Art" (1876), advocated a more purposeful aesthetic capable of connecting perceptual and cognitive faculties with spiritual values. He argued that "interest in art begins only at the moment when interest in literary content vanishes. The content of a work of visual art that can be grasped conceptually and expressed in verbal terms does not represent the artistic substance which owes its existence to the creative power of the artist." Restated as recently as 1893 in The Problem of Form in the Plastic Arts, a book by the sculptor of Adolf von Hildebrand, such notions created an intellectual atmosphere favorable to the almost spontaneous generation of the Blue Rider. The leader of this group, Vasily Kandinsky, would, for the sake of heightened spiritual meaning, organize colors according to their inherent expressive qualities, as free of the need to illustrate the phenomenal world as musical sound. Here the word meaning is important, for while the Expressionism of both France and Germany led eventually to complete abstraction, the deeply subjective German-based painters, unlike the objective, analytical French, would never concede that even the most autonomous, or nonrepresentational, forms might be less than symbolic of something greater than themselves.

Die Brücke

The first systematic evidence of the incursions of the Gothic spirit into modern German art came with the banding together in Dresden of four artists, all in their twenties: Ernst Ludwig Kirchner, Karl Schmidt-Rottluff, Erich Heckel, and Fritz Bleyl. They had found common interests in Munch as well as in primitive and folk art. In 1906-the year after the Fauves' debut-they exhibited together in a disused chandelier factory, calling themselves Die Brücke ("The Bridge"), by which they meant to express a sense of their art as a revolutionary link between the present epoch and the creative future. The most vital expressive forms of high art of the past as well as the artifacts of primitive cultures were viewed as part of a new, all-embracing creative program. Writing to Emil Nolde to invite him to join them, Schmidt-Rottluff amplified the intentions of the Bridge group: "One of the aims of the Bridge is to attract all the revolutionary and surging elements-that is what the name . . . signifies."² And, in a memorable declaration of principle on the occasion of their first public exhibition, Kirchner reached out to form a new community, especially among the young, of related and responsible spirits: "With faith in the development and in a new

generation of creators and appreciators we call to all youth. As youth, we carry the future, and want to create for ourselves freedom of life and of movement against the long-established older forces. Everyone who with directness and authenticity conveys that which drives him to creation belongs to us."

Written to attract support for the first exhibition of the Bridge, these words might have been used as a credo for young artists throughout Germany in the years before World War I. New ideas were abroad, new attitudes toward man and society, calling for exciting new means of expression. Socially, the young artists were publicly protesting the hypocrisy and materialistic decadence of those in power. In art, they were rebelling against the old tyranny of the Academy and the new tyranny of Impressionism and Neo-Impressionism, whose tasteful, painted tapestries of bright color no longer seemed meaningful in the fast-moving, amoral, machine-age world in which the emerging generation suddenly found

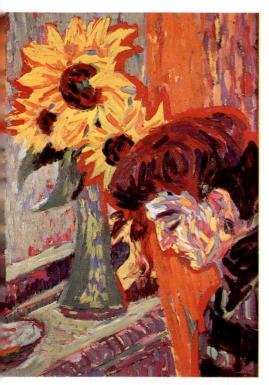

left: 180. Ernst Ludwig Kirchner. Woman in Front of a Vase of Flowers. 1906. Oil on canvas, 271/4×195/8 Collection Franz Burda, Offenberg.

right: 181. Ernst Ludwig Kirchner. Self-Portrait with Model. 1910/26. Oil on canvas, 4'10⁵/8"×3'3" Kunsthalle, Hamburg.

below: 182. Ernst Ludwig Kirchner. Street, Berlin. 1913. Oil on canvas, 471/2×357/8 Museum of Modern Art, New York. Purchase.

itself. The new art in Germany attempted, above all, to be honest, direct, and spiritually engaged. Potent decorative impact, heightened emotional intensity, compelling abstract symbolism, and brutally honest craftsmanship were the chief means to these new ends, and all of the strategies showed an acquaintance with the paintings of the Fauves.

The Bridge was conceived both as a return to the medieval cooperative craft guild and as a 20th-century approach to art. Drawing not only from European sources, but also from the art of Africa and Oceania, its members strove to intensify humanity's realization of itself and nature through jarring contrasts of color, jagged, slashing lines, and forced distortion of natural forms. Primitivism pervades the paintings of these artists, not only in the deliberate crudity of technique, but also in the choice of subjectsthe low life of the streets, the naked form, male and female, often in a woodland setting (Fig. 188). The subject matter was nearly always transformed, however, into new levels of meaning by the consistent distortion and bold, painterly treatment of the forms.

Ernst Ludwig Kirchner (1880-1938) was the acknowledged spiritual leader of the Bridge. His work is perhaps the most characteristic of the group, beginning with a kind of emotionally charged decorative style, very close to Fauvism (Fig. 180), then turning progressively to human commentary, to psychological exploration, often in self-portraiture (Fig. 181), and finally to a quieter, more formalized style close to Cubism (Fig. 182).

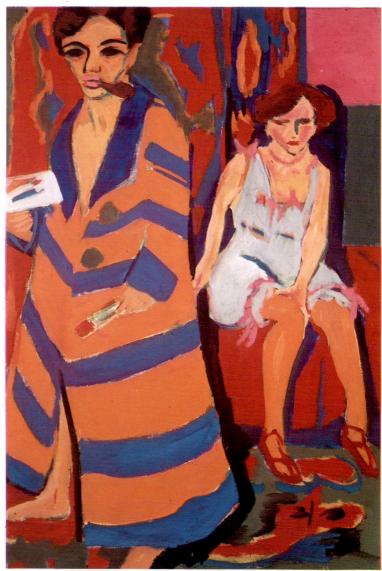

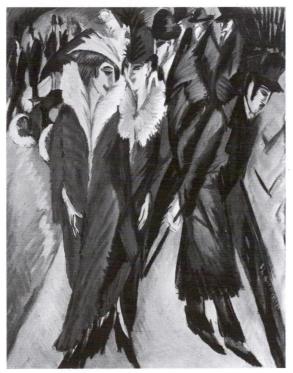

The works of Erich Heckel (1883–1970) are often very close to those of Kirchner, although his subjects are sometimes more lyrical and sometimes more penetrating psychologically than Kirchner's, as here (Fig. 183), in an illustration of Ivan's story of Christ and the Grand Inquisitor from Dostoevski's *Brothers Karamazov*. If Heckel is the most poetic of Bridge members, Karl Schmidt-Rottluff (1884–1976) is the most earthbound—the most authentically "primitive"—but his rough-hewn forms carry few psychological overtones (Fig. 184).

In 1906, soon after the foundation of the Bridge, Emil Nolde (1867–1956), an older artist who had independently arrived at a similar attitude toward art, was invited to join the group. His impact was immediately felt, although he remained associated with them less than two years. Working primarily with strident con-

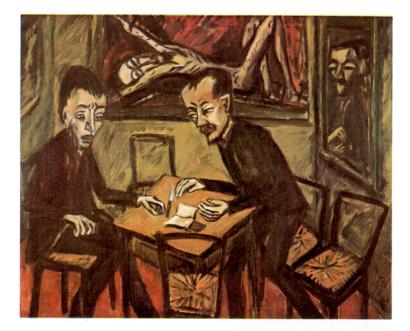

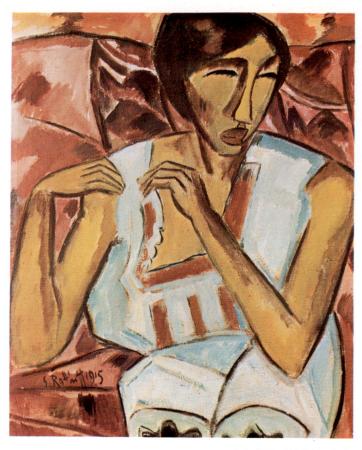

left: 183. Erich Heckel. Two Men at a Table. 1912. Oil on canvas, 38½ × 47¼". Kunsthalle, Hamburg.

above: 184. Karl Schmidt-Rottluff. Woman at Her Toilette. 1915. Oil on canvas, 35½×297%". Kunsthalle, Hamburg.

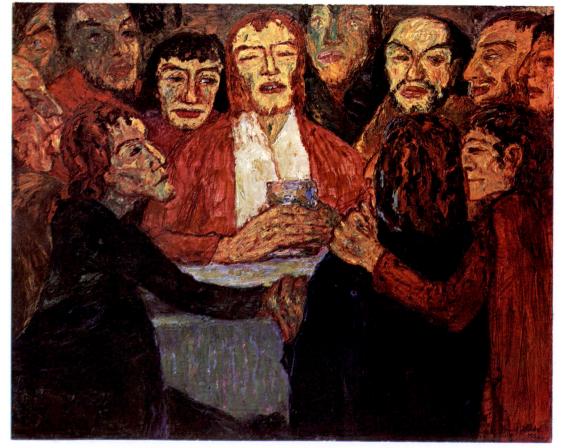

185. Emil Nolde. The Last Supper. 1909. Oil on canvas, 32% × 41¾". Nolde Foundation, Seebüll.

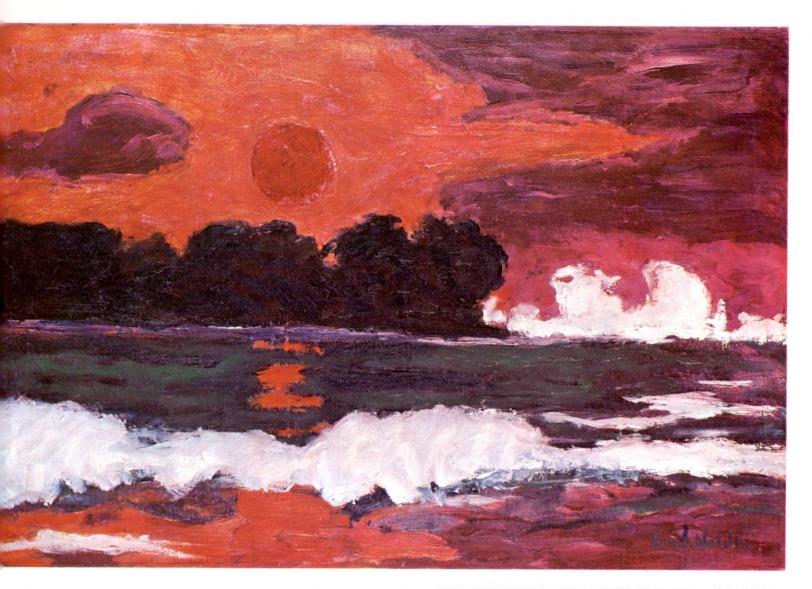

trasts of color, Nolde created visions charged with almost unbearable emotional power. His most impressive paintings are those that depict the life of Christ—especially the series executed between 1909 and 1912. In *The Last Supper* (Fig. 185) Christ and his disciples are portrayed as simple German peasants, in a primitive vision matched by the childlike crudity and simplicity of this powerful painting. Unmixed colors are laid down directly on canvas; the composition is clumsy but sure, the painterly (*malerisch*) touch rugged and unrefined. In Nolde's later work, religious emotion is transferred as a kind of pantheistic aura to landscape—the marine views of his native Seebüll, with its stormy seas and threatening cloud banks (Fig. 186). It is extraordinary how much emotion and what overtones of impending visionary events Nolde could inject into a subject matter that would have suggested serene and idyllic nature even in the hands of the Fauves.

Max Pechstein (1881–1955), also admitted to the Bridge in 1906, had the greatest commercial success, possibly because he responded to the influence of French art and hence was more decorative and less brutal than his associates (Fig. 190). Otto Müller (1874–1930), the last painter to join the Bridge, shared the primitivism and the technical approach of the other artists but was interested primarily in depicting the nude, which he painted in endless variations in natural settings with muted and harmonious colors. An example of the difference in expressive content of the Fauve and Bridge painters can be seen in a comparison of Matisse's *Blue Nude* (Fig. 187) with Müller's *Three Bathers* (Fig. 188). The Ger-

top: 186. Emil Nolde. *Tropical Sun.* 1914. Oil on canvas, 27¹/₂ x 41³/4". Nolde Foundation, Seebüll, Germany.

above: 187. Henri Matisse. Blue Nude ("Souvenir de Biskra"). 1907. Oil on canvas, 3'1/4" x 4'71/8". Baltimore Museum of Art. Cone Collection, formed by Dr. Claribel Cone and Miss Etta Cone of Baltimore, Maryland.

left: 188. Otto Müller. Three Bathers. c. 1915. Distemper on canvas. Collection Gebhard, Wuppertal.

right: 189. Ernst Ludwig Kirchner. Head of Ludwig Shames. 1918. Woodcut, 22⁷/₈ × 10¹/₄". Museum of Modern Art, New York. Gift of Kurt Valentin.

below: 190. Max Pechstein. Landscape. 1919. Woodcut. Institute of Art, Detroit.

opposite: 191. Vasily Kandinsky. Cover for The Blue Rider Almanac. 1912. Woodcut, 11½ × 8½".

man figures look naked and vulnerable, and hence introduce questions concerning the place and propriety of undressed figures in modern life—and, indeed, the whole northern European mystique of nudity and health. Even Matisse's rather brutal image, the product of a sojourn in North Africa, is more serene and ideal by comparison, and lacks the Germans' social or psychological connotations.

Between 1905 and 1911 most of the Bridge artists worked, and often lived, together in Dresden and in the nearby countryside. They published a number of portfolios and re-established the woodcut as an important art form in Germany. This is dramatically illustrated by Kirchner's searching characterization of the art dealer Ludwig Shames (Fig. 189), with its obvious dependence on such German Renaissance masters as Dürer and Schongauer, as well as by Pechstein's *Landscape* (Fig. 190), with its exploitation of the block's natural grain. By the end of 1911 the artists had moved to Berlin. Within two years they would mature in different directions and, given the tensions of the prewar period, find it impossible to maintain the group spirit any longer. The Bridge dissolved in 1913.

Der Blaue Reiter

Munich was a much more important art center than Dresden in the early years of the century. It drew innumerable artists from many countries—Russia, Switzerland, Austria, and even the United States—and exhibitions of Post-Impressionist, Fauvist, and Cubist art from France could be seen in the art galleries. The artists who formed the second major German Expressionist group, *Der Blaue Reiter* ("The Blue Rider"), were quite naturally more sophisticated, more intellectual, and less primitivistic than the members of the Bridge. Instead of seeking to evoke emotional intensity through

impact and distortion, the Blue Rider stressed the spiritual and symbolic properties of natural and abstract forms.

Primarily an informal association of highly gifted individuals who believed in freedom of expression and experiment, the Munich group wanted assurances that proper opportunities could be created to exhibit their work. When the NKV (*Neue Künstler Vereinigung*, or "New Artists Federation"), of which they were among the earliest members, proved too conservative, Vasily Kandinsky, his longtime companion Gabriele Münter, and Franz Marc together organized their own exhibition, which opened in December 1911 under the rather enigmatic title "First Exhibition of the Editorial Board of the Blue Rider."

The Blue Rider rubric also appeared on the almanac that Kandinsky and Marc had been planning for some time, and which they finally managed to publish in May 1912 with an abstract drawing by Kandinsky of a mounted horseman in blue and black on the cover (Fig. 191). According to Kandinsky, "we both loved blue, Marc also loved horses and I horsemen. So the name came by itself."4 This collective volume of aesthetic studies contained illustrations of Bavarian peasant art, primitive art, Gothic sculpture, early medieval woodcuts, and paintings by El Greco (the subject of a monograph written by August Mayer and published that year), as well as paintings by Cézanne, Rousseau, and Picasso. Even more ambitious perhaps than the Bridge, the Blue Rider artists wished to assimilate and synthesize the far-ranging interests and influences of modern art. Under the leadership of Kandinsky and Marc, the group expanded to include August Macke, Heinrich Campendonk, and Gabriele Münter in 1911, and in 1912 Paul Klee had a small drawing reproduced in the Blue Rider Almanac. September 1913 saw the opening at the Sturm Gallery in Berlin of a large and influential exhibition called the "First German Autumn Salon." Among the many groups of artists representing a great variety of tendencies, the Blue Rider members stood out along with two painters newly recruited to their program, Lyonel Feininger and Alexej Jawlensky, the latter a friend and fellow countryman of Kandinsky's. Although the Blue Rider existed officially for only two years, it produced publications, exhibitions, and aesthetic theories that have profoundly affected the art of our time.

If one may hazard a generalization, the Blue Rider artists can be said to have combined in their styles Cubism's geometric structure with the pure, painterly color of Robert Delaunay (Fig. 250) and the Fauves, to which they added a distinctly Teutonic brand of vehement emotionalism and "spirituality." Delaunay's brilliant color disks and rhythms were more systematically ordered and showed a Gallic reserve in comparison with Kandinsky's somewhat parallel manner (Fig. 195). Where the Futurists would exalt modern life and the machine age (Figs. 257-263), expressing a disillusionment with humanistic sentiment, the German artists now turned aside from man to find their solace and inspiration in a more primitive nature, or in an animal mysticism. Marc, an artist celebrated for his animal themes (Figs. 196, 197), wrote: "The impure men and women who surround me . . . did not arouse my real feelings; while the natural feeling for life possessed by animals set in vibration everything good in me."5 Such primitivistic urges, and the forceful artistic means through which they were expressed, perhaps could be related to the remote example of Gauguin. Marc's style, however, was given a stricter formal decorum as the result of his assimilation of Cubist painting, and his whole psychology of expression, and essential mysticism, as we shall see, had other sources and more atavistic meanings.

Vasily Kandinsky (1866–1944) provided the Blue Rider with its guiding spirit and main theorist; he also gave the group its most radical inventor of plastic form. After painting rather freely distorted but still representational landscapes in opulent color, generally in the Fauve manner (Fig. 192), he began in 1910–13 a series

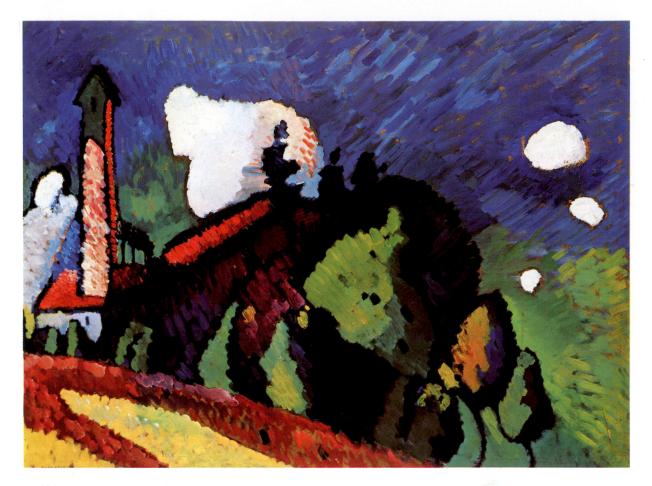

of progressively more liberated and abstract "improvisations" (Fig. 193) that by the end of 1913 would produce what were the first free-form, largely nonobjective art of the new century (Fig. 195). It was Kandinsky who literally fulfilled Maurice Denis's prophecy that Fauvism would lead to a "search for the absolute." In 1911 he had written "Concerning the Spiritual in Art," which appeared in Der Blaue Reiter in 1912. This essay elaborated on his aesthetic ideas and, for the first time, gave theoretical sanction to a nonillustrational art. Kandinsky methodically elucidated his abstract art of pure color and form relationships in terms of spiritual and "musical" ideas. His romantic point of view may be associated with Symbolist doctrine and Gauguin's statement that "color, which is vibration, just as music is, is able to attain what is most universal yet at the same time most elusive in nature: its inner force."6 Kandinsky similarly stressed the inwardness and intuitional qualities of his style of painting, and utilized the arabesque and free color lyricism stemming from both Symbolist and Fauve art. Paintings, he held, should be created in a state of inner tension and looked upon as "graphic representation of a mood and not as a representation of objects." The spiritual and introspective aspects of his art were to have a profound effect on the developing Expressionist tendencies in Germany.

One also finds, most interestingly, a certain utopian idealism in Kandinsky's discussions of abstract art, which recurs somewhat later in Piet Mondrian's writings about his own machine-oriented, totally different style (Figs. 276, 277). Both artists, in fact, treated abstraction as an evolving blueprint for a more enlightened and liberated society. Kandinsky sought this literally during long sojourns in the Bavarian peasant village of Murnau, where he followed Gabriele Münter (1877–1962) in her attempts to emulate the brilliant colorism, simple manner, and spiritual purity of the local *hinterglasmalerei*, a variety of painting on the underside of glass (Fig. 194). In his treatise, Kandinsky wrote: "We have before us an age of conscious creation, and this new spirit in painting is going hand in hand with thoughts toward an epoch of greater spirituality."⁷ From Gauguin and Symbolist painting to Kandinsky, a growing process of abstraction in painting was linked to an undercurrent of mysticism and romantic transcendentalism. The artistic productions of this tendency gave renewed emphasis to irrationality, to an occult spirituality—which almost hysterically opposed the materialism of the age—and to creative intuition, reflecting the emergent German reputation of the popular French philosopher Henri Bergson, whose exaltation of *élan vital* (see p. 23) had become a routine feature of studio talk by 1910. In many ways, these concerns anticipated the Surrealists' conception of artistic creation as an essentially subconscious experience or process, an idea that in turn would provide such a powerful catalyst for the New York School after World War II.

Kandinsky's crucial breakthrough into nonobjective painting that is, to an art emancipated from the motif—was achieved in direct association with the elaboration of his rather complex aesthetic theories. The philosophical justification of a wholly abstract art was empirical in origin, for it grew directly from an experience in Moscow in the 1890s, when Kandinsky saw at an exhibition one of Monet's Grainstack paintings, and never forgot the impact it had on him. Later he wrote: "Deep inside me was born the first faint doubt as to the importance of an 'object' as the necessary element in painting."⁸ It was Fauvism, however, with whose exponents he became acquainted in a lengthy stay in Paris, that provided Kandinsky with the decisive clue that color could be liberated entirely from the object.

The process of dispensing with subject matter in favor of an autonomous pictorial expression, freed from descriptive function, marks such an important historical moment in the evolution of modern art that it is worth pursuing in even more detail. The moment of decisive revelation for Kandinsky came about 1910 when he viewed one of his own landscapes, painted in the countryside around Munich, in an unfamiliar context and had eyes only for its abstract presence and values. He explained this important experience thus, as one who has found a new faith might describe his moment of conversion:

I was returning from my sketching, deep in thought, when, on opening the studio door, I was suddenly confronted with a picture of indescribable, incandescent loveliness. Bewildered, I stopped, staring at it. The painting lacked all subject, depicted no recognizable object and was entirely composed of bright patches of color. Finally, I approached closer, and only then recognized it for what it really was my own painting, standing on its side on the easel. . . .

One thing became clear to me—that objectiveness, the depiction of objects, needed no place in my paintings and was indeed harmful to them.⁹

In his abstract "improvisations" executed in the years 1913– 14, therefore, Kandinsky initiated the fateful process of abstract-

opposite: 192. Vasily Kandinsky. Landscape with Tower. 1909. Oil on cardboard, $28\frac{3}{4} \times 39\frac{1}{4}$ ". Private collection, Paris.

below: 193. Vasily Kandinsky. Composition IV. 1911. Oil on canvas, 5'2¾" × 8'11½". Kunstsammlung Nordrhein-Westfalen, Düsseldorf.

right: 194. Gabriele Münter. The Lady and Her Son. 1912. Painting on glass, 6 × 4½". Courtesy Leonard Hutton Galleries, New York.

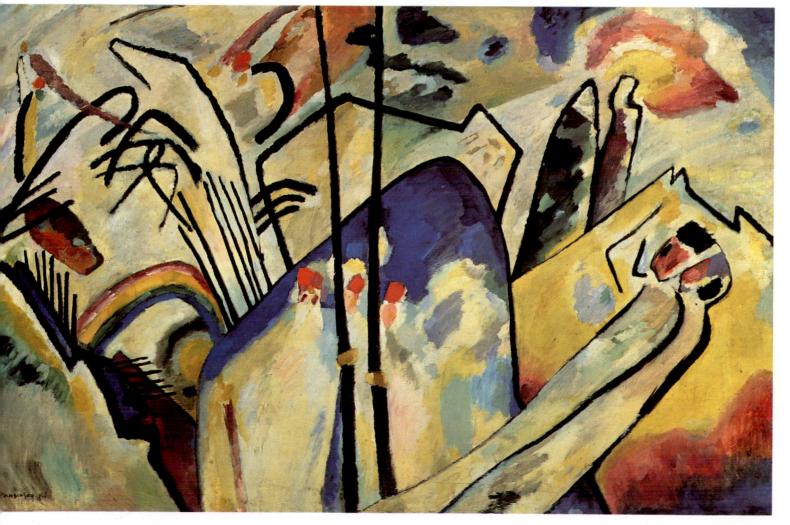

ing natural appearances to create an autonomous structure (Fig. 195), where we can see line and color take on an independent existence, creating dynamism and rhythmic movements that reflect inner agitation rather than observed events or a rational spatial experience. Kandinsky's halting progress toward abstraction, which today we so readily take for granted, was linked with deeply held spiritual views, views whose simplistic, theosophical bias has today fallen into intellectual disrepute. Yet the naïveté of Kandinsky's mystical aspiration and theory should be taken as a measure of the difficulties a sincere man of the spirit might have encountered in overcoming the oppressive materialist assumptions that dominated thought and values in the early years of the century.

Franz Marc (1880–1916), like his colleague Kandinsky, pursued spiritual and mystical values through art, but his symbolism

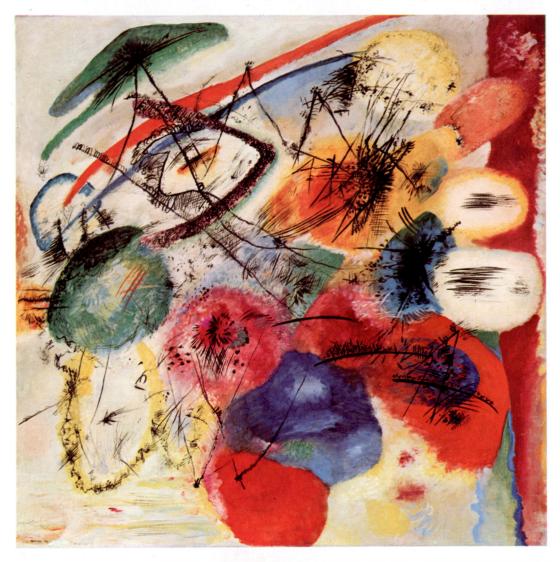

left: 195. Vasily Kandinsky. Black Lines. 1913. Oil on canvas, 4'3" × 4'3%". Solomon R. Guggenheim Museum, New York.

below: 196. Franz Marc. Blue Horses. 1911. Oil on canvas, 3'4¾"×5'10%". Walker Art Center, Minneapolis. Gift of the Gilbert Walker Fund.

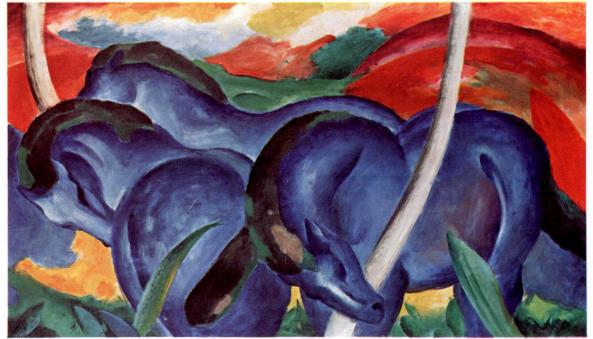

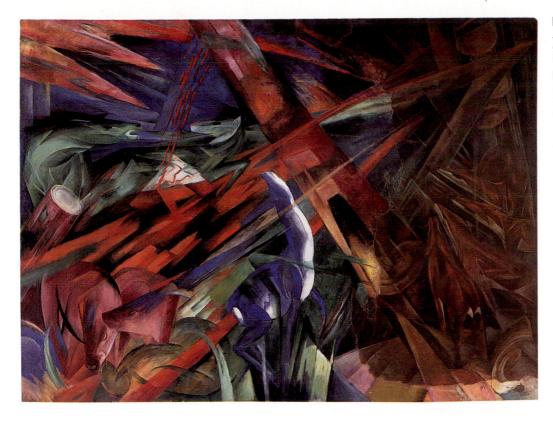

left: 197. Franz Marc. Animals' Fate. 1913. Oil on canvas, 6'4³/4" x 8'9¹/2". Kunstmuseum, Basel.

below: 198. Lyonel Feininger. Gelmeroda VIII. 1921. Oil on canvas, 39¹/4x 31¹/4". Whitney Museum of American Art, New York.

identified feeling with animal existence in nature rather than a purely abstract system of color forms (Fig. 196). He wrote: "I try to heighten my feeling for the organic rhythm of all things, try to feel myself pantheistically into the trembling and flow of the blood of nature-in trees, in animals, in the air. ... I see no happier means to the 'animalizing' of art, as I like to call it, than the animal picture."¹⁰ Thus, Marc described his enthusiasm for animals and nature, not seen from without, with normal human vision, but viewed as if one were emotionally and physically inseparable from the animal portrayed. For Marc, art had a special part to play in a world that had rejected both Christianity and 19th-century materialism. He wanted to "create symbols, which could take their place on the altars of the future intellectual religion." To do this, Marc tried at first to contrast the natural beauty of animal life with the sordid reality of man's existence. The essential mysticism of this approach, so Germanic in its sense of alienation, falls occasionally into a mawkish sentimentality. Curiously, it also raises psychological questions, as did Kandinsky's expressed disgust with the human form of the models of his student days, as to the exaggerated prudery of the artists who founded the Blue Rider.

Marc's greatest paintings, and his assured masterpiece, Animals' Fate of 1913 (Fig. 197), utilized Delaunay's intensified spectral color and a Cubist-Futurist vocabulary as a kind of formal decorum to contain and focus his poignant emotionalism. The picture's original title is written on the back: "All being is flaming suffering." In an apocalyptic holocaust, a blue deer lifts its head to a falling tree; red foxes on the right, green horses at the top left. Colors have symbolic value, as in Kandinsky, but with a different code. Blue stands for hope, but it is in the process of being extinguished just as animal life, in the forest and by implication on earth, is being destroyed by cataclysm. Shortly before his death in action on the Western Front, Marc sent a postcard of Animals' Fate to his wife. "It is like a premonition of this war," he wrote, "horrible and shattering. I can hardly conceive that I painted it. It is artistically logical to paint such pictures before a war-but not as stupid reminiscences afterwards, for we must paint constructive pictures denoting the future."¹¹

American-born Lyonel Feininger (1877–1956) joined the Blue Rider in 1913, bringing with him a firsthand knowledge of Cubism, which he transformed into a sensitive, delicate, and at times humorous version of Expressionism. The bright color and irregular forms of his early canvases gradually gave way to a crystalline structure of interpenetrating planes (Fig. 198). His love of music may have suggested the subtle rhythmic organization of his scenes of ships and cities. Upon his return to the United States, Feininger

below: 199. Alexej Jawlensky. The Hunchback. 1911. Oil on cardboard, 21½×19½". Private collection, Europe.

> right: 200. Käthe Kollwitz. Death, Woman, and Child. 1910. Etching, printed in color, 16½ × 16½". Museum of Modern Art, New York. Gift of Mrs. Theodore Boettger.

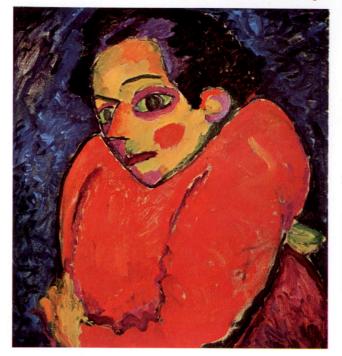

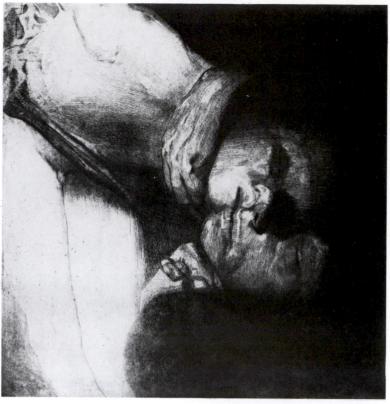

exercised widespread influence upon American art and the appreciation of Expressionism.

The oldest (albeit unofficial) member of the Blue Rider was the Russian Alexej Jawlensky (1864–1941). Preoccupied first with the decorative, then with the psychological, and finally with the spiritual qualities of the human face, as well as with the color symbolism of nature, he painted with an austerity and a monumentality unmatched in the Munich group (Fig. 199). After World War I, Jawlensky became increasingly involved in a personal, introspective, and mystical expression.

Other figures in the Blue Rider group were the Austrian fantasist Alfred Kubin, American-born Adolf Erbslöh, and the Russian Marianne von Werefkin, a former student of Ilya Repin who moved with Jawlensky to Munich and there arrived at her own decorative-mystical style of painting in flat, fire bright colors.

Independent German Expressionists

Many significant artists worked outside the organized groups before World War I. Among them were Paula Modersohn-Becker, Christian Rohlfs, and Käthe Kollwitz (1867–1943), a graphic artist of first importance, as well as a sculptor (Fig. 214), who was obsessed with the plight of the destitute and by the austere themes of suffering and death (Fig. 200). The untimely death of Paula Modersohn-Becker (1876–1907), Dresden-born but active in the Worpswede colony near Bremen, deprived German Expressionism of one of its earliest and most lyrical practitioners. An artist of deep, poetic sensibility, Modersohn-Becker was a friend of the great German poet Rainer Maria Rilke and in part through him gained access to the most advanced movements in Paris, a city she visited several times, beginning in 1901. Under the influence of Gauguin, Cézanne, and the Pont-Aven painters, Modersohn-Becker overcame the sentimentality and genre-like qualities of the Worpswede 201. Paula Modersohn-Becker. Self-Portrait with an Amber Necklace. 1906. Oil on canvas, 23%×19½". Kunstmuseum, Basel.

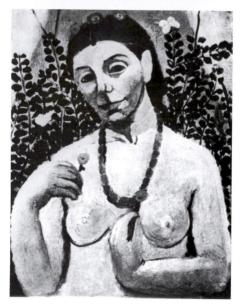

School and in her own very distinctive painting achieved a "great simplicity of form." Whether in peasant scenes, self-portraiture (Fig. 201), or images of pregnant women or nursing mothers, Modersohn-Becker used her cultivated naïeveté and economy of means to express what she called "the unconscious feeling that often murmurs so sweetly within me."¹²

Swiss-born Paul Klee (1879–1940) was the most poetic, original, and certainly the most singular artistic personality to be touched by the Blue Rider, although his relationship with the group's exhibition activities and the theories of Kandinsky and Marc was tangential. Klee participated in the 1912 publication and show, and by the following year had arrived at a virtually abstract style (Fig. 202). His art may best be understood as a form of poetic metaphor, a system of private signs that attain universal meanings (Fig. 203). Marc, whom Klee admired deeply, had impressed him with his description of the condition, or state of mind, of "sensing the under-

lying mystical design of the visible world." And Klee himself sought poetic and visual equivalents, very much like his spiritualizing Blue Rider associate, for some mystical conception of the unity of all being. In the period when he came directly under Blue Rider influence, he wrote: "What a lot of things an artist must be poet, naturalist, and philosopher."¹³ And, in his most famous statement, made during his Bauhaus years (1921–31; see Chap. 15) and symptomatic of his abiding philosophical and poetic inclinations, he said: "Art does not render the visible; rather it makes visible."¹⁴

Klee endeavored to translate his own rather precious visual meanings into universal images of both artistic and cosmic creation. (Fig. 204). He typically referred to his work at one time as "a cosmic picture book." Klee's semiautomatic techniques and hieroglyphs also offer close parallel with the emerging Surrealist movement and its practices after the mid-1920s, especially as expressed in the organic semiabstract imagery of Joan Miró (Figs. 308, 395). His imagination, however, was not directed specifically to the unconscious or to any programmatic exploration of free association. Rather, he sought signs and images for man's tragicomic predicament, in a humorous and punning fashion, without much explicit psychological content, or, alternately, he explored symbols for universal forces much as Marc and Kandinsky had done. It was this mystical aspiration that shaped his art. Essentially a fabulist, a creator of myth, but on a miniaturist scale, Klee admitted to modesty early in his career, when he spoke of preferring the "tiny, formal motif."

Technically, Klee was extremely inventive and scarcely seemed to recognize any formal limitations at all. In fact, he experimented freely in style, with various pastiches of styles, and with every sort of visual effect that came so readily to his virtuoso hand. His art is childlike, deliberately artless and unspoiled even when it evinces rare degrees of sophistication, a paradoxical quality ob-

right: 202. Paul Klee. Individualized Altimetry of Stripes. 1930. Pastel fixed with flour paste, 18½×13%". Kunstmuseum (Paul Klee-Stiftung), Bern.

above: 203. Paul Klee. Around the Fish. 1926. Oil on canvas, 18¾ × 25½". Museum of Modern Art, New York. Abby Aldrich Rockefeller Fund.

Expressionism in Germany

viously enjoyed and taken advantage of (Fig. 204). It is interesting and significant that Klee exhibited with the Blue Rider just as the group began elevating the art of children to the level of subtle and sophisticated expression by illustrating children's art in the almanac. Kandinsky and his associates equated primitivism with instinct, with innocence, and with a refusal to accept established values in society, art, or education, which institutionally seemed to betray or suppress individual truth. As early as 1902, on his return to Bern from his first visit to Italy, Klee typically wrote in his journal: "I want to be as though newborn, knowing nothing, absolutely nothing about Europe, ignoring facts and fashion, to be almost primitive."¹⁵

Early in his career, it was apparent that Klee understood that he was essentially a poet, and that his gnomic art could best be apprehended in terms of a personal search for the succinct symbol, verbal as well as visual (for his suggestive, if mystifying, titles contribute much to the resonance of his art), a symbol that would manifest fantasy, the psychic event, the reality of the unseen experience. In his paintings the metaphysical and the everyday, gentle humor and pessimism, and virtuosity and a deliberate clumsiness achieved a rare, felicitous balance. Behind Klee's mask of the child, or of the clown, lay a profound spiritual quest and a deep moral sense of the plight of man in a corrupt society, which link his work more to Expressionism than to the Freudian fantasies of the French Surrealists or to Paris-based abstract art.

Austrian Expressionism

German Expressionist art had its counterpart in the vivid and powerfully original painting of Austria. Although integrally connected with German idioms, the art of Austria preserved its own strong local accent. At the turn of the century the cultural atmosphere in the Vienna of Sigmund Freud combined excessive refinement with a stifling sense of decadence, fed by Hugo von Hofmannsthal's melancholy poetry, Richard Strauss's frenzied operas, and Franz Werfel's metaphysical quest for God in literature. Viennese art attained an introspective and neurotic content that even the most bizarre examples in contemporary Germany could scarely equal.

The Jugendstil, as we have seen, took more radical forms in Vienna, notably in the art of Gustave Klimt (Figs. 81–84), whose

204. Paul Klee. Siblings. 1930. Oil on canvas, 275¾ × 17¾". Private collection. 205. Egon Schiele. Portrait of the Painter Paris von Gütersloh. 1918. Oil on canvas, 4'7½"×3'7½". Minneapolis Institute of Arts. Gift of P.D. McMillan Land Company.

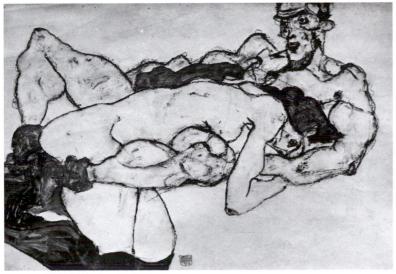

206. Egon Schiele. *Embrace*. 1913. Watercolor and gouache. Courtesy Galerie St. Etienne, New York.

Symbolist mood of despair, although perhaps not his ornate style, anticipated the Viennese Expressionists. Of these, the artist most immediately affected, if only in reaction, was Egon Schiele (1890-1918), who, however, allowed a profound emotional stress and decadent or artificial demonism, rather than suavely decorative considerations, to dictate his startling, angular, and visionary manner, so flattening and claustrophobic in effect that it makes figures seem painfully smothered in the paper or canvas surface (Fig. 205). Schiele's ungainly, contorted human images have been described, appropriately, as suffering some form of spiritual arthritis (Fig. 206). Like Thomas Mann in his novel The Magic Mountain, Schiele was preoccupied with disease and death in the midst of an apparently disintegrating society. His bizarre, maimed, grotesque, but somehow touching, figures have been described as "spiny, thorny, angular, Gothic ... the very antipodes of a world of culture and luxury."¹⁶ Thanks to draftsmanship fully as virtuosic as Klimt's, they show very powerfully the northern European anguished, sardonic, and even ghoulish sensibility, in sharp contrast to the idealizations of French artistic humanism. Schiele's unabashed emphasis on nudity and sexuality is extremely poignant in its effort to establish some kind of human communication (Fig. 206), even in apparent loveless sexual play and contact, despite the

gruesomeness of his desolated figures. But such candor got the artist in trouble with the authorities, who sent Schiele to prison for immorality, in a kind of premonitory warning of more sadistic, repressive acts to follow in Germany and Austria upon the part of the official guardians of public morality. The artist's short and tormented life ended during the influenza epidemic of 1918.

That increasing gap between public or community standards of morality and the sincere artist's psychic reality also found dramatic witness in the life and career of perhaps the most important Viennese Expressionist, Oskar Kokoschka (1886-1980). The public's incensed reaction to his paintings of 1908, followed the next year by the performance of a controversial play-a wild drama of sex and violence-compelled Kokoschka to leave Vienna. Shortly after encountering the work of van Gogh in 1906, he had begun a series of excruciatingly sensitive "black portraits" (Fig. 207), as the artist himself referred to them, which seemed to unmask and bare the soul of his uneasy sitters, often prominent personages in the social, intellectual, or artistic world of Vienna. The artist felt that his visionary portraits performed a kind of cathartic act of selfconfrontation for his trancelike victim-sitters, which forced them. therapeutically, to surrender their "closed personalities, so full of tension," in his words. "My early black portraits," he said, "arose in Vienna before the World War; the people lived in security, yet they were all afraid. I felt this through their cultivated form of living which was still derived from the Baroque; I painted them in their anxiety and pain."¹⁷ Beyond the civilized facade Kokoschka could reveal his sitter's emotional and intellectual disequilibrium. It is difficult not to relate these remarkable disclosures of personality-in-conflict with Freud's studies of the role of the unconscious in human behavior and with his insistence-long in gaining popular credence-that psychic states could be represented in objective, scientific facts. Kokoschka has been called the Freud of painting, and in Vienna it was often said: "He paints the dirt of one's soul."18

The vitality of Kokoschka's early portraiture, the precocious artistic capstone of a long and otherwise less distinguished career, is conveyed by a nervous, highly expressive, insinuating line that scratches the surface like grafitti, quivering with febrile life. Line probes the sitter's inner drama with an unmerciful and uncanny sense of the narrow boundary in human personality between sanity and madness, or, less dramatically, neurosis and normalcy (Fig. 208). His early, pre-World War I paintings, so ruthless and psychologically penetrating, created an atmosphere of nightmarish anxiety and tragic portent, in a city whose complacent indulgence in decadent luxury and pleasure-seeking was only the lull before the storm. In the 1920s, however, his art became less feverish as he was drawn to Cézanne, and more hedonistic color schemes dominated his palette. Along with the luxurious color, a new sense of optimism came to the fore (Fig. 209).

German Expressionist Painting in the Aftermath of World War I

Following the war Expressionism changed radically. The revolution of modern art had been fought and won, temporarily at least. The personal sense of pioneering that contributed to the cohesion of the Bridge and the Blue Rider could not be recaptured. The surviving artists reacted in different ways. At the Weimar Bauhaus

> above: 207. Oskar Kokoschka. "Der Trancespieler." c. 1908. Oil on canvas, 32¾ × 25¾". Musée Royal des Beaux-Arts, Brussels.

> > right: 208. Oskar Kokoschka. The Tempest (The Wind's Bride). 1914. Oil on canvas, 5'11¼" × 8'%". Kunstmuseum, Basel.

Expressionism in Germany 126 after 1922, Kandinsky's style assumed the rigid geometric character of Constructivist art (Fig. 428). For some, such as Kirchner, Heckel, Schmidt-Rottluff, and Pechstein, the end of the artistic revolution meant the end of their most creative periods.

Another kind of revolution took place in Germany in 1918, a social revolution that gave some artists a new cause. Social democracy, as it existed in postwar Germany, was weak, ineffective, and undermined by soaring inflation. A number of intellectuals, artists among them, joined forces in a radical association called the November Group (*Die Novembergruppe*), which affirmed the alliance of the intelligentsia and the poor. Ludwig Meidner wrote in a militant Socialist pamphlet:

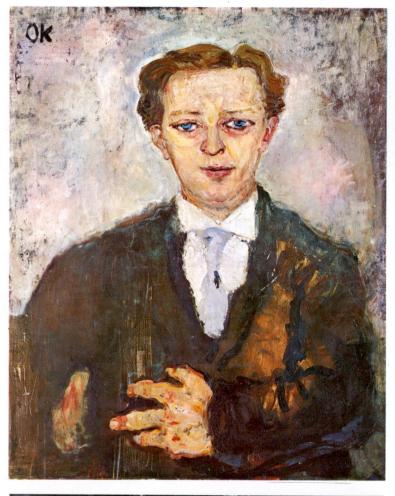

209. Oskar Kokoschka. Dresden: The New City. 1922. Oil on canvas, 31³/₈ × 46⁷/₈". Kunsthalle, Hamburg.

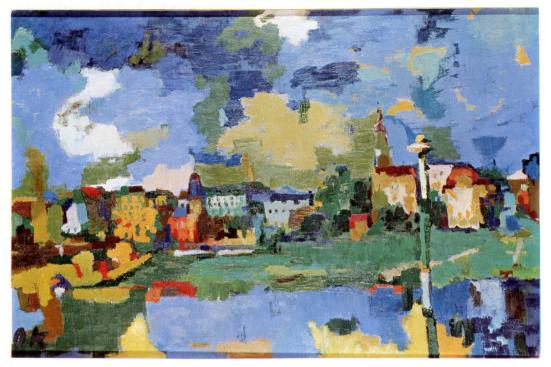

We painters and poets are bound to the poor in a sacred solidarity. Have not many among us learned to know misery and the shame of hunger? ... Are we any more secure in society that proletarians? Are we not dependent upon the whims of the art-collecting bourgeoisie?¹⁹

Other Expressionist artists collaborated on the pamphlet, with Pechstein contributing the cover of a man standing firm against a background of conflagration, a symbolic reference to the idealized proletariat's capacity to reconstruct Germany from the smoldering ruins of war. Much of postwar German art was specifically oriented to the social problems of the time and tried to clothe Utopian socialism in Expressionist forms. The Berliner George Grosz (1893–1959), however, worked out of disenchanted feeling. He became the most savage critic of the bourgeois-dominated, demoralized Germany of 1919 (Fig. 210). His raw, coldly analytic, semi-Cubist pictures of streets filled with wounded veterans, beggars, prostitutes, degenerates, and wealthy capitalists carry all the shock value and emotional intensity of the Bridge painters, but now the ugly and the cataclysmic aspects of life, rather than the strong and the prim-

210. George Grosz. *The Big City*. 1916. Oil on canvas, 391/4 x 401/4". Museo Thyssen-Bornemisza, Madrid.

above: 211. Otto Dix. The Match-seller. 1920. Oil on canvas, collage; 4'7³/4" x 5'5³/8". Staatsgalerie, Stuttgart.

right: 212. Max Beckmann. *Night.* 1918–19. Oil on canvas, 4'4³/8" x 5'1/4". Kunstsammlung Nordrhein-Westfalen, Düsseldorf.

below: 213. Max Beckmann. Departure.
 1932–33. Oil on canvas; triptych, center panel 7'3/4" x 3'113/8"; side panels each 7'3/4" x 3'3'1/4". Museum of Modern Art, New York. Given anonymously (by exchange).

Expressionism in Germany

214. Käthe Kollwitz. Rest in the Peace of His Hands (relief for the artist's tomb). 1936. Bronze, 13¾" high. Peter Stuyvesant Foundation, Liechtenstein.

itive, are insisted upon. Otto Dix (1891–1969) also paraded the indecencies of postwar life before the eyes of the world (Fig. 211). In both Grosz and Dix, however, a non-Expressionist attitude toward modern life can be seen in works that stress the almost magical value of physical reality, an attitude called the New Objectivity (*Die Neue Sachlichkeit*), meticulously exact descriptive techniques of representation in contrast to the spontaneity of Expressionism.

One great Expressionist painter remains to be discussed: Max Beckmann (1884–1950). Although born into the generation of the Bridge artists, Beckmann did not take part in their organization. Before the war, however, he revealed an increasing tendency in his painting toward tragic themes. Experiences in the army as a medical orderly profoundly affected his thinking and his art. Among the first paintings in a new style of grotesque figuration and charged symbolism was *Night*, a work of 1919 (Fig. 212). From that point on Beckmann turned increasingly to the development of powerful Expressionist symbols. Unlike those of Grosz and Dix, his subject was not specifically social criticism. Beckmann delved instead into psychological and spiritual relationships, painting always with such force and solidity that his strange world is absolutely convincing.

Beginning in the war years, and through the early 1920s, Beckmann's imagery was almost pathologically bitter and gruesome. In the 1930s these moods gave way to a more hopeful and universal allegory, but as the artist surrendered some of the pointedness and acuity of content, his painting means became more original and remained intensely expressive and personal. In such works as Departure (Fig. 213), Beckmann's feverish colors and emphatic black outlines were applied to an uncompromising imagery of human violence and affliction, which commented obliquely on the predatory impulses of the period of German Nazism. The picture quite clearly symbolized the artist's own sense of relief on departing from Germany for the Netherlands and freedom, leaving a world of sadistic memories, symbolized by the tortured and trussed figures, to find a more serene life beckoning from beyond the brilliant blue sea. Beckmann's art, which began as an instrument of social and psychological criticism, became increasingly philosophical and spiritual. He saw his work in universal terms, under the light of eternity, and remained preoccupied with the symbolism of human fate, a drama, as he later put it, where "my figures come and go, suggested by fortune or misfortune. I try to fix them divested of their apparently accidental quality."20

German Expressionist Sculpture

Expressionist sculpture seldom reached the extremes of emotional intensity found in painting. Only Käthe Kollwitz and Ernst Barlach (1870–1938), in their profound identification with the laboring and peasant classes, produced forms expressive of the suffering and anxiety of prewar Germany (Figs. 214, 215). Wilhelm Lehmbruck

(1881–1919) created sculpture of power and monumental dignity by drawing on both Classical and Gothic traditions to create grandly simple, elongated figures with pensive, withdrawn expressions (Fig. 216). Georg Kolbe, as we have seen (Fig. 105), worked with the rhythms and natural grace of the human form in a more classical manner, which sets him apart from the mainstream of Expressionism. Several Expressionist painters produced interesting sculpture, but only occasionally. Among them were the members of the Bridge and Klee, Kokoschka, Marc, and Feininger.

German Expressionist Prints

Nearly all the Expressionists were active printmakers. Both the Bridge (Figs. 189, 190) and the Blue Rider (Fig. 217), as well as the independents, Kollwitz, Rohlfs, and Barlach, revived the art of the woodcut and did so with particular vigor. They also used other print media, such as etching, drypoint, and color lithography (Fig. 200). The brutal simplicity of Bridge prints was influenced by the late medieval German woodcut. But Expressionist prints in a variety of media also extended the influence of Japanese woodcuts, Félix Vallotton's bold juxtapositions of large black-and-white surfaces (Fig. 61), and, most significantly, Edvard Munch (Fig. 59). Munch's rough cutting tools, utilization of the natural textures of his wood blocks, and morbid or highly emotional subject matter deeply impressed the early Expressionists. In the case of the Bridge

painters, the efforts in woodcut not only belonged among their most important accomplishments, but decisively determined the character of their painting. The critic Hartlaub wrote: "It is the knife of Munch, which in contradiction to all classical idealism and Renaissance taste first spoke its own peculiar barbaric dialect in rough wood."²¹ The influence of the Expressionists has been deeply felt by graphic artists everywhere.

The Expressionist movement as such effectively ceased when the Nazis took power in the 1930s and labeled almost all Expressionist work degenerate. In the thirty years of its existence, Expressionism had drawn sustenance from many roots, flowered splendidly just before World War I, sown the seeds of new movements to come, and produced numerous important artistic personalities. Many German artists fled before the Nazi persecution, taking refuge in other European countries and in America. The Expressionist approach was thus widely dispersed and became one of the major directions of art in this century. Kirchner's moving summons to the younger generation in his program for the Bridge in 1906, inviting them to join in creating a new and more hopeful artistic future, has been answered by artists throughout the civilized world. Whenever the urgencies of personal passion have overcome a dominant formal order or decorative values in painting and sculpture, the original Expressionist spirit finds itself renewed, as it did with particular force in the 1980s.

215. Ernst Barlach. Singing Man. 1928. Bronze, 19¾" high. Museum of Modern Art, New York. Abby Aldrich Rockefeller Fund.

Expressionism in Germany 130

Wilhelm Lehmbruck. Kneeling Woman. 1911. Cast stone, 5'9'/2" high. Museum of Modern Art, New York. Abby Aldrich Rockefeller Fund.

below right: 217. Franz Marc. Genesis II. 1914. Color woodcut, 9½ x 77/8". Museum of Modern Art, New York. Katherine S. Dreier Bequest.

right: 218. Ernst Ludwig Kirchner. White House in Hamburg. 1910. Lithograph, 13½ x 15½". Collection Wolfgang Budczies, Bremen.

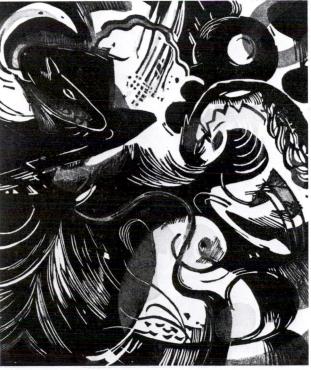

Expressionism in Germany

The Cubist Revolution: Braque and Picasso

he years between 1905 and 1908 were as critical to the development of 20th-century styles as the early 1880s had been to the formation of Post-Impressionism. In both cases, painting moved from free color expression toward firmer pictorial structure. Seurat, Cézanne, and, in the later years of the decade, van Gogh and Gauguin, had used more explicit design in their compositions and had gone well beyond pure optical sensation and the basic pictorial premises of Impressionism. In 1906, when Matisse painted Joy of Life (Fig. 175), the informality and inspirational character of the Fauvism of the previous year were superseded, just as a new formalism had supplanted Impressionism. In 1907 Paul Cézanne's correspondence with Émile Bernard appeared. It contained, among other remarks, the advice to "treat nature in terms of the cylinder, the sphere, the cone," an expression of formal principle that in a short time would be adopted as a major premise by Georges Braque and Pablo Picasso, the founders of the new Cubist movement.

Unlike the Fauves, however, the Cubists attracted critical attention and their epithetical name the very first time they exhibited pictures realized in the new style-thanks to the wit and perception of Henri Matisse. By the fall of 1908, Braque, the youngest of the painters who joined the Fauve circle, had discovered Cézanne and, in a new series of landscapes painted that summer at L'Estaque, had allowed the Cézannism of his 1907 La Ciotat to become dominant (Figs. 219, 174). The last of the Fauves was now fleeing the pack and beginning to see Cézanne as something other than the master of form through color, but rather as the modern Poussin, a classicist whose "sculptural" paintings evinced the ordered and essential structures thought to underlie the randomness of natural appearances. Braque's novel and boldly abstracted pictures-their color reduced to ochres and dark, hatched greens, the planes of their angular imagery so intersected as to seem transparent, and so gridlocked and fused as to make space and mass scarcely distinguishableshocked even the progressive and open-minded Matisse. After rejecting the work for the autumn Salon, a show he helped jury, Matisse grumbled to Louis Vauxcelles of Braque's petits cubes, whereupon the critic wrote how the young painter had reduced his canvases à des cubes. By 1909 he was speaking of Braque's bizarreries cubiques. With the term now fixed in the art-critical canon, Vauxcelles had inadvertently named the new movement, just as he had done for Fauvism three years earlier.

As with so many modern movements, Cubism was the product of a collaborative effort. While recent, and persuasive, scholarship, holds that Braque gave the new language its fundamental syntax and thus provoked its name, it was Picasso whose volcanic genius undoubtedly transformed Cubism into the irresistible force it became for over half a century. Cubism might claim the same ancestry as Matisse in his *Joy of Life*—Symbolism, Cézanne's late Bathers, the classical antique, and the sculpture of Black Africa but while looking to a common source, Braque and Picasso together found a wholly different inspiration. Fauvism had liberated art into the 20th century by a process of drastically purifying the formal usage inherited from the giants of the Post-Impressionist era. The Cubism of Picasso and Braque went far toward replacing this received vocabulary with an utterly new and different visual language. The Cubist experiment brought about a revolution in pictorial vision so total that it all but shattered that of the Renaissance, whose spatial conventions had dominated European painting for over four hundred years. Renaissance illusionism, long menaced by the friezelike compositions increasingly favored since the time of David (Fig. 3), had been decisively rejected as inadequate to the needs of modern reality.

Taking their lead not only from Cézanne but also from various types of archaic art, medieval and Egyptian for instance, the

219. Georges Braque. Houses at L'Estaque. 1908. Oil on canvas, 28¹/4 x 23¹/4". Kunstmuseum, Bern.

Cubists offered, in lieu of the unitary, fixed, egocentric focus of Renaissance perspective, multiple and mixed perspectives, thus presenting the subject in its many aspects all at once. In a Cubist painting, a head may be seen simultaneously in both profile and full face, a still life or a landscape both from the front and from above. Being composite, an image represented in this fashion conformed to the new, scientific knowledge that human perception derives not from a single, all-encompassing glance but from a succession of "takes," from experience stored in the memory, and from the intellect's capacity to conceptualize form. In this way, the Cubists gave painting not only a novel kind of pictorial spaceshallow or flat in the manner of bas-relief-but also a new, fourth dimension: time. By doing so, they also challenged the age-old sanctity and significance of the human image. The Fauves, albeit daringly disruptive in color, proved meek in their approach to the figure, by comparison with the fearless deformations imposed upon it by Braque and Picasso. Breaking up the face and figure into planar components comparable to the geometries used for representing every other aspect of the picture, including its space, Cubism declared that the human presence had become secondary to the formal requirements of the total concept. Once this had been established, reality as recognized in nature would come to seem irrelevant to painting.

Cubism has sometimes been characterized as the very opposite of Fauvism: the rational vs. the intuitive, monochromy vs. color, sobriety vs. wildness, the classical vs. the romantic. Transcending all comparisons, however, Cubism is quite simply the dominant aesthetic of the 20th century, offering artists a language of infinite potential, including a route to total abstraction. Braque and Picasso, like Matisse, would make the journey at high speed. But with their art still "drenched in humanity," they would also choose to stop short of the full distance, leaving the arrival at complete nonobjectivity to a second generation of modernists.

Picasso's Blue and Rose Periods

Pablo Picasso (1881-1973) was born in Malaga, on the Mediterranean coast of Spain. In 1895, after living for several years in Coruña, his family moved to Barcelona where his father, Don José Ruiz Blasco, an art teacher, became an instructor at the School of Fine Arts. (According to Spanish custom, Picasso was free to choose either of his parents' surnames, and he took his mother's.) Barcelona was a lively intellectual center, and Picasso's precocious artistic talent soon brought him into contact with local poets and painters of progressive tendency, and in time stirred him to go to Paris. Between 1900 and 1904, he stayed for a number of lengthy periods in the international capital of art, and after 1904 he lived there permanently. On his first visit he had painted street and café scenes in alternately somber and vivid colors, with savage brushstrokes and a disenchanted eye (Fig. 220). These rather melodramatic paintings evoke Lautrec, Théophile Steinlen, and an exacerbated, febrile fin-de-siècle atmosphere.

Toward the end of 1901, Picasso began to use a pervasive monochromatic blue tonality that seems to have been chosen because of its association with melancholy. There were precedents for the use of dominant blue in Degas's paintings of toiling laundresses, Gauguin's mystic allegories set in the tropical jungles of Tahiti, and Cézanne's Provençal skies. Picasso's blues also suggested the void, and visually echoed the sense of unreality and infinity of *l'azur* of Mallarmé's sonnets, which seemed to encapsulate in a phrase and a color the Symbolist age's longing and *tristesse*. His subject matter—human derelicts, beggars, and the emaciated, starving children and oppressed poor of Paris—may have reflected his own actual economic distress. By 1902, when he painted *Two Women in a Bar* (Fig. 221), he had achieved a number of remark-

220. Pablo Picasso. End of the Number (detail). 1900–01.
Pastel on canvas, 28×18".
Pablo Picasso Museum, Barcelona.
221. Pablo Picasso. Two Women in a Bar. 1902.
Oil on canvas, 31½×35%".
Hiroshima Museum of Art.

able works in a consistent style, full of brooding personal poetry and an almost morbid emotionalism. The lugubrious, bluish darkness of these canvases recalls the somber tonalities of Spanish painting, and their motifs are reminiscent of Manet's picturesque *Topers* and his elegant Parisian version of Velázquez's early subject matter of human pariahs, beggars, and entertainers. To these sources, Picasso added an El Greco-like attenuation of form and an excruciating spirituality, reflected in the poetic vulnerability of his figures' faces and attitudes.

In a period when he was engaged in intense experimentation with many influences, Picasso also seems to have discovered Gauguin's primitivism, and felt the impact of his great painting Where Do We Come From? What Are We? Where Are We Going? (Fig. 50). Not only does his palette of blues and ochres recall the mysterious, synthetic color of Gauguin's painting, but the large, flattened forms and hieratic profiles of Picasso's figures have a similar primitivistic character. Picasso fused these elements into a highly personal style, and his affecting imagery served as commentary on the human wreckage of the modern city, rather than as an invitation to taste the pleasures of a tropical Eden. Interestingly, the allegorical content of Gauguin's masterpiece and other paintings of the 1890s, under the aegis of Symbolism especially, did not escape his attention. La Vie (Fig. 222), like so many turn-of-the-century paintings, deals poetically with the theme of the human life cycle, and evidently represents three stages of Juman existence, from young love to a weary disillusionment and maternity. Like other paintings of the Blue period, it is haunted by a mood of pessimism and stoic suffering. And like virtually all of Picasso's art, it vibrates with personal allusions, among them the artist's mourning

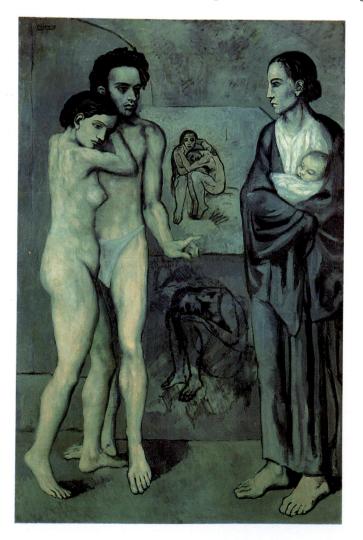

for a younger sister and a close friend, the latter recently dead by suicide, and his guilt-ridden longing to liberate himself from a domineering and possessive mother.¹

About 1905 Picasso lightened his palette, relieving it with pink and rose, while also restraining the more extravagant pathos of his Blue period. Having entered his Pink, or Rose, period, he began to paint circus performers in a more airy and graceful manner, with extraordinary subtlety and sensibility. These moving, fugitive visions of a strange gypsy tribe of entertainers, half mournful, half heroic, are among the most poetic visual creations of the modern period. Certainly the touching troupe of mountebanks in Family of Saltimbanques is a profoundly poignant witness to alienation (Fig. 223). In a sense, Picasso revived a special theatrical world even more acutely than Degas and Lautrec had done with their ballet and cabaret scenes. Yet Picasso's stoic old saltimbanques and emaciated young acrobats with reproachful eyes haunt us like a dream: they are the stuff of vision rather than reality. They also express something of a metaphor for Picasso's sense of his own artistic isolation. These figures eloquently express the plight of the man of superior sensibility whose gifts outlaw him from conventional society and force him to wander, rootless, in a shadowy limbo of heroic, if futile, dreams. Throughout his brilliant career, Picasso demonstrated affection for the melancholy lyricism of the clown. and even in his more abstract inventions he consistently used figures of commedia dell'arte origin.

As in the Blue period painting, one of the striking features of Picasso's obsessive theme of acrobats and circus performers is the degree of his personal involvement, for a passionate, if muted, subjective emotionalism pervades every inch of the canvases. When he painted *Family of Saltimbanques*, he also must have intended us to see the fate of the circus performers, condemned to a wandering existence and unstable relationships, as symbolic of the fate of humanity. That, at any rate, is how the German poet Rainer Maria Rilke sensed the picture in a celebrated Duino elegy. Meanwhile, a more recent, deeply researched interpretation, by Mary Mathews Gedo, tells us that:

The artist himself appears in this picture as the idealized Harlequin, setting out on an artistic journey under the protection of the wise old buffoon, the leader of the family of saltimbanques, who also symbolizes his partner, Guillaume Apollinaire. The Majorcan woman—added to the painting as an afterthought—represents Picasso's Spanish past and the childish ties he has relinquished. But one aspect of Spain remains with him: the faceless little girl standing next to him, who surely represents his dead sister, clutching her own basket of funeral flowers. For he could never forget her, never forgive himself for her death, and he was destined to walk through all the days of his life hand in hand with the spirit of little Conchita.²

In the Rose period (1905–06), generalization and a greater breadth of style became evident in Picasso's figuration and suggested the supple grace of Hellenistic sculpture or Pompeian frescoes. The pinks, terra-cottas, and siennas of his palette summon up the warm colors of Roman wall decorations and the atmosphere of classical Mediterranean culture. This was part of his search for a less emotional, more objective art. He had begun to look closely at Greek vase painting and Etruscan and archaic Greek sculpture in the Louvre, and his interests quickly expanded, in a year of dramatic developments, to include primitivist, pre-Christian Iberian carving. The even more revolutionary influence of recently discovered African sculpture was also soon to play a dominant role in his shifting style. In such mercurial changes was the first hint of a con-

222. Pablo Picasso. *La Vie.* 1903. Oil on canvas, 6'5³/8" x 4'2⁵/8". © Cleveland Museum of Art, 1999. Gift of the Hanna Fund.

The Cubist Revolution
134

right: 223.

Pablo Picasso. Family of Saltimbanques. 1905. Oil on canvas, 6'113/4" x 7'83/8". National Gallery of Art, Washington, D.C. (Chester Dale Collection). © Board of Trustees.

below: 224.

Pablo Picasso. *Two Nudes*. 1906. Oil on canvas, 4'11⁵/8" x 3'⁵/8". Museum of Modern Art, New York. Gift of G. David Thompson in honor of Alfred H. Barr, Jr.

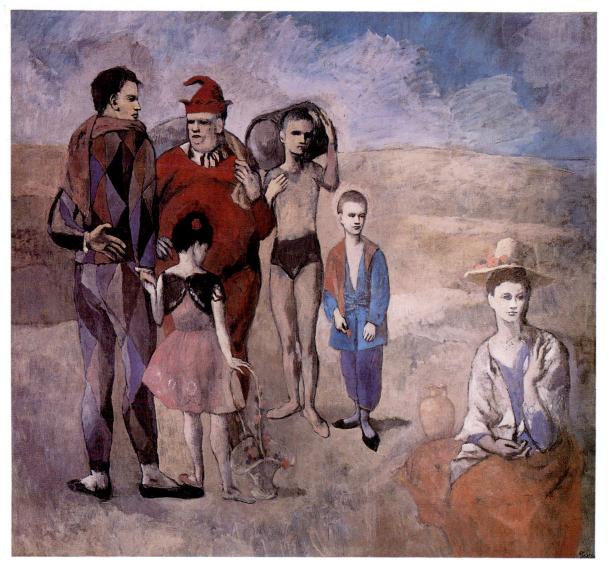

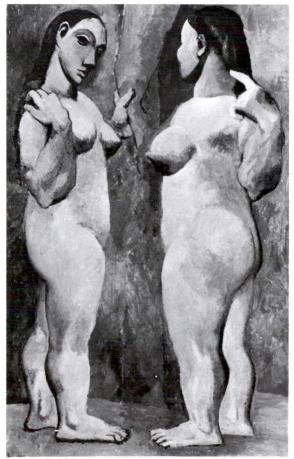

stant element in Picasso's art, lost and recovered again throughout his career: a remarkable ability to re-create the mannerisms of classical figuration, which evoke, in turn, the atmosphere of the first dawn of Mediterranean humanism, and, further, to oppose this mood of civilized humanism with allusions to the discordant violence of primitivism (Fig. 224). Out of the tension between the elements of classical humanism and primitivism evolved the rich iconography of Picasso's art and its formal diversity. He even used the disparate styles and artistic sources metaphorically, to express mental states analogous to the idea of ego control and a subconscious fantasy life, and thus suggested the evident discontinuities of modern culture, as well as the complex depths of human personality.

Picasso's primitivism was fused with a system of revolutionary, formal ideals in the summer of 1906, which he spent at Gosol, a small town in the Spanish Pyrenees. At this time, the precocious and charismatic Spaniard was only twenty-five years old. During the previous five years, he had produced over two hundred paintings and many hundreds of drawings, developed a style of intense originality—two complementary styles, in fact—and revealed exquisite poetic gifts, an achievement that would have satisfied all but the most restive of temperaments. Like Matisse during his Fauve period, Picasso was driven to pursue deeper visual truths, even when they threatened momentarily to brutalize his finer sensibilities. He seemed to sense that new and more vital artistic solutions lay before him, when he began, at Gosol, to realize, in stylized and forceful painting and drawing, his interest in the simplified forms of archaic Iberian sculpture.

Before he left Paris, Picasso had been at work on a portrait of Gertrude Stein (Fig. 225). Despite some eighty sittings, he had failed to render the face to his satisfaction and had left it unfinished. He returned in the fall to repaint the face in a completely different style, transforming it into a stiff but powerfully expressive mask. The soft, gentle style of his Rose period was now a thing of the past. In *Two Nudes* (Fig. 224) and subsequent paintings of 1906 and 1907, Picasso went on to create squat, angular, primitive-looking figures. Heavily pigmented until the paint stood out in low relief, they were at once sculpturesque and intensely expressive of brute paint matter.

Les Demoiselles d'Avignon

Modernist art received a climactic impulse in 1907 when Picasso marshaled his phenomenal energies and launched upon an enormous, revolutionary picture known as *Les Demoiselles d'Avignon* (Fig. 226). According to André Salmon:

Picasso was unsettled. He turned his canvases to the wall and laid down his brushes... During the long days and as many nights, he drew, giving concrete expression to abstract ideas and reducing the results to their fundamentals. Never was a labor more arduous, and it was without his former youthful enthusiasm that Picasso began on a great canvas that was to be the first result of his researches.³

This work, like Matisse's critical Joy of Life (Fig. 175), with which the Demoiselles was no doubt intended to compete, took its general inspiration from Cézanne's monumental Bathers compositions (Fig. 34). In a similar spirit, Picasso emphasized the architectural development of a group of nudes whose anatomies form the ribs of a vaultlike space. However, the painting's violent dissonances obviously make it a far more ugly and difficult work of art than Cézanne's. On one revealing occasion, Picasso said: "What forces our interest is Cézanne's anxiety," meaning his fear of never realizing his sensations of the conflict between art and nature. While the Demoiselles still contains some evidence of Picasso's preoccupation with classical figuration, and with the pink and ochre coloration of Roman fresco painting, the two heads at the far right are completely out of character. Although Picasso later denied that any influence shaped these figures other than Iberian sculpture, which he had seen at an exhibition in the Louvre, on purely visual grounds the right-hand visages seem almost irrefutably inspired by African art of the French Congo. And, in fact, the artist explained in a conversation with André Malraux in 1937 that the Congolese masks in Paris's Trocadero Museum had plumbed the depths of his artistic identity and revealed to him a raison d'être that went far beyond mere formal considerations:

The masks weren't just like any other pieces of sculpture. Not at all. They were magic things.... The Negro pieces were *intercesseurs*, mediators.... They were against everything—against unknown, threatening spirits. I always looked at fetishes. I understood; I too am against everything. I too believe that everything is unknown, that everything is an enemy! Everything!... I understood what Negroes use their sculptures for. They were weapons. To help people avoid coming under the influence of spirits again, to help them become independent. They're tools. If we give spirits a form, we become independent. Spirits, the unconscious (people still weren't talking about that much), emotion—they're all the same thing. I understood why I was a painter. All alone in that awful museum, with masks, dolls, made by the redskins, dusty mannekins. *Les Demoiselles d'Avignon* must have come to me that day, but not at all because of the forms; because it was my first exorcism painting—yes absolutely.⁴

Thus moved, or even shaken, by Negro art, Picasso introduced it into the *Demoiselles* whereupon he struggled heroically to unite Cé-

136

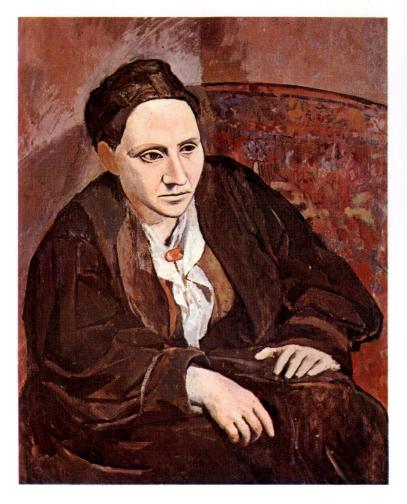

zanne's structural aesthetic with the geometric volumes from Africa, with their crude forms and expressive intensity, in order to liberate an utterly original artistic style of compelling, even savage force. When Braque saw the *Demoiselles*, he declared that the picture "... made [me] feel as if someone were drinking gasoline and spitting fire."⁵

The grotesque figures on the right, with their angular pink bodies and their dark, synthetically colored, scarified faces, ushered into the general scheme of modern art a new psychological content, as well as different criteria for pictorial consistency. The visible evidence of the artistic process is allowed to stand in the finished painting, rather than being eradicated or assimilated to a more unified image. Henceforth, an art work might contain divergent tendencies and describe within the same visual field a diversified morphology, covering a stylistic spectrum from realism to total abstraction, or show pictorial ideas in a state of incomplete realization. As in the case of the *Demoiselles*, such irresolutions may even charge the work with an electrifying expressive power.

Clearly, it is the two figures at the right, mainly, that Picasso painted, or repainted, under the new, non-European influence. Their barbaric spirit and vehemently textured surfaces surpassed the most violent coloristic and formal distortions of the Fauves. Picasso, with unprecedented daring, had injected his painting with a strident note of psychological terror. The shocking anomaly of these two masks prophesied the perfervid fantasies of the Surrealist incubus dredged up from the subconscious mind, which would appear in Picasso's art of the late 1920s and in the works of the Surrealist movement.

Parallel to the *Demoiselles*, primitive forms became assimilated with classical or traditional art in other forms of expression at the time, most particularly in the music of Picasso's close friend, Igor Stravinsky. In 1910, he composed *The Firebird* and, three years later, *The Rite of Spring*, with wild rhythms and even more uncivilized, dissonant sounds. A decade later, T.S. Eliot wrote his classic poem *The Wasteland*, an elaborate allegory describing the plight of overcivilized modern man in search of spiritual rejuvenation, with rich allusions to the fertility rites of a more primitive society. If we consider the morbidity and self-indulgence of the late Romantic decadence of Symbolist art, we can better understand the search for new sources of passion in the individual's instinctual life and in tribal art forms embodied by the Expressionist violence of early 20th-century painting, whether Fauvist or Cubist. It should be noted in this context that by 1900 Sigmund Freud had published his great work on dreams and begun his exploration of the unconscious, an investigation which indicated that a more primitive instinctual life lurked beneath modern man's civilized veneer.

Just as baffling as the primitivizing revisions in the right portion of the *Demoiselles* has been the suspected allegorical significance of the figural grouping. The issue eventually came to center on a number of previously unknown sketches, posthumously released by the Picasso estate, that disclose some of the inferences hidden in the painting's ultimate state to have originated as an explicit, even autobiographical, fable of innocence and experience. At its genesis, the composition included seven figures, two of them young males bearing an unmistakable likeness to the artist—a medical student carrying a skull, as a *memento mori*, and a sailorsurrounded by voluptuous nudes. Moreover, the latter had yet to yield their classical graces to the fetishistic grimaces and rude distortions of the two intimidating figures that now dominate the right half of the *Demoiselles*.

Today, however, the painting's complex sources and its iconographic meaning as a metaphor of love and death, or as an unconscious representation of ambivalence toward women, have been eclipsed by a new controversy concerning the priorities the Demoiselles may rightfully claim in subsequent Cubist developments.⁶ Owing to its anatomical deformations, especially in the geometricized figures and the profile noses on frontal faces, the shallow space and overall network of planes and edges, like fragments of broken glass, the picture has long been viewed by many as a major watershed work among whose conflicts and contradictions Cubism was born. The great Alfred H. Barr, Jr., called it "the first Cubist picture," but then, with more scholarly circumspection, characterized it as "a transitional picture, a laboratory, or, better, a battlefield of trial and experiment ... a work of formidable, dynamic power unsurpassed in European art of its time."⁷ Recently, in two lengthy articles by art historian William Rubin, Barr's successor at the Museum of Modern Art in New York, it has been argued that Picasso's "breakaway" painting can no longer be considered the first proto-Cubist work or that it even necessarily

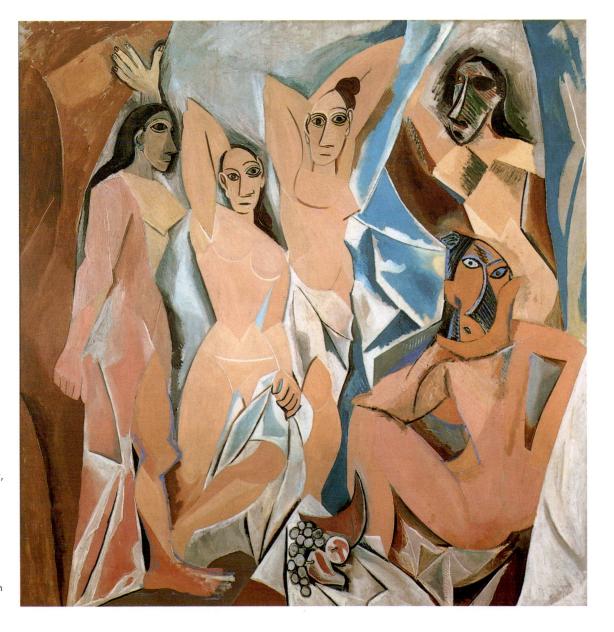

opposite: 225. Pablo Picasso. Portrait of Gertrude Stein. 1905–06. Oil on canvas, 39% × 32″. Metropolitan Museum of Art, New York. Bequest of Gertrude Stein.

right: 226. Pablo Picasso. Les Demoiselles d'Avignon. 1907. Oil on canvas, 8' × 7'8". Museum of Modern Art, New York, Acquired through the Lillie P. Bliss Bequest. led to the kinds of formal resolutions that, as we shall see, the mature Cubist paintings of Barque and Picasso introduced in 1908 and 1909. Rubin goes so far as to suggest that Picasso was not necessary to effect the birth of Cubism. By 1908, he writes, Braque had "made it clear that he would have created early Cubism had Picasso never existed."⁸

Not surprisingly, this highly revisionist assessment of the Demoiselles has generated lively disagreement. Notable among the reservations are those of Leo Steinberg,⁹ who does not so much deny Braque's role in inventing Cubism as try to maintain a balanced view of the powerfully innovative and expressive contribution made by Picasso's seminal painting of 1907, and others that followed in 1908, including the extraordinary Three Women in Moscow (Fig. 229). Further scholarly contributions, which seem to gather ever more feverishly, if productively, around Picasso's inexhaustible masterpiece, give sharper public focus to erotic and autobiographical aspects of the great figure composition. The strongly differentiated approaches range from art history and Freudian psychology to radical feminism. The Demoiselles thus continues to engage scholars, critics, and the general public on many levels, formal and iconographic, even as opinions fluctuate about its precise meaning and implications for the vanguard art that would follow. The richly contradictory Demoiselles began as a metaphoric statement of good and evil and then became magically transformed into one of our most influential modernist icons, and a climactic if transitional example of the expressive force and depth of Picasso's art. Originally, its five nude females seemed close in spirit to the demonic *femmes fatales* of the late 19th-century Symbolist allegory (Figs. 35, 55, 73, 82, 84), but as they became more stylized and, at the same time, vehicles for a ferocious primitivism, they moved toward abstractness. This unique combination of formal and psychological factors anticipated important aspects of both abstract and Surrealist art of the new century.

During the remainder of 1907 and 1908 Picasso continued painting figures and heads with the simplified planes of African Negro sculpture, which not only provided emotional stimulus but also suggested that such radical simplifications of form might have new aesthetic meaning. Thanks to his enthusiasm for the primitive, Picasso developed an interest in the painting of le douanier Henri Rousseau (Fig. 278), who had been taken up by Guillaume Apollinaire, the Steins, and other friends of Picasso's. In 1908 Picasso found a large portrait by Rousseau in a junk shop and bought it. To celebrate the purchase, he gave a now famous studio party commonly referred to as le banquet Rousseau. The guests included Braque, Apollinaire, Marie Laurencin, Leo and Gertrude Stein. Fernande Olivier, and a number of avant-garde critics. The guileless Douanier (so-called for the minor job Rousseau long held in the French customs service) was overwhelmed by speeches, toasts, and a poem that Apollinaire wrote and recited for the occasion. Picasso and the vanguard painters had "discovered" for the first time in the obscure Rousseau a "naïve" painter. In his innocence of artistic traditions, his powerful archaic forms, and flat presentation, they found a sympathetic note; the search for a new simplicity was the order of the day. A sober, rather timid petit bourgeois, on canvas Rousseau created heroic personages and exotic dreamlike settings that conveyed the powerful fantasy and myth-making powers slumbering in the brain of Everyman. His untutored forms had the primitive authority of the urgent shapes found on fantastic Romanesque capitals, yet his art was also accessible and popular in character, as bright and gay as a contemporary color print. Apart from a few landscapes and still lifes executed by Picasso in 1908-09, among them the monumental Bread and Fruitdish on a table in Basel (Fig. 227), where the Spanish artist paid stylistic tribute not only to Rousseau-his naïve drawing, firm contours, and high finish-but also to Cézanne, it was some time before the Douanier's inventions

The Cubist Revolution **138**

received the flattery of imitation. In the 1920s, Fernand Léger adapted Rousseau's robust forms to his own purposes; and in the 1940s, Picasso directly referred to the more fantastic and mysterious side of Rousseau's genius in some of his compact and monumental figure studies.

Analytic Cubism

In the manner of the tortoise and the hare, great conservatives often arrive well ahead of their time.¹⁰ Thus, rather than the mercurial, protean Picasso, it was the earnest, systematic Braque who, by following a consistent line of development, formulated the essential syntax of Cubism before he met his great Spanish contemporary. Reflective and slow-working, Braque naturally identified, not with the "anxious" Cézanne who fascinated Picasso, but with the "modern Poussin," whom the young Frenchman thought "as great for his clumsiness as for his genius." Little wonder that Braque, a born classicist, soon found Fauvism too wild for his taste. "You can't," he said, "remain forever in a state of paroxysm." Even in his late Fauve pictures (Fig. 174) Braque had developed an all-over pattern of stylized drawing and the generalized distribution of chiaroscuro accents that, once intellectualized into the pictorial equivalent of plane geometry, would become the very foundation of the new Cubist style. Unlike Picasso, with his passion for the sculpturesque figure, Braque could more readily abstract subject matter by virtue of his primary commitment to landscape and still life, motifs free of the psychological tensions implicit in the human image. And abstract he did in late 1907, mainly by finishing in his Paris studio pictures he had begun that summer at L'Estaque on the Mediterranean coast. As Braque later recalled:

I had learned to paint from nature, and so when I came to the conclusion that I had to be free to work without a model, I did not find it at all easy. But I struggled on, following my intuitions, and gradually found that I had become more and more detached from motifs. At such time, one has to follow dictates which are almost unconscious, since there is no knowing what will happen.¹¹

What resulted was, among other canvases, Landscape with Houses (Fig. 228), a work in which the artist has so simplified his Cézannism as to transform it into proto-Cubism. Still, Cézanne remains the primary inspiration, for now Braque has demonstrated a sure grasp of the 19th-century master's passage, the opening or breeching of contours that allows planes at varying depths to "bleed" into one another, thereby, through a process of elision, collapsing the sense of three-dimensionality into a shallow, bas-relief space. With color restricted to a relatively uniform dispersal of green and ochre, so that figure and ground, or solid and void, seem not separate but more or less continuous, the viewer experiences the exhilarating sensation-so characteristic in Cubism-of simultaneity, of being led into depth by the same means that transforms the journey into an exploration of surface. Reinforcing the pictorial unity are the suppression of doors and windows, for the sake of simpler geometry, and the stylization of sky and foliage, as if they were extensions of the purified architectural forms.

In *Houses at L'Estaque* of 1908 (Fig. 219), the historic painting that provoked the term Cubism, Braque took the final step toward mature Cubism by selecting a hillside motif that eliminated every vestige of a horizon line. This permitted the entire visual field to be filled with a compact assortment of nothing but houses and trees, all simplified and analogized as if an elementary family of forms underlay every variety of phenomenon.

Through Daniel Henry Kahnweiler, the dealer most interested in the Cubists, Braque met Picasso, Apollinaire, and their circle. While Braque would hold that Cubism "was the materialization of a new space," meaning the "visual space" that he sensed separating "objects from each other," Picasso, with his passion for the human image, could define Cubism as "an art dealing primarily with form." Always quick to see the possibilities of every new material, process, or idea, Picasso took a lesson from Braque and applied it in a large, vigorously sculptural, blatantly colored "African" work, *Three Women* (Fig. 229), repainting the canvas until he had transformed its expressionist energies into something as controlled, consistent, and subtly modulated as Braque's own

contemporary art. According to William Rubin, *Three Women* gives us the earliest known attempt by Picasso to utilize the Cézannian technique of *passage* in a systematic and comprehensive way.¹²

But to achieve full mastery of the new pictorial space, Picasso had to follow Braque's example still further and momentarily relinquish the figure for a rare involvement with landscape, which he

above: 228. Georges Braque. Landscape with Houses. 1907. Oil on canvas, 21¼×18¼". Private collection, France.

left: 229. Pablo Picasso. Three Women. 1908–09. Oil on canvas, 6'6¾"×5'10½". Hermitage Museum, Leningrad.

opposite: 227. Pablo Picasso. Bread and Fruitdish on a Table. 1908–09. Oil on canvas, 5'45%" × 4'4¼". Kunstmuseum, Basel. did in the summer of 1909 at Horta de Ebro in Spain. With *Houses* on the Hill, Horta de Ebro (Fig. 230), he achieved one of his first completely Cubist works, its colors reduced to khakis, beiges, and steel greys, and its forms abbreviated to a kind of visual shorthand of angular fragments, all coordinated with the shape and two-dimensionality of the painting surface.

From late 1909 until the guns of August blew them apart in 1914, Braque and Picasso collaborated so intimately that the Frenchman could say: "We were like two mountain climbers roped together." While Braque brought to the enterprise the sort of systematic, meditative concentration that Picasso would otherwise avoid in his career, the latter contributed the full force of his plastic imagination, which normally could be absorbed by a whole eclectic range of expression, and thus endowed Cubism with a kind of heroic splendor altogether alien to the quietude of Braque's native classicism. For the duration of their joint venture, however, the artistic relationship of Picasso and Braque would be so close that in

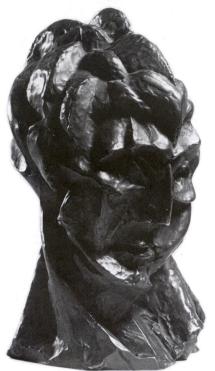

below: 230. Pablo Picasso. Houses on the Hill, Horta de Ebro. 1909. Oil on canvas, 25% × 31%". Museum of Modern Art, New York. Nelson A. Rockefeller Bequest.

left: 231. Pablo Picasso. Woman's Head. 1909. Bronze, 16¼". Museum of Modern Art. Purchase.

right: 232. Georges Braque. Violin and Palette. 1909–10. Oil on canvas, 36½×16⅔. Solomon R. Guggenheim Museum, New York.

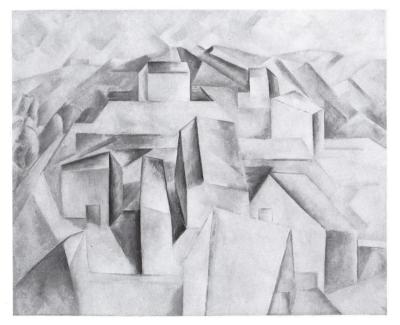

the absence of signatures—and they rarely signed or dated their works at this time—it is almost impossible to determine who made which individual contribution to the progressive evolution of the Cubist style. But even in the common form language of Cubism, it seems inevitable that Picasso's touch would remain relatively plastic and emotional and Braque's more lyrical and sensitive.

With Picasso breaking down form into its planar components and Braque materializing space into the same kind of simple geometry, the two masters worked so analytically that the highly refined, sophisticated art they now produced came to be known as Analytic Cubism. In 1909 Picasso even tested the planes of Cubism as a sculptural strategy in *Woman's Head* (Fig. 231). Shortly thereafter Braque painted *Violin and Palette* (Fig. 232), a still life whose lower half seems to have been crystallized as a glittering continuum of fragmented form and faceted space. A witty style, Cubism became more so when, in the midst of so much abstraction, Braque used a traditional trompe-l'oeil technique to render the nail, complete with shadow, that held the palette on the wall. By thus juxtaposing a bit of Renaissance illusionism with Cubism's largely symbolic style of representation, the artist would seem to be saying that art, whatever its form language, is a world of ar-

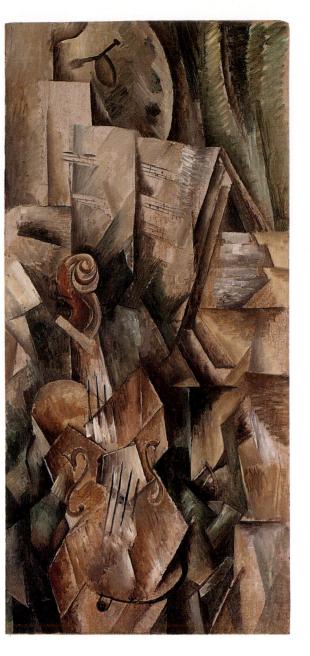

right: 233. Pablo Picasso. Portrait of Ambroise Vollard. 1910. Oil on canvas, 36¼ × 255%". Pushkin Museum, Moscow.

far right: 234. Pablo Picasso. Nude Woman. 1910. Oil on canvas, 6'¾" × 2'. National Gallery of Art, Washington D.C. Ailsa Mellon Bruce Fund.

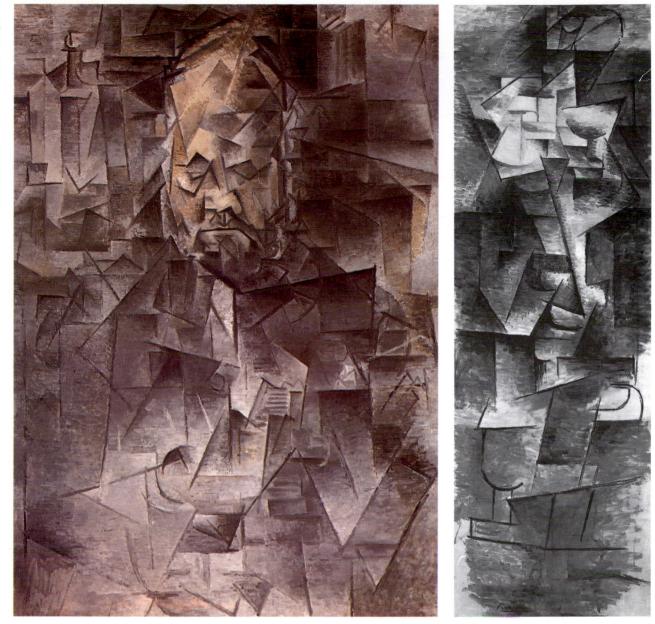

tifice, and that Cubism gains by the integrity of its refusal to be anything else, such as a simulacrum of the visible world. He would also seem to be announcing that the original Cubists, unlike many of their successors, would never relinquish their humanistic hold on perceptual reality and enter the realm of pure abstraction.

In his Portrait of Ambroise Vollard (Fig. 233) Picasso caught up with Braque and applied their analytical method so comprehensively that he all but dissolved the famous dealer's solid, Buddhalike image in a shimmering atmosphere of silvery facets. While their intersecting angles define those surfaces as transparent, they also structure the picture as a kind of architectural scaffolding and its space as indeterminately shallow. In crucial passages they cluster or dissolve and shift in color, even toward flesh tone, to reveal a form and face whose identity is unmistakably that of the man Cézanne had painted fifteen years earlier (Fig. 31). A comparison of the two works discloses not only how far modernist art had progressed, but also the degree of verisimilitude still possible in a work bordering on total autonomy. The primary aesthetic delectations that Analytic Cubism provided were certainly of the mind, rather than the senses, but despite the monochromes of the style and its mechanization of form, such masterpieces of obsessive, analytical

intelligence as the Vollard portrait represent a triumph of subtle lyrical sentiment over impersonal formalism.

The impetuous and fundamentally revolutionary Picasso soon outdistanced Braque and pushed their pictorial innovations to the logical conclusion of near abstraction. The closest either of the founding Cubists came to this resolution occurred in the paintings Picasso produced while spending the summer of 1910 at Cadaqués, Spain. In the work seen here (Fig. 234), the tall female figure seems little more than an open structure of interlocking arcs and angles, painted with the hatched, luminary delicacy of a mature Rembrandt. The image struck Alfred Barr as less that of a standing nude than "the slight lifting, overlapping, and subsiding of shingles lying upon rippling water."¹³ At the 1913 Armory Show in New York a similar work reminded one critic of a"fire escape." This was the period, lasting into 1911, when Braque and Picasso so faceted both solid and void that their pictures formed a continuous, unified whole and took on a tangible surface. Landscape, still life, and human figure motifs were reduced to an almost nonrepresentational arrangement of overlapping flat planes, wedges, and curves, guite as if natural appearances had been exploded and their fragments schematically reassembled.

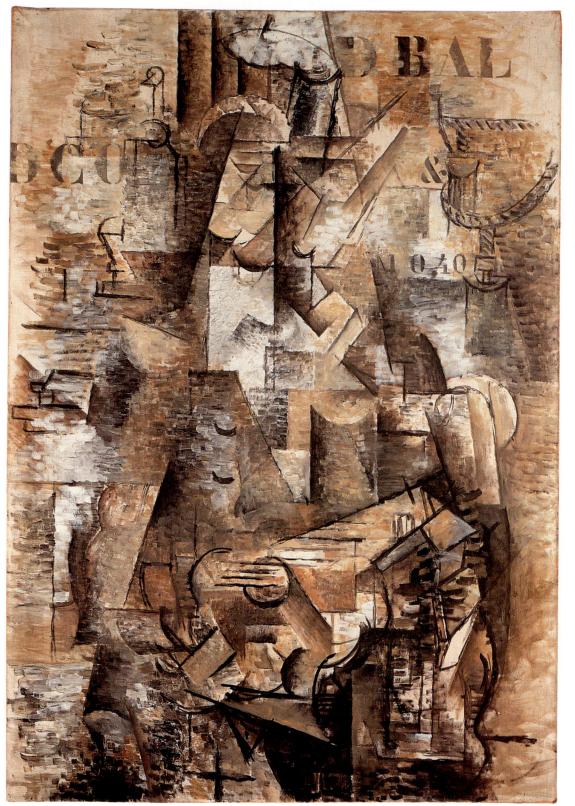

left: 235.

Georges Braque. The Portuguese. 1911. Oil on canvas, 45¹/8 x 32¹/8". Kunstmuseum, Basel. Donation Raoul La Roche.

opposite left: 236.

Pablo Picasso. *Guitar.* 1912. Sheet metal and wire, 30¹/₂ x 13³/₄ x 7⁵/₈". Museum of Modern Art, New York. Gift of the artist.

opposite right: 237. Pablo Picasso. Still Life

with Chair Caning. 1912. Oil and pasted oilcloth on canvas, surrounded with rope; 10⁵/8 x 13³/4". Musée Picasso, Paris.

Braque's *The Portuguese* (Fig. 235) provides another supreme example of this uncompromising, mandarin phase that managed to hold to an exquisite tension the observed subject and independent formal invention. While Cubism had, at this point, almost severed ties to recognizable reality, it was nevertheless far from being dryly intellectual or entirely nonsensuous. Taking their cue from the Neo-Impressionists, the Cubist painters strongly emphasized touch and a brushstroke that stood out in assertive texture and relief, employing this painterly resource to reaffirm the phys-

ical concreteness of the painting surface as well as the sensory pleasure of a retinal art. In his *Portuguese* Braque built the surface up in small loaded strokes, thus giving body to an elevated formal concept in palpable medium. No matter how fragmentary and remote, references to the object are still discernible, and one can piece together a plausible subject matter of musical instruments and anatomical allusions. In such works as *The Portuguese* Western civilization attained a rare and exalted moment of both cerebral and sensuous elegance.

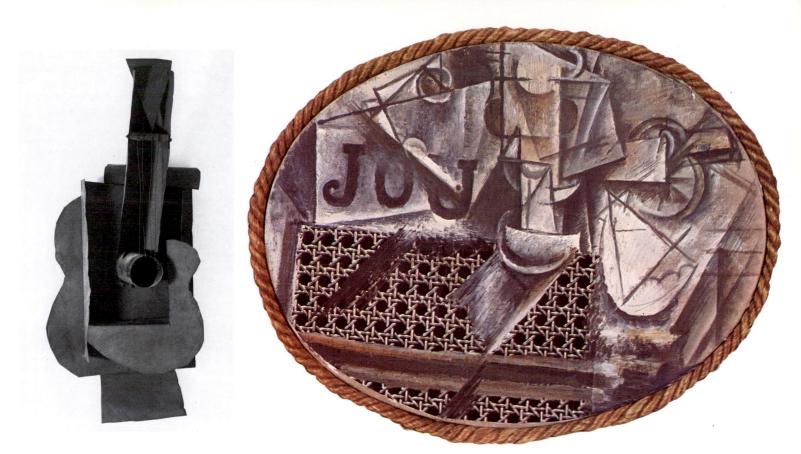

Beginning with *The Portuguese*, stenciled or commercial lettering appeared on the surface of Cubist pictures for the first time, to be followed at a later date by the trompe-l'oeil imitation of wood grains and varied textural effects. Although normally alien to conventional painting methods, Braque had mastered such techniques during his early training as a house and decorative painter. Visual *non sequiturs* of this sort violated the traditional integrity of painting's "noble means." But by introducing bits of reality out of context, the Cubists achieved an effect of psychological surprise and dislocation, while also forcing the frontal plane into new prominence and thus stressing the reality of the painting surface.

Synthetic Cubism

With his witty bit of illusionism in Violin and Palette (Fig. 232), Braque had metaphorically "nailed" his art to external reality even as he moved it toward ever greater abstraction. Cleverer yet, he subsequently served the same purpose by the more purely pictorial means-means that affirmed rather than denied the physical flatness of the painting surface-of stenciled letters and simulated wood grain. Continuing this line of development, Picasso in early 1912 made an actual bas-relief, not by the traditional technique of modeling, which he used for the monolithic 1909 Woman's Head (Fig. 231), but by the revolutionary technique of constructing a guitar from the industrial materials of sheet metal and wire (Fig. 236). In this way he realized a three-dimensional, openwork equivalent of the shallow space and frontalized, interpenetrating planes found in the Analytic pictures. With typical Cubist irony, Picasso cut the front of the instrument's body away and built the sound hole as a cylinder, thereby making the central void the only positive and integral form in the composition.

Eager to recover other aspects of reality—positive color and texture, for instance—and increase the legibility of his pictures, without resorting to the outmoded conventions of older art, Picasso forfeited oil and brushwork in favor of real components pasted directly onto the support. This led him, in early 1912, to produce *Still Life with Chair Caning* (Fig. 237), and, with it, to invent *col*-

lage (from the French word *coller*, meaning "to glue"), one of the most fertile and liberating techniques ever conceived in modern art. Here Picasso took the logic of imitating the banal aspects of the physical environment one important step further. *Still Life with Chair Caning* includes a piece of oilcloth printed in imitation of actual caning. To leave no doubt about the coexistence of dual realities—the representation of the still life and its evocation with real-life fragments of materials—the artist framed the small oval canvas with a hemp rope, which paradoxically imitated the scroll-like shapes of a conventional gilt-wood picture frame.

The curious combination of banality and metaphysical doubt that Picasso's collage symbolized was first pointed out by Apollinaire in the most poetic and perceptive appreciation of Cubism. He wrote of Picasso:

Then he sharply questioned the universe. He accustomed himself to the immense light of depths. And sometimes he did not scorn to make use of actual objects, a two-penny song, a real postage stamp, a piece of oil-cloth furrowed by the fluting of a chair. The painter would not try to add a single picturesque element to the truth of these objects.

Surprise laughs savagely in the purity of light, and it is perfectly legitimate to use numbers and printed letters as pictorial elements; new in art, they are already drenched with humanity.¹⁴

These disruptive and antitraditional effects of the collage strangely achieve a consoling harmoniousness. The strategem of using untransformed materials, or a variety of details selectively edited from external reality, seemed irrational and perverse at the time, or at best frivolous. Now it can be understood as a sincere and serious method of exploring the new expressive possibilities of mixed media, while at the same time freeing the art object from the pretentious associations of its fine arts status by resituating it in the commonplace environment. This represents the first instance in our century where the modern artist utilized a deliberately vernacular, or vulgar, visual language to challenge so-called high art.

Moved by Picasso's new, constructive method of creating art, Braque soon invented *papier collé* (''pasted paper''), a pictorial composition assembled from fragments of paper applied to the

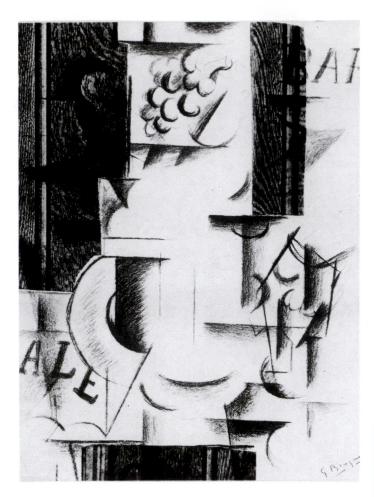

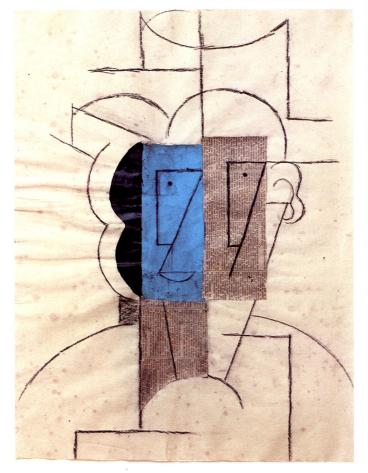

support with an adhesive. In *Fruit Dish and Glass* (Fig. 238), the first such work, the artist used imitation-oak wallpaper to represent the drawer of a table set with a still life of fruit and wine glass. The charming little picture would seem to challenge us to determine where truth lies—in the artificial wood of the real wallpaper or in the honest deception of the Cubist still life?

Needless to say, Picasso immediately tried his hand at *papier* collé and found new possibilities of droll condensation and paradoxical juxtapositions of art and life. Man with a Hat, for instance, contains one visual pun after another (Fig. 239). Here the artist suggested volume, but avoided illusionism, by stripping in sections of sharply contrasted sheets of paper, newsprint for the light-struck side of the face and solid blue for the aspect in shadow. And far from being randomly selected, as Robert Rosenblum has discovered, the newsprint fragment over the chest comments on a treatment for tuberculosis, while that adjacent to the mouth and nose refers to teeth and nasal cavities!¹⁵

left: 238. Georges Braque. Fruit Dish and Glass. 1912. Pasted paper and charcoal on paper, $24 \times 17\frac{1}{2}$ ". Private collection.

below left: 239. Pablo Picasso. Man with a Hat. 1912–13. Charcoal, ink, and pasted paper; 24½×185%". Museum of Modern Art, New York. Purchase.

below right: 240. Pablo Picasso. *Portrait of a Young Girl.* 1914. Oil on canvas, 4'3¼"×3'2¼". Musée National d'Art Moderne, Paris.

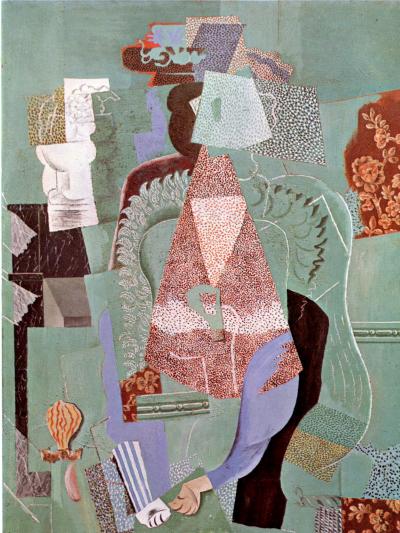

The Cubist Revolution
144

241. Pablo Picasso. Three Musicians. 1921. Oil on canvas, 6'7" × 7'3¾". Museum of Modern Art, New York. Mrs. Simon Guggenheim Fund.

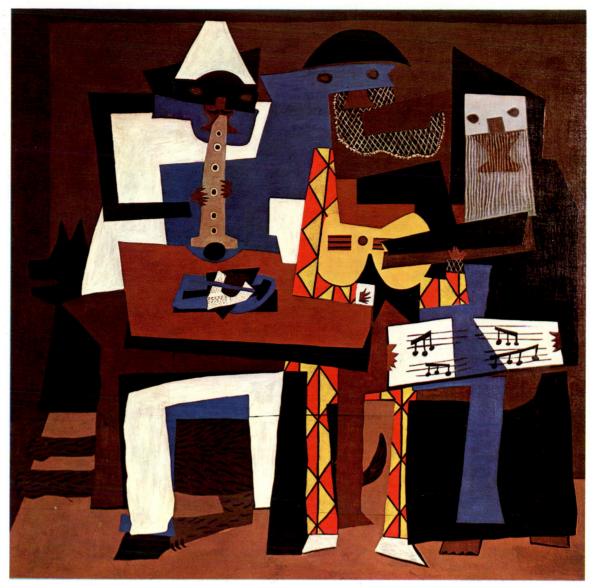

Now in command of a much-expanded range of pictorial means, Picasso and Braque began to make pictures less by breaking forms down than by assembling or building them up. Because the new approach was constructive and therefore synthetic rather than analytic, the style it generated came to be known as Synthetic Cubism. Less hermetic and cerebral than its immediate antecedent, Synthetic Cubism remained a dominant mode of expression right through the 1920s, and in certain fundamentals the aesthetic endures even today. In its more accessible, Synthetic phase, Cubism became an international style, providing fertile ground for artists of every temperament and producing pictures of greater flatness and monumentality than those of Analytic Cubism, as well as works richer in color and texture and far more varied in mood.

When Picasso and Braque reverted to the oil medium, they laced it with sand for added texture and further enriched their surfaces with stippled effects, bright colors, and rococo pictorial ornament. This decorative manner is handsomely represented by Picasso's *Portrait of a Young Girl* (Fig. 240), where the object fragments of Analytic Cubism have been synthesized into distinct and legible color masses. It reached its apogee in two magnificent versions of a monumental composition, *Three Musicians*, both of which the Spanish master painted at Fontainebleau in the summer of 1921. The figures recall a classical theme taken from the iconography of the *commedia dell'arte*. In the Museum of Modern Art's

version (Fig. 241), a Pierrot at the left is playing a woodwind, a harlequin at the center plays a guitar, and a monk at the right, masked like his fellow performers, sings from sheet music in his lap. The simplicity of the theme is countered by the extraordinary intricacy of a system of interlocking jigsaw-puzzle fragments and by the theatrical brilliance of the color. Both works have fantastic overtones and even a touch of the sinister in their distortions, which anticipate the dreamworld imagery of Surrealism, a movement launched in the mid-1920s to which the ambiguous, shifting identies of Cubist imagery contributed significantly.

Cubist Sculpture

The great wave of Cubist pictorial innovation and abstraction altered the character of contemporary sculpture just as decisively as it had painting. We have already seen how Picasso tested the planes of Cubism in three-dimensional form with his *Woman's Head* of 1909 (Fig. 231). Only with the *Guitar* of 1912 (Fig. 236), however, did the artist find the means—construction with prefabricated materials—to liberate his sculpture from mass and achieve an openwork form comparable to the transparent planarity of Analytic Cubist painting. Then, under the accelerating impact of Cubist analysis of form and the notion of interpenetrating solid and void, Picasso's constructed sculpture soon became almost completely left: 242. Pablo Picasso. Violin and Bottle on a Table. 1915–16. Construction of painted wood, tacks, string, and charcoal; 17% × 16% × 7½". Musée Picasso, Paris.

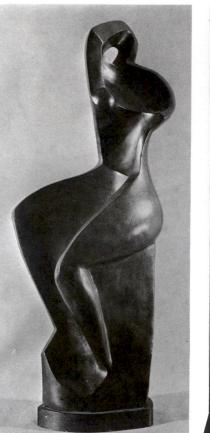

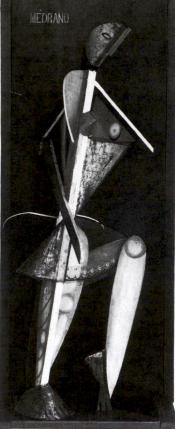

above left: 243. Alexander Archipenko. Seated Woman. 1916. Bronze, 30" high. Private collection, Milan.

above right: 244. Alexander Archipenko. *Médrano II.* 1913. Painted tin, wood, glass, painted oilcoth; 4'17/₈" high. Solomon R. Guggenheim Museum, New York.

abstract. In *Violin and Bottle on a Table* (Fig. 242), a work of 1915– 16, the artist left tradition even further behind in favor of a painted wood and string construction, which is marginally representative of the objects the title describes. Only remote hints of the musical instrument remain, in the jagged sound hole, vertical strings painted yellow, and the F-holes cut into the violin surface. The solidity of early Cubist sculpture volumes has been abolished in favor of "virtual" volumes and an effect of shallow relief.

Julio González, a compatriot and sculpture assistant to Picasso, before he was recognized as an independent figure in his own right (Figs. 405, 406), reported how Picasso radically conceived of the new sculptural object. Picasso managed to transform Cubist sculpture by employing humble materials such as wood and metal, a strategy that would exercise a profound influence on the contemporary Russian Constructivist movement. Linking Picasso's first Cubist paintings of 1908 and his constructed sculpture of the late 1920s (Fig. 335), González wrote:

Picasso gave us form not as a silhouette, not as a projection of the object, but by putting planes, syntheses, and the cubes of these in relief, as in a "construction." With these paintings, Picasso told me, it is only necessary to cut them out—the colors are only indications of different perspectives, of planes inclined from one side or the other—then assemble them according to the indications given by color, in order to find oneself in the presence of a 'Sculpture'.¹⁶

Others were quick to explore and expand the new vision. Among the most important Cubist pioneers in sculpture were the Russian-born Alexander Archipenko (1887–1964) and Polish-born Jacques Lipchitz. With its interplay of concave and convex volumes, *Seated Woman* by Archipenko is typical of the new definition that Cubist sculpture now gave to form and space (Fig. 243). One of this artist's most influential innovations was the use of a void to represent the human head—a solid volume pierced and opened, so that the surrounding spatial ambience became an integral part of the total form. Other Archipenko inventions included a series of semiabstract figures constructed of painted wood, metal, and glass, among them the *Médrano II* (Fig. 244). These illusionistic figures, which adapted the techniques of collage to sculpture, tended to be rather mannered and garish, however, and decorative styling replaced that concern for re-creating spatial relationships which provided inspiration for the most serious Cubist sculptors, Lipchitz, Duchamp-Villon, and, of course, Picasso.

Jacques Lipchitz (1891–1964) produced mannered, Art Nouveau-type decorative sculptures before attempting the Cubist methods of open-volume construction in late 1914. In his art he benefited considerably from his association with Juan Gris (Figs. 248, 249). Lipchitz apparently submitted to the influence of Gris's aesthetic ideas as they were later set forth in the magazine *L'Esprit nouveau*, where the Spanish artist described his deductive method and thereby gave late Synthetic Cubism its most essential definition (see p. 149). During the years of his friendship with Gris, in 1916–19, Lipchitz introduced a different approach to Cubist sculpture. He made his subjects—bathers, sailors, a Pierrot playing a clarinet, men playing guitars—less abstract and more legible (as Gris was doing in his painting), while emphasizing their mass (Fig. 245). In these figures, Lipchitz used chunky, geometricized forms,

far left: 245. Jacques Lipchitz. Man with a Guitar. 1915. Limestone, 38¼" high. Museum of Modern Art, New York.

left: 246. Henri Laurens. Bottle and Glass. 1918. Metal construction, 10½×23¾". Galerie Louise Leiris, Paris.

below: 247. Raymond Duchamp-Villon. Large Horse. 1914. Bronze, 39½″ high. Musée National d'Art Moderne, Paris.

which he articulated subtly to evoke fuller volumes than had Archipenko. In total formal impact, these powerful, and yet elegant, masterpieces of Cubist sculptural method are a far more complete and satisfying expression of the spirit of Cubism than Archipenko's interplay of shallow convexities and concavities. Lipchitz's *Man with a Guitar* creates a vertical, ascending rhythm of light masses set in opposition, not unlike the compact setbacks of skyscraper architecture.

Another important Cubist sculptor whose later work in the 1930s and 1940s changed, like Lipchitz's mythical and more urgent themes (Figs. 407–409), from the geometric to Baroque, rounded, voluptuous figures was Henri Laurens (1885–1954). Besides his extremely refined and straightforward Cubist work, Laurens, as early as 1914, anticipated later developments with colored abstractions made of sheet iron (Fig. 246).

Raymond Duchamp-Villon (1876–1918; brother of Marcel Duchamp and Jacques Villon) showed promise of being the major Cubist sculptor until his career ended with tragic abruptness in 1918, when he died of typhoid contracted at the Front. Duchamp-Villon sought not only new sculptural form, but also an integration of sculpture with architecture. His mastery of the Cubist idiom attained an epic power in the *Large Horse* (Fig. 247), a striking representation of machine and animal imagery in a synthesis utilizing the contemporary language of abstract mass movement and suggestive symbol. Duchamp-Villon began the sculpture as a group with a rider trying to restrain a rearing, almost mechanically impelled, horse. At that time, the obsession with machines, speed, and motion effects was very much under discussion, and he had

already seen how they were embodied and expressed in the work of his brother Marcel Duchamp, the Futurists, Francis Picabia, and Fernand Léger (Figs. 252, 255, 260, 261). Combining fragments of an identifiable horse's anatomy—head, neck, and hoof—with machine forms, the compact, dynamic design suggests both straining, muscular animal energy (of a kind that would at that moment in time prove equally fascinating to the German Blue Rider group [Figs. 191, 197]), and the piston thrusts of an engine. The *Large Horse* marks an early high point in Cubist sculpture.

The logical extension of the pictorial ideal that Braque once described as "the materialization of a new space" into convincing sculptural objects was but another of the many imaginative developments of the spreading Cubist revolution. The same Cubist spatial concepts that permeated three-dimensional sculptural form also had far-reaching effects, both in social and aesthetic terms, for architecture, as we shall see.

In its formal dimension, as well as in its psychological expression of the multiplicity of individual experience in a technologically complex age, Cubism has become the cornerstone of the modern movement in the fine arts and inseparable, generally, from modern consciousness. Without an awareness of Cubism's formative role in stimulating a unified style in art, architecture, and design, we could scarcely appreciate the visual character of the modern world, or understand our own complex interaction with that world. Basically, the Cubist artists replaced an outworn traditional illusionism and undercut the spiritual or symbolic values which had supported that artistic vision.

From Cubism to Abstract Art: Futurism, Suprematism, De Stijl

F or Renaissance certitude—the clear, hierarchical relationships of all things and the measured proportionality of space—Cubism substituted ambiguities and contradictions, in content as well as in form. By devaluing subject matter, or monumentalizing simple, personal themes, and by allowing mass and void to elide, the Cubists gave effect to the flux and paradox of modern life and the relativity of its values. But while expressing the fugitive and discontinuous character of the phenomenal world, it proclaimed the absolute validity of its own pictorial world. A Cubist picture is therefore suspended in tense equilibrium between

abstraction and illusion, between autonomy as a two-dimensional object—'essentially a flat surface covered with colors assembled in a certain order' — and an analogue of the three-dimensional universe. A tantalizing equivocation, Cubism brought forth an aesthetic language of such flexibility and power that it became the *lingua franca* of the avant-garde wherever this emerged in the Western world.

Beginning in 1912, a host of young painters adopted the new Cubist idiom: Juan Gris, Jean Metzinger, Albert Gleizes, Fernand Léger, Francis Picabia, Roger de La Fresnaye, Jacques Villon,

248. Juan Gris. Bottle of Banyuls. 1914. Collage, pencil, and gouache on canvas; 215% × 181%". Kunstmuseum, Bern. Hermann and Margit Rupf Foundation.

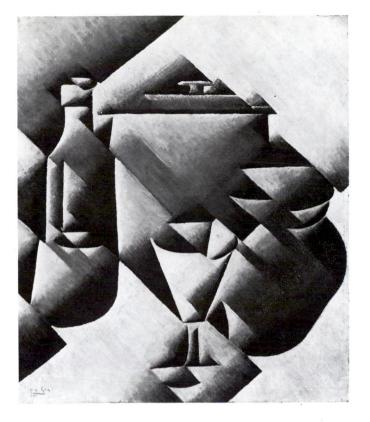

Marcel Duchamp, Robert Delaunay, Le Fauconnier, and others. Some were content to work in almost anonymous, impersonal manners, but not without recognizable individual distinction; others not only added their own inflections but, in some cases, radically altered the character and structure of Cubist style. The most generative and influential movement of the period, Cubism directly inspired a variety of foreign movements, dedicated to other objectives, with vastly differing results and visual character in Italy, Germany, England, and Russia.

One of the most original and important of the converts to Cubism was Juan Gris (1887–1927) from Picasso's Spain, who arrived in Paris in 1906 and moved into the Bateau-Lavoir, the ramshackle tenement where Picasso, Apollinaire, Max Jacob, and others of the Cubist circle lived. Shortly after its invention in 1912, Gris took up *papier collé*, a technique with which he created some of Cubism's most beautiful and serious works. *Bottle of Banyuls* (Fig. 248) offers an extraordinary harmony of vivid and sober colors, and of subtle textures in conjunction with delicately muted, shaded drawing, all of which lend an air of fragile mystery to the banal fragments of the bottle's label, the newsprint, the silhouetted pipe and glass that comprise its imagery.

Having adopted the Cubist language just as its creators were moving from their analytical to their constructive mode, Gris immediately understood Cubism as an intellectual system of composition, rather than as an experimental method (Fig. 249). As early as 1912 he was using the mathematically derived proportions of the golden section to control the two-dimensional relationships of his picture. In an article for L'Esprit nouveau, published in 1921, Gris described his approach and, in fact, provided the classic definition of the last phase of Synthetic Cubism: "I try to make concrete that which is abstract. ... Mine is an art of synthesis, of deduction. . . . Cézanne turns a bottle into a cylinder, but I begin with a cylinder and create an individual of a special type: I make a bottle-a particular bottle-out of a cylinder. ... That is why I compose with abstractions (colors) and make my adjustments when these colors have assumed the form of objects."¹ As these remarks and the painting in Figure 249 suggest, Gris also had natural gifts that helped him introduce light, as well as color, into Cubist art.

In further significant innovations, based on Cubist principles of design, the Frenchman Robert Delaunay (1885–1941) and Frank Kupka (1871–1957), a Czech working in Paris, together developed a new heresy in the form of abstract color painting (Figs. 250,

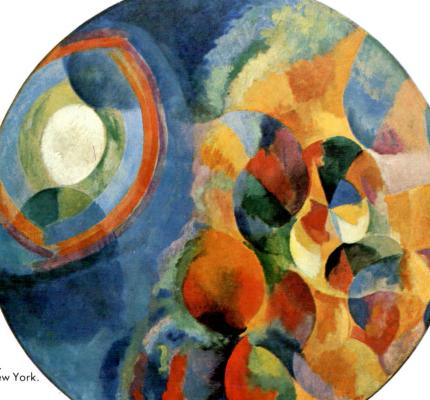

above 249. Juan Gris. Still Life. 1911. Oil on canvas, 23½ × 19¾". Museum of Modern Art, New York Acquired through the Lillie P. Bliss Bequest. left: 250. Robert Delaunay. Simultaneous Contrasts: Sun and Moon. 1913 (dated on painting 1912). Oil on canvas, 4'5" diameter. Museum of Modern Art, New York. Mrs. Simon Guggenheim Fund.

From Cubism to Abstract Art

right: 251. Frank Kupka. Amorpha: Fugue in Two Colors. 1912. Oil on canvas, 6'11%"×7'2%". Národní Gallery, Prague.

below: 252. Fernand Léger. Contrast of Forms. 1913. Oil on canvas, 4'3¾"×3'2½". Philadelphia Museum of Art (Louise and Walter Arensberg Collection).

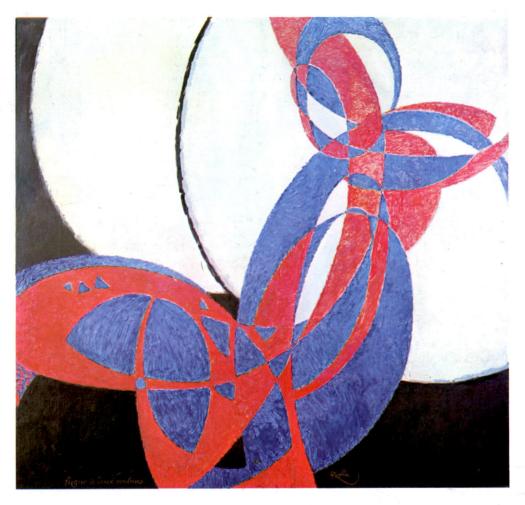

251). They fused the spectrum colors of Fauvism with Cubist design and created the pure color abstraction that Apollinaire later called Orphism. Using softened circular forms to interpret mystical intensities of radiant light, Delaunay anticipated by two years certain of Severini's and Balla's most interesting abstract geometric representations of brilliant color patterns alluding to the dynamic energies of modern life. Delaunay and Kupka, meanwhile, arrived at some of the first systematically abstract painting of the century, coincidental with Kandinsky's abstract improvisations in Munich (Figs. 193, 195). The artists' paintings preserved the triangular and circular segment forms of the Cubists, but melted the edges of their arcs and planes into radiant cores of light of graduated intensities.

After an apprenticeship in Analytic Cubism, Fernand Léger (1881–1955) began to employ lightly tinted color planes, fixed shapes, and silhouettes suggesting machine parts (Fig. 252). In 1919 with his painting *The City* (Fig. 253), surely one of the most powerful and memorable of Cubist compositions, Léger emerged into a style of epic breadth and unselfconscious modernity. It represents a brilliant synthesis of detached aesthetic objectives and the contemporary preoccupation with machine imagery. By 1921 Léger had painted such monumental figure compositions as *Three Women* (Fig. 426), which showed an even more extreme, machine-like transformation of his tubular Cubist imagery.

Léger's paintings were allied to the contemporary efforts of the Purists, a group composed of the painter Amédée Ozenfant (Fig. 427) and the architect Le Corbusier (Figs. 341, 635)—who painted under his actual name, Charles-Édouard Jeanneret (1887–1965) to re-establish the aesthetic worth of ordinary manufactured objects within the basic form language of Cubism (Fig. 254). The simplicity and anonymous felicity of machine-made objects and bare, functional furniture would later dominate Le Corbusier's architectural interiors and design.

During the war and early postwar years, a more sardonic spirit and irrational fantasy took root, in the machine art of Marcel Duchamp (1887-1968) and Francis Picabia, proclaiming a new mood of nihilism. Duchamp's famous Nude Descending a Staircase, No. 2 of 1912, had scandalized the American public at the Armory Show in New York in 1913 (Fig. 255; see pp. 250-251). Although still working within the Cubist convention, Duchamp had begun to exploit extra-pictorial associations. His figure in motion symbolized the almost coercive sense of the new mechanical factors at large and their dehumanizing effect. Soon Duchamp and Picabia began

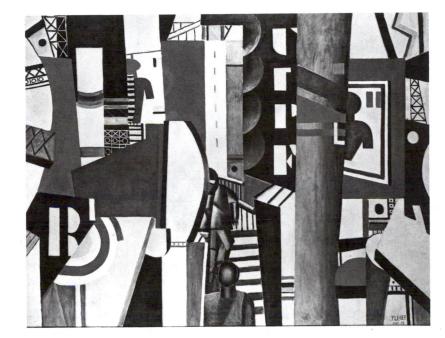

above left: 253.

Fernand Léger. The City. 1919. Oil on canvas, $7'7'' \times 9'\frac{1}{2}''$. Philadelphia Museum of Art (A.E. Gallatin Collection).

left: 254.

Charles-Édouard Jeanneret (Le Corbusier). Still Life. 1922. Oil on canvas, 25³/₈ × 31¹/₂". Musée National d'Art Moderne, Paris.

above right: 255. Marcel Duchamp. Nude Descending a Staircase, No. 2. 1912. Oil on canvas, $4'10'' \times 2'11''$. Philadelphia Museum of Art (Louise and Walter Arensberg Collection).

to fashion even more literal machine forms to which they gave absurdly romantic or satirical titles. An example is Picabia's bizarre *Amorous Parade* (Fig. 295), whose designation adds an erotic component to the fantastic machine creatures and stirs an ancient fear in man of being replaced in his vital functions by robots. These images and their meanings, either explicit or veiled, were calculated to shock and disturb the public, thus anticipating the disruptive iconoclasm that became the official program of the organized Dadaists.

Even within the Dada movement, Cubist design made itself felt in the collage constructions of waste materials made by Kurt Schwitters (1887–1948). In Germany after World War I Schwitters brought to the collage a degree of refinement that was nothing short of uncanny, given both the limitations of the medium and the iconoclastic character of the artist's commonplace subject matter (Figs. 256, 300, 301). Implicit in his collages is a commentary on a shredded and disintegrated postwar society, which Schwitters interpreted from a profoundly disenchanted, Dadaist point of view.

And the savage attacks mounted by George Grosz upon the moral disintegration of wartime German society also reveal an underlying Cubist structure (Figs. 210, 298), as does the witty and fantastic imagery of Paul Klee (Figs. 202–204). In Germany, where the more habitual and charged emotional climate for art could have been expected to impede the acceptance of an analytical, objective style, Cubism nonetheless had a direct influence. As we have seen (Figs. 197, 198), works by members of the Blue Rider group combined the geometric syntax of Cubist style and Delaunay's intense, prismatic color with a native Teutonic tradition of romantic transcendentalism.

Futurism

In Italy, Cubism provided the major impetus for the furiously modern innovations of the Futurists, who first gained respect as serious and original artists when, in 1912, they began to show with the Cubists in Paris. While the Futurists wanted their paintings to express speed, violence, dynamic movement, and the passage of time, their technique nonetheless derived from the more static and contemplative art of the Cubists. Their militant program of action, however, vehemently opposed the Cubist spirit. In 1909 the Belgian Symbolist poet Emile Verhaeren wrote a prophetic declaration: "Future, you exalt me as once my God exalted me."² That same year the Italian poet who was the ideological father of the Futurist movement, Filippo Tommaso Marinetti, wrote in a manifesto composed in Paris that the modern bard should henceforth sing only of "the multicolored and polyphonic surf of revolution in modern capitals; the nocturnal vibration of arsenals and docks beneath their glaring electric moons \dots ; factories hanging from the clouds by the threads of their smoke."³ Then he proceeded to distribute the manifesto throughout the world, proclaiming, in alternatively idealistic and rather brutal rhetoric, the demise of the art of the past and the birth of the art of the future.

Around him Marinetti gathered a group of painters, the most important of whom were Umberto Boccioni, Carlo Carrà, Luigi Russolo, Giacomo Balla (1871–1958), and Gino Severini. Together, the artists composed the *Manifesto of the Futurist Painters*, which they published on February 11 and publicly proclaimed on March 8, 1910, in a disruptive meeting before an outraged audience at the Chiarella Theater in Turin. This official declaration of Futurist artistic principles was followed on April 11 of the same year by the *Technical Manifesto of Futurist Painting*. Further manifestoes and demonstrations of an increasingly provocative character appeared in quick succession. In 1912 the group organized an exhibition of their work in Paris, and in 1914 Boccioni published a book that gave their ideals final expression. Living in the shadow of Italy's overwhelming artistic tradition, which ranged from Etruscan and Roman antiquity through the Renaissance and Baroque periods, the Futurists felt impelled to rid themselves of the past, and used their art to celebrate modern urban existence. They underwent a ritual baptism as children of the machine, which had become a burning issue in art, both as imagery and form, and, appropriately enough, proclaimed themselves "the primitives of a new and transformed sensibility."⁴ An exalted sense of change and an almost mystic transport of identification with some universal dynamism, experienced through the machine, marks the romantic rhetoric of their jointly sponsored manifesto of April 11, 1910, where they declared:

- That all forms of imitation must be despised, all forms of originality glorified.
- 2. That it is essential to rebel against the tyranny of the terms "harmony" and "good taste" as being too elastic expressions, by the help of which it is easy to demolish the works of Rembrandt, of Goya and of Rodin.
- 3. That the art critics are either useless or harmful.
- 4. That all subjects previously used must be swept aside in order to express our whirling life of steel, of pride, of fever and of speed.
- 5. That the name "madman" with which it is attempted to gag all innovators should be looked upon as a title of honor.
- 6. That innate complementariness is an absolute necessity in paintings, just as free meter in poetry or polyphony in music.
- That universal dynamism must be rendered in painting as a dynamic sensation.
- 8. That in the manner of rendering nature the first essential is in sincerity and purity.
- 9. That movement and light destroy the materiality of bodies.⁵

Indeed, with this manifesto and others that followed, it became clear that polemics on the part of poets, literary propagandists, and the artists they represented were to play a major role henceforth in the formation of artistic movements. Futurism was perhaps the first militant movement of this distinctly modern character, where radical aesthetics and a program of action joined hands.

Curiously, the Futurists all showed the influence of the fantastic Symbolist styles of *fin-de-siècle* decadence, even as their new ideas were taking plastic form (Fig. 257). After 1911, however, their art took its formal cues from Cubist innovation but charged Cubist formal structure with new bustle, aggressive movement, and feverish energy (Fig. 258). From Cubism's pictorial language of shifting planes, the Futurists had also learned to break through the surfaces of objects and show them moving in space, and to make such movement reflect states of mind. The Futurists glorified the modern delirium of speed, and, with perhaps an undiscriminating appetite, swallowed the contemporary machine environment whole, discharging their new impressions in a kaleidoscope art of force lines, vectored shapes, and mobile patterns.

Umberto Boccioni (1882–1914) was one of the most expressive and artistically powerful members of the Futurist group. His *Dynamism of a Soccer Player* (Fig. 258) synthesized the two important lines of Futurist investigation, that of the representation of movement and that of the creation of a pictorial equivalent for the machine. Through an interest in the Neo-Impressionists' brushstroke and bright palette, Boccioni and his fellow Futurists also contributed to the revival of the interest in color. Indeed, just when monochrome Cubism was at its height, Gino Severini (1883–1966), working in Paris, had already repudiated the beiges, grays, and tans

From Cubism to Abstract Art

Kurt Schwitters. Merz Construction. 1921. Painted wood, wire, and paper; 15 × 8¹⁄₂ × 2¹⁄₂". Philadelphia Museum of Art (A.E. Gallatin Collection).

opposite above: 257.

Giacomo Balla. Street Light. 1909. Oil on canvas, 5′8¾″ ×3′9¼″. Museum of Modern Art, New York. Hillman Periodicals Fund.

right: 258. Umberto Boccioni. Dynamism of a Soccer Player. 1913. Oil on canvas, 6'4¼"×6'7¼". Museum of Modern Art (Sidney and Harriet Janis Collection), New York. of Braque and Picasso in favor of a brilliant palette that made the initial Cubist mood of chromatic repression seem antiquated (Fig. 259).

The major painter of Futurism, Boccioni was also its only significant sculptor. Calling traditional sculpture "a mummified art," he wished to reconcile it with the movement and dynamism of the modern world and to relate his shapes to the ubiquitous machine. His highly imaginative, streamlined sculptures emerged as mobile in form as contemporary stroboscopic photography. In 1912 Boccioni wrote the *Technical Manifesto of Futurist Sculpture*, which boldly and prophetically called for new space concepts and new materials: "The enclosed statue should be abolished, the figure must be opened up and fused in space. . . . We shall have in Futurist composition planes of wood or metal stationary or mechanically mobile."⁶

Boccioni's sculptures, cast from maquettes of plaster, were homogeneous in their metal, rather than assembled or constructed. In *Development of a Bottle in Space* (Fig. 260) the solid sculptural volumes are opened and penetrated by concavities symbolizing intersecting rays of light and force lines, which suggest the thrust and wake of movement, much as they do in his paintings. As the bottle emerges from a table-like base, it is analyzed into planes that extend explosively beyond the circumscribed contours of a delimited mass into the surrounding atmosphere. The sculpture achieves

above: 259. Gino Severini.

Dynamic Hieroglyphic of the Bal Tabarin. 1912. Oil on canvas, with sequins; 5'35%" x 6'1½". Museum of Modern Art, New York. Acquired through the Lillie P. Bliss Bequest.

right: 260. Umberto Boccioni. Development of a Bottle in Space. 1912. Silvered bronze (cast 1913), 15 x 127% x 23¾". Museum of Modern Art, New York. Aristide Maillol Fund.

below: 261. Umberto Boccioni. Unique Forms of Continuity in Space. 1913. Bronze, 43⁷/₈ x 37⁷/₈ x 15³/₄". Galleria d'Arte Moderna, Milan.

below right: 262. Giacomo Balla. Dynamism of a Dog on a Leash. 1912. Oil on canvas, 35% x 45½". Albright-Knox Art Gallery, Buffalo. Courtesy George F. Goodyear and the Buffalo Fine Arts Academy.

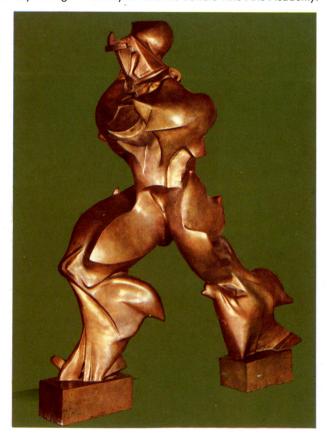

From Cubism to Abstract Art 154

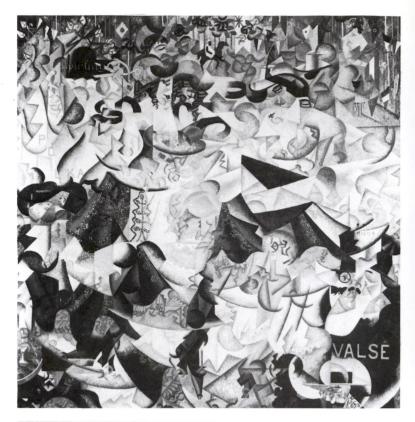

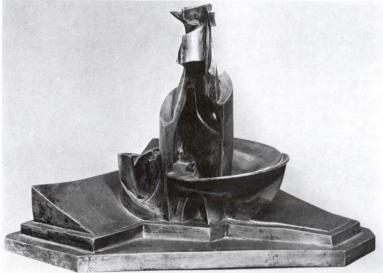

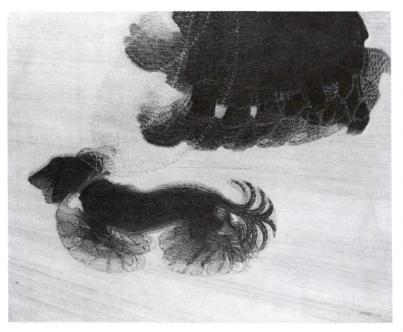

monumental scale on the powerfully rotated plinth from which it rises, although the piece is intimate in actual size.

With his Unique Forms of Continuity in Space (Fig. 261), Boccioni created the classic of Futurist sculpture as well as a riveting evocation of power and speed. Here the artist encased the massively muscled human form in spiraling scallops of metal that reinforce the impact of continuous motion. A famous figure, this icon of modernism seems to epitomize Marinetti's phrase: "A roaring automobile, which appears to run like a machine-gun, is more beautiful than the Victory of Samothrace."⁷⁷

The Futurists' mechanolatry, in effect, translated such images as Boccioni's speeding figure of Machine-Age Man into a kind of Nietzschean Superman and clearly contained an element of irrational worship, just as certain aspects of the movement's more overheated rhetoric sounded like science fiction. Some may find in the Futurists' boast and stridency a prophecy of Fascism, and in

fact Marinetti was an early follower of Mussolini. Certainly their emphasis on kinetic sensation, their insistence that "art enter into life at any price," and the generally programmatic character of their art put them at some distance from the French Cubists' conception of painting as an object of aesthetic contemplation. Curiously, however, despite the evident attraction to raw sensation and machine culture, the Futurists also managed to tap a source of mysticism and spirituality, putting them surprisingly close in mood to the Expressionists Marc and Kandinsky (Figs. 191-193, 195-197). Moreover, Futurism evolved toward a universalized and nonspecific art of abstract harmonies, not unlike Kandinsky's. Balla's development, for instance, from the witty depiction of motion in his celebrated Dynamism of a Dog on a Leash of 1912 to the abstract Mercury Passing before the Sun as Seen through a Telescope, two years later (Figs. 262, 263), marks a significant change from the visual, almost cinematic record of the movement of objects to the

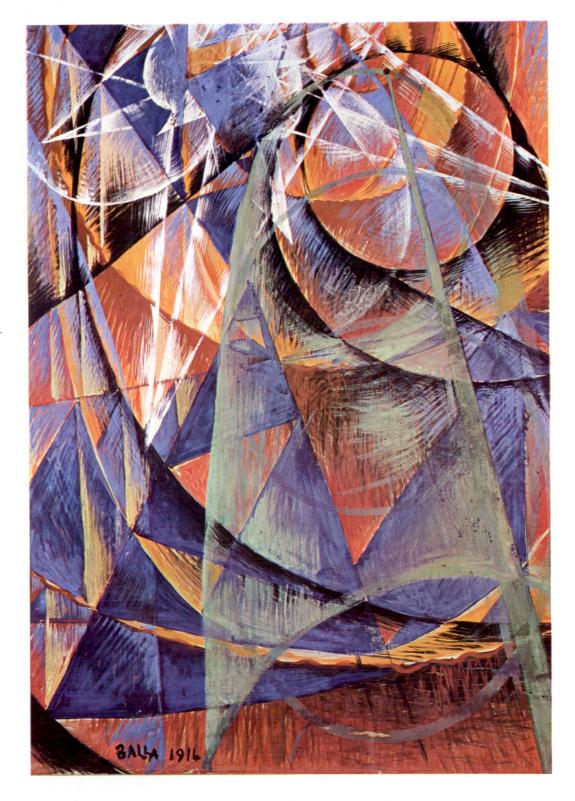

263. Giacomo Balla. Mercury Passing before the Sun as Seen through a Telescope. 1914. Tempera on paper, 47¼ × 39″. Private collection, Milan.

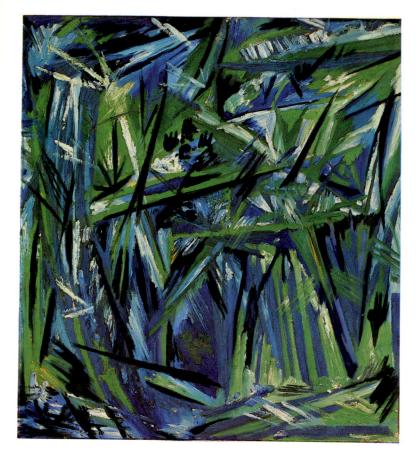

consciousness of the dynamic aspects of form itself—some universal rhythm in nature that knows no boundaries and recognizes no distinction or barrier, finally, between mind and matter.

Abstract Art in Russia

Perhaps the most durable meaning of the Cubist heritage for the future lay in its impact on entirely nonrepresentational art forms, first in Russia and then in the Netherlands during the decade between 1910 and 1920. Unlike the Futurists, who were so eager to throw off the burden of their artistic past, progressive Russians, after generations of enthusiastic consumption of Western cultural forms, had begun in the mid-19th century to nurture a desire for a purely Russian art based on Russian sources. Then, with the advent of the new century, the quest for national identity transformed itself into something considerably more ambitious and aggressive. It became the intellectual ferment that made the cultural life of pre-Revolutionary Russia, as Hilton Kramer has written, "a testing ground of every incendiary aspiration known to the modern mind. Religious mysticism, revolutionary politics, symbolist aesthetics, educational reform, sexual emancipation, and a consuming social idealism were conflated in a visionary attitude that decisively transformed the conception of everything-from the forms of art to the structure of the state-that fell within its ken. And in no realm of life were its results more radical than in the changes it brought to the very conception of art itself."8

The sheer backwardness of Russia, with its ancient peasant culture and mystical, even messianic Orthodox religion, would seem to have made it especially fertile ground for the growth of the idealizing tendencies of the new Western art. And the Russian intelligentsia had ample access to that Western experience, not only through such avant-garde publications as Diaghilev's *The World of Art (Mir Iskusstva)* and the fabulous collections of French modernism assembled by the Muscovites Shchukin and Morosov (Fig.

From Cubism to Abstract Art 156 178), but also through personal contacts made by Russian painters, sculptors, and architects in such cosmopolitan centers as Munich and Paris. By some unique combination of factors-the legacy of abstraction fundamental to the icons and patterned folk art of Old Russia, the freshness of minds remote from the melting pots of modernism, a chauvinistic desire to beat the West at its own game-the Russian avant-garde assimilated the most daring of European innovations with breathtaking speed and brilliantly carried them to the absolutist conclusions that Picasso, Braque, and Matisse, with their humanistic love of sensuous life, had steadfastly refused to accept. Russian vanguard artists, by their precocious, perhaps even ferocious embrace of total nonobjectivity, transformed what they would call Cubo-Futurism into something essentially Russian in spirit. From the beginning, it was not formalism or aesthetic experimentation for its own sake that fired the Russian imagination, but, rather, the radical, visionary values-religious or social-for which radical art seemed to offer not only a counterpart but also a powerful and effective means toward realization. Thus driven by a profoundly utopian conception of modernism, the Russians, in their resolute, uncompromising, but soul-felt abstract art, anticipated by fifty or sixty years such recently celebrated movements as Minimal Art and Color Field Painting.

Early Russian exponents of 20th-century modernism were Mikhail Larionov (1882–1964) and Natalia Gontcharova (1881–1962), who, no doubt moved to some degree by the primitivizing simplifications of Gauguin, the Nabis, and Picasso, evolved a kind of nativist art based on icons, traditional ornament, such as that in embroidery, and popular scenes of peasants, soldiers, and sailors. Then, in 1912–13, Larionov invented Rayonism (Fig. 264), a personal idiom that, with its storm of slashing, colored lines of force, the artist described as a purely Russian synthesis of Cubism, Futurism, and Orphism. After emigrating to France in 1915, Larionov and Gontcharova worked mainly in their folk-art style.

The Russian avant-garde movement was also notable for the number and unquestionable genius of its women members. The Cubist works produced by Liubov Popova (1889–1924), who in 1912–13 frequented the Paris studios of Metzinger and Le Fauconnier, must be counted among the strongest and most individual of all those to come from the followers of Picasso and Braque. Popo-

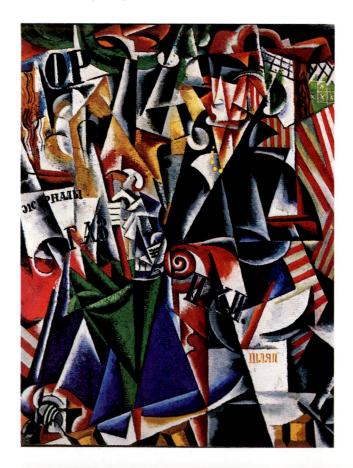

opposite above: 264.

Natalia Gontcharova. Green Forest. c. 1912. Oil on canvas, 215% × 195%". Collection McCrory Corporation, New York.

opposite below: 265.

Liubov Popova. The Traveler. 1915. Oil on canvas, 4'8" × 3'5½". Norton Simon Museum, Pasadena, Calif.

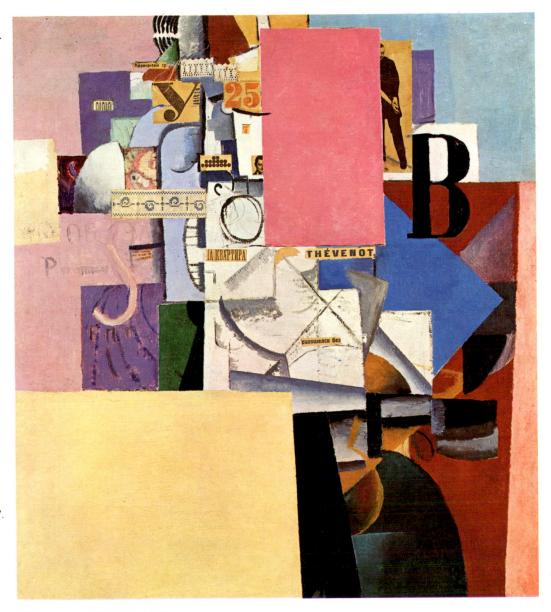

right: 266. Kasimir Malevich. Woman before an Advertisement Column. 1914. Collage and oil on canvas, 28 × 25¼". Stedelijk Museum, Amsterdam.

below: 267. Kasimir Malevich. Suprematist Painting (Eight Red Rectangles). 1915. Oil on canvas, 22½ × 18%". Stedelijk Museum, Amsterdam.

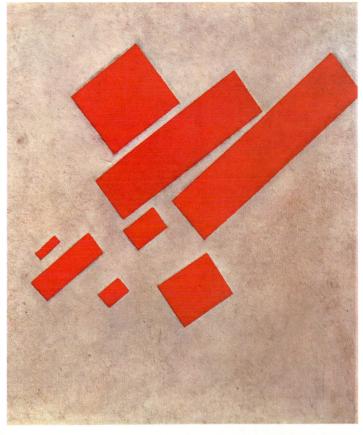

va not only mastered Cubist form and space, along with Futurist dynamism, but also made them a vehicle for her own special talents as a colorist (Fig. 265). Like other Russian modernists, Popova moved rapidly towards total abstraction, only to have her dazzling career cut short by death at the tragic age of thirty-five.

The Russian avant-gardist who first used the term Cubo-Futurist in relation to his own art seems to have been Kasimir Malevich (1878–1935). For Malevich, Cubism became a profound inspiration and then, surprisingly, an unsatisfactory halfway house en route to an absolute rejection of materialism and the objective world. By 1913 Malevich had worked his way through a variety of vanguard styles from Symbolism to his own form of Cubist collage. He termed the collage "nonsense realism," because it combined abstract structure and trompe-l'oeil fragments of actuality cut out with shears, all reassembled in a new and, at first glimpse, incoherent syntax (Fig. 266). Devoid of particularities of texture and object definition, his painted squares and rectangles became the basis of a purely abstract art. The first demonstration of his ideas came when the artist designed the backdrop of a Futurist opera, Victory Over the Sun, performed in St. Petersburg in December 1913. He paradoxically defined his invention of Suprematism as "the supremacy of . . . feeling in . . . art."9 Suprematism was perhaps the most revolutionary conception to date in modern art (Fig. 267). When Mal-

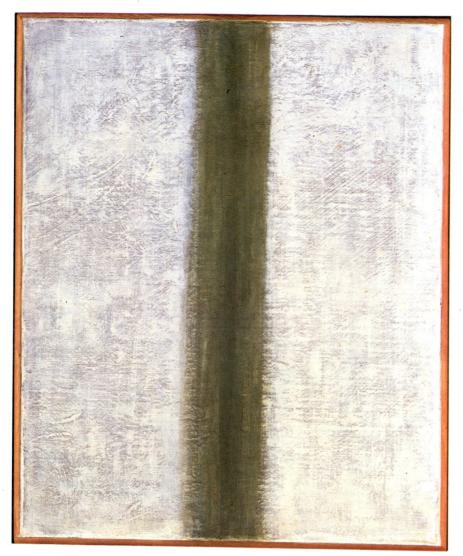

evich painted his first radical abstract picture of a black square on a white ground, he explained it with a missionary fervor typical of the pioneer generation of abstractionists. "In ... 1913, in my desperate attempt to free art from the ballast of objectivity, I took refuge in the square."¹⁰ Furthermore, this Russian believed that painting had become an instrument of universal knowledge, and he sought in abstract art the same mysticism and cosmic unity that Kandinsky was then pursuing outside Russia. Both artists had inherited their mysticism from the ideology, if not from the actual imagery, of Symbolism. The feeling to which Malevich alluded, however, is not personal emotion connected to the individual's psychic life but, rather, a form of revelation and transcendence. All psychic tensions dissolved in the apprehension of a new kind of absolute truth. Abstract art replaced the familiar world of naturalism, mundane objects, and events to form an aesthetic blueprint for a utopian world and for superior forms of personal expression.

By now, other artists, Kandinsky and Mondrian among them, were making the great leap into nonobjectivity, but Malevich, unlike the others, did not derive his repertory of forms from landscape but made an absolute break with external reality. Even Larionov and Gontcharova were appalled when they saw their colleague's *Black Square on a Black Ground*, while Alexandre Benois, an artist associated with Diaghilev, declared that ''all that we loved and that constituted our reason for living, has vanished.''¹¹ Proclaiming that ''the old green world of flesh and bone'' had been exhausted as a source of inspiration, Malevich wanted Suprematism to materialize the structures of a new, purely spiritual unileft: 268. Olga Vladimirovna Rozanova. Untitled (Green Stripe). 1917. Oil on canvas, 28 × 20%". George Costakis Collection, Athens. Illustration © George Costakis.

below: 269. Vladimir Tatlin. Counter-Relief. 1917. Wood and zinc sprayed on iron, 39% × 25¼". Tretiakov Gallery, Moscow.

bottom: 270. Alexander Rodchenko. Suspended Construction in Space. 1920. Wood. Private collection, USSR.

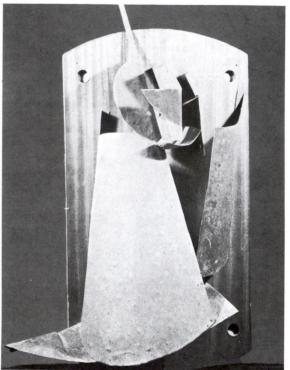

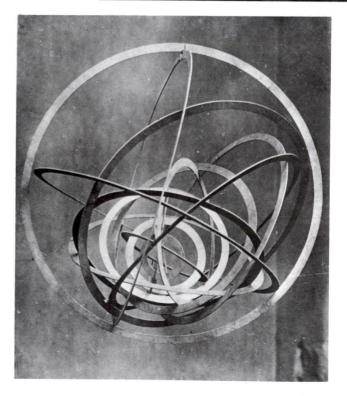

verse. Since these were not to be gratuitous or subjective, but rather the objective manifestations of a brave new world, every Suprematist canvas may be considered, in the words of Pierre Schneider, "an annunciation or, better still, an incarnation."¹² Naïve as such intellectual pretensions or such self-assurance may have been, the paintings they brought forth were genuinely and profoundly original. "In artistic creation," Malevich noted, "there must be a miracle."¹³ And by the very weight of his passionate, essentially religious, belief, Malevich created the miracle of transforming the most minimal of means—small-scale colored rectangles—into a kind of planetary imagery evoking a sense of sublime boundlessness.

Almost as precocious an abstractionist was Olga Rozanova (1886–1918), whose 1917 canvas articulated by little more than a vertical green stripe seems more at one with Barnett Newman's austere "zip" pictures, painted after World War II (Fig. 496), than with Matisse's *The Green Stripe* (Fig. 168), a high Fauve work executed only a dozen years earlier than the painting seen here.

Because of his faith in the mystical content of his art, Malevich was more akin to his contemporaries Kandinsky and Chagall than to the Utilitarian and Productivist faction within the Russian avant-garde, whose leader was Vladimir Tatlin (1885-1953). Tatlin had visited Picasso in his Paris studio in 1913 and probably knew his three-dimensional constructions, which the Russian emulated in his earliest counter-reliefs (Fig. 269). An abstractionist but also a dedicated materialist in art, Tatlin changed his ideas radically when the Revolution arrived. Indeed, he became convinced that art should be primarily social in its purposes and function. And it was his view, rather than Malevich's, that would dominate the new Soviet art. In time, the insistence that art be practical, easily comprehensible, and socially useful led directly to the emigration of the most vital and internationally influential Russian avant-garde artists, the Constructivists (Figs. 410-412), whose adventurous abstraction would be replaced in the Soviet Union by a banal, unchallenging Socialist Realism. The most memorable achievement realized by Tatlin was his proposed Monument to the Third International, an open spiral metal tower designed to contain revolving chambers housing governmental agencies (Fig. 354).

The many-talented Alexander Rodchenko (1891–1956), a disciple of Tatlin and Malevich, may be the most representative figure for all those who began in the Russian avant-garde movement and then adapted to the demands of the new Soviet age. While his black-on-black paintings anticipated the reductivist canvases with which Ad Reinhardt would shock an unsuspecting public in the 1960s, his stripped-down, nonreferential constructions (Fig. 270) might well seem at home in an exhibition of the Minimalist sculptures produced by New York artists in the 1970s. Yet Rodchenko, a true idealist in action, went on to prove himself a master of form in many other branches of the visual arts, from photography and typography to film and stage design.

The irreconcilable differences between the Suprematist viewpoint and that of Utilitarianism were momentarily resolved in favor of Malevich in 1920 when the brothers Naum Gabo (1890–1977) and Antoine Pevsner (Fig. 412) arrived at a novel synthesis of Tatlin's conviction that art must adapt itself to modern technology and the nonobjective style of Malevich's detached abstractions (Fig. 271). In 1920 the two artists published their historic *Realist Manifesto* (actually written by Gabo but co-signed by Pevsner) to explain and defend their own constructions, which they exhibited in Russia for the first time that year. In that document Gabo proposed

> 271. Naum Gabo. Head of a Woman. c. 1917–20 (after a work of 1916). Construction in celluloid and metal, 24½×19¼".
> Museum of Modern Art, New York. Advisory Committee Fund.

an art constructed of modern materials and "in the forms of space and time,"¹⁴ thus simultaneously accepting the modern world and yet opposing materialist ideology. Another novel departure was the statement that they would affirm "a new element, a kinetic rhythm, as the basic form of our perception of real time,"¹⁵ a promise of a new kind of motion sculpture that, curiously, was realized in only one art object, Gabo's *Kinetic Construction: Vibrating Spring* of 1920 (Fig. 435). Gabo's transparent structures in glass, metal, and plastic suggested not only an affirmation of modern technology, but even a dependence on certain topological models and mathematical formulations (Figs. 410, 411). However, qualities of sensibility and invention reclaim his works from sterile formula or excessive worship of scientific models. Indeed, his sculptures even hint at organic and spiritual experiences, in keeping with the universalist aims of the other pioneers of 20th-century abstraction.

In time, as the official Soviet party line in aesthetics asserted the equality of the practical arts to the fine arts, Socialist Realism of an anecdotal and unchallenging character supplanted Constructivist "realism." The consequences for the gifted and dedicated modernists who remained in the Soviet Union, as well as for that nation's culture, were nothing short of catastrophic. Throughout Europe, however, Constructivist ideals and methods were disseminated in the 1920s and 1930s by El Lissitzky and László Moholy-Nagy (Figs. 430, 433, 434). The latter, in particular, became influential through his teaching at the Bauhaus.

De Stijl

Perhaps the most consistent development of abstract art took place in the Netherlands, through a movement called De Stijl, meaning simply "The Style." The collectivist group that produced it took form under the leadership of the painters Piet Mondrian and Theo van Doesburg, and included architects J.J.P. Oud and Gerrit Rietveld (Figs. 351, 352), as well as furniture makers, sculptors, and designers. Their aim was to reconcile the findings of Cubism with a more

From Cubism to Abstract Art

right: 272. Piet Mondrian. The Red Tree. c. 1909. Oil on canvas, 27¾ × 39″. Gemeentemuseum, The Hague.

below: 273. Piet Mondrian. Flowering Apple Tree. c. 1912. Oil on canvas, 30¾ × 41¾". Gemeentemuseum, The Hague.

comprehensive machine-age aesthetic that could have meaning for all the arts, fine and applied.

When Piet Mondrian (1872–1944) arrived in Paris late in 1911, he came with a mind shaped, like that of Kandinsky, by the spiritualizing ideas of theosophy, which no doubt made him, as in the case of the Russian master, all the more susceptible to direct influence from the abstracting strategies of Cubism. The results were immediate and can be seen in the rigor with which the Dutch artist began to tame the high color and emotional energy of his somewhat curvilinear, Art Nouveau style (Figs. 272, 273). Then, by 1914–15, in his so-called Plus and Minus compositions, he was already abandoning references to representational subject matter (Fig. 274). Mondrian now composed oval fields of repeated, but minutely varied, crosses and small vertical and horizontal lines that did not intersect, his purpose being to create new pictorial rhythms, or, as he put it, "a pure new plastic representation of space." Despite a greater uniformity of design in these drawings and related paintings, and their nonobjective appearance, the works nevertheless evoke the Cubists' geometric honeycomb and tonal modulations, vaguely suggesting light and atmospheric depths of space.

Mondrian soon turned away even from these austere works, because he found their Cubist derivations too naturalistic. He opposed Cubism for not "accepting the logical consequences of its own discoveries" by "developing abstraction toward its ultimate goal, the expression of pure reality." Furthermore, he wrote: "While in Cubism, from a naturalistic foundation, there sprang forcibly the use of plastic means, still half object, half abstract, the abstract basis of our pure plastic art must result in the use of purely abstract means."

It was not until 1917 that Mondrian began to combine flat areas of pure color with geometric form, following the example of Bart van der Leck, whom he had met the year before. In 1917 Mondrian also began the historic collaboration with the painters van der Leck and van Doesburg (Figs. 275, 353), the architects Rietveld and Oud, and the sculptor Georges Vantongerloo in founding the influential review *De Stijl*. But his art still had to pass through a number of intermediate stages before he reached his characteristic, and now famous, manner.

In 1919 Mondrian began to build his paintings exclusively of horizontal and vertical lines intersecting at right angles to form perfect squares. The resulting small, uniform planes were massed in pairs, triads, and subdivided squares and painted in grays and pastel shades of red, yellow, and blue. That same year Mondrian wrote the first important theoretical exegesis of his art, the small pamphlet Neo-Plasticism (initiated in 1917 as a series of essays for De Stijl), and he began work on the extensive and brilliant imaginary dialogue on aesthetics, Natural Reality and Abstract Reality, completed the following year. In 1920 and 1921 he replaced the small squares in his compositions with simplified grids whose broad connecting planes were painted evenly in brilliant primary colors. Disposed in asymmetric balance, the colored rectangles were set against a ground of neutral hue. In the early 1930s he evolved his mature art, using a background of pure white (Fig. 276). From that time until the last two years of his life in New York, Mondrian made no essential changes in style. And even in New York, when his compositions became more impressionistic and he momentarily returned to a color scheme of intermediate hues, he religiously pre-

> 276. Piet Mondrian. Composition (Blue, Red, and Yellow). 1930. Oil on canvas, 28½×21¼". Courtesy Sidney Janis Gallery, New York.

left: 274. Piet Mondrian. Composition No. 10: Pier and Ocean. 1915. Oil on canvas, 33½ × 42⁵%". Kröller-Müller Museum, Otterlo.

below: 275. Theo van Doesburg. Composition in Halftones. 1928. Oil on canvas.

Kunstmuseum (Marguerite Arp Collection), Basel.

277. Piet Mondrian. Broadway Boogie-Woogie. 1942–43.
 Oil on canvas, 4'2" square.
 Museum of Modern Art, New York. Given anonymously.

served his right-angle theme and uncompromising nonobjectivity (Fig. 277).

Out of the exquisite formalism of Analytic Cubism, Mondrian created a supraindividualist expression more in tune with the modern age of standardization and machine products. In the modern world, mass society and production have supported an artistic ideal of collective expression, a "constructive" spirit, that still, even with the recent advent of "post-modernism," dominates machine-age art and architecture. The arts are in many ways the anonymous, rational servants of the machine, expressing its epoch as profoundly and as unconsciously as the Byzantine mosaic expressed the age of faith. One of the first and most radical rebels against traditional easel painting, Mondrian felt compelled to work out a systematic ideology for his drastic pictorial innovations. In Neo-Plasticism he envisioned a universal panacea, an art directed at an ideal society not yet born, or, as he put it, at the "new man." It is important to remember that many of the pioneer abstractionists-Mondrian, Malevich, and Kandinsky, among others-felt that the ideal order of nonobjective art was linked to a coming utopian social order, and that artists had been summoned to help reconstruct humanity's life and world.

Of all the doctrinaire programs and utopian prophecies of modern art, Mondrian's actually proved the most viable and came closest to success. Through Neo-Plastic painting he sought to express the unity of the modern spirit, but he suspected that its most satisfactory expression might come ultimately in modern architecture and design. The concreteness and simple factuality he wanted for painting seemed to conflict with the vagaries of individualistic temperament. He identified his aesthetic ideal with the precision of the engineer and the impersonality and predictability of manufactured materials. Indeed, he even insisted that Neo-Plastic painting itself must finally wither away, like the political state of the radical social thinkers. Mondrian anticipated the day, in an ideal social order, when art would have no role; he foresaw:

 \ldots the end of art as a thing separated from our surrounding environment, which is the actual plastic reality. But this end is at the same time a new beginning. \ldots By the unification of architecture, sculpture, and painting, a new plastic reality will be created. Painting and sculpture will not manifest themselves as separate objects, nor as "applied" art, but being purely constructive will aid the creation of a surrounding not merely utilitarian or rational but also pure and complete in its beauty.¹⁷

Mondrian's total artistic vision was transmitted to modern architecture, furnishings, interiors, typography, and objects of everyday use by the Stijl group. The scrupulous regrooming of the modern environment in accordance with stern abstract principles received an even more decisive international impulse from the artist-designers of the Bauhaus with whom van Doesburg made contact in 1922 and whom he influenced.

Today, there is ample evidence in America and Europe of the triumph of De Stijl, although inevitably much of its influence has been corrupted by popularization. But where modern techniques of manufacture, geometric abstraction, and artistic genius have been harmoniously married, as in the architecture of Mies van der Rohe (Fig. 636), Mondrian's prophecy of the unity of the arts reaches a convincing fulfillment, even though the millenium is not any nearer at hand than it was during the more hopeful period of early abstraction. Mondrian and the Stijl group of architects and designers have had a more direct and revolutionary impact on the modern environment, perhaps, than any other artistic movement rooted in Cubism.

Cubism remains relevant to the creative expression of the artist today, and to contemporary architects and designers as well. It haunts even such unlikely but vital expressions of our turbulent postwar world as Willem de Kooning's powerful and frenzied distortions of the female form in his Woman series (Fig. 488). Cubism was also clearly the inspiration for the last monumental constructions of David Smith, perhaps the most original and powerful American sculptor of the postwar era. Significantly, Smith called his finest late sculpture series by the name Cubi (Fig. 509). More recently, the works of the English Minimalist sculptor Anthony Caro combine Cubist geometry and painted industrial steel to create confounding effects of weightless mass and sensuous color (Fig. 624). An unexpected heroic scale introduces a new psychological element of inappropriate size in this, as well as in related serial constructions by the Americans Don Judd and Robert Morris (Figs. 596, 598, 673). Here the Cubist geometric principle is turned against itself as a result of the new emphasis given to a single, saturated hue, or to the uniformity of the design components and their expansion into a continuous field of repeated units. While Cubism may not be entirely relevant either to the psychology or to the deliberate formal redundancy of today's avant-garde art, it nevertheless still constitutes a living language of some currency, after more than eight decades of development and transformation.

Dada and Fantastic Art

he element of fantasy has charged the history of art with a powerful current, running, at least, from Romanesque visions of souls gloriously saved or hellishly damned, through the apotheoses of secular rulers soaring in monumental trompe-l'oeil on Baroque ceilings, realized, like the stone grotesques scattered about the gardens of Versailles, at the height of the Age of Enlightenment. The earliest modern manifestations came with the advent of Romanticism, especially as expressed in the mystical imaginings of William Blake and the nightmares of Francisco Goya (Fig. 4), haunted by the horrors of war and other forms of human madness. Even as the 19th century plunged ever deeper into rationalistic materialism, fantasy acquired a great champion in Baudelaire, who in the 1860s commented disapprovingly, if not altogether accurately, that the Impressionists painted "not what they dream but what they see."1 Thirty years later Odilon Redon would deplore the evident fact that "great art no longer exists," a condition he attributed to "the right that has been lost and which we must reconquer: the right to fantasy."² But as we saw in Chapter 3, the Symbolist artists did reclaim that right and made the strongest possible reaction to the Impressionists' faithful observation of nature.

The allure of the enigmatic, the shock appeal of the bizarre, the disquieting character of hallucinatory visions in art of different periods later sanctioned and inspired the work of the Dadaists and Surrealists in the second and third decades of the 20th century. Their delighted rediscovery of the irrational in the visual arts drew upon the tradition of Symbolist poetry, with its quest for a superior reality and metaphysical knowledge, but also upon its contrary evangelical, reformist impulse to "change life," as the poet Arthur Rimbaud had put it. The general tendency to question rationalist views of the world found itself linked to human personality by Freud's theories of psychoanalysis and the popularization of his findings during the first two decades of the new century.

The emergence of explicit fantastic content in art after 1914 was undoubtedly hastened by the destructive drives unleashed in the war, which impelled artists to answer social violence with a violence internalized in imagery and technique, and which also produced a revolutionary attitude toward traditional aesthetics. Even the rational art of the Cubists acknowledged the new mood, and introduced surprising elements of ambiguity within its rigorously structured forms. The Cubist collage dislocated normal reality in order to make room for anti-art materials, visual wit, and a gratuitous upheaval, or associations with the grotesque. But the commitment to radical new forms of visual skepticism that challenged conventional assumptions about observed reality, and the subversion of the traditional integrity of medium, required the disruptive shock of a revolutionary political situation to sustain first Dadaist and then Surrealist objectives. The disillusionment of the war years provided the necessary catalyst for change. The visionary art that

finally emerged, sanctioned by the wartime turbulence, found inspiration in the rediscovery of the work of three artists of fantasy whose example helped unlock the forces of the unconscious mind and consecrated revelation and dream: Henri Rousseau, Marc Chagall, and Giorgio de Chirico.

The Forerunners of Modern Fantasy

The naïve vision and exoticism of Henri Rousseau (1844–1910) gave the Surrealists an important forerunner (Fig. 278). His work prompted the question always pertinent to the Surrealists, whether, and in what degree, it was the product of imaginative vision, an arbitrary invention of the mind's eye, or a remembered experience.

The remarkable exhibitions devoted to Rousseau at the close of the 19th century brought before the world the first childlike art of the modern period and provided new standards for an acceptable primitivism and romantic innocence. His paintings also make an interesting parallel to the wild, theatrical caricature of the poetplaywright Alfred Jarry, both scandals in terms of traditional artistic values, although the Douanier, as Rousseau was known to his friends (see p. 138), would scarcely wish to compete with Jarry's mocking provocations of the bourgeoisie. Both artists were formal iconoclasts who cheerfully subverted previous assumptions about the nature and content of art, and even the level of literary or visual literacy. Rousseau's archaic style and grave icons, however, were actually meant to be as respectful of tradition as Jarry's inventions and blasphemous language were deliberately subversive. Significantly, it was Jarry who first discovered and sang the praises of the painter at the 1886 Independents Salon, treating Rousseau, to everyone's astonishment, as a serious innovator.

Unlike the Surrealists, who later admired him, Rousseau needed neither the inspiration of a movement nor a literary program to liberate his remarkable visions. In his own life he drew no hard and fast line between the real and the supernatural, and the invisible world of his own imagination seemed as concrete and plausible to him as nature. He believed in the reality of ghosts, and even complained about his own private specter because it followed him about and annoyed him. The artist explained The Dream (Fig. 278), his final masterpiece, as a depiction of the jungle scene into which the seductive, albeit awkwardly drawn, lady fancies she has been transported, all the while reclining in splendid nudity on a fine Victorian couch. The sheer magic of the conception is matched by the magical, or typically archaic, way the artist has accreted a vast quantity of meticulous detail, yet so controlled the abundance that it produces both a grand, frontalized design and an eerie sense of spaciousness. Equally poetic is the mysterious inner light with which every exotic form glows-the improbable lions, the lurking bison, the brilliantly feathered fowl, the swarthy lute player with his rainbow loincloth, all peering wide-eyed from the confines of a lush equatorial jungle festooned with tropical fruit and flowers.

Rousseau's instinct for the supernatural and his utter credulousness captivated Apollinaire, and elicited from the poet the comment that Rousseau ''sometimes took fright and, trembling all over had to open a window'' while painting his fantastic creations. Overlooked in the Surrealists' official register of honored precursors of the First Surrealist Manifesto, Rousseau's trancelike paintings finally generated a myth that even André Breton, poet and high priest of the Surrealist movement, acknowledged with the observation that ''it is with Rousseau that we can speak for the first time of magic Realism ... of the intervention of magic causality.''³

In his later years Rousseau became something of a celebrity for two successive avant-garde generations, first when Apollinaire rediscovered him as a "primitive," and then when Breton and the Surrealists admired his visionary subject matter. Although the

above: 278.

Henri Rousseau. The Dream. 1910. Oil on canvas, 6'8½" ×9'8½". Museum of Modern Art, New York. Gift of Nelson A. Rockefeller.

left: 279. Marc Chagall. I and the Village. 1911. Oil on canvas, 6'3%" × 4'115%". Museum of Modern Art, New York. Mrs. Simon Guggenheim Fund.

opposite: 280. Giorgio de Chirico. The Soothsayer's Recompense. 1913. Oil on canvas, 4'5¾"×5'11". Philadelphia Museum of Art (Louise and Walter Arensberg Collection).

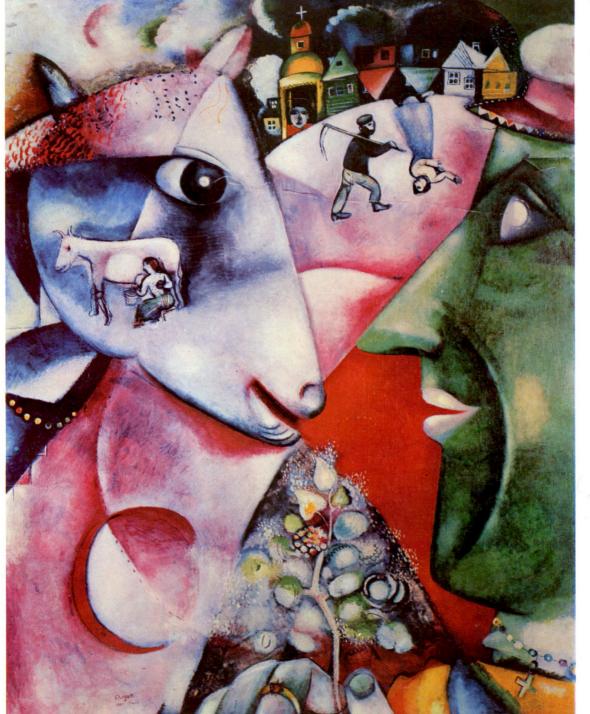

Douanier had been showing regularly at the Independents Salon and could boast of a small coterie of admirers, it was only in the early years of the 20th century, when the taste for primitivism and for archaic and stylized forms approached a climax, that he first became widely appreciated.

Another influential artist of fantasy was the Russian-born Marc Chagall (1887–1985). After studying in an experimental school in St. Petersburg directed by the Symbolist-influenced theater designer Leon Bakst, Chagall emigrated to Paris in 1910, entering the circle of Apollinaire and the Cubists and meeting such fellow émigrés as Amedeo Modigliani, Chaim Soutine, and Jules Pascin, all of whom were later identified with the School of Paris (Figs. 374–378). For his nostalgia-soaked art, based on memories of his native village of Vitebsk, Chagall soon attained a reputation as a fantasist comparable to Rousseau. Still, the Surrealists generally showed little interest in Chagall, although Breton did praise him. "With Chagall alone. . .," he wrote, "metaphor makes not merely as a formal device but as a system of values. The Cubists' structures apparently symbolized for him a belief in constructive and innovative intelligence, which gave tension to his fantasies. Although Breton admired Chagall for introducing metaphor into modern painting, Chagall tended to reject literary explanations of his work. He said of his paintings (Fig. 379):

I don't understand them at all. They are not literature. They are only pictorial arrangements of images that obsess me. . . The theories which I would make up to explain myself and those which others elaborate in connection with my work are nonsense. . . . My paintings are my reason for existence, my life, and that's all.⁵

The artist of fantasy destined to play the most decisive role in the development of Surrealist painting was the Italian Giorgio de Chirico (1888–1978), born in Athens but educated in Munich. Coming to Paris from Italy in 1911, de Chirico made contact with Picasso and the ubiquitous and influential Apollinaire. His art

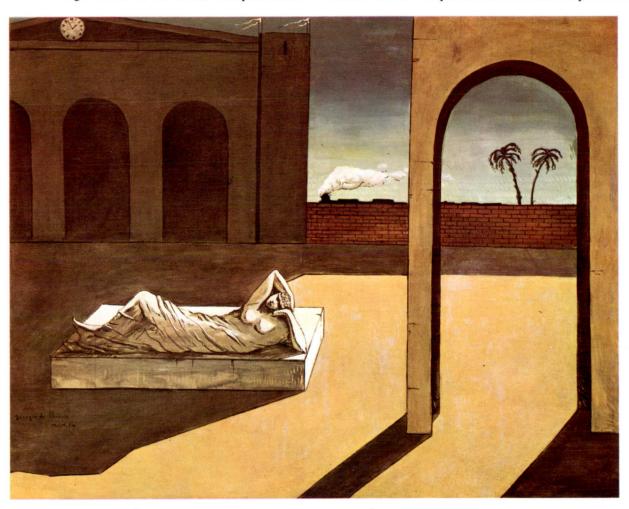

its triumphant entry into modern painting."⁴ Unlike the orthodox Surrealists, however, Chagall presents a dreamlike imagery that is gently lyrical rather than Freudian and disturbing.

In the delightful painting *I* and the Village, shifts and displacements of images take place as in the dream process, and the metamorphic principle dominates (Fig. 279). The "dreamer" of the painting (with whose perceptions the artist makes us identify) is an implausible but appealing cow, which impresses the viewer both as icon and nature spirit. Chagall communicates a highly individual poetry, but he also concerns himself with the abstract dynamics of the painting process. His uninhibited zest stems as much from Cubist inspiration as from native Russian Jewish folkloristic memory. Chagall adopted the Cubist rearrangement of visual reality

seemed to address itself directly to Rimbaud's exhortation to the artist that he make himself "a seer" in order to plumb the depths of the "unknown," and to attain an hallucinatory state of "clair-voyance."⁶ In a brief four years in Paris, de Chirico created a body of work that fulfilled the poet's program as well as Jarry's admonition to seek a fantastic world "supplementary" to our familiar universe.

Not only did de Chirico create an authentic, troubling dream imagery of great power and intensity for the first time in the century, but he also managed to capture the spirit of the age, to convey, in Breton's words, its "irremediable anxiety" (Fig. 280). Influenced by such antecedents of 20th-century fantasy as the melancholy, romantic landscape and diminutive figures of Arnold

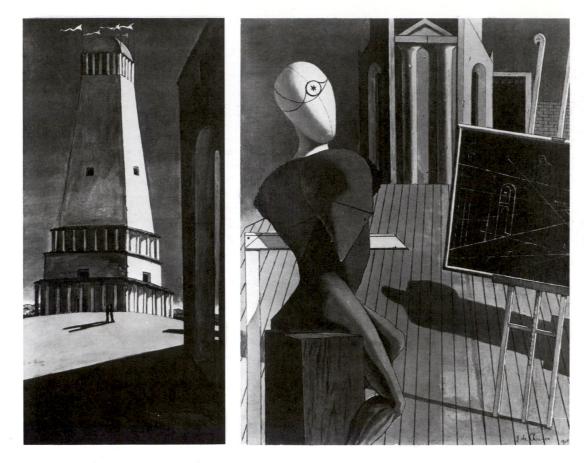

far left: 281. Giorgio de Chirico. The Nostalgia of the Infinite. 1913–14? (dated on the painting 1911). Oil on canvas, 4'51/4" × 2'11/2". Museum of Modern Art, New York. Purchase.

left: 282. Giorgio de Chirico. The Seer. 1915. Oil on canvas, 35¼ × 275%". Museum of Modern Art, New York. James Thrall Soby Bequest.

opposite: 283. Jean (Hans) Arp. Arrangement According to the Laws of Chance (Collage with Squares). 1916–17. Torn-and-pasted papers on paper, 19½ × 135%". Museum of Modern Art, New York. Purchase.

Böcklin, Max Klinger's fetishism of objects (Fig. 5) and the chimeras of Alfred Kubin, de Chirico's art attained the mystical and prophetic state that had been the aim of Symbolist art since the period of Baudelaire. Its luminous ensembles of disjunctive objects-modern images such as locomotives and mannequins set among monuments of the past-present us with a new and enigmatic system of poetic metaphor, whose meanings are deliberately obscure. The phantomic figures and deserted squares that de Chirico showed at the Paris Autumn Salon in 1913 attracted the attention of Apollinaire, who commended "these curious landscapes, full of new intentions, of a powerful architecture, and of great sensibility."⁷ The artist had defined his program as the "enigma of sudden revelation," and he was deeply influenced by the German idealist philosophers, particularly Nietzsche, who had described his sense of "foreboding that underneath this reality in which we live and have our being, another and altogether different reality lies concealed."8 De Chirico poetically apprehended this alien reality, in the mysterious relationships between banal objects set against incongruous modern and antique backgrounds. Such illogicality baffled the ordinary viewer by subverting visual sense, yet the artist remained faithful to the condensed, vividly heightened, and portentous symbolism of actual dreams, with their charge of anxiety.

De Chirico painted his haunting cityscapes at a time when everything in art and life opposed their dominant mood of romantic melancholy. Cubism had reached its height of formal exploration in a highly intellectual, geometric mode of expression. Italy responded to the Cubist challenge with the militant activism, the exaltation of progress and machine culture, and the noisy assault on tradition launched by the Futurists (Figs. 257–263). In this heady atmosphere, the program of meditation and poetic nostalgia offered by de Chirico, and even the archaism of his clumsy technical means, could only seem both perversely conservative and irrelevant to the most productive moods of art. By 1913–14 his *Nostalgia of the* *Infinite* had reintroduced anecdote, sentiment, and an outmoded descriptive technique into his art (Fig. 281). More importantly, a decade and more before the Surrealists, he made painting an occasion for actualizing the dream process with baffling, illogical imagery, and for exploring, in the artist's words, the "troubling connection that exists between perspective and metaphysics." The word "metaphysical" frequently appeared in his discourse, and in 1916 it was officially adopted to describe his work when he met Carlo Carrà in a Ferrara hospital. Together, de Chirico and Carrà formed a new artistic association called the Metaphysical School (*scuola metafisica*).

The pictures painted by de Chirico freeze his reality into a trancelike immobility, amid a scenario of oneiric vistas, perspectives with conflicting vanishing points, and dramatically heightened contrasts of deep shadow and intense light (Fig. 282). In a strangely ominous atmosphere, where time has ceased to exist, curious events transpire: unseen presences cast long shadows; in the motionless air, pennants catch a hidden breeze and flutter; the illusion of infinite spatial extension does not dispel anxiety but only confirms it, giving the viewer the sense of being imprisoned in a nightmare. Everything has too bright and disturbing a clarity, creating an unnatural luminosity from which we seek release. In The Nostalgia of the Infinite (Fig. 281) the tower becomes a desolate and forlorn image, like Gérard de Nerval's famous "forsaken tower" in the poem so admired by the Surrealists, "The Prince of Aquitaine." Yet it is transfigured by a mystic brilliance of light. Remote, inaccessible to the artist's diminutive and impotent human phantoms, it also carries subtle Freudian overtones in its phallic power, although the associations seem almost innocent and naïve by comparison with Dali's later self-conscious eroticism (Figs. 312, 313).

In his mannequin figures (Fig. 282) de Chirico translated the sense of emotional numbress into an imagery of mutilated, armless, and eyeless tailors' dummies. These seem to allude both to an heroic past of antique statuary and to a lost world of silence, im-

potence, and poignant longing for human community. Like Picasso in his neoclassical and traditionalist figures (Figs. 332, 333), de Chirico riddled his meditation on a noble past with irony and selfdoubt. He could only perceive the heroism of a bygone age through the eyes of his own melancholy, until the past became merely a distorted dream image. It was the strongly original forms of this influential imagery that later so deeply impressed the official Surrealist movement and a number of individual artists. In words and by example, Ernst, Tanguy, Magritte, and Dali (Figs. 303, 312, 314, 318), among others, showed a rare unity in acknowledging de Chirico as a forerunner master. He provided the primary inspiration for the illusionistic Surrealists, who made an effort to convert the indispensable and creatively liberating, if disruptive, Dada episode of the war years into a more systematic and constructive romanticism.

Dada

The Dada movement took form simultaneously during wartime in a number of art capitals, and among them, significantly, were two neutralist centers, New York and Zurich. This spontaneous revolt against reason in art represented many of the same deliberately infantile impulses that had surfaced in the primitivist art of Rousseau, in Jarry's theatrical grotesquerie, with its contemptuous bravado, and in the nostalgic fantasy world of de Chirico's paintings. One of the founders of the Zurich Dada group, the German poet Hugo Ball, significantly hailed the spontaneity and irresponsibility of childhood as a "new" artistic model in a diary entry of 1916, which was the year of the official birth of the Swiss movement. "Childhood," he wrote, "as a new world, and everything childlike . . . and symbolic in opposition to the senilities of the world of grown-ups."9 In keeping with that defiant spirit, the nonsense vocable dada, meaning a child's hobbyhorse, was selected at random from a dictionary, probably by Hugo Ball and Richard

Huelsenbeck, and came to symbolize the release of new psychic energies based on instinct, which the Zurich group celebrated.

By loudly proclaiming the uselessness of social action, the Dada artists acknowledged their sympathetic identification with the futility of those dying senselessly in the monstrous charade of World War I. Dada began primarily as a wrecking enterprise, an art of protest directed against the insane spectacle of collective homicide. Yet its nihilism also embraced a sweeping summons to create a *tabula rasa* for art and presented serious creative options despite its disorder and anarchy. Dada unlocked new sources of spontaneity, fantasy, and formal invention and left a lasting imprint both on the art of its time and on the future. Adapting the slogan of the revolutionary Bakunin that destruction is also creation, the Dadaist put art on the barricades, redefined the nature of artistic experience, and extended its material possibilities even when that meant accepting scandalous objects as works of art.

Official Dada came to birth as a collaborative activity in wartime Zurich. There, in 1916, Hugo Ball gathered around him a group of exiles from the war, a group that included the writer (and later psychiatrist) Richard Huelsenbeck; the Rumanian poet Tristan Tzara; the Rumanian painter Marcel Janco; the Alsatian painter and sculptor Jean (Hans) Arp; and Arp's future wife, Sophie Taeuber. The following year their ranks would expand with the arrival of the German painter and later experimental filmmaker Hans Richter. In an old quarter of the town, Ball and his fellow refugees founded the Cabaret Voltaire, inviting all the wartime disaffected to join their courageous new association of free spirits in order "to remind the world that there are independent men, beyond war and nationalism, who live for other ideals," in Ball's words. Arp, a gifted poet as well as visual artist, eloquently described the spirit with which he entered into the mad games, playful entertainments, and somewhat more sober artistic activities of the Cabaret Voltaire group:

In Zurich in 1915, losing interest in the slaughterhouse of the world war, we turned to the Fine Arts. While the thunder of the batteries rumbled in the distance, we pasted, we recited, we versified, we sang with all our soul. We searched for an elementary art that would, we thought, save mankind from the furious folly of these times. We aspired to a new order that might restore the balance between heaven and hell.¹⁰

In another revealing statement that prophesied the new prerogatives conferred upon fantasy and irrational association, and which also comically summarized the Dada contempt for the public's superstitious reverence toward traditional art, Arp wrote:

Dada aimed to destroy the reasonable deceptions of man and recover the natural and unreasonable order. Dada wanted to replace the logical nonsense of the men of today by the illogically senseless. That is why we pounded with all our might on the big drum of Dada and trumpeted the praises of unreason. Dada gave the Venus de Milo an enema and permitted Laocoön and his sons to relieve themselves after thousands of years of struggle with the good sausage python... Dada is senseless like nature. Dada is for nature and against art. Dada is direct like nature. Dada is for infinite sense and definite means.¹¹

Once Tristan Tzara had joined the group, the Zurich Dadaists directed still more aggressive assaults at the audience, who, curiously, attended the public Dada demonstrations in the tradition of the mass meetings that greeted the provocative behavior of the Italian Futurists. Poets recited inaudible nonverse, drowned out by deafening noise-music, or *bruitisme*, thus adopting directly the Futurists' strategy of insult and outrage. Poems were made by picking from a bag words randomly cut from newspapers. Tzara's "accidental poems" coincided with Arp's experiments in automatism in his collage compositions, among them *Arrangement According to the Laws of Chance* (Fig. 283). Bewildered specta-

tors at Dada meetings found themselves called upon to function as chairmen and then ignored or humiliated. Pandemonium was encouraged, perhaps as a parody and an exposure of the falsity of public rhetoric with its appeals to patriotism in support of the war. Today this kind of antic, more familiar and even stereotyped in the Happening, seems outdated. In its time, however, Dada nihilism had more relevance as social criticism; moreover, it frequently resulted in bouts of inspired wit and verbal invention, and the liberation of significant new forms of poetry and art.

Strasbourg-born Jean (Hans) Arp (1887–1966) was the major figure in the plastic arts to emerge from Zurich Dada, following a significant earlier career that included studies at Weimar in Germany and the Académie Julian in Paris, an encounter with Klee in Switzerland, and exhibition with the Blue Rider in Munich and with the Expressionists in the first Autumn Salon in Berlin (1912). Just before the outbreak of war Arp had also made contact with the Parisian avant-garde, including Apollinaire, Max Jacob, Modigliani, and Delaunay. His first Zurich works in collage and relief sculpture reflected the inventive disorder and wit of Dada, but he later developed more soberly as a sculptor of forms in the round. Arp's works of about 1916, often the result of experiments with chance and automatism carried out with Sophie Taeuber, were the first artistic creations deliberately, perhaps self-consciously, designed to realize Tzara's principles of "continuous contradiction" and "immediate spontaneity," in both poetic and plastic terms (Fig. 283). The chance compositions produced by Arp became the basis of a primary Surrealist creative principle. They were made by tearing up fragments of paper, letting them fall on a surface at random, and then gluing down the accidental arrangements. Speaking of compositions made by such procedures, Arp declared: "The 'law of chance,' which embraces all laws and is unfathomable like the first cause from which all life arises, can only be experienced through complete devotion to the unconscious."¹² Arp's collages of the period, however, were actually closer to a more relaxed version of Cubism than to what the later Surrealists understood as "automatic" drawing (Fig. 284).

In subsequent reliefs Arp began to utilize free forms, kidney and amoeba-like shapes resembling Miró's (Fig. 285). These forms became an important link between the nascent biomorphism of Gauguin and Kandinsky and the mature configurations of Miró (Figs. 49, 195, 395). Arp's elegant and increasingly abstract reliefs of the late 1920s, whose contour lines suggest living organisms, established free-form, or biomorphic, abstraction as an alternative to geometric form. Soon after, in 1932, Arp abandoned

left: 284. Jean (Hans) Arp. Before My Birth. 1914. Collage, 4¾ × 3⅔". Estate of Herta Wescher.

above: 285. Jean (Hans) Arp. Mountain, Table, Anchors, Navel. 1925. Oil on cardboad, 29% × 23½". Museum of Modern Art, New York. Purchase.

opposite: 286. Marcel Duchamp. Bottlerack (Bottle Dryer), full-scale replica of a lost 1914 original. Galvanized iron Readymade, 25¼″ high. Courtesy Schwartz Gallery, Milan.

> opposite below: 287. Marcel Duchamp. The Passage from Virgin to Bride. 1912. Oil on canvas, 23%×21¼". Museum of Modern Art, New York. Purchase.

Dada aims altogether for sculpture-in-the-round (Fig. 328), which he insisted on describing as "concrete" rather than "abstract," or as "autonomous and natural forms," another kind of dream nature in line with the Surrealist aspiration to create a supplementary universe. But Arp replaced Surrealist dislocations and grotesquerie with a more gentle and poetic whimsy. His voluptuous abstract forms were essentially celebrative of nature's bounty rather than disturbing or convulsive dreams.

The most enigmatic Dada intellectual and a primary innovator was Marcel Duchamp, one of the legendary figures of 20th-century art. Already, as we have seen (Fig. 255), a master of Cubist idiom, Duchamp became a pioneer spirit of Dada, even though he never officially declared himself a Dadaist. It was Duchamp who anticipated the Dadaists' most fertile and challenging conceptions, including the whole complex of anti-art ideas, which refuse to make elitist distinctions about the art object. Duchamp tried instead to reconcile art experience to a society dominated by mass-produced, manufactured objects. The challenges posed by his art were evident as early as 1912 when he showed his Cubist, mechanist anatomies in Nude Descending a Staircase, No. 2 (Fig. 255). This original and rather baffling picture outraged the orthodox Parisian Cubists, including the artist's brother Jacques Villon, as much as it scandalized American audiences in New York a year later in the celebrated Armory Show. With Duchamp's arrival in New York in 1915, and the formation of the periodical 291 under the auspices of the photographer and art impresario Alfred Stieglitz, New York Dada came to birth actually a year in advance of the Zurich events that gave the movement its name. Overnight, Duchamp emerged as the leader of a new breed of iconoclasts.

Rejecting the decorative values of Cubism for a more ambiguous content, Duchamp's mechanized nudes suggested a metaphor for the Conquest of Man by the Infernal Machine, in sharp contrast to the mechanized world that the Futurists, Léger, and other Cubists had uncritically celebrated. The robot-like action of Duchamp's figures opened up startling vistas of paradox in what had heretofore seemed an iconographically neutral area. Duchamp turned away with disdain from the traditional image of the artistcraftsman and his dependence on his sense impressions. Beginning in 1912, he struck out on a boldly independent course, breaking with what he contemptuously termed "retinal" painting, meaning Impressionism, which he considered intellectually inferior since it appealed to the eye and the senses rather than to the mind. "I was interested," he later said, "in ideas-not merely in visual products."13 And with added vehemence, stated that he preferred "an intellectual expression ... to [being] an animal. I am sick of the expression bête comme un peintre-stupid as a painter."¹⁴ Duchamp conceived of the work of art freshly as an autonomous reality that mediated between the physical world and his own psychic perceptions. Art was to become a "brain fact," to adopt his epithet.

The work of art could be painted, constructed, or merely "designated," a word Duchamp applied to the Readymade, or common manufactured product that he elevated to the level of an art object (Fig. 286). Duchamp thus broke down one of the primary attributes of the work of art, which defined its privileged fine

arts status. By associating art with non-art, he confused the traditional hierarchy of artistic values and produced objects and new ideas about art that remain profoundly disconcerting. With Francis Picabia (Figs. 294, 295), his friend and associate in the New York Dada adventure, Duchamp insisted on challenging audience preconceptions about art and taste. "There is no rebus, there is no key," wrote Picabia. "The work exists, its only *raison d' être* is to exist. It represents nothing but the wish of the brain that conceived it."¹⁵

The themes that appeared only tentatively with Duchamp's *Nude Descending a Staircase* received further definition in the following years in his familiar combination of mechanical form and imagery, erotic content, and esoteric titles. *The Bride* and *The Passage from Virgin to Bride* both suggest human organs transposed into machines, alluding clearly to automated male and female sexual organs and sexual activities (Fig. 287). Duchamp's erotic ob-

session, combined with an extremely complex iconography and erudite philosophical references, culminated in a "love machine," a construction the artist mysteriously called *The Bride Stripped Bare by Her Bachelors, Even* (Fig. 288). This intricate invention cannot be understood, however, without first examining Duchamp's own notes of explanation, and without considering his effort to reappraise the world of ordinary manufactured objects in the form of the Readymade.

As early as 1911 Duchamp had been attracted to banal, everyday artifacts. In his notes for the *Large Glass*, as his love machine became known, he observed: "One day, in a shop window, I saw a real chocolate grinder in action and this spectacle so fascinated me that I took this machine as a point of departure."¹⁶ Soon he was doing the *Chocolate Grinder* (Fig. 289), which as a result of its dry, academic facture became all the more a symbol of male bachelor sexuality. It was but a short step to the discovery of the Readymade, and in 1913 and 1914 Duchamp designated the first of these: *Bicycle Wheel* and *Bottle Rack* (Figs. 290, 286), the former entering history as the prototype of all subsequent mobile or kinetic sculpture. Mounted on a stool, it also parodied the museum sculpture on its conventional pedestal. With superb disdain for traditional art values, he conferred a kind of derisive prestige on found objects by

288. Marcel Duchamp. The Bride Stripped Bare
by Her Bachelors, Even (The Large Glass). 1915–23.
Oil, lead, wire, foil, dust, and varnish on glass; 9'1½"×5'9½".
Philadelphia Museum of Art. Katherine S. Dreier Bequest.

the act of his choice of them. It was a tribute to the power of his wit and ironic intelligence that Duchamp was able to make publicly acceptable such outrageous appropriations of commonplace items from the cycle of used and disused products.

Significantly, Duchamp divorced his Readymades from aesthetic criteria. Their choice, he declared in his notes for the *Large Glass*, "was never based on aesthetic delectation," but, rather, "on a reaction of visual *indifference*, with at the same time a total absence of good or bad taste, in fact, a complete anesthesia."¹⁷ The Readymades were the familiar mass-produced stock and trade of department and hardware stores or other commercial outlets. In addition, Duchamp signed a urinal "R.Mutt," entitled it *Fountain*, and submitted the piece unsuccessfully to the Independents Exhibition in New York in 1917. The same paradoxical value he conferred on the Readymades and the mocking, intellectual gamesmanship their choice involved also motivated the *Large Glass*, his most remarkable invention, which Duchamp began planning as early as 1912 but executed in New York after his arrival there in 1915.

The Large Glass is a window-like, transparent structure made of two panes of double-thick glass, diagramming in wire relief, oil, and tin foil, the amatory subject matter that had been evolving in his paintings and objects of the preceding years. The work has become the focus of a cult and spawned numerous conflicting interpretations, which range from its relationship to machine-art imagery to a symbolism of the occult and alchemical. Its most plausible meanings are still those elaborated by Breton in a well-known essay, which describes the work's lavish ingenuity as a mechanistic interpretation of love.¹⁸ The Large Glass, in its own symbolic way, depicts the bride disrobing in its upper portion, as she both frustrates and attracts her suitor, setting off a series of reactions visible in the "Bachelor Machine" below, a stereometrically drawn contraption of "Nine Malic Molds" suspended in a "Cemetery of Uniforms and Liveries" over a "Glider" whose "Water Mill" appears prepared to activate, through a pair of scissors, a replica of the Chocolate Grinder seen before. The fact that the bachelors merely "grind their chocolate," and thus fail to reach the bride and fulfill the "love operation" (Duchamp's words), seems clearly a metaphor of both narcissism and sublimation. As has so often been the case, celibacy is associated with intellect and with a creative aberration in opposition to nature's cycle of sex and procreation. In this case, there are other levels of meaning, especially as regards the Bride, recognizable as a vestigial survivor from the Mechanistic Virgin and called *la pendu femelle* ("the hanging female part") by Duchamp. The artist also saw in her, a three-dimensional form, an implication of the fourth dimension, just as a two-dimensional rendering stands for a three-dimensional form. Attached to the Bride floats the amorphous "Milky Way," the shapes of whose three holes, or "draft pistons," were determined by the chance appearance of square-cut cheesecloth hung in an open window. Further randomness came into play when Duchamp allowed dust to collect on the glass for over a year and then cleaned the entire surface except for several of the Bachelor Machine's cone-shaped sieves, which he then fixed with glue. Accidentality also intervened when in 1926 the Large Glass cracked while being returned to its owner, Katherine S. Dreier, from an exhibition at the Brooklyn Museum. Delighted with the weblike network of fissures, which create new

opposite left: 289.

Marcel Duchamp. Chocolate Grinder, No. 1. 1913. Oil on canvas, 24¾ x 25‰". Philadelphia Museum of Art (Louise and Walter Arensberg Collection).

opposite center: 290.

Marcel Duchamp. Bicycle Wheel, replica of a lost 1913 original. Bicycle wheel on wooden stool, 4'2½". Museum of Modern Art (Sidney and Harriet Janis Collection), New York.

relationships between the Bride and her Bachelors without in any way increasing their intimacy, Duchamp in 1936 clamped the top and bottom panels between two panes of new, heavier glass and declared the composition completed "by chance."

The acts of defiance incorporated in Duchamp's elaborate mythology of sex and technology both in the Large Glass and in his signed Readymades achieved memorable public scandals in his famous reproduction of the Mona Lisa with a moustache drawn on it (Fig. 291). He entitled this "assisted" Readymade L.H.O.O.Q., which when said quickly in French sounds like elle a chaud au cul, or "she's got hot pants." The Surrealists responded even more enthusiastically to the discoveries Duchamp made in the realm of fantasy. His more bizarre objects evoked the classical example of incongruity in the writings of the French 19th-century Romantic poet Isidore Ducasse, the self-styled "Comte de Lautréamont." One of Lautréamont's phrases became, in fact, a critical definition of beauty and a household aphorism for the Surrealists: "as beautiful as the chance encounter of a sewing machine and an umbrella on a dissection table." The power and mystery of unexpected juxtapositions, unlocking fantastic content, was evident, perhaps for the first time since de Chirico's painted images, in Duchamp's Why Not Sneeze, Rose Sélavy? (Fig. 292). (Rose Sélavy, Duchamp's

below: 291. Marcel Duchamp. *L.H.O.O.Q.* 1919. Assisted or rectified Readymade (reproduction of Leonardo da Vinci's *Mona Lisa* altered with pencil), 7³/₄×4¹/₈". Private collection, Paris.

left: 292. Marcel Duchamp. *Why Not Sneeze, Rose Sélavy?,* replica by Ulf Linde of a 1921 original. Semi-Readymade, consisting of painted metal cage, marble cubes, thermometer, and cuttlebone; $4^{7}/_{8} \times 8^{3}/_{4} \times 6^{3}/_{8}$ ". Moderna Museet, Stockholm.

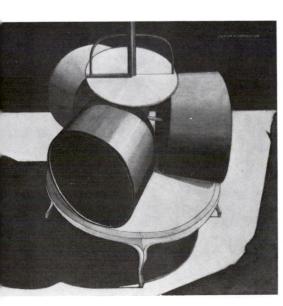

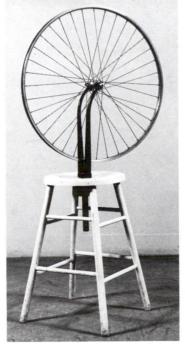

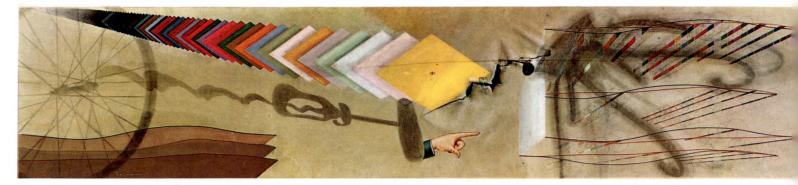

above: 293. Marcel Duchamp. Tu m'. 1918. Oil and graphite on canvas, with bottle-washing brush, safety pins, nut, and bolt; 2'3½"×10'2¾". Yale University Art Gallery, New Haven. Katherine S. Dreier Bequest.

below: 294. Francis Picabia. *Ici, C'est Ici Stieglitz.* 1915. Pen and red and black ink on paper, 29% × 20″. Metropolitan Museum of Art (Alfred Stieglitz Collection), New York.

right: 295. Francis Picabia. Amorous Parade. 1917. Oil on cardboard, 37¾ × 28¾". Collection Mr. and Mrs. Morton G. Neumann, Chicago.

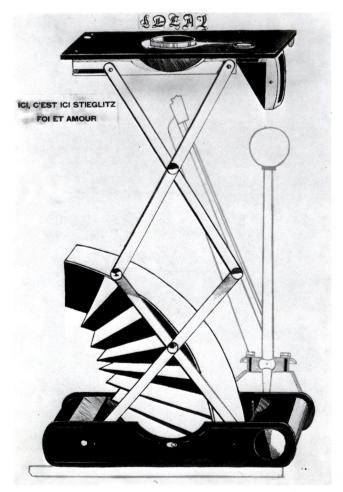

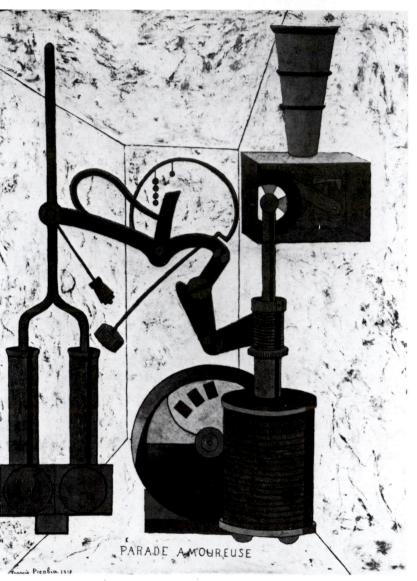

"cast" by several unseen Readymades, is a trompe-l'oeil realized by the artist, the safety pin holding the tear is real. For the pointing hand, Duchamp engaged the services of A. Klang, a commercial sign painter who "signed" his work. As if to make a visual pun on the famous 1890 dictum of Maurice Denis, quoted earlier— "Remember that a picture, before being a warhorse, a female nude, or some anecdote, is essentially a flat surface covered with colors assembled in a certain order"—Duchamp introduced an assortment of color samples, by painting them to look as genuine as the actual bolt that "appears" to secure the shadow-casting sheets. Here may be the ultimate ancestor of the pure color abstraction that, in the early 1960s, would develop into Hard-Edge and Op Art (Figs. 584, 585).

female alter ego, is a pun in French: *Eros est la vie*, or "Eros is life.") The construction is a bird cage filled with marble lumps simulating sugar, a cuttlebone, and a thermometer, predicting the irrational and mysterious objects later developed by the Surrealists.

Although he long continued to work secretly as an artist, Duchamp painted in oil on canvas for the last time in 1918, when he produced $Tu \ m'$ (Fig. 293), a mural-like work bristling with irony and visual conceit. While the rent in the canvas, like the shadows

In 1923, when he stopped work on the Large Glass, Duchamp virtually abandoned art for chess, occasional experiments in optics and mechanics, or assisting the Surrealists in exhibition installations. His explorations with chance, the designation of the manufactured Readymade as art, and his many acute observations on the problem of art and anti-art were particularly influential and today continue to shape the conceptions of contemporary art.

In 1910 Duchamp had met Francis Picabia (1879-1953), a wealthy Parisian of Cuban and French descent, who shared his taste for paradox and public obfuscation. Picabia visited New York in 1913 at the time of the Armory Show, where he exhibited a number of Cubist-derived paintings with enigmatic overtones. Two years later, like Duchamp who inspired him, Picabia launched a similar erotic-mechanical style. A typical creation, which made a visual pun on American innocence and machine worship, was the Young American Girl in a State of Nudity, nothing more than a mechanical drawing of a spark plug with the brand name For-Ever. In another "machine portrait" of 1915 Picabia represented Alfred Stieglitz (Fig. 294), the celebrated photographer and sponsor of New York's first gallery devoted to advanced art, as a broken camera with its automobile brake on and its gear shift in neutral position, symbolizing, heraldic fashion, the difficulties confronted by experimental movements in the New World.¹⁹ Despite the problem. Picabia helped stimulate certain phases of American vanguard art, and his machinist imagery in Amorous Parade (Fig. 295) exerted a direct impact on the so-called Precisionists: Charles Demuth. Charles Sheeler, and others (Figs. 451, 452). He also bore

direct responsibility, no doubt, for America's most daring native Dada object, a miter box with a plumbing connection ironically entitled God (Fig. 296), by Morton Schamberg (1881–1918). Picabia injected a Proto-Dada spirit into Stieglitz's review Camera Work, and later the gallery journal 291, which affected the course of American modernist art for some time.

Sharing his activities, perceptions, and inspired forms of wit was the American photographer, and tireless experimenter in form, Man Ray (1890–1977), who expatriated himself to Paris in 1921, where he devised a type of abstract, cameraless photography by printing patterns of forms directly on sensitized paper. He called the sheets produced by this process Rayographs. Man Ray also created a corpus of remarkable paintings of fantastic content and some of the most enigmatic Dada objects, among them the sadistic Gift, a small flat pressing iron whose face is studded with tacks turned outward (Fig. 297).

Between 1918 and 1920 Dada spread from Zurich into Germany, creating not so much a consistent artistic style as a wave of liberating nihilism. In Berlin, Dada took its most overt political form, shaped by the sense of disillusionment of the desperately harsh postwar years. In Zurich, Tzara had insisted that Dada meant nothing, but in Germany, he said, Dada "went out and found an adversary."20 There it was linked with Communism, and militantly involved itself in urgent political issues. Although Berlin Dadaists produced little significant painting, their contribution to the development of collage and caricature was unique. George Grosz, whose origins were in German Expressionism (Fig. 210),

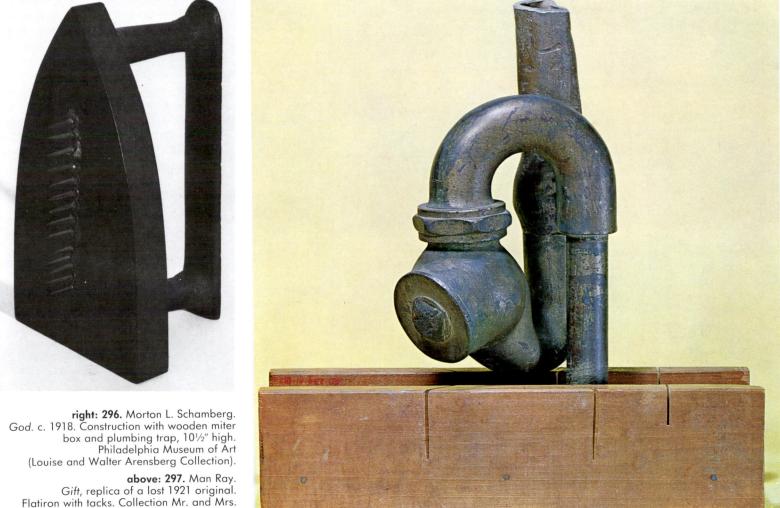

Dada and Fantastic Art 173

Morton G. Neumann, Chicago.

created savage satires on the corrupt bourgeoisie, clergy, military, and bureaucracy of Berlin that are grotesque, subhuman, and altogether memorable (Fig. 298).

Also in Berlin were artists who used photographic images directly. Hannah Höch (1889–1978; Fig. 299), Raoul Hausmann, and others found in photo-collage a dramatic mode of registering their crushing indictment of capitalism and militarism in the period

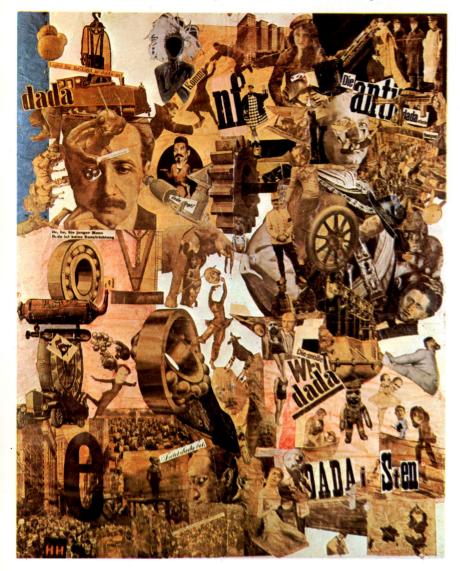

between the wars, when the dissident Nazi movement came to birth. In Hannover, Kurt Schwitters, using Cubist design (Fig. 256), created trash pictures and constructions that poetically redeemed anonymous rubbish salvaged from the gutter in exquisite formal structures (Fig. 300). He coined the word Merzbild, a "meaningless" term arrived at by chance when Commerz- und Privatsbank appeared on a letterhead the artist was fitting into a collage Bild, or "picture." The first Merzbilder were exhibited at the Sturm Gallery in Berlin in 1917, and however unaesthetic their materials, the magpie works produced by Schwitters constitute an art whose quality seems more genuine with every passing year. By incorporating commonplace object fragments taken directly from life, Schwitters posed the question of non- or anti-art content, but in a manner different from Duchamp's. He also extended the material possibilities of artistic expression. And in a subtle, poetic way, he commented on contemporary materialism by collecting in structures of indubitable artistic merit the detritus of society.

Given his formalist bent, Schwitters inevitably drew close to the Constructivists, and in 1922 he joined Theo van Doesburg on

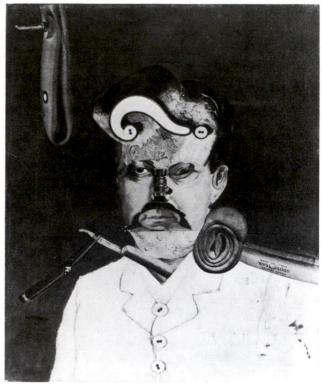

above: 298. George Grosz. Remember Uncle August, the Unhappy Inventor. 1919. Oil on canvas, with cut-and-pasted magazine advertisements and buttons; $19\frac{1}{7} \times 15\frac{5}{8}$ ". Collection Mr. and Mrs. Bernard Reis, New York.

left: 299. Hanna Höch. Cut with the Kitchen Knife. 1919. Collage of pasted papers, $44\% \times 35\%$ ". Nationalgalerie, Staatliche Museen, Berlin.

right: 300. Kurt Schwitters. Merz 94 Grünflec. 1920. Collage, 6³/₄×5¹/₂". Collection Eduard Neuenschwander, Zurich.

opposite below: 301. Kurt Schwitters. *Merzbau* (detail). Hannover. c.1924–33.

a Dada lecture tour through the Netherlands. Later on he even had the wit, energy, and conviction to monumentalize his Merz work to architectural proportions. Calling it *Merzbau* (Merz "building"), he gradually assembled a vast constructivist sculpture in his own house, building up the junk until it penetrated the ceiling and towered into the second story (Fig. 301). Condemned as a "degenerate" artist by the Nazis, Schwitters took refuge in Norway and began a new Merzbau, only to abandon this one when again he had to take flight, this time to England. There, aided by funds from New York's Museum of Modern Art, Schwitters launched upon his third, and only surviving, Merzbau, which stands unfinished at the University of Newcastle.

Many years later, Joseph Cornell united Schwitters's mania for collecting discarded objects and visual ephemera with a Surrealist juxtaposition of found objects and his own private world of fantasy to create some of the most enchanting "junk" constructions of modern art (Figs. 561–566).

The transition from Dada to Surrealism was hastened dramatically in Germany by the Cologne Dada group, dominated by Max

Ernst (1891-1976), whose inexhaustible fantasy took its original impetus from such Late Gothic Northern masters as Dürer, Grünewald, and Bosch, by way of Max Klinger and Alfred Kubin (Fig. 5). With the assistance of Jean Arp, who later assumed the leadership of an opposite, abstract school within the Dada-Surrealist movement, Ernst began in 1919 to make a remarkable group of collages from illustrations cut from sales catalogues, scientific journals, popular Victorian fiction, and machinery advertisements (Fig. 302). The visual and psychological impact of these works was startling, since he used machine forms, strange apparatuses, and geological strata to explore what were often explicit themes of sexuality, following the example of Duchamp and Picabia before him. But Ernst added a new and personal mythos and intensity to his collages, discovering in his imagery an hallucinatory potential. He conceived of the collage in a paraphrase of Lautréamont's famous epithet, as "the exploitation of the chance meeting of two distant realities on an unfamiliar plane," or as "the culture of systematic displacement and its effects."²¹ The overt libidinal content present in many of his material paste-ups and objects represented a signif-

Dada and Fantastic Art
175

above: 302. Max Ernst. A Little Sick, the Horse. 1920. Tempera and collage on cardboard, 5% × 8%". Galleria d'Arte Moderna, Turin.

icant advance in the realm of fantasy from the preoccupation with protest and scandal as such, which had heretofore dominated Dadaist expression. The description Ernst made of his initial discovery of the hallucinatory power of commonplace materials is the first direct acknowledgment by a 20th-century artist of the appeal of the unconscious:

One rainy day in 1919 ... my excited gaze is provoked by the pages of a printed catalogue. The advertisements illustrated objects relating to anthropological, microscopical, psychological, mineralogical, and paleontological research. Here I discover elements of a figuration so remote that its very absurdity provokes in me a sudden intensification of my faculties of sight—an hallucinatory succession of contradictory images, double, triple, multiple. ... By simply painting or drawing, it suffices to add to the illustrations a color, a line, a landscape foreign to the objects represented—a desert, a sky, a geological section, a floor, a single straight horizontal expressing the horizon, and so forth. These changes, no more than docile reproductions of *what is visible within me*, record a faithful and fixed image of my hallucination. They transform the banal pages of advertisement into dramas which reveal my most secret desires.²²

Influenced by de Chirico's deep space and trancelike reverie (Figs. 280–282), Ernst began to make illusionistic paintings that transposed some of the monstrous imagery hinted at in his collages into more complex visual symbols. De Chirico's presence accounts for such enigmatic, if more aggressive images as *The Elephant Celebes* (Fig. 303), a boiler-bodied monster crowned with a Synthetic Cubist construction and swinging a cow-skull-headed tail that could just as well be a stovepipe or a trunk. Despite the sinister warning of a smoky emission, fish flying in the sky, and an enormous pair of tusks protruding from the opposite end of the beast, its head all the more unimaginably horrible for being invisible, a

right: 303. Max Ernst. The Elephant Celebes. 1921. Oil on canvas, 4'1¹/4" x 3'6". Tate Gallery, London.

opposite: 304. Max Ernst. Two Children Are Threatened by a Nightingale. 1924. Oil on wood, with wood construction; $27 \frac{1}{2} \times 22 \frac{1}{2} \times 4\frac{1}{2}$ ". Museum of Modern Art, New York. Purchase.

seductive but headless female nude beckons whatever may come from Ernst's Gothic fancy.

In the construction *Two Children Are Threatened by a Nightingale* (Fig. 304), made the year Surrealism was launched (1924), de Chirico's pacific dream world has been supplanted by a sense of nightmare. The terror of the children is perhaps reminiscent of Gothic novels of the late 18th century, or earlier German fairy tales. Much like Ernst's collages, these more realistic dream images are based on incongruous juxtapositions of strange material objects and painted human figures set in a picture-postcard space. The painting supports the same conception of "the culture of systematic displacement," or of alienation and disorientation, which Ernst defined as the inherent technique of the collage. Ernst's original paintings and constructions in illusionistic form of the early 1920s dramatize the growing differences between Dadaist disgust or protest and the Surrealist affirmation of a new reality that was becoming evident in other art of the period. They represent the true beginnings of Surrealist painting even before Breton had officially codified the movement in his first manifesto.

Ernst quickly gained a reputation in Paris after Breton arranged an exhibition for him there in 1921. He settled in the French capital the following year, sponsored by an admiring Breton who, together with the poets Soupault and Paul Éluard, gave birth to literary Surrealism. Breton brought focus to and soon thoroughly dominated the movement, proving himself as effective an art propagandist as he was a gifted poet and insatiably curious intellectual. With his cerebral interests, the poet had grown weary of the Dadaist provocations and infantile rebellion. He felt it was time for intellectuals to act more constructively, and he built Surrealism out of the ruins of Dada, whose unrelieved pattern of nihilism had become sterile and self-defeating. In negating everything else, Dada logically had to end by eliminating itself. The February 1920 *Bulletin Dada* carried a prophetic inscription in large type: "The real Dadaists are against Dada. Every one is a director of Dada."²³

Surrealism: The Resolution of Dream and Reality

nlike Dada, the Surrealist movement was composed of a highly organized group of artists and writers who rallied around André Breton in Paris when the poet issued his First Surrealist Manifesto in 1924. The document made it clear that Breton had adopted for Surrealism the basic premises of psychoanalysis. Indeed, he actually believed quite literally in the objective reality of the dream. For Breton, automatism, hallucinatory and irrational thought associations, and recollected dream images offered a means of liberating the psyche from its enslavement to reason. Automatism, in his frame of reference, meant a process of tapping the unconscious by writing in a trancelike state and registering the involuntary, vivid images that tumbled out. Although the manifesto stresses automatism, and contains a long section devoted to dreams as the expression of the unconscious mind, the document actually proposes ideas contrary to Freud's intentions, for it glorifies irrationality and gives an objective status to a wide range of fantastic imagery that science would consider symptomatic and thus

305. André Masson. Battle of Fishes. 1927. Sand, gesso, oil, pencil, and charcoal on canvas, 14¼ × 28¾". Museum of Modern Art, New York. Purchase. seek to cure. Rather than use psychology to illuminate human conduct, Breton decided that the wellspring of Freudian psychology the subconscious mind, repressed desire, the imagery of dreams was itself worth exploiting. In fact, even the dream was to be understood only as a mode of perception and experience, which permitted the Surrealists to transform the world of concrete reality completely in response to man's desire, dispelling all contradictions in a new and blissful state of psychic unity. Some time later, in an interview published in the *Corero Literario*, Breton insisted that Surrealism reconciled all contradictions in thought and in the human condition, enabling "the mind to leap the barrier set up for it by the antinomies of reason and dreaming, reason and madness, feeling and representation, etc., which constitute the major obstacle in Western thought."¹

In one of the best-known passages of his 1924 Manifesto, Breton made a simplistic statement of the redemptive side of Surrealist vision and of its search for a higher reality through the medium of the subconscious: "I believe in the future resolution of these two states, dream and reality, which are seemingly so contradictory, into a kind of absolute reality, a surreality, if one may so speak."² To achieve this condition Breton therefore proposed the

306. André Masson. *Iroquois Landscape*. 1943. Oil on canvas, 31⁵/8 x 39". Collection Mme Simone Collinet, Paris.

systematic exploration of the unconscious, and as the technique to that end he provided a dictionary definition of Surrealism of admirable succinctness:

Surrealism, a. Psychic automatism in its pure state, by which one proposes to express—verbally, by means of the written word, or in any other manner—the actual functioning of thought. Dictated by thought, in the absence of any control exercised by reason, exempt from any aesthetic or moral concern.

Encyclopedia. *Philosophy*. Surrealism is based on the belief in the superior reality of certain forms of previously neglected associations, in the omnipotence of dream, in the disinterested play of thought.³

A long passage in the Manifesto concerns the "Surrealist image," defined as the product of the chance juxtaposition of two different realities, in terms very similar to Breton's preface to Ernst's first Paris exhibition. In the beginning, however, Surrealism was primarily a literary movement, and for precursors it looked to the poets Baudelaire, Lautréamont, Rimbaud, and Apollinaire. (The name of the movement came from Apollinaire, who in 1917 had first used it for his fantastic farce, The Breasts of Tiresias, subtitled A Surrealist Drama.). No plastic artist was invited to sign the 1924 Manifesto, and only a few names of painters were even mentioned in it, and those in a footnote. A strange company, it included, among others, Seurat, Moreau, Picasso, Picabia, Duchamp, Klee, Ernst, Masson, de Chirico, and Paolo Uccello, the latter dead since 1475! A number of the living artists exhibited together the following year as Surrealists, at the Pierre Gallery. Although Breton wrote the preface for the exhibition, he later referred to painting as a "lamentable expedient," and never arrived at a consistent or convincing definition of Surrealist art. Surrealist painting did exist, however, independently of Breton. But while Surrealism gave artists access to new subject matter, and a process for conjuring it, a movement so devoted to individualism and alienation could hardly be expected to produce any significant degree of stylistic consistency. Still, as Surrealist painting emerged in the mid-1920s, it quickly divided itself into two major directions-automatism and an illusionistic dream imagery.

The First Surrealist Masters

André Masson (1896-1987)-seriously wounded during the Great War and driven to express the violence it had inflicted upon him and the world at large-independently and precociously discovered his own visual equivalents for the automatism of the poets. His example became extremely influential, affecting artists as different as Joan Miró and Jackson Pollock. The particular automatism developed by Masson was a kind of abstract calligraphy, where the rhythm of swift lines or cursive brush marks generated images of violence and dramatic encounters of form (Fig. 305). His pen-and-ink drawings of 1924, made just after meeting Breton, are remarkable not only because they disclose the artist's invention of a visual automatism, but also because they plausibly create a magical and autonomous world, with hints of anatomical and mythic imagery. Some of Masson's most effective ensembles of metamorphic hybrids were made in 1927, in a medium that mixed tube pigment and sand randomly poured over areas of spilled glue. The animal violence of works in this style, like the Battle of Fishes seen here, became powerful analogues of human passion, reflecting the artist's troubled preoccupation with destiny and his vague but profound belief in the symbolic unity of all things (Fig. 306).

Although Joan Miró (1893–1983) had shown in the 1925 Surrealist exhibition and Breton later claimed him as "the most Surrealist of us all," the artist steadfastly refused to be officially assimilated by either the Surrealists or any other school. Miró held himself somewhat apart from all Parisian movements, even while acknowledging Surrealism as a powerful and formative influence on him, and he used automatism to free his paintings from both Cubism and an earlier, tightly representational style. Masson, who in 1924 occupied the studio directly next door to Miró in Paris, introduced the Spaniard to current literary romanticism as well as automatism. Miró wrote:

Masson was always a great reader and full of ideas. Among his friends were practically all the young poets of the day. Through Masson I met them. Through them I heard poetry discussed. The poets Mas-

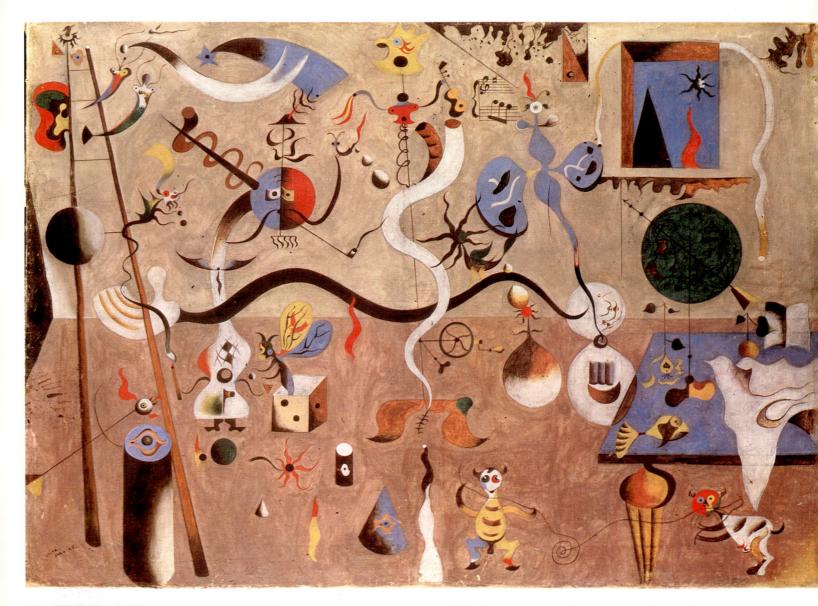

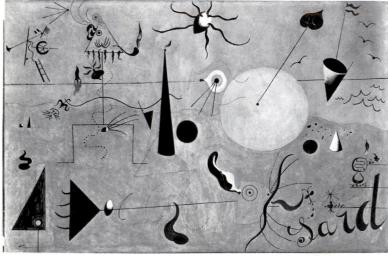

son introduced me to interested me more than the painters I had met in Paris. I was carried away by the new ideas they brought and especially the poetry they discussed.

As a result of this reading, I began gradually to work away from the realism I had practiced \ldots until, in 1925, I was drawing almost entirely from hallucinations. At the time I was living on a few dried figs a day.⁴ left: 307. Joan Miró. The Hunter (Catalan Landscape). 1923–24.
Oil on canvas, 25½ × 39½". Museum of Modern Art, New York.
above: 308. Joan Miró. The Harlequin's Carnival. 1924–25.
Oil on canvas, 25¼ × 35½". Albright-Knox Art Gallery, Buffalo.

opposite above: 309. Max Ernst. To 100,000 Doves. 1925. Oil on canvas, 32 × 39½". Collection Mme Simone Collinet, Paris. opposite below: 310. Max Ernst. Gray Forest. 1927. Oil on canvas, 31% × 39%". Private collection, Liège.

The influence of Masson, and perhaps Arp, liberated Miró's poetic fancy, and a radical process of formal elision and evocative association became apparent in his increasingly abstract and fantastic art. One of the first mature examples of Miró's Dada-Surrealist style was *The Hunter* (Fig. 307). Here the artist introduced a freely moving, cursive calligraphy and ideographs in place of descriptive detail. While still managing to suggest the familiar scenes of his favorite motif, his farm at Montroig, he derived his forms more from fantasy and childhood memory than from visible nature. His invention reached a climax of humor and dramatic enrichment in the dense, brilliant detail of *The Harlequin's Carnival* (Fig. 308), an agitated colorful dance of insectile phantasmagoria, animated toys, and gaudy baubles—as if the nursery had sprung to vigorous life.

Unlike many of the orthodox Surrealist painters, Miró never embraced the more picturesque tendencies of the movement, its trompe-l'oeil techniques of illustration and incongruous association. He worked within the formal side of Surrealism mainly, adopting its automatism and its hyperactive principle of analogy. His paintings remained plastic creations first and last, and in them even the data of the unconscious submit to the control of an unerring pictorial logic. The material function of expressive means remained uppermost in Miró's mind. Ideas and poetry were embodied

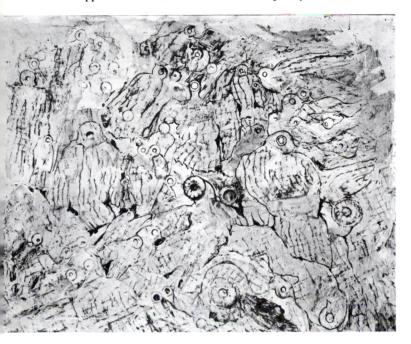

rather than illustrated, and they communicated directly through pictorial values. The independent position taken by Miró, and his utter devotion to painting per se, understandably roused ambivalent feeling among the more orthodox Surrealists. While Breton praised him for his "pure automatism," he also reproached him for his stubborn individualism as an artist. "Pure imagination," wrote Breton, "reigns supreme over everything it day by day appropriates, and Miró should not forget that he is nothing but its instrument."⁵ Nevertheless, Miró gave not only the Surrealist circle but also the whole of 20th-century art one of its greatest, most joyous, prolific, and, as we shall see (Figs. 395–400), influential talents, a master ranking after Picasso, Matisse, and few others.

Max Ernst, already found to be equally adept in automatic techniques and in illusionist forms of painting (Figs. 302-304). replaced his machine-like Dadaist imagery with more complicated image-metaphors as he continued to experiment with the visual process. In 1925, and now thoroughly within the Surrealist circle, the artist produced a series of drawings called "Natural History" in which he obtained various textures by rubbing objects and surfaces on sheets of paper and then arranged the latter in suggestive sequences. Ernst called the technique frottage (for the French verb frotter meaning "to rub") and used it as his form of spontaneous creation, akin to the Surrealist literary method of automatic writing (Fig. 309). He simply allowed his tracings and rubbings, uncensored except for minor alterations, to evoke fantastic visions of landscapes, animals, and hybrid creatures. The ambiguous stains, blots, and "hallucinatory" textures recorded by frottage prompted the artist to elaborate the imagery of his persistent bird-personage, Loplop, and the thematic Forests, Hordes, and other obsessive figures and scenarios of his illusionistic paintings (Fig. 310).

Undoubtedly inspired by Ernst's frottages, Oscar Dominguez (1906–57) exploited the possibilities of decalcomania by lifting

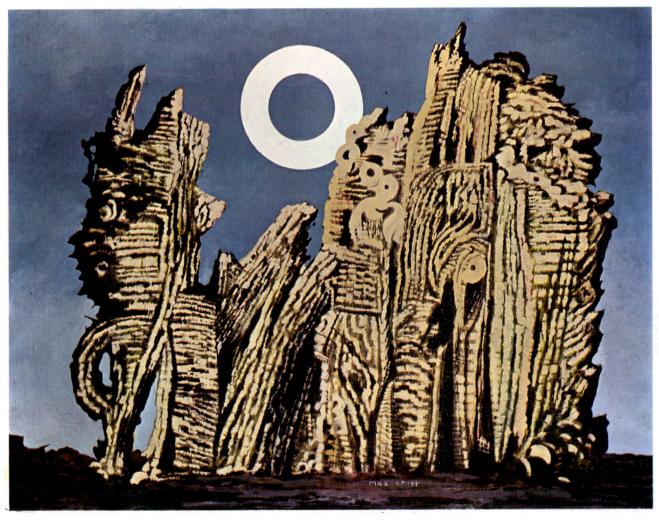

below: 312. Salvador Dali. *The Persistence of Memory.* 1931. Oil on canvas, 9½ x 13". Museum of Modern Art, New York. Given anonymously.

right: 313. Salvador Dali. Soft Construction with Boiled Beans: Premonition of Civil War. 1936. Oil on canvas, $43\frac{1}{4} \times 33\frac{1}{6}$ ". Museum of Modern Art, New York. James Thrall Soby Bequest. **311.** Oscar Dominguez. Untitled. 1936. Gouache transfer (decalcomania), 14½ × 11½". Museum of Modern Art, New York.

paint off paper with another sheet to which it adhered, and using the process to create accidental and dreamlike configurations of exotic flora and fauna in imaginary landscapes (Fig. 311).

The automatism of Masson and Miró, and Ernst's frottage technique, dominated the first year of Surrealist painting following publication of the Manifesto. With the emergence of René Magritte and Yves Tanguy in 1926 and 1927, a contrasting style, which fixed hallucinatory and fantastic subject matter in meticulously painted images of academic precision and clarity, became a viable alternative. In 1929 Salvador Dali (1904–), Miró's fellow Catalan,

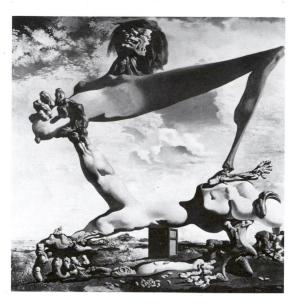

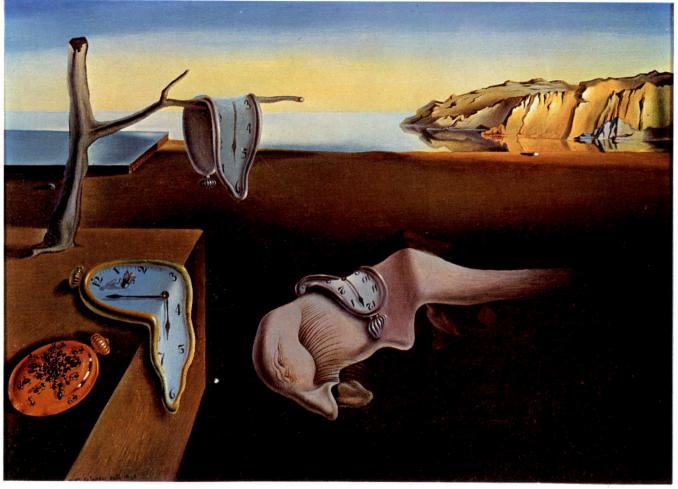

joined the Surrealists and, in Breton's view, best "incarnated the Surrealist spirit."⁶ With Dali's arrival as a full-fledged member, illusionistic technique rather than automatism and spontaneity became the dominant form of Surrealist painting. Dali's haunting and credibly realistic "hand-painted dream photographs," as the artist styled them, not only brought a new objectivity to Surrealism but a startling new subject matter and an elaborate scheme of rationalization for dealing with personal fantasy. Dali joined the movement at a time when Surrealism was torn by personal and political conflicts. His microscopically detailed, realist style and imagination provided a new focus for Surrealism. In The Persistence of Memory (Fig. 312) Dali created an enigmatic and controversial imagery of limp watches, arid landscape, and a monstrous fetal creature, at once jewel-like and putrescent in physical substance. At their best, such paintings encapsulated the anxieties, the obsessive eroticism, and the magic of a vivid dream imagery.

Dali also wrote copiously in elaborate defense of his methods and proposed a point of view based on what he called "paranoiac thought." He defined his "paranoiac-critical" methods as a "spontaneous assimilation of irrational knowledge based upon the critical and systematic objectification of delirious phenomena."⁷ In place of the passive trancelike state of automatism favored by the early Surrealists, Dali recommended an aggressive principle of subjectively distorted vision and the cultivation of delusional thought patterns. His scheme still adhered to the paramount Surrealist objective in art of creating a convincing counterreality. As Freud had analyzed the Oedipus legend, for example, Dali transformed the innocent legend of William Tell from one of filial devotion to a scandalous theme of incestuous mutilation. By such consciously shocking perversions of sentimental folklore, Dali hoped to bring common-day reality to its knees, as it were, and open up fresh imaginative possibilities. He adopted outrageously provocative attitudes in his public behavior and utterances, and he incited passions and criticism by the fanaticism and imperious tone of his critical writing. "I believe," he predicted, "that the moment is near when by a procedure of active paranoiac thought, it will be possible . . . to systematize confusion and contribute to the total discrediting of the world of reality."

In discarding automatism as an artistic strategy, Dali proposed to paint like a "madman" rather than a somnambulist. He added, paradoxically, that the only difference between himself and a madman was that he was not mad. By simulating madness, however, he hoped to demonstrate the absurdity of worldly existence, to comment mockingly on what passed for reason, and to awaken in others an awareness of their irrational selves. Dali paraded in his painting a challenging repertory of taboo sexual symbols and thus imposed, with some violence and with a keen appetite for public scandal, the painter's dream of reality (Fig. 313). Dali, Ernst, and the other illusionistic Surrealists particularly, whose fantasies the public could not mistake in the form of a meticulously exact imagery, discovered that the uncensored dramatizations of their private psychological states and tastes carried many possibilities of meaning beyond simply defending artistic freedom. Their often perverse and grandiose imagery also yielded a heady sense of power. In the realm of the imagination, the artist found he enjoyed special prerogatives. Dali's obsession with such themes as castration, impotence, voyeurism, putrefaction, and coprophilia, for which he invented obvious, if theatrical, visual symbols, not only reflects his awareness of studies in abnormal psychology, such as those by Krafft-Ebing; it also represents a sincere intellectual effort to achieve the kind of absolute freedom that was part of the Surrealist program to promote the revolutionary transformation of consciousness.

The poetic aggrandizement of a personal fantasy life in a startlingly lucid, compelling dream imagery, originated in de Chirico's dazzling apparitions and inexplicable confrontations of symbols (Figs. 280–282). Dali transformed de Chirico's illusionism into new perspectives of delirium, and the Frenchman Yves Tanguy (1900–55) used the same source to create a more precious and magical submarine dreamworld, inhabited by barely living creatures rendered in three-dimensional biomorphic form. Tanguy began to paint his tight, academic, illusionist works even before Dali, and his manner reached maturity in 1927. After seeing a picture by de Chirico that deeply moved him, he painted *Mama*, *Papa is Wounded!* a key work in his own repertory of images (Fig. 314). It represents a visionary re-creation of some desolate desert plateau, or ocean floor, where even natural properties are confused and mingled in their own liquid, gaseous, and crystalline states. His paintings have the ambiguous perspectives, long vistas, and

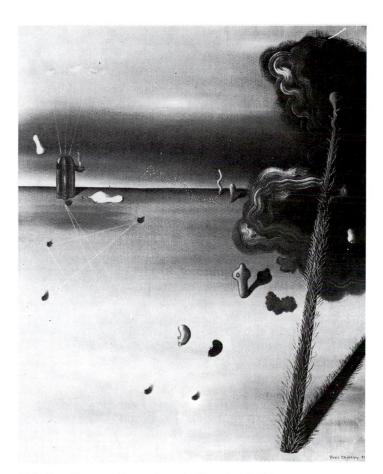

314. Yves Tanguy. Mama, Papa is Wounded! 1927. Oil on canvas, 36½ × 28¾". Museum of Modern Art, New York. Purchase.

distant horizons of de Chirico's, and also the contradictory ambience of air, water, and light that makes Ernst's early Surrealist paintings so ambiguous in locale. There are obvious Freudian allusions in the hairy membranous pole, at right, with its bulbous tip and its elongated geometric shadow. His biomorphs seem to anticipate Dali's amoeba-like, fetal forms as directly and transparently as Tanguy had assimilated de Chirico's oracular statuesque forms and hallucinatory brightness of light and space. For Breton, Tanguy's paintings seemed to realize his own dream, recorded in the book *Clair de terre*, of reconstituting the banal earth as a new habitat. He wrote that Tanguy had the ability ''to yield to us images of the unknown as concrete as those which we pass around of the known,'' and added that his paintings provided ''the first non-

legendary glimpse of the considerable area of the mental world which exists at the Genesis."⁹

Like a remembered dream that haunts waking consciousness, Tanguy's locales are familiar without being specifically recognizable. Amoebas, bones, soft bean forms, waving hairs, clouds, smoke puffs, earth, sky, water, amphibians, all are, in their own particular contexts, perfectly normal and natural enough. In Tanguy's paintings, however, their irrational relationships to each other create the confounded identity so beloved by the Surrealists. The combination of bizarre humor in Tanguy's titles with a sense of fatality and eerie menace reminds us that Breton had warned, in his novel *Nadja*, that "beauty will be convulsive or it will not be." Curiously, even the title *Mama*, *Papa is Wounded!* reflects the quest for new means of probing the unconscious, since, at the suggestion of Breton, it was taken from a statement made by a patient in psychiatric treatment.

In Tanguy's last works an even more cruel and enigmatic drama is enacted, in a more foreboding atmosphere that the critic James Thrall Soby called "a sort of boneyard of the world" (Fig. 315). These are dream, or nightmare, pictures of an almost unrelenting oppressiveness, where the sense of the miraculous is strongly qualified by repeated vistas of tiered boulders and intricate stacks of bone- or pebble-like forms, in a nearly black light, that seem designed to eliminate any possibilities of animate survival, or of human hope.

The Belgian Surrealist René Magritte (1893–1967) frequented the Breton circle in Paris in 1927–30 and then returned to Brussels, where he painted his haunting visual conundrums in a scrupulously exact and banal technique. Among the illusionistic Surrealists Magritte bears the most relevance to contemporary art, because his dissociated images and contrasts of objects and unre**315.** Yves Tanguy. *Time without Change*. 1951. Oil on canvas, 36 × 28". University of Arizona Museum of Art, Tucson.

Gift of Edward J. Gallagher, Jr.

lated words pose questions of meaning and relationship between painted and real objects. They present the problem of creating new forms of identity as part of the creative process. In a 1929 article in *La Révolution surréaliste* the painter explained his riddles with such illogical statements as: "An object is not so attached to its name that one cannot find another which might suit it better."

Magritte had formulated within his own more commonplace system of visual images another strategy for evoking the new Surrealist reality, in which the normal associations of objects, images, and their names dissolved in a scheme of identities whose rules were still to be fathomed and reconstructed. In one painting, a woman's face has been overprinted with letters spelling out the French word for "mountain" (Fig. 316). The device is disruptive, but it also has the suggestive effect of modifying and petrifying her features, by association, into a kind of landscape. In another picture, The Wind and the Song, Magritte painted a brier pipe with such trompel'oeil fidelity that it could be mistaken for the real thing, only to counter the effect with a painted-in label: "This is not a pipe." What the viewer sees, of course, is not a pipe but rather an image, which, Magritte held, the *peinture-poésie*, or "painting-poem," distinguishes from the object itself just as poetry sets a thing apart from the word for it.

One of his best-known visual enigmas is *The Human Condition I*, with its easel and transparent canvas that manage thoroughly to confound depicted art and natural landscape (Fig. 317). The contradiction between the painted illusion and the actual scene questions the nature of reality, but the real magic of the work lies in the threatening sense one has that neither nature nor subjective vision can be anything more than an hallucination or a fabrication.

opposite: 316. René Magritte. The Phantom Landscape. 1928–29. Oil on canvas, 211/4 × 283/4". Private collection, Turin.

above: 317. René Magritte. The Human Condition I. 1934. Oil on canvas, 39% × 31%". Private collection, France.

right: 318. René Magritte. The Empire of Lights. 1954. Oil on canvas, 4'11½"×3'8½". Musées Royaux des Beaux-Arts, Brussels.

below: 319. René Magritte. *The Lovers*. 1928. Oil on canvas, 21¾ × 28⅛". Collection Richard S. Zeisler, New York.

While he often painted residential interiors or street scenes in his native, essentially bourgeois city, Magritte still achieved a startling effect of the fantastic from juxtapositions of images, some of which even scramble night and day (Fig. 318). For such art, critics have renovated the term Magic Realism, originally used by Breton in reference to Douanier Rousseau (Fig. 278). Magritte's plain but limpid technique probed the contradictions of existence and, in the painter's own words, revealed "the present as an absolute mystery."¹⁰ This conviction sometimes led toward the erotic, even the gruesome or sadistic (Fig. 319). Magritte himself perhaps best explained his intentions and the profoundly disturbing impact his paintings have had on their audience:

In my pictures I showed objects situated where we never find them. They represented the realization of the real, if unconscious, desire existing in most people.

The creation of new objects, the transformation of known objects, the change of matter for certain other objects, the association of words with images, the putting to work of ideas suggested by friends, the utilization of certain scenes from half-waking or dream states—all were means employed with a view to establishing contact between consciousness and the external world. The titles of the pictures were chosen in such a way as to inspire a justifiable mistrust of any tendency the spectator might have to overready self-assurance.¹¹

Another Belgian painter, Paul Delvaux (1897—), came to Surrealism later under the influence of Magritte, primarily. His transcriptions of a dream imagery with obvious erotic content in the repeated forms of vacuous and wistful female nudes, owe a debt to his fellow countryman, but the elongated vistas and disquieting city perspectives evoke de Chirico as well (Fig. 320). The gentle, erotic dreams painted by Delvaux are amusingly reminiscent of classical ideals in their figuration, but the clash of his metropolitan settings, statuesque females, and formally attired voyeuristic males

creates a poignant tension between frustration and desire. His bizarre scenes simultaneously evoke an innocent golden age, a somewhat sinister prurience and sense of guilt, and a dated, genteel urban environment of the turn of the century. Frustrated passion, heterosexual and homosexual, and anxieties scarcely veiled about the passage of time and the ineluctability of death haunt this original iconography.

Surrealist Objects

Like Delvaux, the Polish-French artist Hans Bellmer (1902–75) explored new veins of eroticism in his paintings, in extremely refined drawings, and in a group of provocative Surrealist objects that culminated in the *Poupée* (''Doll''), which he showed in many variations at the controversial International Exhibition of Surrealism, held in Paris in 1938. The confused combination of limbs and erogenous areas, made from the members of an articulated or jointed mannequin, and the fetishistic character of the aggressive sexual object seen here (Fig. 321) echo Bellmer's rather sadistic, unpublishable drawings of pubescent girls.

The preoccupation with a perverse sexuality became a salient feature in many later Surrealist works, as well as in many late paintings by Ernst, and in the work of Bellmer, Delvaux, and others. Their art represented the pathological side of the more usual Surrealist exaltation of romantic love. With Breton's publication of *Mad Love (L'Amour fou)* in 1937, the adoration of Woman with a kind of sublime love, not to be confused with eroticism or its travesty in pornography, joined automatic writing and spiritism as a major strategy for attaining the desired state of revelation. Benjamin Peret described love as a new divinity fusing dream and reality, as one of the "exalting and incredible myths which will send one and all to lay siege to the unknown."¹² But the inclination toward the perverse persisted as the dark and anguished side of Surrealism, and it became an important part of its heritage.

By the mid-1930s Surrealist images and fantasies had found fresh and enriching outlets in a context of three-dimensional execution. In order to make their pictorial vision tangible in material terms, painters turned directly to the physical world for inspiration. The Dadaists had already provided rudimentary prototypes of Surrealist objects in Duchamp's assisted Readymades or in Man Ray's *Gift* (Figs. 286, 290, 297). Having been created primarily to embody intellectual concepts or simply to shock, these objects failed

> above: 320. Paul Delvaux. Phases of the Moon. 1939. Oil on canvas, 4'7"×5'3". Museum of Modern Art, New York. Purchase.

> **left: 321**. Hans Bellmer. *Ball Joint*. c.1936. Plaster, lifesize. Present whereabouts unknown.

Meret Oppenheim. Object (Le Déjeuner fourrure). 1936. Fur-covered cup, saucer, and spoon; cup 4³/₄" diameter, saucer 9³/₈" diameter, spoon 8" long, overall 2⁷/₈" high. Museum of Modern Art, New York.

opposite left: 323. Joan Miró. Poetic Object. 1936. Assemblage of stuffed parrot on wood perch, stuffed silk stocking with velvet garter and doll's paper shoe suspended in a hollow wood frame, derby hat, hanging cork ball, celluloid fish, and engraved map; 317/₈×117/₈×101/₄". Museum of Modern Art, New York. Gift of Mr. and Mrs. Pierre Matisse.

> opposite below right: 324. Salvador Dali. *Rainy Taxi,* at the International Exhibition of Surrealism, Beaux-Arts Gallery, Paris. 1938.

to explore a full range of imaginative possibilities, and in the end proved somewhat limited in their appeal. With the emergence of Dali and his painted objects of concrete irrationality, however, the Surrealist process of dépaysement, or "disorientation," was applied directly to physical reality, and objects were endowed with new functions and relationships. The most notable public evidence of the phenomenon appeared at the Exhibition of Surrealist Objects held at the Charles Ratton Gallery in Paris in 1936. It was this exhibition that inspired Breton's article "Crisis of the Object," published in the May number of Cahiers d' art that year. There, Breton recalled that he had as early as "1924 ... proposed the fabrication and circulation of objects appearing in dreams."13 He conceived fanciful objects as a way of downgrading conventional objects "whose convenient utility (although often questionable) encumbers the supposedly real world."¹⁴ And he repeated the various classifications and types of objects presented in the Ratton Gallery exhibition: "Mathematical objects, natural objects, primitive objects, found objects, irrational objects, ready-made objects, interpreted objects, incorporated objects, mobile objects."15 And the Ratton Gallery show had been preceded in 1933 by a smaller exhibition of objects at the Pierre Colle Gallery in Paris offering, among other things, "disagreeable objects, sexes, phobias, interuterine memories, taciturn conflicts, sausages, hammers, palaces, fried eggs, failed portraits, breads, photos, tongues."16

Among the Surrealist objects in the Ratton Gallery exhibition was the popular favorite and by now classic *Object* (Fig. 322) by the Swiss-German artist Meret Oppenheim (1913—). Unlike the Dada objects, Oppenheim's fur-lined cup, saucer, and spoon were not designed merely to startle the viewer but, rather, to release anthropomorphic associations. Implements normally used for drinking tea have here assumed a strange animate life of their own suitable for a beast or even a coat but disconcerting in a domestic context. In other instances, Surrealist assemblages such as Miró's *Poetic Object* proved to be more aesthetic and formal than disruptive (Fig. 323), and they formed a coherent and recognizable part of the artist's development, somewhat alien to the more extravagant Surrealist objects of fantasy.

Carrying their interest in fantastic objects into a total environmental and theatrical expression at Paris's 1938 International Exhibition of Surrealism, participating artists created a "Surrealist street" lined with intriguing mannequins, decked out by Ernst, Arp, Tanguy, Man Ray, Dali, Miró, and Duchamp. Duchamp also arranged the ingenious main installation area by hanging 1,200 sacks of coal from the ceiling and covering the floor with dead leaves and moss around a water pond framed by real ferns and reeds. At the entrance Dali produced perhaps the exhibition's most sensational object, *Rainy Taxi* (Fig. 324), a derelict vehicle with dummies drenched by a continuous shower inside. One of the mannequins

was a wild-eyed, unkempt female figure on whom live snails crawled. The elaborate and spectacular exhibition became the last major Surrealist event before World War II. Dispersed by the outbreak of hostilities, many of the Surrealists, including Breton, Ernst, Masson, and Tanguy, took refuge in New York, where, however brief their stay, they helped stimulate the formation of American Abstract Expressionism.

Surrealist Sculpture

Several years before the 1936 Exhibition of Surrealist Objects, Swiss-born Alberto Giacometti (1901–66) had begun to construct

below: 327. Alberto Giacometti. *The Palace at 4 A.M.* 1932–33. Construction of wood, glass, wire, and string; $25 \times 28\frac{1}{4} \times 15\frac{3}{4}$ ". Museum of Modern Art, New York. Purchase.

his own rather aggressive objects, anticipating the fetishism and sadomasochism of works in that exhibition. Yet he translated the sense of dream and the disparate realities of the Surrealists into authentic sculptural form, distinct from the conglomerate Surrealist object. His pioneering effort directly affected the only other artists who can also be said to have made Surrealist sculpture in the 1930s: Arp and Ernst. In 1929 Giacometti became a formal member of the Surrealist group, and in 1934–35 he made *The Invisible Object* (Fig. 325), which Breton described as "an emanation of the desire to love and be loved, in quest of its true human object and in all the agony of this quest."¹⁷ The strange figure, bound to an imprisoning armature, emerging fearfully from its confines and holding the

below: 325. Alberto Giacometti. The Invisible Object (Hands Holding a Void). 1934–35. Bronze, 5'1" high. Collection Mrs. Bertram Smith, New York.

left: 326. Alberto Giacometti. Woman with Her Throat Cut. 1932 (cast 1949). Bronze, 8 × 34½ × 25". Museum of Modern Art, New York. Purchase.

void, evokes the poignancy of human yearning and, paradoxically, the hollowness of hope, thus echoing the disenchanted mood that undermines so many of even the bravest Surrealist fancies. *Woman with Her Throat Cut* (Fig. 326), executed two years earlier, constitutes an even more exasperated and violent evocation of the human form and of the human predicament, with its terrifying imagery of a presumed sexual murder and the female anatomy transformed into a crustacean.

Giacometti's cage sculptures, of which the best known is The Palace at 4 A.M. (Fig. 327), provided key prototypes in the evolution of open-form, welded sculpture made after World War II in America and elsewhere. The compulsive and memorable image of this dream palace is the artist's most complex Surrealist invention. It seems to be a visual recollection of a love affair, which Giacometti later elliptically described in a lengthy and moving prose poem. The construction, he wrote, "is related without any doubt to a period in my life that had come to an end a year before, when for six whole months, hour after hour was passed in the company of a woman who, concentrating all life in herself, magically transformed my every moment."¹⁸ The work set a precedent for narrative sculpture that was at the same time rigorously formal and derived essentially from Picasso's and Lipchitz's constructions (Figs. 242, 245, 335, 407). Despite the obvious fertility of his Surrealist period, Giacometti disavowed the movement only six years after he had joined it, and thereafter sought a more personal vision based on a consciously tentative, impressionistic technique of modeling his familiar anguished, spindly human figures (Figs. 522, 523)

Although the sculpture-in-the-round created by Jean Arp recalls Brancusi's in its reductive abstraction, the work is associated with Surrealism by reason of its poetic metaphor of growth and change (Fig. 328). Arp, who, we should remember, was a founding associate of Zurich Dada (Figs. 283–285), believed that "art left: 328. Jean (Hans) Arp. Human Concretion. 1933.
Stone, 22×31⁷/₈×21¹/₄". Kunsthaus, Zurich.
right: 329. Max Ernst. Lunar Asparagus. 1935.
Plaster, 5'5¹/₄" high.
Museum of Modern Art, New York. Purchase.

is a fruit which grows in man, like a fruit on a plant, or a child in its mother's womb." He called his organic sculptures "human concretions," insisting they were not abstractions despite their obvious resemblance to Brancusi's Purist forms (Fig. 122). "Concretion," wrote Arp, "is the result of a process of crystallization: the earth and the stars, the matter of the stone, the plant, the animal, man, all exemplify such a process. Concretion is something that has grown."¹⁹ Often his sinuous forms suggest the human figure, but they simultaneously evoke cloud shapes, stones, plants, beasts, and a host of associations from nature. Arp purged his forms of the violence and aggression that was so much a part of Surrealist painting, with its emphasis on the forces of unconscious inspiration.

Max Ernst, another Dadaist who led the way to Surrealism (Figs. 302–304, 309, 310), first tried his hand at sculpture in 1934, after spending the summer with Giacometti in Maloja, Switzerland. The chance discovery of some rounded granite rocks in a mountain stream, worn smooth by the rushing waters, provided the necessary found object to stimulate his creative impulses. His first sculptures were these small stones, simply painted or carved in shallow relief. In the winter of 1934–35, under the influence of Picasso, Ernst embarked on a different and far more interesting sculptural process, combining ensembles of casts of whole and fragmentary common objects until a personage or presence emerged. The rather fortuitous method of assembling reproductions of real objects echoed his graphic and frottage techniques, and it launched Ernst into one of his most fruitful periods. *Oedipus* and *Lunar Asparagus* (Fig. 329), for example, are totally sculp-

left: 330. Max Ernst. Capricorn. 1964 (cast of 1948 concrete original). Bronze, 7'10½" high. Collection Mr. and Mrs. Albert A. List, New York.

below: 331. Pablo Picasso. Bull's Head. 1942. Assemblage of bicycle saddle and handlebars, $13\frac{1}{4} \times 17\frac{1}{8} \times 7\frac{1}{2}$ ". Musée Picasso, Paris.

tural works whose images have been transformed into something altogether new and surprising. Perhaps Ernst's most impressive mythology in sculpture was the monumental Capricorn group (Fig. 330). It was made in cast cement (later cast in bronze) at the artist's temporary home in Sedona, Ariz., in 1948. The forms combine the exoticism of African or Oceanic art with suggestions of astrological symbolism and allusions to ideas of fertility and rebirth in what is essentially a group portrait of himself, his wife, and their two dogs. Ernst's plaster sculptures and the one monumental figure group in cement all dated from the 1930s and 1940s, but they remained largely unknown in those decades, since the pieces were not cast in bronze or shown publicly until much later. They form one of the most impressive bodies of rare Surrealist sculpture by a genuine master whose universality has been increasingly recognized in recent times, especially by the post-Pop generation of neo-Dadaists and Expressionist fantasists.

The Expanding Surrealist Influence

Between the wars, Surrealism did not generally encourage the production of sculpture. The movement developed its most fertile ideas either in painting or in the alternately magical and scatological Surrealist objects shown in Paris in 1936. Interestingly, Picasso occasionally essayed Surrealist methods like those of Max Ernst in sculpture, depending on subjective metamorphosis to transform simple found objects into fantastic imagery with double meanings. His well-known *Bull's Head* is, for instance, a casting of an ingenious ensemble of a bicycle seat and handlebars formed into a powerful animistic presence (Fig. 331). But with some exceptions, the meanings and intentions espoused by Picasso were rarely so perverse or obscure as the Surrealists'. Even in the *Bull's Head*, the motivating spirit had more to do with plastic invention than with archetypal poetry, just as it did in Les Demoiselles d'Avignon (Fig. 226), where there was something proto-Surreal, as well as Expressionist, about the savage fear and desire which had erupted in that volcanically experimental work of 1907. Thus, despite an involvement with automatic poetry and the always intimate relationship between his art and his psychosexual life, Picasso did not make paintings and sculpture "with the eyes closed," as Breton indicated, but rather with them wide open, to seize upon some bit of immediate reality capable of stimulating the artist's imagination-admittedly an imagination equal to any possessed by the Surrealists. Picasso moved easily among the Surrealists and often exhibited with them; inevitably, however, he, like Miró, generally stood apart from their dogmas and methods. Still, at certain dramatic moments of his career, Picasso lent a strongly personal vision credence in images of public nightmare and anguish based on Surrealist fantasy and figurative prototypes.

Picasso was perhaps the first modern artist of major stature to show elements of Dada, and later Surrealism, in his painting. We have seen that his wooden constructions and many collages done about 1913 contained deliberate visual inanities in the ironic spirit of Dada (Figs. 237, 239). During the later phases of Cubism, Picasso allowed a fantastic and grotesque character increasingly to assert itself in his art. The dualism this brought forward between a realistic figurative style and highly charged abstraction, or collage, with Dada overtones continued throughout the early 1920s. While Picasso pushed Cubism to new heights of monumental decoration, which reached its peak in 1921 with the Three Musicians (Fig. 241), he was working simultaneously in a Neoclassical style (Fig. 332). His compositions of violently distorted figures running on a beach, of sleeping peasants, and of nudes modeled after antique gods and goddesses, and his occasional meticulously realistic portraits (Fig. 333), grew more gigantic in scale. There was a flavor of Roman or Egyptian decadence in Picasso's classicism, in the colossal, nerveless torsos and stuffed and lifeless heads.

Then about 1923, just before the official announcement of Surrealism, Picasso's Neoclassical figures underwent traumatic rebirth into monstrous parodies of themselves. They endured brutal deformations of limb and gesture, and uncomfortably occupied a space that was dramatically foreshortened. By the end of the decade, Picasso had replaced the huge, stolid figures with sculpturesque, almost entirely abstract forms (Fig. 334). He painted these so that they might suggest grotesque monuments set in a natural environment against a wide blue Mediterranean sky or a stretch of sea. Although classical figuration had challenged Picasso in his virtuoso powers, it provided scant refuge from the brutal dissociations of modern life, and given the strongly autobiographical character of the Picasso oeuvre, it is not altogether irrelevant to point out that the skeletal iron maiden in *Seated Bather*, incongruously posed like one of Matisse's sumptuous nudes, came forth during a period when Picasso was suffering the miseries of a collapsed marriage. In endowing the figure with a mantis-like head, the artist must surely have been aware that the female praying mantis, who consumes her partner in the mating act, had provided the Surrealists with an image ripe in symbolic portents of sexuality and aggression. Furthermore, as William Rubin has written, "the menacing nature of the bather is intensified by her beady eyes and daggerlike nose, but above all by her vise-like vertical mouth, Picasso's personal version of a favorite Surrealist motif, the vagina dentata."²⁰

left: 332. Pablo Picasso. Three Women at the Spring. 1921. Oil on canvas, 6'8¼"×5'8½". Museum of Modern Art, New York. Gift of Mr. and Mrs. Allan D. Emil.

above: 333. Pablo Picasso. Harlequin: Portrait of the Painter Jacinto Salvado (detail). 1923. Oil on canvas, 4′3¼″×3′2¼″. Musée National d'Art et de Culture Georges Pompidou, Paris.

below: 334. Pablo Picasso. Seated Bather. 1930. Oil on canvas, 5'4½" × 4'3". Museum of Modern Art, New York. Mrs. Simon Guggenheim Fund.

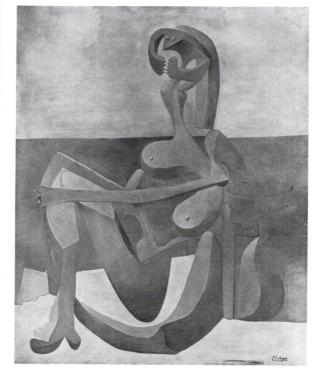

Surrealism 191

As the armature of a form in Seated Bather would suggest, Picasso had begun to think of making sculpture for the first time since 1914. Now, however, he worked neither by modeling from clay nor by assembling found objects and materials, all freighted with old meanings while producing new ones as a result of their unexpected context, but by returning to the kind of open construction, made with neutral material, that he had introduced with the Guitar in 1912 (Fig. 236). Moreover, instead of wiring or clamping his metal pieces together, Picasso would weld them, an industrial process he learned from Julio González (Figs. 405-406), a Spanish sculptor descended from a long line of smiths. The discovery of new means and materials rarely failed to release in Picasso a flood of inspired invention, and in Woman in a Garden (Fig. 335) the method of openwork welded-metal construction yielded not only one of the great, and most innovative, sculptures of the 20th century but also a work that found the artist charmed and delighted, rather than threatened, by his female subject. From the witty asymmetry of the triangular base, through a miscellaneous scaffolding of kidney shapes and bowed rectangles, to the windblown "hair" of cut metal, the form is a drawing in space that for all its openness and abstraction comes across as a solid, firmly structured feminine image, as elegant as it is amusing and as dynamic as life itself. Schematic as they are, the assembled forms provide a vivid evocation of youthful beauty exulting in the long-stemmed lushness of summer. Unlike any sculpture created before, and distinctly different from the nonobjective, architectural pieces produced by the Constructivists (Figs. 410-412, 434, 435), the figurative Woman in a Garden is a work so complete that it left Picasso without further immediate interest in the direct-metal pro-

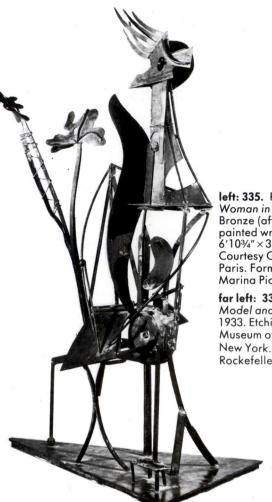

far left: 336. Pablo Picasso. Model and Surrealist Sculpture. 1933. Etching, 10½ × 75%". Museum of Modern Art, New York. Abbey Aldrich Rockefeller Fund.

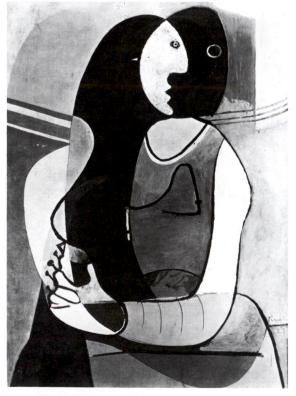

337. Pablo Picasso. Seated Woman. 1927. Oil on wood, 4'3½"×3'2¼". Museum of Modern Art, New York. James Thrall Soby Bequest.

cess, which, however, would flourish in the art of González and, after World War II, in that of David Smith and Anthony Caro.

An admission of the irreconcilable conflict of styles and divided psychic content in Picasso's protean art, and one of his most explicit Surrealist inventions, was an etching for the series "The Sculptor's Studio" (Fig. 336). Here a bemused and radiantly lovely, nude classical model contemplates a monstrous, fantastic anatomy of ambivalent sexual character, a hybrid of furniture, legs, cushion, and human limbs. The dreamlike confrontation of classical image and grotesque object places the print close to Surrealism and reminds us that late in the 1920s Picasso's art had been convulsed by Expressionist violence. *Seated Woman* (Fig. 337) is typical of the psychological tremors of his art of the period. The jigsaw arrangement of curved and angular shapes makes a brilliantly succinct design and a psychologically gripping complex of profiles, each more spectral than the last.

The culminating work to come from Picasso's preoccupation with confronted opposites may be the famous *Girl before a Mirror* (Fig. 338), a masterpiece of color and design in which the artist succeeded in momentarily resolving the conflict between the formalist and Expressionist, classical and Surreal, public and private aspects of his art. Here, in a modern revival of the ancient *vanitas*

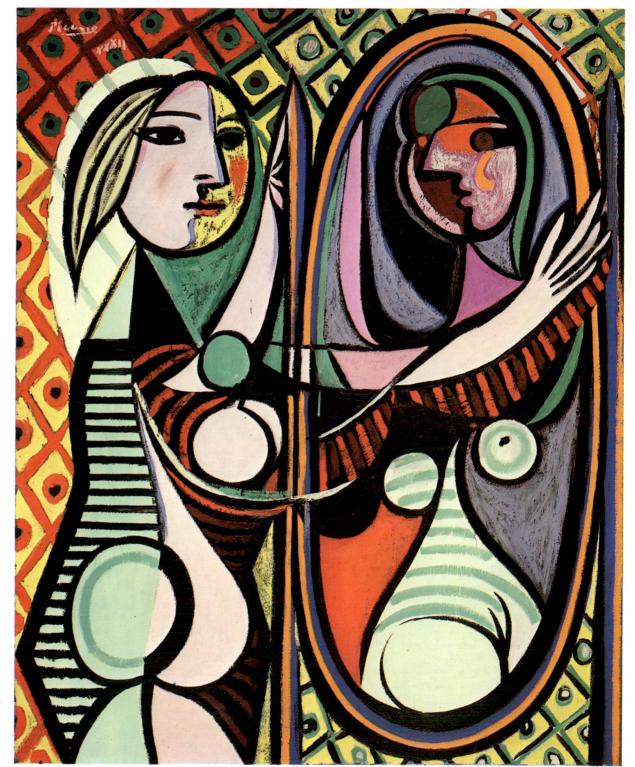

338. Pablo Picasso.
Girl before a Mirror. 1932.
Oil on canvas,
5'4" × 4'3¼".
Museum of Modern Art,
New York. Gift of
Mrs. Simon Guggenheim.

theme, Picasso has posed a golden-haired, lavender-fleshed, voluptuous young woman (a recognizable portrait of Picasso's new love, the twenty-two-year-old Marie-Thérèse Walter, albeit stylized in a late Cubist manner) in front of an oval mirror, where with apparent serenity she considers her reflection, a dark, distorted, and altogether sinister image. As if to accept the duality of her nature, or destiny, the subject stretches her arm to grasp the mirror, a linkage that finds reinforcement in the almost Byzantine richness of the patterned background, the continuously moving lines of the pervasive ovoid shapes, and the audacious colorism of the whole. After *Girl before a Mirror* entered the collection of the Museum of Modern Art in 1938, it provided a major inspiration for the American painters who would found the Abstract Expressionist movement in New York just after World War II.

Evidently encouraged by the Surrealist movement, Picasso indulged his own tendency to explore bizarre content. During the ists, in and out of the Surrealist movement, as different as Masson and Lipchitz.

The Spread of Surrealism to New York

The last notable cultural success of Surrealism occurred far from the scenes of its earlier triumphs, in New York during World War II, where Breton and most of the leading figures associated with him took refuge around 1940. Here the European artists helped sow the seeds of the American postwar movement, Abstract Expressionism. A particularly important catalyst in the adoption, by Americans, of certain critical aspects of Surrealist ideology and method was the Chilean painter Matta (Echaurren), the last young artist, along with Gorky, officially embraced by Breton as a member of the Surrealist movement. Matta (1911—) came to New York in 1939, just in advance of his more celebrated older colleagues,

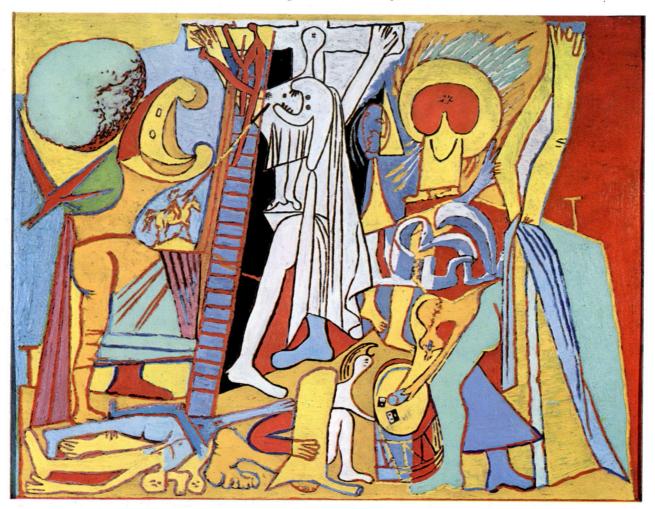

last years of the 1920s, Picasso kept his art in constant metamorphosis, producing drawings and paintings of visionary, colossal bone forms and stonelike monuments. These potent abstractions suggest themes of aggression and sexual tumult, and creatures with subhuman intelligence cast in distorted human images. The same bold distortions of the human form and elements of the grotesque make his *Crucifixion* unique and remarkable (Fig. 339). It was preceded by many drawings in which Picasso executed fantastic variations on Grünewald's great 15th-century altarpiece at Isenheim in Alsace. The agonized mood of these works, for which Picasso formulated his extraordinary visual equivalents, anticipated the invention of *Guernica* seven years later (Fig. 391). Picasso's paintings of the 1930s offered a point of reference for younger Surrealist painters, and their traumatic mythologies of pain affected older art-

Surrealism

and made contact in the early 1940s with several of the younger American abstract artists. Arshile Gorky felt his influence most directly, and in his own paintings he fused Matta's ideas on automatism, subconscious imagery, and the role of myth in art with a previous style based on Picasso's Cubism (Figs. 482, 484). For Gorky and a few other Americans, Matta's fantastic landscapes, or "inscapes" (Fig. 340), as the artist termed them, were of more interest for their morphologies than for their visual and theatrical effects, often reminiscent of the fantasies of Dali and Tanguy. Gorky also assimilated something of Matta's veiled eroticism, but he turned his own sensuality to a different account. Matta's brilliant forms, whether psychological, cosmic, or machine-oriented, were basically illusionistic and rather cinematic. The American artists who responded to Matta's painting, however, eliminated deep

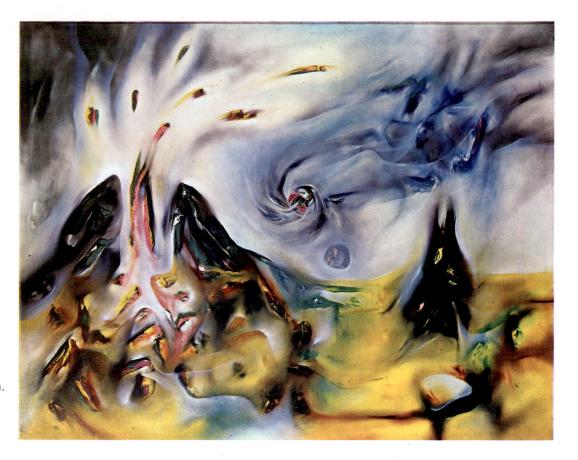

opposite: 339. Pablo Picasso. Crucifixion. 1930. Oil on wood, 1934 × 257%". Musée Picasso, Paris.

right: 340. Matta (Sebastian Antonio Matta Echaurren).

Listen to the Living. 1941. Oil on canvas, 29½ × 37¾". Museum of Modern Art, New York. Inter-American Fund.

space for an abstract, anti-illusionistic style (see Chap. 17). More important than the visual illusion for artists like Gorky, Jackson Pollock, Willem de Kooning, Hans Hofmann, Franz Kline, Adolph Gottlieb, Robert Motherwell, and others was their own compelling belief in the act of painting itself, as a primary source of content and meaning of the work of art.

Vestiges of Dada and Surrealist ideas can be discerned in subsequent artistic movements of the 1950s and 1960s: in assemblage, in Europe's so-called New Realism, and in Pop Art and Happenings, which incorporated elements of Dada to make ironic comment on a rampant and reckless consumer society. But the original inspiration has become so diffused as to merge imperceptibly into a vocabulary of international forms and pass quietly into common intellectual currency. Yet, the Dada and Surrealist vision, its compelling urge to reorient reality to the extravagant needs of the psyche and to fabricate a world more consoling than the actual, can never be extinguished entirely. The mysticism and sense of revolt have surfaced unexpectedly in the immoderate scale of Earthworks of the late sixties and early seventies, or in the hermeticism and riddles of Conceptual Art, not to mention even more current works of a new fantastic order of burgeoning Expressionism (see Chaps. 22 and 23). Here, as in the case of Duchamp, the whole point of the aesthetic idea lies in concept. Albert Camus, implying that Surrealism was inadequate either as philosophy or as a plan of action, described the movement in this way: "Absolute revolt, total insubordination, sabotage on principle, the humor and cult of the absurd—such is the nature of Surrealism, which defines itself, in its primary intent, as the incessant examination of all values."

The genius and universality of Surrealism, however, lay in its affirmations rather than its presumed negations. It was Dada and not Surrealism that engaged in provocative gesture for its own sake, and in "total insubordination, sabotage on principle," as Camus put it. Breton's Surrealism imposed a concrete philosophical system and a program upon Dada's open-ended assumptions, systematically exploring the subconscious mind in the search for a higher reality behind our common-day perceptions of objects. This search was linked to a reformist impulse and a rather muddled identification with social revolution. Breton incorporated the ideas of chance, automatism, and the irrational, which had already erupted in Dada, into orthodox Freudian and Marxist viewpoints within his own typically French and ingeniously structured theoretical principles. Apart from its intellectual substance, Surrealism also presented artists with possibilities of fantastic image elaboration, which proved, in many ways, to be an eloquent, expressive vehicle peculiarly suited to the modern psyche in a troubled historical moment as the world stood on the brink of another calamitous war.

The Shaping of a New Architecture: 1918–40

Before 1914, progressive architecture was represented by multiple, sometimes contradictory, tendencies and uncertain autonomous developments whose filiations would become clear only through subsequent events. Abruptly, after 1918, these disparate elements joined together in a common direction, if not into an exactly unanimous creative pattern. Unlike that of the preceding decades, the architectural activity of this new period may be conveniently arranged into relatively clear-cut strata; and the avant-garde minority, more aggressive than before, stood distinctly apart from the routines of the professional majority.

The sweeping reformist and revolutionary programs of this young, impetuous, postwar generation represented a vociferous indictment of recent design practices, even certain of the more progressive ones. Academic ways, which earlier had seemed malleable and fertile in the hands of Peter Behrens or Auguste Perret, suddenly appeared tainted and compromised (Figs. 146, 147, 150, 151). Architects like Ludwig Mies van der Rohe and Le Corbusier, who, before the war, had tended to modify or transform, rather than reject, academic methods of design, suddenly turned about and developed autonomous styles based on totally different assumptions and ideals. Whereas the diluted classical tradition had influenced their earliest works, their subsequent purpose was to create an architecture wholly new and unheralded, one seemingly free of traceable historic roots, incorporating ideas from fields as different as engineering and technology, on the one hand, and the arts of painting and sculpture, on the other. So profound was this upheaval that even established architects of the generation of Hendrikus Petrus Berlage (Fig. 136) and Behrens with respected, progressive prewar styles felt compelled to make drastic changes in their work after 1918.

The Appearance of the International Style

Few periods in history have witnessed the appearance of an authentic innovative style of such far-reaching consequence. For architecture, the decade of the 1920s was one of those privileged epochs. It was a turbulent, immoderate era, offering the spectacle of a new architecture locked in mortal combat with an established order capable of all sorts of devious and superficial compromises. Throughout the years between the two wars, this professionally isolated vanguard, subsequently identified as the International Style, found its rational clarity challenged by other progressive movements such as Expressionism and organic or empiric architecture and even such subversive fashions as Art Deco, or "streamline," industrial design, early examples of radical chic. Recently, most of these once-scorned rivals of the International Style, even the most parasitic, have attained a new respectability with historians and critics, not always an undeserved rehabilitation. Much as such rediscoveries may complicate, and even distort, they do not nullify the general picture of a unified, integrated, modernist tradition dating from 1918.

It is at once easy and difficult to characterize this revolutionary style, especially as it became established during the last half of the 1920s, since today, more than a half-century later, the style is a commonplace, even banal, one. Because of overfamiliarity, it is now difficult to re-create the excitement surrounding the initial appearance of the International Style, and the intense partisan feelings and virulent hostility that it originally provoked. During this period, buildings and projects of "modern design" were matters of concept and ideology, and not mere exercises in form and space. Only later, after 1930, do we encounter efforts to develop and expand the new and originally narrow formal language per se. In the 1920s, what the building represented was often what counted most. These radical designers commonly lacked opportunities to put their ideas into practice in large-scale projects. More commonly, they received commissions for small buildings, frequently houses, where demonstrative, even polemical, design may have been justified on an instructive, symbolic level, but sometimes compromised functional appropriateness in the process.

Of course, no single building can encapsulate all of the theories and forms of the period, but one house, the Villa Savoye by Le Corbusier, came forth as an archetype of advanced architectural design (Fig. 341). So complete, calm, and integrated is this weekend retreat in the outer suburbs of Paris, so utterly a concise spatial manifestation of the Cubist-inspired machine aesthetic, that it is tempting to look upon the structure as the classic realization of its time. Even more, in general histories, its generic and discrete classicism is today commonly associated with the distant, familiar classicism of Doric temples or Palladian villas. Sited in a broad, tree-lined meadow, the Villa Savoye appears from a distance as a pure, unadorned rectangular cube elevated above the landscape on remarkably thin columns. The lowest of its three stories is sharply recessed to accommodate a wraparound driveway; the second level is as much open, roofless deck as it is enclosed living space; and the deck is carried to the upper level by means of a gently inclined reverse ramp. Concrete wall surfaces are rigorously planar; many walls are transparent rather than opaque, and the possibilities of seeing through the basic structural form are many. What seems to be a regular, enclosed shape turns out, on closer examination, to be a complex of forms and volumes perpetually shifting in relation to each other as the position of the observer changes. Le Corbusier here perfected a fundamentalist architecture, at once artful and artless, which he and his contemporaries had been fashioning for a decade. The Villa Savoye may superficially suggest an ocean liner's superstructure, but otherwise it is quite independent of familiar formulas. Its planar surfaces, apparently weightless volumes, sweeping areas of glass, and asymmetrically open plans have been viewed as the hallmarks of the new architecture.

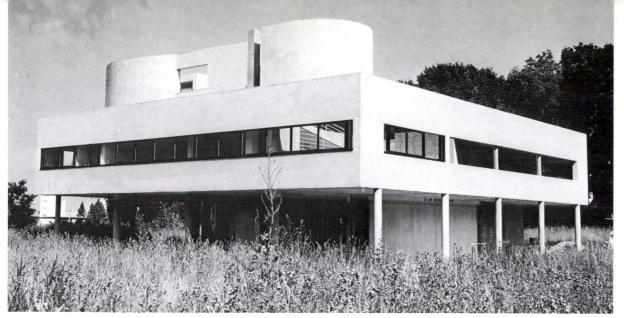

left: 341. Le Corbusier. Villa Savoye, Poissy, France. 1928–30.

below: 342. Bruno Taut. "Crystal House in the Mountains," from Alpine Architecture. 1919.

At first, the architects of Le Corbusier's generation wanted to escape from style altogether, and this quixotic goal helps explain the unanimity with which designers from such varied cultural backgrounds hit upon a simple, reductive mode-negative, yet ironically susceptible of stylization through the adjustment of proportion and the manipulation of solid and void. This fundamentalism, recognizable in the works of Le Corbusier, Walter Gropius, Ludwig Mies van der Rohe, and other major, if less well-known, figures, is not, contrary to popular belief, founded upon an overriding concern for functionalism, but, rather, with a passionate altruistic need to reject the trappings of the past, especially anything remotely resembling applied ornament. Nevertheless, there were certain style sources that these new architects consulted, creations of modern engineering and technology, such as bridges, hangars, silos, factories, ocean liners, automobiles, and airplanes. In the realm of architecture, primitive and vernacular sources were also sought out, and even examples of certain historical styles were studied although chiefly for their mathematical and proportional systems or for the nature of their placement on the site. Supplementing this novel encyclopedia of forms was the crucial influence of Cubist and abstract painting of several sorts; this is remarkable since the visual and representational arts had exerted almost no influence upon architecture for more than a century, some exception made for Art Nouveau.

The war lent special urgency to the clamor for profound change in architecture, which was coming to be viewed as an instrument that could provide the setting for a new life, one freed from those patterns and habits of the past that had led to the recent cataclysm. The proliferation of utopian designs immediately after 1918 and the feedback of this passion for universality into the design of the smallest building component were characteristic of the 1920s. After 1918, the design of ideal cities became a major concern of architects, and these large-scale aspirations were reflected in the enthusiasm with which this generation addressed the question of an altogether new style. The idealism of the new architecture ran altogether counter to the idealism of the waning academic tradition. The old order was the institutionalized heir of the Renaissance-Baroque tradition; in the 19th century, this tradition had been codified in France into the Beaux-Arts system, based upon bureaucratic state patronage and the endless elaboration of formal planning patterns. These rigid compositional values stressed permanence and continuity with the past and, quite simply, offered little or no help in solving new quantitative problems in the fields of housing, industrial construction, office buildings, and the like. All that remained useful from the academic tradition was an axial type of design which occa-

sionally might serve as the formal infrastructure of vast contemporary-scaled urban plans. In contrast, the new post-1918 idealism rejected this heritage and opted for either an implicit or an explicit Futurism.

These hopes for a new era were first manifest in the mythic, fantastic projects of Bruno Taut (1880-1938) and his followers, best seen in his Alpine Architecture (1919), a book whose contents must be compared with the remote, otherworldly communities later imagined in the novels of Hermann Hesse and Thomas Mann. By the end of the decade, in his landmark volume Modern Architecture (1929), Taut had transformed himself into a rationalist and champion of what soon became known as the International Style. As in the case of so many other German architects in the years immediately after 1918, his dreams for a new architecture attained a purely fictive realm, an idealism as remote from current circumstances as was that of the despised, rejected Beaux-Arts. In 1919 Taut asked: "Is there any architecture today? Are there any architects? ... Are not we, who are at the mercy of all-devouring society, parasites in the fabric of a society that knows no architecture. wants no architecture and therefore needs no architects! For we do not call it architecture to give a pleasant shape to a thousand useful things.... We call upon all those who believe in the future. All strong longing for the future is architecture in the making. One day there will be a world-view, and then there will also be its sign, its crystal—architecture."¹ Out of this declaration of despair Taut fashioned some of the most transcendental designs ever set to paper (Fig. 342). It was a momentary outpouring necessary to clear the way for the more mundane design tasks to come. Taut, Sant'Elia (Fig. 163), and their successors, by placing themselves in an extreme, admittedly unrealistic, pose of autonomy and summarily dismissing their architectural heritage along with many of the values of contemporary culture, founded, for the first time in centuries, a new style.

At an early date, the overriding importance of three figures — Le Corbusier, Gropius, and Mies van der Rohe—in the evolution of the new architecture was recognized; and today, after their passing from the scene and after much research that has justly rehabilitated the reputations of numerous forgotten, overlooked contemporaries, there is nothing in the record that would substantially negate their earlier reputations, even though it is now recognized that each man was, in various specific instances, stimulated or influenced by the contributions of lesser-known peers. These three architects began their practices before World War I and, in varying degrees, were radically transformed by that experience.

Le Corbusier (1887–1965) came from an arts and crafts background and subsequently, as we have seen (Fig. 254), participated in the evolution of the post-Cubist style known as Purism. Walter Gropius (1883–1969) was the organizer of a remarkable institution, the Bauhaus (1919-33), a fusion of an arts and crafts school and a conventional art academy, first in Weimar and after 1925 in Dessau. Gropius's appointment had been encouraged by the former director of the arts and crafts school, Henry van de Velde, once a pioneer of Art Nouveau (Figs. 75, 76) and eventually the designer of a proto-Expressionist theater at the 1914 Cologne Werkbund exhibition. As director, Gropius was responsible for the inclusion on the Bauhaus faculty of such major artists as Kandinsky, Klee, and Moholy-Nagy (Figs. 202-204, 428, 433, 434). Soon the school produced such students as the architect Marcel Breuer and the painter Josef Albers' (Figs. 431, 432), each of whom later taught there. After 1933, these masters, Gropius included, dispersed to Zurich, Paris, London, and, in the United States, Cambridge, Chicago, and New Haven. As teachers at Harvard, Gropius and Breuer guided the professional education of the American architects Philip Johnson and Paul Rudolph. The more taciturn Ludwig Mies van der Rohe (1886-1969) was, during the 1920s, a vice-president of the Deutscher Werkbund, an influential organization dating from the prewar period, and the organizer of an important international exhibition of contemporary housing, the Weissenhof project, at Stuttgart in 1927 (with buildings executed by himself, Gropius, Le Corbusier, and other architects from the Netherlands, Belgium, France, Germany,

and Austria). After 1930, during the troubled political period preceding the Nazi assumption of power, Mies served as director of the Bauhaus and, several years after its closing, joined his fellow architects in exile, becoming chairman of architecture at the Illnois Institute of Technology in Chicago (then known as the Armour Institute). There he refined, perfected, and classicized his laconic style (Figs. 634, 636), establishing by 1950 a mode of skyscraper design that would become the norm for architecture worldwide for decades to come, a mode that also seemed to relate historically to the pattern of Chicago designs of the 1890s by Sullivan and his contemporaries.

The factory at Alfeld (Fig. 343), by Gropius and his partner Adolf Meyer (1881–1929), has been cited as perhaps the most advanced building in Europe of its date by virtue of its continuous three-story glass wall and, particularly, by the way it is joined together at one of its angles without a structural column at the corner. This effect of transparency is created by the cantilevering of the concrete floor slabs of the interior, which can just be detected through the glass from the outside. To twist a phrase, this compositional principle of transparency, with its implication of weightlessness where the eye would expect a more conventional opaque supportive material for the wall, is the cornerstone of the new architecture. It is significant that the architect *later* acknowledged the importance of these characteristics, but it will probably always be a moot point as to how aware he was of the significance of this phenomenon at the moment of design.

In any event, Gropius and Meyer, in their next major work, the Model Factory at the Cologne Werkbund exhibition, developed this architecture of transparency in a more deliberately formalist way. The layout is curiously academic: an office wing with central entry leading to a courtyard, giving excuse for a second formal façade, and, finally, a machine hall on axis on the opposite side of the court. The façades are, in their outlines, adaptations of a composition by Frank Lloyd Wright of 1909 that had been published along with many others in the form of elegant, simplified drawings by Ernst Wasmuth in Berlin in the year 1910. Actually, this publication and a smaller companion volume of photographs of Wright's buildings were much studied and emulated by the new generation of European designers. Gropius and Meyer transformed the Wrightian formula into something radically different through the extensive use of glass on the court façades and the "wraparound" corner spiral stairs, with its Futuristic implications of movement. However, it is the pervasive transparency and the hovering,

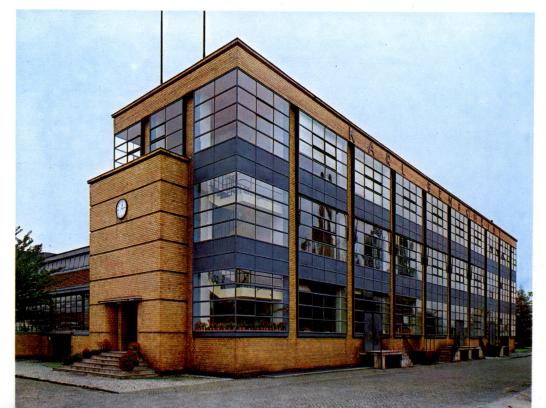

left: 343. Walter Gropius and Adolf Meyer. Fagus Shoe Factory, Alfeld-an-der-Leine. 1911–16.

opposite: 344. Le Corbusier. Schwob House, La Chaux-de-Fonds. 1916. Photograph courtesy Museum of Modern Art, New York.

weightless, floating form of the court façade's glass wall, which runs unbroken around each end of the building and provides a revealing, see-through effect, that create the unique sensation. The building is no longer bounded at its angles by emphatic structural verticals, no longer confined by opaque walls into which windows intrude. Here the tables are turned, and glass appears to be the ambiguous "enclosing" surface (of course, visually, it is not exactly an enclosure), and the brick piers and planes seem to be the intruders. There are suggestions of a space infinitely extendable beyond the glass-enclosed volume—qualities that have been much discussed but little exploited in subsequent modernism, perhaps because their implications seem to lead to a renunciation of architecture itself, so long as architecture remains a matter of structure, volume, and space.

If, from the foregoing analysis, it would seem that Gropius and Meyer had forged ahead into a new constructive aesthetic by 1914, they nonetheless relied upon a formalist academic composition, which substantially mutes their achievement, placing it squarely in the prewar period of contradictory tendencies. Much is likewise true of the Schwob House (Fig. 344), built in 1916 at La Chaux-de-Fonds, Switzerland, by Le Corbusier, then still known as Charles-Édouard Jeanneret. This villa, framed in reinforced concrete, climaxes a decade of work in domestic architecture by a young man who had spent much of his time traveling through Europe in search of ancient and contemporary architecture-venturing from Istanbul, Athens, Rome, and Pisa to Vienna, Berlin, and Paris. His education was a self-administered Grand Tour suggestive of the practice of 18th-century English gentlemen, but also in the spirit of contemporary postgraduate traveling fellowships awarded to architectural students. In any case, it was a cosmopolitan education that provided a curious alternative to the customary French academic one: five years as a prize-winning laureate in Rome following the successful completion of a long series of competitions at the École des Beaux-Arts in Paris.

The Schwob House was the only one of his pre-1918 houses that Le Corbusier himself published in his own works. Significantly, he went out of his way to ignore, if not exactly suppress, his juvenilia, preferring to give the idea that his work had sprung spontaneously and parthenogenetically from a fresh, chaste reconsideration of architectural problems around 1918 rather than from firsthand experience in the building of private dwellings. Not surprisingly, this house is ambivalent, in keeping with its period, stylistically a restatement of themes adapted from Hoffmann, Behrens, and Perret. Conceptually it is something else: a foretaste of ideas that will be fulfilled in his work later. The flat roof is more than a device; it is a matter of theory—a terrace for activities that otherwise might be conducted on the ground. But it is also, arrogantly, a matter of Le Corbusier's subjective taste, since he wrote that he was repelled by the sight of pitched or hipped roofs, feeling that they destroyed the geometry of the rest of the house. The twostory, studio-like living space with balcony and with a full glass wall at one end is another key feature of doctrinaire Corbusian significance. It is at the heart of his conception of the ideal dwelling form, individual or collective, from the 1920s to the end of his creative life. These features are as fundamental to Le Corbusier's unique design orthodoxy as are the column, capital, and entablature to the Greek Doric.

In 1918, Le Corbusier turned his energies to paintingrefining and perfecting his sense of form-and collaborating with Amédée Ozenfant (Fig. 427) on a book, After Cubism, which laid the basis for the Purist aesthetic. In Vers Une Architecture (1923), he proposed a series of models for contemporary architects, images for "eyes which do not see," such as industrial buildings, automobiles, pipes, the Greek temples, and, on a somewhat tentative note, the works of ancient Rome and of Michelangelo. This repertory has since become a sacred spring for aspiring modernist architects. These heterogeneous elements are unified by the practical efficiency of their design together with the exacting geometric clarity of their form, which, through convention and familiarity, is made to seem logically inevitable. The Parthenon is interpreted with a lyric enthusiasm that seems appropriate to a paean for a machine, and it is proposed that the formal history of the automobile might be expounded in terms analogous to the evolution and refinement of the Doric temple. It was in the pages of this volume that the notion of the house as a machine for living was first declaimed, a contentious proverb that has been fought over more than any other in the history of modernism.

Expressionism in Architecture

However, complementing the Purist aesthetic of Le Corbusier were other adventurous strands that found outlets shortly after 1918. Expressionism is a sufficiently difficult concept in the history of painting, but its application in architecture is even more problematic; moreover, architectural Expressionism is largely independent of that movement in the representational arts. The projects of Bruno Taut have already been mentioned as instances of an idealistic architecture striving toward a mythic, even mystic, state. His building at the 1914 Cologne Werkbund exhibition, the pointed domical Glass House (Fig. 345), was already a symbolist manifesto, in contrast to the rational exploitation of clear glass in the Gropius and Meyer Model Factory. Employing colored glass and Luxfer prisms, a type of glass brick, Taut created a phantasmagoria of light on the twolevel interior, a sanctuary of luminous space and translucent surfaces that no black-and-white photograph can possibly hint at. Bruno Taut was at the center of the Expressionist maelstrom in Germany, which included a group of architects calling themselves the "Glass Chain," whose members assumed such symbolic names as "Glass," "Mass," "Beginning," or "Prometheus" and believed that an "architecture of glass" would create the atmosphere for a new culture. The participants included Gropius, Taut and his brother Max, Hans Scharoun, and the Luckhardt brothers. Mies, although he had participated in some exhibitions, was conspicuous by his absence from this group. Nonetheless, he designed two Expressionist-influenced glass skyscraper projects that have become two of the most important incunabula of the modern movement. Understandably, the forms imagined by Taut and his circle found no realization in actual building, nor were they meant to. Utopian architecture has a demonstrably polemic function in which the chimerical and even the preposterous find a proper place. This was, indeed, the most important function of Expressionism in the midst of a nascent modern architecture.

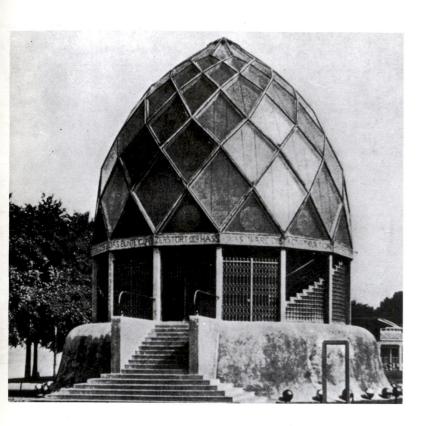

One of the most remarkable Expressionist works was the Grosses Schauspielhaus in Berlin (Fig. 346), designed by Hans Poelzig (1869-1936) in collaboration with the theater director Max Reinhardt. Its auditorium was a stage-set-like fantasy of a stalactiteencrusted dome, with intriguingly concealed sources of light, built inside the vast space of an old riding hall. Equally notable is the Goetheanum at Dornach, Switzerland (Fig. 347), the design of the philosopher and mystic Rudolph Steiner (1861-1925). The first building, a vast double-domed affair in wood that was begun in 1913, burned to the ground in 1923 and was replaced by an even more extravagantly massed concrete building completed in 1928. The first Goetheanum seems to have been a distant cousin of the architecture of Otto Wagner and the Viennese Secession. In contrast, the second building seen here is a more extravagantly sculpted work rivaling Gaudí, so unusual in shape as to defy description in familiar architectural terms. As a temple to a secular religion it seems to be the one challenging realization of the notion of the Cathedral of the Future referred to in Expressionist literature, though its dense, molded forms bear no relationship to the linear, skeletal, luminous interiors of the Gothic era, and its opacity is a world removed from most Expressionist projects.

Probably the best known Expressionist building is by Erich Mendelsohn (1887–1953), the Einstein Tower (Fig. 348) for the Astrophysical Institute at Potsdam, near Berlin. Its svelte, undulating forms, a kind of baroque abstraction, are suggestive of Gaudí (Figs. 139, 140). It was designed to be executed in concrete, but for practical reasons the shape of the tower was built up in masonry and then covered in stucco. This was a common, if not very candid,

above left: 345. Bruno Taut. Glass House, Werkbund Exhibition, Cologne. 1914. above right: 346. Hans Poelzig. Grosses Schauspielhaus (Great Theater), Berlin. 1919. center right: 347. Rudolph Steiner. Goetheanum II, Dornach, Switzerland. 1925–28.

below right: 348. Erich Mendelsohn. Einstein Tower, Potsdam. 1920–21.

The Shaping of a New Architecture: 1918–40 **200**

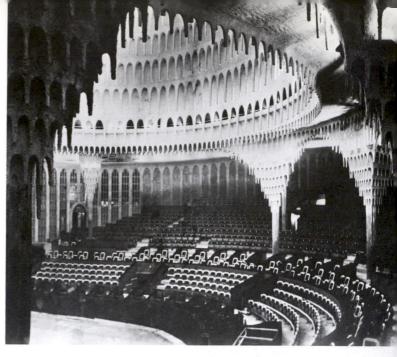

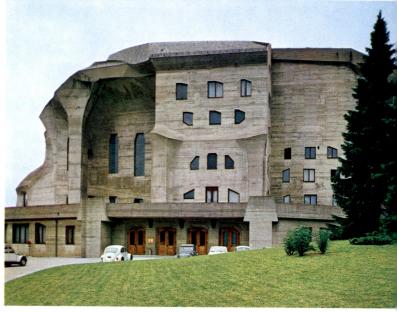

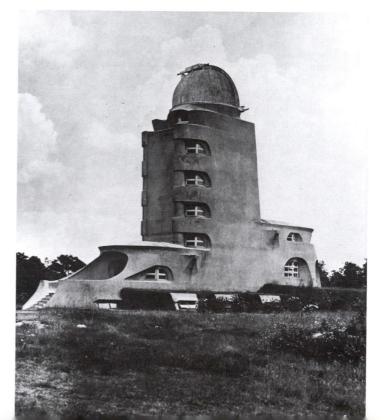

right: 349. Hans Scharoun. Berlin Philharmonic. Interior. 1956–63. below: 350. Piet Kramer. Dageraad Housing, Amsterdam. 1918–22.

procedure at a time when concrete was being held up in many quarters as an ideal building material for the new architecture; yet this counterfeiting of effect seems foreign to the high moral tone of the period. Mendelsohn's Einstein Tower was based upon sketches similar to a series of imaginary studies that the architect had done during his military service: small drawings of vast edifices, some proposed as hangars or cinema studios, others simply titled "Toccata and Fugue." Although, like Sant'Elia's Futurist projects (Fig. 163), Mendelsohn's drawings seem to have been developed from the late works of Otto Wagner (Figs. 132, 134), they have a distinctive personal quality of rounded contours that contrasts with the angularity characteristic of the work of the Italian designer. Unlike most other Expressionists, Mendelsohn went on to a varied international career. Leaving Germany in 1933, he worked in England, Israel, and the United States, settling in the San Francisco Bay area just before his death. Never a member of Taut's Expressionist circle, he became more typically international in his work during the late 1920s. Most of his stores and offices of this period in Germany, his best works, have vanished, and he is now remembered for several synagogues built in the United States in the 1940s and 1950s, designs in which he sought to revive the rhetorical forms of his youth, but, alas, did so with indifferent success.

Of the other, younger men who adhered to the Glass Chain, Hans Scharoun (1893–1972) should be singled out. His early projects were typical of the movement, although in 1927 he built a house for the Weissenhof project under the aegis of Mies that is scarcely representative of his early allegiance. He remained in Germany, without work, during the Nazi era, and his major building, the Berlin Philharmonic (Fig. 349), is one of the most dramatic realizations of Expressionist ideals, even if, historically, it is an anachronism by virtue of its mid-century date. By then, historians of the contemporary movement who had ignored, or sidestepped consideration of, the romantic, irrational strain in modern architecture were ready to accept and even welcome Scharoun's work, which, ironically, shares its site with Mies's temple-like glass and steel National

Gallery (Fig. 634), the monumental culmination of his stern architectural vision.

Expressionism was largely, but not exclusively, a German phenomenon. In the Netherlands, a group of architects known as the Amsterdam School were especially active in the field of public housing in the years before, during, and after the war. Taking their cues from the local brick architecture of Berlage, Michael de Klerk and Piet Kramer (1881-1961) designed such groups of flats as de Klerk's Eigen Haard, and Kramer's Dageraad (Fig. 350), which stand out from the miles of uniform brick façades thrown up in the new residential quarters of Amsterdam. Taking off from the 19thcentury neomedieval rationalism of Berlage, the younger architects expanded the mode into something bordering on fantasy. De Klerk's work is characterized by turrets, casement windows, chimney pots, and spires that are freely borrowed from the Middle Ages, but not in the rational spirit of an earlier day. An octagonal spire rising above the pitched roofs of the Eigen Haard flats is stark yet vaguely Gaudíesque, an ecclesiastical image in a domestic context, a quality that is likewise present in the curving frontispiece of Kramer's Dageraad.

De Stijl in Architecture

If the Amsterdam architects found ways to update aspects of prewar modernism in their work, the handful of architects adhering at one moment or another to the organization of painters and sculptors known as De Stijl represented a more radical departure, closely linked with new developments in abstract painting that were largely the work of Piet Mondrian and Theo van Doesburg (Figs. 272-277). In architecture, the major figures were Jacobus Johannes Pieter Oud (1890-1963), builder of a number of housing projects in the 1920s (Fig. 351), and Gerrit Rietveld (1888-1964), who began as one of the most original furnituremakers of the century and went on to design the most remarkable structure of the movement, the Schroeder House at Utrecht (Fig. 352). Oud had been associated with van Doesburg since 1917, the year of the movement's founding, and in 1919 he produced two sketch projects for a small factory. One of these has been widely reproduced and also frequently cited as conclusive evidence of the fruitful coming together of the Wrightian strain of

above: 351. J. J. P. Oud. Workers' Housing Estate, Hook of Holland. 1924–27. right: 352. Gerrit Rietveld. Schroeder House, Utrecht. 1925 (demolished).

American modernism (the horizontal extension of forms and the dynamically balanced asymmetry of various parts) with the language of contemporary post-Cubist, abstract painting (the interlocking mesh of horizontal and vertical elements), a style dubbed Neo-Plasticism by Mondrian.

The nature of this mode, the precision in the use of various materials-some cheap and hard to maintain-the incisive contours separating part from part, together with the appearance of efficiency through repetition of elements, standardization of parts, and the absence of ornamentation, grew out of specific theoretical commitments combined with a loyalty to a compositional technique shared with painters and sculptors. This was a formal language developed as one of the first nonrepresentational styles in modern art. In the history of painting, the key figure was the solitary Mondrian; but for architects and designers the key painter was the energetic, gregarious van Doesburg (Fig. 353). He was briefly the collaborator of the architects Cornelis van Eesteren and Rietveld in several projects of 1923, visionary schemes that had widespread influence upon actual buildings, then and subsequently. Had it not been for this intimate collaboration, one could doubt that Rietveld's Schroeder House would have emerged as so encyclopedic a demonstration of the

movement's aims and potential in architecture. Had it not been for Oud's even earlier collaboration with van Doesburg, it is doubtful that his remarkable, poster-like façade for the restaurant-café De Unie, Rotterdam, would have possessed so graphic a stylistic imprint.

De Stijl produced numerous pronouncements and manifestoes to explain its universal goals. In 1922 Mondrian wrote on architectural problems: "Building and decoration as practiced today are compromises between 'function' on the one hand and the 'aesthetic idea' or 'plastic' on the other ... the two will have to be combined. Use and beauty purify each other in architecture... Function or purpose modifies architectural beauty."² This effort to fuse art with life, imagination with reality, was phrased another way by van Doesburg and van Eesteren in 1923:

Art and life are no longer separate domains.... The word 'art' no longer means anything to us.... We demand the construction of our environment according to creative laws derived from a fixed principle ... linked with those of economics, mathematics, technology, hygiene.³

These principles would include the creation of a balanced unity out of spatial contrasts and dissonances, the creation of a new dimen-

The Shaping of a New Architecture: 1918–40

353. Theo van Doesburg. Color Study for a Building. 1922. Collection Mrs. N. van Doesburg, Meudon, France.

sion in space and time through the use of color, the creation of a final unity from the relating of dimension, proportion, space, time, and material, and the elimination of the interior-exterior duality through the breakup of enclosing walls.

There is, of course, a certain amount of pretentious cant in these lines by van Doesburg, but they provide a firsthand statement of the visionary and practical intentions fundamental to the creation of Rietveld's Schroeder House. His earlier furniture designs give more than a hint of the "assembled" look of the dwelling's exterior, with its projecting slabs on several planes setting in motion an otherwise static cube. Nonetheless, the crucial sources for the building are the imaginary architectural projects of van Doesburg and van Eesteren of 1923, multilayered, multiplaned, asymmetrically fused assemblages of rectangular cubes-their surfaces alternately voids, whites, grays, blacks, yellows, blues, and reds. These projects and models, along with Rietveld's seminal masterpiece, are thoughtful projections into three dimensions of the carefully considered, stabilized imbalances of Mondrian's paintings of the 1920s (and of many of van Doesburg's as well) so that, in entering the living space of the Schroeder House, one has the sense of literally stepping into the pictorial world of Mondrian. It is a sensation that Mondrian would certainly have approved, to judge by photos of his Spartan studios in Paris and, subsequently, New York.

Compared to this artful, extravagant design, crammed with surprises and conceits and featuring such up-to-date contrivances as folding interior walls, thus rendering the space adjustable at the will of the occupant, the contemporary row houses of Oud, equally exemplary of De Stijl ideals, seem stark, uncontrived, and minimal. Such designs as the Kiefhoek, Rotterdam, imply an ideal life-style, a sparse, Spartan materialism that is reflected not only in the privation apparent in Mondrian's studios but in the frugal dwelling ideals of Le Corbusier. This mode is, of course, a reaction to the crammed bourgeois interiors of the late 19th century, but it also represents an imposition of a kind of stark Bohemian existence upon ordinary inhabitants, plain unadorned surroundings that were often the artist's lot not through choice but through deprivation. As will be seen later, this character, implicit in much housing of the 1920s, becomes an explicit subject, literally "represented" in Le Corbusier's houses of the period, where time and time again he uses the two-story space of the artist's studio as a crucial functional and compositional element.

The contribution of the Netherlands to the emerging International Style has sometimes been associated with the carefully arranged paintings of interior scenes of such 17th-century Dutch artists as Vermeer and Ter Borch, domestic spaces where doors and windows leading to other interiors, or opening out to the town and sky, imply spatial relationships that are characteristic of the new architecture. Strained as this analogy is, it does accord with the placid harmony of much Netherland architecture of our day.

The International Style in the Soviet Union

Nothing could be more of a contrast with the equally original, equally International radical buildings of Russia in the same epoch, an architecture which was programmatically and socially revolutionary, at least for a brief period before the Stalinist reaction. However, the creative flow begun in the Soviet Union during the 1920s was abruptly shut off as part of the purge and the Socialist Realist academic reaction of the 1930s. Thus, it is difficult to single out major figures, since individual careers had too brief a span for development. Some of the earliest Soviet projects are chimerical, but in a more rationally propagandistic way than the work of the Berlin Expressionists. Little was actually built because of economic difficulties, and that little often was constructed in a haphazard, unsatisfactory way. Vladimir Tatlin's tower, the Monument to the Third International (Fig. 354), is an extravagant scheme comparable to the imaginary architecture of Sant'Elia and Taut and, also, lest it pass wholly into the realm of the fanciful, to the Eiffel Tower, that singular work of engineering vision which somehow, in the most prosaic and conservative of times, was actually erected. Tatlin's project, though never realized, was carried as far as a large-scale model. Unlike Eiffel's tower, Tatlin's was intended to contain three revolving architectural volumes of glass-in the shape of a cube, a pyramid, and a cylinder-spaces housing the various functions of the Communist International. They were to revolve at different speeds-year, month, and day-possibly to reflect the frequency of meeting of the various agencies. The 1,300-foot-high spiral frame, representing the advance of humanity, was an expressive, abstract warping of the contours of the Eiffel Tower, and one cannot help wondering if Tatlin had not been inspired for his "invention" by Robert Delaunay's numerous Cubist alterations of its structure.

Tatlin's extravaganza is representative both of the utopian urges of the post-armistice period elsewhere and of the distinctive role that architecture was to play in the new Soviet state. Other achievements of Russian architecture in the 1920s include the development of new programs and plans for housing, featuring the

inclusion of a number of collective services within blocks of flats such as canteens, implying a broad reorganization of urban family life and social relationships-transformations that never came about on a large scale. However, some of these concepts were later adapted by Le Corbusier and incorporated in his schemes for large collective dwellings in the West, with predictably meager social results even though designed with consummate panache-one of the finer ironies of contemporary architecture! Of the Russian architects, Alexander, Leonid, and Victor Vesnin were among the most prominent with their project of 1923 for the Palace of Labor, Moscow (Fig. 355), which would seem to have provided a more functional, though less monumental, resolution to the program of Tatlin's tower. Quirkier is their Pravda project of the same year, a miniskyscraper of varied rectangular shapes, its twin elevators manifestly visible (shades of Sant'Elia), and banner-headline lettering the principal decorative feature.

By 1925 the new Russian architects were ready to demonstrate their achievements abroad in the Paris Exposition des Arts Décoratifs, where Le Corbusier would also be an exhibitor and, stylistically, an equally alien one. Konstantin Melnikov was the architect of the Soviet Pavilion, a small wood building with large glazed areas and a diagonal roof structure echoing the diagonal path of the stair cutting through the partly open structure. In addition to constructing for himself, in 1929, one of the rare private dwellings of the time in Russia, a unique double-circle plan with a large studio window and numerous smaller hexagonal ones, Melnikov participated in the design of workers' clubs, the so-called social condensers in the often immoderate party language of the period. The most remarkable of these was the Club Rusakov in Moscow, notable for its exterior volumes, slanted, projecting shapes that contained the three separate balcony areas of the theater interior,

left: 354. Vladimir Tatlin. Model for Monument to the Third International, 1919–20. Original model destroyed; reconstruction, 1968. Wood and metal with motor, 15'5" high. Moderna Museet, Stockholm.

top: 355. Alexander, Leonid, and Victor Vesnin. Project for the Palace of Labor, Moscow, 1923.

above: 356. Ilya Golosov. Professional Workers' Club, Lesney Street, Moscow, 1926. the division accounting for the fact that it could be divided into three spaces or opened into one—a preoccupation with the possibilities of transformable spaces that we have already seen in the living area of Rietveld's Schroeder House. Of the other clubs, the Professional Workers' Club on Moscow's Lesney Street (Fig. 356) by Ilya Golosov (1883–1945), is notable for its dramatic contrast of glass cylinder with concrete slabs and rectangles, although its exterior is not so startlingly revealing of its interior as is Melnikov's.

El Lissitzky enjoyed a special, international prominence in Russian architecture during this period when, visiting Germany in the 1920s, he came in contact with De Stijl and the Bauhaus, encountered Moholy-Nagy and Mies van der Rohe, founded groups and magazines, and spread Russian Constructivism through all these connections (Fig. 430). He was the designer of several important projects, including the Skyhook towers, a 1924 project for novel skyscrapers-done in collaboration with Mart Stam-in which tall elevator shafts supported large volumes of working space above the skyline of the city, thus necessitating only a minimum of demolition to insert these mammoth new buildings into the existing urban fabric. Mention should also be made of the architectonics of the abstract painter and sculptor Kasimir Malevich, founder of Suprematism (Figs. 266, 267), fantasies whose forms suggest the distinctive geometric massing of American ziggurat, or setback, towers of the 1920s. If Soviet design was given to a certain extravagance, surely in part a by-product of the economic and bureaucratic difficulties encountered in actual construction, much of it was aimed at re-equipping Russian society for its leap into the industrial age. While Russians like Lissitzky traveled abroad to spread ideas, foreigners came to Russia to engage in actual building. From the Bauhaus came Hannes Meyer, Gropius's successor as director (not to be confused with his partner, Adolf Meyer), and from the Netherlands and the fringes of De Stijl came Mart Stam, who had participated in the Stuttgart Weissenhof project in 1927.

But of all the European architects who traveled to Russia, the most successful was Le Corbusier. In 1929 he was commissioned to build the Moscow headquarters of the organization of cooperatives, the Tsentrosoyuz, a spectacular glass-walled composition of three interconnected slabs, crystalline forms raised on *pilotis*, or stilts, much as he was doing in the contemporary Villa Savoye. This was the architect's largest work actually built before World War II and preceded an invitation to participate in the competition for the design of the Palace of the Soviets (Fig. 357), a program that must have evoked memories of Tatlin's tower in the minds of many. It certainly did in the case of Le Corbusier, as his vast project, with the volume of the large auditorium suspended from a colossal parabolic arch, is clearly of the same techno-expressive, Constructivist genre as the earlier monument. There were other solid, contemporary-style projects by Gropius and Mendelsohn, but these were somewhat conventionally ponderous, if otherwise modern. Le Corbusier's extraordinary scheme was certainly the most daring, far-reaching effort by a proponent of the new architecture in the realm of symbolic, public governmental buildings. Programmatically it was the 20th-century equivalent of the 19th-century Neo-Gothic London Houses of Parliament or the Neoclassical Washington Capitol. Yet the forms of Le Corbusier's Palace of the Soviets grew out of an already-rich modernist tradition, its infrastructure drawn from Tatlin's scheme and the Constructivist sculpture of Naum Gabo. The architectural details came from the vocabularies of Purism, the Bauhaus, factory architecture, and experimental theater and exhibition design. Long recognized by critics and historians, but still only incompletely appreciated, Le Corbusier's unsuccessful project for this competition possesses historical importance equal to Bramante's unrealized central plan for St. Peter's. It draws together innumerable facets of a new style, then just reaching its full potential, into an ideal scheme that unfortunately exceeded political, if not architectural, realities-a crucial event for just that reason, since it probed and extended the frontiers of creative possibility.

The winning entry in the 1931 Palace of Soviets competition was not one of the several by leaders of the modern movement, Russian or otherwise, but a wedding-cake project by Yofan, Gelfreikh, and Shchuko that signaled the onset of the architectural reaction of the 1930s, a movement of international scope, represented in Nazi Germany by the neoclassicism of Troost and Speer; in Italy by Mussolini's Third Rome, the architecture of Piacentini and the ill-starred EUR; in Geneva by the League of Nations Palace, constructed by an international committee of academicians following the intrigues that had discarded Le Corbusier's project; and, in the United States, by the banal classicism of New Deal Washington, culminating in the Pentagon. It is an immeasurable catastrophe that the new architecture was checkmated at the very moment that broad public success seemed near at hand. Never before in history had the majority of political institutions been so inflexibly massed against the creative talents of the architectural profession, an art and a science that even the most repressive regimes had used effectively in times gone by.

The academic and Socialist Realist aspects of the Yofan-Gelfreikh-Shchuko project for the Palace of the Soviets, itself unexecuted because of other priorities in the Soviet state, brought together just about all the current platitudes imaginable: the Eiffel Tower

357. Le Corbusier and Pierre Jeanneret. Project for the Palace of the Soviets. 1931. Model. Collection Museum of Modern Art, New York.

and the Empire State Building were to be exceeded in height; the statue of Lenin seems as colossal as the Franco-American Statue of Liberty; and the terraced, layered design seems more inspired by the set-back profiles and proportions of large-scale "modernist" skyscrapers in the capitalist United States than by the ambitious socialist dreams of earlier Russian Constructivism or the crisp, energetic silhouettes of the International Style, now denounced in the Union of Soviet Socialist Republics as formalist and individualistic.

Baubaus Architecture

German modernism suffered a similar fate in the early 1930s when the best architects were driven into exile, where they sowed the seeds of a postwar revival. However, for a brief period, Gropius's Bauhaus in Dessau (Fig. 358) served as the Sainte Chapelle of modern building, providing in its educational plant a paragon of modern design and offering in its curriculum the ultimate model for the postacademic "academy." Though sadly mutilated after its closing, the buildings of the Bauhaus, a multiwinged block consisting of offices, classrooms, workshops, and dormitories, with each interconnected pavilion distinct in shape and the whole organized like the blades of a windmill about an imaginary hub, formed a key part of modernism's classical canon. It would seem that Gropius had here simply picked up the thread of the new architecture, epecially the glazed, transparent mode that he and Meyer had developed before the war in their factories at Alfeld and Cologne. In reality, the path leading to this rational, even functionally stark, Bauhaus "style" (an application of the term which its members would have found repugnant, since their goals were beyond any single style) was much more complicated.

In 1918 Gropius was a member of various action groups in Berlin, and, although no fanciful, utopian projects from his pen are known, he was an articulate pamphleteer. "Artists," he wrote, "let us at last break down the walls erected by our deforming academic training between the 'arts' *and all of us will become builders again!* Let us together will, think out, create the new idea of architecture."⁴ These lines were written just as Gropius was preparing to take over the Weimar Bauhaus, whose ideals were originally conceived in a spirit of stylistic independence but, nonetheless, within the emotional and aesthetic climate of Expressionism.

The ultimate aim of all visual arts is the complete building! ... Today the arts exist in isolation, from which they can be rescued only through the conscious, co-operative effort of all craftsmen.... The old schools of art were unable to produce this unity.... They must be merged once more with the workshop.... Architects, sculptors, painters, we must all return to the crafts! For art is not a 'profession.' There is no essential difference between the artist and the craftsman.⁵

The very name Bauhaus, deliberately chosen by Gropius to identify the uniqueness of his new school—a union between an academy and a craft school—resembles the German word for the medieval cathedral master-mason's lodge, the *bauhütte*.

Gropius's change during the next few years is explained by his encounters with other masters of the modern movement and the development of an encyclopedic awareness of the new rational style. During his travels, Gropius met van Doesburg, who settled briefly in Weimar in 1922, causing some dissension among faculty and students but apparently influencing a stylistic shift there, the source and importance of which have long been a matter of debate. The Dessau buildings of 1925–26 can be analyzed either as a nonacademic evolution by Gropius and Meyer from their prewar factories, which preserved traces of Behrens-like classicism in the midst of a progressive, innovative use of glass, or as constructive adaptation of the asymmetrical cubic assemblies of van Doesburg and his Dutch associates. In fact, both inspirations would seem germane. In Gropius's statement "Principles of Bauhaus Production" (1926), new concepts supplement the earlier ideals, concepts that nicely match the commitment to an architecture of glass, concrete, and right angles:

The Bauhaus wants to serve in the development of present-day housing from the simplest household appliances to the finished dwelling.... Modern man, who no longer dresses in historical garments but wears modern clothes, also needs a modern home.... An object is defined by its nature. In order, then, to design it to function correctly ... one must first of all study its nature ... it must fulfill its function usefully.⁶

Moreover, he goes on to call for a "resolute affirmation of the living environment of machines and vehicles . . . the limitation to characteristic, primary forms and colours," and asserts, "The creation of standard types for all practical commodities of everyday use is a social necessity." Clearly Gropius has been affected here by De Stijl, by a rethinking of Futurism, and by the hortatory writings of Le Corbusier, where, among other things, an enthusiasm for the machine, for the painstaking analysis of all objects, however humble, and for standardized elements, is crucial. Gropius's style and ideas became purified by the mid-1920s, but, ironically, this seems to have been accomplished by an eclectic receptivity to the works of his contemporaries. So, the Bauhaus, cited above as the Sainte Chapelle of the new architecture, was also, to coin a Bolshevism, an "artistic condenser," an artist's union where many threads came together. Interestingly, if architecture was considered there to be a kind of ultimate art, it was not at first a formal part of the program, Gropius having postponed its creation until after the first generation of students had been formed in its unique ateliers, where two masters held forth simultaneously, one a formgiver, like Klee or Kandinsky, the other the master of the particular craft in question.

In 1928 Gropius resigned as director, turning the post over to Hannes Meyer, to devote himself to his architectural practice. His unsuccessful project, with Adolf Meyer, for the Chicago Tribune Tower (Fig. 359), the first international competition of the decade that would presage the relentless determination of those hostile forces ranged against the new architecture, marked his abandonment of any lingering Expressionism. After the construction of the Bauhaus, Gropius's most revealing work occurred in the flats at Siemensstadt in Berlin, whose extensive horizontal four-story façades are typical of the high level of collective housing of this epoch in the German capital, work by architects such as Taut, Scharoun, and Hugo Haring, as well as Gropius. The advent of the Nazi regime put an end to this endeavor, and Gropius departed in 1934 for England, where he worked in association with the pioneer British architect E. Maxwell Fry.

The International Style in Great Britain

Although Britain had been a leader in the development of both eclectic and industrial architecture during the 19th century, the generation of Voysey and Mackintosh (Figs. 137, 138) had no immediate successors, and, in the years just before 1914, their commissions became increasingly rare. It was only in the 1930s that the new architecture took roots as a foreign import. Gropius's timely arrival gave support to a fledgling movement that was spurred on by partnerships like Tecton, led by the Russian émigré Berthold Lubetkin, who gained fame through their Highpoint Flats, Highgate, Hampstead, and their Penguin Pool at the Regents Park Zoo in London; or by Connell, Ward, and Lucas, who built a series of still much-admired houses in studied emulation of the new Continental manner. Soon Gropius was joined in exile by Mendelsohn and Marcel Breuer. However, the gathering clouds of a new war dispersed these wanderers once again in the late 1930s to the United right: 358. Walter Gropius. Bauhaus, Dessau. View from the northwest. 1925–26. Photograph courtesy Museum of Modern Art, New York. below: 359. Walter Gropius and Adolf Meyer.

Project for the Chicago Tribune Tower. 1922.

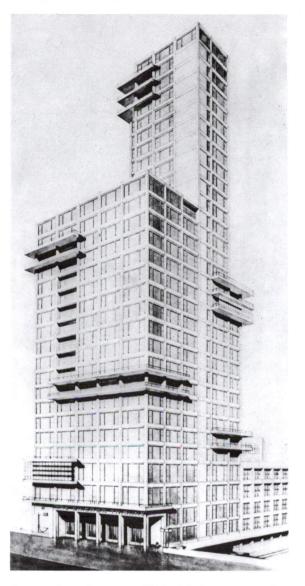

States, where they re-established their careers on firmer ground, in a land that was itself just becoming curious about the new European architecture.

Le Corbusier: The Prometheus Figure of the International Style

Crucial to the establishment of what was to become the International Style was Le Corbusier, already mentioned here as the architect of the Villa Savoye (Fig. 341), virtually a sacred shrine of the new style, the architect of a Moscow ministry, and the designer of a spectacular scheme for the Palace of the Soviets. Le Corbusier is the Prometheus figure of the movement, an artist of Leonardesque proportions, much of whose work has either been lost or mutilated, or has remained unbuilt. His concepts, first formulated in the aesthetic of Purism, are more comprehensive than those of the Expressionists' idealism, De Stijl's universalism, or Gropius's early aspirations. The English translation of the title of his first book, Towards a New Architecture (Vers Une Architecture), errs grievously by the seemingly innocent insertion of the word New since

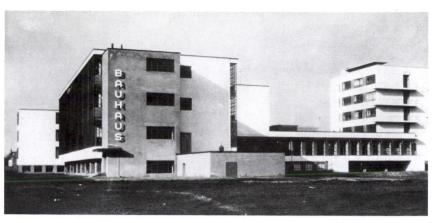

Le Corbusier's subject was the common ground between all architecture. He was not intent upon creating a revolutionary architecture per se; for him there was an inexorable choice: "architecture or revolution."

Le Corbusier represents a peculiar, idiosyncratic fusion of ideals drawn from two seemingly opposed sources: the French classical tradition of Descartes, Poussin, Racine, Versailles, the Place de la Concorde, and even the Beaux-Arts, on the one hand, and on the other, the new tradition in art and literature of Courbet, Baudelaire, Manet, Symbolism, and, more recently, Cubism and Futurism. Consequently, he is the most complete and integrated figure of his generation in architecture and the most intellectually gifted and influential creator and disseminator of the new formal language. Architecture was for him a mistress, a religion, to a degree that is virtually without precedent: "Architecture is the first manifestation of man creating his own universe, creating it in the image of nature, submitting to the laws of nature, the laws which govern our own nature, our universe."⁷ For Le Corbusier the ultimate game of architecture may not have resided solely in the creation of visionary cities, which he so fluently conjured up with his pen, but equally in his private rivalry with such matchless monuments as the Parthenon, the houses of Pompeii, the works of Michelangelo, and that notable symbolic achievement of contemporary engineering, the cylindrical, concrete grain silo-those granaries of the modern world that a primitivist like Adolf Loos (Figs. 155, 156) might have ironically likened to the corresponding mud-plastered structures of tribal Africa.

The litany that opens Vers Une Architecture is as important for the lapidary economy of its prose style as for its substantive content:

The Engineer's Aesthetic, and Architecture, are two things that march together and follow one from the other; the one being now at its full height, the other in an unhappy state of retrogression.

The Engineer, inspired by the law of Economy and governed by mathematical calculation, puts us in accord with universal law. He achieves harmony.

The Architect, by his arrangement of forms, realizes an order which is a pure creation of his spirit; by forms and shapes he affects our senses to an acute degree ... he determines the various movements of our heart and of our understanding....

Our eyes are constructed to enable us to see forms in light.

Primary forms are beautiful forms because they can be clearly appreciated...

The great problems of modern construction must have a geometrical solution...

The Plan is the generator.

Without a plan, you have lack of order and wilfulness....

A great epoch has begun.

There exists a new spirit.8

Le Corbusier's frugal prose matches the style of his projects and buildings of the 1920s. His measured, rhythmic version of the International Style and his subsequent plastic inventions invariably contained an idealistic substructure, possessed implicit goals that went far beyond the momentary realization of the specific building, and hinted at urban or environmental consequences beyond the building's four walls—later to be realized in projects for the ideal city.

Fundamental to this is his concept of the individual dwelling unit, a minimum space arranged for livability. Le Corbusier's prototype, the Citrohan House project (Fig. 360), was as revolutionary as some of the housing ideas that would be developed in Russia at the time, yet was based upon some remarkable sources: the two-story artist's studio living space is taken over from the familiar ateliers of Parisian artists and mechanics; moreover, it has been proposed that this form is akin to the ancient Mycenaean megaron, the planning type of almost legendary antiquity comprising the apartment unit familiar from the Cretan palace and, still more important, the antecedent of the porticoed Doric temple. The Citrohan House illustrates the five points of his architecture, principles that are characteristically more actual than abstract, more a matter of concrete building components than of universal categories. The five points are: *pilotis*, raising the building above the ground; the roof terrace, functioning as garden and outdoor recreation room; the free plan, achieved by interior walls independent of structural supports; the free facade, a concomitant of the previous point, its composition liberated from repeating the structural frame; and, finally, the continuous, horizontal window, a point virtually synchronous with the free facade. These elements remained in various guises in nearly every project or building until the end of his career, with the exception of those few instances when the nature of the vault or covering did not permit a flat roof. Together with certain secondary features, such as his use of gently inclining ramps, multistoried spaces with galleries, and the like, these elements may be thought of as Le Corbusier's "order," much as such elements as base, shaft, capital, entablature, and pediment comprise the order of a columnar Greek temple.

Although Le Corbusier built a number of houses in the 1920s, each a special demonstration of spatial and formal resourcefulness, his most important manifestation of domestic architecture was the temporary Pavilion of *L'Esprit nouveau*. Sponsored by the avantgarde magazine that he had cofounded and edited since 1920, the Pavilion was erected in 1925 at the Paris "Exposition des Arts Décoratifs" (whence the contraction Art Deco). It represented a rethinking of the Citrohan House type, featuring an outdoor terrace-balcony to one side and at the same level as the main two-story living area, and could thus be considered either a detached private villa or the individual component of a multiple dwelling. Here Le Corbusier responded to the problem of confinement encountered in the conventional urban flat—of how to provide space, air, and direct contact with the green landscape—since his intention was for the units

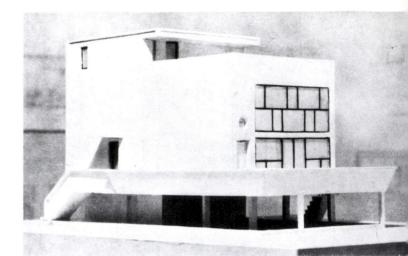

above: 360. Le Corbusier. Second Citrohan House. 1922. Model. **below: 361.** Le Corbusier. Project for A Contemporary City of Three Million Inhabitants. View of center. 1922.

to be assembled as multistoried terraces in an urban context made up entirely of buildings set in a park. At this same exposition he showed his Voisin plan for Paris, a scheme for the total reconstruction of the Right-Bank commercial center of the French capital that was adapted from his more schematic, philosophical project of 1922, generally known as "A Contemporary City of Three Million Inhabitants" (Fig. 361).

Le Corbusier's villa type of 1925 and its various predecessors, or the various houses actually constructed at the time, are basic components of his vision of the city, tailored to fit with precise tolerances, as in a car, ship, or plane. For the business district of his city Le Corbusier took over the American tall office building, but characteristically rationalized it into his Cartesian skyscraper. While visiting New York in the 1930s, he quipped to reporters at the dock that the skyscrapers were not big enough-good bait for gullible journalists, but also his elliptical way of saying that it was the concept, not the actual bulk, of Manhattan's towers that was wanting for grandeur. For his ideal "City of Three Million," as for the later Voisin plan and still later "Radiant City" variants, Le Corbusier visualized a regular parade of uniform, fifty-story glass skyscrapers, cruciform in plan, isolated on verdant superblocks between networks of freeways with limited-access approaches. Vehicular traffic was separated into isolated levels so that the pedestrian could stroll across terraces and through green parks free of the menace of traffic. Beyond this center were vast ribbon terraces of houses five stories tall.

Significantly, the plan for this contemporary city was firmly rooted in tradition. Much had been adapted, albeit vastly enlarged, from Ebenezer Howard's Garden City scheme of 1899 but, faithful to the traditions of his adopted land, Le Corbusier employed a Versailles-like street network, star-shaped, with avenues radiating from the center, with a superimposed rectangular grid—a planning technique that had been employed with varying results from Paris and Washington to New Delhi and Canberra. Sant'Elia's Futurist City was also of great help.

Le Corbusier and his supporters might later argue that these schemes were but diagrams, that in execution the Cartesian skyscrapers might be the different works of different designers, and that the plans would bend to circumstances; but to little avail. The hypnotic, classic, ironically academic rigidity made an indelible image, one instinctively likened to totalitarianism by many who might otherwise have been sympathetic to the ideals. And by applying it to Paris, Le Corbusier brought down a fury of abuse matched only by that provoked by Eiffel two generations earlier because he had dared to tamper with the sacred skyline of the historic city. Le Corbusier's threat was a mere paper one; at this time no one could possibly have carried out the proposals.

The International Style in Italy

The unflagging plastic invention of Le Corbusier, and his disciplined composition of abstract elements possessing an uncanny, classic certainty, cast into deep shadow the works of several deserving radical contemporaries working in France. However, they lacked his polemical flair and could not match the broad sweep of his philosophy. Indeed, the only European architect of the epoch who could match him in formal composition was Giuseppe Terragni (1904-42), designer of several houses and apartments in Como, Italy, as well as of the Casa del Fascio there (Fig. 362). The youngest of the masters of the heroic International Style, Terragni could carry out his ideas in a totalitarian Italy since the authorities there were somewhat vacillating and inconsistent in their repression of radical cultural manifestations. The rhythmic articulation of his façades in regular, modular bays is characteristic of a distinctive style, and the projection and recession of surfaces indicate a compositional system different from that of Le Corbusier's free plan and free facade, a system that seems more akin to Renaissance notions of order.

Art Deco in Architecture

Le Corbusier's unique position in French architecture also obscures the achievement of the Art Deco mode popularized at the 1925 exposition. It was an impure, mod-eclectic style, officious, if not exactly official, which had partly supplanted academic Beaux-Arts classicism in the 1920s. This mode not only invaded the realm of the decorative arts but also touched that of monumental architecture, not just in France. Art Deco had widespread consequences in the United States, where it strongly influenced designs of largescale office buildings by Beaux-Arts-trained architects looking for an alternate to the familiar historical modes. Indeed, an echo of Art Deco's chic, up-to-date quality can even be detected in the reactionary architecture of Italy, Germany, and Russia in the 1930s, where established proportions and exact classical detail were typically altered, attenuated, and simplified. In the midst of this stylistic chaos, featuring a ravaged, aesthetically ineffectual academic tradition, rife with a pathological uncertainty as to the appropriate

> **362.** Giuseppe Terragni. Casa del Fascio (Casa del Popolo), Como, Italy. 1932–36.

stylistic choice or direction, Le Corbusier, the Bauhaus, and several parallel or related movements of the 1920s offered the profession and the public an articulate, resounding architecture whose distinctive style, for all its limitations and immaturity, was an integral part of the art and science of the 20th century.

Astoundingly, this new architecture, which proposed to resolve the technical and plastic quandaries, as well as the menacing urban and environmental problems of the day, with functional and monumental solutions, was generally rejected. Subsequent critics and historians may have deplored this negative, reactionary trend, but they have also been too free with petty, if obvious, criticisms of the new architecture's social, technical, and formal shortcomings to realize the unprecedented magnitude of the disaster, which, for the first time in history, deprived an entire emerging civilization of an architecture rightfully its own. The cumulative effects of this rejection so traumatized the modern movement that when, belatedly, recognition was finally accorded, a generation later, the earlier proponents could only respond in a way that was largely private and self-indulgent. They could create personal masterpieces attesting to their own design capacity, but they were no longer inclined to provide useful guidance to younger architects, many of whom were uncertain whether to accept or reject the earlier modernist tradition, which had fallen on evil days only a decade after its initial successes.

Ludwig Mies van der Robe

If Le Corbusier, the most protean inventor of modern architecture, was, for historical as well as personal reasons, the great creative loner of the day, in contrast to Gropius, there is a solitary, isolated quality to the taciturn Ludwig Mies van der Rohe as well. Both men maintained very private lives, but Mies went further, revealing his professional thought in only a few impersonal formulas and distilling an architectural style that became so concise and simple (or simple-seeming) that, at the end, it appeared reduced to at least a common denominator. He was as concerned with eternal verities as was Le Corbusier, though his manner of address was not as hortatory. His comments on the contemporary situation, made in 1930, reveal an attitude more detached and dispassionate than most: "The new era is a fact.... But it is neither better nor worse than any other era. It is a pure datum and in itself neutral as to value.... Let us also not overestimate the question of mechanization, standardization and normalization... . All these things go their destined way, blind to values."9 Although his work, even from an early date, seemed more narrowly formalist than most, Mies was, in fact, concerned with the more generative aspect of architecture:

The Shaping of a New Architecture: 1918–40

I do not oppose form but only form as a goal.... Form as a goal always ends in formalism. For this striving is directed not towards an inside, but towards an outside...

Only intensity of life has intensity of form....

We do not evaluate the result but the starting point of the creative process. Precisely this shows whether the form was discovered by starting from life, or for its own sake.

That is why I consider the creative process so essential. Life is for us the decisive factor.¹⁰

Mies preferred his buildings to be good rather than novel or inventive. Sometimes his works seem bland or uninteresting, though this fault, more properly, should be laid at the feet of his often inept imitators who have thoughtlessly repeated his formulas ad infinitum, producing bowdlerized clichés.

The earliest projects of Mies after 1918 were Expressionist glass skyscraper projects, down-to-earth versions of Taut's glass architecture, or studies of country houses in brick or concrete and glass in which the geometric austerities of De Stijl were used to clarify the open plans of Wright's Prairie Houses, much admired and emulated at the time. There is little invention here, but much condensation, and, in a work such as the Barcelona Pavilion (Fig. 363), an exhibition structure built for the German marble industry, much jewel-like precision. This open structure, with its unrestricted flow of space and its hovering, overhanging slab roof reflected in the podium's pool, representative of Mies's view of the ideal dwelling, should be compared to Le Corbusier's ideal dwelling, the Citrohan House project (Fig. 360). The latter was intended as a machine for living; Mies's pavilion did not aim to be a house in the functional sense of a habitation, but a more abstract shelter of a stylish, artful sort. In the Barcelona Pavilion, the style of modern architecture has become the subject and content of the building. The style is no longer expressive of function but used by Mies in a lyrical way, much as an eclectic architect might select a given historical style for expressive effect. This metamorphosis was, of course, a great artistic achievement for which Mies deserves credit-but, it proved to be the Trojan Horse of the new architecture when the Miesian style was later taken over by less disciplined designers. Lacking the intense moral purpose of Mies, more commercially inclined imitators have travestied his forms. They have largely overlooked his feeling for space, scale, and proportion and, through their endless repetitions of the steel and glass package, have sullied the reputation of one of the most meditative architects of the early 20th century. His perception of a universal, open, flexible space is as fundamental to modern architecture as is the free plan of Le Corbusier.

The Skyscraper Style

Although it confuses issues to acknowledge that there was an innovative aspect within the Beaux-Arts tradition during this period—a tentative American venture related to Paris Art Deco—such innova**left: 363.** Ludwig Mies van der Rohe. German Pavilion, International Exhibition, Barcelona. 1929. Photograph courtesy Mies van der Rohe Archive, Museum of Modern Art, New York.

below: 364. Shreve, Lamb, and Harmon. Empire State Building, New York. 1930–32.

tion nonetheless helps explain the compromising circumstances under which the new architecture itself was much later-after 1950-accepted as the commercial norm in the United States. One should hasten to add that the movement was altogether distinct from the later work of that elder pioneer, Frank Lloyd Wright, or from the emerging International Style in the United States, then largely centered in southern California. The somewhat autonomous Beaux-Arts development, neither radical nor academic, was focused upon the continuing, vexing problem of skyscraper design. Historians have tended to assume, but with incomplete evidence, that the early Chicago style of the 1890s, with its expressed skeletal frame, was the right solution and that subsequent mercantile classicism and its companion Gothic idiom were altogether false paths with no exit. Moreover, until recently it was felt that such "modernistic" successors of 20th-century urban eclecticism as New York's Chrysler and Empire State (Fig. 364) buildings are flawed, unworthy of consideration alongside the skyscraper proposals of Mies, Le Corbusier, and other European pioneers. Such a view is much too simplistic and overlooks the fact that the architects of these American commercial edifices of 1918-39, academically trained either at home or abroad, were interested in a variety of new movements, mostly non-International Style ones, such as the romantic brick architecture of Germany and the Netherlands, a remnant of Expressionism, as well as the more innovative aspects of Art Deco as it spread from Paris to London and across all of Europe. In fact, the greatest Art Deco ornament on the exteriors of monumental buildings is to be found on the skyscrapers of American cities.

Significantly, it is in American architecture of the 1920s and 1930s that the actual confrontation with the question of skyscraper

construction took place. In Europe it was, to all intents and purposes, a question of theory, of conjectural projects, and, for an architect like Le Corbusier, of polemic. The skyscraper is the unique architectural genre invented by modern Western architecture, as distinctive as the pyramid to Egypt, the colonnaded temple to Greece, the pagoda to China and Japan, the tepee to the American Plains Indian. Yet the characteristic architectural mode of our time, the European International Style and its progeny, evolved along a largely independent course, taking over the American-developed skyscraper type when it finally served its purpose. Indeed, the ultimate coming together of the new building type and the new style is achieved only in the 1950s.

Until then, we are really confronting two separate histories with an interesting set of conflicts and relationships. It is worth remembering that such pioneers as Gropius and Le Corbusier are not thought of as architects of skyscrapers, except in their unexecuted projects, and that, of the key masterpieces of the new architecture, none are towers, again, save for projects. Mies is the chief exception to this rule, and, indeed, it was through his honed-down, reductive style of metal and glass that the tenets of the International Style were universally, if tardily, adopted for urban high-rise structures.

The history of the tall office building has been influenced to a greater degree by real estate speculators, financial institutions, aggressive patrons, and even municipal regulatory codes than by architectural designers. The visionaries of the genre, in one sense, were skyscraper builders like Frank Woolworth and Colonel Robert McCormick, patrons who were more responsible for the Gothic fantasies of the Woolworth Building in New York and the Tribune Tower in Chicago than their malleable Beaux-Arts-trained architects, Cass Gilbert for the first and Raymond Hood for the second. Hood, one of the few who might be called venturesome, if not pioneering, in the context of American architecture during the 1920s and 1930s, stated that he was unsure of the style that was appropri-

ate to a skyscraper, and it is reported that this designer of Gothic, Art Deco, and International Style towers was also an admirer of Le Corbusier's projects. But despite a 1932 exhibition at New York's Museum of Modern Art, many architectural critics cast doubts on the importance of the International Style, and, for a decade more, it remained a mode popularly associated with contemporary art but not with contemporary American building. The one clear-cut exception is the distinctive Philadelphia Savings Fund Society Building (Fig. 365) designed by George Howe (1886-1955), a renegade eclectic, and the Swiss architect William Lescaze (1896-1969), who brought direct knowledge of the new style to the development of this edifice. Hood's McGraw-Hill Building, featuring horizontal bands of windows and blue-green cladding tiles, contradicts the inherent verticality of the form and the recent tradition of American skyscraper design that virtually mandated vertical window strips. The skyscraper thus remains a genre slow to be drawn into the history of modern architectural design, an essentially American phenomenon like the suburban cottage or villa-open to the space and light of nature-culminating in the Prairie Houses of Wright.

The ideals of American architecture during the first third of the century are represented by the extravagant drawings of an architectural renderer, Hugh Ferriss (1889–1962), whose services were used by many architectural firms of the day. In 1929 he published *The Metropolis of Tomorrow*, which reproduced a selection of his shadowy, twilight renderings of recent skyscrapers, along with several schemes showing how to gain maximum enclosure advantage with the new building codes mandating that skyscrapers be set back from the street a certain distance beginning at a specific height. These drawings (Fig. 366), done in collaboration with the architect Harvey Corbett, later one of the designers of Rockefeller Center, became the models for the legions of site-filling ziggurat buildings that gave the New York skyline its characteristic silhouette during the next few decades. In the final part of Ferriss's book,

right: 365. George Howe and William Lescaze. Philadelphia Savings Fund Society Building, Philadelphia. 1931–32.

below: 366. Hugh Ferriss. "Looking West from the B.C." from The Metropolis of Tomorrow. 1929.

"An Imaginary Metropolis," he seeks to associate the image of the skyscraper with the legendary splendors of the past, a vision worthy of comparison with the contemporary, cinematic visions of D.W. Griffith, Cecil B. de Mille, and other Hollywood masters. Looking like romantic archaeological reconstructions, and sharing their unreality with the less ponderous visions of Berlin Expressionism, Ferriss's tower cities seem the murky opposite of Le Corbusier's luminous Radiant City of glass, concrete, and verdure. True, the style of his rendering makes the forms seem too obscure and remote, perpetually lost in shadow, much as the opposite is true in the sharply lined ink drawings of Le Corbusier, where an even, shadowless solar light perpetually reigns.

One of the inherent problems of the skyscraper was that its form was so prone to romanticizing, either in picture or prose. In varying degrees and directions, Sullivan, Ferriss, and Le Corbusier are all answerable in this respect, and, indirectly, each is responsible for the urban blight that has been generated by the highrise. Only recently has it been recognized that the skyscraper, seemingly the most original characteristic architectural form of the industrial-age city, is a contradictory beast possessing numerous destructive antiurban features. The contents of its vertical mass require services which the network of choked city streets is hardpressed to provide, especially when that street system is one of an earlier century, meant originally to service an architectural horizon of no more than four or five stories. Even allowances for pedestrian plazas and underground parking at the foot of towers frequently exceeding fifty stories are woefully inadequate. More comprehensive efforts at planning, in which tall buildings are situated on vast. often elevated plazas that would seem to provide sufficient space above and below ground for the necessary services and urban amenities, have their own inherent vices, since such buildings tend to cut themselves off from the established urban network of streets and services. The plazas turn out to be lonely, windswept wastelands of pavement, as alienated from the city as the buildings they are meant to serve, fragments of a Radiant City that cannot work out of context. Presumably, buildings came to be as high as they are because of pressing economic reasons. However, many of these now seem to have come about through manipulative speculation, created more to drive up property values, and, concomitantly, to raise the tax rolls of financially strained municipalities, than merely to answer the need for more space at less cost in a desirable location. The characteristic form of the industrial-age city, providing much of its characteristic sublime splendor, is equally the instrument of its relentless decay.

left: 367. Rudolph Schindler. Lovell House. Newport Beach, Calif. 1926.

below: 368. Richard Neutra. Dr. Lovell's "Health" House, Los Angeles, Calif. 1927–29.

opposite below left: 369. Frank Lloyd Wright. Administration Building, S.C. Johnson and Son, Racine, Wisc. 1936–39, 1950.

opposite top: 370. Frank Lloyd Wright. Solomon R. Guggenheim Museum, New York. 1957–59.

opposite below right: 371. Frank Lloyd Wright. Kaufmann House, Bear Run, Pa. 1936.

Frank Lloyd Wright and the International Style in America

Frank Lloyd Wright carried on a profound love-hate relationship with the city during the last half of his life. During the construction of the Tokyo Imperial Hotel (Fig. 159) he settled temporarily in Los Angeles, where he worked on a number of extraordinary houses that were thoroughly unlike his Prairie dwellings. Built up of a patterned concrete block, they lacked the broad overhanging eaves of the Midwest, their sculpted forms distantly inspired by pre-Columbian monuments and the adobe architecture of the Southwest. Their individuality contrasted with the prevailing bungalow and Spanish colonial revival popular in the area, and their opaque monumentality was at variance with the fragile, open forms of the International Style, which would soon be introduced into southern California by two Austrian architects, Rudolph Schindler (1887-1953) and Richard Neutra (1892-1970). Ironically, the former had worked as a close associate of Wright's before striking out on his own in the early 1920s, and the latter, who came to the United States at Schindler's urging, spent a few weeks in transit at Wright's studio. In his Lovell House at Newport Beach, Calif. (Fig. 367), Schindler produced the first International Style residence in the United States. In his house for the same clients in Los Angeles (Fig. 368), Neutra produced one of the great canonical structures of the heroic phase of the International Style, a concrete and glass volume on a steel frame of great elegance and refinement.

Wright turned away from this new European idiom, ridiculing it in his writings and seeking alternate forms of expression. A New York tower apartment project of 1929, a form unlike any skyscraper image of the day, American or European, came to naught because of the Depression, but its form was adapted for a skyscraper constructed in Bartlesville, Okla., in the 1950s. During 1930-34 Wright developed the plan of Broadacre City, an ideal scheme that, like Ferriss's imaginary city, was a critical reaction to the terse, linear diagrams of the Radiant City. Otherwise, they bear not the slightest relationship to each other, though both visions were probably raided by Norman Bel Geddes for his city-of-the-future model at the General Motors Futurama of the 1939 New York World's Fair, a rare and successful presentation of a futurist fantasy to a wide audience. Wright's Broadacre City is in reality an anticity, a realization of that facet of the American dream that turns its back on congested, densely populated urban centers with their tall buildings and impersonal human relationships-an intellectual tradition that has contributed to the urban blight that was worsened, if not originally caused, by the frantic construction of ever taller buildings. Broadacre is super-suburbia, a pastoral fantasy which seeks to build upon the rural implications of the typical American residential subdivision. To bring industrial-age urban man back into contact with nature, Wright would give him individual houses on large, one-acre lots, establishing an even, low density of population across what then seemed to be an endless countryside. There would be occasional towers, presumably to house stubborn urbanites (perhaps artists, intellectuals, managers), and this extended horizontal city would, of course, be highly mechanized and automobile-oriented. Le Corbusier's way of bringing man back into contact with nature was the alternate, high-density solution, stressing collective, rather than personal, open space. The compact tall offices and the ribbons of apartments of the Radiant City made possible the open space for landscaped public parks directly adjacent to the monumental structures. Alas, neither vision was to prevail, and in the years after World War II urban builders gradually adopted Mies's reductive modern style rather than Le Corbusier's more plastic one, with only token allotment of spatial amenities on the ground. As for the suburbs, they grew by speculation rather than design, a tragic parody of Wright's vision.

The offices for the Johnson Wax Company at Racine, Wisc. (Fig. 369), the brick and tubular glass forms likely inspired by the Expressionism of Mendelsohn and Poelzig, together with his numerous "Usonian" houses of the 1930s and 1940s, updated versions of the Prairie motif, give some idea of the kind of architecture that would have populated Broadacre City. The Guggenheim Museum in New York (Fig. 370), designed in 1943 but not completed until 1959, the year the architect died, expands upon the circular and spiral motifs introduced in the Johnson Wax offices. Widely criticized as a structure inimical, if not hostile, to the exhibition of works of art, the domed well surrounded by the continuous spiral gallery demonstrates a spatial effect that was central to his work. The Guggenheim is a tour de force expressing Wright's antipathy to the rectangular towered architecture of the city, its curving lines indicating his love of the park across the avenue; it is a cenotaph dedicated by the artist to his distinctive achievement, to an aborted architectural revolution that had never been, indeed could never have been, welcomed in the modern city. It was a personal architecture that could exist only in remote hideaways, and it was in such situations that Wright invariably gave his utmost. The Kaufmann House, or Falling Water, at Bear Run, Pa., is not only a masterpiece of his own genius; it is also a belated example of International Style geometry, its concrete and glass form admittedly enriched with the natural textures of native stone (Fig. 371).

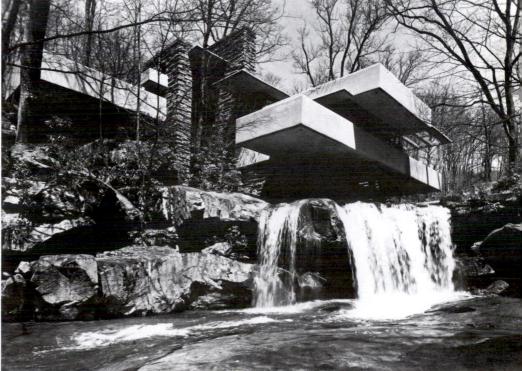

Wright may have inveighed against the attenuations and exaggerations of the new architecture in Europe for more than a decade, but he was willing enough to challenge these architects on their own ground, to come away the victor in a battle, if not the war. A manybalconied, cantilevered construction, Falling Water's hovering horizontal strata echo the rock formations in the bed of the stream over which the house is sited. In his writings, Wright liked to point to the fact that the principal form of Falling Water had appeared much earlier, in one of his Prairie Houses of the 1900s, his way of chiding his historians and biographers who had, with equal truth, claimed much of his later work as a transformation of the International Style, which, as a matter of personal honor, he had to contradict.

In his eyries at Taliesin, built on family land at Spring Green, near Madison, Wisc., and at Taliesin West, Scottsdale, Ariz., begun in 1938, Wright remained a splendid solitaire, surrounded by an admiring family and his constant apprentices. Taliesin West is a particularly apt instance of his acculturation to a new environment, and of his facility, when unhampered by the preconceptions of the client, at the manipulation of free forms, inclines, diagonals, and triangles. The house and studio are sited on a low, artificial mesa that contains watered lawn, souvenir of another climate in the midst of the arid desert, constructed out of timber and of native stone embedded in concrete. Its complex layout, full of surprises, is representative of his genius as it mellowed with age-comparable in its transcendental elaboration, though totally unrelated in style or theme, to certain of the late works of such contemporary 20th-century masters as Matisse or Picasso. Along with Le Corbusier, Wright is the only 20th-century architect deserving of mention in such company, an artist who well outlived his "own" epoch, still potently creative but working in a world of his own, publicly lionized yet largely out of touch with artistic, professional, or critical establishments. The architecture designed by Wright in the last decades of his life was widely admired. Nevertheless, his influence upon the further evolutions of architectural form had taken place much earlier, in the 1910s and 1920s. He built some of the great monuments of the 1950s, but, although admired, they had no substantial influence upon current and subsequent events. Regrettable? Perhaps. Yet society and the profession had taken certain directions that had long ago rendered his architecture irrelevant, as, to a lesser degree, it would render Le Corbusier's proposals inoperative. The phobia of comprehensive planning in any

372. Reinhard, Hofmeister, Morris, Corbett, Harmon and MacMurray, Hood and Fouilhoux. Rockefelier Center, New York. 1931-37. field—economic, environmental, or architectural—ensured, then as now, the limited role that innovative architects could play in future building developments.

The only new progressive architect of consequence to appear on the scene during the troubled, contradictory 1930s was the Finn Alvar Aalto (1898–1976). His work is properly studied in the context of the style of the 1920s pioneers and of Wright's new achievements of the 1930s. The International Style characteristics of his early sanitorium, Paimio, mark a point of departure for his life work, whereas contemporary works by Gropius or Mies represent a culmination of efforts to overthrow the past. Understandably, Aalto's maturity came in the 1930s and 1940s and was upset for some years by the dislocations of the war. His modifications of the International Style are parallel to those introduced by Wright at the same time, but his designs are of personal inspiration, revealing distinctive insights into the characteristics of a wide range of materials. Related to this sensitivity for textures is a personal inventiveness with respect to compositional masses and details that goes beyond the geometrical rigors of the new architecture. Aalto's was the first major reaction against the machine aesthetic that was creative rather than reactionary. His Viipuri Library illustrates this new progressive trend, which was carried even beyond the canon of the International Style in the dark brick of his Baker House at MIT in Cambridge, Mass. There the river front is serpentine, regular rectangular windows replace the orthodox glass curtain wall, and the opposite side features a contrasting sawtoothed geometry. The result is the expansion of the vocabulary of avant-garde architecture (by reviving some of the Expressionist practices of two decades before) to the point where the original sources of the new style have virtually vanished. But this is to anticipate the story.

The Reactionary Modernism of the 1930s

By the late 1930s the new architecture was in disarray, a turnabout from the situation a decade earlier. Economic and political forces had constrained it, severely limiting opportunities to build and excluding the new masters from significant, symbolic public monuments. Privately, internally, new architecture was itself changing, a normal process of evolution and growth, but one that was now taking place hidden and ignored. The one big building project completed in the 1930s was New York's Rockefeller Center (Fig. 372), a work of innumerable associated architects, including Harvey Corbett, Raymond Hood, and Wallace Harrison, the latter of whom would become prominent on the postwar architectural scene. As a multiple collaboration among several firms, this collection of skyscrapers turned out to be a typical compromise effort with pallid, characterless detailing and a lack of stylistic or ideological commitment. Its vertical ribboned towers are thinneddown American Art Deco, and yet the slablike forms, differing from conventional, slender New York spires, suggest European modernism. Bland and composite in style, trying, with partial success, to be a city within a city, seeking to provide open recreational space in an urban context yet being of economic necessity too stingy, Rockefeller Center symbolizes the defeat of the new movement through systematic compromise. Hailed in some early histories as an encouraging instance of the salutary influence of the new architectural movements upon large-scale office buildings, Rockefeller Center, even taking into account its limited amenities, instead should have sounded a tocsin in perceptive critics and progressive architects. Elegant, up-to-date in appearance, it contained the look of modernism but virtually none of its substance. Later, the new style would be used more literally, even daringly, in the "development" of the new city, a process that would also bring with it the wasting, if not complete destruction, of the undervalued heritage of the recent past.

The School of Paris between the Wars

W ith their public provocations and liberating techniques for investigating the unconscious, Dada and Surrealism were anticlassical and antiscientific, in the mechanistic and rationalist sense. They opposed not only traditional academic art, but also the more formal avant-garde expressions of their own time. Even when Schwitters, Arp, or Ernst borrowed the collage technique from Cubism, their purposes and processes were ultimately different. They used the collage method to reveal new kinds of social and psychological meaning, rather than to create new kinds of forms.

For many other artists of the 1920s and 1930s, however, traditional values could not be so easily surrendered. Imagination still afforded the possibility of dreaming another reality or contriving a superior or more attractive world-a world that an artist like Marc Chagall might build, innocently enough, with visual symbols of love and wonder rather than anguish. The period between the two cataclysmic world wars became one of laissez-faire in which many conflicting artistic styles coexisted. While the Dadaists and Surrealists aimed at provoking the public and liberating themselves from the constrictions of rationality and materialism, Social Realists addressed themselves to the cause of social revolution in artistic forms comprehensible to the common man. At the same time, the great modern masters-Matisse, Braque, Léger, and others-continued to create a reasonable art based on order, without compromising the formal innovations of the heroic prewar period of experiment and adventure. Picasso and Miró extended those innovationsparticularly the expressive fantasies that Surrealism released-in order to comment on a tragic and anguished social epoch. The diverse art of the 1930s offered innumerable alternatives based on its creators' response to the world about them. In a broad sense, art continued to mirror the world of outer reality, with the difference that the formal advances made by modern art complicated both its mode of presentation and the subjective input of that dialogue. Each artist carried his own mirror within himself.

Following Surrealism, no truly revolutionary developments emerged until the advent of Abstract Expressionism during and after World War II. In the period immediately after World War I, a general reaction to the experimental excesses and sense of intellectual excitement of the preceding epoch manifested itself, most notably in Paris. It took the form of a renewed emphasis on classical clarity and order and a return to realism. In Germany, however, George Grosz, Otto Dix, and Max Beckmann (Figs. 210–212, 298), perhaps understandably, returned to the object with a certain anguish and element of powerful fantasy that indicated a relationship to nascent Surrealism.

The battle of styles in the 1920s and 1930s underscored the endemic problems of School of Paris art, and raised questions about the validity of its particular kind of ingratiating taste, hedonism, and traditional regard for *belle peinture*. A period that saw a worldwide depression and the growing threat of international fascism brought to art moods of caution, intellectual ferment, and protest. In the context of social events, the distinctions between an art of ideas engaged by contemporary history and an art that expressed the inherent possibilities of the means of painting also came into sharper focus. It is worth considering these many pertinent issues in relation to the standard artistic product of the School of Paris and how the antithetical positions assumed by perhaps the two greatest artists of the century, Matisse and Picasso, shed light upon them. The relationship between art and politics in an expanding industrial society received a dramatic new impetus from Picasso's activism and even more so from the emergence of a significant mural art in revolutionary Mexico (Figs. 463-466). Matisse, preferring intimacy, moved from Paris to the Riviera and in that sensual climate transformed his art into a new definition of luxe, calme et volupté, always, however, with the lofty aim of continuously self-revitalizing means and expression. In the panorama of evolving styles, a fascinating contrast to Social Realism was supplied by the utopian aesthetic of the Bauhaus, whose artists and architects, as we saw in Chapter 13 and will rediscover in Chapter 15, dreamed of a renewal of society through abstract art and design.

Les Peintres Maudits

Particularly associated with the School of Paris in the 1920s were paintings from a group of extremely gifted, mostly foreign, artists whose miserable bohemian lives in the French capital earned them the reputation of *peintres maudits*. The work produced by these "cursed" masters was figurative and representational and, despite its stature, clearly peripheral to the truly momentous developments of 20th-century painting and sculpture. Obvious differences aside, their pictures share a curious and sometimes unstable amalgam of agreeable, well-made, tasteful effects and vivid Expressionist color and distortion of form for emotional purposes. Amedeo Modigliani, Chaim Soutine, Jules Pascin, Maurice Utrillo, the only nativeborn Frenchman in the group, and sometimes Marc Chagall have been linked as members of this school. They partake of the common fact that none has been a significant innovator with a following, that they have all stood outside the great movements of their time, and that they wished to inject more sentiment into painting. In a period of movements and countermovements, they remained apart, and their rather conservative individualism perhaps proved a limitation. They were romantic, either in their lives or in their art, and all but Chagall shared a fatal enchantment with the unconventional studio-and-café ambience of Montmartre and Montparnasse. The collective experience of Modigliani, Soutine, and Chagall included, moreover, residence at la ruche ("the beehive"), as the artists styled the old rotunda-shaped building they

left: 373. Maurice Utrillo. Rue des Saules. c. 1917. Oil on cardboard, 20½ × 29½". Kunstverein, Winterthur, Switzerland.

below left: 374. Jules Pascin. Claudine at Rest. c. 1923. Oil on canvas, 235/8×311/4". Art Institute of Chicago.

below: 375. Chaim Soutine. The Communicant. 1927. Oil on canvas, 243/8 × 201/4". Private collection.

inhabited in the slaughterhouse district near Montparnasse. Although ramshackle, this structure probably made poverty bearable, even poetic, for at one time or another it also sheltered Archipenko, Lipchitz, such French artists as Léger, Delaunay, and Laurens, as well as the writers Blaise Cendrars, Apollinaire, and Max Jacob.

The legend of Paris bohemia began innocently enough with the Impressionists (Fig. 18) and later received a more sinister twist from Toulouse-Lautrec, who painted Montmartre in its first bloom as an artistic quarter and gaudy district of nocturnal pleasures (Fig. 68). Maurice Utrillo (1883-1955) saw the same sector as a ruin of its former self, burned out and dying (Fig. 373). He injected a melancholy poetry into the decaying walls and façades and tortuous streets of the "Martyr's Hill" with his almost compulsively repeated motifs. A monody of bleak walls, impoverished foliage, and leaden skies, particularly during his best phase, the so-called White

The School of Paris between the Wars 216

Period between 1909 and 1914, represents the last twinge of a romantic 19th-century Impressionism. The touching lyricism of these early paintings and their feeling of emptiness and fatalism are matched by the unhappy story of his life. The neglected, illegitimate son of Suzanne Valadon (Fig. 67), an alcoholic in his teens,

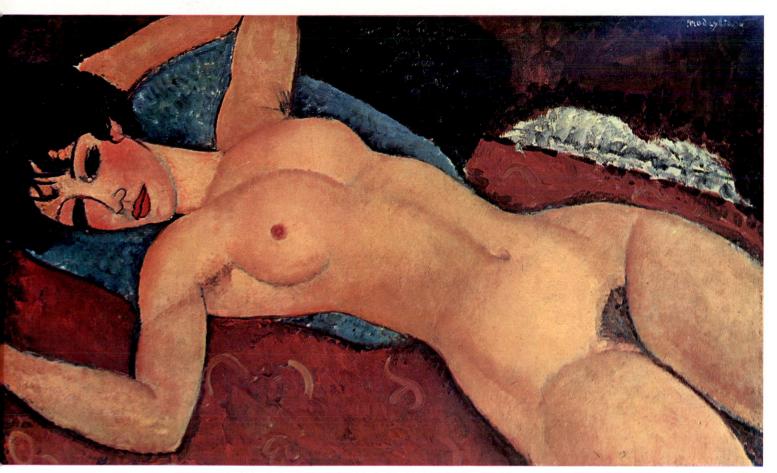

376. Amedeo Modigliani. Reclining Nude (Red Nude). 1917–18. Oil on canvas, 231/2×361/4". Private collection, Milan.

trading pictures for wine and food and lodging, Utrillo grew up like a rank weed in a sunless, unwholesome atmosphere. The pathos of his painting is at least in part the triste chronicle of the depressed fringe of Paris bohemian life, which however did not prevent either Utrillo or his fellow *maudits* from producing a considerble body of important and popular work.

The same tragic-sensitive mood also prevails, but with more aesthetic power and merit, in the painting of Jules Pascin (1885-1930), who came to Paris, from Bulgaria, and committed suicide there at the age of forty-five, just as he was to receive a major exhibition in the French capital. A compulsive and accomplished draftsman, Pascin developed an evocative but economical linear technique applied against zones of pale color washes (Fig. 374). The shimmering translucent tints evoke the female flesh, in a mood combining eroticism and melancholy. His delicate and touching paintings of prostitutes and degraded adolescents are remarkable works of nervous sensibility, although Pascin never made any startling technical discoveries and proved almost obsessively limited in his subject matter. Perhaps for these very reasons, in addition to the sheer professionalism of his work and the friendly, fun-loving nature of his personality, Pascin had considerable influence on the more alert elements in American art during his sojourns in the United States in 1914-20 and 1927-28.

A more virile spirit inhabited Lithuanian-born Chaim Soutine (1893–1943), who too was something of a painter of despair. In the early 1920s Soutine developed a powerful Expressionist style, loading his pigment, often searingly brilliant, on canvas until it stood out in low relief (Fig. 375). His tormented, cataclysmic landscapes and violent figure pieces, all set down in breathtaking color, added a new richness and emotionalism to School of Paris painting. Symptomatic of pure delight in pigment, apart from representational aims, the freedom and fury of his paint manipulation

endow even the most putrescent subjects, such as the rotting beef carcasses the artist liked to paint (in homage to Rembrandt), with a luminous, transcendent beauty. Such qualities also made him heir not only to Rembrandt but also to Chardin, Courbet, and van Gogh, as well as an acknowledged and legitimate forerunner of the American Abstract Expressionists (Fig. 488).

A remarkable portraitist, Soutine painted the work seen here as one of a series devoted to the human figure shown in some vocational or ceremonial dress, such as a religious vestment, a porter's uniform, or a chef's white toque and apron. In his figures he balanced elements of the grotesque, almost to the point of mutilation, with authenticity of class or function and totally invented abstract shapes. Throughout these powerful images, however, the act of painting, at white heat it would seem, finally subdued and reconfigured the social reality of the models. The free, elliptical shorthand of Soutine's impassioned brushstrokes creates, virtually in a single dramatic phrase, an unforgettable impression of freshness and vitality. Although Soutine enjoyed the patronage of an eccentric American collector, he died during World War II of a perforated ulcer brought on, at least in part, by a lifetime of nervous instability, exacerbated by his clandestine existence, as a Jew, in occupied France.

The greatest waste, perhaps, in recent artistic history came with the untimely death from tuberculosis of Amedeo Modigliani (1884– 1920) at the very young age of thirty-six. Modigliani's demise was hastened by his disorderly living habits, his dissipations, unavoidable poverty, and reckless indifference to the general state of his body. He came to Paris from Italy in the early years of the century and discovered the art of Cézanne, Cubism, and the vogue of Negro sculpture. Out of these influences, which he perhaps never explored very profoundly in formal terms, Modigliani fashioned an aristocratic and mannered figure style (Fig. 376). Elegantly linear,

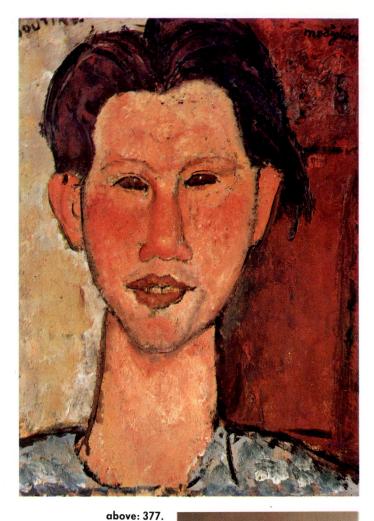

Amedeo Modigliani. Portrait of Chaim Soutine. 1915. Oil on canvas, 147% × 11". Staatsgalerie, Stuttgart.

> Amedeo Modigliani. Head. c. 1912. Limestone, 25" high. Solomon R.

Guggenheim Museum,

The Green Violinist. 1918. Oil on canvas, 6'5¾" × 3'6¾".

Guggenheim Museum,

right: 378.

New York. far right: 379. Marc Chagall.

Solomon R.

New York.

his stylized and masklike heads with their columnar necks and ravishing, rich color are among the most enchanting portraits in modern painting (Fig. 377). He left behind a gallery of many of the most celebrated figures of Paris bohemia, and some of the most sensuous nudes of the century. In all his work, Modigliani struck a fine balance between touching, poetic sentiment and stylistic dignity, between romantic vision and some sad, cold reality. The sculpture Modigliani did from time to time embodies a refined, highly personal synthesis of African masks, medieval elongation, and Greek purity of form (Fig. 378).

Romance, pushed to the point of fantasy, as we have seen (Fig. 279), played a large role in the ingratiating art of the decidedly un*maudit* Marc Chagall. After working in a Cubist manner modified by personal and emotional color, Chagall began to explore his imagery of rabbinical figures, village steeples, brides, bouquets, and clocks, derived from memories of Russian-Jewish village life and folklore (Fig. 379). Like so many of the School of Paris painters, Chagall found a satisfying pictorial formula and doggedly stuck with it, becoming in later years a sometimes repetitious performer, although an undeniable popular success, not only in easel painting but also in stained glass and murals, projected on the monumental scale of churches, synagogues, and opera houses.

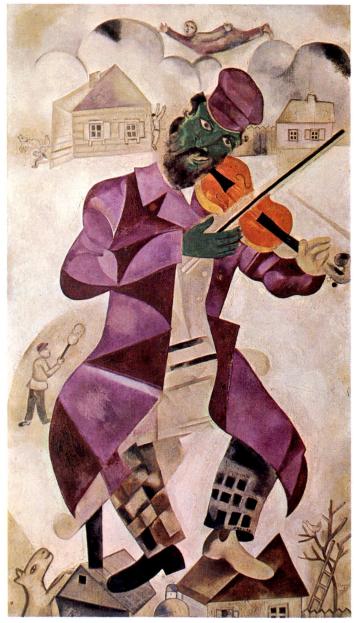

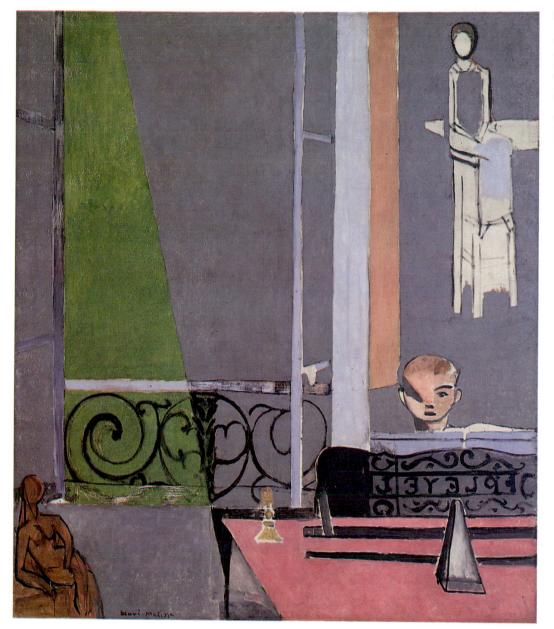

left: 380. Henri Matisse. Piano Lesson. 1916. Oil on canvas, 8'1/2" x 6'113/4". Museum of Modern Art, New York. Mrs. Simon Guggenheim Fund.

below: 381. Henri Matisse. *The Music Lesson.* 1916–17. Oil on canvas, 8' x 6'10¹/2". Barnes Foundation, Merion, Pennsylvania.

Matisse: The Triumph of Pictorial Logic

The popularity and success of Henri Matisse's later work, executed mainly in the South of France, present a remarkable exception to the School of Paris pattern of winning public approval for a tasteful and less challenging type of art. Despite the mundanity and inexhaustible delight of his subtly erotic theme of the female figure, often painted as an exotic odalisque in costume, Matisse's paintings remained so attached to a rigorously logical pictorial process that they must be exempted from the charge of mere decorativeness. Indeed, the return from the formal austerities of such canvases as the Red Studio (Fig. 179) to a more anecdotal and intimate style occurred at the very climax of a period in Matisse's career often called "heroic" or "constructive," for the monumental response the artist made to the challenge of Cubism without ever abandoning his own long-deliberated coloristic principles. In his various interpretations of a given theme, Matisse had always worked progressively toward ever more radical simplification, but in 1916-17 he moved from the culminating, architectonic simplicity of the Piano Lesson to an almost rococo elaboration in the equally grand Music Lesson (Figs. 380, 381). But even in the earlier gray-toned

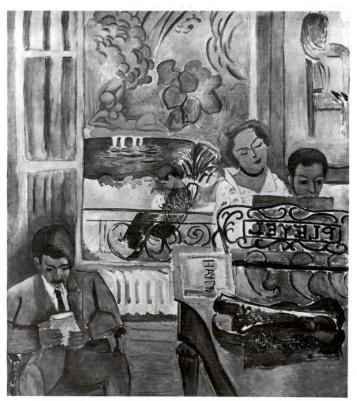

below: 382. Henri Matisse. *The Plumed Hat.* 1919. Pencil on paper, 20¹/8 x 14³/8". Detroit Institute of Arts. Bequest of John S. Newberry.

bottom: 383. Henri Matisse. *The Yellow Dress*. 1929–31. Oil on canvas, 3'3³/8" × 2'8". Baltimore Museum of Art. Cone Collection, formed by Dr. Claribel Cone and Miss Etta Cone of Baltimore, Maryland.

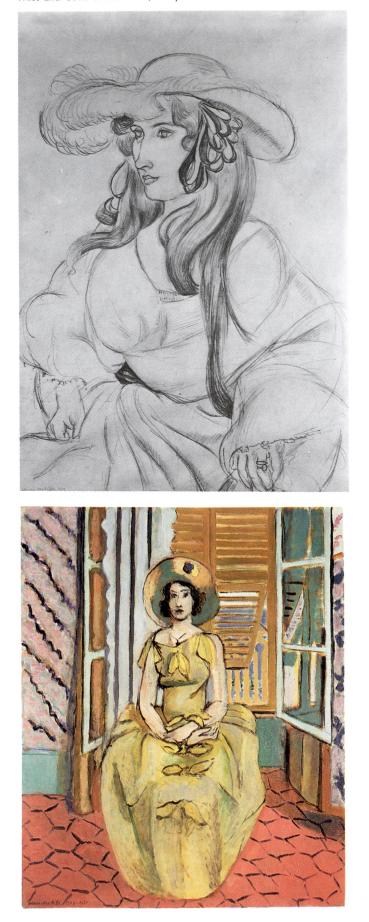

picture, so ruled and structured that the composition conforms almost perfectly to the Golden Section, with its mathematically determined proportions (possibly a tribute to the Section d'Or Cubists of 1912), Matisse balanced his more cerebral, severe, monumental side against the sensuous, lyric, decorative aspects of his artistic nature, the latter clearly evident in the ornamental curves of the window grille and music rack, in the isolated fields of delicate color, and in the intimacy of the family interior.

Here, once again, Matisse triumphed in the fine, Cézannian art of making harmony deep and rich by deriving it from a daring resolution of fundamentally incompatible factors. But while the serenity of such a picture struck some as a reflection of gross indifference to the torments of war-torn Europe, it could also be taken as a statement of the artist's actual credo of optimistic humanism. The latter seems especially valid in the light of the speed with which Matisse reversed his stylistic course in *Music Lesson*, a picture as curvilinear and complex as the Piano Lesson is straight-edged and spare. Although using the same hues, he now allowed vividness to dominate gray, and, along with color, he readmitted both depth and atmosphere. Such shifts proved to be harbingers of things to come in the decade after 1917, when one of the very greatest painters of his century would replace sublime abstraction with charm, intimate scale, soft-focus illusionism, and lush, almost Oriental color, thereby giving free rein to what Matisse himself had termed his "suppressed voluptuousness." Yet, even within an essentially less ambitious manner, the artist remained capable of a monumental and opulent accomplishment. The Plumed Hat is an example of his more relaxed style (Fig. 382), a style that could nevertheless express the more profound implications of form in an image of solemn magnificence.

In the early 1920s Matisse began to paint the exotic odalisques with which the artist is identified in the public mind. In some he used thin medium as radiantly transparent and delicate as watercolor (Fig. 383); in others he modeled form solidly and enriched his surface with pigment that stood out almost in relief (Fig. 384). Whatever his methods, Matisse sought, as always, a solution to the problem that had so concerned the Post-Impressionists: the reconciliation of the illusion of deep space and the flat painting surface. To this end he alternately emphasized elaborate ornament in wallpaper patterns and in a variety of colorful pictorial accessories, and then, by contrast, rudely simplified his models and their settings until they appeared as schematic as the flat, half-blank oval of the child's head in Piano Lesson (Fig. 380). Where Matisse's sentiment and decorative detail threatened to compromise his aesthetic detachment, or trivialize subject matter, he managed to offset this impression by emphasizing the abstracted mood of his models. Their introspective aspect provided a psychological stiffener and gave depth to the prevailing atmosphere of untroubled hedonism.

In his odalisques Matisse revealed himself as an excellent connoisseur of feminine flesh, in the apt phrase of one of his critics. A playful eroticism has been a staple item of French sensibility from the great 18th-century decorators-Watteau, Boucher, Fragonard, among others (Fig. 2)-through such 19th-century exponents as Ingres, Chassériau, and Renoir (Figs. 7, 18). In the more relaxed moments of his "rococo" style Matisse proved himself worthy of that tradition. But by 1927, with the Decorative Figure on an Ornamental Background (Fig. 384), he had again forsaken the minor seductions of subject and medium for a greater expressiveness. Here the artist thickened his pigment to give form sculpturesque definition, at the same time that he also embedded the figure in a wall of florid, insistent decoration, flattening it into the frontal plane. The competition between the nude and her setting, between volume and the planarity of the loaded ornament, is extremely unrestful. If Matisse has not altogether successfully reconciled depth

illusion and the two-dimensional surface, his failure, if indeed there be one, is brilliant and breathtaking for its boldness. As we have seen, Matisse never hesitated to turn his back on his earlier successes and seek more expressive means, "even at the risk," as he once put it, "of sacrificing ... pleasing qualities."

The question of pleasure and its affirmation or denial in artistic form has become basic to an understanding of the oeuvre and ultimate artistic stature of Matisse. Monet had described his later Water Lilies cycle as an island of tranquility for the troubled modern, a decoration in whose presence "nerves strained by work would relax" (Fig. 21). In 1908 Matisse explained his own artistic position in hedonistic terms not unlike Monet's when he alluded to his dream of "an art of balance, of purity and serenity devoid of troubling or depressing subject matter, an art, which would be for every mental worker . . . something like a good armchair in which to rest from physical fatigue."¹

In his search for this ideal, however, Matisse was tireless, as we know from a series of twenty-two photographs taken during the artist's work on the *Pink Nude* of 1935 (Figs. 385, 386). Already past the age of sixty, Matisse set about, with all the vigor of the great 1905–17 period, to strip away the luxuriance of his 1920s style until he had achieved something close to the boldest simplifications of his entire career. By uncrossing the figure's legs and aligning them parallel to the picture plane, by frontalizing the space and reducing the colors to pink, blue, black, and white, by generalizing the nude as a series of flowing, rhythmic curves, gridlocked to the rectilinear flatness of the painting surface, Matisse realized an image that seems the very antithesis of the sculpturesque *Blue*

top: 384. Henri Matisse. Decorative Figure on an Ornamental Background. 1927. Oil on canvas, 4'31/2" × 3'2%". Musée National d'Art Moderne, Paris.

above right: 385. Henri Matisse. Pink Nude, photographed in an early state. c. 1935. Baltimore Museum of Art (Cone Collection).

right: 386. Henri Matisse. *Pink Nude*. 1935. Oil on canvas, 26 × 36½". Baltimore Museum of Art (Cone Collection).

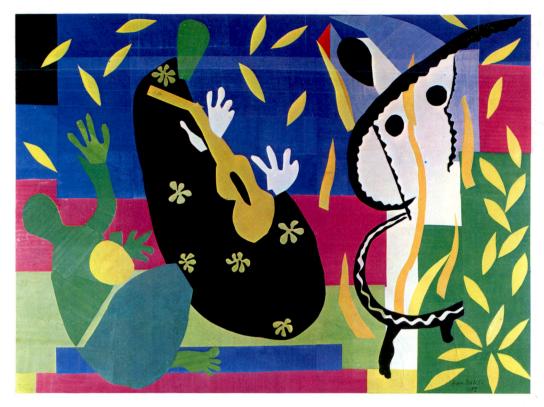

left: 387. Henri Matisse. Sorrows of the King. 1952. Gouache on cut-and-pasted paper, 9'7¹/4" × 12'8". Musée National d'Art Moderne, Paris.

below: 388. Henri Matisse. Chapel of the Rosary of the Dominican Nuns, Vence, France. Consecrated June 25, 1951.

Nude he had painted in 1907 (Fig. 187). While admirers of the earlier work might maintain that in the *Pink Nude* the artist had run, perhaps even been caught in, the risk "of sacrificing … pleasing qualities," the uncompromising pictorial logic that he exercised here so renewed his art, once gain, that the possibilities the 1935 picture revealed—above all, its majestic simplifications and brilliant color shapes—were yet being explored not only by the master himself when he died in 1954, but also by a whole generation of younger abstract painters who emerged in America during the 1940s.

The last two decades of Matisse's career must be measured not only by the easel paintings and occasional sculpture the artist did, but also by his achievement in a variety of forms of what can be loosely termed "decoration." The first of a number of illustrated books, *The Poems of Stéphane Mallarmé*, appeared in 1932, published by Albert Skira. For the twenty-nine etchings reproduced in the volume Matisse worked without light and shade or even the interior modeling of his early graphic work. Instead, he expressed everything by a rhythmic, cursive line of descriptive economy that renders form almost abstractly, yet endows it with a suggestion of ample volumes.

Like many of the truly great artists of history-Michelangelo, Titian, Rembrandt, and Ingres, among them-Matisse found, in his old age, hitherto untapped reserves of creative energy. Crippled with arthritis and maimed by inept surgery, he developed an incredibly vigorous and joyful style in the technique of découpage ("cut" paper). Lying on his back in bed, sketching with charcoal fastened to the end of a stick, on paper suspended overhead, and working with cut shapes colored with gouache according to his directions, Matisse "cut into color," as he put it, and created some of the most exultant and noble compositions of this, or any other, time (Fig. 387). In 1951 he designed murals, chasubles, stained-glass windows, and furniture decorations for the Dominican Chapel of the Rosary at Vence (Fig. 388). These gay designs attest to the lyrical upsurge of the splendid twilight of the artist's long career. They also bring to a fitting conclusion the Fauvist tendency to juxtapose broad areas of pure tone in order to endow color with maximum

The School of Paris between the Wars **222**

intensity. Matisse's late mural-like art, moreover, provided an acknowledged source of inspiration for the powerful New York School that emerged after World War II. Once this developed into that purely optical art called Color Field Painting (Figs. 496, 497, 576–582), it proved all over again the conviction of both Cézanne and Matisse that by itself color could create the full range of effects—depth as well as flatness, contours as well as planes, the substantive as well as the illusory.

Matisse did not attempt to comment on the tragic events of his time in the scalding manner of Picasso in his politically motivated *Guernica* (Fig. 391). But there are absolute values in painting, beyond good and evil and beyond the pressure of history. Matisse addressed himself unsparingly to major pictorial problems, mastering them in his own vital idiom. His formal solutions were actually as convincing and pertinent as any, including the inspired geometries of orthodox Cubism. Although Matisse has frequently been disparaged for ignoring the urgent moral and political issues that raged about him, his art is a perpetual challenge to the pessimistic

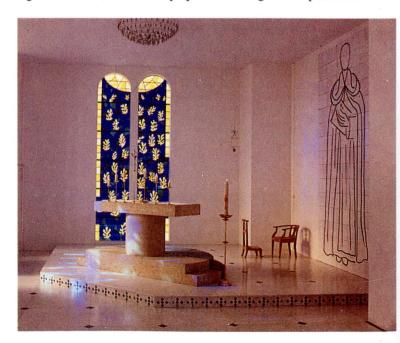

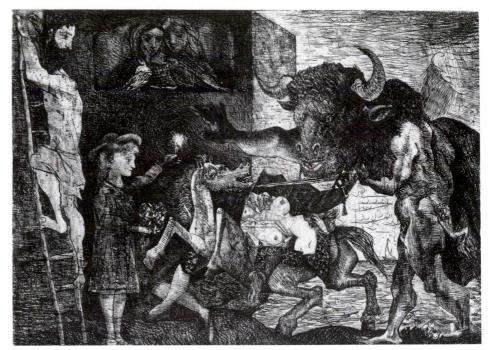

right: 389. Pablo Picasso. Minotauromachy. 1935. Etching, 19½×27¼". Museum of Modern Art, New York. Purchase Fund.

> below: 390. Pablo Picasso. The Dream and Lie of Franco II. 1937. Etching and aquatint, 12% × 16½". Museum of Modern Art, New York. Gift of Mrs. Stanley Resor.

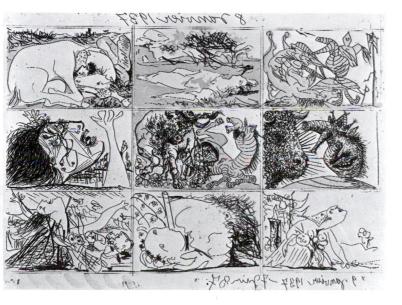

mood and sense of estrangement and anxiety that sometimes seem to dominate the age. His range of content was more limited than Picasso's in that he did not try to interweave formal invention and an art of ideas. Yet his creation of an art of profound intellect and sensuousness, an essentially civilized art, was also a way of preserving important human values in a time of social crisis. As a painter per se, he was without peer; within his own genre, he is the only artist who truly challenges Picasso for the right to be considered the dominant painter of the first half of the 20th century.

Picasso: Protean Master of Ideas and Passions

Perhaps there is no real rivalry after all between the two greatest artists of our time because they partake of different spheres. Matisse belongs to that order of artists who express themselves through possibilities inherent in the language of painting, and Picasso identifies with those who use painting to express ideology, states of mind, the life of the passions, or some of the more mysterious aspects of human and aesthetic experience (see Chap. 9 and Figs. 331–339). In the period between the wars Picasso continued to enlarge the possible meanings of art by inventing visual symbols and new myths to deal with the violence that increasingly held sway over European history. After 1930 he began to explore the symbolism of the bull and the bullfight, themes that had played such an important role in Goya's art. The bull became a projection of Picasso's deepest atavistic impulses and, in the next years, an even more precise moral symbol of the threat of fascist tyranny.

In 1935 Picasso created a powerful, fearful, and yet somehow hopeful image in his greatest etching, Minotauromachy (Fig. 389). After a visit to his homeland, soon to be plunged into a suicidal civil war, and with fascism sweeping across Europe, the artist turned to the bullfight and to Greek mythology for images sufficiently terrible and rich in meaning to convey his feelings. In the etching he made the great man-bull form of the Minotaur (symbol of virility and oppressive power) the dominant image. The beast advances on a seashore into a shadowed corner toward the figure of a young girl holding flowers and a candle, reminiscent of the innocent childvictims of Picasso's circus paintings (Fig. 223). A female matador lies rigid in death across the back of a gored and terror-stricken, perhaps expiring, horse-the ritualistic sacrifice of the bull ring. The child calmly faces the monster bull, while a Christlike man tries to escape on a ladder. In a window overlooking the scene, a pair of young women behind two doves watch the drama. As an allegory, the scene does not explicitly declare its meaning, but one can discern Picasso's familiar play of harmonious and convulsive images, all evoked with a Rembrandtesque command of graphic means and chiaroscuro effects.

Picasso was a fervent Loyalist partisan in the Spanish Civil War and accepted from the Republican government an appointment as director of the Prado, although he never succeeded in getting to Spain to assume official duties. The artist fought his personal war against fascism, however, in visual images that became the most eloquent indictments of organized brutality in modern times. In 1937 he did a series of etchings entitled *The Dream and Lie of Franco* (Fig. 390) and wrote a violent Surrealist poem to accompany the plates. It described Franco as "an evil-omened polyp

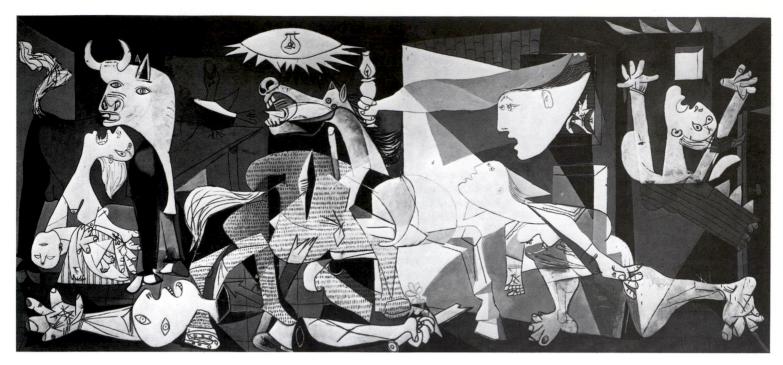

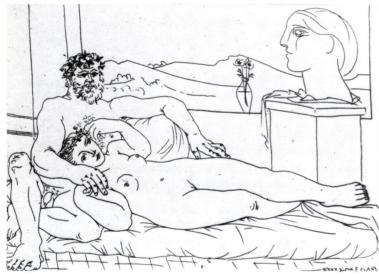

his mouth full of the chinch-bug jelly of his words," and the dictator emerges in the drawings as a hairy, three-pronged turnip with carious teeth and a ludicrous paper-hat crown. The rape of Spain is shown in an episodic sequence of scenes and images: a moribund horse, human cadavers, women fleeing with dead children. The Franco "polyp" turns into a horselike beast in one episode, only to be disemboweled by an avenging bull. In another the majestic head of a bull confronts Franco's animal-vegetable incarnation and shrivels into impotence.

In the same year, Picasso painted his huge, tragic mural *Guernica* (Fig. 391), surely the most celebrated of all antifascist art works. Commissioned for the Spanish Pavilion at the Paris World's Fair, *Guernica* came forth as a commemoration of the Basque town attacked by German dive bombers under Franco's command, the first instance of a civilian population subjected to the devastations of military air power. To dramatize the wartime agony of death and senseless destruction, the artist restricted his coloristic means to stark black, white, and gray. A broken, mangled form of a warrior at the base of the composition, his sculpturesque features askew; a woman with a dead child; a disemboweled horse at the center with a spear-point tongue; another woman whose

above: 391. Pablo Picasso. Guernica. 1937. Oil on canvas, 11′5½″ × 25′5¾″. Prado, Madrid.

left: 392. Pablo Picasso. Vollard Suite No. 63
(Sculptor and Reclining Model by a Window Viewing a Sculptured Head, from the Sculptor's Studio Suite). Paris, 1933.
Etching, 7% × 10½". Museum of Modern Art, New York.

nipples have become bolts and who is crazed and cross-eyed with pain and grief—all these images and the expressive deformations have now become potent, universal emblems of bitter affliction. Two forms dominate the composition: the triumphant bull and the dying horse. Out of a window juts the fearful face of a woman and a long arm, like an hallucination. She holds a lamp over the scene, a symbol of the conscience of a horrified humanity.

Picasso explained the symbolism of the work with a childlike simplicity, declaring that the bull "is brutality and darkness the horse represents the people." The painting has the impact of a nightmare and the bold schematic presentation of the comic strip. By formalizing pain and grief, the strict decorative arrangement and strong figurative conventions managed to intensify the emotions Picasso wished to convey. Much of Guernica's force derives from the cruel distortions of the imagery, all pioneered by the liberating procedures of Cubism and Surrealism and made all the more dramatic for being organized within the shallow, compressed depth and gridlike structure of Cubist space. In these forms Picasso found a powerful subjective equivalent for public chaos and aggression. By dissociating the anatomies of his protagonists, he expressed our deepest fears and terrors. Many writers have pointed out the resemblance of drawings of the insane to Picasso's inventions: the disorganized anatomy, the double-profile, the compulsive repetition of ornamental pattern. One of the profoundly tragic meanings of Guernica is the projection, through a controlled symbolism, of a kind of mass insanity in the language of psychotic drawing. Goya (Fig. 4), in his "Caprices," had written an inscription to one of his etchings that "the sleep of reason produces monsters." In Guernica Picasso added an up-to-date, clinical postscript to Goya's vision of man's inhumanity to man in one of the most eloquent and memorable artistic statements of our century.

In the years after *Guernica* Picasso explored, with inexhaustible variation, the themes of portraits and figures with features

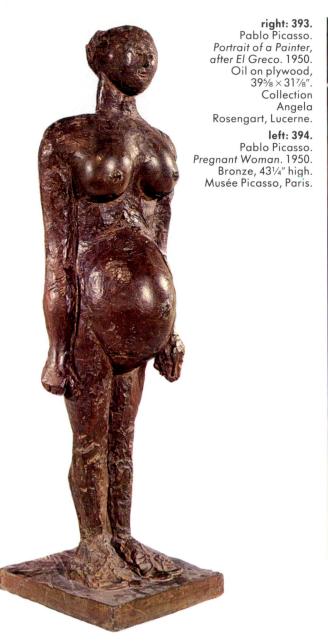

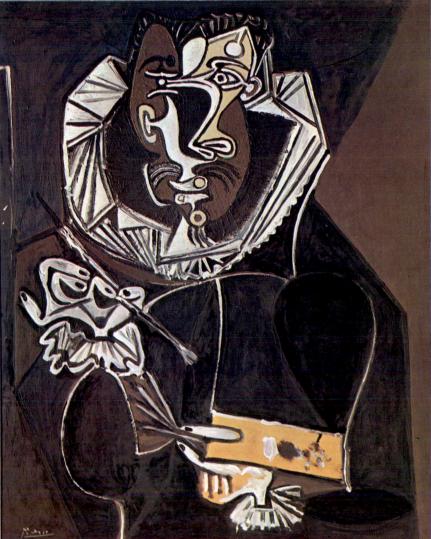

askew, constantly intensifying their Expressionist violence. At the same time, he continued to draw and make prints in a classical spirit (Fig. 392). In fact, Picasso became a kind of voracious master thief able to transmute influence and style from any period of culture and make them his own. Behind his stylistic virtuosity and his insatiable historical memory lies the conviction that all art styles exist simultaneously and form one continuous living present. "To me there is no past or future in art," he wrote. "If a work of art cannot live always in the present, it must not be considered at all. The art of the Greeks, of the Egyptians, of the great painters who lived in other times, is not an art of the past; perhaps it is more alive today than it ever was."² Picasso possessed a universal mind in the grand style of Delacroix (Fig. 8), and had a vast artistic culture at his disposal. The rich resources in art history that he could command were evident up to the very close of his life, when he played repeated variations on artistic themes, and in styles that evoked such illustrious names as Rembrandt, Cranach, El Greco, and Velázquez (Fig. 393). Picasso's arbitrary changes of manner often seemed comparable to James Joyce's parodies of literary modes. Like Joyce in literature, Picasso became perhaps our greatest myth-maker in the visual arts.

Without worrying unduly about formal consistency, Picasso drew freely from the Hellenic mainstream of humanist culture, from peripheral Mediterranean civilizations, and from the barbaric imagery of primitive peoples. In his imagery he shuttled brilliantly between Greco-Roman tradition and primitive art and found inspiration in their opposition. The bland, ideal beauty of Classical heads was recaptured in a lithograph; in a ceramic or a bronze, Cycladic, Etruscan, or Negro sculpture could be the inspiration, passed through the sieve of Cubism. Often the two sources fused in a painting or a drawing, establishing that characteristic psychological frisson between the civilized outer person and the awareness of subconscious forces that lurk not far beneath the surface (Fig. 338). What gave significance to Picasso's erudition and recondite insight was pure artistic temperament. Sensibility vitalized every material and medium he touched in prints, paintings, sculptures, or the decorative arts. Almost seventy years old, Picasso made Pregnant Woman (Fig. 394) in 1950 as "a form of wish fulfillment," according to Françoise Gilot, the mother of the artist's two small children. By embedding large ceramic jars into the plaster cast and positioning them like breasts and belly, Picasso gave literal expression to his notion of woman as a vessel of the life-engendering principle. Until his death at the age of ninety-four, Picasso went on creating passionate and formally coherent imagery in a variety of modes. He always seemed capable of refreshing his vision, and behaved as if his art stood at the threshold of new beginnings, unprejudiced by his past achievement or taste.

395. Joan Miró. Personnages rythmiques. 1934. Oil on canvas, $6'4'' \times 5'7\%'$. Kunstsammlung Nordrhein-Westfalen, Düsseldorf.

Miró: Protest and Poetry Through Plastic Means

Among the great modern masters working in Paris between the wars, Joan Miró, first seen in the context of Surrealism (Figs. 307, 308, 323), provides a remarkable balance of political involvement and artistic detachment, which places him halfway between the positions of Picasso and Matisse. In 1933, after several years of making collages, Miró began to see in his compositions of realistic details, torn and pasted together from newspapers, the possibilities of an organic kind of abstraction that for him was new, although the sensuous biomorphic imagery it produced resembles that of Arp (Fig. 328). The painting in Figure 395 must be included among the most majestic, yet whimsical and mysterious in the whole of Miró's

396. Joan Miró. Still Life with Old Shoe. 1937. Oil on canvas, 32 × 46". Museum of Modern Art, New York. James Thrall Soby Bequest.

The School of Paris between the Wars

oeuvre. On a dusky, atmospheric ground that modulates from green to blue to brown and finally to orange float immaculate, grandly curvilinear shapes that play a witty game of alternating between opacity and transparency, between color and black or white, and between free form and humanoid figuration, the latter complete with tiny monster-like heads and sly sexual implications.

Shortly after this serene interlude, however, Miró joined Picasso in his angry reaction to the Spanish Civil War. Although never so outspoken as Picasso, Miró did use painting as an eloquent vehicle to express his feelings of wrath and dismay at the course of events in his homeland. In 1937 he painted his most naturalistic representation in many years, Still Life with Old Shoe (Fig. 396), at the same time that he riddled it with double images, as if the incorporation of Surrealist techniques of dissociation might expose the underlying hallucinatory chararacter of solid material existence. Both his realism and the adaptation of that genre to Surrealist methods represented an effort to reconcile the return to objective reality with the pressure of somber events in Spain. "Between the years 1938 and 1940," the artist declared, "I once again became interested in realism. Perhaps the interest began as early as 1937 in Still Life with Old Shoe. Perhaps the events of the day, particularly the drama of the war in Spain, made me feel that I ought to soak myself in reality. I used to go every day to the Grande Chaumière to work from a model. At the time I felt a need to control things by reality."3

With the tragic war in Spain very much on his mind, Miró also painted, in 1937, a large mural decoration entitled The Reaper (now lost) as a pendant in the Spanish Pavilion to Picasso's Guernica. The intensity of The Reaper (Fig. 397), its vehemence of color and form, suggests that it had some special significance for the artist. The torn, disjointed figure with its tuberous snout and stemlike neck possesses definite affinities with Picasso's animal-vegetable incarnation of Franco in The Dream and Lie of Franco (Fig. 390). Miró's figure seems to push its way up out of a malevolent soil like some obscene growth, into a flaming apocalyptic night. Another powerful example of the figural distortions he worked in 1937 is Woman's Head (Fig. 398), so reminiscent of Picasso's stricken, weeping women in the Guernica. Both Miró and Picasso present us with fearsome images of violence, incomprehension, and perhaps even madness. The younger artist's figure is grotesque in its brutal transformation of the human form into an insectile creature. Yet the supplicating gesture of the arms and the curiously blank, red eye strangely invite pity.

top: 397. Joan Miró. The Reaper. 1937. Mural decoration for the Paris Exposition of 1937. Oil on masonite, 13'6" × 8'2½". Present whereabouts unknown.

right: 398. Joan Miró. Woman's Head. 1938. Oil on canvas, 18×215%". Minneapolis Institute of Art. Gift of Mr. and Mrs. Donald Winston. At the end of the 1930s Miró redirected his art once more. Abandoning the emotionalism and high-pitched dramatic expression of the works inspired by tragic public events, he embarked upon a more neutral, flat calligraphic manner and produced a series of brilliant gouaches called Constellations (Fig. 399). It was a period when his farfetched, poetic titles often suggested the irrational system of causality in a Rube Goldberg cartoon, for example, *Drop* of Rose Falling from the Wing of a Bird Waking Rosalie Asleep in the Shade of a Cobweb. If the punning titles seemed gratuitously fey, they did capture the linking-and-chaining action of the artist's inexhaustible, metamorphic invention. Miró described these exotic and elegant paintings, whose fable-like qualities and aestheticism seemed remote from the anguished mood of work he made during the Spanish Civil War:

In 1939 began a new stage of my work ... about the time when the war broke out. I felt a deep desire to escape. I closed myself within myself purposely. The night, music, and the stars began to play a major role in suggesting my paintings. Music had always appealed to me, and now music in this period began to take the role poetry had played in the early twenties.⁴

Even after the fall of France in 1940 and his abrupt departure for Palma de Mallorca, Miró continued making rather decorative work in a new spirit of controlled objectivity. The Constellations, he asserted, "were based on reflections in water," since his "main aim was to achieve a compositional balance."⁵

The Constellation paintings reduced Miro's familiar signs to a molecular structure of points, dots, and crisp interconnecting lines, forming an intensely active surface animated by bright color accents. It does seem rather incredible that at such a desperate moment in history Miró could have so completely withdrawn from outside events and created these untroubled lyrical images. But rather than evade, perhaps he wished to console. It was as though, the worst having happened, the artist rejected pessimism and illogically discovered new possibilities for the expression of humor, joy, and therefore hope and reconciliation. With the paintings of 1939 and 1940, he gave greater emphasis to the material function of medium, thereby identifying action and passion with immediate physical sensations rather than with the drama familiar from his fabulous world of personages.

The shifting aesthetic grounds of Miró's expression, from the development of an iconic imagery to a free graphism, became even more apparent during World War II once the artist renewed his interest in ceramics. Like Picasso, Miró now seemed able to find ever new, expressive possibilities in a wide range of materials and to work freely in a new mood of resolution and relaxed playfulness (Fig. 400). In the postwar years his art changed little; yet, so firmly did Miró establish his distinctive way of seeing that even his most casual forms and rudimentary gestures in his chosen medium seem masterful and carry a resonance of residual poetic and plastic meanings.

below: 399. Joan Miró. On the 13th, the Ladder Brushed the Firmament (Constellation Series). 1940. Gouache and oil wash on paper, 18½×15″. Collection Mrs. H. Gates Lloyd, Haverford, Pa.

bottom: 400. Joan Miró, executed with Joseph Lloréns Artigas. *Alicia*. 1965–67. Ceramic tile, 8'1" × 17'4½". Solomon R. Guggenheim Museum, New York.

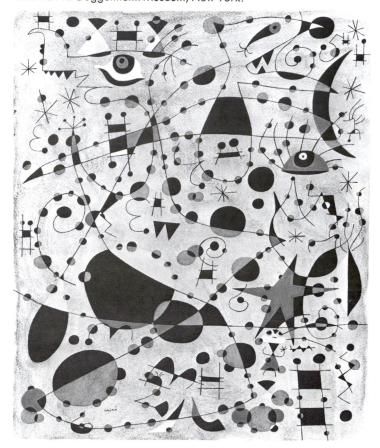

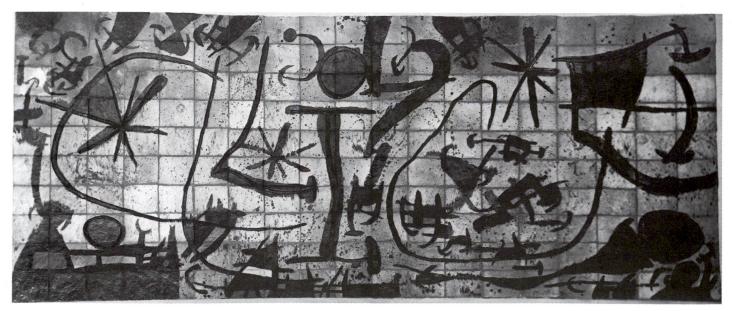

The School of Paris between the Wars 228

Braque and Dufy: The Enduring Vigor of French Classicism

Unlike the Spaniards Picasso and Miró, Braque-the great cofounder of Cubism (Figs. 219, 228, 232, 235, 238)-continued to be involved with the problems of paintings rather than politics all during the twenties and thirties. Reflecting the conservative mood after the war, Braque made a tentative return to the representation of natural appearances. His forms became even freer and less schematized, as his descriptive content grew more particularized, most remarkably in a series of grandly conceived, large-scale still-life pictures with their contents-guitar, music score, compote and fruit, pipe, newspaper-arranged on small marble-topped pedestal tables called guéridons (Fig. 401). But instead of leading the way in a relationship with Picasso, Braque in the years after the warwhich had left him with a permanent injury-followed the Synthetic Cubist precedent set during the hostilities by Gris as well as Picasso (Figs. 240, 249). Flattening and shuffling his forms like playing cards, he lent his composition a new sense of spacious opulence by means of steep views, overlapping, broadly cursive contours, sumptuous textures (sometimes laced with sand), and subtle but color-enriched tonal harmonies. Against low-keyed backgrounds of beige-gray, apple green, and brown he painted in the most delicate tones the "dark purple of a grape, the bloom of a peach, the yellow brown of a pear,"⁶ as Henry Hope described these effects in his monograph on the painter. Then, contemporaneously with Picasso's neoclassical figures, Braque began to paint large, semidraped female figures of classical inspiration, his so-called *canéphores*, or "basket carriers" (Fig. 402). They vaguely suggested Renoir's late "strawberry" nudes in their ample proportions and loose modeling, albeit schematized as flat, abstract shapes.

During the 1930s Braque made a number of sketches, prints, plaques, and sculptures of nymphs and classical figures, utilizing a flowing calligraphic line. And, in the late years of the decade, he began to play off dramatically illuminated areas against deep shadow, and out of these contrasts to create a pictorial world of serene and gentle phantoms. At the same time he also completed a masterly series of compositions in which figures occasionally appear among a host of still-life compositions, only to be rendered as flat silhouettes, divided in half somewhat like Picasso's double heads and shaped to fit within an overall angular pattern of color

left: 401. Georges Braque. Le Guéridon (The Round Table). 1929.
Oil on canvas, 4'11¹/4" x 3'8³/4". Phillips Collection, Washington, D.C.
right: 402. Georges Braque. Canéphore (Nude Woman with a Basket of Fruit). 1926. Oil on canvas, 5'3³/4" x 2'5¹/4".
National Gallery of Art (Chester Dale Collection), Washington, D.C.

The School of Paris between the Wars
229

opposite above: 403. Georges Braque. The Trellis. 1954. Oil and sand on canvas, 4'3'/4" square. Private collection.

opposite below: 404. Raoul Dufy. Normandy Landscape. c. 1949. Oil on panel, $6\frac{1}{2} \times 14\frac{7}{6}$ ". Private collection.

and design (Fig. 403). Into these complex and fully integrated compositions the artist poured his enormous skill in orchestrating rich textures, elaborate configurations, and somber tonalities, whose dusky glow emanates from a unifying coat of black underpainting. Like the colors "liberated from form," the sovereign unity within the complexity of these paintings simply reinforces the themeclearly a model posed in the artist's studio-to reassert the modernist belief in the self-sufficient world of art and the imagination. Braque seemed almost Buddhist in his desire to make objects identifiable but important only for their share in the pictorial unity of the whole. "Objects do not exist for me," he said, "except insofar as an harmonious relation exists between them and also between them and myself. When one attains to this harmony, one reaches a sort of intellectual nonexistence which makes everything possible and right."⁷ While Picasso energetically expanded his art in all directions, Braque sought ever greater concentration and refinement, and so transformed Cubism into an Old Master art that he entered the pantheon of French classical painters. As an artist of supreme sensibility, measure, clarity, and balance, Braque was a legitimate heir to the poetic classicism of Poussin, Watteau, and Cézanne.

And so too was Braque's fellow Havrais Raoul Dufy (Fig. 173), who, unlike Braque, remained almost as faithful to Fauve principles as Matisse. In the course of a prodigiously active career, which produced not only thousands of oil paintings, watercolors, and drawings, but also high-fashion textile designs, illustrated books, ceramics, and stage designs, Dufy refined his style until it became famous for the independence the artist allowed his radiant color and highly simplified, rhythmic drawing (Fig. 404). Treating the one in broad, rainbow washes and the other as a terse but graceful form of representational shorthand, Dufy made his civilized art an ongoing celebration of his favorite subjects—regattas, racecourses, concert halls, and illustrious musicians, such as Mozart. Rarely has a major artist given so much pleasure—or received so little critical attention, until, that is, the recent advent of new decorative art, some of whose practitioners regard Dufy as a true avatar.

School of Paris Sculpture

We have considered a number of the principal modern sculptors working in Paris between the wars, notably Brancusi (Figs. 118, 123) and those identified with Surrealism: Giacometti, Arp, and Ernst (Figs. 325-330). One of the most original and influential developments took fire in the 1920s when Julio González (1876-1942), Picasso's fellow countryman and technical assistant, began to help the Cubist master construct a number of his own welded sculptures (Fig. 335). Together they invented open, welded-iron construction, a form of drawing in space made possible by modern industrial technology. In later decades González's independent role as one of the true makers and shapers of modern sculpture became apparent (Figs. 405, 406). More than perhaps any other individual, González had initiated the era of welded-metal sculpture-a technical innovation that would play a dominant role among the post-World War II generation of sculptors. Cubism, abstraction, and even Surrealist fantasy were all deftly blended in his work.

González had an innate passion for iron. Not only did his native Spain endow him with an ancestry long famous for its master craftsmen in metal, but the entire González family worked professionally in bronze and forged and beaten iron. With this background, González later wrote: The age of iron began many centuries ago by producing very beautiful objects, unfortunately, for a large part, arms. Today, it provides, as well, bridges and railroads. It is time this metal ceased to be a murderer and the simple instrument of a super-mechanical science. Today the door is wide open for this material to be, at last, forged and hammered by the peaceful hands of an artist.⁸

Still, painting interested González more than sculpture for many years after he settled in Paris in 1900. It was not until the mid-1920s that he came to grips at last with his true medium of expression, experimenting with incised sheet metal to make relief masks styled in the Analytical Cubist manner. Even then his mature style emerged only when he began to assist Picasso in forming welded-iron constructions. As a consequence, González made his great contribution to modern art only in the last dozen years of his life. Under Picasso's influence, he achieved a more abstract style and began to use space and intervals between forms as expressive sculptural elements. In *Woman Combing Her Hair* (Fig. 405) the artist schematized his motifs in conventions very close to Picasso's openwork fantastic bone figures and anatomies of the same year. Although Picasso stimulated González's welded-metal sculpture,

> 405. Julio González. Woman Combing Her Hair. 1936. Wrought iron, 4'4"×1'111½"×2'5%". Museum of Modern Art, New York. Mrs. Simon Guggenheim Fund.

406. Julio González. *The Montserrat*. 1936–37. Sheet iron, 5′5″ high. Stedelijk Museum, Amsterdam.

the artist asserted his independence in a personal, rugged expressive manner. For the Spanish Pavilion at the 1937 Paris World's Fair, González, like Picasso and Miró, delivered a memorable monument and a public symbol of Spain's anguish (Fig. 406). His figure was more humanist than his formidable abstract sculptures, many of which closely resembled Picasso's nightmarish Surreal

The School of Paris between the Wars

232

opposite top: 407. Jacques Lipchitz. Reclining Nude with Guitar. 1928. Bronze, 27" long. Hirshhorn Museum and Sculpture Garden, Smithsonian Institution, Washington, D.C.

opposite below left: 408. Jacques Lipchitz. Figure. 1926–30 (cast 1937). Bronze, 7'11¼" x 3'25%". Museum of Modern Art, New York. Van Gogh Purchase Fund.

opposite below right: 409. Jacques Lipchitz. Mother and Child II. 1941–45. Bronze, 4'2" x 4'3". Museum of Modern Art, New York. Mrs. Simon Guggenheim Fund.

imagery. For the pavilion González used sheet metal to create a recognizable and poignant peasant woman holding a child in one arm, a scythe in the other. He named the sculpture *The Montserrat* after Catalonia's holy mountain. The title thus suggested that the sculpture was a symbol of Spanish populist will and resistance to Nazi intervention and aggression in the civil war.

The open-iron sculptures of Picasso and González had antecedents in the work of the Cubist Jacques Lipchitz (Fig. 245), although this artist always made a point of realizing his more composed metal forms in finished bronze castings. Cubism liberated Lipchitz from an earlier, stylized representational work, but even after he deserted Cubism, the visual language it had announced-the compression of many forms into a compact mass and adventurous probing of many viewpoints-remained central to his philosophy of art. Although his later work became the antithesis of his early flat, vertical images, Lipchitz continued to call himself a Cubist. In the 1920s he developed a more open, wiry style involving space as an integral element in the sculptures known as Transparents (Fig. 407). Almost all of these pieces were done on a smaller scale (none over 20 inches high and most much smaller). Related to them, but virtually unique in Lipchitz's oeuvre, was the ferocious primitive icon called simply Figure (Fig. 408). This monstrous yet compelling image stands totem-like with hypnotically staring eyes, dominating its environment. It is the one example of monumental work done in the manner of the small Transparents, and it demonstrates the artist's ability to integrate three-dimensional mass and space in a rhythmically organized plastic form of great expressive energy.

Later, Lipchitz developed a powerfully rhythmical, undulant, Baroque style. In his work during and since World War II appeared swelling, massive volumes with tumultuous shapes and a curving, complex flow of lines, with an almost Rodinesque counterpoint of solid and void and light and dark. These sculptures were far removed from his early production in both theme and form. As in Figure 409, Cubist Harlequins and guitars were replaced by subjects imbued with stirring feelings, poetic statements on the tragedy of human existence, personal heroism, and even a religious symbolism of transcendence. Fully as forceful in design as Figure and more complex in its symbolism, the Mother and Child II seen here conveys with potent eloquence the shattering mood of World War II. First there is the visual impact of unusual shapes and a decided somberness of mood as the legless mother and the truncated arms impress themselves on the spectator. Gradually, one is aware that these arms join the torso to form the image of a bull's horned head. According to the sculptor, the statue had materialized almost subconsciously. Only after it took on its final appearance did Lipchitz recall the full origin of the haunting image and its meaning for him. Years before, the artist had heard a musical voice in a rainy square and seen a legless beggar woman, supported on a cart, singing courageously into the night. The beast's head refers to the ancient Greek myth of Zeus in the guise of a bull carrying off Europa, who gave her name to the Continent. Thus, the total composition became a moving wartime elegy to an occupied but undaunted Europe.

 The School of Paris between the Wars

 233

International Abstraction: Constructivism and the Bauhaus

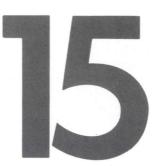

nder the dominant influences of Cubism, Constructivism, De Stijl, abstract Surrealism, and, of course, Brancusi, abstraction rather than a humanist imagery became the favored mode of sculpture in the period between the great world wars. The approach ranged between two extremes: the biomorphism, on the one hand, of Arp's concretions, with the somewhat related forms of a new figure in England, Henry Moore, and, on the other, Purist geometric and architectural forms purged of all human or naturalistic reference. We have seen how Constructivism emerged in Russia at the outbreak of the Revolution when an adventurous avant-garde, with utopian visions of a new society, created a vital art in rigorously abstract modes (Figs. 264-271). The Constructivists managed to make their disciplined forms symbolic statements at the same time, inspired encomia to a new world of science and technology, with its unfolding possibilities for social betterment in an egalitarian society. Very shortly, however, the conservative Soviet regime would patronize only academism and Social, or Socialist, Realism, repudiating abstract innovation entirely. Official disapproval became apparent in 1922, the year of the most impor-

left: 410. Naum Gabo. Linear Construction, Variation. 1942–43. Plastic and nylon thread, 24¹/₈" square. Phillips Collection, Washington, D.C.

above: 411. Naum Gabo. Construction for the Bijenkorf Department Store, Rotterdam. 1954–57. Steel, bronze wire, and freestone substructure; 7'1" high. tant international showing of Constructivist art at a Soviet-sponsored exhibition held at the Van Diemen Gallery in Berlin. As a result of the interest generated by that show, Naum Gabo and Antoine Pevsner left Russia in 1922, and in 1924 the brothers held their first joint exhibition in Paris at the Percier Gallery, where Alexander Calder a few years later was to show his first mobiles.

The Old Masters of Constructivism: Gabo and Pevsner

Naum Gabo, after first settling in Berlin, disseminated his Constructivist ideas in Great Britain, where he moved in 1935, and then in the United States, his residence following the war. During the 1930s and 1940s he made more use of new and stronger transparent plastics than those originally available to him (Fig. 271), always for the purpose of incorporating space as a positive element rather than something displaced or enclosed. In several works Gabo wound skeins of plastic thread around frameworks composed of a few planes, cut as identical parts but placed in reverse relation to each other (Fig. 410). In 1954 he turned to metal again to create the largest and most impressive example of Constructivist sculpture, the colossal freestanding form beside the Bijenkorf Department Store in Rotterdam (Fig. 411).

Gabo's brother, Antoine Pevsner, who also left Russia in 1922 but wound up based in Paris, preferred to work consistently, not with the transparent and translucent plastics favored by Gabo, but rather with metals, such as bronze, which reflect rather than transmit light, thereby calling attention to the surface. In 1948 Pevsner created Construction in the Egg, a complex organization of curved planes and spaces based on an egg shape (Fig. 412). Bundles of bronze rods organized in curving sheets define the complicated, intricately interacting planes. Both light, reflected from the metal surfaces, and space play major roles in the total form, while the egg motif relates the notions of the cell and growth to that of form. The dynamism of the growth concept becomes very active as the shapes seem to spiral, almost tornado-like, around a core of centrifugal energy. In the years that followed, Gabo and Pevsner continued to evolve their Constructivist ideas-ideas dealing mainly with the definition of space as a major element in sculpture through the use of new materials and the application of engineering principles. Pevsner remained in France, working there, with few interruptions, until his death in 1962.

412. Antoine Pevsner. Construction in the Egg. 1948. Bronze, 28" high. Collection P. Peissi, Paris.

Abstraction's Heirs in Great Britain

Great Britain produced the only new sculptor of international stature to emerge in the 1930s, which seems all the more remarkable given the genteel reaction that had set in following the explosive violence of the Vorticist movement on the eve of World War I. During that brief and abortive interlude, British artists such as Wyndham Lewis (1882–1957) and David Bomberg had made some of the first totally abstract paintings and drawings to be achieved in modern Western art (Fig. 413). Although the term Vorticism, coined by the poet Ezra Pound in 1913, was meant to suggest a whirling force powerful enough to absorb and synthesize all the positive elements then present within the chaos of modernist theories, the actual imagery formulated by the Vorticists was neither centrifugal nor circular but uncompromisingly angular, diagonal, and harsh. What these artists hoped to do, as they stated in their publication Blast, was integrate the dynamics of Futurism with the static monumentality of Cubism and thus attain an overall effect higher-more ideal, classical, and certainly more abstract-than was possible with either the Cubists' studio motifs or the Futurists' mechanolatry. Vorticism disintegrated in about 1915 from the disruptions caused first by the movement's own internecine quarrels and finally by the outbreak of the real war. Still, remnants of it could long be found in the lines of force and other aspects of Cubo-Futurist style that Lewis continued to effect in his more conventional art (Fig. 414).

In the 1920s, when caution rather than boldness seemed in order, British art was dominated by something like the very mode the Vorticists had rebelled against: the decorative Fauve manner of Vanessa Bell (1879–1961) and Duncan Grant, a manner these artists had practiced with sustained freshness and vitality since they first acquired it during Roger Fry's celebrated Post-Impressionist exhibitions at the Grafton Galleries in 1910-11 and 1912 (Fig. 415). As so often has been the case with British artists, Bell and Grant adhered to a highly personal vision, in this instance shaped more by their membership in the Bloomsbury Group, with its "significant form" aesthetics, than by the latest Continental experiments. The spirit of English insularity also brought forth Stanley Spencer (1891–1959), who had survived the shattering experience of war to transfigure it in such mystical and figurative works as that in Figure 416, its intensity of religious feeling and faux-naïf style often compared to the art of William Blake.

While Bell, Grant, and Spencer had little impact outside their immediate circles, Henry Moore (1898–1986), another unmistakably "English" master, emerged as a major figure who created an independent position for his art halfway between what appeared to be the mutually contradictory tendencies of Surrealism and abstrac-

above: 413. Wyndham Lewis. Composition. 1913. Pencil, pen and ink, watercolor; 13½ × 10½". Tate Gallery, London. © of Mrs. G.A. Wyndham Lewis. By permission.

right: 414. Wyndham Lewis. Portrait of Edith Sitwell. 1923–25. Oil on canvas, 33⅓ × 42⅔." Tate Gallery, London.

International Abstraction

above: 415. Vanessa Bell. Interior with a Table. 1921. Oil on canvas, $21\frac{1}{4} \times 25\frac{1}{4}$ ". Tate Gallery, London.

right: 416. Stanley Spencer. Christ's Entry into Jerusalem. c. 1920. Oil on canvas, 3'9" × 4'9". Leeds City Galleries.

below: 417. Henry Moore. Recumbent Figure. 1938. Elmwood, 6'3" long. Private collection.

International Abstraction

right: 418. Pablo Picasso. Bathers. 1928. Pen, brush, and India ink; 11⁷/₈ × 8³/₄". Musée Picasso, Paris.

tion (Fig. 417). Moore made himself welcome in both camps, joining the International Surrealist Exhibition held in London in 1936 and contributing to *Circle*, the Constructivist manifesto edited in London in 1937 by Gabo and Ben Nicholson. Picasso's drawings and paintings of imaginary monuments in the late 1920s and Arp's biomorphism (Figs. 328, 418) all bore a relationship to Moore's organic forms, with their holes and rounded protuberances. Yet even the most blank and expressionless figures created by the English artist had tremors of mysterious energy that spoke of psychic awareness. Moore evolved his highly personal sculptural manner by taking elements from both types of art, the psychological probing and the blandest abstraction. To these he added the influence of English Romantic tradition and that of primitive cultures, particularly such ancient Mexican art as the sacrificial urns carved in the form of recumbent Chacmool (Rain Spirit) figures from the Yucatan (Fig. 419). Moore always evinced an interest in such natural forms as eroded bones and water-worn pebbles, objects shaped by time which seem to possess a special significance for human experience. In this sense he was primarily the Surrealist and humanist rather than the pure abstract artist. Moore accepted Surrealist notions of the hidden meanings of natural shapes, the central role of intuition in perceiving such meanings, and the analogous character of primitive and mythic

420. Henry Moore. Shelterers in the Tube. 1941. Pen and ink, chalk, and watercolor; 15×22". Tate Gallery, London.

imagery. In one revealing statement, the artist said: "Because a work does not aim at reproducing natural appearances it is not, therefore, an escape from life—but may be a penetration into reality . . . an expression of the significance of life, a stimulation to greater effort in living."

Among the principal images to preoccupy Moore were his monumental reclining female figures. The one in Figure 417 offers a fine example of the theme, which the artist carried out year after year in so many versions, in wood, cast metal, and stone, always with a commitment to a "truth of materials" principle reminiscent of the English Arts and Crafts movement. The human form is defined in a series of rhythmical relations between massive or attenuated solids and pierced voids, with open, "negative" areas developed altogether as deliberately as the positive densities. Formally, this work demonstrates Moore's involvement with the problem of correlating internal and external elements. Iconographically, it illustrates his continuing concern with a female image suggesting the ancient theme of the Great Mother. Moore endowed his archetypal fertility figure with ample, generalized masses that evoke natural landscape as much as they do thighs, breasts, and other features of the female anatomy. Few sculptors have expressed the relationship of hollow cavities to solid form so powerfully or effectively. Moore once said: "The hole connects one side to the other, making it immediately

left: 421. Henry Moore. *Madonna and Child.* 1943–44. Hornton stone, 4'11" high. Saint Matthew's Church, Northampton, England. By permission of the Vicar.

below: 422. Henry Moore. Nuclear Energy (Memorial to the First Self-sustaining Controlled Nuclear Chain Reaction). 1967. Bronze, 16'6" high. University of Chicago.

more three-dimensional. A hole can itself have as much shapemeaning as a solid mass. The mystery of the hole—the mysterious fascination of caves in hillsides and cliffs." While here may indeed be the voice of the traditional English nature poet, Moore cultivated his special sensibility until in art it rings with almost Shakespearean breadth and universality.

During World War II Moore made a memorable series of drawings of the huddled sleeping figures who were sheltered in London's subway tunnels (Fig. 420). From these drawings dated his interest in figure groups and the design potentialities of drapery, which resulted in the notable public commission after the war of his *Madonna and Child* in Saint Matthew's, Northampton, among others (Fig. 421). When Moore received a large retrospective at New York's Museum of Modern Art in 1946, and then won the major sculpture prize two years later at the Venice Biennale, his international reputation was assured. Following the war, he continued to develop the themes that interested him in the 1930s, while adding some new ones, such as his relatively mechanistic *Nuclear Energy* (Fig. 422) and numerous large-scale public commissions

International Abstraction
239

in bronze, many of them enlarged with the help of assistants working from small models (Fig. 423). The most monumental of these are powerfully telluric in character, resembling vast mountainscapes broken apart and "scattered" across the terrain. But even though the "boulders" can be walked about and the "caves" entered, the arrangement of the whole still evokes the peaks and valleys of the human body, with the result that the compositions, however vast their scale, continue to assert the artist's enduring humanism.

Closely associated with Henry Moore and still more committed to abstraction was Barbara Hepworth (1903–75), who with her husband, the painter Ben Nicholson (Fig. 425), Moore, and the art critic Herbert Read formed the generative center of British avantgarde art in the years leading up to World War II. Even before she met Braque, Brancusi, Picasso, and Mondrian, during a trip to Paris in 1932, Hepworth had experimented with the "hole," the pierced form that became a virtual hallmark of her art, and that Moore himself would adopt in the early thirties. But while Moore tended toward Picassoid figuration, Hepworth favored the organic abstraction pioneered by Arp or, subsequently, the Constructivism of Gabo. A representative work is Sculpture with Color and String (Fig 424), oval or spiral in form, excavated at the center, and harp-strung in the manner first introduced by Gabo (Fig. 410). Hepworth also liked to color the interior of her circular shells. "The colour in the concavities," she said, "plunges me into the depth of water, caves, of shadows deeper than the carved concavities themselves."² Like Moore, Hepworth had a profound feeling not only for nature but also for the nature of materials, which she worked and finished with loving care. An advocate of direct carving in wood during the thirties, Hepworth eventually took up both bronze and marble.

The painter Ben Nicholson (1894–1982) completed the trio of important British abstractionists who came into their own in the 1930s. When Naum Gabo arrived in England in 1937, bringing with him the ideas of Abstraction-Création (see p. 246), Nicholson joined the great Russian Constructivist to publish the review *Circle*, which contained contributions by Mondrian, among others. Nicholson and his wife, Barbara Hepworth, were just beginning to break away from an art tied to observation and create works using the visual

vocabulary defined by Theo van Doesburg in his well-known *Manifesto of Concrete Art*. With the arrival of Mondrian from Paris in 1938, they received both reinforcement and resplendent example (Fig. 276). The geometrical abstraction that Nicholson practiced with such purity throughout four decades, often in the form of low, cardboard-thin reliefs, essentially came to birth at this time (Fig. 425). After meeting Mondrian, Nicholson developed the characteristic arrangements of circles, squares, and fine vertical-horizon-tal linear divisions that he would scarcely modify thereafter. Over time and in contact with new movements, he endowed them with still more delicate color, exquisitely calculated composition, and challenging qualities of optical ambiguity.

above: 423. Henry Moore. Lincoln Center Reclining Figure. 1963–65. Bronze, 16' high. Lincoln Center for the Performing Arts, Inc., New York.

left: 424. Barbara Hepworth. Sculpture with Color and String. 1939–61. Bronze. Private collection.

The Bauhaus and the Purist Aesthetic

The art of Henry Moore and Barbara Hepworth may be stamped with picturesque reminders of English Romantic tradition, but the abstract conventions they so fluently mastered confirmed the fact that a new universality, and even a somewhat academic spirit, had overtaken international abstract art. The major sources of the new visual language essentially represented an amalgam of the fantasy of abstract Surrealism and the geometric vocabulary of Cubism, the absorption in science, engineering, and the new industrial materials of Constructivism. By the 1930s it had become clear that a lingua franca was evolving not only in European sculpture but in painting, architecture, and design as well. The establishment and the influential activities of the Bauhaus (Fig. 358) did a great deal to replace the rather tarnished romantic individualism of contemporary Expressionist or Surrealist art with a different ideal based on the similar feeling for form in various fields of art. The free, organic shapes favored by Brancusi, Arp, Miró, Moore, and Hepworth, the formal rigors of Mondrian's De Stijl, and Constructivist art in three dimensions, with its kinship to the engineer's precise structures, soon made themselves felt in the design of everyday objects and buildings.

In its technical teaching, however, the Bauhaus neither attempted to propagate nor did it achieve a particular style or doctrine; instead, the school sought to come to some kind of artistic reconciliation with the machine age, to open it up to new forms and new potentialities of creativity. The Bauhaus episode generated a fresh awareness throughout the world that the machine and its products were capable of producing beauty in art based not merely on craftsmanship but also upon functional appropriateness, clarity, and precision—a beauty not of applied ornament but of abstract forms.

Among the Cubists, Fernand Léger had for some time operated on the optimistic Bauhaus assumptions that art made in the industrial age would do well to adopt the character of machine forms, but in a eulogistic spirit rather than through the derisive ironies of Duchamp and Picabia (Figs. 288, 289, 295). The climax came in 1919 with *The City*, already seen in Figure 253. An ardent socialist, Léger hoped to bring forth a popular as well as an aesthetically progressive art. Thus, he could take the brilliant, simple colors of poster art and combine them with machine imagery—disks and drive shafts, for instance—to produce, by means of Cubist principles, pictures that came close to the pure abstraction of his 1913–14 work (Fig. 252). In 1921 Léger joined the return to classical taste and for *Three Women* (Fig. 426) revived a subject long

above: 425.

Ben Nicholson. Painted Relief. 1939. Synthetic board mounted on plywood, painted; 32⁷/₆ × 45". Museum of Modern Art, New York. Gift of H.S. Ede and the artist (by exchange).

left: 426.

Fernand Léger. Three Women (Le Grand Déjeuner). 1921. Oil on canvas, 6'1/4" × 8'3". Museum of Modern Árt, New York. Mrs. Simon Guggenheim Fund.

below: 428. Vasily Kandinsky. On White. 1923. Oil on canvas, 3'5"×3'2¼". Private collection, Paris.

above: 427. Amédée Ozenfant. The Vases. 1925. Oil on canvas, 4'3%"×3'2%". Museum of Modern Art, New York. Acquired through the Lillie P. Bliss Bequest.

traditional in French painting—nudes in an interior—only to make the normally voluptuous figures look as if they had been assembled from hub caps and other such machined and interchangeable parts. One wit called them a cross between Poussin and Voisin motors. But although unmistakably a work by Léger, the painting speaks with the syntax of the international modernism then emerging. In the grandeur of its scale, in its mural flatness and theatrical impact, *Three Women* belongs to the same world as Picasso's exactly contemporaneous *Three Musicians* (Fig.241). Meanwhile, Purism seems acknowledged in the still life filling the upper right corner, De Stijl in the rear wall, Synthetic Cubism in the patterned floor, and Art Deco in the sleekness and polish of everything.

Léger's interest in common objects was extended into a coherent aesthetic philosophy by the contemporary effort of the socalled Purists Amédée Ozenfant (1886-1966) and Charles-Édouard Jeanneret (better known as the architect Le Corbusier; Figs. 341, 344), who in a 1918 manifesto entitled After Cubism attacked that style for having degenerated into what they considered mere decoration. The Purists proposed to launch "a campaign for the reconstitution of a healthy art" and to "inoculate artists with the spirit of the age." Their model, as we saw in Figure 254, would be "the lessons inherent in the precision of machinery"; thus, they advocated that form be adjusted to function. In Figure 427 Ozenfant illustrated the point by creating a picture of cool abstraction, composed of the fundamental shapes of basic tools and utensils, painted in subdued colors, and arranged in the frontal, flattening Synthetic Cubist manner. The Purists' impulse to establish intelligible visual conventions for painting based upon machine design and manufactured objects of common use ultimately became institutionalized and codified in the Bauhaus curriculum.

When Kandinsky arrived at the Bauhaus in 1922 he had already begun to work in the new international language of severe geometric forms (Fig. 428), rather than in the spontaneous, painterly style of his first nonobjective improvisations (Fig. 195). The shift actually took place in Russia, where the artist had returned after the outbreak of World War I and remained long enough to be influenced by Malevich, Rodchenko, and Tatlin (Figs. 267, 269, 270). Under the Lunacharsky administration he even had an opportunity to convert his theoretical ideas about the nature of art into practical projects within the general program of state-controlled cultural education. Like Malevich, however, Kandinsky found his conception of art as a spiritual process at odds with the Utilitarian doctrines of the Constructivists. Thus, when his programs were rejected, he decided to leave Russia, which he did for the last time in 1921, and join the Bauhaus faculty, a position that gave him paramount influence over the direction of modernist art throughout the 1920s. At the Bauhaus, however, Kandinsky himself submitted to the influence of his fellow teacher Paul Klee (Figs. 202–204), and even the crisper, more geometrical and precisely defined abstractions that the Russian master produced at Weimar retained some of the Expressionist, romantic mood of his Blue Rider period in prewar Munich.

With the closure of the Bauhaus in 1933, Kandinsky moved to Paris and proved as sensitive as ever to new ideas, this time from Surrealism and the Abstraction-Création group (Fig. 436). As if liberated from old conflicts, the artist proceeded toward a late style in which he integrated the intellectual and lyrical aspects of his inspiration and brought his art to full flower in a series of masterpieces of almost Oriental—perhaps Mongolian—splendor (Fig. 429). Now the dynamism of old resolved into a kind of serene exuberance, yielding brilliant, stellated works in which freedom and control, the geometric and the organic, lush color and rigorous form play against one another in a state of vital equilibrium.

Another important figure in the fundamental changeover at the Bauhaus from the aesthetics of Expressionism to a structured abstract art was the Russian El (Eliezer) Lissitzky (1890–1947). Following engineering studies in Germany, Lissitzky returned to his native land at the outbreak of war and studied architecture in Moscow. In 1919 he moved to Vitebsk in order to work with Malevich and develop what he perceived to be the possibilities of Suprematism. In the same year, while teaching in the studio of Graphic Arts, Printing, and Architecture at Vitebsk's Popular College of Art, he executed his first *Proun* ("For the New Art"), to use a term the artist would later give his abstract paintings. Like Kandinsky, Gabo, and Pevsner, Lissitzky could not tolerate the growing conservatism of Soviet Russia and left for Germany. After designing and arranging the famous 1922 exhibition at Berlin's Van Diemen Gallery, the first comprehensive view the West had of Russian mod-

above: 429. Vasily Kandinsky. Tempered Élan. 1944. Oil on cardboard, 16½×227%". Private collection, Paris.

left: 430. El Lissitzky. Proun. 1924. Gouache, 20¼×19½". Van Abbemuseum, Eindhoven.

ernism (later seen in Amsterdam), Lissitzky went on to touch almost every base of modernist vanguard activity in Central Europe, and thus served as a key agent in the cross-fertilization and spread of the Constructivist doctrine. He helped bring together the Suprematism, or nonobjectivism, of Malevich, the Constructivism of Tatlin and Rodchenko, and Theo van Doesburg's De Stijl (Fig. 353), and then, through Gropius and Moholy-Nagy, transmitted those ideas to the Bauhaus, whose international student body guaranteed their wide dissemination. Lissitzky had further impact when, with Hans Richter and Mies van der Rohe, he cofounded the Constructivist group and its magazine G. In his own art, Lissitzky transformed the Constructivist vocabulary of geometric forms on one plane into an illusion of three-dimensionality (Fig. 430). He also sought a multiple spatial and functional identity for his forms, declaring: "A Proun is a station for changing trains from architecture to painting." Proun demonstrated the artist's unusual ability to organize two-dimensional and three-dimensional abstract figures in compositions of great purity and balance while avoiding symmetrical arrangements.

Another Bauhaus figure who did much to convert abstraction into universal currency was Josef Albers (1888–1976). As did Lissitzky, but by different means, Albers explored three-dimensional illusion, first in glass paintings and woodcuts, which he called

431. Josef Albers. Walls and Posts (Thermometer Style). 1928. Sandblasted opaque glass colored red, white, and black; 11¾ × 12¼". Metropolitan Museum of Art, New York. George A. Hearn Fund.

Impossibles (Fig. 431). Their titles, like their forms, suggest contradictory systems of perceiving the same geometric configuration, somewhat in the manner of the reversible optical illusions that gestalt psychology utilized to demonstrate perceptual dynamics. Albers and Moholy-Nagy gave the celebrated preliminary course in basic design at the Bauhaus, which has had such a powerful and enduring effect on visual education throughout the world. When Hitler suppressed the Bauhaus in 1933 Albers embarked on a long and influential American teaching career, first at Black Mountain College in North Carolina, then at Harvard, and finally for another decade at Yale, until his retirement in 1960. In the course of his teaching, he renewed the foundations of abstract Constructivist art, and went far beyond the original Bauhaus precepts and practices to discover a new basis for a perceptually heightened color expression. His most universally famous works are those in the long series of paintings entitled Homage to the Square (Fig. 432), their compositions reduced to "nests" of squares each of which is defined by a subtly contrasting hue or tone, chosen to interact with the other colors and thus induce sensations, such as contraction and expansion, altogether contrary to the squares' flat, static, locked-in character. Simply stated, Albers's art and teaching brought the closest possible focus to the problem of "how do we see the third dimension when created as an illusion by the artist in terms of lines, flat shapes, and colors on a two-dimensional surface?" Such concerns, combined with his Homage to the Square pictures, have given Albers the reputation of father of the postwar Op Art movement (Figs. 583, 584).

The presence at the Bauhaus after 1923 of Hungarian-born László Moholy-Nagy (1895–1946) helped crystallize a drastic

432. Josef Albers. Homage to the Square. 1961. Oil on board, 23%" square. Collection Cardazzo, Venice.

International Abstraction

433. László Moholy-Nagy. Composition No. 2. 1923–24. Woodcut, 4×4½". Museum of Modern Art, New York. Katherine S. Dreier Bequest.

change in Bauhaus aesthetics of far-reaching consequences. In place of the individualistic Expressionism and a mysticism about materials employed in its original pedagogy, the Bauhaus negotiated a distinctive shift to the atmosphere of controlled laboratory exercises. Johannes Itten, an Expressionist painter, had taught the preliminary course. When Albers and Moholy-Nagy replaced him in 1923, they abandoned his intuitive approach for more objective and rationalist methods. Taking advantage of many aspects of modern technology, such as visual experience derived from photography, and using industrial materials, among them clear plastics, they organized their teaching essentially around a core of Constructivist aesthetics (Fig. 433). At the Bauhaus, Moholy-Nagy's influence was second only to that of Walter Gropius, the director. With Gropius, Moholy-Nagy edited the fourteen Bauhaus books that appeared between 1925 and 1930 and included major theoretical statements by Malevich, Mondrian, van Doesburg, Gropius, Klee, and himself. His books, particularly The New Vision (1938) and Vision in Motion (1947) have been widely read and remain influential throughout the world.

One of Moholy-Nagy's boldest and most prophetic inventions was his *Light-Space Modulator*, the first electrically powered sculpture that emitted light (Fig. 434). It stood with Gabo's *Kinetic Construction: Vibrating Spring* (Fig. 435), made in 1920, as the paradigm and archetype of kinetic art for sculptors of later decades. Moholy-Nagy considered his metal, glass, and plastic light machine to be both a Constructivist sculpture in its own right and an instrument for articulating light in motion—what he called an "architecture of light," and what today we would call a "light environment." The work engages our interest as a complex open-form sculpture of revolving mesh grids and perforated disks, and for its

> **435.** Naum Gabo. Kinetic Construction: Vibrating Spring. 1920. Metal rod, vibrating by means of a spring; 18" high without base. Tate Gallery, London.

below: 434. László Moholy-Nagy. Light-Space Modulator. 1921–30. Mobile construction of steel, plastic, and wood; 4'11½" high. Busch-Reisinger Museum of Germanic Culture, Harvard University, Cambridge, Mass. Gift of Mrs. Sibyl Moholy-Nagy.

436. Auguste Herbin. Air, Fire. 1944. Oil on canvas, 5' × 7'8". Musée National d'Art Moderne, Paris.

projections of changing configurations of light and shadow on the walls and ceiling of a room as it rotates. An emphatic advocate of the Constructivist doctrine that so-called "fine art" must be integrated with the total environment, Moholy-Nagy saw his machine as a forerunner of controlled light shows on a vast scale, to be projected on clouds and used in an industrial and urban context-a program that was actually fulfilled in the 1960s by such artists as Otto Piene and Nicolas Schöffer (Fig. 630). Moholy-Nagy was also a visionary in regard to Minimal Art and the modern concept of anonymous authorship. As early as 1922 he ordered a group of enamel "paintings" over the telephone from a sign factory, which meticulously followed his specifications but carried out all the details of execution without the artist present. In his first Bauhaus book, Painting, Photography, Film (1925), he wrote with startling foresight: "People believe that they should demand hand execution as an inseparable part of the genesis of a work of art. In fact, in comparison with the inventive mental process of the genesis of a work, the question of its execution is important only insofar as it must be mastered to the limits. The manner, however, whether personal or by assignment of labor, whether manual or mechanical, is irrelevant."

Abstraction-Création

When Hitler suppressed the Bauhaus in 1933, Kandinsky moved to Paris, where he joined Gabo, a refugee from Berlin, his brother Pevsner, already a resident, as well as many other foreign abstractionists, to bring to the European art capital more "concrete art," as abstraction was often called, than the humanist, classicizing French had ever been willing to accept. Matisse and Picasso, as we know, had long before gone to the brink of totally nonrepresentational art, and both Delaunay and Léger had actually crossed over it (Figs. 250, 252), briefly, but all four ended up firmly committed to the perceptual experience of external reality, even in their most liberated works. Still, abstraction survived as a kind of underground movement carried on by lesser masters, until 1930 when the artist-critic Michel Seuphor and the Uruguayan painter Joaquín Torres-García founded *Cercle et Carré* ("Circle and Square") and began publishing a periodical by the same name.

Although short-lived, Cercle et Carré led to the formation in 1931 of a comparable group called Abstraction-Création, led by Georges Vantongerloo and Auguste Herbin. Under its broad umbrella gathered abstract artists (as many as four hundred!) from every branch of modernism and every part of Europe, with the result that distinctions broke down and abstraction took on a very general character compounded of both organic and geometric modes. Apart from the great nonobjective works already seen from the 1930s in Paris, by Mondrian and Kandinsky, for instance (Figs. 276, 429), Abstraction-Création was most distinctive for having encouraged a few French artists to go the whole way in abandoning identifiable subject matter. Working mainly under the influence of French Cubism, especially the machine style of Léger, and De Stijl, these artists included Jean Hélion and Jean Gorin, in addition to Auguste Herbin (1882–1960), whose compositions based on flat colors, hard edges, and geometrical shapes (Fig. 436) made him an elder statesman of both Op and Pop movements in the postwar period. In 1949 Herbin published L'Art non-figuratif et non-objectif, in which he drew on the color theories of the poet Goethe for his ideas about the psychological effects of color.

As the Nazi menace grew, Moholy-Nagy, Gropius, and many of the other leading figures at the Bauhaus emigrated first to Britain and then to America. In the United States their theory and design methods entered the basic teaching curricula of innumerable art and architecture schools, based upon Moholy-Nagy's example at his own Institute of Design (now part of the Illinois Institute of Technology) and of Albers's at Yale. The architecture and design principles developed at the Bauhaus circulated broadly through the American work of Ludwig Mies van der Rohe, Marcel Breuer, Herbert Bayer, and others (Fig. 636). The Bauhaus thus had a direct impact on both American design and fine arts, and it became an important force in either establishing or reviving in the United States the international abstract traditions that the European avant-garde had long before assimilated.

American Art in the Wake of the Armory Show

Although comparatively few in number, American artists had been active at the centers of European art—not only London and Paris but also Munich, Düsseldorf, Florence, and Rome since colonial times, when Benjamin West and John Singleton Copley migrated to London and became court painters in the reign of George III. And as we have seen in the case of Whistler (Fig. 78), Americans such as Mary Cassatt made an honorable place for themselves in Europe's most advance aesthetic movements as these evolved in the late 19th century. However, the American

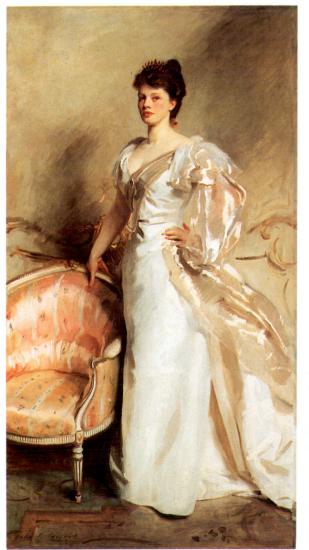

artist who enjoyed the highest international reputation prior to the Great War was John Singer Sargent (1856–1925), a dazzling technician in the painterly manner of Hals and Velázquez (Fig. 437), but a master largely content, despite his sophisticated awareness of the latest ideas, to exploit the easy taste for an enhanced realism required by fashionable sitters eager to commission sumptuous and flattering portraits. Less compromising contemporaries were Thomas Eakins (1884–1916) and Winslow Homer (1836–1910), who, after considerable study abroad, remained at home and pro-

left: 437. John Singer Sargent. Mrs. George Swinton (Elizabeth Ebsworth). Oil on canvas, 24¹/₂ × 17¹/₄". Art Institute of Chicago. Wirt D. Walker Collection.

below: 438. Thomas Eakins. *Miss Van Buren.* c. 1889–91. Oil on canvas, 45 x 32". Phillips Collection, Washington, D.C.

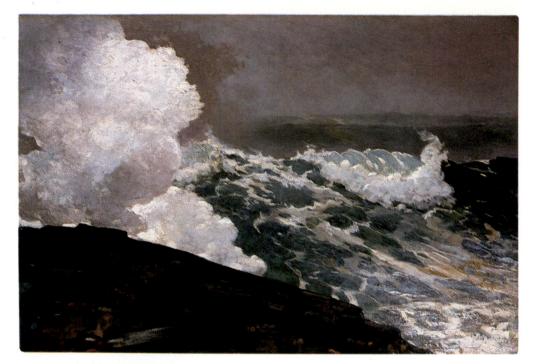

duced landscapes, portraits, and genre paintings so rigorous in their pictorial integrity and so unsentimental in spirit that they encountered scant success outside a small circle of hardy admirers (Figs. 438, 439). Even more obscure and self-determined was Albert Pinkham Ryder (1847–1917), a supreme example of the flip side of the American Realist coin. This reclusive naïf saw nature in pantheistic, visionary terms and painted land, sea, and moonlight as if imbued with sublime, supernatural meaning (Fig. 440). But, for all his admirable qualities as a poet in paint and an ancestor of the great Abstract Expressionists who would appear after World War II, it was not Ryder but Homer and Eakins who worked within the mainstream of American art, the realism announced so clearly by West and Copley. Thus, when the reaction against academic values came, just as it did in Europe, the movement went in the direction of an even more insistent realism and brought forth the Ash Can School, so-called for its practitioners' tendency to favor subject matter rooted in the grimy urbanscape of New York (Figs.

American Art in the Wake of the Armory Show

above: 439. Winslow Homer. Northeaster. 1895. Oil on canvas, 20'10¾" × 4'2¼". Metropolitan Museum of Art, New York. Gift of George A. Hearn, 1910.

left: 440. Albert Pinkham Ryder. Moonlight Marine. 1870–90. Oil on wood, 11% × 12". Metropolitan Museum of Art, New York. Samuel D. Lee Fund, 1934.

below: 441. Robert Henri. Laughing Child. 1907. Oil on canvas, 24 × 20". Whitney Museum of American Art, New York.

442. John Sloan. Hairdresser's Window. 1907. Oil on canvas, 31⁷/₈ × 26". Wadsworth Atheneum (Ella Gallup Sumner and Mary Catlin Sumner Collection), Hartford, Conn.

441, 442). It was this that scandalized the public and made the Eight—as the eight Ash Can painters called themselves—the object of heated discussions at the time of their first group exhibition in 1908. Aesthetically, however, Robert Henri and his immediate followers had scarcely progressed beyond Courbet and Daumier, with an occasional but uncomprehending gesture toward Manet and the Impressionists. Even so, they represented, in the minds of most, radical modern art in the United States when suddenly the real thing burst upon the scene just before the outbreak of World War I.

Stieglitz, 291, and the Armory Show

Lacking in the strong visual traditions of European modernism, or its commitment to theoretical principles that linked avant-garde art, especially abstraction, to a vision of an ideal society, American progressive art in the 20th century would follow an erratic course, alternating between initial enthusiasm for the experimental and then retrenchment during the 1920s and 1930s in a more provincial and familiar vein of pastoral or urban realism. Before the Armory Show had its broad and shattering effect, the primary catalyst for the bolder attempts to reconcile true European modernism with the American scene was the pioneer photographer and impresario of the arts, Alfred Stieglitz, who as early as 1906 had established his tiny New York gallery on Fifth Avenue, a gallery later known by its street number, 291. In a characteristic declaration, mixing highmindedness and sympathy for radical aesthetics, Stieglitz had promised that his little gallery would remain hospitable to artistic effort in any medium so long as it showed "honesty of aim, honesty of self-expression, honesty of revolt against the autocracy of convention." On a more exalted note the American poet Marianne Moore later described 291 as "an American Acropolis so to speak, with a stove in it, a kind of eagle's perch of selectiveness, and like the ardor of fire in its completeness."² Almost immediately, the gallery became the headquarters for international mod-

American Art in the Wake of the Armory Show

ern art in the United States. Despite the minute scale and limited influence of the 291 program, the list of important European artists whose work was first shown in America by Stieglitz, on the advice of the Paris-based American photographer Edward Steichen, is an impressive one: Rodin, Cézanne, Toulouse-Lautrec, Henri Rousseau, Matisse, Picasso, and Brancusi; and native debuts were made there by some of the most adventurous American moderns: Max Weber (Fig. 443), Arthur Dove, John Marin, Alfred Maurer, Marsden Hartley, Joseph Stella, and Georgia O'Keeffe.

A far more decisive factor in the development of a native avantgarde was, however, the celebrated Armory Show, so-called for the cavernous home of the 69th Regiment, which still exists on Manhattan's Lexington Avenue at 26th Street, where a tremendous collection of modern European art, numbering some two thousand pieces, hung for almost a month in early 1913. Organized by a group of New York artists, calling themselves the Association of American Painters and Sculptors, it set out to bring before the public art "usually neglected by current shows." Curiously, the impetus came from conservatives and members of the Eight, who, while hopelessly out of tune with the latest European trends, maintained a free, open, vehemently antiacademic attitude, in contrast to the more exclusive, doctrinaire stance of the relatively progressive Stieglitz camp. Under the leadership of the socially influential and enlightened Arthur B. Davies, a sylphs-inthe-moonlight Symbolist member of the Eight, and Walt Kuhn, a powerful if somewhat primitive painter of Fauvist high-colored clowns, the Association managed to have shipped to New York a good portion of the great Sonderbund exhibition held in Cologne during the autumn of 1912, as well as works from Roger Fry's concurrent Matisse and Picasso show at the Grafton Galleries in London. Through Walter Pach, an American painter and critic resident in Paris, Kuhn also made contact with the Stein circle, the avantgarde dealer Ambroise Vollard, and the painters Marcel Duchamp and Jacques Villon. Back home and euphoric over the exhibition's prospects, Kuhn wrote to Pach: "We want this old show of ours to mark the starting point of a new spirit in art, at least as far as America is concerned."3 By "a new spirit," Kuhn meant that he wanted the exhibition to unite the laissez-faire, democratic approach of the Eight with the aesthetic sophistication of Stieglitz's 291.

left: 443. Max Weber. Chinese Restaurant. 1915.
Oil on canvas, 40 × 48".
Whitney Museum of American Art, New York.
below: 444. The Rude Descending the Staircase (Rush Hour at the Subway).

Cartoon illustrating "Seeing New York with a Cubist" in the New York Evening Sun, March 20, 1913.

When the Armory Show opened, festooned with banners and pine bows paid for by Gertrude Vanderbilt Whitney, herself an active artist and later the founder of the New York museum bearing her name, it brought before the public-a public scarcely aware of art more recent than Rosa Bonheur's Horse Fair (1853-55)-works by Ingres, Daumier, Courbet, Corot, and Manet, the major Impressionists, Gauguin, van Gogh, Cézanne, Seurat, Cross, and Henri Rousseau, the Fauves, including thirteen Matisses, the Cubists, not only Picasso and Braque but also Léger, de la Fresnave, Gleizes, Picabia, and Duchamp. Davies, with his Symbolist proclivities, had made certain that Puvis de Chavannes and the Nabis would also be present, moreover that Redon would dominate the exhibition with thirty-two oils. While clearly rich in its account of French art, the Armory Show did little to inform Americans about German Expressionism, represented by a single Kirchner landscape and one Kandinsky improvisation. Unacceptable provisions for hanging cost the exhibition not only the Orphic Cubists but also the Futurists. Cubist sculpture too got short shrift, even though works by Rodin, Maillol, Brancusi, and Lehmbruck stood among the pictures.

As for the Americans, they contributed hundreds of their most ambitious works, only to see them overwhelmed, first by the sheer authority of the European pieces, but then by the avalanche of notoriety that an ignorant and jingoistic press unleashed upon the foreign entries. Critics, reporters, editorial writers, and cartoonists had a field day lampooning what they took to be the scandalous manifestations of an alien, degenerate, and politically dangerous culture. Duchamp's *Nude Descending a Staircase* (Fig. 255) became a *cause célèbre* by inspiring the most shameless and frequent mockery (Fig. 444). Even the liberal-minded Teddy Roosevelt confessed that the picture reminded him of a Navajo blanket, while others called it "an explosion in a shingle factory" or a "staircase descending a nude." Paris, although less vulgar about it, had been equally hostile to new art from Manet onward, and only recently had a Parisian critic rejoiced that no one but crazy Americans and Russians were collecting the works of Matisse and Picasso. Americans, however, had always considered themselves revolutionary, eagerly pushing out to fresh frontiers, but these were social, political, or economic, if not geographical. Thus, when confronted with the Armory Show, they felt all the more outraged and threatened, mainly by confusing radical aesthetics with radical political and social behavior. The New York Times, after describing the show as "pathological," went on to editorialize that the Armory modernists were "cousins to the anarchists." Art and Progress, the official magazine of the American Federation of Arts, compared the European artists not only to anarchists but even to "bomb throwers, lunatics, depravers." Chicago and Boston, where selections from the show traveled, proved no less indignant, although, remarkably, cool and appreciative voices could also be heard in all three cities, arguing that the liberating values of contemporary art were actually the values basic to American society.

But whatever the individual persuasion and however circus the atmosphere, the public flocked to behold the innovative artistic wonders from Europe, and by the time the show closed, nearly 300,000 people had seen it. Although relatively few in number, enough of these had been converted for the exhibition to be counted a success in its aim of initiating "a new spirit in art." Coming at such a moment of unprecedented and intense ferment in European culture, the Armory Show lifted its audience out of the narrowness of a complacent provincial taste and compelled them to judge American painting and sculpture by a more exacting and ambitious world standard for the first time in the new century. Even as the West became embroiled in a distracting military conflict, art galleries began to flourish in New York, and a few brave private patrons-John Quinn, Walter Arensberg, A.E. Gallatin, Lillie P. Bliss, Katherine Dreier, Dr. Albert C. Barnes, Duncan Philipps-commenced assembling the nuclei of the great public collections of modern art that Americans know today.

Apart from exposing the best efforts of the Americans as stodgily representational, derivative, hesitant, and provincial, the immediate impact of the Armory Show on American artistic development actually was mixed. On the one hand, it stimulated numerous artists like Stuart Davis, who later acknowledged that he had discovered Cubism in the exhibition, but in other cases it stirred up resentment over the fanfare generated by the dominant modernist schools of painting and sculpture. William Glackens, a Renoirobsessed member of the Eight, articulated one prevalent view when he said: "We have no innovators here. Everything worthwhile in our art is due to the influence of French art. We have not yet arrived at a national art."

Many of the American artists whom Stieglitz first showed were, however, surprisingly original, despite their obvious dependence on European models. Their provincial innocence was a source of strength as much as weakness, and actually in some instances it shielded the artist from the theoretical preoccupations and formulaic rigidities of some advanced European movements, with their hectoring spate of manifestos, polemics, and public scandals. As an example, the fierce individualism of John Marin (1870-1953) proved refreshing rather than the customary liability of the marginalized artist. The work he produced does not easily date, despite the fact that his formula of Cubism-cum-Expressionism at times seems predictable enough, and even stereotyped (Fig. 445). With his love of movement and flux, his empathy for urban dynamism, and his sometimes explosive energy, Marin in certain works seems a forebear of the postwar Abstract Expressionists. But the lyrical effusions so often associated with his art, and his scintillating mastery of the watercolor medium, interested those artists less than Marin's expressive surfaces. Late in life when he had begun to work more in oils, Marin told a biographer that he wished "to give paint a chance to show itself entirely as paint." This insistence on the stubborn, irreducible, material reality of medium would become the very heartbeat of contemporary artistic creation in America, with the emergence of the New York School and Clement Greenberg's formalist criticism.

Arthur G. Dove (1880–1946) and Georgia O'Keeffe (1887–1986), who became Stieglitz's wife, were among the most original artists shown at 291. Both worked fruitfully within an idiom of organic abstraction that had not yet defined itself with the completeness of Cubism and thus afforded more freedom to the individual sensibility. In *Light Coming on the Plains III* (Fig. 446)

left: 445. John Marin. *Lower Manhattan* (Composing Derived from Top of the Woolworth). 1922. Watercolor and charcoal with paper cutout attached with thread on paper, 21⁵/8 x 26⁷/8". Museum of Modern Art, New York. Lillie P. Bliss Bequest.

above: 446. Georgia O'Keefe. *Light Coming* on the Plains III. 1917. Watercolor, 12 x 9". Amon Carter Museum of Western Art, Fort Worth.

American Art in the Wake of the Armory Show

O'Keeffe boldly reduced her pictorial means to a simple scheme of symmetrically elaborated, radiant color stains. The imagistic and Symbolist overtones of these simple configurations are all the more surprising since, at first sight, the means are so thin, unpromising, and nonaggressive. In such early painting the entirely Americantrained O'Keeffe explored ideas of distinctness and indistinctness, concentration and diffusion, until they took on the character of statements about the essential ambiguities of experience itself. Relative to the conspicuous patterning of the art of Kandinsky (Fig. 195), from whose work her own abstract paintings derive, the greater "openness" of O'Keeffe's amorphous, stained image represents a sharp departure. In her sublimation of pictorial matter, in her feeling for limitless boundaries and self-renewing images, O' Keeffe treated her earliest abstraction not merely as an occasion for formal exposition, but as a mode of intense personal experience. The critic Arthur Jerome Eddy, writing in Cubists and Post-Impressionists (1915), the first serious American study of the new art, made the "expression of inner self" the keynote of the modern movement. This strongly expressionist and introspective tendency was reflected in the current of organic abstraction, both in the Symbolist overtones of work by O'Keeffe, and in Alfred Stieglitz's nature mysticism, which later marked his "Equivalents," a series of abstract cloudscape photographs made in the 1930s.

Dove seemed to approach related formal problems in a similar spirit. As early as 1910 he precociously painted what was undoubtedly America's first entirely nonrepresentational painting, Abstraction Number 2 (Fig. 447). It coincided in time with Kandinsky's gradual self-liberation from dependence upon identifiable subject matter (Figs. 193, 195), although Dove's discovery of abstraction now seems to have been fragmentary and inconclusive, since it did not lead the artist to a consistent nonobjective style in the years immediately following.

The uncompromising abstract paintings that Dove and O'Keeffe made just before and during World War I stand in an equivocal relationship to European abstraction of that period. Both artists accepted the European mode of biomorphic abstraction, but subtracted some of its explicitness of effect in favor of an unbounded and more permissive personal encounter. By standing aloof from final solutions, their art seems characteristically American. What must have once seemed a curious lack of commitment to formal exposition, or at least a weak and muffled echo of it, has today become a prevailing way of art in which we see reflected the ambiguity of our own penetration of reality. Owing to their essential modesty of scale and ambition, the paintings of O'Keeffe and Dove produced no specific influence; nevertheless, they prefigured attitudes and an imagery that belong to contemporary abstraction (Fig. 448). Thus, the works transcend vast shifts in scale, from an intimate to a mural or public impact, to establish an intelligible continuity of taste and change between two otherwise antithetical generations.

All the Stieglitz-sponsored Americans emerging in advanced styles, whether organic or Cubist, also shared a significant intellectual excitement as they explored new paths in the radical modes of European vanguard art. Yet each of the major figures left a residue of identifiable and personal emotive characteristics. Max Weber (1881–1961), more than any other early American modernist, mastered the Synthetic Cubist idiom, which he proceeded to display in an unforgettable series of pictures based on commonplace New York City themes (Fig. 443). Marsden Hartley (1877-1943), following a sojourn in Paris, moved to Berlin and there achieved a remarkable synthesis of German and French approaches. In Portrait of a German Officer (Fig. 449) he flattened and interlocked Prussian military emblems to create an image more structured than Expressionist art and yet freer than anything found in orthodox Cubism. Joseph Stella (1877-1946) acquired his modernism directly from the Futurists during a trip to Italy in 1910–11, but the whirling, ferris-wheel dynamism of Battle of Lights, Coney Island (Fig. 450) is his own, its all-over, centrifugal organization not only reflecting the laws of Cubism but also anticipating the sort of explosive configuration and gyrating energies of the Action Painting

447. Arthur Dove. Abstraction Number 2, 1910. Oil on canvas, $9 \times 10^{"}$. Collection Mr. and Mrs. George Perutz, Dallas.

American Art in the Wake of the Armory Show 252

above: 448. Georgia O'Keeffe. Blue Morning Glories, New Mexico, II. 1935. Oil on canvas, 12¼×9". Private collection.

above right: 449. Marsden Hartley. Portrait of a German Officer. 1914. Oil on canvas, 5'8¼"×3'5¾". Metropolitan Museum of Art (Alfred Stieglitz Collection), New York.

right: 450. Joseph Stella. Battle of Lights, Coney Island. 1913. Oil on canvas, 6'3¾"×7'. Yale University Art Gallery, New Haven. Gift of Collection Société Anonyme.

that would emerge in New York after World War II (Fig. 493). Meanwhile, the Precisionists Charles Demuth (1883–1935) and Charles Sheeler (1883–1965) sought Cubism's unifying abstract design, sometimes by means of Futurist lines of force, but without fracturing the image, and brought forth pictures of a rare and fastidious elegance (Figs. 451, 452).

Synchromism

A comparable pattern of development revealed itself in the phenomenon of Synchromism (Fig. 453), the only American movement sufficiently formulated in its aesthetic to issue, in 1913, an actual manifesto. The founders were Stanton Macdonald-Wright (1890-1973) and Morgan Russell (1886-1953), who wanted to apply to their logical conclusion the same scientific laws of color that the Neo-Impressionists had obeyed. Although Macdonald-Wright and Russell may have arrived at the essential idea of Synchromism independently while living in Paris, they probably made their commitment to an abstract style in response to the Orphism of Delaunay and Kupka (Figs. 250, 251). The Americans based their paintings on combinations of color planned in dynamic rhythm, which, according to Macdonald-Wright, would refine art "to the point where the emotions of the spectator will be wholly aesthetic." In theory, the Synchromist doctrine, which would attract several other American painters, anticipated the most advanced developments of New York painting of the 1950s, as did the works of Dove and O'Keeffe. But the Synchromists soon lost interest in these objectives, and the movement came to an end after a very few years. American art has often been filled with brave beginnings that are without consequence, it being apparently a basic characteristic of American culture always to head for new and more distant frontiers and rarely to look back and consolidate gains.

above: 451. Charles Demuth. I Saw the Figure 5 in Gold. 1928. Oil on composition board, 36 × 29¾". Metropolitan Museum of Art (Alfred Stieglitz Collection, 1949), New York.

left: 452. Charles Sheeler. *River Rouge Plant.* 1932. Oil on canvas, 20 × 24". Whitney Museum of American Art, New York. right: 453. Morgan Russell. Synchromy in Orange: To Form. 1913–14. Oil on canvas, 11′3″×10′3″. Albright-Knox Art Gallery, Buffalo. Gift of Seymour H. Knox.

> below: 454. Georgia O'Keeffe. Cow's Skull: Red, White, and Blue. 1931. Oil on canvas, 39% × 35%". Metropolitan Museum of Art (Alfred Stieglitz Collection, 1949), New York.

American Scene Painting

In the 1920s a conservative reaction set in, just as it did elsewhere in the Western world, gaining strength in the United States until finally the center of artistic gravity shifted once again, away from Europe and artistic innovation to the native scene and a revival of Naturalism. The realist impulse in American painting ran too deep to be uprooted by a still-controversial modernism. Even Alfred Stieglitz and a number of his artists began to veer toward a more nativist accent and symbolism. O'Keeffe emphasized objective reality and a sense of place, whether in the meticulously rendered and chilling geometries of New York architecture or in the sharpfocus detail of fragments of domestic buildings in her summer home at Lake George. Stieglitz, responding to the search for American roots, called his gallery An American Room, from 1924 to 1929, and then changed its name once more, this time to An American Place. The sense of alienation from European modernism was made explicit by O'Keeffe in 1931, when she painted a specifically American painting, Cow's Skull: Red, White, and Blue (Fig. 454), curiously anticipating the undoubtedly more ironist projection of a patriotic mood in Jasper Johns's iconic American flag paintings of the late 1950s (Fig. 548).

American Art in the Wake of the Armory Show

By 1920, when the first effects of the Armory Show had largely worn off, the American scene returned vigorously, both as an inspiration for artists and as a popular subject. Edward Hopper (1882-1967) and Charles Burchfield (1893-1967)-the former romanticizing the unpicturesque loneliness of American town and country life (Fig. 455), the latter dreaming up near-fantasies of similar subjects in his imaginative watercolors (Fig. 456)-emerged as its most prominent figures. Their art was cheerless and harsh, haunted by nostalgia but addicted to the grotesque, to what Hopper called the "hideous beauty" of America, its "chaos of ugliness." Both artists sought refuge in the commonplace, as a rebuke to the aesthetic conundrums of the modernists. But the scene they disclosed was not reassuring, and the reality their pictures set forth was a world of shadows. Like some of the Duchamp-influenced modernists who had begun to react negatively to the machine and to the new landscape of power, the romantic realists, employing different pictorial metaphors, also told the story of the disenchantment and spiritual vacancy behind the American success story.

Hopper was primarily a poet of human isolation, whose themes at their best have a universal appeal and relevance beyond the immediate social circumstance or their rather drab technique of Naturalism. *Nighthawks* demonstrates his ability to reveal with poignancy the solitariness that is so much a part of modern, highly organized urban existence, a kind of alienation so tellingly expressed earlier in the proto-Surrealist art of de Chirico (Figs. 280–282). The painting presents the figures of a counterman and three customers in a nocturnal café, with empty stools, windows, and streets echoing the empty faces of the lonely figures whose lives touch briefly and accidentally. Other works by the artist have similar themes—for example, an all-night gas station attendant, a single figure in a cheap hotel room, a pensive theater usherette standing alone in a corner off an aisle, and a depopulated main street early on a Sunday morning. But however retardataire the

American Art in the Wake of the Armory Show

illustrational aspect of this art, Hopper had not been an indifferent student of pictorial sophistication during his early European sojourn, and he increasingly revealed this in the reductive simplicity of his forms, the meticulously calibrated balance of his lights and darks, and the clear, rectilinear coordinates that align his compositions to the shape and flatness of the painting surface.

The American urbanscape had equally sincere but aesthetically more timid witnesses in the paintings of such artists as Reginald Marsh, Yasuo Kuniyoshi, Moses and Raphael Soyer, and Isabel Bishop (1902–88), who attempted to ennoble their workday sub-

above: 455.

Edward Hopper. Nighthawks. 1942. Oil on canvas, 2'6" x 5'. Art Institute of Chicago (Friends of American Art Collection).

left: 456.

Charles Burchfield. Church Bells Ringing, Rainy Winter Night. 1917. Watercolor, 30 x 19". Cleveland Museum of Art. Gift of Louise M. Dunn in memory of Henry G. Keller.

above: 457. Isabel Bishop. Waiting. 1938. Oil and tempera on gesso, 29×22½". Newark Museum, New Jersey. Arthur F. Egner Memorial Committee Purchase, 1944.

above right: 458. Thomas Hart Benton. The Hailstorm. 1940. Tempera on gesso panel, 33 × 40". Joslyn Art Museum, Omaha. Gift of the James A. Douglas Memorial Foundation.

below: 459. Grant Wood. American Gothic. 1930. Oil on beaverboard, 29% × 24%". Art Institute of Chicago. Friends of American Art Collection.

jects by means of perhaps exhausted, but hard-earned and often virtuosic, Renaissance and Baroque formulas (Fig. 457).

In the early 1930s another kind of grass roots, or Regionalist, realism, chauvinistic in its optimism and its strident distaste for European modernist traditions, asserted itself in the Midwest. Regionalism's creed can be summed up in the words of Thomas Hart Benton (1889–1975), one of the movement's leading figures and spokesmen: "A windmill, a junk heap, and a Rotarian have more meaning to me than Notre Dame or the Parthenon."⁵ With that belief, Benton painted ruggedly picturesque landscapes (Fig. 458), doing so with the rude ardor of a soul born again, since, paradoxically, Benton had been a Synchromist and a devotee of the Stieglitz circle and all it stood for. Moreover, this advocate of undefiled Americanism composed in a purely abstract manner and filled his compositions with figures whose bulging muscles and writhing energy derived from the Renaissance art of Michelangelo. Needless to say, an activist like Benton would paint large, and he figured prominently in the Mexican-inspired revival of mural art during the 1930s. The abstract sense of design, the Expressionist vigor, and the rugged individualism would all reappear in the totally different art of Benton's one-time student and lifelong friend, Jackson Pollock.

A far more charming and popular Regionalist, or American Scene, painter was Grant Wood (1892–1941), whose satirical painting of Americans managed eventually to beguile even the satirized (Fig. 459). Thus, a picture like *American Gothic* has become a true and cherished national emblem, especially since the advent of the comic-strip taste fostered by Pop Art in the 1960s and 1970s. But for all his populism and Precisionist qualities, Wood too had foreign roots, this time in the miniaturizing primitivism of 15th-century Flanders.

When American Social Realist painting appeared in the 1930s, it sprang not only from Burchfield's and Hopper's disillusioned views of the American scene, or of the Regionalists' effort to build a sustaining myth of the frontier; it also reflected the economic crisis of the Depression. The impact of that traumatic and tragic event was to force a new kind of reappraisal among American artists of their cultural identity, first through themes of social protest in a style of parochial realism. But then came the WPA Federal Art

American Art in the Wake of the Armory Show

Project, which, as we shall see, made it possible for artists to survive, and for Social Realism to flourish, at the same time that, ironically, it had the eventual effect of stimulating bold and surprising experiments with Constructivist abstraction.

What could be defined loosely as Social Realism was the prevailing style of work done under the innovative federal government program of assistance to artists, which operated from 1934 to 1939. It became the standard pictorial language of the more directly political artists who also benefited by the Federal Art Project. Painters such as Robert Gwathmey, Philip Evergood (1901– 73), Ben Shahn (1898–1969), and Jack Levine practiced in a sharp and allusive representational manner, entirely suitable for their main purpose, the communication in art of their strong feelings about the abuse of privilege and social justice (Figs. 460, 461). Social Realists found their chief inspiration in the revolutionary and polemical mural art of such Mexican masters as Diego Rivera and

above: 460. Philip Evergood. Lilly and the Sparrows. 1939. Oil on composition board, 30×24". Whitney Museum of American Art, New York.

right: 461. Ben Shahn. The Blind Accordion Player. 1945. Tempera, $25\frac{1}{2}\times38\frac{1}{4}$ ". Neuberger Museum, State University of New York at Purchase. Gift of Roy R. Neuberger.

above right: 462. Milton Avery Yellow Jacket. 1939. Oil on canvas, 36×24''. Courtesy Borgenicht Gallery, New York.

José Clemente Orozco (Figs. 463, 464), a fact as evident as the Social Realists' indifference to the sophistication of modernism and the presumed art-for-art's-sake attitudes of the abstractionists.

Of the Americans who worked in figurative styles, and out of humanist motives, only a few tried to stay more or less abreast of European modernism, as did Ben Shahn, with his evident awareness of the painting of Paul Klee (Figs. 202–204). A more purely aesthetic approach was that of Milton Avery (1893–1965), who used his American directness and simplicity to make something altogether fresh and independent of Matisse's abstract drawing and flattened color masses (Fig. 462).

The Mexican Renaissance

In the early 1920s the Mexican Revolution (1910–20) triggered a surge of nationalistic mural painting, as the government began to commission monumental frescoes celebrating its achievements. While other Latin American countries remained tied to the School of Paris, Mexico went on to create a new kind of propagandistic and inspirational public art, reflecting the nation's history and the socialist spirit of the revolutionary experience.

Diego Rivera (1886–1956) returned from Paris, where for ten years (1911–21) he had investigated every form of modernism, to become the best-known Mexican muralist and the busiest (Fig. 463). He filled the walls of public buildings with murals that preached the ideal of social reform and the evils of capitalism in a flat, simplified style combining decorative elements of Post-Impressionism, occasional savage caricature, and the hieratic quality of 14th-century Italian religious art. In the United States, Rivera executed murals for the San Francisco stock exchange, the Detroit Institute of Art, and, in 1933, Rockefeller Center. The last work, however, was destroyed and painted over after the sponsors found that the artist had included a portrait of Lenin.

José Clemente Orozco (1883–1949), a largely self-taught artist, was neither so formal nor so decorative in his work as Rivera. Orozco moved closer to the Expressionists in spirit, at first working in the stylized, sculpturesque manner of Barlach, before later adopting the more dynamic and fluid forms of El Greco, often on a scale of almost Nietzschean gigantism. Orozco too worked in the United States, and stayed there from 1927 to 1934, during which time he carried out important mural assignments at Pomona College in California and the New School for Social Research in New York, as well as in the Baker Library at Dartmouth College (Fig. 464). In the climactic scene reproduced here, from a panoramic series on the his-

below: 463. Diego Rivera. *The Fertile Earth.* 1926–27. Mural. National School of Agriculture, Chapingo, Mexico.

above: 464. José Clemente Orozco. Modern Migration of the Spirit (panel from Gods of the Modern World series). c. 1933. Fresco, 10'7" x 10'6". Baker Library, Dartmouth College, Hanover, N.H.

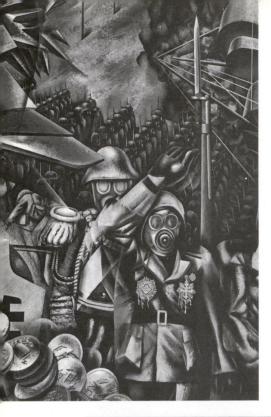

left: 465.

David Alfaro Siqueiros. Portrait of the Bourgeoisie (detail: "The Military Leaders"). 1939. Pyrosylin on cement, mural. Electrical Workers' Union Building, Mexico City.

below: 466.

Rufino Tamayo. Man Contemplating the Firmament. 1944. Gouache. Courtesy Iturbide Gallery, Mexico City.

right: 467.

Frida Kahlo. *Diego and I.* 1949. Oil on Masonite, 11⁵/8 x 8¹³/16". Courtesy Mary-Anne Martin/ Fine Art, New York.

tory of the Americas, a Resurrected Christ takes an ax to his own Cross in the ruins of a self-destroyed Machine Age.

The third remarkable social-minded Mexican artist was David Alfaro Siqueiros (1896–1974), who tried to modernize his colleagues' techniques and reinforce his revolutionary message by employing industrial materials, such as plastic paints, spray guns, and other mechanical devices (Fig. 465). A fiery, impetuous personality, Siqueiros frequently found himself either jailed or exiled for political reasons. He made his polemical art equally dramatic, using photomontage and violently distorted illusionism learned from the great Soviet filmmaker Sergei Eisenstein.

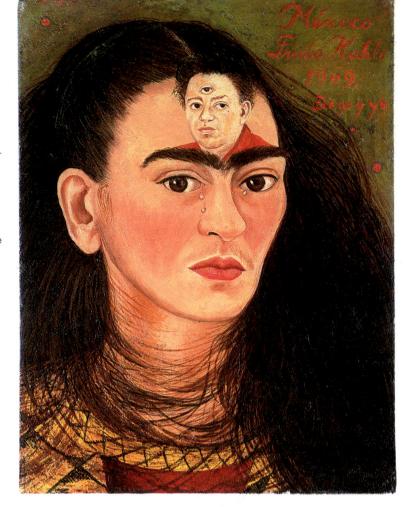

Rufino Tamayo (1899-1991) also made distinguished contributions to the revival of Mexican art, but, unlike the muralists, he reacted positively to the influence of the School of Paris and became his country's outstanding modernist (Fig. 466). Tamayo too was impressed by the Latin American past, especially its Tarascan sculpture, as well as by later native forms, such as the colored papier-mâché figures used in holiday celebrations. Still, he found a career in Mexico rather difficult for a long time, particularly since he was neither a muralist nor a leftist. Feeling alienated from the dominant art forms of his native land, Tamayo came to New York in the early 1930s, and there he directly experienced the modern movement through the exhibitions at the Museum of Modern Art. These contacts, added to his already instinctive modernist tendencies, settled the future course of his art. In the United States, Tamayo got his first opportunity to do mural painting at Smith College in 1943. A decade later his murals in the Palace of Fine Arts in Mexico City, where they appeared alongside those of Rivera, Orozco, and Siqueiros, marked the acceptance of Tamayo and his entry into the pantheon of high Mexican art. In his mural style the artist combined the social content of Mexican nativist painting with his own adaptation of Abstract Cubist dynamism, rendered in a unique palette of incandescent magentas and ochres.

During the 1930s and early 1940s Diego Rivera counted among the most famous artists alive; by the end of the 1980s, however, his renown had been eclipsed by that of his wife, Frida Kahlo (1907–1954), a painter little known in her own time but today the object of a veritable Fridolatry cult. Resurgent feminism may have plucked Kahlo from relative obscurity, but it is the undeniable power of her work (Fig. 467), as well as the saga of her tortured life, that prompted the critic Peter Schjeldahl to speculate that Kahlo "may turn out to be the greatest Mexican artist of our century." Rivera himself sometimes said as much. Blessed with exotic looks, a gift for visual invention, and a miniaturist's technical aplomb, Kahlo was also cursed with ill health-polio in childhood, spinal injuries caused by a traffic accident, repeated miscarriagesand chronic mental anguish, the latter flowing primarily from her husband's helpless philandering. Like the muralists, Kahlo embraced leftist politics and the passionate "Mexicanism" of her time, but while her male colleagues committed themselves to public art on a grand, hortatory scale, she opted for a deeply private, inward, spiritual kind of painting, easel art that prompted André Breton to claim her for Surrealism. An obsessive self-portraitist, Kahlo reveled in her distinctive features-heavy, continuous eyebrows, piercing gaze, shadowy mustache, small but ripe, cherry-red mouth, massive dark hair braided like a halo in the traditional Mexican style. Moreover, she set them off with the most striking emblems of her suffering: a thorn necklace, nails worn like beauty spots, her torso tightly harnessed and opened to reveal a spine in the form of a broken column, wild spider monkeys embraced in lieu of the children she could never have. For the self-portrait seen here, Kahlo added the likeness of Rivera to her own forehead, cradled in those dramatic eyebrows, its presence (complete with a Cyclopean third eye at the center of his own brow) suggesting a manic preoccupation with her husband at a time when he had taken up with a well-known Mexican actress. Here the weeping artist's hair swirls about her neck like the dark sea in which she felt herself drowning. In the eyes of posterity, Kahlo not only remains afloat; she even rides the crest of the cultural wave.

American Abstraction between the Wars

During the years of the Depression, when all cultural values necessarily reflected material needs, and Social Realism held sway in both Mexico and the United States, abstract art led a precarious existence. But as the threat of economic collapse receded in the late 1930s, socially conscious art lost its urgency, and the traditions of international modernism assumed new life. Their survival in the face of a skeptical and distracted public owed much to the achievements of the sculptor Alexander Calder and the painter Stuart Davis.

Alexander Calder (1898–1976), the son and grandson of sculptors but trained as an engineer, figured among the few American artists who continued to work in an experimental mode during the discouraging decade, and to give the Constructivist ideal meaning without sacrificing his own native qualities. Calder first won recognition in Paris in the 1930s as a kind of toy maker, the consequence of his having produced a famous miniature circus teeming with expressive wire-and-wood marionettes representing big-top performers (Fig. 468). At this time Calder worked in the French capital most of the year, visiting America only occasionally. Direct contacts with Mondrian and Miró, who delighted in the circus, were important factors in the formation of his style. By 1932 Calder had put aside the caricatural clowns and acrobats for his first kinetic pieces, mechanically driven or wind-propelled, the latter now universally known as "mobiles," a term first applied to Calder's constructions by Marcel Duchamp. Sculpture in actual motion had challenged only a few of the pioneer modernists: Duchamp, Gabo, and Moholy-Nagy (Figs. 290, 434, 435). Like Gabo in 1920, Calder first tried motorized movement, as well as movement created by a hand crank, but however ingenious the forms and mechanisms, the mathematically repetitive rhythm of such artificially induced action bored him. It was then that he worked out forms so well balanced and carefully engineered that, in response to air currents and wind, they create a rhythmic but varied movement (Fig. 469). As the shapes hang suspended in space, the combinations of movement continually pro-

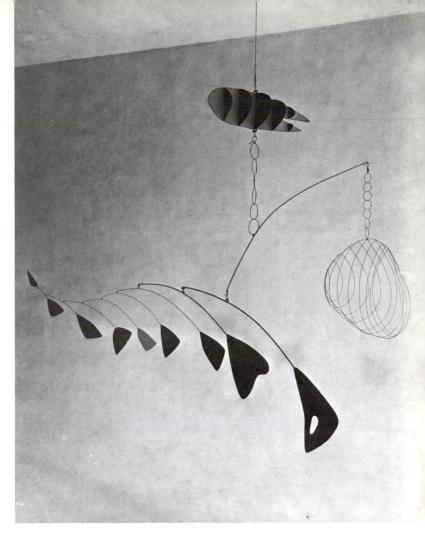

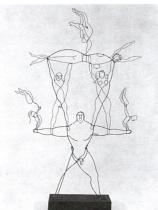

left: 468. Alexander Calder. The Brass Family. 1929. Brass wire, 5'4" x 3'5" x 8'1/2". Whitney Museum of American Art, New York. Gift of the artist.

above: 469. Alexander Calder. Lobster Trap and Fish Tail. 1939. Steel wire and sheet aluminum, painted; c. 8'6" x 9'6". Museum of Modern Art, New York.

duce new compositions and relationships. For Calder, this element of change, and of engaging surprise, constituted an important factor. By cutting, shaping, and assembling sheet aluminum, sheet metal, and wire, by using color, by inventing largely abstract forms that present tantalizing hints of objects in nature, and by letting natural motion act as the dominant element, Calder achieved one of the most distinctive and personal styles in modern sculpture.

The mobiles sprang from many sources. First and foremost, Calder's inventiveness, his light-hearted wit, his sense of balance, and a whimsical homespun nature poetry account for the expressive originality of the art form. Almost equally important were a number of other factors—the artist's personal reaction to the age of science and engineering, to its new tools and new materials, also the rise of abstraction, Dada's jest and unorthodoxy, the simplicity of Mondrian, and the fantasy of Miró. All the elements meet and mingle in Calder's mesmerizing mobiles.

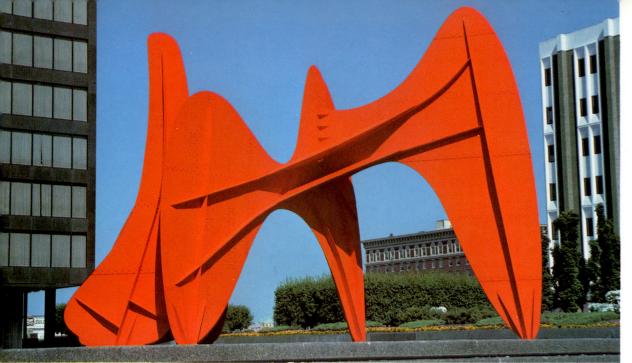

left: 470. Alexander Calder. La Grande Vitesse. 1969. Painted steel plate, 55' wide. Calder Plaza, Vandenberg Center, Grand Rapids, Mich.

below left: 471.

Stuart Davis. Lucky Strike. 1921. Oil on canvas, 33¼ x 18". Museum of Modern Art, New York. Gift of the American Tobacco Co.

below right: 472. Stuart Davis. Eggbeater No. 1. 1927–28. Oil on canvas, 27 x 38¼". Phillips Collection, Washington, D.C.

Besides his mobiles, Calder made what Arp dubbed "stabiles," or freestanding static sculptures, often heroic in scale (Fig. 470). Indeed, the term applies mainly to the very large outdoor pieces. In the last decade of the artist's life, the magnificent stabiles became environmental in dimension, and must now rank among the most impressive monumental metal sculptures of the century. The elegant and reductive shapes of these poetic ensem-

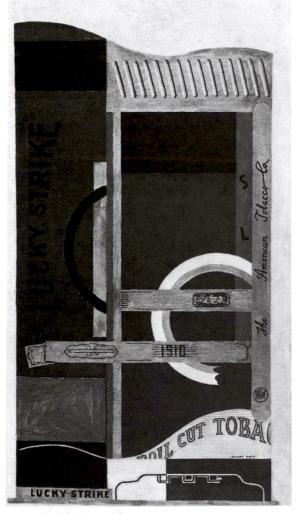

American Art in the Wake of the Armory Show **262**

bles of form associate them with the work of the contemporary Minimalists (Fig. 597). As has so often been the case with an acknowledged master of modern art, Calder identified his vitality, undiminished to the end, with the work of a youthful generation whose vast scale and industrial materials and techniques his stabiles predicted so many years ago.

It is rather ironic that the American painter who drew much of his inspiration and vigor from the so-called American Scene should have been a confirmed abstractionist. Stuart Davis (1894-1964) helped American art maintain contact with European modernism at a time when it was under brutal attack for its presumed indifference to native experience. Like so many of America's modernists, Davis converted to vanguard art in response to the Armory Show. "The Armory Show," he said, "was the greatest shock to me—the greatest single influence I have experienced in my work. All my immediately subsequent efforts went toward incorporating Armory Show ideas into my work."⁶ By 1921 Davis was creating such novelties in American art as Lucky Strike (Fig. 471), his own vital, painted version of the Cubists' papiers collés. In 1927 he began the first of a series of abstract variations in the spirit of decorative Cubism based on the motifs of an eggbeater, an electric fan, a rubber glove, and other household objects (Fig. 472). In these paintings Davis drastically simplified his forms, eliminating all but the most schematic descriptive content, and reducing that to a system of flat planes and geometric shapes. The "Egg-

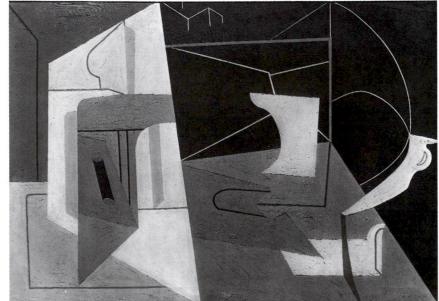

beaters" proved to be the first truly abstract pictures painted in America in nearly a decade.

Although clearly indebted to decorative Cubism and perhaps most of all to Léger, Davis gave his European sources a distinctly native inflection, a special lightness, and an altogether personal. whimsical humor. An avowed lover of jazz and other popular art forms, he sought to inject brisk new rhythms and mildly irreverent gaiety into abstract painting. For the stage properties of Cubismthe pipes, mandolins, and Harlequins-Davis substituted the artifacts of American life: ensembles of gas pumps, colonial houses, local street scenes, disembodied lettering and signs (Fig. 473). Some of his more abstract, irregular silhouettes and his bright, even daring color effects resembled the vital and playful cut-outs created by Matisse in his last years (Fig. 387). Davis's shapes, however, retained a quirky, somewhat brittle quality, his edges a hard, Precisionist exactitude, his surfaces a no-nonsense texture, his tempos a fast, jaunty pace, and his colors a Fourth of July brightness far more distinctively American than the near-Oriental sumptuousness and serenity of Matisse's art.

Close to Davis in his popular imagery and picture-puzzle compositions was the otherwise anomalous, and somewhat dilettante, artist Gerald Murphy (1888–1964), the wealthy expatriate American on whom Scott Fitzgerald modeled the hero of *Tender Is the Night*. The untrained Murphy worked slowly, produced one picture a year, and no more than fourteen in all, a mere six of which survive. Still, he achieved a witty, sophisticated, authentically original art compounded of simple, emblematic forms, surface-clinging Cubist design, and Art Deco elegance, all on a very grand scale (Fig. 474). Although a true avatar of the New York avant-garde that would come into its own after World War II, Murphy, owing to his isolation in the South of France, had absolutely no influence on that later development.

Another American émigré abstractionist of the period, but a highly trained one, was Chicago-born John Storrs (1885–1956), who too worked in a sleek and sophisticated manner (Fig. 475),

left: 473. Stuart Davis. *Blips and Ifs.* 1963–64. Oil on canvas, 5'11" x 4'5". Amon Carter Museum of Western Art, Fort Worth.

above: 474. Gerald Murphy. The Watch. 1925. Oil on canvas, 6'6½" square. Dallas Museum of Art. Foundation for the Art Collection. Gift of the artist.

right: 475. John Storrs. Forms in Space, No. 1. 1920–23. Marble, 6'4¾" high. Whitney Museum of American Art. Promised 50th Anniversary Gift of Mr. and Mrs. B.H. Friedman in honor of Gertrude Vanderbilt Whitney, Flora Whitney Miller, and Flora Miller Irving.

476. Ilya Bolotowsky. *Blue Diamond*. 1940–41. Oil on canvas, 21" square. Courtesy Washburn Gallery, New York.

producing tall, emblematic sculptures that bear a striking resemblance to the Art Deco skyscrapers drawn in the 1920s by Hugh Ferris and built in the 1930s by Shreve, Lamb, and Harmon (Fig. 364). Because of his long residence in France, Storrs had no perceptible influence on subsequent developments in American art, even though his skyscraper sculptures clearly prophesied some of the Pop Art monuments of the 1960s, and only recently has the true quality of the Storrs oeuvre become generally known.

While Gerald Murphy and John Storrs have entered the history of American art as gifted, engaging mavericks, Stuart Davis forged a powerful, if rare, link of continuity between America's first phase of formalist art and postwar abstraction. Today, curiously enough, the all-important Davis, with his billboard style and American Scene content, appears, like Murphy and Storrs, more related to Pop Art than to abstract painting, but in the 1930s he provided a sturdy frame of reference and a point of support for many of the young artists then beginning to move toward abstraction. David Smith, the sculptor (Fig. 507), later indicated that he found stimulation in Davis's liberal viewpoint on the WPA Federal Art Project during the period dominated by Regionalist styles and a somber urban Expressionism. Arshile Gorky's geometric abstractions (Fig. 482) bear a striking resemblance to Davis's work of the Eggbeater type, as do many of the canvases painted by members of the American Abstract Artists group (Figs. 476, 477).

To the generation of Hopper, Burchfield, and others who drew on the American Scene, Davis's art posed a challenge, for it offered more refreshing answers in the quest for a native art than the style of romantic realism could offer. "In my own case," Davis wrote, "I have enjoyed the dynamics of the American scene for many years, and all my pictures . . . are referential to it. They all have their originating impulse in the impact of the contemporary American environment." For the generation of emerging artists who would soon be involved with more radical modes of abstraction, Davis's achievement confirmed a growing resolve to find their artistic iden-

The New York School: Abstract Expressionism
264

tity outside representational styles. In the 1940s the Abstract Expressionists could reject Davis's forms and what the younger artists considered his anachronistic themes. They certainly took heart from his example, however, and from such steadying affirmations of principle as his statement: "The act of painting is not a duplication of experience, but the extension of experience on the plane of formal invention."

Also inspired by Davis, and forming a bridge between him and the giants who would surge up in the New York School after 1945, were the American Abstract Artists, a group that came into being, significantly, in 1936, the year in which Alfred Barr organized the historic and trend-setting exhibition "Cubism and Abstract Art" at the Museum of Modern Art. With their annual shows, the American Abstract Artists made New York a haven for the native vanguard at a time when the various strands of the international abstract movement, after having been briefly woven together in Paris-based Abstraction-Création (Fig. 436), were about to become unraveled by the hostile winds gathering force in Nazi Germany. By the late 1930s the modernist influences flowing from Europe were numerous, but most of the young Americans allied their art with the Neo-Plasticism of Mondrian, as in the case of Russian-born Ilya Bolotowsky (1907-81; Fig. 476), or with Constructivism, which found a sensitive new exponent in Irene Rice Pereira (1901-71; Fig. 477), known for her controlled handling of planes floated freely over colored grounds in a shallow, indeterminate space. A perhaps more significant development occurred in the art of Arshile Gorky (Fig. 484) and Lee Krasner (Fig. 481), who adopted Picasso's Cubism and Miró's biomorphism, thereby anticipating the synthesis of Cubist formalism and Surrealist automatism that would yield the Abstract Expressionist style of the late 1940s.

477. Irene Rice Pereira. Ascending Scale. 1937. Oil on canvas, 27 × 22". Collection of the Lowe Art Museum, University of Miami, Coral Gables.

The New York School: Abstract Expressionism

t was a full 170 years after Americans had won their political revolution that they waged and won an aesthetic revolution that finally permitted American art to throw off its inhibiting shacklesprovincialism, overdependence on European sources, an indifferent or even hostile public-and liberate itself into a quality and an expressive force equal to, or exceeding, that of art produced anywhere within the period. Indeed, few would argue that the painting and sculpture to emerge from the so-called New York School was, from the mid-1940s to the end of the 1960s, the foremost artistic phenomenon of its time, a reality that virtually transferred the center of the art world from Paris to New York. Interestingly, the circumstances surrounding this extraordinary development paralleled, to a remarkable degree, those that had prevailed in Russia during the pre-Revolutionary era, when inspiration from Western Europe blended with native preparedness to carry long-developing international trends to resolutions well beyond anything anticipated, or desired, by their most advanced previous exponents. Like those early Russian avant-gardists (Figs. 264-271), the Americans, for generations, had sought to achieve their own artistic maturity and had largely failed, either by inadequate assimilation of European models or by spurning those sources in favor of a truculently chauvinistic and retardataire mode. Yet, a few American artists, like their Russian antecedents, had gained strength through adversity and isolation, at the same time that they were heir to certain native, even archaic traditions that enabled them to perceive in Cubism the possibilities of a new, utterly transcendent kind of art. Toward the end of a long and closely argued study of particular qualities that, throughout its history, have tended to make American art special, Barbara Novak has written:

From the limners on, American artists had held, in one way or another, to the adamant control of idea. Enlisting measure, mechanics, and technology as aids toward a certainty that was often as ideal as it was real, American artists guarded the unbroken integrity of the objects or things of this world, which became, very often, vessels or carriers of metaphysical meaning. Tempered by the dual planar inclinations of a continuing folk tradition and a classic mensuration, matter, in American nineteenth-century art, was often stable, fixed, weighted, the pictorial parallel of an age still dominated by Newtonian physics. Dissolution of matter, when it occurred, was rarely scientific or analytical, but emotive and lyrical, becoming part of a quietistic tradition and reaching through memory to another area of Mind.

And so when progressive American artists became, paradoxically, the beneficiaries of the stricken 1930s and 40s, they seized on their opportunities and, as had Malevich, Tatlin, and Popova before them, realized a breakthrough to total abstraction, but an abstraction rich in emotive content. Tempered by adversity to probe and make the most of every experience and to be independent in their use of it, the artists who became the New York School brought forth works that, by virtue of their highly original, monumentally scaled synthesis of modernism's most salient trends—Cubism, Expressionism, and Surrealism—achieved an art of truly heroic grandeur. In time, that art would leave little doubt about its power and importance, its legitimacy as successor to the best in European modernism, or the genuine Americanness of its vigor, boldness, and simple integrity.

Art is never without context, and the context in which the New York School evolved was to a considerable extent that described in Chapter 16. As we have seen, most American artists responded to the disasters of the 1930s—economic collapse at home and the rise of fascism abroad—by working in socially conscious styles. Patriots like Thomas Hart Benton (Fig. 458) and socialists on the order of Ben Shahn (Fig. 461) met on common ground in their preference for illustrational art and their consequent detestation of the high-brow aesthetics of European modernism. But since, as Gorky said, "poor art for poor people" seemed futile, however noble the cause, younger artists determined to renew their work by deriving it, not from politics, but from personal experience and by embodying this in contemporary forms.

Ironically, it was the paralyzing poverty of the Great Depression that gave younger American painters and sculptors their first advantage. Beginning in 1935, with the Federal Art Project organized under the WPA (Works Progress Administration), artists of the Gorky-de Kooning-Pollock generation could earn a subsistence living as artists and do so free to create in whatever manner they might choose. They could even gravitate to New York, traditionally America's safe haven for the revolutionary, and there band together as a beleaguered community. Just as Paris had nurtured such foreign artists as Picasso, Gris, and Miró, Modigliani and de Chirico, Chagall, Soutine, and Ernst, along with its host of native French masters, New York attracted a cosmopolitan assortment of aspiring painters and sculptors. The twenty-two-year-old Dutchman Willem de Kooning had appeared in the late 1920s, as had Mark Rothko from Russia by way of Portland, Ore., and Arshile Gorky from Armenia. Jackson Pollock had been born in Wyoming and raised in California and Franz Kline in the coalmining country of Pennsylvania, while Robert Motherwell hailed from San Francisco, Clyfford Still from Spokane, Wash., and David Smith from Indiana. Barnett Newman, Adolph Gottlieb, Lee Krasner, and Ad Reinhardt were the native New Yorkers in the group that made up the first generation of what would become the New York School. Meeting in dingy downtown lofts and greasy all-night cafeterias, these ragged (all but Motherwell), would-be avant-gardists found an environment in which they could emulate the café-studio life of Paris. Like their more sophisticated counterparts abroad, the Americans developed strength and an independent spirit by sharing their discoveries, debating ideas from the latest issue of Cahiers d'art or Minotaure and generally making a virtue of their isolation from the philistine world outside.

top: 479. Hans Hofmann. Composition. 1942. Oil on board, 35½ x 41½". Private collection.

above: 480. John D. Graham. Blue Abstraction (Still Life). 1931. Oil on canvas, 26 x 36". Phillips Collection, Washington, D.C.

The courage and independence of these New Yorkers was symptomatic of the era's growing radicalism, following the conservative reaction that had overtaken American art in the wake of that "shock of the new"-the Armory Show of 1913. In 1927, abstraction had reappeared in American art for the first time in nearly a decade when Stuart Davis began his Eggbeater series (Fig. 472). Yet, in their determination to throw off the yoke of provincialism, the younger artists rejected such works, as well as those of Marin and Avery (Figs. 445, 462), as overreliant on extrapictorial reality, and proceeded to immerse themselves in and master the rich heritage of European modernism. Moreover, this was increasingly available to them, not only in imported magazines, but also in the accelerating activity of the Museum of Modern Art, which, beginning in 1929, mounted a series of major exhibitions designed to survey European modernism from the Post-Impressionists through Cubism and the Bauhaus to Dada and Surrealism. Hardly less

important were the Gallatin Collection with its Neo-Plasticist and Constructivist canvases on display at New York University, and the Museum of Non-Objective Painting (later the Solomon R. Guggenheim Museum), which began exhibiting its vast collection of Kandinskys as early as 1936. Meanwhile, the Société Anonyme had been promoting the study of modern art and ideas since its founding in 1920 by Katherine Dreier, Marcel Duchamp, and Man Ray.

Native abstract art, although little more than a match struck in the dark, could be seen with greater regularity in the exhibitions of the AAA (American Abstract Artists). This organization, which dated from 1936, came into being somewhat as a local manifestation of the general, even international resurgence of nonobjective expressions, such as those that had occurred in Paris under the aegis of Abstraction-Création (Fig. 436) and in London among artists related to the Hepworth-Moore-Nicholson circle (Figs. 417, 424, 425). In New York, as we saw in the instances of Ilya Bolotowsky (Fig. 476) and Irene Rice Pereira (Fig. 477), the model was Mondrian, who provided not only a system for transforming Cubism into pure abstraction but also a utopian and universalist philosophy capable of sustaining those in need of an alternative to Marxism and nationalism. However, apart from Krasner and Reinhardt, none of the leading figures of the New York School belonged to the AAA, despite their appreciation of its ideals, for while adding to the intellectual ferment necessary for genuine innovation, the AAA's narrow insistence upon nonobjectivity could hold only limited interest for artists eager to explore all the possibilities offered by modernism.

For the development of the New York School, the most important influence to come from Europe in the thirties may have been a teacher, the great Hans Hofmann (1880-1966). Arriving in New York in 1932 from Munich, where he had directed his own school, Hofmann was already internationally known for his ability to impart the principles of Picasso's drawing and Matisse's color. Harking back to Cézanne, the German master taught that the painter should so handle his means-drawing and color-that the finished picture would evoke a sense of depth while also affirming the two-dimensionality of its actual surface (Fig. 479). This would be done by translating nature's volumes into planes of color that by their temperature (the hot or cold characteristics that make a given hue seem to advance or recede, expand or contract) tend to collapse solids and fill voids. Once organized into "complexes," the planes would not only structure the pictorial field in a Cubistic manner but also "push" and "pull" in relation to one another, as well to the painting surface, and thus, in purely abstract, modern terms invest the avowed flatness and rigidity of that surface with a sense of dynamic, deepbreathing three-dimensionality. Yet, systematic as he was in his procedures, Hofmann warned students against allowing preconceived formulas to take control of their creation. "A picture should be made with feeling, not with knowing," he said in 1949. "The possibilities of the medium must be sensed." And although preoccupied with process, Hofmann joined Kandinsky and Mondrian in their insistence that process was merely a means of achieving spiritual syntheses. "The quality of the work," he wrote in 1932, "originates in this transposition of reality into the purely spiritual." Hofmann, however, claimed no social purpose for art but, rather, stressed its selfsufficiency.

Another catalytic figure from Europe was the Russian artist John Graham (1881–1961), who, following his early years in the Russia of Gabo and El Lissitzky, had been in New York since 1920 (Fig. 480). A cosmopolite with active contacts among Europe's Surrealists, Graham would have a profound effect upon New York's young modernists, not so much through his aesthetics, which differed little from those of Hofmann, but through his interest in Jung and Freud and the methodology this produced. In his book *System and Dialectics of Art*, Graham wrote that the artist had to "re-establish a lost contact with the unconscious . . . with the primordial racial past... in order to bring to the conscious mind the throbbing events of the unconscious mind." Thus, while rejecting Surrealism's love of literary symbolism and illustration, he recommended the Surrealist technique of automatic writing, which led Gorky, de Kooning, Gottlieb, and, most of important of all, Pollock to discover their fabled, emotion-laden, and distinctive styles of painterly drawing.

What with their fervent and thoroughgoing assimilation of all that was to be learned from journals, the museums and collections, the AAA, Hofmann, and Graham, the vanguard just emerging in New York had become the most eagerly receptive and knowledgeable in the world, especially about Kandinsky and Mondrian, masters still little known even in Paris. One of the most sophisticated of all in her command of modernist aesthetics-both formalism and expressionism-was Lee Krasner (1911-84), whose untitled painting of about 1940 is reproduced in Figure 481. As this work suggests, the Americans were in a high state of readiness when, by a fortuitous turn of ugly fate, they found themselves at the center of the international art scene, which in 1940 moved to New York from Nazi-occupied Paris. Suddenly, the one-time provincials experienced the glory of being physically surrounded by the likes of Chagall, Dali, Ernst, Léger, Lipchitz, Masson, Matta, Mondrian, Ozenfant, Kurt Seligmann, Tanguy, Tchelitchew, Zadkine, and the Surrealist "pope" himself, André Breton. Although impressed and edified by the presence of these grandees of high modernism, the New Yorkers had already built enough backbone to take what they needed from their superiors, while also rejecting the Europeans' condescension and Breton's open advocacy of Dali's "hand-painted dream photographs" (Figs. 312, 313). These, with their retrograde, academic form, struck the Americans as little better than the paintings of the despised Regionalists and Social Realists. Meanwhile, the New Yorkers absorbed the nonobjective, biomorphic Surrealism of Miró, Masson, and Matta (Figs. 305, 306, 340, 395), and eagerly followed the latter in his continuing exploration of automatic drawing. This truly engaged the Americans, for not only did it tap the deep, inner wells of feeling from which they wanted to extract their art, but it also yielded all the freshness and individuality of personal handwriting.

At the same time that the war helped the New Yorkers to perfect their methodology, it also aided them in their search for significant content. The holocaust in Europe exposed all too cruelly that, instead of the utopian rationality evoked by the immaculate and measured works of the Constructivists, the human race appeared to be dominated by the dark and irrational underside of its nature. To express this, the Americans followed the Surrealists and probed within themselves as individual but representative human beings. Thus, Surrealism showed the way, but when the dream psychology of Freud, the Surrealists' great mentor, proved alien and overintellectualized, the Americans turned to Jung and his theories of archetypes and the collective unconscious. And instead of illustrating their dreams, they relied on the automatic process itself, the graphic equivalent of free association. Such a methodolgy gave precedence to process over conception, which reversed the order of values in Cubist abstraction, with its intellectually derived notion of form. But when controlled by the New Yorkers' sure grasp of Cubism's flat, structured space, the approach provided not only a means of mining the subconscious for emotions common to all humanity, but also a way of transforming, through self-revelation, color and drawing into a visual metaphor for existential values, a grandiose, universal metaphor of the transient, ambiguous, and ultimately tragic nature of the human condition.

Finally, the war benefited the Americans by sending them, along with the glittering stars of modernist art, one of their most important collectors and promoters, Peggy Guggenheim. In 1942, when Miss Guggenheim inaugurated her gallery-museum called Art of This Century she wore one earring designed by Tanguy and another by Calder in order to show her "impartiality between Surrealist and abstract art." Almost immediately she began to present the canvases of young American painters whose work represented a startlingly original synthesis of these two major tendencies: Pollock, Motherwell, Baziotes, Rothko, Still, Gottlieb, and David Hare. Moreover, she showed them right along with the great masters of European modernism. Miss Guggenheim placed Pollock under contract and gave the sixty-seven-year-old Hofmann his first one-man show in New York City, and by the time she returned to Europe in 1947 the New York School had already crossed the threshold to its place in history.

For all the commonality of their experience and aspiration, however, the artists of the New York School did not actually think of themselves as a group with common ideals. Though all wanted to use personal intuition to make something new, distinctively American, yet universally valid out of the modernism inherited from Europe, each sought to avail himself of an infinite set of options, and each strained after his own direction. As the critic Harold Rosenberg noted, each was "fatally aware that only what he constructs for himself will ever be real to him." As a result, the term Abstract Expressionism, generally used to identify the art of the first generation, is much too broad and inclusive to be any more apt than such previously arbitrary terms as Fauvism and Cubism. Although first used by Alfred Barr in relation to Kandinsky's early improvisations, Abstract Expressionism came into common currency only after 1950, when critics began trying to characterize the qualities peculiar to the new American painting. In actual fact, however, the New Yorkers who painted in an overtly expressionistic manner did not always produce purely abstract works, and those who pursued more programmatic nonobjective styles assiduously avoided the vehement, personal brushwork usually associated with Expressionism. Cutting across their myriad differences, however, many viewers

> **481.** Lee Krasner. Untitled. c. 1940. Oil on canvas, 30×25". Courtesy Robert Miller Gallery, New York.

The New York School: Abstract Expressionism

have tended to see the New York School in terms of its members' all-important process, and thus divide the group between those who revealed themselves in an extrovert, spontaneous, gestural, or painterly kind of drawing and those who adopted a more quietistic, cerebral, or contemplative facture, yielding open fields of flat or atmospheric color.

Action Painting

Around 1950 the gestural branch of Abstract Expressionism earned the label "Action Painting" from its most ardent apologist, Harold Rosenberg. The earliest painter eligible (posthumously) for such a designation was Arshile Gorky (1905–48), who arrived in New York from Armenia in 1920, haunted by the Turkish massacre of his countrymen, thus doubly endowed with a tragic vision. A veritable "Geiger counter of art," as de Kooning called him, Gorky set upon the ambitious task of humbly working his way through the entire history of modern art, from the Impressionists forward. Eager to embrace it all, he finally attempted nothing less than a fully integrated merger of modernism's two most divergent streams: Cubism and Surrealism. For long, his paintings seemed too obviously subservient in their dependence on Picasso, Matisse, Gris, and Miró (Fig. 482), although even in his most self-effacing pastiches he left the unmistakable stamp of a unique artistic personality, marked by

color of almost Asian opulence, an elegant, ecstatic, or even painfully attenuated line, and plumelike, biomorphic shapes ripe with sexual fantasy. Finally, in the early 1940s, the Surrealists, especially Matta and Masson, and landscape enabled Gorky to liberate himself from eclecticism and achieve his own mature style (Fig. 484).

Matta, as we observed in Figure 340, used translucent washes to create an illusion of fluid forms dissolving in an infinite spatial depth. The Chilean artist called his landscapes psychological morphologies or "inscapes," and he created them by spilling thin films of paint on canvas, spreading these with rags, and then using the brush to define smaller areas and shapes. Accidents of spilling suggested definition and meanings, and thus upheld the improvisational and random bias of the formal Surrealists. For Gorky, Matta's fantastic interior landscapes were clearly of more interest for their fluid forms than for their theatrical effects, which often seemed too reminiscent of the meticulously painted pictorial illusions of Dali and Tanguy. Gorky therefore assimilated the atmosphere of Matta's veiled eroticism but turned his own sensuality to a different account. He transformed Matta's spatial theater into abstract and anti-illusionistic shapes that had their impact principally through paint marks and material surface.

In 1944, Gorky finally succeeded in subsuming the more obvious Surrealist influences to create a more personally identifiable and authentic imagery. That year, working on farms in Connecticut and Virginia, he sketched in open fields, but, instead of recording the exact image of nature, he reconstituted it imaginatively in automatic, doodled drawing (Fig. 483). Back in the studio, he then proceeded almost as a Renaissance master would have and transformed his drawings "from nature" into full-scale paintings, works that have all the freedom and color of Kandinsky's improvisations, the draftsmanly refinement of Ingres (for whom the artist harbored a deep admiration), Cubism's firmness of structure, and a Miró-like fantasy, all blended into a unified whole by the artist's own special poetry.

In Agony (Fig. 484) the characteristic Surrealist ambiguity of shape and the emphasis on spontaneity fostered by automatist techniques remain pronounced but have been assimilated to a highly personal style. Mixed references to botanical elements and to male and female genitalia are the only recognizable forms to emerge from an anarchistic swarm of linear overwriting and color spotting. The vaguely erotic mood is perhaps the most important aspect of Gorky's continuing attachment to Surrealism, but the element of pictorial improvisation also evokes Kandinsky and, more significantly, links this work to the pictorial methods of such emerging Abstract Expressionists as Pollock, Hofmann, and de Kooning, who also gave surface, material pigment, and brushstroke a wider role at the expense of traditional illusionism.

The refugee Surrealists took Gorky to be one of their own, and indeed he and Matta, Gorky's closest friend, were the last painters whom Breton officially admitted to the charmed circle. But the Abstract Expressionists were also happy to claim him. Actually, he was a great synthesizer and may be viewed as a transitional figure, for even with all his remarkable instincts and painterly gifts, Gorky lacked the primitive force and energy to bring on the "new" in art. If his work was perhaps equivocal in marking out new possibilities for painting, on another level it also represents the most voluptuous flowering of abstract Surrealism in the generation that succeeded Miró. At the peak of his powers, Gorky suffered a new series of

left above: 482. Arshile Gorky. *Enigmatic* Combat. c. 1936. Oil on canvas, 35¾ × 48″. San Francisco Museum of Art, San Francisco. Gift of Miss Jeanne Reynal.

left below: 483. Arshile Gorky. The Apple Orchard. 1943–46. Pastel on paper, 3'6"×4'4". Collection Mario Tazzoli, Turin.

misfortunes. In 1946 a fire in his Connecticut studio destroyed a large portion of his recent work. When an operation for cancer the same year left him impotent, his marriage disintegrated. In 1948 he broke his neck in an automobile accident and committed suicide shortly thereafter.

The German-born Hans Hofmann (Fig. 479), whose immense influence as a teacher of the American avant-garde has already been discussed, can justly claim priorities in exploring the freer modes of Action Painting. As early as 1944, in the painting titled *Spring* (Fig. 485), he invented the technique of dripping and spraying paint on the canvas surface, a method that Pollock would later appropriate, develop more consistently, and then canonize. In his conversations, Hofmann distinguished between traditional concepts of fixed form and the idea of mobile form that might serve a process of continuous mutation and spatial movement. In his work, paint stroke, mark, drip, and splash instantly registered as coherent and intelligible

above: 484. Arshile Gorky. *Agony.* 1947. Oil on canvas, 3'4"×4'2". Museum of Modern Art, New York. A. Conger Goodyear Fund.

left: 485. Hans Hofmann. *Spring.* c. 1944–45. Oil on wood panel, 111/₄×141/₈". Museum of Modern Art, New York. Gift of Mr. and Mrs. Peter A. Rübel.

The New York School: Abstract Expressionism

when they encountered the canvas surface. This was the generic painting style that would revolutionize art produced in the United States during the 1940s.

Another New Yorker from abroad, this time from Holland, and rich in the culture of modern art, was Willem de Kooning (1904-97), who brought with him, when he jumped ship in 1926, the rigorous academic training of his early years in a Rotterdam art school. Although closely associated with Gorky and, for long, as eclectic as that artist, de Kooning would mature to become one of the most original of the Abstract Expressionists and a true giant of Action Painting. He would also be the member of the New York group with the most enduring commitment to the human presence. Among the several styles that, Picasso-like, he practiced simultaneously in the thirties, de Kooning did a series of portraits and figure studies whose eroded forms seemed to anticipate the late images of Alberto Giacometti, although the nascent energies of his powerful, slashing brushstrokes predicated a different and more violent pictorial expression. In the 1940s, under the impetus of Surrealist automatism, de Kooning so fragmented human forms that their explosive distortions and incompleteness recalled Picasso's fantastic anatomies of the late 1930s (Figs. 486, 391). From such imagery, essentially rooted in Surrealism, it was only a short step to the freely registered, abstract color shapes of his mature style.

In a series begun around 1947, de Kooning seemed determined, like Gorky, to realize his own personal synthesis of Cubism and Surrealism, but by eliminating color, as the Analytic Cubists had done, in favor of a simplified black-and-white palette and by so dismembering the figure that, once composed montage fashion, the anatomical parts become little more than abstract vectors of human meaning. Pictures such as *Excavation* (Fig. 487) exhibit all the

above: 486.

Willem de Kooning. Pink Angels. c. 1945. Oil and charcoal on canvas, 4'4" x 3'4". Weisman Family Collection, Beverly Hills.

eft: 487.

Willem de Kooning. Excavation. 1950. Oil on canvas, 6'81/8" × 8'41/8". Art Institute of Chicago. Mr. and Mrs. Frank G. Logan Puchase Prize; gift of Mr. and Mrs. Noah Goldowsky and Edgar Kaufmann, Jr. flatness, interpenetration, and firm infrastructure of a high Analytic Cubist work, but the planes have been shifted and shuffled far more dynamically, even compulsively, and their ambiguity is of the dark, anxious sort dredged up from the Surrealist subconscious. Moreover, the abstract biomorphic imagery has been so impacted that it connotes, even in flatness, a plenitude of form symptomatic of an artist weaned on the opulent painterliness of Rubens and Rembrandt. A teeming composition, Excavation is representative of de Kooning's complex and dense style, with its suggestions of both human anatomy and the life of the city. As one critic described the work, "parts do not exist. . . . It is impossible to tell what is on top of what." Clearly the product of countless revisions, the picture in certain passages resembles a palimpsest of overlaid stages, with vagrant, unsuspected colors seeping through the cracks from lower strata laid down during earlier campaigns of frenzied brushwork. The sheer activism of the atomized surface links the work with Jackson Pollock's concurrent open drip paintings (Fig. 493).

In de Kooning's art, as in most of Abstract Expressionism, process by disclosing itself with such dramatic candor becomes content, and the sheer weight of this achievement assured de Kooning a leadership position in the new American avant-garde. With brilliance and éclat, he managed to combine qualities of personal intensity and plastic finesse, a furiously muscular brushwork and refined abstract calligraphy, traditional figuration with a tensely structured, depthless space. For a new generation of American artists intent on selfdefinition through painting, de Kooning came to represent the essence of their sense of commitment in the search for contemporary authenticity. Overnight he attained the status of Existentialist hero, one who risked everything willingly in the "act" of painting and boldly lived his personal drama through the creative process. The speed with which he executed his paintings, the hot improvisational rush of his images, and even his messy, overworked surfaces fused time, gesture, and event in a new unified pictorial structure.

For de Kooning, art and life were to be conquered dangerously, each by means of the other. His painting became the potent antidote to lifeless abstraction and any rigid formal principle. "Art never seems to make me peaceful or pure," he once wrote. "I do not think of inside or outside—or of art in general—as a situation of comfort... Some painters, including myself, are too nervous to find out where they ought to sit. They do not want to 'sit in style.' Rather, they have found that painting ... any style of painting ... to be painting at all ... is a way of living today. That is where the form lies.'"

It was in this context that de Kooning invented his most famous image series, Woman (Fig. 488), which seems to have an ancestress in the figural paintings of Chaim Soutine (Fig. 375), as well as in Picasso's Girl before a Mirror (Fig. 338), a masterpiece acquired by New York's Museum of Modern Art in 1938 and a source of vital inspiration for the Abstract Expressionists. Even a solidly academic artistic education and the mandarin influence of Gorky did not prevent de Kooning from returning to an early obsession with this cult image. The series scandalized the more rigidly nonobjective American vanguard artists, who viewed it as a surrender to a pallid neohumanism. In fact, the Woman pictures were just the opposite, an assertion of individual freedom, and they established the relevance for high art of American pop culture and the urban environment, which in due course produced Andy Warhol's more detached, mechanical Marilyn Monroe series, ironically enough. The open de Kooning "image" repudiated style and studio professionalism, but it nonetheless seemed to encourage a surprising

> **488.** Willem de Kooning. Woman and Bicycle. 1952-53. Oil on canvas, 6'4½"×4'1". Whitney Museum of American Art, New York.

range of expression, from the refined lyricism of Jack Tworkov, the structured fluencies in paint and collage of Esteban Vicente, to the distinctive personalizations of the de Kooning idiom among an emerging corps of brilliant young painters, soon to be encountered (Fig. 541). For a decade and more, after his first one-man show in 1948, de Kooning became the acknowledged leader of progressive American painting, providing a dictionary of vital pictorial ideas and a departure for new explorations.

In later years the trapped energies of de Kooning's claustrophobic spaces escaped into a more controlled and calm external environment. Eventually, the Woman would include elements of both comedy and lyricism in her metamorphosis as landscape (Fig. 489). Many of the familiar color contrasts of virulent pinks and yellows set against electric blues and greens remained in evidence, but they no longer evinced the old bite of aggression. The mood became pastoral and even tender, identifying the torn and dismembered human figure with the vast expanses and openness of nature. De Kooning's late paintings seem bathed in the pristine light of the gentle Long Island seaside, where, for many years, the artist has maintained his studio, reminding one in mood, luminosity, and even configuration of Dutch landscapes. The sense of personal crisis and desperation that linked de Kooning's earlier paintings with the philosophical concept of alienation finally dissolved in the vast reaches of sky, the brilliant light and soothing horizontals of a benevolent marine environment.

The most dramatic evidence that a limited repertory of gesture and a monochrome palette could densely elaborate pictorial structure was to come from Franz Kline (1910–62), one of the powerfully concentrated talents in the American vanguard. Until 1950 Kline had been a figurative painter of Social Realist inclinations, and even when he gave up recognizable subject matter, his abstract pictorial structures tended to evoke the snowbound, coal-stained industrial architecture of his native Pennsylvania. Always a passionate draftsman, Kline discovered abstraction in 1949 when he began to examine his black-and-white drawings by enlarging them through a projector. Magnified in this way, they assumed the monumental simplicity of abstract art. Using cheap, commercial paints and housepainter brushes, he attached canvas to the wall and completed his conversion to a full-fledged Abstract Expressionist style (Fig. 490). In his first one-man show in 1951 Kline demonstrated something of de Kooning's vigorous decisiveness within an essentially equivocal expressive language. By drastic simplification of image, and the reduction of his palette to black and white. Kline made his brushstroke convey with unexampled directness the surging moment of creation. The forms he produced have often tempted viewers to see them as related to Asian art, as gigantic enlargements of ideograms, but the resemblance is misleading. As Kline said, "People sometimes think I take a white canvas and paint a black sign on it, but this is not true. I paint the white as well as the black, and the white is just as important." Because his great ciphers immediately transmitted the energies of bodily action and the physical movement of his brush, Kline produced an art that seemed to express perfectly the idea of gesture and action in painting as a value system. That such a stark, heroically reduced visual rhetoric could communicate with authority and encompass the most complex meanings in the interplay of forms has been one of the enduring revelations of Action Painting.

Wyoming-born Jackson Pollock (1912-56), one of the most mythic of modern painters, emerged as a major luminary of the New York School as early as 1943, when Peggy Guggenheim gave him his first one-man show at Art of This Century. Startled viewers seemed to sense already that here was an American artist capable of "going the full length." And in this may lie Pollock's greatest contribution, his willingness to expend himself extravagantly and profligately, often at the cost of the harmony and coherence of individual paintings, in order to take possession of the modern abstract picture with a power and intensity that have become legendary (Fig. 493). The paintings Pollock exhibited in 1943 made the first and most emphatic public expression of the new mood (Fig. 492). Everything that had been amorphous, contingent on circumstance, and unstable in advanced painting came into focus in his new art. The unwavering pitch at which he registered his own sensations and even revealed his uncertainties lent a new confidence and security to the American vanguard.

Pollock had grown up in Arizona and Southern California, and geographical impressions may very well have played a significant role in the development of his painting. He described his delight as a

above: 489. Willem de Kooning. Woman in Landscape IV. 1968. Oil on canvas, 4'113⁄4"×4'. Private collection. Courtesy Xavier Fourcade, Inc., New York.

right: 490. Franz Kline. Monitor. 1956. Oil on canvas, 6'6" × 9'6%". Private collection, Milan.

below: 491. Jackson Pollock. Square Composition with Horse. c.1934–38. Oil on rough side of masonite, $17V_4''$ square. Estate of the artist.

right: 492. Jackson Pollock. *Pasiphaë*. 1943. Oil on canvas, 4'8½"×8'. Metropolitan Museum of Art, New York. Purchase, 1982.

youth at seeing the Western landscape, immense and illimitable, unroll before him from freight trains or his old Ford. He retained something of the restiveness of his youth and an unformulated, primitive sense of the vastness of things American. A rootless feeling that was as sharp as his instinctive distaste for social restraints, real or imagined, persisted throughout his life. Growing up in the Far West but maturing in New York City, Pollock would struggle the whole of his life with the conflict, brutishness, passion, and chaos of his nature and experience-which included not only poverty, alienation, and world holocaust, but also alcoholism-until he wrested from them an order so transcendent that in certain of his works it possesses the harmony and balance of the genuine classic. However, an ever-present threat of violence charges even the most serene works with a special tension, and indeed the artist would die at the age of forty-four in an automobile accident, a tragedy that seemed more self-inflicted than purely fortuitous.

Pollock began his artistic education in 1929, when he appeared at the Art Students League in New York and entered the class of Thomas Hart Benton, the master of homely American Scene realism (Fig. 458). It is significant that Pollock found his independence not so much in reaction to Benton as *through* him, by re-creating, amplifying, and exaggerating his first teacher's rhythmic distortions under conditions of greater intensity, until his forms achieved a different order of life. Pollock also claimed to have been affected by the free, mythic quality of Indian sand painting, as well as by the brooding inwardness of Ryder's art (Fig. 440), painted and repainted until the pictures verge on an Expressionist variety of abstraction. And in a sense Pollock did arrive at nonobjectivity by pushing Expressionism to a point where subject matter was so improbable that all need to retain it had been eliminated.

The arrival occurred immediately afterwards, first in his bold distortions based on Mexican painting and then in his rapid and aggressive assimilations of Picasso and European modernism. In the late thirties, Pollock filled notebooks with abstract anatomical themes that were Picassoid, but with a difference. To Picasso's delimited, contained abstract imagery of the period Pollock applied his own expansive energies, with startling and novel results (Fig. 491). His nervous, broken line shredded Picasso's fantastic anatomies, reducing them to a system of expressive accents or more generalized thematic variations. Carried away perhaps by a random inventiveness in line, Pollock had begun to create more evenly distributed effects. They broke up the unity of Picasso's abstract figuration and became the first step toward a free and cursive calligraphy that would totally dispense with image suggestion.

In 1942, Pollock participated in his first New York group show, organized by John Graham at the McMillen Gallery. Showing with him were Graham, Lee Krasner (eventually Mrs. Pollock), and Willem de Kooning. Also in 1942 Robert Motherwell introduced Pollock to Peggy Guggenheim, who the following year would give the thirty-one-year-old artist his first one-man show, mounted at Art of This Century. Among the paintings he offered at this time was *Pasiphaë* (Fig. 492), a work whose totemic image and mythic theme reflected the artist's current involvement in Jungian analysis, as well as the general interest the New Yorkers then had in Jung's theories of archetypes and the collective unconscious. In *Pasiphaë* Pollock's baroque energies took him to a new form of expression that relieved the dense, impacted surfaces of Picasso's late Cubism with the

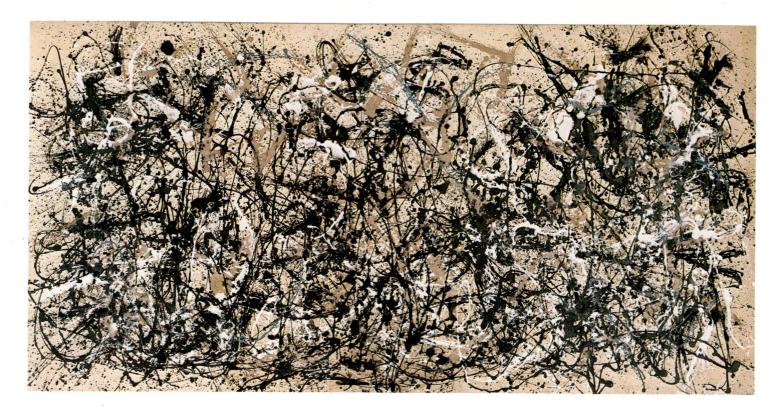

fluent, abstract imagery of Miró and the "automatism" of André Masson. To the Surrealists Pollock owed not so much the form of his own distinctive all-over "writing" as the notion that the painting was to be ejected continuously, in one seeming burst. The wriggling lines and agitated movements of Pasiphaë recall Miró in his 1924-26 period (Figs. 307, 308). Miró, however, floated his shapes on a ground, giving his pictorial incident a setting and hinting at illusion. His shapes kept their integrity as individualized forms despite their metamorphoses. From Miró's ingenious and inventive mind streamed an anarchic abundance of new life and pictorial incident, with an effect of multiplicity and particularity. Rooted in modern tradition, he could afford to play and pun, to sport with his own fears and to make an enchantingly witty game of them. For Pollock, on the other hand, abstract painting was an altogether more solemn and even desperate matter. He felt compelled to be more savage and self-absorbed and had nothing of the artistic playboy about him. The ambivalent artist saw the abstract picture as the elementary expression of belief, and in this conviction lay his power and originality. Pollock's paintings groped from the particular to the general, from a

top: 493. Jackson Pollock. Autumn Rhythm. 1950. Oil on canvas, 8′9″×17′3″. Metropolitan Museum of Art. George A. Hearn Fund.

below: 494. Jackson Pollock at work in his studio at East Hampton, Long Island. 1950. Photograph by Hans Namuth.

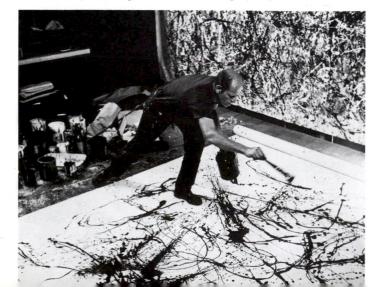

chaos of expressive accents to the single statement. He dissolved and fused his vague references to a chimerical subject matter into a unified, impersonal scheme. After the picture was completed, he named it for the chimera it still rather irrelevantly suggested. In the end, however, the painting had become a continuous field of uniform accents where it was impossible to distinguish between scrolling lines of paint and phantasmagorias, between the near and the far, the symbolic and the plastic.

Aided by the famous, or notorious, "drip" technique that he began using in 1947, Pollock gradually found the means to spread his gloomy and morbid intuitions over a broader surface, and to surrender most of his inner compulsions to a calm and measured lyricism (Fig. 493). The vaguely imagistic references to his own fears and fantasies stopped crowding him and gave way to more sweeping and grandiloquent rhythms and a new clarity. His work no longer suggested presences, fearful or otherwise, or a mood of exasperation, but only a generous and impersonal flow of pictorial energy. He had won a new breadth of feeling as he learned to master larger surfaces. As Hans Namuth's dramatic series of still photographs and his film of Pollock at work demonstrate (Fig. 494), the artist painted by standing over a canvas and letting paint spill onto it from above until he had achieved the rhythmic movements, varied densities, and textures desired. The results were probably the most original series of paintings of the immediate postwar period in American art. Yet they were a logical, if unexpectedly ambitious, extension of Pollock's early style. He had merely given his open, drip paintings a larger theater. An aerated web of silver and black line, of spattered paint, against a background of delicate color diffusions and stains, replaced the old opaque, resistant pigment. But despite the lyrical sublimation of his more turgid style, something of the original tension of Pollock's feeling remained. In Cathedral of 1947 and the beautiful Lavender Mist of 1950 there are congealed puddles of color and blotches of dark tone swimming ominously amid all the elegant rhythmic phrasing, like disembodied ghosts of the artist's earlier black moods.

In his predominantly silver monoliths, Pollock took painting ever closer to a kind of fragile, open-form, continuous-space relief sculpture. Simultaneously, he also pulverized the flat, two-dimensional effect that he had in the past been at pains to emphasize, and which had been perhaps his strongest link with Cubist surfaces. But Pollock's modernity, his mistrust of anything but the immediately given sensation, always asserted itself in the end. Even in his freest inventions he restored the physical reality of the planar surface by letting his pigment clot or by slapping the unsized edges of the canvas with his paint-dipped palms. Sometimes the synthetic, industrial textures, the moraine of sheer pigment matter, seemed to choke his instinctive grace and lyricism, and a kind of gummy, displeasing effect resulted. Occasionally, Pollock also sowed his painting surface with such vulgar debris as cigarette butts, matches, keys, and even a toy horse's head, the better to anchor the art to the sensuous world even as the abstract image verged on escape into a realm of pure spirit. At their finest, however, the great silver paintings from 1947 to 1950 breathe an easy, natural grandeur that has few parallels in contemporary American art. For many, they arouse primitive feelings associated with such sonorous phrases as "the deep" or "the starry firmament," identifying a universe beyond the human. It was one of Pollock's signal accomplishments to give such magnitude and impressiveness to the act of painting as to make us think of the mysteries of natural creation, of that "first division of chaos" at the origin of our world.

Pollock's technique of spreading uncut lengths of duck over the floor and of pouring or flinging liquid paint onto it from above permitted him to "literally be in the painting," to move about within it and thus give equal emphasis to all parts. In this way he brought to a culminating moment the tendency first felt in 19th-century Impressionism to orient a composition not toward a specific climax within a hierarchy of images but in favor of a single characteristic image articulating the whole of the visual field as a densely packed continuum. Confronted with the *perpetuum mobile* of Pollock's calligraphic complexity, the eye gives up following along endless convolutions and accepts the indivisibility of the total labyrinthine configuration. Although anticipated in Impressionism, this—the socalled "holistic" composition—was something new in modern art.

495. Mark Tobey. *Tundra.* 1944. Tempera on board, $24 \times 16\frac{1}{2}^{\prime\prime}$. Neuberger Museum, State University of New York at Purchase. Gift of Roy R. Neuberger.

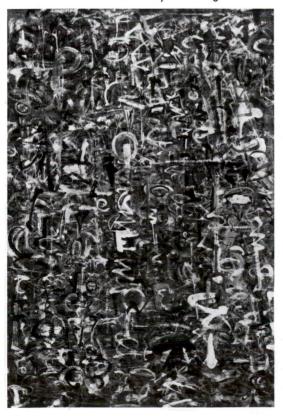

Instead of a composition as a unity made up of intimately related parts—a traditional concept that even Mondrian endorsed—Pollock succeeded, as a result of his automatic process, in reconceiving the picture as a single undifferentiated image without segregable parts.

Elsewhere this "optical" character of Pollock's "field" paintings would hold more interest than their gestural vehemence, and the idea would be carried to the point of treating the picture's space as unbounded and unstructured. Number One, Autumn Rhythm (Fig. 493), and other monumental canvases of about 1950 eventually ceased to be understood simply as manifestations of emotional release. Now they are valued for their environmental scale and visual dynamics, which seem to erase the frontiers between the work of art and the space the audience occupies. More often than not, Pollock's greatest works are linked historically with the late water landscapes of Monet (Fig. 21), as well as with the Color Field Painting that would mature in the 1960s. In his own art, however, Pollock remained the committed Cubist and controlled his vortex by containing it within the shape of the support. The pattern is not run-on, as in wallpaper or yard goods, but oriented toward the edges of the canvas, as if the rectilinear scaffolding of Cubism had been enlarged to universal scale and then dematerialized into atmosphere without any loss of its structuring power. Thus, in its never-ending resolutions, the drawing, which has now been transformed into painting, seems to lie on the surface or hover within a shallow space in front of and free from the background, the uniform color of which suggests infinite depth, or a near plane like that in the recess of a basrelief.

By 1952 Pollock could no longer sustain the tense and precarious balance he had struck between so many fundamentally hostile elements—Cubism and Surrealism, form and content, reason and emotion, control and expression, surface and depth. After 1950 he tried other approaches, but not enough time remained in his short life for him to develop any of those to the epic level of his "all-over" poured paintings made in the incredibly fertile years of 1947–50.

An artist who anticipated Pollock's all-over abstract image was Mark Tobey (1890-1976), a much older American and essentially unrelated to the New York scene, since he spent the years between the World Wars in Europe and China. Moreover, his route to a proto-holist composition lay not through Cubism and Surrealism, but rather through Chinese calligraphy and brushwork, which he studied in a Zen monastery. The sheer refinement of his so-called "white writing" and genial mysticism stands in marked contrast to the raw power and tragic obsessions of the Abstract Expressionists (Fig. 495). While Pollock, de Kooning, and Franz Kline registered their abstract imagery with vigorous gestures of the entire body, or at least of the arm, and with broad muscular strokes, Tobey restricted his cursive writing to wrist and hand movements. His paintings, although transcendental in mood, are also more intimate and elegant than those of his American contemporaries. He utilized a wiry, crisp, and fluid line in rich combinations to build a texture of strokes that makes space a tangible reality and finally, too, a persuasive symbol of universal meanings. Little wonder, then, that Tobey enjoyed a high reputation in Europe, where he spent his last years, living near Basel.

Color Field Painting

The absorbing drama of Pollock's great paintings of 1949 and 1950, *Number One, Autumn Rhythm*, and *Lavender Mist*, for instance, and de Kooning's *Excavation* and *Attic*, are not to be understood merely as gestural display or virtuoso performance. They are too sustained, profound, and deeply meditated structures for a restricted reading as cathartic, Expressionist outbursts. Moreover, the uniform painting field and the monolithic kind of pictorial order they embodied was already visible in the paintings of Newman, Rothko, and Still. The

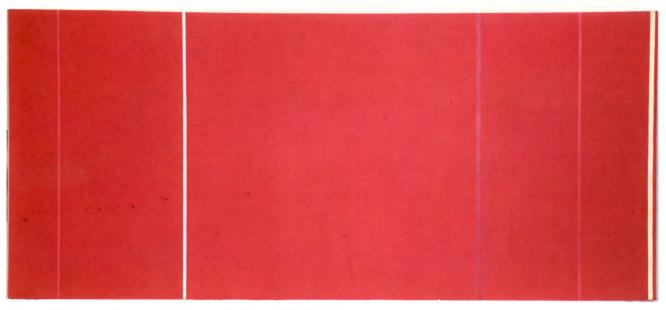

above: 496. Barnett Newman. Vir Heroicus Sublimis. 1950–51. Oil on canvas, 7'11¾"×17'9¼". Museum of Modern Art, New York. Gift of Mr. and Mrs. Ben Heller.
below: 497. Mark Rothko. Maroon on Blue. 1957–60. Oil on canvas, 7'8"×5'10½". Private collection.

art of these masters had disengaged itself from excited linear drawing, fragmentation of forms, and dynamic gesturalism, and by the late 1940s it stood at the antipodes of energetic Action Painting. Whereas Pollock and de Kooning articulated space on a monumental scale by the acceleration and disintegration of form, Newman, Rothko, and Still gained a potent expansive force by decelerating the motion of their small variegated shapes and merging them into dominant islands, zones, and boundless fields of intense, homogeneous color. In place of the hand's motor activity, chromatic sensation and retinal ambiguity played on the dynamics of perception to express qualities of change. Still more important, the rich painterliness of the conventional Action artists gave way to thinner medium, thus allowing material sensuousness to be supplanted by a new kind of purely optical experience. In this way the chromatic abstractions created unvaried stretches of usually bright hue in unbroken "color fields," rather than fields of sequential linear detail, agitated surface, and formal diversity. Painting large, they intended their canvases to subdue the spectator's ego and create a sense of tranquil awe.

Some of these significant changes can be experienced in the immense red color field of Vir Heroicus Sublimis (Fig. 496), by Barnett Newman (1905-70). This picture, measuring almost 18 feet wide, deals with pictorial decorum in a new way. The familiar, nervous spatial movement, flux, and calligraphic signs of Abstract Expressionist painting have been eliminated, and replaced, absorbed, and grandly solemnized by a complex pulsation of highkeyed color over a pictorial terrain of vast expanse, divided by five vertical bands. These fragile and oscillating "zips," as the artist liked to call them, play tricks on the eye and the mind by their alternate compliance and aggression. Brilliantly visible yet all but subliminally lost against the vivid color ground, they produce curious retinal afterimages. For Newman, the zips served to "cut" the great plane of saturated hue and shock it into waves of visual energy that roll back and forth between bands and edges, thereby making dynamic what otherwise might seem a totally static image. The zips can also be read as abstract figures standing out against a wall of color; in this way, a third dimension enters the viewer's perception of what is an irreducible flatness. Still, their cunning equivocation subverts the concepts of division and geometric partition, replacing Cubist compositional strategy with a single-image, or field, gestalt. In this powerful and transfiguring visual drama, which Robert Rosenblum has

The New York School: Abstract Expressionism

characterized as "the romantic sublime," the enormous expanse of red mystically subdues the mind, as any "oceanic" experience in nature moves us off our ego center. At the same time, the encounter is intellectually challenging, since problems in visual interpretation are posed which require special attention and alertness. For instance, just as the powerful vermilion seems about to soar out of control, the

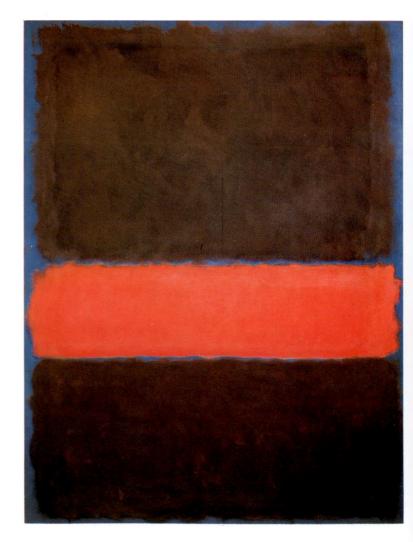

zips remain stable enough to define a perfect, "secret" square at the center and another in the combination of irregular, secondary fields that unfold on either side. Newman's sources, like Pollock's, were momentary and, despite his repeating optical stripe and geometric structure, take account of the spectator's psychological absorption in the large spread of color form and the effort required to perceive the work as an equilibrated totality.

The most renowned of all the Color Field painters may be Mark Rothko (1903-70), who with his stacks of glowing, atmospheric rectangles (Fig. 497), carried the idea of pure color abstraction to less radical lengths than did the starkly flat planes and straight-edged zips painted by Newman. Rothko gave up figural painting, for, despite the inspiration he found in Nietzsche's The Birth of Tragedy, Expressionist distortion of the human image struck him as fraught with intolerable connotations of sadism. Instead, he adopted Surrealist automatism to conjure up biomorphic cryptographs combining various forms of life and rendered them with a soft, disembodied facture, to evoke, as the artist stated, "the Spirit of Myth, which is generic to all myths of all times. It involves a pantheism in which man, bird, beast and tree-the known as well as the unknowable-merge into a single tragic idea." Around 1947, for the sake of endowing the Spirit of Myth with a greater sense of the supernatural, Rothko eliminated every vestige of identifiable subject matter from his art, and by 1950 he had realized his archetypal form, consisting of a large rectangular field, usually tall, subdivided into two or three superposed or symmetrically arranged rectangles set against a ground of contrasting color (Fig. 497). By staining the shapes directly into unprimed duck and by bleeding their blurred contours almost to the edges of the canvas, he etherialzed the forms and fused them to the flatness and format of the canvas. This technique, carried out more with sponges and rags than with brushes, not only had the hallucinating effect of rematerializing the immaterial; it also endowed the total field with the holism and indivisibility of the classic Abstract Expressionist composition. With his love of thin, radiant color and his conviction that color, in its infinite variety of possible combinations, constituted a self-sufficient medium powerful enough to express any idea or emotion, Rothko found kinship with both his friend Milton Avery (Fig. 462) and the great Matisse. But as his frontal, iconic, altar-like pictures imply, Rothko had a transcendental vision remote from the optimistic, earthbound spirit of his hedonistic associates. Lest the viewer be tempted to treat his pictures as objects designed for pure aesthetic delectation. Rothko made this statement:

I am not interested in relationships of color or form or anything else. . . . I am interested only in expressing the basic human emotions—tragedy, ecstasy, doom, and so on—and the fact that lots of people break down and cry when confronted with my pictures shows that I *communicate* with those basic human emotions. The people who weep before my pictures are having the same religious experience I had when I painted them. And if you, as you say, are moved only by their color relationships, then you miss the point!

True to the modernist tradition of mixed modes and media, several of the New York artists succeeded in formulating distinctive new styles by combining characteristics of both gesture and chroma. The most striking example of this intramovement eclectism may be the art of Adolph Gottlieb (1903–74), who favored a field—again tall and heraldic—split between a flat, stained-in, glowing disk suspended above a spectacular display of broad, liberated brushwork (Fig. 498). Whereas the one invites a quiet, slow assimilation of the painting's components, the hurried tempo and helter-skelter randomness of the other demands a more active kind of involvement. Complicating the tension between such polarities is the aggressive color of the essentially passive disk and the withdrawing, relatively inert color—often black—of the dynamic explosion below. Meanwhile, the background of contrasting hue, depending on its relation-

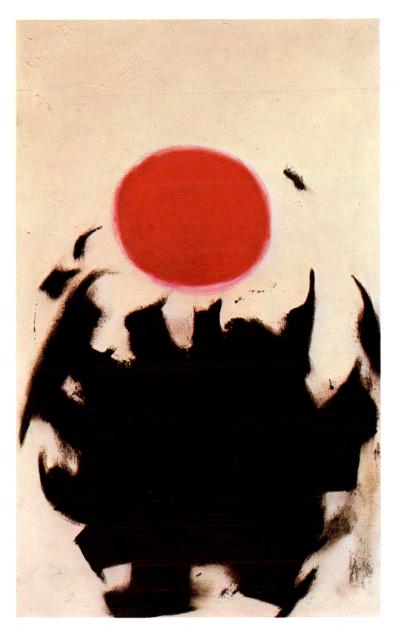

498. Adolph Gottlieb. *Red Earth*. 1959. Oil on canvas, 4'11%" × 2'11%". Collection Cavelini, Brescia.

ship to the other two colors, serves to unify a surface beset with conflict and fix its dominant mood. Gottlieb's so-called "Burst" pictures can be seen as mutants of superseded Expressionist form, in transition from Expressionism's familiar content of freedom and decontrol to one of geometric stabilization. In an age of unabating nuclear anxiety, however, the Bursts have also, and often, been invested with awesome symbolic content by those unable to suppress the haunting memory of Hiroshima and Nagasaki.

Harvard-educated Robert Motherwell (1915–91), perhaps the most articulate of the Abstract Expressionists and the most thoroughly steeped in the culture of European modernism, provides another, as well as brilliant, exception to the either/or rivalries of liberated, painterly drawing and stable, controlled fields of color (Fig. 499). As early as 1944 the artist wrote that "all my works consist of a dialectic between the conscious (straight lines, designed shapes, weighted colors, abstract language) and the unconscious (soft lines, obscured shapes, *automatism*) resolved into a synthesis which differs as a whole from either." And within this synthesis lies the content of Motherwell's pictures, a content that reflects the artist's sensitive, cultivated response to the riven nature of contemporary

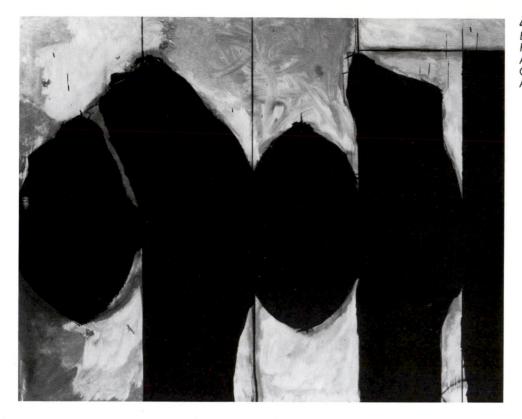

499. Robert Motherwell. Elegy to the Spanish Republic No. 128. 1974. Acrylic on canvas, 8 × 10'. Courtesy Knoedler Contemporary Art, New York.

experience, with its terrible conflicts of freedom and necessity. Thus, it was the Freudian, rather than the Jungian, elements within the repertoire of Surrealist iconography that drew Motherwell. From his earliest works, such as *Pancho Villa Dead and Alive*, through his long Spanish Elegy series, dedicated to the memory of the Spanish Civil War, Motherwell was concerned, like Freud, with the life-and-death opposition of Eros and Thanatos. This can be seen in *Elegy to the Spanish Republic No. 128* (Fig. 499), where light and dark, color and monochromy, austere design and sensuously evocative shapes, grand, sweeping planes of pigment and free, intimately gestural edges have been overlapped and interlocked until they resolve the contrary demands of rational pictorial structure and romantic painterly expressiveness.

Acute in intellect and historical sensibilities, Motherwell always felt impelled to identify his art with both emotions and events, under the literary influence of French Surrealism and the Symbolist poets and through contact with Picasso and Miró. Whether in the heroic Spanish Elegy pictures or in the Je t'aime series of paintings and the collages, celebrating moments in his personal life, Motherwell consistently regarded his art as a form of confession as well as a plastic expression within the modernist mainstream. In his collages especially, works guided by the mixed example of Picasso, Matisse, and Schwitters, Motherwell attained both personal catharsis and playful invention. This can be seen in Stravinsky Spring (Fig. 500), the impressive scale of which approaches that of the paintings themselves. Such is their quality that, over the years, Motherwell's collages have invited comparison with the great Cubist works of Picasso and Braque and with Matisse's cut-outs.

The Abstract Expressionists, in their manifest determination to reject all limitations on the formal and emotional possibilities of art, could readily embrace two decided but remarkable, and ultimately highly influential, mavericks. The senior of these was Clyfford Still (1904–80), an ornery and independent genius if ever there was one. Far from devoting his considerable energies to the assimilation of Europe's modernism, Still declared the past to be nothing but "a body of history matured into dogma, authority, tradition. . . . The

homage paid to it is a celebration of death." For the Cubists he reserved a special scorn, believing their paintings to be mechanically produced parlor art, and the Bauhaus variant of Cubism to derive from an authoritarian rationale capable of enslaving the human race. Like the pioneers of the American West, whence he came, Still revered the individual struggling in solitary, courageous effort to attain an absolute vision all his own. To whatever limited degree Still had antecedents, they would surely include J.M.W. Turner and Paul Gauguin. After 1947, when he began painting nonobjectively, the vision that Still would make famous consists of tundra-like fields of tarry, knife-applied pigment penetrated, from both above and below, by long fissures of contrasting color, as if rivers of acid lava were burning into one another from rival volcanoes (Fig. 501). With these flat, shredded shapes interlocked by their jagged edges and with the overall plane empty of horizontals capable of relating it to the shape of the canvas, the miasmatic surface assumes the holism and soaring expansiveness already seen in the paintings of Pollock, Newman, and Rothko. In rhetoric almost as molten as his abstract imagery, Still wrote of the artist as something of a Nietzschian hero seeking epic self-realization in metaphors of the sublime: "It was a journey that one must make, walking straight and alone. . . . Until one had crossed the darkened and wasted valleys and come at last into clear air and could stand on a high and limitless plain. Imagination, no longer fettered by the laws of fear, became as one with Vision. And the Act, intrinsic and absolute, was its meaning, and the bearer of its passion."

If Still can be seen as the most romantic of all the Abstract Expressionists, then his polar opposite within the group would have to be the equally absolutist *and* utterly rationalistic Ad Reinhardt (1913–67). But whereas Still denounced the past as "a celebration of death," Reinhardt derided the Abstract Expressionists themselves for what he called their love of "transcendental nonsense, and the picturing of a 'reality behind reality." Reinhardt joined the Abstract Expressionist movement after Cubist abstraction had gone dead for him and become little more than what Still had declared it to be: a mechanical picture-making technique. Owing to his Cubist background, however, the artist quite naturally avoided gesturalism and

below: 500. Robert Motherwell. Stravinsky Spring. 1974. Oil and collage on canvas, 47½ × 235/8″. Private collection.

right: 501. Clyfford Still. *Painting.* 1951. Oil on canvas, 7′10″ × 6′10″. Museum of Modern Art, New York. Blanchette Rockefeller Fund.

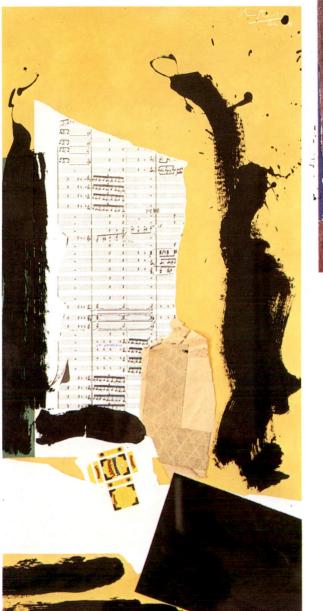

gravitated toward the field painting pioneered by Newman, Rothko, and Still. Gradually, by a rigorously intellectualized process of elimination, he reduced color, drawing, and, of course, imagery until he had refined his art to its very essence: a rectangle hand-painted in a single color and in the flattest way possible, but with enough differentiation in tone and texture to disclose a hard-edged internal structure of plane geometry (Fig. 502). The irony here is that not only do the squares into which Reinhardt subdivided the field come together as a cruciform configuration, but the exquisitely subtle variations by which this shape is revealed requires such close, concentrated looking that viewers may find themselves drawn into a trancelike state. Moreover, at the same time that Reinhardt repudiated everything supernatural, his uncompromising quest for an art of absolute purity

tended to elevate the nonobjective, totally self-referential painting to the status of holy object. Thus, for all his anti-romantic bias, Reinhardt had more affinities than he would have wished with the mystical Malevich of forty years earlier (Fig. 267), in the content as well as the form of his paradoxical and radically abstract pictures.

Eventually, Reinhardt's reductionism, both as an aesthetic and a process, would prove to be a major trend within the New York School, and a prediction, if not a direct influence upon, the dominant

502. Ad Reinhardt. *Abstract Painting*. 1960. Oil on canvas, 5' square. Courtesy Pace Gallery, New York.

Minimalist styles of the sixties, with their austere geometries and impassive, mechanically rendered or produced forms. But in the early 1950s, when Abstract Expressionism crested, it was Willem de Kooning, the master of broad-stroke, emotion-laden "action painting," who reigned supreme as the artist in whose work the new, upcoming generation of painters found the most promising possibilities (Fig. 541). In a famous article, written for *Art News* in 1952, Harold Rosenberg explained why, by pinpointing what he considered to be Action Painting's unprecedented departure from all known styles and aesthetic criteria:

At a certain moment the canvas began to appear to one American painter after another as an arena in which to act—rather than as a space in which to reproduce, re-design, analyze or "express" an object, actual or imagined. What was to go on the canvas was not a picture but an event. . . . The act-painting is of the same metaphysical substance as the artist's existence . . . what gives the canvas its meaning is not psychological data [as in Surrealism] but *role*, the way the artist organizes his emotional and intellectual energy as if he were in a living situation.

Postwar American Sculpture

The period after World War II produced a major breakthrough in American sculpture comparable to Abstract Expressionist painting, many of whose stylistic characteristics and expressive powers the sculpture shared. By the mid-1940s an idiom of fluid metal construction emerged as the dominant tendency among advanced American sculptors. Adopting from Surrealism its addiction to accident and spontaneity, the new welder-sculptors built open forms in a variety of techniques that combined improvisation and new kinds of metal alloy surfaces, while some vestiges of the formal ideals of modern Constructivist tradition remained evident, too. Although symbolic references to violence and elements of fantasy appeared frequently, as they had in the paintings of de Kooning and Pollock, the mood of sculpture was perhaps less extreme. It embraced a range of effects, including anti-Expressionist and quietist styles, in contrast to the familiar agitation of Action Painting. One notable

> **505.** Herbert Ferber. Cage. 1954. Lead, 4'6" high. Courtesy André Emmerich Gallery, New York.

The New York School: Abstract Expressionism
280

left: 503. Ibram Lassaw. *Clouds of Magellan.* 1953. Welded bronze and steel, 4'4"×6'10"×18". Collection Philip Johnson, New York.

below: 504. Seymour Lipton. Sorcerer. 1958. Nickel-silver on monel metal, $5'3_4''$ high. Whitney Museum of American Art. Gift of the Friends of the Whitney Museum of American Art, New York.

example, Ibram Lassaw (1913—), welded intricate cage constructions in the early 1950s (Fig. 503) that seem almost three-dimensionalizations of Pollock's airborne skeins, albeit in an atmosphere of detached and luminous serenity, as opposed to the more familiar stereotypes of Existential anguish found in postwar art.

Seymour Lipton (1903–86) established in his works a relationship between organic natural form—dramatizing the life processes—and the dynamics of the creative act (Fig. 504). Theodore Roszak and Herbert Ferber (1906–91) invented new sculptural symbols reminiscent of clutching tree roots or an imaginary crown of thorns (Fig. 505), but the anguished character of their imagery was less distracting than that of their European counterparts (Figs. 522, 523, 526), neutralized by its elegant spatial and structural coherence. These American artists, along with David Hare and Reuben Nakian, among others, provided a liberating lesson for the younger generation that artistic self-definition could be achieved in the process of making spontaneous and improvisatory sculptural form.

The leading innovator in American sculpture, and perhaps the most original and capacious 20th-century American sculptor, was David Smith (1906–65). Descended from an Indiana blacksmith-settler, and early employed in metal-assembly factories, Smith could be said to have had metal in his blood. Inevitably, it seems, he was the first American sculptor to work consistently in what would become a widely influential mode, that of welded metal. In 1933, shortly after he had been deeply impressed by an issue of *Cahiers d'art* devoted to the iron constructions of Picasso and González, Smith borrowed welding equipment and did his first crude metal sculpture. He had already studied painting with modernist Jan Matulka at the Art Students League, and had begun to break away from painting into a form of painted-wood construction related somewhat to Picasso's hybrid construction-collages of 1914. Explaining his own development, Smith wrote:

While my technical liberation came from Picasso's friend and countryman, González, my esthetics were influenced by Kandinsky, Mondrian and Cubism. My student period was involved only with painting. The painting developed into raised levels from the canvas. Gradually the canvas became the base and the painting was a sculpture. I have never recognized any separation between media except one element of dimension.

My first steel sculpture was made in the summer of 1933, with borrowed equipment. The same year I started to accumulate equipment and moved into the Terminal Iron Works on the Brooklyn waterfront. My work of 1934–36 was often referred to as line sculpture, but to me it was as complete a statement about form and color as I could make. The majority of work in my first show at the East River Gallery in 1937 was painted. I do not recognize the limits where painting ends and sculpture begins. Smith then followed an inevitable, lonely, and pioneering course in American sculpture. He always worked directly in iron and steel without a surfacing of bronze, brass, or nickel silver. His rugged architectonic schemes were both more closely related to Constructivism and more potent with symbolic import (Fig. 506), than the comparable welded sculpture of Lipton, Ferber, Roszak, or Lassaw. For Smith, steel had striking natural attributes and certain positive values. "The metal," he wrote, "possesses little art history. What associations it possesses are those of this century: power, structure, movement, progress, suspension, destruction, brutality."

Iron and steel are malleable and yet have a stubborn refractoriness. They may be easily cut, forged, and shaped by the oxyacetylene torch; they also powerfully assert their permanence, and arouse sensations directly related to our industrial age. Thus, the medium combines the advantages of contemporary painting, or the painted collage, with the enduring, intrinsic appeal of the sculpture medium as structure and space enclosure.

Smith always made a point, at times even a fetish, of dramatic content, loading his structures with a wealth of symbolic references. In the mid-1940s, when he had come to be known as a Social Realist, the artist cast in bronze a sculpture called *The Rape* (Fig. 506), showing an outstretched female figure menaced by a cannon on wheels, with the ambiguity of the cannon making it an inescapable symbol of two types of aggression, both war and sex. Stanley Meltzoff interpreted the violent sculptural pun as a reflection of Smith's interest in Joyce's *Finnegans Wake*. "Using adjectives found in the first chapter of *Finnegans Wake*," Meltzoff conjectured, "Smith's canon is 'sexcaliber' and 'camiballistic.' The canon, like Joyce's Sir Tristram, is a 'violer d'amores,' an amoral musical amorist, part viola and part violater."

Unlike González (Figs. 405, 406), whom he first emulated, Smith showed more candor about his materials and their raw, untransformed qualities. His forms were harsh and physical; moreover, they resisted conventional acsthetic criteria. González, on the other hand, was sometimes trapped by seductive surface, by patinated texture, and by the operation of his own cultivated sensibilities. He let his raw industrial materials assert themselves, but only to add force to an essentially contemplative, refining formalism. In the sculpture created by Smith, however, elementary force and assertive materialism go beyond the limits of the permissible defined by modern European tradition. Still, his work at its best has the power to show us the expressive limitations of traditional taste.

506. David Smith. The Rape. 1945. Bronze, 9×5%×3½". Collection Mr. and Mrs. Stephen D. Paine, Boston.

The New York School: Abstract Expressionism

below: 507. David Smith. Australia. 1951. Painted steel, 6'7½" x 8'11%" x 16½"; at base 14 x 14". Museum of Modern Art, New York. Gift of William Rubin. right: 508. David Smith. Tanktotem IX. 1960. Painted steel, 7'6" x 2'7" x 2'¼". Courtesy M. Knoedler & Co., Inc., New York. bottom: 509. David Smith. Cubi XVIII (left). 1964. Stainless steel, 9'8" high. Museum of Fine Arts, Boston (anonymous centennial gift). Cubi XVII (center). 1963. Stainless steel, 9' high. Dallas Museum of Fine Arts. Eugene and Margaret McDermott Fund. Cubi XIX (right). 1964. Stainless steel, 9'5" high. Tate Gallery, London.

Smith's imagery also invokes a more general Surrealist atmosphere, and some of those conventions used, by both Picasso and Giacometti, to convey apprehension. But despite his continuing social preoccupations, Smith was primarily a constructor of plastic forms that are most rewarding when considered in their architectonic aspect. His artistic strength derived primarily from a remarkable mastery of structure, rhythmic movement, and a varied play of sculptural silhouettes. At the time he did *The Rape* the artist insisted quite properly on the necessity of dramatic content as a mandatory spur to plastic invention. If his imagery was decidedly anecdotal at times, his symbolism was also a fertile source of his expressive individuality.

In the late fifties, Smith showed less concern with symbolism. There remained residual ties to Surrealism in his "found" objects those parts of actual machinery or their convincing facsimiles that he incorporated into his work—and in the suggestions of an aggressive life in the forms themselves. He also worked at times during this period in a bare, linear style—what González had called "drawing-in-space"—which depended largely on rhythmic invention and a balance of dynamic movements springing from a single fulcrum.

Australia (Fig. 507) and many sculptures in the Agricola series are among his most successfully realized ventures in this idiom. Smith also created monumental standing figures, curiously suggestive of primitive totems, in which large steel cusps and trough-like lengths of metal are disposed in a system of weights and counterweights rising from a tripod or single metal column (Fig. 508). These *Tank Totems* (so called because the disk forms were actually readymade plating used in boiler construction) must rank with the most original and monumental contemporary sculpture in America of its period.

Then, at the end of the fifties, Smith also experimented with flat, attenuated steel bars and slabs of irregular contour, rising to great heights, like totems denuded of their imagery and symbolism. The ruthless process of formal reduction continued into perhaps his most significant period of production, from 1960 until his death in 1965. In these years he created, among others, his magnificent Cubi series (Fig. 509), structures allied to sculptural Cubism, as their rubric suggests. The Cubis' monumental scale, economy, expressive power, and the scintillation of light on their wire-brushed and burnished surfaces elicit quite different responses, however, from the refined chamber music of historical Cubism. With their shining, square-cut masses in stainless steel, these last climactic works were classical in their order and lucidity, and severely nonpersonal. Surprisingly, too, insubordinate energies seemed to be released by the vast scale and illusionistic surface effects, which offset an otherwise restricted range of artistic decisions regarding balance, structure, and size of component masses.

Smith's continuing devotion to industrial materials, from painted T-beams to his welded and polished boxy forms in stainless steel, and his passion for a simplified but ambiguous geometric order, directly transformed the work of the influential English sculptor Anthony Caro (Fig. 624), who taught at Bennington College in the sixties and worked closely with Smith as well as with their painter friend Kenneth Noland (Fig. 580). The inflated scale, open forms, spatial torsions, and, above all, highly reductive means of the "Primary Structures" that emerged after Smith's death were prophesied by his radical change in style. It is characteristic of David Smith that he was able to reappraise himself in terms of the changing aesthetic climate of his age, just before his untimely death in an automobile accident. His passion for a new kind of austere yet sensuous, heroic but personal art of geometric form echoed the preoccupations of his younger artist friends in painting, and also showed young sculptors a new path to the future.

While sculptors using welded metals dominated the American scene in the 1950s, other artists with considerable gifts were also

working in more traditional materials. One of the age's most prodigious and independent abstract sculptors was the Japanese-American Isamu Noguchi (1904–88), who studied with Brancusi in Paris and returned to New York in 1928. Here Noguchi mounted the first one-man show of his distinguished abstract forms, which a half-century later he continued to produce with undiminished vitality and invention. The artist's open-form metal sculptures of the thirties, however, were closer in spirit to the Constructivists than to Brancusi, at the same time that they also recalled childhood memories of kites and the paper objects so common to Japan. During the forties

> **510.** Isamu Noguchi. Kouros. 1944–45. Pink Georgia marble, slate base, $9'9'' \times 2'10!/s'' \times 3'6''$. Metropolitan Museum of Art, New York. Fletcher Fund.

Noguchi used a variety of polished stones to demonstrate a suave and fluent mastery of abstract idioms with Surrealist overtones (Fig. 510), deftly creating interlocking systems of flattened biomorphic forms akin to those of Arp and Miró. When he began designing for Martha Graham's dance company, Noguchi paved the way for many such interarts collaborations later in the century, especially his own public art, realized as monumental site sculptures or huge environmental playgrounds and multi-purpose urban plazas. Meanwhile, he also made freestanding terra-cottas in rounded, doll-like shapes and ingeniously grouped on a vertical post varied kasama forms, the durable earthenware used for centuries as vessels in Japanese kitchens. The tension between the naïve conventions of popular art forms and a sophisticated modernity gives these playful inventions a distinctive individuality. Noguchi was a master of elegant form and refined materials, including a wide variety of carved stones, from whose surfaces he rarely failed to coax a special sensuous poetry, no matter how severely geometric his structure (Fig. 511). Although thoroughly American in his career, Noguchi had roots that sank deep in French modernist tradition as well as in the East.

Among the rarest and most mysterious figures in American sculpture was Joseph Cornell (1903-72), who in the 1930s began making box constructions that deserve to be placed on the highest level of contemporary American creation (Fig. 512). His work combines the formal austerities of Constructivism with the fantasies of Surrealism and utilizes subtle painting and collage techniques. His boxes are deceptively modest and extremely personal; they are also as subtly articulated in their internal relationships as the best threedimensional structures of the Dutch or Russian Constructivists. However, the almost amateurish-looking, unadorned forms house the most surprising and entrancing romantic bric-a-brac: pasted fragments of nostalgic photographs, scenes from a Victorian "grand tour," a Surrealist "poetic object," or snatches of a counterfeit but somehow touching modern mythology culled from astrological illustrations. The curious fusion, at poetic intensity, of precious sentiment, bizarre imagery, and a stern formal rectitude gives Cornell's constructions a quality entirely their own. If these boxes are so compelling, it is because they bear the unmistakable stamp of authentic experience. Such works consecrate the monkish life of art, a life more often than not of renunciation and crushing isolation, which finds its creative meaning in the assiduous cultivation of childhood memories, fantasy, and images of desire. At one time the boxes seemed too private and confined in sensibility to occupy the mainstream of American art, rather like a highly personal and quixotic diary. Cornell, however, became an honored precursor for, if not a direct influence upon, such artists as Louise Nevelson in her boxed "junk" assemblages and Jasper Johns in his targets with anatomical casts hutched and mounted above them (Figs. 547, 564). Certainly Lucas Samaras's containers of fantasy and dream (Fig. 566), and other enigmatic constructions or poetic documentation in contemporary American art, suggest that a tortured "gothic" inwardness may be as native to our culture as grandiose aspiration, physical power, or heroic action.

above: 511. Isamu Noguchi. To Love. 1970. Rose Aurora and black Porticoi marble, $5'^{3}/4'' \times 1' \times 1'$. Courtesy the artist and PaceWildenstein, New York.

right: 512. Joseph Cornell. *Soap Bibble Set.* c. 1947–48. Box construction, 127/8 x 18³/8". Private collection.

The New York School: Abstract Expressionism

The Postwar European School: L'Art Informel, Expressionist Figuration, Welded Sculpture

he close of World War II marked the opening of a new era in European art. A serious reappraisal of antebellum modernist movements began, prompted not only by numerous exhibitions of the work of Matisse, Picasso, Soutine, and other great figures of modernism, but also by the stirring of novel ideas among younger artists. Europeans everywhere longed for fresh points of departure that would overcome the contemporary mood of despair arising from the devastations of war. Influenced by Existentialist philosophy, with its riveting concern for the dilemma of individual freedom and responsibility, the artist struggled to inject a more meaningful content into the exhausted Purist-Constructivist aesthetic by inventing a more personal or subjective kind of abstract art. The Abstract Expressionism already examined in the New York School assumed international dimensions, alternately identified with Paris as well as with the American city. It seemed to have arisen from a worldwide cultural crisis, and neither capital could legitimately claim priority as the sole source of significant formal innovations. As we have seen, the terms used to classify the free abstractionists in New York were Action or Color Field Painting as well as Abstract Expressionism. Across the Atlantic, the counterparts of these artists inspired the labels l'art informel and tachisme, often rendered in English as Informal Art, or Informalism, and Tachism. Today it is clear that the developments were essentially parallel and quite independent of each other, although derived from the same sources: Cubist structure, Expressionist feeling, the abstracting tendencies at work in both, and the liberating processes, as well as the mythic or poetic preoccupations, of Surrealism.

Immediately after the war, surviving School of Paris painting appeared to suffer diminished prestige, at least in the eyes of critics who saw it as a safe, predictable formula. This usually consisted of Bonnard's hot palette combined with loose variations on the Cubist or Orphist formal order, a kind of art exemplified by the painting of Roger Bissière (1888–1964), Jean Bazaine, and Alfred Manessier (Fig. 513). The noble French tradition of *belle peinture*, of the painting as a sensuous and appealing object of good taste, stood in the way of radical change. The artists just cited and a number of others even went so far as to identify their carefully modulated, bright colors and abstract arrangements with national artistic characteristics; thus, in 1941, during the Occupation, they produced a show of nonfigurative work called "Painters in the French Tradition." By contrast, the first prominent group of emerging postwar artists in Paris—Hans Hartung (1904–91), Wols, Jean Fautrier, Nicolas de

513. Roger Bissière. The Forest. 1955. Oil on canvas. Musée National d'Art Moderne, Paris. **right: 514.** Hans Hartung. *T.* 1947–25. 1947. Oil on canvas, 28½×18%". Private collection, Paris.

below: 515. Pierre Soulages. Painting. 1952. Oil on canvas, 6'5¾"×5'3¼". Solomon R. Guggenheim Museum, New York.

Staël, and Pierre Soulages (1919–)—painted forms conceived as autonomous expressions in themselves, without the necessity of figurative reference or justification in some nationalistic sense (Figs. 514, 515). The self-proclaimed painters of French tradition drew or painted from the motif, later transposing their landscapes or figures into a kind of naturalist symbolism. Bazaine, Manessier, and a few others, however, denied their association with the new School

of Paris abstractionists. Nonetheless, members of both variants on Paris painting did share an opposition to traditional geometric abstraction and the lucid if somewhat academic design that continued the Constructivist, De Stijl, and Bauhaus traditions in Europe.

With the advent of the new Paris generation of de Staël, Soulages, Hartung, Wols, Fautrier, the influential Jean Dubuffet, and a group of painters in northern Europe who called themselves the CoBrA, the dichotomy between figurative and nonfigurative styles resolved itself. In a few short years a broad new Expressionist abstraction came forward as the prevailing European mode. The emerging generation shared an interest in the most popular of postwar philosophies, Jean-Paul Sartre's Existentialism. Sartre gave them a convenient program for dealing with the emotional aftermath of the war years, which had left so many European intellectuals feeling demoralized and rootless. The individual's sense of alienation from any system of belief made even symbolic action imperative, and it became a saving catharsis in art. The act of painting represented release from an anguished paralysis of will. All the complex motor operations and the emphatic brush marks of the new activist painting and sculpture functioned as a visible graph of the artist's rediscovered capacity to make effective decisions. Painting thus symbolized a renewed and affirmative commitment to reality. The most serious postwar artists felt compelled to reinvent their art ex nihilo, and in so doing redefined the human condition, admittedly with a certain self-consciousness, much as in Europe the ordinary man rebuilt new cities out of the rubble and devastation of the war.

L'Art Informel and Tachisme: Europe's New Expressionist Abstraction

From the rhetoric of Existentialist criticism, and from the new mood of subjectivism, a number of different types of expression emerged. In Paris, Georges Mathieu (1921–), Gérard Schneider, Soulages, Hartung, and others explored a brilliant draftsmanship in paint, giving effect to a style the critics soon labeled *l'art informel* (Fig. 516). They relied almost exclusively on swiftly registered calligraphic signs, and often worked in a palette restricted to black and white rather like their American counterpart, Franz Kline (Fig. 490), with similarly broad, constructional brushstrokes (Figs. 514, 515). *Tachisme*, meaning an art of accidental "stains" or "blots," evolved when the spontaneity of "informal" abstract painting was married to rich texture and color obtained from a heavy impasto—*matière*—by such artists as de Staël in France, Antoni Tàpies (1923—) in Spain, and Alberto Burri (1915–95) in Italy (Figs. 517, 518). Burri evinced an obsessive interest in surface textures and slow-moving rather than rapidly activated form. Often he obtained them from burlap and other foreign matter, stitched together with surgical precision and

combined with generous passages of red paint, signifying the bloodsoaked bandages the artist, a medical doctor, knew from his wartime service with the Italian army. The symbolism may have been more potent originally, since it is the sensuous beauty of Burri's canvases, rather than their memories of pain, that now appeal. Fautrier and Dubuffet (Figs. 527, 528), as well as Tàpies, provided the decisive influences in the development of relief-like paint surfaces, the mode that Lawrence Alloway aptly described as "matter painting." More delicately textured were the quietist, small-scale linear

left: 516. Georges Mathieu. *Shunyata*. 1958. Oil on canvas. Kaiser-Wilhelm-Museum, Krefeld.

below left: 517. Antoni Tàpies. Ochre Relief with Rose. 1965. Mixed media on plywood, 5'31/s" × 3'81/2". Private collection, Paris.

below right: 518. Alberto Burri. *Sack.* c. 1954. Mixed media on canvas, 39 x 34³/8". Private collection, Parma.

The Postwar European School

abstractions of the German artist Wols (1913–1951), who enjoyed, for a brief time after the war, an apocalyptic and legendary status much like Jackson Pollock's (Fig. 519). Wols painted melancholy, self-revelatory, spidery abstractions of poignant intensity and despair.

One of the most textural, or *tachiste*, and sensitive of the new abstractionists was Russian-born, but Belgian-educated, Nicolas de Staël (1914–55), who had joined the French Foreign Legion at the outset of the war and then returned to Paris during the Occupation, at which time he began to paint in a purely nonrepresentational manner (Fig. 520). However, de Staël had hardly attained his mature expression—marked by luscious slabs of often brilliant paint, applied with a palette knife, so loosely joined, mosaic-fashion, that they allow glimpses of even brighter surface color below—when he began to long for subject matter. Gradually de Staël rediscovered landscape, still life, and even figures, but treated them so freely that the viewer generally sees only an abstract composition. The conflict this evidently reflected in the artist may account for his suicide at the early age of forty-five.

The New Expressionist Figuration

The Expressionist current in the new abstraction received its major impetus from a series of interrelated artistic developments: the paintings of the CoBrA (a contracted abbreviation of the names of the cities from which the artists came—Copenhagen, Brussels, and Amsterdam); the new humanist sculpture of Alberto Giacometti; the masterfully structured, eerily still, but erotically charged figure compositions of Balthus; and the powerful images of the two most important postwar European artists, Jean Dubuffet and Francis Bacon. As European artists assimilated the wartime experience, they

conceived a new interest in the human image, reflecting an awareness, as never before, of man's condition of loneliness and his will to endure. Thus, they mediated Expressionist abstraction with an often fragmented, anguished humanistic imagery. Generally, it can be said that European vanguard painting and sculpture after the war evinced a more somber character than its American counterpart, in both figurative and abstract modes.

Prominent among the CoBrA members were the Dane Asger Jorn, the Dutchman Karel Appel (1921–), and the Belgians Corneille and Pierre Alechinsky. In a description of his more volcanic paintings (Fig. 521), their pigment whipped and dragged over the canvas with the knife in a kind of ecstatic frenzy, Appel indicated the distance postwar abstraction had traveled from the cool rigor of geometric and Constructivist art: "A painting is not a construction of colors and lines, but an animal, a night, a cry, a man, or all of them together."¹ Appel's rather brutal images managed to avoid melodrama or despair by their exuberance and visible pleasure of execution.

The tormented new European "humanism" evident in postwar figurative painting undoubtedly received a major impetus from the haunted and elongated sculpture forms of Alberto Giacometti, the greatest sculptor to emerge within the milieu of prewar Surrealism (Figs. 325–327). Jean-Paul Sartre introduced Giacometti's major one-man show in New York in 1948,² and his eloquent homage may be an indication of the artist's problematic and Existential content (Fig. 522). Giacometti had tried to unify individual human

left: 519. Wols. Champigny Blue. 1951. Oil on canvas, 28½×23¾". Courtesy Galleria Schultz, Milan.

above: 520. Nicolas de Staël. Composition of Roof Tops. 1952. Oil on board, 6'6¾"×4'11". Musée National d'Art Moderne, Paris. forms with a space that eroded their recognizable humanity, and covered his figures with "the dust of space," in Sartre's challenging phrase. Giacometti expressed by analogy the profound sense of solitude and anxiety of modern humankind, bereft of traditional institutional consolations. Confronting a Giacometti sculpture, one sensed the predicament not only of postwar humanity, but also of the urban individual in mass society, dwelling in psychological isolation within large and complex social, political, and architectural structures that depersonalized everyone. In *City Square*, so closely related to the earlier *Palace at 4 A.M.* yet so tellingly different in its shift of emphasis from form to feeling, Giacometti created one of his most poignant metaphors of alienation. The rough, corrugated surfaces and blank, expressionless faces in telescopic

scale give the diminutive figures an air of desolating remoteness from one another, as well as from the observer.

Much of this effect comes from Giacometti's long and nearmystical search for a means to represent reality as it is, a search involving civilization's never-ending quest for the nature of both reality and its perception. As shown in the works reproduced here, this led, at one point, to tiny figures, as if seen from a distance, but it also yielded very large images, still with the attenuated, ravaged look of the artist's postwar style, their size expressing an aesthetic equivalence of perceived reality (Fig. 523). The agonized integrity of the investigation carried out by Giacometti can perhaps be best appreciated in his drawings and paintings (Fig. 524), where not only the network of feverishly repeated lines but also the erasures attest

523. Alberto Giacometti. Figure from Venice II. 1956. Painted bronze, 471/2" high. Middeheim Museum, Antwerp.

right: 521. Karel Appel. Exploded Head. 1958. Oil on canvas. Kunstmuseum, Winterthur, Switzerland.

below: 522. Alberto Giacometti. City Square. 1948. Bronze, 8½ × 25¾ × 17¼". Museum of Modern Art, New York. Purchase.

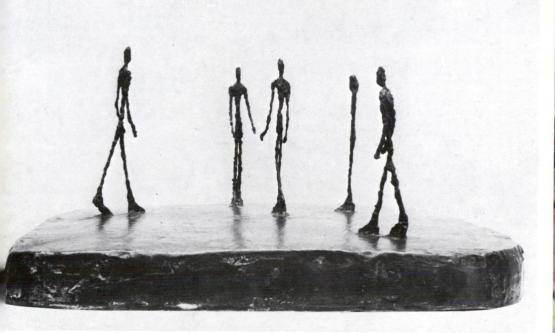

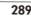

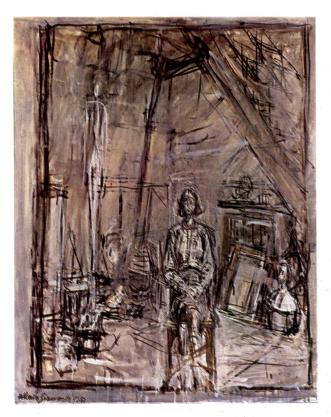

to a desperate and frustrated attempt to fix upon both the subject and the space that individual inhabits.

A close personal associate of Giacometti's since the early thirties is the painter Balthus (Balthasar Klossowski; 1908-), whose formidable powers as a pictorial architect, in a league with such classical masters as Poussin and Cézanne, place him at a far remove from the emotionally driven procedures characteristic of Expressionist artists (Fig. 525). But along with his stable structures of rhyming rectangles and counterbalanced diagonals, his slow buildup of smoothly scumbled surfaces, Balthus has always indulged a furtive obsession with the erotic potential of half-aware pubescent girls. The title of the work seen here suggests that the loosely clad juvenile sprawling in the foreground merely celebrates a week of uninterrupted holiday (since French schools formerly held no classes on Thursday³). Flanking this scene of innocently liberated adolescence, however, are the tense, fully clothed young woman standing watch at the window and a leering cat (no doubt an emblematic stand-in for the painter), who charge an otherwise serene atmosphere not only with illicit sexual longing but also with a kind of foreboding and menace. Thus, in a world as calmly material as Giacometti's is nervously eroded, the extremely private Balthus would seem to share the great Swiss sculptor's public concern for the individual caught in a renascent Europe riven with anxiety and alienation.

The kind of nonheroic, figurative sculpture made by Giacometti directly stimulated the amorphous forms and tortured imagery of Germaine Richier (1904–59) and César (Fig. 526). Sharing a fascination with the grotesque, these Paris-based artists invented horrid and fantastic insectile creatures or mythical personages, often spontaneously assembled from scrap metal. The savagery of Richier's forms, with hydra heads, spider's legs, and arms like tentacles, was countered by a lusty expressiveness of means, much as in the case of Appel, or Willem de Kooning in his Woman theme (Fig. 488). For the composite figure shown here, the French artist also drew on a wide range of references, from legend, magic, and subconscious fantasy to child art and graffiti.

A similar range of resources, used even more powerfully, can be found in the art of Jean Dubuffet (1901–85), who in a vital new

290

left: 524. Alberto Giacometti. Annette. 1951. Oil on canvas, 31⁵/₈ × 25³/₈". Courtesy Beyeler Gallery, Basel.

below: 525. Balthus. La Semaine des quatre jeudis. 1949. Oil on canvas, 38½×33". Private collection.

bottom: 526. Germaine Richier. *The Bullfight*. 1953. Bronze, 46" high. Maison de la Culture, Caen.

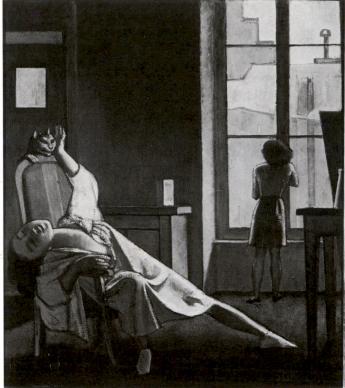

left: 527. Jean Dubuffet. Mother Goddess. 1945. Oil on paper mounted on cardboard, 12¼×11″. Kunstmuseum, Basel. Gift of Werner Schenk.

below: 528. Jean Dubuffet. Blood and Fire (Corps de dames). 1950. Oil on canvas, 13³/₄ × 6¹/₄". Courtesy Pierre Matisse Gallery, New York.

form of primitivism gave postwar Europe's dominant mood of solitude and anxiety a resolution both awesome and comical (Fig. 527). Until his forties, however, Dubuffet had been little more than a sporadic dilettante in art, expending most of his energy on running the prosperous wine business he had inherited and on living well in Paris. What brought him resoundingly back to art was his discovery of Hans Prinzhorn's book Bildnerei der Geisteskranken on the art of the insane. Now Dubuffet deliberately turned to the art of children, the mad, and the aesthetically naïve, which he himself systematically collected under the rubric art brut, and made these expressions the model for his strangely vital, gnomic, figurative painting and sculpture. Whether in wall graffiti, pathological art, or other primitivistic expressions, Dubuffet's astonishingly diverse formal explorations took the human situation rather than abstract pictorial values as their point of departure. The early exhibitions the artist received in Paris immediately after the Liberation were a revelation and became extremely controversial. His first crude effigy figures were blatantly childlike, scribbled and daubed in thick, sand-choked pigment, and they made their point dramatically both as surface and as disturbing hallucinatory imagery. Grotesque and cruel, they were at the same time culturally sophisticated and self-conscious despite the affectation of technical ignorance and their obviously macabre clowning. The coarsely textured visages and the anatomies that Dubuffet devised for the Corps de dames series (Fig. 528), which followed in the early 1950s, read like textured maps of the female form, recalling archetypes that go back to paleolithic fertility-cult

529. Jean Dubuffet. The Forest. 1959. Natural elements, $20\frac{1}{2} \times 22\frac{1}{2}$ ". Courtesy Pierre Matisse Gallery, New York.

models rather than to the ideal beauty of the Greeks. But their material surface, placement, and spatial ambiguity lend them an expressive force comparable to the best of contemporary abstract painting. Dubuffet's art bears some relationship to Surrealism, the influence of which is less a matter of method than of attitude. The artist has said that "the key to things must not be as we imagine it, but that the world must be ruled by strange systems of which we have not

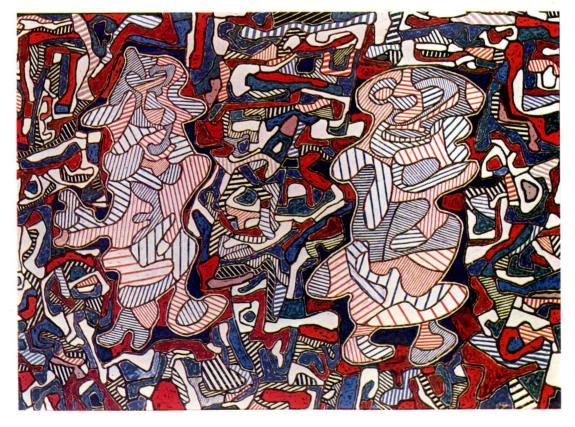

530. Jean Dubuffet. Change of View. 1963. Oil on canvas, 10'5"×7'1¾". Courtesy Beyeler Gallery, Basel.

The Postwar European School

the slightest inkling." In his *assemblages* (Fig. 529), a personal term for collage, he used organic matter—lichens, leaves, dissected butter-fly wings, sponge, cinder, lava stone—just as the Cubists had incorporated paper and wood in their collage constructions. In another notable difference, Dubuffet consciously emulated ancient cult objects to create what he aptly called a "mixture of familiarity and terror."

In the early 1960s Dubuffet initiated a decorative painting series with the deliberately meaningless title of *L'Hourloupe* (Fig. 530). The new style, which continued to the end of the artist's long life, in paintings, sculptures, and installations, disclosed an additional debt to the ritualistic tightness of design and the sense of estrangement of psychotic art. The invented fantasy worlds of the disturbed mind appealed to Dubuffet for their visual and psychic drama, and as an expressive alternative to an overeducated aesthetic system. Fragments of the human comedy, commonplace objects that lead an uncommon life, furniture impersonating men impersonating trees, and environments that illustrate ideas populate Dubuffet's new cosmology. Categories, species, and even physical properties are muddled and blurred, thanks to his masterful ambiguities of form. From the time of his first cruel and hilarious portraits of the 1940s, Dubuffet allowed an element of sinister farce to color his human comedy, whose dark psychic stirrings find an echo in the inanities and wild caricatures of the playwright Ionesco, a close friend. The fantasy world of *L'Hourloupe* presents a deceptive surface cheerfulness in its elementary patterns and bright nursery colors, but, upon closer inspection, the jumbled maps reveal obsessively tortured masks and the repetitive visual counterpoint of the mind in chains.

Until the Hourloupe cycle and its attendant large-scale, fantastic sculptures and architectural environments, such as *Group of Four Trees* (Fig. 531), one could very well consider Dubuffet's achievement almost exclusively within the framework of the anguished postwar mood when Giacometti produced his spectral figures. However, with the Hourloupe paintings, monumental sculptures, and visionary architecture, Dubuffet enlarged his image and boldly sought a more expansive public style. Altogether, he emerged as one of European art's contemporary giants, a master whom Clement Greenberg called "the most original painter to have come from the School of Paris since Miró." At the same time that he seems a cousin to such earlier modernists as Klee and Schwitters as well as Miró, Dubuffet could also be the alter ego, if not the godfather, of the 1960s Pop and Funk artists.

531. Jean Dubuffet. Group of Four Trees. 1971. Tubular steel frame with walls of aluminum, honeycombed epoxy coating, reinforced with layers of fiberglass, 40' high \times 16' \times 16'. Museum of Modern Art, New York. Courtesy Pace Gallery, New York.

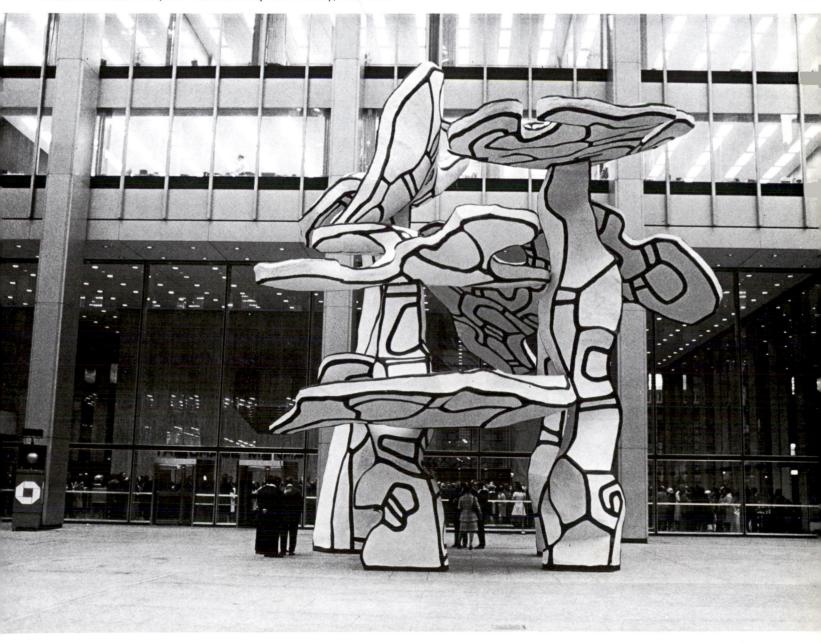

Eight years younger than Dubuffet, and self-taught like his French counterpart, Francis Bacon (1909-92) was certainly the only British figurative painter to rank with the most distinguished artists to emerge in the immediate postwar period (Fig. 532). Bacon dealt with the same Existential sense of isolation and anguish, which he pushed to an even further point of psychic distress than did Dubuffet and Giacometti. His preoccupation with terror was both melodramatic and psychological in impact, and it often seemed to be drained off directly from catastrophic journalism and visual accounts of the death camps and the holocaust that surfaced after World War II. With his sense of Surrealist menace and an imagery blurred as if in motion, Bacon stated the case for postwar European despair with a vehemence and an originality that earned him a special place among contemporary Cassandras. His first important painting series consisted of variations on Velázquez's Portrait of Pope Innocent X, beginning around 1950 (Fig. 533). These vivid and powerful inventions transformed the crafty and smug Prince of the Church into a monstrously depraved image. Influenced by early film classics as well as by tabloid journalism, Bacon synthesized media representations of gunmen, Muybridge's motion studies, Eisenstein's Battleship Potemkin, and direct allusions to news photographs of Hitler and his barbarian lieutenants to create a half-real, half-fantastic world, a public chamber of horrors and private nightmares.

Bacon's distorted and idiosyncratic images bear eloquent witness to the actual events of the postwar period and more generally to humanity's innate capacity for violence. They may be considered the modern-day Freudian equivalents of Goya's savage visual commentaries on irrational brutality in his "Disasters of War." For Francis Bacon, pain and suffering were irremediable, inseparable from individual consciousness and the human condition. The only elation for the artist, he once observed, comes in the manipulation of paint, through the act of painting. The exhilaration of technique raises the public sense of crisis to the level of a great human drama of remarkable poetic intensity. One of Bacon's first sympathetic critics, Robert Melville, complimented the artist on his power and freedom of execution, but noted that Bacon's bravura pictorial effects occurred in the atmosphere of "a concentration camp." Set within veiled dream spaces defined by transparent perspective boxes, Bacon's howling prelates and sadomasochistic couples seemed to have anticipated the obscene image of Adolf Eichmann, tried while protected by a bulletproof glass box from the rage of his onetime victims. Such art assumes a perverse beauty when its bilious colors-often a somber green combined with a brutal red, rather like dried blood-have been stroked on with the sumptuous, loaded-brush mastery of a Rubens or a Velázquez. In 1964 Bacon said: "I would like my pictures to look as if a human being had passed between them, like a snail, leaving a trail of the human

below left: 532. Francis Bacon.

Two Figures. 1953. Oil on canvas, 5' x 3'97/8". Private collection, London.

below right: 533. Francis Bacon. Study for a Pope. 1954. Oil on canvas, 5'3/4" x 3'1". Private collection.

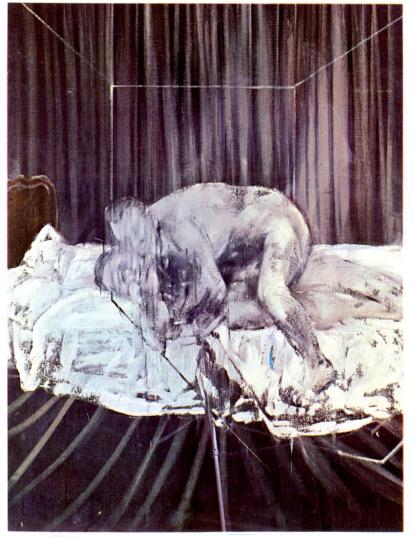

The Postwar European School

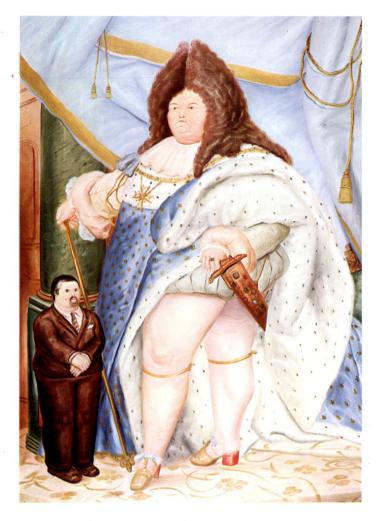

presence and memory trace of past events as the snail leaves its slime."

The most original and compelling figurative painter to emerge in Latin America during the postwar years was the Colombian Fernando Botero (1932—), later a resident of both Paris and New York. At first glance (Fig. 534), his stubborn loyalty to a style of naïve and meticulous realism might seem a pose of ingenuous primitivism, were it not contradicted by plentiful evidence of sophistication in the way the artist manipulates scale and laces his bizarre art with elements of savage social satire. Undisguised in his respect for the Old Masters, from Rubens and Caravaggio to Rigaud and Goya, Botero is also frankly puzzling. He would seem to conduct his life and art innocently, as if Picasso and Bacon had never painted.

Upon careful consideration, however, it becomes clear that Botero has seriously committed his energies to the historical past and to his own sense of role, whether as commentator or sycophant, thereby making himself subject to a profound oedipal ambivalence. Even his most accomplished exercises in portraiture carry the thrust of hidden allegorical meaning and fantasy. With a social irreverence worthy of Goya, Botero delineates the brutish physiognomy of a dissolute and vicious society comparable in cruelty and decadence to the grotesque caricature of the Spanish master's *Family of Charles IV*. His effigies of military, clerical, and political leaders mercilessly lampoon the corruption of power.

Like the painters of medieval and quattrocento altarpieces, Botero himself takes a modest position in the diminished scale of a patron standing outside the main action. There is considerable irony in such distortion as it appears in his reconstruction of Rigaud's florid portrait of France's Grand Monarch (Fig. 534). Botero entitled this curious painting *Self-Portrait with Louis XIV*, as if to make the pneumatic and swollen historical fiction seem a projection of the artist's—and perhaps Everyman's—private fantasies of dominance and unconstrained narcissism.

The New Painterly Sculpture

European sculptors for the most part found it difficult to respond in kind to the challenge of the Expressionist or Tachist painting styles that dominated the postwar period. A number, however, did manage to learn a new approach from pictorial examples, and revitalized their art by transferring to a different medium the vehement brush-strokes, improvisational methods, and occasional calligraphic effects of the best Informalist painters. Eduardo Paolozzi (1924—), in England, followed the pattern of Richier and César in assembling discarded industrial waste, which he cast into eroded human images. But by the late 1950s Paolozzi had turned to more elegant, finished materials, polished aluminum and stainless steel, using them to create abstract architectural ensembles (Fig. 535).

One of the most suave sculptors who explored metal relief and industrial scrap was the Swiss artist of Hungarian origin Zoltan Kemeny (1907–65). Kemeny employed metal not only to evoke,

above: 534. Fernando Botero. Self-Portrait with Louis XIV (after Rigaud). 1973. Oil on canvas, 9'6" × 6'5½". Museum of Contemporary Art, Caracas. right: 535. Eduardo Paolozzi. Akapotic Rose. 1965. Welded aluminum, 9'1" × 6'1" × 4'2". Courtesy Pace Gallery, New York. by analogy, a nature of forest imagery, leaves, and winding streams; he also exploited its properties to effect an imagery alluding to a microscopic and submicroscopic world of textures, and even to scientific patterns of stress, refraction, and molecular distribution (Fig. 536). Kemeny was one of the few artists emerging from Art Informel and then from assemblage traditions to draw inspiration directly from the findings of modern science and technology.

In Italy the lacerated surfaces of the thematic spheres, columns, and disks of Arnaldo Pomodoro (1926–) recalled Dubuffet's materially dense "landscape-tables" and the humanoid robots of Paolozzi of the early postwar years (Figs. 537, 531, 535). In the late 1950s Pomodoro gave his picturesque and sensitive surface

above: 538. Eduardo Chillida. Dream Anvil No. 10. 1962. Iron on wooden base, 17⅓ × 20⅓ × 15⅛". Kunstmuseum, Basel. Emanuel Hoffmann Foundation.

abeve: 536. Zoltan Kemeny. Lines in Flight 2. 1960. Cut, bent, and beaten metal, soldered to metal base; 35½×45¼". Private collection, Rome.

right: 537. Arnaldo Pomodoro. Rotating First Section. 1966. Polished bronze, 46%" diameter. Private collection, Boston. calligraphy the character of limited fractures, faults, and openings in otherwise unflawed geometric forms, whose mirror-like surfaces recalled Brancusi's pristine volumes (Fig. 114). Although the artist made clear allusions to technology in the simulations of gear teeth and machine parts, his flawed and bitten areas became acceptable expressive metaphors for introspection and a sense of human vulnerability. Later Pomodoro elevated the postwar convention of personal torment beyond the private expressive plane to a mythic and public level by creating monumental outdoor sculptural forms whose structuring and elaborate fabrication both mask and refresh his symbolism.

Eduardo Chillida (1924—), continuing the wrought-iron sculpture tradition initiated by his fellow Spaniards Gargallo and González (Figs. 405, 406), forged powerful arrangements of iron bars from single continuous forms without welding (Fig. 538). Miraculously, he attained calligraphic effects resembling to some degree Franz Kline's constructional brushstrokes (Fig. 490), as well as aspects of David Smith's open-form ironworks (Figs. 507–508). Chillida brought about a new development in the art of the late 1950s towards austerity and reductive form, a bare and linear structural art. His straightforward ensembles of contorted and skillfully manipulated metal bars may be taken as symbols of the tension between individual effort and civilization's enormous, newly mar-

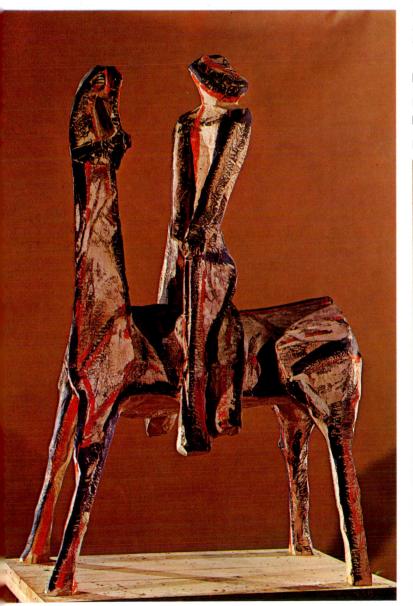

shaled industrial powers, something the artist was nonetheless loath to trust fully.

Some figurative sculptors of the postwar period tried to arrive at a compromise between modernism and traditional expectations, especially in Italy, where at least two significant artists made a serious effort to come to terms with the Italian past. Marino Marini (1901–80) modeled his anguished equestrians on T'ang Dynasty statuettes and the bronze horses of St. Mark's in Venice, with echoes of Etruscan art (Fig. 539). But the most powerful single inspiration for them, he revealed to a critic, were the homeless crowds of the common people of Milan desperately fleeing on horseback before the advancing Allied armies at the closing of the war. Implying a tragic symbolism in the horse-and-rider works, Marini labeled their theme a kind of "Twilight of the Gods." His traditionalism, however, is qualified by suggestions of eroticism in striving phallic imagery and energy as well as by a certain reliance on primitivism.

Giacomo Manzù (1908–91) is a famous anomaly because his seductive portraits in bronze (Fig. 540), and such commemorative works as his bronze doors for St. Peter's, have all the vigor and conviction characteristic of modern art, but bear almost no relationship to contemporary modes of sculptural expression. Thus, while paying tribute to Medardo Rosso (Fig. 96), the artist alluded mainly to Donatello's low relief and to Bernini's love of texture and painterly effects. But virtuoso modeling, undeniable charm, and clarity of statement assured Manzù both public admiration and ready patronage, despite his failure to make any original contribution to the ongoing history of aesthetic form.

left: 539. Marino Marini. The Concept of the Rider. 1955. Polychromed wood, 7'4¹/2" high. Collection the artist.

below: 540. Giacomo Manzù. *The Cardinal.* 1952. Bronze, 30³/4" high. Private collection.

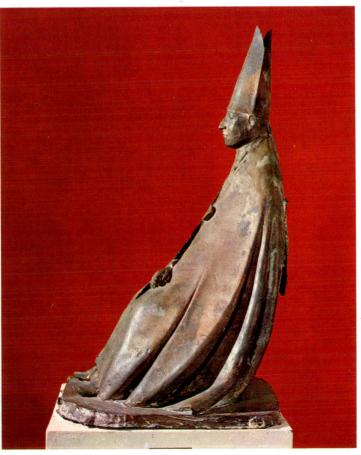

American Art of the Sixties: Pop Art and Minimalism

he very fragility of the balance that Jackson Pollack struck in his great webs of poured pigment-each a compound of freedom and control, surface and depth, gestural linearity and generalized fieldlike color-suggests not only the heroic precariousness of the performance but also the inevitability with which such exquisitely unstable art would be pulled apart by the rivalries of its own internal components. And in this case the components were formidable forces indeed, deriving as they did from the age-old split in the American character, between its pragmatic love, on the one hand, of literal reality and, on the other, its puritan prejudice against the material world as dross matter to be spiritually transcended. In 1973, Claes Oldenburg put it this way: "... the American problem remains the schizoid psyche and its reeling from one extreme to another, from puritanism to abandon, from solicitude to aggression." As we have seen, the dichotomy prevailed even among Pollock's fellow Abstract Expressionists, a group composed of extroverted artists like de Kooning and Kline, committed to such physical factors as gesture and texture, as well as of introspective painters on the order of Newman, Rothko, and Reinhardt, whose discreet handling made color seem either atmospherically disembodied or ascetically flat. By the time Pollock died in 1956 the two trends had polarized into traditions so fertile with possibilities that, through endless, almost incestuous mixing and crossing, they would beget one powerful movement or style after another. Most of these-whether expressed in Neo-Dada attempts to make art evermore inclusive of the most ordinary reality or in a systematic process of excluding from art all but its own most essential properties-were pursued in cool, usually deadpan reaction against what was perceived to be the first generation's overheated subjectivity and the sublime muddle this produced in both form and content. But if American painting and sculpture could take off from the original New York School and burst into a spectacular array of proliferating invention, it was thanks to sociocultural conditions radically altered from the grim austerities that had blighted, while paradoxically blessing, the generative years of the Abstract Expressionists.

The cool, self-assured professionalism that dominated the artists who gave the New York School its second generation was a luxury made possible, in considerable part, by the growing power and affluence of postwar America. Whereas Pollock and his associates had scraped through on odd jobs and WPA stipends, while taking night classes under the retardataire faculty of the Art Students League, their successors might count on the GI Bill and other lucrative grants-in-aid to finance study with such proven progressives as Hans Hofmann at his own school in New York, Josef Albers and John Cage at Black Mountain College in North Carolina, Still, Rothko, and Reinhardt (for various short durations) at the California School of Fine Arts in San Francisco, or yet in Paris, even though that former capital of world art could scarcely match the creative ferment on the frontier side of the Atlantic. And instead of poring over the latest journals imported from abroad, up and

coming American artists sparked the new ideas among themselves. abetted by such enlightened and supportive critics as Professor Meyer Schapiro, Thomas Hess, Harold Rosenberg, Clement Greenberg, Robert Goldwater, Frank O'Hara, and Barbara Rose. Being much better educated than their predecessors, the emerging generation had verbal as well as visual language at their command and could contribute substantially to the period's expanding body of critical literature, as did Elaine de Kooning and Allen Kaprow, joining Robert Motherwell and Ad Reinhardt from the older generation. When they wrote, it was with thoughts sharpened by exchange not on the park benches or in the all-night cafeterias of the Depression and war years, but at the Cedar Tavern on University Place, the nearest thing to a Parisian style artist's café ever seen in North America, and The Club on East Eighth Street, organized in 1949 by leading members of the New York School as a place for lectures and freewheeling discussions of every conceivable aesthetic issue. If still irrelevant to the mainstream of American life, the growing numbers of artists now active in New York, drawn by the powerful work and personalities of the Abstract Expressionists, made an enclosed, vibrant society all but sufficient unto itself. As Irving Sandler, an eyewitness, has written:

The energies that gave rise to, and were generated by, semi-public dialogue and the sense of vital community it implied were so elating to the participants that most recognized that they were witness to a rare phenomenon: a living culture and American at that.

Gratifying as all this may have been for the New York School's second wave, the relative ease of the conditions the artists encountered robbed them of the very experience that had given the hard-pressed first generation their moral and aesthetic authority. Commenting on the agony of being a young artist in Depressionridden America, Gorky had said that "if a human being managed to emerge from such a period, it could not be as a whole man." Untested by the harrowing challenges that had enabled the Abstract Expressionists-those who survived-to produce an art genuinely heroic in both form and content, the younger painters could only admire and imitate their elders, the most compelling of whom seemed to be Willem de Kooning. With his dramatic struggle to re-create his art with each stroke and picture, with his European sense of tradition and his openness to figuration as well as to abstraction, the accessible and articulate de Kooning seemed to provide, both in himself and in his painting, the best guide to the greatest number of important new possibilities. But as the title of the painting by Joan Mitchell (1926-92) in Figure 541 might suggest, a close follower of de Kooning who lacked that master's hard-earned sense of tragedy would seem to have been doomed to transform the gestural colorism of Action Painting into something lyrical and decorative in form and hedonistic, or even whimsical, in mood. Charming and superbly deft as George Went Swimming at Barnes Hole, but It Got Too Cold

may be, it inhabits a relaxed world remote from the riveting tensions of Newman's *Vir Heroicus Sublimis* (Fig. 496) or the art of Rothko, who said of his paintings that "if you . . . are moved only by their color relationships, then you miss the point!"

To their credit, the younger New York artists soon got the point. As if to prove it, Robert Rauschenberg produced Factum I and Factum II, the first a characteristic work, combining collaged imagery with free, abstract passages of de Kooningesque brushwork, and the second an exact copy or simulacrum, right down to the last drip and splash. In this way Rauschenberg not only betrayed the automatism and spontaneity on which the older generation had based their authenticity, but also asserted that his own authenticity lay not in angst but, rather, in irony. The mentor of this new attitude was John Cage, the composer of aleatory music and a dedicated student of both Marcel Duchamp, the great Dadaist, and Zen Buddhism. Hostile to the Abstract Expressionists' "elitist" sense of themselves as existential heroes and of their art as a body of holy objects, Cage called for an expression not aloof from ordinary life but integral with it, somewhat like Duchamp's Readymades. He insisted that the true sources of art lay not in subjective feeling and the creative process, but in the everyday physical environment, for the purpose of art was, above all else, "the blurring of the distinction between art and life." Preferring laughter to tears, Cage saw art as "a purposeless play . . . [which], however, is an affirmation of life-not an attempt to bring order out of chaos, nor to suggest improvements in creation, but simply a way of waking up to the very life we're living, which is so excellent once one gets one's mind and one's desires out of its way and lets it act of its own accord." As this would infer, Cage, unlike Duchamp, was not subversive but positive in his conception, thus more in tune with Zen, which, along with the Neo-Dadaism about to emerge, saw the relationship between art and life in a joyous, if brash and always unsentimental, manner.

While Cage encouraged the use of accident and discontinuity, as did the Abstract Expressionists, he also rejected the older artists' dependence upon automatism as a means of suspending conscious behavior in order to arrive at deeper truths. Rather, he viewed chance as nature's own forming principle, one that required the artist to avoid the rational creation of patterns, hierarchies, and points of climax, in favor of repetition and a kind of all-over relatedness. In his utter devotion to an accident-determined art, Cage has often seemed to pursue an almost pantheistic line of thought, suggesting that by closing the gap between art and life, the artist would achieve a kind of self-elimination. Eventually this helped provide an ideological underpinning for the formal rigors and serialism of Minimal Art and the Post-Painterly phase of Color Field abstraction. It also led, in an opposite direction, to the all-inclusive theater-like Happenings of Allen Kaprow and, with more Duchamp than Zen, to the visual and verbal puns, paradoxes, and games of Conceptual Art. However, the most immediate impact of Cagean ideas was felt in a series of brilliant Pop works, redeemed from the startling vulgarity of their sources by the virtuosity of the handling, as in the great "combine" paintings of Rauschenberg and Jasper Johns, the soft "hamburger" sculptures of Claes Oldenburg, the cartoon paintings of Roy Lichtenstein, or the tabloid imagery of Andy Warhol's silkscreen pictures. Although these painters and sculptors shared little, if any, of the composer's quasi-mysticism, they did mingle his Zen-like humor with Duchamp's spirit of mockery to renew contact with the kind of vernacular subject matter that had been elaborted by such earlier masters as Edward Hopper, Stuart Davis, Charles Demuth, and Gerald Murphy (Figs. 451, 455, 471, 474), this time, however, with the scale, bravura, and aesthetic sophistication inherited from Abstract Expressionism. The high-art cachet made Pop Art all the more attractive to the burgeoning American media, voracious in their appetite for "accessible" material-art recognizable in its imagery-with which to entertain a newly affluent, culture-

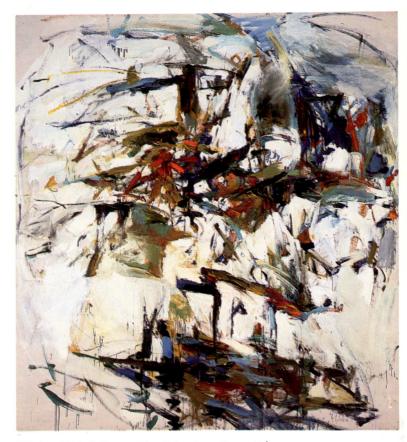

541. Joan Mitchell. George Went Swimming at Barnes Hole, but It Got Too Cold. 1957. Oil on canvas, 7'1½"×6'6½". Albright-Knox Gallery, Buffalo. Gift of Seymour H. Knox.

conscious mass audience. Although shot through with irony and ambiguity, Pop flattered and delighted that public, which soon accorded the new art's creators a fame unlike any encountered before or since in the history of American art.

Pop Art

The disconcerting alliance that Pop Art made with the objects and visual modes of consumer society did not appear *ex nihilo*, but came gradually in a drift away from the gestural, painterly modes of Action Painting toward a more inclusive art. In fact, the first significant evidence of adulterations in art derived from the surrounding urban environment could be observed in the aggressive Woman series initiated by the overwhelmingly influential Willem de Kooning in the late 1940s (Fig. 488). The dominant Woman image evolved from a collage method whereby the artist juxtaposed fragmentary commercial illustrations of lipsticked mouths with transpositions in paint of mass-culture sex idols and film stars. By allowing something of the blatancy of his visual sources to remain unassimilated in the paintings, de Kooning also left the disrupting references to the real world poetically suspended in a freely handled paint medium.

In 1953, while de Kooning was working on that controversial series, Larry Rivers (1923—), first known as a second-generation de Kooning follower, had begun to reappraise the pictorial cliché with his equally controversial work, *Washington Crossing the Delaware* (Fig. 542). Inspired by Leutze's popular 19th-century academic painting, Rivers's historically important picture signaled a general shift in outlook that made formerly scorned salon paintings and trite themes admissible in high art. Overly familiar imagery from popular sources and nostalgic Americana, but refreshed by an unexpected context, began to establish itself as a provocative new current, in

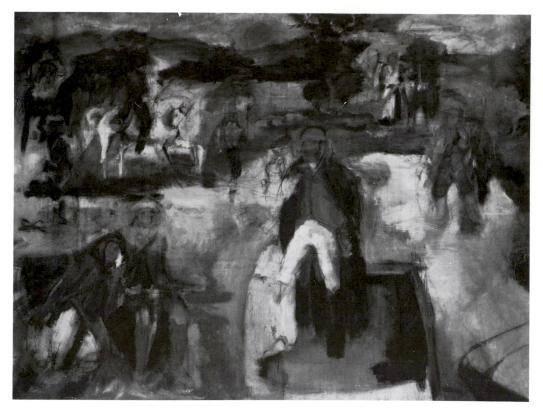

left: 542. Larry Rivers. Washington Crossing the Delaware. 1953. Oil on canvas, 6'11⅓"×9'3¾". Museum of Modern Art, New York.

Museum of Modern Art, New Fork.

below: 543. Robert Rauschenberg. *Rebus.* 1955. Oil on canvas with collage, 7′10″×11′9″. Collection Mr. and Mrs. Victor Ganz, New York.

sharp contrast to the subject preoccupations and idealism of Action Painting.

Robert Rauschenberg (1925—) treated the banal subject matter that Rivers introduced with even more formal daring outside the tradition of figurative realism; the results virtually transformed the values and the look of American painting in a few short years. By the mid-fifties Rauschenberg had begun to counter de Kooning's free brushstroke by loading his paintings with rags and tatters of cloth, reproductions, fragments of comic strips, and other collage elements of waste and discarded materials, almost Dadaist in the intensity of their challenge to all established aesthetics (Fig. 543). He worked the packed surfaces of his "combines" over with paint in the charac-

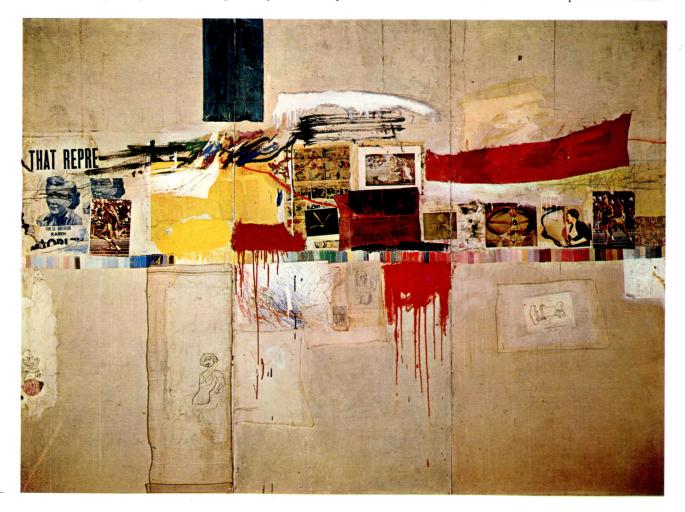

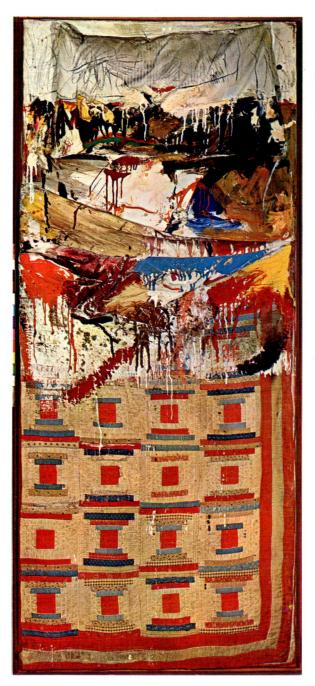

teristic, spontaneous gestural language of Action Painting, but painterly expressiveness enjoyed reduced powers and prerogatives in an artistic structure choked with alien matter. In describing his method of creation as a collaboration with materials, the artist made an oft-quoted statement that became a slogan of the new radical realism: "Painting relates to both art and life. Neither can be made. (I try to act in the gap between the two.)"

The pillow and quilt in Rauschenberg's *Bed* (Fig. 544), a work that shocked the tasteful, serve ambiguously both as an Abstract Expressionist painterly event and as a literal derelict object. Incorporating fragments from the domestic world in his paintings, Rauschenberg objectified and depersonalized the Action Painters' "gesture"; he thus managed to keep the dialogue between the sense of art and everyday experience open and unresolved. Short of canvas at the time he made the *Bed*, Rauschenberg simply substituted the pillow, sheet, and patchwork quilt from his own cot. He then hung the work straight up on the wall like a conventional stretched canvas, in contradiction to the bedding's original function, and

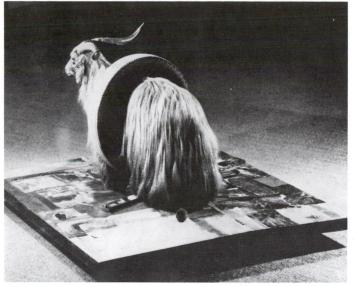

left: 544. Robert Rauschenberg. *Bed.* 1955. Mixed media, $6'2'' \times 2'7''$. Collection Leo Castelli, New York.

above: 545. Robert Rauschenberg. *Monogram.* 1959. Construction, $4 \times 6 \times 6'$. Moderna Musset, Stockholm.

thereby brought forth one of his first and most provocative assemblages. Widely exhibited, the *Bed* helped to earn the artist his reputation, which still persists, as an *enfant terrible*.

The notoriety garnered by Rauschenberg may have been inevitable, since the junk materials that he and others established in a new aesthetic context could be read as a symbol of alienation from the dominant folkways of an aggressive consumerist society, a society that extravagantly valued a gleaming, ersatz newness in its possessions. By forcing a confrontation with outcast and despicable object fragments, these artists effectively countered a culture maniacally geared for new, and soon obsolete, products. Their strategies cunningly posed troubling questions about the nature of the art experience and mass culture that gave rise to such blatant violations of the traditional integrity of medium. Rauschenberg radically deepened the alliance with the image world of popular culture and with articles of daily life by incorporating Coke bottles, stuffed animals, rubber tires, and miscellaneous deteriorating debris into his work (Fig. 545). And against these shocking intrusions, he then forced the painterly qualities and the fluid formal organization of Abstract Expressionism to operate. Unlike the poetic objects of the Surrealists, Rauschenberg's debris was not calculated to shock by its incongruity primarily. Indeed, the artist avoided the associational or fantastic meanings of his junk, and sought to use it in an optimistic matter-of-fact spirit. Thus, if social commentary could be read into the content, it was on an elementary and unspecific level, referring primarily to the life cycle of objects in our periodical culture, and their rapid decline into waste as the flow of new goods pushes them aside.

As his style evolved, Rauschenberg utilized silkscreened imagery taken from photojournalism, which in the sixties had begun radically to transform the art experience. New spatial and communication ideas infiltrated art through the process-oriented media of films, television, exhibitions, "Happenings," and other events, opening up unexpected creative opportunities and changing the forms of traditional painting. Rauschenberg was perhaps the first artist to test the new technical and aesthetic frontiers, now so familiar, in response to the communications dynamism of the contemporary electronic age. In *Rodeo Palace (Spread)*, a work created for an exhibition in Texas devoted to the American rodeo (Fig. 546), he

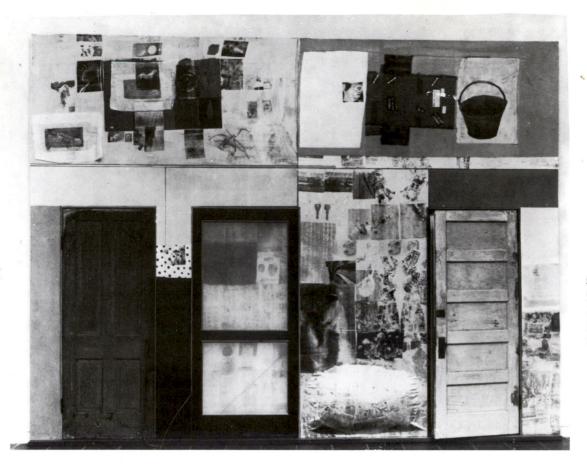

546. Robert Rauschenberg. Rodeo Palace (Spread). 1975–76. Mixed media, 12'×16'×5½". Collection Mr. and Mrs. Sidney Singer, Mamaroneck, N.Y.

combined some of the synoptic, flashing juxtapositions of his silkscreened imagery of the sixties with collage techniques and material contrast preserved from his earliest work. Here and there deliberately untidy contours and paint smears remind us that such a picture bridges the gap between Action Painting and Pop Art. The Zen-influenced ideas of John Cage, historical Dada, and Surrealism, augmented by the continuing presence in America of Marcel Duchamp, became significant factors in the development of Rauschenberg's art. Sometimes described as "Neo-Dada" because of their "found" elements and ironic character, the great combine paintings, like that in Figure 543, were also, as we shall see, linked to the phenomenon of the Happening.

The formal innovations of Jasper Johns (1930-) have had an even more far-reaching influence than Rauschenberg's in bringing on the radical new objective art of the sixties. His historic paintings of flags and targets, first exhibited in 1957-58, and his subsequent maps, rule-and-circle devices, and other subject matter created new forms of representation from a commonplace imagery. Many of his structures elucidated the creative process itself in a challenging intellectual kind of interrogation, breaking down and reconstituting elements of illusion and literal fact, and inviting the audience to participate in re-forming the magical unities of aesthetic experience. The first characteristic and innovative image created by Johns was the target (Fig. 547). In two separate versions, he set fragmentary painted casts of body parts and a repeated partial mask of the face in a series of boxes over a centered bull's eye. The sober formality of the hypnotic form and the subdued human associations of the casts created a powerful interplay of thwarted alternatives. Feeling was suspended, in effect, between the waxworks and a dehumanized geometry, the body's cage and a mental prison, and either image system proved curiously opaque and enigmatic. One expected to be able to decode messages from secret regions of the psyche, but they were effaced in "impersonality," in the received and sanctified modern fashion.

In his celebrated, albeit originally scandalous, flag paintings (Fig. 548), Johns revealed his nature as a Neo-Dadaist, an artist who elevated banal objects to the status of fine art but not by the simple act of selection such as that performed by Duchamp (Fig. 286). Instead of a readymade, Johns presented an exquisitely hand-painted image of a universally familiar artifact, thereby compounding the already ironic relationship created by the original Dadaists between art and life. While as caught up in sly aesthetic games as Duchamp, Johns differed from his mentor in that he played them in a wholeheartedly affirmative spirit. Not only did he make new art; he also made a new realist art unlike any seen before, an hallucinatingly persuasive representation that also happens to be as involved with modernist pictorial ideas as anything then produced in abstract painting. By choosing a subject from the real world with the same flatness and shape as the canvas support, Johns could so represent that reality as to create genuine confusion between it and his own painted version. Moreover, his strategy permitted him to achieve two-dimensionality without traducing any necessary three-dimensional relationship between figure and ground. Having used his image to endow it with a suggestion of depth by means of dense, translucently painterly surfaces, built up, however, not with the inspired spontaneity of the Abstract Expressionists but by the slow, craftsmanly process of patiently laying on sheet after sheet of waxsoaked newsprint. The ancient, Old Masterish medium of encaustic merely added to the ambiguity of a work that fused such antithetical factors as subject and object, geometric and painterly abstraction, the literal and the illusionistic, the optical and the tactile.

In *Painting with Two Balls* (Fig. 549) Johns carried his preoccupation with the equivocal nature of vision a step further. Here the canvas slit, pried open by small wooden balls, destroys the inviolable flatness that the paint surface, parodying Abstract Expressionistic brushwork, is at pains to emphasize. The interplay between flatness and perforated depth, between the free brush and the mechanical lettering, evokes many paradoxes of representation and

American Art of the Sixties: Pop Art and Minimalism

below: 547. Jasper Johns. Target with Plaster Casts. 1955. Encaustic collage on canvas with wood construction and plaster casts, 4'3"×3'8"×3'/2". Collection Mr. and Mrs. Leo Castelli, New York.

right: 548. Jasper Johns. Three Flags. 1958. Encaustic on canvas, 30% × 45½ × 5″. Whitney Museum of American Art, New York. 50th Anniversary Gift of the Gilman Foundation, Inc., the Lauder Foundation, and the Painting and Sculpture Committee.

below right: 549. Jasper Johns. Painting with Two Balls. 1960. Encaustic on canvas with assemblage, 6'5"×5'6". Collection the artist.

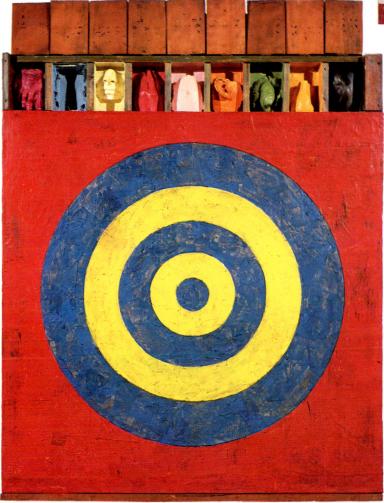

signification. Because meticulously lettered by hand at the bottom of the field, the title becomes part of the painting's content. The verbal legend thus contributes to the mix of different levels of conceptual and visual reality, incidentally shocking us by its elementary forthrightness. *Painting with Two Balls* describes and documents itself with a deadpan explicitness, as if to say that art can be plain fact as well as metaphor. If Action Painting could be said to symbolize the great, uniquely inspired work of art, and thereby to certify transcendental values—values of individual freedom and personal authenticity—then Johns's new spirit of factualism symbolizes a game of confounding identities where fact and object have enhanced

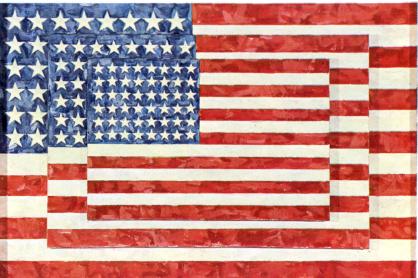

status, coequal with the evocative and associative powers of painting. The new objective mood that Johns introduced with such éclat coincided with the more intellectually controlled abstractions of his contemporaries, Kelly, Noland, and Stella (Figs. 580, 585, 586, 589, 590). All conceived of the work of art with more conceptual rigor than the Action painters, since for them painting was less a mode of self-discovery or self-definition than a specific set of facts, or a controlled formal system. Among these, however, Johns stood alone in his dry humor, prompting some viewers to interpret *Painting with Two Balls* as an hilarious send-up of the perceived machismo of the Action painters.

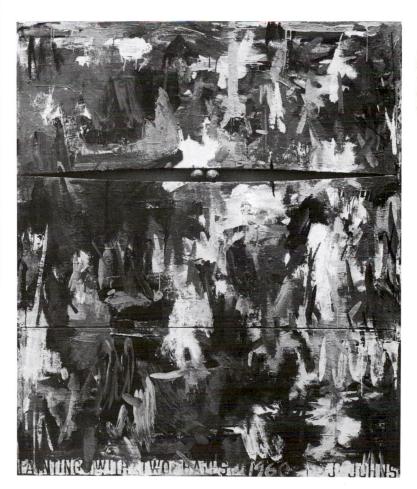

American Art of the Sixties: Pop Art and Minimalism

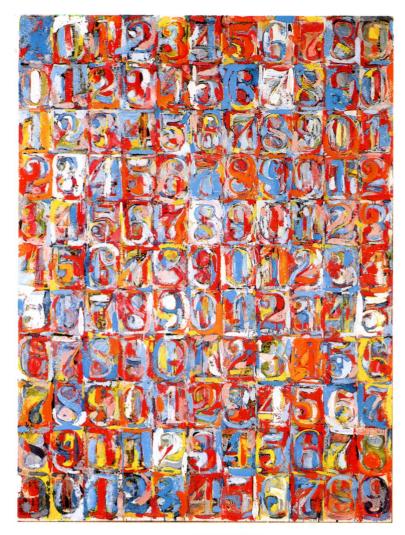

Nowhere is Johns's resolute command of pictorial structure more evident than in *Numbers in Color* (Fig. 550), where the artist once again revived the Cubists' use of letters and numbers to tether their art simultaneously to the realities of both the painting's flat, fixed surface and the temporal, volumetric world outside. But true to his own time, he did so by means of a serial whose anonymity and repetitiousness transform Cubism's rectilinear grid into the kind of single, holistic image preferred by the New York School in the wake of Pollock and the Color Field painters. The serial also permitted him to build into his picture the element of time, that fourth dimension with which the Cubists so enriched their art, but by doing it with sequential numbers, rather than with multiple perspectives or "takes," Johns retained the unitary quality characteristic of the New York formalists.

Johns not only invented new representations of old things but also converted objects into artful facsimiles. His mounted flashlight and Savarin coffee cans with paint brushes are painted casts in bronze of actual objects (Figs. 551, 552). They too differ in intention and impact from the readymades of Duchamp, for whereas the latter used everyday objects to launch an attack on the pretensions of museum culture, Johns concerned himself to a much greater degree with the old romantic game of illusionism. In more relevant contemporary terms, his art acknowledges the distinction between the work of art as a unique creation and its current devaluation by the ubiquitous reproduction. Individuality of touch and "fine art" handling remain a marginal and furtive activity in Johns's sculpture combines. The facsimile object enters the context of art by reason of its expressive and delicately painted surfaces, in which we recognize the operation of traditional sensibility.

Jim Dine (1935—) occupies a unique position among those artists emerging after 1960 who have been associated loosely, and in his case perhaps exaggeratedly, with Pop Art. His paintings with object attachments and his environments have an abrupt power that rebukes the indirection and muted poetic sentiment of his first mentor, Jasper Johns. Dine extends the paradoxical play between literal experience and illusionistic representation by regenerating, with a rivaling skill, the painterly direction of Action Painting, then assimi-

> 552. Jasper Johns. Painted Bronze (Ale Cans). 1960. Painted bronze, 5¹/₂ × 8 × 4³/₄". Kunstmuseum (Ludwig Collection), Basel.

top: 550. Jasper Johns. Numbers in Color. 1965. Encaustic and collage on canvas, 5'6½"×4'1½". Albright-Knox Art Gallery, Buffalo. Gift of Seymour H. Knox.

> above: 551: Jasper Johns. Painted Bronze (Savarin). 1960. Painted bronze, 13½ × 8″ diameter. Collection the artist. On loan to the Philadelphia Museum of Art.

lating it to a wide repertory of artifacts rich in human association of personal use or admired strength. His household furniture, portions of room environments, bathroom cabinets, tools, palettes, and robes are meant to be enjoyed for their expressive power within the formal scheme of his constructions, and are not underscored for their scandalous potential (Fig. 553). They do strike an overtly aggressive note (an axe plunged in a plank, a saw bisecting a blue field of paint) and release no small amount of sexual fantasy. Dine's prosaic directness and mechanical resourcefulness are in the American grain, more related in temper to David Smith perhaps than to Johns, and thus free of the hermeticism that has been one of the liabilities of Johns's art for his followers. The unsubtlety so purposefully cultivated by Dine has been characteristic of the mode of realism in the past, whenever a preceding strategy tended to become ritualized by a particular individual sensibility. His almost programmatic "brutalism" is, however, only one note in a virtuoso range of effects that include exquisitely controlled draftsmanship, powerfully expressive color, and the skilled mastery of large expanses of evenly accented surface.

When American Pop Art made its dramatic public debut in 1962, with the individual exhibitions of Roy Lichtenstein, Claes Oldenburg, James Rosenquist, Andy Warhol, Tom Wesselmann, and Robert Indiana, the term by which the movement became best known had already been coined in 1958 by the English critic Lawrence Alloway, who used it to characterize the precocious activity of British artists (see Chap. 20). For a long time "Neo-Dada" also served to describe the Pop phenomenon, and when New York's Sidney Janis Gallery showed the new American artists in November of 1962 the controversial but now forgotten exhibition opened under the rubric "New Realists." It did not soften the blow, for many artists and virtually all older critics reacted with shock and dismay to an imagery that seemed scarcely to transform its sources in the newspaper comic strip (Lichtenstein), the billboard (Rosenquist), repeated or isolated commercial brand symbols (Warhol), or imagery from "girlie" magazines (Wesselmann). The more obviously aesthetic intention of Robert Indiana (1928-) in his lettered signs and directional symbols was found only slightly more acceptable, since this artist, too, appropriated explicit and routine media fare, road signs, and mechanical type faces (Fig. 554). Image banality was matched as a source of provocation by the apparent indifference of these artists to individualized handling, and their uncritical enthusiasm for the bald visual stereotypes of commercial illustration. Mechanical image registration in the period's styles of commercial art ran strongly counter to the accumulated store of knowledge, craft, and painterly expressiveness built up by previous generations. Those with a vested interest in established art forms could tolerate Expressionistic rawness in "high" art, but slickness struck them as meretricious and thus unacceptable.

By monumentally dilating a billboard detail, James Rosenquist (1933-) discovered iconic possibilities in the advertising image and created confusing alternative readings of his compartmented paintings (Fig. 555). These relate both to the ambiguous legibility of contemporary abstraction and to the deliberate confusions of different realities by the Surrealists. Between 1954 and 1960 Rosenquist worked as a billboard painter, even in Times Square, and the experience of dealing with huge commercial images at close range and the use of Day-Glo paints would become important in his paintings of the late 1960s and the 1970s. Some of them would be large-scale canvases painted in a technique reminiscent of billboards but also prophetic of Photorealism (Fig. 722), which summarizes with epic grandeur America's taste for objects, material progress, and social optimism, despite the vulgarization of such impulses by the media and various forms of popular culture.

Roy Lichtenstein (1923-97) decelerated the cartoon image by enlargement (Fig. 556). He also conspicuously overstated the Ben

above: 553. Jim Dine. Hatchet with Two Palettes, State No. 2. 1963. Oil on canvas with wood and metal, $6' \times 4'8'' \times 1'$. Harry N. Abrams Family Collection, New York.

below: 554. Robert Indiana. Alabama, 1965. Oil on canvas, 5' × 4'2". Collection Walter Netsch, Chicago.

American Art of the Sixties: Pop Art and Minimalism

Day screen dots and thus made them an integral part of his form, compelling our attention to medium and process as significant content and as an undoubtedly ironic commentary on the adolescent celebration of modern warfare. Lichtenstein achieved another kind of distancing effect by his choice of somewhat out-of-date comics for his early subjects. Modern life speeds up the sense of time's passage and makes us more sharply aware of changing styles and of the obsession with change and novelty through the communications media. The intuition of this reality lies at the heart of much Pop Art. The mass media have become a collective vehicle for instant history-making, contracting time and space into a blurry, continuous present, so that even the recent past seems as remote as events of ancient archaeology.

Above all else, Lichtenstein was concerned with art and style, despite the lowbrow sources and extremely mechanical look of his early work. This is particularly evident in later paintings, which represent an effort to reconcile the artist's comic-strip manner with such admired 20th-century masters as Matisse. In *The Artist's Studio: The Dance* (Fig. 557) Lichtenstein discovered points of correspondence in taste between the Art Nouveau element of Matisse's cursive style (Fig. 177) and his own deliberately vulgarized decoration and linear convolutions. He often boldly tested "high art" values by contrasting them with a vernacular mode and by introducing references to fashionable art-historical models and to his own artistic evolution. Within his chosen scheme, he remained a constantly inventive artist,

masterfully manipulating contour, color, shape, scale, and a variegated repertory of surface marks to create powerful compositions.

Andy Warhol (1928–87) appropriated and serially repeated images of automobile crashes, movie stars, political figures, and soup cans snatched from the daily unfolding of the headlines and space ads in the print media, or the life cycle of processed articles and food (Fig. 558). The iconic gravity of his imagery arrests on canvas the speeded-up transience of what Alloway called "admass" culture. Like the assemblage sculptors (Figs. 561–566), Warhol constructed victual, soap, and Brillo cartons of painted wood and stacked them to imitate a supermarket storeroom. These objects exist artistically by a nuance of contradiction between the actual product and its simulation and by the artist's fine calculation of his audience's differing responses to each.

Nothing actually happens in Warhol's art in the sense of conventional narrative or storytelling. Its point, at least in part, is to confront us with boredom as an issue, with a subject matter neutralized by a remorselessly mechanical presentation (Fig. 559). The detached stance adopted by the artist effectively thwarts any sense of emotional involvement or identification. Yet, despite the iconography of blankness and impassivity, Warhol operated in the area of public myth and parable. He may even be considered a modern history painter, since his dominant imagery and visual ironies are inextricably bound up with the conditions and dailynewspaper events of urban culture. Because Warhol affected

above: 555.

James Rosenquist. Flamingo Capsule. 1970. Oil on canvas with aluminized mylar, 9'6" x 23'. Courtesy Leo Castelli Gallery, New York.

right: 556.

Roy Lichtenstein. Whaam! 1963. Magna on canvas, 5'8" x 13'4". Tate Gallery, London.

American Art of the Sixties: Pop Art and Minimalism

an anti-narrative approach, using his canvas surface much like his film as a random and continuous medium in the spirit of *cinéma vérité*, visual facts are perceived as arbitrary and isolated moments rather than as an observed series of particular events. One of his important subjects is the reproduction technology itself, the coarse scrim of halftone dots that mediate his images in the photomechanical silkscreen process. The handmade original painting, with its sacrosanct historical and ceremonial associations, has been renounced in favor of commercial reproduction, whose ubiquity assures the subjects' swift decline into nostalgic clichés.

Tom Wesselmann (1931-) resorted to an essentially emblem-

atic treatment of the female body in his first important series of paintings, which grew out of his early student interest in cartoon illustration. He studied cartooning at the Cincinnati Art Academy, then in the late 1950s transferred to Cooper Union in New York. As early as 1961, when he started the Great American Nude series, Wesselmann limited his palette to red, white, and blue, which clearly associated the erotic theme with the American flag colors. Eventually he looked to more exalted sources than those of his original inspiration and found Matisse, often taking the *Pink Nude* (Fig. 386) as his comparatively innocent model and restyling it with an airbrush interpretation of the flat cut-out color forms of the French

above left: 557. Roy Lichtenstein. The Artist's Studio: The Dance. 1974. Oil and magna on canvas, 8'×10'8". Collection Mr. and Mrs. S.I. Newhouse, New York.

left: 558. Andy Warhol. Green Coca Cola Bottles. 1962. Oil on canvas, 6'10"×8'9". Private collection, New York.

above right: 559. Andy Warhol. *Mao 6.* 1973. Acrylic and silkscreen on canvas, 4'2"×3'6". Courtesy Ace Gallery, Venice, California.

master's late style (Fig. 560). Wesselmann's interest in singling out parts of the female body and in collage are visual factors closely linked to Surrealism, once again reaffirming the fantastic content of much American Pop Art.

Assemblage and Environments

The intensified use of heretofore scorned, subaesthetic materials challenged the hierarchy of distinctions between the "fine art" status of the traditional art object and untransformed brute materials drawn from the urban refuse heap. "Junk art," as the critic Lawrence Alloway described this mode, gathered momentum in the late fifties and acquired added emphasis in the conglomerates of rusting machine discards in the sculpture of Richard Stankiewicz (1922-83; Fig. 561). In the crushed and shaped sculptures assembled by John Chamberlain (1927-) from polychrome auto-chassis fragments, it also gained, in three-dimensional form, something of the color and frozen dynamism that Rauschenberg and Johns had carried forward from Abstract Expressionism (Fig. 562). But while the work seen here discloses obvious links with de Kooning's colliding brushstrokes, as well as an echo of the Dutch-American artist's verve and energy in securing a precarious, momentary order from chaotic fragments, Chamberlain in his choice of throwaway materials was moti-

vated by considerations beyond the aesthetic. Junk art opened up a new relationship with urban experience only hinted at in de Kooning's collage method, and it was conditioned by contemporary attitudes toward the mass-produced object. Although no explicit critical commentary was intended, an orientation to the idea of planned obsolescence, which quickly abandons and replaces objects from the assembly line, exists at least by implication. Automobile debris, like the decayed matter in Rauschenberg's combines, represents the last stage in the product's cycle from manufacture to functional use and

top left: 560. Tom Wesselmann. Long Delayed Nude. 1967–75. Oil on canvas, 5'7¾" × 8'5½". Collection Dieter Brusberg, Germany.

top right: 561. Richard Stankiewicz. Untitled. 1961. Welded steel, 5'7''×3'×2'10''. Collection Mr. and Mrs. Burton Tremaine, Meriden, Conn.

left: 562. John Chamberlain. Toy. 1961. Welded auto parts and plastic, $4' \times 3'2'' \times 2'7''$. Art Institute of Chicago. finally to uselessness as waste. The poet Randall Jarrell has noted that we speak of planned obsolescence, but it is more than planned; it is an assumption about the nature of contemporary reality. By incorporating disposable materials in his work, the artist acknowledges that inexorable process, and also assimilates it to the different uses of art. The very worthlessness of street litter makes it peculiarly adaptable to the art process, which by its nature treats of the gratuitous and the nonfunctional.

One of the great masters of sculpture assembled from junk was Marc di Suvero (1933—), who worked on a vast, environmental scale, using beams, tires, chains, chairs, and scrap salvaged from demolished buildings and junkyards (Fig. 563). Endowed with the bold energy of the Abstract Expressionists and an engineer's grasp of Constructivist principles, di Suvero hoisted huge beams and rough-hewn planks into daring, asymmetrical balance. To help the viewer participate in the work's space and tension, he sometimes built makeshift seats into his colossal constructions. More recently, di Suvero has limited his materials to industrially fabricated steel plates and I-beams. But even as his work evolved from the massive forms of the early period to the structural clarity and linear elegance of newer pieces, the artist continues to utilize the Constructivist compositional elements of strong diagonals, tetrahedral forms, and precise suspension systems.

Foremost among all sculptors working with orphaned objects retrieved from the environment was Louise Nevelson (1899–1988), who chronologically belongs to David Smith's welder-sculptor generation, but whose materials and methods accord more with those of Pop's combine and assemblage artists. In her uncompromising formal rigor, moreover, Nevelson betrayed the Cubist-derived aesthetic

sophistication that underlay the art of the sixties and provided a common bond among virtually all its practitioners, whatever their stylistic persuasion. Nevelson's famous "walls" contain disowned objects in stacked and interconnected boxes and crates (Fig. 564). Newel posts, finials, parts of balustrades, chair slats and barrel staves, bowling pins and rough-cut wood blocks, all sprayed a uni-

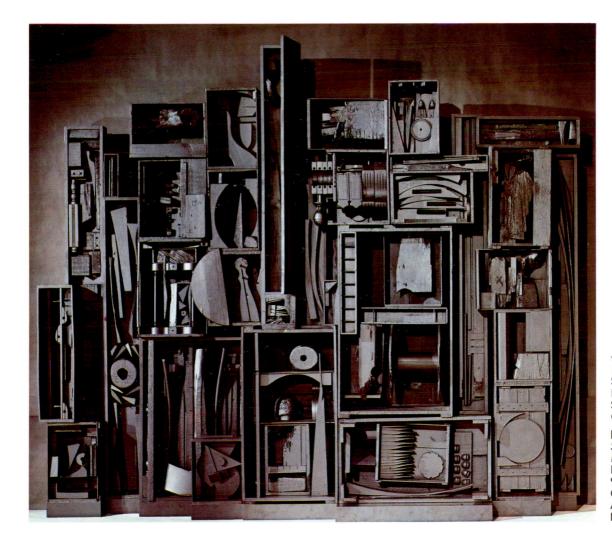

top: 563. Mark di Suvero. For Lady Day. 1968–69. Steel, 54 × 40 × 35′. Park Forest South Cultural Foundation, III. Gift of Lewis Manilow.

left: 564. Louise Nevelson. Sky Cathedral—Moon Garden Plus One. 1957–60. Black painted wood, $9'1'' \times 10'2'' \times 1'7''$. Collection Arnold and Milly Glimcher, New York.

above: 565.

Louise Nevelson. Transparent Sculpture VI. 1967–68. Lucite, 19 x 20 x 8". Whitney Museum of American Art, New York. Gift of the Howard and Jean Lipman Foundation, Inc.

right: 566.

Lucas Samaras. Untitled, Box No. 3. 1963. Wood, pins, rope, and stuffed bird; 241/2 x 111/2 x 103/4". Whitney Museum of American Art, New York. Gift of the Howard and Jean Lipman Foundation, Inc.

above right: 567.

Lee Bontecou. Untitled. 1962. Metal and canvas, 6'4" x 5'101/2 x 2'3". Courtesy Leo Castelli Gallery, New York.

form white, black, or gold, constitute some of the myriad components that the artist cunningly set in the shallow recesses of her additive, Cubistic constructions. But for all their intricacy and ingenuity of formal relations and dazzling variations of shape, the walls achieve both a powerfully unified impact as well as liberating possibilities of expansion. They operate forcefully upon the spectator and his or her own spatial environment. The rigorously formalized structures also have the air of being collections of treasured trophies. The ensembles put together by Nevelson function with the ambiguity of a de Chirico painting (Figs. 280-282), where geometric style acts as a source of poetic mystery rather than of clarity and precision. The same unerring balance of expressive power and hermeticism sustains the inventions that she poured forth with undiminished vigor to the very end of an exceptionally long and distinguished career. Even her large, public outdoor sculptures, usually erected in Cor-Ten steel, and the transparent Lucite structures of later years (Fig. 565) carry the personal stamp of her first works, despite their monumental-though sometimes tabletop-scale and look of impersonal fabrication.

American Art of the Sixties: Pop Art and Minimalism

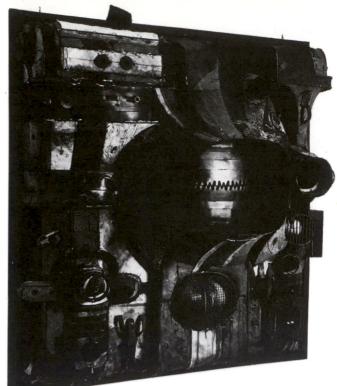

Another artist obsessed with messily irregular junk assembled in the classic conformity of cubic containers is the much younger and more explicitly autobiographical Lucas Samaras (1936—), whose perversely elegant boxes (Fig. 566) transform disparate objects and materials into new realities, just as certain aspects of Dada and Surrealist art did. Also Surrealist in character is Samaras's exploration of magic and alchemy, as well as the fascination with violence the artist reveals in his detailed photographic examination of his own body (Fig. 695). Integral to such work and essential to its impact is a canny awareness that sadomasochistic content will be certain to engage the viewer's emotions. The anticipation of pain provoked by the sight of a box stuffed with a porcupine thicket of glittering pins conforms to the Duchampian strategy of compelling the audience to complete the creative act.

The savage constructions fashioned by Lee Bontecou (1931-), from canvas, metal, and wire, regularize and codify within a highly idiosyncratic formal system the tears, bulges, erosions, and accretions of the waste materials associated with assemblage (Fig. 567). Strong elements of fantasy are brought to terms with a structural aesthetic and emblematic form. The aggression of her earlier images (jagged sawteeth suggesting mouths, sealed-off or grated apertures evoking mystery and frustration) and their coarsely textured surfaces have an irrational intensity about them. Bontecou used obtrusively inelegant materials, such as fragments of laundry bags, and junk components with a surgical precision, but her forms manage to remain intensely primitivistic. They expand in scale as their deep relief elements are emphasized, and thus attain a dramatic, environmental presence. Surface detail, texturing, and pictorial illusionism support their environmental versatility, for they function both as sculpture-objects and as a rather threatening dream imagery.

The transformation of "assemblage"—the apt term coined by Dubuffet but then canonized by the Museum of Modern Art curator William Seitz—into an expansive environmental art, often theatrical in content, was expressed with sharp dramatic tension in the mordant and memorable tableaux of Edward Kienholz (1927–94). The vicious allegories concocted by this artist can be viewed as the grotesque horror-film countercurrent to the mindless California fascination with a world of hot rods, baroque car designs, high-polish craftsmanship, and other evidences of a shallow, ersatz visual culture. Kienholz's brutal creations belong to an American moralizing tradition, and comment on such topics as abortion, patriotism, eroticism, and even psychic disintegration, frequently with an almost unbearable literalism, as in the searing *State Hospital* (Fig. 568).

Just as much as in the case of Kienholz's dark, subcultural world, the dehumanizing impact of our surroundings supports the white world of spooky and moving sculpture created by George Segal (1924-). His is a dramatic art that defies conventional distinctions between sculpture and painting, object and setting, visual elaboration and poetic sentiment (Fig. 569). The images formed by Segal often seem a vulgar intrusion on a brightly lit, artificial urbanscape that takes no heed of human beings and has only a marginal place for them. The ghostly human replicas that populate it have been pieced together from castings of friends patient enough to leave their impressions in plaster. The surfaces of the molds are freely manipulated, shaped, and expanded by hand in quick-drying plaster. These stolid and insensible dream figures dwell in the lonely limbo created by the chrome-and-neon vacancies of such public areas as gas stations, cleaning establishments, and mass-transportation vehicles, or occupy the privacy of a home where they tend themselves blindly and absorbedly as animals do, waiting impassively for some external stimulus to move them off dead center. The subtly modulated surfaces of Segal's plaster robots are quite literally shells. They make no explicit social commentary, and their "message" is their theatrical presence and illusion in an environmental situation. Humanly anesthetized, they simply exist as objects exist. Their most vivid identities and energies are aesthetic. Denied the power of action, they can only serve the gratuitous life of the work of art, just as Oldenburg's dispossessed and poetically suspended objects do (Fig. 572).

As adept at handling wood as Nevelson, even to the mastery of traditional wood carving, Marisol (1930—) otherwise conforms to her own artistic generation, especially that branch of it led by Johns and Dine, by mixing the modes of sculpture, painting, and drawing. In her characteristic work she creates an interplay of literal object and pictorial illusion in *tableaux vivants* inhabited by life-size manikins (Fig. 570). The brilliant, richly autobiographical theater created by Marisol abounds in self-portraits; moreover, personal fantasies enter freely into the work and become a major feature of it. Cast as her own heroine, the artist emerges fiercely alienated in arbitrary or hallucinated images strangely dissociated from feeling. In this fantastic and forceful sculpture, the far-out point of impersonali-

top: 568. Edward Kienholz. State Hospital. 1964–66. Cast plaster and fiberglass figures, hospital beds, bedpan, hospital table, goldfish bowls, live goldfish, lighted neon tubing, steel hardware, wood, paint; $8 \times 12 \times 10'$. Moderna Museet, Stockholm.

above: 569. George Segal. *Picasso's Chair*. 1973. Plaster, wood, cloth, rubber, and string; 6'6"×5'×8'6". Collection Dr. Milton D. Ratner, New York.

left: 570. Marisol. *The Party*. 1965–66. Figures in mixed media, 9'11"×15'8"×16'. Collection Mrs. Robert Mayer, Winnetka, III.

American Art of the Sixties: Pop Art and Minimalism

left: 571. Red Grooms. Ruckus Manhattan: Wall Street and Chase Manhattan Plaza. 1975. Mixed media. Courtesy Marlborough Gallery, New York.

below: 572. Claes Oldenburg. Giant Hamburger with Pickle Attached, Slice of Iced Layer Cake, and Ice Cream Cone. Installation of one-man exhibition at the Green Gallery, New York. 1962.

ty arrives when the artist views herself as a spirit object or as human furniture. Otherwise, the principal subjects of Marisol's magical transformations, and very considerable formal ingenuity, have been American folklore, the hipster world, and caustic caricatures of international leaders. Recently Marisol has joined Lichtenstein, and so many others in this art-historically conscious period, to make her own inimitable replications of familiar masterpieces, among them Leonardo's *Last Supper*, rendered as a three-dimensional frieze of carved and carpentered wood. True to precedent, the artist makes an appearance, but only as an onlooker.

With more than a touch of Marisol's caricatural wit, but "buckeye" American in his broad, extroverted humor, Red Grooms (1937—) has extended the environmental character of Pop until it encompasses whole cities, from Chicago to New York and, recently, back to medieval Japan, in a marvelously fascinating reconstruction of a besieged moat-bound castle. One of the most comic of Grooms's brilliantly colored and wildly askew environments is *Ruckus Manhattan* (Fig. 571), an enormous and elaborate piece that seems to mock, as well as three-dimensionalize, John Marin's *Lower Manhattan* (Fig. 445). The installation also takes on Dubuffet's Group of Four Trees (Fig. 531), miniaturizing and destabilizing the great site sculpture until it resembles a battered toy.

When it comes to inventive re-creations and transformations of familiar objects, no artist has been more precocious than Claes Oldenburg (1926—), whose wide-ranging interests and formidable energies make him perhaps the single most important innovator of the 1960s. Oldenburg was educated in Abstract Expressionism, but

broke with that movement around 1959, opening paths to a variety of new expressions, including Pop Art. With the Happening, as we shall see, he extended Action Painting into a form of improvisational Expressionist theater, but he is best known for the food constructions in painted canvas and plaster created after 1960 (Fig. 572). The

573. Claes Oldenburg. Model (Ghost) Typewriter. 1963. Cloth, kapok, and wood; 27½ × 26 × 9″. Courtesy Sidney Janis Gallery, New York.

surfaces of these bloated, dropsical facsimiles of the lunch and drugstore counter were at first freely handled in the splatter-andsplash technique of Action Painting, but the reference to their real-life models was inescapable. A repeated emphasis on comestibles seemed rather innocently to draw on the preoccupations of advertising, along with the infantile oral obsessions of most Americans. Thus, the cult of literal experience that appeared with Rauschenberg's objects became less diffuse when Oldenburg adopted it, focusing on sets of objects with greater symbolic depth and meaning. The famous giant hamburgers transformed food into a dream fetish so outrageous in scale as to appear comical. The aggrandizing impulse of Abstract Expressionism seemed to have run amok at the local diner.

In subsequent years, Oldenburg has renovated his objects, the better to "improve" on man-made nature. Now he shifted his ambience from the Downtown secondhand-clothes emporia or open food markets to the Uptown department store milieu. A series of soft telephones, toasters, and typewriters made in the mid-sixties of shiny vinyl plastic look freshly manufactured, slick, and grossly opulent instead of derelict or decayed (Fig. 573). The object was of a mechanical character, to be consumed by use rather than assimilated physiologically. It entered the new context of art in a virginal state, before it had been caught up in the consumer cycle from use to junk. But these creations were as preposterous as ever, both in their immensity and in their contradiction of the normal properties of things they dissembled. We identify telephones by their hard and metallic qualities, but Oldenburg's are collapsed and baggy shells, all epidermis and no working parts. They stand on the threshold of animistic and magical life but can never quite slip out of their utilitarian identity, and this fine nuance is their whole point: they are objects divorced from function. By taking them through such a poetic metamorphosis and making them useless, Oldenburg associated his telephones, typewriters, and appliances with the art object, which is by definition impractical. His dummies and substitute items create a rich play of shifting identities that enters into the very fabric of the art work itself.

More recently Oldenburg has been designing and drawing, with great elegance and wit, imaginary urban monuments-a toilet ballfloat for the polluted Thames, a teddy bear for Central Park, a mammoth block of cement for a downtown street intersection, a gargantuan Good Humor Bar for Manhattan's Park Avenue (Fig. 574)and a few of them have actually been built such as the colossal Clothespin in Philadelphia (Fig. 711). These visionary inventions are grafts of the fantasies of childhood on a civic realm whose dehumanization, overcrowding, and apparently hopeless problems of litter, traffic, congestion, crime, and spoiled air resist rational solution. The irrationality of the modern post-industrial scene, with its threat to human survival, makes Oldenburg's visual gibes seem humane and plausible by comparison. At least his own fetishes, no matter how regressive or infantile, have been humanized, and are sustained by the values of authentic personal experience. The language of the nursery shows us an adult world through the eyes of a child-as in Blake's Songs of Innocence. Indeed, the ironic visual commentary made by Oldenburg becomes a vigorous form of criticism directed at an impotent society that refuses to save itself from itself. The celebrated re-creations of food are appealing, as Lucy Lippard noted, "because they combine gaiety and elephantine sadness." Oldenburg's new monuments are far more pessimistic, and convey a mood of black humor more appropriate to our condition.

The Happening

At the very genesis of the Pop movement was the phenomenon of the so-called "Happening," perhaps the most radical manifestation of the impact of the visual arts made by the Black Mountain College composer John Cage, who taught the Zen Buddhist doctrine of art as "a purposeless play," or an activity whose purpose was "the blurring of the distinction between art and life." Carrying this conception to something like its ultimate conclusion, Allen Kaprow (1927—) invented the Happening in order to bring visual artists into more fertile interaction with the actual world around them, by opening a new dialogue with overlooked materials of the quotidian environment. Many well-known artists, painters and sculptors gained their first significant notice as originators of Happenings-Oldenburg, Dine, Grooms, Robert Whitman-and the young Lucas Samaras performed in a number of them. In an article of 1958, "The Legacy of Jackson Pollock," Kaprow proposed "a quite clearheaded decision to abandon craftsmanship and permanence" and advocated "the use of . . . perishable media such as newspaper, string, adhesive tape, growing grass, or real food" so that "no one can mistake the fact that work will pass into dust or garbage quickly." Seeing how Pollock had incorporated waste material in his pigment and finding a quality of environmental "sprawling" in that artist's work, a quality that broke down barriers between art and actual experience in his larger canvases, Kaprow became a powerful advocate of the notion that art no longer be considered a selfcontained, autonomous entity divorced from life but, instead, continuous with it:

Pollock left us at the point where we must become preoccupied with and even dazzled by the spaces and objects of our everyday life.... Not satisfied with the suggestion through paint of our other senses, we shall utilize the specific substances of sight, sound, movement, people, odor, touch. Objects of every sort are materials for the new art: paint, chairs, food, electric and neon lights, smoke, water, old socks, a dog, movies, a thousand other things which will be discovered by the present generation of artists. Not only will these bold creators show us, as if for the first time, the world we have always had about us but ignored, but they will disclose entirely unheard-of happenings and events, found in garbage cans, police files, hotel lobbies, seen in store windows and on the streets, and sensed in dreams and horrible accidents.

574. Claes Oldenburg. Proposed Colossal Monument for Park Avenue, New York: Good Humor Bar. 1965. Crayon and watercolor, 23³/4 x 18". Collection Carroll Janis, New York.

ing of roles, nor even an imaginative setting. People involved were treated literally as physical props. However, the author, or authors, of the "piece" offered a program and a sequence of viewing, and both the dramatic action and the objects could often be taken as symbolic. Happenings were also loosely associated with the dance performances of Merce Cunningham, as well as with the music of John Cage, both of whom collaborated extensively with visual artists, most notably with Rauschenberg, Johns, and Warhol. Together these aesthetic developments, bridging a number of different media, had the effect of exposing the art scene to entirely new expressive possibilities. Not only was it in the context of the Happening that Rauschenberg conceived his method of working as a collaboration with materials, but the ideas of Kaprow traveled to Europe and there found an outlet in the experimental, even political art of Yves Klein and Joseph Beuys (Figs. 609, 695, 760). They survive today in Performance Art and in a new generation of environmental works.

Post-Painterly Abstraction

Thus, the Happening came into being, a kind of animated collage of events involving persons and materials in a theatrical situation before an audience (Fig. 575). While clearly devoted, like assemblage and Environments, to a closer integration of art and life, the Happening differed from the former pair in that these were relatively fixed and static, the one made to be "walked around" or contemplated from without, and the other to be "walked into," with observers enveloped and manipulated by what surrounds them. The Happening, by contrast, partook of all these dimensions and perceptions but only as an "event," something akin to the performance arts that could very well occur outside the confines of a gallery. Consistent with the theories of John Cage, who gave paramount importance to chance in the artistic process, Happenings were meant to be "spontaneous, plotless theatrical events," requiring no specific participation or response on the part of anyone, even though the purpose was to alter the consciousness of all, audience and performers alike. There was no simulated time sequence in the events, no narrative, no play-

While the initial reaction of the cool second-wave New York School to the overheated sublimities of Action Painting came in the form of Pop Art, doing so by extending as well as departing from the gesturalism and inclusiveness of de Kooning, another branch of the same generation expressed its detachment by rejecting de Kooning totally and by turning to Pollock. But the Pollock they saw was not the artist of spontaneity, ambiguity, and complexity, but rather the creator of the single, clear, all-over, "holistic" abstract image. Needless to say, the younger artists of this bent also found inspiration in the nonpainterly styles of the Color Field painters, mainly Newman, Rothko, and Reinhardt. For ideological support, they could also turn to the New York critic Clement Greenberg, who, like John Cage, had ties to Black Mountain College in North Carolina, that mecca of the American avant-garde in the 1950s. As defined in a series of articles and reviews, beginning as early as 1939, Greenberg's aesthetic held that "modernist" painting, from the time of its inception in Impressionism, had an overriding desire to become "pure," mean-

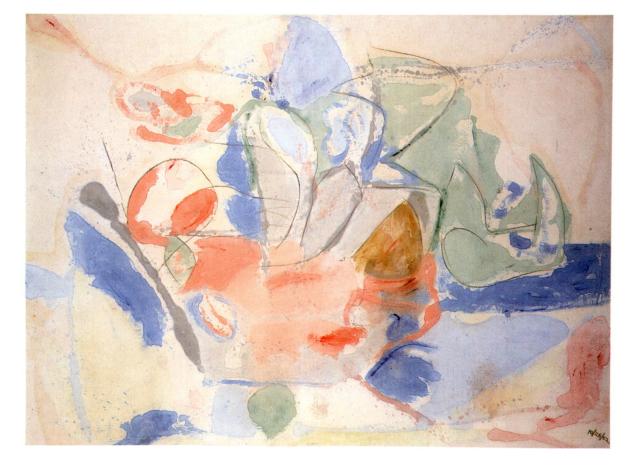

top: 575.

Alan Kaprow. "Car Wash", part of *Household*, a Happening at Cornell University, Ithaca, New York. September 1964.

right: 576.

Helen Frankenthaler. Mountains and Sea. 1952. Oil on canvas, 7'2⁵/8' x 9'9'1/4''. Collection the artist (on extended loan to the National Gallery of Art, Washington, D.C.). © Helen Frankenthaler. ing that its creators had always sought, and should continue to seek, an art based with increasing exclusivity on those properties that are uniquely and irreducibly its own: color and the two-dimensional surface, or plane, on which the medium is applied. Thus, Greenberg rejected "painterly painting" because its tactility and value contrasts must inevitably create illusionistic space and therefore work against pictorial flatness. Prompted by this rationale, he also dismissed Cézanne and the Cubism that master had inspired, and urged progressive painters to rediscover Monet, long ignored by reason of his presumed lack of structure, and see the late water-lily pictures as a prophecy of contemporary Color Field Painting. Because Impressionism, with its generalized distribution of small strokes, "is not broken by sharp differences of value or by more than a few incidents of drawing or design," Greenberg wrote, "color breathes from the canvas with an enveloping effect, which is intensified by the largeness itself of the picture." But the descendants of Monet and the Color Field painters could also find a mentor in John Cage, for while his theories may have worked primarily to minimize the intervention of the creative individual between art and life, they also called for a nonhierarchical, all-over relatedness of design and a serial-like repetitiousness of imagery, factors that could only encourage painters and sculptors intent upon realizing an ever-more purified and reductive form.

Altogether, it was this seemingly obsessive and common drive to wipe the slate clean of Expressionist overkill that produced the art of the 1960s, whether Pop or Post-Painterly Abstraction, to use Greenberg's own term for the new Color Field Painting. The Europeans characterized their version of the trend as arte povera. Yet, as Susan Sontag has written, these programs for the impoverishment of art were as much "strategies for improving the audience's experience" as they were simplistic rejections of media-induced acceptance by a mass public with an unslakable thirst for the latest sensation. "The notions of silence [as in Cage's music], emptiness, and reduction sketch out new prescriptions for looking, hearing, etc.-which either promote a more immediate sensuous experience of art or confront the artwork in a more conscious and conceptual way." Thus, a psychology of the tabula rasa combined with a more attentive perception of art's internal meanings to link the influential new literalism-evident in the work of Jasper Johns, with its clear legibility and its repertory of reconstituted bromidic imagery-to the audacious emptiness and concretion of the virtually blank or invisible canvases, the latter painted not only by Rothko, Newman, and Reinhardt but also by their Post-Painterly progeny working in color-stained or hard-edged, conceptually based modes.

Within her generation Helen Frankenthaler (1928—) was a pioneer, for while contemporaries like Joan Mitchell (Fig. 541) considered de Kooning's art the open gateway to the future, Frankenthaler found the path to new possibilities by taking a close look at

the stained canvases of Jackson Pollock, generally considered in the early 1950s to have exhausted the potential of his own radical art. Urged by Greenberg to try soaking liquefied pigment directly into raw, unprimed duck, she made her breakthrough in the historic painting of 1952 entitled Mountains and Sea (Fig. 576), a tentative work but prophetic in its lyrical, airy openness and thin, translucent colors, applied on canvas laid on the floor, rather than stretched on the wall, and worked in a stained manner to resolve, as Pollock had done, the inherent conflict between drawing and painting. By pouring and running thinned paint washes down the canvas, Frankenthaler blurred and transformed the directional energies and brushstrokes of Action Painting. The wandering edges of her forms were determined only by gravity and the drying process. Thus, color began to speak for itself, released from gesture and from romantic rhetoric of the "abstract sublime," thereby presenting the artist with a new set of formal alternatives.

A work such as Frankenthaler's *Movable Blue* (Fig. 577) is distinguishable by its monumental scale, mastery of color space, and sheer aesthetic presence. The manifest ease and confidence reflect a firm maturity, a product of the artist's having combined spontaneity of handling with unexpected chromatic oppositions and evidence of an effusive, lyrical temperament under control. Yet, even now, when the pigment surface had grown more opulent, her work continued to evince vague metaphors of sky and water. Having abandoned clearly defined shapes, which once recalled Matisse's large-scale cutouts, Frankenthaler cultivated her taste for looser edges and a much thicker color paste on the unprimed canvas. In pictures like *Movable Blue*, she often modulated the whole with a meandering line, a draftsmanly touch that resembles a fault or crevice on a rock face.

Frankenthaler's washes and stains, with their vibrant luminosity, led directly to Morris Louis's overlapped veils of translucent color and to the more cleanly structural emblem forms of Kenneth Noland. In the process of depersonalizing and codifying the Action painter's autographic and Expressionist brushstrokes, this significant trio of artists managed to create a new kind of color painting divorced from drawing, and injected new intellectual meanings into the art of their time.

By age and origin Morris Louis (1912–62) should claim a place in the pioneer generation of Pollock and Rothko, with whom he shared many formal characteristics. But his impact would be felt mainly in the late fifties or early sixties, and his patent anonymity of style and optical dynamics helped to release new energies among a younger group of artists. In his first mature work, produced in 1954, the Washington-based painter flowed thin films of acrylic pigment on unsized canvas to form faint, muted color shapes vaguely reminiscent of Action Painting, but less active and aggressive. The even consistency of these diaphanous shapes, their slowed velocities, and their relatively indeterminate flow paralyzed the urgent emotional-

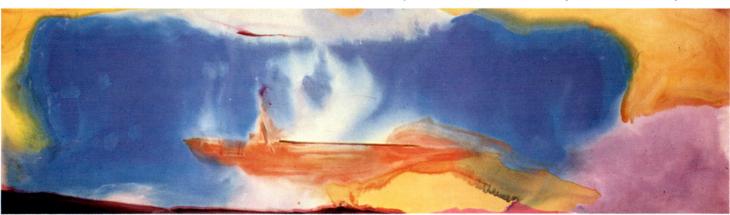

577. Helen Frankenthaler. Movable Blue. 1973. Acrylic on canvas, 5'10"×20'3". Courtesy André Emmerich Gallery, New York.

American Art of the Sixties: Pop Art and Minimalism

ism of Action Painting. Defining edges resulted from the natural process of drying rather than from any dynamic inflection of the hand. In the picture seen in Figure 578, transparent overlays of color give way to open and clearly differentiated ribbons of distinct hue and shape. In the Floral works (Fig. 579), individual color notes detach themselves with extraordinary limpidity and distinctness from a swarming melee of color forms. It is as if Louis had magnified and played back Pollock's splatter-and-splash technique in slow, disembodied motion, with a rare, new sense of reserve. His

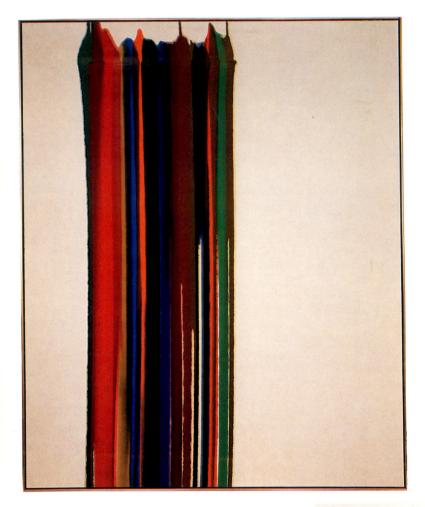

elegant tendrils of jeweled radiance no longer serve internal psychological pressures but set off a chain reaction of objective phenomena in which the artist's traditional sovereignty is minimized. Yet color gains a richer role as its energies are liberated from "handwriting," palpable texture, and emotional accent. In their simplicity, sensuous fullness, and boldness of scale, Louis's paintings belong to Abstract Expressionism, but their immaterial, optical emphasis and factual rather than existential view of the artistic process identify them with an emerging younger generation of objective tendency.

Kenneth Noland (1924-) sprang from the group of Washington, D.C., color painters headed by Morris Louis, but his targets, diagonal swaths of color, chevrons, and horizontal stripes (Fig. 580) all contributed to the formation of a more strict, formal art, despite its chromatic brilliance. As Alan Solomon noted: "By contrast, Noland's paintings, although they are just as deeply committed to pure color sensation, confront us with a certain toughness, a certain psychological complexity, which makes them much more than an untrammeled delight for the eye." Louis embraced accident as a natural occurrence beyond his control, allowing paint to have its way with him up to a point, in the interest of proliferating sensations whose individual notes and interminglings he relished with an almost extravagant symbolist delight. In Noland's more intellectuially demanding art, sumptuous attenuations of hues occur in a situation of ambivalence and answer to internal pressures for order. Further, the emblematic forms impose a tightly circumscribed yet fluid scheme, keeping our attention occupied in a problematic dualism of structure and chromatic elaboration. Noland insists that we stay hypnotically within the repeating circles, angles, or parallel stripes, and excludes associational subtleties. His determined formalism is relieved, however, by the soft luminosities of thinned plastic pigments, so that an alternating current is established between focus and dispersion, between concentration within a structural framework and the resonating expansion of color forms to the limits of their fields. The use of diluted pigment provided another variation on modes of dealing with the problem of movement on the flat modern painting surface. As paint sinks into the canvas weave more readily, its color saturation must be pitched higher to draw it forward and restore the necessary oscillation in depth.

Although Sam Francis (1923–94) studied in Paris after the war and developed under the influences of *l'art informal* (Figs. 514–516), he also achieved, as Frankenthaler did, a more open and lucid statement by adopting Pollock's technique of pouring liquid

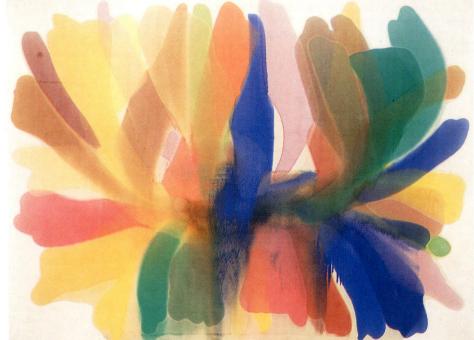

above: 578. Morris Louis. *Bellatrix.* 1961. Acrylic on canvas, 7'1³/4" x 5'10". Courtesy Diane Upright Fine Arts, New York.

right: 579. Morris Louis. Point of Tranquility. 1959–60. Magma on canvas, 8'5³/4" x 11'3³/4". Hirshhorn Museum and Sculpture Garden, Smithsonian Institution, Washington, D.C. Gift of Joseph H. Hirshhorn, 1966.

American Art of the Sixties

top: 580. Kenneth Noland. *Trans Flux*. 1963. Acrylic on canvas, 8'6"×13'8". Collection the artist.

right: 581. Sam Francis. Shining Black. 1958. Oil on canvas, 6'7%" × 4'5½". Solomon R. Guggenheim Museum, New York. paint directly onto raw canvas (Fig. 581). But for his massed and congested kidney shapes, relieved by the marginal activity of brilliant touches, Francis owed a debt to Clyfford Still.

An important feature of the new Color Field Painting was the progressive dematerialization of the art object. This appears to striking effect in the influential large spray paintings of Jules Olitski (1922-), which made their particular impact by diffusing the luminous effect of color so that both the rectangular boundaries of the frame and the material substance of the paint seem almost incidental to the perceived intensities of continuous optical sensation (Fig. 582). Successive spravings caused colors literally to dissolve into one another, producing a luminosity of unprecedented brilliance and a fluctuating, mistlike atmosphere that made Olitski's paintings seem the first totally abstract versions of Monet's late Impressionism. To hold his buoyant, evanescent hues-drawn mainly from a voluptuous palette of mauves, ochres, sunburst yellows, and dusky greens-to the shape of the canvas, from which they threatened to coalesce optically with the real atmosphere, Olitski began to structure the plane by drawing in the edges with flat, resonant chords of the colors used in the generalized mix.

Op Art

The shift in emphasis from the visible, material data of creative action to the perceptual experience itself legitimized a kind of witty, but near scientific, play upon the perceptual ambiguities created by purely optical devices exploited to shock and disrupt vision. An accomplished Post-Painterly artist whose canvases earned the name Op Art, during "The Responsive Eye" exhibition at the Museum of Modern Art in 1965, was Larry Poons (1937—). In his painting of that period (Fig. 583), Poons so disposed elliptical dots of one or more colors on saturated fields of a different hue that the light hallations emanating between figure and ground made the entire painted surface appear to jump with nervous afterimages. By the end of the sixties, however, Poons had moved into a more deliquescent, textural style, but even now he remains true to the visual experience of color.

A leading figure in the Op Art movement was Josef Albers (Figs. 431, 432), the great Bauhaus master who taught at Black

583. Larry Poons. Untitled. 1966. Acrylic on canvas, 12'10''×7'6''. Whitney Museum of American Art, New York.

582. Jules Olitski. Green Goes Around. 1967. Acrylic on canvas, 5'½"×7'5½". Collection Mr. and Mrs. Arnold Ginsburg, New York.

American Art of the Sixties: Pop Art and Minimalism

Mountain College until 1949, as well as at Harvard from 1938 to 1941, before moving to Yale in 1950. Through his many paintings entitled *Homage to the Square* Albers may have achieved the most substantial artistic results of anyone associated with Op Art, as well as the first unequivocal example of the "serial" composition in American art. Like Bach, Albers had a genius for stating and restating the same themes and variations, without exhausting their vitality or mercurial unpredictability.

Although Albers's influence as a teacher was considerable, only one of his students, Richard Anuszkiewicz (1930—), has seriously and profitably pursued his investigations of the "interaction of colors" and perceptual ambiguities (Fig. 584). Like many of his fellow Op artists in Europe (Figs. 626, 627), however, Anuszkiewicz created his startling effects by manipulating pattern and scale, for instance, in addition to color. Here, as elsewhere, such strategies depended for their success upon hard-edge, machine-like clarity in the definition of images and surfaces.

Hard-Edge Painting

The new regard for formal ordering and classical restraint that set in as a response to Action Painting also found an outlet in paintings whose almost mathematically calculated designs and immaculate surfaces made them known as Hard-Edge Painting. The first American painter to discover the power of pure, undetailed color and the **left: 584**. Richard Anuszkiewicz. *Temple of Golden Orange*. 1982. Acrylic on canvas, 7×6'. Courtesy Graham Gallery, New York.

above: 585. Ellsworth Kelly. Blue, Green, Yellow, Orange, Red. 1966. Acrylic on canvas, each of five panels 5×4'. Solomon R. Guggenheim Museum, New York.

below: 586. Ellsworth Kelly. *Blue Green*. 1968. Oil on canvas, 7'7" square. Private collection, New York.

shaped canvas may have been Ellsworth Kelly (1923-), who matured artistically in Paris, courtesy of the GI Bill, before joining the New York School in 1954. As early as 1952 Kelly had painted a series of joined vertical canvas panels in separate flat hues as prosaic and familiar as a horizontal commercial color chart, a theme first attempted by Marcel Duchamp in 1918 (Fig. 293) and then reworked by Kelly in 1966 (Fig. 585). Fascinated by the arch of a Paris bridge and its reflection in the water, Kelly made the first shaped canvas in 1953, fusing an empirical observation of nature with the Constructivist tradition. In later years, his flat swelling color shapes set within the rectangular format came forth scrupulously innocent of detail and surface irregularities that would betray any manual gesture (Fig. 586). As in the horizontal sequence of color panels, the effect, far from being mechanical, was to introduce a new kind of sensuousness into contemporary art, or what E. C. Goosen characterized as a "principle of abated tension."

A painter closely associated with Kelly since their student days in Paris is Jack Youngerman (1926—), who, too, has consistently worked with flat, uninflected shapes defined by vivid colors and hard edges (Fig. 587). But far from ruling those edges, he lets them flow along lazy, sensual paths clearly inspired by Matisse, whose late cut-out painted-paper compositions had a profound effect on American color abstraction in the 1960s.

In their shaped canvases, Kelly, Charles Hinman (1932—), and Frank Stella, among others, created a new hybridization of illusionistic pictorial space and the three-dimensional object (Fig. 588). The contoured or notched stretcher provides a literal emphasis on the physical properties of the canvas, while color planes act to elaborate a more traditional kind of pictorial metaphor. Hinman's elegantly poised and tipped boxlike volume of stretched and pinned canvas can be read both as suspended color plane and solid form, with cast shadows seen in perspective. The apparently uncomplex structure poses problems of identity, for we are compelled to understand it ambiguously as volume and flat plane. The reversal of conventional pictorial illusionism into a denotative object may be taken as a sign of the exhaustion of one kind of visual mode and its replacement by

below: 587. Jack Youngerman. Bahia. 1967. Acrylic on canvas, 8'3" square. Wichita Art Museum.

left: 588. Charles Hinman. Poltergeist. 1964. Synthetic polymer paint on canvas, mounted on wood armature; 8'2³/₄"×5'1⁷/₈"×16³/₈". Museum of Modern Art, New York. Larry Aldrich Foundation Fund.

a more structural one. Neither sculpture nor painting, it subtly fuses the two different rationales of expression.

Minimal Art

By the mid-sixties the simplifying spirit that arose in rebellion against Action Painting had grown so dominant and progressive that it produced what came to be known as Minimalism. Writing in *Arts Magazine* in January 1965, Richard Wollheim, a Professor of Logic at the University of London, may have provided the earliest postwar definition of Minimalism's underlying character:

If we survey the art situation of recent times, as it has come to take shape over, let us say, the last fifty years, we find that increasingly acceptance has been afforded to a class of objects that, though disparate in many ways—in looks, in intention, in moral impact—have also an identifiable feature or aspect in common. And this might be expressed by saying that they have a minimal art-content: in that either they are to an extreme degree undifferentiated in themselves and therefore possess a very low content of any kind, or else that the differentiation that they do exhibit, which may in some cases be very considerable, comes not from the artist but from a nonartistic source, like nature or the factory. Examples of the kind of thing I have in mind would be canvases by Reinhardt or (from the other end of the scale) certain combines by Rauschenberg or, better, the non-"assisted" ready-mades of Marcel Duchamp.

In keeping with the major trend of the period, therefore, the new term implied two concepts, decidedly different from one another but joined in a kind of obverse relationship. On the one hand, there had been the extreme and reductive formalism of the Post-Painterly abstractionists, who, as Clement Greenberg prescribed, sought to purify painting of everything but its most irreducibly essential properties. On the other hand, the urge to simplify had been voiced by John Cage and expressed by the Neo-Dadaist Pop artists as the use in high art of objects from low, everyday life with minimal or no modification imposed upon them by the artist. When initially absorbed into current usage, however, Minimalism stood for stripped-down form beyond anything seen before in the New York School, an "ABC Art," as Barbara Rose called it, "whose blank, neutral, mechanical impersonality contrasts so violently with the romantic, biographical Abstract Expressionist style which preceded it that spectators are chilled by its apparent lack of feeling or content." According to Rose, the new abstraction deliberately abrogated the traditional requirements of uniqueness, emotional or expressive content, and complexity. Typically, Minimal works, whether painting or sculpture, avoid the virtual qualities of illusionism and conform to the holistic, or nonrelational, form pioneered in American art by Pollock and Newman to make a unified total impression that negates all ambiguity. Because of the singleness of the image or configuration usually presented in Minimal painting, the critic Lawrence Alloway coined the term "Systemic Art" to designate such work.

Perhaps the most decisive impulse in creating a new, Minimalist kind of literal painting-object came from Frank Stella (1936—). Beginning with his black "pinstripe" canvases of 1959–60 (Fig. 589), and continuing through his protractor patterns of segmented arcs in vivid acrylic color, Stella managed to reverse the role of geometry and of Bauhaus design principles in contemporary art. With his symmetrical repeating grids and uniform or coded color bands, he neutralized ideas of structural development and hierarchical order. In their place emerged a more unified impression of the entire canvas shape as a single image—a gestalt—which supplanted the outworn compositional devices of conventional geometric abstraction. By extinguishing pictorial variety, development, and climax, Stella in his early work opened up new expressive possibilities, which helped force a fundamental change in artistic outlook. Stella's

series paintings and permutations of Vs, parallelograms, rhomboids, hexagons, and circle fragments constantly de-emphasized traditional composition by repetition and standardization of shape, thus transferring emphasis to the holistic experience of the painting as a single object (Fig. 590). The particular kinds of opacities and redundancies have actually generated, as we shall see in later chapters (Figs. 678, 766), a gloriously self-fulfilling and ever-expanding new art, for Stella has indeed proved to be one of the most prodigiously inventive talents to appear in Western art during the second half of the 20th century.

above left: 589. Frank Stella. "Die Fahne Hoch!" 1959. Enamel on canvas, 10'1" × 6'1". Whitney Museum of American Art, New York.

above: 590.

Frank Stella. Hagmatana I. 1967. Fluorescent acrylic on canvas, 12×15'. Private collection, New York. Courtesy Leo Castelli Gallery, New York.

591. Agnes Martin. White Stone. 1965. Oil on canvas, 5'10" square. Courtesy Robert Elkon Gallery, New York.

The long and distinguished career of Agnes Martin (1912-) climaxed with the Minimalist mode of the 1960s, when she produced a highly refined perceptual art utilizing grids and simple visual systems (Fig. 591). However, Martin was never more than superficially concerned with activating the kind of retinal games that lay at the heart of Op Art. Her bent seemed more towards Constructivism, but without its narrow ideological program. An explanation of the profound influence of her work may be the gift Martin demonstrated for resolving contradictory interests. At her most characteristic, she based her paintings on geometric structure, or parallel color bands, doing so in a way to acknowledge the surface in its material limits. Yet her form dematerializes into a visual field, a new presence of light. The ability to balance the sense that the picture is no more than its physical attributes against the contrary implication that it has a subliminal spiritual life undoubtedly accounts for Martin's importance in the minds of admiring contemporaries.

Among the outstanding Minimalists engaged by the same pictorial contradictions as those that Agnes Martin's paintings so elegantly straddle are Robert Ryman, Brice Marden, Robert Mangold, and Dorothea Rockburne. Like other leading figures of his generation, Robert Ryman (1930-) has worked on such unconventional surfaces as steel and aluminum and used acrylics, matte enamel, and other materials to emphasize the importance of tangible surface (Fig. 592). His keen awareness of medium, support-whether metal, paper, or canvas-and brushstroke, and his consistent use of monochromes, usually white, reflect a new and fruitful preoccupation with the given physical conditions and internal syntax of painting. The result is an oeuvre that at first sight may look programmed and ideological in the austerity of its controlling ideas, yet manages to emerge as a highly nuanced and optically rewarding exercise in sensibility. In recent years Ryman has expanded his scale and tested environmental spaces with thinly painted wall-like surfaces that stand physically away from the actual gallery walls. Their scale is heroic, and thus difficult to encompass as a single visual field within a confined viewing space. At the same time, works such as the one seen here establish important, if elementary, distinctions between art-making activity and dumb objects, art as an expansive environmental cliché and its creator's stubbornly intact sense of the painting as a rare and integral image.

Brice Marden (1938—) also accepted the condition of flatness of the canvas support and surface as a physical reality, on which he worked in a medium of wax and oil in muted colors, usually close to asphalt and putty in hue. Since his stretchers were massive in depth and stroked with visible, brushy paint built up to a palpable materiality, the effect located the picture plane off the wall, as a mural surface in its own right. Later, using primary colors in equalsized, stacked, and parallel rectangles, Marden abandoned his somber tones for a more chromatic scale (Fig. 593). His independent and formally rigorous, yet intuitive, drawings of ambiguous spatial grids can usually be sensed as subtly integrated into his painting concepts and procedures. And this remained true even in the 1990s, after Marden, as we shall see in the Cold Mountain series, made a startling yet philosophically consistent modification in both his style and his process (Fig. 780).

Robert Mangold (1937—) became known for his tinted, shiny composition boards in eccentric shapes with ruled, subdivided interior circle segments, the overall impact of which was to give the picture plane the mirror-like opaqueness and finish of industrial

above: 592. Robert Ryman. *Classico III.* 1968. Polymer on paper, 7'11" x 7'5". Stedelijk Museum, Amsterdam.

left: 593. Brice Marden. *Elements III.* 1983–84. Oil on canvas, 7x 3'. Courtesy PaceWildenstein, New York.

products (Fig. 594). Yet the experience of his work is subtle, more in the way of the art created by Martin or Marden than a commercial plastic artifact. Like the work of all the Minimalist painters seen here, Mangold's requires intense mental concentration on the part of the spectator and yields a slow and prolonged revelation. He paints on board with a spray gun and roller, always in monochrome. In whatever color key, this artist maintains the same objective of establishing a delicate equilibrium between atmospheric color space and his sense of art as a depersonalized, architectural structure.

In her drawings and paper folds, Dorothea Rockburne formerly created an intricate interplay of mathematical concepts and permutations of "set theory" ideas. Her art was both cerebral and sensuous in the care with which she manipulated her surfaces. It was based, as she explained, on "making parts that form units that go together to make larger units." Eventually, Rockburne took advantage of the textured surface of raw linen and utilized a natural brown hue to create a dramatic presence as a shaped canvas (Fig. 595). The subdileft: 594. Robert Mangold. One-half Gray-Green Curved Area. 1967. Oil on canvas, 4"×8". Collection Phil Schrager, Omaha.

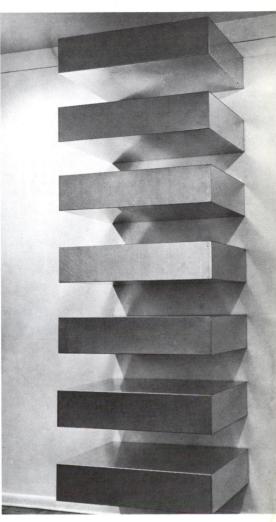

vided, prismatic sections often recall Mangold's geometric art. Any sense of color and haptic surface as a source of aesthetic pleasure is repudiated, however, as an accidental feature in an exceedingly severe program. Rockburne's work brilliantly and delicately balances perceptual pleasure and logical structure in modified threedimensional objects that aggressively intrude upon our own space.

left: 595.

right: 596. Donald Judd. Untitled. 1965. Galvanized iron, 11'3" high. Collection Henry Geldzahler, New York.

Dorothea Rockburne. Levelling. 1970. Oil on paper and chipboard, 6' × 6'111½". Collection the artist.

Minimal Art assumed its most monumental, and probably most significant, form in the work of sculptors. For younger artists in the late 1960s, a time of war and protest, sculpture seemed a more compelling alternative than painting, because of its greater reality, its inescapably literal, object quality. Owing to a manifest taste for such simplified geometries as regular polyhedrons and the frequent use of industrially fabricated elements, the pieces produced by Minimalist sculptors have often been called "Primary Structures" or "Primary Forms." "Serial," as well as "Systemic," is another operative term in this domain, for the reason that essential forms and industrial procedures lend themselves to uniform units or objects, such as bricks, cement blocks, or ceramic magnets, capable of being assembled in accordance with a strict modular principle. It was a principle frequently employed to spectacular, and sometimes scandalous, effect by Minimalist sculptors.

The best early rationale for Minimalism, with its rejection of pictorial illusionism and its trust in real space, came from a leading exponent, Donald Judd (1928–94), known for his standardized,

American Art of the Sixties: Pop Art and Minimalism

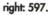

Tony Smith. *Cigarette*. 1961–66. Pianted steel, 15'1"×25'6"×18'7". Museum of Modern Art, New York. Mrs. Simon Guggenheim Fund.

below: 598.

Robert Morris. Untitled. 1965. Gray fiberglass, 16×2×1'. Collection Count Panza di Biumo. Courtesy Leo Castelli Gallery, New York.

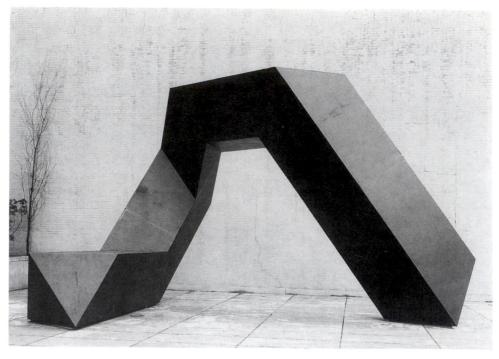

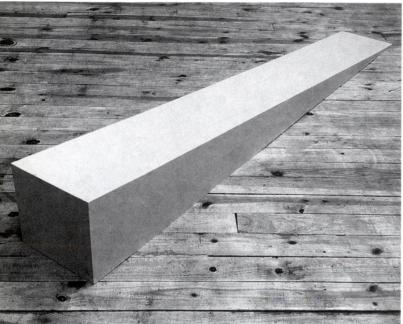

repeated, boxy galvanized iron and aluminum permutations in colorful motorcycle paint (Fig. 596). In the early 1960s Judd published prescient art criticism in which he pinpointed the aesthetic issues involved. Describing his own practice, he wrote in 1965:

Three dimensions are real space. That gets rid of the problem of illusionism and of lateral space, space in and around marks and colors which is riddance of one of the most salient and most objectionable relics of European art. . . . Actual space is intrinsically more powerful and specific than paint on a flat surface.

By the mid-sixties Judd was fabricating metal forms—"Specific Objects, " as he called them —of blocky, unitary character or in modular, repetitive serial schemes such as the one seen here, reflecting, to some degree, the influential anti-Cubist compositions of Frank Stella (Figs. 589, 590). Although Judd often employed neutral, unadorned industrial surfaces, in later years he experimented with a new kind of sensuousness based on fluorescent commercial colors. The asceticism of these elementary box-

like forms was countered by the play of colored surfaces as Judd continued to investigate a wide range of expressive possibilities in new industrial materials and techniques.

Perhaps the most important pioneer of the new sensibility was Tony Smith (1912-80), a member in good standing of the Abstract Expressionist community, although best known in his early years as a visionary architect and occasional painter. Smith did not make his first modular steel sculptures until 1962, but their impassive physical bulk and intense romantic presence almost instantly erased the frivolous illusionism of the recent sculpture and decisively established new directions for three-dimensional construction (Fig. 597). He evolved a sculptural program based on a rather complicated organic geometry, derived from many sources, including Frank Lloyd Wright, an interest in topology and crystallography, in the language inventions and puns of James Joyce, and some novel ideas about architectural sculpture. Smith wished to create new monuments that could coexist with such modern landmarks as massive oil tanks, smokestacks, airport runways, parking lots, and other constructions on a vast scale in the industrial landscape.

In the sixties Tony Smith and other Minimalist sculptors began to execute commissions for public sculpture, taking advantage of opportunities available from such skilled fabricators as Lippincott in North Haven, Connecticut. The resulting forms—colossal, invariably geometric, and reductive—created a new, often popular, but sometimes extremely controversial tradition of outdoor or "site" sculpture. During the last thirty-five years, communities and corporations throughout the United States have acquired heroic-size works for civic and commercial plazas designed by abstract artists and fabricated industrially (Figs. 470, 712). Set on the ground, these immense pieces are largely self-referential and yet invite intimacy with the circulating, viewing public.

Robert Morris (1931—), another leading Minimalist, took a relentlessly cerebral approach to three-dimensional form. By the mid-1960s Morris was working in geometric structures devoid of detail and obsessive in their emphasis on wholeness of vision, but he also showed a sense of irony, a chess-player's cunning, closer in spirit to Marcel Duchamp than to the formal purist. His first one-man show in New York (1963) consisted of lead and Sculpmetal reliefs with imagery clearly referring to Duchamp and Johns. Soon thereafter Morris also exhibited bland geometric forms in gray fiber-

American Art of the Sixties: Pop Art and Minimalism

below: 599. Larry Bell. Untitled. 1969. Vacuum-plated, mineral-coated glass with metal binding; 20" cube. Courtesy Pace Gallery, New York.

bottom: 600. Robert Irwin. *Untitled*. 1968. Acrylic on cast acrylic, 4'6" diameter. Fort Worth Art Museum.

right: 601. Dan Flavin. A Primary Structure. 1964. Red, yellow, and blue fluorescent light; $2 \times 4'$. Collection the artist.

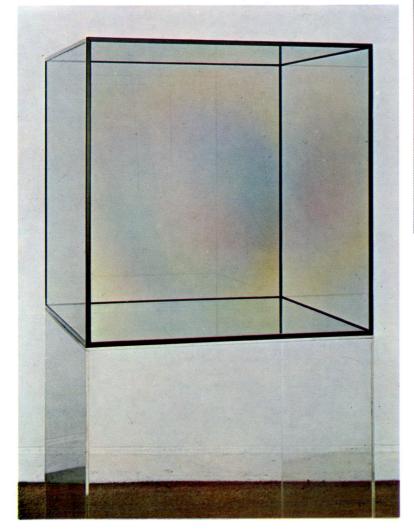

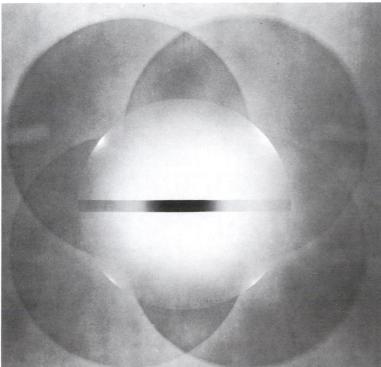

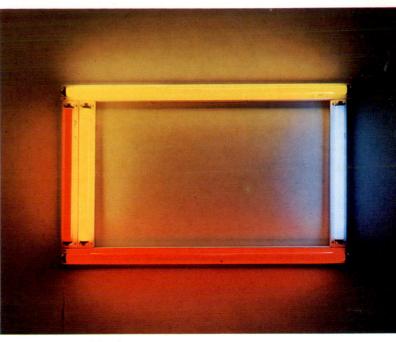

glass (Fig. 598) that reflected the paradoxical mental processes of the composer John Cage, a friend of the artist's who, as we have seen, probably influenced the striking shift in visual aesthetics as much as any single figure. At this time, Cage summarized the Minimalist inspiration and its ironic vacuous effects with the aphorism: "I have nothing to say, and I am saying it." After 1965 Morris adopted a more eclectic approach but remained unfailingly innovative in his modular sculpture, experiments with soft materials and random pilings of "antiform" and Process Art (Fig. 699), Earth or Land Art, steam environments, and other brilliantly original and daring projects in ecology, communications, and information systems.

It soon became quite evident that the new Minimalism had engaged the most forceful rising talents. Exciting possibilities of invention were dramatically opened up, among them the precious refinement of the more intimately scaled transparent boxes in fragile, coated optical glass (Fig. 599) by the West Coast artist Larry Bell (1938—). Robert Irwin (1929—) composed large, subtly curved disks set off the wall, whose overlapped shadows create an illusion of immaterial phenomena (Fig. 600). These evanescent shapes, spotlit at an angle, make a quatrefoil of shadows suspended between the contoured disk, the wall, and the observer's eye. Subsequently, Irwin went on to work with scrims of fine white rope and cheesecloth mounted in galleries, creating in those spaces an environmental field and new presence of contained light. Irwin may have been the most influential individual figure in Los Angeles art throughout the late sixties and the seventies.

Dan Flavin (1933–96), in his first one-man show in New York (1964), found a new and surprising use for commercial fluorescent light tubing. He proceeded to arrange his tubes in the gallery as if they were in his studio. In explanation, he wrote: "I knew that the actual space of a room could be broken down and played with by planting illusions of real light (electric light) at crucial junctures in the room's composition." Flavin envisaged each of his succeeding exhibitions as a total ensemble and the exhibition space as an entity within which his fluorescent tubes, often radiating an austere white light but sometimes glowing with subtle color, created luminous zones related to each other and to the overall containment of the room (Fig. 601). The meditative and chaste quality of his lights set Flavin apart from the more sensational manipulators of pulsating light environments in a period dominated by the faddist interest in

American Art of the Sixties: Pop Art and Minimalism

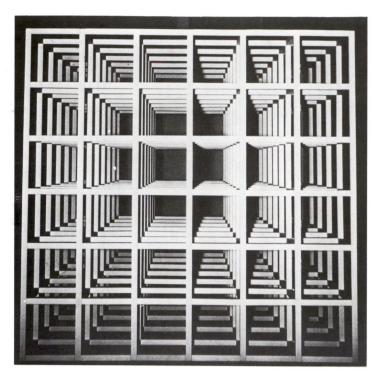

American Art of the Sixties: Pop Art and Minimalism

left: 602. Sol LeWitt. *Untitled*. 1966. Baked enamel and aluminum, 5' cube. Courtesy John Weber Gallery, New York.

below: 603. Len Lye. Fountain II. 1959. Steel, motorized; 7'5" high. Collection Howard Wise, New York.

bottom left: 604. George Rickey. Two Lines Oblique. 1967–68. Stainless steel, 25' high. Collection the artist.

eye-popping intermedia shows. The artist's cleverly wrought intellectual propositions, acerbic wit, and sense of dedication to a highly principled art form were rivaled only by Ad Reinhardt's previous example of stern integrity (Fig. 502). Flavin's speculative concerns were close to the theoretical interests of Morris, Judd, and Carl Andre, and their sculpture paralleled his own in providing a framework of new artistic practices and attitudes.

A straw in the wind blowing toward the Conceptualist future came in the art of Sol LeWitt (1928-), whose open-frame, glassless, multicompartmental structures of baked enamel on aluminum grids made him an authentic Minimalist, while also providing one of the most fascinating developments in serialism (Fig. 602). Purely Euclidean in their geometric order, LeWitt's cages are salient examples of Primary Structures, but skeletalized, rather than represented as physical mass, by their structural beams. Clearly, the controlling factor in this sculpture had become its conceptual, not is material, dimension. Indeed, LeWitt spoke of idea as "the machine that makes the work." The artist's aim, he wrote, is "not to instruct the viewer, but to give him information. Whether the viewer understands this information is incidental to the artist. ... He would follow his predetermined premise to its conclusion, avoiding subjectivity. Chance, taste, or unconsciously remembered forms would play no part in the outcome. The serial artist does not attempt to produce a beautiful or mysterious object but functions merely as a clerk cataloguing the results of his premise." And the work seen here would be difficult to improve upon as an instance of the serial or modular principle,

which, unlike the traditional way of making art from adjustable, differentiated parts, permits the construction of a finished work whose precise nature is known beforehand.

Tie-ins with industry or technology and progressive simplification made Minimal Art a close cousin to a variety of sixties Constructivism concerned with motion and, more than anything seen thus far, with light. The first symptom of this trend appeared with Op Art (Figs. 583, 584), the antecedents of which were to be found in Constructivist and kinetic traditions remote from the more subjective character of postwar American art, despite the presence in the United States of Josef Albers, one of the inventors of perceptual aesthetics. But however brief its moment of glory, Op Art played a catalytic role, leading to new forms of collaboration with industry in esoteric technological form, and establishing new connections between optical and kinetic phenomena and art on the environmental scale encouraged by the Minimalists' Primary Structures.

New Zealand-born Len Lye (1901–80) may have been the most remarkable of the numerous motion sculptors who activated material forms with a movement so rapid that they created an optical imagery and the effect of disembodied energies. His "tangible motion sculptures" were, in effect, programmed machines constructed of exquisitely fine stainless-steel components (Fig. 603). In motion, they created tongues of light and images of flickering radiance. In a kindred spirit, George Rickey (1907—) has constructed on a large scale attenuated stainless-steel blade forms, eggbeater "space churns," and pairs and quartets of rectangular, uniform volumes that are driven gently, slowly, by air currents, but all their reflective, burnished surfaces also appear to melt away in motion (Fig. 604). The sense of weightlessness derives from Rickey's admirable mastery of monumental scale, light play, and rhythmic movement.

Since light is pure energy, the history of its involvement with kinetic art goes back at least to Moholy-Nagy's *Light-Space Modulator* of 1921–30 (Fig. 434). However, the pioneer light artist was Thomas Wilfred (1889–1968), who, starting in 1905 "with a cigar box, a small incandescent lamp, and some pieces of glass," developed a large-scale, totally abstract, and new artistic medium, independent of music, that yielded flowing, variegated light compositions that the artist called "Lumia." For some time his innovative *Lumia Suite* played at New York's Museum of Modern Art and, while producing mildly euphoric "light ballets," anticipated the optical experiments and the "psychedelic" art of the 1960s. However, it took a combination of McLuhanism and the new cult of technology—which included the interest in the retinal dynamics of Op Art—to create the necessary climate in America for widespread explorations of light media.

Even earlier than Flavin, Chryssa (1933—) became the first American artist to use emitted electric light and neon, rather than projected or screened light. Her imagery was also unique since its sources were the lettered commercial signs of the urban environment, especially her preferred subjects—the neon signs of Times Square. Chryssa created her best-known series using delicate neon variations on the letters W and A and the ampersand, aligned in refulgent, parallel banks (Fig. 605). The fuguelike effect of the let-

above: 605. Chryssa. Ampersand III. 1965. Neon lights in plexiglas, 30¼″ high. Harry N. Abrams Family Collection, New York.

below: 606. Ernest Trova. Falling Man (Carman). 1966. Polished silicone bronze and enamel, 72 × 28 × 20". Courtesy Pace Gallery, New York.

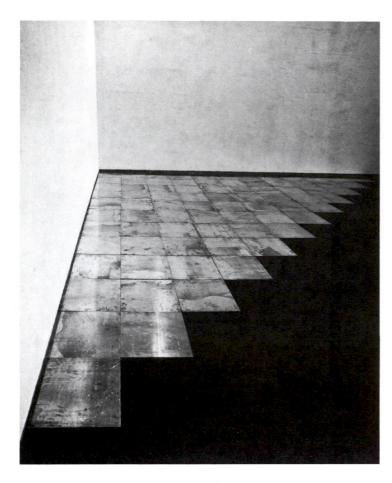

ters produces resonating light impulses that seem to oscillate, although the "kineticism" occurs only in the eye of the beholder.

Another well-known sixties sculptor associated with technology was Ernest Trova (1927—), whose hybrid, "minimalized" figures cast in gleaming metal and mounted on esoteric apparatuses may have been the most notable contemporary examples of spaceage imagery, transcending even the cold perfection of Detroit aesthetics (Fig. 606).

As the pieces by Chryssa and Trova suggest, Minimalism, like all climactic moments in human achievement, had within it the seeds of its own destruction. The reappearance of Pop subject matter, derived from the world at large, within an overriding formalist, if not purely Minimalist, context betrayed an emerging dissatisfac**607.** Carl Andre. *Twelfth Copper Corner*. 1975. Copper, 78 plates each 19½" square. Courtesy Sperone Westwater Fischer Gallery, New York.

tion with what the 1970s and 80s would come to view as Minimalism's "aesthetics of boredom." One of the new directions this generated can be found in the work of Carl Andre (1935—). When this Minimalist laid down his 34 feet of unattached firebricks on the floor of the Jewish Museum during the "Primary Structures" exhibition, or, in 1968, a much longer row of 184 bales of hay extending 500 feet across an open field, he was elaborating the idea of site as sculpture, an idea that had already been explored by Morris and Flavin. In such projects as these Andre arrived at a new spatial concept (Fig. 607). Adopting an admirably condensed and characteristically oracular statement, he described his indifference to materials as such and to their potential for aesthetic development in traditional terms:

The course of development Sculpture as form Sculpture as structure Sculpture as place

Horizontal orientation offered Andre a vastly increased opportunity for spatial extension. "The ideal piece of sculpture is a road," he declared when he began to use the gallery floor as the plane for not only bricks but also logs, Styrofoam bars, magnets, metal squares, and "scatter pieces" of old nails. Such ordinary materials laid on the floor served to democratize art, to level and humble the traditional vertical, anthropomorphic view of sculpture. When artists later moved into the landscape literally with Earth Works, the same philosophy would guide their sense of enlarged scale and their essentially bird's-eye viewpoint. Composing brute, non-art materials in checkerboard patterns of metal squares like rugs, Andre destroyed any possible identification of his flattened, ground-hugging art with pedestal sculpture and with the dimensions and posture of a standing person. Instead, he forced the viewer into a new relationship with sculptural form, including thermal and bodily sensations produced by walking over plates of aluminum, copper, steel, lead, or zinc, whose different conductive qualities were discernible even through the soles of one's shoes. As James Monte noted in the catalogue to the Whitney Museum's "Anti-Illusion: Procedures/Materials" show (1969), "the act of conceiving and placing . . . pieces [like Andre's] takes precedence over the object quality of the works." By this time, the Conceptual Art to be reviewed in Chapter 22 had already come into being.

Europe's New Realism, Pop Art, and Abstraction

willingness to settle for tasteful refinements and traditionalist revivals increasingly came to dominate postwar European painting and sculpture as artists progressively assimilated the tachiste and renascent figurative tendencies. By the mid-1950s l'art informel had clearly exhausted its vitality and sunk into an agreeable but unchallenging set of stylistic mannerisms. A second postwar generation then came forward to claim its liberation with art forms based on Neo-Dadaism and strongly related to the material surfaces of contemporary life. The idea of establishing some parity in painting between representation and object qualities had been implicit in Jackson Pollock's freewheeling abstractions (Fig. 493), which incorporated sand, old pigment tubes, and other debris in the pictorial surface, as did also the organic collages of Dubuffet (Fig. 529), Burri's burlap and paint arrangements (Fig. 518), and the collage process that Willem de Kooning adopted to arrive at his famous Woman series (Fig. 488). Younger artists began to appropriate actual objects taken from daily life in constructions, tableaux, and environments-attaching them physically to their painting and sculpture, the better to create dislocating shifts of identity between actual objects and their constructed or painted simulacra. This was the period when discards from the industrial junk heap, random accumulation of commonplace commercial products, and the theatrical Happening, which utilized object fragments in a performance situation (Fig. 575), gained favor as the basis of a new environmental art.

The New Realism

In Europe the trend was called le nouveau réalisme, after the movement founded by the French critic Pierre Restany in conjunction with the artist Yves Klein (1928-62) and others. "New Realism," which held its first show in Milan in 1960, had been anticipated by Klein's monochrome paintings (Fig. 608), his outrageous promotional methods, and a sensational exhibition, called simply le Vide, two years earlier at a Paris art gallery (Fig. 673). Dedicated to the antimaterialist, Rosicrucian theme of emptiness, "The Void" consisted of nothing more than the white-washed gallery stripped bare of all art works, a member in full regalia of the French Garde Républicaine stationed at the door, the artist, and spectators drinking blue cocktails, the color itself an emblem of the world dematerialized into pure spirit. Klein displayed his interest in modern technology and urbanist ideas when he and Jean Tinguely (Figs. 610, 611) collaborated on motion sculpture in another 1958 exhibition where Tinguely's kinetic machines spun monochrome blue disks at different speeds. Unlike his New Realist associates, Klein placed far more importance on gesture and his own symbolic actions, using such unorthodox methods of producing works of art as a flamethrower, or rain, and directing a troupe of twenty musicians who

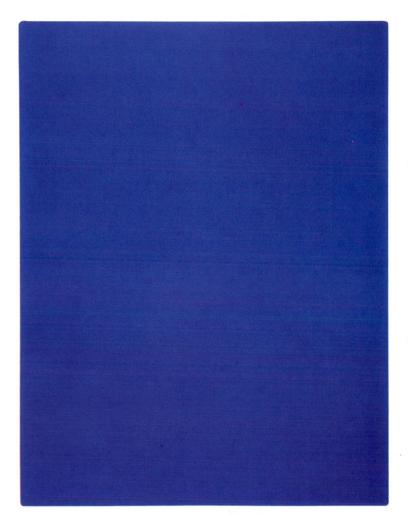

608. Yves Klein. *Blue Monochrome (IKB 42).* 1960. Dry pigment in synthetic resin on fabric on board, 6'6'1/4" x 5''1/4" x 1". The Menil Collection, Houston.

played the artist's one-note *Monotone Symphony* while naked girls smeared in blue paint—patented IKB, or "International Klein Blue," so intense that it seemed to contain phosphorous—rolled about on canvases laid over the floor (Fig. 609). A sequence from this spectacular 1960 event, so far ahead of its time, was recorded for the film *Mondo Cane*. Klein appeared to hark back to Kandinsky, not only in his preference for blue but also in his conception of pure color abstraction as a means of endowing art with metaphysical import. "And without doubt," he wrote, "it is through color that I have little by little become acquainted with the immaterial."

The motorized junk sculptures of Swiss-born Jean Tinguely (1925–91) were more obviously inspired by urban life, like New Realist art in general, and also more given to social critique (Fig. 610). In 1958 Tinguely made what he called a Meta-matic, a ramshackle machine that literally produced on sheets of paper, at the press of the activating button, automated *tachiste* paintings, or Action Painting, replicating recent contemporary work by Hartung, Mathieu, and Pollock (Figs. 514, 516). These visual parodies effectively closed out the epoch of Abstract Expressionist painting, with its romantic view of the creative process. Having thus illustrated his conviction that a work of art is not something absolute, but creative and continuous within the possibilities conferred upon it, Tinguely went on with a kind of mad logic to construct a machine designed to destroy itself, thereby transforming kinetic art into performance art. Homage to New York (Fig. 611), built in the sculpture garden of New York's Museum of Modern Art, failed to self-destruct as programmed, but rather by catching fire. Still, it caused a sensation great enough to get the artist's point across. With his poetic sensibility, his witty, even sublime love of the ridiculous, and his astonishing mastery of form, Tinguely seems as much akin to Kurt Schwitters as to the American junk sculptors (Figs. 561–564). If the Meta-matic helped shatter the pretensions of Action Painting, the example seen in Figure 610 took aim at the next generation, not only Op and Pop Art but also kinetic sculpture itself (Figs. 603, 604).

Similarly, Arman (1928—), born in Nice as Klein was, created random accumulations of object fragments, which imitated the finesse and touch of Abstract Expressionist form, but without denying the insistent object status of his materials (Fig. 612).

The aesthetic devices and theoretical speculations of the New Realists coincided with the exacting and relentless descriptions of objects and physical environment, at the expense of a psychology of human motivation, in the new French novels (*nouveaux romans*) of the late 1950s and early 1960s. "The importance of objects, especially artifacts, in the recent films of Resnais and Antonioni," a New

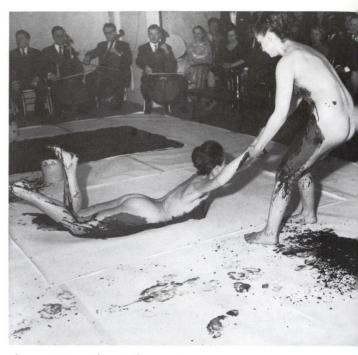

above: 609. Yves Klein. Anthropometries of the Blue Period. Paris, March 9, 1960. Photo © Harry Shunk, New York.

below left: 610. Jean Tinguely. *Pop. Hop. and Op & Co.* 1965. Painted steel, toys, feathers, etc., with motor; $3'7'_{4''} \times 6'10^{5}/_{8''}$. Courtesy the artist.

below right: 611. Jean Tinguely. *Homage to New York.* 1960. Mixed media, motorized. Created for the Sculpture Garden of the Museum of Modern Art, New York.

York critic noted in a 1962 exhibition review, matched the emphatic materialism of both Pop Art and New Realism.

Perhaps the *reductio ad absurdum* of the New Realist object assimilations occurred in 1962 when the Bulgarian artist Christo (1935—) blocked the Rue Visconti in Paris with oil drums, turning the art of assemblage into an environmental experience on a grand scale, and a disorienting one at that (Fig. 613). Four years earlier in Paris, he had begun to make small-scale "packages" and to wrap objects, using a technique that mysteriously concealed but also revealed the salient shapes of forms covered by progressively larger expanses of fabric and plastic materials. Settling in New York in 1954, Christo initiated his proposals for wrapping Manhattan skyscrapers. Finally in 1968 he wrapped the Kunsthalle in Bern, Switzerland, using 27,000 square feet of reinforced polyethylene tied with nylon rope, the first of his large realized

far left: 612. Arman. *Helices.* 1968. Metal propellers in polyester and Plexiglas, 6'3" x 4' x 2' overall. Courtesy Marisa del Re Gallery, New York.

left: 613. Christo. Wall of Oil Barrels-Iron Curtain, Rue Visconti, Paris. June 27, 1962. 240 stacked oil barrels, 14' x 13' x 5'6". Photo by Jean-Dominique Lajoudx. © Christo 1962.

below: 614. Christo. Packaged Kunsthalle. 1968. Bern, Switzerland. 27,000 square feet of synthetic fabric tied with

10,000 feet of rope. © Christo 1968. **bottom: 615.** Jacques de la Villeglé. *Rue du Grenier Saint-Lazare*. 1967. Torn posters on canvas, 23 x 201/2[']. Courtesy Zabriskie Gallery, New York.

environmental schemes (Fig. 614). Christo has regularly produced large-scale land- or urbanscape *empaquetages* ever since (Fig. 714), based on his early association in Paris with the New Realist group, and all prepared by superb drawings, the sale of which helps finance the colossal undertakings.

Rather than objects, Raymond Hains and Jacques de la Villeglé (1926-) in Paris and Mimmo Rotella in Milan-all associated with New Realism-appropriated wall posters, especially those pasted one over the other and attacked, by vandals as well as by weather, until so pealed and shredded that odd bits of all the layers showed through (Fig. 615). Carefully detaching the found collage from its public site, the affichistes ("poster artists") thereupon invented a kind of décollage. To complete the piece, they not only mounted it on canvas but also distressed the salvaged sheets still further, finally producing a Pop variant of Cubist fragmentation as flat, grandly sealed, and dynamically "all-over" as an Abstract Expressionist painting. For Villeglé, the palimpsest of interpenetrated but crazily disassociated imagerymovie promos, soap ads, political statements-seemed less chaotic or inarticulate than a manifestation of postwar society's collective unconscious.

Europe's New Realism, Pop Art, and Abstraction

Europe's Pop Art

Though already seen here in its American version, Pop Art actually began in England in the 1950s as an involvement with popular culture, almost a decade before it was associated with a distinctive artistic style or method. It originally grew out of discussions and exhibitions held at the Institute of Contemporary Art in London by a number of artists, critics, and architects who called themselves the Independent Group. By the winter of 1954-55 the word "pop" was in current use in relation to popular culture, according to one leading member of the IG, the art critic Lawrence Alloway. The group included Eduardo Paolozzi (Fig. 535), Richard Hamilton, and the architectural and cultural historian Reyner Banham. Urban folklore-popular culture and its visual embodiment in advertising imagery and signs-became the obsession of the group. In 1956 they held an exhibition at the Whitechapel Art Gallery in London called "This Is Tomorrow," which showed a series of contemporary environments developed from photographs of architecture and the vernacular imagery of the advertising world. Richard Hamilton (1922—) contributed a small collage that later became justly famous as the Pop Art forerunner (Fig. 616), although it was actually unknown in America by the Pop artists, who arrived at their styles independently either in the mid-fifties or in the early sixties. The collage picture was entitled Just what is it that makes today's homes so different, so appealing?, and it showed a modern interior occupied by a pin-up girl wearing only a lampshade-hat and a muscle-man holding a large lollypop with the word POP inscribed on it in bold letters. Crammed with the icons of the consumer world-tape recorder, canned ham, television, comic-book cover, Ford advertisement, vacuum cleaner-and giving a view through

below: 617. David Hockney. The Splash (detail). 1966.
Acrylic on canvas, 6' square. Private collection.
right: 618. Allen Jones. Holding Power. 1974.
Oil on canvas, 8×4'. Courtesy Marlborough Gallery, London.

above: 616. Richard Hamilton. Just what is it that makes today's homes so different, so appealing? 1956. Collage, $10^{1}/_{2} \times 9^{3}/_{4}$ ". Kunsthalle, Tübingen.

the window onto a movie marquee touting Al Jolson in *The Jazz Singer*, the apartment reflects postwar Britain's nostalgic admiration for American material prosperity and technological progress, a subject long before glorified by way of parody in the works of Duchamp, Picabia, and Schamberg (Figs. 288, 295, 296). Unlike these Dadaist forebears, however, Hamilton and his fellow Pop artists, for all their radical departures, despised neither tradition nor modern vulgarity, and, far from being anti-art, they had a consuming interest in problems of a purely pictorial nature, and to what extent a symbol can be reduced without loss of informational value. In the end it was, as we have seen, just such concerns that would prevail over the more sociological interests of the Pop movement.

The profound change in artistic values wrought by Pop Art became clear in a statement that Hamilton made to the architects Alison and Peter Smithson the following year. He irreverently listed the desirable qualities for a new art as "popularity, transience, expendability, wit, sexiness, gimmickry and glamor."3 Parenthetically, Hamilton urged in the letter that Pop Art be low-cost, designed for a mass audience, aimed at youth, and emulate "Big Business." It should be noted that the artist was not alluding to an existing body of painting, for Pop Art as we know it had not yet crystallized. He was merely describing its source material, with the same uncanny prescience shown by Marshall McLuhan in 1951 when he analyzed the hidden symbolism of advertising messages, verbal and visual, in his first brilliant book on popular culture, The Mechanical Bride. The English Pop artists themselves began to emerge in significant styles only in the early 1960s, coincident with those all-time most popular of media figures, the Beatles.

Among the most captivating in dealing with the clichés of commercially inspired iconography were Peter Blake, David Hockney, Allen Jones, Patrick Caulfield, and Kitaj. Not all these artists, however, were concerned simply with imitating the model of commercial art. In breaking down the barrier between high art and kitsch, they attempted to invigorate the one while dignifying, as well as assimilating, the other. A master of the process is David Hockney (1937—), one of the most precocious and gifted artists to emerge in recent times. Even before he graduated from London's Royal College of Art, a spawning ground for the British Pop movement, Hockney had realized an international commercial and critical success. But instead of the all-too-familiar banalities of the consumer society, Hockney seeks his subject matter within his own life, itself a product of the taste-making power of the media, and bases his pictures on photographic images of his friends, the intimate spaces they and he inhabit, in London, Paris, and New York, as well as in that haven of the media moguls themselves-Southern California (Fig. 617). With skills in drawing, composition, and color almost as cunning as those of Matisse, Hockney even exceeds the French master in his witty dedication to luxe, calme et volupté, albeit with a deadpan poetry that may be the Pop equivalent of traditional English reserve. Thus, whereas Matisse opened windows onto a warm and sparkling sea (Fig. 166), Hockney seems to peer at his swimming pools through a very large glass, almost voyeuristically, from within the chill atmosphere of an airconditioned room, the northerner's addiction in hot climates. As if to confirm his total identification with the media, Hockney has even starred in a movie entitled A Bigger Splash, based, no doubt loosely, on his own life. Both the title and the nude scene the artist seems quite cheerful in evoke the hedonism of a life style for which the synthetically colored swimming pool provides a perfect symbol. An accomplished designer and stylist, Hockney has recently been especially happy in his sets and costumes for such operas as Mozart's Magic Flute and Richard Strauss's Rosenkavalier. He has also been busy with the camera, especially the Polaroid, using it to deepen his long study of Cubism and to join the trend toward an environmental art

Another successful British Pop artist is Allen Jones (1937—), a contemporary of Hockney's at the Royal College of Art. Although Jones may seem fetishistically obsessed with themes derived from advertisements for women's intimate wear (Fig. 618), the artist insists that he begins with "a formal picture and that leads me to the imagery. The shapes themselves suggest the subject, not the subject the shapes."⁴

Somewhat more highbrow is the art of R.B. Kitaj (1932-), who attended the Royal College at the same time as Hockney and Jones but, while giving his art the comic-strip look typical of Pop, found his sources more in his vast knowledge of world literature than in the popular media. Thus, Kitaj often includes in his pictures snatches of prose or poetry as clues to the works' content, but warns that his meanings are as multivalent as his imagery is composite. For Arcades (Fig. 619) the subtitle discloses the artist's preoccupation with Walter Benjamin, the German-born writer and critic who committed suicide when Hitler's army occupied Paris in 1940. By their physiognomy, the portrait-like figures wandering through the lucid rationality of a classicized architecture would seem to memorialize those aspects of humanity and civilization most threatened by the Nazis' barbaric rise to power. Although born in the United States and thoroughly established in the American art world, Kitaj has always seemed most at home among the British Pop artists. He prides himself on having found his main formal inspiration in Abstract Expressionism, and on modeling his figuration less on popular imagery than on the pictorial art of Edward Hopper, Ben Shahn, and Francis Bacon (Figs. 455, 461, 532, 533).

Pop Art found a kindred, and visually subtle, spirit on the Continent in the Italian painter Michelangelo Pistoletto (1933—), who arranges mysterious and poetic juxtapositions of oil-painted photographic figures set life-size on mirrored surfaces (Fig. 620). As spectators see themselves reflected in these scenes, they complete the compositions in the space of the real world, with a result-

619. R.B. Kitaj. Arcades (after Walter Benjamin). 1972–74. Oil on canvas, 5' square. Courtesy Marlborough Gallery, New York.

below: 620. Michelangelo Pistoletto. He and She Talk. 1964. Collage of photograph on polished stainless steel, 3'11¼"×7'6%". Collection the artist, Turin. right: 621. Martial Raysse. A. 1963. Neon on canvas, 16×11". Courtesy Iolas Gallery, Paris.

ing Pirandellian confusion of art and life. In France, Martial Raysse (1936—) began the familiar pattern of parodying Old Master art in sentimental or erotic scenes, but in the process he became enamored of modern technology as exploited for crass, commercial purposes. Still mindful of the historic masterpieces, he seems here (Fig. 621) to have reinterpreted *The Scarlet Letter* in terms of the neon blatancy of a shopping mall sign.

The Survival of Concrete Art or Constructive Abstraction

While Pop Art represented a rather rude and deliberately vernacular reaction both to the ideological narrowness and the increasingly evident mannerisms of *l'art informel*, Europe continued to produce another kind of abstract art, an art that showed surprising survival powers in the face of Expressionist abstraction. The work of a number of artists still rooted in an essentially Bauhaus tradition of Constructivism, usually described as Concrete Abstraction, converged in a broad tendency of systematic and orderly, but continuously experimental, abstract painting and sculpture. Opposed to the intuitive and expressionist methods of *tachisme*, theirs was an art of clear forms, anonymous touch, clean, or hard, edges, and, above all, intellectual control. For the most part aesthetic conservatives, the Concrete Abstractionists, nonetheless, bridged the considerable distance from Bauhaus formula to a more current interest in the dynamics of vision and optical illusion.

Concrete Art, as we saw in Chapter 15 (p. 246), had centered mainly in Paris during the 1930s, where two important groups were formed—Circle and Square (*Cercle et Carré*), led by Michel Seuphor and then *Abstraction-Création*. Artists from many countries participated in these groups and worked in a style of Concrete Abstraction: from Russia, Kandinsky and Pevsner; Moholy-Nagy from Hungary; van Doesburg, Cesar Domela, and Mondrian from The Netherlands; Friedrich Vordemberge-Gildewart from Germany; while France was represented by numerous artists, among them such figures as Jean Arp, Auguste Herbin, and Jean Hélion. Naum Gabo took the ideas of the Abstraction-Création to England, where they were eagerly adopted by Ben Nicholson and Barbara Hepworth.

Later, Concrete Art found a major exponent in the Swiss artist Max Bill (1908–94), whose impact would be felt mainly after the war, especially in South America. Notable for his "systemic" and logical procedures, Bill embraced an extensive range of formal invention (Fig. 622). In his early painting and sculpture he adhered closely to the rationalist design principles of the Bauhaus, with its view of the artist as a combined technician, researcher, and plastic inventor. He had actually studied at the Dessau Bauhaus from 1927 to 1929, and later worked as a painter, sculptor, architect, commercial artist, curator, and pedagogue. Bill became perhaps his generation's leading representative of the effort, widely publicized by van Doesburg and set forth in his manifesto, to integrate art, science, and human reality. For Bill the concrete concept could best be expressed through a mathematical formulation of reality in the visual factors of shape and color. The artist experimented, for example, with many variations in different scale of topological models of the Möbius strip and in metal strips of high finish. Like Pevsner before him, Bill demonstrated that art could absorb and transcend its mathematical models. Nonetheless, he steadfastly upheld the earlier abstractionist tradition by emphasizing intellectual control in works notable for their austere beauty, precision, and lucidity, but devoid of much personal and emotional involvement.

Lucio Fontana (1899–1968), in Italy, provided an unusual and influential example of a truly protean inventor who spanned many different modern traditions, from conventional Concrete Abstraction through *l'art informel*. He even anticipated, at an early date, some of the artistic attitudes and Conceptual projects of the 1960s. As early as 1946, while living briefly in Buenos Aires, Fontana published his prophetic *White Manifesto* proposing a closer alliance between art and science, an alliance that would be free of aesthetic artifice and the utopian theorizing of the pioneer Constructivists. Then, after a brief flirtation with *tachisme*, he began to slit and perforate his canvases with a knife or lacerate metal surfaces with an acetylene torch, in order to demonstrate what he termed his "spatialist" ideas (Fig. 623). In 1949, in Milan, Fontana built a large-scale spatial environment that consisted of sculptural forms hung from the ceiling, coated with reflective paint and illuminated by ultraviolet light. His spatialist, or environmentalist, philosophy and his unusual techniques conceived of matter and space as pure energy and a dematerialized environment. It was this orientation that helped set the scene for later experiments along similar lines by such intransigents as Yves Klein, Piero Manzoni, the so-called Group Zero in Germany, and GRAV in France (see pp. 337–339).

Fontana's monochrome, albeit perforated, canvases are among the few significant examples of contemporary European painting that can be related to Post-Painterly Abstraction and Minimal Art in America. The new styles of such impersonal Color Field Abstraction that, from the late 1950s, played a crucial role with the emergence of Morris Louis, Helen Frankenthaler, Kenneth Noland, Ellsworth Kelly, and others (Figs. 577–583, 585–587) had very little impact on the European art scene, except perhaps in the work of some English abstract painters of minor stature. In threedimensional art, however, the very elements of simple polychromy, reductivist form, and optical ambiguity that failed to in-

left: 622. Max Bill. Black Column with Triangular Octagonal Sections. 1966. Swedish granite, 13'8" x 1'11¹/4". Marlborough Gallery, New York.

right: 623. Lucio Fontana. *Spatial Concept.* 1962. Varnish on canvas, 25³/8 x 21". Private collection, Milan.

Europe's New Realism, Pop Art, and Abstraction

spire pictorial ventures can be associated with a wide range of European experiment in structuralist sculpture, light and movement art, and mixed media.

The sculpture of the British artist Anthony Caro (1924—) presents an intriguing case of a truly major talent whose work mediates between pictorialism, in its elegant color surfaces, and modern structural expression on the highest level of formal achievement (Fig. 624). Caro has been grouped with the American primary formalists and Minimalists (Figs. 596-598) because of the simplified geometric character of his work. Yet the differences from them are perhaps even more decisive. His sculpture emerged from the constructionist tradition of Picasso, González, and, most importantly, David Smith (Figs. 506-509), but it also has affiliations with the "antirelational" paintings of Noland, Frank Stella, and the other Post-Painterly abstractionists in America. Caro articulates structure in a manner much like that of the Cubists, through an intuitive and improvisatory approach, rather than as a theoretical embodiment of doctrinaire ideas. It was David Smith who helped place Caro on his artistic course, beginning in 1959 when the two sculptors met. Smith's influence deepened subsequently when Caro arrived to teach at Bennington College in 1963-64. Following the American's example, Caro used readymade steel parts of I-beams, sheet steel, tank tops, propeller blades, coarse metal mesh, etc., but he often painted these elements in homogeneous and thematically evocative color, with far greater sensuous impact than Smith's. He assembled his forms in horizontal, sprawling, and linked compositions. Unlike Smith, Caro dispensed with anthropomorphic suggestion, and showed much more concern with abandoning pedestals and with occupying space along the horizontal plane, thereby engaging the spectator environmentally, than with establishing the vertical totemic presences characteristic of Smith. Caro is also something of a mannerist, admittedly eclectic in his borrowings and extremely refined in surface finish and polychromy. Even his deliberately crude surfaces in rolled, rusted steel of the 1970s reject, by virtue of their varnish, Smith's deliberately unaesthetic and raw directness. In its weightlessness and its formal rigor, the Caro oeuvre shares the ambiguities of mass and sensuous, polychrome surfaces found in Minimalist sculpture. Paradoxically perhaps, the complex and exquisite sculptures created by Caro have strong ties not only to David Smith's more simplistic structuralism, but also to the pictorial concerns of the late 1960s.

Philip King and William Tucker (1935-) were students of Caro's at London's St. Martin's School of Art, and they acknowledge his influence (Fig. 625). Both make sculpture that rises from the ground without traditional bases, and make the ground serve essentially as a reference point to work against, rather than a stabilizing element or source of gravitational pull. They too distribute the volumes in their work in such a way as to contradict traditional notions about weight and gravity. King and Tucker use aluminum and processed industrial materials like polyester and fiberglass to model forms, and a color skin associated with mass-produced objects. Even more than Caro's-and like that of many abstract sculptors since, among them the German Kaspar-Thomas Lenk and the American John McCracken-their sculpture reflects an impersonal, efficient technology, in either materials, color effect, or the fabrication process. Despite their alliance with modern technology, King and Tucker attempt to strike a balance in their art, choosing to make sculpture, as Tucker has put it, "which is neither a private cult object nor a public monument."

European Optical and Kinetic Art

Postwar Europe's Optical Art represents a new alliance of abstract painting and sculptural traditions with contemporary techniques, novel materials, and a more dynamic psychology of perception. It

Europe's New Realism, Pop Art, and Abstraction

includes works that appear to move, because of mysterious optical phenomena activated by the juxtaposition of certain color forms, and those that actually do move and change shape or position, usually driven by motor power. In 20th-century modernism, the idea of movement had first been expressed in illusionistic terms, by the Futurists about 1911, and then, in 1920, in terms of actual motion when Gabo electrified his *Kinetic Construction: Vibrating Spring* (Fig. 435). Only after World War II did artists like Josef Albers (Fig. 432) and the Hungarian-French Victor Vasarely (1908–97) seek to reconcile movement with an activated perceptual experience (Fig. 626). For these fathers of Op Art, painting became a complex form of revelation and a means to explore visual process rather than a clever exercise in multiplying decorative possibilities.

Vasarely, Albers, and such gifted young European followers as Britain's Bridget Riley (1931—) set every inch of their canvases in dynamic formal activity (Fig. 627), to create the sort of exciting perceptual ambiguity already seen in the canvases of the Americans Larry Poons and Richard Anuszkiewicz (Figs. 583, 584). It was this restless activism of surface and the perpetual flux of their color forms that would link Op Art to the personally expressive varieties of contemporary abstraction. While the debt to the structural forms and schematic reductions of Mondrian, Moholy-Nagy, El Lissitzky, and the classical Constructivists is clear and acknowledged, the retinal dynamics of the new, scientifically manipulated imagery subverts the closed geometric order of the old Purist generation. A sometimes subtle and often strident opticality assaults the eye in almost intolerable color intensities, and registers, in this way, the pulse of personal artistic sensibility. The optical approach to abstract art of the 1960s lent an essentially human dimension to the otherwise coldly rational art of geometric abstraction.

In Europe, Vasarely's dominant interest in affirming the relationship of art and technology through his optical experiments directly stimulated the formation in 1960 of GRAV (*Groupe de Recherche d'Art Visuel*) by eleven artists of different nationalities. Instrumental in creating the idea of the "multiple," the inexpensive fabricated object or print, which took advantage of the technology of large-volume production, Vasarely had been the first postwar European artist to dispel the idea of the individual masterpiece. "The masterpiece," he wrote, "is no longer the concentration of all the qualities into *one* final object, but the creation of a *point-of-departure prototype*, having the specific qualities, perfectible in the progressive numbers."⁶ GRAV endorsed the rejection of traditionally admired personal creativity, reflecting a more factual view of artistic process already evident in art forms of the 1960s as different as Color Field Abstraction and Pop Art. A dec-

opposite above: 624. Anthony Caro.

Midday. 1960. Steel, painted yellow; 7'¾" × 2'117%" × 12'1¾". Museum of Modern Art, New York. Mr. and Mrs. Arthur Wiesenberger Fund.

opposite below: 625. William Tucker. Memphis. 1965–66. Plaster, 2'6"×4'10". Tate Gallery, London.

above right: 626. Victor Vasarely. Orion MC. 1963. Oil on canvas, 6'10¾"×6'6½". Courtesy Denise René Gallery Paris.

right: 627. Bridget Riley. Canto II. 1967. Emulsion on canvas, 7'6" × 7'5½". Courtesy Rowan Gallery, London.

Europe's New Realism, Pop Art, and Abstraction

ade earlier, artists such as Yaacov Agam, Pol Bury, Jesús Rafael Soto, Nicolas Schöffer, and Jean Tinguely had sought a new synthesis of technology and art forms, either in optical or kinetic art, that would actively involve the spectator in the work through movement or through changes induced by the spectator's circulation and shifting viewpoint.

Tinguely and Schöffer, however, represent the antipodes of a physically mobile kinetic art, or the "Movement movement," as Dada filmmaker Hans Richter wittily characterized it. Tinguely, as we know, remained attached to obsolescent machine culture in the midst of the electronic age. His works take advantage of this irony by acting as antimachine gestures, and they maintain a precarious existence between mechanical efficiency and farcical malfunction. Tinguely enjoyed his greatest and most entertaining moment of success with the remarkable, rattletrap, and self-destructing work he created in 1960 for the Museum of Modern Art's garden in New York (Fig. 611).

By contrast, the Belgian artist Pol Bury (1922—) normally works on an intimate scale and with infinite craftsmanship (Fig. 628). But his art too is extremely droll, especially in the speed of its movement, so slow that the effect is almost hallucinatory when the viewer perceives it at all.

Instead of moving, the work of the Israeli artist Yaacov Agam (1928—) changes as spectators shift their own position (Fig. 629). Using as many as thirty thousand small images organized over entire walls and ceilings, Agam has integrated in the same work up to eight clearly differentiated abstract themes, which slowly separate and then reunite as the viewer moves from left to right.

Meanwhile, Nicolas Schöffer (1912—), another Hungarianborn French artist, makes use of the new computer technology, doing so in a mood of basic social optimism. Schöffer has called a number of his ingeniously automated and programmed sculptures CYSPS (derived from the words "cybernetics" and "spatiodynamics"). They move, rotate on their bases, and project light shows and color spectacles in response to human presence (Fig. 630). Schöffer has fulfilled his social interests and idealism in a number of monumental structures of architectural scale. During the 1950s he built the first of his so-called Cybernetic Towers for national exhibitions in France, and in 1961 he erected a permanent tower in Liège, Bel**left: 628.** Pol Bury. *Red Points*. 1967. Plastic-tipped nylon wire in wood panel. Courtesy Obelisk Gallery, Rome.

below: 629. Yaacov Agam.

Double Metamorphosis II (detail). 1964. Oil on aluminum, 8'10" × 13'2¼" overall. Museum of Modern Art, New York. Gift of Mr. and Mrs. George M. Jaffin.

gium. Plans have been approved for a tower in Paris higher than the Eiffel Tower, which will perform electronic concerts, present light shows, provide weather and traffic information, and even warn of atomic disaster.

The most important pioneer in postwar European light art was actually the prolific Yves Klein (Figs. 608, 609). By the late 1950s he had created a blue-light environment, which represented only one of his many strategies in a broad campaign to dematerialize the art object and to saturate the world with spiritualized "International Klein Blue." Shortly thereafter three young German vanguard artists banded together to form Group Zero, which included Klein's brother-in-law, Günther Ücker, Otto Piene, and Heinz Mack. The German painter Otto Piene (1928—) created a loose kind of outdoor light Happening utilizing powerful arc lamps and searchlights, aluminum foil, soap bubbles, white balloons, and the mobile forms of spectators themselves. Representative of what Piene called "Light Ballet" is his *Hot Air Balloons* (Fig. 631).

Group Zero, GRAV, and other European artistic collectives pushed their experiments in light and movement to an extreme point of impersonality, in collaborative efforts at anonymous authorship which exchanged the conventional studio atmosphere for that of the scientific laboratory. By de-emphasizing the artist's normal egoism, and by depersonalizing and standardizing artistic creation, collectives felt that art could be made more democratically viable and

comprehensible to the layman. As early as 1960, François Morellet, Julio Le Parc, Jean-Pierre Yvaral, and other GRAV artists had produced electrically driven mobiles and light sculptures that reduced identifiable personal style and the idea of sculptural presence to a pure optical pulsation.

Ironically, the most acclaimed artist of the group, Venezuelanborn Jesús Rafael Soto (1923—), formulated a style that is unmistakably his own, consisting of thin rods suspended and left to move with the fluctuating atmosphere in front of a vertical, horizontally striated panel (Fig. 632).

Apart from achieving a remarkable sense of collaborative effort, Europe's artist collectives also went far beyond Gabo's rudimentary pioneering venture in motion sculpture (Fig. 435), or the machine-powered Constructivist sculpture subsequently produced at the Bauhaus, such as Moholy-Nagy's *Light-Space Modulator* (Fig. 434), to evolve new forms of kineticism more appropriate to the contemporary world. What proved particularly innovative about their works was that they no longer existed primarily as form but as an immaterial energy. With the arrival of Conceptual Art in the late 1960s, Optical and kinetic art approached other European forms of dematerialized art in a period when, as we shall see, both electronic technology and the philosophical preoccupations of the contemporary artist seemed to be directing a combined assault on the integrity of the traditional art object.

above left: 630. Nicolas Schöffer. Chronos 8. 1967–68. Stainless steel and motors, 9'10'/8"×4'1'/4"×4'3'/8". Collection the artist, Paris.

above right: 631. Otto Piene. Hot Air Balloons. 1969. Briggs Athletic Field, Massachusetts Institute of Technology, Cambridge.

right: 632.

Jesús Rafael Soto. Yellow Plex. 1969. Metal, wood, nylon cord, and paint; 6'6"×2'7". Courtesy Galleria del Naviglio, Milan.

The Diffusion of the New Architecture: 1954–75

This second postwar period did not generate anything in architecture like the previous wave of utopian idealism either in theories or in projects, let alone in actual constructions (see Chap. 13). There was no urgent search for new beginnings but, instead, a wary effort to follow closely in the tracks of the avant-garde of the 1920s and 1930s. This time the slate was not wiped clean. There were no dramatic appearances of radical personalities or organizations, no vanguard effort, no sweepingly comprehensive manifestoes for the rejuvenation of design. Characteristically, about the most significant event of the period was the widespread infiltration, by the masters and disciples of the new architecture, of established architectural schools, which had, for the most part, remained bastions of academicism.

From International Style to Personal Style or Corporate Anonymity

Caution and, significantly, a kind of narcissism prevailed. One new architectural figure to emerge at this time, Philip Johnson (1906–), may not have been exactly typical, but his background and inclinations were indicative of the times. Emerging from the ranks of criticism to become a student of Gropius's and Breuer's at Harvard, Johnson evolved into a devoted follower and sympathetic biographer of Mies van der Rohe. For the first decade of his career as a designer, ending in the mid-1950s, he built houses and other small buildings that were, if anything, more Miesian than those by Mies himself. On a conceptual level, Johnson's renowned Glass House (Fig. 633), the nucleus of his country seat in New Canaan, Conn., is as representative of these new tendencies as Le Corbusier's Villa Savoye was of the formal innovations of an earlier era (Fig. 341). Johnson's dwelling was essentially a sophisticated emulation of an idea originating with Mies, enriched by historical references to earlier events in the modernist tradition, whereas Le Corbusier's house, while based upon Cubist-inspired spatial inventions, had been created with a will to break new ground rather than merely refine and consolidate a volatile aesthetic into something fixed and constant. The modernist impulse was, in the late 1940s and 1950s, being harnessed into a traditional pattern, being reduced to yet one more historical style.

The utopian urgency of post-World War I architecture, whose social and cultural idealism had originally justified its austere geometries and innovative planning, was now replaced by the limited goal of creating precise, beautiful contemporary forms for their own sakes, as *style*. Goals and horizons contracted, and the modern idiom became introverted and, finally, even fashionable. Some of these compact, handsome architectural forms of the past quarter-century, such as Johnson's Glass House or Mies's more monumental, more recent, National Gallery in Berlin (Fig. 634), a glass house of temple-like proportion and configuration, are already anachronisms, even though they manage to look smartly contemporary. In their careful refinement of proportion and execution they even succeed in eclipsing their sources.

This narrowing of focus on the part of one older master and the most important of his disciples was contemporary with an opposing phenomenon, best represented in the work of Le Corbusier, notably in his chapel of Notre Dame du Haut at Ronchamp (Fig. 635), and in several explosive designs built during the succeeding years. The stunning surprise of the prowlike shape of the chapel at Ronchamp overwhelmed and confused its beholders at first, but, once mastered, its forms seemed to follow logically from the less constrained nature of his projects of the 1930s, especially those urban schemes where curves replaced right angles. Thus, in the late works of two great leaders, the once-unified modern tradition had been abruptly sundered. Yet the new works of both preserved a single point in common: the creation of distinct autographic images, sometimes private and personal in meaning. These images, seductively photographed and handsomely published, formed a tempting, irresistible, yet dangerous, challenge for others to emulate. At first, Le Corbusier was admired but avoided, since his works seemed to be, in effect, a secret voyage, and Mies was turned to as the source for a more recognizably public architecture. Later, as architects became bored or disenchanted with the possibilities of these Spartan forms, some of the epigones began to follow Le Corbusier. Only a hardy few could find distinctive ways of their own.

Thus arose a new species of form-making, the creation of a personal style, which became the goal of many ambitious architects. Whereas, formerly, a major goal of the new architecture had been to replace individual expression with an averaged-out universal mode, the prominent, admired modernist architects of the postwar era took the opposite direction. Whether imitating, adapting, or transforming some aspect of the International Style heritage, a prime goal of new designers was to establish their distinctive stamps, generally to the applause of critics on the lookout for architects whose personal expression just might equal the creative heroics so often, if too enthusiastically, ascribed to the more lionized contemporary painters and sculptors. A number of presentday architects have been beneficiaries of a cult of personality, an exaggerated adulation that has its origins in the homage rendered to the persons of Wright, Mies, Gropius, and Le Corbusier by teachers, students, and writers in the years immediately after 1945. This is the one common theme of our period, and it compares perversely with the impersonal, altruistic idealism inherent in the original work of the remarkable pioneers. It is difficult to imagine a greater paradox, a more complete about-face.

Hand in hand with this individualization, in which architectural personalities are commented upon in the press in a tone not unlike that enjoyed by professional athletes or pop musicians—although in appropriately sedate language—comes its exact opposite: corporate design anonymity. Curiously, this phenomenon, especially characteristic of American practice, although now widespread throughout Europe, is partly the outgrowth of one important theoretical aspect of the International Style. Contemporary architectural firms, whose office organizations rival, in rationalized structure, those of their gigantic corporate patrons, have carried on those earlier ideals of cooperation and teamwork that were notable in the theory and practice of the Bauhaus and implicit in the ideals of De Stijl and Purism. Indeed, many of the realities of postwar design depend upon this type of business organization, with its natural bent for inhibiting original, personal expression.

The legacy of the original International Style has been internationalized in a most uneven way, in part being incorporated into

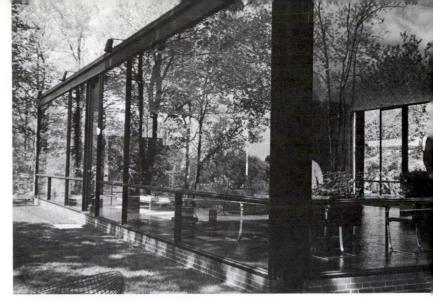

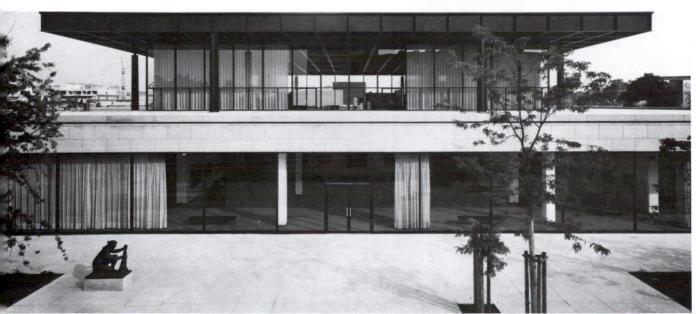

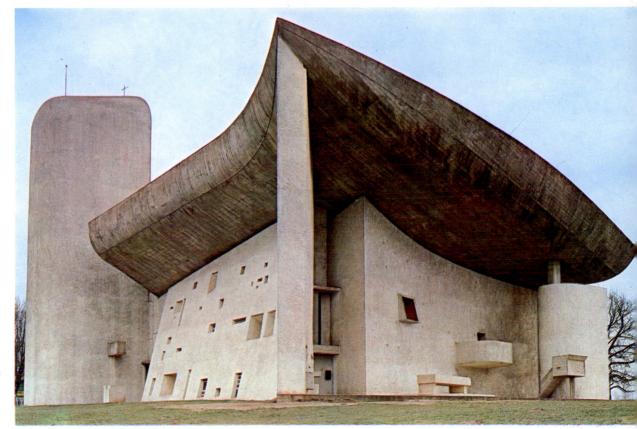

top: 633. Philip Johnson. Glass House, New Canaan, Conn. 1949.

above: 634. Ludwig Mies van der Rohe. National Gallery, Berlin. 1962–68.

right: 635. Le Corbusier. Notre Dame du Haut, Ronchamp, France. 1950–54.

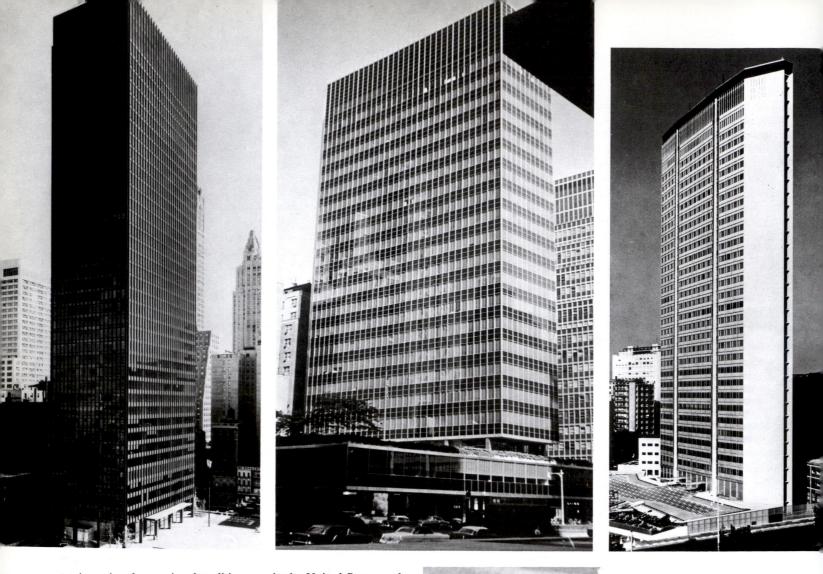

certain national or regional traditions, as in the United States and Latin America, while simultaneously serving as a force breaking down such provincial barriers. The International Style became, by the 1950s, an architectural koine, a common jargon employed by high and low alike everywhere, for the most diverse purposes, often to the despair of critics who rightly deplored the disappearance of local traditions. This lowering of the International Style heritage into a vulgar street language naturally produced reactions, countermovements, revisionist modernisms, and the like. It also produced a complex situation whereby one significant part of the profession continued to practice an entrenched manner of commercial modernism, working from and within the Miesian mold; a second, more venturesome, explored the plastic freedom contributed by the late works of Le Corbusier; while a third, a "nongroup," developed patterns of its own, at variance with some of the now-historical categories of early 20th-century architecture.

Representing the first group is the highly regarded firm of Skidmore, Owings and Merrill, archetype of the large American architectural office, producing a corporate-styled, standardized product of great repute. Among the many who, with greater and greater frequency after 1960, opted for the Corbusian plastic tradition would be Kenzo Tange and Paul Rudolph. Of the independendent-minded, the most renowned is Louis I. Kahn; but that collection of free spirits would include many others with little in common, save perhaps a disenchantment with Bauhaus aesthetics, such as the Archigram group of England and those who were not precisely architects, for example, the engineer Frei Otto or the selfstyled universalist R. Buckminster Fuller. Alvar Aalto also stood apart, following a personal line of growth away from the Interna-

The Diffusion of the New Architecture 342

above left: 636. Ludwig Mies van der Rohe and Philip Johnson. Seagram Building, New York. 1958.

above center: 637. Skidmore, Owings and Merrill. Lever House, New York.

above right: 638. Gio Ponti, Pier Luigi Nervi, and others. Pirelli Tower Milan. 1956-59.

Skidmore, Owings and Merrill. Sears Roebuck Tower, Chicago. 1966-69.

tional Style that is not easily typed. Sometime around 1960, these various trends and possibilities became equal in their modernity, although they remained vastly unequal in terms of their established bases, their patronage, and their potential for academic or critical recognition. An eclecticism both simultaneous and polymorphous resulted, a range of possibilities that included the jet-set commercial and industrial architecture of seamless glass containers, the sturdy neo-Corbusian masses of a Boston City Hall, the rugged shapes and spaces of Kahn, the inflatable structures, the light-weight geodesic domes, and the even more perishable edifices made from the detritus of the auto-consumer civilization.

Architecture in the late 20th century has been likened, for purposes of historical analysis, to the situation that prevailed in European architecture during the late 16th century, the period of the Late Renaissance and Mannerism, two simultaneous historical phenomena that were intertwined in a baffling ballet of interrelations and contradictions. Indeed, there are analogies of more than passing importance between a collection of architects from that period-Sebastiano Serlio, Giulio Romano, Jacopo Sansovino, Andrea Palladio, Philibert Delorme, and Michelangelo-and the major figures of today. These were all designers much concerned with style and its sources, preoccupied with scholarship and history, interested in both the canonically correct proportion and the bizarre effect for expressive ends, and concerned with the establishment of their own distinctive reputations. Historically, it was a period of shifting political authority, with the rapid rise and fall of power centers across Europe. However, the "complexity and contradiction" (to borrow the phrase from the influential book of 1966 by Robert Venturi) of late 20th-century architecture is of a vastly different scale and involves values that are infinitely more permissive than the humanistic ones that prevailed four centuries ago, formal values that are not answerable to any political, social, or even intellectual system. Architecture today exists in an ideological void without precedent, one which did not, until recently, even find a counterpart in the other visual arts or in literature.

In surveying the history of the 1920s, it was possible to single out a certain few pivotal men and movements. The significant achievements were in their hands, and what was created on the periphery of the new architecture is clearly recognizable for just that. However, the expansion of the International Style brought about both its popularization and its breakdown as a coherent movement, partly through growth and evolution, partly through a kind of corruption in which the forms, but not the theories, were taken over by the profession. Thus, it is much more difficult to separate today's vanguard from today's establishment modernism in many cases. Moreover, even before considering the accomplishments of the younger generation, which took an unexpectedly long time to find itself, it must be stressed that the late styles of the old masters diverged rather than converged, contributing to a chaotic situation.

The Legacy of Mies van der Robe and Le Corbusier

The iconic buildings of the 1950s, such as Ronchamp, the Glass House, the Guggenheim Museum (Fig. 370), and a few others, were by then very ancient in the aesthetic principles they embodied. Mies's Seagram Building in New York (Fig. 636), designed in collaboration with Philip Johnson, became the most important of the structures for the simplified shape that the new towered city would take. It was not the first built of Mies's simple, rectangular glass shafts with proportionally exact metal detailing and vertical I-beams used externally as if they were classical pilasters, but it was the most beautiful. Mies's collapsing of complex 1920s abstract geometry into one main form is not completely carried through here, but the effect is close (some lower forms cluster inconspicuously at the rear and sides). The architect made something timeless and universal out of a newly popular, yet thirty-year-old, idiom, providing a paradigm for subsequent urban high-rise design that did not, in the succeeding two decades, wear out its welcome with patrons, developers, and a certain coterie of architects. It has, however, become a building type largely ignored of late by much of the architectural intelligentsia and even, on occasion, ridiculed in the critical press. Stylistically, it was quite out of line with the gestural, Abstract Expressionist painting then at the peak of its creative success, although Mies's aesthetic accorded perfectly with the contemporary paintings of squares by Josef Albers (Fig. 432).

Mies's Seagram Building was a triumph of reduction. It eliminated the complex, interlocking geometry of flux characteristic of his earlier designs, and especially characteristic of the Barcelona Pavilion (Fig. 363), where form actually became content in an ideal structure. Also, it eliminated the familiar formal and decorative features of the American skyscraper as it had evolved in its special way during the 1920s and 1930s: it suppressed the setback silhouette and the turret or tapered spire at the summit and transformed the vertical strip window into the vertically accented glass wall. Modern style here joined the new building type in a seamless unity. When finished in 1956, Seagram was situated in an old, but not antiquated, urban environment featuring brick-clad structures of moderate height, detailed for the most part in a subdued Renaissance manner. The only exception was the glass-slab Lever House (Fig. 637), by Skidmore, Owings and Merrill, diagonally across the avenue, actually the first "Miesian" building in the city-a reminder of how often followers were able to get the concepts of the pioneer architects built first. Almost before Seagram's completion, a glass-architecture fever spread up and down the avenue, and within a few years a city of crystal blocks had been thrown up, a dismal parody of the dreams of Bruno Taut (Figs. 342, 345), whose extravagant visions of a glass architecture were a world removed from such superficial, simpleminded applications.

Mies's hermetic way with the new tradition was the likely one to evoke wide public support, a certain critical acclaim, and, most important, a generous, well-heeled clientele who felt secure with this respectable-looking, yet clearly contemporary, type. There is no historical precedent for the international success of this sheer tower, with its restrained, calculated modifications of proportion, size, tinting, and surface relief, and its technique of assemblage. True, there was an increasing variety in exterior treatment during the subsequent fifteen years, a definite tendency to reduce the amount of glass surface or obscure it with façades designed in greater relief with a massive structural grid projecting in front of the curtain wall. There were also increasingly frequent modifications away from the rectangular box shape, substituting polygonal or curved profiles for the four-square, and this solution proved especially popular in Europe. The Pirelli Building in Milan (Fig. 638), a pioneer European skyscraper by Gio Ponti (1891-1979) in collaboration with the engineer Pier Luigi Nervi, was the prototype of this nonrectangular shape, with slightly bowed glass curtain walls on the long flanks terminated at both ends by distinctive prowshaped stair towers.

Space does not permit more than a trifling sample of these new skyscrapers. Skidmore, Owings and Merrill, with offices in several cities, were the most accomplished masters of this architecture, derived, and even debased, from Mies. Distinguished, if rather cautious and unoriginal, in design yet often breath-taking in the scale of parts or of the whole, their works succeeded through the use of a narrow range of luxurious-looking materials. The firm's most remarkable achievements have been two towers during the 1960s and early 70s in Chicago, the John Hancock Center, with inclined walls and diagonal steel bracing, and the Sears Roebuck Tower (Fig. 639), a design that re-introduced the old setback form in what is, for the

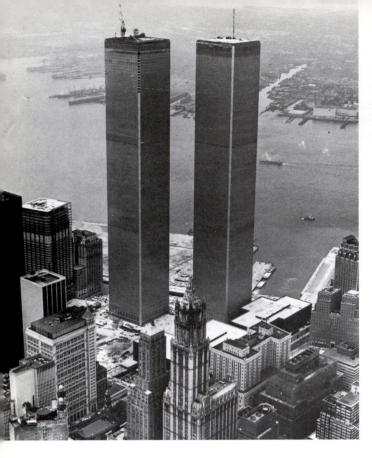

moment, the tallest building in the United States. Local boosters would point out that these aspiring forms are but the most recent in a long line of tall office buildings in that Midwestern metropolis, but the new behemoths are a far cry from the early skyscrapers of Sullivan and his contemporaries-many of which are now being demolished or threatened by their ambitious, outscaled successors. In the same vein are the two towers of the New York World Trade Center (Fig. 640), a project conceived in the mid-1960s by Minoru Yamasaki (1912-86), a prominent, fashionable designer, whose work is indicative of how easily this genre of building can become a matter of packaging and external design, even when a major new structural concept featuring a load-bearing wall is introduced. These cracker-box forms have dwarfed the skyline of Manhattan in a way in which no other buildings have before, and seem more alien to their neighborhood and to the entire metropolis than any other imaginable forms.

Europe has been a victim of this plague to a somewhat different degree. One of the tallest buildings there, the Montparnasse Tower in Paris, completed in 1973 after long years of planning and construction, is not quite 700 feet high, about half that of the tallest American building. However, since the historic building horizon was lower and, in fact, not seriously pierced by skyscrapers until well after mid-century, the mutation seems even more deplorable. However, criticism of such drastic changes in the more sacrosanct historic skyline of these older urban centers should be tempered by reminders of the early hostile criticism of such now-recognized innovative masterpieces as the Eiffel Tower, and of the drastic urban surgery practiced on Paris by Baron Haussmann more than a century ago. Fortunately for Paris, a large part of the new skyscraper development has been concentrated in an area to the west of the capital proper, the Défense quarter, an integrally planned commercial city incorporating mass housing as a secondary feature (Fig. 641). It forms its own center apart, although alas not quite invisible, from the historic nucleus of Paris. The tall buildings of La Défense are clever variations on the international commercial norms of the 1970s, with more unusual geometries and surfaces than might be expected. Although there are generous terraced

left: 640. Minoru Yamasaki. World Trade Center, New York. Begun 1967.

above: 641. Défense District, outside Paris. Commercial plaza and office towers.

> spaces just above ground level, these seem haphazard and often bleakly overscaled. Altogether, it appears as a tarted-up Radiant City, albeit lacking in the plastic intensity and planning coherence of a Le Corbusier.

London has met the skyscraper in a rather different way. The worst that can be said is that the builders and architects of the 1960s accomplished something that eluded the efforts of the German bombing of 1940: the leveling of the historic skyline of the city (Fig. 642). The dome of St. Paul's, the towers of Parliament, and the spires of Wren's churches have all been dwarfed and obscured by the random distribution of new tall buildings, forms that are dispersed rather than concentrated in particular districts. Nonetheless, many bombed-out sites have at long last been built over; and it should not be forgotten that a city like London, no less than in the equally special cases of Paris, New York, and Chicago, is a living entity, not an exclusively historic monument, and that growth within as well as without the historic center is inevitable. London's skyscrapers are an undistinguished lot, especially by comparison with the high standard of British architecture elsewhere. In a somewhat ghoulish way, they are, to be sure, more impressive in the ensemble, at least as seen from the dome of St. Paul's or from the several bridges spanning the Thames, than in the individual buildings.

It is impossible, even when considering only formal and stylistic matters, to remain insensitive to the questionable social role played by the omnipresent towers, alienated objects in the midst of our contemporary metropolis, where they exist presumably as architectural demonstrations of contemporary society's power and efficacy. These sheer forms create a destructive visual tension between the old and the new. This vicious confrontation was not foreseen in the initial vision of the Radiant City, and it remains unclear whether the major flaw lies in the concept of the Cartesian skyscraper itself or in the superficial adaptation of a grand scheme in fragments rather than the entire plan. Also, it did not improve matters to have employed a design formula bowdlerized from an earlier generation of modernists in the first place. One thing is certain: there has been too little large-scale, architecturally determined planning and too much concern for short-term financial rewards, manipulation of private land values, speculation, and increases in the tax base. Predictably, there has been little concern for genuine social amenity and livability in nearly all gigantic building enterprises. One strains to find a convincing major exception to this rule.

Given the pernicious social consequences of so much postwar architecture inspired closely or at a distance by the sixty-year-old images of Le Corbusier, Mies, and their generation, the temptation

is to blame them for these present failures. This is to fix responsibility in the wrong place and to ignore not only the idealistic content of the original Radiant City or the true Miesian tower but also the logically thought-out details and refinements as well. Focusing upon an inherently commercial building type does Mies's reputation a disservice: his Berlin National Gallery, mentioned above as one of the perplexing yet characteristic anachronisms of more recent modern design (Fig. 634), is a splendid formal example of late modern, a demonstration of the architect's famous epithet "less is more," and a space that exists more for its own sake than for its contents. Mies's structure is as much a cenotaph to architectural ideals as is Wright's very different Guggenheim Museum (Fig. 370). Buildings of this sort, abstract demonstrations of space and structure, remain as necessary monuments in an age that gives short shrift to the grand gesture. The temple-like image and the elegance of the Berlin National Gallery's structural joinery demand comparison with Mies's house projects of a quarter-century before and especially with the Farnsworth House in Plano, Ill. Careful analysis of the means of support and of the specific relation between horizontal and vertical lines in each building shows a surprising variety of solutions for an architect who, in matters of volume and space, seemed to aim for the most elementary standard.

The Late Architecture of Le Corbusier and Its Influence

Thirty years ago, it appeared as if the Miesian mode would form the permanent substance of a contemporary vernacular, and, to a degree, it did produce an establishment idiom. However, the quality and the motivating spirit of this commercial vernacular became increasingly depressing. At the same time, the later works of Le Corbusier gained wider recognition. Simultaneously, his earlier works in the more simple, Purist idiom underwent reappraisal, and these laconic designs were found to contain still other elements that could serve the further advancement of the new architecture. Thirtyfive years ago it was generally felt that in comparison to the clear, direct message of Mies's formalist architecture, Le Corbusier's efforts were too personal, complex, and exclusive to serve as useful models. In those days one admired Le Corbusier's formal manipulation and ceaseless invention but followed Mies's example, or possibly that of some regional contemporary mode; *or* one established a distinctly personal alternative, as was notably the case with Aalto.

The career of Alvar Aalto, from the 1950s to the 1970s, resulted in numerous buildings, public and private, that generally stand aloof from either the simplifying or elaborating strains of new design. Irregular, even picturesque, shapes and masses dominate his work, but the very informality of his buildings, such as the Helsinki Cultural Center (Fig. 643), a meeting hall for several labor unions and for concerts, or the church near Imatra, defies comparison with the more urgent, passionate rhetoric of Le Corbusier. Moreover, the gentility of his style and detailing is a world removed from the overwrought and sometimes misplaced precisionism of the Mies imitators or the strained, sculptural images and studied façade effects of other architects of this period.

Ironically, other alternatives, exemplified variously during the 1950s and 1960s by the works of such otherwise unrelated architects as Philip Johnson, Eero Saarinen, and Louis I. Kahn, were

above: 642. London skyline, with dome of St. Paul's and Barbican towers.

left: 643. Alvar Aalto. House of Culture, Helsinki. 1955–58.

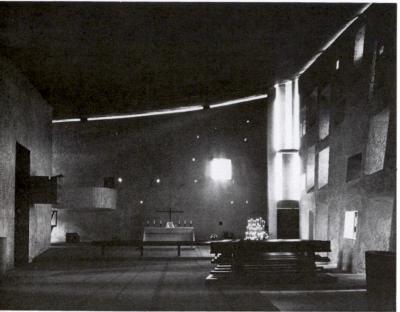

sufficiently revisionist to merit such epithets as neotraditional or counterrevolutionary, although such labels are too blunt and gross to accurately describe a complex, even confused, phenomenon. These designers freely indicated their skepticism of each other's work, and their interests diverged widely, as did their clientele. They sought to establish separate identities for themselves and for their generation in the face of the idolatrous acclaim showered upon the older masters, especially Le Corbusier, who continued to pose an active threat to everyone, young and old, until his death in 1965.

Le Corbusier's late works, neither numerous nor located in frequented or easily accessible places, are a unique resource. In them the principles of the free plan and free façade expand into free form—a sculptural instinct previously held back by the planar fixation of the International Style. Each of the later buildings designed by Le Corbusier makes specific formal gestures toward the landscape, revealing an attachment for nature that his earlier works, many of them urban, did not suggest. His early city schemes were tabletop exercises, but, by about 1930, in sketches and in detailed plans for Algiers, Rio de Janeiro, São Paulo, and Buenos Aires, he had shown an interest in transforming the Cartesian skyscraper into curving, ribbon-like slabs expressive of the topography of the site. Indeed, it is something of a jolt to realize that Le Corbusier never built a true skyscraper, that the form taken by his postwar mass housing was that of a tall slab that was invariably greater in length left: 644. Le Corbusier. Unité d'Habitation, Marseilles. 1947–52.

below: 645. Le Corbusier. Interior, Notre Dame du Haut, Ronchamp, France. 1950–54.

than in height. At Marseilles, the first and richest Unité d'Habitation (Fig. 644) was seventeen stories high, but its greater length gives a sense of horizontality that somewhat conceals its height. Here the architect first employed *le béton brut*, rough concrete left as the actual surface, untreated or unrendered to make a smooth face throughout the building, a technique that would be imitated and adapted widely later—until very recently still the standard alternative to the shiny, clear, manufactured look of the contemporary urban tower. This rough concrete gave a sense of the accidental, introduced an ironic feeling of handicrafts in the product of a partly industrialized building technique in which common labor plays a larger role than does specialized craftsmanship.

The plans of the Marseilles project featuring duplex apartments with balconies on each façade to ensure cross ventilation, have been much discussed but little imitated; in fact, their unique layouts evolved from an economical reduction of the Citrohan scheme (Fig. 360), but incorporated ideas that had appeared in Soviet housing projects in the 1920s. On the roof terrace, the architect provided recreational facilities and simultaneously indulged in romantic sculptural fantasy. The ventilation stack was shaped into a tapered funnel form, various levels with stairs and ramps were introduced, and freely shaped concrete forms molded as a children's play structure, which, in fact, echoed in miniature the ridge of mountains on the distant horizon. Art, or rather architecture imitating nature, was a challenge that the architect could not resist, and in 1950 he would be designing an entire building, the chapel of Notre Dame du Haut (Fig. 635), as a free form echoing the contours of nature in a way utterly foreign to the traditions of European architecture-though Wright had, from time to time, sought something akin to this effect in his more advantageously placed houses, but in a rather more functional way. At Ronchamp, Le Corbusier sought to meet nature as an equal, creating a gestural form uniquely destined to the Place—a site on top of a domed hill that had been a Christian sanctuary for centuries and before that, perhaps, an acropolis for pagan cults antedating the Roman advent in Gaul.

This church, architecturally more an evocation of older rites and mysteries than a Christian sanctuary, is loaded with memories, allusions to forms of indescribable antiquity, and a profundity of expression in the use of mere architectural forms that reaches the explicit poignancy of the representational arts. It is not even easy to describe the building mass, so apparently free is its geometry of curves and angles. An aggressive prow greets the pilgrim as he mounts the hill; from this initial climax the forms subside, their curves leading one around and finally within, where all is dark, subdued, the curving lines now falling rather than rising (Fig. 645). The curve of the concrete shell vault may suggest the shape of an airplane wing fragment, yet the massive vault seen from the exterior overhanging its massive supporting walls resembles the megalithic funerary architecture of millennia before. Nothing could seem less modern, at least in the futuristic or even machine-age sense, yet its expressive primitivism is so elementary that its creator could rightly be called the noble savage of the new architecture. His primitivism here was, however, no sentimental Rousseauian device but a means of probing the essence of architecture as no one before had done.

Ronchamp seemed to be an architecture without issue; no other architect was equipped, technically or morally, to carry out anything remotely in its class, and yet its hard-to-grasp liberties, its apparent yet illusive freedom from the exacting rigors of more fa-

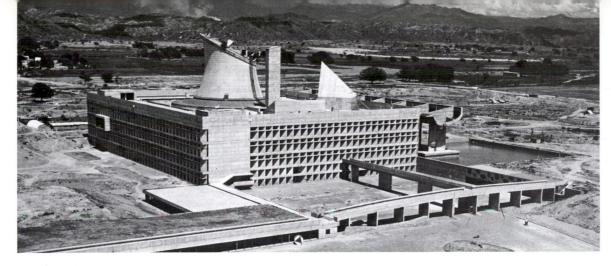

miliar modern shapes beckoned, and several prominent architects of the late 1950s could not resist. The results were, at best, equivocal. Other architects, in admiration but also despair, were prompted by Ronchamp to turn back again to a study of Le Corbusier's earlier work, finding there a more useful and even inexhaustible text upon which to found their own work. Since the mid-1950s, no other architect has so occupied the minds of architects and critics, as much as an irritant as an idol but also an inexhaustible source for ideas and motifs of infinite variety.

Like so many modernist monuments of the 1950s, Ronchamp is built of paradoxes and inversions; it literally turns the rational idealism and the formal rectitude of the International Style inside out. The same is true of Le Corbusier's capitol at Chandigarh, projected from 1950, the ensemble never actually completed. The impressively scaled monumentality of the High Court, and the Assembly (Fig. 646), both with amply proportioned porticos, is an original, contemporary conception that achieves a degree of grandeur commensurate with that of the Beaux-Arts tradition, which the modern movement had originally sought to dethrone. The powerfully sculpted, virtually inimitable, forms of Chandigarh are some small consolation for the even vaster, unexecuted Palace of the Soviets project (Fig. 357), a vision so different in conception that it seems not only to belong to another day, but also to be the work of a totally different artist.

The Neotraditionalists

Unlike the great styles of the past, the Doric or the Gothic, the nature of modern monuments is their Promethean audacity. They remain solitary, defiant creative gestures in a kind of intransigence that, besides being detrimental to orderly development, is a disturbing inversion of another manifest principle, or characteristic, of contemporary design: the need and desire to create uniform building types that can serve at least the partial industrialization of the traditional building crafts. Of the architects of the century's **left: 646.** Le Corbusier. Assembly Building, Chandigarh, India. 1962.

bottom: 647. Eero Saarinen. TWA Terminal, Kennedy Airport, New York. 1962.

below right: 648. Eero Saarinen. Dulles International Airport, Chantilly, Va. 1961–62.

middle years, none is perhaps more representative of the pyrrhic effort to rival the older masters than Eero Saarinen (1910–1961), the son of Eliel Saarinen (Fig. 153). The younger Saarinen's background was, by the standards of the day, traditionalist, despite the fact (or perhaps because of it) that his father was a major pioneer of the early years of this century. While the forms of Eero Saarinen's architecture after 1950 are unmistakably modern, his style is randomly eclectic, the result, he maintained, of searching out a special, appropriate, distinctive style for each building job. Often his designs were inventive, sometimes imitative of something familiar; in all cases, the buildings seem strained, restless, and insecure. Above all else, his monuments should be regarded as neotraditional; that is to say, he made use of modernisms in his designs as a Beaux-Arts architect of the 19th century might adapt, manipulate, transform, or even reinvent motifs from the Roman-Renaissance tradition.

Interestingly, Saarinen's best work comprises two concrete airport structures, the TWA Terminal at Kennedy International Airport in New York (Fig. 647) and Washington's Dulles Inter-

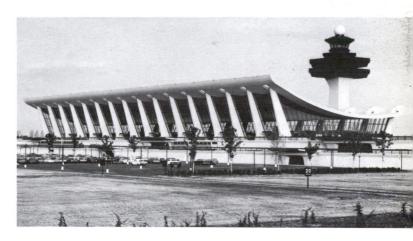

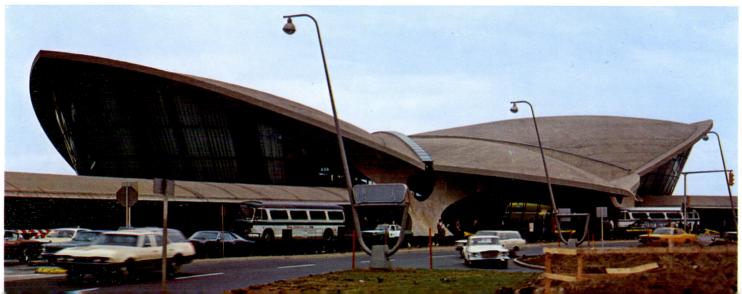

national Airport Terminal (Fig. 648), the one expressionistic and the other neomonumental. Moreover, both are different from the simple, boxy geometries of his earlier General Motors Technical Center in Warren, Mich.—loosely Miesian in layout—or the tentative, much-criticized formalism of his domed Kresge Auditorium at MIT. Schematically the outline of a bird-in-flight, TWA resembles, among other things, an Art Nouveau brooch or perhaps a pre-1918 sketch by Erich Mendelsohn, but the most pungent association was surely inade by two inadvertently overheard German-speaking travelers who waxed eloquent over this concrete *Fledermaus*!

Saarinen was, of course, inspired by aerodynamics for these winglike canopy shells, wishing to anticipate, through architectural form, the exhilaration of flight-a somewhat naïve romantic literalism quite inappropriate to the ungainly giant jets whose forms are in fact much tamer. Many years earlier, Le Corbusier had suggested that airplanes be studied by architects, not as a source of formal ideas, but, rather, as an example of a new, distinct form resulting from the direct, hardheaded solution to a difficult functional problem. Saarinen's stylish manipulation of these forms would seem to blunder right by Le Corbusier's admonitions without the faintest comprehension of the principle involved. Even more insensitive to the core of modernist doctrine is the structural inefficiency of the seemingly thin concrete shells; they were shaped rather arbitrarily with care for the admittedly effective spatial flow, but, as a result, the engineers had no choice but to build a thick concrete canopy with much reinforced steel, further adding to weight in order to make the idea stand.

Dulles is a much larger, more grandiose project, with outthrust piers holding a tension vault in place high above massive terrace structures. Again, flight is suggested through the rising contours of the building, and, again, the profile of the building might just possibly be an adaptation of a Mendelsohn sketch. However, in its scale and with its rather formal portico, Saarinen's Dulles seeks to compete with the "façades" at Chandigarh, though they are too calculated to make a comparable impact. Saarinen was in the habit of studying the design of his buildings through the use of elaborate models, a praiseworthy effort to avoid spatial miscalculations. Ironically, many of his constructed works look just like that, like enlarged models, often ill-detailed and often with incoherent scale relationships. Still, his monumental forms are vastly superior to many contemporary efforts that strive for rhetorical effect.

Philip Johnson is a more impeccable formalist, a gadfly, by turns ironical, cynical, and generous. A coauthor of the book that effectively christened the International Style in 1932, he began a creative career only after World War II and, as we have seen, was, for a decade, not only an orthodox Miesian but one of those who gave the idea, albeit fleetingly, that this mode of glass, brick, and steel might become the permanent style of the century. Johnson is also a serious admirer of the works of Wright and Le Corbusier and even sought to transform some of Wright's motifs into his work, but without serious result. Another object of his admiration was the 19th-century romantic-classic architecture of Karl Friedrich von Schinkel, likewise venerated by Mies. This kind of modular classicility design was behind his change of style in the late 1950s, a neotraditionalism added to his previous "revival" or continuation of Mies-although there were other forces at work as well. While his wit and intelligence sometimes deserted him in occasional lapses in taste, usually confined to details, Johnson was probably the only architect among many-Edward Durell Stone, to name one-to work successfully in a new academic mode without creating a style of solecisms plucked randomly from the new architecture and from historical tradition. Johnson's Sheldon Art Gallery in Lincoln, Neb., is a model of this sort of gem-box design; his new wing for

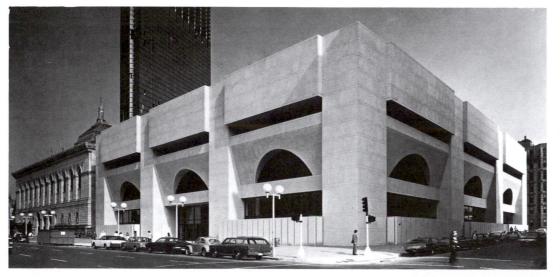

left: 649. Philip Johnson. New Wing, Boston Public Library. 1972.

below: 650. Lincoln Center for the Performing Arts, New York. 1962–68.

opposite above left: 651. Jørn Utzon. Sydney Opera House, Bennelong Point, Sydney Harbor, Australia. 1973.

opposite above right: 652. Louis I. Kahn.

National Assembly Complex, Dacca, Bangladesh. Begun 1963 (photograph July 1975).

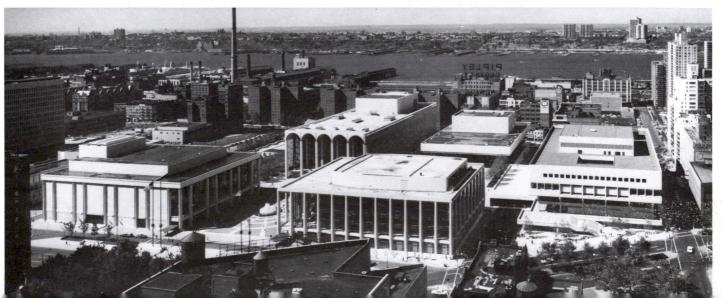

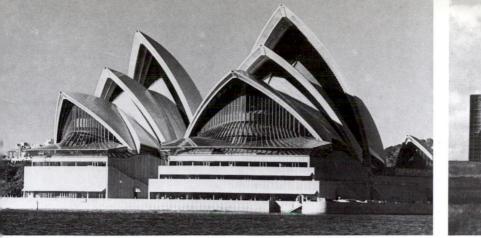

the Boston Public Library (Fig. 649) is a most striking instance of applying formalist principles adapted from the classical or classicizing styles to a contemporary design idiom that is mostly free of eclectic overtones.

The most conspicuous, even imitated, large-scale instance of this 1960s brand of neotraditionalism is Lincoln Center in New York (Fig. 650), where Johnson was the architect of the New York State Theater, the building to the left of the major façade of the Metropolitan Opera, which dominates the stiff, symmetrical layout. Wallace Harrison, who previously contributed to Rockefeller Center and was the executing architect of the United Nations Buildings, where Le Corbusier had been a consultant, served as project coordinator for Lincoln Center as well as architect of the Opera, while his partner Max Abramovitz was architect of the Philharmonic (Avery Fisher) Hall, with the design of the Beaumont Theater placed in the hands of Eero Saarinen. Johnson's New York State Theater, on the interior, offers a vast open gallery space of true grandeur, an effect regrettably vitiated by the cheesy detailing of the gallery balustrades, a miscalculation altogether out of character for that architect. It would be pointless to belabor too much the design weaknesses of Harrison's Opera and Abramovitz's Hall: they aspire to the monumental but fall flat perhaps through naïveté, presuming an unsophisticated public and also displaying their rather superficial grasp of historical phenomena. The plaza spaces are potentially stately in proportion, but rather petty detailing and unimaginative planting cancel out the intended effect.

On the other end of the formalist, neotraditional spectrum of monumental architecture is the Sydney Opera House (Fig. 651), one of the more dramatic architectural forms of our time but also a painful and even scandalous design. The competition project, more or less faithfully executed for the exterior, was the work of the Danish architect Jørn Utzon (1918-), although he resigned in outrage midway through construction. The scheme, hardly more than a sketch when it was selected (at the urging of Eero Saarinen, it is reported), was another overblowing of a concept by Erich Mendelsohn, a series of sail-like concrete canopy vaults set on a terrace dramatically sited on a promontory overlooking the harbor. Unfortunately, the architect had conceived the curvature of his shells without reference to the possibilities of construction, and the engineers, Ove Arup and Partners, were hard-pressed to build the form in anything like the architect's vision. Moreover, the curved shells were acoustically pointless and performing spaces had to be built whole within the monument. Taken together with the more prosaic, four-square, articulated elements of Lincoln Center, we can again see the confusing range of formal possibility inherent in our architecture.

Louis I. Kahn (1901–1974), the most original and incisive architect of the century after Wright, Le Corbusier, and Mies by dint of his unique traditionalism within the late modernist ambient, belongs with this group of revisionist architects whose work was in partial reaction to the formal dynamics and idealistic rationalism

of the International Style. However, Kahn's traditionalism is less superficial, less motivated by a simple desire to be different or to prettify and make more publicly acceptable the harsher realities of the original radical style. The traditionalism forged by Kahn is more inward, a personal assimilation of architectural forms as he found them, analogous to Le Corbusier's absorption of historical and vernacular forms, a gathering of resources and materials that would gradually, slowly, even painfully, be released toward the end of his life in a series of sturdy, unfamiliar forms. Unlike the neotraditionalism of his contemporaries, Kahn's architecture was neither easy nor popular. Like Wright, Le Corbusier, and even Mies, Kahn was the solitary artist, tragic even, facing material and professional adversity out of his lack of conformity. He won an enormous following among students in the 1950s, and it is possible that his early success as a stimulating design critic helped release his own creative forces that so long lacked a means for expression.

A number of works by Kahn before the late 1950s are tentative, as if the architect were searching for some quality or effect that had not yet appeared in the principles or practice of the new architecture. After a reluctant acceptance and use of some of the standard formulas of post-International Style composition, in the final two decades of his career he fairly consistently rejected this language and created forms out of his own resources of study and reflection that are among the most autonomous of our time. While admired by the intelligentsia, Kahn's work was not taken up as an alternate mode, was not successful except with unusual or especially perceptive, patient clients, and has not yet formed a school of disciples even among his ardent admirers. At the outset, when few of his buildings had been completed, Kahn devised a method of composition and a rather personal language about the building process that received wide notice. Indeed, some of his early works, such as the tentative, pivotal Yale Art Gallery, with the combination of a rather drab, conventionally Miesian exterior shell of brick and glass hiding an interior with a distinctive ceiling plan and structure in reinforced concrete, a honeycomb of tetrahedral voids, were rather mistakenly claimed by partisans of an unrelated contemporary movement, New Brutalism, as an example of their principles. Beginning about 1960, a new creative confidence appeared; from that point on until his death fourteen years later, each of his works added something vital and crucial to his evolving style. At a time when the new architecture had grown fat with success, Kahn's work was a refreshing, primitive, archaistic throwback, out of step with the commercial demands of the times and most effectively rejecting the immediate heritage of modernism's heroic years.

The geometry of Louis Kahn is as elementary as that of the International Style, but there would be no confusing the two. Made of clusters of cylinders and squat towers, with walls often as forbidding as a medieval fortress, his buildings sit directly on the ground, giving an effect of powerful tactile masses alien even to the late works of Le Corbusier. Significantly, one of Kahn's major works, the capitol at Dacca, Bangladesh (Fig. 652), is an ensemble of public buildings for a Third World nation, one more reminder of the apartness of modern architecture from its roots in Western culture. Significantly, just as Le Corbusier's object-buildings appear as sculptured forms set in a landscape, analogous to the practices of ancient Greece, Kahn's architecture offers substantial analogies with ancient Rome. His buildings are inward-oriented, aspiring toward vaulted spaces even when the ceiling could well have been a flat plane. Inside and out the eye is riveted by heavyseeming planes and masses illusively suggestive of the constructive bulk of Roman piers and vaults. Moreover, there is more than a hint of the snowflake patterns of Beaux-Arts planning in Kahn's layouts. These geometries appeared first tentatively and then, by 1960, more explicitly in his work, as he recognized his instinctive antipathy to the free plan of Le Corbusier, the open, continuous spaces of Mies, and the complex asymmetries of De Stijl.

Kahn's work thus represents a revisionist aesthetic, one more paradox in a history that seems to defy coherence through its innumerable inversions, reversals, and contradictions. However,

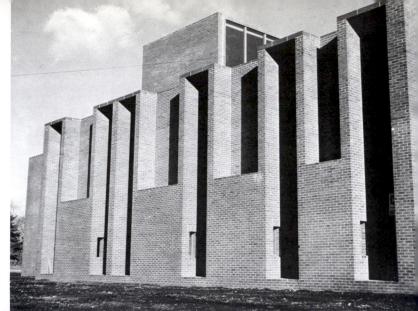

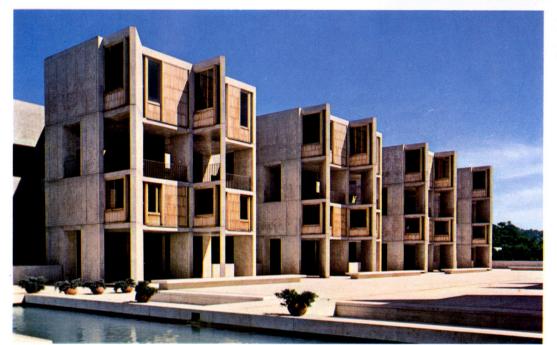

left: 653. Louis I. Kahn. Salk Institute of Biological Studies, La Jolla, Calif. 1959–65.

above: 654. Louis I. Kahn. Unitarian Church, Rochester, N.Y. Street façade. 1962.

there is simultaneously an integrative role in the work realized by Kahn. His distinctive brand of modernism, one appropriately monumental in its applications, makes viable once again certain procedures and even forms (though not details) of the academic heritage, rendering even clearer the importance of the Richardsons and the Wagners in the prehistory of the new architecture. By implication, Kahn's example (Figs. 653, 654) also brings into historical perspective the work of the American Beaux-Arts-trained architects of the 1920s and 1930s, skyscraper designers who flirted with the modern idiom while remaining glued to their earlier ideals of dense monumental form (Fig. 372). In effect, certain formal aspirations of Taut, Le Corbusier, and Ferriss (Fig. 366) seem to run together in the subterranean regions of Kahn's design thinking, and further compounding this syncretism are a number of parallels between Kahn's work and that of the early Wright. This is in no way the result of conscious borrowing or adapting; Kahn's roots are not those of an eclectic like Saarinen or of an historian-architect like Johnson, even though all are beholden to tradition, indeed to two traditions, one of the 20th century, the other of all that went before. The uniqueness of Kahn is that he did not choose to perceive a difference between the two.

The Diffusion of the New Architecture **350**

In his will to comprehend the wholeness of architecture Kahn joins Le Corbusier, and, for this reason, it is important to study his Dacca with Chandigarh (Fig. 646). The differences are those of personality and of profound oppositions in the modernist tradition, an isolated heritage that has yet to establish itself as an integral part of contemporary culture. If Kahn's work represents one of the last mighty statements of a formalist, monumental aesthetic—and there are many who would maintain the opposite—then it is ironic that his achievement is also admired by many who purport to represent alternate positions.

The Neomodernists

If Kahn, Johnson, and Saarinen can all, for various reasons, be called neotraditionalists, there is reason to dub as "neomodern" a very diverse, stylistically heterogeneous group of more recent designers. These architects span more than a generation and include, among others, Oscar Niemeyer, Kenzo Tange, Paul Rudolph, James Stirling, and Richard Meier. In one way or another, they have been influenced by Le Corbusier, but given the many-sided aspects of his work, this can mean many things. Blending the master's concepts to their distinctive national heritages, their own wellformed impressions of recent history, their individual predilections, and the nature of the commissions that have come their way, they have produced extraordinarily individual styles. Outwardly their work seems eclectic, but this is deceptive. Rather than borrow surface elements from earlier designers, the neomoderns have bored deeper, examining the motivations for the new architecture and even censuring it for its failure to live up to advertised goals. Indeed, these architects have sought to perpetuate the revolution of the 1920s, not to revive it. So, if one speaks of the eclecticism of Rudolph or Stirling, it is a matter of philosophy and design and not a simple surface borrowing of formal device or a hubristic gesture.

Oscar Niemeyer (1901-) is one of the more perplexing phenomena of the modern movement. While he was the earliest of Le Corbusier's gifted disciples, his work has proved with time to have been the least satisfactory. Yet this does not diminish Niemeyer's historical importance, for his apparent shortcomings have clearly indicated specific vulnerabilities inherent in the new architecture, especially its refractoriness when it comes to imitation or development of forms passed from master to disciple. In the case of the Johnson-Mies van der Rohe relationship, the style was passed with deceptive ease, Johnson making it look much easier than it probably was. In the case of Niemeyer, the transplant was subject to a gradual deterioration. A hybrid of Le Corbusier's architecture had been created in Brazil by 1950, but the offshoot was not rugged. Part of the problem was Niemeyer's graphic virtuosity; the buildings often seemed not to develop, in real scale, the suggested, implied promises of the sketch. Indeed, Niemeyer, like all Latin American architects, found his work compromised by shoddy building procedures and by unstable, and then repressive, political regimes. Brasilia (Fig. 655), the new capital city in the hinterland, built to a general plan of Lúcio Costa, another pioneer of the new architecture in Latin America, and with its official capitol buildings by Niemeyer, is one of the most telling indictments of the new architecture. Political reality decreed that it had to be designed and built in great haste, which accounts for many of the shortcomings. Niemeyer's concept for the capitol proper, two tall skyscrapers

> below: 655. Lúcio Costa and Oscar Niemeyer. Brasilia. 1950–60.

right: 656. Kenzo Tange. Town Hall, Kurashiki, Japan. 1958–60. flanked by two low saucer domes, one inverted, containing the legislative branch, was a fairly straight adaptation from the earliest Radiant City sketches. So, before all else, the architect failed to realize he was working with an outmoded, largely irrelevant model. And finally, it becomes clear that in the capitol buildings as well as the courts and the executive mansion, Niemeyer settled for simplistic formal concepts, tentative enrichments of the architecture of the heroic age, lacking in urgency and, if anything, rather precious and pretty, in the spirit of the fashionable American architecture of the late 1950s.

The early works of Kenzo Tange (1913–) are pale exercises in the international idiom and hardly prepare one for the originality of his concrete architecture beginning in the late 1950s. His robust constructive details, rugged surfaces, and striking forms were a welcome relief to the pervasive wanness of the modernist clichés then popular in the West; and the passage of two decades has not blunted the effect of such works as the Kagawa Prefecture at Takamatsu or the Kurashiki Town Hall (Fig. 656). Both contain minor

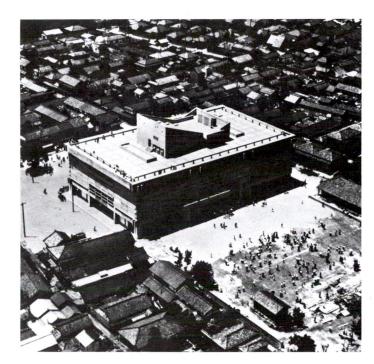

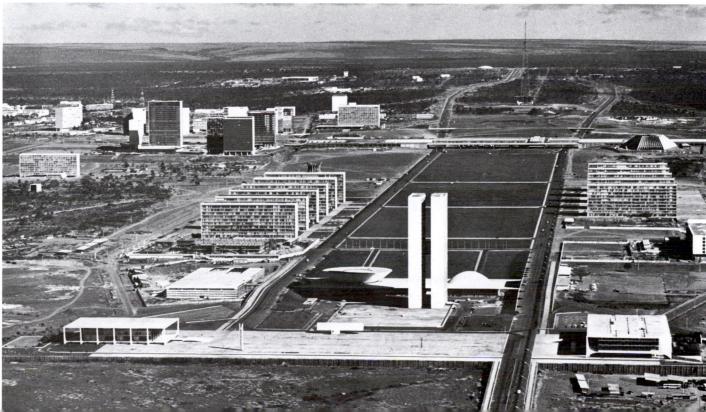

top: 657. Kenzo Tange. National Gymnasia, Tokyo. 1964.

center: 658. Kiyonori Kikutake. Civic Center, Miyakonojo, Japan. 1965–66.

above: 659. Paul Rudolph. Art and Architecture Building, Yale University, New Haven. 1963.

The Diffusion of the New Architecture **352**

solecisms and are jolting impositions upon the scale and materials of traditional Japanese architecture and towns. However, Tange's monumentality is free of the vulgarity of the commercial Western architecture then proliferating in Japan, an indication of the simultaneous high and low roads taken by modern architecture in its colonization of distant parts. Less obviously dependent upon the formulas of Le Corbusier's late style than others were, Tange draws upon certain elements of traditional indigenous composition, such as pronounced horizontal constructive elements and emphatically varied surface textures, but has transformed these beyond casual recognition. His work of this period is eclectic in its use of elements from two cultures to make a distinctive architecture, one more Western than not.

Tange's subsequent work, which has included remarkable urban schemes for Tokyo and for the earthquake-ravaged Yugoslavian city of Skopje, has evolved along original lines that have taken him far beyond his sources in Le Corbusier. His urban schemes grow out of the Corbusian projects of the 1930s and later and are even more grandiose visions of a Radiant City. These urban schemes form an important, if symbolic or fictive, element in the contemporary tradition, and ultimately they will probably be as indicative of our day as were the unbuilt designs of Leonardo da Vinci, Boullée, and Ledoux of theirs. Hypothetical architecture is frequently dismissed by practitioners with unimpeachably radical, modernist credentials, but such speculation and experimentation—the testing of the frontiers and limits of planning and design—are, if anything, presently increasing in frequency and importance.

Tange's work has in fact been influenced by one of the more recent experimental, utopian groups, the Metabolists, established in 1960, one of whose members is Kiyonori Kikutake (1928-). In 1964 Tange joined this group, whose ideas about urbanism and architecture revolve around a conviction that buildings should not be static but mutable, susceptible of transformation, addition, and amputation without compromise of the design as a whole. This updated futurism, akin to the sentiments of other radical groups of the 1960s, most notably Archigram in London, remains a kind of nirvana, although the ideal has given rise to certain forms in the recent works of Kikutake, Tange, and others which, although actually permanently anchored, give an illusion of movement. The tentlike, suspended structures by Tange for the Tokyo Olympics (Fig. 657) and the accordion-like profile of Kikutake's Miyakonojo Civic Center (Fig. 658) are instances of this trend, which has now led the major Japanese architects to the creation of distinctive, original buildings that continue to draw upon their unique national tradition.

Of the American architects of the 1960s who instituted a reevaluation of the formal and spatial elements of the earlier modernist tradition, Paul Rudolph (1918-) is by far the most important. His early designs manifested some of the uncertainty of the postwar decade, but by the early 1960s he had worked out a rich, virtually Baroque concrete style, less obviously dependent upon Le Corbusier than contemporary architecture in Japan but, rather, a more calculated mode influenced by the multiple strands of earlier radical architecture, including even certain images stemming from Wright. However, his distinctive, striated, brutal concrete surfaces invariably demand the closest comparison with the raw, brut concrete of Le Corbusier. The older architect had obtained his surfaces by allowing the imprint of the rough, crude formwork to remain uncovered. Rudolph secured his effect by more calculated means, deliberately roughening the surface or by employing a concrete block with a rough, tubular form embedded in the surface, which then textured the entire wall surface. Such effects were a deliberate reaction to the smooth, shiny exteriors of much American building of the day, and they were not immediately welcomed. Indeed, raw concrete still remains a material of dubious repute and respectability, even today, decades after its first appearance.

Rudolph's personal distillation of various sources into his characteristic mode came in the Yale University Art and Architecture Building (Fig. 659), a work of considerable controversy despite, or perhaps even because of, its powerful external image and complex interior spaces, which, to many, seemed self-indulgent. Worse, some serious functional flaws that were not corrected exacerbated the building's notoriety. There was a deep antimonumental sentiment flowing at the time of its completion. Feelings among students that questioned the very utility and relevance of architecture and its educational system were rife, and Rudolph had just produced the quintessential elite monument, devoid, to many eyes, of social responsibility or human values. During the student upheavals of the late 1960s, the building came to symbolize all that was felt to be unresponsive and negative in modern design, and, subsequently, a fire of mysterious origin gutted part of the interior in the spring of 1969, still one more curse on a curiously ill-starred structure. Despite these calamities, the building survived, albeit with extensive alterations, and Rudolph has gone on to demonstrate the viability of his stylistic convictions in a series of dramatic projects, including one for mass housing along the New York waterfront that in its complex, cubic articulation of dwelling units was a notable relief from the customary shapes of commercial highrise construction.

Of his actual buildings, one of the most typical is the campus of Southeastern Massachusetts University at North Dartmouth, begun in 1963, a complex that is dramatic in ensemble and detail, even though Rudolph was relieved of his role as designer for a period of time during construction. Here the architect's skill at picturesque composition linking the buildings to each other and to the landscaped exterior spaces is manifest. With vast overhanging bays dominating the exterior, Rudolph estabished a characteristic, monumental silhouette employing a time-hallowed formula out of the International Style, but with a constructive sculptural emphasis that is distinctively his. The major interior spaces-complex galleried stair halls serving as lounges-are further indications of his inventiveness. The popular breakthrough for this rugged, sculpturesque style came with the construction of the new Boston City Hall (Fig. 660), from a competition-winning project of 1962 by Kallmann, McKinnell and Knowles, a design that owed its characteristic topheavy shape to a Le Corbusier design of the period, the Monastery of La Tourette, near Lyons. Of course, all of these adaptations of the older architect's imagery have tended to reduce his impulsive forms into more calculated, rationalized, and systematic formsyet, ironically, this does not seem to distract from the expressive effectiveness of the derivative buildings. Such extravagant-seeming contemporary monuments contrast with the shallow, servile orthodoxy of the standard urban office or apartment tower.

The Americanization of European Architecture

As we have seen, American architecture was drastically Europeanized about 1950, not by sudden infusion of new designers and new ideas from the Continent but, rather, by a spontaneous adoption of limited aspects of an older modernism. Now, more than three decades later, a reverse flow has been accomplished, and European architecture seems to have become Americanized, at least in its more public manifestations. In this interval, English architecture has enjoyed a very special role, and many of its architects played the parts of gadflies in the development of recent architecture. The architectural culture of Britain seems more profound; its magazines maintain a high level of literacy, perceptiveness, and critical and historical insight. Moreover, its writers and correspondents have been eager and willing to engage in controversy and to expand their intellectual horizons beyond the conventional limits of architecture and urbanism. Significantly, for nearly three decades English designers have been earnestly sought out as visiting critics and lecturers in American schools, creating a vast movement of ideas across the Atlantic.

English architects were initially Americanized not through architectural channels but through a much broader and deeper curiosity concerning American culture as a whole. New Brutalism, the rallying cry that could not decide whether it was an ethic or an aesthetic, was, in fact, nurtured by the same set of circumstances and many of the same sources that were simultaneously giving birth to Pop in British painting and graphics (Figs. 616-619). The Americanophile attitudes current in England during the pre-Beatles era were highly skeptical of mainstream American modernism in architecture but were fascinated by the products of industry, especially the recent advances in auto and appliance design that Britain and the Continent had missed because of the dismal years of economic stagnation following the war. They also followed the contents of slick magazines-ads as much as photo and text copyand were influenced by the seamier pulp trash, "girlie" magazines, and the like. The New Brutalists were interested in overturning the rather polite modernism of postwar English architecture, and they were not interested in its slick American counterpart. Instinctively, they went for the vulgar, tough forms and were tempted by any kind of model that had a low degree of finish, and, if it had a lowly function to begin with, all the better. Intransigence and iconoclastic attitudes were more important for the New Brutalists than buildings themselves or even a coherent theory. Their effective tactics were a little those of a street gang, which, as it grew up, became a bit pompous, losing its original fresh, brash quality. They bequeathed several important features to British architecture as it

660. Kallmann, McKinnell and Knowles. City Hall, Boston. 1964–69.

came to be practiced in the 1960s: a knowledge and love of the heroic tradition of modernism dating from the 1920s, something they discovered only rather late in their passage, and a continuing love of architectural polemic and exciting adversary journalism unlike that of any other country.

The first of these predilections has given us a series of architects, of whom James Stirling (1926–92) was by far the most dramatic example, his work seeming to rejoin the innovating architecture of the 1920s across a twenty-year design vacuum. Revived modernism also spawned a group of boisterous utopians, the experimental architects of Archigram—Peter Cook, Dennis Crampton, Warren Chalk, Ron Herron, David Greene, and Michael Webb—a rock-group-like formation of young architects who published an occasional underground magazine that soon gained international renown. In effect, Archigram took over the graphics of the Pop movement and fed them into utopian projects that were the belated post-World War II explosion of imaginative architecture.

In the midst of this turmoil, Stirling, who had been practicing in partnership with James Gowan since the mid-1950s, produced a building, the Engineering Laboratories at Leicester University, which achieved instant international recognition as a landmark design (Fig. 661). In the early 1950s, Stirling briefly had been in the Brutalist group, but his own interests, not seriously different perhaps, led him apart from the others. He had mixed feelings about the new, rough, less precise forms of Le Corbusier and a greater admiration for the exactness and planar character of the early work. He also admired architecture of the 19th-century functional, industrial tradition-docks, warehouses, breweries, factories, and the like-and he had a particular passion for glass as a constructive material, not in any way out of step with 20th-century traditions but, nonetheless, a new glass architecture, expanding the various concepts of Taut, Mies, Johnson, and the American high-rise architects. Stirling's architecture is decidedly that of an intellectual but very different in tone and intensity from the intellectualisms of Philip Johnson. It is calculated in its organization and relation of parts-an inversion of the apparent spontaneity of Le Corbusierfull of difficult, expressive junctures, and the exact opposite of the more seamless designs of his established contemporaries who sought to draw everything together in an inexorable whole. Stirling's work may be complex, but it is not gratuitously compli-

above: 661. James Stirling and James Gowan. Engineering Laboratories, Leicester University, England. 1959–63.

> above right: 662. Archigram. Project for a "Plug-in City." 1964.

right: 663. R. Buckminster Fuller. United States Pavilion, Expo '67, Montreal.

The Diffusion of the New Architecture **354**

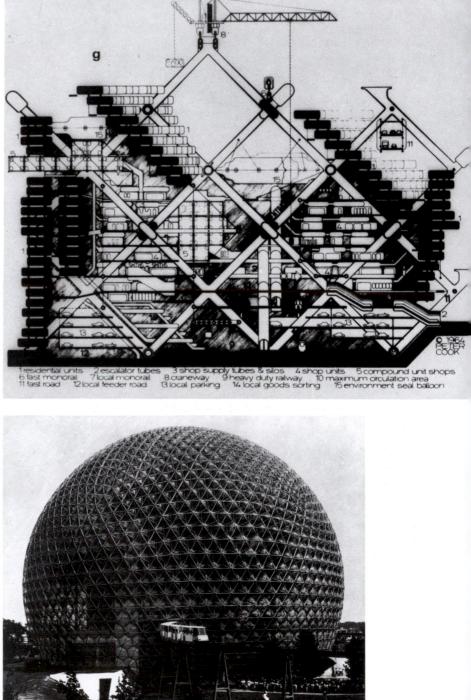

664. Pier Luigi Nervi and Annibale Vitellozzi. Sports Palace, Rome. 1956–57.

cated, and Leicester is an example of the clearly articulated working together of a multifunctioned structure. In its red brick, tile, metal, glass, and exposed concrete, various incompatible strands of the modern and protomodern tradition are spun together. Leicester is an integrative monument, implying a much greater possibility of unity in contemporary design than has appeared in decades, and this combination comes about without compromise in a building that also contains a powerful, iconic image.

If a neomodern, Stirling is also, albeit with a certain irony, a neo-Victorian, an artist of a Balzacian appetite when it comes to appreciating earlier styles. At the same time, he possesses prodigious powers of invention, and his subsequent work demonstrates that Leicester was not a momentary burning flame. The same materials, building technology, and imagery were used in buildings at Cambridge and Oxford. Moreover, at St. Andrews University in Scotland, Stirling built a group of student residences using a precast concrete technology, the individual elements bearing a diagonal herringbone pattern that gives a texture as uniquely personal to this architect's work as were the striations to Rudolph's concrete surfaces. Along with Kahn, Stirling is perhaps the most conspicuous inventor of new forms in the architecture of the last thirty-five years. Moreover, his work is admired by critics of many colors.

Although Stirling produced designs beholden to many facets of earlier architecture, his flexings of form were in line with that youth movement Archigram, which could find little else in contemporary architecture to admire. Archigram developed images out of science fiction and related comics, and was willing to engage in an experimental, futurist architectural design at the expense of actual building (Fig. 662). Crusaders and missionaries, its members lectured and taught everywhere, organized conferences of counterculture architects, and continued to publish. Their activity was closely linked to the various radical and youth activities of the 1960s. Their "plug-in" architecture was that of the turned-on, swinging London generation, English Pop painters, Carnaby Street fashions, and the pop music movement, which drew together such unlikely strands as American rhythm-and-blues and British turnof-the-century music-hall into such novel hybrids as the Rolling Stones and the Beatles and, ultimately, such failed utopian enterprises as Apple. Its forms were drawn from space technology and futuristic speculation: ranging from hardware to software, Archigram was capable of several varieties of anti-architecture, dwelling bubbles, walking cities, and other fantasies.

Godfather of Archigram and guru of the counterculture designers, alternative-architecture protagonists, and utopian hopefuls of all sorts was the American Richard Buckminster Fuller (1895–1983), a man for whom an adequate professional title had yet to be invented. He was the proponent of a comprehensive design science, known as the World Game. Best known as the inventor of the geodesic dome, an approximate sphere made up of a rigid assembly of three-dimensional triangles and related forms, he spent his career in seeking ways to make technology work to maximum efficiency in order to improve the human environment, and this vast effort brought him into close relationship with the history and practice of architecture. Another Leonardesque figure in his universality of interests, Fuller might better be compared with Euclid, Aristotle, Archimedes, and a slew of medieval scholastics than to any architects or artists, past or present. Delighting in his maverick role, he was that necessary generalist in an age of specialization and information explosions. His influence upon contemporary architecture has been more invisible than visible. Although the inventor of several ideas for industrialized dwellings, building components, and the like, Fuller made his greatest contribution to the realm of ideas. Nonetheless, his most characteristic form, the geodesic dome—one of the most spectacular being the one built as the United States Pavilion at Expo '67 in Montreal (Fig. 663)—is worth special mention in a text primarily devoted to built forms.

Megastructures

The dome is, of course, one of the most ancient of architectural forms, taking on sacred and cosmic meanings from remote antiquity and being re-employed in the Renaissance as the only proper capstone of the ideal building. Of 20th-century builders who have employed this form, only one besides Fuller, and an engineer at that, Pier Luigi Nervi (1891–1979), has used it with grace and conviction in our time, as can be seen in his concrete arena for the Rome Olympic Games (Fig. 664). Fuller's domes tend to have very special applications-as exhibition pavilions, as conservatories, as shelters for fragile electronic radar equipment, and even decoratively as nonenclosing space-frames. For the rest, his principles were adopted by the counterculture-by the publishers of Domebook and The Whole Earth Catalog-as dwellings for those moving out and away from the rigors and horrors of late machine-age cities and their suburbs. The geodesic dome proved an ideal, and perhaps even practical, house type for alternate living in remote areas, as a do-it-yourself architecture that also, through its distinctive form, became symbolic of a rejection of many contemporary values. Fuller's notions concerning the complete integration of energy and natural resources to construct a livable world form one of the most convincing of utopian visions, one that just might be realizable. Remarkably, his appeal was to a wide, otherwise incompatible, audience embracing the angry cultural dropout, the anxious architectural student, the suburban homesteader, and even certain autocrats of the Third World. However, Fuller's ideas had little or no response from the architectural profession as a whole, where the habits and traditions of generations have permitted a stylistic revolution in the 20th century but have not been able to tolerate so sweeping a change in patterns of thought and technique as implied in the theories of the inventor of the geodesic dome. The notion of living in a domical house, or of covering our cities with colossal miles-wide domes, as Fuller proposed for New York (Fig. 665), in order to regulate and improve the urban microclimate, struck us initially as eccentric and then as preposterous, impractical, even fanatical, mad. Yet there is a more immediate, menacing madness

in the form of our city as it is presently constituted: an organism in precipitous physical and social decline, despite, and most likely because of, the vast resources that have been squandered in building motivated by speculation rather than planning.

Under such harrowing circumstances, it seems almost inconceivable that an architect of the late 20th century would actually venture into the design and building of a comprehensive settlement that might serve as an urban alternative, but this is exactly the goal of the Italian-born architect Paolo Soleri (1919-), who has been active in the American Southwest for some four decades. After working with Wright at Taliesin West, Soleri struck out on his own, building a partially subterranean desert house with movable dome in 1950. During the next decade, he experimented with concrete forms at his own studio and residence at Scottsdale, Ariz., and simultaneously developed schemes for vast megastructures, which first took the form of sculpturesque models for bridges of no particular function and then developed into numerous sketches for mesa cities. Working in isolation and in a landscape still offering vast wilderness, he developed a theory of high-density settlements, cities contained within one vast building of expressive structure and form. These arcologies (architecture/ecology) were published in 1969 in a book, Arcology: The City in the Image of Man, and, simultaneously, his drawings and models were exhibited in museums in New York and elsewhere, eliciting great admiration. However, this seemed to be but one more endeavor destined to remain fantastic, exhibitionhall architecture-dream cities whose idea alone somehow would have to be sufficient to relieve the pressures and frustrations of realcity life.

Whereas Wright's prescription for remedying urban congestion was the decentralization of Broadacre City, the remedy proposed by Soleri is to meet congestion head on with a scheme for even greater density, thus ensuring the protection or, if necessary, the reclamation of the landscape as open space. While his formal means of expression are totally different, the conceptual underpinnings of his vision

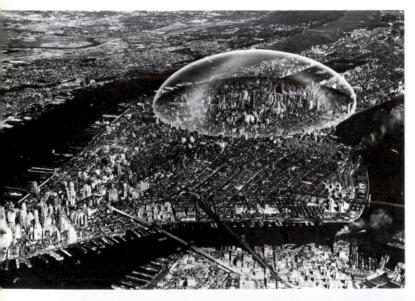

left: 665. R. Buckminster Fuller. Two-mile Hemispherical Dome for New York City. 1961.

bottom: 666. Paolo Soleri. "Arcosanti," a prototype Arcology for 3,000 people, being constructed near Cosanti, Arizona, since 1970.

right: 667. Moshe Safdie. Habitat, for Expo '67, Montreal.

are virtually identical to those of the Radiant City: high population concentration to allow for landscape to intervene between the buildings. Soleri's forms are futuristic, suggestive of the lunar and planetary cities of science fiction, with their complex, closed mechanical life-support systems; but they also owe something to such arcane sources as the endless, theatrical, spatial fantasies of Piranesi and to the cliff dwellings and other remains of pre-Columbian Indian cultures. Nor are Soleri's visions mere fantasies; for the past fifteen years he has been engaged in the construction of an arcology on a site near Prescott, Ariz. (Fig. 666).

Other architects were engaged in work on megastructures in the 1960s, among them Paul Rudolph, whose projects constitute some of his most important works. The Israeli architect Moshe Safdie (1938-), naturally drawn to the problem of human collectives through his upbringing on a kibbutz, was the author of Habitat (Fig. 667), a megastructure-like apartment complex, which was carried out as a housing exhibit for Montreal's Expo '67. Overambitious ideas concerning the prefabrication of the individually articulated dwelling units-stacked above, not directly on top of one other in order to ensure private open-deck space for each unitsecured only a qualified success for this scheme, and a more efficiently structured Habitat project for New York did not elicit the support necessary for construction. Safdie's ideas for clearly articulated multiple dwellings are less idiosyncratic than Soleri's. They are meant to meld into the fabric of the existing city rather than replace it outright, and the geometry of Habitat is more recognizably a part of the modern idiom's formal mainstream.

The Post-Minimal Seventies: From Conceptual Art to New Image

B y 1970, or even 1968, modernism had triumphed in art—in Minimalism, that is—to the point where its rationalistic search for "breakthroughs" to ever-greater formal refinement would carry self-purification to the brink of self-eradication. Once the modernist process had eliminated from art all but its most irreducible physical properties, what remained-a mere box or cube-seemed to have become little more than an object among other objects in the world, interesting less for what met the eye than for the appeal the logic of its creation made to the mind (Figs. 596-601, 668). And as the quick-minded soon grasped, a form so simplified or unitary as to be devoid of internal relations could not but establish relations with the ambient world. In other words, by shutting out everyday reality, Minimalism seemed to have engaged in the ironic act of expanding our consciousness of it. Alas, the reality the disenchanted saw mirrored upon the pristine, machine-finished surfaces of Primary Structures could scarcely have been more remote from the monolithic purity and oneness so prized by advanced formalist or modernist aesthetics.

After almost a quarter-century of accelerating prosperity and relative peace, Western civilization found itself riven by all manner of problems and divisive, competing interests-political assassination and environmental pollution, oil embargoes, drug and consumerist addiction, ban-the-bomb rallies, Red Brigade violence, the demands of the excluded, mainly women and minorities. Most troublesome of all, perhaps, the Cold War had exploded in flames all over Southeast Asia, triggering campus protests everywhere from Berkeley, Kent State, and Columbia to the Sorbonne. Meanwhile, late modernism continued along its own serenely aloof and deterministic way, convinced, as the Bauhaus architect Mies van der Rohe had stated in the 1920s, that "less is more." After Frank Stella, Morris Louis, and Kenneth Noland "corrected" Abstract Expressionism in order to render painting less emotional, gestural, textural, and thus flatter as well as more "autonomous," they found their own "advances" taken still further or corrected by Minimalists such as Donald Judd, Robert Morris, Dan Flavin, Tony Smith, and Richard Serra. These radical purists had given up painting altogether and had even declared the genre "dead," from its inability to become as literal and objectlike as sculpture-free of illusionism and thus of all reference to the world outside itself. Simultaneously, Bauhaus-inspired housing blocks were being abandoned and would soon be demolished because too minimalized, or dehumanized, to be habitable. Confronted with contemporary humanity's mounting distress as well as with the failure of modernism to acknowledge it, a number of younger, thinking artists decided that less was not more but, rather, a bore. As the critic John Perreau would write in 1979, "presently we need more than silent cubes, blank canvases, and gleaming white walls. We are sick to death of cold plazas, and monotonous 'curtain wall' skyscrapers . . . [not to mention] interiors that are more like empty meat lockers than rooms to live in."

668. Donald Judd. 5 Elements. 1968. Painted steel, $4'^{3}/8'' \times 1'^{1}/8'' \times 10'$ (overall). Museum of Modern Art, New York, Mr. and Mrs. Simon Askin Fund.

In an impure world, beset by shortages and outages, stagflation and devaluation, the arms race and fears of nuclear Armageddon, purity of form came to seem less a manifestation of noble ideals than a neurotic escape from life. Worse, the modernist vision, which had originated in an egalitarian dream of liberating art as well as society from the tyranny of old hierarchies, had itself become elitist, even academic, and as specialized or brutal as the science it chose to emulate. Certainly, it could no longer hold the imagination of creative individuals eager to go further than Pop to revitalize art by reintegrating it with life, by aligning it less with science and technology than with philosophy, language, poetry, narrative, theater, and decoration, with nature, the earth, and their organic processes. Most of all, the new generation would rediscover the past, a whole world of human experience progressively discarded by modernism in the overriding interests of its own "originality" and "presentness." Gradually, in the years 1968-72, the modern art of Europe and America ceased to be modernist and became first "post-Minimal" and then, more generically, "post-modern." It also provoked the term "pluralism" to characterize the numerous and varied ways in which post-modernism shifted art's emphasis not only from form to content but also from stylistic unity to stylistic diversity.

From the time Impressionism ventured into optics—began to treat perceived reality as a phenomenon of light—the modernist tradition in art had increasingly partaken of the methods and logic of science. Modernism, therefore, constituted an aesthetics of inverse progress, its pursuit of purposeful economy best summed up in the Mies dictum cited above. Reinforced by ever-more efficient technology, modernism grew confident, optimistic, and utopian, promising not only an endless succession of stylistic advances but also their salutary effect on the human condition. And the sense of modernism's messianic role remained intact throughout Abstract Expressionism, whose principal exponents-Pollock, de Kooning, Rothko, and Newman in the United States, Wols, Soulages, Tapies, and Dubuffet in Europe-evinced a profound belief in sublime, transcendent form and its power to somehow redeem the tragedy of the economically and politically stricken 1930s and 40s. However, with the arrival of a less wounded, cooler generation, Abstract Expressionism proved more absurd than sublime in the hands of the original masters' imitators. Witnessing this decline, the New York critic Clement Greenberg felt all the more persuaded that modernism's greatness lay in its urge towards self-criticism, the result of which would be complete autonomy, an art-for-art's-sake speaking most effectively when referring to nothing but its own timeless physical perfection and problem-solving process of realization. "The essence of Modernism lies," Greenberg wrote in 1965, "in the use of the characteristic methods of the discipline to criticize the discipline itself-not in order to subvert it, but to entrench it more firmly in its area of competence." However, by the time Greenberg wrote these words, his practical philosophy was being transformed by Minimalists into narrow, totalitarian orthodoxy, producing an extremist if splendid form of modernism that resulted-inevitably it would seem-in the reaction now known as post-modernism.

Pop, meanwhile, had already shown the way out of the formalist box, by preserving modernist auto-criticism while also forcing it to embrace not only art but life as well. For the sake of mocking both elitist formalism and popular culture, Johns and Lichtenstein, for example, had introduced into high, monumental art such low or everyday subject matter as flags and comics, imagery whose inherent flatness coincided exactly with the rectangular two-dimensionality of the painting surface (Figs. 548, 556). By the late sixties, however, Minimalism's preoccupation with objecthood had proved so overbearing that post-Minimalists departed from Pop in choosing not to parody form so much as to dematerialize it altogether. Taking Minimalist literalism one step further, its adversaries would therefore jettison the object but retain the thought behind its production, for as Sol LeWitt, a leading Minimalist, had written in 1965, "the idea or concept is the most important aspect of the work. . . . The idea becomes the machine that makes the art." That the object as concept might become more self-evident, LeWitt had reduced the Minimalist cube to an open skeleton of its own essential, permuted structure (Figs. 602, 669). Here, the ground was being laid for Greenberg and "the dogma of modernism" to be replaced by Marcel Duchamp, the old Dadaist who, as Pop artists understood, had long

669. Sol LeWitt. *Serial Project (A,B,C,D).* 1966. Stove enamel on aluminum, 2'8⁵/8" x 18' x 18'10". The Saatchi Gallery, London.

ago-back in 1913-invented the Readymade and, with it, demonstrated how art dependent entirely upon context for meaning could articulate a language other than form and still deliver a potent message (Figs. 286, 290). The language adopted by the first anti-Minimalists was verbal, preferred for its capacity to impart ideas and, once presented in the context of an art gallery, to become daringly visual (Fig. 670). This ushered in Conceptualism, brought forward by philosopher-artists, such as Joseph Kosuth and the British-American Art & Language group, convinced that art must, first and foremost, be information. Other Conceptualists would sabotage Minimalist stability by replicating its geometries in materials vulnerable to the eroding forces of time and tide (Fig. 671). Along with such Process Art, or arte povera as it would be called in Italy, came Performance or Body Art, whose practitioners endowed their work with the ephemerality of songs, dances, recitations, and video or antic theaterlike "pieces," often carried out in such cost-free or lowbudget "alternative spaces" as street corners, storefronts, abandoned schools, and derelict industrial lofts all over the world. Earth and Site Works constituted another category of post-studio/post-gallery art, huge, outdoor projects that rematerialized the object while ironically tending to undermine it, since an unprecedentedly colossal scale made the forms subject not only to the corrosive powers of nature but also to those of public opinion.

For all aspects of Conceptualism, documentation in the printed form of texts and/or photographs was crucial, since ideas could transform only if conveyed to an audience larger than that of the marginal enthusiasts willing to pursue the new radicality in its flight from mainstream venues. Finally, photographic documentation itself proved so central to the post-modern enterprise that it provided a conceptually "correct" means for artists to regain the studio and renew painting, painting moreover of an eye-fooling, illusionistic sort that modernism had tabooed at the very outset of its long hegemony. By hand-rendering a color transparency, Photorealists could represent the phenomenal world as only the post-industrial age would recognize it, processed through the media. Meanwhile, pictorial art gained a further new lease on life when Pattern and Decoration artists-first cousins to Arte Povera's ragpickersbetrayed the austere Minimalist grid by translating it into "found" variants appropriated from wallpaper and fabric designs, folk art, "women's work," and the Third World. Then, like a crowning moment in a pluralistic decade that ranged from severe restraint to recomplication, the "New Image" show opened in New York at the very end of the seventies, confirming the power of painting to survive its indictment by both Minimalism and Conceptualism. It also revealed the myriad ways in which artists commenced to revive the past without repeating it, mainly by using Conceptualist license to treat styles-abstract, representational, surrealist (Fig. 672)-as if they constituted a glossary of terms available for combination in whatever syntax seemed likely to warrant art-making, in the after-

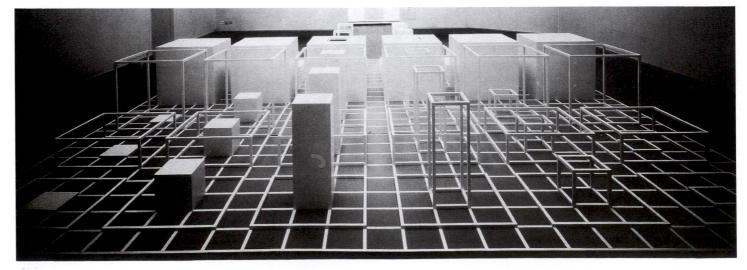

im-age (im'āj), n. [OF. F. image, < L. imago (imagin-), copy, likeness, image, semblance, apparition, conception, idea, akin to imitari, E. imitate.] A likeness or similitude of something, esp. a representation in the solid form, as a statue or effigy; also, an optical counterpart of an object as produced by reflection, refraction, etc. (see phrases below); also, form, appearance, or semblance (as, "God created man in his own image, in the image of God created he him": Gen. i. 27); also, an illusion or apparition (archaic); also, a counterpart or copy (as, the child is the image of its mother); also, anything considered as representing something else; a symbol or emblem; also, a type or embodiment (as, "An awful image of calm power... now thou sittest": Shelley's "Prometheus Unbound," i. 296); also, a mental picture or representation, as formed by the memory or imagination; an idea or conception; also, a description of something in speech or writing; in *rhet.*, a figure of speech, esp. a metaphor or a simile.-**real image**.

math of Minimalism's suicidal excess, which many believed had brought the history of Western art to its end.

What appeared quite genuinely to have ended was the avantgarde, killed off not only by the demise of its major cause-modernism-but as well by the total-information age, whose all-powerful media permitted the market to hype and "commodify" even the most "difficult" art-Minimalist bricks or the antics of fringe performance groups-thereby afflicting everything new and improved with almost instant familiarity and thus obsolescence. Also fueling post-modernism was a Conceptualist drive to supplant art-for-art'ssake with art-for-ideology's-sake. Theory, it seemed for a while, would all but replace practice, a development pioneered by Duchamp when he gave up art-making for conundrums and chess. Helping to rejuvenate practice were the writings of Walter Benjamin, the unfortunate German-Jewish writer, and onetime member of the so-called Frankfurt School, whom Kitaj memorialized in Arcades (Fig. 619). Even before World War II, Benjamin had forecast the predicament of "art in the age of mechanical reproduction," when rampant mediation would cost art its "aura" or "authenticity," the precious, unique quality once bestowed by unreproducible originality. Already nostalgic for what would be lost, Benjamin proposed that the "auratic" be salvaged through memory and "subtextual" analysis, a process that post-modernists made concrete in their "appropriations" and "layerings," techniques innovated by Picasso, reactivated by Pop, and then elaborated into a signature manner by several New Imagists, among many others to come in the eighties and nineties. Neo-Marxism, post-Freudian psychology, feminism, linguistics, and structuralism all contributed to postmodernists' theory-induced practice, with the names of certain 20thcentury European intellectuals-Ludwig Wittgenstein, Ferdinand de Saussure, Claude Lévi-Strauss, Roland Barthes-often invoked like a litany of saints. Once distilled, this brimming stew of speculative thought yielded post-structuralism, which would view all cultural products more or less semiotically-that is, as a sign system or language in which meaning arises less from the author's intentions than from the work's structure, composed of signifiers (words, motifs, forms) so arbitrarily defined by habit that, like black/white or hot/cold, they signify largely by virtue of their differences from other signifiers. Yet, with signification born of difference, of something that is never inherently or immediately present but always to some extent absent, every representation or "discourse"—visual, verbal, abstract, realistic—becomes so ambiguous and uncertain as a carrier of meaning that, according to Benjamin, it would appear to strip the author/artist of the authority once attributed to him/her and the "text"—the work—of both "presence" and, again, "aura." However dispiriting this may seem, it also allowed artists to go on creating, or at least mimicking the act, primarily by "deconstructing" Minimalist values—universality, originality, self-sufficiency, and steady, incremental progress towards stylistic purity—while

left: 670.

Joseph Kosuth. Art as Idea as Idea. 1966. Mounted photostat, 4' square. Courtesy Leo Castelli Gallery, New York.

right: 671.

Michelangelo Pistoletto. Venus of Rags. 1967. Mica on garden statue and cloth. Collection Mr. and Mrs. Tommaso Setari. Courtesy P.S.I, New York.

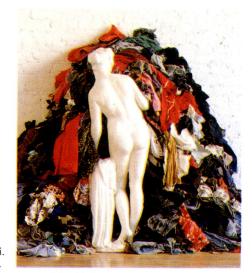

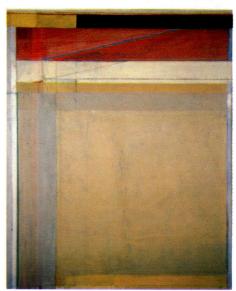

672. Richard Diebenkorn. Ocean Park #90. 1976. Oil on canvas, 8'4" x 6'11". Collection Eli and Edythe L. Broad, Los Angeles.

also courting their opposites: topicality, stylistic diversity, and active, nondeterministic engagement with ideas, history, and contemporary experience. Still, thanks to its democratic openness, the post-Minimal age would prove hospitable even to the classic Minimalists, now matured into the revered Old Masters of their own time. Some became "maximalists," as did Frank Stella, whose increasingly baroque, graffiti-scrawled, dynamically shaped and stratified reliefs would help inspire many a post-modern development (Fig. 755). At the same time, California's Richard Diebenkorn (1922–93) also continued to be admired for the pure, process painting of his Ocean Park series (Fig. 672). Here, a view of the Pacific through the artist's studio window becomes a celebratory occasion to fuse geometric facts with poetic feeling, the Cézanne/Matisse tradition with that of Abstract Expressionism.

Conceptual Art

Writing in 1967, Sol LeWitt coined the term Conceptual Art to characterize works, like his own, "made to engage the mind of the viewer rather than his eye or his emotions." Since "the idea becomes the machine that makes the art," planning and decisions should come before all else, which then relegates execution to the condition of "a perfunctory affair." Moreover, LeWitt continued, "ideas may [even] be stated with numbers, photographs, or words or any way the artist chooses, the form being unimportant." In 1969, however, he denounced painting and sculpture that "connote a whole tradition, and imply a consequent acceptance of this tradition, thus placing limitations on the artist who would be reluctant to make art that goes beyond the limitations." In his own work, as we have seen, LeWitt reduced the Minimalist cube to a schematic outline and its mass to a virtual rather than an actual volume, while simultaneously recomplicating it through mathematical permutations that often carried the most rigorous logic to mad, even if predictable, conclusions (Fig. 669). Thus treated as "pure information," LeWitt's open modular cube prompted Mel Bochner, a fellow Conceptualist, to remark: "Old art attempted to make the non-visible (energy, feeling) visual (marks). The new art is attempting to make the non-visual (mathematics) visible (concrete)."

Increasingly, however, younger artists had gone further and embraced ideas, at the expense of palpable form, until their work scarcely existed in the physical realm other than as "documentation"-numbers, words, or photographs. In 1968, Lucy Lippard and John Chandler wrote of "the dematerialization of art," a trend that could "result in the object's becoming wholly obsolete." Antecedents for the urge to move beyond Minimalism by "bracketing out" its conceptual component could be found in earlier postwar art. Back in 1953, Rauschenberg had erased a drawing given him, for that purpose, by de Kooning. Titling the ghostly yet lovely residual image Erased de Kooning Drawing, Rauschenberg said: "I felt it was a legitimate work of art created by the technique of erasing [rather than marking]. So the problem was solved and I didn't have to do it again." Rather, he sent a telegram, in lieu of a painting, when asked in 1961 to join other artists and submit a portrait of Iris Clert for an exhibition at the dealer's Paris gallery. The Dadaesque message read: "This is a portrait of Iris Clert if I say so-Robert Rauschenberg." Three years later, Yves Klein stripped Clert's gallery clean of all but its whitewashed walls and designated the empty space an exhibition called Le Vide, or "The Void," an emblem of the Rosicrucian belief that art's true significance lay beyond both sight and touch (Fig. 673). In Italy, Klein's Milanese disciple Piero Manzoni (1933-63) invented the achrome, a support spread with white kaolin and then pleated laterally from edge to edge (Fig. 674) or invested with other substances-cotton balls, fiber, pebbles, felt-composed in grids and often kaolin-covered. For Manzoni, the elementary, continuous space this produced constituted a primary sign representing nothing but its own existence—"simply being."

Only in 1970, however, did such epistemological concerns move from the wings to center stage in the theater of contemporary art, their arrival decisively aided by two exhibitions, the first, entitled "Contemporary Art and Conceptual Aspects," mounted by the New York Cultural Center and the second, called simply "Information," organized by the Museum of Modern Art. A key figure in the latter event was its co-curator, young Joseph Kosuth (1945—), an artist who went further than LeWitt and declared serious writing about art to be, on its own, a form of art. While LeWitt granted that "the idea itself, even if not made visual, is as much a work of art as a product," he also insisted that his articles "comment on art, but are not art." Kosuth, on the other hand, believed it imperative that he save art from commodification and transform it into a self-justifying act of inquiry with intrinsic worth to the human spir-

The Post-Minimal Seventies

it. For Kosuth, the Readymades of Duchamp marked the revolutionary turning point in the history of art, which shifted significance from "appearance" to "concept." According to this ideology, the aesthetics of formal quality and the depiction of reality have nothing to do with true art, which finds its validation in art activities themselves, not in the physical products of those activities. Thus, the strategies adopted by artists must be self-verifying in the same way that a mathematical equation is self-verifying.

To illustrate the principle, Kosuth exhibited a folding chair along with a full-scale photograph of it-a visual representationand an enlarged photograph of a dictionary definition of a chair—a verbal representation-calling the piece One and Three Chairs (Fig. 675). As this infers, Kosuth and like-minded Conceptualists would deal more with communication and linguistic problems than with formal objects. Thus, One and Three Chairs becomes a very simple model for the rather complex theory and practice of semiotics (the science of signs), as well as for an investigation into how meaning may be constructed or even deconstructed. Here, the phenomenal, or physical, chair constitutes the "referent" (something from the real world), which however seems less important than its representation by a sign-comprising a "signifier" (a percept in the form of an image, word, colors, etc.) and a "signified" (a concept or definition)—within a structure or "text" (the art work). In the constructed, human-made realm of culture, a chair assumes communicable meaning only when named or imaged-given a signifier that, because culturally determined rather than innate, makes sense largely through its "difference" from some other signifier. For semioticians, "cat" and "dog," like "dark" and "light," "male" and "female,"

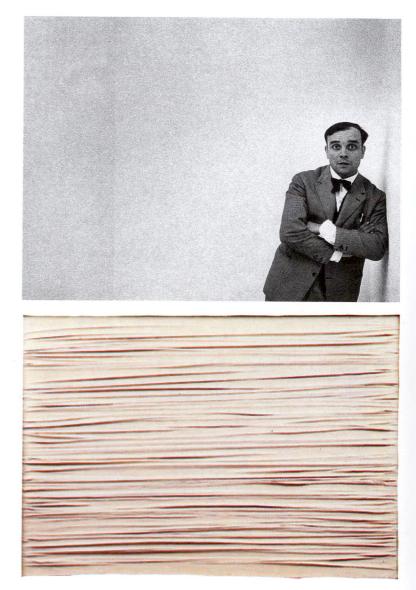

opposite below: 673. Yves Klein. *Le Vide* (being re-created by the artist at the Musée d'Art Moderne de la Ville de Paris). January 6, 1962. Photo © Harry Shunk.

opposite bottom: 674. Piero Manzoni. Achrome. 1957. Kaolin on pleated canvas, 291/8 x 41". Courtesy Hirschl & Adler Modern, New York.

below: 675. Joseph Kosuth. One and Three Chairs. 1965. Wooden folding chair, photograph of chair, and photo enlargement of dictionary definition of "chair"; chair 32³/8 x 14⁷/8 x 20⁷/8", text panel 24¹/8 x 24¹/2". Museum of Modern Art, New York. Larry Aldrich Foundation Fund.

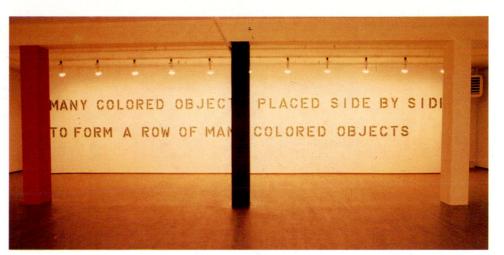

above: 676. Lawrence Weiner. Many Colored Objects Placed Side by Side to Form a Row of Many Colored Objects. 1979. Wall statement. Collection Annick and Anton Herbert, Ghent. Courtesy Alice Weiner, New York.

further and go straight for the metasign in the economical *Art as Idea as Idea* panels (Fig. 670). For this series, Kosuth had dictionary definitions of art-associated words blown up photostatically into negative, white-on-black squares. By thus mimicking Minimalist reductiveness and seriality, he deconstructed them, while also pursuing his own goals, which were to demonstrate how the verbal and the mental become visual, even aesthetically elegant art.

Already a Conceptualist by the mid-sixties, Douglas Heubler (1924—) gave the new dispensation one of its most ringing, antimaterialist statements when, in 1969, he announced: "The world is full of objects, more or less interesting; I do not wish to add any more. I prefer, simply, to state the existence of things in terms of time or of place." Four years earlier Heubler had abandoned Minimalist sculpture and turned to systems of documentation—verbal descriptions, photography, maps, and drawings—as the means to create works with "no privileged position in space." For certain pieces, he sought to "plug into" such non-art systems as the US Postal Services, which became the "medium" of *Duration Piece #9*. Heubler's proposal, which ultimately documented the work once completed, read:

On January 9, 1969, a clear plastic box measuring $1^{"} \ge 1^{"} \ge 1/4^{"}$ was enclosed within a slightly larger cardboard container that was sent by registered mail to an address to Berkeley, California. Upon being returned as "undeliverable" it was left altogether intact and enclosed within another slightly larger container and sent again as registered mail to Riverton, Utah—and once more returned to the sender as undeliverable.

Similarly another container enclosing all previous containers was sent to Ellsworth, Nebraska, similarly to Alpha, Iowa; similarly to Tuscola, Michigan; similarly and finally to Hull, Massachusetts, which accomplished the "marking" of a line joining the two coasts of the United States during a period of six weeks of time.

That final encounter, all registered mail receipts, and a map join with this statement to form the system of documentation that completes this work. January 1969.

When Lawrence Weiner (1946—) took account of language's capacity to stand for something, he gave up painting in favor of statements made to stand on their own as sculpture. Using stenciled, Letraset, outlined, or hand-drawn words, or yet printed books and posters, as his mode of presentation, Weiner began describing how a three-dimensional work of art might exist either as a mental construct or as a constructed work, should anyone care to take the description as a proposal and act on it (Fig. 676). However, he made the descriptions so general—MANY COLORED OBJECTS PLACED SIDE BY SIDE TO FORM A ROW OF MANY COLORED OBJECTS (1979) or TAKEN TO A POINT OF TOLERANCE (1973)—that viewers found themselves

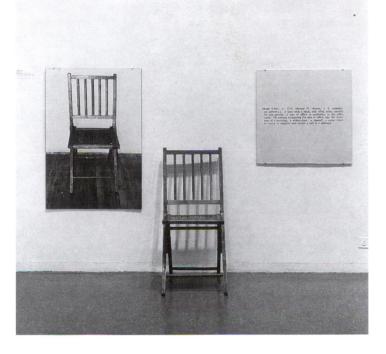

signify most clearly when locked together in the mind through their "binary" differences. But meaning that arises from "discourse" among such complementary rivalries-that is dependent upon something it is not-must always remain elusive, especially as it becomes "disseminated" along a whole chain of signifiers, forever present yet also absent in a layered, weblike, open-ended play that, as in One and Three Chairs, never resolves into a single center or essence. Given this view of art as ineluctably unstable and relative in its signification, Kosuth and his post-modern cohorts could readily cast doubt upon---"demystify"---all classical, universalizing notions of truth, reality, or knowledge as well as all modes of representing them. The immediate target was, of course, Minimalism, whose Primary Structure or Form revealed itself, under subtextual, semiotic analysis, to be less autonomous or literal than the product of a long, historical campaign of progressive exclusion, a trope for all manner of self-serving power systems, which "foregrounded" themselves too as simple and direct, the better to remain unchallenged in their exercise of power's nefarious ways.

In *One and Three Chairs*, Kosuth employed three components to lead the viewer from the real to the ideal in his exploration of the possibilities of "chairness," thereby transforming analysis into art and producing a kind of "metasign," which finally triggers further analysis of how art means. Soon, he would simplify, yet complicate,

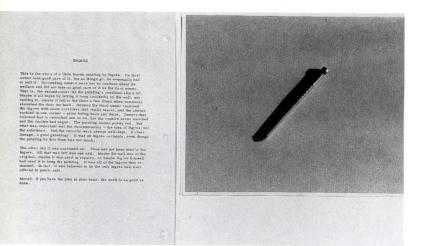

below: 677. Art & Language (Ramsden). 100% Abstract (95% + 5%).
1968. Oil on canvas, 16¹/₈ x 15³/₄". Courtesy Lisson Gallery, London.
above: 678. John Baldessari. "Ingres," from Ingres and Other Parables.
1971. Photograph and typed text, 11 x 25". Collection Angelo Baldessari, Bari.

making the piece their very own once they supplied such missing elements as how many, what kind, or from what point. In this way art could function overtly as the new post-structural linguistics or semiotics had revealed that it inevitably did, for, in the words of Roland Barthes, "it is language which speaks, not the author."

Robert Barry (1936—), who together with Kosuth, Heubler, and Weiner completed the quartet of hard-core Conceptualists active in New York, cultivated an art even more fugitive than the dematerialized works just seen. He also evinced charming touches of whimsy that seem especially welcome in the sober, even sanctimonious realm of Conceptual Art. In a characteristic formulation, Barry described a piece as:

All the things I know But of which I am not At the moment thinking— 1:36 PM, June 1969.

Like Klein, albeit for quite different reasons, Barry believed "nothing" or "the void" to be the most potent thing in the world. As a result, he particularly liked citizens-band radio transmitters, whose airwaves are invisible yet inarguably real and could scarcely have offered greater potential for delivering information.

Nevertheless, the more art sloughed its materiality the more it posed the problem of how, as Seth Siegelaub wrote in 1967, "to make someone else aware that an artist had done anything at all." As it turned out, the best media for communicating ideas about art were the print ones. Eager to promote Conceptualism, Siegelaub organized and published catalogues, which he considered not only a primary source of information for an exhibition but also the exhibition itself. With this as his motive, he joined with John Wendler in 1968 to produce *The Xerox Book*, in which LeWitt, Kosuth, Heubler, Weiner, Barry, and Carl Andre had each contributed a twenty-fivepage piece made, for the most part, by Xerox. In 1969, after Siegelaub mounted an exhibition comprised of nothing but catalogues arranged on a coffee table surrounded by a few chairs, the critic Jack Burnham praised the installation and called Siegelaub the best artist in the show.

Like Kosuth, with whom they collaborated, the Anglo-American collective known as Art & Language claimed the status of art for their criticism and theory, reasoning that if critical issues were inseparably bound up with whatever art was made of, then the discourse itself must be art. Of all the Conceptualists holding this view, Art & Language may have been the most radical and doctrinaire, from the time of the group's founding in 1968, a year before the first

The Post-Minimal Seventies

issue of their journal Art-Language appeared. In addition to Kosuth, members included London-based Terry Atkinson, David Bainbridge, Michael Baldwin, Ian Burn, Charles Harrison, Harold Hurrell, and Mel Ramsden, all of them passionate advocates of a politically engaged art practiced through the media of "conversation, discussion, and conceptualism," registered not only in print but also on tape, microfilm, and posters (Fig. 677). Steeped in analytical philosophy, the later writings of Wittgenstein, Marxist theory, and, especially, post-structural semiotics, Art & Language made art by "collaging" their various treatises as a way of foregrounding or exposing the contradictions within both the aesthetics of "normal art" and the "systems" assuring the art's dominance. When finally presented, their work could be wall panels, installations, or even vast files, none of which, however, had much impact beyond the insider world of experimental art. To solve this problem, Art & Language, together with many other Conceptualists, later found it more efficacious to undermine modernist painting by doing it-as a mole would, that is (Fig. 750).

Binary opposition-visual/verbal, order/chaos, diachronic/synchronic, appearance/essence-also reigned in the Story Art of Southern California's John Baldessari (1931-), who as a Conceptualist rose from the ashes of his own modernist work-thirteen years of it-which the artist ritually cremated in 1970, a year before he promised, in a new wall piece: "I will not make any more boring art." Instead, he adopted an aesthetic derived not only from straight text (information) and straight images (photography) but also from his habit of teaching by telling stories. Like many good storytellers, Baldessari would make his illustrated tales as simple as parables, but, as in parables, their simplicity would also be deceptive, replete with sly, witty paradox sure to make the alert think twice about even the most commonplace assumptions. A student of information theory, Baldessari became obsessed with the semantic and the aesthetic, the obvious and the unsuspected in every message. In a 1967 piece, for example, he had a sign painter (à la Duchamp) inscribe the following in block letters on a sized canvas: EVERYTHING IS PURGED FROM THIS PAINTING BUT ART, NO IDEAS HAVE ENTERED THIS WORK. By its very directness, the picture could only cause viewers to rebel while at the same time obliging them to inquire why they were rebelling, which then led into a new mental territory filled with questions about the nature of art, painting, and ideas. In Ingres and Other Parables, the most famous of his early narratives, Baldessari collided the serious and the silly, the linguistic and the pictorial until they both undercut and illuminate one

right: 679. Bruce Nauman. *Waxing Hot.* 1966–67. Color photograph (edition of 8), 19³/4 x 20". Courtesy Leo Castelli Gallery, New York.

below: 680. Bruce Nauman. *Life Death.* 1983. Neon, 37" diameter. Courtesy Leo Castelli Gallery, New York.

below right: 681. Ed Ruscha. *She Gets Angry at Him.* 1974. Egg yolk on moiré, 36 x 40". Courtesy Leo Castelli Gallery, New York.

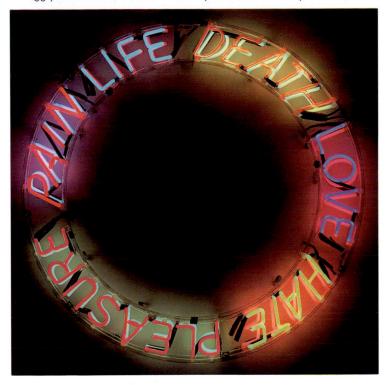

another. Here (Fig. 678), inspired by a pun on Ingres, France's great 19th-century Neoclassical painter, Baldessari imagined a "hang nail" or the nail on which a neglected painting by Ingres hung until it deteriorated, leaving only the nail to stimulate thoughts about the glory, as well as the market value, of the master's art. At the end of an allegory on how modernism's progressive reductiveness finally produced Conceptualism, "Ingres" concludes with this moral: "If you have an idea in your head, the work is as good as done."

Still more literally than Baldessari, Bruce Nauman (1949—), a much younger California Conceptualist, sought to dematerialize the art object by the ironic process of materializing words as sculpture. In a color photograph subtitled *Waxing Hot*, from the set of eleven such pieces, Nauman applies wax to a row of freestanding letters that spell HOT (Fig. 679). Later, he would shape neon tubing into binary pairs of words, sometimes together with images, that take turns flashing on and off in syncopated sequences to comment on the human and social predicament (Fig. 680). With the mesmerizing power of anonymous advertising signs, these linguistic sculptures "confer material form on signification, and, in this way," as Anne Rorimer wrote in 1989, "alternatively bestow signification on material form."

Also in Southern California, Ed Ruscha (1937—) took up words as representational subject matter at such an early date (1959) that his art normally appears in the context of Pop Art. Typically, Ruscha selected single nouns, verbs, names, or short banal phrases from the oceanic utterance of everyday life and isolated each at the center of a field as spare as a Minimalist canvas (Fig. 681). Adding to the objectification wrought upon words by their displacement from a verbal to a visual context, Ruscha tended to render them in such attention-getting, non-art media as egg yolk, silk moiré, blood,

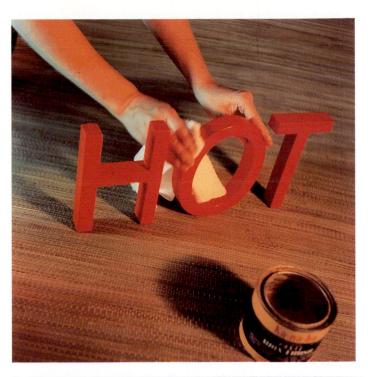

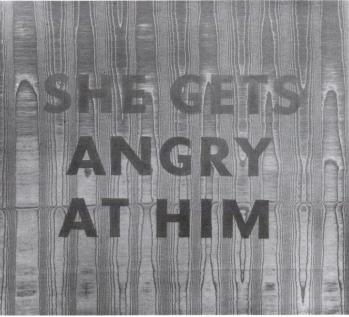

fruit juice, Mexican bean soup, gunpowder, and Pepto Bismol, sometimes with trompe-l'oeil, Photorealist effects. The laconic/ ironic results spurred Ralph Rugoff to suggest that the word pictures could be "read like homespun samplers of contemporary paranoia and decadence."

If not the homespun, certainly the commercial side of American culture came to the fore when Ruscha periodically forsook words in favor of photography and made some of the first artists' books, a medium through which Conceptualists of every stripe discovered endless possibilities for satisfying their puritanical urge to deny the hedonist pleasures of "decadent" painting and sculpture (Fig. 682). Since the title of *Every Building on the Sunset Strip* says it all about the book's content, Ruscha provided no text in the interest of absolute neutrality, which, as he clearly anticipated, would prove unfeasible once the deadpan stretches of pure iconography began to speak more loudly about their subject's aesthetic impoverishment than could a thousand words of editorial commentary.

The Post-Minimal Seventies

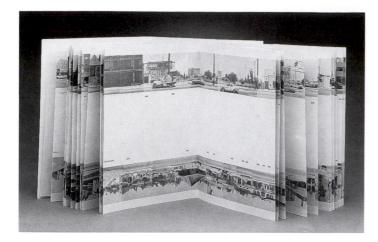

In Germany, Bernd and Hilla Becher (1931—; 1934—), as far back as the sixties, focused their camera on fine, old industrial architecture—water towers, gas tanks, blast furnaces, mine heads—and then treated the images as if they were words in a specialized vocabulary capable of being shaped into a grammar for communicating messages about the miracle of beauty in unsuspected places (Fig. 683). Organizing their specimens by type, scaling them to the same size, and cropping extraneous environment, the couple finally structured each set—an eerie balance of stylized repetition and inventive variation—within the serial matrix of a classic Cubist/Minimalist grid. Yet, while the aesthetic may appear to dominate both subject and format, it cannot but serve, in a polluted world, to question the beneficence of industrialization.

Hanne Darboven (1941—), the Bechers' compatriot, also retained the grid format for her preoccupation with the effects of time, while acknowledging the fourth dimension's essential abstraction by creating narratives rendered abstract twice over (Fig. 684). That is, she articulated them in her own handwriting but often, instead of spelling out actual words, merely enumerated or scrawled, rather like a graffitist, as though time were too ineffable an experience to be captured in readable signs, even as the gridlocked sheets of calligraphy endeavor to make it concrete.

The similarly motivated On Kawara (1931—), a Japanese artist active in New York, attempted to "seize the moment" by painting Minimalist canvases cleared of all but a single, solid color and, block-lettered in white, the date of each work's execution (Fig. 685). If the traditional medium and painterly touch acknowledged the immediacy of the moment, the unfolding of the series, in one new picture painted on every succeeding day throughout extended periods, could only confirm the transience of all human experience.

As an oppositional challenge to established culture, Conceptual Art of every sort could be said to have engaged in what Benjamin Buchloh has called "institutional critique." However, three European Conceptualists-Daniel Buren, Hans Haacke, and Marcel Broodthaers-focused with almost unwavering intensity on this aspect of the post-modern project. Daniel Buren (1938-), a French artist determined to rid painting of illusionist as well as expressionist features, decided in 1965 to reduce the form and content of his pictorial work to awninglike vertical bands 8.7 cm (about 31/2 inches) wide. Noting how Minimal objects tended to illuminate their surroundings more than themselves, Buren took advantage of the phenomenon when he set about to dramatize the interdependence of art and its context. For 140 Stations du Métro Parisien, he pasted rectangles of his generic abstractions on the ad-thronged billboards-ironically picture-framed like huge, "salon-machine" paintings-in just that many stations deep inside the Paris subway (Fig. 686). Here, Buren's art could extricate itself from the authority of the gallery/museum network, at the same time that the sheer

open-endedness of the art allowed it to escape commodification at the heart of its temporary refuge, an escape increasingly less available to museums. In a further irony, recontextualization endowed Buren's anonymous stripes with a near-autographic identity, a distinction they would never have enjoyed in a gallery among all the other varieties of stripe painting made in the fifties and sixties.

Germany's Hans Haacke (1936—) waxed even more trenchant in his critique of the art "situation," which he continues to pursue not by recontextualizing art but rather by making its institutional con-

far left: 682. Ed Ruscha. Every Building on the Sunset Strip. 1966. Artist's book, 71/8 x 5⁵/6". Courtesy the artist.

left: 683. Bernd and Hilla Becher. Water Towers. 1980. Nine black-and-white photographs, mounted; each 201/4 x 16 x 1/4". Courtesy Sonnabend Gallery, New York.

text play host to its glossed-over compromise with the outside world. In a 1975 piece called *On Social Grease* Haacke exhibited six large metallic plaques engraved with quotations from corporate executives extolling the benefits of culture to the capitalist enterprise. The leading excerpt came from Exxon's Robert Kingsley, who had announced: "Exxon's support of the arts serves the arts as a social lubricant. And if business is to continue in big cities, it needs a more lubricated environment." By this means, Haacke deconstructed the vaunted, albeit presumptive autonomy of high art, as well as the opportunism of big-business patronage of the arts.

Far from wishing to evade commodification, the Belgian poet Marcel Broodthaers (1924–76) began making art objects precisely to sell for the income to support himself while he wrote poetry as a purely spiritual experience. After his first encounter with Pop Art in 1964, Broodthaers said: "The idea of inventing something insincere finally crossed my mind, and I set to work straightaway." Yet, as he well understood, nothing so playfully subtle as his parodies could ever sell like the proverbial hotcakes, especially when self-directed, as they often were, even while aimed at the "system." For a number of early "sculptures," he filled a steam pot to overflowing with the empty shells of mussels-a plentiful, flavorsome food in Belgium often harvested by the impecunious Broodthaers along the northern seacoast-to create a Pop/Minimal object casual enough to suggest insincerity, yet so evocative of previous pleasure as to infer that herein lies its meaning (Fig. 687). More important, perhaps, Broodthaers assembled what he called "museums," complex gallery installations serving as vehicles of provocative thought on a wide range of issues related to aesthetic experience. The most celebrated of the museums was the one he installed at the Düsseldorf

Kunsthalle in 1972, under the assumed authority of the "Musée d'Art Moderne, Département des Aigles" and entitled "The Eagle: from the Oligocene Era Till Today." With 266 items from collections in Europe and America, as well as from Broodthaers's own magpie holdings, and a two-volume catalogue entirely by the artist, the exhibition incorporated every conceivable kind of mediumpainting, sculpture, wine-bottle and cigar-box labels, comics, national emblems-to represent the eagle from its existence as a fossil to its role in myth and symbol. An exuberant semiotician, Broodthaers also made nimble, allusive use of the word "eagle," citing it as a synonym for Napoleon, as part of the French phrase "he's no eagle," meaning that he is a bit of an idiot, and the name of a Swiss village. By treating all the disparate materials alike, regardless of their relative aesthetic, historical, or market value in other contexts, and by cataloguing them alphabetically-from Basel to Zurich—according to the source of the loan, Broodthaers allowed his simulated museum to transcend the hierarchical ordering common in art exhibitions. And whereas Duchamp had raised a vulgar urinal to the status of abstract sculpture merely by using his authorial power to exhibit the object as art, Broodthaers reversed the tactic through an inclusiveness designed to foreground the authority of museums to exclude all but whatever they may deem consonant with some arbitrary standard of taste. Equally leveling was the card placed before every exhibit, reading: "This is not a work of art." Here, Broodthaers countered the great Belgian Surrealist René

left: 684. Hanne Darboven. 24 Songs: 7-Form Index. 1974. Ink on vellum; 48 panels, each 497/8 x 117/8". Courtesy Leo Castelli Gallery, New York.

left center: 685. On Kawara. *Today.* Ongoing series, from 1966. Courtesy Sperone Westwater, New York.

bottom left: 686. Daniel Buren. 140 Stations du Métro Parisien. 1970. Courtesy John Weber, New York.

right: 687. Marcel Broadthaers. Moules sauce blanche (Mussels in White Sauce). 1967. Casserole, mussel shells, and paint; 19⁵/8 x 14¹/8 x 14¹/8". Courtesy Galerie Isy Brachot, Brussels.

below: 688. Robert Rauschenberg. *Pelican.* 1963. Performed here by the artist, Carolyn Brown, and Alex Hay. Photo © 1965 by Peter Moore.

Magritte, a onetime mentor who had labeled his trompe-l'oeil painting of a briar pipe "This is not a pipe." Instead, of course, it was a representation, not reality despite eye-duping appearances to the contrary. Moreover, by the very fictitiousness of his museum, Broodthaers made wry commentary on the supposed fictions through which cultural institutions elevate art above life, a fossilizing process that robs art of social relevance—renders it "insincere."

Performance Art

For certain rebels against formalist tyranny, even works on paper proved too material, a confinement they sought to escape by literalizing the theatrical element in Action Painting. Eventually, these dissenters recast Story Art into Performance Art, which drew so many adherents that critics have sometimes thought it the genre most characteristic of the period. Very much as Michael Fried had predicted, sculpture reduced to its physical minimum yielded not autonomy but, rather, contingency and a kind of theater, since the relationless work seemed inevitably to establish relations with its "situation"setting, lighting, atmosphere. Most of all, it depended upon the performance of viewers, who by approaching the piece from various angles transformed themselves into "actors." Now, Performance artists would on their own become actors and, while eliminating the object, take the whole world for their stage, a radical departure that found key inspiration in Happenings, of course, but more especially, perhaps, in photographic images of Jackson Pollock, "rope dancing" with pigments, or Yves Klein making Anthropometries before a live audience, or yet Robert Rauschenberg on roller skates in his 1963

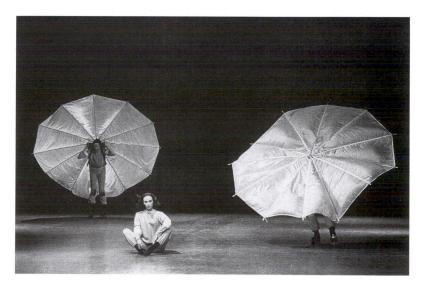

piece entitled *Pelican* (Figs. 494, 609, 688). Too, if Performance triumphed in the late sixties and early seventies, it was owing in part to a sense of logical imperative within the development, given that modernism, for a century or more, had progressively divested itself of all extraneous matter until the artist emerged as his own best subject—"in many cases," to quote Jack Burnham, "his only legitimate subject." With themselves—their bodies, voices, movements, ideas—as the essential medium, Performance artists could "exhibit" any time or anywhere and in direct contact with viewers, thereby controlling the presentation and consumption of their work without the intervention of dealers, critics, and curators.

No one realized the possibilities of Performance more movingly than Joseph Beuys (1921–86), the German sculptor/activist/ teacher/guru who, even now, years after his death, may be the most

right: 689. Joseph Beuys. *Coyote: I Like America and America Likes Me.* 1974. Week-long action staged in the René Block Gallery, New York. Photo Caroline Tisdall. Courtesy Ronald Feldman Fine Arts, New York.

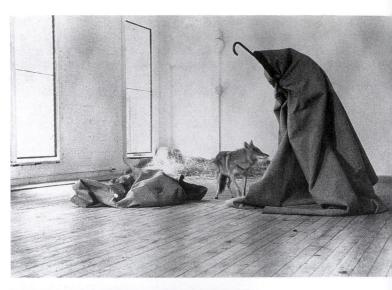

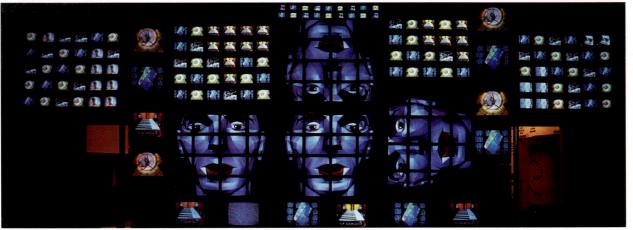

left: 690. Nam June Paik. Fin de Siècle II. 1989. Video installation, 300 television sets of various sizes. Collection Laila and Thurston H. Twigg-Smith. Courtesy Whitney Museum of American Art, New York.

influential European artist of the post-modern era. Richly endowed with the Germanic impulse towards myth, poetry, abstract thought, and transcendental values, Beuys could only deepen his view of human experience and organic life as mystically, even mutually redemptive once he embraced the miracle of his return from the death trap of Germany's eastern front during World War II. Shot down while on a mission over the blizzard-swept Crimea, Beuys survived thanks to his rescue by nomadic Tatars and the care they gave him in their warm, felt-insulated tents. Never would he forget how they had thawed his frozen, shattered body with applications of fat, felt wrappings, and a pungent diet of cheese, fat, and milk. Nor would he ever lose consciousness of the Tatars' rugged independence, their courage to get on with their lives utterly contemptuous of Soviet and German armies alike. Thereafter, he would rarely make a work of art without using or evoking felt and fat, materials that for him could serve as potent emblems of healing. Equally significant for Beuys was the metaphoric import he found in wild fauna, such as those hunted yet mythologized by the Tatars, especially the swan, the stag, and the hare, creatures that he believed resonant with spiritual power and thus treasurable companions of the soul. Drawing on the trauma of his own life and that of Eurasia as well as Europe, Beuys sought to rehumanize both art and politics, mainly by creating works like none ever known before in art: "Thinking Forms," "Spoken Forms," and, particularly, "Social Sculpture," meaning "how we mold and shape the world in which we live. Sculpture as an evolutionary process: everyone is an artist." "That is why," he said, "the nature of my sculpture is not fixed and finished. Processes continued in most of them: chemical reactions, fermentations, color changes, decay, drying up. Everything is in a

The Post-Minimal Seventies

as when he filled chair angles or room corners with great clumps of animal fat or ritualistically wrapped himself in fat and felt. To heal a United States sickened by the Vietnam War, just as the Tatars had healed him "homeopathically," Beuys arrived in New York to perform one of his most memorable and photogenic "actions" (Fig. 689). Calling the piece *Coyote*, the artist engaged in a three-day "dialogue" with a live specimen of the eponymous beast from the American wild, both "actors" housed in a gallery and surrounded by folded sheets of felt, a bed of hay, and fifty copies daily of the latest Wall Street Journal. As the coyote slept on the felt, fouled or ate the Journal, peered out the window at Manhattan's stone "wilderness," or glowered at the gaggle of spectators, Beuys silently followed and mimicked, secure inside a felt tent that he held aloft, like a tall sculpture, with a kind of shepherd's crook, before concluding with a smoke while he relaxed on the hay next to his now-companionable protagonist. Gradually, an illuminated flashlight peeking out from the pile of felt had dimmed as its battery ran down, a poignant "entropic indicator" of the human condition. In the Red Man's veneration of the coyote and the White Man's persecuting hatred of the animal, Beuys saw a ruinous polarity-of instinct and intellect-that cried out for resolution. Just as he had attempted, in earlier pieces, to find the crossing point of energy and trauma in Europe and Eurasia, here he made a similar effort for the benefit of North America.

state of change." Thus constituted, his forms might appear sentient,

For three hectic years in 1962–65, Beuys collaborated with a neo-Dadaist German/American group led by George Maciunas and known as Fluxus, a Greek word for "flowing" adopted from the ancient philosopher Heraclitus, who said: "All existence flows in the stream of creation." One of the many avant-garde manifestations

of the Cagean desire for an art integrated with life, Fluxus engaged in mixed-media events, publications, and mailing activities, but specialized in performance because of the immediacy of the communication it allowed between art/self and audience/society. Moreover, several key members, such as Nam June Paik, happened to be trained musicians, whose ability to produce acoustic effects attracted a relatively large public to Fluxus "concerts." Yet, in the process of breaking down barriers separating theater, poetry, music, the visual arts, and dance, Fluxus did not so much articulate an ideology of self-regenerating creativity as give rather anarchic demonstrations of how to drink beer, urinate in public, or sound notes in a score with arrows hitting their targets. And so, while sympathetic towards the group's animistic belief in the hidden life of objects and materials, Beuys severed relations with Fluxus because "they held a mirror up to people without indicating how to change anything."

Korean-born Nam June Paik (1932-), a Fluxus star in whose genuinely original art the Fluxus spirit survives at its best, began his career as a classical pianist and electronic-music composer in Germany. By the early sixties, however, he had switched media and moved to New York after discovering in video the means to enrich his musical concerns with a visual dimension. The metaphoric possibilities of sound combined with sight proved irresistible to an artist who perceived the post-modern world as a fluid synthesis of great ideas from both East and West. Instead of ignoring admass television, as most intellectuals did. Paik felt drawn to its technology, first because the kind of music he composed made him comfortable with electronic circuitry, but also because the very ubiquity of the medium made it seem an ideal vehicle for progressive concepts. Working with Schuya Abe, a brilliant Japanese engineer, Paik discovered so many variables within the optical/chemical/electronic workings of color television that the whole system ended up being statistically random, rather like humanity itself, where individuals all have the same "wiring" but look and behave quite differently. Consistent with their hope of reaching into society for the sake of changing it, Paik and Abe reached into their TV sets and modified them until imagery stretched almost beyond recognition, scrambled in response to microphones picking up local noises, changed colors or turned black and white, among myriad other tricks. Once the collaborators developed their sophisticated video synthesizer, the artist had at his command a medium of such vast creative potential that he felt confident enough to boast: "As the collage technique replaced oil paint, the cathode ray tube will replace the canvas." Always eager to humanize both technology and culture, Paik became notorious for such erotic pieces as Opera Sextronique and TV Bra for Living Sculpture, both performed in 1969 in collaboration with the classical cellist Charlotte Moorman, who for the second piece wore a pair of miniature "boob tubes" over her otherwise bare breasts. As Moorman played compositions by Paik and others, the image

changed on the tiny screens, shifting back and forth between a droning politician and a young woman watching him from the privacy of her bath. Needless to say, *TV Bra for Living Sculpture* made unforgettably hilarious comment on the degree to which the total-information age increasingly muddles the personal and the public. Since then Paik has made video pyramids, gardens, robots, triumphal arches, and, most spectacular of all, an immense billboard gridded to alter its jazzy, complex pattern of display in sync with or in counterpoint to a wildly rocking electronic sound score (Fig. 690).

The empress of Performance Art was and remains Laurie Anderson (1947-), a handsome young woman from Chicago who studied Egyptology in college and whose manifold talents embrace sculpture, singing, composing, graphic design, and electronic effects. Early in her career Anderson worked as a street performer, in cities like Genoa and New York, the better to mediate between art and popular culture. In Duets on Ice she played the violin while wearing a pair of ice skates embedded in blocks of ice and swaying to an obbligato of cowboy songs emitted from a tape cassette hidden inside her violin (Fig. 691). The skating and the music, both redolent of nostalgia for a lost rural America, would seem, like the solitary Pierrot-clad performer, to comment on the lonely existentialism of any creative act. Beginning in 1979, Anderson dropped her faux-naïf persona for a New Wave one and produced United States, a grandly scaled, four-part, exceedingly complex Performance piece (Fig. 692). For this punk opera, she added still more arrows to her crowded quiver, now drawing on semiotics, all manner of communications technology, and a backup band comprised of saxophone, drums, synthesizer, and riffing bagpipes. With her speech filtered or chorded by a voice-activated synthesizer, Anderson achieved the live equivalent of Timese, a signature effect simulating the disembodied editorial or corporate voice pretending to be that of an individual. Through endless plays on words, images, lights, sounds, and impeccable, hip timing she stood alone-with her spiked hair and androgynous attire, her electronic violin and organ, her blinking control dials-and swept huge, bedazzled audiences through whimsical/ironic morality tales about transportation, politics, love, and money in the USA. In a mock tribute to Jules Massenet and his aria O Souverain, Anderson wrote and sang "O Superman," the keynote song of United States that appealed to a modern deity for salvation from all the various "authorities" busily going about their covert and coercive ways within the American superpower. "O Superman" climbed to the top of the charts, while

left: 691. Laurie Anderson. *Duets on Ice*. June 1975. Performance, Genoa. Courtesy Holly Solomon Gallery, New York.

above: 692. Laurie Anderson. *United States.* 1980 performance at the Orpheum Theatre, New York.

The Post-Minimal Seventies

its composer went on to accomplish her goal of transforming Performance Art into something more professional, a crossover form with much broader impact than the typical Conceptualist work confined to the gallery/loft world.

In England, a partnership styling itself Gilbert (1943-) & George (1942—) employed what might be called "low tech" in their humorous, yet genteelly mordant Performance Art. Members of a British generation reacting against the formalism taught by sculptor Anthony Caro at London's St. Martin's School of Art, Gilbert & George proclaimed themselves "living sculpture" and, to prove it, mounted a tabletop plinth or stage to mime ("sculpt") old recorded renditions of such British music-hall staples as "Bloody Life and Dusty Corners" (Fig. 693). They also adopted punctilious Victorian manners, slicked down their hair, and donned proper, comically illfitting "city" suits. To complete the "sculptural image," they painted their heads and hands bronze, copper, gold, or red and lipsynched their numbers with the jerky, robotic movements of windup toys. If this appeared to fuse art with life, it also reopened the famous gap between them, since by fashioning their whole existence into art, Gilbert & George set themselves resolutely apart from the world at large. Nevertheless, they soon began to perform before the camera as "continuous sculpture" in wall-size "photo-pieces" that have involved the anachronistic pair in all sorts of unambiguously "now" experience, from race and power relations to urban blight, sexual preference, and AIDS (Fig. 694). With Hogarthian moralism, they manage to deal with yet cool down the most inflammatory content, mostly by surrounding it with lush botanical imagery hand-dyed in stained-glass colors, structured along cruciform lines, and distanced beyond mullion grids.

The demure distance kept by Gilbert & George largely disappeared in the work of Conceptualists who transformed Performance Art into Body Art, bringing about an intimacy between artist and audience that some found risible, if not intolerable, and others exhilarating. In Seedbed, for instance, Vito Acconci (1960-) spent hours in onanistic activity under a ramp in New York's Sonnabend Gallery while unsuspecting visitors overheard the artist's amplified fantasies about his erotic identification with them. The piece, supposedly, dramatized the narcissism and risk at the heart of the creative enterprise, two of the very factors that make it an effective means of communication. But what Acconci did out of sight, Lucas Samaras performed in full view of, first, his Polaroid camera but ultimately, through its documentation, the entire world (Fig. 695). Meanwhile, however, he had intervened in the scientific process and altered the film's emulsion, thereby disguising himself, sometimes as a surreal monster reminiscent of his own pincushion assemblages (Fig. 566), even while engaging in self-exposure and providing a metaphor for the artist's desire to affect society. Outrage over the Vietnam War **left: 693.** Gilbert & George. The Red Sculpture: "Bloody Life and Dusty Corners." Performance March 23–27, 1976. Courtesy Sonnabend Gallery, New York.

below: 694. Gilbert & George. *Sleepy.* 1985. Hand-dyed photograms, 7'11" x 6'7". Courtesy Sonnabend Gallery, New York.

drove some Body or Performance artists to still more violent extremes, even generating a revived fascination with the Marquis de Sade and Antonin Artaud's "Theater of Cruelty." Thus, in Germany, a group of "exiled" Viennese started the *Orgien Mysterien Theater* ("Orgies Mysterious Theater") and staged a long series of *Aktionen*. At these sadomasochistic public events, Hermann Nitsch, Rudolf Schwartzkogler, Günter Brus, and Otto Mühl ritually defecated, slaughtered animals, and spilled the blood over naked collaborators, the latter sometimes bound as if for an upside-down crucifixion.

In Southern California, at the epicenter of anti-Vietnam activity, Chris Burden (1946—) carried out several very high-risk body works while still enrolled at the University of California in Irvine. The most daring of these was *Shooting Piece*, in which the artist had an intrepid friend fire a revolver at his right arm. However mad such acts, Burden insisted that he carefully calculated their danger and felt sufficiently in control, just as television seemed to be in command of all the gore and mayhem it either reported or simulated. More redemptive is the remarkable, martyr-image documentation that survives from *Doorway to Heaven* (Fig. 696), which could easily have become the real thing when Burden pushed two live wires into his chest, causing them to cross, explode, and, for that reason, save him from electrocution.

Process Art

In Process Art, Conceptualists again sought to counter Minimalism's steely timelessness and structural unity, now by turning towards the fresh energy as well as meaning to be gained from timebound and mutable materials. Beuys, among others, had led the way when he introduced fat and felt into art for the very reason that "processes continued... in them: chemical reactions, fermentations, color changes, decay, drying up." In perishability the German artist found a metaphor for the fragile brevity of the human condition. Yet, it was Robert Morris who, having begun to use felt as a way of rendering Minimal forms formless, theorized Process in an *Artforum* article of 1967. His model was Jackson Pollock, whose "recovery of process involved a profound re-thinking of the role of both materials and tools in making. The stick which drips paint is a tool which acknowledges the nature of the fluidity of paint."

Europe's Tachists had also attempted to wrest significance from matière, as did Rauschenberg after them, but by 1970 post-modernists had gone much further and appropriated for art such organic, non-art materials as rags, rubber, grass, ice, lettuce, and sawdust (Fig. 671). Moreover, they would allow natural forces, with all their indeterminacy, to participate as a forming principle. Process could be found at work in the subverted Minimalism of Richard Tuttle's flimsy, loosely tacked canvases (Fig. 697), or in that of Hans Haacke's early Plexiglas "weather boxes," works or "real-time systems" so attuned to the atmospheric "system" without that the modernist cube often seemed to dissolve from within (Fig. 698). It also functioned in Morris's Unitary Objects made of thick, charcoal-gray felt, a structureless material that could only collapse from its own inert weight submitting to gravitational pull (Fig. 699). Lynda Benglis (1941-), fascinated by the interrelationship of painting and sculpture, worked rather like Pollock or Morris Louis, but instead of pouring liquefied pigments, she spilled latex or polyurethane onto the floor and allowed it to "dictate its own form" (Fig. 700). Then, to complete the translation of painting into sculpture, or vice versa, **below center: 698.** Hans Haacke. *Condensation Cube.* 1963–65. Acrylic plastic, water, climatological conditions of the environment; 11³/4" cube. Courtesy John Weber Gallery, New York.

below far right: 699. Robert Morris. Untitled. 1967–68. Gray felt, ³/8" thick. Courtesy Leo Castelli Gallery, New York.

below: 700. Lynda Benglis. *Corner Painting*. 1969. Poured pigmented latex, ¹/4" x 8'11" x 8'10¹/2". Courtesy Paula Cooper Gallery, New York.

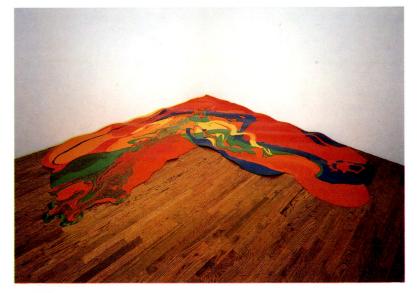

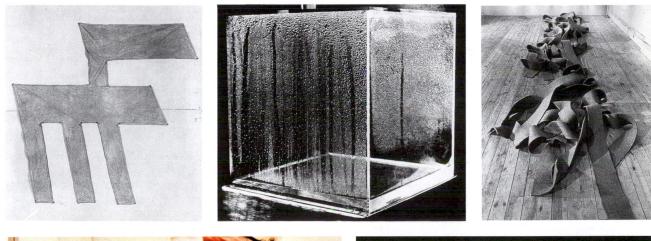

right: 695. Lucas Samaras. Untitled. 1973–74. Photo-transformation, 3 x 2". Collection Arnold and Milly Glimcher, New York.

far right: 696. Chris Burden. Doorway to Heaven. November 15, 1973. Performance with two live wires pushed into the artist's chest. Courtesy the artist.

above left: 697. Richard Tuttle. Pale-Blue Cloth Piece. 1967. Cutout dyed canvas, 5'4" x 5'10". Stedelijk Museum, Amsterdam.

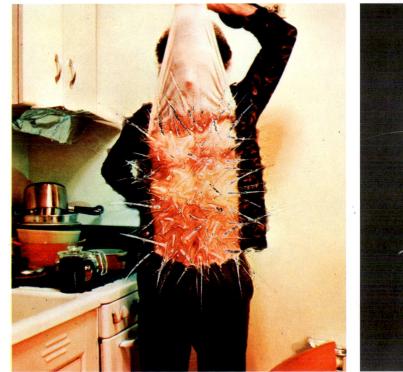

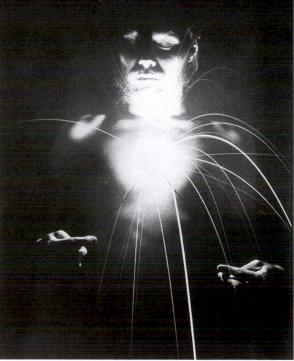

Benglis stirred various Day-Glo colors into the flowing mass before it could set. Sam Gilliam (1933—), somewhat closer to Louis because of his residence in Washington, D.C., entertained similar interests but kept to canvas, which he spattered with colors and then draped, swagged, or hung until it assumed the undulating topography of an abstract landscape (Fig. 701).

After Beuys, the figure most readily identified with Process Art may have been the late Eva Hesse (1936–70), born in Germany but an American citizen for most of her shockingly abridged life. Taking note of Hesse's work, together with that of Louise Bourgeois, Keith Sonnier, and H.C. Westermann, the critic Lucy Lippard coined the term "Eccentric Abstraction" to characterize the unexpected synthesis these artists had made of Minimalism and aspects of Surrealism (Fig. 702). Hesse retained the formalists' modular, gridlike structures but humanized them with sensuous, erotic feeling. Quite simply, she replaced industrial materials with organic, malleable ones rubberized cheesecloth, papier-mâché, rope or string dipped in fiberglass—which left her work looking paradoxically tough yet flabby, independent as well as vulnerable, and very much subject to the entropic effects of time. Thus, her planes, boxes, and webs tend to lean, flop, sag, or nod, like passion spent or waiting to happen.

In Italy arte povera, meaning "poor art," was how the critic Germano Celant distinguished the work of anti-materialists-Giovanni Anselmo, Luciano Fabro, Giulio Paolini, Jannis Kounellis, Mario Merz, Giuseppe Penone, Gilberto Zorio, and Michelangelo Pistoletto-who found vitality as well as metaphysical import in every kind of common, even perishable materialrags, twigs, fire or smoke, charcoal-and chose to present rather than represent it (Fig. 671). In an environment saturated with history, it seemed better to acknowledge the past-to admit the contingency of the present-and use simple objects or substances to arouse memories and associations, especially if these might illuminate the human dilemma and advocate its amelioration. As Jannis Kounellis (1936-) stated: "I believe that the artist, whether of today or yesterday, never engages in a dialogue with the present, the present in a pejorative sense. But he is engaged in a permanent dialogue with the culture of the past." Acting on this conviction, Kounellis took his discourse with earlier matter- or processinvolved Italians-Lucio Fontana, Alberto Burri, Piero Manzonito such extremes that, for an "exhibition" in Rome, he stabled eleven white horses in a pristine white gallery (Fig. 703). By this provocative strategy he dramatized the contrast and necessary relationship between nature and culture, as well as between the Classical tradition (the horse) and modern innovation (the gallery).

A metaphysician like de Chirico, or a "witch doctor" after the manner of Beuys, Mario Merz (1925—) harked back to the migration age when Germanic tribes repeatedly harried Roman Italy and eventually fused their wild spirituality with the harmonious hedonism of the Mediterranean world. In the igloo—made with clay, wax, slate, shards of glass, tree branches, or almost anything but ice—Merz discovered his primary metaphor, a globe cut in half and therefore balanced—a restless form rested—to signify a refuge for humanity rich in things but poor in spirit (Fig. 704). To the magpie igloo, with its conflation of the organic and the artificial, Merz frequently added in neon a series of Fibonacci numbers, an arithmetic projection of the growth principle common to both culture and nature, albeit one that turns horrific when viewed against the staggering proliferation of human artifacts.

right: 701. Sam Gilliam. *Thrust.* 1971. Acrylic on canvas, 9'10" x 18'. Courtesy the artist.

left: 702. Eva Hesse. *Right After.* 1969. Fiberglass, c. 5 x 18 x 4'. Milwaukee Art Museum. Gift of Friends of Art.

below: 703. Jannis Kounellis. *Cavalli (Horses)*. 1969. Installation with 11 stallions. Galleria L'Attico, Rome. Courtesy the artist.

bottom: 704. Mario Merz. Double Igloo: Alligator with Fibonacci Numbers to 377. 1979. Mixed-media installation. Courtesy Sperone Westwater. New York.

Earth and Site Works

Not only is landscape one of art's oldest subjects; being relatively anonymous, all-over, and dispersed, it also permitted, far better than the human face and figure, the kind of antinatural distortions that modernists believed necessary in order to break free of Renaissance illusionism and make painting reflect the abstract state of modern, urban existence. But having served as a vehicle of advanced aesthetics, landscape gradually disappeared from painting, along with every other subject, as modernists progressed towards nonobjectivity and technology. Still, even in its absence, a preindustrial kind of landscape could be felt as a powerful presence throughout Abstract Expressionism, with its environmental expansiveness of gesture and color, as well as in the earthy matière painting of Europe's Tachists. And late-modern sculpture too registered a telluric impulse, as in the cavern-and-mound forms of Moore and Hepworth, the wave-swept surfaces of Kemeny's metal reliefs, the jagged fault lines of Arnoldo Pomodoro's gleaming spheres, the arboreal structures of both David Smith and Chillida, or the horizonlike stretch of Caro's steel assemblages. Moreover, it was Minimalism that, unwittingly, drew freespirited artists back towards environmental issues, since, being relationless, Unitary Objects tended to solicit relations with the world outside. Meanwhile, Happenings and Environments had also prepared the way when Conceptualists, in the late 1960s, allowed poststudio consciousness to evolve into earth or land consciousness, which soon meant siting art works far from galleries and placing them in some remote wilderness, occasionally urban but mostly natural. In the words of Michael Heizer, a leading Earth artist: "The position of art as malleable barter-exchange item falters as the cumulative economic structure gluts. The museums and collections are stuffed, the floors are sagging, but real space still exists."

While Beuys called everything he did "social sculpture," the critic Rosalind Krauss included Earth and Land Art along with such post-studio activities as Conceptual, Performance, and Process Art when she wrote of "sculpture in the expanded field." Urging artists to expand the field into fallow territory was a newly aroused, Beuyslike social conscience. It seemed that if Performance could reintroduce into Western civilization, now thoroughly secularized, a degree of sacred ritual, then Earth Art might at least formalize the growing concern for salvaging the ecology and preserving or revering such spiritually resonant archaeological marvels as Stonehenge, Angkor Wat, and the ruins of pre-Columbian America. However, since most Earth/Land artists had passed through Minimalism, they tended to fuse "Abstract Expressionism's impulse for grandeur . . . to Minimalism's emblematic forms," as Robert Morris wrote, once it appeared acceptable to recommence making objects at all. This was true preeminently in the United States, where a relative plenitude of surplus space permitted artists to indulge their American taste for heroic scale and costly, industrial methods as never before. In Europe, meanwhile, an old and long-inhabited world necessitated a more discreet approach to Land Art, one that left precious nature as little disturbed as possible. But light or heavy in their touch, the new "environmentalists," like most Conceptual artists, depended upon documentation-photographs, maps, drawings, videotapes-to convey the revelatory message of works either too ephemeral or too colossal and inaccessible to be known in situ by more than a privileged few. Fundamental to the message of "situational" art was the occasion this provided for artists to re-experience the outer world, rather than represent it, ultimately to rejuvenate the human psyche as well as its engagement with both life and living.

Earth Art graced the world with a masterpiece after Robert Smithson (1938-73) managed to transform a barren shore on the Great Salt Lake into a huge, exceedingly romantic metaphor for his fascination with entropy-the rate at which all matter decays (Fig. 705). Not only had the site been wrecked by oil prospectors; the cove seemed to quake with its own internal strife, rather like an "immovable cyclone" or the underwater vortex that, according to local mythology, welled up from a source in the faraway Pacific Ocean. In this felt but motionless spin, together with the corrroded drilling equipment, scattered shards of black basalt, cracked lake floor, and pinkish-red, algae-infested water, Smithson saw the poetic possibilities of an earthen gyre built with bulldozers as a beautiful but melancholy symbol of the entropic realities of all creation. Yet, since Spiral Jetty appears to open outward as well as inward as if decaying into its own dead center, the piece could be read as emblematic of life's complex process of simultaneous self-renewal and self-destruction.

Michael Heizer (1924-), a native Westerner, created Double Negative in the Nevada badlands by using bulldozers not to build a new form but rather to excavate 240,000 tons of rhyolite and sandstone from Mormon Mesa (Fig. 706). When finished, the Herculean labors left two 30-foot-wide ramps cut 50-feet deep and facing one another across a narrow canyon. While evoking the sublimity of

left: 705. Robert Smithson. Spiral Jetty. 1969–70. Black rock, salt crystal, and earth; spiral 1,500' long. Great Salt Lake, Utah.

right: 706. Michael Heizer. Double Negative. 1969–70. Earthwork, 1,500 x 50 x 42'. Mormon Mesa, Nevada. Courtesy Museum of Contemporary Art, Los Angeles.

19th-century American landscape painting, this colossal piece recalls, even more powerfully, the symbiotic relationship between the natural and the engineered that ancient Egyptians achieved in the great pharaonic cliff tombs along the Nile Valley. According to Heizer, "one of the implications of earth art might be to remove completely the commodity status of a work of art and allow a return to the idea of art as . . . more of a religion."

For one of his early pieces Walter De Maria (1938-), a pioneer Earth artist, carpeted the floor of an entire gallery with 1,760 cubic feet of moist, aromatic topsoil, which transformed both the country material and the city space, causing gallery-goers to think about the world in fresh, unexpected ways. For Lightning Field (Fig. 707), De Maria reversed this procedure and took civilization, in the form of high-tech materials and methods, into the open nature of New Mexico, there planting a level-top forest of stainless-steel poles in a grid pattern spread over a 1-mile-by-1-kilometer tract of scrub-covered plateau. Designed to make the "invisible real," this extraordinary convergence of nature and culture comes into its spectacular own when summer storms roll across the field, "sense" the glistening "energy bars," and explode, filling the sky with fiery, crackling thunderbolts. If the performance suggests doomsday, it also makes the day for the few visitors fortunate enough to witness Lightning Field and its sublime atmospheric effects.

Restrained by taste, as well as by the intimacy and densely populated character of his island nation, the English artist Richard Long (1945—) has emulated Wordsworth and avoided the heroic in order to engage in Land Art mainly by rambling through the natural environment. To make his presence felt there, he often does little more than pluck wild flowers or rearrange such found items as seaweed, sticks, stones, or fallen tree limbs (Fig. 708). Like Gilbert & George, Long revolted against the formalist teaching of Anthony Caro at the St. Martin's School. Yet, while abjuring commodifiable objects, he continues to favor such primary forms as straight lines, squares, crosses, triangles, and, especially, circles, which, once photographed, often resemble the dolmens, megaliths, and mounds of prehistoric Britain. In this documented state they also become important post-structuralist icons of pantheistic feeling created by an artist convinced that "art should be a religious experience."

In the Netherlands, a terrain still more constricted than Britain, Jan Dibbets (1941—) employed the camera exclusively in his Land Art, even while reshaping the world, at least conceptually, beyond anything attempted by Long (Fig. 709). To satisfy a Lowlander's craving for mountains, Dibbets, like most European environmentalists, rejected bulldozers; instead, he worked his will upon the Dutch **left: 707.** Walter De Maria. *Lightning Field*. 1971–77. 400 stainless-steel poles, with solid stainless-steel pointed tips, arranged in a rectangular grid array (16 poles wide by 25 poles long) spaced 220' apart, average pole height 20'7" but rising to form an even plane. Courtesy Dia Art Foundation, New Mexico.

below: 708. Richard Long. Bolivia. 1972.

bottom: 709. Jan Dibbets. *Sea-Horizon, 0-135 Degrees.* c. 1971. Two sets of 10 color photographs on aluminum; each set 1'7³/4" x 16'5". Collection the artist, Amsterdam.

polder by shooting it from sequential angles and axes. When collaged edge to edge, the serial images create the illusion that the platitudinous sea-level horizon has become animate and decided to heave, swell, or tilt, sometimes even to imitate the Alps.

Back in the United States, Charles Simonds (1945-) found himself obliged to work with European economy of scale and means once he determined to site his pieces in the hivelike world of mean streets and crumbling tenements on Manhattan's Lower East Side. What remained large was his ambition, which aimed at nothing less than a fresh mythology of life itself, from birth through decay, death, and renewal. In performances, written and oral texts, but most particularly in diminutive structures built in a single day on some abandoned window ledge, street gutter, or cracked wall, Simonds has narrated the epic of his "little people," an imaginary civilization living, unseen but distinctly felt, in sacred and sexual union with the soil whence they came (Fig. 710). Tiny clay brick by tiny clay brick, he brings their temples, houses, and pueblolike villages into being, always with the aid of passing street folk, young and old alike. Witnessing the miraculous arrival and eventual departure of these Lilliputian settlements-victims of weather if not vandals-and the spontaneous reappearance of new ones in differing sites, slum dwellers may evince a larger sense of time and possibilities, of life less fatalistically trapped and immune to change.

Gradually, artists' concern for the environment expanded to embrace the urban scene on a scale sometimes approaching that of the grandest Earth Works. Now the applicable term became Site Works, and the paradigm the great 19th-century local and national parks, or such vast open-air projects as Brancusi's war-memorial complex at Tirgu-Jiu in Romania. Fueling this development was alarm over central-city decay, in the wake of suburban sprawl, and the baleful effects of International Style planning. All the more reason, therefore, that Site artists would conceive urbanistic works to be so bound up with a given setting—so "site specific"—as to derive their very meaning from that condition and its power to make the world seem revealed anew. However, once operating in the public domain, artists found themselves confronted with the need to reconcile the demands of artistic freedom with the demands of the general, tax-paying audience for an art capable of speaking in more than a private voice.

To address the problem of the public monument in a supposedly egalitarian nation, Claes Oldenburg made a series of old-masterish drawings proposing that popular items like baseball bats, bananas, lipstick, and teddy bears be transformed into high cultural emblems-that is, erected in key civic spaces and on the skyscraper scale that Americans seem always to find impressive. Just as feudal Europe has always memorialized its monarchs and intellectuals in publicly sited sculptures, a democratic America should glorify its own true heroes, such as the Good Humor Bar, which, as shown earlier, Oldenburg suggested replace the crushing, modernist mass of the Pan American Building astride Park Avenue in Midtown Manhattan (Fig. 574). Relishing the savage wit and irony of Oldenburg's "monuments," the Marxist philosopher Herbert Marcuse declared that, if ever built, they would be sure to bring down American society, "because the people cannot take anything seriously, neither their president, nor the cabinet, nor the corporation executives . . . it would be one of the most bloodless means to achieve a radical change." Yet, the Republic stands despite the realization of several of Oldenburg's schemes, including the giant Clothespin unveiled in Philadelphia in 1976, during the Bicentennial year no less (Fig. 711). Indeed, the mockery proved tonic, once the attentive perceived that Clothespin could be punned into "Claes's Penn," which made the work a Pop variant of the many portrait sculptures of William Penn scattered about Pennsylvania. It was also possible to read the monument more lyrically, as a humanizing critique of the old, all-American puritan spirit, like that of Pennsylvania's founding father, since Clothespin parodies even as it

right: 710. Charles Simonds. *Dwellings (Part III).* 1981. Clay, sand, sticks, stones, wood, plaster, cloth, and chicken wire; $8 \times 29 \times 13^{3}$ /d". Whitney Museum of American Art, New York. Gift of the Louis and Bessie Adler Foundation, Seymour M. Klein, Pres.

below left: 711. Claes Oldenburg. *Clothespin*. 1976. Cor-Ten steel with stainless-steel base, 45' high. Center Square, Philadelphia.

below right: 712. Richard Serra. *Tilted Arc.* 1981. (removed in 1989). Hot-rolled steel, 120' long. Federal Plaza, Foley Square, New York. Courtesy Leo Castelli Gallery, New York. pays tribute to the interlocked lovers in Brancusi's *The Kiss*, a masterpiece of early 20th-century modernism in the Philadelphia Museum of Art (Fig. 115).

Like many other sculptures "plunked down" in barren plazas during the worldwide rebuilding that took place after World War II, Clothespin is a freestanding work that in formal terms might be equally satisfying in a number of different locations. Conceptually, however, Oldenburg made the piece so integral with context that it must be regarded as a genuine site-specific work. Richard Serra, on the other hand, evinced little but classic Minimalism's preoccupation with form-with forceful maneuverings of space as well as with pared-down shapes-when he conceived Tilted Arc for the peculiar characteristics of Federal Plaza in Lower Manhattan's Foley Square (Fig. 712). Thus, as with virtually all Minimal sculpture, Tilted Arc proved meaningful only in relation to its exact physical and social environment. At least this was how Serra viewed the situation, with the result that, for him, Tilted Arc was utterly destroyed once the US Government decided, at the court-approved demand of offended civil servants, to remove it for storage until some alternative disposition could be made. Yet, while detractors anathematized the 120-foot-long, 12-foot-high slab of rust-patinated steel as "the Berlin Wall of Foley Square," the work's defenders-mainly art-world professionals with no daily experience of New York's federal enclave-saw Tilted Arc as a magnificent presence whose slow, canted, sweeping curve brought coherence to an otherwise confused and disjunctive space. Indeed, the sculpture was subtle and complex enough to seem, from certain angles, as menacing as an oncoming locomotive, at the same time that, from other

vantage points, it appeared gently to beckon, enfold, and protect all who approached. And from above, where the aggrieved employees work, *Tilted Arc* gave the impression of slicing across the pinwheelpatterned plaza like a gracefully counterpointed Cor-Ten rainbow. Finally, property rights prevailed over the moral rights claimed by the artist, which meant that the much-vaunted Art-in-Architecture program, initiated under the culture-conscious Kennedy administration, had lost the most ambitious of the more than two hundred art works it had commissioned with one-half of one percent of the total construction cost for every new federal building.

Rather than make a large, inscrutable monument intended to dominate its physical and social site, Nancy Holt (1938-) worked with government and arts officials, architects and engineers to convert a strangled traffic intersection into an open, landscaped sculpture that acknowledges every aspect of its setting-pedestrian islands and adjacent office buildings alike-yet remains as mysterious and intriguing as any work of serious art should be. Drawing on her background in photography, Holt likes to refashion a site into a sighting experience that unites the cosmic and the human in the midst of urban chaos. In the Dark Star Park complex (Fig. 713), she included pools that reflect the heavens, steel poles whose shadows track the time of day, gunite spheres that evoke the solar system, tunnels through which to focus on different objects, and serpentine walks that not only flow into surrounding roadways but also play with perceptual illusions. Thanks to their placement, spheres and tunnels permit viewing one element through another, so that, from certain angles, the miniplanets appear to move into mutual eclipse. Moreover, the alignment is such that once a year the shadows cast by poles and moons coincide with asphalt shadow patterns on the ground, precisely at 9:32 AM on August 1-the day in 1860 when William Henry Ross purchased the land that became Rosslyn, the Virginia site of Dark Star Park. Here a historical moment and ongoing time fuse and assume a physical presence in a reclamation project that succeeds by making itself compatible with the technological age instead of pretending to be a new Garden of Eden.

No environmental art could be more site specific or, oddly enough, more impermanent than the huge *empaquetages*— "wrapped" segments of land- or urbanscape—that Christo began to execute all over the world in the aftermath of his *Wall of Oil Barrels*—*Iron Curtain* (Fig. 613). For the large wrapped works, he manages to mingle and magnify virtually every ingredient of his mixed background, from the intellectuality and entrepreneurism of his Bulgarian family, through the collectivist life-style and Social Realist aesthetics imposed by a Soviet-backed regime in Sofia, and,

beginning in 1958, the abstraction-dominated, competitive art world of France and the United States. From his experience with Wall of Oil Barrels Christo also brought a new mastery of public relations, as well as fund-raising, the better to require nothing of those in power but their approval. To finance his enveloping of the Pont-Neuf, the oldest and most beautiful bridge in Paris (Fig. 714), Christo, together with his wife and loyal collaborator, Jeanne-Claude, amassed a war chest of \$4 million, entirely from the sale of the artist's preparatory studies and early works. Slowly but steadily, the couple persuaded all who worked for them and much of French officialdom that Le Pont Neuf Empaqueté would become the most important event in their lives. And so, by the time President Mitterrand cut through all remaining red tape, they had assembled a crack team of engineers, builders, and electricians, even a mathematician needed to compute weights and stresses. Meanwhile, a German mill had been weaving 40,000 yards of nylon the color of "Paris stone," prior to the fabric's transfer to Armentières, where needle wielders spent seven months sewing it. Thereafter, a staff grown to some three hundred members, among them frogmen and mountaineers, would be engaged in stretching the fabulous cloth over the span's twelve bays, securing it with 60 miles of rope and not a single nail. When fully wrapped, the Pont-Neuf had ceased to be one of painting's favorite subjects and become a splendid work of modern art in its own right. As elegantly draped, pleated, and tucked as a masterwork of French couture, the new "package" seemed to evolve in personality as hour by hour, dawn to dusk, the texture of the fabric appeared to modulate from silk to satin to heavy-duty linen, and as the basic "stone" color became by turns blond, bronze, gold, bamboo, and champagne. Further, not only were the hallowed forms of the ancient bridge protected, but here and there, as John Russell wrote, "they make themselves felt in a teasing, delicately erotic way that is truly Parisian." After two weeks, during which The Wrapped Pont Neuf drew 215,000 delighted visitors a day, Christo and company restored the structure to its original state as swiftly and efficiently as they had transformed it. From beginning to end, auto, pedestrian, and river traffic had never been stopped, nor had the clochards ("winos") long resident under the bridge suffered anything more than sheer wonderment. What had altered were local attitudes, towards the possibilities of an enhanced, or less abusive, relationship between humanity and the environment it depends upon.

right: 713. Nancy Holt. *Dark Star Park.* 1984. Site work. Rosslyn, Virginia. **left: 714.** Christo. *The Wrapped Pont Neuf*, Paris. 1975–85 (destroyed two weeks after completion). Nylon, rope, and wood. Courtesy the artist.

Photorealism

Given the important role played by photographic documentation in virtually all the post-modern works just considered, it seems almost inevitable that the documents themselves would become subject matter for new art. Thus, while some artists literalized Minimalism's environmental impulse by moving out of their studios and into Performance, Process, and Earth Art, others preferred to remain studio-bound and embrace the world as only the children of the media age could-through a photograph. These post-modernists, in other words, would literalize-or legitimate-photographic imagery as central to their experience by rendering it in oil or acrylic on canvas, materials identified with art of the highest order. In this way they too could distance themselves from the kind of reality-cityscapes, still life, the human face and figure-that modernism had progressively banished, while at the same time they re-embraced it, along with the ostensibly moribund practice of painting and a trompe-l'oeil verisimilitude already deemed retardataire by the mid-19th century. If Photorealism scandalized a critical community still dominated by Minimalist values, it nonetheless received enthusiastic market support. Not only were the pictures collectible; they also proved to be as cool, conceptually intriguing, and formally rigorous as anything then available within the purlieus of "cutting-edge" art. Unlike countless earlier artists influenced by photography, Photorealists strove to make the peculiar qualities of their source those of painting itself, complete with stop-action stillness, extreme foreshortening, and sparkling luminosity. Moreover, by disciplining themselves to simulate a readymade two-dimensional simulacrum of the phenomenal world, Photorealists made process and flatness, even in an image of illusory depth, altogether as much the determining conventions of their art as did the modernists.

Often in the history of Western civilization, realism has come to the rescue when art got into trouble, as it did in the 1860s and 70s, prompting the future Impressionists to make nature freshly encountered a means for overcoming the dry, academic formulas of salon painting. With the arrival of Minimalism, painting once again seemed to have reached a dead end, blocked by its failure to become as literal and objectlike as sculpture. Pop Art, with its appropriations from admass culture, had taken the first steps towards renewal, but for artists desiring a more complete account of perceptual experience, Pop led in the wrong direction. Looking elsewhere, they rediscovered the spectacle that lay all about, which now consisted less of nature in the wild than of the constructed, technological world of the mid-20th century. But while Photorealists would feel themselves truer to this realm by viewing it through the lens of a camera, other artists more interested in appearances than in essences found equal satisfaction by working in a direct manner continuous with antecedents dating as far back as Impressionism, or indeed the Early Renaissance. Thanks to the publicity generated by Photorealism, these less obviously radical imagists also came to the fore, with pictures of such impact that their importance could not be denied, confirming that a broad-based realist revival was under way, from Pop Art and Photorealism to post-modern variants of Old Master painting.

As the works of Henry Moore, Giacometti, Balthus, Manzù, Marini, Richier, Dubuffet, and Bacon attest, representational or quasi-figurative art survived more vigorously in Europe than in the United States during the Abstract Expressionist years. Lucian Freud (1922—), a younger painter often identified with Francis Bacon and the "School of London," has brought that tradition to full glory in an ever-expanding range of still lifes, urbanscapes, portraits, and nude studies. If these last appear to be his most characteristic work, it is perhaps because Freud treats every subject as if it were a nude, laying bare the motif with such avid, voyeuristic desire to possess, at least in paint, that ultimately the physical passes into the psychological, as here in the "portrait" of a studio sink (Fig. 715). One has

top: 715. Lucian Freud. *Two Japanese Wrestlers by a Sink*. 1983–87. Oil on canvas, 20 x 31". Art Institute of Chicago. Restricted gift of Mrs. Frederic G. Pick; through prior gift of Mr. and Mrs. Carter H. Harrison.

above: 716. Claudio Bravo. *Blue Package with Ostrich Eggs.* 1971. Oil on canvas, 3'7" x 4'7". Private collection. Courtesy Staempfli Gallery, New York.

only to note the torn image of two male torsos perched above a pair of old-fashioned faucets streaming into a dark, hungry-looking drain to be persuaded that Freud may indeed claim the great Sigmund as his natural grandfather. However, the telling juxtaposition of forms would scarcely rise above household banality were it not for the libidinous ferocity with which Freud exploited painterly skill and a complex, variegated palette—ocher, olive-gray, and russet—to register his up-close, seismic inspection of what lay before him. Such is the technical command of this artist, as well as the penetrating intensity of his gaze, that however scrambled the bravura brushwork may appear at near range, from a certain distance it resolves into an image almost as meticulously descriptive as those of his early paintings, which once made Freud known as the "Existentialist Ingres." In response to his own question, "What do I ask of a painting," he answered, "I ask it to astonish, distract, seduce, convince."

By comparison with Freud and his Expressionist love of dramatizing the harsher realities of the "post-lapsarian" world, Claudio Bravo (1936—), the Chilean master long resident in Tangiers, seems to have arrested reality before the Fall—that is, before time began its relentless round of decay and rebirth (Fig. 716). Thus, if Christo's packages plead on behalf of an environment threatened by confar right: 717. Alice Neel. Mother and Child (Nancy and Olivia). 1967. Oil on canvas, 39¹/4 x 36". Courtesy Robert Miller Gallery, New York.

right: 718. Romare Bearden. *The Gamble*. 1968. Mixed media and collage on board, 22 x 29³/4". Estate of Romare Bearden. Courtesy ACA Galleries, New York.

sumer waste, the pristine packages rendered by Bravo suggest an unspoiled world present to eyes still innocent and miraculously clear. However, for all its crystalline veracity, Bravo's art comes forth as less a product of the photographic age than a modern reinvention of 17th-century Spanish still-life painting, with its riveting combination of microscopic realism and abstract form. What most distinguishes the work seen here from its Baroque ancestry is the cool absence of the didactic burden assumed by such masters as Sanchez Cotán and Francisco Zurbarán.

Even in an America overwhelmed by the secular miracle of Abstract Expressionism, some artists found the demands of palpable reality more urgent than those of purist form. Throughout this period, Alice Neel (1900–84), for instance, persevered in her practice of "collecting souls," especially those of the walking wounded who surrounded her, a lone Anglo-Saxon woman, in Spanish Harlem. Come Pop and the interest it reawakened in the language of realism, Neel found herself "discovered" by the Downtown art world, at the same time that she discovered in it a whole new population whose souls she proceeded to thieve in portraits as probing as those she had painted during the dark Harlem years (Fig. 717). Nevertheless, Neel painted this brighter world in the improvisational, Expressionist manner always indicative of her work, emphasizing the face, especially the eyes, and making sure to capture the conflict at the heart of every personality.

In Romare Bearden (1914–88) Harlem found its own history painter, an artist who won dominion over form by studying the Old Masters and then reinvigorated it with the jazzy rhythms pioneered in painting by Stuart Davis, the master of Americanized Cubism (Fig. 473). By the end of the sixties, Bearden had come into his artistic own with a collaged combination of found, drawn, or painted images and an interlocking, syncopated mix of flat, brightly colored, rectangular planes (Fig. 718). An unforgettable, signature style, it helped universalize memories of life in black America while also rekindling memories of 20th-century modernism's sources in African tribal art.

If the New York School "triumphed" in the 1950s, it was owing in good part to the lucid critical writings of Fairfield Porter (1907–75), whose stubbornly independent mind had been trained at Harvard by the philosopher Alfred North Whitehead and in Florence by the Renaissance scholar Bernard Berenson. Thus, even as he explained and extolled Abstract Expressionism, Porter was also developing into one of the best realist painters of his time (Fig. 719). To him, it was Vuillard, rather than Cézanne, who had "made of Impressionism something solid and durable like the art of the museums," the very kind of change that Porter hoped to work upon Abstract Expressionism, combining, as he believed Vuillard did, a "love of the medium" with a "love of visual reality" in order that the wholeness of the world might be felt in a uniquely modern way. At the same time that his landscapes, still lifes, interiors, and portraits fully reflect the civilized Yankee domain inhabited by Porter, they also bloom as only such conventional motifs could in the hands of a technician whose fluency rivaled that of Velázquez or de Kooning, and whose incandescent palette radiates gold, orange, and green electrified by swatches of icy blue or lavender.

Alex Katz (1927-), as well, challenged Abstract Expressionism, in his case by mixing a personal compound of Matisse, Newman, and Piero della Francesca. To get what he could see, rather than what he felt, into paint, and yet make the picture stand up to the New York School at its best, Katz perfected a maverick style of heroic simplicity, convinced that realist painting could succeed in an abstraction-crazed era only if treated with formalism's own rigor (Fig. 720). This meant eliminating all but the bare minimum detail needed to yield a persuasive illusion, modeling forms entirely in broad-brushed color, defining them with clean, razorsharp edges, and setting figures as well as objects in nature against flat fields of strong, pure hue. Color, moreover, would be quite specifically what the artist perceived, not what convention might dictate; thus, a green sunlit lawn could turn out yellow, or the background of a twilight cocktail party deep marine blue. For content, Katz depends upon the "bland power" of his luxuriously "pulled" surfaces and subject matter drawn from a circle of intimates or from cherished scenes around a holiday house in the Maine woods. Yet, once cropped at the elbows or even higher, posed full front or in absolute profile, and scaled to fill the pictorial space, the figures assume an iconic quality reminiscent of Piero, thereupon becoming less portrayals than symbols with ambiguous, multiple meanings.

The eye of a realist like Katz never seems so exclusionary or aesthetic as when compared to the genuinely new variety of depictive art that arrived with Photorealism. By making their images contingent upon what the camera sees mechanically rather than what the individual artist may perceive selectively, Photorealists produced a sharp-focus, freeze-action view of things that left the world looking more complete than ever before in art and yet also, paradoxically, more abstract. Owing to the unedited mass of minute three-dimensional information it records, a painted replica of whatever a camera has resolved upon its focal plane, at the click of a shutter, allows the presence of that plane to be felt even more emphatically than in the flattest of Minimal canvases. Further, while it may have required a Photorealist painter months to transcribe so

much data, the data remain that of an isolated split-second of time, leaving the image as abstracted from the ongoing flow of experience as from the volumetric world it represents. Katz too bound his figures to the specifics of time and place by the exactness of their clothing and hair styles; meanwhile, he also made sure that the subjects transcend those very factors, through a built-in sense of the timeconsuming process involved in transforming, or simplifying, individuals into icons. Chuck Close (1940-), on the other hand, spent months painting the portrait seen in Figure 721, only to endow the image with the instantaneous look of a snapshot. To escape the possibility of slipping back into the Abstract Expressionism where he began, Close determined not to make his art dependent upon the vagaries of existential self-discovery but rather on the pre-established facts of a photograph. Using this as his preparatory drawing or study, he would then render it so slavishly in acrylic on canvas as to know the end result even before starting to paint. Just as radical for the time was his parody of the Minimalist grid wherein he revived the age-old technique of squaring the model for transfer to a similarly sectioned surface, but with a matrix so fine that when scaled up to the mural dimensions de rigueur in New York, the ratio of enlargement would be 1 to 10. To imitate the smooth, thin, impersonal substance of a photographic print or slide, Close gave up thick, sensuous oils and bristle brushes for airbrush painting, which required only a few ounces of diluted medium to cover an entire canvas. Thereafter, he proceeded to reproduce the prototype tiny square by tiny square, addressing each as a single unit masked off from all the others on the field, a process so conducive to "blind" objectivity that the completed portrait candidly discloses not only the sitter's every last pore, line, and hair but also the variable focus of the original photograph's shallow depth of field. To realize such tight, facsimile realism in color, Close had to overpaint the gray-

left: 719. Fairfield Porter. Amherst Parking Lot #1. 1969. Oil on canvas, 5'2¹/4" x 3'10". Courtesy Hirschl & Adler Modern, New York.

far left: 720. Alex Katz. Patti and Martha (Panel 1 of Eleuthera). 1984. Oil on canvas, 10' x 5'6". Courtesy Marlborough Gallery, New York.

above: 721. Chuck Close. Mark. 1978–79. Acrylic on canvas, 9 x 7'. Collection the artist. Courtesy Pace Gallery, New York. scale version of the image three times, in cyan, magenta, and yellow, thereby imitating the dot-screen separations that combine in color printing to reproduce the rainbow spectrum found in nature. Yet, for all the chilly, distancing mechanics of his system, Close managed not to dehumanize his sitters but, on the contrary, to make them appear quite touchingly human, vulnerable in their mug-shot exposure and entrapment within a suffocatingly limited space. At the same time, they also seem aggrandized, projected as they are like film stars on a giant silver screen.

Like Canaletto in the 18th century, Richard Estes (1936-) became a vedutist who uses camera optics for understanding perceived reality-the reality of the contemporary urban world-well enough to render it so convincingly that the art conceals art-the covert formal manipulations-behind the trompe-l'oeil effect (Fig. 722). In other words, Estes's Ektachrome-based paintings appear to be perfect counterfeits of their clear, luminous models largely because the artist avoids servile copying and exercises considerable freedom in the task of miming photographic veracity. Not only does he work from several different shots, combining them until the composition assumes a more complex "feel" than the camera's monocular lens could ever record; he also employs his own Canaletto-like instinct for deft, painterly brushwork capable of bringing a great wealth of visual information into sparkling, uniform focus throughout the wide-angle vista. In this way, Estes extracts from quotidian chaos the diptych order so characteristic of his work, often realized with the equally hallmark sheets of gleaming plate glass. While these analogize the transparent planarity of the filmic source, their reflections not only flatten the image but even reverse the sense of recession by disclosing less what lies beyond than what lies behind the artist/viewer. Still, only through photography could Estes create the impression of the momentary made timeless, since everything in the scene-light and shadow, season, traffic, commercial displayswould have changed long before he got it all down by working

below: 722. Richard Estes. American Express Downtown. 1979.
Oil on canvas, 24 x 36". Courtesy Allan Stone Gallery, New York.
opposite above: 723. Malcolm Morley. Race Track. 1969–70. Acrylic with encaustic on canvas, 5'10" x7'4 1/2". Courtesy Pace Gallery, New York.
below right: 724. Duane Hanson. Shoppers. 1976. Vinyl,

plein-air in the painstaking, bit-by-bit methods of traditional realist painting. The better to make the dynamic jumble of modern existence look suddenly flash-frozen into a beautiful, dust-free vacuum, Estes tends to eliminate human figures, whose absence, however, becomes a presence through the surrogate of their abundant handiworks.

The English painter Malcolm Morley (1931-) anticipated Photorealism when he liberated himself from addictive abstraction by taking up an old, childhood fascination with warships, only to find them too immense to paint except from souvenir postcards. Calling his new work Super-Realist, he gridded the image just as Close did but then turned it upside down before proceeding to render each of the cells one by one. Far from wishing to fuse abstraction and realism in the Close manner, Morley acted out of hostility towards a certain segment of the established order, both in his choice of subject matter and in his molecularized, inverted way of addressing it. Gradually, the stroke too became expressionist, as the artist scaled up his format and moved on to other problematic themes, such as a "race" track in South Africa and the bourgeoisie at mindless leisure on beaches and cruise ships (Fig. 723). Moreover, he sometimes undermined his own carefully wrought illusion by painting in the white border that surrounded the photographic motif, which acknowledged the counterfeit nature of that source, while simultaneously implying the dubious character of the twiceremoved referent in the real world.

Photorealist painting found its sculptural counterpart when Duane Hanson (1925–96) began life-casting stereotypical Americans in fiberglass-reinforced polyester resin, painting them with pitiless fidelity to every chilblain or sunburn, and finally decking the effigies out in the very clothing and accoutrements they would be likely to sport in reality (Fig. 724). Once exhibited, these human simulacra appeared so utterly to have vaporized the gap between art and nature that they shocked viewers mainly by failing to speak. Herein lay the key to the art's subtext, readable through the choice of specimens, seemingly individuals already half-dead from a lethal combination of junk-food addiction and intellectual anorexia. As a result, the Hyper-Realist figures seen here could be the soul-deprived booty of the Body Snatchers, even by comparison with George Segal's ghostly life casts, which evince all the vitality of the artist's painterly handling of plaster (Fig. 569). And this is true despite the extra step

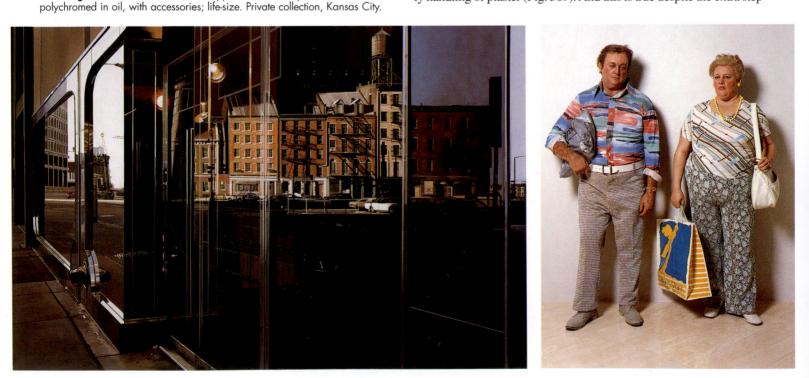

The Post-Minimal Seventies

taken by Hanson to get closer to breathing humanity—that is, to cast the negative form within the mold that Segal would have let stand as the finished work. But, as Kim Levin wrote, "the spectator, released from an illusion, becomes a participant in a mystery as well as witness to a comic melodrama of mistaken identity."

Even among illusionists contemptuous of camera mediation there appeared important artists so at one with the age of mechanical reproduction that their painting displayed much of the same finetuned, literal descriptiveness of the Photorealist works just seen. Yet, in telling ways, they also revealed their freedom from the camera, especially from its tendency to leave the world looking freeze-dried and ironed-out as if pressed under glass. Moreover, they evinced a love of inventive, instead of found, composition, as did Philip Pearlstein (1924-), an advocate of figure painting equal to Alex Katz but one whose nudes seem descended less from Manet's "playing-card" silhouettes than from the fleshy women favored by Courbet (Fig. 725). Keen that his subjects appear animate rather than dead, Pearlstein has them adopt extreme anticlassical poses, models their coruscating surfaces and contours as if they were gleaming silk, and arranges them in choreographic combinations that fill the pictorial field with large-scale, baroque energy. Meanwhile, to save their nakedness from expressionist or pornographic overtones, he cultivates a rather clinical sense of plastic form. At the same time, he also works from the center out, thereby allowing figures to be further deindividualized as their extremities-heads, hands, feet-disappear beyond the format's edges. While this, together with the ramified distribution of shapes, helps bond the robust masses to the two-dimensional plane, a cold, demystifying light and the steeply tilted perspective thrust them boldly forward, monumentalizing the whole until it becomes a thoroughly post-modern extension of a very old, academic or Renaissance tradition.

In her limpid views of an ordinary domestic world, Catherine Murphy (1946—) concentrates on the real until, by her own admission, it becomes surreal. This paradox could scarcely be more evident than in *Cellar Light* (Fig. 726), where, by placing herself at the nexus of her own house, Murphy permitted the continuous scene to subdivide both psychologically and structurally into a triptych, with a surprise awaiting the vigilant in each of the self-contained worlds. On the left, a plain kitchen discloses a covert bit of luxury in the triangular corner of an Oriental rug, while in the right, the luminous, leafy exterior, glimpsed through a mullioned window, invades the shadowy interior in the surreptitious form of a vertical bar of light reflected on the door jamb.

below: 725. Philip Pearlstein. *Female Model on Adirondacks Rocker, Male Model on Floor.* 1980. Oil on canvas, 6' square. Whitney Museum of American Art, New York. Gift of the Friends of the Whitney Museum by exchange, and Painting and Sculpture.

bottom: 726. Catherine Murphy. *Cellar Light*. 1985. Oil on canvas, $35^{1}/2 \times 46^{"}$. Courtesy Lennon, Weinberg Gallery, New York.

Bracketed at the center is the tour de force of the cellar stairs, a startling presence not only because threateningly open but also because invaded at its darkest depth by another slip of unexpected, voyeuristic nature. No wonder the half-concealed incandescent bulb overhead beams so competitively, transforming the painting's title into a double entendre. Too, the surprises serve as a metaphor for the artist's process, which involves working over the entire canvas again and again, until layer by layer the image "comes up" all together, gradually emerging into focus, from loose and distant to fine-grained and intimate, with every particular seized for itself and as part of the whole. For Murphy, abstraction and representation are but two aspects of the same artistic enterprise.

left: 727. Robert Kushner. Tryst. 1983. Mixed media and acrylic on fabric, 8'5" x 17'5/8". Courtesy Holly Solomon Gallery, New York.

Station Vestibule. 1984. Glazed ceramic tiles,

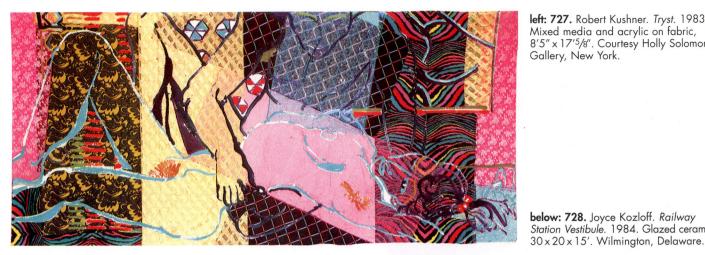

Pattern and Decoration

By the mid-seventies the post-modern revolt against monolithic Minimalism had grown so diverse that increasingly the period came to be known as "pluralistic." This was especially true after a group of artists reached into the environment, as had so many anti-Minimalists, and rediscovered the vast world of pattern and decoration, a realm largely ignored by "serious" artists, at least since the time of Matisse, but still vigorously alive among those concerned with endowing utilitarian objects with a degree of sensuous delight. If aloof, puritanical modernism had blind-sided everything associated with crafts, "women's work," folk and Third World art, then Miriam Schapiro and Robert Zakanitch, Robert Kushner, Kim McConnel, Valerie Jaudon, and Joyce Kozloff, among others, would seek inspiration in those very traditions. Not only could patterned decoration mimic and thus mock Minimalism's own systemic flatness and modularity; it might also reinvest them with spiritual value, derived from the depth of feeling experienced by the anonymous and the excluded. Like Matisse, the P&D movement could find legitimating precedent in the hallowed arabesques of Islam, the pantheistic interlaces of the medieval Celts, and the symbolic geometries of Native American art, all recently restored in general consciousness by major exhibitions. As these sources suggest, P&D artists sought fullness of inherent content within formal beauty, the better to fill the Minimalist void and humanize its cerebral aridities. At the same time, their new art would offer a celebratory alternative to Conceptualism's dour, anti-form theorizing and the visual impoverishment this produced.

P&D, meanwhile, had its own theorists, beginning with the critic Amy Goldin, whose writings had done much to elucidate the aesthetic and philosophical import of Islamic and Oriental art. During 1970-71, while teaching at the University of California in San Diego, Goldin helped catalyze future P&D through her encounters with Schapiro, Zakanitch, McConnel, and Kushner. Even more significant for conceptualizing P&D was the women's movement, in which Schapiro, Jaudon, and Kozloff all became active participants, helping to articulate feminism's critique of the Eurocentric, male-dominated art-historical discourse as too exclusive and egotistic to satisfy either the formal or the expressive needs of more than a tiny segment of the human community. Rather than limit the canon of high-art ideas, means, and materials, feminists wished to enlarge it, drawing on women's experience as nurturers and their desire to reach out, embrace, and move. Towards this end, P&D joined postmodernism's campaign to demystify the creative act and reject the notion of the artist as a solitary genius giving miraculous birth to precious, quasi-sacred objects. Instead of denying the past for the sake of pursuing the new, P&D strove to piece culture together again, thereby giving rise to a layered, multivalent, ecumenical art

assembled from shattered traditions everywhere. Their sources included Japanese kimonos, Slavic embroidery, and the close-out fabric shops along Manhattan's Canal Street; they also ranged from the tiles of Isfahan to the stone reliefs of Mayan Mexico, from the paintings of Gauguin, Klimt, and Matisse to Frank Stella's Indian Bird series.

Impressed by Amy Goldin's ideas about the spiritual and intellectual content of Oriental motifs, Robert Kushner (1949-) joined the critic on a grand, postgraduate tour of Iran, Turkey, and Afghanistan. It was, however, in New York that the artists identified with Pattern and Decoration began organizing their first important exhibition, mounted in 1976. Here, Kushner proved resourceful in making do with what lay about him, mainly drapery- and garment-industry close-out shops along Canal and 14th Streets. And while replacing tile, stone, and mosaic with chintz, velveteen, and glitter, he also translated arabesque abstraction into an equally fluent, organic iconography of both flora and fauna. Tacking his fabrics together in loose, free-falling arrangements, overpainted by hand, Kushner exhibited them first in gallery performances that found him slipping in and out of as many as fifty resplendently imaginative costumes before removing each from his otherwise nude body and hanging the exotic creation on the wall like a tapestry. At the same time that these events burlesqued fashion shows and burlesque itself, they also provided welcome relief from the visual destitution of the performances then being given by hard-line Conceptualists. Meanwhile, Kushner used the same technique to make autonomous wall pieces that, because left unstretched, tend to billow slightly against the vertical support (Fig. 727). Here, following the example of Matisse, whose own *luxe, calme et volupté* had found a key source in Islam, Kushner synthesized Asian patterning with Western culture's devotion to the classical nude in a symbolic fusion of spirit and flesh. Once again, however, the work becomes a variety of striptease, thanks to the patchwork matrix of competing yet coordinated designs that leaves the artist's voluptuous contour drawing at once both concealed and revealed.

Energized by feminism, Joyce Kozloff (1942-) gave up high modernism for patterned decoration, a "third category" halfway between abstraction's formal rigor and illustrational art's popular appeal. In P&D Kozloff saw possibilities for a genuine public art, total environments serious enough to reward continuing interest, yet accessible rather than confrontational like Serra's Tilted Arc (Fig. 712). Kozloff too looked towards the Third World, whose cultures had never acknowledged rigid distinctions between fine and applied arts. Most particularly she felt enticed by the brick-and-tile façades of Mexico's old Churrigueresque churches as well as by their source in Morocco and other regions of Islam. This influence came into full play when Kozloff undertook to decorate the vestibule in Frank Furness's Wilmington Station, a 1908 structure recently restored by Amtrak (Fig. 728). Here, in a 30-by-11-foot space containing a broad flight of stairs, the artist veneered every wall in a dazzling, crazy-quilt pattern of colored and hand-painted tiles, all styled after ornamental themes found in a variety of different buildings designed by Furness, an architect active in the international Arts and Crafts movement, which Kozloff views as one of P&D's most relevant antecedents. Once refurbished, the old station vestibule ceased to be a nowhere passageway for harried travelers and became a realm of both manifest permanence and transcendence, its glazed, graffitiresistant splendor serving to enhance the architecture while visually dematerializing it in shimmering light.

The New Image

By the late seventies, the decade struck many as not only pluralistic but also trendless, a time of confusion and a certain timidity, of many departures but few arrivals, at least by comparison with the certitudes, aggressive energy, and confident innovation so characteristic of the sixties. Moreover, this dispersed, "after-the-Fall" sense of things seemed merely confirmed when, in late 1978, the Whitney Museum of American Art presented a somewhat disparate group of ten artists in an exhibition called "New Image Painting." Apart from common presence at a given time and place, the New Imagists shared little save their status as "emerging" artists who had evidently passed through Minimalism and Conceptualism on their way towards a revived interest in figuration. Symptomatic of the journey and the striving was a taste for idiosyncratic subject matter presented within generally nonillusionist contexts, the result of a rather tentative, tongue-in-cheek tendency to combine formalist system and cool objectivity with Dadaesque wit, visual/verbal play, social and aesthetic critique, psychological self-examination, narrative, performance, and sensuous process. From hindsight, the most remarkable aspect of the show may have been the unremarkable stir it caused, given that most of the artists in the original group-especially Jennifer Bartlett, Neil Jenney, Robert Moskowitz, and Susan Rothenberg-continued to move from strength to strength, acquiring major, international reputations. Furthermore, the desire to salvage the aesthetic object-from Minimalist death warrantsthrough a fruitful mating of abstraction, conception, and representation could be found in the work of many artists of the New Image generation, sculptors and painters alike, in Europe as well as in the United States. Today, the New Image moment seems less a manifestation of feckless pluralism than a glowing conclusion to a decade that proved to be the densely sown seedbed for explosive developments that would follow, beginning in 1980.

For a legitimating straw in the wind, New Imagists could look to the public conversion that Philip Guston (1913–80), a legendary survivor of the original New York School, had made in 1970 from his exquisitely evanescent Abstract Expressionist style (Fig. 729) to a clumsy, funky, even raucous kind of narrative reminiscent of vintage Krazy Kat cartoons (Fig. 730). Twenty years earlier Pollock and de Kooning had shocked their most ardent admirers when they "backslid" from high-minded abstraction into the supposedly low, mindless realm of figuration. Yet, this precedent, or the triumph of Pop, scarcely softened the blow when Guston appeared suddenly to have become, as Hilton Kramer wrote, "a mandarin pretending to be a stumblebum." It soon became evident, however, that Guston could only be what he always was, a leading member of the Existentialist generation dedicated to inner necessity and the consequent requirement that painting re-create itself with every new stroke. In pictures like To B.W.T., with its quivering equilibrium of hesitant plus and minus marks, of gray monochromy and fugitive color, Guston had brought to full maturity his personal aesthetic of doubt and indecision, especially about the demands of art and those of life. Having

below: 729. Philip Guston. To B.W.T. 1952. Oil on canvas, 4'1/2" x 4'31/2". Collection Richard E. Long and Jane Long Davis, Medina, Washington.
bottom: 730. Philip Guston. Double Portrait. 1969.
Oil on canvas, 4 x 5'. Courtesy McKee Gallery, New York.

groped his way into formalism from a 1930s background in Social Realism and political comics, he now swung back to these roots, declaring, as his daughter later wrote, "American Abstract art is a lie, a sham, a cover-up for a poverty of spirit." To Guston, poverty of spirit meant failure to acknowledge what, during the Nixon years, he regarded as cultural and economic incongruities equal to those rampant in the 1930s. Nostalgic for the utopian idealism with which that decade had faced its troubles, the artist regenerated the humanist imagery and style of his earlier work, while retaining the ambivalent touch seen in To B.W.T., this time, however, in the service of a black, Goyaesque humor. He also continued to paint as automatically as before, a process that ceased to evoke the glimmering, Monet-like surface of a lily pond and brought up whatever lurked below-old shoes, rusted nails, cigarette butts, naked light bulbs, stubble-jawed cyclopean heads. Preeminently, however, it conjured and parodied the Klansmen who had haunted the artist and his work during the Depression era, all the while commenting on everything from art to ethics, or, finally, materializing apocalyptic visions of endgame terribilità.

Like Guston, young Susan Rothenberg (1948-), one of the Whitney's New Imagists, has allowed her canvas to function as though it were a Ouija board, a place on which to summon frail Giacometti-like imagery while harmonizing it with an impulse towards Mondrianesque purity of form. For a long while, what came forth was the flat silhouette of a horse, coalesced, more than shaped, from an all-over mass of feathery, reiterating strokes dipped into a palette as sooty as Guston's (Fig. 731). Once the equine image had surged up in her working process, Rothenberg cultivated it, just as many others had in the history of art, as a symbolic self-portrait or a surrogate for human feeling. Later, she switched from acrylic to oil and accepted the human figure that floated up from the submarine world of her increasingly fluid brushwork. Albeit more direct, the image eludes clear definition as it escapes into Rembrandtesque luminescence, becoming a metaphor for painting itself, a ground where the searching eye, mind, and hand may momentarily coordinate their nervous intuitions of what lies beyond all three.

The "installation" artist Jonathan Borofsky (1942—) also creates by mining his deepest personal, spiritual, and psychological self, to a degree more redolent of automatism as practiced by the Surrealists than by their heirs, the Abstract Expressionists. Trapped between Minimalism and Conceptualism, Borofsky began simply counting—that is, numbering blank sheets of paper from 1 to infinity—as a way of breaking clear to make art and yet not make it. Gradually, he found himself doodling on the sheets, there visualiz-

ing not only an inner world of dreams but also intensely remembered moments experienced in the outer world. Before long, Borofsky seemed to produce images almost as prolifically as he numbered plain paper, projecting them, moreover, on a scale grand enough to fill entire galleries with the messy, abundant contents of his free-associating mind (Fig. 732). The dizzying, circuslike mélange Borofsky took to the Whitney Museum of American Art in 1984 included paintings hung upside down or cut in half, drawings on walls and ceilings alike, a Running Man and a Flying Man, several giant, freestanding, two-dimensional Molecule Men drilled full of "cheese holes," five equally colossal Hammering Men with motorized arms, and the Dancing Clown at 2,845,325, a tall androgvne with an Emmet Kelly head and a ballerina's body toe-dancing to "My Way." Also present was a plastic bubble-wrap Everyman, his thin, elongated figure doing pushups, or indeed praying, over broadly strewn copies of a letter by some unknown person with much woe to recount. While this generalized scatter of "found" work served as an element of continuity within a staggering diversity, so did the permeating sounds and rhythms emitted by chimes, mantralike chants, and flickering chains of blue neon loops. As an aid to the puzzled, Borofsky wrote in 1982: "Most of my work is an attempt to reconcile opposites-to wed the Western rational mind with that of the Eastern mystic."

No less hungry for exhibition space than Borofsky, Jennifer Bartlett (1941—) avoided mess as if it were the plague; instead, she utilized Minimal/Conceptual system, mathematics, and process as a fuss-free way of getting into as well as sticking with painting. Eager for the self-educational experience of creating a work with "everything in it," Bartlett eliminated all the familiar, and messy, aspects of painting—canvas-stretching, oil, turpentine, rags—and settled on the fastidious, labor-intensive act of marking with hobby-store Testors enamel on 1-foot-square steel plates. These supports had

above: 731. Susan Rothenberg. *Wishbone*. 1976. Acrylic and Flashe on canvas, 8'6" x 6'4". Collection Mr. and Mrs. Harry W. Anderson. **left: 732.** Jonathan Borofsky. *Installation*.

lett: 732. Jonathan Borotsky. *Installation.* 1984–85. Whitney Museum of American Art, New York.

The Post-Minimal Seventies

been precoated, to the artist's own specifications, with baked-on white enamel and then silkscreened with a grid matrix of light-gray lines. Determined, rather like Frank Stella or Sol LeWitt, to invent a system and then let it generate the art, content as well as form, Bartlett began combining and permuting patterns of color dots applied in grid formation. From this came the square, the circle, and the triangle, which, in a reversal of Cézanne's search through nature for the "cylinder, sphere, and cone," evolved into such archetypal real-life forms as a house, a tree, and a mountain, each filling a single plate. Gradually, Bartlett expanded her repertoire to include figurative as well as nonfigurative imagery, while also allowing certain themes to spread over several plates and eventually over many of them. Along the way, she explored color, various kinds of line, and ways of drawing or painting (freehand, tight, impressionistic, kitsch, etc.). Incremental move by incremental move, Bartlett found herself engaged in a vast, unfolding project with something like the narrative qualities of a lengthy Dickensian novel (Fig. 733). When finally she had exhausted her selected range of linguistic possibilities, the work encompassed 988 plates, just enough to fill Paula Cooper's New York gallery with an intricate yet expansive orchestration whose harmonic flow the critic John Russell compared to a "good conversation," in which "one idea thrives on another and three or four separate kinds of speculation can be kept going at once." The climax came in a massive pictorial chord-the "Ocean" sectioncomposed of 126 plates incorporating 54 different tones of blue. After scanning the entire symphony of visual ideas and motifs, a friend proposed that it be titled Rhapsody. Russell declared the painting to be "the most ambitious single work of new art that has come my way since I started to live in New York." "Rhapsody is new," he went on, "in that it is motivated by problems that are peculiar to our time, by knowledge that is peculiar to our time, and by a quirky panoramic point of view that would have been unacceptable (or unworkable) as recently as twenty years ago."

Bartlett, with her voracious curiosity, has never ceased to investigate how artists translate nature into the signs and systems of culture. Frequently, she has worked in series whose constant theme or themes liberate her to explore, compare, and contrast Impressionism, Expressionism, Realism, Rayonism, Matisse, Mondrian, Pollock, etc. She may even attain the same results in single canvases, sometimes extrapolated into freestanding, sculptural forms (Fig. 734). As one of post-modernism's first appropriators, Bartlett gains distinction not through personal style but rather through rediscovering—or losing—herself in whatever new world she may explore.

Whereas Bartlett maintained thematic continuity in order to demonstrate how a change of medium produces a shift in style, Neil Jenney (1945—) perfected an unchanging "Bad" style of painting in the hope that form would not obscure the cause-and-effect nature of

left: 733. Jennifer Bartlett. *Rhapsody* (detail). 1975–76. Enamel and silkscreen on steel plates; 988 1'-square plates, 7'6" x 153'9" overall. Collection Sidney Singer, New York. Courtesy Paula Cooper Gallery, New York. **below: 734.** Jennifer Bartlett. *Water.* 1990. Oil on canvas,

7' square. Private collection. Courtesy Paula Cooper Gallery, New York.

his moralistic content. Earlier in 1978 than "New Image," Jenney had starred in the ironically titled "Bad' Painting" exhibition at New York's New Museum of Contemporary Art, a show disdainful of "good" painting-that is, the emotionally detached art favored by formalists-and convinced, like Duchamp as well as the post-structuralists, that words and objects alike signify more through context than intrinsic worth. Thus, Guston's late "bad" pictures-a major inspiration for Jenney-must be "good" if present in the most prestigious venues and collections, as they increasingly were. Flaunting his "badness," Jenney-a supreme technician-developed a broadbrush manner of applying medium that came unnervingly close to children's finger painting (Fig. 735). He also heaped simple-mindedness upon simple-mindedness, by narrating elementary victim/victimizer-binary signifier-situations and then presenting the scenes in black frames emblazoned with such titles as Saw and Sawed, Cat and Dog, Them and Us. The catch came once the visual/verbal play prompted viewers to imagine-and thus become psychologically implicated in-some prior action responsible for the pictured consequences. By 1981, however, Jenney had so reformulated his art that "good" ceased to be a qualifier that even the antielitist Jenney could escape. Now, he dismissed jokiness, enlarged the dark frame to coffinlike heft, labeled the impeccably trompel'oeil glimpse of a ravaged or renascent nature with soul-shivering titles like Acid Story or Meltdown Morning (Fig. 736). Here again, with even greater resonance, Jenney seduced viewers into identifying with an event and its after-effects, this time in relation to global anxieties over ecology and the doomsday bomb.

Although present in neither the "New Image" nor the "Bad" show, Robert Colescott (1925—), a French-trained African-American artist, is generally associated with the ideas and aesthetics of both. Colescott proved his satiric "badness" by recasting key monuments in the history of Western art with black figures and steamrolling the whole in what some have viewed as a burlesque of

Expressionist brushwork (Fig. 737). In *George Washington Carver Crossing the Delaware*, for instance, he parodied a famous academic painting by Emanuel Leutze once quite familiar to most American schoolchildren. In Colescott's version, it is the great Tuskegee scientist who leads a boatload of hearties, the latter comically designed to send up, and thus deconstruct, all manner of racist stereotypes, while also challenging the sensitive and the tasteful.

Robert Moskowitz (1935—), another member of the original New Image group, combines the banal and the sublime on a nearenvironmental scale. Like Colescott, he appropriates images, barnacled icons on the order of New York's Flatiron Building, The Thinker by Rodin, or the Seventh Sister in Yosemite National Park (Fig. 738). Further, he strips them of all but their flat silhouettes, so that they compete, one on one, with the equally planar and featureless surrounding field. Having lured observers into the picture with a familiar motif, Moskowitz next involves them in the ambiguity of a figure/ground relationship so taut and abstract that the two elements interlock rather like pieces in a gestalt exercise. Adding to the effect of negative/positive reciprocity is the monochromatic coloron-color palette favored by the artist, almost in tribute to Ad Reinhardt's last black-on-black paintings. And just as in these works, the picture seen here seems transformed into a mysterious, enchanted realm, not least because of Moskowitz's magical way with oils, variously silken, dragged, flecked, and scraped.

Painting never lost its aura for Elizabeth Murray (1940—), who once declared that, "for better or worse," her artistic strategy con-

far right: 737. Robert Colescott. George Washington Carver Crossing the Delaware: Page from an American History Textbook. 1975. Acrylic on canvas, 7 x 9'.Courtesy Phyllis Kind Gallery, New York.

right: 738. Robert Moskowitz. *Thinker*. 1982. Oil on canvas, 9' x 5'3". Courtesy Helman Gallery, New York.

below: 735. Neil Jenney. Girl and Doll.

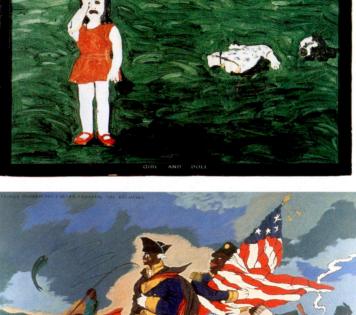

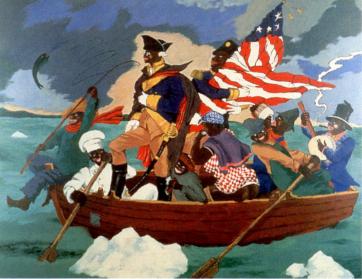

sisted quite simply of "painting with all my heart and soul." As much a student of Disney as of the great modernists, Murray achieved a major breakthrough in her art when, following a series of personal crises, she realized that by struggling to resolve her divided aesthetic interests she would also gain a metaphor for the human desire to make the shattered whole again. With this, she began splitting the standard rectangular support into separate panels and assembling them "to look as if they had been thrown against the wall and . . . got stuck there" (Fig. 739). Inspired by their relationships, Murray then set about to integrate the mismatched parts visually and conceptually through a kind of "global" drawing continued right across the broken surface. In the work seen here, the artist

left: 739. Elizabeth Murray. Can You Hear Me? 1984.Oil on 4 canvases, 8'10" x 13'3" x 1'. Dallas Museum of Art. Foundation for the Arts Collection, Anonymous Gift.

below: 740. Nancy Graves. Variability and Repetition of Similar Forms II. 1979. Bronze on Cor-Ten steel, 12 x 16 x 6'. Akron Art Museum.

bottom: 741. Nancy Graves. *Bel-Smelt*. 1984. Bronze with polychrome patina and enamel, 3'8³/4" x 8' x 1'7". Courtesy Knoedler & Co., New York.

Thanks to her father's directorship of the Berkshire Museum, an institution specializing in art, history, and science displayed side

by side, Nancy Graves (1940-1995) grew up with a polymath respect for natural as well as human creation, for the spirit of open inquiry, for the craft of installation, and for drawing as well as painting of scientific, or "Eyckian," precision. Thus, when frustrated in her early struggle to subvert Conceptualism with modernist logic, Graves sought inspiration in a Florentine natural-history museum. There she conceived a notion of working like a taxidermist to re-create the Bactrian camel, but for the totally different purpose of realizing an image "specific" enough to test the boundaries of art, yet sufficiently enigmatic to symbolize the secret, metamorphic life of sculpture. Having constructed a set of freestanding camels that, even though fashioned almost entirely from memory and imagination, look more camel-like than the real thing, Graves began to use them as organically abstract forms, interesting in their own right and thus subject to all manner of aesthetic reordering, particularly in serial variations within groups of similar, repeating forms (Fig. 740).

began with a set of layered, variously oriented stretchers shaped like the numbers 1, 2, and 3; by the time she finished, however, these arabic integers had all but disappeared in a vividly colored ensemble of real and invented configurations. At first, the total image may appear utterly nonreferential, but close looking reveals it to be legible as an overhead view of a cerulean room or bath in which a genderless person with a large blue body and a small green head flails about in a whirlpool of energy, all the while emitting an elongated "balloon" yell painted what Murray called a "screechy" green. While the shrieking head may echo Edvard Munch (Fig. 56), the abstract illusionism Al Held, or the shaped canvases Frank Stella, the large-scale, intuitive assimilation of such traditionally incompatible factors as "bloopy," cartoonish drawing, Fauve color, and tough formalism became an achieved objective unique to Murray. Albeit eager to unify the disparate, Murray prefers that her pictorial dialogue among opposites remain indeterminate, the better to infuse an abstract image with thought and feeling. Instinctively, this artist has eschewed bravura display and, remembering Cézanne, allowed her work to appear both sophisticated and colloquial, overworked and yet unfinished. It is a tribute to Murray's genius that such eccentric cohabitation of supposedly incompatible qualities transcends itself to become emblematic of an existential search for "something . . . exploded out of the ordinary context into a new state."

Moving from beasts in nature to bones in the ground, Graves hit upon a motif of such appeal that she began casting her bone sculptures in bronze. This took her to the Tallix Foundry in Upstate New York, a firm whose virtuosic command of the lost-wax process and color patination proved as catalytic for the artist as had her encounter with the Bactrian camel. Now, Graves could telescope geological time and create instant fossils, simply by bronze-casting whatever natural or man-made objects captured her fancy, everything from palmette leaves and fiddlehead ferns to sardines, pretzels, pleated lampshades, and plastic bubble-wrap. With a stockpile of such quick-frozen elements at her disposal, Graves undertook to improvise rather than preplan sculpture, soldering part to dissimilar part in tall, filigreed structures that pirouette into the air like madcap genetic chains (Fig. 741). To complete the translation of nature into culture, she painted or patinated each of her one-of-a-kind hybrids-fusions of the real and the ideal-in vivid, synthetic colors, selecting and applying them with all the freedom and fantasy she exercised in combining the wildly alien forms. With unabating wit and surprise, a work like the one seen here leads the viewer from slow recognition of the familiar to astonishment at how much the given has been made to yield something quite beyond itself.

Although not moved by science, Scott Burton (1929-89) too fostered meaningful discourse between art and nature, including human nature, as well as between these and the constructed world. Seeking a way to make art play host to the human figure at a time when art-world ideologues could scarcely have been more hostile to it, Burton became a Performance artist with a particular interest in "found" body movements, a preoccupation that soon produced the need for "found" props. The first of these came into play after Burton moved into an apartment furnished with a fake Queen Anne side chair abandoned by the previous tenant. Once he saw the artifact as a presence signifying the absent body it was intended to accommodate, Burton had the piece cast in bronze and began to revisualize furniture as a device for returning Minimal sculpture to its source in the utopian ideals of early modernism. Like De Stijl, Burton would condescend to no one, insisting that taste be improved rather than reified. Thus, he set about producing furniture as the simplest, most elegant of Primary Forms, fashioned of sumptuous materials, such as mother-of-pearl combined with galvanized steel, while at the same time making certain that it would function in all the

practical ways expected of furniture (Fig. 742). In more complicated pieces, like the one reproduced here, he so designed the parts that they rub together, interlock, or mount one another in ways that subtly, as well as good-humoredly, mimic the human performance itself.

Barry Flanagan (1941—), another rebel against the constructed-steel formalism taught by Anthony Caro at the St. Martin's School in London, became an unofficial New Imagist by working with substances—clay, hessian, rope, felt, sand—malleable enough to "unveil" a subject as the natural, organic outcome of the artist's handling. The most famous image to emerge from the process was a hare, born, with all the capering energy characteristic of the species, while Flanagan rolled and squeezed a lump of moist clay. And once there, the lanky, flop-eared animal proved as frisky and ingenious as its natural prototype in the wild—shadow-boxing, leaping over bells, balancing on the backs of elephants (Fig. 743). If the blithe-spirited creature seems a trope for the artist himself, it also engages the viewer, not only through its kinesthetic energy but also through the hare's long role in myth and history, which no one understood more poetically than Joseph Beuys.

Whereas Flanagan's feral rabbit tends to make viewers identify with it, the Weimaraner that William Wegman (1942—) starred in a

left: 742. Scott Burton. *Two-Part Chair*. 1986. Granite, 40 x 23 x 36". Courtesy Max Protetch Gallery, New York.

right: 743. Barry Flanagan. Baby Elephant. 1984. Cast bronze (edition of 7), 5'8³/4' × 3 '5'' × 2'¹/2''. Courtesy PaceWildenstein, New York.

long series of costume dramas insisted upon identifying with the human race, foibles and all (Fig. 744). Moreover, the collaboration between Wegman and his dog gave post-modernism some of its most seductive new images. It began when the puppy grew up so stage-struck for a place before the artist's camera that Wegman decided to make him his principal subject and let photography satisfy "the need for . . . dealing with formal issues." Calling his pet Man Ray, after the Dada/Surrealist photographer/painter (Fig. 297), Wegman therewith reversed roles to become Man's best friend, which was only the beginning of the satirical role-playing that would unfold in the career of the prodigiously talented canine. Owing to his sleek, velvety handsomeness and his pointer's ability to hold a pose. Man triumphed in all kinds of persona, from a jeansclad Brooke Shields to a stereotypical Hollywood producer, a television addict, Louis XIV, a Blue Period Picasso. Adding to the sense of vanitas was the increasingly hedonist beauty of the photography,

as Wegman began setting up theater in a Polaroid studio and using the large-format Land camera. Usually absurdist in its Beckett-like mockery, the Man Ray series took on a darker tone as the dog aged, turned gray, and finally grew frail with cancer, all of which Wegman continued to photograph. After viewing the last images of the "immortal Man Ray," Lisa Liebman wrote: "What you will see is an old Weimaraner, out of costume this time and stripped of all obvious artifice, as King Lear."

Joel Shapiro (1941-) found his way into figuration through exposure to the sculptural marvels of India. Yet, while wishing to explore a broad range of human emotion, just as the Indian works do, Shapiro remained true to this generational wariness of Expressionist overstatement. Thus, he adopted a Minimalist vocabulary of forms even as he converted its boxy brevity into the language of feeling and intuition. At first, moreover, he approached the figure obliquely, in the symbolic mode of cottage-like dwellings, stripped of all but their essential geometry and scaled to Lilliputian, or Charles Simonds, proportions. In time, the imaginary occupants escaped into the viewer's own space, which Primary Structures had always rendered more vital than themselves. Although giants by comparison with their former abodes, Shapiro's race of stick figures-humanoid assemblages of square-cut timbers cast in iron or reddish-gold bronze-rarely stood taller than knee high (Fig. 745). Nevertheless, they finally overcame Minimalist stoicism to writhe, dance, and pratfall through a whole gamut of emotive poses and gestures, as if Rodin's overwrought personages had been crossbred with David Smith's Cubis for the sake of regenerating modernism by humanizing it.

A younger "new imagist" and, perhaps for that reason, bolder in his direct embrace of the human figure, the English sculptor Antony Gormley (1950—) makes body casts, just as George Segal and Duane Hanson did, but with radical and expressively significant recomplications of the process. To begin with, the nude body he casts is usually his own; then, to deindividualize this most personal of realities, he retains the outer cast or shell, instead of materializing the intimate, negative shape within, and clads the overall mass in hammered sheets of lead seamed together along the figure's major vertical and horizontal axes (Fig. 746). Yet, having metamorphosed

left: 744.

William Wegman. Heels. 1981. Color Polaroid, 24 x 20". Courtesy Holly Solomon Gallery, New York.

far left: 745. Joel Shapiro. Untitled. 1983–84. Bronze, 6'8³/4" x 6' x 4'4". Courtesy Paula Cooper Gallery, New York.

below: 746. Antony Gormley. *Three Calls*. 1983–84. Lead, plaster, and fiberglass; life-size. Collection Anne and Martin Z. Margulies. Courtesy Salvatore Ala Gallery, New York.

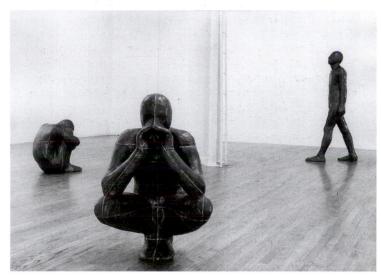

his own life into art, Gormley assures that his absence becomes an unmistakable presence by the mood-drenched poses he adoptspeering into infinity, acknowledging erotic arousal, leaning back prayerfully, regressing into a fetal position. Featureless but far from sexless, Gormley's figures come into the world like a post-bomb Everyman, delivered by a kind of mummification and rebirth ritual reminiscent of Beuys's shamanistic performances and diver-suited in a material-lead-favored by the German master for its nearmetaphysical capacity to survive everything, including radioactive fallout. By placing himself physically at the center of his art only to inhabit it as a ghost, Gormley ties intellect to sensation and thereby universalizes both, since, for this sculptor, the sensuous experience of rational beings is common to all, however diverse humanity may otherwise be. In form and content alike, Gormley seems at one with the more overt, as well as more subjective, figuration that would erupt within advanced art at the turn of the 1980s, even as English understatement leaves him spiritually at home in the ethos of New Image.

The Post-Minimal Seventies

The Post-Modern Eighties: From Neo-Expressionism to Neo-Conceptualism

n 1980, the famously inarticulate yet forever apt and quotable Andy Warhol announced: "The 1980s are so much like the sixties it's sort of peculiar.... Today the kids are painting the same way we did twenty years ago, like it's new to them or something. When Salvador Dali used to come around in the sixties, he thought he had done everything we were doing. We thought it was new, but we were doing things he had already done." "Sort of peculiar," one might add, not only because "the kids" were painting like mad, despite the condemnation of such activity by both Minimalists and Conceptualists, but also because Warhol himself was painting, despite his having pretended, pace Duchamp, to kick the habit way back in 1965 (Fig. 747). From a historical perspective, however, there could be nothing so very peculiar about the pandemic revival of painting-this time called "Neo-Expressionist" and spearheaded in Europe rather than America-that suddenly claimed excited notice in 1980, since painting had already prevailed over several death warrants issued against it by the radical avant-garde. In 1921, for example, the artists of post-Revolutionary Moscow voted by overwhelming majority to declare painting irrelevant to the "utilitarian" world of the new Soviet society. Almost a decade later, David Alfaro Siqueiros, Mexico's great muralist, took a similarly Marxist view to pronounce easel painting finished, and in a 1948 essay, none other than Clement Greenberg, the chief apologist for Abstract Expressionism and Color Field Painting, offered a gloomy prognosis for the easel picture. As if to prove him correct, the critics writing for October tirelessly composed and recomposed painting's obituary throughout the seventies, even as the painters associated with Photorealism, Pattern and Decoration, "Bad" and New Image refused to oblige. However, neither these artists nor the Neo-

Expressionists worked as Warhol did in the sixties but, rather, as he had just commenced to do in the Reversal and Retrospective series, canvases drenched in moody nostalgia for the Pop master's own past (Fig. 747). Here, as if to gather the whole of that experience into one echoing chord, he flipped the signature imagery's billboard brightness into Rembrandtesque chiaroscuro and replaced the big, single-image scheme, like that in Mao 6 (Fig. 559), with a medley of appropriated motifs, collaged together in a free, baroque manner more characteristic of Rauschenberg and Johns than of Warhol himself (Fig. 748). With its longing for something primary and unrecoverable, its quotational or pastiche technique, its ironic involvement with admass culture, its mixture of desire and death, Retrospective Painting (Reversal Series) demonstrates why Warhol would become one of the most influential artists of the eighties, not only for the skeptical neo-Popsters or Neo-Conceptualists coming to the fore in the second half of the decade, but as well for the unabashed romantics among the Neo-Expressionists dominant during the first half. As the most celebrated of the latter, Germany's Anselm Kiefer, said in 1987, Warhol "was so superficial in such a precise way that he went very deep," a strategy that many a postmodernist would attempt to emulate throughout the eighties.

As the world entered the penultimate decade of the 20th century, it seems almost inevitable that artists, as well as culture at large, would wax increasingly retrospective and thus pluralistic, like Warhol's newly mixed forms, themes, and messages. Consequently, while painters, with a vengeance, overcame Minimalist/Conceptualist prohibitions against pictorial art, they did so in ways that rarely failed to reveal them as very much the sum of their own history, including the ideological sixties and seventies. Pop Art itself had

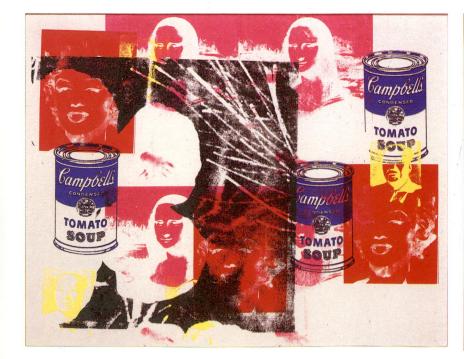

far left: 747. Andy Warhol. Retrospective Painting (Reversal Series). 1979. Acrylic and silkscreen on canvas, 4'23/8" x 5'33/4". Courtesy Galerie Bischofberger, Zurich.

left: 748. Jasper Johns. Fall.

1986. Encaustic on canvas, 6'3" x 4'2". Courtesy Leo Castelli Gallery, New York. rediscovered Duchamp, through John Cage, and anticipated Conceptualism, by assembling or recontextualizing the most disparate of found, often non-art elements so that they remain forever locked in mutually critical discourse, a critique addressed as much to life as to aesthetics. In no way, therefore, would the revivalism of the eighties sanction a general return to modernist myths, to the grand "metanarrative" of the unique genius struggling in heroic isolation to advance civilization by purifying art into an ever-more autonomous, self-referential state, or by conveying universal import through the expressive power of a genuinely singular, stylistically consistent touch. What would be encouraged by the post-modern agenda—which remained the production of a viewer-engaging art

left: 749. Joseph Beuys. From Berlin: News from the Coyote. 1979. Sculptural environment. Courtesy Ronald Feldman Fine Arts, New York.

right: 750. Art & Language. Index: Incident in a Museum XIII. 1986. Oil on canvas, 6'1/2" x 9'5". Courtesy Lisson Gallery, London.

as significant for its broadly meaningful text as for the particulars of its plastic form—were sensuous works that might prove less artworld-bound than either materialist Minimalism or anti-materialist Conceptualism and hence more effective as carriers of socially transformative ideas. Although no painter himself, Joseph Beuys (Fig. 749)—an activist, mystical master fully as influential on the art of the eighties as the passive, deadpan Warhol—urged Kiefer, for instance, to paint. Being fatally illusionistic and therefore inadequately real, as the Minimalists charged, painting could, according to Beuys, work like magic as a vehicle of subversion once sheer visual or tactile allure caused it to be absorbed into a greater universe as delusionary as the present one.

In London, Michael Baldwin (1945-) and Mel Ramsden (1944---), two members of the Art & Language group cited in the last chapter (Fig. 677), heeded Beuys's advice, or on their own arrived at similar conclusions, when they gave up their austere word art and developed a beautiful Johnsian stroke in order to render the gridded, Breuer-designed interior of New York's Whitney Museum of American Art (Fig. 750). Meanwhile, they also subverted both the surface-affirming qualities of the facture and the Minimalist space by holding them hostage to the rushing depth illusion of an ironclad Renaissance perspective. If this leaves a temple of high artistic pretensions resembling a bank vault or even a prison, the picture could be said to have succeeded as critique. For Art & Language, New York School abstraction was not only an exclusionary and totalitarian aesthetic but, correspondingly, the ideal art for, as well as an index of, the allegedly exclusionary and totalitarian institutioncultural, financial, political-that supported it.

In comparing the eighties to the sixties, Warhol may also have detected that, after the cerebral, cautious, almost puritanical plural-

ism of the seventies, the art of the new decade appeared set to rival the Pop/Minimal era not only in formal variety but as well in the aggressive vigor of its philosophical arguments and public appeal. Starved by Conceptualism's dry uncollectibility, dealers and their clients, if not all leading critics, could scarcely have been more elated when the ambitious yet seductive new painting-mostly figurative, grandly scaled, rich in content, boldly gestural-arrived in the world's art capitals from Germany and Italy. Although dubbed Neo-Expressionist, the canvases of Kiefer, Georg Baselitz, A.R. Penck, and Sigmar Polke, Francesco Clemente, Sandro Chia, and Enzo Cucchi could just as easily have been called Neo-Surrealist, as Warhol implied in his reference to Dali, or as the Americans Julian Schnabel, David Salle, and Eric Fischl would confirm, once their own brand of pictorial fantasy and free association got caught up in the frenzy of "high hype and ballyhoo" ignited by the Europeans. Such was the catalytic effect of Neo-Expressionism, together with a raffish cousin known as Graffiti Art, that it demolished Conceptualism's lingering interdiction against objecthood, which soon cleared the path for counter-reactions to Neo-Expressionism's own excesses. By mid-decade these had surged up in a brilliant array of "post-industrial" sculpture, the mixed-style dialectic of Neo-Abstract painting and sculpture, the "endgame" formalism of New York's Neo-Geo group, and the photo-based panels, materialized texts, and simulacra of Neo-Conceptualists everywhere.

If Neo-Expressionism and succeeding movements flourished in the eighties, it was, to a considerable extent, because post-structuralist theory virtually licensed artists to invite co-optation by an investment-craving market, where, following dispersal, their work would supposedly function as a moral corrective from within. Mindful of Conceptualism's failure to impress anyone much beyond the same elite, insider world it had sought to elude and unsettle, the new post-modernists determined to embody their ideas in provocative forms that, far from regenerating modernism's futile search for progress and perfection, tended to emulate the messy workings of the total-information age itself. Alert minds had only to look about to grasp that, more than ever, "reality" consisted not in nature, traditionally the model for all serious art, descriptive or abstract, but rather in culture, a "spectacle" or surrogate world of human-made products, "hyper-realities" understandable as symbols or representations of absent "nature"-the "referent." And, as we saw in the last chapter (pp. 360-362), Continental semiologists had long since explained culture as a kind of language, a sign system in which meaning arises not from anything inherent in words or images, for example, but rather from binary differences between or among such "signifiers," as in near/far, large/small, fair/foul, red/green. Consequently, signification or meaning sprung from difference, from something always more absent than present, must be consid-

ered relative and thus uncertain or ambiguous rather than absolute. If this robbed the author/artist of the authority once attributed to him and his art-his "text"-of both "presence" and "aura," so did the oft-cited writings of Walter Benjamin, the Frankfurt School philosopher who foresaw the time when "mechanical reproduction" would muddle the distinction between original and copy. Yet, instead of discouraging younger artists, post-structuralist thought seemed to spur them on, if not to innovate as modernism had pretended, then to mimic the act in the manner of the media-the realm of pure spectacle and hyper-reality-merely by simulating or appropriating, recontextualizing, and layering images and forms. While this satisfied a yearning to fill the void at the heart of anything as metaphorical or substitute as culture, it also provided a strategy for demystifying or "deconstructing" whatever system-aesthetic, social, economic-might still claim to embody universal, authoritative originality and truth.

Many artists, of course, continued to believe in the possibility of direct, unmediated experience and its expression through aesthetic objects. Germans especially, feeling themselves grounded in solid reality by the palpable evidence of their nation's dark past and problematic present, tended to retain an old-fashioned belief in the "myth" of art as a transcendent force. Many others, however, harkened to the writings of Walter Benjamin and Roland Barthes, Jacques Derrida, Jacques Lacan, and Jean Baudrillard, all poststructuralists persuaded of culture's irremediable contingency and doubtful about any assertion of spontaneous feeling or independent thought. Ironically, the more artists appeared to be less the creators of culture than its creatures, the more their critical audience stepped into the picture, so to speak, and assumed a creative role, wresting, or "foregrounding," momentary import from the work's subtextual discourse among "decentered," free-floating signifiers. With this, verbal language itself came under great stress, as writers made regular use, as well as misuse, of terms like "ontology" (what one knows) and "epistemology" (how one knows), both of them reflecting the struggle for meaning even as it escaped into chronic irresolution.

The sense that contemporary life had truly become spectacle could scarcely have been resisted, given the phantasmagoric range of events conveyed by the all-leveling media. Voracious in its appetite for audience-enthralling fare, ubiquitous television mixed and matched, fused and confounded the domestic and the foreign, canned ads and breaking news, sitcoms and the classics until they all

appeared equally intimate as well as oddly alien. Yet, a decade in which the huge baby-boom generation came truly into its own must have been foredoomed to extremes, unforgettably characterized by Tom Wolfe in his novel The Bonfire of the Vanities. After opening with New Wave music, Reaganomics in the United States, Thatcherism in Great Britain, the Green Party in Germany, and the death of Brezhnev in the Soviet Union, the period rolled through assassinations attempted or achieved on the lives of such public figures as President Reagan, Pope John Paul II, and Egyptian President Anwar Sadat, the biggest rally ever and final bust in both stock and art markets, shuttle space flight, the Jarvick heart, and superconductivity at 30°K, the devastating spread of terrorism, homelessness, and AIDS, wars in Afghanistan, Nicaragua, and the Falklands, the decline of apartheid in South Africa, and the collapse of totalitarian Communism in Eastern Europe and the Soviet Union, offset by the Tienanmen Square massacre in Beijing.

Wrestling with ways to make a mark, despite the dismaying potency of mediated imagery and the inescapable codedness of representation, artists like Gerhard Richter, Sigmar Polke, Julian

far left: 751.

Jane Kaplowitz. Art in Living Room. 1986. Oilstick on paper, 3'4" x 4'2". Collection Mr. and Mrs. Avrom Doft, New York. Courtesy Jason McCoy Gallery, New York.

left: 752.

Richard Artschwager. Low Overhead. 1984–85. Formica and polychrome on wood, 8'x7'10" x 1'8". Courtesy Leo Castelli Gallery, New York.

above: 753.

Cindy Sherman. Untitled Film Still. 1978. Black-and-white photograph, 8 x 10". Courtesy Metro Pictures, New York. far right: 754. Chris Burden. Medusa's Head. 1991. Mixed media, 14' diameter. Installation, Brooklyn Museum. Courtesy Josh Baer Gallery, New York.

below: 755.

Frank Stella. Shards III. 1983. Mixed media on aluminum, 11' 41/2" x 9'103/4" x 2'1/2". Detroit Institute of Art. Founders Society Purchase, Acc. 1983.35.

above left: 756. Cy Twombly. Untitled. 1969. House paint, oil crayon, and pencil on canvas; 6'6³/4" x 7'11". Collection Steve Martin. Courtesy Gagosian Gallery, New York.

Schnabel, and Ross Bleckner have painted in two or more styles at once in the hope of denying the absolute rightness of any one canon of beauty or truth. Here they found a model in Picasso, of course, but also in Francis Picabia, among others. Meanwhile, numerous artists scavenged and mingled imagery almost as promiscuously as the media, but while David Salle conflated high art and low schlock in order to mirror the meaninglessness of the total-information age, Jane Kaplowitz (1949-) made witty, roman-à-clef assemblages of details from canonic modernism more in loving tribute than in righteous dismissal or envy (Fig. 751). The sculptors Tony Cragg and Bill Woodrow spliced the invented with the found, the artificial with the natural, suggesting that once reproduction confuses the original with its representation, no single image of reality can be reconstructed. An older hero of this development was Richard Artschwager (1924---), whose furniture-like Formica-veneered objects crossbred not only Pop and Minimal Art but also concretion and illusion, painting, sculpture, and architecture, the hand-crafted and the mass-produced. Works such as the one in Figure 752 anticipated the eighties' love of readymades and simulacra as devices for

commenting on a civilization increasingly removed from primary reality by the secondary reality of its own technology.

Like the Conceptualists, women artists frequently avoided painting, a genre too long preempted by men, and turned to photography or text, as did Cindy Sherman (Fig. 753), Sherrie Levine, and Jenny Holzer, the better to assert multiple identities as the "other" and thus challenge stereotypes imposed by popular media in the interests of white-male-dominated power structures. But while these Neo-Conceptualists explored issues of race, gender, class, and environment, so did such influential older Conceptualists as Bruce Nauman and Chris Burden, the former in neon words (Fig. 680) and the latter in anxiety-ridden sculpture (Fig. 754). For Medusa's Head, a five-ton spherical mass of rock and concrete, Burden objectified the personal risk of the early Performance pieces (Fig. 696) in a sculpture as craggy as an asteroid and all but strangled by snaking, interwoven rail lines loaded with toy freight trains. Just as the burntout globe hangs ominously in the balance from a single heavy chain, so does the work's meaning, left open as to whether industrialization has been more or less beneficial for life on planet earth. Neo-Conceptualism, as Medusa's Head implies, would evince puritan critique not through the anti-object deformation practiced by its forebears in the early seventies but, rather, in sardonic wit whose grudgefulness Andy Warhol could not possibly have seen as "so much like the sixties."

Such themes even found a vibrant metaphor in abstraction, which progressively overrode Conceptualist hostility the more artists took account of the synthetic or abstracted state of contemporary life. Frank Stella had pointed the way, beginning as early as 1971, when he forsook the late Minimalism of his Protractor series (Fig. 590) and began literalizing their banded planes into the "maximalism" of wall reliefs, works whose growing complexity reflected the artist's desire to make nonrepresentational painting as richly diverse and involving as depictive art (Fig. 755). Like Caravaggio, who in the late 16th century had revived Italian painting by infusing listless Mannerism with full-blooded, Baroque vitality, Stella sought to save formalist painting from terminal reductiveness by charging it with boisterous, albeit abstract reality. This he found not only in a set of drafting tools-French curves, the Flexicurve, the pantograph-but also in the graffiti and glitzy colors of street art, combining their serpentine rhythms and buoyant spatiality with such

drama that works like the one seen here do indeed appear to revivify Abstract Expressionism, this time after "the tough, stubborn materialism of Cézanne, Monet, and Picasso." Meanwhile, Cy Twombly (1928-), an American associate of Rauschenberg's long resident in Rome, gradually emerged from relative obscurity into prominence as the apostle of the very kind of fluidly reversible abstract/concrete painting most appealing to post-modernism's nonfigurative artists (Fig. 756). Instead of replacing the Northern spirituality of Abstract Expressionism with Mediterranean hedonism, as Stella did, Twombly allowed intellect, rather than soul, to become the engine of his mercurially sensitive hand. For inspiration, he looked to Rome's ancient walls, with their countless, multilayered signs, symbols, Latin inscriptions, hieroglyphics, and common graffiti, and then free-associated his way across a slate-gray or chalk-white canvas, leaving doodled, smeary traces of dreamlike encounters with everything from Ovid to Fragonard and Mallarmé, from myth and history to arcane numeration and vulgar scatology.

Neo-Expressionism

If, in 1980, German artists managed to make painting seem more important than anyone had thought possible since the heyday of the Color Field school in the early 1960s, it was perhaps because, as Beuys had revealed, Germans could claim demons far more pressing than Minimalism to work against, once they rejected the kind of Informal/Tachist abstraction seen in Chapter 18. Viewing such art as little more than an analogue of postwar Germany's escape from history into amnesia, younger artists made their own escape from stylistic tyranny into Pop and Beuys-like individualism, as well as into confrontation with the alienating realities of late-20th-century existence. This meant formulating distinctive ways to register the discontinuity brought on by the Nazi interregnum, which not only left Germany split between occupied East and West zones, but also severed German artists, on both sides of the Iron Curtain, from their natural roots in the nation's own pre-Nazi modernism. While certain painters-Baselitz and Kiefer among them-acknowledged rupture by self-consciously imitating themes and styles from earlier German Romanticism or Expressionism, their colleagues-Polke and Richter especially-took a more ironic approach, recalling the radical experiments accomplished in Germany at the Bauhaus as well as by Schwitters and Dada. However, it was the Expressionist component in the new European painting that proved most striking when the artists seen here came to general notice at several big international shows, beginning with the 1980 Venice Biennale.

Although recognized abroad only in the 1980s, Georg Baselitz (1935—) had been known in Germany for bravely independent art since 1961, when he began exhibiting his "Pandemonium" paintings, the "divine madness" of whose volatile, dispersive energy was meant to challenge conformity of every kind. For Baselitz, the enemy included not only the Tachist abstraction then dominant in West Germany but also the state-mandated Socialist, or Social, Realism the artist had fled when he abandoned East Berlin for the Western sector in 1955. Not least because of his "cross-over" status, Baselitz hoped to make his art a "bridge" between the present and that springtime of Germany's modernist project when Die Brücke in Dresden and Der Blaue Reiter in Munich flowered, until blighted by World War I (see Chap. 8). Thus, he confessed more interest in the liberty with which he could treat a motif than in the motif itself, calling his formal distortions "anamorphic" and "ornamental." By 1969, the process gave post-modernism one of its most unforgettably signature images, a figure painted so freely that it looks molten-and then hung upside down, like the alien unconscious

> **above: 757.** Georg Baselitz. *Der Bote* (*The Messenger*). 1983. Oil on canvas, 8'2¹/2" x 6'6³/4". Courtesy Michael Werner Gallery, New York.

left: 758. Sigmar Polke. *Treppenhaus* (*Stairwell*). 1982. Dispersion on printed fabric, 7'7⁵/8" x 13'2¹/2". Hirshhorn Museum and Sculpture Garden, Smithsonian Institution, Washington, D.C. Jacob and Charlotte Lehrman Foundation and Holenia Purchase Fund.

opposite: 759. Gerhard Richter. 572-5 Wiesental. 1984. Oil on canvas, 35¹/₂x 37¹/₂". Courtesy Sperone Westwater Gallery, New York.

asserting itself against petrified expectations (Fig. 757). If the work seen here echoes the primitivist Kirchner as well as the spiritualist Kandinsky, its fluidly *malerisch* colorism also pays tribute to the great Emil Nolde, whose controversial, as well as contradictory, allegiance to and suffering under the Nazis Baselitz appeared to redeem further by sometimes appropriating the older master's Christian themes. With their paradoxical Renaissance dignity, Baselitz's large-scale, topsy-turvy figurations become vivid metaphors for a postwar world divided against itself and struggling to become whole again, as well as celebrations of the disruptive pandemonium at the root of all creative life and effort.

Far from trying to bridge the gap between rival worlds, Gerhard Richter and Sigmar Polke (1941-), two other cross-over artists from East Germany, found extraordinary creative energy, as well as surprising artistic identity, while exploring the near impossibility of resolving antipodal differences-aesthetic, cultural, political. Arriving in West Berlin in 1953 by feigning sleep on the subway, the twelve-year-old Polke learned an unforgettable lesson about the exciting possibilities of simulation-of pretending-even after those of immediate, primary experience seemed to have been swept away by the media. They began to open wide for Polke after Pop Art made its local debut, just when the kitsch banality of West Germany's American-style consumer or "PX" culture made the would-be sublimities of Tachist abstraction appear intolerably out of touch with reality. Adopting Warhol's admass imagery and Lichtenstein's Ben Day screen, the new German Popster translated them into painting more literally as well as more haphazardly than had the Americans, with the result that subjects embedded in a matrix of layered, scrambling "Polke dots" became half-seen and thus suspect in whatever truth they might convey. By the 1980s Polke would command an ever-expanding repertoire of means and

feints, improvising with virtuoso élan among a vast serendipity of unconventional media, styles, and high as well as low varieties of borrowed iconography (Fig. 758). In *Treppenhaus*, for instance, he began with a textile offering a found pattern of colored bands and then proceeded to make this ordinary artifact look extraordinary, the consequence of its role as the background for an intriguing, if largely undecipherable, drama of semantic diversity. Competing with or even shooting at one another across the "stairwell"—a pictorial

Berlin Wall-are paired male and female figures, the one on the right descriptive even if stylized and the one on the left so abstract as to be legible only after the closest looking. While the artist appropriated the solid-black silhouette of the gunslinger on the steps from a movie still, and the black outline profile of his high-fashion companion from Beardsley's Lady of the Camellias, he discovered their blue, red, and white counterparts through process, which evidently involved a roller only partly loaded with pigment, blotting, and spraying on drifts of white acrylic. If the gangster/moll situation on the right implies the West, or specifically the United States, the artist has deconstructed its glamour through imagery old-fashioned enough to satisfy the totalitarian demands of the East's Socialist Realism. Similarly on the left, the tall, jut-jawed, gun-pointing military profile, together with a big-bosomed friend, may suggest the Stalinist bloc, but the artist has sabotaged that ossified world with the impish license of his color and handling. Ultimately, however, interpretation loses its way in the enigma of commingled, overlapping disparities, but, as the critic Kay Larson wrote, "it's in not understanding [Polke] that you grasp the force of his presence," since his art is "about freedom-spiritual, existential, and perverse." This emerges most impressively in the myriad guises he adoptsalchemist, sage, buffoon-in works that may be straight or sardonic, mysterious or matter-of-fact, that depict landscapes, figures, flamingos, cooking pots, or prison-camp towers, sometimes all at once, that mock the conventions of abstraction or yet treat them as vessels of ravishing beauty. Further, the means have included fur, potatoes, violets, cinnabar, iodine, and meteorite dust, as well as chemical, even toxic brews that metamorphose for years, endowing the picture with an organic life entirely its own.

Having abandoned the gulag of Socialist Realism, Gerhard Richter (1932-), together with his close friend Sigmar Polke, invented "Capitalist Realism" in defiance of the Informalist or Tachist abstraction dominant in West Germany when he arrived there in 1961, just before the notorious Wall went up. Unable to return home, Richter found himself trapped in an art environment scarcely less alien to his own liberal spirit than the one he had left behind. To deal with the deep conflicts this caused, he used extraordinary natural facility, reinforced by technical ease gained from the kind of retardataire art-school education dictated in the Communist East, to treat painting as a dialectic of divergent aesthetics. After mastering matière painting with astonishing brilliance but little personal satisfaction, Richter too emulated Pop and began appropriating motifs from the burgeoning field of popular culture. For him, Capitalist Realism meant photography, or so he said, although behind this glowed light, the real, overriding theme throughout what would evolve into an exceedingly multifarious body of work. Taking personal snapshots as well as purloined imagery as his point of departure, Richter rendered them in tabloid black-and-white, sometimes accurately enough to be mistaken for the real thing, but also with a wide range of idiosyncratic handling designed to investigate every kind of stylistic variation. In the later works-mostly landscapes-Richter brought glory not only to Photorealism but also to a Northern, Romantic tradition of pastoral painting scarcely known in European art since the time of Caspar David Friedrich in the early 19th century (Fig. 759). Yet, while soaked in nostalgia, these limpid, delicately tinted, light-suffused works reflect less the reality of nature than the flawed focus of the original image, which Richter faithfully copied with a finesse as coldly efficient as that of the camera itself. In this way he saved his art from reactionary Romanticism, while delivering a kind of visual pleasure dear to the artist through his classical training but, in the West, long barred to modern art.

Simultaneously, Richter was also exploiting photography to reinvest Abstract Expressionism with new and unexpected potential. Now, he made a series of original color sketches in varying degrees of coolness or warmth, freedom or precision, photographed them for

color slides, and then sequentially projected and painted these on canvas as a sandwich of sliver-thin, filtering strata of luminous spaces. To intensify the dialogue between painting and photography, surface and depth, the real and the ideal, Richter sometimes raked the surface of his finished picture with a blending brush, which left the image looking as if viewed by candlelight. By the 1980s when he began producing Abstrakte Bilder directly-unmediated by photography-Richter had so assimilated photographic vision that it became even more pronounced, with the focus growing sharper, the light more prismatic, and the overlapping tissues of transparent color and gesture more dramatically contrasted (Fig. 760). To create what one critic called "giant photographic details of a silent underwater world," Richter became a veritable tactician of pictorial effectsscraped, flung, masked, offset-most of which left the artist as distanced from his canvas as Pollock was in his spilling. Thus, however bravura or even baroque the picture may initially seem, continued observation reveals it to be utterly lacking in the sense of throbbing life so characteristic of Western art from the Renaissance onward. That is, until media-dominated Photorealism introduced the freezedried look, which Richter transformed into a heroic symbol of the artist caught not only between contentious political/aesthetic worlds but also between post-structuralist skepticism about the validity of painting and an irresistible passion for doing it.

The most renowned of the new German painters happened also to be the youngest, Anselm Kiefer (1945—), born in the Black

above: 760.-Gerhard Richter. Juni (June). 1983. Oil on canvas, 8'2¹/2" square. Courtesy Marian Goodman Gallery, New York.

left: 761. Anselm Kiefer. *Märkischer Sand* (*March Sand*). 1980–82. Oil, emulsion, shellac, sand, and photograph (projection paper) on canvas; 10'9" x 18'. Stedelijk Museum, Amsterdam.

opposite below: 762. Magdalena Abakanowicz. Backs. 1976–80. Burlap and resin, lifesize. Courtesy Marlborough Gallery, New York.

opposite above: 763. Sandro Chia Outdoor Scene. 1984. Oil on canvas, 7'8" x 6'6'/2". Courtesy Sperone Westwater, New York.

Forest as Allied armies roared through it during their final drive to crush the monstrous Third Reich. This meant that he grew up in the postwar years when Germans coped with their common disaster mainly by suppressing all memory of its sources in the bedeviled past. Nothing could have shocked them more than the works of a twenty-four-year-old artist intent upon exploring the "tension between the immense things that happened and the immense forgetfulness." In 1969, for example, Kiefer undertook a Conceptual or Performance series called "Occupations," in which he "reoccupied" various historic sites in France, Italy, and Switzerland by having himself photographed shod in jackboots and giving the Nazis' Sieg heil! salute, a gesture that turned arrogance into black comedy. Soon thereafter, Kiefer switched to painting without changing his program, for, as Joseph Beuys advised him, no material or approach seemed so banal or degraded that it could not, through the artist's alchemical touch, be reconstituted into art, thereby initiating a "healing process" for the modern world's sickened spirit. Thus, Kiefer set

The Post-Modern Eighties

out, almost like a missionary, to create a pictorial oeuvre so richly layered in both content and substance that it might serve rather like an archaeological tool for excavating the primal forms of human consciousness buried in history, science, literature, and music (Fig. 761). To prepare, he delved further back than the pre-Nazi avantgarde so beloved by Baselitz, looking to Tacitus, the Bible, and the Kabbalah, to Nordic, Greek, and Egyptian mythologies, to studies in alchemy and theoretical physics, to Bach, Wagner, and Mahler, to Goethe, Hegel, Nietzsche, Hölderlin, Rilke, Joyce, and, especially, Shakespeare. In art, he rediscovered Friedrich, Rodin, van Gogh, and Picasso, all taken as beacons of enlightenment in a world rushing towards dark, moral oblivion. As the interest in Friedrich would suggest, Kiefer helped revive German Romantic landscape painting; moreover, he did it on a grand, Wagnerian scale. "You cannot just paint a landscape after tanks have passed through it," he once said. "You have to do something with it." In Märkischer Sand, the work seen here, he applied blown-up photographs to evoke a vast,

panoramic field with furrowed lines sweeping majestically towards convergence on a high horizon. To render the abstract image concrete, he then reified its ruts and textures not only with thick pigments and real earth but also with paper labels stapled to the surface and hand-scrawled to identify towns on Brandenburg's March plain. Together, several orders of reality-visual, verbal, material-convey the sense of a land blackened and ploughed for recultivation. And so, just as the sand metaphorically cools the scorched earth, the picture offers an uncanny doubleness of vision whereby a surface of extreme materiality-elsewhere realized with tar, lacquer, straw, lead, or iron-yields a spatial illusion of something like infinite depth. For having achieved this paradox, Kiefer credits not only Pollock but also, as we saw earlier, Warhol. "I tell stories in my pictures to show what's behind the story," Kiefer said to Steven Henry Madoff. "I use perspective to draw the viewer in like a bee to a flower. But then I want the viewer to get by that, to go down through the sediment, so to speak, and get to the essence."

Virtually all the Neo-Expressionists seen here made sculpture, none of it, however, equal to the power of the artists' painting. The

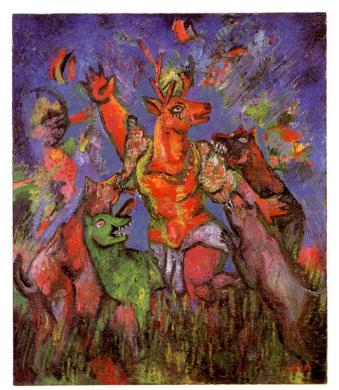

reverse must be said for Poland's Magdalena Abakanowicz (1930-), who, like Beuys and Kiefer, works "alchemically" to transform base matter into objects so gravid with mysterious meaning as to transcend the awful particulars of European history and express the universal human condition at its most tragic. As a daughter of the landed aristocracy, Abakanowicz needed whatever grit she inherited from Genghis Khan, a distant ancestor, in order to survive and obtain an education in a Communist state totally hostile to her kind. She also drew strength from a lonely childhood immersed in nature on her family's estate as well as in the lingering animistic beliefs of the local peasantry. From such a background Abakanowicz experienced great love of the most elementary, organic materials, especially woven ones like coarse, brown burlap, from which the artist made what may be her most celebrated piece, a huddled mass of hunchedover half-figures so downtrodden and diminished that they consist of mere backs, all headless, limbless, and sexless (Fig. 762). Yet, while molded on a single form, these pathetic victims evince sufficient diversity-through the randomly wrinkled, twine-laced, glue-stiffened fabric-to become icons of the individual spirit still unbowed before the dehumanizing forces of regimentation and repression.

Before ever the term Neo-Expressionism entered post-modern vocabularies, the trend it signified had been observed and characterized by Achille Bonito Oliva as the transavanguardia, primarily in regard to a group of Italian painters who, like Baselitz and Kiefer, would attract international notice at the 1980 Venice Biennale. As the label itself infers, the Transavantgarde reacted against modernist reductiveness, including Arte Povera's own minimalizing tendency, and sought to recover everything that over-determined self-denial had rejected. This meant avoiding politics yet total involvement with history, popular culture, and non-Western art as well as ideas. The Transavantgarde included Nicola De Maria, Mimmo Paladino, and Remo Salvadori, but found its true stars in Francesco Clemente, Enzo Cucchi, and Sandro Chia (1946-), collectively known as Italy's "three Cs." Chia-the first Florentine artist since the 16th century to be known more than locally-passed through Arte Povera experiments in Conceptual, Performance, and Process Art before he succumbed to the Renaissance/Baroque masters in the Uffizi and Pitti and recommenced painting (Fig. 763). This time it would be in an ample, narrative mode marked by Michelangelo's hypertrophied figures, floating with Chagall weightlessness against backgrounds exploding in hothouse, Mannerist color, and highoctane energy reminiscent of Futurism or of Pollock in works like Pasifaë (Fig. 492). Endemic to this flamboyant but genially ironic oeuvre is a fairytale mythology of the artist as a picaresque hero doing battle for poetry in a prosaic world.

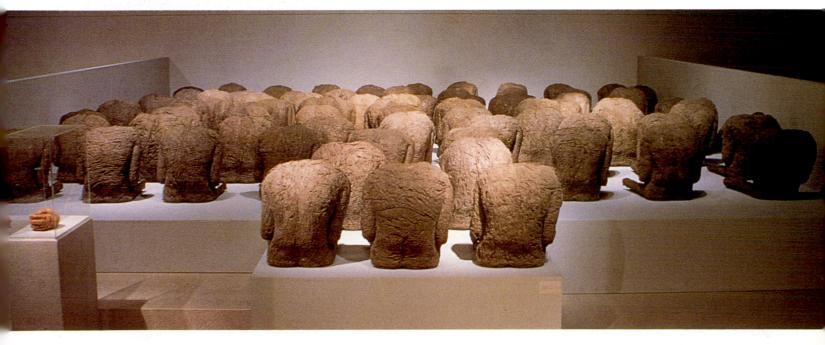

Francesco Clemente (1952—) emerged as one of the most prodigiously varied and prolific artists since Picasso. A Neapolitan aristocrat and self-professed "dilettante," Clemente has wandered like a cultural nomad, from Rome to New York and Madras, annually setting up shop in each and absorbing its special ambience in a rising tide of metamorphic painting, drawing, printmaking, and even sculpture. "All my work is based on the fantasy that things which come from other cultures have a greater significance," Clemente said in 1989. The result has been ceaseless, quicksilver shifts in medium, style, format, and scale, all interlinked by the artist's selfabsorbed, surreally imaginative examination of the senses as a source of meaning, meaning nonetheless enriched by both meta-

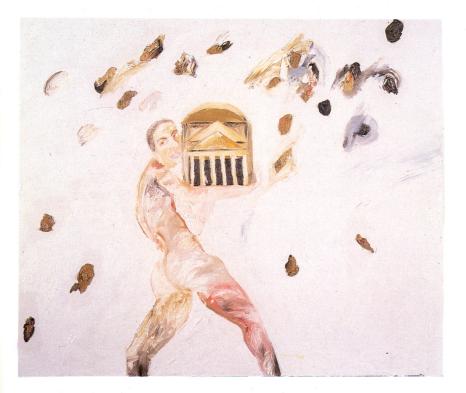

physics-Christian, alchemical, astrological, Tantric, Tarot-and history, especially historical art-Egyptian, Greco-Roman, Renaissance, Hindu, "decadents" like the later Picabia and de Chirico. Also active in his recondite mix of referents are Beuys, the Arte Povera master Alighiero e Boetti, and the Rome-based American artist Cy Twombly, Duchamp and Kierkegaard, Barthes, Borges, and William Blake. Always in search of osmotic fusion and fresh, mutating experience, Clemente has evinced a dreamlike curiosity about "orifices," often depicting characters in reciprocal, polymorphous-perverse exploration of those mediators between the inner psyche and the outer cosmos, between the One and the Other. Although this may reflect a Zen-like desire for transcendence, it also connotes a Tantric love of total immersion, in the physically impure as well as in the spiritually clean. Such permeability of the magical and the scatological can be seen to dramatic effect in the large-format Perseverance (Fig. 764), where the artist's auto-parody allows obsessive narcissism to signify beyond itself. Here, a naked Clemente impersonates Atlas staggering under the weight not of the world but of its foremost symbol in Western culture, the Roman Pantheon, a domed structure with an oculus through which interior and exterior flow into one another. Meanwhile, as if the antiheroic did not already prevail in the muscular figure's struggle with the toylike monument, a muddy, fecal rain mercilessly pelts the scene from all sides. The messy handling of oils also parodies de Kooningesque Abstract Expressionism, indicating that Clemente executed the

The Post-Modern Eighties

painting in hyperactive, stressed-out New York. In Rome, however, he tends to go native and employ serene fresco, while in India he switches to such indigenous media as natural pigments on paper, applied in a suitably refined, miniaturist manner, even for a male figure ceremoniously squatting to lay a very large white egg. To illuminate marvels of this sort, Clemente has said: "Eroticism and humor aren't held hostage by any age, whereas ideas are."

As the most promoted, as well as self-promoted, and the most critically debated painter of the early 1980s, Julian Schnabel (1951—), from Brooklyn by way of South Texas, may have given the art scene of the boom decade its most representative figure. However, neither the commerce nor the controversy would have

occurred but for the prior reality of Schnabel's own achievement, which was to have brought to maturity, while still in his twenties, two of the most original, or "bankable," styles to appear since Minimalism, both as inclusive of the mongrel world as that notoriously exclusive art had been free of it. In the more sensational of these, the artist assembled an all-over ground of broken crockery (Fig. 765), an explosive-looking field, inspired by the tiled architecture of Barcelona's Antoni Gaudí, which the artist rendered cohesive by overpainting it with a pastiche image often composed of quotations from a variety of sources in global culture, both low and high. The effect suggests a pointillist painting by Seurat literalized and heroicized, which contradiction also made Schnabel a paradigmatic artist in a period largely averse to the romantic except when laced with deconstructive irony. The "sense of being in two places at once," as Schnabel himself put it, became all the more apparent wherever he reinforced the operatic/burlesque quality of his "plate" paintings with such three-dimensional combine elements as antlers and spruce roots.

Paradox reigned as well when, in contrast to the menacing shards, Schnabel made soft, plushy velvet the ground of his second, only slightly less contested style. With its sonorous found color—purple, pink, black, ochre—and rich nap, velvet could endow painting with a mysterious sense of space, indeterminately both matte flat and luminously infinite.

Although forever linked to Schnabel through one of the most intense professional rivalries in the furiously competitive 1980s, David Salle (1952—) arrived in New York fresh from study at Cal Arts under the neo-Dadaist John Baldessari (Fig. 678) and thus burdened by none of Schnabel's romantic preoccupations with the tragic and the sublime. Indeed, so boldly did Salle (pronounced Sally) foreground, scale up, and allegorize the late-modern world's substitutive processes that, for some, he appeared to revel in rather than critique the inauthenticity, anomie, and disjunction of contemporary, information-dependent culture. Dismissing originality as myth, Salle nonetheless managed to cobble together an oeuvre of singular impact, thanks to the bravado with which he appropriated images, objects, styles, and techniques from the polar reaches of rarefied art and raw pornography, then combined them in muralsize paintings whose layered compositions solicit interpretation but ultimately frustrate it. For models, he went to Picasso, Rauschenberg, Johns, and Rosenquist, of course, but also to Picabia and Polke. However, none of these gave birth to anything as resistant to decoding as the triptych entitled Muscular Paper (Fig. 766). Here, in the left panel, Salle copied in grisaille halftone a photograph of a Picasso sculpture so stylized that the female subject could easily be mistaken for a piece of driftwood. He then neutralized this potent image-deprived it of "aura"-first, by superimposing an outline trace of a recumbent, Stag-like nude viewed from the bottom, but then, as well, by a galaxy of blue pegs driven into the sup-

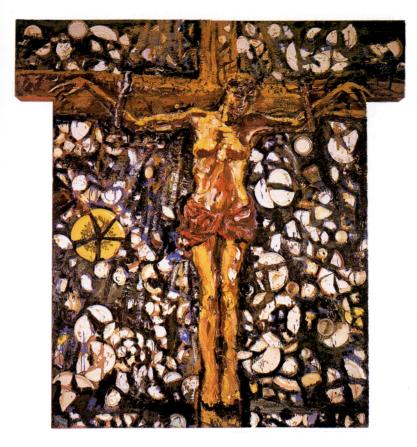

port. In the orange center panel, a pair of rope-dancing nudes are also canceled, not only by the grinning head of a male pilfered from Ribera's Clubfooted Boy (1652) and applied to each of the bare posteriors, but also by the ghost of a cervix-shaped fountain and a long, red "cancellation" stroke or smear. Finally, on the right, the plaid fabric ground and the bridge excerpted from a Beckmann painting screen one another into near illegibility. Within the evident meaninglessness of such arbitrary juxtapositions, what appears certain is that several different realities-abstract and concrete, modeled and schematic, full color and monochromy, arcane and common-have been irredeemably leveled, all together yielding a symbol of the post-industrial world, where everything becomes instantly consumed fodder for the undiscriminating and ravenous media. According to post-structuralist thought, it should be remembered, meaning is fugitive at best, something, moreover, to be supplied by the reader/viewer instead of imposed by the auithor/artist and only insofar as the former may be able, by virtue of his/her own creative imagination, to snatch momentary signification from a universe of whirling signs—representations or simulations—utterly decentered from their referents in the real but long-absent world. Regarding *Muscular Paper*, Janet Kardon wrote: "The modernist idealization of the viewer as one on trial for entry into utopia, a future where the unworthy present is redeemed, is seen in this art as a bad joke. Salle's viewer . . . is in the world, unredeemed and fallen. It is one of Salle's major achievements that he has conceived an art that is not prospective or retrospective in the modes sanctioned by modernism, but that restores to us the presentness of our experience."

During their time at Cal Arts studying under John Baldessari, Salle and Eric Fischl (1948-) shared a studio and an anachronistic commitment to painting but, it would seem, to little else. Whereas Salle set out quite deliberately to stump viewers, even while leading them on with sensational imagery, Fischl gradually developed a painting style as accesssible as Edward Hopper's for the very purpose of making the picture's narrative clearly readable. Yet, once caught up in the kind of psychodrama favored by this artist, his audience may well find themselves as indignantly mystified as many are by Salle's rebarbative non sequiturs. Having chosen to portray white bourgeois America with a Winslow Homer painterliness the subject culture would find most flattering, Fischl then challenges both by making them occasions for exposing comfortable society at its most private and vulnerable, as when the members of a nuclear family furtively cast incestuous eyes on one another's nudity while ostensibly enjoying an innocent Sunday afternoon on their pleasure boat at sea. In Fischl's art, water makes a frequent appearance, in backyard pools, at upscale resorts, off the shores of New England or the Caribbean, always providing a complex symbol of privileged recreation, subliminal menace, and the volatile, inchoate source of human life itself. Something of all this can be sensed in Cargo Cults (Fig. 767), where a group of five men relaxing on a tropical beach, in various states of dress or undress, suddenly find their vacation disturbed by a pair of strolling female nudists and the exhortations of what could be a native shaman. Distraction reigns as the central figures rise up or sink down, their attention divided between the instrusion on the right and the one on the left. But what does any of it, or the whole, signify? Is the black man seeking alms or souls? Is the standing male importuning the two women, or taunting them, or calling to some ship beyond the picture frame? In such art, Manet is vaguely recalled in the fluid handling, Degas in the insidious sexuality and voyeurism, and Daumier in the social critique, all of which Fischl proudly admits. However, by the paradox of his blunt yet enigmatic approach to the strained taboos of an upper-class universe still dominated by puritan chill, Fischl, like Eakins and Homer before him, managed to make even holiday scenes resemble what Robert Rosenblum called "joyless environments, the very opposite

opposite: 764. Francesco Clemente. Perseverence. 1982. Oil on canvas, 6'6" x 7'11". Collection Paine Webber. Courtesy Sperone Westwater, New York.

above: 765. Julian Schnabel. *Vita.* 1983. Oil and bondo with shattered crockery on wood, 12'6" x 10'. Courtesy PaceWildenstein, New York.

right: 766. David Salle. *Muscular Paper*. 1985. Triptych: acrylic and oil on canvasand printed fabric; 8'2" x 15'1/2". Douglas S. Cramer Foundation, Los Angeles, and the Museum of Modern Art, New York.

of their French counterparts, where landscapes smile along with the people in them and where erotic juices produce pleasure, not shock and guilt." Another source acknowledged by Fischl has been Max Beckmann, the later German Expressionist whose image-clogged paintings bristle with mixed messages that defy literal or linear reading and thus encourage a range of personal interpretation, fed by memory, myth, imagination, history, and the collective unconscious (Figs. 212, 213). And so too the post-modernist master plants disjunctive, contradictory clues the better to involve viewers in the rewarding process of bringing an open-ended plot to closure. Goading them out of passivity into active participation are telltale, commonplace elements of such dead-on rightness-sagging or sunburnt flesh, ghosted with the shape of discarded swimwear, a Pan Am flight bag plopped down by "frequent fliers"-that they cannot but implicate everyone in the unfolding scenario of race, gender, and class. Yet, stern moralist though he may be, Fischl would also have us empathize with the subjects of his mordant disclosures-the victims of a graceless and sterile even if affluent social structure-for, as he stated to Nancy Grimes in 1986: "The longer you look at [the picture], the more you realize that the point of view is not the victimizer's but the victim's. I think [a] painting is successful precisely because it stirs your preconceptions-and then becomes a clearer, more dimensional reality. I start off despising these people and work toward compassion."

Graffiti

In a development often related to Neo-Expressionism, the postmodern desire to remap the art scene, by allowing the "margins" to become the center of critical-collector interest, received glowing satisfaction when a number of small storefront galleries—"alternative spaces" with whimsical names like Fun, Civilian Warfare, Gracie Mansion, PPOW, Nature Morte, International with Monument—opened on Manhattan's Lower East Side and began showing a "funky-retro" brand of populist art inspired by street/subway graffiti and Hanna-Barbera animated cartoons. Now called the East Village, the dilapidated old immigrant neighborhood had experienced one earlier fling with art-world celebrity, back in December 1961, when Claes Oldenburg opened *The Store* and helped launch Pop with his "inedible edibles" made of painted plaster. In the two decades since Oldenburg spent time on the margin, the quarter's resident underclass had found themselves increasingly joined by col-

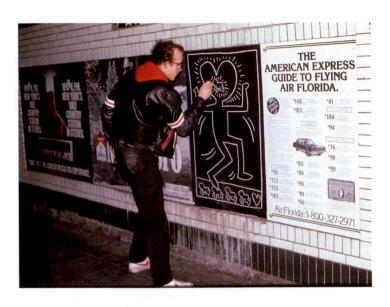

lege students, especially those enrolled at the nearby School of Visual Arts. As the New Wave generation arrived, seeking low rents and affordable exhibition/performance venues, they brought with them a love of nightspots in which to get high on rock music and dance, among other things. This led the SVA crowd to make a home away from home at Club 57, housed in a church basement courtesy of parishioners concerned for the welfare of local young folk. Here, art students, steeped in late-adolescent nostalgia for The Jetsons and The Flintstones, interfaced with some of the big city's "writers" who habitually turned the MTA, or subway, trains into traveling exhibitions of their drive to mark a bit of the world in a violently distinctive, truly "signature" manner. As SVA students like Keith Haring and Kenny Scharf recharged their aesthetic batteries with energy from the grafittists' festooning "tags" and "logos"-among the most eruptive of all forms of expression-the underground Krylon, Red Devil, or Rustoleum masters learned about the above-ground, "legit" world of dealers, critics, and collectors. Soon, this cross-cultural exchange would benefit from the NEA (National Endowment for the Arts), which funded Fashion Moda, a South Bronx storefront gallery offering an outlet, other than the city's vandalized walls and subways, for indigenous "bombers"-spray painters-with pseudonyms such as A-One, Daze, Toxic, and Futura 2000. In 1980, the

left: 767. Eric Fischl. Cargo Cults (for DS "King Kong").1984. Oil on canvas, 7'8" x 11'. Courtesy Mary Boone Gallery, New York.

above: 768. Keith Haring. Art in Transit. 1982. Courtesy Estate of Tseng Kwong Chi, New York.

marginalized became less so when they went public in the "Times Square Show," co-sponsored by Fashion Moda and Colab, an East Village collective made up of some thirty artists locked out of the commercial gallery system. Taking over an old, rickety Midtown building, the participants brought "outsider" art inside and transformed it into a total environment, even to closets, stairwells, and toilets. By 1983, Graffiti had become a movement with a capital letter, acknowledged not only by the media but also by such prestigious showcases as New York's Sidney Janis Gallery and Rotterdam's Boymans-van Beuningen Museum.

The SVA student most immediately identified with Graffiti was Keith Haring (1958–90), who traveled to New York from Kutztown, Pennsylvania, and then kept moving throughout the MTA subway

left: 769. Keith Haring. Untitled, 1982. Day-Glo paint on wood, 4' diameter. Courtesy Tony Shafrazi Gallery, New York.

right: 770. Jean-Michel Basquiat. Horn Players. 1983. Acrylic and mixed media on canvas, 8' x 6'5". Collection Eli and Edythe L. Broad, Los Angeles.

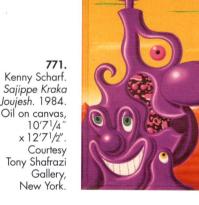

system. There, he never touched a train but made a beeline for every one of the black wall panels used to "cancel" defunct advertising (Fig. 768). Spurred by the risk of arrest, Haring perfected a technique of rapid chalk drawing that enabled him to cover the slatelike ground with a linear maze pattern of barking dogs, radiant babies, copulating couples, anthropomorphic appliances, and zapping spaceships. Famous as the anonymous master of subway art, he gradually moved with hipster ease into ever-more "respectable" arenas, not only SoHo's major galleries but also Uptown museums, as well as similar sites the world over. Such was his command of means that he could readily adapt his "New Wave Aztec" manner to the demands of virtually any format—T-shirts, buttons, pottery vases, or neo-Grecque pseudo-stone jars. Most memorably, he

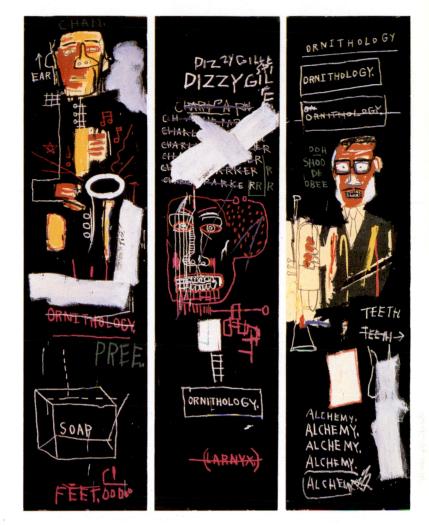

painted standard canvases with his personal repertoire of cartoon figures so woven into a dense, energized, abstract web that they resemble Pop variants of Pollock's holistic pourings (Fig. 769). Towards the end of a life cut short by AIDS, Haring returned to public spaces, this time for colossal, open-air billboards emblazoned with messages for young people, such as: CRACK IS WACK.

The most gifted and career-minded of the indigenous graffitists to appear at Club 57 was Jean-Michel Basquiat (1960-88), today fabled not merely because he died tragically, at a still earlier age than Haring, but also because he seems to have realized that rare phenomenon, an "art springing unfiltered and unedited from life," as Roberta Smith wrote in 1989 (Fig. 770). This occurred, moreover, despite his being from a stable, bourgeois Haitian-Hispanic family in a good Brooklyn neighborhood, where even a private school could not hold the boy when at seventeen he decided to hit the streets and, on his own, make it as the Picasso of his race and generation. Already savvy enough to take Rauschenberg and Johns as models, as well as to avoid the subways, Basquiat teamed up with a fellow dropout, Al Diaz, and headed for SoHo, where the art world soon knew the pair through their concrete poetry writ large on outdoor walls and tagged SAMO[®]. After winning a place in the "Times Square Show," SAMO[©] broke up, which left Basquiat free to sign his own name to a set of graffiti-scrawled, unprimed canvases and enter them in P.S.1's "New York/New Wave" exhibition, held in early 1981. With the gallery support that followed, he began producing what many consider his strongest work, large canvases arrayed in rudely calligraphed names, titles, phrases, and poetry that periodically metamorphose into mock-primitive imagery-skyscrapers, grinning, Africanized masks and skulls, oddly dangling

robotic figures. With its rhythmic, unifying admixture of improvised slashes of black or brilliant color, abstract signs and symbols grids, crowns, arrows, rockets—the mature painting created by twenty-two-year-old Basquiat easily invites comparison with the art of Dubuffet and Twombly but, like the work of these senior artists, remains so distinctive as to lie beyond comparison. An achievement of this order makes it all the more grim that so much promise—for making inside and outside meet—should be lost to an overdose of heroin at the age of twenty-seven.

Even the School of Visual Arts found itself marked by SAMO[©], thanks to Haring's fellow student Kenny Scharf (1958-), who got Basquiat in, for a quick tour, by forging a set of "teacher's notes." But while Scharf, a star reveler at Club 57, worked briefly with graffiti writers, he proved less turned on by populism or social protest than by the fantasy realm of The Flintstones and The Jetsons, both of which originated virtually next door to his childhood home in Los Angeles (Fig. 771). On canvas he used his flair for action-packed illusionism to re-create the series' phantasmagoric animation effects, shamelessly exploiting Kool Aid colors and Surrealist tricks to suggest a spaced-out, Saturday-morning television world aswarm with melted-jellybean monsters, saber-toothed pixies, forests of snaky Jujube-green vegetation, whirling cannonballs, and cottoncandy clouds, often afloat in busy, magpie profusion against a dazzling, interglactic depth. Thus, however goofy, visually entrancing, and sugar-coated, a certain angst abounds in this funfair almost as much as in the art of Haring and Basquiat.

Following graduation from Cornell University and a start in Colab, Fashion Moda, and the "Times Square Show," John Ahearn (1951—) moved to the South Bronx and made its hard-pressed but valorous citizens his subject in a continuing series of body-cast sculptures, works that never fail to show just how irrepressibly individual even the most anonymous folk are in reality (Fig. 772). Unlike George Segal and Antony Gormley, Ahearn and his assistant, Rigoberto Torres, cast the form within the mold, as did Duane Hanson (Fig. 724). But unlike Hanson, he then paints face and figure with a Rembrandtesque touch that not only leaves them radiant with all the subtle, halftone colors of black and Hispanic skin; it seems as well to evoke their very temperature and ambient lights—their aura. In this way, the sculptures escape the mere representational to become heroic presences whose meaning reverberates as much in the barrio where they originate as in the museums, where much of the art goes.

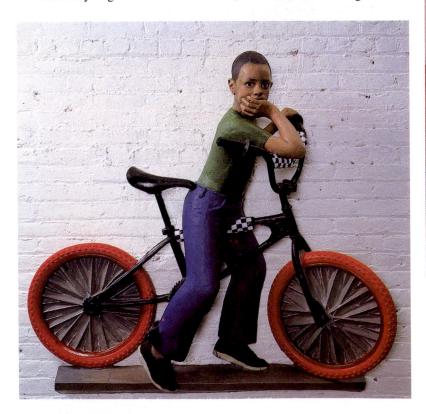

Sculpture

Artschwager, Burden, Abakanowicz, and Ahearn-the four sculptors already seen in this chapter-did not prevail alone against Conceptualism's dematerializing attack upon the commodifiable art object. So did the post-modern sculptors met in the last chapter-Simonds, Hanson, Graves, Flanagan, Burton, Shapiro, and Gormley-along with the leading Minimalists themselves, who today enjoy the status of Old Masters. Indeed, by the mid-eighties, when the Neo-Expressionists had thoroughly shattered puritan restraints of both Minimalism and Conceptualism, sculpture made a comeback, at least in artists' preference and critical esteem, even more impressive than that of painting. At a time of increasing cultural diversity and aesthetic pluralism, sculpture could offer responsive artists not only the possibilities of multiple dimensions and endless multimedia, but also those of the "expanded field," as Rosalind Krauss called the fresh dispensations of Performance and Process Art, Arte Povera, scatter, earth, and site works. Consequently, the sculpture of the new fin de siècle would find its identity not in style, which has varied almost seismically with the personalities and intentions of the artists involved, but rather in triumphant idiosyncracy and a hungry, revivalist curiosity about the entire sculptural tradition, all pursued in reaction against Minimalism's ahistorical self-centeredness and depersonalized, manufactured quality.

In this open, almost anarchic climate, even Minimalism continued to have an impact, especially where artists like Jackie Winsor (1941—) took up formalist concerns—with mass/void, object/environment, artist/process relationships—mainly to turn them on their heads. Working serially as did the Minimalists, the Canadian-born Winsor has rehumanized Primary Forms—squares, grids, and spheres but most of all cubes—by crafting them in the most archaically personal, labor-intensive manner. After months spent in ritualistically repetitive activity—laminating sheets of paper-thin plywood, unraveling and rewinding old hemp ropes, stapling layer

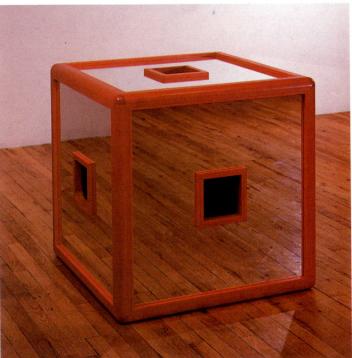

left: 772. John Ahearn. Jay with Bike. 1985. Oil on fiberglass, 4'4" x 4'7" x 1'4". Courtesy Brooke Alexander, New York.
 above: 773. Jackie Winsor. Interior Sphere Piece. 1985.
 Mirrored glass, wood, and paint; 31" cube. Collection Rayovac Corp. Courtesy Paula Cooper Gallery, New York.

upon layer of wire mesh-the artist could rest confident that she had replaced Minimalism's factory-built impersonality and timelessness with a mysterious sense of time-consuming thought, feeling, and exertion. To reveal this secret, narrative content, Winsor characteristically opened "portholes" on the five visible sides of her cube, penetrating right through the mass and intersecting at the center to form a three-dimensional cross. For one series (Fig. 773), she also rewarded the inquiring eye and mind with a Minimalist version of a Russian Easter egg interior-a shiny, lacquered lining in one, a sphere fashioned of wood blocks in another-by way of apertures that look solid because surrounded by walls faced in mirror. By reflecting the ambient world, the glass vencers seem to render the boxy volume transparent, thereupon endowing it with the very illusionism that Minimalist literalness sought to banish from art. They also foreground the theatrical element always covertly present in Minimal Art, which, by its silent, static simplicity or utter lack of drama, manages to translate the surrounding space into a stage and its perambulating viewers into actors.

While Winsor warmed chilly, hands-off Minimalist geometry with the intimacy of hands-on, extended endeavor, the French-American artist Louise Bourgeois (1912—) came close to igniting

it, under pressure from a subconscious outraged since her youth in prewar, Surrealist Paris. Even after arriving in New York, as the bride of art historian Robert Goldwater, Bourgeois never ceased to defy natural reticence and allow her art to grow however eccentric it must in order to vent frustration over life in her parental home, a place torn by conflict between a passive, caring mother and an engaging but irresponsible father romantically entangled with the family's live-in English governess. For years, she devised symbolic human parts and effigies from plaster, flabby latex, or found wood, exhibited as base-free, solitary or grouped icons of anxiety and alienation. With the advent of feminism, however, Bourgeois discovered a large and enthusiastic audience, whose support has enabled her to work on a grander scale and in finer materials, among them bronze, granite, and marble (Fig. 774). This simply increased the shock and surprise of works such as the one reproduced here, carved from a large block of flesh-pink marble so that forms of almost Neoclassical perfection rest on a thick, rusticated slab. Crushed below the silken sphere is a trio of exquisite forearms with the hands turned up, like suppliant female emotion in unequal contest with the hard, rounded ideal of male rationality. To compound the pain and irony, a devastating subtitle runs along the base: We Love You We Love You. As a further trope for bruised, polarized life-or perhaps the power of art to retrieve beauty from a world drenched in tragedy-the rough-hewn base stands in contrast to the trembling delicacy of the finished passages, their translucence shot through with the cobweb ramifications of tiny blue veins.

Between them, in their brazenly individual ways, Artschwager, Burden, Abakanowicz, Ahearn, Winsor, and Bourgeois managed to embrace three of the formal issues-figuration, organic abstraction, and building- or architecture-related abstraction-that seemed most compelling for sculptors coming to the fore in the 1980s. A fourth concern-the transformed object-had proved especially important to Bourgeois earlier in her career. Now, during the eighties, this Duchampian strategy would engage younger sculptors quite as much as image appropriation captivated the Neo-Expressionist painters, as well as other pasticheurs to be seen under different headings later in this chapter. It found richly gifted exponents in Britain, where, perhaps in response to a sense that the nation was being overwhelmed by technological obsolescence, several new sculptors turned the modification of industrial discards into a three-dimensional "poetics of decay." With this, they continued a process begun by Eduardo Paolozzi back in the 1950s (Fig. 535), only to replace

above: 774. Louise Bourgeois. *Untitled (with Hands).* 1989. Pink marble, 35 x 29 x 34". Courtesy Robert Miller Gallery, New York.

below: 775. Tony Cragg. New Stones—Newton's Tones. 1982. Plastic floor construction, 16'5" x 6'. Courtesy Marian Goodman Gallery, New York.

his proto-Pop irony with a new kind of romanticism, art in which potato-chip bags, old tire irons, or broken-down appliances plucked from the environment would hold as much metaphysical import as Wordsworth's brooks, stones, and trees. Tony Cragg (1949-), the senior of these "post-industrial" sculptors, abandoned science for art in the hope of spanning the gap between the average person's understanding of the world and the complicated place it had become. As an argument for the futility of trying to turn back to organic nature from the constructed state of modern existence, Cragg scavenged a hoard of colorfast plastic discards from a Sussex beach and organized the shattered toys, tools, and kitchen utensils into a rectangular, carpetlike floor piece entitled New Stones-Newton's Tones (Fig. 775). With scraps as his atoms, he recapitulated in contemporary terms the 17th-century experiment whereby Sir Isaac Newton refracted white light through a prism and, for the first time, broke solar energy into its rainbow array of spectral colors. Subsequently, Cragg has indulged his scientific curiosity to explore a bewildering

miscellany of media and forms, the latter often discovered in laboratory equipment while the former have included plaster, bronze, wood, granite, polystyrene, and glass. For what he once called "the single object that I am most proud of," Cragg scaled a pharmaceutical retort to fantastic proportions and then cast it in bronze, but not before modifying the object until its swelling mass and elongated, ductile "lip" recalled the erotic biomorphism of Henry Moore's pantheistic figures (Figs. 776, 417). While grateful to Minimalist toughness for clearing away Moore's "humanitarian wishy-washiness," Cragg would seem nonetheless to conflate the two precedents by seeking the natural in the artificial, the symbolic and the humanist in the most humdrum, practical concretions of the man-made universe.

Influenced by Richard Long, Bill Woodrow (1948—) rebelled against Caro-taught formalism at the St. Martin's School of Art, but soon relinquished open nature for urban culture as the site for new art, explaining that "walks in the countryside and rural atmospherics don't play a very large part in my life." With this, he too became a "post-industrial" sculptor, fostering a kind of reverse evolution wherein old technology or artifacts might give birth to dreams of revived harmony between the world and its predatory, all-consuming populations. For the sake of identifying content with context, Woodrow likes to make his work "ambience-specific," fashioned,

left: 776. Tony Cragg. Untitled. 1988. Bronze, 6'11"x 6'11" x 9'4". Courtesy Marian Goodman Gallery, New York.
 above: 777. Bill Woodrow. Eclipse. 1985. US mailbox, tin globe, aluminum saxophone mute, enamel paint; 34¹/₂ x 37¹/₂ x 15³/₄". Courtesy Barbara Gladstone Gallery, New York.

that is, of cast-off materials salvaged from dumpsters, junkyards, swap meets, and thrift shops near the intended place of exhibition (Fig. 777). In scenic, security-obsessed La Jolla, California, he assembled Eclipse from a dented saxophone mute, a battered, upended mailbox, and a world globe resting on its north pole, each of which served as the mother of an offspring form cut, twisted, and shaped from the host object, to which it remains attached by an "umbilical cord." As the negative passages in the "mothers" attest, the bowler-hat-like mute yielded a black-painted 35mm camera, the mailbox a video camera, and the globe a red rose. Although the particular combination of elements and images evidently evolved from "intuitive or gut reactions, not a philosophy or program," Woodrow allows that "the piece is maybe about cameras watching the world; a world turned upside down, and hiding from the camera's eyes is this beautiful natural thing, a rose." However, the key metaphor arises not only from the oedipal relationship between primary and secondary images but also from a process through which the artist, using simple tools and a lot of imagination, transformed dumb rubbish into something both beautiful and thought-provoking.

An equally eccentric and hybrid appeal radiates from the craftsmanly, organic, quasi-abstract pieces of Martin Puryear (1941—), whose slow but sure development finally brought him forward as one of the strongest new talents to emerge in American sculpture during the eighties (Fig. 778). What sets Puryear apart from Cragg and Woodrow, as well as everyone else, is his gift for making a seamless fusion of all the cultural and aesthetic worlds to which he has exposed himself throughout a life of utmost diversity. After graduating from Catholic University in Washington, D.C., this son of a black middleclass family joined the Peace Corps for service in Sierra Leone, where he conceived an abiding interest in carpentry and building, which led to further studies at Sweden's Royal Academy and shipyards, then at Yale and in Japan. Meanwhile, he pondered the great modernist exponents of biomorphically abstract as well as Surreally tinged sculpture, from Brancusi and Arp to Noguchi and Bourgeois. As Michael Brenson noted, Giacometti too can be sensed in the untitled work seen here, especially when compared to the Swiss master's Woman with Her Throat Cut (Fig. 326), inasmuch as both display the arabesque of schematic feminine forms sprawled upon or arching against the floor. But whereas the Giacometti sculpture connotes violation, Puryear's exudes tenderness, like a witty analogue of ebbing and flowing generations, from a small, nuclear knob through the sweeping, swan-neck stem that finally bursts into a spoked and fluted, bell-mouth "flower." Puryear himself has likened this step-by-step movement to the African theme of polygamy, expressing it as well in the sequence of materials, which shift from ponderosa pine to ash, cypress, and rattan. In the interest of form and content merged in one meaningful whole, Puryear becomes almost shamanistically involved with his materials-often tar, steel mesh, earth, and fieldstone-until every line, volume, and planed or staple-marked surface seems animate with spiritual presence. The site of both tension and ease, ungainliness and elegance, Minimalist simplicity and psychological complexity, Puryear's sculptural art opens wide to universal human capacity, just as the work also reverses the absorption of African art into Western modernism by assimilating the latter tradition into a tribal context.

The most architectural of all the sculpture produced in the eighties came from the studio of Siah Armajani (1939-), an Iranian long resident in Minneapolis and committed to a populist art that, through discourse between an ancient culture and a relatively young one, longs for the rebirth of hard-working, civic-minded egalitarianism, an ideal once commonplace and generally practiced in Middle America (Fig. 779). In the subtitled Hall Mirror with Table in Front, for instance, he combined such purist sources as De Stijl, Russian Constructivism, and vernacular American carpentry-balloon-frame, clapboard houses, Shaker furniture, covered bridgesto re-create a once ubiquitous combination of furniture in a surreally crossbred form that the post-modern architect Robert Venturi characterized as "complexity and contradiction." Drawn to what appears simultaneously familiar and strange, viewers find themselves frustrated by a mirror whose tilt renders both it and the table dysfunctional, thereby forcing the mind to seek satisfaction elsewhere, on the surrounding frame with its brass inscription of a verbal dictum from America's pragmatic philosopher John Dewey: "As long as art is the beauty parlor of civilization, neither art nor civilization is secure." By introducing this conceptual element and thus

further complicating his deceptively simple sculpture, Armajani suggests that along with the rights and expectations promised by democracy goes the responsibility of the system's beneficiaries to measure up—morally, intellectually, aesthetically. And since accountability means that little of genuine value comes without some earnest effort, the artist composed the simplicities of his old-fashioned/modernist vocabulary in an intricate syntax more reminiscent of Persian design than of the structural order known in the West.

Neo-Abstraction

As the robust "maximalism" of Frank Stella, the cross-cultural calligraphy of Twombly, the ironic Abstract Expressionism of Gerhard Richter, and the humanized Minimalism of Jackie Winsor indicate, plastic art more concerned with essence than appearance could be admired as well as made in the seventies and eighties, despite the post-modern bias against it. By the mid-eighties, furthermore, it became evident that these several artists did not flourish in a vacuum; indeed, their enterprise was being shared by a great number of pictorially articulate individuals convinced that in an age as abstracted by its own technology as the present one, abstraction may in fact be the most expressive of all available aesthetic languages. Oddly enough, the same post-modern or semiotic theories espoused by figurative Neo-Expressionists like Polke and Salle seemed also to validate the argument for abstraction, even though many of the artists working in this mode care little if anything about ideology. To a multitude of Baudrillard followers, abstract art offers a perfect metaphor for contemporary existence dominated by "simulation," "hyper-reality," or "spectacle," provided, of course, that the art make no attempt to revive idealizing, modernist myths of heroic originality and authenticity, or to recover the modernist project of progressive formal autonomy. Whereas modernism had longed for the void of transcendence-self-elimination-the new abstraction, like the rest of post-modern art, would be tantalized by the void at the core of life-the life of human beings, creatures of nature-forever removed from its "referents" in the pre-industrial or natural world. In today's make-believe environment, where, as in verbal language, things mean less for what they are than for what they are not, presence seems invariably to evoke absence. Once pure gesture and pure geometry could no longer signify desire for a disappearance already achieved, they ceased to be logical imperatives and

right: 778. Martin Puryear. Lever #2. Rattan, ponderosa pine, and cypress; 5'11" x 24'5" x 4'7". Baltimore Museum of Art. Caplan Family and the Collector's Circle Funds.

far right: 779. Siah Armajani. Dictionary for Building: Hall Mirror with Table in Front. 1982–84. Bronze, mirror, and painted wood; 7' x 2'1/2" x 1'81/2". Courtesy Max Protetch Gallery, New York.

became options or possibilities, conventions in a glossary of formal terms subject to endless combination and recombination and entirely dependent for meaning upon not only context but also interpretation. Now, the abstract and the representational seemed to function like coefficients of one another, as fluidly interchangeable as linguistic signifiers and signifieds. Back in 1958, Jasper Johns had made the point quite unforgettably, when he gave birth to both Pop and Minimalism by depicting realities-common signs like flags and targets-that were intrinsically abstract, images the artist then transformed into concrete objects by making them coincident with their supports. As already shown, Richter too dissolved the fine, flickering line between description and abstraction by working in both allusive and nonallusive styles but for the single purpose of embodying light in paint on canvas. In other, equally idiosyncratic ways, Neo-Abstractionists managed to create pictures generally devoid of recognizable imagery without becoming modernist clones, the better to express the anomie of current life rather than the optimism so characteristic of art from Manet through Donald Judd. By transforming their art into a nonhierarchical discourse of speculation, mystery, and difference, in place of the monolithic, materialist certitude of Stella's "what you see is what you see," Neo-Abstractionists have mirrored the virtuality of the post-industrial world, distinguished themselves from their predecessors in the modernist tradition, and finally redefined abstraction, which the critic/dealer Jeffrey Deitch speculated "may eventually be recognized as the great artistic innovation of the 1980s."

The artist whom the critic Robert Hughes once called "the finest American abstract painter of his generation," is Brice Marden, already seen as one of the last and youngest of the Minimalists (Fig. 593). Even though an authentic figure from the cool sixties, Marden early proved himself a Johns-like maverick by investing his flat fields of color with such romantic qualities as human scale, waxy or even fleshy translucence, and pigments applied with a spatula in broad, cursive movements. The "drawing" involved in this kind of nuanced handling became all-important to the artist when, in the mid-eighties, he found himself in aesthetic as well as personal crisis and eager to reconstitute both his life and his art. Encouraged by study of a T'ang dynasty poet/sage known as Cold Mountain, for the Buddhist monastery where he lived in retirement from China's imperial court, Marden began to consider Pollock's linear spillings in relation to Oriental poetry and its beautiful, calligraphic texts. For a long while, he simply drew on heavy, small-format paper, using ailanthus twigs-the "tree of heaven" weed that sprouts from cracks in urban sidewalks-dipped in ink to produce a purely abstract, **left: 780.** Brice Marden. *Cold Mountain 3 (Open).* 1988–91. Oil on linen, 9 x 12'. Courtesy Mary Boone Gallery, New York.

New York School version of Chinese characters piled in couplet towers slowly marching across the page. Gradually, Marden scaled up his gestural image to formats as large as 9 by 12 feet, realized with a long-handled brush that left the artist almost as distanced from his wall-hung painting surface as Pollock was while flinging liquid medium onto canvas spread over the floor (Fig. 780). The result is a Pollockian web now moving over whitish ground at a philosophical, rather than lightning, pace and airily open to reveal not the confidence of a virtuoso but rather that of a contemplative as bold about his hesitations and pentimenti as about his final decisions. Ghosted not only by wash-thin oils, overpainting, rubbing out, and sanding but also by a muted gray-green or gray-umber tonality, the vinelike tangle of lines seems to hover before the shadowy, layered remains of its own regeneration, emblems of evolving consciousness as well as of mountains viewed through wind and mist.

Although Denmark's Per Kirkeby (1938—) might be called a stylistic survivor from the Abstract Expressionist fifties, he has successfully indulged a polymath array of interests—criticism, poetry, novels, films, performances—that place him well within the confines of the post-modern, post-Conceptualist era (Fig. 781). Still, he avoids the flash-frozen look of Gerhard Richter's Expressionist

abstractions in favor of a baroque, fluidly ample manner of painting, a manner that begs comparison with the original New York School as well as with the Neo-Expressionism of Kirkeby's friend Georg Baselitz. It would also appear to acknowledge a precursor in Asger Jorn, the preeminent Danish member of CoBrA whose abstract fields played host to a kind of vague figuration that seems also to hover within the ambiguous dreamscapes painted by Kirkeby. However, the artist has declared his pictures to be "about color . . . color outside the language. The only way to do it is through memory—perhaps a certain sunset on the day your wife left you." With their Proustian echoes, the works seem built up from billowing masses of pigment stiffened with a musculature of sketchy brushwork in contrasting hues and held to the plane with networks of dark, wiry drawing. If the facture itself registers heat, the palette seems to bank the fires, until the pictorial world looks invaded by a cool, slightly foggy, Nordic light. Nordic as well is the artist's way of working, which Kirkeby likens to the Existentialism initiated by his 19th-century countryman Søren Kierkegaard.

"Time regained" also fueled the talent of Howard Hodgkin (1932-), who too developed slowly before bringing his art to refulgent glory at the end of the seventies. For this Englishman, looking at another person has always seemed "like staring into the sun," with the result that the act of recalling the encounter pictorially becomes an experience of almost burning intensity, which in turn accounts for the starlike brilliance and abstraction of the image, even though Hodgkin insists that he is a realist, painting "representational pictures of emotional situations." To make his recollections as concrete as possible, he begins with a solid, wooden support, preferably something with a built-in frame and history. such as the door panel from an old cabinet (Fig. 782). In painting on this haptic surface, he proceeds less like an existentialist Kirkeby than like the Nabis Bonnard and Vuillard, nurturing his reverie in full consciousness and in full command of a spectacular repertoire of blazing colors and erotic strokes-swipes, blobs, zigzags, vaporous plumes, shredded scumblings. In Goodbye to the Bay of Naples, shaggy enlargements of Neo-Impressionist spotting reify the frame and, by tumbling onto the central plane, make its illusion-of deep cerulean space-appear quite sensuously there. After recovering from the initial shock-the blinding radiance-of the most narcotic colors and gestures ever put on canvas by an English painter, viewers may find themselves motivated to heed the picture's title and read the intimate drama it implies. Here, the triangular silhouette of an orange-hot Vesuvius and the encircling puffs of black, volcanic smoke evoke not geology but rather a private affair, signaled by a green phallus surging up to caress a broad, chunky lick of Mediterranean blue, laid down like a cancellation mark or ideogram for "goodbye." Gorgeously patterned, in the way of Matisse, as a collage of color-forms in buoyant equipoise. Hodgkin's layered hues and textures recapitulate a process of distillation meant to transform feeling into an aesthetic object capable of making elusive, cumulative memory as vibrantly present to the viewer as it became for the artist himself.

Rather than the intimism of autobiography in Fauve color, Sean Scully (1945-), an Anglo-Irish artist domiciled in New York since 1975, attempts "to give expression to the larger structure," using stripes-banal, ubiquitous, and thus neutral-as his endlessly adaptable building block (Fig. 783). And they work best, for Scully and his purposes, when employed not to generate optical/spatial effects, as in the sixties striations of Louis, Noland, or Riley, but instead to articulate the pictorial field, which in turn depends upon how the stripes-the pictures' surfaces-have been painted. Here van Gogh, followed by Velázquez, Goya, and Manet, showed the way, by stroking the canvas with such physical urgency that the overall image became both tangible and abstract. Broad-brushed freehand, rather than over tapes, and wet-on-wet so that different, layered colors seep through from below as well as along wavering edges, Scully's mature paintings recall Frank Stella's early "pinstripes" more than his later Hard-Edge works, particularly where the younger artist makes lustrous black dominant in a palette often warmed by brown, siena, Indian red, and grayed blue. As something

opposite: 781. Per Kirkeby. Fünf (Five). 1989. Oil on canvas, 6'6³/4" square. Courtesy Michael Werner Gallery, New York.

left: 782. Howard Hodgkin. Goodbye to the Bay of Naples. 1980–82. Oil on wood, 22×26¹/4". Courtesy Knoedler & Co., New York.

above: 783. Sean Scully. A Bedroom in Venice. 1988. Oil on linen, 8 x 10'. Museum of Modern Art, New York. Fractional gift of Agnes Gund.

The Post-Modern Eighties

below: 784. Ross Bleckner. Knights Not Nights. 1987. Oil on canvas, 9 x 6'. Courtesy Mary Boone Gallery, New York. right: 785. Philip Taaffe. *Easter Choir*. 1990. Mixed media on linen, 7'7" x 9'7". Courtesy Gagosian Gallery, New York.

more "for the viewer to grab onto"—something comparable to the figure in representational art—Scully scales his polyptychs to human, albeit heroic, proportions and combines "active" vertical stripes with "passive" horizontal ones, sometimes even with diagonals, as if the total had been agglomerated from sections of diverse field paintings, or of Johns's Flags. Further, he has abutted panels so various in their dimensions and depths, as well as in the colors and widths of their banding, that they seem like assemblies of interactive social beings. Occasionally there may be an inset, a small independent panel applied to or countersunk within a large one, like a reminder of the "other" always present within greater society, or an emblematic window in the taut, built-up, two-dimensional world of an artist disinterested in either expressionist or illusionist fictions.

Whereas all the painters just examined remain untainted by post-modern doubts about the relevance of painting in an era of drastically devalued meaning, Ross Bleckner (1949—) has discovered the exploration of those doubts to be so compelling that he usually paints in at least two contrasting styles at once, both of them appropriated, critically massacred in their own time, and thus perfect as vehicles for elegiac reflections on the "death" of both painting and modernism. Like David Salle and Eric Fischl, his classmates at Cal Arts, Bleckner seems to have taken John Baldessari's "post-studio" course as a perverse, oedipal excuse for making the studio the very site of his own creative endeavors, if only with the purpose of deconstructing all that traditionally went on there. For example, in reviving Op Art—once phenomenally popular but always reviled by most cognoscenti—Bleckner took on a kind of

painting whose retinal razzle-dazzle had seemed to epitomize the giddy optimism of the youth-cultured sixties. He then replaced Op's tape-edged precision and snap with slowly wavering, hand-brushed stripes, blurring their edges until they blend into one another, thereby muffling whatever light might otherwise have radiated from the candy-bright colors. The sense of failure and mourning encoded into Bleckner's oddly glamorous pictures became overt in a series of purple-black paintings (Fig. 784), where deep midnight voids glow with a strange, shimmering light from spooky chandeliers, candelabra, fountains, urns, and intricate wrought-iron gates. Sometimes, as here, the image consists of nothing more than a scatter of what Robert Storr likened to "dying stars in a polluted firmament." For these almost self-indulgently beautiful works, the artist appears to have dipped into the necromantic world of the last fin de siècle, when the morbid, generally dismissed wing of Europe's Symbolists-Moreau, Redon, Burne-Jones, Khnopff-cultivated decadence as though without it there could be no transcendence. Known to be AIDs memorials, Bleckner's inky-dark, spectral paintings seem to confirm that only through seductive recycling of modernism's pariahs can art be endowed with significance for a post-Vietnam generation haunted by its own loss of faith, by incurable disease, and by the fear of hydrogen annihilation.

As an early follower of Jean Baudrillard, Bleckner more or less pioneered the "simulationist" process of balancing the rival goals of formalism and conceptualism-that is, creating an art capable of ravishing the eye while also exposing the means by which the ravishment occurs. Among the several artists influenced by Bleckner, Philip Taaffe (1955-) tilts increasingly towards the hedonist side of the seduce/critique equation (Fig. 785). And he too began with startling reinterpretations of Op Art before daring to transform the heroic austerities of Barnett Newman into high decorative painting laced with elements from fashion design and Islamic ornament. Subsequently, Taaffe moved on, from New York to Naples but also to abstractions as culturally mixed and layered as the Mediterranean world he then inhabited. Thanks to a découpage technique inspired by Matisse's late work, he could experiment with every sort of borrowed motif, all simulated by himself in monoprints, linocuts, or serigraphs and then maintained like an index of stylistic signifiers democratically available for whatever new intention the artist might conceive. Behind the work reproduced here would appear to lie the broad, cataractlike fields of shafted color painted in the 1950s by Clyfford Still. Now, however, Abstract Expressionist sublimity has been translated into the sensual, arabesque language of old Cairo or Naples itself and recast as a jewel-toned fretwork as beckoning as a beaded curtain in some ancient pleasure house or yet a choir screen in Seville at Eastertime. Rather than imitate Still's abstract stroke, Taaffe represented it, the sure sign of which is the textureless surface and sharp edges of his silhouetted ropes of hue, the latter realized as cut-out prints collaged onto canvas and then enameled throughout to simulate the all-overness once so prized by the New York School. Living at a "sublimity-deprived" moment, Taaffe "will construct a mock-sublime to summon the sublime by indirection, because teasing or entertaining the sublime is just another way of aspiring toward sublimity."

Neo-Conceptualism

For the Neo-Conceptualists who began showing around 1982, the simulationist "endgame" constituted "a no-man's land," as Sherrie Levine once said, "that a lot of us enjoy moving around in." Here, a "theory-dense subtext"—together with a still more pronounced reversibility of fact and fiction, the abstract and the depictive— would make all the difference, yielding a shift of emphasis that, just barely, distinguishes the works to be seen under the present rubric from all the other deeply ideated art examined elsewhere in this chapter. Far more striking is the difference that the new Conceptualists drew between themselves and their ascetic forebears in the late sixties and early seventies. While no less engaged

with semiotics, epistemology, and cultural deconstruction than Joseph Kosuth, for example, Peter Halley, Cindy Sherman, Katharina Fritsch, and Christian Boltanski, among others, shared none of the older artist's anti-materialist disdain for the art object and its commodification, as long as the milking of both might also appear to be a strategy of ironic send-up. For certain leading Neo-Conceptualists, the technique that seemed most likely to achieve this contradictory goal originated with Walter Benjamin, the illfated German-Jewish philosopher memorialized by R.B. Kitaj in Arcades (Fig. 619). Fascinated by the glittering, shop-lined arcades of Paris in the 1930s, Benjamin saw in them a theaterlike spectacle offering a "facade" or "illusion" of well-being so seductive that it could easily transform productive individuals into abject consumers, leaving them entertained but also hopelessly deceived about the emptiness of their passive, manipulated lives. To partake of today's vastly expanded spectacle-to remain hip, novel, up to date-an ever-larger public accepts its artificial lures acritically, voting for the most telegenic among political candidates, or buying art at fantastically inflated prices merely to have a stake in newsworthy, tradable objects of desire-fetishes. As an escape from culture's "forest of signs" or "prison house of language," Neo-Conceptualists too engaged in making simulacra, or appropriating objects and images for that purpose, the better to foreground and thus undermine hyper-reality's power not only to enslave but also to make enslavement seem fun. This meant that Neo-Conceptualist paintings, sculptures, assemblages, and installations would be as visually stunning as the original Conceptualism had been visually destitute.

Few Neo-Conceptualists have met this challenge more dramatically than Barbara Kruger (Fig. 787), or Allan McCollum (1945—), whose Surrogates, Perfect Vehicles, and Individual Works parody Minimalist seriality by contrasting its would-be sameness with mass-produced wares attempting, rather poignantly, to satisfy the human desire for the unique and the precious (Fig. 786). In the remarkable installation shown below McCollum further identified contemporary art with the consumerist culture of the endlessly "new" and "improved" by crowding the walls of a large gallery with hundreds of Surrogates, small plaster stand-ins for monochromatic paintings that vary only in their dimensions and sometimes in the color of their absolutely blank "pictures." If sham differences among nonpaintings suggest modernism's voided promise—especially when amassed by the "new" collectors seeing in art little more

below: 786. Allan McCollum *Plaster Surrogates.* 1983. Enamel on solid-cast Hydrostone. Courtesy John Weber Gallery, New York.

left: 787. Barbara Kruger. Untitled (The Marriage of Murder and Suicide). 1988. Photographic silkscreen on vinyl. 6'11" x 8'6". Courtesy Mary Boone Gallery, New York.

788. Peter Halley. V. 1991. Day-Glo acrylic, acrylic, and Roll-A-Tex on canvas; 7'8¹/2" x 11'³/8". Courtesy Sonnabend Gallery, New York.

than fungible value—the presence and éclat generated by such a plenitude of empty rectangles bears out the post-structuralist contention that art, stripped of its onetime aura, is precisely the sum of its parts. Warming this cold demonstration of theory, however, is a humanist subtext embodied within the repetitiveness of the trivially individuated units, its meaning revealed by an artist who, like his parents, once labored on an industrial assembly line.

Drawing on her early background as a graphic designer and photo editor at Condé Nast, Barbara Kruger (1945-) creates large photomontages with terse, aphoristic captions superimposed and the whole rendered in old-fashioned Life magazine black, white, and red (Fig. 787). If the stock images, like the format, are nostalgically outdated, they function all the better as devices for causing viewers to reconsider the familiar in a new, critical light, especially when the issue happens to involve culturally defined gender, the contradictions of the media, and the mechanisms of the art market. All seem intertwined in The Marriage of Murder and Suicide, where the close-up of a man holding a bitten apple evokes destructive male/female relations going all the way back to Adam and Eve. Now, the conflict has been recomplicated by the possibility that it is a man, rather than a woman, who offers instead of accepting the apple, an apple moreover poisoned by chemicals flowing from scientific laboratories controlled by men and sold by the come-on tactics of advertising, another male-dominated industry. However, it was a woman who repackaged the latter as art, thereby further compounding the love/hate ironies, since Kruger's work succeeds largely because of the very strategies accused of having ruined the world's artistic patrimony by endless recycling through the admass culture

The term "endgame" came into usage through a group of young artists active in New York's East Village who, like so many postmodernists, found a mentor in Marcel Duchamp, Conceptualism's ur-parent. In one of his more notorious jokes, the aging Duchamp pretended he had given up art-making for chess, which, with its endgame ploys of trying to win out with ever-more diminished resources, not only mocked the modernist game but also appeared, from hindsight, to anticipate the strategies of post-modernism. The chief spokesman and theorist of the East Village Neo-Conceptualists was Peter Halley (1953-), whose own art, combined with the wellhoned rhetoric accompanying it, provoked such furious debate that a term, Neo-Geo, relevant almost exclusively to the Halley oeuvre became a group designation, applied to, among others, Ashley Bickerton, Jeff Koons, Sherrie Levine, Heim Steinbach, and Meyer Vaisman. For Halley, the abstract belongs to the real, given that reality for contemporary urbanites consists almost entirely of the socially constructed environment. Thus, while the painting seen here (Fig. 788) may appear to echo the geometrically pure art of Albers crossed with Newman and the early Frank Stella, Halley would insist that it does not transcend itself to become autonomous but instead represents or simulates the wired and plumbed, cell-like compartments in which most people live and work-"the apartment house, the hospital bed, the school desk-the isolated endpoints of industrial structures." If the Roll-A-Tex, "stucco" surfaces recall motel ceilings, as Halley suggests, the blatantly contrasted Day-Glo colors rippled over them vibrate with something like the artificial glare of omnipresent video light, as well as the high-intensity power required to drive the total-information age.

The eighties produced no artist more controversial than Jeff Koons (1955-), a former commodities trader who as a Neo-Conceptualist continued to employ market tactics of the most aggressive sort, promoting his enterprise to the point of seeming to celebrate shameless opportunism while ostensibly critiquing it (Fig. 789). For sympathetic observers, this contradiction is merely the most obvious among many that permeate works such as Michael Jackson and Bubbles, finally bestowing upon them the tension and complexity endemic to all art worth serious notice. What the crosspurposes signify would appear to be the theme of primal innocence lost and provisionally redeemed. At first, Koons sealed spanking new vacuum cleaners and basketballs in Plexiglas vitrines, bathing the former in white light and floating the latter in clear water, so as to preserve them forever in all their virgin freshness, a surrogate value available to anyone willing to pay dearly for objectifications of the desire to have cake and eat it too. Later, the artist cast both luxury items (a Baccarat cocktail set) and kitsch souvenirs (a bunny balloon, troll figurines) in gleaming stainless steel, thereby translating upscale decadence as well as downscale vulgarity into aesthetic but even more commodifiable products. In Michael Jackson and Bubbles, Koons heightened the risk factor of his art-the tenuous equilibrium struck between the pure and the perverse, the banal and the brilliant-to an almost unbearable pitch, as he portraved the rock megastar in gilded white porcelain, which not only changed black into its opposite but also embellished the figure with a metaphor for the commodity most measured by the roaring eighties: money. Further, while remaining at arm's length, he had the bigger-than-life sculpture crafted, from an appropriated photograph, by Italian artisans normally engaged in making religious statuary. Still further, the crass and the cultivated collide even in the pose, which harks back, as Michael Brenson detected, to the reclining husband-and-wife effigies on a famous Etruscan sarcophagus. By replacing the female partner with a monkey, Koons threatened to make the cute turn nasty, but then deflected racist implications into the overall androgyny of the lipsticked image, which appears symbolically to offer some midway resolution of the work's antithetical ingredients, not the least of which are the contending drives of adolescent fantasy and monumental ambition.

Like Andy Warhol, Koons has subsequently starred himself more than anyone else in his art, having become a star—even a porn star—within the art-world firmament almost as glittering as Michael Jackson on MTV. Scarcely new in art, narcissism also reigns supreme throughout the expansive oeuvre created over the past twenty years by Cindy Sherman (1954—), who began in live

right: 789. Jeff Koons. *Michael Jackson and Bubbles*. 1988. Porcelain, 3'6" × 5'10¹/2" × 2'8¹/2". Courtesy Sonnabend Gallery, New York. **above: 790.** Cindy Sherman. *Untitled*. 1989. Color photograph, 5'1¹/2" × 4'1/4". Courtesy Metro Pictures, New York.

Performance Art but then switched to satiric dramas staged before the camera, there simulating a long series of old noir film stills or illustrations for Modern Romance magazine (Fig. 753). By impersonating scores of female stereotypes-slattern, dreamy adolescent, bored housewife, budding starlet, femme fatale-the chameleonic Sherman became everyone and thus no one, except the darling of the post-structuralist critical machine, which saw in her project a devastating exposure of representation as myth largely divorced from the facts of life. Forever playing the "other," Sherman deflated the tradition of the artist as Nietzschean superhero, even as she herself underwent mystification as the most important artist of her generation. Certainly Sherman has been both formally and conceptually fertile, moving from small-format black-and-white prints to 6-foot Cibachrome transparencies and ever-more elaborate re-creations of German fairy tales, messy scenes from horror movies, and portraits in the generic manner of historic masters-Piero, Raphael, Rembrandt, Holbein, Caravaggio, Watteau, Goya, Ingres (Fig. 790). Aided by props and costumes, wigs, false beards, and startling prosthetic noses, bosoms, and pregnant bellies, biceps and hairy chests, Sherman has succeeded in linking photography to its prehistory in painting, at the same time that she explores not only a vast range of characters outside pop culture-men and women alike-but as well the role of an artist when this meant almost invariably being male and a "genius." If these "masterworks" look strange, with their jolting juxtapositions of the real and the hyper-real, they also suggest that inhabiting another's body, space, and time may be as strange as inhabiting one's own.

If Duchamp was the great sorcerer of 20th-century art, Sherrie Levine (1947—) must be his trickiest apprentice, expropriating the primal appropriator himself as a strategy for making art despite the irreversible doubts he cast upon hallowed notions of originality, expression, ownership, and the autonomous masterpiece. Whereas Duchamp had sabotaged these values by signing non-art objects and thus transforming them into "readymade" art, Levine re-presented

established icons of modernism before signing the results and by this means recomplicated the discourse. Simultaneously, she also staked out a feminist claim on what had been a largely exclusive, patriarchal canon of unique or peerless inventions. For a scandalous beginning, she rephotographed posterlike reproductions of "seminal" works by famous male photographers and exhibited the prints as her own work, candidly titling them After Edward Weston, After Walker Evans, After Alexander Rodchenko, etc. Next, to increase the sense of her own presence even in what were confiscations, Levine gave up the camera for watercolor-a medium long identified with "women's work"-in order to hand-copy photomechanical reproductions of paintings by such high modernists as Kandinsky, Mondrian, and Léger, a process that caused a triple take once the artist used her delicate, "feminine" touch to render the muscular Expressionism of an auto-erotic self-portrait by Egon Schiele. Moving on-in a by-now proven tactic, for which Rosalind Krauss coined the oxymoron "added subtraction"-Levine abandoned copying and commenced simulating Minimalist painting, but in a generic manner that, through its humor, scuttled the exalted seriousness and perfection of work by Barnett Newman, Frank Stella, and Brice Marden (Fig. 791). Rather than elegant, complete, and imperiously self-confident, Levine's Broad Stripes, with their dumpily proportioned three and a half vertical bands of oddly contrasted colors, look funny, tentative, and therefore contingent for their meaning upon things beyond themselves. Ultimately, all such art refers back to Duchamp, a reality that Levine made clear when she undertook to cast Fountain-the common urinal whose gender and condition the Dadaist had altered by laying the fixture on its back and signing it "R. Mutt"-in polished, golden bronze (Fig. 792). Since the sumptuously "modified readymade" might well be mistaken for a Brancusi, it literalized Duchamp's complaint: "I threw the urinoir in their faces, and now they come and admire it for its beauty." Here, Levine turned irony inside out and finally escaped her own appropriation by theory-mad Marxist critics, who had supported her work solely for its politics of market critique, while ignoring the artist's meditation on "the uneasy death of modernism"-uneasy given the new meanings that clever post-modernists prove capable of distilling from a supposedly dried-up tradition.

For Robert Gober (1954—) too, Duchamp's urinal served as an emblem of thwarted desire, especially in the era of AIDS, which the artist signaled by setting three of the plumbing fixtures side by side and right-side up. In this chaste arrangement the sculptures appear less eroticized than humanized by the artist's denial of appropriation in favor of handwrought simulation, a process clearly evident in the irregularities of surfaces that are merely smooth rather than porcelain perfect. More frequently, however, Gober has worked his recreative will upon less sensational artifacts, mainly outmoded domestic furniture—beds, cribs, chairs, sinks—which he renders accurately enough, in wood, wire, plaster, and enamel, to be unmistakable but also sufficiently distorted to leave viewers imagining themselves caught up in a surreal nightmare of frustration, loss, and despair (Fig. 793). Deprived of faucets and drains, the holes in the sinks become anthropomorphic, as if they were the eyes and mouth **above left: 791.** Sherrie Levine. *Untitled (Broad Stripe: 2).* 1985. Casein on wood, 24 x 20". Courtesy Mary Boone Gallery, New York.

above center: 792. Sherrie Levine. *Fountain (After Duchamp:1).* 1991. Bronze, 15 x 25 x 15". Courtesy Mary Boone Gallery, New York.

left: 793. Robert Gober. *The Split-Up Conflicted Sink*. 1985. Plaster, wood, steel, wire lath, semigloss enamel paint; 6'11" x 6'111¹/z" x 2'1". Private collection, New York. Courtesy Luhring Augustine, New York.

above right: 794. Katharina Fritsch. Warengestell mit Madonnen (Display Rack with Madonnas). 1987–89. Aluminum and plaster; 8'10¹/4" high; 2'8¹/4" diameter. Courtesy Jablonka Galerie, Cologne.

opposite left: 795. Mike and Doug Starn. *Yellow and Blue Raft of the Medusa*. 1990–91. Toned ortho film, glue, ink, paper, Plexiglas, and pipe clamps; 19' x 14' x 1'10". Courtesy Leo Castelli Gallery, New York.

opposite right: 796. Christian Boltanski. *Reserve of Dead Swiss* (*Large*). 1990. Photographs, tin biscuit boxes, and lamps; 6'8" x 26'11" x 3'81/2". Courtesy Marian Goodman Gallery, New York.

of a ghost or, where Gober elongated and split the splashboard, the features of a personality divided against itself. A child of Minimalism, the artist still works with a vocabulary of simple forms destined to activate the surrounding space; however, he goes further by making the forms representational in the hope that, with their emotional, biographical, and hallucinatory quality, they may seep into the observer's consciousness and lodge there as signifiers of psychological predicament.

As resistant to romantic notions of aura as any simulationist, the Düsseldorf artist Katharina Fritsch (1956-) nonetheless assures her work a near-mystical nimbus, first by working with images of inherent, if sometimes comical or degraded, mystery; second, by hand-copying for limited-edition remanufacture objects commonly available in mass-produced form; and, third, by exhibiting them in the sanctuary-like spaces of galleries and museums (Fig. 794). Moreover, once stacked in pyramid, tower, or hourglass formation, Fritsch's serialized yellow Madonnas, gray brains, green elephants, and black cats acquire the status of totems, especially when encircled by viewers spellbound at the sight of so much ordinariness rendered so unexpectedly original, with, furthermore, a perfectionist touch bordering on the obsessive. Spectators may even sense the fragility of structures assembled in such exquisite balance as to stand unaided by adhesive. Equally compelling is the tension between what once inspired awe-a sacred object, the intellect, a wondrous creature-the cheap commodity it became through the trivializing effects of commercial reproduction, and its surprising rebirth as monumental sculpture. If unable to put Humpty-Dumpty together again, Fritsch would at least use the instruments of art to reveal the potential for the unique, the spiritual, and the exotic within the products of everyday culture.

Like Cindy Sherman, Boston-based Mike and Doug Starn (1961-), generally known as the Starn Twins, undermine the Renaissance/modernist notion of the artist as a unique, all-powerful creator, but instead of doing it through a simulated multiple-personality syndrome, they work collaboratively, just as their identical, mirror-image twinhood has allowed them to face the world as if they were two in one. While devoted to photography, the medium of choice for Sherman and so many other post-modernists, the Starns eschew deconstructive irony in favor of the purely romantic, regressing all the way back to Victorian "pictorialism," the very sort of morbidly poetic imagery and dark, moody camera work the modernists struggled against (Fig. 795). However, the Twins could scarcely be more à la page in the way they produce their theatrical effects, which depend upon a scale so large that the cobble-together technique required to attain it often ends by transforming the work into a variety of installation. After making multiple or piecemeal images from a single negative, as well as exposing photographic paper directly, the duo "age" the developed material by splashing it with toners, by scratching, ripping, creasing, crumpling, and cropping. Next, they collage the distressed fragments together, using staples and Scotch Magic Tape to realize a rough-edged mosaic or Cubistic arrangement, the Beuys-like impact of which gains still greater immediacy once the whole has been mounted in a massive frame carpentered by the artists themselves, or, as here, simply tacked, bolted, or taped directly to the wall. Observing so much improvised, faux decay, ghoulish beauty, and simulated Weltschmerz, critic Roberta Smith commented that if Dickens's Miss Havisham had made photographs, they would look like the Starns' one-of-a-kind assemblages.

While the Starn Twins mourn the loss of innocence by pretending it never happened, France's Christian Boltanski (1944—), together with Anselm Kiefer and other Europeans born in the closing days of World War II, cannot so readily disabuse himself of what history has wrought. Indeed, memories of the Holocaust appear even more disturbing when "documented" with fictitious evidence

like that amassed in Boltanski's "archives" and "altars"-somber, melodramatic installations composed of blurry old school portraits, faded articles of children's clothing, and "time capsules" in the form of rusted biscuit tins, with the whole spottily illuminated by small "votive" lights (Fig. 796). But even as these lugubrious catacombs trigger feelings of grief and guilt about the wanton destruction of countless young lives, titles like Reserve of Dead Swiss give it away that Boltanski has provided a sham rather than a factual witness to genocide, since neutral Switzerland suffered isolation but not invasion by Nazi Germany. Yet, in the words of the artist himself, "there is nothing more normal than the Swiss. There is no reason for them to die, so they are more terrifying in a way. They are us." For a fake "archaeologist" plagued by post-structuralist disbelief, reinventing history as a novelist would serves well as a metaphor for the vagaries of memory and the ways it can be stirred to supply narratives otherwise withheld by the numberless anonymity of the subjects. Thus, a past increasingly more imagined than experienced can become vividly immediate and personal, thanks to the almost magical hyper-reality of metal boxes fashioned and artificially aged by the artist himself, found photographs of girls and boys who may be neither Jewish nor dead, and black, cobweb ganglia of cords from gooseneck lamps beamed to make spectral images seem more blinded or interrogated than revealed. However noir his wit, it permits Boltanski to endow impoverished materials with the power to connote, thus with the power to induce meditation on the absent and the forgotten-that is, on the ultimate fate of virtually everyone.

Lest there be any question about the born-again nature of eighties-style Conceptualism, one has only to consider Jenny Holzer (1952—), who remains as wedded to verbal texts as were the first Conceptualists, but presents them in glittering, dynamic spectacles that meet the spectacle of the late 20th-century head-on (Fig. 797). Still, even though Holzer has programmed her "mock clichés" for the giant Spectacolor board in Times Square, the "information blitz" she likes to visit upon the public achieves the greatest impact in traditional art contexts. The explanation would seem to lie in her preference for open-ended, unpredictable, thought-provoking apothegms—the very kind of utterance most avoided by the commercial media. A populist from plain-spoken Ohio, Holzer began writing simple aphorisms on matters of life,

far left: 797. Jenny Holzer. Installation. 1990. Horizontal 3-color LED signs, each on far wall 91/2" x 14'8" x 41/2". United States Pavilion, 44th Venice Biennale. Courtesy the artist.

left: 798. Ilya Kabakov. The Man Who Flew into Space from His Apartment, from Ten Characters. 1981–88. Mixed-media installation. Courtesy Barbara Gladstone Gallery, New York.

death, and power in horrified reaction to the impenetrable jargon rife among contemporary art's radical theorists. After plastering her slogans on the graffiti-scarred walls of SoHo, she discovered the computer-animated LED (light-emitting diode) machine and quickly gave bright new red, green, and yellow meaning to the old McCluhan dictum about the equivalence of message and medium. Now she could send "Truisms" like PROTECT ME FROM WHAT I WANT and ABUSE OF POWER COMES AS NO SURPRISE rocketing up structural piers at the Dia Center or slowly winding round the coiled ramps of the Solomon R. Guggenheim Museum. Most eye-popping of all, Holzer lined the walls of two galleries in the United States Pavilion at the 1990 Venice Biennale with horizontal or vertical musings, lettered ribbons that seemed to recast sixties stripe painting as abstract social realism and set it in fiery, surreal motion. "Laments" mixed with "Truisms," and English with French, Italian, Spanish, and German, to glide across broad surfaces like materialized thought-WHAT URGE WILL SAVE US NOW THAT SEX WON'T?-each phrase distinguished not only by blazing, needle-pointed color but also by font, and all together giving voice to a vast plurality of coolly subversive, Beckett-like homilies. To overcome the often-alleged "thinness" of word art, Holzer simply energized the texts with visual buzz, at the same time that she also lent them the gravity of marble or granite engraved like tombstones, whether set as diamond-grid paving or as benches in a dimly lit chapel. For Venice, these several site-specific solutions made a rich and mercurial, yet solemn, almost apocalyptic installation that paid tribute to both the democratic American spirit and the opulent lagoon city of Giorgione, Titian, and Veronese.

Given its lavish Venetian context, the Holzer Truism MONEY CREATES TASTE assumes an extra layer of irony, especially since the piece for the US Pavilion appeared, in hindsight, to bring the curtain down on the extravagant eighties while at the same time raising it on the debt-ridden early nineties, when politically aroused installation art would come very much into its own, albeit in *povera* terms entirely at odds with pricey stone and high-tech electronics. Another Truism, PRIVATE PROPERTY CREATED CRIME, also gained a curious echo, once *glasnost* and *perestroika* allowed the Soviet Union's "unofficial" artists to use installation as a medium for informing the West about the mind-boggling crimes committed against a humaniartists were those who, even while employed in state-approved work, quietly formed an "underground" world of resistance. Here, unknown to the public, they made and exhibited the kind of modernist art-art involved with aesthetic and/or social critiqueanathematized by Soviet authorities long hostile to all cultural expression but kowtowing Socialist Realism. Remarkably, by the time the Iron Curtain collapsed at the end of the eighties, the Moscow underground had already brought to maturity an indigenous variety of Conceptualism so steeped in necessity and wit that it immediately found a rapt audience in London, Paris, Cologne, Zurich, and New York. The most brilliant of the Moscow Conceptualists may be Ilya Kabakov (1933-), who excels at an old Russian genre in which messages must be delivered through the voice of someone, usually invented, other than the artist. In Kabakov's text-cum-found-image albums, paintings, and installations, the characters are invariably absent but urgently present through manifold evidence of their attempts to cope with the failed Utopia of postwar Soviet life. For the installation called Ten Characters (Fig. 798) the artist re-created a communal apartment remembered from his childhood, a shabby, gray-brown, ill-lit kommunalka subdivided into ten cabinetlike cells linked to a common corridor, kitchen, lavatory, and children's corner. Thrown together by random, bureaucratic draw, the tenants became both inmates and prison guards, so totally deprived of self that for individual identity they retreated into extremes of personal oddity and escapist fantasy. Strolling through the maze, visitors encounter The Short Man who insisted that callers stoop to his own level; The Man Who Never Threw Anything Away and ended up at the center of a hive held together by his own elaborate set of mysterious rules; and The Man Who Flew into Space from His Apartment, leaving his postercovered room brightly illuminated by a gaping hole opened in the ceiling as he blasted skyward. When photographed, the image created by this part of the installation suggests a post-bomb, blackhumored spin on Baroque visions of heavenly apotheosis. Kabakov has called himself a "fanatic about installation," by reason of its immense potential for satire designed to torpedo all totalizing systems "predestined" to build a "radiant future."

ty deprived of all rights to private property. In Moscow, unofficial

The Nineties: Art for the Millennium

he 1990s produced no new art movement coherent enough to gain a title, leaving Neo-Geo, which had surfaced in 1986, to serve as the last of the many "isms" coined during the 20th century. The decade, however, saw the arrival of many promising young talents as well as the full emergence of important older ones. And whatever their ages, the artists who won critical attention tended, for the most part, to work in backlash reaction to the perceived excesses of the 1980s, now viewed as a period whose vulgar, over-hyped market turned art into a commodity and artists into globe-trotting celebrities. This frenzied scene had survived the stock market crash of late 1987, only for the art market itself to plummet two years later, almost like a prelude to the collapse of the Soviet Union and the Berlin Wall, bringing an abrupt end to the Cold War, on New Year's Eve 1989. Politically, the world began the last decade of the old century a freer, more hopeful place than it had been in generations. but in the specialized realm of contemporary art, a new sobriety quickly took hold. As galleries began to close all over SoHo and in other art centers of the world, it became all too clear that straitened, post-crash economics, as well as the ongoing tragedy of AIDS, would provide an opportunity for nothing so much as a thorough reconsideration of what art should be and what it should be for.

In the absence of a commanding new style, pluralism on a scale not seen since the 1970s would prevail throughout the waning years of the second millennium, a time, like T.S. Eliot's April, for "mixing memory and desire." Indeed, the nineties proved nostalgically hospitable to almost every medium, process, and tactic essayed in the course of the 20th century, particularly the more subversive ones innovated decades earlier by Marcel Duchamp or the Surrealists and then revived by the Conceptualists in the late sixties. Yet painting too would flourish, figurative as well as abstract, much of the new work unabashedly committed to Old Masterish standards of beauty and facture (Fig. 799). It prospered, moreover, despite the death sentences still regularly pronounced upon the art by those believing it too elitist and decadent—too easily co-opted by the market—to retain its aesthetic integrity. As this suggests, attitudes, if not style, would dominate the *fin de siècle*, continuing a trend already very much present since the demise, in the late 1960s, of modernist formalism. These, in turn, were to dictate a preferred range of strategies, beginning with performance, photography, film or video, text, and collage or assemblage. Often, particularly in the first half of the decade, they could all be found mixed together in those *Gesamtkunstwerke* known as installations, a hybrid or multimedia genre already well advanced in the art of Jenny Holzer and Ilya Kabakov, seen in the last chapter (Figs. 797, 798).

Come the nineties, installation/performance art would find one of its most admired practitioners in Ann Hamilton (1956-), a native and resident of Columbus, Ohio. In essence, her work comprises poetic, visually striking combinations of unusual objects or stuffs, communal labor, transformed environment, and the ongoing presence of a woman or man engaged in some quiet, ritualistic task, like sewing or knitting. Each project is site-specific, temporary, and created with a singular set of materials, such as a ship-length cradle of votive candles, shiny copper coins used as floor tiles laid in a bed of golden honey, or a huge stack of obsolete patent books. Trained as a child in needlework, Hamilton majored in weaving at the University of Kansas, after which she studied sculpture at the Yale School of Art. For the Dia Center in New York City, Hamilton orchestrated one of her boldest installations, taking advantage of a vast, floor-through space maintained in a onetime factory building near the Hudson River (Fig. 800). The very title of the piece, Tropos, a Greek word meaning "turn," suggests the tropic or metaphoric purpose of the Hamilton enterprise. On this occasion it required importing 3,000 pounds of long hair-black, brown, and blondgroomed from horses in China and then spreading it over the entire

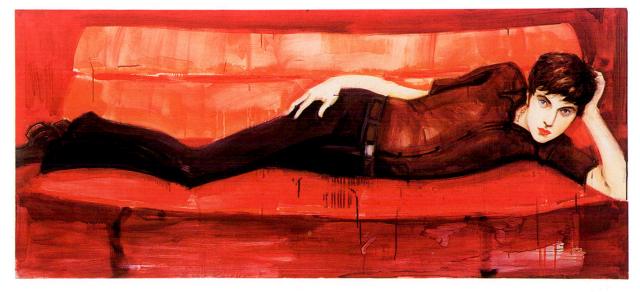

799. Elizabeth Peyton. *Piotr.* 1996. Oil on canvas, 3'2" x7'4". Courtesy Gavin Brown Enterprise, New York.

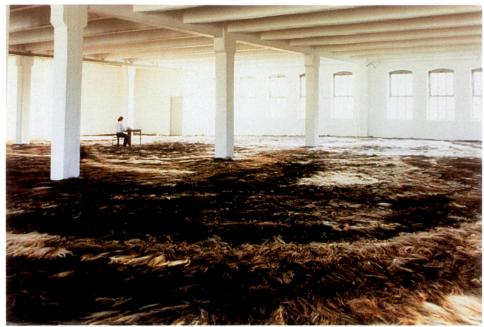

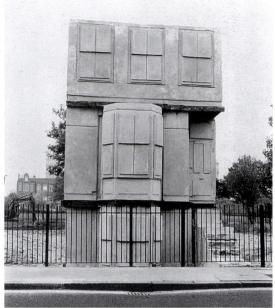

floor to create the effect of a gently roiled sea giving off a faint but sweet, gamy odor. This immense, pelt-like carpet-so luxuriously thick that visitors stumbled as they explored the strange site-had been made by sewing the horsehair into lengths of fabric, a job undertaken at the Fabric Workshop in Philadelphia, following which students, friendly volunteers, and Dia staffers stitched or glued the shaggy lengths together. In the meantime, the brick walls of the space had been stripped and painted white and the clear panes in the windows replaced with opaque glass. While this evoked the site's industrial past, it also made the urban world outside seem more removed and the interior more present, with its aromas and sounds correspondingly heightened. Mingled with the whiff of horsehair was a slightly ominous, acrid smell, traceable to a small table near a far corner of the floor. Here a lone person sat burning away every line in a book with a wood-etching instrument. If this implied the elusiveness of language or the difficulty of communicating, so did the low, muffled sound of a recorded voice, the voice of a man suffering from aphasia. Yet Hamilton always approaches her art as a community effort, with her collaborators working together as did the quilting bees of old. This alone would invest Tropos with a feminist subtext, as would the textual effacement, the slow process of "unwriting the book of culture," as Leslie Camhi phrased it. Along with loss, however, there was also memory in Tropos, recalling not only the industrial, communal past but also the preindustrial, even archaic world, all of which nourish the way human beings assume their mature identities.

Nothing in the nineties unleashed more universal discussion of what art should be or for than *House* (Fig. 801), a public monument so controversial that on the same day in 1995 its creator, Rachel Whiteread (1963—), was declared both the best and the worst sculptor in Great Britain. On the positive side, Whiteread won the Turner Prize, the most prestigious award available to a young British artist; meanwhile, she also received \$60,000 in cash, twice the money conveyed by the Turner Prize, from the K Foundation, created by a pair of onetime rock stars known for their counter-cultural antics. Determined that the "anti-Turner Award" be accepted, the K Foundation threatened to burn the prize money on the steps of the Tate Gallery unless the artist accepted it. She did, but only for distribution to Shelter, an organization for homeless people, as well to several needy young artists. As for the prize-winning *House*, Whiteread had created it by spray-casting in steel-reinforced con-

414

above left: 800. Ann Hamilton. *Tropos*. 1993–94. Site-specific installation. Dia Center for the Arts, New York.

above right: 801. Rachel Whiteread. *House*. 1993. Spray-cast steel-reinforced concrete. London project sponsored by Artangel Trust. Courtesy Luhring Augustine, New York.

opposite top: 802. Rachel Whiteread. *Model for the Judenplatz Wien Monument and Memorial Site*. 1996. Height c. 10'. Courtesy Luhring Augustine, New York.

opposite above: 803. Guy Limone. In 1995, 1,170 People Were Killed in New York City (detail). 1996. 1,170 plastic figures and metal shelf. Courtesy Nicole Klagsbrun, New York.

crete the interior of a modest row dwelling in Bow, a run-down, working-class neighborhood in the East End of London. Once the brick shell of the narrow, three-story structure had been removed, along with other houses on the lot, the cast of the "negative" space remained, like a ghostly monument to the generations of family life that had unfolded in the old Victorian residence. Truly, things seemed to have been turned inside out, not only structurally but also culturally, with one critic proclaiming the work a masterpiece and the local population calling it an eyesore. As in the case of Richard Serra's *Tilted Arc* in New York (Fig. 719), local choice prevailed, causing the sculpture to be demolished, after a brief delay but consistent with the original plan to install a park.

Like Serra, Bruce Nauman, and others before her, yet with more impressive results, Whiteread seeks out and casts-in plaster, rubber, resign, wax, or concrete-not forms but the spaces around them, particularly the ignored ones, such as the underside of a chair or the void behind shelved books. The latter has become an important theme in Whiteread's work, thanks in part to a commission for a Holocaust monument in Vienna's ancient Judenplatz (Fig. 802). Here too a Whiteread sculpture-a kind of inside-out library-has become a subject of open dispute, this time less for the quality or character of the form than for the terrible history embodied in the memorial. When completed, the Viennese project will comprise a closed, windowless double cube of a building, about 12 feet high and 33 feet long, with a flat roof, a plain parapet, and a base inscribed with the names of towns near which Jews were mass-murdered during World War II. The concrete walls are to be textured with the cast imprint of books packed together in blocky, serried ranks on stacked shelves with their spines facing inwards, leaving the vertical, striated edges of pages and bindings to face outwards.

Not only would this library-without-walls commemorate "the people of the book," lost during the Nazis' infamous "final solution," but it would also project towards the ambient world, interacting with it as a formidable presence "uncannily" resonant with absence, as Sigmund Freud, a Viennese Jew, might characterize the effect. In purely aesthetic terms, the richly haptic, bunker-like library has been likened to Minimalism, Constructivism, or even Brutalism humanized and invested with Expressionist feeling.

Alternative approaches, deemed marginal to such mainstream forms as painting and sculpture, held particular appeal for artists, critics, and curators committed to art as social critique or advocacy. To these reformers, art should be a vehicle for leveling hierarchies, breaking down barriers, and remapping culture so as to integrate the margins more equitably with the center. By 1990 the kind of critique pursued by artists obsessed with language and the mass media-John Baldessari, Cindy Sherman, Katharina Fritsch, and Jenny Holzer, among others-had become so common as to forfeit its power to persuade, especially younger artists with other problems on their minds. Deconstruction, espoused by the likes of Hans Haacke, Barbara Kruger, and Sherry Levine, lost its seductiveness as well. After the fall of the Soviet Union, with its vast disinformation machine, the neo-Marxist notion, articulated by the French intellectual Jean Baudrillard, that a society forever bombarded by propaganda or the "spectacle" of untrammeled consumerism would prove too passive to distinguish between media imagery and reality struck many as implausible. Theory in general came to seem academic and more restrictive than liberating, especially after the appropriation strategy it had legitimated, and seen to full effect in the last chapter, ran afoul of court decisions in favor of plaintiffs charging artists with copyright infringement. Less and less, after 1990, would

such revered names as Barthes, Foucault, Derrida, and Lacan be cited as authority for whatever happened in art or criticism.

More relevant for the early part of the nineties were so-called "quality-of-life" issues, concerns that particularly motivated artists involved with feminism, multiculturism, gay liberation, and the environment. While the global economy began to revive before the end of 1990, it left the art world behind, which made activist artists all the more sensitive to the pathological aspects of life, to problems of race, class, and gender, to political and ecological terrorism, the population explosion, homelessness, drug abuse, urban decay, genocide, and such hot wars as those in the Persian Gulf and the Balkans. Guy Limone (1958—), a Marseilles-based Conceptualist, addresses the woes, as well as absurdities, of the day with a degree of wit and charm rare in activist art. His approach is to transform dry statistics into miniature dramas with titles like Two Percent of the French Cannot Stand Marguerite Duras, staged with such commonplace items as toy figures, lengths of string, vinyl tiles, fluorescent tubes, snapshots, and pictures clipped from magazines. For a solo show in New York, Limone crunched some local numbers and then reimagined them as a long, narrow shelf so densely populated with tiny, red-painted figures that even from a brief distance the installation resolved in the eye as a thin red line stretched the full length of the

804.

Robert Mapplethorpe. Ajitto. 1981. Unique gelatin silver print, 40 x 30". Collection Lois and Bruce Berry.

wall (Fig. 803). Up close the figures proved to be delightfully individualized and quite animated—pushing prams, riding motorbikes, running up flags, fishing from the edge of the shelf, swinging from below it, playing stickball, mugging a passerby. Viewers' chuckles soon turned to shock, however, once they read the title: *In 1995, 1,170 People Were Killed in New York City.* Clearly, this was the number of Lilliputians on the shelf, which meant that their beautiful red color signified blood, just as its uniform application symbolized their erasure, their abstraction from life into statistics.

In 1990 the art world found itself galvanized by an event that seemed to raise the spectre of censorship and abridged freedom of expression. What became a cause célèbre erupted when Dennis Barrie, director of the Cincinnati Art Center, was indicted for mounting a retrospective exhibition devoted to the photographs of Robert Mapplethorpe, an artist widely acclaimed, as well as frequently denounced, for his sleek, sculpturesque images of nude men, usually black and sometimes in homoerotic situations, and rather disarming photographs of children with their privates unselfconsciously exposed (Fig. 804). Within this context, even the beau-

The Nineties

tiful, close-up views of single flowers assumed an air of coldly elegant, perverse sexuality, leaving the entire Mapplethorpe oeuvre open to charges of pornography. They were not long in coming after Washington's Corcoran Gallery, in 1989, canceled the same show, fearing the wrath of conservative members of Congress eager to prevent a reauthorization of the National Endowment for the Arts, which had partially funded the Mapplethorpe retrospective. Congress did, in fact, pass an unrelated bill amended, by Senator Jesse Helms, so as to prohibit the use of public money to "promote, disseminate, or produce obscene or indecent materials." Barrie, when brought to trial, was acquitted, but the struggle to save the NEA and the debate over censorship continued virtually to the end of the decade. Several artists-Karen Finley, Tim Miller, Holly Hughes, and John Fleck ("the NEA 4")-sued the agency, claiming the "decency" provision imposed upon the grant-making process violated their First Amendment rights. In 1998, however, the Supreme Court found no evidence that the law had suppressed freedom of expression. With this, Congress reauthorized and re-funded, somewhat more generously than anticipated, the long-beleaguered NEA, which, however, had now lost its power to support the creative efforts of individual artists. And this despite the fact that of the near 100,000 grants made by the agency since its inception in 1965, only a handful-some twenty odd-had triggered public controversy. One of these was Andres Serrano's Piss Christ, the color photograph of a small plastic crucifix submerged in a glass jar containing the

below left: 805. Kiki Smith. Virgin Mary. 1993. Bronze with silver inlay; $5'7^{1}/2'' \times 2'2'' \times 1'2^{1}/2''$. © Kiki Smith. Private collection. Courtesy the artist and PaceWildenstein, New York.

below center: 806. Stephan Balkenhol. *Big Man in Grey Shirt and Black Trousers.* 1999. Linden wood, 8'4" x 2'7" x 1'5". Courtesy Barbara Gladstone Gallery, New York.

right: 807. Adrian Piper. *Cornered.* 1988. Video, table, lighting, birth certificates, and videotape. Courtesy John Weber Gallery, New York.

below right: 808. Glenn Ligon. Untitled (I Do Not Always Feel Colored). 1990. Oilstick and gesso on panel, 6'8" x 2'6¹/16" x 1¹/2". Whitney Museum of American Art. Promised gift of the Bohen Foundation in honor of Tom Armstrong. artist's own urine. While Mapplethorpe's homoerotic imagery seemed to undermine family values, the Serrano work, which succeeded in making the cheap little icon look curiously monumental and radiant, appeared to be a bigoted affront to Christian sensibilities.

Meanwhile, the censorship fray spread to Europe, where Gran Fury, a gay-activist organization, mounted billboard-like works at the 1990 Venice Biennale attacking the Roman Catholic Church for its condemnation of homosexual and safe-sex practices. One wall, for instance, featured an erect penis together with such statements as "Sexism Rears Its Unprotected Head." This time it was Italian obscenity laws that kicked in, shutting down the Gran Fury venue, at least for a while. What the Gran Fury project reflected was a growing preoccupation, in art communities everywhere, with socalled "identity politics" and with the body as the locus for such identity—gender, sexual orientation, race, class, age, and/or, alas, disease. In this area of concern, few contemporary artists have worked more consistently or eloquently than Kiki Smith (1954—), who, though largely self-trained, springs from a family of artists,

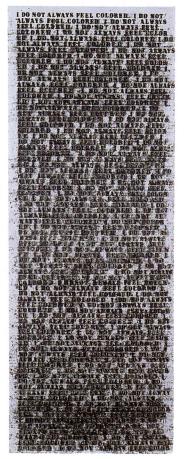

among them the noted Minimalist Tony Smith. But true to generational trade-off, the fragile figurations created by his daughter (Fig. 805) inhabit an aesthetic universe remote from monumental, blacksteel abstractions like those seen in Chapter 19 (Fig. 597). Where Kiki Smith found her artistic bearings was in Colab, the East Village artists' collective cited earlier in relation to John Ahearn. Sharing Colab's emphasis on social activism, humble materials, and accessibility, Smith, like many feminists, saw the body as a political battleground and set about to explore it. Fragmenting the human anatomy, translating its organs into sculptures, and using materials in unfamiliar ways, she allowed her work to oscillate, even in the same piece, between melodrama and understatement, Neo-Expressionism and the cooler strategies of revived Conceptualism. For an exhibition at MoMA, Smith laid out a prim row of twelve glass, apothecary-like jars, each inscribed in Gothic letters with the name of a bodily fluid, everything from semen to blood and tears, as if to roadmark the human journey from conception to final decay. Transforming the private into the public, Smith ranges through all manner of materials, including embroidery, wax, bronze, and especially paper, as well as through themes both mythic and harrowingly literal. In style too she operates freely, embracing the decorative as well the heroic. For one installation Smith offered a white-plaster Daphne with branches of blue glass sprouting from arms and legs, a columnar Lot's Wife rough-cut from plaster mixed with salt, and a bronze Virgin Mary with downcast eyes, outstretched arms, flayed musculature, and ramified veins picked out in glinting silver. All about, the gallery sparkled with silver- and bronze-cast daisies scattered over one wall, a flight of tiny nude butterfly-women on another, and overhead a fantastic chandelier made of iron, glass, and a host of burning lamps. Smith casts her figures and body parts from life, as George Segal, Jasper Johns, and many others did long before, but she also endows them with a complex moral urgency entirely her own, yielding messages that seem all the more provocative for being uncertain or open-ended.

Few societies have suffered an identity crisis like that of postwar Germany, a nation defeated, divided, finally reintegrated, and still struggling to overcome its Nazi and Communist past. While the sculptor Ulrich Rückriem, like numerous West German artists during the fifties and sixties, dealt with the problem by working in an abstract or Minimalist style, his pupil Stephan Balkenhol (1957-) followed a different path, towards figurative sculpture. This led him deep into history, all the way to Egypt and the Classical world, as well as to the Middle Ages and the German Expressionism of more recent times. The last proved especially appealing, because of the abuse it had suffered under the Nazis. Balkenhol, in keeping with many a German antecedent, became a wood carver, hacking overlifesize men, women, and animals from whole tree trunks, as well as smaller figures from wooden slabs (Fig. 806). Left unfinished except for color, the images look as if they had been "gnawed into existence by some extremely talented beaver," as one critic suggested. Perhaps in reaction to the degraded Classicism so beloved by Hitler, Balkenhol avoids heroics and class distinctions in favor of portraying generic humanity, people facing the world straight on, with guileless, untroubled expressions. Poses are simple-usually standing with feet apart and hands at sides, on hips, in pockets, or akimbo-but not always, particularly when the artist gives way to overt humor, reinterpreting Rodin's Thinker. Like a naïf in love with Greek and Roman sculpture, Balkenhol presents his male figures clothed, in shoes, pants, and open-collared shirts, and his women nude. Yet, despite the rough-hewn generalization, the artist's technique allows for many a deft touch, as in the wrinkled fall of trousers caused by hands jammed into pockets. The sheer ordinariness of the imagery allows only a limited palette, applied to hair, facial details, and clothing, with the natural color of wood reserved for flesh. The equally generic animals, which appear to be as numerous as people

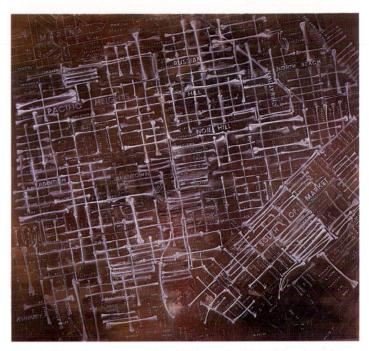

809. Guillermo Kuitca. *Untitled (San Francisco).* 1995. Oil and acrylic on canvas, 6'4" x 6'7". Courtesy Sperone Westwater, New York.

in Balkenol's iconography, give rise to a wider range of hues. Together, Balkenhol's sculptures form a contemporary variant of the old Peaceable Kingdom, investing the space around them with a Zen-like aura of tranquillity, much welcomed in the fraught atmosphere of a *fin-de-siècle* Germany.

The new identity politics, ironically enough, required an ideological about-face, a step taken by some of the same art theoriststhe post-structuralists seen earlier-who had proclaimed the death of the author/artist, making the value or meaning of an art work entirely relative, according to the eve of the beholder. Identity, however, required that the author be resurrected and distinguished, the better for those at the peripheries-women, gays, African-Americans, Asians, Hispanics-to find their place at the center and themselves represented there-empowered-by authentic images of their own making, rather than the traditional caricatures imposed by others. To advance this cause, New York's New Museum, in 1990, staged The Decade Show, for which it had Adrian Piper (1948-) re-create her installation entitled Cornered in the Museum's front window facing the busy sidewalk along Lower Broadway (Fig. 807). Here the Harlem-bred artist drew upon her mixed heritage (black father/white mother) and education (sculpture, New York School of Arts; philosophy, Harvard Ph.D.) to give a lesson in logic on the violent illogicalities of stereotypes. From a video screen draped in funereal black and shoved into a corner behind a tilted table, the well-spoken artist, smartly attired in navy blue and pearls, addressed her audience (presumably Caucasian) in a slightly bemused tone, beginning with the statement: "I'm black." Above the "talking head" hung her father's black-framed death certificate in duplicate, one document identifying him as white and the other as black or "octoroon." In a twenty-minute monologue the artist interrogated and mourned the loss of identity or singularity suffered by those "cornered" by received, unexamined attitudes commonly found in society at large.

Similarly motivated, Glenn Ligon (1960—) came to the fore in the early nineties with a series of mysteriously glimmering, blackon-white paintings that translated hand-stenciled texts into lush pictorial imagery scaled to the proportions of the door panels on which some of them were painted (Fig. 808). The Bronx-born, Wesleyaneducated artist had abandoned the purely abstract style which first claimed him once he realized that "too much of my life was left out when I walked into the studio." That life involved the experience of a black man in a white society who also happened to be gay, which made Ligon feel himself an outsider twice over. An avid reader given to frequent re-examination of favorite texts, he has sought to explore and assert his own identity through "found language" appropriated from the writings of Rita Dove, Zora Neale Hurston, Nella Larsen, James Baldwin, Jean Genet, and Mary Shelley, among others. The result is elegantly abstract but also concrete, its special allure derived significantly from the working process developed by the artist. Beginning at the top of the field, Ligon reuses the stencil and, letter by letter, repeats the chosen phrase ("I am somebody"; "I feel most colored when I stand against a sharp white background"; "I remember the very day that I became colored") until the paint clots and smudges as the lines descend towards the bottom. Gradually, the simple black-and-white contrast mutates into a smoky haze of variable gray and the words into semi-legibility. As the critic Roberta Smith wrote in 1991, "the accumulating grays seem appropriate for an artist who says he's 'not interested in a clear pro or con'." The deep humanity of Ligon's art emanates even from the format, its dimensions those of an architectural member scaled to accommodate the human frame.

As the Argentine-born grandson of Jewish immigrants from Ukraine, Guillermo Kuitca (1961-) has long pondered such issues

Yayoi Kusama. Cosmic Door. 1995. 463/8 x 357/8". Courtesy Robert Miller Gallery, New York.

right: 812. Yayoi Kusama. Infinity Net Painting, Accumulation #2, Macaroni Floor, and Kusama. 1966. © Yayoi Kusama. Courtesy Robert Miller Gallery, New York.

as identity and place, the "other" and "elsewhere," always taking a somewhat Surrealist approach, thanks in part to his mother, a prominent psychoanalyst in Buenos Aires (Fig. 809). Further major influences include the Argentine writer Jorge Luis Borges and the Mexican painter Frida Kahlo, both known for their freely associated mixtures of fact and fantasy. About Borges, Kuitca has said: "The idea of universality in Borges is so precise, so clear. A basic stance of Borges is to say that one man is another man, one place is another place, the idea that no matter what you do, you are doing everything. I find that very liberating." A prodigy, Kuitca began painting seriously at the age of six and had his first commercial exhibition when he was thirteen. Today he is best known for his paintings layered with road maps, charts, or blueprints for cities, houses, small apartments, and even cemeteries, all of them specific in origin but so modified as to become heightened metaphors-geographical

The Nineties

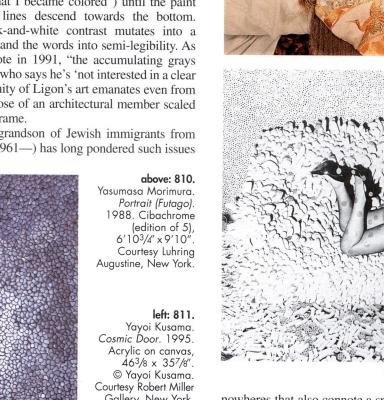

nowheres that also connote a spiritual everywhere. For the Tablada Suite Kuitca appropriated a map of the Jewish cemetery located in Tablada, a suburb of Buenos Aires, but then removed many of the identifying labels, such as one for a Holocaust memorial, projected the overall image on a heroic scale, and called the picture Untitled, the better to underscore its abstract quality. The canvas thus becomes a delicately executed field painting, as evanescent as an Agnes Martin grid, but haunted by an ambiguous though unmistakable sense of loss and longing. Inspired by Kahlo, Kuitca has sometimes allowed his lines to mutate into thorns or bones, motifs identified throughout Latin America with Christian martyrdom. In the work seen here, he used bones to trace out, on a dark ground, the pattern of a city some may identify as San Francisco, a metropolis with a gay population decimated by AIDS. Given this association, the network of urban arteries becomes a symbol for the arterial system within the human body, martyred by incurable malady. Increasingly, Kuitca has dedicated himself to charting volatile places where the personal and the public collide and struggle for meaning.

The hothouse world of gender and identity politics produced no more exotic a flower than Yasumasa Morimura (1951-), often viewed as Japan's answer to Cindy Sherman. Morimura, in other words, is a photographer/performance artist who stars himself in restaged versions of famous paintings, works for which he too has made the costumes and props, designed the makeup, set the camera, timed it, and then posed for the shot. But whereas Sherman re-inter-

418

prets historic genres or styles-old movie stills, Rembrandtesque portraiture, illustrations of Grimm fairy tales-Morimura mimics specific masterpieces, such as Manet's Olympia (Fig. 810). And however populous the scene, Morimura performs every role himself, including both Olympia and her black maid, a feat made possible by his mastery of computer technology, which allows him to splice the figures into the background of the original painting. Although best known perhaps for his quotations and deconstructions of key images from Western art history, Morimura has also transformed himself, wittily, into subjects familiar in Japanese painting, among them fish, birds, and vegetables. Another series, entitled The Sickness Unto Beauty-Self-Portrait as Actress, finds Morimura assuming the likenesses of great film stars in their most famous roles-Marlene Dietrich as the Blue Angel, Vivien Leigh as Scarlett O'Hara, Audrey Hepburn as Holly Golightly in Givenchy's "little black dress." Yet, the precision and craft involved in these performances, as well as the clear artificiality of the images, owe much to Japanese traditions, despite the artist's manifest obsession with Western culture. One has only to think of the Kabuki onnagata, or female impersonators, whose white, mask-like makeup and stylized gestures signal the feigned or theatrical nature of what is being presented. So too Morimura never entirely disappears into the characters he plays, however convincing the initial impression, a fact he confirms by calling the actress pictures "self-portraits." With stunning imagination and technical aplomb, Morimura appears to comment on the many ironies inherent in the cross-currents of an increasingly globalized culture, deeply affecting even the insular world of Japan.

Coincident with the concern for identity, authenticity, and the other, "outsider art" sparked more interest during the nineties than at any time since Dubuffet and his fascination with the art of the insane (l'art brut). Today outsider art has come to mean art made by untutored individuals compulsively driven to objectify some inner, often mad, but always idiosyncratic vision. A famous outsider already seen in this book is Henri Rousseau (Fig. 278), the French naïf viewed by the Surrealists as a forerunner of their own visionary art. Similarly, multiculturists discovered a forerunner of their own, Yayoi Kusama (1929-), a Japanese artist who had spent a lifetime precariously balanced between active involvement with mainstream avant-gardism and her status as a genuine outsider, self-confined to a private psychiatric hospital while feverishly engaged in artistic projects as a means to cope with mental disorder. At a very young age, Kusama had defied the conventions of her country in order to become an artist, impelled by a sense that artistic creativity would help her keep at bay the terrifying hallucinations she had suffered throughout childhood. One of these came when, after staring at a tablecloth decorated with red flowers, she looked up and "saw the same pattern covering the ceiling, the windows, and the walls, and finally all over the room, my body and the universe. I felt as if I had begun to self-obliterate . . . and be reduced to nothingness." In another, she sensed herself being enveloped in "a thin silk-like grayish colored veil." On the day this happened, Kusama went on, "people receded far away from me and looked small." Out of these nightmarish visions the artist forged the motifs of her strongest work, beginning with the Infinity Nets, large-format paintings with allover, interlocking patterns of white arcs on a white ground (Fig. 811). First exhibited in New York in 1959, the pictures brought Kusama the interest and friendship of Donald Judd and Frank Stella, then in the process of formulating what would be known as Minimalism. Although reductive in form, relative to Abstract Expressionism, the Infinity Nets, like the rest of Kusama's art, would never evince the cool, seemingly impersonal quality of true Minimalism. Even before Warhol made his rubber-stamp pictures, Kusama fashioned collage paintings from such banal materials as airmail stickers, overlapped in rows that move across the canvas in waves rather like those of the Infinity Nets. In 1962 she turned to

sculpture, appropriating all manner of everyday items—chairs, tables, stepladders, a rowboat, a sofa—and covering every inch of their surfaces with hundreds of plump, cotton-stuffed sacs or pods, ranging in length from three to twelve inches. It was during the same year, if somewhat later, that Claes Oldenburg, another Kusama friend, would make his first soft sculptures from sewn and stuffed materials. In her humorous, porcupine pieces, Kusama claimed to have projected her obsessions with "sex and food." Nowhere does this seem more ripe with period charm than in a photograph for which Kusama, nude but for highheel pumps, lounged face down in an environment burgeoning with polkadots and handmade phalluses, the former covering even the artist's bare back (Fig. 812).

In 1972 Kusama returned to Japan, where she committed herself voluntarily and went on with her creative life, writing by night and making art by day. Often the themes are continuous with those of her earlier work, including polkadots and undulant veils (Fig. 811). Gradually, Kusama earned the respect of her countrymen, who canonized her in 1993 with a one-person show at the Venice Biennale. Called "the greatest comeback story of the nineties," Kusama moved

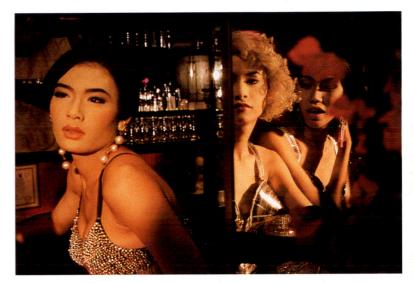

813. Nan Goldin. At the Bar: Toon, C, and So, Bangkok. 1992. Cibachrome print, 30 x 40". Courtesy the artist.

Calvin Tomkins to write: "It's been a gutsy performance, her refusal to self-obliterate, and the work bears that out."

Nan Goldin (1953-), another instinctive rebel, left home at thirteen and has spent the rest of her life seeking the youthful ideal of an alternative family, a colorful tribe of bohemian friends who together create a society more sympathetic than that of their bourgeois, judgmental parents. The better to hold on to this surrogate clan, Goldin has never ceased to capture it on film (Fig. 813), a compulsion that began during her adolescent days at a free, hippietype school in Massachusetts. By the age of eighteen she was taking pictures seriously, motivated by a new-found ambition to become a fashion photographer. This, in turn, had been quickened by the milieu in which Goldin found herself living, the world of fashionconscious drag queens in downtown Boston. At first drawn to the early films of Warhol and Fellini, as well as to the fashion photographers Guy Bourdin and Helmut Newton, Goldin gradually discovered art photography while studying at the New England School of Photography and the Museum of Fine Arts School in Boston. For rich subject matter, she had only to focus on the exotically clad denizens about her, whom she saw as a "third gender," people who had "stepped out of the circle," thereby emancipating themselves from "gender dysphoria." Her desire, Goldin told the critic/painter Stephen Westfall, was "to kind of glorify [the queens] because I really admire people who re-create themselves and who manifest their fantasies publicly." Goldin succeeded, in part because she also joined wholeheartedly in the doings of her chosen, sexually diverse ambiance, photographing from within, even to the point of finding herself a battered woman in need of detoxification. The emotional immediacy of the resulting pictures first came to general attention in The Ballad of Sexual Dependency, a sweeping, diaristic slide-show (800 images in 45 minutes!) with taped music-rock, reggae, blues, opera-that had its debut in 1979 at the Mudd Club in New York's SoHo district. Here, in unforgettable combination, were the messy content and meticulous form that are the hallmarks of Goldin's art. The first consists of fetchingly punk youth-artists, writers, poets, thrill-seekers at their revels or on the nod-and the latter of "pornolurid" colors-saturated reds, greens, bilious yellows-that snap into place with picture-puzzle perfection. By 1986, when The Ballad of Sexual Dependency appeared in book form, the narrative had assumed a tragic dimension, reflecting the cruel impact of AIDS on the very community Goldin had made her own. From the East Village and Times Square setting of The Ballad, Goldin, in the nineties, has moved on to the world stage-Berlin, London, Tokyo-without ever abandoning her romantic, counter-cultural stance, as the work seen here discloses. By making herself an active participant in the story, Goldin neutralizes charges of voyeurism and exploitation. Not for this artist the ironic, distancing strategies of post-modernism, about which she once said: "I have the same aversion to post-modern theory as I did to technology. I don't think either of them has anything to do with the creative process."

Nor did the prodigious David Wojnarowicz (1954-92) need postmodern irony as a pretext for art, fueled as his creative instincts were by an autobiography so breath-stopping that bare facts utterly trumped the kind of fantasy cherished by Nan Goldin's crossdressers. Not only a gay man but also an inspired sensualist, Wojnarowicz understood and accepted his sexual identity at a very early age, even turning his first trick as a child prostitute while still a nine-year-old playing in Central Park. Brutalized by his drunken, suicidal father, the boy had fled New Jersey for life with his divorced mother and two sisters in Hell's Kitchen, an old Irish slum close by Times Square and the Hudson River waterfront, both of them cruising grounds for New York City's rough trade. Encouraged by his mother to draw and paint, Wojnarowicz attended the prestigious High School of Music and Art, where he earned lunch money by rendering his classmates' lubricious reveries in quick sketches. At sixteen, however, he dropped out and went his own, highly independent way, hustling and thieving, yet agonized by his sense of himself as a social outcast. Fortunately, Wojnarowicz was also driven to project his anger into confessional drawings and journals of searing candor, "reveal[ing] everything that people are pressured not

to reveal," as he traveled, Beat-style, around the United States and Europe. Like many of his generation-Keith Haring, Kenny Scharf, Jean Michel Basquiat, Nan Goldin-Wojnarowicz soon gravitated towards the East Village, from which base he shot Super-8 films of abandoned warehouses, stenciled images of burning children on gutted buildings, and joined a "post-punk" noise band. Identifying with Arthur Rimbaud, the great poète maudit of late-19th-century France, he had a lover don a Rimbaud mask and pose for photographs shot at various sites in New York City, as if to say: "We are everywhere." By the mid-1980s, Wojnarowicz had become an East Village legend, for his bold activism but also for his increasingly powerful paintings-brooding, mortality-obsessed works marked by collage-like arrangements packed with the most disparate, metaphorically potent imagery (Fig. 814). The iconography, micromanaged and painted with a labor-intensive, almost naïf touch, ran to flaming houses, volcanic eruptions, sprinting soldiers, pornographic stills, scientific illustrations, bits of animal or vegetal nature, maps, and dollar bills. Frequently it was laced with words.

A compulsive writer in the free-associative yet lucid manner of Jack Kerouac, Wojnarowicz is today admired perhaps even more for his texts than for his visual art. His view of the world, as a place rife with antagonisms—between mainstream and marginal society, the powerful and the vulnerable, man and nature, eroticism and right-eousness, the organic and the mechanical—could only be reinforced by the onslaught of AIDs. The epidemic would carry away his great friend, the photographer Peter Hujar, and then Wojnarowicz himself in 1992, but not before he had produced some of his most impressive work. Thanks to this surge of creativity, fired by icily clear-

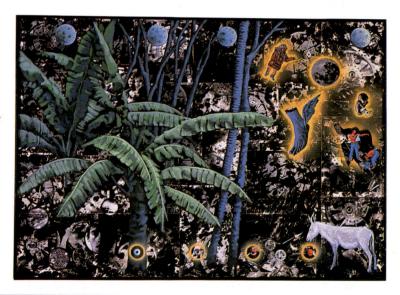

above: 814. David Wojnarowicz. Where I'll Go If After I'm Gone. 1988–89. Black-and-white photographs, acrylic, spray paint, collage on Masonite; 3'9" x 5'4". Collection Ninah and Michael Lynne, New York.

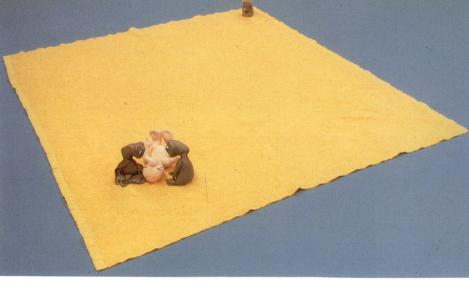

left: 815. Mike Kelley. Arena #5 (E.T.s). 1990. Stuffed animals on a blanket, 8'1" x 7'3". Courtesy Metro Pictures, New York.

headed, unsentimental grief and rage, the artist came in for a kind of universal fame he had never quite known in less fraught days. It also helped that he won a widely publicized lawsuit against the head of the American Family Association, who, in his zeal to stamp out pornography, had violated Wojnarowicz's rights by reprinting in a pamphlet, for distribution to members of Congress, the erotic bits excerpted from a large and multivalent painting. In writing, as well as in visual art, Wojnarowicz could range from the choleric to the elegiac, as here, in some of the last lines he ever wrote, for a book entitled *Memories that Smell like Gasoline*:

Sometimes I come to hate people because they can't see where I am. . . . I'm a blank spot in a hectic civilization. I'm a dark smudge in the air that dissipates without notice. . . . I am screaming but it comes out like pieces of clear ice. I am signaling that the volume of all this is too high. I am waving. I am waving my hands. I am disappearing. I am disappearing but not fast enough.

At the outset of the nineties, the always quotable Jean Baudrillard framed the challenge of the moment in a terse rhetorical question: "What are you doing after the orgy?" Many artists, as already noted, would respond with installations recalling the povera ones of the late sixties and early seventies. These were the post-Minimal years when the first Conceptualists attacked formalism by renouncing sculpture as well as painting in favor of working with eccentric, formless materials-devalued, everyday objects or soft, organic, even unstable substances-presented in equally eccentric, "scatter" arrangements (Figs. 676, 706, 709). A master of the genre, now called "pathetic art," is Los Angeles artist Mike Kellev (1954-), who says: "I'm not interested in things that rise above but rather that sink below. Anything that people don't like." True to this word, Kelley, a Cal Arts graduate, fashions installations whose black humor savages the sentimental fictions by which humanity attempts to redeem its spiritual poverty and moral failure. Yet, however uneasily, one cannot but laugh, inasmuch as a perverse, even terrifying funniness runs through, for example, Kelley's Arenas (Fig. 815). In this series, a found infant's blanket serves as a kind of gladiatorial field on which discarded toys-dolls and stuffed animalsbelie their bright, cuddly charm to act out manipulative power plays common to the adult world-common for the simple reason that, according to the artist, they begin in the sandbox and playpen. If idealizing parents imagine children to be so sweet and innocent that only the freshest, cutest, most sexless toys are fit for them, Kelley disabuses such self-delusion by working with cast-off, thrift-shop baby fare, all of it soiled and odorous from much rough play and messy adoration. An unsettling message arises not only from titles like More Love Hours Than Can Ever Be Repaid but also from arrangements on the order of that in Arena #5, where a pair of E.T. dolls bend over a recumbent third, who could be their patient, their sexual partner, or indeed both, while a fourth E.T. cowers in the opposite corner, head bowed as if in shame or horror. A true artist for an old century racing toward burn-out, Kelley spurred Ralph Rugoff to make this summary comment: "Above all, [his] art rebels against the tyranny of the ideal-and its degenerate counterpart, the cliché. ... The pulling down of cultural façades is carried out at times with an enjoyable viciousness, but mostly with a playfulness and vitality that is loose-limbed, raucous, intelligent, and bluntly honest."

The beleaguered dummies made by Tony Oursler (1957—), another Cal Arts graduate, have sometimes been viewed as emerging from the same "psychic swamp" as Mike Kelley's sorry stuffed animals. In the Oursler dramas, however, animation is key, a temporal, narrative dimension made possible by a clever exploitation of video, creating a hybrid, mixed-media art typical of the early nineties. Working as playwright, sculptor, puppeteer, and camera man, Oursler brings to installation art a welcome measure of beauty, vitality, lugubrious humor, and emotional intensity. Always con-

816. Tony Oursler. Untitled. 1996. Video projection of eyes on 13 painted fiberglass globes with soundtracks. Courtesy Metro Pictures, New York.

cerned with social issues, especially the toxic effects of not only industry but also substance abuse and technology, most of all the media, Oursler began his career making videos of Punch and Judy psychodramas, staged within painted-cardboard sets recalling those of early children's television. Only after he discovered the potential of miniature video-projection technology, however, did Oursler begin to achieve his signature works-soft-sculpture dummies with faces brought to unnerving, sometimes hilarious life by pre-recorded video. In Getaway #2 the blank, stuffed head of a dummy, with an inert, empty bedjacket and pajama bottoms for a body, is wedged or squashed under the near corner of a twin-bed mattress. In the darkened gallery, the head comes radiantly, even fleshily alive oncc the tape begins to play, whereupon the androgynous features (actually those of the performance artist Tracy Leipold) contort with rage and resentment over the public predicament in which the figure finds itself. Incredibly, the eyes seem to fix on startled visitors just as the mouth appears to speak directly to them: "Hey, you. Get out of here. What are you looking at?" For another penumbral installation, Oursler hung a veritable galaxy of fiberglass orbs, mostly the size of basketballs, each of them luminous with a single eye-that proverbial "window to the soul" (Fig. 816). Darting, squinting, weeping, or slowly opening wide as if in shock or disbelief, the oculi derived, in fact, from close-up views of art-world people mesmerized by some unfolding drama-a video game, a television show, a pornographic film. All about, meanwhile, individual soundtracks murmured with random noise, the audio completing a metaphor for the ubiquitousness of media culture and its capacity to induce an altered state of mind, a power as insidious as that of drugs, emotional trauma, or atmospheric pollution.

Critical and public support for socially aroused art made by alternative means climaxed and then crashed in 1993. What appeared to send the whole syndrome over the top was the Whitney Biennial, this time dedicated almost entirely to artists who "raise important questions about the changing role of the artist in society; the politics of representing racial and sexual difference; the boundaries between art and pornography; the function of art as a sociopolitical critique; the interrelationships of self, family, and community; and the influence of new technologies." Of the eighty-two artists included in the exhibition, only eight were painters. Robert Hughes, writing in *Time*, dismissed the Biennial as "a saturnalia of political correctness, a long-winded immersion course in marginality... one big fiesta of whining agitprop." For many writers, the show merely dramatized

The Nineties

the eternal problem faced by artists engaged in social critique: how to translate strong moral convictions into visually compelling statements. Peter Schjedahl, one of the more generous critics, found the affair baleful but allowed, in *The Village Voice*, that "the episode will last until a generation emerges that is tired of it or until universal justice occurs on Earth, whichever comes first. Neither can come too quickly for me." Two years later, Mark Stevens, critic for *New York Magazine*, could still write of the "widespread didactic strain in contemporary art," which the Biennial had highlighted, "reveal[ing], better than any critic, the exhaustion of the form."

In elderly London, meanwhile, exhaustion evaporated as a wave of enterprising "YBAs" (Young British Artists) burst upon the scene, straight out of some of the most vital art schools anywhere, particularly Goldsmiths College, known for its democratic approach to material and meaning. Trained to debate their ideas, vehemently, in seminars and tutorials, the articulate young Brits could readily jump-start their careers by curating their own shows, designing their own catalogues, reviewing one another's exhibitions, and providing generous mutual support, often in smoke-filled rock clubs popularly known as "raves." Immune to British reserve, they also manifested a gift for publicity worthy of their principal collector, Charles Saatchi of Saatchi & Saatchi, the premier advertising house based in London. In other words, the YBAs exemplified-despite the leftist sympathies usual among artists-the entrepreneurial spirit endlessly preached in Great Britain by Prime Minister Thatcher's Conservative government. The most universally respected YBA is Rachel Whiteread, seen earlier (Figs. 801, 802). The most notorious, as well as indispensable, is Damien Hirst, who, while still a student at Goldsmiths, launched his generation into public awareness by curating the now legendary Freeze show, a three-part cooperative event held during the summer of 1988 in an abandoned Docklands warehouse in London's East End. Freeze proved to be a clinching

right: 817. Damien Hirst. Away from the Flock. 1994. Steel, glass, sheep, and formaldehyde solution; 3'2" x 4'11" x 1'8". The Saatchi Gallery, London.

below: 818. Marcus Harvey. *Myra.* 1995. Acrylic on canvas, 13' x 10'6". The Saatchi Gallery, London.

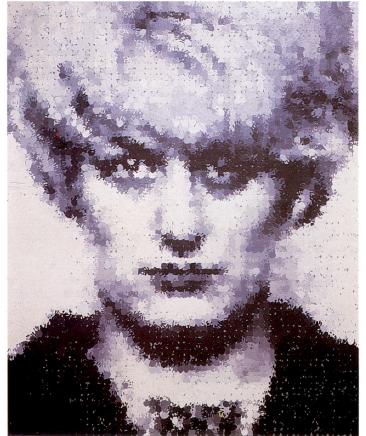

moment, one that quickly reverberated across the waters, not only because of the sheer initiative displayed by its organizers but also because of the rambunctious diversity of the art on offer. Like most of the artists encountered in this chapter, the "Brit Pack" tended to perpetuate themes and strategies inherited from earlier, more innovative decades; yet they also radicalized them, doing so, moreover, with nose-thumbing, proletarian energy and high visual impact. As Martin Maloney wrote in 1997, the YBAs, echoing Duchamp and the Conceptualists, enforced "a belief in art's ability to show ideas as physical things."

Only later, after *Freeze*, did Damien Hirst (1965—) become a household name, for a signature series of works as scandalous as any created in recent times. With the processes of life and death as his motive interest, Hirst began as a painter, producing randomly organized, color-spotted canvases bearing pharmaceutical terms for titles. In his "spin" paintings, he used centrifugal force to achieve a new form of Abstract Expressionism, with such demotic, lower-case titles as *beautiful, kiss my fucking ass painting*. Then came the cabinet pieces, glittering glass vitrines displaying collections of surgical tools or great quantities of pill bottles. Taking a cue from Jeff Koon's basketballs afloat in fish tanks, Hirst produced his most challenging work: a dead shark suspended in an immense tank of formaldehyde. Title: *The Physical Impossibility of Death in the Mind of Someone*

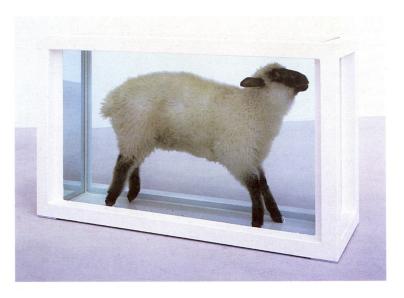

Living. Here the artist seemed to have recast the gothic horror of a Francis Bacon painting into a kind of literal reality characteristic of YBA art. A gentler, Arcadian variant is *Away from the Flock*, a tank containing the pickled body of a fluffy, sweet-faced sheep (Fig. 817). Here, in a strange new way, Hirst managed to bring the joy of life together with the inevitability of death.

Sensation, the title of a 1997 Royal Academy show derived from the Saatchi collection, aptly summarized the overall personality of much YBA art, the most tabloid example of which was, at the time, a mural-size canvas entitled *Myra* (Fig. 818). Painted by Marcus Harvey (1963—), the picture could, at first glance, be mistaken for one of Chuck Close's more loosely painted black-and-white, Photorealist portraits. On closer inspection, however, the bland, pointillist image turns ugly, as viewers realize that the paint marks are actually children's handprints, giving a sinister clue to the identity of the blonde, big-haired subject: Myra Hindley, a woman convicted and long imprisoned for a string of child murders committed in the 1960s. If art's purpose is to provoke, as the avant-garde has always insisted, *Myra* must be deemed a lurid triumph, given that, during the run of *Sensation*, the painting drove one viewer to vandalize it, forcing the Royal Academy to rope off a section of the main gallery.

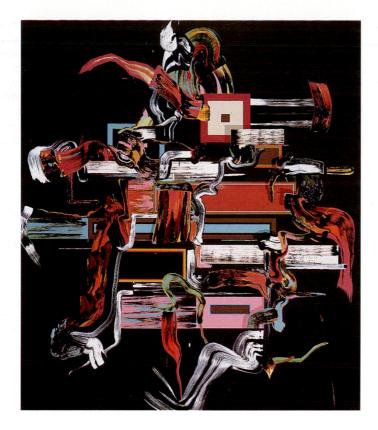

In the anything-goes world of YBA art, even abstract painting could flourish, at least in the ironic, appropriationist manner perfected by Fiona Rae (1963-). Acutely aware of the old argument that nothing new can be done, especially in painting, Rae has candidly pilfered from such older masters as Hans Hofmann, Gerhard Richter, and Sigmar Polke, creating her own tricky amalgam of 20th-century formal devices (Fig. 819). The effect is one of avid eclecticism, a promiscuous, edgy mélange of Hofmannesque pushpull planes in smacking hues, Pollock-like spills, rainbow skid marks in the style of Richter or de Kooning, Tachist textures, Color Field disks, powerful Picassoid strokes, and, always, hues boldly contrasted to rival those of Matisse or Kandinsky. Clearly, Rae responds to the profligacy of visual and material culture at the end of the millennium. It should hardly surprise, therefore, that she may sometimes admit an electronic diagram, as here, or even a cartoon figure, but never to the point of compromising the essential abstraction of her pictorial world, wherein planes are so interwoven that all sense of deep, illusionistic space vanishes. Rae's is a self-conscious, post-modern art, making no attempt at transcendence à la Mark Rotho; rather, it offers a heady cocktail of colliding images and styles, in which many viewers have found a surprising coherence, even freshness and delight.

When it came to the sculptures of Dinos and Jake Chapman (1962—; 1966—), the Royal Academy feared not so much vandalism as traumatized children and thus, for *Sensation*, assigned the brothers a room of their own, accessible only by adults. What they saw was a ring of blue-glass-eyed child mannequins—shop-window dummies—joined like a circular daisy chain of Siamese twins, some of them with a Pinocchio nose in the form of a full-grown phallus, sprouting above a yawning anus in place of a mouth. Almost as intimidating was the title: *Zygotic acceleration, biogenetic, de-sublimated libidinal model (enlarged x 1000)*. A more jolting image than this group has rarely been encountered in the history of art, even though, as Robert Rosenblum noted in 1996, it takes "us back to a Surrealist inventory of monsters whose anatomies are shaped by an all-consuming sex drive: Salvador Dali's Freudian humanoids, Hans Bellmer's fetishistic female dolls." In other pieces, the Chapmans have allowed their mutant brats to retain normal facial features and merely to pair off as genderless, self-reproducing couples, the better to roam about an Eden-like setting, as if to show where demon libido first erupted and went awry (Fig. 820).

The *fin-de-siècle* London inhabited by the YBAs may have found its most acute eyewitness in the young German photographer Wolfgang Tillmans (1968—). Sometimes called Gen-X's answer to Andy Warhol, Tillmans, like the sixties Popster, entered art by way of fashion, celebrating the latter right along with admass, corporate, and youth culture (Fig. 821). And he too is an active, nonjudgmental presence among his chosen glitterati, a cool, gender-bending throng of models, rock stars, and movie actors willing to be photographed in rave or techno clubs, in the street, or at home, clothed, nude, or sexually entangled. Though born in Remscheid, near Düsseldorf, Tillmans has pursued his career mainly in the British capital, documenting his crowd for such trendy magazines as *i-D*,

left: 819. Fiona Rae. *Evil Dead 2*. 1998. Oil and acrylic on canvas, 8 x 7'. Courtesy Luhring Augustine, New York.

below: 820. Jake and Dinos Chapman. *Tragic Anatomies* (installation). The Saatchi Gallery, London.

bottom: 821. Wolfgang Tillmans. *Installation* (Regen Projects, Los Angeles). 1994. Courtesy Andrea Rosen Gallery, New York.

The Nineties

Interview, Spex, and Vibe. But he also permits his interest to wander-again like Warhol-beyond the narrow confines of celebrityville to picturesque details of life-admittedly not electric chairs or highway accidents but, rather, sheets, cast-off garments, factories, a pile of half-eaten fruit spilling over like autumn foliage. Exhibitions of his work thus become installations, arranged by the artist himself so that images function as bytes of information randomly scaled and jumbled together with fashion shots in ad hoc groups like those currently favored in hip magazine layouts. Color photographs in sizes ranging from huge to postcard dimensions, regardless of subject, are taped to the gallery walls from floor to ceiling. Given this distancing, uncritical approach, narrative import remains inchoate, apart from the drive towards social and aesthetic leveling ever more present in Western civilization since the 1960s. Like Nan Goldin, Tillmans offers an intimate but unsentimental portrait of his generation-at least in that part of the forest he frequents-yet rejects Goldin's personal, diaristic approach, insisting that his work "is not about capturing or remembering things." "I want," he says, "to describe a particular thing in the most universal way. Even though I feature strongly in my work, it's more a screen for each viewer's projection. . . . When I put people or couples together, it's a dream, really, and when people see it, it empowers them to be that way themselves. I can make my idealism look real."

In the early 1990s, the art-world irony of Damien Hirst, producing the brashest art imaginable in a culture historically given to reticence, was further compounded by the Mexican artist Gabriel Orozco (1962-). Although heir to the grandiose rhetoric of his country's mural tradition, Orozco has won broad critical acclaim for a hybrid Conceptual art blessed with eloquent understatement. Sometimes called a "Marxist of immateriality," Orozco travels lightly through the world, redeeming the discards of consumer culture by recasting them as art works that loom larger in the imagination than in reality. For the Penske Project, the artist drove about New York City in a Penske truck, collecting detritus and, on the spot, transforming it into modified readymades. One of the sculptures consisted of three cast-off wallboard-compound buckets cut and joined into a single trilobate vessel. Inside it was mimicked by a miniature version of the same object, this time made out of three paper cups. Exhibited along with the Penske works were the Dents de Lion, or "dandelions," beige tumbleweed-like structures, each with seven branches budding out into seven clusters of seven leaves, all meticulously crafted of fabric and paper (Fig. 822). But the ultimate in "trash minimalism" was a set of four lids from yogurt containers, mounted one to a wall, each a blind porthole revealing nothing but alluding to much—absence, presence, waste, simple perfection, or merely a personal taste for dots and circles. In video and still photography Orozco may be at his poetic best, as when he explored Berlin on a yellow Schwalbe, an old East German motorbike, in search of a "mate," another yellow Schwalbe. Whenever he spied one the artist pulled alongside and snapped a double portrait of the two bikes, thereby creating an absurdist love story worthy of Surrealism—an object longed for and serendipitously found, then sought and discovered at random all over again.

An equally deft, witty touch distinguishes the way Jessica Stockholder (1959—) deals with found objects and materials. At first taken for yet another installation artist in "penitential reaction to the glitz and materiality of the 1980s," the Yale-educated Stockholder soon revealed herself as much involved with Matisse-like color formalism as with the editorializing potential of the funky *trouvailles* she typically appropriates. The inspired lunacy of her oxymoronic fusions—of low-rent objects, gorgeous, ecstatic colors, and off-handed but balanced compositions—has called forth comparisons with such luminaries of the sixties and seventies as Robert Rauschenberg, David Hockney, Judy Pfaff, and even Ellsworth Kelly. Stockholder makes independent sculptures, but she is best known for her vast installations with poetic names like *Your Skin in This Weather Bourne Eye-Threads & Swollen Perfume* (Fig. 823). For this piece, created at the Dia Center in late 1995, Stockholder

above: 822. Gabriel Orozco. *Penske Project* (installed at the Musée d'Art Moderne de la Ville de Paris). 1998. Courtesy Marian Goodman Gallery, New York.

left: 823. Jessica Stockholder. Your Skin in This Weather Bourne Eye-Threads & Swollen Perfume (installation, Dia Center for the Arts). 1995-96. Paint, concrete, Structolite, various building materials, carpet, lamps, electrical cord, purple plastic stacking crates, swimmingpool liner, welded steel, stuffed-shirt pillows, papiermâché, balls; 3,600 square feet, 18' ceiling Courtesy Gorney Bravin + Lee, New York.

enticed visitors into her surreal world along a lime-green linoleum path (the nineties equivalent of the "yellow-brick road"?) bounded on the right by a rough-textured cement wall. The oblique angle of the lino strip provided a foretaste of the visual delirium that would soon follow. First to be encountered was a stage fashioned of robin's-egg-blue concrete laid on like cake frosting and an overhead platform piled with a jumble of gaudy household lamps, the latter fed by fat yellow cables that hung to the floor before radiating in tent-like swags above and even beyond the installation. On the left an irregular steel grid served as another wall fronted by wooden posts and draped with a large spread of luscious pink carpeting. Farther along, on either side, stood cubic masses of purple milkcrates stacked to the ceiling, and then, straight ahead, a bulging mound of white shirts stuffed with foam rubber and partially painted green and orange. The great pile rested there like a benign, inscrutable Buddha functioning as a centerpiece for the entire show. From this point on the cement wall sported a blue plastic swimmingpool liner, its blazing color in full vibration with patches of floor painted lemon yellow and rusty red. Last to be encountered, on the left, was a door cut into the structural wall and covered with a wire grid, through which could be seen Dia's storeroom for building supplies. In this way Stockholder declared the site-specific nature of her work. Overflowing the 3,600-square-foot room into the lobby and even spilling through the windows into the alley next door, Your Skin suggested to one critic "the crazed nightmare of a homemaker imprisoned by the imperatives of nest-building." Others saw the piece as celebratory, as big, buoyant, and replete with moments of extreme beauty sprung from knowing juxtapositions of the most ordinary materials. "My work," Stockholder contends, "often arrives in the world like an idea arrives in your mind. You don't quite know where it came from or when it got put together; nevertheless, it's possible to take it apart and see that it has an internal logic. I'm trying to get closer to thinking processes as they exist before the idea is fully formed."

Although deeply political, Cuban-born Felix Gonzalez-Torres (1957-1996) also adopted a sly, subtle approach to installation art, creating works of spare but affecting beauty before he died of AIDSrelated causes at the age of thirty-eight. Like David Wojnarowicz, Gonzalez-Torres made love and loss the primary substance of his art, Conceptualist in nature but realized with eccentric, vernacular materials and a near Minimalist sense of form (Fig. 824). Following graduation from the Pratt Institute in Brooklyn, he joined Group Material, an art-and-politics collective based in New York City. Thereafter Gonzalez-Torres never flagged in his commitment to such urgent causes as gay rights. Among the most poetic of his creations must be counted elegant strings of low-wattage incandescent bulbs that were allowed to burn out during exhibitions. Many saw them as sculptural first cousins to the dark, spectral elegies painted by Ross Bleckner. Just as collectors or curators were encouraged to arrange the lights as they wished, viewers found themselves invited to dip into sculptures made of brightly wrapped candies, piled in pyramids or laid out in rug-like expanses, as if the austere Carl Andre had suddenly turned cheerful and become a Pop artist. As the sweets disappeared into mouths and pockets, the artist or others replaced them, so that the mass would always have the body weight of the person in whose memory the piece had been made. In this way the work not only evoked the transience of all things; it also questioned concepts of ownership and value. Nowhere did Gonzalez-Torres's sense of restraint and beauty combine with his celebratory soul to better effect than in a series of beaded curtains, like the example shown here, its blue and gold colors suggesting, for one critic, the artificial hues of chemotherapy drugs. An equally simple, allusive work had the artist posting a photograph of an empty, unmade bed on twenty-four billboards throughout New York City. It served as a memorial to his life companion, another AIDS victim.

824. Felix Gonzalez-Torres. Untitled (Beginning). 1994. Plastic beads and metal rod. Courtesy Andrea Rosen Gallery, New York.

Here, as elsewhere, Gonzalez-Torres quietly but steadily eroded the boundaries between social commentary and intimate disclosure, between private experience and public politics.

Midway through the nineties, the oversupply of sprawling, moralistic art vielded what one critic termed an "anything-butinstallation" mood. This cleared the air for a resurgent interest in painting, a medium even its most grudging critics had to admit was probably here to stay, having been around since prehistoric cave culture. As already observed in London, painting could be deemed a viable artistic option among many, continuous with pictorial art like that of Howard Hodgkin, Per Kirkeby, Brice Marden, Ross Bleckner, and others met in the last chapter. Among the leading painters of the decade must be included Jonathan Lasker (1948-), a New York artist who, along with Fiona Rae, produces a hybrid, mediated, even jarring form of abstraction. Like Gerhard Richter in his abstract paintings, Lasker practices self-quotation as a technique for denying the kind of inspired, automatist spontaneity so dear to the Abstract Expressionists. For these postwar artists, "things were different," Lasker once said. "They were seeking something cosmic, but their assumptions about the big metaphysical picture were based on some pretty basic beliefs-like the answers of religion, like the idea that the family was intact, like the principle that people are accountable for their actions. All of that has broken down. We're in a period of history where a lot of culture has been leveled, and we're trying to recompose what can have meaning for us." The pieces Lasker works with are invariably figure, ground, and line, a set of simple, familiar elements in which he discovers inexhaustible visual interest, endlessly permuting them without regard to the ideals of either formalist or expressionist abstraction. The result is an oeuvre with a presence unlike anything else in today's art. A representative work, with a characteristic title, is The Eternal Silence of Infinite Space (Fig. 825), identifiable as a Lasker by its curiously awkward, unresolved composition, all-over flat field, strident colors, unvirtuosic touch, and disparately handled abstract images. If the artist succeeded in making oil paint look like plastic, as one critic asserted, it was in part because he had scrupulously copied, on a grand scale, a small study made with ballpoint and felt pens. Such a distancing process served perfectly to transform clumps of thin, meandering lines or slashing brushstrokes into mere signifiers or cartoon versions of the Abstract Expressionist styles pioneered by Pollock and de Kooning. If Franz Kline is recalled in the upper right figure, the angular mesh of heavy black lines is so chaotic that it breaks free along the bottom, forming a base or horizon line below the two images immediately to the left, each of them realized in a different kind of graphic language. Adding to the discord among the shapes is the off-center tangle of pink and red lines messily painted wet on wet and superimposed over both field and figures as if flung there from across the room. Clearly the unifying possibilities of the cold-

ly bright yellow ground are denied. And so is the flattening effect of the all-over field of solid color, given that the variously treated images—among them the mock signature in the lower right—tend to snap back and forth in space, jockeying for their special positions without ever finding them. Thus, if Lasker's Pop-bright paintings, with their odd, indecipherable blend of clumsiness and sophistication, optimism and irony, humor and seriousness, look rather "off," or even a bit *faux-naïf* or Art Brut, it is for "on" reasons, painted as they are in "today's universe," when, to quote Jude Schwendenwein, "signals are crossed, meaning is filtered and dispersed, and a picture is still worth a thousand words."

When Mary Heilmann (1940-) took up painting in the early 1970s, she brought to the task the experience and sensibility of an accomplished ceramist. Thus fortified, Heilmann enjoyed the selfconfidence to defy Minimalist doubts about painting, then at their peak. She also moved from California to New York, where she had the wit to co-opt formalism's structures, and then to humanize them with a ceramist's fluid, personal touch, love of fortuitous accident, and translucent colors (Fig. 826). This "rebellion-through-relaxation" process has served Heilmann well ever since, enabling her, at the turn of the millennium, to claim the aesthetic high ground as an abstract painter whose work sails triumphantly above fashion. Loyal to modernism's concern for objecthood, Heilmann frequently flows medium over the edges of her canvases, giving them a three-dimensional look. As for the two-dimensional surface, she often acknowledges its flatness by the modernist device of a grid, only to loosen and soften the armature in fluent, even splashy washes of color. Applied one hue over another, the paint is laid on so adroitly that an upper layer appears to be peeking through a lower one. With a rare gift for feigning nonchalance, this most sophisticated and steadfast of artists has reinvented formalism and made it seem not only insouciant but also ever-green. Yet, in the words of the critic Peter Schjeldahl, "there is a haunting undertone, an existential gravity, to Heilmann's never-fail spontaneity. Meanings that do not arrive do not cease to be wanted. Heilmann's funky and frolicsome layouts wait for Godot. A quality of tense, fateful irresolution accounts for her staying power. . . .'

Elizabeth Peyton (1965—), a Gen-X soul-mate to the mature Mary Heilmann, was lucky enough to study at New York's School of the Visual Arts, where a general disinterest in painting, especially portraiture executed in the deliquescent manner of Rubens, enabled her to grow strong through stubborn resistance. The SVA was still famous, after all, for having nurtured the graffiti-related talents of Keith Haring, Kenny Scharf, and, unofficially, Jean Michel left: 825. Jonathan Lasker. The Eternal Silence of Infinite Space.
1994. Oil on canvas, 7'6" x 10'. Courtesy Sperone Westwater, New York.
below: 826. Mary Heilmann. Popocatepétl. 1998.
Oil on canvas, 5' x 6'3". Courtesy Pat Hearn Gallery, New York.

Basquiat. Peyton, a determined painter since the age of eleven, is nostalgic not only in style but also in her love of such 19th-century writers as the French poet/art critic Charles Baudelaire. In a celebrated essay entitled "The Painter of Modern Life," Baudelaire argued for the dandy as a heroic type, who, in revolt against the leveling effects of mass culture, gives way to a "burning need" to invent a "personal originality," to a "kind of cult of the self." It follows, therefore, that Peyton would discover a hero in Andy Warhol, the inveterate and dandyish portrait painter who made his "stars" look almost surreally beautiful. Like Warhol, Peyton works from mediated imagery, discovering her subjects in history (Ludwig II of Bavaria, Napoleon) and the celebrity world, as well as among her East Village friends (Fig. 799). Furthermore, she paints them, as Baudelaire would say, "with an intoxication of the pencil or the brush" so as "to express . . . their luminous explosion in space." Rock culture, especially, attracts Peyton, who has depicted the likes of John Lennon, Liam Gallagher, and Kurt Cobain, the last a favorite because "he made great music despite everything." To reveal them as magically transformed, people who could change the world as well as themselves, Peyton endows her dandies, male or female, with luxuriant hair, cherry-red lips, dreamy eyes, and a general air of androgynous, melancholy charm. Most of all, she assures their "luminous explosion in space" by ravishing them, as well as the viewing eye, with one of the most seductive and painterly styles to emerge since de Kooning. Shameless in her preference for pinks and purples, Peyton strokes on intense, glaze-like color with a brushy, bang-on virtuosity that harks back to such masters of the loaded brush as Velázquez and Sargent. Fortunately, the sheer aura of her spectacular technique transcends self-regard to illuminate the aura and mystery of popular culture, a glamorous, narcissistic world replete with the tragedy of overnight fame and early burn-out.

The *Newsweek* critic Peter Plagens, in summary remarks made at the end of 1997, lamented what he called the "tired carny sideshow" of contemporary art, citing, in particular, the work of Barbara Kruger, Andres Serrano, and the Chapmans. "While outrage artists might fantasize that they're simply speaking truth to power, it's more likely that they merely know that what gets press isn't beauty but wretched excess." Ironically, beauty, a concept once demonized as socially constructed and thus discriminatory, was by then making a much-discussed comeback, in a form, moreover, that pre-post-modern eyes might recognize. Evident in the paintings of Peyton and Heilmann, beauty as a crucial component of art would find steady reinforcement in a series of wildly popular museum exhibitions dedicated to acknowledged masters from the near or distant past. The shows began with van Gogh in 1990 and then moved on to Titian, Vermeer, Monet, Cassatt, Picasso, Braque, and Matisse, among others, before ending with Jackson Pollock in 1998-99. The Pollock retrospective broke all attendance records but one at MoMA, where younger viewers queued up six deep for the first chance in years to behold the great Abstract Expressionist in real depth. The nostalgic hunger for "authentic" art-for "quality," another forbidden word-even caught the eye of the German artist Thomas Struth (1954-), who, like Bernd and Hilla Becker, his onetime teachers, specializes in a form of documentary photography, albeit on a grander scale than the Beckers' black-and-white stills and in rich Cibachrome (Fig. 827). What most startles about Struth's images is the hyper-reality of the all-over focus. This makes for a near surfeit of data about an art-jammed space like that inside the

below: 827. Thomas Struth. *Louvre 4, Paris.* 1989. Cibachrome print (edition of 10), 6'1/2" x 7'11/2". Courtesy Marian Goodman, New York.

bottom: 828. Bill Viola. *The Greeting* (production stills) from *Buried Secrets*. Video/sound installation created for the United States Pavilion, Venice Biennale, 1995. Courtesy the artist.

Louvre, where the public becomes symbiotic with the mesmerizing objects of its gaze. A fortunate few within that public, flush with new wealth from a soaring stock market, finally rekindled the art market, at least that segment of it dealing with Old Master works, one of which—a Cézanne still life—fetched an unprecedented \$60 million when sold at auction in May 1999.

"Beauty" is rarely absent from comments about the oeuvre of Bill Viola (1951-), who as a video-installation artist works in a medium much favored by the "rage" masters so deplored by Peter Plagens. Together with Nam June Paik and such younger practitioners as Mary Lucier and Gary Hill, Viola has transformed video installation into a high art, capable of elevating "a merely pretty event into something truly beautiful," as Plagens wrote in 1995. Like Paik, Viola came to video from electronic music, which he studied at Syracuse University before establishing his studio in Southern California. Although a pioneer in video, beginning in the 1970s, Viola did not have a gallery exhibition until 1992, thanks to the unsalability of his pieces, which require such costly technology as well as labor-intensive preparation that, usually, they can exist only on commission from major art institutions. His most celebrated project to date was for the 1995 Venice Biennale, where Buried Secrets occupied the same space taken over by Jenny Holzer in 1990 (Fig. 797). Inspired by a verse from the 13th-century Persian poet Rumi-"When seeds are buried in the dark earth/Their inward secrets become the flourishing garden"-the Biennale work continued Viola's exploration of such big subjects as life and death, conscience and memory, Eastern and Western mysticism, city and nature, and time itself. A favorite device is slow motion, which allows an event, a landscape, or a moving body to unfold like a languorous dream. At Venice this was best seen in The Greeting, one of the five room-size installations making up Buried Secrets. Here a radiantly smiling, pregnant woman approaches two other women and then whispers in the ear of the one she recognizes (Fig. 828), the action accompanied by a whispering audio mixed from the sounds of wind, rushing traffic, and a babble of human voices. For the art-historically aware, the elaborate set and ravishing colors evoked a Visitation painted by the great 16th-century Florentine Mannerist Jacopo Pontormo. Viola, explaining how he achieved a truly Renaissance effect of transcendent reverie, said to Steven Henry Madoff: "I used a high-speed camera, shooting 300 frames per second—1,000 feet of film in under 50 seconds—and then slowed the work down so that it takes 10 minutes, revealing every ambiguous dynamic of their gestures as the secret moves through them." According to the critic Anne Doran: "It is a tribute to the sincerity of Viola's work that it is neither sentimental nor didactic, but deeply human and somehow heroic."

The longing for beauty, coming at the end of a century of art often indifferent to it, has entailed a certain morbidity, an apocalyptic sense consistent perhaps with the end of the millennium. A similar ethos emerged during the last fin de siècle when Symbolism's aesthetics of decadence found pictorial counterparts in the works of Gustave Moreau, Edward Burne-Jones, Fernand Khnopff, and Toulouse-Lautrec, or such Art Nouveau stars as Aubrey Beardsley and Gustave Klimt. The Symbolist era itself has frequently been understood as a nostalgic revival of Romanticism, that grandly poetic, long-lived movement whose late-18th-century founders had defined the sublime as beauty tinged with terror. And this at a time when a medieval or Gothic revival was under way, all of which flowed into such "Gothik" confections as Mary Shelley's Frankenstein (1818), the ur-prototype of exquisitely wrought horror fiction. Not surprisingly, the new fin de siècle has produced another wave of strange, unsettling beauty, encouraged by all manner of current realities, among them sci-fi fiction, monster films, cloning, biogenetically altered food, global warming, and the Y2K problem, plus all the pathologies encountered earlier in this chapBellini and continuing right through Rembrandt and Velázquez to Manet and the Impressionists. For imagery, however, Yuskavage takes her cue from the Surrealists, allowing her subconscious to dictate a feminist-inspired obsession with the female body, its sexual characteristics so exaggerated as to become a weird caricature of the fantasy life behind "the male gaze." Her breakthrough came with two series entitled Bad Babies and Big Blondes, the paintings notorious for their "demonically distorted Kewpie-doll women" presented in silken, atmospheric spaces radiant with a palette of golds, sea-greens, purples, and hot pinks. More recently, Yuskavage has composed on a grander scale, again working in the Renaissance tradition, this time by modeling small figures, arranging them in light boxes, and making a series of preparatory studies. As a result, a picture like Honeymoon resonates with art history (Fig. 830), especially Georges de La Tour's Penitent Magdalenes, figures with long, flowing tresses and bowed heads picked out of an enveloping gloom by the magical light of a glowing candle. The "bride" seen here, with her pert, almost piggish nose and open, bee-stung mouth, would appear to be, as in so many Yuskavage canvases, a partial

right: 830. Lisa Yuskavage. Honeymoon. 1998. Oil on linen, 6'5¹/2" x 4'7". Courtesy Marianne

> Boesky Gallery, New York.

right: 829. Alexis Rockman. Harvest. 1991.Oil on wood, 5'8" x 9'4". Courtesy Gorney Bravin + Lee, New York.

ter. Contemporary gothic, with its intimations or narratives of death and decay, its deliciously potent mixture of mourning and celebration, gorgeousness and grotesquerie, has already been seen, to one degree or another, in the works of Ross Bleckner, Robert Gober, Kiki Smith, Damien Hirst, and, especially, the Chapman brothers. Among younger painters, gothic finds its most theatrical exponent in the New York artist Alexis Rockman (1962—), whose tightly focused, Old Masterish renderings of a nature run amok recall the apocalyptic scenes of that 16th-century fantasist Hieronymus Bosch, including the black comedy (Fig. 829). In Rockman's absurdist vision, the world has become a post-nuclear, evolutionary bog rife with miscegenation, its bestiary of creatures from the earth's past, present, and imagined future "red in tooth and claw."

Lisa Yuskavage (1962—), as skilled and droll as Alexis Rockman, has also given birth to a devilish, gothic beauty in her mischievous blends of elegance and vulgarity. She has even been credited with making contemporary art adventurous again, not least because of her willingness to place a Titianesque mastery of oil glazes at the service of subject matter some have seen as both misogynist and kitchy. By way of explaining her choices, the Yaleeducated artist confesses fidelity to her "white-trash" origins in Philadelphia as well as to the high European tradition of luminous, oil-based colorism, beginning with Jan Van Eyck and Giovanni

The Nineties

self-parody. The figure is backlit through a window giving on to an exquisitely painted grisaille mountainscape, the very kind of view the early Romantics would have called sublime, its beauty now tinged with post-modern irony perhaps more than terror. The lambent light, though pale and misty, all but sets the tumble of heavy, blond hair on fire, not to mention the swollen breast with its huge, bright jewel of an upturned nipple. Kneeling on the bed in an open robe, this nubile nymphet seems to radiate vulnerability, as if sexuality had come upon her with the puzzling, unbidden stealth of an incurable disease. Acknowledging the disturbing though seductive quality of her art, Yuskavage has said that, in the age of MTV, "painting no longer has the power to affect anybody's morals. . . . The hoopla caused by what I do always surprises me because painting seems so ineffectual. . . . I've always known you don't change the world through painting. I think that's part of the reason why I allow myself to take such liberties." What saves and glorifies pictures like Honeymoon is the artist's ability to plunge headlong into depths of molten feeling and yet navigate this roiling sea with icy, cunning clarity.

A gothic stew of allure and horror pervades the art of Matthew Barney (1967—), a figure as polarizing as any to appear in the nineties. His sudden acclaim has even been likened to the egregious sort achieved by Jeff Koons a decade earlier, and for some of the

same reasons. Barney, a native of San Francisco, played football in high school, earned a B.A. at Yale, and modeled for J. Crew. As this would imply, he is physically well equipped to star, glamorously, in his own performance/installation pieces-bizarre, surreal sagas exploring ideas about beauty, cultural history, gender ambiguity, mythic narrative, and the body's potential for transformation. Obsessed with such athletic performers or escape artists as Harry Houdini and football-legend Jim Otto, Barney turns every work into a terrifying variety of ritualistic endurance art. At his 1991 debut show in New York-Mile High Threshold: Flight with the Anal Sadistic Warrior-the naked artist strapped on a harness and, by means of titanium ice screws and hooks, played the human fly, negotiating his way across the gallery ceiling and down the stairwell to the basement, a laborious journey that yielded a forty-twominute video (Fig. 831). His destination was a refrigerated glass box furnished with a sculpture shaped like a weight lifter's incline bench but thickly coated in frozen petroleum jelly. Viewed from below while swinging overhead, the macho Barney made himself appear open and vulnerable in a way many women claim to have always felt, and the bench, a traditional site for hard-body he-men, as soft and delicate as female flesh.

Soon thereafter Barney launched into the Cremaster series, so called for the muscle that contracts the testicles in response to stimuli such as fear or cold. In *Cremaster 4: The Isle of Man*, filmed in bright, storybook colors on the eponymous island in the Irish Sea, noted for its strangely hybrid creatures, the artist appears as a horned, hooved, henna-haired, and goat-eared satyr nattily attired in a white-linen suit and two-toned shoes (Fig. 832). Moving through a sequence of birth or initiation rites, the

Laughton Candidate, as the satyr is called, tap-dances a hole in the floor of a pier, walks along the seabed, wriggles through a narrow, intestine-like tunnel filled with gooey Vaseline, and picnics with three androgynous fairies. All the while a pair of cyclists on sidecar motorbikes race one another from opposite directions, until the video ends just as they are about to collide with a native Laughton ram, its fleece died red like the satyr's hair and its curious horns, one pair ascending and another descending, beribboned in yellow and tartan. The related gallery installation, by contrast with the action-filled video, seemed a bit flat, overstuffed with beautifully crafted props already viewed on the screen and then displayed like luxurious anthropological artifacts. Barney's artistic ancestry clearly lies among the Conceptualists, especially performance and video artists like Bruce Nauman, but it also includes the Surrealists, among them Buñuel and Dali, as well as their nemesis, Jean Cocteau. More important, Barney appears to belong very much to the present or the future, hailed as he already is as the mythographer of the millennium. Commenting on his work, the artist remarked to the critic Roberta Smith in 1997: "I want to get at the moment of freedom between things, between formlessness and form, which is the exciting moment, the moment of conflict. The goal of the work isn't about something being fulfilled but about setting out to find perfect symmetry, true equilibrium. I think of it as a tragic goal; the pursuit of it is what the narratives in the videos are based on."

 below: 831. Matthew Barney. Mile-High Threshold: Flight with the Anal Sadistic Warrior. 1991. Videostill © 1991 Matthew Barney. Courtesy Barbara Gladstone Gallery, New York.
 bottom: 832. Matthew Barney. Cremaster 4. 1994. Videostill
 1994 Matthew Barney. Courtesy Barbara Gladstone Gallery, New York.

Post- and Neo-Modernism in Architecture

n the visual arts, the term "post-modern" may have gained cur-rency first among architects and critics persuaded that International Style modernism had failed to achieve the utopian ideals pronounced by Le Corbusier and Mies van der Rohe; indeed, it seemed actually to have grown brutal and inhumane, once co-opted by government as well as private developers eager to exploit reductivist aesthetics for the ruthlessly pragmatic purpose of giving less while charging, or paying, more for it. Architecture being shelter and thus far more involved with quotidian reality than either painting or sculpture, the evidence appeared inescapable that the purified-really stripped-downforms of modernist buildings could not, by themselves, purify the attitudes and behavior of their resentful or even vandalizing inhabitants. The symptoms lay everywhere, thanks to modernism's having been mass-produced on a megascale throughout the industrialized world during the first two decades following the end of hostilities in 1945. Further, as this world increasingly replaced industry with information, the more it seemed a global village crowded with cultures far too pluralistic to be well served by a uniform style meant to express the universal, rather than the particulars of anything save those unique to the Machine Age, now deemed

left: 833. Philip Johnson and John Burgee. AT&T (today Sony) Building, New York. 1978–83.

opposite: 834. Complexity and contradiction in Las Vegas, along a highway "strip" catering to the automobilized public. c.1960. obsolete. For a media-driven moment ever-more alive with a multiplicity of competing voices and values, monolithic purity of form could no longer suffice. It would soon give way to an architecture as diverse as the world itself, to the very qualities that modernism had attempted to eliminate, ostensibly for the sake of making the world a better place in which to live.

Modernism began to lose its stranglehold on serious architecture as early as 1961, when Jane Jacobs published The Death and Life of Great American Cities, the first of many writings in which the author denounced the modernist program of bulldozing old, cobbled-together neighborhoods and supplanting them, at a single stroke, with all-alike, high-rise stumps designed to house thousands of wholly unalike people. Noting the squalor, alienation, and crime engendered by this totalitarian approach to the human environment, Jacobs argued for an urbanism rather like that in pre-industrial Europe, a self-organized place of mixed ages, mixed uses, mixed styles, and all the decorative symbols relevant to such a miscellaneous, organically evolved universe. In the wake of Jacobs's ground-breaking treatise, sympathetic designers began to understand architecture as a language perceived through codes, codes that gain or enrich meaning primarily as a result of their differences. Simultaneously, they also found their efforts to counter modernist unity with post-modern plurality reinforced by similar impulses in many other areas of inquiry and practice-ecology, biology, psycholinguistics, neural networks, and so forth. However, it was semiotics that yielded the surest theoretical underpinning, a development already noted, relative to other arts, in Chapters 22, 23, and 24. If signs and symbols, like words in verbal language, signify solely through their opposition to one another, then an architecture of multiple codes or signifiers stands to generate far more meaning than the single, purified code-the bare-bones functionalism-characteristic of the International Style. Gradually, therefore, post-modern architecture emerged as a kind of organized complexity, a field of tensions in which designers would attempt to double- or multiplecode buildings and by this means allow them to signify on more than one level (Fig. 833). While delighting professionals with an arcane combination of Classical motifs and advanced engineering, a post-modern skyscraper or a large subsidized housing project might also gratify sponsors as well as a public merely longing for a sense of revived continuity with the past.

As this would infer, post-modernism liberated architects from the tyranny of technological determinism, allowing them to base new work on history, context, culture, ornament, or whatever else might concern themselves, their clients, and the world at large. As in the other arts, post-modernism became the cutting edge in architecture primarily because of the wit and irony with which its practitioners quickly learned to mingle popular as well as traditional elements as if they were units in a language game. However, given the openness of the new dispensation—which developed bit by bit from

the mid-sixties through the seventies to achieve dominance only in the eighties-it is hardly surprising that post-modernism has been defined in a variety of conflicting ways. The less convinced tended to view its collage of appropriations as facile pastiche, historicism, or "façadism" comparable to the constant recycling of styles in the fashion industry. More seriously, however, post-modernism has been called the pursuit of "form as communicating sign" meaningful to more than a coterie of specialists. Thus, critics like Charles Jencks, the earliest and most prolific of all the apologists for an architecture called "post-modern," adopted a broadly liberal position. This enabled them to regard even the "neo-modernism" and "deconstructivism" of the 1980s as subsets of the same emancipating ethos, since both revised, ironized, and distorted abstract modernism. As Jencks wrote in 1991, "tolerance, a respect for differences, an enjoyment of variety are the attitudes suited to the information age, and pluralism is its philosophy. No difference?---no richness, no meaning."

The father of architectural post-modernism is unquestionably Robert Venturi (1925-), a Philadelphian whose little book entitled Complexity and Contradiction in Architecture (1966) has been called, by Yale architecture historian Vincent Scully, "probably the most important writing on the making of architecture since Le Corbusier's Vers une Architecture" in 1923. Just as this treatise had successfully countered the academic sterility of long-dominant Beaux-Arts formula with a plea for a new, rationalist, purist, and entirely abstract order, Venturi's "gentle manifesto" labeled what resulted-ubiquitous modernism-as the new academy, this one as dull and dogmatic as ever the old historicism had been. The journey that Venturi would make into the future through the past began at Princeton, where he studied under Jean Labatut, a Frenchman whose mastery of Beaux-Arts aesthetics left the young American well prepared to make the most of a sojourn in Rome while there on a post-graduate fellowship in 1954-56. It also helped that he had done a stint in the atelier of Louis Kahn, another Philadelphian, and come to know the Rome-inspired ruggedness and monumentality of Kahn's almost archaic or Expressionist modernism (Figs. 652-654). For Venturi, the Imperial/Papal City survived not as a museum of great monuments but rather as a living city, a rich and vibrant environment remarkable for its human scale and sociable piazzas, its intricate, urbanistic weave of the extraordinary and the everyday. In Italy, he also developed a taste for the quirky, inventive Classicism of such 16th-century Mannerist architects as Michelangelo, Giulio Romano, and Giacomo da Vignola. Steeped in this background, Venturi argued that, prior to the modernist revolution, architecture had always reflected a mixed palette of practical values, not the

835. Robert Venturi. Guild House, Philadelphia. 1960–64. Courtesy Venturi, Scott Brown, and Associates.

polarized black and white of idealized perfection—moreover, that it was time to go back and reconnect with the varied continuum of historical experience. Exasperated with "the puritanically moral language of orthodox Modern architecture," the witty, erudite Venturi parodied Mies van der Rohe's dictum "less is more" and declared, "less is a bore," the battle cry of post-modernism already encountered in this text. "I am for richness of meaning rather than clarity of meaning," he wrote. "I like elements which are hybrid rather than 'clear,' distorted rather than 'straightforward,' ambiguous rather than articulated . . . conventional rather than 'designed,' accommodating rather than excluding. . . . I am for messy vitality over obvious unity. I include the non sequitur and proclaim the duality." Confronted with the ahistorical, inhuman giantism and machinelike uniformity of International Style architecture, Venturi decided that "Main Street is almost all right."

In 1972, Venturi collaborated with his wife, Denise Scott Brown (1931—), a specialist in popular culture and urban planning, and the architect Steven Izenour, to write Learning from Las Vegas, a book fully as controversial yet influential as Complexity and Contradiction. Here the authors insisted that in the modernist nightmare of what was Las Vegas-a wasteland of highway "strips" lined with honky-tonks, filling stations, fast-food restaurants, pool-side oases, casinos, and parking lots, all clamoring for the automobilized public through a visual cacophony of electronic billboards (Fig. 834)—contemporary architects should seek inspiration quite as earlier generations had sought it in medieval Europe or ancient Rome and Greece. Further, they should study this "vernacular architecture" for the same reason, to apprehend its effectiveness in satisfying the society it served, while at the same time discovering how to do it even better, given that exurban sprawl had clearly come to stay. Intrigued by its "vitality and validity," Venturi and his associates found in garish Las Vegas a kind of degraded modernism, a concatenation of simple boxes submerged under a welter of signs and symbols. What this signified was the irrelevance of a "heroic" architecture concerned primarily with space, form, and structure, as well as a corresponding need for what the authors called "dumb buildings" or "decorated sheds." Consequently, Learning from Las Vegas denounced architectural "ducks"-buildings whose form proclaimed their function, whether a poultry store shaped like a duck or Eero Saarinen's eagle-like TWA Terminal (Fig. 647).

Owing to the freshness of his vision and the aphoristic brilliance of his writing, Venturi soon gained a towering reputation as a theo-

Post- and Neo-Modernism in Architecture

rist. Meanwhile, he had to suffer the disappointment of seeing major projects go to his own disciples, architects willing to flatter patrons with a more literal, glamorous interpretation of historical precedent than the subtle, nervy combination of the grand and the commonplace realized in, for example, Guild House, commissioned by Philadelphia's Society of Friends (Fig. 835). For this block of ninety-one apartments built for the elderly, Venturi decided to create something "double-coded" so as to be at one with its old, inner-city neighborhood but sophisticated enough to fascinate the architecturally informed. Thus, while Guild House may at first seem no more than a run-of-the-mill example of red-brick public housing, a second look reveals it to be slyly "off," as in the way the cubic mass steps forward in three chordlike phases, to climax, as a Baroque palace would, in a centralized façade elaborated upwards. From its white-glazed ground floor and notched entrance, the foremost section rises through a series of tiered balconies to a neo-Palladian lunette crowned by a gold-anodized television antenna breaking free above the roof line. Like Pop Art's soup cans and comics, then being seen for the first time, the antenna is fake, an applied symbol of the chief activity pursued by Guild House's residents. In the same ironic spirit, Venturi announced the place with a sign as bold as a movie marquee, another Pop device counterbalanced by the ennobling symmetry, as well as the delicacy, with which he aligned standard square and ribbon windows on either side of the main vertical axis.

Finally, in 1986, the Venturi firm-Venturi, Scott Brown, and Associates—received what may be the most prestigious commission of the decade, for the long-planned Sainsbury Wing of London's National Gallery, a museum with one of the world's premier holdings of European painting. The award came in the third round of a competition that had collapsed under an unprecedented attack by none other than the heir to the throne, Prince Charles. Making his debut as an amateur-but effective!-critic of Britain's postwar architecture, His Royal Highness had damned the scheme that initially won as a "monstrous carbuncle on the face of a muchloved and elegant friend." Venturi, by contrast, prefers to get his "kicks from accommodating to different places, different ethoses or situations." In London, however, he found himself having to adapt not only to the squeezed corner reserved for the Sainsbury but also to the eccentric Neoclassicism of the old National Gallery, designed in the 1830s by William Wilkins, as well as to the whole of Trafalgar Square out front, complete with Saint Martin-in-the Fields Church, Nelson's Column, swarming pigeons, and snarled traffic. Choosing reticence over flamboyance, he matched both the height of the 19thcentury National Gallery and its pale Portland stone (Fig. 836). He also borrowed Wilkins's Corinthian order but ganged the elements near their source before allowing pilasters and blind windows to fade away in progressively lower relief, suppressed detail, and wider intervals above "huge, almost rude openings." These Venturi compared to "a sports facility," which museums, with their weekend crowds, have come to resemble. To this playful mix of the patrician and the demotic the architect added the bold touch of a stone frieze, iron trusses like those in 19th-century railway stations. and colorfully painted "Egyptian" columns set just inside the big, square entrances. For each of the Sainsbury's other façades, Venturi prepared something quite different-brickwork adorned with stone, granite, and iron on the rear and west, and, facing the old Gallery, a cylindrical bridge springing from a glass and steel wall, whose transparency allows visitors walking up a broad granite staircase a splendid view across Trafalgar Square towards the Strand and Whitehall. What greets them at the top of the tall flight are sixteen variously sized galleries that afford the Renaissance collection some of the most successful exhibition spaces ever built in modern times. Taking their model from Filippo Brunelleschi, the 15th-century Florentine master, Venturi, Scott Brown, and Associates combined oak flooring and light-gray plaster walls with Italian sandstone skirtings and surrounds to create a palatial yet austere environment washed by cool, limpid light from clerestories. While Britain's pro-modernist critics have excoriated the Sainsbury's outside appearance-calling it, for example, "a dull, cowardly edifice designed not by an architect but an exterior designer"-even these have, for the most part, been completely seduced by the remarkable and daring interior.

left: 836. Venturi, Scott Brown, and Associates. Sainsbury Wing (left) of the domed National Gallery (designed in the 1830s by William Wilkins), London. 1986–91.

above: 837. Charles Moore with the Urban Innovations Group. Beverly Hills Civic Center, Beverly Hills, California. 1983–1991.

At about the same time that Venturi and Scott Brown were learning from Las Vegas, the similarly motivated Charles Moore (1925-93), a former student of Louis Kahn's, was taking lessons from Los Angeles, and, especially, Disneyland, the latter becoming for him the very embodiment of the American dream, as well as the model of an outstanding public space. To find such a space at the heart of automobile-dependent, suburbanized America struck Moore as nothing short of a miracle. Concerned about the lost "sense of place" in postwar America, Moore devoted his career in education and design to the "making of places," places whose "presence of the past" emulates that of Mediterranean Europe. For affluent Beverly Hills, Moore had the opportunity to develop a sense of place while expanding the City Hall, a Spanish Baroque pile built in 1932. Here he gave the community not only a plaza with facilities for police and fire departments, the municipal library, and ample parking space but also a truly urban event that quite brilliantly fuses new architecture with old. Now the ten-acre Civic Center celebrates local architectural history-Spanish Colonial, Art Deco, Mediterranean, Industrial-in a pale-stucco, palm-shaded complex whose grand sequence of stairs, public walkways, circular plazas, arched passages, ramps, and bridges evince such witty eloquence and jazzy coherence as to invite Rodeo Drive shoppers to abandon their cars and actually move about on foot.

Venturi and Moore influenced few architects more than Robert A.M. Stern (1939—), who studied under Moore at Yale and has subsequently become the master of "contextual architecture." Indeed, Stern proved so respectful of "American vernacular"—at least, the left: 838. Robert A.M. Stern. Ohrstrom Library, St. Paul's School, Concord, New Hampshire. 1987–91.
 above right: 839. Philip Johnson and John Burgee. AT&T (today Sony) Building, main entrance flanked by loggias, New York. 1978–83.
 above left: 840. Johnson and Burgee. Arcade, AT&T Building.

above center: 841. Johnson and Burgee. Lobby with Evelyn Longman's *Golden Boy*, AT&T Building.

variety practiced by Stanford White at the turn of the century-that he has been accused of violating post-modernism's double code. In other words, he creates houses so totally in the spirit of their prototypes that, far from making ironic comment on them, they seem virtually indistinguishable therefrom. However, for the new Ohrstrom Library on the campus of St. Paul's, an elite prep school in Concord, New Hampshire, Stern achieved an almost perfect balance between accommodation with the traditional architecture of the embracing quadrangle and a distinctive presence (Fig. 838). The secret lay in the synthesis rather than in the imitation of an 1888 neo-Gothic chapel by Henry Vaughan and an administration building designed by James Gamble Rogers, whose Sterling Memorial Library at Yale, with its magnificent high-vaulted reading room, appears also to have served as a model. Frank Lloyd Wright can be sensed as well in a graceful stylistic blend that produced a sumptuous, rambling redbrick structure articulated with gables, dormers, bay windows, an octagonal corner tower, and a spirelike chimney. Inside, students enjoy the quietude and spaciousness of a two-story reading room with a gently vaulted ceiling plastered in diagrid relief, walls paneled in white oak, and circle/stick metalwork balconies, chandeliers, and huge bay windows overlooking a pond. Here, one could scarcely imagine that the contemplative age of print had given way to the video-crazed total-information age.

Although a self-proclaimed Johnny-come-lately in revisionist aesthetics, Philip Johnson may have done more than anyone to make post-modernism respectable—even fashionable—among corporate patrons. Not only did the septuagenarian master bring to the new dispensation a lifetime of distinguished achievement in architecture (Figs. 633, 649); he also spoke with the powerful rhetoric of one who had co-authored, with Henry Russell Hitchcock, the 1932 book that had translated Bauhaus modernism into the International Style, which attained its apogee in Mies's Seagram Building, a project in which Johnson himself had a hand (Fig. 636). Perhaps only Johnson, the doyen of American architects, could have persuaded conservative American Telephone and Telegraph to go post-modern for the new corporate headquarters on New York's Madison Avenue (Figs. 833, 839–841). And perhaps only Johnson, with his droll wit, wide frame of reference, and long memory, could have found in Colonial furniture an American counterpart of European Baroque and thus an authentic native source of historicist monumentality. For him and his partner, John Burgee (1933—), the 18th-century highboy could be revisualized as a skyscraper, its stack of drawerlike floors set on high legs, clad in light-mahogany granite, and crowned with a scroll pediment. While this feature, soaring above the Manhattan skyline, gave AT&T a fresh and instantly striking logo, at street level the Chippendale concept offered the public a pair of open, trabeated loggias. That is, until this great forest of "legs"—six stories tall!—was filled in for commercial use by the building's new owner, Sony Corporation. At the same time that the loggias joined with the entrance lobby-its façade an oculus over a Manneristically steep arch-to evoke Brunelleschi's 15thcentury Pazzi Chapel, the ground-floor lobby itself recalled a groin-vaulted Roman sanctuary, suitably enough since it would house AT&T's personified Genius of Electricity, or Golden Boy, taken from the topmost spire of the old AT&T headquarters on Lower Broadway (Fig. 841). Having salvaged this giant statuea triumphantly nude, cable-encoiled male modeled by the American artist Evelyn Longman-Johnson had it gilded and posed on a tall plinth like a cult figure. Altogether, the AT&T building worked wonders, creating a sensation that made it the breakthrough work for post-modern architecture, which would soon become as much the lingua franca of corporate design as the International Style had been.

Michael Graves (1934-), once a confirmed disciple of Le Corbusier, matured into something more during a year spent at the American Academy in Rome, there discovering, as he later commented, that "the language of modernism was simply not rich enough to say everything I wanted to say. I love Borromini and want to get some of the feeling of the richness of that architecture into my work." But while re-embracing history, Graves took pains to include modernism itself, with the result that, among architects of his generation, he quickly achieved a genuine signature style-Cubism combined with Classicism in buildings that could never be mistaken for anyone else's. Perhaps for this reason, as well as the practical economy and efficiency of his designs, Graves became the first post-modernist to win a major public commission (Fig. 842). Thoroughly double-coded, the Public Services Building in Portland, Oregon, appeals to the general population not only through its pictorial colorfulness but also through its resemblance to a giant toy assembled from a set of children's blocks; at the same time, the building rewards those cognoscenti able to sort out the clever way in which Classicism has been not so much quoted as alluded to or represented in a purely contemporary, abstract manner. Rome had shown how the harsh modernist box could be civilized, by scaling it to the Classical orders, whose base, column, and

above: 842. Michael Graves. Portland Public Service Building, Oregon. 1980–82.

below: 843. Ricardo Bofill and Taller de Arquitectura. Le Viaduc at Le Lac, St.-Quentin en Yvelines, France. 1971–83.

capital derive from the human form itself-feet, body, and head. Like Borromini, Graves chose to exaggerate their proportional relationships and thus achieve intimacy even within monumentality, causing the windows to look tiny relative to the colossal pilasters, imposts, and four-story keystone overlaid upon the main façade from platform to attic. Close reading yields a still more layered anthropomorphism, in which the façade becomes a huge face, or its mirror-glass center a great cyclopean eye, or, more relevant to the region, a totem in the tradition of the Northwest Native Americans. Further, the metaphoric figure may be understood as either male or female, depending on how one interprets the only three-dimensional elements on an otherwise flat surface-the paired imposts at chest height and the single sculpture, the bronze Portlandia, capping the entrance at the center of the lower "torso." As this ceremonial access implies, Graves wanted to restore a sense of ritual to civic architecture, a purpose served as well along the sides, where fiberglass garland swags-flattened and stylized like Art Decofestoon the lintel "supported" by pilasters whose fluting is nothing more than vertical rows of ribbon windows. A similar spirit prevails within, where Graves, using his idiosyncratic vocabulary of symbolic hues and motifs, has created public rooms whose processional sequence unfolds with both nobility and ease. The magnificent Oregon landscape-ancient sequoia forests and glacier lakes overlooking the Pacific Ocean-has also been acknowledged in the building's colors, a painter's palette of green for the base, garlands, and Portlandia, cream for the walls, maroon for the pilasters, brick or earthen red for the keystone, and sky blue for the mirror glass. Meanwhile, modernism underpins the whole, its structural cage evident not only in the grid of small windows but also in the thinness of the Classical features. Clearly nonfunctional, or purely decorative, the latter have been pieced together as in Cubist collage and hung like the curtain walls of a building by Mies van der Rohe. To explain the rarefied yet communicative quality of his work, Graves cited the poet Wallace Stevens, who "said that any language has to be figurative enough to get us into it, but abstract or ambiguous enough to allow us to use it to say more than one thing."

To overcome the more brutalizing aspects of modernism, Ricardo Bofill (1939—), a Catalan architect, has healed the urban/suburban fabric of French life by injecting it with a spectacular series of mass-housing projects unique in their integration of monumentality and populism, advanced industrial technology and Classical forms. Aided by an atelier of not only architects but also philosophers, poets, artists, and mathematicians, collectively known as Taller de Arquitectura, Bofill had the audacity to model a new commuter town—St.-Quentin en Yvelines—on no less than the nearby royal domain at Versailles, complete with a large artificial lake. At either end of this calm sheet of water his neo-Baroque

 left: 844. Hans Hollein. Austrian Travel Agency, Vienna. 1976–78.

right: 845. James Stirling, Michael Wilford, and Associates. New State Museum and Theater, Stuttgart. 1977–84.

buildings spread like carved forests formally sectioned by axes and cross axes until they become squares with a clearing, or open plaza, at the center of each. Even more startling is the march into the lake of a segment called Le Viaduc (Fig. 843), its sequence of five-story towers linked by tall arches whose silhouette recalls not only the celebrated Château de Chenonceaux spanning a tributary of the Loire but also the aqueducts built to feed Louis XIV's numerous thirsty fountains at Versailles. Host to 463 well-designed, relatively spacious apartments-some subsidized, others for sale-Le Viaduc and Les Arcades at St.-Quentin en Yvelines provide their inhabitants with a robust sense of place, a grandiose yet egalitarian place clearly derived from history but responding to contemporary needs without resorting to the characterless slabs of most lowincome housing run up in the postwar era. Pointing to any one of these, Bofill likes to boast that his "populist palaces" have been constructed with the same technology-tunnel casting and prefabricated concrete-as well as with the same economic constraints. Quoting Roland Barthes, the architect says: "The signs are timeless, but the use changes."

During the same critical period that found the Venturis, Jack Kerouac, and Nabokov's Humbert Humbert and Lolita on the road throughout the American West, the Austrian architect Hans Hollein (1934—) was also there discovering Las Vegas complexity and contradiction, in his case as an antidote to the doctrinaire Minimalism then being taught at Mies van der Rohe's Illinois Institute of Technology. Back in Europe, however, Hollein has proved to be less a Pop architect than an heir to the elegantly mixed language of the Viennese Secession (Figs. 132, 143, 135, 154–156), including its tradition of luxurious media, exquisite craftsmanship,

and careful detailing. Something of an architectural Wittgenstein, Hollein approaches shelter as if it were language, using forms, materials, and images as signifiers, capable not only of evoking history but also of doing so in wholly contemporary terms. Seeking an architecture with "conscious overlays of many different intentions . . . an architecture that has multilayered elements," Hollein realized one of his most characteristic successes at the main office of the Austrian Travel Agency in Vienna, on a key site directly opposite the fabled Vienna State Opera (Fig. 844). For this extraordinary interior he designed a post-modern reprise of Otto Wagner's 1904-05 Post Office Savings Bank, but then filled it with artful inducements to spend everything for the sake of gratifying dreams of worlds far away, in time as well as space. After waiting on cubic chessboard squares, or under a sleek Indian pavilion, clients may approach an information counter through a grove of stylized palm trees, or the theater reservation desk under a bronze curtain hanging before a backdrop copied from Sebastiano Serlio's 16th-century Comic Scene. Their next stop would be at cashier windows fashioned like Rolls Royce radiator grilles. If travel holidays are transformative, Hollein confirms the notion through palm trees fashioned of polished brass (a quotation from John Nash's early 19th-century Royal Pavilion in Brighton), as well as through a Greek column broken at the waist, where it becomes a shiny steel cylinder that supports the ceiling under which a plaster pyramid disappears into the wall. Elsewhere eagles soar against a painted sky, while airplane wings and ocean-liner railings signal the various booking desks, all part of a scheme designed to disrupt an otherwise neutral space and endow it with metaphoric power. By altering their properties, Hollein not only transforms objects; he also makes them triggers of multiple associations and keeps common archetypes from degenerating into background decoration.

Writing in the *New York Times* in early 1987, Paul Goldberger characterized James Stirling's State Museum and Theater complex in Stuttgart as "arguably the one building that sums up the current concerns of Western architecture better than any other built in this decade" (Fig. 845). Not only does the acropolis-like assemblage of structures gracefully acknowledge a vast array of historical antecedent; it also proves "that strong museum architecture need not be incompatible with respect for the art within." Moving beyond the Brutalist modernism of his earlier work (Fig. 661), Stirling, together with his partner Michael Wilford, found himself having to accommodate a Renaissance-style museum already standing next door, as well as a hillside site hemmed in by an eight-lane highway along its lower edge and a terraced street

846. Aldo Rossi. Town Hall, Borgoricco, Italy. 1988

above. In response to these manifold problems, Stirling decided to create "a collage of old and new elements . . . to evoke an association with museum." The most immediate impression produced by Stirling's museum may be the sequential massing of colossal stone walls, antiphonally ramped in a manner reminiscent of both pharaonic Egypt and Roman Palestrina. Meanwhile, the polychromy of the striped sandstone and travertine masonry, like the blue and pink tubular railing, recalls medieval Italy. From the Ushaped galleries, whose plan echoes the old palacelike museum to the side, spills an ordered diversity of powerful forms: a "domeless" rotunda enclosing a sculpture garden; a glazed and greenmullioned entrance shaped like the flowing arabesque of an accordion or a grand piano, suggesting the performance arts that share the site with painting and sculpture; and, finally, the taxi stand, its metal and glass, hutlike structure a high-tech gloss on Hector Guimard's entrance to the Paris Métro, especially the Louvre station (Fig. 145). Quite apart from Stirling's mastery of composition, what holds the huge eclectic mix together is the path wound through the complex, up the zigzagging ramps, through the beautifully lit, well-proportioned galleries, and around the rising circuit of the sculpture garden before exiting at the top of the hill. Once there, the visitor may remember that Stirling was British, an artist with the interlinked circles, crescents, and spectacular perspectives of 18th-century Bath in his bones.

Disturbed by the chaotic suburban sprawl that developed around cities like Milan and Rome after World War II, the Milanese architect Aldo Rossi (1931-) helped organize the Neo-Rationalist or Tendenza ("Tendency') group in the hope of restoring some measure of architectural order to the contemporary scene. Rather than collage a variety of images that together may, à la Stirling or Hollein, signify "museum" or "travel bureau," Rossi prefers to work with "typologies"-categories of buildings, such as museums, churches, domestic dwellings, schools, factories, lighthouses-and distill from each of them a quintessential archetype so resonant with historical echoes that it yields a great diversity of meaning. A house, for instance, becomes a gabled block that Paul Goldberger has likened to an oversized version of the tiny red house in a Monopoly game. To compound the possibilities for cultural recall, Rossi assembles several of his primal forms in village-like arrangements characterized not only by condensed reductiveness but also by internal repetition, exaggerated scale, and strange juxtapositions, unexpected color contrasts, eerily blank walls, and rigorous symmetry (Fig. 846). The results, with their dramatic play of light and dark shadows, suggest a dreamscape by de Chirico or Magritte come to life, a stage-set place where human beings find their banal, transient lives stirred by a haunting sense of memory, of experience more complex, poetic and enduring than the everyday.

Post- and Neo-Modernism in Architecture

Deconstruction

By 1987, post-modernism in architecture appeared to have climaxed in a neo-conservative process of easy, even empty and indiscriminate quotation from traditional prototypes. As the global economy boomed during the Reagan/Thatcher era, fueling wildly speculative construction of commercial real estate, the industrialized world found itself treated to a proliferation of glassand-steel office buildings masquerading as Gothic cathedrals, discount stores decked out as pagodas, and drugstores embellished with Classical orders. "The past began to seem not like a source for modern government," wrote Paul Goldberger in late 1988, "but more like a warm bath in which we could wallow. The thinkers who began post-modernism were gradually supplanted by the wallowers in it, as the monument became more and more a victim of its own commercial success." In response to this dilemma, at least two fresh departures could be discerned, one a neo-modernist movement committed to functional though vigorously permuted forms. The other, more debated and published but much less built, claimed kinship with "deconstruction," the semiotic theory and critical practice discussed earlier. As articulated by France's Jacques Derrida, deconstruction held that cultural products, like the elements of language, mean not in and of themselves but rather through their differences from one another. Consequently, it also insisted that signification plucked from difference could never be entirely present but always, in some degree, absent, "decentered" and "dispersed" along an infinite, interlinked or "intertextual" chain of signs, of signifiers and signifieds whose ultimate "referent" is even further afield. To make architecture more at one with the decenteredness-the inherent disorder and conflict-of the real world, "deconstructivist" architects would avoid stability, harmony, and security-values

opposite below: 847. Frank O. Gehry. South Instructional Building and Chapel, Loyola Marymount University Law School, Los Angeles. 1981–84.

opposite bottom: 848. Frank O. Gehry. Loyola Marymount Univesity Law School, Los Angeles.

right: 849. Bernard Tschumi. Folly 1.5, Parc de la Villette, Paris. 1982–86.

revered by both modernism and post-modernism-in favor of "transforming architecture into an agent of instability, disharmony, and insecurity," as one wall label at the Museum of Modern Art's "Deconstructivist Architecture" show announced. Curated in 1988 by Philip Johnson (that onetime primary thinker behind both the International Style and post-modernism) and Mark Wigley, the exhibition featured works by Frank Gehry (born in Canada, based in California), Peter Eisenman (born in New Jersey, based in New York), Bernard Tschumi (born in Switzerland, based in New York), Daniel Libeskind (born in Poland, based in Italy), Rem Koolhaas (born and based in the Netherlands), Zaha M. Hadid (born in Iraq, based in England), and Coop Himmelblau (born and based in Austria). As a measure of the controversy "Deconstructivist Architecture" stirred up, it should be said that one of the starring architects, Gehry, disqualified himself as a deconstructivist, possibly because his critically acclaimed buildings embody not only subversive features but also constructive, neo-modernist ones.

Still, nowhere would the disorder and fragmentation of contemporary life seem more profoundly sensed than in the architecture of Frank O. Gehry (1929-), even if the motivation is to learn from chaos rather than to celebrate it. Briefly famous in 1972 for his Easy Edge chairs, a playful, functional line of furniture manufactured from sandwich-layered cardboard, Gehry subsequently specialized in "difficult," quirky buildings, hamletlike assemblages that manage to compel despite their ad hoc look, imperfect details, and off-the-rack materials-asphalt shingles, Sheetrock, rough concrete. Notoriety came in 1978 when Gehry built, or rebuilt, a house for himself and his family in Santa Monica. Here, the architect took an ordinary Dutch Colonial, tore out sections of its exterior, as well as most of its interior plaster, and constructed a shell of corrugated metal, chain-link fencing, and glass carbuncles. Describing the unfinished-looking structure as something from "a new-wave Oz," Kurt Andersen wrote: "It is as if the tornado dropped Dorothy's house into Mad Max land." More seriously, it set up a rather passionate, even touching, "intertextual" dialogue between the spirit of an old, genteel suburban structure and the rather punk, angular addition made to it. By 1984, when finished a new complex for the Loyola Maryhe mount University Law School in Los Angeles, Gehry had moved beyond his perverse, architecture vérité phase into a variety of personal classicism notable for its miraculous synthesis of the banal and the bold (Figs. 847, 848). In this relatively serene bit of urbanism-a great rarity in sprawling, suburbanized, antipedestrian Los Angeles-the architect re-created something like an Italian hill town, its elementary geometries clustered about a small plaza or square. Among the structures are a glass and Finnish-plywood chapel complete with campanile, a yellow stucco Burns Building with a dark, cubo-baroque stairway breaking free of a façade dominated by a towering *galleria*, and the boxy South Instructional Building set behind a screen of functionless concrete columns and crowned by an abstract version of the tiny Athena Nike Temple in Athens. However pull-apart or rearrangeable they may seem, the structures have been so composed—like a set of objects interrelating as sculpture—that, in the words of one critic, "they may tell us more about the nature of classicism than almost any other more literal piece of historicism our age has produced."

Unlike Gehry, Bernard Tschumi (1944-), a Swiss architect established in New York, identifies wholeheartedly with deconstructivism, even while resisting the definition provided by Johnson and Wigley, who inferred stylistic affinities between the asymmetrical balances favored by revolutionary Soviet Constructivists (Figs. 267, 269, 270, 354, 433) and the deconstructivists' preference for skewed, interrupted forms, curved surfaces, and diagonal planes. Rather than style, Tschumi argues, deconstructivism consists in attitude, "one that would stress not only the dispersion of the subject and the force of social regulation, but also the effect of such decentering on the entire notion of unified, coherent, architectural form." All this can be seen at work in Tschumi's Parc de la Villette in Paris, a deconstructivist monument par excellence commissioned by the Mitterrand government as one of its several "grand projects" for the French capital (Fig. 849). To create this 125-acre "park for the 21st century," Tschumi designed three autonomous systems-points, lines, planes-and superimposed them randomly as well as at right angles to one another, the better to increase their incongruity and thus their role as an overall abstraction of the social reality-the heterogeneous fragmentation-lying all about in Paris itself. As built, the planes become sites and the lines a 2.86-mile-long undulant gallery snaking across the terrain like an unrolled filmstrip. It connects the points-some thirty fire-engine-red pavilions or "follies"set among small gardens individually designed by such rival artists and architects as John Hejduk, Dan Flavin, Jean Nouvel, Gaetano Pesce, Daniel Buren, and Peter Eisenman, the last in collaboration with none other than Jacques Derrida. With their sizzling color, the kiosks add dramatically to the park's intertextual discord, each being a unique, fantastically maverick permutation and combination of open as well as closed circles, squares, and triangles. Even though more like sculpture or Constructivist fragments than architecture, they function as galleries, restaurants, and information centers, offering delight and pleasure that simply add to the aura of estrangement or challenge prevalent throughout what is a high-tech version of a folly-strewn 18th-century English garden, a stunning example of which is Paris's own Parc Monceau.

Post- and Neo-Modernism in Architecture

Neo-Modernism

By 1986 the New York critic Douglas Davis could observe this "incontrovertible fact": "despite the flood of modernicidal polemics, many architects are producing extraordinary structures, models, and drawings that confirm rather than reject the ideals of the early modern movement, as expressed in its heroic phase." During the same year another critic, Germany's Heinrich Klotz, wrote at length about "a new start" or a "Second Modernism" in contemporary architecture. Viewing post-modernism's historicizing pastiches as mere "façadism" totally unrelated to the ultramodern structure they concealed, and deconstructivism as little more than another theory of surface style, the emerging neo-modernists, like those already seen in Chapter 21 (Figs. 655-659), preferred to renew, but not imitate, the spare, functionalist aesthetic of early modernism, as well as something of its ethical commitment to reform and enlightenment. At the same time, however, they would also take greater account than modernism had of site, need, and advanced modes of construction. Among the foremost neo-modernists should be included Richard Meier, James Stewart Polshek, and John Hejduk in the United States, Jean Nouvel and Henri Ciriani in France, Richard Rogers, Norman Foster, and Max Gordon in England, Renzo Piano in Italy, and Fumikiko Maki and Arata Isozaki in Japan. For these architects, as Davis wrote in 1989: "The idea of the modern carries with it not only the connotations of a visionary commitment. It carries as well an obligation to get on with the present tense if not the future, to try unpredictable solutions, to dare if not to innovate."

The New York architect Richard Meier (1934-) double-codes neo-modernism by signaling both his source in Le Corbusier's Villa Savoye and his considerable distance from it (Figs. 341, 850). While the Swiss-born architect reinterpreted Cubism as a simple, openplan arrangement of solid planes and ribbon windows resting on thin columns (pilotis), Meier elaborates this calm, Mondrianesque scheme into a crystalline but dynamic assembly of white rectilinear coordinates set with huge plate-glass windows of various sizes, all counterpointed with sovereign virtuosity. A characteristic Meier house suggests a complexity of parts making larger geometries and breaking out of them, so that planes succeed planes to layer the space and yield all manner of vignetted views. Living rooms often soar to the height of three stories, with pipe railings crisscrossing at many levels and light streaming in through openings from every direction. If these elegant structures appear determined to translate Cubism into the Baroque, they also avoid the clear sense of hierarchy and climax of traditional design in favor of the generalized distribution of accents long classic in Cubist-derived composition.

When Britain's Richard Rogers (1933—) and Renzo Piano (1937—) from Genoa won the commission for the Pompidou Center in Paris, they gave monumental neo-modernism a rocketlike

left: 850. Richard Meier. Ackerberg House, Malibu. 1984–86.

below: 851. Renzo Piano and Richard Rogers. Centre National d'Art et de Culture Georges Pompidou, Paris.1971–84.

bottom: 852. Arata Isozaki. Okanayama Graphic Art Museum, Nishiwaki, Hayaga, Japan. 1980–84.

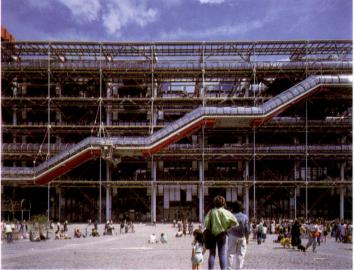

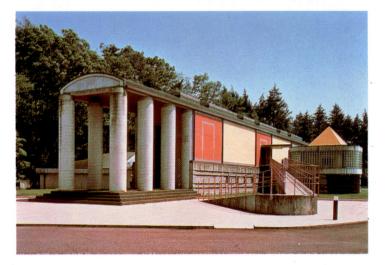

relaunch. By 1977, the year the Pompidou opened, jazzy, sci-fi, plug-in images recalling those visualized by Archigram (Fig. 662) had become a reality on a titanic scale, in a boxy spaceplatform of a building with a colorful exoskeleton of bristling trusses and service conduits shaped like marine funnels and vents (Fig. 851). Whatever its resemblance to New Wave comics or Rube Goldberg contraptions, the turned-out structure satisfies the worthwhile purpose of creating an unobstructed, barnlike interior capable of being subdivided for such functions as those of France's national museum of 20th-century art, the first centralized public library in Paris, a design center, and video as well as multimedia works. In addition, it breaks up the façade to yield an almost toylike, erector-set image that humanizes the colossal mass by keeping it from overpowering the venerable host city. Also defanging the high-tech Pompidou is the fivestory escalator hung on the exterior in transparent plastic tubes, a joy-ride device that affords visitors a spectacular, moving view of Paris and the great open plaza below. In this public space, Europe has gained a forum comparable to the parvis of medieval cathedrals-that is, a magnet for the entire human carnival, from street performers and political orators to armies of tourists and even Parisians on their daily rounds.

right: 853. Norman Foster and Associates, with Ove Arup and Partners. Hongkong and Shanghai Bank Building, Hong Kong. 1979–86.

below: 854. Richard Meier with Michael J. Paladino. Courtyard and entrance to the J. Paul Getty Museum, Getty Center, Los Angeles. 1984–97.

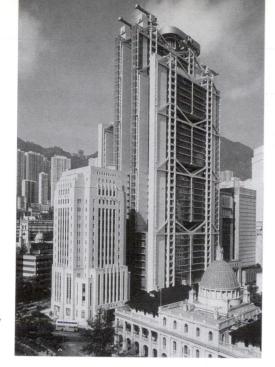

"I'm post-Modern, not post-Modernist," says Arata Isozaki (1931-), signifying that, like many architects in the late eighties and the nineties, he has preferred to avoid adherence to any one idiom, Eastern or Western, in favor of synthesizing elements from all of them in an inventive, playful manner. Following graduation from the University of Tokyo, Isozaki did an eight-year stint under Kenzo Tange, Japan's leading architect during the first three decades after World War II (Figs. 656, 657). Since then, he has worked independently, not only in his practice but also in his way of designing what he once called "perfect crimes," buildings that, because of their surprising combination of formal clarity and sardonic metaphor, manage to challenge as well as tease the tradition-bound Japanese both aesthetically and culturally. In Nishiwaki, at the very heart of the nation, Isozaki found himself assigned to a site at the edge of a railway line, which he proceeded to acknowledge rather than ignore in a small museum dedicated to the graphic works of a local master named Tadanori Yokoo (Fig. 852). Three skylit exhibition spaces succeed one another as if they were boxcars in a train, pulled by the powerful visual engine of a colonnaded portico and linked by small halls, each decorated to suggest the themes pursued by Yokoo throughout a decade of artistic activity. Yet, for all its Pop qualities, the Nishiwaki museum is a composition of pure cylinders, cubes, and pyramids, borrowed from Classical Europe but then assembled so as to deny the stasis of Classical perfection. Instead, they evoke a sense of calm movement, of Japanese ma, of space and time collapsed into one. Thus, the two-directional ramp at the side leads not only to the collection but as well to the meditation room, a freestanding, glass-walled cube with rounded corners and a pyramidal crown. "Architecture is a machine for the production of meaning," says Isozaki.

Commissioned to design a new headquarters for the Hongkong and Shanghai Bank, England's Norman Foster (1935—) took the "idea of the modern" and ran with it (Fig. 853), to achieve the goal of a strong architectural statement capable of asserting faith in a rapidly approaching future, when Hong Kong would lose its protected status as a British Crown Colony and once again become politically integral with mainland China. As a result, the Hongkong and Shanghai Bank Building, with its dramatically expressed steel structure rippling across the light-filtering, glass façade "like a prize-fighter's pectorals," becomes a celebration of modern engineering equal to such iconic monuments as the Eiffel Tower or the

Chrysler Building. Because of fire and air-traffic codes, as well as the several distinct kinds of public and private, local and international functions performed by the bank, Foster needed to avoid the sameness of interior space traditional in skyscrapers and allow for a variety of configurations never attempted before in such a structure. The solution, devised in collaboration with Ove Arup and Partners, consists of three tall slabs defined at either end by paired masts (clusters of tubular steel columns) supporting double-height suspension trusses that divide the building into five stacked zones, each of them suspended from a single line of steel hangers. The result, at its maximum, is approximately 100 feet of unimpeded floor space, three times the amount available in conventional spans. Not only does the system make possible a ground-level atrium rising the full nine-story height of the first zone; it also permits washrooms and elevators to be housed within the exterior mast towers, thereby freeing the interior of the usual space-devouring service core. While circulating within zones mainly by escalator, and only from zone to zone by elevator, the building's occupants find their world illuminated by an array of motorized "sunscoops," attached to the roof as well as to the top of the atrium and computer-programmed to track the sun for delivery of its light within, all the way down to the atrium floor. Above this zone, given over to public banking, the building progressively sets back to narrower dimensions, reflecting the hierarchy of the resident culture, until only the central slab reaches the full 47-story height. From the waterfront site without, facing the sole green, open space in desperately crowded Hong Kong, the white-and-gray structure rises in a series of gradually diminished heights, each marked off by wide triangular trusses yet unified by twinned, ladderlike masts, to climax in the bank director's penthouse and a helicopter pad. All in all, Foster went far towards redefining both modernism and the skyscraper as a form, reinvesting them with architectural meaning and rewarding Hong Kong with a landmark ripe in symbolic as well as compositional interest.

On the eve of the third millennium, the pivotal building of late-20th-century architecture appeared to have been the Pompidou Center in Paris, the high-tech, exoskeletal wonder completed in 1977 (Fig. 851). This sense of things, voiced by the British architecture critic Hugh Pearman, emerged in the light of two later buildings—Richard Meier's Getty Center in Los Angeles (Fig. 854) and Frank Gehry's Guggenheim satellite in Bilbao—both of which opened in 1997 and immediately became, like the Pompidou, cultural magnets powerful enough to alter pilgrimage routes all over

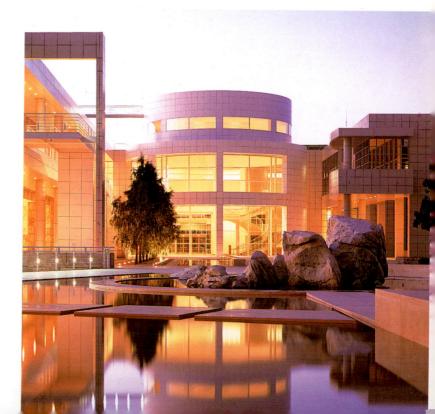

the world, just as the great Christian shrines of the Romanesque and Gothic periods had. By the late nineties, it seemed almost axiomatic among civic leaders that a sure way to regenerate the spirit, prestige, and economic life of a tired urban center was to endow it with a trophy arts venue designed by a brand-name architect. Thanks to the Getty and the Bilbao Guggenheim, the dominant brand names of the *fin de siècle* were Meier and Gehry, with the former, perhaps, winning the larger share of the headlines, by reason of the \$1 billion price tag attached to the Getty, making it the most costly piece of nonmilitary architecture ever built in the United States.

The Getty Center, financed by a stupendously rich bequest from the late J. Paul Getty, is a gleaming, white acropolis-an entire complex of crisp, Meieresque geometries set amidst green natureatop a hill in Brentwood overlooking the entire Los Angeles basin. From a white tram traveling up the hillside, visitors alight at the base of a grandiose flight of marble stairs. Mounting it, they find themselves surrounded by a veritable "garden of Euclidean delights," as Herbert Muschamp wrote-an exquisitely composed and counterbalanced array of squares, cubes, arcs, cylinders, and grids, their sober rectilinearity enlivened by the occasional biomorphic curve. To warm the cerebral classicism inherent in his neomodernist style, Meier clad the concrete-built structures in superbly cut travertine, its beautiful cream color set off by contrasting walls of ivory metal panels and broad expanses of clear glass. The whole of this aesthetic program-metal, glass, and especially the pale stone with its delicate stratifications of shadowy fissures-appears designed to trap the famous light of Southern California and materialize it into a new Parnassus. Adding to the effect, and further mollifying the overall formality, is the fragmentation afforded by an ingenious variety of balconies, windows, cuts through walls, canopies, screens, elevator shafts, and yet more stairs.

Within the J. Paul Getty Museum (Fig. 854), which is the largest of the six structures making up the Center, the collection of post-Classical, pre-20th-century art is displayed throughout a traditional enfilade of boxlike galleries, illuminated by natural light softly filtered through glazed ceilings. As a draw for the public, however, nothing in the collection—which includes many a masterpiece, owing to the ability of the Getty to outbid all rivals for whatever it wants—equals the sensational architecture. Even the critique that the Meier-designed Getty Center is an aloof, elitist institution—a citadel of privilege detached from the struggling world below merely enhances its notoriety and thus allure. Moreover, the very debate stirred up by the architecture may, in the long run, serve a good purpose in a community never before known for excessive engagement with matters of high culture.

The Bilbao Guggenheim, far from floating high above the fray, rests solidly at the center, even on the riverfront, of a rusty 19th-cen-

tury industrial town, the capital of semi-autonomous Basque country in the northwest corner of Spain. The city fathers, eager to reconstitute the image of their community as a place ready for the information age, must have taken note of nearby Santiago de Compostela, a major pilgrimage destination since the Middle Ages, and decided that Frank Gehry and the Guggenheim together might work a secular miracle comparable to the sacred ones attributed to the relics of Saint James. In the eyes of most critics, the miracle did occur, and the worshipful have indeed arrived, in droves, allowing tourism and cultural enterprise to fill the economic void left by factory jobs long since exported to the Third World. What attracts the informed and the merely curious alike is the glinting, silvery artichoke of a building Gehry designed to house rotating exhibitions of modern masters selected from the New York Guggenheim's matchless collections, in addition to special exhibitions mounted by its curators. As at the Getty-or at the New York Guggenheim, with its sculpturesque, helical building conceived by Frank Lloyd Wrightthe architecture for the Bilbao museum is a signature work whose breathtakingly original form is likely to impress more than anything that could ever be shown there (Fig. 855). If Richard Meier is the Apollonian architect of the millennium, then Frank Gehry must be its Dionysiac, an artist bold enough to call for a vast rotunda rising 138 feet above the floor, its great well of space swaddled in voluptuous curves of steel clad in titanium panels whose muted shimmer is like "shining from shook foil," to quote a poet who too believed in miracles. The petals of this surging blossom constantly change color, reflecting as they do the sky above and the river alongside. Below the flower lies a grand staircase-actually a reverse flightwhich leads visitors down a full story below ground, funneling them into the museum's atrium, its sensuous agglomeration of stone, glass, and metal, curves and straight lines, opacity and transparency, openness and enclosure a veritable paean to diversity. Off the atrium stream the galleries, their classically rectangular shape disguised outside by the exterior's whorling titanium leaves. One astonishing departure is a tunnel-like gallery extending 433 feet under a trussed vault whose height gradually modulates from 85 feet to less than half that. Consistent with this daring act of generosity is Gehry's incorporation of the urban infrastructure, so that a corner of the building snuggles under an old bridge spanning the River Nervión. Hovering above the riverfront side of the museum is a vast metal canopy, its billowing, windswept shape held 92 feet aloft by a single slender column. In his ecstatic review of the Bilbao Guggenheim, Herbert Muschamp asked: "Is it possible, once again, to think about beauty as a form of truth?" Be that as it may, the Bilbao Guggenheim, like the Getty, has come in for its share of critique, which alleges not cultural aloofness but rather new evidence of American cultural imperialism.

855. Frank O. Gehry and Associates. Guggenheim Museum, Bilbao. 1991–97

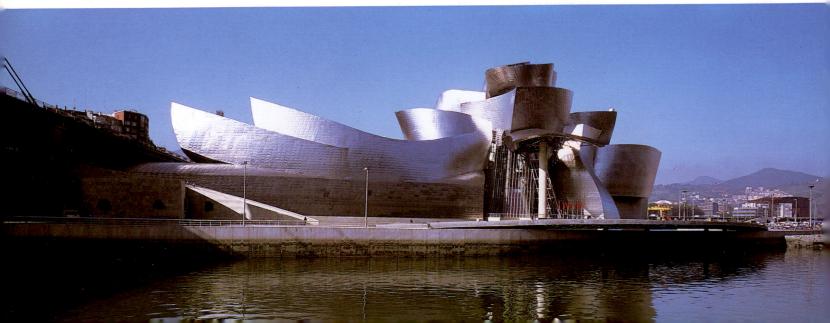

Chapter 1. 1) Tucker, Monet at Argenteuil (1982), p. 2.

Chapter 2. 2) Rewald, *Georges Seurat* (1943), p. 62; 3) *Ibid*, pp. 61–62; 4) Rewald, *Impressionism* (1961), p. 526; 5) Hunter, Modern French Painting, p. 75; 6) Rewald, ed., Camille Pissarro: Letters to His Son Lucien (1943), p. 158; 7) Rewald, ed., Paul Cézanne: Letters (1941), p. 239; 8) Ibid, p. 251; 9) Ibid, p. 157; 10) Rewald, Pissarro: Letters, pp. 275-276.

Chapter 3. 1) Moréas, "Le Symbolisme," Figaro Littéraire, Sept 18, 1886; 2) Ibid; 3) Kahn, "Réponse des Symbolistes," L'Événement, Sept 28, 1886; 4) Ross, ed., The First Collected Edition of the Works of Oscar Wilde: 1908-1922 (1969), vol. "Intentions and Soul of Man," pp. 53-54; 5) Jullian, Dreamers of Decadence: Symbolist Painters of the 1890s (1971), p. 34; 6) Ibid, p. 204; 7) Ibid, pp. 40-41; 8) (1971), p. 34, 0) *Ibid*, p. 204, 7) *Ibid*, pp. 40-41; 8) Baudelaire, *The Flowers of Evil*, ed. by Mathews (1955), p. 34; Lafenestre, "Salon de 1873," *Gazette des Beaux-Arts* (June 1873), in Bowness, ed., French Symbolist Painters (1972), p. 105; 10) Malingue, ed., Lettres de Gauguin à sa femme et ses amis (1946), pp. 299-301; 11) Bernard, Charles Baudelaire (Brussels, n.d.), p. 45; 12) Chipp, ed., Theories of Modern Art: A Source Book by Artists and Critics (1968), p. 119; 13) Jullian, The Symbolists (1973), p. 44; 14) Goldwater, Paul Gauguin, p. 82; 15) Rotonchamp, Paul Gauguin: 1848–1903 (1925), p. 243; 16) Goldwater, op cit, p. 80; 17) Pielkovo, trans., The Letters of Paul Gauguin to Georges Daniel de Monfreid (1922), p. 95; 18) Goldwater, op cit, p. 144; 19) Ibid, p. 158; 20) van Gogh-Bonger and van Gogh, eds., The Complete Letters of Vincent van Gogh (1958), vol. 3. letter 520, p. 6: 21) Ibid, letter 534, p. 30; 22) Ibid, letter 564; 23) Ibid, letter 534, p. 28; 24) Ibid, letter 531; 25) Deknatel, Edvard Munch (1950), p. 18; 26) Cooper, Henri de Toulouse-Lautrec (1956), p. 24.

Chapter 4. 1) Schmalenbach, Jugendstil (1935), pp. 31-32; 2) van de Velde, Déblaiement d'art (1894). 18; 3) Crane, The Claims of Decorative Art (1982), p. 93.

Bibliography

Abbreviations: ACGB: Arts Council of Great Britain, Audreviaturis: ACOB: Arts Council of Chicago; AKAG, Albright-Knox Art Gallery, Buffalo, N.Y.; CGP, Centre Georges Pompidou, Paris: HMSG, Hirshhorn Museum and Sculpture Garden, Smith-sonian Institution, Wash., D.C.; ICA: Institute of Contemporary Art, Boston, London, or Philadelphia; LACMA: Los Angeles County Museum of Art; MoCA, Museum of Contemporary Art, Los Angeles MoFA, Boston and Dallas; MoMA: Museum of Modern Art, New York and Oxford; NGA: National Gallery of Art, London or Wash, D.C.; RAA: Royal Academy of Arts, London; SRGM, Solomon R. Guggenheim Museum, New York; TG: Tate Gallery, London; WMAA: Whitney Museum of American Art, New York.

General References

Anderson, Wayne. American Sculpture in Process: 1930-70. Boston and N.Y., 1975

Arnason, H.H., M. Prather, and D. Wheeler. History of Modern Art: Painting, Sculpture, Architecture Photography, 4th ed. N.Y., 1998

Ashton, D. American Art Since 1945. N.Y., 1982.

Barr, A.H., Jr. Matisse: His Art and His Public. N.Y., 1951 ed.. Painting and Sculpture in the Museum of

Modern Art: 1929–1967. N.Y., 1977. ____. Picasso: Fifty Years of His Art. N.Y., 1946.

Battcock, G., ed. Why Art: Casual Notes on the Aesthetics of the Immediate Past. N.Y., 1977.

Ballerini, L. Spelt from Sibyl's Leaves: Explorations in Italian Art. Milan, 1982. Boime, Albert. The Academy and French Painting in

the 19th Century, N.Y., 1971. Bois, Y. 1991. Y.-A. Painting as Model. Cambridge, Mass.,

Bolton, R., ed. Culture Wars: Documents from

Recent Controversies in the Arts. N.Y., 1992 Britt, David, ed. *Modern Art: Impressionism to Post-Modernism*. London and Boston, 1989. Broude, N., and Mary Garrard, eds. *The Expanding*

Discourse: Feminism and Art History. N.Y., 1992. Brunette, P., and D. Wills, eds. Deconstruction and the Visual Arts: Art, Media, Architecture. Combined to 1005 Cambridge, 1995. Bryson, N. Calligram: Essays in New Art History

Chapter 5. 1) Elsen, Origins of Modern Sculpture (1974), p. 5; 2) Selz, Modern Sculpture (1963), p. 72; 3) Rilke, *Auguste Rodin* (1945), p. 18; 4) *Ibid*, p. 11; 5) Rodin, *Art* (N.Y., 1912), p. 166; 6) Elsen, "The Gates of Hell: What They Are About and Something of Their History," in Elsen, ed., Rodin Discovered (1981), p. 65; 7) Rodin, On Art and Artists (1957), pp. 103-104; 8) Elsen, Rodin (1963), p. 101; 9) Jamison, "Rodin's Humanization of the Muse," in Elsen, ed., Rodin biscovered, p. 114; 10) Signed "X", the article appeared in Journal (Paris), May 12, 1898; 11) Hamilton, Painting and Sculpture in Europe: 1880–1940, p. 153; 12) Giedion-Welcker, Contemporary Sculpture (1960), p. 24; 13) Elsen, Origins of Modern Sculpture, p. 25; 14) UCLA, Henri Matisse Retrospective (1966), p. 20; 15) Blanc, Grammaire des arts du dessin: architecture, sculpture, peinture (1880), p. 14; 16) Morand, in preface to cat. of the artist's first one-man exh. at the Brummer Gallery, N.Y., Nov-Dec 1926; 17) Jianou, Brancusi (1963), p. 67; 18) Read, Barbara Hepworth: Carving and Drawings (1952), facing pl. 16.

Chapter 6. 1) Benevolo, History of Modern Architecture (1971), vol. 2, pp. 396-397.

Chapter 7. Walden, "Kunst und Leben," Der Sturm, vol. 10 (1919), p. 2: 2) Schmidt, "Die Expressionisten," Der Sturm, vol. 2 (1912), p. 734; 3) Schiefler, Edvard Munch Graphische Kunst (1923), p. 2; Barr, Matisse: His Art and His Public (1951), p. 119; 5) Ibid, p. 120; 6) Duthuit, *The Fauvist Painters* (1950), pp. 27–28; 7) Raymond, Free Painters (1950), pp. -28; 7) Raymond, From Baudelaire to Surred (1949), p. 58; 8) *Ibid*, p. 59; 9) Barr, *op cit*, p. 122; 10) Duthuit, *op cit*, p. 26; 11) Barr, *op cit*, 63–64; 12) *Ibid*, p. 78; 13) Ibid, p. 120; 14) Ibid, p. 136.

Chaper 8. Worringer, Form in Gothic (1927), pp. 71-76; 2) Nolde, Jahre der Kämpfe (1934), pp. 90-91; 3) Selz, German Expressionist Painting (1957), p. 95; 4) Ibid, p. 344, n. 22; 5) Chipp, Theories, p. 182; 6) Rewald, Paul Gauguin: Letters to Ambroise Vollard and André Fontainas (1943), p. 22; 7) Kandinsky, Concerning the Spiritual in Art (1947), p. 77; 8) Wassily Kandinsky Memorial (1945), p. 54; 9) Ibid, p. 61; 10) Lankheit, Franz Marc (1950), p. 18; 11) Marc, Briefe, Aufzeichnungen und Aphorismen, vol. 1 (1926); 12) Guterman, The Inward Vision: Watercolors, Drawings and Writings by Paul Klee (1959); Chipp, op cit, p. 186; 15) Benesch, Egon

Schiele as a Draughtsman (1950), p. 5; 16) Selz, op cit, p. 165; 17) Ibid, p. 340, n. 18; 18) Ibid, p. 313; 19) Chipp, op cit, p. 188; 20) Selz, op cit, 81.

Chapter 9. 1) Gedo, "The Archaeology of a Painting: A Visit to the City of the Dead Beneath Picasso's *La Vie*," *Arts*, Nov 1981, p. 128; 2) *Ibid*, p. 129; 4) Malraux, *La Tête d'obsidienne* (1974), pp. 18-19; 6) Rubin, Art Bulletin, Dec 1983, pp. 151-202; Rubin, Art in America, Mar/Ap, 1979, pp. 128–147; 7) Rubin, Picasso in the Collection of the Museum of Modern Art (1972), p. 42; 8) Rubin, "Cézannisme . . .", in MoMA, Cézanne: The Late Work (1977), p. 152; 9) Steinberg, Art in America, Nov/Dec 1978; Art in America, Mar/Ap, 1979, pp. 115–127; 10) Rubin, "Cézannisme . . . "; 11) Ibid. "; 11) Ibid; 12) Ibid; 13) Barr, Picasso; 14) Chipp, op cit, p. 231; 15) Rosenblum, Cubism and Twentieth-Century Art; 16) González, "Picasso Sculpteur," Cahiers d'art, vol. 11 (1936), nos. 6-7, pp 189-191.

Chapter 10. 1) Kahnweiler, Juan Gris: His Life and Work (1947), p. 138; 2) Raymond, From Baudelaire to Surrealism (1949), p. 217; 3) Chipp, Theories, p. 286; 4) Ibid, p. 292; 5) Ibid, pp. 292–293; 6) Taylor, Futurism (1961); 7) Ibid; 8) Kramer, N.Y. Times Mag., Oct 11, 1981, p. 57; 9) Chipp, op cit, p. 341; 10) *Ibid*, p. 342; 11) Schneider, *N.Y. Times*, My 7, 1978, p. 71; 12) *Ibid*; 13) *Ibid*; 14) Chipp, *op cit*, p. 328; 15) Ibid, p. 329; 16) Herbert, ed., Modern Artists on Art, p. 126; 17) Ibid, p. 130.

Chaper 11. 1) Rubin, Dada and Surrealist Art, p. 127; 2) Ibid; 3) Breton, L'Art magique (1957), pp. 36-37; 4) Rubin, op cit, p. 145; 5) Sweeney in
 MoMA, Marc Chagall (1946), p. 7; 6) Chipp, op cit,
 p. 416; 7) Soby, Giorgio de Chirico (1955), pp. 244–250; 8) Hamilton, Painting and Sculpture in Europe, p. 260; 9) Ibid, p. 240, for Ball's diary entry of Aug 5, 1916; 10) Arp, On My Way: Poetry and Essay, 1912-1947 (1948), p. 39; 11) Ibid, p. 48; 12) Ibid, p. 77; 13) MoMA Bulletin, vol. 13, nos. 4-5, p. 20: 14) Ibid. p. 21: 15) Picabia. Jésus-Christ Rastaquouère (1920), p. 44; 16) Duchamp, statement made at "The Art of Assemblage: A Symposium," MoMA, Oct 9, 1961; 17) *Ibid*; 18) Breton, "Phare de la mariée," *Minotaure*, no. 6 (1935), p. 246; 19) Homer, *Art Bulletin*, vol. 57 (Mar 1975), pp. 110-115; 20) Coults-Smith, Dada (1976), p. 82; 21) Ernst, Beyond Painting and Other Writings by the Artist and His Friends (1948), p. 13; 22) Lieberman,

from France. N.Y., 1988.

Burnham, J. The Structure of Art. N.Y., 1970. CGP. Paris-Berlin (exh. cat., texts by G. Metken, et

- al.), 1978. Paris-Moscow (exh. cat., texts by J.H. Martin,
- et al.). 1979. Paris-New York (exh. cat., texts by H. Seckel,
- D. Abadie, and A. Pacquement). 1977 Chave, A. Constantin Brancusi: Shifting the Bases of
- Art. New Haven, 1993. Craven, W. American Art: History and Culture.
- Madison, 1994. Cummings, P. Dictionary of Contemporary American Artists. N.Y., 1994.
- Elsen, A.E. Modern European Sculpture, 1918-
- 1945: Unknown Beings and Other Realists. N.Y., 1979. Origins of Modern Sculpture: Pioneers and
- Premises. N.Y., 1974. Fineberg, J. Art Since 1940: Strategies of Being.

Englewood Cliffs, 1995.

Flam, Jack. Matisse on Art. N.Y., 1973.

- Matisse, the Man and His Work. Ithaca and London, 1986. Fletcher, V.J. Dreams and Nightmares: Utopian
- Visions in Modern Art. Wash, D.C., 1983. Frascina, F., and C. Harrison, eds. Modern Art and
- Modernism: A Critical Anthology. N.Y., 1982. Geist, S. Brancusi: The Sculpture and Drawings. N.Y. 1975.
- Gordon, R., and A. Forge. Monet. N.Y., 1983. Goldwater, R. Primitivism in Modern Art, rev. ed.
- N.Y. 1967 Hambourg, M.M., et al. The Waking Dr. Photography's First Century (exh. cat., MMA).
- NY 1993 Hamilton, G.H. Painting and Sculpture in Europe:
- 1880–1940. Baltimore, 1967. Harrison, C., and P. Wood, eds., Art in Theory, 1900–1990. Oxford, 1995.
- Heller, J., and N. Heller. North American Women Artists of the Twentieth Century: A Biographical Dictionary. N.Y., 1995.
- Haskell, B. The Amerian Century: Art and Culture, 1900–1950 (exh. cat., WMAA). N.Y., 1999.
- Herbert, R.L. Impressionism: Art, Leisure, and Parisian Society. New Haven and London, 1988.
- , ed. Modern Artists on Art. Englewood Cliffs, 1964. Hess,
- less, T. Abstract Painting: Background and American Phase. N.Y., 1951.

ed., Max Ernst (1961), pp. 11-12; 23) Barr, ed., Fantastic Art, Dada, Surrealism (1937), p. 30.

Chapter 12. Matthews. Introduction to Surrealism (1965), p. 49; 2) Seaver and Lane, Manifestoes of Surrealism (1972), p. 14; 3) Ibid, p. 26; 4) Sweeney, Partisan Review, vol. 15, no. 2 (Feb 1948), p. 209: 5) Breton, *Le Surréalisme et la peinture*, p. 70; 6) *Ibid*, p. 145; 7) *Ibid*, pp. 133–134; 8) "L'Ane pourri," *Le Surréalisme au service de la révolution*, vol. 1 (1930), no. 1, p. 9; 9) Breton, *Le Surréalisme et la* peinture, p. 46; 10) Artist's statement, dated 1957, in Magritte (Chicago, n.d.), p. 6: 11) Lieberman, ed., Modern Masters: Manet to Matisse (1975), p. 6; 12) Peret, Anthologies des mythes, légendes et contes populaires d'Amérique (1960), p. 31; 13) Lippard, ed., Surrealists on Art (1970), p. 53; 14) Ibid; 15) Ibid, p. 54, n. 1; 16) Ibid, p. 51; 17) Jean, The History of Surrealist Painting (1960), p. 228; 18) MoMA, Alberto Giacometti (1965), p. 44; 19) Giedion-Welcker, Jean Arp (1957), p. XXVII; 20) Rubin, Picasso in the Collection of the Museum of Modern Art, p. 132.

Chapter 13. 1) Conrads, Programs and Manifestoes on 20th-Century Architecture (1970), p. 47: 2) Jaffe, De Stijl (1970), p. 169; 3) Conrads, op cit, p. 67; 4) Ibid, p. 46; 5) Ibid, p. 49; 6) Ibid, pp. 95-96; 7) Le Corbusier, Towards a New Architeture (1927), pp. 69-70.

Chapter 14. 1) Barr, Matisse: His Art and His Public, p. 122; 2) Barr, Picasso: Fifty Years of His Art, pp. 270–271; 3) Sweeney, Partisan Review, vol. 15, no. 2 (Feb 1948), p. 210; 4) *Ibid*; 5) *Ibid*, p. 211; 6) Hope, *Braque* (1949), p. 91; 8) Ritchie, *MoMA* Bulletin, vol. 23, nos. 1-2 (1955-56), p. 42.

Chapter 15. 2) Cited in Osborne, ed., The Oxford Companion to Twentieth-Century Art (1981), p. 255.

Chapter 16. 3) Quoted in Brown, Story of the Armory Show (1963), p. 26; 4) Hunter and Jacobus, American Art of the 20th Century (1973), p. 114; 6) Ouoted in American Artists Group, Stuart Davis (1954), n.p.; 7) Lane and Larsen, Abstract Painting and Sculpture in America: 1927-1944 (1983), p. 63: 8) Ibid, pp. 227-228; 9) Walker Art Center, Stuart Davis (1957); 10) Kelder, ed., Stuart Davis (1971), pp. 131-132.

- Hickey, D. Air Guitar: Essays on Art and Democracy. L.A., 1997. Hoffman, K. Explorations: The Visual Arts Since
- 1945 NY 1991 Howell, J. Breakthroughs: Avant-Garde Artists in Europe and America, 1950-1990, N.Y., 1991.
- Hughes, R. The Shock of the New. N.Y. and London, rev. ed. 1990.
- Hunter, S., ed. An American Renaissance: Painting and Sculpture since 1940. N.Y., 1986.
- Modern American Painting and Sculpture. N.Y., 1959.
- Modern French Painting: 1855-1956. N.Y., 1956.

and J. Jacobus. American Art of the 20th

- ______, and J. Jacobus. American Art of the 20th Century, 3rd ed. N.Y., 1992.
 Kern, S. The Culture of Time and Space: 1880–1918. Cambridge, Mass., 1980.
 Kirby, M. The Art of Time: Essays on the Avant-Garde. N.Y., 1972.

Garae, N.Y., 1972.
Kramer, H. The Age of the Avant-Garde: An Art Chronicle of 1956–1972. N.Y., 1973.
Krauss, R.E. Passages in Modern Sculpture. London, 1977; Cambridge, Mass., 1981. Lynton, N. The Story of Modern Art, 2nd ed. Oxford,

1080 Marks, C. World Artists: 1950-1980. N.Y., 1984

- Miller, S. Constantin Brancusi: A Survey of His Work. Oxfod, 1995.
- Moszynska, A. Abstract Art. London and N.Y., 1000
- MoCA. Individuals: A Selected History of Cont-emporary Art: 1945–1986 (exh. cat., texts by K. Linker, D. Kuspit, H. Foster, R.J. Onorato, G. Celant, A. Bonita Oliva, J.C. Welchman, and T. Lawson). L.A. and N.Y., 1986. MFA. *Monet in the '90s: The Series Paintings* (exh.

- Cat., text by P.H. Tucker). Boston, 1989.
 MoMA. Contrasts of Form: Geometric Abstract Art: 1910–1980 (exh. cat., texts by M. Dabrowski and J. Elderfield). 1985.
- An International Survey of Recent Painting and
- Sculpture (K. McShine, ed.). 1984. —. High & Low: Modern Art and Popular Culture (exh. cat., texts by K. Varnedoe and A. Gopnik). 1990.
- Pablo Picasso: A Retrospective (exh. cat., text by W. Rubin). 1980.
- ... 'Primitivism' in the 20th Century: Affinity of the Tribal and the Modern (texts by W. Rubin and K. Varnedoe), 2 vols, 1984.

Nairne, S., and N. Serota, eds. British Sculpture in the Twenieth Century (exh. cat., Whitechapel Art Gallery). London, 1981.

- Naylor, C., ed. *Contemporary Artists*, 3rd ed. Chicago and N.Y., 1989.
- Nochlin, L. Gustave Courbet: A Study of Style and

O'Connor, F.B. Art for the Millions: Essays from the 1930s by Artists and Administrators of the WPA

- Federal Art Project. Boston, 1975. O'Doherty, B. American Masters: The Voice and the
- Myth in Modern Art. N.Y., 1982. Pollock, G. Vision and Difference: Feminini Feminism, and the Histories of Art. N.Y., 1988. Femininity,
- Redstone, L.R., and R.R. Public Art: New Directions. N.Y., 1980.
- Rosenberg, H. Discovering the Present: Three Decades in Art, Culture, and Politics. Chicago, 1973
- Rosenblum, N. A World History of Photography, rev. ed. N.Y., 1989.
- Rosenblum, R. Modern Painting and the Northern Ro-mantic Tradition: Friedrich to Rothko. NY, 1975. ______, and H.W. Janson. 19th-Century Art. Englewood Cliffs and N.Y., 1984.
- Rosenthal, M. Abstraction in the 20th Century: Total Risk, Freedom, Discipline (exh. cat., SRGM). N.Y., 1996.
- RAA. British Art in the 20th Century: The Modern Movement (exh. cat., ed. by S. Compton). London and Munich, 1987.
- Joachimides, N. Rosenthal, and W. Schmied). London and Munich, 1985.
- Italian Art in the 20th Century: Painting and Sculpture: 1900–1988 (exh. cat., ed. by E. Braun). London and Munich, 1989.
- Rewald, J. The History of Impressionism, 3r ed. N.Y., 1973 Russell, J. The Meanings of Modern Art, rev. ed.
- N.Y. 1991 Schapiro, M. Modern Art: 19th and 20th Centuries. N.Y., 1978.
- Selz, P. Art in Our Times: A Pictorial History:

Selz, P. Art in Our times: A Fictorial fusiory. 1890–1980. N.Y., 1981. Shone, R. The Century of Change: British Painting since 1900. Oxford, 1977

441

- SRGM Transformations in Sculpture: Four Decades of American and European Art (exh. cat., text by D. Waldman). 1985.
- Spalding, F. British Art since 1900. London and N.Y., 1986.
- Stangos, N., ed. Concepts of Modern Art, 3rd ed. London and N.Y., 1994. Steinberg, L. Other Criteria: Confrontations with
- Twentieth-Century Art. N.Y., 1972. Stiles, K., and P. Selz. Theories and Documents of
- Conemporary Art: A Sourcebook of Artists' Writings. L.A., 1996. Szarkowski, J. Photography Until Now (exh. cat.
- MoMA). N.Y., 1990. Varnedoe, K. A Fine Disregard: What Makes
- Modern Art Modern. N.Y. and London, 1990. Weiss, J.S. The Popular Culture of Modern Art: Picasso, Duchamp, and Avant-Gardism. New
- Haven, 1994. Wheeler, D. Art Since Mid-Century: 1945 to the Present. N.Y, Englewood Cliffs, London, 1991.
- WMAA. 200 Years of American Sculpture (exh. cat., texts by T. Armstrong, W. Craven, N. Feder, B. Haskell, R.E. Krauss, D. Robbins, and M.
- Tucker). 1976. Wilkins, D.G., B. Schultz, and K.M. Linduff. Art Past/Art Present. N.Y., 1994. Willett, J. Art and Politics in the Weimar Period.
- N.Y., 1978 W. Abstraction and Empathy. Worringer,
- Contribution to the Psychology of Style. N.Y., 1953

Impressionism/Post-Impressionism

Anderson, W. Gauguin's Paradise Lost. N.Y., 1971.

- Rinderson, W. Georges Seurat. N.Y., 1992.
 Cachin, F. Cézanne (exh. cat.). Philadelphia, 1996.
 Clark, T.J. The Painting of Modern Life: Paris in the Art of Manet and His Followers. N.Y., 1985. Comini, A. Gustav Klimt. N.Y., 1975.
- Dabrowski, M. *The Symbolist Aesthetic*. N.Y., 1980. Denvir, B. *Post-Impressionism*. N.Y., 1992.
- _.The Thames & Hudson Encyclopedia of Impressionism. N.Y., 1990.
- Duncan, A. Art Nouveau, N.Y., 1994
- Farmer, J.D. Ensor. N.Y., 1976. Frèches-Thory, C. The Nabis: Bonnard, Vuillard, and Their Circle. N.Y., 1991. Fried, M. Manet's Modernism, or, the Face of
- Painting in the 1860's. Chicago, 1996. Gerhardus, M. and D. Symbolism and Art Nouveau
- Oxford, 1979.
- Goldwater, R. Paul Gauguin. N.Y., 1957. _____. Symbolism. N.Y., 1979.
- L. Symbolism, N. 1, 1972.
 Herbert, R. Georges Seurat: 1859–1891 (exh. cat., MMA). N.Y., 1991.
- Impressionism: Art, Leisure, and Parisian
- Hobbs, R. Odilon Redon. Boston, 1977. Homer, W. Seurat and the Science of Painting.
- Cambridge, Mass., 1964.
- Howe, J.W. The Symbolist Art of Fernand Khnopff. Ann Arbor, 1982.
- Hulsker, J. The Complete van Gogh: Paintings,
- Hulsker, J. The Complete van Gogn: Fanlings, Drawings, Sketches. N.Y., 1980.
 Lovgren, S. The Genesis of Modernism: Seurat, Gauguin, Van Gogh, and French Symbolism in the 1880s. Stockholm, 1959.
- Musées Royaux des Beaux-Arts de Belgique. Le Symbolisme en Europe. Brussels. 1976.
- MMA. Georges Seurat, 1859–1891 (exh. cat., texts by R.L. Herbert, F. Cachin, A. Distel, S.A. Stein, and G Tinterow) 1991
- MoMA. Vienna 1900: Art, Architecture and Design (exh. cat., text by K. Varnedoe). 1986.
- Nochlin, L., ed. Impressionism and Post-Impre-sionism: 1874–1904. Englewood Cliffs, 1966. Partsch, S. Klimt: Life and Work. London, 1993.
- Pincus-Witten, R. Occult Symbolism in France. N.Y. 1976
- Reade, B. Aubrey Beardsley. N.Y., 1967

Reff, T. Manet and Modern Paris. Wash., D.C., 1982. Rewald, J.. Post-Impressionism from Van Gogh to

- Gauguin, 3rd ed. N.Y., 1978. _____, ed. Paul Cézanne: Letters. London, 1941. Roskill, M. Van Gogh, Gauguin, and the
- Impressionist Circle. Greenwich, Conn., 1970. RAA. Post-Impressionism: Cross-Currents in
- European Painting, 1979. Rubin, W., ed. Cézanne: The Late Work. N.Y., 1977. Schapiro, M. Paul Cézanne, 3rd ed. N.Y., 1965.
- ____. Van Gogh. N.Y., 1980. Shiff, R. Cézanne and the End of Impressionism
- Chicago, 1984. tuckey, C. F. Claude Monet: 1840-1926 (exh. cat., Stuckey,
- IIC), Chicago, 1995. Sweetman, D. Van Gogh: His Life and His Art. N.Y.,
- 1991. Thomson, B. Gauguin, London and N.Y., 1987
- Inomson, B. Gauguin, London and N.Y., 1987 Tinterow, G., and H. Loyrette. Origins of Impres-sionism (exh. cat., MMA). N.Y., 1994.
 Van Gogh-Bonger, J., and W.V. van Gogh, eds. The Complete Letters of Vincent van Gogh, 3 vols. Greenwich, Conn., 1979.
- Varnedoe, K. Northern Light: Realism and Symbolism in Scandinavian Painting: 1880–1910. N.Y., 1982.

442

Fauvism/Expressionism

Comini, A. Egon Schiele's Portraits. Berkeley and L.A., 1974

- Dabrowski, M. Kandinsky Compositions (exh. cat., MoMA). N.Y., 1995. Duthuit, G. *The Fauvist Painters*. N.Y., 1950.
- Elderfield, J. The Cut-Outs of Henri Matisse. N.Y., 1978 Henri Matisse: A Retrospective (exh. cat.,
- MoMA). N.Y., 1992. Flam, J.D., ed. *Matisse on Art.* N.Y., 1994
- Matisse, the Man and His Work, Ithaca and
- London, 1986. Gordon, D.E. Ernst Ludwig Kirchner. Cambridge, Mass., 1968.
- Grohmann, W. Expressionists. N.Y., 1957. Wassily Kandinsky: Life and Work, N.Y., 1958
- Jacobus, J. Henri Matisse. N.Y., 1973. Herbert, J.D. Fauve Painting: The Cultural Politics. New Haven, 1992. The Making of
- Jordan, J.M. Paul Klee and Cubism. Princeton, 1984. LACMA. The Fauve Landscape (exh. cat., text by
- Judi Freemen). L.A. and N.Y., 1990. indsay, K.C., and P. Vergo, eds. *Kandinsky:* Lindsay, K.C. Complete Writings on Art. 2 vols. Boston, 1982.
- Lloyd, J. German Expressionism: Primitivism and Modernity. New Haven, 1991. MoMA. The "Wild Beasts": Fauvism and Its
- Affinities (exh. cat., text by J. Elderfield). 1976. Oppler, E.C. Fauvism Reexamined, N.Y., 1976.
- Plant, M. Paul Klee: Figures and Masks. London and N.Y., 1978.
- Poling, C.V. Kandinsky: Russian and Bauhaus Years: 1915–1933. N.Y., 1983. Richard, L. Phaidon Encyclopedia of Expressionism.
- N.Y., 1978 Roethel, H.K. The Blue Rider, N.Y., 1971
- ____, and J.K. Benjamin. *Kandinsky: Catalogue Raisonné of the Oil Paintings*, 2 vols. Ithaca, 1982 and 1984
- Roskill, M. Klee, Kandinsky, and the Thought of Their Time: A Critical Perspective. Urbana, 1992 Schneider, P. Matisse. London and N.Y., 1984.
- Schulz-Hoffmann, C., and J.C. Weiss. Max Beck-mann Retrospective. St. Louis, 1984.
- Vogt, P. Expressionism: German Painting: 1905-1920. N.Y., 1980.
- Expressionism: Washton-Long, R.C. German Documents from the End of the Wilhelmine Empire to the Rise of National Socialism. N.Y., 1993.
- Kandinsky: The Development of an Abstract Style. Oxford, 1980.
- Weiss, P., ed. Kandinsky, special ed. of Art Journal, spring 1983.
- . Kandinsky in Munich: 1896-1914. N.Y., 1982. Worringer, W. Form in Gothic. London and N.Y.,

Cubism/Futurism

- Barr, A.H., Jr. Cubism and Abstract Art. N.Y., 1936.
- Cognat, R. Georges Braque: Retrospective (exh. cat., Maeght), St.-Paul de Vence, 1994. Cohen, A.A., and D. Shapiro, eds. *The New Art of Color: The Writings of Robert and Sonia*
- Delaunay. N.Y., 1978. Cowling, E., and J. Golding. Picasso: Sculptor/ Painter. London, 1994.
- Daix, P., and J. Rosselet, Picasso: The Cubist Years: 1907–1916. Boston, 1980.
- d'Harnoncourt, A. Futurism and the Internatinal Avant-Garde. Philadelphia, 1980. DeFrancia, P. Fernand Léger. New Haven, 1983.
- Gedo, M.M. Picasso: Art as Autobiography. Chicago, 1980.
- Golding, J. Cubism: A History and an Analysis, 1907–1914, 3rd ed. Cambridge, Mass., 1988.
- and R. Penrose, eds. Picasso in Retrospect. NY 1980
- Green, C. Juan Gris. New Haven, 1992.

Green, C. Juan Oris, New Haven, 1992.
Léger and the Avant-Garde. New Haven, 1976.
Hanson, A.C., ed. The Futurist Imagination: Word+Image. New Haven, 1983.
Harrison, C., F. Frascina, and G. Perry. Primitivisism, Cochiene. The Evel 20th Continues.

- Cubism, Abstraction: The Early 20th Century. New Haven, 1993.
- Leighton, P., ed. Revising Cubism, special ed. of Art Journal, winter 1988, with texts by Leighton, D.
- Robbins, S. Platt, E. Fry, C. Poggi, L. Henderson. R. Antliff, D. Cottington, and R. Jensen,
- Martin, M.M.W., and A.C. Hanson, eds. *Futurism*, special ed. of *Art Journal*, winter 1981.
- MoMA. Picasso and Braque: Pioneering Cubism (exh. cat., text by W. Rubin). 1989. Nash, S.A., and R. Rosbenblum. Picasso and the
- *War Years: 1937–1945* (exh. cat., Fine Arts Museums). S.F., 1998. Perloff, M. The Futurist Movement: Avant-Garde,
- Avant Guerre, and the Language of Rupture. Chicago and London, 1986.
- Richardson, J. A Life of Picasso, N.Y., 1991. with Marilyn McCully. A Life of Picasso, vol. 2. N.Y., 1996
- Rosenblum, R. Cubism and Twentieth-Century, rev. N.Y., 1976.
- __. "Picasso and the Typography of Cubism," in Golding and Penrose, *Picasso in Retrospect*, pp. 49-75.

Rubin, W. "From Narrative to 'Iconic' in Picasso: Bequest at Yale University, New Haven, 1984.

Huelsenbeck, R. Memoirs of a Dada Drummer.

Jean, M., ed. The Autobiography of Surrealism

Jones, A. Postemodernism and the Un-Gendering of Marcel Duchamp. N.Y., 1994.
Lanchner, C. Joan Miró (exh. cat., MoMA). N.Y.,

Lavin, M. Cut with the Kitchen Knife: The Weimer

Lewis, B.I. George Grosz: Art and Politics in the

Weimar Republic. Princeton, c. 1991.
Lippard, L.R., ed. Dadaists on Art. Englewood Cliffs, 1971.

..., ed. Surrealists on Art. Englewood Cliffs, 1970. Motherwell, R. The Dada Painters and Poets: Anthology. N.Y., 1951.

Ray, M. Self-Portrait, 2nd ed. N.Y., 1979. Richter, H. Dada: Art and Anti-Art. N.Y., 1970

Rubin W.S. Dada and Surrealist Art. N.Y., 1967. ____. De Chirico. N.Y., 1982. Schwarz, A. New York Dada: Duchamp, Man Ray,

Picabia. Munich, 1973. SRGM. Surrealism: Two Private Eyes: The Nesuhi

Ertegun and Daniel Filipacchi Collections, 2

Spies, W. Max Ernst: A Retrospective (exh. cat.,

Sylvester, D. Magritte: The Slience of the World.

University Art Museum. Anxious Visions: Surrealist

Abstract Expressionism/Art Informel

Anfam, D. Abstract Expressionism. London and

(exh. cat., Menil Collection). Houston, 1994. AKAG. Robert Motherwell (exh. cat., texts by D.

Ashton, J.D. Flam, and R.T. Buck). 1983. ACGB. Giacometti: Sculptures, Paintings, Drawings

(exh. cat., interview with the artist by D. Sylvester,

Auping, M., ed. Abstract Expressionism: The

Critical Developments. N.Y. and London, 1987. Barbican Centre. Aftermath: France 1945–54: New

Centre d'Art Plastique Contemporain.

Images of Man (exh. cat., texts by G. Viatte and H.H. Cousseau). London, 1982.

Autre/Un Autre Art (exh. cat., text by D. Abadie).

Les Années 50 (exh. cat., texts by D. Abadie, P. Arbaizan. L. Boyle, C. Eveno, and R. Guido).

Chastel, A., G. Viatte, and J. Dubourg. Nicolas de

Chave, A.C. Mark Rothko: Subjects in Abstraction. New Haven, 1989.

Des Moines Art Center. Art in Western Europe: The Postwar Years: 1945-1955 (exh. cat., text by L.

Brederick S. Wright Art Gallery, U. of Calif. Alberto Burri: A Retrospective View: 1948–77 (exh. cat., essay by G. Nordland). L.A., c. 1977.

Geldzahler, H., ed. New York Painting and Sculpture: 1940-1970. Includes reprints of H.

Rosenberg, "The American Action Painters"; R.

Rosenblum, "The Abstract Sublime"; G. Greenberg, "After Abstract Expressinism"; W.S.

Rubin, "Arshile Gorky, Surrealism, and the New American Painting." N.Y., 1969.
 Gibson, A., and S. Polcari. New Myths for Old:

Redefining Abstract Expressionism, special ed. of

Art Journal, fall 1988, with texts by Gibson,

Polcari, M. Sawin, W.J. Rushing, M. Halder, D. Robson, F.V. O'Connor, and D. Kuspit.

Robson, F.V. O Connor, and D. Kuspil.
 Gimenez, C. Tàpies (exh. cat., SRGM), N.Y., 1995.
 Goodman, C. Hans Hofmann, N.Y., 1986.
 Greenberg, C. Art and Culture: Critical Essays.
 Boston, 1961; London, 1973.
 Guilbaut, S. How New York Stole the Idea of Modern

Art. Chicago, 1983. Heron, P. *The Changing Forms of Art.* London, 1955. Hess, T.B. *Barnett Newman*. N.Y., 1971.

_. David Smith: Painter, Sculptor, Draftsman (exh. cat., text by E. Fry and M. McClintic). 1982.

Hobbs, R.C., and G. Levin. Abstract Expressionism: The Formative Years. N.Y. and Ithaca, 1981.

_____. Isamu Noguchi. N.Y., 1978. Inch, P., ed. Circus Wols: The Life and Work of

Wolfgang Schulze, with essays by J. Tardieu. D. Ashton, C. van Damme, P.L. Inch, R. Cardinal,

Hunter, S. Arnaldo Pomodoro, N.Y., 1982.

Berthored and R. Hohl), 1988.

Elsen, A. Seymour Lipton. N.Y., 1974.

Un Art

Yes, but. . . : A Critical Study of Philip Custon.

Franz Kline: Black and White: 1950-1961

Ades, D., and A. Forge. Francis Bacon. 1985

others). Berkeley and N.Y., 1990.

autumn 1964). 1981. Ashton, D. About Rothko. N.Y., 1983.

Art (exh. cat., texts by S. Stich, J. Clifford, and

Photomontages of Hannah Höch. New Haven,

N.Y., 1974.

N.Y., 1980.

1993

1003

vols. N.Y., 1999.

NY 1994

N.Y., 1990.

N.Y., 1976.

Paris., 1984.

Staël, Paris, 1968.

Alloway). 1978.

1988.

TG). London, 1991.

- _______ radio and Din and Constant Dirich and Dirich America, Mar. Apr. 1979, pp. 128–147. ________. ed. Pablo Picasso: A Retrospective. N.Y., 1980. ________. ed. Picasso and Braque: Pioneering Cubism (exh. eat., MoMA). N.Y., 1989.
- Schiff, G., ed. Picasso in Perspective. Englewood Cliffs 1976 Chins, 1976.
 Spate, V. Orphism: The Evolution of Non-figurative Painting in Paris: 1910–1914. Oxford, 1979.
 Steinberg, L. "The Philosophical Brothel," Art News, vol. 71, Sept 1972, pp. 20–29; Oct 1972, 22 (2017).

"The Polemical Part," Art in America, Mar-Ap 1979, pp. 114–127. TG. Essential Cubism: 1907-1920. 1983.

Constructivism/De Stijl/The Baubaus

Albers, J. Interaction of Color, 2 vols. New Haven

Bayer, H., W. Gropius, and I. Gropius, eds. Bauhaus, 1919–1928. N.Y., 1938.

Blotkamp, C. Mondrian: The Art of Destruction

Bowlt, J.E., ed. Russian Art of the Avant-Garde:

Cork R Vorticism and Abstract Art in the First

Machine Age. Berkeley and L.A., 1976. Franciscono, M. Walter Gropius and the Creation of

the Bauhaus in Weimar: The Ideals and Artistic Theories of Its Founding Years. Urbana, 1971.

Gray, C., and M. Burleigh-Motley. The Russian Experiment in Art 1863-1922, rev. London and

Grohmann, W., ed. Painters of the Bauhaus.

Itten, J. Design and Form: The Basic Course at the Bauhaus, rev. N.Y., 1975.

Jaffe, H. De Stijl. N.Y., 1968. _____, et al. De Stijl: 1917–1931, Visions of Utopia.

Karginov, G. Rodchenko, London and N.Y., 1979

Lewison, J. Ben Nicholson (exh. cat., TG). London,1993.

Lodder, C. Russian Constructivism. New Haven,

Marter, J. Alexander Calder (exh. cat.), Cambridge,

Malevich, K. The Non-Objective World. Chicago,

Milner, J. Kasimir Malevich and the Art of

Geometry. New Haven, 1996. __. Vladimir Tatlin and the Russian Avant-Garde.

Moholy-Nagy, L. Vision in Motion. Chicago, 1947. MFA. Geometric Abstraction: 1926–1942 (exh. cat.,

Overy, P. De Stijl. London and N.Y., 1991.

cat., BMFA), Boston, 1994,

Spies, W. Josef Albers. N.Y., 1962

Whitford, F. Bauhaus. London, 1984.

(exh. cat., MoMA), N.Y., 1993. Clair, J. Marcel Duchamp: Catalogue Raison

texts by J. Elderfield and M. Seuphor). Dallas,

evsner, N. Pioneers of Modern Design form William Morris to Walter Gropius. Harmonds-

Roman, G.H., ed. The Russian Avant-Garde, special

ed. of Art Journal, fall 1981. Rudenstine, A., ed. Piet Mondrian: 1872–1944 (exh.

SRGM. Art of the Avant-Garde in Russia: Selections from the George Costakis Collection (exh. cat.,

texts by M. Rowell and A.Z. Rudenstine). 1981. . The Great Utopia: The Russian and Soviet Avant-Garde (exh. cat.). N.Y., 1992.

Troy, N.J. The De Stijl Environment. Cambridge,

Dada/Surrealism

Breton, A. Manifestoes of Surrealism. Ann Arbor,

Camfield, W.A. Francis Picabia. Princeton, 1979. Max Ernst: Dada and the Dream of Surrealism

Dachy, M. The Dada Movement: 1915–1923. N.Y., 1990.

d'Harnoncourt, A., and K. McShine, Marcel

Duchamp. N.Y. and Greenwich, Conn., 1973. Dietrich, D. The Collages of Kurt Schwitters: Tradition and Innovation. N.Y., 1993.

Foster, H. Compulsive Beauty. Cambridge, Mass.,

Foster, S., and R. Kuenzi. Dada Spectrum: The Dialectics of Revolt. Madison, Wisc., 1979.

Goldwater, R. Space and Dream. N.Y., 1967. Hayward Gallery. Dada and Surrealism Reviewed

(exh. cat., text by Dawn Ades). London, 1978. Herbert, R. The Société Anonyme and the Dreier

Giedion-Welcker, C. Jean Arp. N.Y., 1957

Ashton, D. A Joseph Cornell Album. N.Y., 1974.

Theory and Criticism, 1902-1934, rev. London and N.Y., 1988.

Wilkin, K. George Braque. N.Y., 1991.

pp. 38-45.

and London, 1963.

N.Y., 1995.

N.Y., 1986.

1983

1991

1959

1972

worth 1960

Mass., 1983.

1972.

Paris, 1977.

1993

Pev

New Haven, 1983.

London, 1962.

Minneapolis, 1982. _. *Mondrian*. N.Y., 1985.

and O. Fahlström. Todmorden, Lancs, 1978. Jordan, J., and R. Goldwater. *The Paintings* of

Arshile Gorky: A Critical Catalogue. N.Y., 1982. Kingsley, A. The Turning Point: The Abstract Expressionists and the Transformation of

American Art. N.Y., 1992. Krauss, R.E. Terminal Iron Works: The Sculpture of

David Smith. Cambridge, Mass., 1971. Lader, M. Arshile Gorky. N.Y., 1985. Leja, M. Reframing Abstract Expressionism:

Subjectivity and Painting in the 1940's. New Haven, 1993. MMA. Balthus (exh. cat., text by S. Rewald), 1984.

Museum of Fine Arts. *Lee Krasner: A Retrospective* (exh. cat., text by B. Rose). 1984.

MoMA. *The New American Painting* (cat. for exh. sent to eight European countries, with "Introduction" by A.H. Barr). 1959.

_____ The New Decade: 22 European Painters and Sculptors (exh. cat, text by A.C. Ritchie), 1955. O'Connor, F.V. Jackson Pollock, 1967. Includes

transcript of interview with the artist. ____, and E.V. Thaw. Jackson Pollock: A Catalogue

Raisonné of Paintings, Drawings, and Other Works. New Haven, 1976. Paulhan, J. L'Art informel, Paris, 1962

Polcari, S. Abstract Expressionism and the Modern Experience. N.Y. and London, 1991.

Rand, H. Arshile Gorky: The Implications of Symbols. Montclair, N.J., 1980.

Rose, B. Ad Reinhardt: Black Paintings: 1951-1967 (exh. cat., Marlborough Gallery). N.Y., 1970. Rosenberg, H. "The American Action Painters."

Artnews, Sept 1952. The Tradition of the New. N.Y., 1959.

Rubin, W.S. "Jackson Pollock and the Modern Tradition," *Artforum* (4 parts), vol. 5, Feb 1967, pp. 14–22; Mar 1967, pp. 28–37; Ap 1967, pp. 18–31; My 1967, pp. 28–33.

16–51, My 1907, pp. 26–55. ... "Pollock as Jungian Illustrator: The Limits of Psychological Criticism," Art in America, Nov 1979, pp. 104–123, and Dec, 1979, pp. 72–91.

Sandler, I. The Triumph of American Painting: A History of Abstract Expressionism. N.Y., 1970.

Shapiro, D. and C. Abstract Expressionism: A Critical Record. N.Y., 1990. SRGM. Alberto Giacometti: A Retrospective (exh.

cat., texts by T.M. Messer and R. Hohl). 1974. _. The Fifties: Aspects of Painting in New York

(exh. cat., text by P. Rosensweig). 1980. __. Jean Dubuffet: A Retrospective (exh. cat., texts

by T.M. Messer and M. Rowell), 1973.

Stokvis. W. CoBrA: An International Movement in Art after the Second World War. N.Y., 1988. Sylvester, D. Interviews with Francis Bacon, 3rd ed.

London, 1987 TG. British Painting since 1945 (exh. cat., text by R.

Alley). 1966. Tuchman, M., ed. The New York School: The First

Generation: Paintings of the 1940s and 1950s. L.A., 1967. Varnedoe, K with P Karmel, Jackson Pollock (exh

Varnedoe, K., with P. Karmel. Jackson Pollock (exn. cat., MoMA). N.Y., 1998.
 Walker Art Gallery. New Italian Art: 1953–71 (exh. cat., text by G. Carandente). Liverpool, 1971.
 Waldman, D. Willem de Kooning. London and N.Y., 1999.

1988 Weiss, A.S. Shattered Forms: Art Brut, Phantasms,

Modernism. Albany, N.Y., 1992. WMAA. The Third Dimension: Sculpture of the New

York School (exh. cat., text by L. Phillips). 1984. Wilkin, K. David Smith, N.Y., 1984.

Pop Art/Assemblage/Happenings

Alloway, L. Roy Lichtenstein. N.Y., 1983. This Is Tomorrow (exh. cat., Whitechapel Art

Gallery). London, 1956. Art Gallery of New South Wales. *Pop Art:* 1955–1970 (exh. cat., text by H. Geldzahler).

Sydney, 1985. Ferguson, R. Hand-painted Pop: American Art in Transition, 1955-1952 (exh. cat., MoCA). L.A.,

1992 Goldberg, R.L. Performance Art. London and N.Y.,

1988

Goldman, J. James Rosenquist. N.Y., 1985. Hayward Gallery. The Human Clay: An Exhibition

Selected by R.B. Kitaj (exh. cat., text by Kitaj). London, 1976. Hopps, W., and S. Davidson. Robert Rauschenberg:

Hopps, w., and S. Daviason. *Robert Rausceneberg: A Retrospective* (ext. cat., SRGM). N.Y., 1997. Hunter, S. *George Segal*. N.Y., 1984. Institute for the Arts, Rice U. *Yves Klein:* 1958–1962: A Retrospective (texts by D. de Menil, D. Bozo, J.T. Mock, P. Restany, T.

Menni, D. Bo20, J.T. Mock, F. Kestany, I. McEvilley, and N. Rosenthal. Houston, 1982. Janis, S., J. Ashbery, and P. Restany. *New Realists* (exh. cat., Sidney Janis Gallery). N.Y., 1962. Kaprow. A. Assemblage, Environments & Happen-ings. N.Y., 1966.

Kramer, H. The Age of the Avant-Garde: An Art Chronicle of 1956–1972. N.Y., 1973. Livingstone, M., ed. Pop Art (exh. cat., RAA),

London, 1991. LACMA. David Hockney: A Retrospective (texts by R.B. Kitaj, H. Geldzahler, C. Knight, G. Schiff, A.

Hoy, K.E. Silver, L. Weschler, and the artist). L.A. and London, 1988. Mahsun, C.A. Pop Art and the Critics. Ann Arbor.

1087 Morphet, R., ed. R.B. Kitai (exh. cat., TG), London,

1994

Musée d'Art Moderne de la Ville de Paris. 1960: Les Nouveaux Réalistes (exh. cat., texts by B. Contensou and P. Restany). 1986.

MoMA, Andy Warhol: A Retrospective (exh. cat., texts by K. McShine, R. Rosenblum, B.H.D. Buchloh, and M. Livingstone). N.Y. and London, 1989.

Assemblage (exh. cat., text by W.C. Seitz). 1961. Claes Oldenburg (exh. cat., text by B. Rose). 1970.

Sandford, M. Happenings and Other Arts. N.Y., and London, 1995.

Sandler, I. American Art of 1960's. N.Y., 1988. SRGM. Richard Hamilton (exh. cat., text by J.

Russell). 1973. Tomkins, C. Off the Wall: Robert Rauschenberg and

the Art World of Our Times. N.Y., 1980. WMAA. BLAM! The Explosion of Pop, Minimalism, and Performance: 1958-1964 (exh. cat., text by B. Haskell and J.G. Hanhardt). 1984.

Post-Painterly Abstraction/Minimalism

AKAG. Bridget Riley: Works 1959-78 (exh. cat., text by R. Kudielka). 1978. Baker, K. Minimalism: Art of Circumstance. N.Y.,

1988

Barrett, C. Op Art. London and N.Y., 1970 Brett, Guy. Kinetic Art: The Language of Movement.

London, 1968. Elderfield, J. Frankenthaler. N.Y., 1989.

Fenton, T. Anthony Caro. London, 1986. Fogg Art Museum, Harvard U. Three American Painters: Kenneth Noland Jules Olitski Frank Stella (exh. cat., text by M. Fried). Cambridge., Mass., 1965.

Guberman, S. Frank Stella: An Illustrated Biography. N.Y., 1995. Haskell, B. Agnes Martin (exh. cat., WMAA). N.Y.,

1992. Hulten, P. Jean Tinguely-"Meta". Paris, 1974; London, 1976.

Judd, D. Complete Writings, 1959–1975, N.Y., 1975.

Juda, D. Complete Writings, 1959–1975. N., 1975. Kertess, K. Joan Mitchell, N.Y., 1997. LACMA, American Sculptures of the Sixties (exh. cat., texts by L. Alloway, J. Coplans, C. Greenberg, M. Kozloff, L.R. Lippard, J. Monte, D. D. M. G. M. Kozloff, L.R. Lippard, J. Monte, D. D. M. G. M. Kozloff, L.R. Lippard, J. Monte, D. B. M. G. M. Kozloff, L.R. Lippard, J. Monte, D. B. Kozloff, L.R. Lippard, J. Kozloff, L B Rose) 1967

Post-Painterly Abstraction (exh. cat., text by C. Greenberg). 1964.

Leggio, J., and S. Weiley, eds. American Art of the Sixties (exh. cat., MoMA). N.Y., 1991.

Moffett, K. Kenneth Noland. N.Y., 1977. Museum of Finc Arts. The Great Decade of American

Abstraction: Modernist Art. 1960 to 1970 (exh. cat. text by E.A. Carmean, Jr.). Houston, 1974 MoMA. Anthony Caro (exh. cat., text by W. Rubin).

N.Y. and London, 1975. __. Frank Stella (exh. cat., text by W. Rubin). 1970. _. The Machine as Seen a the End of the Mechanical Age (exh. cat., text by P. Hulten). 1968.

Morris Louis (exh. cat., text by J. Elderfield). 1986 Sol LeWitt (exh. cat., texts by A. Legg, L.R.

Lippard, B. Rose, and R. Rosenblum). 1978. Lippard, B. Rose, and R. Rosenblum). 1978. Necol, J., and D. Droll. Abstract Painting: 1960–1969. NY, 1983. O'Doherty, B. Inside the White Cube. S.F., 1986.

Rickey, G. Constructivism: Origins and Evolution. N.Y., 1967.

Rose, B. "ABC Art," Art in America, Oct/Nov 1965,

pp. 57-69. Rosenblum, R. Frank Stella. Baltimore, 1970

Rubin, L. Frank Stella Paintings: 1958–1965: A Catalogue Raisonné. N.Y. and London, 1986.

Sandler, I. The New York School: The Painters and Sculptors of the Fifties. N.Y., 1978. San Francisco Museum of Modern Art. Unitary

Forms: Minimal Sculpture by Carl Andre, Don Judd, John McCracken, Tony Smith (exh. cat., text

by S. Foley). 1970. Schmied, W. Zero: Mack, Piene, Uecker. Hannover, 1965.

Serota, N. Carl Andre Sculpture: 1959–1977 (exh. cat., Whitechapel Art Gallery). London, 1978.

_, S. Bann, and R. Smith. Brice Marden: Paintings, Drawings and Prints (exh. cat., Whitechapel Art Gallery). London, 1981.

SRGM. Kenneth Noland (exh. cat., text by D. Waldman). 1971.

Robert Morris: The Mind/Body Problem (exh. cat.). N.Y., 1994. ____. Systemic Painting (exh. cat., text by L.

Alloway). 1966. Storr, R. Robert Ryman (exh. cat., MoMA), N.Y.,

1993

TG. Optical and Kinetic Art (exh. cat., text by M. Compton). 1967. Stich, S. Yves Klein (exh. cat., Hayward Gallery).

London, 1995.

London, 1995.
Varnedoe, K. Cy Twombly: A Retrospective (exh. cat., MoMA), N.Y., 1994.
______, Jasper Johns: A Retrospective (exh. cat., MoMA), N.Y., 1996.

Waldman, D., ed. Ellsworth Kelly: A Retrospective

M. Tucker and R. Pincus-Witten, interview by N.

Price, J. Video Visions-A Medium Discovers Itself.

Ratcliff, C. Gilbert and George: The Complete

SRGM. Joseph Beuys (exh. cat., text by C. Tisdall).

TG. Hans Haacke (exh. cat., text by the artist; inter-

views with W. Grasskamp and T. Brown), 1984.

Walker Art Center. Marcel Broodthaers (exh. cat., texts by M. Goldwater, M. Compton, D. Crimp, B.

Jenkins, and M. Mosebach). Minneapolis, 1989.

WMAA. Nam June Paik (exh. cat., texts by J.G. Han-

Earth and Site Works

Beardsley, J. Earthworks and Beyond: Contem-

porary Art in the Landscape. N.Y., 1984. Brenson, M. "The Case in Favor of a Controversial

Holt, J., ed. The Writings of Robert Smithson. N.Y.,

Oldenburg, C., and C. van Bruggen. Large-Scale

Projects. N.Y., 1994. Senie, H. Critical Issues in Public Art: Content,

Context, and Controversy. N.Y., 1992. SRGM. Richard Long (exh. cat., text by Long). 1986.

Sonfist, A., ed. Art in the Land: A Critical Anthology

Realism/Photorealism

Hodin, J.P., et al. Figurative Art Since 1945. London

Hughes, R. Lucian Freud: Paintings. London and N.Y., 1988.
Kuspit, D. "What's Real in Realism," Art in

America, Sept 1981, pp. 84–95. Levin, K. "The Ersatz Object," Arts, Feb 1974, pp.

Lindey, C. Superrealist Painting and Sculpture. N.Y., 1980.

Lucie-Smith, E. Super Realism. Oxford and N.Y.,

Lyons, L., and R. Storr. Chuck Close. N.Y., 1987.

Meisel, L.K. Photo-Realism. N.Y., 1980. _____. Richard Estes: The Complete Paintings, 1966–1986. N.Y., 1986.

Milwaukee Art Museum. Philip Pearlstein: A Retrospective (exh. cat., texts by R. Bowman, P.

hard Richter, Paintings. London and N.Y., 1988. Narda Kitner, raintings, Enhound and N. 1, 1988.
Nochlin, L. "The Realist Criminal and the Abstract Law," I, Art in America, Sept/Oct 1973, pp. 54–61; II, Nov/Dec 1973, pp. 97–103.
Varnedoe, K. Duane Hanson, N.Y., 1985.

WMAA. Alex Katz (exh. cat., texts by R. Marshall

The New Image

Carlson, P. "Neil Jenney," Art in America, Ap 1985,

M.E. Shapiro. The Sculpture of Nancy Graves: A Catalogue Raisonné. Fort Worth and N.Y., 1987.

Cooke, L. Antony Gormley (exh. cat., Salvatore Ala

Gallery). N.Y., 1984. Dallas Museum of Art. *Elizabeth Murray: Paintings*

and Drawings (exh. cat., text by R. Smith). 1987. ICA. Siah Armajani (exh. cat., texts by J. Kardon

Kalamazoo Institute of Arts. New Image/Pattern & Decoration (exh. cat., text by S. Hunter). 1983.

New Museum of Contemporary Art. Bad Painting (exh. cat., text by M. Tucker). N.Y., 1978.

Perreault, J. "Issues in Pattern Painting," Artforum,

1979, p. 46. errone, J. "Approaching the Decorative,"

Artforum, Dec 1976, p. 30. Philadelphia Museum of Art. Jonathan Borofsky

(exh. cat., texts by M. Rosenthal and R. Marshall).

1984.
Rickey, C. "Pattern Painting," Arts, Jan 1978, p. 17.
Russell, J. "On Finding a Bold New Work [Jennifer Bartlett]." N.Y. Times, My 16, 1976, pp. III-31.
Smith, R. "The Abstract Image," Art in America.
Next(A) 1072 (197) 1021 105

Gallery). N.Y., 1987. Walker Art Center. Jennifer Bartlett (exh. cat., text

Minneapolis, 1985. WMAA. New Image Painting (exh. cat., text by R.

by M. Goldwater, R. Smith, and C. Tomkins).

Bibliography

443

"The New Decorativeness," Portfolio, Je/Jy

and K. Linker). Philadelphia, 1985.

A.J., Jr., L.L. Cathcart, R. Hughes, and

Nasgaard, R., I.M. Danoff, and B.H.D. Buchloh.

Pearlstein and I Sandler) 1983

and R. Rosenblum). 1986.

American

Battcock, G., ed. Super Realism. N.Y., 1975. Goodyear, F.H., Jr. Contemporary Realism Since 1960. Boston, 1981.

of Environmental Art. N.Y., 1983.

Hills P. Alice Neel, N.Y. 1983

and N.Y., 1971.

52-55

1979

p. 206.

Nov 1977, p. 33

Marshall), 1978.

Perrone, J.

1984

Carmean,

Sculpture [Serra's Tilted Arc]," N.Y. Times, My 19, Scupture [Serra's Inited Arc], N. J. Innes, My 19, 1985, pp. III-35. Fairchild, P.A. Primal Acts of Construction/ Destruction: The Art of Michael Heizer, 1967–1987, Ann Arbor, 1994.

hardt, M. Nyman, D. Ronte, and D.A. Ross). 1982.

Pictures, 1971–1985. N.Y. and London, 1986

Drew). N.Y., 1982.

N.Y. and London, 1979.

N.Y., 1977.

1979

Waldman, D., ed. LISWORIN Keuy: A Ketrospective (exh. cat., SRGM). N.Y., 1996.
Whiting, C. A Taste for Pop: Pop Art, Gender and Consumer Culture. Cambridge, 1997.

WMAA, Donald Judd (exh. cat. text by B. Haskell). 1988

Kienholz: A Retrospective: Edward and Nancy Reddin Kienholz (exh. cat.) N.Y. 1996 Minimalism to Expressionism (exh. cat., text by

P. Sims). 1983. Wollheim, R. "Minimal Art," Arts, Jan 1965, pp.

26-32.

Post-Modernism/General

AIoC. Europe in the Seventies: Aspects of Recent Art. Chicago, 1977. Connor, S. Postmodernist Culture: An Introdu

to Theories of the Contemporary. Oxford, 1989. Danto, A. Encounters and Reflections: Art in the Historical Present. N.Y., 1992.

Eagleton, T. Literary Theory: An Introduction. Minneapolis, 1983. Foster, H., ed. The Anti-Aesthetic: Essays on Post-

Frascina, F., ed. Pollock and After: The Critical

Frascina, F., ed. Pollock and Ajter: The Crucca Debate. N.Y., 1985. _____, and C. Harrison, eds. Modern Art and Modernism: A Critical Anthology. N.Y., 1982. Hertz, R., ed. Theories of Contemporary Art. Debate Cliffs. 1995

Kramer, H. The Revenge of the Philistines: Art and Culture: 1972–1984. N.Y., 1985.

Krauss, R.E. The Originality of the Avant-garde and Other Modernist Myths. Cambridge. Mass., 1985.

Levin, K. Beyond Modernism: Essays on Art from the '70s and '80s. N.Y., 1988.

Millet, C. L'Art Contemporain en France. Paris, 1988.

MoCA. A Forest of Signs: Art in the Crisis of Representation (exh. cat., texts by A. Goldstein,

Pincus-Witten, R. Postminimalism into Maximalism:

American Art, 1966–1986. Ann Arbor, 1987. andler, I. Art of the Postmodern Era: Fro Late 1960s to the Early 1990s. N.Y., 1996.

M.J. Jacob. A. Rorimer, and H. Singerman). L.A.,

Modernism, Revisionism, Pluralism, and Post

Modernism, special edition of Art Journal,

fall/winter 1980, with texts by Sandler, K. Varnedoe, R. Pommer, L.R. Lippard, K. Levin,

variadoe, R. Foniner, L.K. Lippard, K. Levin, and R.L. Goldberg.
 Smagula, H. Currents: Contemporary Directions in the Visual Arts. Englewood Cliffs, 1983.
 _____, ed. Revisions: New Perspectives of Art Criticism. Englewood Cliffs, 1991.

Taylor, P. Post-Pop Art. Cambridge, Mass., 1988.
 Wallis, B., ed. Art After Modernism: Rethinking Representation. N.Y. and Boston, 1984.

Welish, M. Signifying Art: Essays on Art after 1960.

Wood, P., et al. Modernism in Dispute. New Haven,

Conceptual Art Armstrong, E., and J. Rothfuss. In the Spirit of

Fluxus (exh. cat., Walker Art Center). Minneapolis, 1993.

and Robert Nickas, eds. The Art of

Battcock, G. Idea Art: A Critical Anthology. N.Y.,

Performance: A Critical Anthology. N.Y., 1984.

Burnham, J. Great Western Salt Works: Essays on

Cooper, H.A. Eva Hesse: A Retrospective. New

Harrison, C., and F. Orton. A Provisional History of Art & Language. Paris, 1982.

Henri, A. Total Art: Environments, Happenings, and

Performance. N.Y., 1974. Kaiser, W.M.J. Joseph Kosuth: Artworks and

Theories. Amsterdam, 1977. Kaprow, A. Essays on the Blurring of Art and Life

(ed. by J. Kelley). Berkeley, 1993. LeWitt, S. "Paragraphs on Conceptual Art," Artforum, summer 1967, pp. 79-83.

Lippard, L.R. *Eccentric Abstraction* (exh. cat., Fishback Gallery). N.Y., 1966.

Morgan, R. Conceptual Art: An American Perspective. Jefferson, N.C., 1994.
Morris, R. "Anti-Form," Artforum, Ap 1968, pp.

35-35.
... "Notes on Sculpture, Part 4: Beyond Objects," Artforum, Ap 1969, pp. 50-54.
.... "Some Notes on the Phenomenology of Making: The Search for the Motivated," Artforum, Ap 1970, pp. 67-75.
MoMA. Information (exh. cat., text by K. McShine).
N Y. 1072.

New Museum. John Baldessari (exh. cat., texts by

"Sentences on Conceptual Art," 0-9, Jan 1969,

, ed. Six Years: The Dematerialization of the Art

the Meaning of Post-Formalist Art. N.Y., 1974. Celant, G. The Knot: Arte Povera. Turin, 1985.

From the

Lucie-Smith E. Art in the Seventies Ithaca, 1980

modern Culture. Port Townsend, Wash., 1983. Foucault, M. This Is Not a Pipe. London, 1983

Englewood Cliffs, 1985.

1989

Sandler, I

N.Y., 1999

1993.

1973.

Haven, 1992.

pp. 3-5.

33-35.

N.Y., 1970.

Fin de Siècle/Eighties/Nineties

Adams, B. "Proliferating Obsessions (Y. Kusama)," Art in America, Ap 1990, pp. 228–232. Allen, J.A. "Pluralism and Postmodernism:

Assessing a Decade [the 80s]," New Art Examiner, Jan 1990, pp. 20-24.

Alphen, E. van. "Matthew Barney: Cremaster 4." Colofon (Rotterdam), no. 49, Ap 1998. Art Gallery of Toronto. The European Iceberg:

Creativity in Germany and Italy Today (exh. cat. text by G. Celant). Toronto, Milan, and N.Y., 1985

AIoC. Anselm Kiefer (exh. cat., text by M.

AIoC. Anselm Kiefer (exh. cat., text by M. Rosenthaï). 1987.
Audiello, M. "Ross Bleckner: The Joyful and Gloomy Side of Being Alive," Flash Art (summer 1995), pp. 112–115ff.
Auping, M. Francesco Clemente. N.Y., 1985.
Benezra, N., and O.M. Viso. Distemper: Dissonant Themes in the Art of the 1990s (exh. cat., HMSG).
Washington D.C. 1996.

Washington, D.C., 1996.
 Bonami, F, ed. Echoes: Contemporary Art at the Age of Endless Conclusions. N.Y., 1996.

Age of Enders Conclusions, N. 1., 1990. Cameron, D. Fever: The Art of David Wojnarowicz (exh. cat., New Museum). N.Y., 1999. Camhi, L. "Animated by Belief [A. Hamilton]," Village Voice, Oct. 26, 1993. Carnegie-Mellon U. Art Gallery. Abstraction/

- Abstraction (exb. cat., texts by E.A. King and D. Carrier). Pittsburgh, 1986. Celant, G., ed. *Keith Haring*. Munich, 1992.

Clearwater, B., ed. Defining the Nineties: Con-sensus-Making in New York, Miami, and Los Angeles (exh. cat., MoCA). Miami, Fla., 1996. Collings, M. Blimey! The London Artworld free

Francis Bacon to Damien Hirst. London, 1997. Cooke, L. "Your Skin in this Weather Bourne Eye

Threads & Swollen Perfume," Jessica Stockholder (exh. cat., Dia Center). N.Y., 1996.

Cotter, H. "The Tenderbox Career of a Lengendary Truth Teller [D. Wojnarowicz]," N.Y. Times, Jan 22, 1999, pp. E-35, 38.

Danto, A. After the End of Art: Contemporary Art and the Pale of History. Princeton, 1997.

and the Fale of History Frinceton, 1997.
Deitch, J. Young Americans: New American Art in the Saatchi Collection (exh. cat.). London, 1996.
Dobrzynski, J. H. "A Painter and Her Art Trade Places [L. Yuskavage]," N.Y. Times, Jan 28, 1999, p. E-1.
"Expressionism Today," interviews with 19 artists

by C. Ratliff, H. Herrera, S. McFadden, and J. Simon. Art in America, Dec 1982, pp. 58–75

Filler, M. "Slightly Stateless, but At Home with Him-self [G. Kuitca]," N.Y. Times, My 8, 1994, p. II-34. Gambrell, J. "Notes on the [Soviet] Underground,"

Art in America, Nov 1988, pp. 127ff. Glueck, G. "Go Figure If You Wood [S. Balkenhol]," N.Y. Observer, Je 10, 1995,, p. 21. Godfrey, T. *The New Image: Painting in the 1980s.* Oxford and N.Y., 1986.

Goldin, N., D. Armstrong, and H.W. Holzwarth, eds. Nan Goldin: I'll Be Your Mirror. N.Y., 1992.

Grosenick, U., and B. Riemschneider, eds. Art at the Turn of the Millennium. Cologne, 1999.

Halle, H. "The Vision Thing," Time Out N.Y., May 1–8, 1996, p. 22. Halley, P. Collected Essays, 1981–87. Zurich, 1988

Haring, K. Art in Transit, with intro. by H. Geld-zahler and photography by T.K. Chi. N.Y., 1985. Hickey, D. The Invisible Dragon: Four Essays on

Beauty. L.A., 1995.

HMSG. Culture and Commentary: An Eighties Perspective (exh. cat., text by K. Halbreich). Wash., D.C., 1990.

ICA. Endgame: Reference and Simulation in Recent Painting and Sculpture (exh. cat., texts by T. Crow, Y.-A. Blois, E. Sussman, D. Joselit, H.

Foster, and B. Riley). Boston, 1986. ICA. David Salle (exh. cat., texts by J. Kardon and

L. Phillips). Philadelphia, 1986. ____. *The East Village Scene* (exh. cat., text by J. Kardon). 1984.

Joachimides, C., and N. Rosenthal. Zeitgeist (exh.

cat., Internationale Kunstausstellung). Berlin, 1982. Kimmelmann, M. "Exuberantly Operatic, in Scale and Emotion [J. Stockholder]," N.Y. Times, Oct 6, 1995

"Matthew Barney's Surreal Visions, on Film and in the Gallery," N.Y. Times, Ap 23, 1995, p. C-33. Kramer, H. "Internationalism in the Eighties,

Carnegie International (exh. cat., ed. by C.R. Lane and J. Caldwell), pp. 84-87. Pittsburgh, 1985.

Kuspit, D. "Acts of Aggression: German Painting Today," Art in America, Jan 1983, pp. 91–99. ____. "Keith Haring," Artforum, Feb 1986, p. 102.

Arbor, 1988.
La Jolla Museum of Contemporary Art. Bill Woodrow (exh. cat., text by L. Forsha). 1985.
Lewis, J.A. "Stephan Balkenhol: Wooden Figures," Kulturchronic, 1996, pp. 4–6.
Lindauer, M.A. Devouring Frida: The Art History

and Popularity of Frida Kahlo. Hanover, N.H., 1999. Linker, K. Love for Sale: the Words and Pictures of

Barbara Kruger. N.Y., 1990. Lyall, S. "Is It Art, or Just Dead Meat? [D. Hirst],"

N.Y. Times Magazine, Nov. 12, 1995, pp. 29-31.

444

Madoff, S.H. Abstract/Issues (exh. cat., Sherry French/Tibor de Nagy/Oscarsson Hood Galleries). N.Y., 1985.

"Anselm Kiefer," Artnews, Oct 1987, pp. 125-130. Marcoci, R., D. Murphy, and E. Sinaiko, eds. New.

N.Y., 1997. McEvilley, T. "I Think therefore I Art," *Artforum*,

summer 1985, pp. 74–84. __. "The Case of Julian Schnabel," Julian Schnabel: Paintings 1975-1987 (exh. cat.,

Whitechapel Art Gallery). London, 1987. IcGee, C. "A Certified 'Genius' Tangles with Horsehair [A. Hamilton]," *N.Y. Times*, Oct 2, McGee, C.

1993, p. 41 Mendel Art Gallery. Eric Fischl: Paintings (exh.

cat., texts by J.C. Ammann, D. Kuspit, and B.W. Ferguson). Saskatoon, 1986.

Morgan, R. The End of the Art World. N.Y., 1998.MoMA. Current Affairs: British Paintings and Sculpture in the 1980s (exh. cat., text by I. Biggs, et al.). Oxford, 1987. MoMA. Frank Stella: 1970–1987 (exh. cat., text by

W. Rubin), N.Y., 1987.

Nairne, S., G. Dunlop, and J. Wyner. State of the Art: Ideas & Images in the 1980s. London, 1987.

Neff, T.A., ed. A Quiet Revolution: British Sculpture Since 1965, with essays by G. Beal, L. Cooke, C. Harrison, and M.J. Jacob. N.Y. and London, 1987. A.B. The Italian Transavantgarde. Milan, Oliva, 1980.

Pincus-Witten, R. Entries (Maximalism), N.Y., 1983. Plagens, P. "These Days, It's the 'old of the shock'." Newsweek, Dec 29, 1997, p. 89.

Princenthal, N. "Intuition's Disciplinarian [Martin Pur year]," Art in America, Jan 1990, pp. 131–136, 181. Rosenblum, R. "Dinos and Jake Chapman, Artforum, Sept 1996, p. 101.

"Eric Fischl," Contemporanea, My/Je 1988, pp. 62-65.

RAA. A New Spirit in Painting (exh. cat., texts by C.M. Joachimides, N. Rosenthal, and N. Serota). 1981.

_. Sensation: Young British Artists from the Saatchi Collection (exh. cat.). London, 1997.

Rubenstein, R. "Counter-Resolution," Art in America, Ap 1995, pp. 85-89.

St. Louis Art Museum. Expressions: New Art from Germany: Georg Baselitz, Jörg Immendorff, Anselm Kiefer, Markus Lüpertz, H.R. Penck (exh. cat., text by J. Cowart, S. Gohr, and D. Kuspit). 1983. Saltz, J. "Felix Gonzales-Torres, Untitled (Beginning)

1994," *Time Out N.Y.*, Jan 23–30, 1997, p. 41. _. "Here . . . ? (G. Orozco)," *Village Voice*, Jan. 6, 1999

Schjeldahl, P. "Get Out of Here [T. Oursler]," Village Voice, Nov 25, 1997, p. 97. "Isle of Male [M. Barney]," Village Voice, My 9,

1995, p. 87. "Peyton's Place," Village Voice, Mar 25, 1997,

p. 93. "Purple Nipple [L. Yuskavage]," Village Voice, Sept. 29, 1998.

'Tender Sentience [F. Gonzalez-Torres]," Village Voice, Mar 21, 1995.

and I.M. Danoff. Cindy Sherman. N.Y., 1984. Smith, R. "Ann Hamilton 'Tropos'," N.Y. Times, Oct 22, 1993, p. C-24

The Horror: Updating the Heart of Darkness,"

N.Y. Times, June 1, 1997, p. 733. _. "Lack of Location Is My Location [G. Ligon],"

N.Y. Times, Je 16, 1991, p. II-27. _. "Seeing Three Images in One Face [Y. Morimura]," N.Y. Times, Dec 6, 1996, p. C-30.

"." "The Best of Sculptors, the Worst of Sculptors [R. Whiteread]," *N.Y. Times*, Nov 30, 1993, p. C-15. SRGM. Refigured Painting: The German Image: 1960–88 (exh. cat., texts by T. Krens, J. Thompson, M. Govan, J. Schilling, H. Klotz, and

H.A. Peters). N.Y. and Munich, 1989.

Stella, F. Working Space. Cambridge, Mass., 1986. Storr, R. Dislocations (exh. cat., MoMA). N.Y., 1991

1991 Taaffe, P. "Sublimity, Now and Forever. Amen," Arts, Mar 1986, pp. 18–19. Tomkins, C. "On the Edge (Y. Kusama)," New Yorker, Oct. 7, 1996, pp. 100–103. WMAA. Image World: Art and Media Culture (exh.

cat., texts by M. Heiferman, L. Phillips, and J.C. Harkardt). 1989.

Zelevansky, L. Guillermo Kuitca (exh. cat., MoMA). N.Y., 1991.

Architecture

Amonsoneit, W. Contemporary European Architects.

Cologne, 1991. Architectural Design. Contemporary Architectura London, 1988.

Deconstructivism in Architecture, issue conceived by C. Jencks. London, 1988. Post-Modernism on Trial, ed. by A.C. Papa-

dakis. London, 1990. Arnell, P., and T. Bickford, eds. *Robert A.M. Stern*,

1965-1980: Toward a Modern Architecture after Modernism. N.Y., 1981. Arnheim, R. The Dynamics of Architectural Form.

Berkeley and L.A., 1977.

Banham, R. Age of the Masters: A Personal View of

Modern Architecture. N.Y., 1975.

_. The Architecture of the Well-tempered Environment. Chicago, 1969. Benevolo, L. History of Modern Architecture, 2 vols. Cambridge, Mass., 1977.

Towards a New Architecture. N.Y., 1970

Princeton, 1996.

Chicago, 1991.

Style. N.Y., 1978.

N.Y., 1964.

1976

1970.

1924.

1969

Scully.

1965

N.Y., 1969.

Levine, N. The Architecture of Frank Lloyd Wright.

Mallgrave, H.F. Otto Wagner: Reflections on the

Manglave, 117: Jola magner, Repretations on Ine Raiment of Modernity, Santa Monica, 1993. Martinell y Brunet, C. Gaudí: His Life, His Theories, His Work, Cambridge, Mass., 1975. McHale, J. R. Buckminster Fuller, N.Y., 1962.

Mumford, L. Roots of Contemporary American Architecture. N.Y, 1952. MoCA. Louis I. Kahn: In the Realm of Architecture

(exh. cat., texts by B. Brownlee, D.E. De Long, and V. Scully). L.A., 1992.

(exh. cat., texts by A.H. Barr, Jr., H.R. Hitchcock, and P. Johnson). 1932.

Neutra, R. Life and Human Habitat. Stuttgart, 1956.

Norbert-Schulz, C. Existence, Space, and Archi-tecture. N.Y., 1971.

Ockman, J., ed. Architecture Culture, 1943-1968: A Documentary Anthology. N.Y., 1993. O'Gorman, J.F. Three American Architects

Richardson, Sullivan, and Wright, 1865-1915.

Pearman, H. Contemporary World Architecture.

London, 1998. Pearson, P.D. Alvar Aalto and the International

Pehnt, W. Expressionist Architecture. N.Y., 1973.

Pevsner, N. A History of Building Types. Princeton,

Design. N.Y., 1968. Pommer, R., ed. Revising Modernist History: The

of Art Journal, summer 1983. Richards, J.M. An Introduction to Modern Archi-

tecture, rev. N.Y., Baltimore, 1962. Riley, T., and P. Redd, eds. Frank Lloyd Wright,

Roth, L. Understanding Architecture: Its Elements, History, and Meanings. N.Y., 1993.

Saarinen, A.B., ed. *Eero Saarinen on His work*, rev. New Haven and London, 1968.

Safdie, M. Beyond Habitat. Cambridge, Mass.,

Schildt, G. Alvar Aalto: The Complete Catalogue of

Architecture, Design, and Art. N.Y., 1994. Scully, V. American Architecture and Urbanism: A

_. The Shingle Style: Architectural Theory and Design from Richardson to the Origins of Wright.

Sharp, D. Modern Architecture and Expression. N.Y., 1966.

A. L. 1900.
 ed. The Rationalists: Theory and Design in the Modern Movement. N.Y., 1979.
 Sources of Modern Architecture: A Bibliography. N.Y., 1967.

Illustrated Guidebook and Appraisal. Cleveland and N.Y., 1961.

Spath, D. Mies van der Rohe. N.Y., 1985. Stern, R.A.M. New Directions in American Architecture. N.Y., 1969.

_, et al. New York 1900: Metropolitan Architecture and Urbanism, 1890–1915. N.Y., 1983.

_____. Raymond M. Hood. N.Y., 1981. Sterling, J. Buildings and Projects: 1950–1974.

N.Y., 1975. Introduction by J. Jacobus. Sullivan, L.H. *The Autobiography of an Idea*. N.Y.,

Tafuri, M. History of Italian Architecture, 1944–1985. Cambridge, Mass., 1989. Taut, B. Modern Architecture. London, 1929.

Tigerman, S. Versus: An American Architect's

Toshio, N., ed. Robert Venturi and Scott Brown. Toshio, N., ed. Kobert Venturi and Scott Brown. Tokyo, 1981.
Trachtenberg, M., and I. Hyman. Architecture from Prehistory to Post-Modernism: The Western Tradition. Englewood Cliffs and NY, 1986.
Venturi, R. Complexity and Contradiction in

, D. Scott Brown, and S. Izenour. Learning from

Las Vegas. Cambridge, Mass., 1972. Webb, M. Architecture in Britain Today. London,

Wheeler, K., ed. Michael Graves: Buildings and Projects: 1966-1981. N.Y., 1982. Essay by V.

Whittick, A. Eric Mendelsohn, 3rd ed. London,

__. European Architecture in the Twentieth Century, 2 vols. London, 1950–53.

Wiebenson, D. Tony Garnier: The Cité Industrielle.

Kindergarten Chats. N.Y., 1947.

Alternatives. N.Y., 1982.

Architecture. N.Y., 1966.

Architecture. Greenwich, Conn., 1972. Smith, G.E.K. The New Architecture of Europe: An

A Visual History of Twentieth-Century

Historical Essay. N.Y., 1969. _. Frank Lloyd Wright. N.Y., 1960.

New Haven, 1955.

Architect (exh. cat., MoMA), N.Y., 1994.

Architecture of the 1920s and 1930s, special ed.

ed. Encyclopedia of Modern Architecture.

The Sources of Modern Architecture and

MoMA. Deconstructivist Architecture (exh. cat.,

Blake, P. Form Follows Fiasco: Why Modern

Architecture Hasn't Worked. Boston, 1977. __. God's Own Junkyard. N.Y., 1964.

The Master Builders NY 1960.

No Place Like Utopia: Modern Archiecture and the Company We Kept. N.Y., 1993.

____. Philip Johnson. Basel, 1996. Blaser, W. Mies van der Rohe: The Art of Structure,

rev. N.Y., 1972.

Boesiger, W., and H. Ginsberger. *Le Corbusier:* 1910–1960. N.Y., 1960. Brolin, B.C. The Failure of Modern Architecture.

N.Y., 1976. Brown, T.M. The Work of G. Rietveld, Architect.

Utrecht, 1958. Brownlee, D., and D. De Long. *Louis I. Kahn: In the* Realm of Architecture (exh. cat., LACMA). L.A.,

1991 Cannell, M.T. I.M. Pei: Mandarin of Modernism

NY 1995 Christ-Jenner, A. Eliel Saarinen, rev. Chicago, 1979. Collins, P. Changing Ideals in Modern Architecture. Montreal, 1967.

Concrete: The Vision of a New Architecture: A

Study of Auguste Perret and His Precursors. N.Y.,

Condit, C.W. The Chicago School of Architecture.

Conrads, U., ed. Programs and Manifestoes on 20th

Century Architecture. Cambridge, Mass., 1970. Cooper, J., ed. Mackintosh Architecture: The Com-

plete Buildings and Selected Projects. N.Y., 1980. _____, and H.G. Sperlich. The Architecture of

Fantasy: Utopian Building and Planning in

Cook, P. Experimental Architecture. N.Y., 1970.

Chapter on modern architecture by J. Jacob

____, ed. Archigram. N.Y., 1973. Copplestone, T., ed. World Architecture. N.Y., 1963.

Crawford, A. Charles Rennie Mackintosh. N.Y.,

Curtis, W.J.R. Modern Architecture since 1900.

Drexler, A. The Drawings of Frank Lloyd Wright. N.Y., 1962.

19/9.
Fleig, K., ed. Alvar Aalto. N.Y., 1963.
Frampton, K. Modern Architecture: A Critical History. N.Y. and Toronto, 1980.
______. Richard Meier, Architect: Buildings and Projects, 1966–1976. N.Y., 1976.
Fuller, R.B. Nine Chains to the Moon. Philadelphia and NY 1938.

Giedion, S. Mechanization Takes Command. N.Y.,

Giurgola, R., and J. Mehta, Louis I. Kahn. Boulder,

Goldberger, P. On the Rise: Architecture and Design

in a Post-Modern Age. N.Y., 1983. Gössel, P., and G. Leuthäusen. Architecture in the

Twentieth Century. Cologne, 1991. Gropius. W. Scope of Total Architecture. N.Y., 1955.

Hamlin, T., ed. Forms and Functions of Twentieth-Century Architecture, 4 vols. N.Y., 1952.

Hitchcock, H.R. The Architecture of H.H. Richardson and His Times, rev. Hamden, Conn., 1961.

Architecture: Nineteenth and Twentieth Cen

turies, 4th ed. Harmondsworth and Baltimore, 1977.

Jacobus, J. Philip Johnson, N.Y., 1952. _______. Twentieth-Century Architecture: The Middle Years, 1940–1965. London, 1966.

Jonison, F. Mies van der Kone, ICV, N. F., 1955.
Jordy, W.H. American Buildings and Their Architects, vols. 3 and 4. Garden City, 1970-72.
Kaufmann, E., Jr., ed. The Rise of an American Architecture. N.Y., 1970. Essays by H.R. Hitchcock, A. Fein, W. Weisman, and V. Scully.

Kostof, S. History of Architecture: Settings and Rituals, 2nd ed. N.Y., 1995.Krier, R. On Architecture. N.Y., 1982.

Kultermann, U. Architecture in the 20th Century.

..., ed. New Japanese Architecture, rev. N.Y., 1967., Kenzo Tange: 1946–1969. N.Y., 1970. Larkin, D., and B. B. Pfeiffer. Frank Lloyd Wright:

Leach, N. Rethinking Architecture: A Reader in Cultural Theory. N.Y., 1996.

Le Corubsier. Creation Is a Patient Search. N.Y.,

The Masterworks. N.Y., 1993.

Johnson, P. Mies van der Rohe, rev. N.Y., 1953.

Jencks, C. Architecture Today. N.Y., 1982.

Gutheim, F. Alvar Aalto, N.Y., 1960.

Gaudí, N.Y., 1957.

N.Y., 1993.

1960.

_. Space, Time, and Architecture: The Growth of a New Tradition, 5th ed. Cambridge, Mass., 1967.

. Ludwig Mies van der Rohe. N.Y., 1960. . Transformations in Modern Architecture. N.Y.,

1959

1995.

1979

1948.

and N.Y., 1938.

Colo., 1975.

Chicago, 1964.

Modern Times. N.Y., 1962.

Englewood Cliffs, 1982.

- Aalto, Alvar: 214, 342, 345; Baker House, M.I.T., 214; House of Culture, 345 (643); Paimio, 214; Vilpuri Library, 214Abakanowicz, Magdalena 394, 395, 400, 401, *Backs*, 394, 395 (762) Abe, Schuva: 367
- Abe, Schuya: 507 Abstract Expressionism: 15, 21, 188, 194, 195, 215, 217, 248, 251, 264, 267, 269–272, 275-280, 298, 299, 301, 302, 308, 309, 313, 316, 320, 321, 324, 330, 333, 343, 357, 358, 359, 371, 376, 381, 382

Abstraction-Creation: 240, 242, 244, 246, 264, 266

Abstraction-C-reation: 240, 242, 244, 246, 266 Acconci, Vito: 368; Scedbed, 368 Action Painting: 252, 268-276, 278, 285, 298, 300, 301, 302, 303, 305, 312, 314, 315, 318, 321, 330, 360, 365

AEG Turbine Factor, Berlin: 94 (150), 95, 196 affichistes: 331

African art: 76, 80, 102, 111, 113, 117, 132, 134, 136, 138, 139, 207, 217, 218, 225 Agam, Yaacov: 338; Double Metamorphosis II, 338,

(629)

- Ahearn, John: 400, 401; Jay with Bike, 400 (772)
- Aheam, Jonn: 400, 401; Jay with Dike, 400 (112) AIDS: 369, 401, 409 Albers, Josef: 198, 243, 244, 245, 298, 318, 319, 327, 336, 343; Homage to the Square, 198, 244 (432), 318, 319, 336, 343; Walls and Posts (Thermometer Syle), 198, 244 (431), 318 Alighiero e Boetti: 396

Andersen, Kurt: 437

- Anderson, Laurie: 367–368; Duets on Ice, 367 (691); United States, 367 (692), 368 Andre, Carl: 325, 328, 362; Twelfth Copper Corner,
- 328 (607)
- Anuszkiewicz, Richard: 244, 319, 326, 335, 336; Temple of Golden Orange, 319 (584)
- Apollinaire, Guillaume: 138, 139, 149, 150, 163, 165, 166, 168, 179, 215
- 165, 106, 108, 179, 215 Appel, Karel: *Exploded Head*, 288–290 (521) Archigram: 342, 352, 354, 355, 438; "Plug-in-City," 354 (662)
- Archipenko, Alexander: 146, 147, 216; Médrano II,
- Mirror with Table in Front, 403 (779) Arman: 330; Helices, 331 (612)
- Armory Show, New York: 18, 141, 151, 169, 173, 247–264
- Arp, Jean (Hans): 167–169, 175, 180, 187-189, 215, 226, 231, 238, 240, 241, 262, 284, 334, 403; 220, 231, 256, 240, 241, 202, 284, 534, 403; Arrangement According to the Laws of Chance (Collage with Squares), 167 (283), 189; Before My Birth, 168 (284), 189; Human Concretion, 169, 189 (328), 226, 231, 238; Mountain Table, Anchors, Navel, 168 (285), 189
- Art & Language: 358, 360, 362, 389; Index: Incident in a Museum XIII, 389 (750); 100% Abstract (95%+5%), 362 (677) Art Brut (*l'art brut*): 13, 419, 435
- Art Deco: 93, 96, 242, 263, 380; architecture, 209-211. 264
- Art Nouveau: 28, 48, 49, 53, 54–60, 88, 89, 112, 146, 160, 198, 428; architecture, 91-93, 95, 97, 197, 348; see Jugendtstil Artaud, Antonin: 368

arte povera/Arte Povera: 315, 359 (671), 370 (703, 704), 395, 396, 421

Arts and Crafts movement: 43, 55, 57, 88, 95, 96 Artschwager, Richard: 390, 391, 400, 401; Low Overhead, 390 (752)

assemblage: 187, 195, 284, 293, 296, 306, 308–310, 343, 369, 370, 386, 413

Atelier Elvira, Munich: 54 (70), 55 automatism: 9, 15, 168, 178, 179, 181–183, 195,

264, 267, 268, 277; see Surrealism avant-garde: 9, 18–22

Avery, Milton: Yellow Jacket, 258 (462), 266, 277

Bacon, Francis: 288, 294, 333; Study for a Pope, 294 (533), 333; Two Figures, 294 (532), 333

"Bad Painting" (exhibition): 383, 388 Baldessari, John: 362, 397, 402, 415; Ingres and Other Parables, 362 (678)

- Balkenhol, Stephan: 416, 417; Big Man in Grey Shirt and Black Trousers, 416 (806), 417
- Ball, Hugo: 167 Balla, Giacomo: 150, 152–155, 166; Dynamism of a
- Dog on a Leash, 154 (262), 155, 166; Mercury Passing before the Sun, 155 (263), 166; Street Light, 152 (257), 153, 166

Balthus: 288, 290, 375; La Semaine des quartre jeudis, 288, 290 (525)

- Banham, Reyner: 332 Barlach, Ernst: 71, 129, 130, 259; Singing Man, 71, 130 (215)
- Barney, Matthew; 428–429; Cremaster 4, 429 (832); Mile High Threshold: Flight with the Anal
- Sadistic Warrior, 429 (831) Barr, Alfred H., Jr.: 110, 137, 141, 264, 267

Barrie, Dennis: 415-416

Barry, Robert: 362

Barthes, Roland: 359, 362, 390, 396, 415, 435 Bartlett, Jennifer: 381, 382–383; *Rhapsody*, 383 (733); *Water*, 383 (734)

Baselitz, Georg: 392–393, 394; *Der Bote*, 392 (757) Basquiat, Jean-Michel: 399–400, 420, 426; *Horn Players*, 399 (770), 400 Baudelaire, Charles: 5, 17, 18, 35, 63, 166, 179, 426

- Baudot, Anatole de: 84, 94; St. Jean-de-Montmartre: 84 (130)
- Baudrillard, Jean: 390, 403, 406, 415, 421
- Bauhaus: 123, 159, 162, 205, 206, 207 (358), 209, 215, 234, 241, 242, 244–246, 266, 278, 286, 318, 320, 334, 335, 339, 341, 342, 357, 392, 433
- Bayer, Herbert: 246 Bearden, Romare: 376; *The Gamble*, 376 (718)
- Beardsley, Aubrey: 36, 393, 428; Salomé with the Head of John the Baptist, 55 (73)
- Becher, Bernd and Hilla: 364, 427; Water Towers, 364 (683) Beckmann, Max: 128, 129, 215, 403; Departure,
- 128 (213); Night, 129 (212) Beckett, Samuel: 419
- Behrens, Peter: 91, 94–98, 196, 199; AEG Turbine Factory, Berlin, 94 (150), 95, 196; German Embassy, St. Petersburg, 95; I.G. Farben, Hoechst, 94 (151), 95
- Bell, Larry: 325; Untitled, 325 (599) Bell, Vanessa: 236, 237; Interior with a Table, 237 (415)
- Bellmer, Hans: 186, 423; Ball Joint, 186 (321) Benglis, Lynda: 369–370; Corner Painting, 369 (700), 370
- Benjamin, Walter: 359, 389, 407, 432
- Benton, Thomas Hart: 265, 273; The Hailstorm, 257 (458)
- Bergson, Henri: 23, 118
- Berlage, Hendrikus Petrus: 84, 86, 87, 90, 91, 196, 201; Stock Exchange, Amsterdam, 86, 87 (136) Bernard, Émile: 37, 40, 43, 46, 51, 132; *Market in* Brittany, 40, 41 (46)
- Beuys, Joseph: 366, 370, 371, 387, 389; Coyote: I Like America and America Likes Me, 366 (689); From Berlin: News from the Coyote, 389 (749)
- Bickerton, Ashley: 408 Bill, Max: Black Column with Triangular Octagonal
- Sections 335 (622)
- Sections, 335 (622) biomorphic abstraction: 9, 252, 267, 271, 277, 370 Bishop, Isabel: 256, 257; *Waiting*, 257 (457) Bissière, Roger: 285; *The Forest*, 285 (513) Black Mountain College: 244, 298, 313, 314, 318
- Blake, William: 396 Bleckner, Ross: 391, 406, 425, 428; Knights Not
- Nights, 406 (784) Blue Rider, The (Der Blaue Reiter): 15, 101, 112,
- Blue Rider, The (Der Biate Retter): 15, 101, 112, 117–130, 147, 152, 168, 242, 392
 Boccioni, Umberto: 147, 152–155; Development of a Botle in Space, 147, 154, (260), 166; Dynamism of a Soccer Player, 152, 153 (258), 166; Unique Forms of Continuity in Space, 147, 154 (261)
- Bochner, Mel: 360 Body Art: 358, 368, 416
- Bofill, Ricardo: 434–435; Le Viaduc at LeLac, St.-Quentin en Yvelines, 434 (843), 435
- Bolotowsky, Ilya: 264, 266; Blue-Diamond, 264 (476)
- (4/6)
 Boltanski, Charistian: 407, 411; Reserve of Dead Swiss (Large), 410, 411 (796)
 Bonnard, Pierre: 33, 43, 48–50, 58, 68, 101, 285, 405; Dining Room on the Garden, 43, 51 (63); "La Revue Blanche," 43, 49 (60)
- Bontecou, Lee: 310; Untitled, 310 (567) Borges, Jore Luis: 396, 418
- Borofsky, Jonathan: 382; *Installation*, 382 (732) Bosch, Hiernonymus: 428
- Botero, Fernando: Self-Portrait with Louis XIV (after Rigaud), 295 (534) Bouguereau, William-Adolphe: Nymphs and Satyr, 17 (16), 18, 62
- Bourdelle, Émile Antoine: 68-70; Beethoven, Tragic Mask, 68 (97); Hercules the Archer, 68 (98)
- Bourdin, Guy: 419 Bourgeois, Louise: 370, 401, 403; Untitled (with
- Hands), 401 (774)
- Brancusi, Constantin: 69, 72, 75–80, 189, 231, 234, 240, 241, 250, 297, 372, 403, 409; Adam and Eve, 240, 241, 250, 251, 512, 405, 405; Adam and Eve,
 77, 78 (118); Bird in Space, 79 (121); The Gate of the Kiss, 75 (115), 80, 374; MIle Pogany, 75 (114),
 79; The New Born, 78 (122); Sleep, 77, 78 (118); Sleeping Muse, 77, 78 (119); The Table of Silence,
- 80; *View of the Artist's Studio*, 80 (123) Braque, Georges: 22, 102, 108, 111, 132, 133, 138, 139, 143, 154, 156, 215, 229, 230, 240; *Fruit Dish* and Glass, 144 (238); Le Guéridon, 229 (401); Houses at l'Estaque, 132 (219); Landscale at La *Ciotat*, 108 (174); *Landscape with Houses*, 139 (228); *Nude Woman with a Basket of Fruit*, 229 (402); The Portuguese, 142 (235); The Trellis 230 (402); *Violin and Palette*, 140 (232) Brasilia: 351 (655)
- Brasilia: 351 (655) Bravo, Claudio: 375–376; Blue Package with Ostrich Eggs, 375 (716)
- Brenson, Michael: 403, 415 Breton, André: 164, 165, 170, 177–179, 181, 183–187, 190, 194, 195, 267
- Breuer, Marcel: 198, 296, 340

Broodthaers, Marcel: 364-365: "Musée d'Art Moderne, Département des Aigles," Moules sauce blanche, 364, 365 (687) 364-365 Brus, Günther: 368

Dada: 11, 152, 167–169, 173, 175-178, 180, 181, 186-190, 195, 215, 261, 266, 299, 301, 302, 310,

Dagerood Housing, Amsterdam: 201 (350)

302, 321, 329

Davis, Douglas: 438

Deacon, Richard: 395 décollage: 331

Deitch, Jeffrey: 404

186 (320)

(709)

(672)

252 (447)

(247)

247 (438)

207, 209–211, 350

Eisenman, Peter: 437 Eliot, T.S.: 413

338, 358, 360, 381, 392; Neo-Data, 190, 298, 299.

Dali, Salvador: 84, 166, 167, 182, 187, 194, 267, 268, 377, 389, 393, 423, 429; The Persistence of

Memory, 84; 166, 167, 182 (312), 183, 267; Rainy Taxi, 187; Soft Construction with Boiled Beans:

Premotion of Civil War, 182 (312) Darboven, Hanne: 364, 365; 24 Songs: 7-Form Index, 365 (684)

Daumier, Honoré: 15, 16, 62, 249, 250, 397; *Ratapoil*, 15 (11)

David, Jacques-Louis: 10, 11, 13, 16, 18, 22, 132; *The Oath of the Horatii*, 10 (3)

Davis, Douglas: 438
Davis, Stuart: 251, 260, 262–264, 266, 298, 376;
Blips and Ifs, 263 (473); Eggbeater No. 1, 262 (472), 266; Lucky Strike, 262 (471)
De Maria, Nicola: 395
De Maria, Walter: 372; Lightning Field, 372 (707)
De Stijl: 98, 148–159, 161, 162, 201–203, 205, 207, 210, 234, 243–246, 286, 341

Degas, Edgar: 19, 20, 27, 44, 45, 50, 53, 67, 68, 133, 134; Little Dancer Fourteen Years Old, 67 (94);

The Tub, 67 (95); Two Ballet Dancers, 21 (20)

Deitch, Jettrey: 404 Delacroix, Eugène: 13, 14, 16, 20, 26, 29, 111, 225; *Tiger Hunt*, 13 (8) Delaunay, Robert: 83, 117, 121, 149, 150, 168, 203,

Delaunay, Robert: 63, 117, 121, 147, 130, 106, 203,
 216, 246, 254; Simultaneous Contrasts, 149 (250)
 Delvaux, Paul: 97, 185, 186; Phases of the Moon,

Demuth, Charles: 7, 254, 299; I Saw the Figure 5 in

Gold, 254 (451) Gold, 254 (451) Denis, Maurice: 33, 43, 48, 101, 105, 118, 172 Derain, André: 75, 77, 102, 106–108; *Crouching Man*, 75 (117); *Westminster Bridge*, 106 (169)

Derrida, Jacques: 390, 436, 415, 437 Despiau, Charles: Young Girl from the Landes, 69 (99)

Dibbets, Jan: 372; Sea-Horizon, 0-135 Degrees, 372

Diebenkorn, Richard: 359: Ocean Park #90, 359

Dine, Jim: 304, 305, 311, 313; Hatchet with Two

Palettes, Slate No. 2, 305 (533) Dix, Otto: 128, 129; The Matchseller, 128 (211)

Dominguez, Oscar: 181, 187; *Untitled*, 187 (311) Doran, Ann: 427

Dove, Arthur: 250, 252, 254; Abstraction Number 2.

252 (447) Dubois, Paul: Military Courage, 61 (85) Dubuffet, Jean: 286–294, 296, 329, 358, 375, 400; Blood and Fire (Corps de dames), 291 (528); Change of View, 292 (530); The Forest, 292 (529), 293; Group of Four Trees, 293 (531); Mother Goldess, 291 (527) Duchamp, Marcel: 147, 149, 151, 169-173, 175, 170, 196 (197, 195, 241, 570, 576, 576, 576, 175, 175, 175);

179, 186, 187, 195, 241, 250, 256, 260, 261, 262, 266, 299, 302, 304, 310, 319, 321, 333, 358, 359,

200, 299, 302, 304, 310, 319, 321, 333, 338, 359, 360, 383; Bicycle Wheel, 171 (209); Botherack, 169 (286); The Bride Stripped Bare by Her Bachelors, Even (The Large Glass), 170 (288), 171, L.H.O.Q., 171 (291); Tu m², 172 (293); Why Not Sneeze, Ross Selavy, 171 (292), 172 webrawn Villan Pavmonet Large Herac 146, 147

Duchamp-Villon, Raymond: Large Horse, 146, 147

Dufy, Raoul: 102, 108, 231; Flag-decked Boat, 108

(173); Normandy Landscape, 230 (404) Dutert, Ferdinand: 86; Machinery Hall, International

Eakins, Thomas: 248, 264, 397; Miss Van Buren,

East Village, New York City: 398, 408 EAT (Experiments in Art and Technology): 365, 367

"Eccentric Abstraction" (exhibition): 370 École des Beaux-Arts (Paris): 13, 76, 84, 85, 90,

Eiffel, Gustave (Eiffel Tower): 82 (127), 83, 89, 203, 205, 209, 334 Einstein Tower, Potsdam: 200 (348), 201

Ellor, Albert: 62, 64, 66, 71, 76 Elsen, Albert: 62, 64, 66, 71, 76 Empire State Building, New York (Shreve, Lamb and Harmon): 206, 210 (364), 264 Endell, August: 54–55; Atelier Elvira, 54 (70), 55 endgame: 389, 408

Ensor, James: 12, 15, 48, 70, 112; Entry of Christ into Brussels, 48 (57) Environmental Art: 308, 310, 314, 329, 331–333, 335, 372; see also Earth Works

epistemology, defined: 394 Epstein, Jacob: 75, 77; *The Rock Drill*, 75 (116), 77 Ernst, Max: 167, 175–183, 186–190, 215, 231, 265,

267; Capricorn, 190 (330); The Elephant Celebes, 176, 177 (303); Gray Forest, 181 (310); A little

Sick, the Horse, 176 (302); Lunar Asparagus, 189

Index 445

199; Beaux-Arts tradition, 22, 61, 91, 97, 197,

Exposition, Paris, 86 (133)

Earth Works: 195, 328, 358, 371-374

deconstruction: 359, 415, 436 deconstructivism (architecture): 436–437

- Brutalism: 415; see also Art Brut
- Buchloh, Benjamin: 364 Buñuel, Luis: 429

363, 397, 406

395 (763)

10, 296 (538)

396 (764) Clert, Iris: 360

Colab: 399, 400, 417

- Burchfield, Charles: 256 264: Church Bells
- Burchfield, Charles: 256, 264; Cnurch Betts Ringing, 256 (456)
 Burden, Chris: 368, 369, 391, 400; Doorway to Heaven, 368, 369 (696); Medusa's Head, 391 (754); Shooting Piece, 368
 Buren, Daniel: 364, 437; 140 Stations du Métro
- Parisien, 365 (686) Burgee, John: see Johnson, Philip
- Burne-Jones, Edward: 38, 406, 428; King Cophetua and the Beggar Maid, 36 (38)
- Burnham, Jack: 366 Burri, Alberto: 287, 329, 370; Sack, 287 (518)
- Burton, Scott: 386, 400; Two-Part Chair, 386 (742) Bury, Pol: 338; Red Points, 338 (628)

Cal Arts (California Institute of the Arts, Valencia):

Calder, Alexander: 235, 260, 261, 262, 267; The

(470); Lobster Trap and Fish Tail, 261 (469) Carnova, Antonio: 12, 13, 18; Venus Italica, 12 (6)

Caro, Anthony: 162, 193, 283, 336, 337, 368, 371, 372, 401; *Midday*, 337 (624)

Carpeaux, Jean-Baptiste: 61, 62; *The Dance*, 62 (86) Celant, Germano: 370

141, 149, 217, 220, 222, 231, 250, 266, 290, 315; The Bay from L'Estaque, 29, 30 (29); The Great

Bathers, 32, 33 (34); The House of the Hanged Man, 28 (28); Luncheon on the Grass, 28 (27);

Mont Sainte-Victoire, 32 (32); Portrait of Ambroise Vollard, 32 (31), 141; Still Life with

Basket of Apples, 30 (30), 31 Chagall, Marc: 159, 265, 267, 395; The Green Violinist, 218 (379); I and the Village, 164 (279)

Chamberlain, John: 306, 308, 330; *Toy*, 308 (562) Chandler, John: 360

Chapman, Dinos and Jake: 423, 426, 428; Tragic

Chapman, Dhios and Jake: 425, 426, 426, 17agic Anatomies, 423 (820); Zygotic acceleration, bio-genetic, de-sublimated libidinal model, 423 Chéret, Jules: 58; Loïe Fuller, 58 (80)

Chia, Sandro: 389, 394, 395; Outdoor Scene, 394,

Chicago Tribune Tower Project: Gropius and Meyer,

207 (359); Loos, 96 (156); Saarinen, 95 (153), 347 Chillida, Eduardo: 296, 297, 371; *Dream Anvil No.*

Chirico, Giorgio de: 12, 38, 97, 163-167, 176, 179, 183, 185, 256, 310, 370, 396, 436; The Nostalgia of the infinite, 166 (281); The Seer, 166 (282)

Christo: 331, 374; Packaged Kunsthalle, 331 (614); Wall of Oil Barrels—Iron Curtain, 331 (613), 374;

Clemente, Francesco: 389, 395, 396; Perseverance,

Close, Chuck: 377–378, 398, 422; *Mark*, 377 (721) Club 57: 398, 399, 400

Colescott: 383–384; George Washington Carver

Crossing the Delaware: Page from an American History Textbook, 384 (738)

History Textbook, 384 (738) collage: 11, 74, 143, 146, 152, 163, 167, 168, 174–177, 190, 215, 226, 284, 293, 308, 329, 332 Color Field Painting: 111, 156, 222, 275, 276, 299, 304, 314, 315, 318, 335, 337, 388, 392, 423 Conceptual Art, Conceptualism: 195, 299, 339, 358, 359, 360–370, 371, 381, 382, 388, 389, 400, 413 Concrete Art: 296, 334, 335 Constructiving: 76, 146, 150, 174, 109, 205, 205,

Constructivism: 26, 146, 159, 174, 192, 205, 206, 234, 235, 238, 240–246, 266, 267, 280, 283–288,

234, 235, 254, 240–240, 260, 267, 280, 283–288, 309, 319, 253, 228, 327, 334, 335, 337, 339 Corbett, Harvey: 211, 214 (373) Cornell, Joseph: 175, 284 (512) Costa, Lucio: 351 (655) Courbet, Gustave: 9, 17, 20, 61, 62, 74, 102, 111,

207, 217, 249, 250, 251, 379; A Burial at Ormans, 16; The Painter's Studio, 9; Seascape, 16 (13)

143–145, 146, 176, 242, 252 Cucchi, Enzo: 389, 395

-Newton's

Cragg, Tony: 391, 401, 402; New Stones—Ne Tones, 400 (775), 402; Untitled, 402 (776)

The Wrapped Pont Neuf, 374 (714) Chryssa: Ampersand III: 327 (605), 328

CoBrA: 286, 288, 289 (521), 404 Cocteau, Jean: 429

Brass Family, 261 (468); La Grande Vitesse, 262

Cage, John: 298, 299, 302, 313-315, 321, 324, 367

(329): To 100.000 Doves, 181 (309)

Estes, Richard: 378; American Express Downtown, 378 (722) Evergood, Philip: 258; Lily and the Sparrows, 258

(460)

(460)
Existentialism: 285, 286, 289, 294
Expressionism: 13, 15, 47, 48, 59, 65, 66, 70, 71, 101–111, 122, 124, 125, 137, 139, 155, 168, 190, 193, 195, 217, 241, 242, 245, 248, 250, 251, 256, 259, 264, 265, 268, 273, 275, 277, 280, 286, 289, 290, 295, 305, 315, in architecture, 95, 100, 196, 199, 200, 201, 203, 207, 210, 212–214; see also Common Europeaniem Non-Europeaniem Non-European German Expressionism, Neo-Expressionism

Fashion Moda: 398, 400

Fauves, Fauvism: 9, 21, 72, 74, 101–112, 117, 118, 132, 133, 135, 138, 150, 222, 231, 236, 250, 267 Feininger, Lyonel: 117, 121, 130, 152; Gelmeroda VIII, 121 (198)

- feminism: 359, 382-384, 415
- Temmism: 359, 352–364, 413
 Ferber, Herbert: 280–281; Cage, 280 (505), 281
 Ferris, Hugh: 211, 212, 264, 350; "Looking West from the B.C.," from The Metropolis of Tomorrow, 211 (366)
- Finley, Karen: 416 Fischl, Eric: 389, 397–398, 406; Cargo Cults (for:
- *DS "King Kong"*), 397, 398 (767) Flanagan, Barry: 386; *Baby Elephant*, 386 (743)
- Flavin, Dan: 327, 357, 437; A Primary Structure, 325 (601)

Fleck, John: 416

Fluxus: 366-367

Fontana, Lucio: 335, 370; Spatial Concept, 335 (623)Foster, Norman: 438-439; Hongkong and Shanghai

Bank (with Ove Arup), 439 (853) Foucault, Michael: 394, 415

- Fragonard, Jean-Honoré: 10, 18, 220, 392; Blindman's Bluff, 11 (2)
- Francis, Sam: 316–317; Shining Black, 317 (581) Frankenthaler, Helen: 314–315, 335; Mountains
- and Sea. 314 (576): Movable Blue. 315 (577) Frankfurt School: 359, 390
- "Free Figuration": 386
- Freeze (exhibition, London): 422 Freud, Lucian: 375; Two Japanese Wrestlers by a *Sink*, 375 (715) Freud, Sigmund: 12, 137, 138, 163, 165, 166, 178,
- 183, 195, 266, 267, 294, 375, 415
- Freyssinet, Eugène: 94; Airship hangars, Orly, 94 (149)
- Fried, Michael: 365
- Friedrich, Caspar David: 14, 15, 393; Abbey Under Oak Trees, 14 (9)
- Fritsch, Katharina: 407, 410–411, 415; Display Rack with Madonnas, 409, 410 (794) frottage: 181, 187, 189

- Fry, Roger: 18, 34, 236, 250 Fuller, R. Buckminster: 342, 354–356; Two-Mile Hemispherical Dome for New York City, 356 (665); US Pavilion, Expo '67, 354 (663) Funk Art: 293
- Futurism: 66, 68, 117, 121, 147, 148, 152-157, 166 167, 169, 197, 198, 201, 207, 213, 236, 250, 252, 254, 336, 341, 352, 356; in architecture, 98, 100
- Gabo, Naum: 159, 192, 234, 235, 238, 240, 245, 246, 261, 265, 266, 334, 336, 339; Construction, Bijenkorf, Rotterdam, 234 (411); Head of a Woman, 159 (271); Kinetic Construction: Vibrating Spring, 245 (159); Linear Construction, Variation, 234 (410), 235; Realist Manifesto, 159
- Garnier, Charles: 81, 85; L'Opéra, Paris, 85 (124) Garnier, Tony: 91, 93, 94; Project for an Industrial City, 94 (148)
- Gaudí, Antoni: 84, 88, 89, 91, 95, 201, 396; Casa Milá, Barcelona, 89 (140), 200, 383; Sagrada Familia Barcelona, 89 (139), 200, 383 Gauguin, Paul: 9, 13, 22, 24, 28, 33, 34, 37, 38–44,
- 45, 47–50, 53, 54, 60, 67, 68, 91, 101, 102, 105, 109, 111, 112, 117, 118, 122, 133, 134, 156, 168, 105, 11, 112, 117, 116, 122, 135, 134, 130, 106, 250, 278, 380; Be in Love and You'll Be Happy, 40 (43); "Eh, quoi, es-tu jalouse?", 43 (90); "Les Miserables," 39 (42); Nirvana (Portrait of Jacob Meyer de Haan), 42 (47); The Vision after the Difference of the State of the State of the State of the State Network of the State of the State of the State of the State Network of the State of the State of the State of the State State of the State Network of the State Network of the State Network of the State of Sermon, 41 (44); Where Do We Come From What Are We? Where Are We Going?, 44, 45 (40); The Yellow Christ, 40, 41 (45)
- gay liberation: 415 Gedo, Mary Matthews: 134
- Gehry, Frank O.: 436–437, 439–440; Guggenheim Museum, Bilbao, 439, 440 (855); Loyola Marymount University Law School, 436 (847, 049) 436 (847, 848), 437
- Generation-X: 423
- Genet, Jean: 418

Index 446

- German Expressionism: 48, 66, 70, 76, 101, 106, 112–131, 392, 398 Giacometti, Alberto: 188, 231, 270, 280, 281, 288
- 289, 290, 293, 375, 382, 403; Annette, 289, 290 (524); City Square, 289 (522); Figure from Venice II, 289 (523); The Invisible Object (Hands Holding a Void), 188 (325); The Palace at 4 A.M., 188 (327); Woman with Her Throat Cut, 188 (326)
- Gilbert and George: 368, 372, 390; The Red

Sculpture: "Bloody Life and Dusty Corners," 368 (693); Sleepy, 368 (694) Gill, Irving: 100; Dodge House, Los Angeles, 100

Gilliam, Sam: 370; *Thrust*, 370 (701) Glackens, William: 251

- *glasnost*: 419 Gleizes, Albert: 148, 250
- Gober, Robert: 410, 428; The Split-Up Conflicted Sink, 410 (793)
- Gogh, Vincent van: 15, 22, 24, 34, 38, 39, 44–48, 50, 51, 53, 54, 65, 67, 71, 92, 101, 102, 104, 112, 126, 132, 217, 250; Garden of the Presbytery at Neunen, 45 (51); Night Café, 46 (54), 47; Self-Portrait, 45 (52); The Starry Night, 46 (53), 47, 48
- Goldberger, Paul: 435, 436 Goldin, Amy: 380 Goldin, Nan: 419–420, 424; At the Bar: Toon, C,
- *and So*, 419 (813), 419 Goldwater, Robert: 401
- Golosov, Ilya: 204; Professional Worker's Club, Moscow, 204 (356) Gontcharova, Natalia: 156, 158, 234, 265: Green
- *Forest*, 156 (264) González, Julio: 146, 192, 193, 231, 232, 281, 297,
- 336; *The Montserrat*, 232 (406); *Woman Combing Her Hair*, 231 (405) Gonzalez-Torres, Felix: 425; Untitled (Beginning);
- 425 (824)
- 42.5 (624)
 Gorky, Arshile: 194, 195, 264, 265, 267, 268, 270,
 271, 298; Agony, 269 (484); The Apple Orchard,
 268 (483); Enigmatic Combat, 194, 264, 268
- Gormley, Antony: 87, 400; *Three Calls*, 387 (745) "Gothik": 428
- Gottlieb, Adolph: 195, 265, 267, 277; Red Earth, 277 (498)
- Gowan, James: 354; Engineering Laboratories, Leicester University, 354 (661) Goya, Francisco: 11, 12, 15, 51, 153, 163, 223, 224, 294, 295, 385, 405; Saint Francis of Assisi Attending a Dying Man, 12 (4) Graffiti Art: 389, 398–400 Graham, John D.: 266, 267, 273; Blue Abstraction,
- 266 (480); System and Dialectics of Art, 266 Gran Fury: 416
- GRAV (Groupe de Recherche d'Art Visuel): 335, 337, 339
- Graves, Michael: 434-435; Portland Public Services Building, 434 (842), 435
- Graves, Nancy: 385–386, 400; Bel-Smelt, 385 (741); Variability and Repetition of Similar Forms II, 385 (740)
- Greenberg, Clement: 251, 298, 314, 315, 321, 358
- Grimes, Nancy: 398 Gris, Juan: 146, 148, 229, 265, 268, 388; Bottle of Banyuls, 148 (248), 149; Still Life, 149 (249)
- Grooms, Red: 312; *Ruckus Manhattan*, 312 (571) Gropius, Walter: 95, 98, 197, 199, 204–207, 214,
- 241, 243, 245, 340; Bauhaus, Dessau, 206, 207 (358), 241; Fagus Shoe Factory, 198 (343); Chicago Tribune Tower, 207 (359) Grosz, George: 127, 129, 152, 173, 174, 215; The Big City, 127 (210); Remember Uncle August the
- Unhappy Inventor, 174 (298)
- Group Material: 425
- Guggenheim, Peggy: 267, 272, ₽73 Guimard, Hector: 55, 91–93, 436; Métro entrance,
- Paris, 92, 93 (145), 436 Guston, Philip: 381–382, 386, 387; *To B.W.T.*, 381 (729), 382; Double Portrait, 381 (730), 382

Haacke, Hans: 364, 369, 415; Condensation Cube, 369 (698); On Social Grease, 364 Hadid, Zaha M.: 437

Hains, Raymond: 331

- Halbreich, Kathy: 395 Halley, Peter: 407, 408; V, 408 (788)
- Hamilton, Ann: 413-414; Tropos 413 (800), 414
- Hamilton, Richard: 332, 333, 353; Just What Is It that Makes Today's Home So Different, So
- Appealing?, 332 (616) Hanson, Duane: 378–379, 387, 400; Shoppers, 378 (724)
- Happenings: 168, 299, 301, 302, 312-314, 329, 365
- Hard-Edge Painting: 319–321, 405 Haring, Keith: 398, 399, 420, 426; Art in Transit, 398 (768); Untitled, 399 (769)
- Harrison, Charles: 362; see also Art & Language Harrison, Wallace: 214, 349; Rockefeller Center,
- New York, 214 (372) Hartley, Marsden: 250, 252, 253; *Portrait of a* German Officer, 253 (449)
- Hartung, Hans: 285, 286, 316, 330; T 1947-25, 286 (514)
- Harvey, Marcus: 422–423; *Myra*, 422 (818) Heckel, Erich: 112; *Two Men at a Table*, 114 (183) Heilman, Mary: 426, 427; Popocatepétl, 426 (826) Heizer, Michael: 371–372; Double Negative, 371 (706)
- Hejduk, John: 437, 438
- Hélion, Jean: 246, 334
 - Henri, Robert: 258; *Laughing Child*, 258 (441) Hepworth, Barbara: 80, 240, 241, 266, 334, 372;
 - *Sculpture with Color and String*, 80 (424) Herbin, Auguste: 242, 246, 266, 334; *Air Fire*, 266 (436)
 - Hesse, Eva: 370; Right After, 37 (702)

Heubler, Douglas: 361, 362; Duration Piece #9, 361 Hill, Gary: 427 Himmelblau, Coop: 437

(844)

(439)

Hughes, Holly: 416 Hughes, Robert: 404, 421

Hyper-Realism: 381

identity politics: 416

(822, 823), 425 (824)

Museum, 438 (852), 439

American Cities, 430

Jarry, Alfred: 163, 165, 167

Jencks Charles: 422 432

and Doll. 384 (735)

Jorn, Asger: 410

418

Janco, Marcel: 167

Jaudon, Valerie: 380

(199)

Hujar, Peter: 420 Huysmans, Joris-Karl: 34, 37

Hinman, Charles: 320; *Poltergeist*, 320 (588) Hirst, Damien: 422, 424, 428; *Away from the Flock* (817), 422

Kandinsky, Vasily: 9–11, 13, 44, 56, 76, 101, 112, 116–123, 126, 147, 150, 155, 158–160, 162, 168, 198, 217, 242, 243, 246, 250, 252, 266–268, 271,

281, 329, 334, 338; Black Lines, 120 (195); Blue Rider Almanac, 116 (191); Composition IV, 119

(193); Landscape with Tower, 119 (192); On White, 242 (428); Tempered Élan, 243 (429)

Wash," part of the Happening Household, 314 (575); "The Legacy of Jackson Pollock," 313

Kaplowitz, Jane: 390; Art in Living Room, 390 (751) Kaprow, Allen: 298, 299, 313, 314, 329, 366; "Car

Katz, Alex: 376, 377; Patti and Martha, 377 (720) Kawara, On: 364, 365; Today, 365 (685) Kelley, Mike: 420, 421; Arena #5, 420 (814); Craft

Keney, Mike: 420, 421; Arena #3, 420 (814); Craft Morphology Flow Chart, 420 (815)
 Kelly, Ellsworth: 172, 303, 305, 319, 335; Blue Green, 172, 305, 319 (586); Blue, Green, Yellow, Orange, Red, 319 (585)

Kemeny, Zoltan: 296, 371; Lines in Flight 2, 296

Khnopff, Fernand: 38, 406, 428; I Lock my Door

Upon Myself, 38 (41) Kiefer, Anselm: 388, 389, 392, 394–395, 411;

Märkischer Sand, 394 (761) Kienholz, Edward: 310, 419; State Hospital, 311 (568) Kikutake, Kiyonori: 352; Civic Center, Miya-komojo, Japan, 352 (658) kinetic art: 64, 66, 170, 245, 326, 329–339

Kirchner, Ernst Ludwig: 112, 113, 126, 130, 131, 250, 393; Head of Ludwig Shames, 116 (189), 117; Self-

(102), while 1008 in Hammary, 137 (216), woman in Front of a Vase of Flowers, 113 (180) Kirkeby, Per: 404–405, 425; Fünf, 404 (795), 405 Kitaj, R.B.: 333, 359, 407; Arcades (after Walter Benjamin), 333 (619), 359, 413

Klee, Paul: 117, 122-124, 130, 152, 168, 179, 198,

242, 245, 258, 293; Around the Fish, 123 (203);

Individualized Alimentary of Stripes, 123 (202);

Klein, Yves: 314, 329–330, 335, 360–362; Anthro-

pometries of the Blue Period, 330 (609); Mono chrome Blue, 329 (608); Le Vide, 360 (673), 361

Klimt, Gustave: 36, 37, 59, 60, 84, 92, 96, 112, 124, 125, 380, 428; *Expectation*, 60 (84); *The Kiss*, 59

Kline, Franz: 195, 265, 272, 275, 286, 297, 298, 425; *Monitor*, 272 (490)

Kokoschka, Oskar: 59, 126, 127, 130; Dresden: The

New City, 127 (209); The Tempest (The Wind's Bride), 126 (208); "Der Trancespieler", 126 (207) Kolbe, Georg: 71, 130; Dancer, 71 (105)

Kollwitz, Käthe: 122, 129, 130; Death, Woman and Child, 122 (200); Rest in the Peace of His Hands,

Kooning, Willem de: 162, 195, 265, 267, 268, 270–273, 275; Excavation, 270 (487), 275; Pink

Bubbles, 408, 409 (789) Kosuth, Joseph: 358, 359, 360–361, 362, 407; *Art as*

Idea as Idea, 359 (670), 361; One and Three Chairs, 360, 361 (673)

Kozloff, Joyce: 380, 381; Railway Station Vestibule,

Kramer, Pet: 201; Dageraad Housing, Amsterdam,

Krauss, Rosalind: 371, 400, 409 Kruger, Barbara: 407, 408, 415, 426; Untitled (The

Marriage of Murder and Suicide), 407 (787), 408 Kuitca, Guillermo: 418; Tablada Suite, 419; Untitled

(San Francisco), 417 (809), 418 Kupka, Frank: 149, 150, 254; Amorpha: Fugue in

Two Colors, 150 (251) Kusama, Yayoi: 418, 419; *Cosmic Door*, 418 (811),

419; Infinity Net Painting, Accumulation #2, Macaroni Floor, and Kusama, 418 (812), 419 Kushner, Robert: 380-381; Tryst, 380 (727)

l'art informel/Informal Art (tachisme): 285-288.

296, 316, 329, 334, 335, 392 Labrouste, Henri: 83; Reading Room, Bibliothèque

Lachaise, Gaston: 71; Standing Woman, 71 (106)

Lasker, Jonathan: 425-426: The Eternal Silence of

Infinity Space, 426 (825) Lassaw, Ibram: 280; Clouds of Magellan, 280 (503)

Le Corbusier (Charles-Édouard Jeanneret): 89, 94, 98, 150, 151, 196, 199, 203–205, 207–214, 242,

Job, 151, 150, 151, 150, 152, 205-205, 201-214, 242, 340-346, 348-350, 352, 354, 431, 438, After Cubism, 242; Building, Chandigarh, 347 (646); Notre Dame du Haut, Ronchamp, 340, 341 (635), 343, 346 (645), 347; L'Esprit nouveau pavilion,

Laurens, Henri: 147; Bottle and Glass, 147 (244)

Nationale, Paris, 83 (128), 91

Lacan, Jacques: 390, 415

Larionov, Mikhail: 156, 158 Larsen, Nella: 418

Larson, Kay: 393

Krasner, Lee: 264, 267, 278; Untitled, 267 (481)

Kounellis, Jannis: 370, 419; Cavalli, 370 (703)

Wilmington, Del., 380 (728) Kramer, Hilton: 156

Angels, 270 (486); Woman and Bicycle, 162, 271 (488); Woman in a Landscape IV, 271, 272 (489) Koons, Jeff: 408, 422, 428; Michael Jackson and

(82), 92, 124; Medicine, 59 (81); Portrait of Adele

Siblings, 124 (204)

Bloch-Bauer, 60 (83)

Klotz, Heinrich: 438

129 (214)

201 (350)

Koolhaas, Rem: 437

Portrait with Model, 113 (181); Street, Berlin, 113 (182); White House in Hamburg, 131 (218); Woman

Kardon, Janet: 397

(536)

- Hitchcock, Henry Russell: 433
- Hoch, Hannah: Cut with the Kitchen Table, 174 (299) Hockney, David: 332, 333, 353, 424; The Splash, 332 (617)
- Hodgkin, Howard: 405, 425; Goodbye to the Bay of Naples, 405 (782)
- Hodler, Ferdinand: 36, 48, 101, 112; *Night*, 48 (58) Hoffmann, Joseph: 60, 96, 199; Palais Stoclet, Brussels, 96 (154)
- Hofmann, Hans: 195, 266, 267, 269, 270, 423; *Composition*, 266 (479); *Spring*, 269 (480) Hollein, Hans: 435; Austrian Travel Agency, 435

Holzer, Jenny: 391, 411–412, 413, 415, 427, 432; *Installation*, 412 (797)

Homer, Winslow: 247, 397, 403; Northeaster, 248

(439)
Hood, Raymond: 211, 214; McGraw-Hill Building, 211; Rockefeller Center, 214 (372)
Hopper, Edward: 256, 264, 299, 333, 397; Nighthawks, 256 (455)
Horta, Victor: 55, 91, 92; Maison du Peuple, 92 (144); Tassel House, 92 (143)
Howe, George: 211; Philadelphia Savings Fund Society Building, 211 (365)
Huebsenbeck, Richard: 167
Huebse Holly: 416

illusionism: 10, 22, 31, 68, 134, 140, 144, 147, 176, 183, 195, 220, 260, 283, 304, 315, 320, 321, 323

Impressionism: 9–11, 13, 18, 19, 21, 24, 25, 29, 33, 34, 37, 38, 45, 49, 50, 51, 62, 67, 68, 93, 104, 105,

113, 163, 169, 215, 249, 314, 315, 357, 376, 428 Indiana, Robert: 305; *Alabama*, 305 (554)

Informalism: 397; see also *l'art informel* Ingres, Jean-August-Dominique: 13, 20, 29, 35,

Hgres, Jean-August-Dominique. 13, 20, 25, 35, 109, 220, 222, 250; Odalisque with Slave, 13 (7) installation art: 382 (732), 407 (786), 411 (795, 796), 412 (797, 798), 413. 414 (800), 415 (803), 416 (807), 420 (815), 421 (816), 423 (821), 424 (822, 822), 425 (804).

International Style (architecture): 88, 91, 98, 196, 197, 203, 205–210, 212–214, 334–343, 346–348

Irwin, Robert: Untitled, 80, 325 (600) Isozaki, Arata: 438, 439; Okanoyama Graphic Art

Izenour, Steven; 431; Learning from Las Vegas, 431

Jacobs, Jane: 430; Death and Life of Great

Japanese art: 17, 18, 20, 21, 43–45, 50, 51, 57, 98, 130, 284, 312, 352

Jawlensky, Alexej: 117, 122; The Hunchback, 122

Jenney, Neil: 381, 383; Acid Story, 383 (736); Girl

Johns, Jasper: 252, 284, 302–305, 308, 311, 358, 388; Fall, 388 (748); Numbers in Color, 304

586; Pali, 586 (146); Numbers In Color, 504 (550); Painted Bronze (Ale Cans), 304 (552); Painted Bronze (Savarin), 304 (551); Painting with Two Balls, 302, 303 (549); Target with Plaster Casts, 284, 302, 303 (547); Three Flags,

Johnson, Philip: 198, 340, 341, 343, 345, 348, 350, 351, 354, 430, 431, 343, 345, 348, 350, 351, 354, 430, 433-434, 437; AT&T (Sony)
 Building (with John Burgeo, 430 (833), 433–434

(339, 840, 841); Boston Public Library, 348 (649); "Deconstructivist Architecture" (exhibition, with Mark Wigley), 437 The Glass House, 341 (635);

Jones, Allen: 330, 332; *Holding Power*, 332 (618)

Judd, Donald: 80, 162, 323, 324, 325, 336, 357, 404,

419; Untitled, 323 (596); 5 Elements, 357 (668) Jugendstil: 54, 55, 59, 112, 124; see also Art Nouveau

Kabakov, Ilya: 412, 413; The Man Who Flew into Space from His Apartment, 412 (798)

Kahlo, Frida: 260, 261; Diego and I, 260 (467), 261,

418 Kahn, Louis I.: 91, 342, 343, 345, 348–350, 355, 431; National Assembly Complex, Dacca, Bangladesh, 349 (652); Salt Institute of Biological Studies, La Jolla, Calif., 350 (653); Unitarian Church, Rochester, N.Y., 350 (654)

Kallmann, McKinnel and Knowles: 353; City Hall,

Sheldon Art Gallery, Lincoln, Neb., 348

Jung, Carl Gustave: 266, 267. 273. 277

"Junk" art: 308, 309, 330

Boston, 353 (660)

Jeanneret, Charles-Édouard: see Le Corbusier

Holt, Nancy: 374: Dark Star Park. 374 (713)

208; "A Contemporary City of Three Million Inhabitants," 208 (361); Palace of the Soviets, 205 (357), 207, 347; Radiant City, 212, 344, 345, 351, 352, 356; Second Citrohan House, 208 (360), 346; Schwob House, 199 (344), 205, 242; *Still Life*, 150, 151 (254), 198, 242; Unité d'Habitation, 346 (644); Vers Une Architecture, 199, 207, 431; Villa Savove, 196, 199 (341), 242, 340, 438; Voisin plan for Paris, 208 Léger, Fernand: 138, 147, 148, 150, 169, 214, 216,

Zeler, Fernandi, 156, 177, 146, 150, 169, 214, 210,
 Z41; The City, 150, 151 (253); Contrast of Forms,
 150 (252); Three Women, 241 (426)
 Lehmbruck, Wilhelm: 66, 70, 71, 129-131; Fallen

Man, 70 (104), 71; Kneeling Woman, 130 (216) Lescaze, William: 211; Philadelphia Savings Fund

Society Building, 211 (365) Lévi-Strauss, Claude: 359

- Levin, Kim: 379
- Levin, Klmi 579 Levine, Sherrie: 391, 407, 409–410, 415; Fountain (After Duchamp: 1), 409, 410 (792), Unitiled (Broad Stripe 2), 409, 410 (791) Levis, Wyndham: 236; Composition, 236 (413);
- Lewis, "yindiani. 250 (e13), Portrait of Edith Sitwell, 236 (414)
 LeWitt, Sol: 358, 360, 362, 383; Serial Project (A.B.C.D.), 358 (674); Untitled, 326 (602)
- Libeskind, David: 437 Lichtenstein, Roy: 299, 305, 307, 312, 358, 393; The
- Artist's Studio: Th Whaam!, 306 (556) The Dance, 306, 307 (557); Liebman, Lisa: 387 Ligon, Glenn: 416, 417–418; Untitled (I Do not
- Always Feel Colored), 416 (808), 417–418 Limone, Guy: 415; In 1995, 1,170 People Were
- Killed in New York City, 414, 415 (803) Lincoln Center for the Performing Arts, New York:
- 348 (650), 349 linguistics: 359, 363, 422; see also structuralism,
- post-structuralism, semiotics, semiology Lipchitz, Jacques: 146, 147, 188, 194, 215, 232, 233,
- Lipcinic, Jacques, 140, 147, 166, 194, 210, 252, 253, 267; Figure, 233 (408); Man with a Guitar, 147 (245); Mother and Child, 233 (409); Reclining Nude with Guitar, 232, 233 (407)
 Lippard, Lucy: 313, 360, 370
 Lipton, Seymour: 280–281; Sorcerer, 280 (540)
- Lissitzky, El: 159, 205, 242, 243, 266, 337; Proun, 243 (430)
- Long, Richard: 372, 390, 402; *Bolivia*, 372 (708) Loos, Adolf: 91, 95–97, 100, 207; Chicago Tribune
- Tower, 96 (155); Steiner House, Vienna, 96 (155) Louis, Morris: 315, 316, 335; *Bellatrix*, 316 (578);
- Point of Tranquility, 316 (579) Lucier, Mary: 427
- Lye, Len: 326-327; Fountain II, 326 (603)
- Macdonald-Wright, Stanton: 254
- machine art: 150, 151, 153, 162, 169, 173, 175, 246, 256, 260, 271, 278, 327
- Maciunas, George: 366; see also Fluxus Macke, August: 117
- Mackintosh, Charles Rennie: 88, 91, 96; Library, School of Art, Glasgow, 88 (138)
- Mackmurdo, Arthur H.: 55, 58; Wren's City Churches, 58 (79) Madoff, Steven Henry: 395, 427
- Magnitic, Seven Henry, 393, 427 Magnitic, René: 97, 167, 182, 185, 365, 436; The Empire of Lights, 185 (318); The Human Condition, 185 (317); The Lovers, 185 (319); The Phantom Landscape, 184 (316); La Révolution surréaliste, 184; The Wind and the Song, 184 Maillol, Aristide: 43, 48, 69, 70–72, 250; Action in
- Chains, 69 (101), 70; The Mediterranean, 69 (100); The Young Cyclist, 70 (102)
- Maki, Fumikiko: 438 Malevich, Kasimer: 157–159, 162, 205, 234, 242, 245, 265, 279; Advertisement Column, 157 (266); Black Square on a Black Ground, 158; Suprematist Painting (Eight Red Rectangles), 157 (267)

Mallarmé, Stéphanie: 35, 39, 40, 44, 133, 222, 392 Malonev, Martin: 422 Manessier, Alfred: 285, 286

- Manet, Éduoard: 9, 18-20, 22, 28, 29, 50, 102, 104 133, 207, 249, 250, 379, 403, 404, 405, 419, 428; Luncheon on the Grass, 17 (15); Olympia, 419
- Mangold, Robert: 322–323; One-half Gray-Green Curved Area, 323 (594)

Manzoni, Piero: 360, 370; *Achrome*, 360 (680), 361 Manzù, Giacomo: 297, 375; *The Cardinal*, 297 (540)

- Mapplethorpe, Robert: 415–416; Ajitto, 415 (804) Marc, Franz: 117, 120–123, 131, 152, 155; Animals Fate, 121 (197); Blue Horses, 120 (196); Genesis
- II, 131 (217) Marcuse, Herbert: 373

- Marden, Brice: 404, 409; Elements III, 312 (593); Cold Mountain 3 (Open), 404 (780) Marin, John: 250, 251, 266, 312; Lower Manhatte
- 251 (445) Marinetti, Filippo Tommaso: 100, 152, 155
- Marini, Marino: 297, 375; The Concept of the Rider, 297 (539)

- Marisol: 311; *The Party*, 311 (570) Martin, Agnes: 320; *White Stone*, 320 (591) Marsim: 15, 195, 359, 362 Masson, André: 178-180, 182, 194, 267, 268, 273; Battle of Fishes, 178 (305); Iroquois Landscape, 179 (306)
- matière: 371, 371, 397

Matisse, Henri: 9, 11, 13, 18, 22, 44, 69, 72–74, 76, 91, 101, 102–106, 109–111, 112, 115, 132, 133, 135. 136. 156. 181, 191, 214, 215, 219-223; Back I, 74 (112); Back IV, 75 (113); Blue Nude, Souvenir of Biskra, 115 (187); Carmelina, 103 (164); Chapel of the Rosary, Venice, 222 (338); Dance, 110 (177); Decorative Figure on Ornamental Background, 221 (384); The Green Stripe (Portrait of Mme Matisse), 106 (168); Girl Stripe (Portrati of mine Matisse), 100 (108); Girt in a Yellow Dress, 220 (383); Jeannette I, 73 (110), 74; Jeannette V, 73 (111); Joy of Life, 109 (175); Luxe, calme et volupté, 103 (165) Music (Study), 111 (176); The Music Lesson, 219 (381); Open Window, Collioure, 104 (166); "Notes of a Painter," 74, 101, 111; Piano Lesson, 219 (380); Pink Nude (early state), 221 (385); Pink Nude, 221 (386); The Plumed Hat, 220 (382); The Red Studio, 111 (178); The Serf, 73 (108); La Serpentine, 73 (109); Sorrows of the King, 222

- (387); Woman with the Hat, 105 (167) latta (Sebastian Antonia Matta Echaurren): 194–195, 267, 268; Listen to the Living, 195 (340) Maybeck, Barnard: 85 McCollum, Alan: 407–408; *Plaster Surrogates*, 407
- (786)
- McConnel, Kim: 380 McKim, Charles F.: 91, 98, 100; Pennsylvania Station, New York, 91 (142)
- McLuhan, Marshall: 333, 412
- McLunan, Marshall: 555, 412 Meier, Richard: 350, 438, 439–440; Ackerberg House, 438 (850); Getty Center (with Michael J. Paladino), 439 (854), 440
- Mendelsohn, Erich: 200, 201, 205, 213, 348, 349; Einstein Tower, Potsdam, 200 (348) Mengoni, Giuseppe: 81, 83; Galleria Vittorio
- Emanuele II, Milan, 82 (126)
- Merz, Mario: 370, 419: Double Igloo: Alligator with
- Fibonacci Numbers, 370 (704) Metaphysical School (scuola metafisica): 166
- Metzinger, Jean: 148, 156 Meunier, Constantin: 62; The Soil, 62 (87)
- Meyer, Adolf: 198, 199, 205, 207; Chicago Tribune Tower, 207 (359); Fagus Shoe Factory, 198 (343) Meyer, Hannes: 205
- Mies van der Rohe, Ludwig: 86, 95, 98, 162, 196-Has tad ter tota barries tota barries of p. 95, 195, 195, 195, 199, 201, 205, 209-211, 214, 243, 246, 340–343, 345, 349–351, 354, 357, 358; German Pavilion, Barcelona, 210 (362); National Gallery, Berlin, 345 (634); Seagram Building, 342 (636), 433
- Miller, Tim: 416
- Millet, Jean-François: 15-16, 17, 62; The Gleaners, 15 (12)
- Minimalism: 156, 159, 162, 246, 262, 279, 298–299, 320–329, 335, 336, 357, 358, 359, 360, 361, 363, 364, 369, 371, 375, 376, 380, 381, 382, 388, 389, 391, 392, 400, 401, 404, 407, 415, 426
- Minne, George: Fountain of Five Kneeling Youths, 70 (103) Miró, Jean: 123, 168, 179–182, 187, 190, 215.
- 226-229, 232, 241, 260, 261, 265, 267-269, 273 220–229, 224, 243, 260, 261, 260, 261, 260, 261, 260, 274, 278, 284, 388; Alicia, 228 (400); The Harlequin's Carnival, 180 (308); The Hunter (Catalan Landscape), 180 (307), Object, 187 (323); On the 13th the Ladder Brushed the Firmament, 228 (399); Personnages rhymiques, 226 (395); The Reaper, 227 (397); Still Life with Old Shoe, 226 (396); Woman's Head, 227 (398)
- Mitchell, Joan: 271, 280, 298–299, 315; George Went Swimming at Barnes Hole, 299 (541) Modersohn-Becker, Paula: 122: Self-Portrait with
- an Amber Necklace, 122 (201) Modigliani, Amedeo: 165, 168, 215, 217, 265; Head.
- 218 (378); *Portrait of Chaim Soutine*, 218 (378) Moholy-Nagy, László: 159, 198, 205, 243–246, 261, 327, 334, 337, 339; Composition No. 2, 244 (433); Light-Space Modulator, 245 (435); The New
- Vision, 245; Painting, Photography, Film, 246; Vision in Motion, 245 Mondrian, Piet: 22, 76, 118, 158, 160, 161, 201, 202, 240, 241, 245, 246, 260, 261, 264, 267, 275, 281,
- 334, 337, 385; Broadway Boogie-Woogie, 162 (277); Composition (Blue, Red, and Yellow), 161 (276); Composition No. 10: Pier and Ocean, 161 (274); Flowering Apple Tree, 160 (273); Natural Reality and Abstract Reality, 161; Neo-Plasticism, 161, 162; The Red Tree, 160 (272)
- Monet, Claude: 15, 19-23, 27, 28, 34, 51, 93, 106. 118, 221, 275, 315, 318, 385, 392; Boulevard des Capucines, 19 (27); Water Lilies, 22–23 (21)
- Moore, Charles: 432–433; Beverly Hills Civic Center, 432 (837), 433
- Center, 432 (857), 433 Moore, Henry: 234, 236, 237–239, 241, 266, 372, 375, 402; Madonna and Child, 239 (421); Nuclear Energy, 239 (422); Reclining Figure, 240 (423); Recumbent Figure, 237 (417) Moorman, Charlotte: 367 Moréne Lever, 24, 25

- Moréas, Jean: 34, 35 Moreau, Gustave: 34–39; *The Apparition*, 34 (35) Morimura, Tasumasa: 418-419; Portrait (Futaga) 418 (810), 419; Sickness Unto Beauty-Self-
- Portrait as Actress, 419 Morley, Malcolm: 378, 379; *Racetrack*, 379 (723) Morris, Robert: 80, 162, 324, 325, 328, 357, 369,
- 371; Untitled, 324 (598) Morris, William: 36, 55, 57, 85, 88, 92; Pimpernel,
- 55 (72)

Moskowitz, Robert: 381, 384; *Thinker*, 384 (738) Motherwell, Robert: 195, 265, 273, 277–279, 298; Elegy to the Spanish Republic No. 128, 278 (499); Pancho Villa, Dead and Alive, 277; Stravinsky Paladino, Mimmo: 395

Rose, 295 (535)

"pathetic art": 421

116 (190)

Pesce, Gaetano: 437

Pfaff, Judy: 424

peintres maudits: 215, 216, 218 Penck, A.R.: 389

Performance Art: 358, 365–368, 413 Perreau, John: 357

House, Rue Franklin, Paris, 93 (146)

Paolozzi, Eduardo: 295, 296, 332, 401; Akapotic

Pascin, Jules: 165, 215, 216, 217; Claudine at Rest, 216 (374)

Paxton, Joseph: 83; Crystal Palace, London, 83 Pearlstein, Philip: 379; Female Model on Adiron-dacks Rocker, Male Model on Floor, 379 (725)

Pearman, Hugh: 439 Pechstein, Max: 115–117, 126, 127, 147; *Landscape*,

Pereira, Irene Rice: 264; Ascending Scale, 264 (477) perestroika: 419

Perret, Auguste: 91, 93–95, 98, 196, 199; Apartment

Pevsner, Antoine: 159, 235, 246, 334, 335; Construction in the Egg, 235 (412)

Peyton, Elizabeth: 413, 426, 427; Piotr (799), 413

photography: 16, 20, 21, 358, 413 Photorealism: 305, 358, 363, 375, 376–379, 388, 394

Piano, Renzo: 438, 439; Pompidou Center, Paris (with Richard Rogers), 438 (851), 439 Picabia, Francis: 147, 148, 152, 169, 172, 173, 175,

179, 241, 250, 333, 391, 396; Amorous Parade, 172 (295); Ici, C'est Stieglitz, 172 (294)

Picasso, Pablo: 9, 13, 18, 22, 32, 74, 76, 105, 110, 111, 132-147, 149, 154, 156, 159, 165, 167, 179,

181, 188, 190-194, 214, 215, 222, 223-225, 226-229, 231, 232, 238, 240, 242, 246, 250, 251, 264-

266, 268, 270, 271, 273, 278, 281, 285, 295, 336, 359; Bathers, 238 (418); Bread and Fruitdish on

357, Balles Y., 258 (16), Bread and Frankish on a Table, 138 (277); Bull's Head, 190 (331); Crucifixion, 194 (339); Les Demoiselles d'Avignon, 137 (226); The Dream and Lie of Franco, 223 (390); End of the Number, 113 (220);

Fanily of Salimbanques, 135 (223); Girl before a Mirror, 193 (338); Guernica, 224 (391); Guitar, 143 (236); Harlequin: Portrait of the Painter Jacinto Salvado, 191 (333); Houses on the Hill,

Horta de Ebro, 140 (230); Man with a Hat, 144 (239); Minotauromachy, 223 (389); Model and Surrealist Sculptor, 192 (336); Nude Woman, 141

(234); Portrait of Ambroise Vollard, 141, (223); Portrait of Gertrude Stein, 136 (225); Portrait of

a Young Girl, 114 (240); Seated Bather, 191 (334); Seated Woman, 192 (337); Still Life with

Chair Caning, 143 (237); Three Musicians, 145 (241); Three Women, 139 (229); Three Women at

the Spring, 191 (332); Two Nudes, 135 (224); Two Women in a Bar, 133 (221); La Vie, 134 (222);

Violin and Bottle on a Table, 146 (242); Vollard

Suite No. 63, 224 (392); *Woman's Head*, 140 (231) Piene, Botto: 339; *Hot Air Balloons*, 339 (631)

Piper, Adrian: 417, 418; *Cornered*, 416 (807), 417 Pissaro, Camille: 19, 20, 24, 26, 29, 31, 39, 51, 93;

Spring Sunshine in the Meadow at Eragny, 21 (19) Pistoletto, Michelangelo: 333, 359; He and She

Talk, 333 (620), 334; Venus of Rags, 359 (671)

Poelzig, Hans: 200, 213; Grosses Schauspielhaus

(Great Theater), Bernin, 215 (346)
 Pointillism: 20, 25, 45
 Polke, Sigmar: 389, 390, 392, 393, 403, 423, Treppenhaus, 392 (758), 393
 Pollock, Jackson: 22, 179, 195, 257, 265, 267, 269,

271-275, 278, 280, 288, 298, 304, 314-316, 321, 329, 330, 358, 365, 369, 381, 394, 395, 399, 404,

411; Autumn Rhythm, 274 (493); Cathedral, 274; Lavender Mist, 274, 275; Number One, 275;

Pasiphaë, 273 (492); Pollock at work (photo), 274 (494); Square Composition with Horse, 273 (491)

Polshek, James Stewart: 438 Pomodoro, Arnaldo: 296, 297, 371; Rotating First

Fonjoldi Center, Faris, see Rogers, Richard Ponto, Gio: 342, 343; Pirelli Building, 342 (368) Poons, Larry: 244, 318, 326, 335; Unitiled, 318 (583) Pop Art: 195, 246, 257, 264, 293, 298–329, 331–334, 353-355, 357, 358, 363, 364, 375, 386 Popola, Liubov: 156, 157; The Traveler, 156 (265)

Porter, Fairfield: 376, 377; Amherst Parking Lot I, 377 (719)

Post-Impressionism: 9, 20, 34, 39, 55, 58, 60, 61, 84,

Post-Painterly Abstraction: 314-318, 321, 335, 336 post-structuralism: 359, 361, 363, 389–390, 403-404, 407, 421–422; *see also* semiotics

Poussin, Nicolas: 13, 16, 28, 29, 32, 109, 132, 138, 207, 231, 242, 290

Primary Forms/Structures: 283, 323, 327, 357, 361

91, 102, 104, 111, 117, 132, 220, 236, 250 post-Minimalism: 357, 359

post-modernism (architecture): 430–436 post-modernism: 357 ff

Pompidou Center, Paris: see Rogers, Richard

. 274

Index 447

(Great Theater), Berlin, 213 (346)

Plagens, Peter: 426, 427 pluralism: 357 ff, 413 ff, 430

Section, 296 (537)

Pre-Raphaelites: 36, 38

Precisionists: 173, 254, 257, 263

387, 400; see also Minimalism

papier collé ("pasted paper"): 143, 144, 149, 262

Pattern and Decoration: 358, 380–381, 388

Spring, 279 (500) Mucha, Alphonse: 55, 56; "*Job*" *Cigarettes*, 56 (74)

Mudd Club: 420 Mühl, Otto: 368

Müller, Otto: 115; Three Bathers, 116 (188)

multiculturism: 415 Munch, Edvard: 15, 24, 37, 47–49, 54, 65, 70, 101, 112, 130, 385; The Cry, 47 (56), 70; The Dance of Life, 47 (55), 70, 101; Death Chamber, 101; The Kiss, 49 (59)

Münter, Gabriele: 117–119; *The Lady and Her Son*, 119 (194)

Murphy, Catherine: 379; *Cellar Light*, 379 (726) Murphy, Gerald: 263, 264, 299; *The Watch*, 263

(474) Murray, Elizabeth: 384–385; Can You Hear Me?, 385 (739)

Muschamp, Herbert: 440

Nabis: 43 47 48 60 69 102 105 156 250 Nadelman, Elie: 72; *Man in the Open Air*, 72 (107) National Endowment for the Arts (NEA): 398, 416

Nauman, Bruce: 363, 391, 414, 429; Life Death, 363 (680); Waxing Hot, 363 (679)

Neel, Alice: 376; *Mother and Child*, 376 (717) Neo-Abstraction: 393, 403–407

Neo-Conceptualism: 392, 393, 407–412 Neo-Expressionism: 293, 392, 393, 388–398

Neo-Geo: 389, 413, 414 Neo-Gothic: 81, 89, 95, 205

- Neo-Impressionism: 13, 20, 26, 34, 55, 101, 102, 104, 113, 142, 254
- neo-Maxism: 359

310 (565)

Neo-Modernism (architecture): 350, 351, 355, 438-449

Neo-Plasticism: 161, 162, 202, 264, 266 Neoclassicism: 13, 61, 69, 86, 95, 96, 190, 191, 205 Nervi, Pier Luigi: 342, 343, 355; Pirelli Building, Milan, 342 (638); Sports Palace, Rome, 355 (644)

Neutra, Richard: 100, 212; Dr. Lovell's "Health House, Los Angeles, 212 (368)

Nevelson, Louise: 284, 309–311; Sky Cathedral-Moon Garden, 309 (564); Transparent Sculpture,

New York School: 21, 118, 222, 248, 249, 251, 265–284, 298, 304, 314, 319, 321, 376, 381
 Newman, Barnett: 159, 222, 265, 275–277, 278, 299, 314, 315, 321, 358, 376, 406; Vr Heroicus

Nicholson, Ben: 238, 240, 241, 266, 334; Painted Relief, 241 (425)
 Niemeyer, Oscar: 330, 351; Brasilia, 330, 351 (655)

Nietzsche, Friedrich Wilhelm: 166, 259, 277, 278

Noguchi, Isamu: 283–284, 403; Kouris, 283 (510); To Love, 284 (511)

Noland, Kenneth: 283, 303, 315, 317, 335, 357, 405; Trans Flux, 317 (580)

Nolde, Emil: 112, 396; The Last Supper, 114 (185); Tropical Sun, 115 (186)

O'Keefe, Georgia: 250–255; Blue Morning Glories, New Mexico, II, 253 (448); Cow's Skull: Red, White, and Blue, 255 (454); Light Coming on the

Olbrich, Joseph Maria: 86, 87, 95, 96: Secession

Gallery, Vienna, 87 (135) Oldenburg, Claes: 97, 299, 305, 311–313, 373, 375,

398; Clothespin, 373 (711); Giant Hamburger with Pickle Attached, Slice of Layer Cake, 312 (572);

Model (Ghost) Typewriter, 312 (573); Proposed Colossal Monument for Park Avenue, 313 (574)

172, 244, 246, 318, 319, 322, 326, 327, 336-

Olitski, Jules: 318; *Green Goes Around*, 318 (582) Oliva, Achille Bonito: 395

Orozco, Gabriel: 424; Dents de Lion, 423; Penske

Project, 424 (822) Orozco, José Clemente: 215, 258–259; Modern

Migration of the Spirit, 259 (464) Orphism: 83, 150, 156, 250, 254, 285 Oud, J.J.P.: 159, 161, 201–203; Worker's Housing

Ozenfant, Amédée: 150, 199, 242, 267; The Vases,

Paik, Nam June: 366, 367, 427; Fin de Siècle II, 366

(690); TV Bra for Living Sculpture, 367

Oppenheim, Meret: 187; Object, 187 (322)

Estate, Hook of Holland, 202 (351)

Oursler, Tony: 421; Untitled, 421 (816)

New Criticality: 393, 419–420 New Image: 358, 359, 381–387, 288 New Objectivity (*Die Neue Sachlichkeit*): 129

New Poverty: 393, 419–420 New Realism: 329–331, 376, 386 New Wave: 390, 398, 438

Sublimis, 276 (496)

Newton, Helmut: 419

Nitsch, Hermann: 368

Nouvel, Jean: 437, 438

Plains III, 251 (446)

ontology, defined: 394

Op Art:

339, 406

outsider art: 419

150, 199, 242 (42)

Novak, Barbara: 265

O'Hara, Frank: 298

primitive art: 13, 43, 102, 109, 112, 117, 124, 134–136, 138, 197, 225, 238

primitivism: 68, 71, 115, 117, 124, 134, 135, 164, 165, 167, 257

Process Art: 324, 358, 368-370

Proun: 242, 243 Purism/Purists: 74, 76, 94, 189–199, 205, 207, 234,

241, 242, 285, 337, 345 Purvear, Martin: 402–403; *Lever #2*, 403 (778)

Puvis de Chavannes, Pierre: 24, 34, 35, 37–39, 250; Summer, 35 (36)

Rae, Fiona: 423, 425; Evil Dead 2, 423 (819) Ratcliff, Carter: 411

Rauschenberg, Robert: 299, 302, 308, 313, 314, 321, 360; Bed. 301 (544); Erased de Kooning

Drawing, 360; *Monogram*, 301 (545); *Pelican*, 365 (688); "portrait" of Iris Clert, 360; *Rebus*, 300 (543): Rodeo Palace (Spread) 302 (546) Ray, Man: 173, 186, 187; *Gift*, 173 (297), 186, 266

Rayonism: 156

Rayonism: 156 Raysse, Martial: 334; *A*, 334 (621) Readymades: 169–173, 186, 187, 283, 299, 303,

304, 321, 358, 360, 409 Realism/Realists: 15–20, 21, 37, 61, 63, 112, 164, 179, 215, 227, 248, 256, 273, 295, 302, 276-379,

381-382 Redon, Odilon: 12, 24, 37, 38; Cyclops, 37 (39);

Head of Orpheus Floating on the Waters, 37 (40) Regionalism: 257, 264, 267

Reinhardt, Ad: 159, 278, 279, 298, 314, 321, 325, 384; Abstract Painting, 279 (502)
 Renoir, Pierre-Auguste: 19, 20, 24, 27, 52, 92; Bathers, 20; Dancing at the Moulin de la Galette,

24, 27; *The Luncheon of the Boating Party*, 20 (18) Richardson, Henry Hobson: 84, 85, 90, 95, 350;

Marshall Field Warehouse, 85 (131), 90 Richier, Germaine: 280, 290, 295, 375; The

Bullfight, 290 (526) Bullight, 290 (526) Richter, Gerhard: 390, 392, 393–394, 403, 404; Juni, 394 (760); 572-5 Wiesental, 392, 393 (759)

Richter, Hans: 167, 243, 338

Rickey, George: 326: Two Lines Oblique, 326 (604) Rickey, George, 520, 700 Entry Complet, 520 (007) Rietveld, Gerrit: 159, 161, 201–203, 205, 390; Schroeder House, Utrecht, 202 (352)

Riley, Bridget: 336, 405; *Santo II*, 337 (627) Rimbaud, Arthur: 18, 163, 165, 179, 420

Rivera, Diego: 258, 259; The Fertile Earth, 259 (463) Rivers, Larry: 299, 300; Washington Crossing the

Delaware, 300 (542) Rockburne, Dorothea: 323; *Levelling*, 323 (595) Rockefeller Center, New York): 211, 214 (372)

Rockman, Alexis: 428; *Harvest*, 428 (829) Rodchencko, Alexander: 158, 159, 242, 243, 265;

Suspended Construction in Space, 158 (270) Rodin, Auguste: 29, 61, 62–72, 74, 77, 387; *The Age* of Bronze, 63 (89); The Burghers of Calais, 66 (92); Eve, 65; The Gates of Hell, 65 (91); The

Man with the Broken Nose, 63 (89); Monument to Balzac, 66 (93); The Old Courtesan, 65; The Three Shades, 65; The Thinker, 64, 65, 386; The Walking Man, 64 (90) Rogers, James Gamble: 433; Sterling Memorial Library, Yale, 433

Rogers, Richard: 438, 439; Pompidou Center, Paris (with Renzo Piano), 438 (851), 439

Romanticism: 13, 15, 16, 18, 40, 85, 103, 210, 218, 238, 240, 392

Rose + Cross Salon (Paris): 38

Rose, Barbara: 321 Rosenberg, Harold: 267, 268, 280, 298, 372

Rosenblum, Robert: 144, 276, 397, 423 Rosenquist, James: 305, 306, 396; *Flamingo*

Capsule, 306 (555) Rossetti, Dante Gabriel: 26; Astarte Syriaca, 36 (37) Rossi, Aldo: 436; Town Hall, Borgoricco, 436 (846) Rosso, Medardo: 68; Flesh of Others, 68 (96) Rotella, Mimmo: 331, 386

Rothenberg, Susan; 381, 382; Wishbone, 382 (731)
 Rothko, Mark: 222, 265, 267, 275–278, 298, 299, 314, 315, 358; Maroon on Blue, 276 (497)

Rouault, Georges: 102; Le Chahut, 107 (171); The

Old King, 107 (172) Rousseau, Henri (le Douanier): 117, 138, 163-165.

167, 185, 250, 419; The Dream, 164 (278) Rozanova, Olga: 158, 159; Untitled (Green Stripe),

158 (268) Rubin, William S.: 137-139, 191

Rückriem, Ulrich: 417 Rudolph, Paul: 198, 342, 351, 352, 353, 355; Art and Architecture Building, Yale University, 352 (659)

Rugoff, Ralph: 363, 421

Index 448

Rugon, Ruph. 505, 121 Ruscha, Ed: 363, 364; Every Building on the Sunset Strip, 364 (682); She Gets Angry at Him, 363 (681)

Bussell, Johns 76, 383
 Russell, Morgan: 354, 255; Synchromy in Orange: To Form, 254, 255, (453)
 Russian avant-garde: 146, 156–160, 205, 206, 265

Ryder, Albert Pinkham: 248, 273; Moonlight Marine, 248 (440)

Ryman, Robert: 321; Classico III, 321 (592)

Saarinen, Eero: 95, 345, 347-350, 422; Beaumo Theater, 349: Dulles International Airport, 347 (648); General Motors Technical Center, 348; Kresge Auditorium, MIT, 348; TWA Terminal, 347 (647), 431

Saarinen, Eliel: 95; Chicago Tribune Tower, 95 (153); Railway Station, Helsinki, 95 (152) Safdi, Moshe: 356; Habitat, Expo '67, Montreal,

356 (667) Salle, David: 389, 391, 396–397, 403, 406;

Muscular Paper, 396, 397 (766) Samaras, Lucas: 284, 310, 368, 369; Untitled, 369 (695); Untitled Box No. 3, 310 (566)

(695); Untitled Box No. 3, 310 (566) Sandler, Irving: 298 Sant Elia, Antonio: 98, 100, 198, 201, 203, 204, 209; Project for a Futurist City, 100 (163)

Sartre, Jean-Paul: 285, 288, 289

Sartre, Jean-Paul: 285, 288, 289 Saussure, Ferdinand de: 359 Schamberg, Morton: 173, 333; *God*, 173 (296) Schapiro, Miriam: 380 Scharf, Kenny: 398, 400, 420, 426; *Sajippe Kraka*

Jouiesh 399 (771) 400 Schiele, Egon: 37, 59, 66, 125, 126, 409; Embrace

- 125 (206); Portrait of the Painter Paris von *Gütersloh*, 125 (205) Schindler, Rudolph: 100, 212; Lovell House,
- Newport Beach, Calif., 212 (367) Schjedahl, Peter: 422, 426
- Schmidt-Rotluff Karl: 112, 114, 126: Woman at Her

Toilette, 114 (184) Schnabel, Julian: 389, 391, 396; *Vita*, 396, 397 (765) Schöffer, Nicolas: 246, 338, 339; Chronos 8, 246, 339 (630)

"School of London": 375 School of Visual Arts (svA): 398, 399, 400, 425

Schwartzkogler, Rudolf: 368 Schwendenwin, Jude: 426

Schwitters, Kurt: 152, 153, 174, 175, 215, 278, 293, 330, 392; Merzbau, 174 (301); Merz Construction,

152 (256); Merz 94 Grünflec, 175 (300) Scott Brown, Denise: 431; Learning from Las Vegas, 431; Sainsbury Wing, National Gallery, London (with Robert Venturi), 423 (820)

Scully, Sean: 405; A Bedroom in Venice, 405 (797) Scully, Vincent: 431

Secession (Sezession): Berlin, 101: Vienna, 86, 87 (135), 95, 435

Segal, George: 311, 378, 379, 387, 400, 417;

Segar, George S. A., 311 (569) semiotics, semiology: 360–361, 362, 389-390, 430 Sensation (exhibition, London): 422, 423 serial art: 323, 326

Serra. Richard: 357, 373–374, 381, 409, 414; Tilted Arc, 373 (712), 374, 381

Serrano, Andres: 416, 426; Piss Christ, 416

Sérusier, Paul: 42, 43, 48; *The Talisman*, 42 (48) Seuphor, Michel: 246, 334

Seurat, Georges: 13, 20, 24–28, 34, 45, 52, 54, 92, 132, 179, 250, 401; Bathers, Anvers, 24 (22); The

Bec du Hoc at Grandchamp, 25 (23); The Circus 27 (26); A Sunday Afternoon on the Island of La Grande Jatte, 26 (25); Woman Fishing, 25 (24) Severini, Gino: 150, 152–154, 166; Dynamic Hieroglyphic of the Bal Tabarin, 154 (259)

Shahn, Ben: 258, 265, 333; The Blind Accordion

Player, 258 (461)

Shapiro, Joel: 387, 400; *Untitled*, 387 (745) Sharoun, Hans: 199–201; Berlin Philharmonic, 201

(349) Sheeler, Charles: 173, 254; River Rouge Plant, 173,

254 (452) Sherman, Cindy: 390, 391, 407, 408–409, 415, 418; Untitled, 409 (790); Untitled Film Still, 390 (753) Shreve, Lamb and Harmon: 210, 264; Empire State

Building, 210 (364) Siegelaub, Seth: 362; *The Xerox Book*, 363

Signac, Paul: 24, 26, 45, 54, 55, 92, 102; Against the Enamel of a Background Rhythmic with Beats and Angles, Tones and Colors: Portrait of M. Félix

Fénénon in 1890, 54 (71) Simonds, Charles: 372, 373, 387, 400; *Dwellings*

(Part III), 372, 373 (710) Siqueiros, David Alfaro: 215, 260, 388; Portrait of

the Bourgeoisie, 215, 260 (465) Site Works: 358, 371, 372–374

'situational" art: 372

Skidmore, Owings and Merrill: Level House, New York, 342 (637); Sears Roebuck Tower, Chicago, 342 (639)

Sloan, John: 249: Hairdresser's Window, 249 (442) Snith, David: 162, 193, 264, 265, 281–283, 297, 305, 336, 371, 387; Australia, 264, 282 (507).

- 283, 297, 336; Cubi XVIII, XVII, XIX, 282 (509); The Rape, 281 (506); Tankotem, 282 (508)
- Smith, Kiki: 416–417; Virgin Mary, 416 (805), 417 Smith, Roberta: 385, 388, 399, 411, 418, 429

Smith, Tony: 262, 324, 336, 357; *Willy*, 324 (597) Smithson, Robert: 97, 371; *Spiral Jetty*, 371 (705) Socialist (or Social) Realism/Realists: 16, 159, 215.

234, 257, 258, 260, 267, 272, 281, 392, 393, 412 Soleri, Paolo: 356; "Acrosanti," 356 (666)

Solomon, Deborah: 375 Sonnier, Keith: 370

Soto, Jesús Rafael: 338, 339; Yellow Flex, 339 (632) Soulages, Pierre: 286, 316, 358; *Painting*, 286 (515) Sounderbund exhibition, Cologne: 250

Soutine, Chaim: 69, 165, 216, 217, 265, 271; The Communicant, 216 (375)

St. Martin's School of Art, London: 368, 372, 402

Staël, Nicolas de: 285, 286-288; Composition of Roof Tops, 288 (520) Stankiewicz, Richard: 175, 306, 308, 330; Untitled. Unitary Objects: 369, 371

(373) 217

349 (651)

video: 413

Vaisman, Mever: 414

Utrillo, Maurice: 52, 215, 217; Rue des saules, 216

Utzon, Jorn: 349; Sydney Opera House, Australia,

Valadon, Suzanne: 52, 215; *After the Bath*, 53 (67) Vallotton, Félix: 49; *Whirlwind*, 49 (61), 130

van de Velde, Henry: 54–56, 58, 91–93, 198; Abstract Composition, 56 (75); Dominical, 56 (76)

van Doesburg, Theo: 76, 159, 161, 162, 174, 201–203, 240, 242, 245, 334, 335; Color Study for a Building, 203 (353); Composition in

Vasarely, Victor: 336, Orion MC, 337 (626) Venturi, Robert: 343, 403, 431–432; Complexity and Contradiction in Architecture, 431; Guild

House, 431 (835), 432; Sainsbury Wing, National Gallery, London, 432 (836)

Venturi, Scott Brown and Associates: 432, Sainsbury Wing, National Gallery, London, 432 (836)

Villeglé, Jacques de la: 331, 386; Rue du Grenier

Viola, Bill: 426; *The Greeting*, 427 (828) Viollet-le-Duc, Eugène: 83–85, 92; Concert Hall,

Viollet-le-Duc, Eugene. 05-05, 22, 201011 (1990)
 Vlaminck, Maurice de: 102, 107, 108; Dancer at the "Rat Mort," 107 (170)
 Vollard, Ambroise: 30, 32, 33, 102, 141, 250

Voysey, Charles F.A.: 84–86, 88, 96; The Orchard,

Chorley Wood, Hertfordshire, 88 (137) Vuillard, Édouard: 43, 48–50, 68, 101, 376, 405;

Wagner, Otto: 84–86, 91, 95, 96, 100, 200, 201, 350, 426; St. Leopold, Steinhof Asylum, 86 (134); Post Office Savings Bank, Vienna, 85

Warhol, Andy: 271, 299, 305, 307, 388, 389, 391, 393, 395, 408, 419. 423; Green Coca Cola Bottles, 307 (558); Mao 6, 307 (559);

Retrospective Painting (Reversal Series), 388

Weber, Max: 250, 252; Chinese Restaurant, 250

Wegman, William: 386–387; Heels, 386, 387 (744) Wegman, William: 386–387; Heels, 386, 387 (744) Weiner, Lawrence, 361, 362; Many Colored Objects, Placed Side by Side to Form a Row of Many Colored Objects, 361 (676)

Wesselmann, Tom: 305, 307; Long Delayed Nude,

Whistler, James McNeill: 247; Peacock Room, 57

White, Stanford: 433; see McKim, Mead and White

Whitehead, Alfred North: 376 Whiteread, Rachel: 414-415, 422; House, 414

Wigley, Mark: 437 Wilford, Michael: 435–436; New State Museum

and Theater, Stuttgart (with James Stirling), 435

Winsor, Jackie: 400-401, 403, 413; Interior Sphere

Wojnarowicz, David: 420–421, 425; Memories that Smell like Gasoline, 421; Where I'll Go If After

I'm Gone, 420 (814) Wolfe, Tom: 390; The Bonfire of the Vanities, 390

Wols: 285, 286, 288; Champigny Blue, 288 (519) Wood, Grant: 257; American Gothic, 257 (459)

WPA (Works Progress Administration): 257, 258, 264, 265, 298 Wright, Frank Lloyd: 85, 86, 88-91, 95–100, 198,

201, 212–214, 324, 341, 345, 346, 348, 349, 352, 356, 433; Broadacre City, 213, 356; Farnsworth

House, Plano, Ill., 345; Kaufmann House, Bear Run, Pa., 213 (371); Imperial Hotel, Tokyo,

(159); Larkin Building, Buffalo, N.Y., 99 (161, 162); Robie House, Chicago, 98 (158); S.C. Johnson and Son Co., Racine, Wisc., 213 (369);

Solomon R. Guggenheim Museum, 213 (370), 440; Unity Church, Oak Park, Ill., 99 (160); Ward

Willetts House, Highland Park, Ill., 97 (157)

YBAS ("young British artists"): 422-423: see also Hirst, Damien; Harvey, Marcus; Rae, Fiona; and Chapman, Dinos and Jake

Yuskavage, Lisa: 428-429; Bad Babies, 428; Big

Blondes, 428; Honeymoon, 428, 429 (830)

Woodrow, Bill: 391, 402; Eclipse, 402 (777)

(801): Model for the Judenplatz Wien Monument and Memorial Site, 414, 415 (802)

Weissenhof project, Stuttgart: 198, 201, 205 Wendler, John: 363; *The Xerox Book*, 363

Werkbund Exhibition, Cologne: 198

Vienna Secession: 59, 60, 88, 91, 95, 96, 200

Saint-Lazare, 331 (615) Villon, Jacques: 147, 148, 169, 250

Vordemberge-Gildewart, Friedrich: 334 Vorticism: 236

Misia and Vallotton, 49 (62)

(132), 435

(747)

(443)

308 (560)

(78)

(829)

Piece, 400 (773)

Worrigner, Wilhelm: 112

Zakanitch, Robert: 380

Zurbarán, Francisco: 376

Wittgenstein, Ludwig: 359, 362, 435

Westermann, H.C.: 370

Halftones, 161 (275) Vantongerloo, Georges: 161, 246

308 (561)

Starn. Mike and Doug: 411; Yellow and Blue Raft of the Medusa, 410, 411 (795) Steichen, Edward: 250

Steiner, Rudolph: 200; Goetheanum II, Dornach, Switzerland, 200 (347)

Switzerland, 200 (347)
 Stella, Frank: 303, 305, 320–321, 324, 357, 359, 360, 380, 383, 385, 391, 392, 403, 404, 405, 409, 419; Bonin Night Heron II, 360 (678); "Die Fahne Hoch", 321 (589); Hagmatana I, 321 (590); Shards III, 395 (766)

Stella, Joseph: 250, 252, 253; Battle of Lights, 253

Stern, Robert A.M.: 433: Ohrstrom Library, St.

Stevens, Wallace: 435 Stieglitz, Alfred: 169, 172, 173, 249–252, 255, 257

Still, Clyfford: 265, 267, 275, 278, 279, 298, 318,

Stirling, James: 350, 351, 354, 355, 435–436;
 Engineering Laboratories, Leicester U., 354 (661); New State Museum and Theater, Stuttgart

(with Michael Wilford), 435 (830), 436 Stockholder, Jessica: 424–423; Your Skin in This

Storrs, John: 263–264; Forms in Space, 263 (475)

Struth, Thomas: 426; Louvre 4, Paris, 427 (827)

Sullivan, Louis: 84, 90, 91, 95, 97, 98, 198, 212, 344; Carson, Pirie, Scott Store, Chicago, 90, 91; Transportation Building (Golden Portal), World's

Columbian Exposition, Chicago, 90 (141); Wainwright Building, St. Louis, 90 Suprematism: 148, 157–159, 205, 242, 243 Surrealism/Surrealists: 9, 12, 15, 38, 84, 118, 123,

136, 145, 164–169, 171–173, 175, 177, 178–195, 199, 215, 223, 224, 226, 227, 231, 232, 234, 236, 241, 242, 264–268, 270, 271, 273, 277, 278, 280, 283–285, 292, 294, 301, 302, 305, 308, 310, 370,

Suvero, Mark di: 309, 330; For Lady Day, 309 (563)

Symbolism: 13, 21, 22, 24, 34–40, 42, 44, 47, 63, 64, 66, 67, 70, 76, 79, 91, 101–103, 110, 113, 117,

118, 121, 125, 127-129, 132-134, 137, 138, 152,

116, 121, 125, 127–125, 152–154, 157, 156, 155, 155, 155, 155, 157, 158, 163, 165, 166, 191, 223, 224, 232, 234, 250, 252, 278, 283, 286, 287, 297, 428

Systemic Art: 321, 323, 335; see also Minimalism

Taaffe, Philip: 406-407; Easter Choir, 406 (785)

tachisme, Tachism: 286–288, 295, 330, 334, 335, 369, 371, 392, 393, 423

Tamayo, Rufino: 215, 260: Man Contemplating the

Firmament, 260 (466) Tange, Kenzo: 342, 350–352; 439; National

Gymnasia, Tokyo, 352 (657); Town Hall, Kurashiki, 351 (656)

Tanguy, Yves: 167, 182, 183–184, 188, 194, 267, 268; Mama, Papa Is Wounded!, 183 (314); Time

without Change, 184 (315) Tàpies, Antoni: 287, 358; Ochre Relief With Rose,

Tatlin, Vladimir: 158, 159, 203–204, 234, 242, 243,

265; Counter-Relief, 158 (269); Monument to the Third International, 204 (159)

Taut, Bruno: 197, 199–201, 210, 343, 350, 354; "Crystal House in the Mountains," 197 (342); Glass House, Werkbund Exhibition, 200 (345);

Modern Architecture, 197 Terragni, Giuseppe: 209; Casa del Fascio (Casa del

The Bridge (*Die Brücke*): 15, 49, 101, 102, 112, 130

Tillmans, Wolfgang: 423–424; Installation (Regen

Tinguely, Jean: 329, 330; *Homage to New York*, 330 (611); *Pop. Hop. and Op & Co.*, 330 (610) Tisdall, Caroline: 367, 372

Torres, Rigoberto: see Ahearn, John Toulouse-Lautrec, Henri de: 28, 39, 45, 50-54, 58,

102 107 133 134 215 250 428. At the Moulin

Rouge, 53 (68); Elles, 53 (69); In the Salon of the

Rue des Moulins, 51 (66): Jane Avril at the Jardin de Paris, 51 (64); The Trace-Horse, 51 (65) transavanguardia, Transavantgarde: 395–396

Trova, Ernest: 327, 328; Falling Man (Carman), 327 (606)

Tschumi Bernard: 437: Parc de la Villette, Paris

⁴⁵⁷ (0⁴⁹)
 ⁴⁵⁷ Ucker, William: 336, 337; Memphis, 337 (625)
 Turner, J.M.W.: 11, 13, 15, 20, 106, 278; Rockets and Blue Lights, 14 (10)

Tuttle, Richard: 369; *Pale-Blue Cloth Piece*, 369 (697) Twombly, Cy: 391, 392, 396; *Untitled*, 391 (756)

Projects, Los Angeles), 423 (821) "Times Square Show": 399, 400

Tobey, Mark: 275; Tundra, 275 (495)

Weather Bourne Eve-Threads & Swollen Perfume,

Stein family: 105, 110, 136, 138, 250 Steinbach, Heim: 408

(450)

Paul's School, 433 (838) Stevens, Mark: 422

407; Painting, 279 (501)

424-425 (823)

Storr Robert 406

structuralism: 359

413 429

Synchronism: 254, 257

287 (517)

Populo), 209 (362)

Tomkins, Calvin: 373

437 (849)

Tzara, Tristan: 167, 168, 173

theory: 359